ENCYCLOPEDIA OF
Twentieth–Century Photography

BOARD OF ADVISORS

Ellen Handy
Art History Faculty, Art Department
City College of New York
New York, New York

Mark Haworth-Booth
Senior Curator of Photographs
Victoria and Albert Museum
London, United Kingdom

Lynn Herbert
Senior Curator
Contemporary Arts Museum
Houston, Texas

Eikoh Hosoe
Photographer and Professor
Tokyo, Japan

John P. Jacob
Director
Photography Curators Resource
Blue Hill, Maine

Deborah Klochko
Director
Ansel Adams Center for Photography
San Francisco, California

Ryszard Kluszczynski
Curator and Writer
Warsaw, Poland

Laura Letinsky
Faculty, Committee on the Visual Arts
University of Chicago
Chicago, Illinois

Asko Mäkelä
Director, Finnish Museum of Photography
Helsinki, Finland

Arthur Ollman
Director and Curator
Museum of Photographic Arts
San Diego, California

Esther G. Parada
Faculty, Art Department, School of Art and Design
University of Illinois
Chicago, Illinois

Ulrich Pohlmann
Director
Münchner Stadtmuseum
München, Germany

Charles Dare Scheips
Archivist
Condé Nast Publications
New York, New York

Charlotte Townsend-Gault
Faculty, Department of Fine Arts
University of British Columbia
Vancouver, Canada

Gary van Wyk
Curator
Axis Gallery
New York, New York

Katherine Ware
Curator of Photographs
Philadelphia Museum of Art
Philadelphia, Pennsylvania

Deborah Willis-Kennedy
Curator
Anacostia Museum and Center for African American History and Culture
Smithsonian Institution
Washington, D.C.

Trudy Wilner Stack
Curator, Historian
Tucson, Arizona

Paul Wombell
Director
The Photographers' Gallery
London, United Kingdom

Tim Wride
Curator of Photography
Los Angeles County Museum of Art
Los Angeles, California

ENCYCLOPEDIA OF
Twentieth–Century Photography

VOLUME 2
G–N
INDEX

Lynne Warren
EDITOR

Routledge
Taylor & Francis Group
New York London

Published in 2006 by
Routledge
Taylor & Francis Group
270 Madison Avenue
New York, NY 10016

Published in Great Britain by
Routledge
Taylor & Francis Group
2 Park Square
Milton Park, Abingdon
Oxon OX14 4RN

Printed in the United States of America on acid-free paper
10 9 8 7 6 5 4 3 2 1

International Standard Book Number-10: 1-57958-393-8 (Hardcover)
International Standard Book Number-13: 978-1-57958-393-4 (Hardcover)
Library of Congress Card Number 2005046287

Library of Congress Cataloging-in-Publication Data

Encyclopedia of twentieth-century photography / Lynne Warren, editor.
 p. cm.
 Includes bibliographical references and index.
 ISBN 1-57958-393-8 (set : alk. paper) -- ISBN 0-415-97665-0 (vol. 1: alk. paper) -- ISBN 0-415-97666-9 (vol. 2 : alk. paper) -- ISBN 0-415-97667-7 (vol. 3 : alk. paper)
 Photography, Artistic. I. Title: Encyclopedia of 20th century photography. II. Warren, Lynne.

TR642.E5 2005
770'.9'0403--dc22 2005046287

Taylor & Francis Group is the Academic Division of T&F Informa plc.

Visit the Taylor & Francis Web site at
http://www.taylorandfrancis.com

and the Routledge Web site at
http://www.routledge-ny.com

Contents

CONTRIBUTORS

Stuart Alexander

Jenny Allred Redmann

Vangelis Athanassopoulos

Andrew Atkinson

Lane Barden

Suvash Barden

Nancy Barr

Terry Barrett

Anne Barthélemy

Rob Baum

Lili Bezner

Momolina Bhattacharyya

Heather Blaha

Anne Blecksmith

Nancy Breslin

Amanda Brown

Leslie K. Brown

Wolfgang Brueckle

Catherine Burdick

Katherine Bussard

Matthew Butson

R.M. Callender

Michael Carlebach

Justin Carville

Peter Caws

James Charnock

Milan Chlumsky

Vincent Cianni

Yves Clemmen

Alan Cohen

Jill Conner

Leslie Humm Cormier

Andy Crank

Mike Crawford

Isobel Crombie

Cristina Cuevas-Wolf

Thomas Cyril

Lorraine Anne Davis

Scott Davis

Peter Decherney

Anthony DeGeorge

Margaret Denny

Penelope Dixon

Julia Dolan

Donald A. Rosenthal

Petra Dreiser

Erina Duganne

Jeffrey Edelstein

CONTRIBUTORS

Diana Edkins

Jan Estep

Hannah Feldman

Jane Fletcher

Stacey Fox

Jason Francisco

Daniel Friedman

Maki Fukuoka

John Fuller

Michel Gaboury

Monika Kin Gagnon

William Ganis

Daniella Geo

Christian Gerstheimer

Constance W. Glenn

Renata Golden

Richard Gordon

Sara Greenberger

Kristen Gresh

Kristina Grub

Justin Gustainis

David Eduard Haberstich

Sophie Hackett

Matthias Harder

Lindsay Harris

Janice Hart

Katharina Hausel

Brigitte Hausmann

Richard Haw

Jennifer Headley

Lisa Henry

Scarlett Higgins

Randy Hines

Katherine Hoffman

Ali Hossaini

Kirsten Hoving

Andrew Howe

Richard Howells

Christina Ionescu

Brandi Iryshe

Steven Jacobs

Philippe Jarjat

Karen Jenkins

Martyn Jolly

Birgit Kaufer

Rachel Keith

Jean Kempf

Kay Kenny

Geraldine Kiefer

Laura Kleger

Peter Kloehn

Lilly Koltun

Sabine Kriebel

Yves Laberge

Kimberly Lamm

John H. Lawrence

Susan Laxton

Bob Lazaroff

Peter Le Grand

Danielle F. M. Leenaerts

Marc Leverette

Linda Levitt

Tricia R. Louvar

Sarah Lowe

Darwin Marable

Sara L. Marion

Kelly Maron

Patrick Mathieu

Stacey McCarroll

Jim McDonald

Sarah McDonald

Bruce McKaig

Lambert McLaurin

Julie Mellby

Ara Merjian

Marco Merkli

Johanna Mizgala

Dominic Molon

Stephen Monteiro

Jean-Luc Monterosso

Allison M. Moore

Susan Morgan

Rebecca Morse

John Mraz

Kevin J. Mulhearn

Alla Myzelev

Yasufumi Nakamori

Caryn E. Neumann

Nathalie Neumann

Jennifer Olson-Rudenko

Robert Oventile

Daniel Palmer

J. P. Park

Sara-Jane Parsons

Martin Patrick

Lori Pauli

Nancy Pedri

John Peffer

Michele Penhall

Nuno Pinheiro

Justin Pittas-Giroux

Mark Pohlad

Maren Polte

Luca Prono

Laurel Ptak

Mark Rawlinson

Shirley Read

Kevin Reilly

Melissa Renn

Yolanda Retter

Lyle Rexer

Kate Rhodes

Edward A. Riedinger

Leesa Rittelmann

Claudia Rivers

Jean Robertson

Naomi Rosenblum

Cynthia Elyce Rubin

Mark Rudnicki

Esther Ruelfs

Roberta Russo

Rolf Sachsse

Marisa Sanchez

Manuel Santos

CONTRIBUTORS

Roger Sayre

Rudolf Scheutle

Elizabeth Schlatter

Franz-Xaver Schlegel

Franziska Schmidt

Jennifer Schneider

Savannah Schroll

Danielle Schwartz

Erin Schwartz

Rebecca Senf

Jeffrey Shantz

Roni Shapira

Carla Rose Shapiro

Nancy Shawcross

Nabeela Sheikh

Scott Sherer

M. Kathryn Shields

Elizabeth Siegel

Christye Sisson

George Slade

Lynn Somers-Davis

Linda Steer

John Stomberg

Ryuji Suzuki

Johan Swinnen

A. Krista Sykes

Blaise Tobia

Susan Todd-Raque

Rebecca Tolley-Stokes

Charlotte Townsend-Gault

Peter Turner

Stijn Van De Vyver

Gary van Wyk

Miriam Voss

Scott Walden

Rachel K. Ward

Grant Warren

Lynne Warren

Shannon Wearing

Max Weintraub

Sarah Wheeler

Elizabeth K. Whiting

Renate Wickens

Brian Winkenweder

Marianne Berger Woods

Kelly Xintaris

Nancy Yakimoski

Shin-Yi Yang

Janet A. Yates

Ronald Young

Stephenie Young

Raul Zamudio

Leon Zimlich

Annalisa Zox-Weaver

Catherine Zuromkis

ALPHABETICAL LIST OF ENTRIES

THEMATIC LIST OF ENTRIES

THEMATIC LIST OF ENTRIES

Franck, Martine
Frank, Robert
Freund, Gisèle
Fukase, Masahisa
Fukuda, Miran
Funke, Jaromir
Furuya, Seiichi
Fuss, Adam

Gelpke, Andre
Gerz, Jochen
Giacomelli, Mario
Gibson, Ralph
Gidal, N. Tim
Gilbert & George
Gilpin, Laura
Gloaguen, Hervé
Gohlke, Frank
Goldin, Nan
Gowin, Emmet
Graham, Dan
Graham, Paul
Grossman, Sid
Gursky, Andreas
Gutmann, John

Haas, Ernst
Hahn, Betty
Hajek-Halke, Heinz
Halsman, Philippe
Hamaya, Hiroshi
Hammarskiöld, Hans
Hartmann, Erich
Heartfield, John (Helmut Herzfelde)
Heath, David Martin
Heinecken, Robert
Hellebrand, Nancy
Henderson, Nigel
Henri, Florence
Hers, François
Hilliard, John
Hine, Lewis
Hiro
Höch, Hannah
Horst, Horst P.
Hosoe, Eikoh
Hoyningen-Huene, George
Hurrell, George
Hütte, Axel

Ishimoto, Yasuhiro
Iturbide, Graciela
Izis (Israel Bidermanas)

Jacobi, Lotte

Janah, Sunil
Jones, Harold
Jones, Pirkle
Josephson, Kenneth

Karsh, Yousuf
Käsebier, Gertrude
Kawada, Kikuji
Keetman, Peter
Keïta, Seydou
Kertész, André
Kessels, Willy
Kesting, Edmund
Khaldei, Yevgeny (Chaldej, Jewgeni)
Killip, Chris
Klein, Aart
Klein, Astrid
Klein, William
Klett, Mark
Koudelka, Josef
Kozloff, Max
Krauss, Rosalind
Kruger, Barbara
Krull, Germaine

Lange, Dorothea
Lartigue, Jacques Henri
Laughlin, Clarence John
Lebeck, Robert
Lee, Russell
Leibovitz, Annie
Lemagny, Jean Claude
Lerski, Helmar
Levinthal, David
Levi-Strauss, Claude
Levitt, Helen
Levy, Julien
Liberman, Alexander
Liebling, Jerome
Link, O. Winston
List, Herbert
Long, Richard
Lüthi, Urs
Lynes, George Platt
Lyon, Danny
Lyons, Nathan

Maar, Dora
Madame d'Ora
Man Ray
Man, Felix H.
Mapplethorpe, Robert
Mark, Mary Ellen
McBean, Angus
Meatyard, Ralph Eugene

Publications and Publishers

Regions

Topics and Terms

THEMATIC LIST OF ENTRIES

GLOSSARY

Editor's note: These definitions err on the side of succinctness and are intended to be beginning points for the serious student. An attempt to standardize terminology commonly found in the medium of fine arts photographs that avoids copyrighted term or trade names ("dye-destruction print" in lieu of "Cibachrome" and so on) has been made using guidelines set forth by the J. Paul Getty Institute. In acknowledgment of the increase in collecting vintage prints and the perennial interest in historical processes, many nineteenth century processes and obsolete terms are included.

Cross referencing within the glossary is indicated by italics; encyclopedia entries are indicated by small capitals.

Additive colors The primary colors of red, green and blue which are mixed to form all other colors in photographic reproduction. See entry COLOR THEORY: NATURAL AND SYNTHETIC.

Agfacolor Trade name for a subtractive color film manufactured by the European company Agfa-Gevaert; analogous to Kodachrome and Ansocolor.

Albumen print Prints obtained from a process in wide use during the nineteenth century in which paper is prepared with an albumen emulsion obtained from egg whites and made light sensitive with a silver nitrate solution. See also *Collodion process*; *Dry plate processes*.

Amberlith An orange acetate historically used for masking mechanicals during the process of preparing plates for commercial printing. The area so masked photographs as black to the camera, printing clear on the resulting positive film. See also *Rubylith*.

Ambrotype An image created by the collodion process, historically on glass, which gives the illusion of being positive when placed against a dark backing, often a layer of black lacquer, paper, or velvet. Also see *Ferrotype*.

Anamorphic image An image featuring differing scales of magnification across the picture plane, especially varying along the vertical and horizontal axes, with the result being extreme distortion.

Aniline A rapid-drying oil-based solvent used in the preparation of dyes and inks for photographic applications.

Aniline process A method of making prints directly from line art (drawings) on translucent materials bypassing the need for a negative. Also see *Diazo process*.

Aniline printing See *Flexography*.

Angle of incidence The measurement in degrees in terms of the deviation from the perpendicular of the angle at which light hits a surface.

Angle of view The measurement in degrees of the angle formed by lines projected from the optical center of a lens to the edges of the field of view. This measurement is used to identify lenses and their appropriateness to capture various widths or degrees of actual space in a photographic representation, thus an extreme telephoto lens captures between 6 and 15°; normal lens generally fall in the 40 to 100° range; a "fisheye" wide-angle is 150 to 200° (or more).

Anscocolor Trade name of a subtractive color film manufactured by the European company GAF Corporation.

Anti-halation layer The light absorbing layer in raw stock that prevents reflection of light back into the light-sensitive emulsion, preventing unwanted fogging.

Aristotype Trade name for a variety of non-albumen printing papers which became a general term; largely obsolete in the twentieth century.

Artigue process Variation on the carbon process; largely obsolete in the twentieth century.

GLOSSARY

Aspect ratio The ratio between height and width in photographic applications.

Autochrome One of the first commercially viable color photography techniques using pigments in potato starch fixed by means of varnish and coated with a light sensitive emulsion (orthochromatic gelatin bromide) on a glass plate. Also known as an additive color process color plate. Used most widely between 1900 and 1930.

Autotype A carbon process for making prints from negatives; originally a trade name which became the generic name for prints made with a variety of carbon processes.

Bichromate processes A family of processes, not utilizing silver, to make prints on various grounds by coating them with a colloid, which can be gum arabic, gelatin, or starch, that has been treated to be light sensitive with potassium or ammonium bichromates. Grounds include papers, films, and fabric. Also known as gum-bichromate or dichromate processes. See also entry NON-SILVER PROCESSES.

Black-and-white print See *Gelatin silver print*.

Bleaching The use of various chemicals, including iodine compounds or potassium ferricyanide, to remove the silver from an image.

Bleach-out process A technique for creating a hand drawing from a black and white print in which a drawing is made over a photographic image, which is then bleached completely away.

Bleed An image that runs to the edge of a print or page; "full-bleed" indicates the image goes to all four edges.

Blindstamp An embossed mark, generally colorless and usually outside the image, used to identify the publisher, printer, photographer's studio or photographer. The stamp may be a symbol, initials, or full name and address. Also known as drystamp and chop.

Blueprint An image created via the cyanotype process that results in blue tones, most often used in architectural plans. See *Ozalid process* and *Diazo process*. See also entry NON-SILVER PROCESSES.

Bromoil process A variation of the carbro process in which the silver image of a bromide print is converted to a carbon image and then prepared with oil-based inks for printing.

Bromide print A print created on a black and white paper in which the emulsion contains silver bromide and silver iodide, resulting in a relatively greater sensitivity to light. See entry NON-SILVER PROCESSES.

Bracketing See entry.

Burning-in See entry.

Calotype An early and widely used paper negative process in which the paper was made light sensitive with silver iodide, also called Talbotype after its inventor, W.H.F. Talbot.

Camera obscura See entry.

Carbon processes Name for the family of photographic processes, originating in bichromate technique, accomplished using particles of carbon or colored pigments that includes the *Carbro process*. See also entries NON-SILVER PROCESSES; PRINT PROCESSES.

Carbro process Carbon process of versatility similar to silver processes in that it can be used for enlarged prints, with capabilities to manipulate during both development and enlarging (such as burning and doding), developed from ozotype and ozo processes; name obtained from a combination of *car*bon and *bro*mide. Standardized as assembly process color print. See also *Ozotype* and entries NON-SILVER PROCESSES; PRINT PROCESSES.

Carte-de-visite French for "visiting card"; a mainly mid-nineteenth century phenomenon of small photographs mounted on cards that became widely popular to exchange or distribute.

CCD For charge coupled device, a sensing device found in most digital cameras consisting of a rectangular grid of light sensitive elements that generate an electrical current relative to the amount of light sensed and replacing film.

Celluloid A type of plastic of dubious stability and extreme flammability developed in the mid-nineteenth century; used toward the end of the nineteenth century for the support for photographic emulsion in film manufacture.

Chloro-bromide print Variation of the gelatin silver print wherein the light sensitive material in the emulsion consists of silver chloride and silver bromide; produces a warmer image than the gelatin silver print. See also *Gelatin silver print*.

Chromogenic development Process in which chemical reactions are used to create colors (dyes) in a light sensitive emulsion. See *Chromogenic development print* and as opposed to *Dye destruction process*.

Chromogenic development print Standard generic name for common trade names such as in which a color image is obtained by means of silver halide coupled with cyan, magenta, and yellow dyes. This process is the opposite of the dye destruction process. See also entry PRINT PROCESSES.

Cibachrome Trade name for prints obtained by means of the dye destruction process originated by the British photographic concern Ilford in concert with CIBA AG of Switzerland. Originally 'Cilchrome.' Standardized as dye destruction print. Also less commonly: silver dye bleach process print.

CIE Color System International color system developed by ICI (CIE) using scientific color measurement to standardize color names and the color they describe. See also *ICI (CIE)*.

Circle of confusion The size of the largest open circle which the eye cannot distinguish from a solid dot, used to determine sharpness and thus depth of field. See entry DEPTH OF FIELD.

Cliché-verre A method for reproduction of drawings or painting by photographic means in which glass is coated with an opaque ground that is scratched away and then used as a photographic negative. Also known as *Hyalotype*.

Collage Two-dimensional or bas-relief image created by gluing or pasting together various pieces of images and materials collected from various sources. See also *Montage*.

Collotype Bichromate process for obtaining printed reproductions of photographic imagery invented mid-nineteenth century using plates of glass coated with a layer of adhesive gelatin followed by a layer of gelatin sensitized with potassium bichromate. Used chiefly for commercial printing applications before superseded by offset lithography in early decades of the twentieth century. See entry NON-SILVER PROCESSES.

Color Key Trademark of Pantone Corporation for a color identification system used largely in graphic design and commercial printing applications.

Color temperature See entry.

Composite photographs A photograph created through the combining of two or more individual images to form a whole and generally rephotographed to create a seamless final image, as distinguished from montage.

Contact print See entry CONTACT PRINTING.

Continuous-tone process Any of a family of processes which create an image in which modulations from dark to light are achieved by variations in density of the image-forming substance, most commonly silver in black and white photographs and dyes in color photographs, in relation to the amount of light exposure received. As opposed to *Halftone process*.

Cyanotype A widely used iron-based process deriving from the discovery in 1841–1842 by Sir John Herschel that many iron compounds were in fact light sensitive. A relatively simple and versatile process that produces white images on a blue ground. Also known as the Ferroprussianate process.

Daguerreotype A photographic process invented by L.J.M. Daguerre at the beginnings of photography in 1839 most commonly achieved by a thin film of silver on a copper plate that achieves a grainless, yet relatively fragile image. Largely obsolete by 1860s.

"The Decisive Moment" See entry.

Densitometry The science of measuring the opacity of silver or dye images in films and prints; when standardized these measurements are used to determine a wide range of photographic aspects, including the speed of film; the length of exposure and development, contrast, and so on.

Depth of field See entry.

Depth of focus The area on either side of an image plane of a lens in which the image remains sharp. See *Circle of confusion*.

Developing-out paper The term for a family of photographic papers that require developing after exposure. See also entry PRINT PROCESSES.

Diazo process A method of obtaining color images through the use of diazonium compounds as the light sensitive medium.

Dichromate processes See *Bichromate processes*.

Digital print Any print created through digital means. See also *giclee print* and *inkjet print*.

Dry mounting Process of using heat-activated adhesives to mount photographs.

Dry plate processes Chiefly used to indicate a family of nineteenth century processes that were advances on the wet collodion process in which the light sensitive medium on glass plates or paper was exposed when dried. Also used more expansively to indicate any dry exposure process. See also *Albumen print*; *Wet collodion process*.

Dye bleach See *Bleach*.

Dye coupler Colorless compounds that when activated react with other agents to form dyes whose color depends on the dye coupler molecule. See entries COLOR THEORY: NATURAL AND SYNTHETIC; DEVELOPING PROCESSES.

GLOSSARY

Dye destruction process Generic name for process that is used by products with such common trade names as Cibachrome in which a color image is obtained by means of bleaching away unnecessary dyes from the emulsion. As opposed to processes that use chromogenic development to create dyes in the emulsion.

Dye destruction print Print made with dye destruction process. Standardized generic equivalent for Cibachrome.

Dye diffusion transfer process color print Print in which the emulsion is composed of multiple layers, including a final backing layer, that together create both the negative and final positive print. Standardized generic equivalent for the Polaroid print, a trademark of the Polaroid Corporation and other systems that create so-called "instant" photographs. See entry INSTANT PHOTOGRAPHY.

Duratrans Trademark of Kodak Company for a large-scale durable transparency generally mounted in lightboxes.

Dye transfer See entry.

Ektachrome Trade name of Kodak Company for a film that produces a positive or transparency (slide).

Emulsion A suspension of light-sensitive materials, generally silver halide crystals, in a support material, generally gelatin.

Etch-bleach process A technique for converting high-contrast images, such as obtained with lith films, to line-art. Also known as and see *Bleach-out process*.

False color image A monochromatic image in which various gradations of tone or densities are assigned arbitrary colors and presented as a color photograph. Generally used in scientific, especially astronomy, applications but also used as an artistic effect.

Ferrotype The generic name of the direct positive process on a metal ground known as Tintype. See *Ambrotype*.

Ferrotyping A process for obtaining a glossy or glazed surface on a photographic print by means of drying the print as in contact with a highly polished surface.

Finlaycolor process A method of full-color imaging by means of screens of specifically spaced elements as opposed to the random, mosaic screen used in the Autochrome process. Used primarily with panchromatic film to create a negative capable of being printed in color.

Film speed The capacity of any given film to record light within a specified timeframe, measured in units known as ASA (after the standardization organization American Standards Association) before 1980 and ISO after 1980. See entry FILM.

Fish-eye lens An extremely wide-angle lens, generally capturing between 140 and 200° (or more) of the angle of view.

Flexichrome process A method of hand coloring in which film is developed so that the exposed gelatin is hardened, allowing the unexposed portions to be washed away. Silver is then removed through bleaching; the remaining hardened emulsion dyed gray to be visible for hand-toning or coloring.

Flexography A process of printing an image using inks onto a nonabsorbent or uneven surface by preparing a negative relief from a photography which is then used to cast a rubber mold that will conform to an irregular surface or can be prepared with inks that will bind to ceramic, plastic or other nonabsorbent surfaces. Also called aniline printing.

Fluorography The recording of images rendered onto a screen in which the screen (as opposed to the object; this is known as fluorescent photography) is illuminated with X-rays.

Focal length A method of determining the basic optical character of a lens by measuring the distance along the optical axis from the rear nodal point (the center or highest point of the lens) to a plane when the camera is set at "infinity" on which an object remains in sharp focus. Also see *angle of view*.

Footcandle A method of measuring the intensity of light. A one candlepower light source emits 12.6 lumens. The amount of illumination is thus measured by the number of lumens falling on a square unit of a specified area such as per square foot or meter. See *lumen*.

Flare Unwanted light that scatters within the lens and can result in loss of contrast in exposed images.

Flash A device for creating a high-intensity light of short duration.

Framing A method used at the time a photograph is taken by which the camera distance and angle of view is used to mark off the edges of the photographic composition. Also the placing of the finished photograph in a frame for final presentation.

Fresson process A method of color printing invented at the turn of the twentieth century in France by Theodore-Henri Fresson that produces an image that is characteristically diffused and subtle, reminiscent of the "pointillism" of Impressionist painting.

Fresnel lens A condenser characterized by a series of concentric rings, each equivalent to a designated section of the curved surface of the lens that maximizes the light output of the lens. Originated by A.J. Fresnel in the early nineteenth century for use in lighthouses; used in photographic applications such as in camera viewing systems and rear-projection systems.

f-stop, _f_-number The aperture settings on a camera. See entries CAMERA: OVERVIEW and LENS.

Fuji-color Trade name of a color negative film manufactured by the Fuji Corporation, Japan.

Gaslight paper A developing-out paper of relatively low light sensitivity used for contact printing in the late nineteenth century. So-called as it was light safe under weak gaslight illumination.

Gelatin silver print Any photographic print achieved using a paper in which silver or its compounds are used as the light sensitive material in a gelatin support, most commonly silver halide crystals but also silver chloride and silver bromide. Also known as black and white print and silver gelatin print. See also _Chlorobromide print; Emulsion_ and also entry PRINT PROCESSES.

Ghosting Any incident of a double-image, but most often used to describe accidental occurrences, such as that which may occur when an electronic flash is used in an exposure with adequate ambient light or to describe the ghostly images that appear in long-exposures typical of early photographic processes where a human would move through the exposure leaving a blur or partial image.

Giclee print A term derived from the French "to spray" adopted in 1990 by Nash Editions to describe fine-art prints produced by digital spray technologies. See also _Digital print_ and _Iris print_.

Glazing See _Ferrotyping_.

Gold toning The application of a bath of gold chloride where each silver particle in a gelatin silver print is coated with a layer of gold, rendering a warm tone and increasing the life of the image, as gold is resistant to tarnishing (oxidation).

Grain A description of the measurable, visible characteristics of the light sensitive medium of an emulsion. In unexposed materials, this measures, in silver processes, the undeveloped silver halide crystals; in a developed image, the bits of metallic silver themselves, expressed in a subjective scale of "fine" grain to "coarse" grain. See _Granularity_.

Granularity The measurement of the number of grains per unit of a specified area in an developed image. See _Grain_.

Gray card A standard to determine exposure and used to evaluate color balance in a transparency or print achieved through a gray-coated card that reflects visible wavelengths equally and reflects approximately 18 to 20% of the ambient light that strikes it, these percentages reflecting an averaging of the typical distribution of light and dark in a typical photographic scene.

Gray scale Description of the shades of gray or more accurately, range of tones from black to white in a photographic print.

Guide number A reference number used to calculate exposure when using flash that is not synched to the camera's light meter (automatic). Film speed, _f_-stop setting, flash unit light output, and the distance between the flash and the subject are the four variables used to calculate this number.

Gum-bichromate See _Bichromate processes_.

Gum ozotype process See _Ozotype process_.

Gum print A print made through one of the many _Bichromate processes_.

Halation An effect wherein excess or unwanted exposure is caused by the reflecting of light off the film base back into the emulsion.

Halftone A photographic image obtained by means of a halftone process.

Halftone process Any of a family of processes which create an image by means of tiny dots or lines not visible to the unaided eye. As opposed to continuous-tone process.

Hand coloring See entry HAND COLORING AND HAND TONING.

Hardener A chemical or compound that by reducing the ability of a gelatin medium to absorb water during the developing and/or processing of film or photographic papers allows for a denser and therefore more durable surface on the final product.

Heliography Term used initially by the pioneer of photography Nicéphore Niépce to describe the process in which he was able to make the first permanent photographic images. From the Greek _helios_ (sun) and _graphien_ (writing).

Heliogravure Alternative French term for photogravure, a mid-nineteenth century photoengraving process made on Nicéphore Niépce's discoveries. See _Photogravure_.

Heliotype A collotype process widely used in commercial printing at the end of the nineteenth century.

High contrast films and papers Photographic products which feature a limited range of gray tones or no gray tones at all. Often known as lith films and papers.

High speed photography Photography undertaken in acknowledgment that there are many physical processes that take place that the unaided human eye cannot resolve, which in its basic definition is photographs made with extremely short exposure times. In general terms, though always evolving, this means photo-

graphy with exposure times shorter than about 1/1000 of a second that almost always require special techniques, especially in light sources. For some purposes, the definition is shutter speeds beyond what is available on general use 35-mm cameras, commonly 1/4000 of a second, up to trillionths of a second. Pioneered in the nineteenth century by Eadweard Muybridge, to demonstrate the galloping of a horse; in the twentieth century, Harold Edgerton, an inventor of high-speed flash techniques, is considered the "father of high speed photography." See entry HAROLD E. EDGERTON.

Hologram See *Holography*.

Holography A technique for making photographs known as holograms which give the illusion of three dimensions through embedding images in the photographic matrix that change in *parallax* and perspective as the angle from which the image is viewed changes. Holographs are made through the recording of "coherent" light—light which is emitted and follows a single wave pattern known commonly as lasers (as opposed to "incoherent" light—ordinary light which is of varying wavelengths with random phase relations). Holograms were described theoretically in 1947 by Dennis Gabor and became more common as advances in the laser technology needed to realize them were made in the late decades of the twentieth century.

Hyalograph A photograph created by means of etching an image from a negative into glass.

Hyalotype A method of creating positive transparencies used in the mid-nineteenth century primarily for lantern slides. See *Cliché-verre*.

Hydrotype A bichromate process in which the master image is transferred to a ground of moistened paper, allowing the creation of multiple copies.

Hypo Common terminology for hyposulfite of soda, a nineteenth century designation for sodium thiosulfate, used during the developing process for films and papers to fix the image. See also entries DARKROOM; DEVELOPING PROCESSES, FILM.

Hypo eliminator Solution used in the processing of film or paper to neutralize the *hypo*. See also entries DARKROOM; DEVELOPING PROCESSES, FILM.

ICI (CIE) International Commission on Illumination based in France; in French, Commission International de l'Eclairage, an organization that sets photographic standards, most notably a system for scientific color measurement in use worldwide to standardize color names and the color they describe. See also *CIE Color System*.

Imperial print A designation of nineteenth century photography indicating a mount for a photograph measuring 7 × 10 inches that could accommodate a contact print from the most common photographic plate then in use.

Incident light The light falling on any surface, in its various combinations of reflected, absorbed, or transmitted light. See entry LIGHT METERS.

Infinity setting The lens focus setting marked ? indicating the setting for photographing in focus objects at the greatest distance from the camera.

Infrared photography See entry.

Intaglio processes The term for a family of processes in which the image is formed by means of incisions below the surface of the material that is being used as a ground (often metal plates). Most commonly used in photoetching or photoengraving, both in commercial and fine arts applications.

ISO International Standards Organization, which sets a wide variety of standards in various fields; in photography, the designation of film speeds.

Iris print A digital print created using the printing equipment, inks, and papers developed by Iris Graphics of Bedford, Massachusetts but also used as a generic term for inkjet print created for fine arts applications. See also *Digital print* and *Giclee print*.

Ivorytype A photographic print transferred to materials manipulated to mimic ivory, popular in the mid-nineteenth century.

Kallitype A printing process using iron compounds developed at the end of the nineteenth century suitable for printing on paper and fabrics. A simple form of the kallitype is the Vandyke print.

Keystoning The linear distortion in which one end of a rectangle is larger than the other, usually as a result of the camera, when taking a photograph, not being parallel to the subject.

Kodachrome Trade name of Kodak Company for a film using a subtractive process (dye destruction) color film.

Kirlian photography A form of electrophotography named for the Russian couple who first identified it in which film in a metal container is placed in direct contact with the object or subject protected by insulating material. A current is passed through the film, and the pattern of energy as affected by the object or subject is recorded and developed.

Kodacolor Trade name of Kodak Company films.

Kodalith Trade name of Kodak Company's high-contrast films and papers.

Law of reciprocity See *Reciprocity*.

Lens hood Simple shielding device attached to front of lens to prevent flare.

Light box A device for viewing negatives or transparencies by internal illumination through a translucent material or a device for the display of photographic transparencies, especially popular in advertising and late-century fine art photography.

Line art In graphic arts and commercial printing applications, a term for a negative or positive image consisting of only two tones and featuring no modulation, as in a *continuous tone* image. See also *Lith films and papers*.

Lith films and papers High-contrast photographic materials most generally used in photomechanical reproduction, especially commercial graphic arts applications, prior to onset of digital technologies. See also *High contrast films and papers*.

Loupe Manual instrument used for viewing contact sheets, slides, or magnifying sections of full sized prints.

Lumen Unit for the measurement of the radiant energy emitted by a light source.

Lux See *Lumen*.

Microfiche A method by which sheet film is exposed by means of microphotography to create miniaturized images; widely used in the second half of the twentieth century by libraries and other institutions for records storage; made largely obsolete by the digital revolution.

Moiré A pattern created when superimposed line art or dot patterns interact and interfere with one another. Indication of poor registration in mechanical reproduction processes that layer multiple images; also used as a special effect by means of screens or filters.

Montage An assemblage of photographic images; generally distinguished from *collage* in both the restriction to photographic images (as opposed to drawn or three-dimensional elements) as well as the presentation of the final image as a unified whole, often by rephotographing. See entries MONTAGE; MANIPULATION.

Munsell system Standard system in the United States for specifying color in pigments and other opaque colorants.

Negative Any photographic film or print wherein the range of tonalities or color is reversed or the opposite of that of the subject or view photographed.

Negative print A photograph in which the opposite tones or colors from the subject of exposure is presented as a final work, usually for artistic effect.

Noble print Prints made with any of the family of bromoil processes, often featuring hand coloring.

Notch code An identity method used by film manufacturers by means of v-shaped notches incised into the right-hand corner side edge of sheet films.

Offset A photomechanical reproduction created when an image is transferred to a plate photographically, transferred in reverse to a roller, and then printed positively on paper or canvas; most commonly used in commercial printing applications. Also known as offset lithography.

Offset print Print created using offset process.

Orotone process A decorative process consisting of the photographic image being printed first onto glass plates, the silver then toned to a rich brown-gold tone. The glass is backed with a dusting of fine gold pigment.

Orthochromatic Designation for photographic emulsion that is sensitive to ultraviolet, blue, green and several yellow wavelengths but does not record red, allowing the use of a red safelight during the developing process. Also known simply as ortho.

Ostwald system Method of specifying color based on subjective (as opposed to scientific or mathematical) criteria. Often displayed as a cone or other form in which variations of hue affected by additions of white, black, and complementary colors are arranged in logical progressions.

Ozalid process A commercial diazo process developed in the early twentieth century to copy plans and drawings; commonly known as blacklines or brownlines. See also *Diazo process*.

Ozobrome process An improvement on the Ozotype process using a bromide print instead of the gelatin-bichromate sheet.

Ozotype process A carbon process developed at the turn of the twentieth century using a gelatin sheet sensitized with bichromate exposed by contact printing with a negative that is then flattened against a prepared carbon-pigmented tissue that hardens or tans the exposed emulsion. A variation on this process using a gum arabic emulsion is known as the Gum ozotype process.

Palladiotype Variation of the platinum print wherein the light-sensitive element of the emulsion is a compound of palladium, developed in the 1910s due to the prohibitive cost of this process due to the rarity of platinum. See entry NON-SILVER PROCESSES.

GLOSSARY

Palladium print More common term for the Palladiotype.

Panchromatic Designating an emulsion for which the light sensitivity is essentially equal for all visible light wavelengths.

Parallax The discrepancies in the field of view or coverage resulting from two differing viewpoints.

Paraglyphe A print resulting from a technique which achieves the illusion of low-relief or bas-relief by using a negative image to mask the same image's positive in creating an image which is a synthesis of the two.

Pinatype A bichromate process in which the master image is transferred to a ground of soft gelatin, allowing the creation of multiple copies.

Pixel The smallest discrete component of an image or picture on a television screen, computer monitor, or other electronic display, usually manifesting as a colored dot. In digital photographic processes, a unit of measurement to determine resolution (clarity of detail) of an image.

Photogram See entry.

Photomontage See *Montage*.

Photogalvanography An early bichromate process used in commercial printing to create printing plates from photographs.

Photoglyphy An early bichromate process used to create printing plates from photographs, patented in 1852 by photographic innovator W.H.F. Talbot.

Photogravure A photomechanical process adapting the traditional etching process that revolutionized commercial printing of reproductions in its ability to reproduce the appearance of the continuous tones found in photographs, an advance on photoglyphy. A sheet of bichromate gelatin tissue is adhered, using heat, against a resin-dusted copper plate and contact-printed with a positive transparency, the exposed gelatin hardening and protecting the plate lying beneath it. The unhardened gelatin is then washed away and the plate is processed in an acid bath, the unprotected copper being etched away at various depths. The plate is then inked; the etched areas holding ink to create the dark tones; the protected areas holding no ink and creating the highlights and used to transfer a positive image to paper.

Photolithography Using photographic methods to create the image in the traditional printmaking technique of lithography.

Photomicrography The recording by photographic means of highly magnified images seen through microscopes, most commonly for scientific and medical purposes, but also in fine arts photography.

Photoserigraphy Using photographic methods to create the image in the traditional printmaking technique of silkscreen or serigraphy. Also known as photosilkscreen.

Photostat A registered trademark for a commercial photocopying process using high-contrast that came into common use referring to a duplicate of an original.

Platinotype Patent name for prints created using papers light-sensitized through the use of platinum compounds marketed in the late nineteenth century.

Platinum print Generic term for any photographic paper using platinum and its compounds combined with iron salts as the light-sensitive material and developed in potassium oxalate, notable for its broad range of subtle, silvery-gray tones and for its relative permanency due to the stability of platinum.

Polaroid print See *Dye diffusion transfer process color print*.

Polaroid transfer A technique in which a Polaroid 669 print is soaked in hot water until the top emulsion layer lifts off its backing, allowing it to be transferred to a broad range of surfaces, including nonabsorbent surfaces such as glass. Also known as Polaroid emulsion lift.

Positive Any photographic film or print wherein the range of tonalities or color duplicates those of the subject or view photographed.

Posterization See entry.

Primuline process A diazo process developed at the end of the nineteenth century using the dye Primuline yellow.

Printing-out papers The term given to a family of photographic papers that require no developing after exposure, in which the emulsion of the negative is placed in direct contact with that of the print material, exposing it to light until an image is formed. Also known as photolithic papers. See also entry PRINT PROCESSES.

Radiography X-ray photography used primarily in medical applications.

Resin-Coated paper Photographic papers coated with resin to prevent absorption of developing bath into fibers, thus reducing washing time. Also known as RC Paper, a trademark of the Kodak Company. See also entry PRINT PROCESSES.

Reciprocity Term used to indicate the responses of film or paper to an exposure time plus amount of light (most often through controlling aperture setting), thus a long exposure with a small aperture opening will result

in a similar exposure as a short exposure time with a larger aperture opening. Also known as Law of Reciprocity.

Reciprocity failure An effect in which a film's sensitivity to light does not respond under conditions that should achieve mathematical reciprocity, such as in long exposures, or changes from the first exposure to the last exposure in a multiple image and overexposure, underexposure, or color shifts may result in the film. Also known as reciprocity effect.

Recto/verso In describing a photographic print, recto is the image side, verso the back or mount.

Resolution In photochemical processes, the size of the silver or other light sensitive elements in the emulsion; in digital technologies, the amount of detail or clarity offered relative to the number of pixels per square inch of an electronic image.

Retouching The manual manipulation of a photographic print or negative with brushes, airbrushes, pencils, inks, bleaching agents and so on to change details such as removing blemishes or filling in wrinkles in a portrait subject, or to correct defects in the exposure, such as dust spots.

Rubylith A red acetate historically used for masking mechanicals during the process of preparing plates for commercial printing. The area so masked photographs as black to the camera, printing clear on the resulting positive film. See also *Amberlith*.

Sabatier effect See entry SOLARIZATION.

Salted paper print Prints created by means of ordinary writing paper that has been light-sensitized with alternate washes of a solution of common table salt and a bath of silver nitrate; invented by W.H.F. Talbot in 1834 and characterized by a matte finish and a soft image resolution.

Scanner Device used in digital photography to electronically convert a visual (analog) image into digital data. See entry SCANNING.

Selenium print A print that has been toned with selenium which creates a warm tone and increases longevity, a misnomer in that the print is generally a gelatin silver print and the selenium is used only as an enhancement.

Sequencing The placing of photographs to create a narrative, visual message, or pictorial effect; a practice developed especially through scientific photography at the end of the nineteenth century by figures such as Eadweard Muybridge or E.J. Marey, and photojournalism and the photo-essay that emerged in the 1930s. Photographs can be those that exist in sequence as photographed with their inherent narrative, or can be disparate images that through such placement create a narrative, a practice especially explored by fine arts photographers in the postwar decades.

Silver-dye bleach process See *Cibachrome*; *Dye destruction print*.

Silver print Variation of *gelatin silver print*, not preferred usage.

Slide See *Transparency*.

Solarization See entry.

Stroboscope Rapidly firing flash used in high speed photography.

Solio paper A printing-out paper utilizing a gelatin-silver chloride emulsion for amateur use produced by Kodak in the late nineteenth century and used well into the twentieth century.

Spotting Method of retouching, most commonly used to describe the repair of imperfections such as dust spots, scratches to the film's emulsion, and so on by means of specially prepared dyes applied with a brush or pen that are matched to common paper tonalties.

Stereoscope A device for viewing photographs either hand-prepared or made with a stereographic camera that creates the illusion of three dimensions. Also stereograph.

Superimposure A combination of images, usually one atop another, in which aspects from the images are combined into a new image. Images can be superimposed in the camera through various exposure techniques, or created in the darkroom with multiple negatives. See entries MULTIPLE EXPOSURES AND PRINTING and SANDWICHED NEGATIVES.

Synchronization The relationship of timing between the action of the camera shutter and the activation of the flash.

Talbotype A short-lived name for W.H.F. Talbot's calotype process.

Test strip A simple method of judging proper exposure by means of creating a sample image on a strip of photographic paper by masking and then allowing progressively longer exposures. See entry DARKROOM.

Thermal imaging Imaging methods that capture radiant energy (heat) as a visual image, used in surveillance, medical imaging, and other industrial applications. Also known at Thermography.

Time-lapse photography The exposing of a series of images at regular intervals in still or motion picture photography or the multiple exposing of a single image in still photography, most often used to create illusions in motion pictures ("stop action") or record a progressive motion or action, such as a rising sun.

Tinting See *Toning*.

Tomography A technique in radiography (X-ray) to obtain clear imaging by means of rotating the X-ray emitting tube in a specified manner.

Tone-line process Alternative name for *Etch-bleach process* and see *Bleach-out process*.

Toning See entry.

Transparency A positive photographic image on a transparent or translucent support, such as glass or film intended for viewing by a transmitted light source, such as a projector or a light box.

Trichrome carbro process An early form of the modern dye-transfer method in which layers of subtractive color images in carbon pigments are assembled in registration to create a color image, developed in the mid-nineteenth century. Also known as three-color carbro process.

Tripod Common form of support for a camera to allow for steady focusing and shooting, especially during long exposures; generally featuring three adjustable or telescoping legs that allow for set up on varying terrain.

T-stop A lens calibration similar to *f*-stop system that takes into account the variance between lens of differing designs in the amount of light transmitted to the film with particular applications in motion picture photography.

Ultraviolet photography Photography which captures light in the blue-violet end of the spectrum, not visible to the human eye, especially useful in evidence photography, and technical and industrial applications.

Uniform system (U.S.) Early calibration system for exposure settings on a camera, predating the *f*-stop system.

Unique print A photograph so printed or altered that only one original exists.

Van Dyke process A print process utilizing iron compounds which is the most basic form of the kallitype. Also known as brownprint.

Variant Used to describe photographs of a subject or view taken at approximately the same time that feature slight variations in either what appears as subject matter or the orientation or framing of the subject matter. Also prints of the same subject featuring varying exposures, cropping, or toning.

Varnishing Coating prints or negatives with varnishes or shellacs both to provide protection and achieve an even appearance.

Velox Trademark of the Kodak Company for a developing-out contact paper.

Vignetting An effect by which the central image is emphasized in a photographic print usually in a roughly circular or oval form. When unintended, vignetting is caused by an incorrect match between lens and camera format or improper lighting or exposure; when intended by masking the image during exposure or projecting image through a mask in the enlarging process.

Waxed paper negative A variant of the calotype negative.

Wash-off relief process See entry DYE TRANSFER.

Wet collodion process An early photographic process in which glass plates were made light sensitive utilizing a solution of nitrocellulose (gun cotton) in ethyl alcohol and ethyl ether. Exposure was made before the plate solution dried. Also known as the wet plate process.

Woodburytype A bichromate process developed in the mid-nineteenth century that achieves a true continuous tone and exceptionally faithful reproduction to the original through the creation of a relief image from a mold or series of molds.

Xerography See entry.

Zone focusing A method by which the *f*-stop can be selected based on predetermination of where the action or view to be photographed may occur.

Zone system Exposure and developing system developed by Ansel Adams and Fred Archer in the 1930s for black and white photography intended to allow the photographer to previsualize and predetermine exposure settings to achieve richest blacks and fullest range from black to white in any individual photograph, and match this to proper development techniques. Zones, which are conceptual rather than actual view areas, are numbered 0 through IX or in a later refinement, 0 through XI, Roman numerals being used to avoid confusion with *f*-stop numbers. Zone 0, for example, is represented by the maximum black tone obtainable in the individual print, with Zone I being the first discernible gray tone, and so on.

INTRODUCTION

Creating, in one useful, comprehensive publication, an encyclopedia of the history and practice of photography in the twentieth century is a daunting task. In any endeavor, the doing of it often best teaches how it should be done; and not only does the doing perfect the process, it refines the understanding of the subject of the endeavor and focuses the content to be more authoritative. Such is the case, certainly, with the current project.

The ambition of this project was to provide a useful resource of the entire scope of photography in the twentieth century. It was neither to be a definitive technical manual nor a compendium limited to the field's aesthetic achievements, but something more. The aim was to create an encyclopedia that would serve as a resource and a tool for a wide readership of students, researchers, and anyone interested in a scholarly discussion of photography history.

In this we believe it succeeds. The encyclopedia introduces the reader to the history of technical issues that have changed over a hundred-year period. It explains the contributions of photographers and situates their contribution within the history of photography. It defines the concepts, terms, and themes that have evolved over a century. It describes the role of institutions and publications in the shaping of that history. Importantly, the encyclopedia also explains the development of the medium in specific countries and regions around the world—offering a global understanding and a more local perspective of photography history.

This is the main purpose of the encyclopedia, to define the broad outlines and fill in the intimate details of twentieth-century photography. The user will find the large and small of twentieth-century photography. The project gathers information on the most often cited names, terms, concepts, processes, and countries, and it also gives ample attention to those most overlooked. Significantly, it provides the historical and theoretical contexts for understanding each entry so that the expanse of photography history in both its distinct and its partial developments is maintained throughout.

As a resource, the encyclopedia supplies the reader with tools for finding information. Extensive cross-referencing allows the reader insight into the various directions a topic or individual entry may lead: historical, theoretical, or technical. A glossary of terms directs the reader to definitions, describes processes as they were standardized at the end of the century, and gives technical information on photographic terminology, equipment, and accessories. In addition to an alphabetical listing of articles, the articles are also listed by subject to help orient the reader. Subjects are straightforward: equipment; institutions, galleries, and collections; persons; publications and publishers; regions; topics and terms. Each article is signed by the contributing scholar; readers can find a list of contributors in the front matter of volume one. Scholarly references are included at the end of each article so that the interested individual may further explore the topic in more detailed publications. Over 200 illustrations and glossy inserts in each volume will aid the reader's understanding of the articles, but the illustrations are not intended to be the strength of the encyclopedia. This is a work of scholarship, a book intended to be read rather than viewed—we point the readers to resources that contain the thousands of photographs that constitute twentieth-century photography. Finally, the analytical index serves as a critical tool that systematically guides the reader through the contents of the three volumes. The index directs the reader to discussions of sought for information but also allows the reader to explore the contents and discover related items of interest.

While it is hoped that the professional will find the publication as useful as someone approaching photography for the first time, the publication was not intended to take the place of the many fine monographs, textbooks, exhibition catalogues, and websites published for the professional audience that

have proliferated in the field at the end of the century. It might be considered a port of entry to the world of twentieth-century photography and photography scholarship.

When this project was conceived, the twentieth century was in its final decade, yet it was not then clear that the arbitrary demarcation of the century as regards photography would be an actual marker as well. The astonishingly rapid rise of digital technologies during the 1990s distinguishes the shape of the medium in the twentieth century in a real way, just as the introduction in 1898 of the mass-use Brownie camera and all its attendant technologies forever wrenched the medium from its nineteenth-century essence as the domain of the dedicated enthusiast, whether professional or amateur. The democratization of the medium certainly seemed to be the main story being told at mid-century, and it may indeed, at further remove, be the overarching feature of the twentieth century. For ironically the digital revolution offers at the same time more and less access—more if one has electricity, a digital camera, and a computer, less if one does not, and many, at the beginning of the twenty-first century, certainly do not. Yet whatever the digital revolution may hold, it seems clear that the obsolescence of the standard photo-chemical processes and the widespread access to the medium they undoubtedly provided will define photography in the new century. Already, in 2005, photo-chemical films and papers have been discontinued or are no longer distributed in the United States; traditional processing labs are vanishing, and items that stocked the traditional darkroom are becoming collectibles, if not landfill.

The encyclopedia had the benefit of the knowledge provided by the distinguished Advisory Board. These individuals freely provided their expertise and advise. The process of selecting the topics and photographers, like anything else, reflects a degree of subjectivity. Yet this subjectivity was tempered by the broad range of experience represented by the Board. Topics were selected to provide snapshots of the entirety of the field utilizing established genres—"fashion photography" or "documentary photography," or obvious entities— "camera" or "Museum of Modern Art." Entries on individuals were more winnowed out than selected. The towering figures are obvious: they fill bookshelves and auction catalogues. But other, lesser known figures of regional importance or photographic innovators were also deemed important to record, and their selection rested on judgment, and to some extent, intuition. The attempt was also to broaden the scope from the United States and Europe, with its long history of photography, to an international one, both in topic discussions and selection of photographers. It goes without saying that many, many other serious, important practitioners of photography and photographic topics and institutions could have been included, yet for the purposes of this publication, we limited the number of entries to 525.

Finally, as tempting as it might have been for the many fine art historians, critics, and writers who authored these essays (and I thank them deeply for their efforts) to come up with original interpretations of photographers' contributions or innovative theoretical stances, the encyclopedia was not intended as an opportunity for scholarship in the form of new interpretations of established figures or revisionary accounts of historical movements.

Conventions and Features

The encyclopedia is arranged alphabetically; spellings of names reflect the most common usage at the end of the century and attempt to use proper diacritical marks in languages which require them. The use of monikers as opposed to given names (i.e. "Weegee" as opposed to Arthur Fellig, or "Madame D'Ora" as opposed to Dora Kallmus) is also based on most common usage. Such "noms-de-photographie" are arranged in the appropriate alphabetical order, with given names included in the entry.

In reference materials, names of institutions are generally given as the full, proper name at the time of the citation. Thus, prior to 1972, it is the George Eastman House; from 1972 onward, the International Museum of Photography and Film, George Eastman House. For the most part, institution names are given in the original language to alleviate confusion about proper translation and ease further research, thus rather than the National Library of France, Bibliothèque nationale de France, and so on.

All entries feature bibliographies or further reading lists. Topics on individuals feature a Capsule Biography for quick reference and a list of Selected Works. Photographers also receive a listing of selected Individual and Group Exhibitions, with as complete information as is available detailing those exhibitions. Websites are occasionally given for governmental agencies, established institutions—especially museums—as well as for some foundations or individual archives. Private websites were generally avoided both to avoid endorsement and the fact that many such websites fail to be maintained over the course of time.

* * *

Although I am a curator of contemporary art, my first love was for photography. I studied it in school and practiced it as a student, taught by photographers who themselves turned out to be "towering figures." As a curator I have organized a number of photography exhibitions, and overseen the collecting of contemporary photography. Yet I am hardly the foremost expert in the field, and thus was truly honored to have been asked to edit this important publication. I hope that my efforts have been equal to expectations.

LYNNE WARREN
Chicago, Illinois

G

GALLERIES

Galleries are physical or virtual spaces where photographic works and the public cross paths. Galleries can have many structures, diverse objectives, and utilize a variety of resources to link photography and public. Examples of some gallery structures include cooperative galleries, commercial galleries, cultural spaces both public and private, web galleries, galleries at temporal events such as art fairs or symposiums, and vanity galleries. Galleries can showcase work by genre such as still life, portrait, landscape, or experimental, exhibiting only photography or various media, exhibiting work on general or specific themes or events, organized by individual authors, institutions, or groups. Each gallery structure will in some way bring photographic works and the viewing public together. Different structures will accomplish these links in different ways, varying their rapport either to photographers, to the public, or both.

In a cooperative gallery, artists become members to participate in gallery activities. There may be a membership fee and members may be asked to participate in gallery functions by helping to hang shows, gallery sitting, newsletter production, etc. Membership may also be open to the general public, who through their membership provide support, both financial and time, to the gallery. Some events and activities at a cooperative gallery may be open to the general public, others to members only. Activities may be educational or promotional, such as juried shows.

Commercial galleries are places of business where gallery directors promote photography as a consumer good. Commercial galleries represent a limited number of artists and apply countless strategies to provoke the sale of a photograph. Some galleries build their reputation by carrying only the work of well-established artists. Other galleries claim to be presenting heretofore undiscovered talent. Some galleries will solicit submissions for group or solo shows, juried by the gallery director or a guest curator. There is a contract between artist and gallery, either implicit or in writing. The contract will determine the division of responsibilities, such as framing, insurance, regulation of exhibits, insurance, prices, fees, and method of payment.

Both public and private institutions can have gallery space for exhibitions. Public institutions such as the commercial attaché to embassies, municipal, state, or federal buildings, public libraries, community centers, or universities can host exhibitions in a gallery, generally open to the public-at-large. Private institutions also, such as private schools, non-profit organizations, theaters, coffee shops, and

churches, may choose to have separate gallery space for exhibitions that incorporate the gallery activity with their otherwise daily business. Some individuals make use of their home to showcase photography as a special occasion.

Less than twenty years after the arrival of the home computer, telecommunications has mushroomed to impressive proportions and the resulting explosion of web galleries devoted to photography is phenomenal. In 0.26 seconds, a Google search for "Gallery Photography" produced 1,210,000 results. This volume of activity is difficult to monitor, measure, or analyze as the virtual, immaterial terrain of activity is everchanging with little to no lasting trace of content. Web galleries allow people to look at images, research photography, buy and sell photographs, advertise and promote photography, and give technical and aesthetic training and instruction.

Calendar events such as community or state fairs, festivals, symposiums, or conferences, can organize temporary galleries to exhibit photography. The exhibitions may have a geographic significance, showcase local authors or local imagery, or have a thematic significance, such as AIDS, dogs, or tornadoes.

Vanity galleries are galleries where the gallery owner exhibits the owner's work. These galleries may be part of the artist's studio or independent spaces. Another form of the vanity gallery exists as rented spaces, where the artist contracts for a specific time at a certain cost to utilize the gallery.

There are several historical antecedents that foreshadowed the evolution of photography galleries in the twentieth century. In the nineteenth century, science and technology fairs began to show arts and crafts, and photography was from its inception a part of such activities. Louis Daguerre made public his photographic process in 1839 and that same year a Daguerreotype was exhibited at the 12th annual Fair of the American Institute in New York City. Until early in the twentieth century, the American Institute remained almost the only institution to exhibit photography in New York City, exhibiting works by Mathew Brady, Napoleon Sarony, and Edward Bierstadt. Some of these fairs were annual events and eventually a need was identified for a permanent exhibition space.

Also in the nineteenth century, some photographers used part of their studio as a gallery space, sometimes becoming a local point of interest beyond the studio's clientele. This practice served both to attract customers and to establish the photographer's expertise. Some of these studio galleries were extravagantly decorated and advertised in grandiose words, such as Mathew Brady in 1853

advertising his studio as a "palace of art," or Charles D. Fredericks'studio description as a "Photographic Temple of Art." In New York and Washington, D.C., Mathew Brady's galleries were successful business endeavors, but the principle income came not from the exhibitions but from the studio photography work.

Interestingly enough, one of the first galleries to exhibit photography in the twentieth century also exhibited paintings and sculpture. This was Alfred Stieglitz's creation of the Little Galleries of the Photo-Secession, referred to as 291, the gallery street number on Fifth Avenue. The Photo-Secessionists included photographers such as Gertrude Käsebier, F. Holland Day, and Clarence White. 291 was from the beginning a gallery space devoted to the promotion of photography in relation to other arts. Urged on by painter and photographer Edward Steichen, Stieglitz and the Photo secession began publishing a newsletter called *Cameraworks* in 1903 and opened Gallery 291 in 1905. After a year of showing photographs, the gallery began exhibiting more European paintings and occasionally Stieglitz's own work until closing down in 1917 following a series of exhibitions including work by the photographer Paul Strand. In 1921, Stieglitz mounted a show of his own work in space borrowed from the Anderson Galleries on Park Avenue were he exhibited other art until 1929. He wanted the space to provide a sense of community for artists and structured it as a cooperative gallery, trying to distance himself from the commodity aspect of works of art. From 1929 until 1946, the year of his death, Steiglitz exhibited art at An American Place on Madison Avenue, mostly paintings and other prints as well as his own photographs and those of Paul Strand.

In 1931, Julien Levy opened the Levy gallery in New York City with a retrospective exhibition of American photography. The gallery had a difficult time finding a market for photography and quickly modified the gallery's agenda to include a broader range of artwork. Photographers who exhibited at the Levy gallery included Berenice Abbott, Eugène Atget, Man Ray, Paul Outerbridge, and Henri Cartier-Bresson. The Bay Area's Group f/64's cooperative gallery, which opened in 1933, was dubbed "683" after its street address in a clear reference and homage to Gallery 291.

In the 1940s and 1950s, more galleries dealing with photography appeared in the United States and in Europe but rarely did this cultural activity prove lucrative. Some galleries organized exhibitions around other activities that could generate revenue, such as bookstores, coffee houses, or

movie or theater lobbies. In the 1950s, the FNAC started in France. The FNAC is a department store devoted principally to music, books, and audio-visual equipment. From its beginning in 1954, the FNAC built retail stores with exhibition spaces devoted to photography. With over 50 stores in France and Europe, these galleries, where work is not for sale, are visited by thousands of people on a daily basis, an impressive volume of public passage that few other gallery structures can achieve. The success of these photography galleries has grown over the decades; the FNAC now hosts regular competitions for new talent and has a growing collection of photography.

In 1954, Helen Gee opened Limelight Gallery in New York City and showed over 60 photography exhibitions until 1961, the gallery income supported by an adjoining coffeehouse. The Limelight Gallery at that time was a major art institution in NYC and their decision to show photography was the beginning of a growth spurt in the art photography market that persisted through the end of the century.

By the late 1960s and through the end of the century, photography galleries found more financial success in the dynamics of the expanding art market in general. An increasing number of universities added photography to their curriculum, public and private grants to photographers peaked during these decades, and major auctions started to include photography. In New York City, the Witkin gallery opened in 1969; the Light Gallery in 1971. Galleries worked at promoting both the sale of photographs and the advancement of the photographer's reputation. In 1968, Harry Lunn opened his gallery in Washington, D.C. and specialized in the sale of limited edition photography portfolios, a format used through the end of the century. In the 1980s, legendary New York dealer Leo Castelli supported photography in his Castelli Graphics site, and Pace/Magill and Robert Miller galleries specialized in the medium, showing numerous contemporary American and European photographers. San Francisco's Fraenkel Gallery. established in 1979, is one of the leading west coast photographic galleries. More recent editions include Chicago's Stephen Daiter Gallery and New York's Janet Borden, Robert Mann, and Edwynn Houk.

In Canada, Jane Corkin founded an influential Toronto-based gallery in the late 1970s. In Paris, Galerie Michelle Chomette exhibited cutting-edge contemporary photography from the 1970s through the end of the century. Also in Paris, Jean-Pierre Lambert's tiny Galerie Lambert off the Place du Marché Ste. Catherine in the Marais exhibited contemporary photography from 1981 to 1998. One critic described the photography exhibited at Galerie Lambert, a space sometimes compared to Stieglitz's 291, as "UFOs," unidentified fotographic objects.

In Washington, D.C., the Kathleen Ewing Gallery has promoted fine art photography since 1976, exhibiting contemporary local artists and historical as well as internationally known artists. Ewing described photography as the one art medium that has not suffered a decline in activity since the growth spurt in the art market in the 1970s. Since 1979, Ewing has been Executive Director of the Association of Independent Photographic Art Dealers (AIPAD), an organization of 130 members. Robert Klein, director of the Robert Klein Gallery in Boston, is President of AIPAD. AIPAD is the only organization specifically for photography dealers. All members of AIPAD have significant, quality inventories of photography that the public can access either through exhibitions or by appointment. AIPAD has a regularly updated publication called *On Collecting Photographs*, which includes a photography timeline, common questions and answers, a glossary of terms, and a bibliography. They also publish a yearly catalogue to accompany their annual exhibition in New York. This catalogue and exhibition describe nearly 100 participants, each representing several photographers. These exhibitions began in 1980 and include a large group show as well as individual booths for each participating gallery. They also post alerts regarding stolen photographs.

In the late 1990s, Paris Photo in France established a yearly event at the Carrousel du Louvre called Paris Photo. Using the underground galleries created in recent renovations of the Louvre, every fall nearly 100 participants and over 30,000 visitors convene for several days to view, buy, and sell photographs. A catalogue accompanies this international event and participants are selected by committees of professionals in photography. Like the annual AIPAD exhibition in New York, Paris Photo usually defines a theme for each year's event.

BRUCE MCKAIG

See also: **Abbott, Berenice; An American Place; Atget, Eugène; Cartier-Bresson, Henri; Group f/64; Käsebier, Gertrude; Levy, Julien; Man Ray; Outerbridge, Paul; Photo Secession; Photo Secessionists; Steichen, Edward; Stieglitz, Alfred; Strand, Paul; White, Clarence**

Further Reading

The Association of International Photography Art Dealers (AIPAD), *www.photoshow.com/* (accessed May 11, 2005).
International Center of Photography. *Encyclopedia of Photography.* New York: Pound Press/Crown Publishers, Inc., 1984.

Paris Photo-Salon International Europeen pour la photo-
graphie d'Art, parisphoto.photographie.com (accessed
May 11, 2005).
Robey, Ethan. *The Utility of Art: Mechanics'Institute Fairs
in New York City, 1828–1876*. Submitted in partial ful-
fillment of the requirements for doctor of philosophy in
the Graduate School of Arts and Sciences Columbia
University, New York City, 2000.

ANDRÉ GELPKE

German

One of Europe's leading postwar photojournalists,
André Gelpke creates in his photographs vibrant,
arresting images by offering an abundance of in-
formation. Precisely composed and perfectly framed
for the composition at hand, his rich black-and-
white pictures freeze time into intense images which,
because of the absence of time and movement, can
seem overwhelming, even alienating. Whether it is
capturing a playground frozen into a timeless frieze
of human and architectural forms (*Bretagne*, 1983)
or human subjects who are photographically trans-
formed into virtual specters or automatons (such
as the three swimmers presenting themselves for a
mist-blurred lens in *Kanalschwimmer*, 1977 or the
handshake and bow captured in *Kunstverein Köln*,
1979), Gelpke uses the unique technical language of
photography to create evocative, emotional reflec-
tions of reality.

Like all of the generation of contemporary Ger-
man photographers, Gelpke, born in 1947, grew
up in a divided Germany that faced huge chal-
lenges of reconstruction after the war. He attended
grammar schools in his hometown of Beienrode
and in the industrial town of Rheydt, and second-
ary schools in Rheydt and Krefeld. After various
trade jobs and service in the military, and after
developing an interest in photography, in 1969 he
entered the Folkwangschule, Essen, where Otto
Steinert, the instigator of the "fotoform" group
which practiced a highly abstract form of pho-
tography (more generally known as Subjective
Photography), taught. It was under Steinert that
Gelpke's style was formed, wherein vignettes of
the world around him are excised and framed, so
to speak. Within this style, Gelpke has produced
rich and varied bodies of work. Series shown in
exhibitions such as *Sea Pieces*, *Plastic People*,
Sankt Pauli and published in books such as *Sex-
Theater*, *Fluchtgedanken*, and the famous *Der
Schiefe Turm von Pisa* demonstrate Gelpke works
in the best documentary tradition, adding a dis-
tinctive, intelligent visual rhetoric.

In 1975, after working as a photojournalist for
about a year, Gelpke was a co-founder of the Visum
Photo Agency in Hamburg, now a leading stock
photo and photographic agency.

André Gelpke is a conservative in the pure sense
of the word. Photography, however, is an immense
store of forgotten and deeply hidden meanings.
Because of its development throughout the entire
culture, every photograph is full of symbol and
meaning, which go unnoticed by most people in
daily life. But the photographic work of André
Gelpke is not merely a store of hidden emotional
values; it also offers imaginative potential. This is
why he at the same time is very much a progressive.
He conserves and reminds us of not only the for-
gotten or overlooked, but also creates, through his
role as "image designer," new worlds, some of
them perhaps even utopias. The works in the series
Fluchtgedanken, completed in 1983, for example,
largely feature people shot, obviously posing, from
behind, thus hiding their faces, or from angles where
the hair obscures the face. Each image is myster-
ious, but taken together, the series evokes a palp-
able sense of otherness, despite the straightforward,
recognizable imagery.

Gelpke's early photographs are also often uni-
quely erotic, not in the conventional sense of depict-
ing nudes or other accepted sensual material, but in
his humanistic vision, which creates dense and evo-
cative worlds within each of his compositions. Each
series, moreover, is built up like a dream, where black
and white shades, nuances of color, and intriguing
compositional forms merge together and where one
image spontaneously evokes another. In this sense,

his work practice resembles that of the Old Masters, who were able to reproduce, in an enigmatic way, space, light, and depth in their paintings. Yet Gelpke's work is unmistakably contemporary and often refers to the modern photographic masters.

Gelpke has said about his work:

> In this visual age, when our consciousness of reality is increasingly permeated by the actualities of television, photography, and advertising, my aim is to present the photographic-bureaucratic fact collector with a selection of my reality clipping form an only apparent "pseudo-reality" and thereby to bring about a new questioning of reality.

(*Contemporary Photographers*, St. James Press)

At the end of the century, his work became more overtly erotic, and he has experimented with shooting in color, as in the series *Fata Morgana*. The series *Amok* and *Familientag*, while showing many of Gelpke's characteristic composition and framing, have the additional formal attribute of often startling, oversaturated, but still realistic color.

For Gelpke, experiences are memories, signs, symbols, levels, and geometric forms. As such, he cannot "do" much with them; they are "nothing." Only after the experiences become solidified in a photographic composition can he begin to change and modify them into a usable code system. He uses codification—spontaneously and impulsively—to make the chaos of the world recognizable, converting chaos through his images into an elementary order.

The Spanish photographer and writer Joan Fontcuberta wrote:

> André Gelpke tends to speak of two categories when referring to his work: the monologues (introspection) and the dialogues (relationships with the external). There is no opposition between them—they are complementary because they basically try to exercise two distinct types of vision upon the same reality: sensual vision and intellectual vision.

(*Contemporary Photographers*, St. James Press)

In 1990, Gelpke relocated to Zurich to teach; he has continued to collect his unique images into increasingly experimental series of works that feature still lifes, portraiture, and landscapes combined into suggestive and timeless narratives.

JOHAN SWINNEN

Biography

Born on 15 March 1947. Studied photography with Professor Otto Steinert at the Folkwangschule, Essen, 1969–1974. Photographer since 1974. Founding member of Visum Photo Agency, Essen-Hamburg, 1975–1978; moved to Zürich, Switzerland in 1990; lecturer in photography at the Höhern Schule für Gestaltlung in Zurich.

Solo Exhibitions

1977 *André Gelpke*; Stedelijk Museum; Amsterdam, Netherlands
1982 *André Gelpke*; Werkstatt für Fotografie; Berlin, Germany
1984 *André Gelpke*; Centre Georges Pompidou; Paris, France
1986 *André Gelpke*; Museum für Photographie, Braunschweig, Germany and traveling
1987 *André Gelpke*; Fotogalleriest; Oslo, Norway
1988 Fotofest; Texas Commerce Bank; Houston, Texas
 Heim-Weh; Fotoforum; Hamburg, Germany
1989 Fotomuseum; Braunschweig, Germany
1990 *André Gelpke*; Museum Folkwang; Essen, Germany and traveling to Sprengel Museum, Hannover, Germany
 Nostalgia; Goethe-Institut, Brussels, Belgium
1992 *Heim-Weh*; Goethe-Institut München, Munich, Germany and traveling

Group Exhibitions

1975 *Landesbildstelle*; Hamburg, Germany
1977 *Recontres Internationales de la Photographie*; Arles, France
 Centre Georges Pompidou, Paris, France
 Sander Gallery, Washington, D.C.
1979 *Fotografie nach 1945*; Kunstverein Kassel; Kassel, Germany
1980 *The Imaginary Photo Museum*; Kunsthalle, Cologne, Germany
1982 *Künstler verwenden Photographie – Heute*; Kunstverein Köln; Cologne, Germany
 Place and Identity in European Photography; Rimini, Italy
1984 *Contemporary European Portraiture*; Northlight Gallery, Herberger College of Arts, Arizona State University; Tempe, Arizona
1988 *Twentieth-Century Photography*; Museum of Fine Arts; Houston, Texas
1990 *Otto Steinert und Schüler*; Museum Folkwang; Essen, Germany
1994 *8 Fotografen zum gleichen Thema*; Siemens Fotoprojekt; Städtische Galerie, Nordhorn, Germany
1996 *Die Klasse*; Museum für Gestaltung, Zürich, Switzerland
2002 *Schupmann Collection - Fotografie in Deutschland nach 1945*; Stadtmuseum Münster; Muenster, Germany

Selected Works

Coney Island, New York, 1972
Adler, 1974
Angelique, 1976
Kanalschwimmer, 1977
Mann mit Brille, 1977
Leere Mitte, 1979
Kunstverein Köln, 1979
Sylt, 1980
Death Valley, Nevada, 1980
Der schiefe Turm von Pisa, 1983
Bretagne, 1983
Houston, 1984

Further Reading

Andries, Pool, ed. *Antwerpen 93: een stad gefotografeerd, a city in photographs*. Antwerpen: Museum voor Fotografie, 1993.

Eskildsen, Ute. *Museum Folkwang: Die fotografische Sammlung*. Essen: Folkwang Museum, 1983.

Gruber L. Fritz, and Renate Gruber. *The Imaginary Photo Museum* by Helmut Gernsheim, Cologne, 1981. English trans: New York: Harmony Books, 1981.

Gelpke, André. *Sex-Theater*. Munich, 1981.

———. *Fluchtgedanken, Ein monoloog*. München: Mahnert-Lueg Verlag, 1983.

———. *Der Schiefe Turm von Pisa, Reisebilder 1972–1985*. Braunschweig: Museum für Photography, 1985.

———. *Siemens Fotoprojekt*. Münich, 1991.

Heller, Martin, André Gelpke, and Ulrich Heller Görlich, eds. *Die Klasse*. Photography Department, Zürich School of Design, Zürich: Museum für Gestaltlung, 1966.

Hopkinson, Amanda, ed. *Contemporary Photographers*, Detroit: St. James Press, 1995.

Neusüss, Floris, ed. *Deutsche Fotografie nach 1945*. Kassel: 1979.

Swinnen, Johan. *Photography on Landscape, the Paradox of André Gelpke*. Alden Biesen: Aksent, 1989.

PHOTOGRAPHY IN GERMANY AND AUSTRIA

Germany and Austria are Central European countries with few natural borders, which has led to several dividing and unifying processes in their history. In the course of the twentieth century, Germany and Austria have changed their frontiers more than once; in the aftermath of World War II, Germany was divided into two parts for over 40 years, reunifying in 1989. The histories of German and Austrian photography therefore have been characterized more by individual contributions and various stylistic approaches than by distinctive national tendencies. On the other hand, the countries' geopolitical situations drew the attention of countless wanderers between East and West, which allowed German and Austrian art and culture to develop integrally within larger international movements.

German and Austrian photography in the twentieth century has been, for the most part, a mirror of the medium's history, but with a certain emphasis on singular developments. This ponderation is mainly due to the German language, which emphasizes precise formulation and descriptive qualities, often at the cost of elegance and dignity. German science and art have been described as conceptually strong and devoted to long-term developments, even if they come comparatively late. The stylistic histories of the visual arts and architecture in Germany and Austria demonstrate that these countries have rarely been the site of inventions or innovations but often that of the maturation of a particular technique or style. As German and Austrian photography encompasses virtually all

developments in photography, they reflect the general historical development of photography in the twentieth century.

The widespread fine art photography, or Pictorialist movement, brandished its waves on the German shore but left little impact on history as a whole. The Viennese Trifolium (Hugo Henneberg, Heinrich Kühn, Hans Watzek), founded in 1891 and dissolved by Watzek's death in 1896, was exhibited in Berlin, Dresden, Hamburg, and Munich, but only a few followed the American Alfred Stieglitz's clarion call for artists. The brothers Theodor and Oskar Hofmeister from Hamburg exhibited widely throughout the country, as well as the Krefeld sports teacher Otto Scharf, the Hamburg merchant Heinrich Wilhelm Müller, the painter Friedrich Matthies-Masuren, and the military officer Ludwig David from Berlin. Some of the fine art photographers specialized within the field, many in portraiture: Rudolf Dührkoop and his daughter Minya Diez-Dührkoop in Hamburg and Bremen, Hugo Erfurth in Dresden, Jacob Hilsdorff in Bingen and Munich, and Nicola Perscheid in Berlin. The Wiener Kamera Klub founded in Vienna spread Pictorialist ideas.

Two men were, on different levels, influential in spreading the idea of photography as a fine art among a larger public. One was the German-American and co-founder of the Photo-Secession Frank Eugene, who, having studied painting in Munich, stayed in town and effectively pursued both arts among the scene; his close collaboration with the

famous painter Franz von Stuck emphasized photography's impact on art. Having taught portrait photography at the Bavarian State School of Photography, he was named Professor of Fine Art Photography at the Academy of Graphics and Book Art in Leipzig in 1913—the first professorial seat in art photography in Germany. The other, Erwin Quedenfeldt in Dusseldorf, was not as lucky; he had wanted to integrate his private school of Fine Art Photography into the local School of Arts and Craft, then under the reign of the well-known designer Peter Behrens, but he had to give up these plans after Behrens' move to Berlin in 1908. Quedenfeldt, a chemist by profession, invented a printing process and was busy inventorying rural architecture in the Lower Rhine area. In Vienna, the Staatliche Graphische Lehr-und Versuchsanstalt (State Graphic Teaching and Research Faculty), founded in 1888, still concentrated on the technical side of the medium, expanding to art only after 1918, mostly under the influence of Rudolf Koppitz.

Both Eugene and Quedenfeldt, as well as the portraitist Hugo Erfurth, had prepared the road to modernism in photography by introducing high contrasts and plain white backgrounds into their work long before these practices were common. On the other hand, the work of two of the most important of the German modernists—August Sander and Albert Renger-Patzsch—is not explicable without noting their backgrounds in the Fine Art movement. While Sander had tried to establish himself as a professional Fine Art Photographer before World War I, Renger-Patzsch came from an amateur background, his father being a widely published author on technical aspects of photography, like gum-printing. In 1925, August Sander was encouraged by some friends from the Cologne art scene to reprint his old portraits on technical paper and to collect them under a sociological scheme. In less than four years, he had identified subjects that he thought represented Germany, his concept incorporating portraiture as well as architectural photography. When his first book appeared in 1929 under the title of *Antlitz der Zeit* (Face of Time), it was acclaimed with great applause as a mirror of German society. Albert Renger-Patzsch had appeared on the scene just one year before with his book *Die Welt ist schön* (The World is Beautiful), which received similar fame, although its title was rejected by nearly all critics.

Albert Renger-Patzsch had brought straight photography to Germany in the manner executed a decade earlier by Paul Strand: images of technical, natural, and artificial objects depicted from low distance under sharp light with overall delicacy in showing surfaces and detail. Recognition for Renger-Patzsch came precisely at the time when avant-garde painters had switched to a style named *Neue Sachlichkeit* (New Objectivity), which applied notions about realistic representation to painting as obviously derived from photography. The climate of these developments was felt more strongly at several art schools and academies of the time in Germany and Austria, one of which has lent its name to a number of stylistic approaches: the Bauhaus. For the first nine of its 14 years of existence, photography was an integral part only of the basic (foundation) course at the Bauhaus. Masters like Georg Muche and László Moholy-Nagy introduced the medium to their students as a means of visual training, a practice that can be traced in the work of avant-garde luminaries like Umbo (Otto Umbehr) or Irene and the Austrian Herbert Bayer.

When Moholy-Nagy began teaching at the Dessau Bauhaus, his wife Lucia Moholy turned from her work in the promotion of literature and took up the documentation of her husband's paintings, the designs of students and other teachers, and with a long series of architectural photographs of the new Bauhaus buildings at Dessau. She also did Moholy-Nagy's darkroom work, reproducing his photograms, preparing his books for print, and advising him on technical details for his camera photographs. For several decades, her work languished in the shadow of her husband's huge and influential œuvre but, according to the recollections of various Bauhaus students, Lucia Moholy was equally influential on their photographic practice.

When the Moholys left the Bauhaus in 1927, Joost Schmidt taught a class in advertising and photography, again as part of the foundation course. In 1929, Schmidt invited Walter Peterhans to start a class in photography, in fact the only photography course at the Bauhaus, which continued until it was closed by the Nazis in 1933. Peterhans's curriculum followed guidelines well known to photography students all over Germany: methods of developing film and prints; studies in densitometry, photograms, setting of light; and the main uses of the medium. The only truly modern curriculum in photography was taught just a few miles away from Dessau, at the arts-and-crafts school at Burg Giebichenstein in Halle. Following an aborted career as an art historian, Hans Finsler, initially the school's librarian, designed a modern curriculum based on photography's unique, intrinsic qualities. In Halle, Finsler was unable to fully explore his ideas, but with his departure for Zurich he was to become the most influential tea-

cher in Swiss photography of his era. Besides Hans Finsler, it was Max Burchartz at the Folkwang school in Essen who had, more or less by chance, introduced photography into his curriculum and practice, and two of his students at the end of the 1920s, Anton Stankowski and Klaus Wittkugel, were to gain fame in the 1950s as graphic designers using photography.

When Walter Peterhans was called for the Bauhaus, he left behind a small advertising studio to two of his private students, Grete Stern and Ellen Auerbach. Under their nicknames "ringl + pit," Stern and Auerbach made this studio well known among advertising agencies and designers of the late 1920s. Although only in their mid-1920s, Stern and Auerbach attained immediate success with their application of modernist principles to advertising, fashion, and object (still life) photography. A number of their competitors at the time were also receiving recognition with their work: Ilse Bing in Frankfurt on the Main started a career in theater and dance photography while studying art history; Gisèle Freund used her camera to document political demonstrations in the same town where she was studing sociology; and Lotte Jacobi, who had taken over her father's photographic workshop, created journalistic portraits of prominent and everyday people. She not only published her photographs in various illustrated newspapers but also accompanied the famous writer Egon Erwin Kisch throughout the Soviet Union and Central Asia.

Lotte Jacobi's work was in the new field of photo journalism. She especially dealt with the political aspects of the field by cooperating with the large commercial papers as well as with communist party activists like the *photo-monteur* John Heartfield (Helmut Herzfelde), for whom she set the protagonists of his posters into the scene. The introduction of photographic journalism into Germany had been delayed, which proved an advantage when it arrived as a force in the late 1920s. The large printing companies not only introduced autotype printing of photographs in 1925 in German tabloids and magazines, but they also devoted considerable space to photographic reproductions, allowing a new generation of young illustrators and photographers to create innovative lay-out and design schemes. In the highly competitive market of German-illustrated newspapers of the 1920s and 1930s, editors welcomed such innovation and counted on the name recognition of the emerging "star" photographers to sell their publications. A star system had soon emerged.

The first "star" of photojournalism was, without doubt, Erich Salomon. After studies in jurispru-

dence, he served the Ullstein publishing house in legal affairs. During a court case, he took candid photographs. Although such activities were strictly forbidden, the resulting images were so respectful to both the court and the litigants that Salomon was thereafter greatly sought out to document the important events of the day. There was no important conference without Salomon present up to the mid-1930s, yet even his distinguished reputation did not prevent his being murdered by the Nazis at Auschwitz in 1944. Other photojournalists of the late 1920s, such as Felix H. Man, followed Erich Salomon's precedent; others, such as the brothers George and N. Tim Gidal, found their themes in everyday life. Austrian press photographers like Lothar Ruebelt concentrated on sports very early, whereas Harald Lechenperg pursued a career as a traveling journalist with long trips to Central Asia and Africa. But most journalistic photographs were provided by press agencies, which gave a number of very young practitioners the chance to introduce themselves into the field. The left-leaning magazines had to rely on a well-organized amateur movement called *Arbeiterfotografie* for the majority of their images. Photographers like Walter Ballhause, Erich Rinka, John Graudenz, Ernst Thormann, Richard Peter senior, and Toni Tripp emerged out of this movement. Among the *Arbeiterfoto* correspondents who survived the Nazi persecution and received positions in the newly founded German Democratic Republic (GDR), Walter Ballhause is the most prominent.

Most journalists in the 1920s treated the Nazi party movement with a mixture of oppression and neglect, and subsequently they were among the first who feared for their lives after the National Socialist party came to power in January, 1933. Erich Salomon did not return from a conference in Den Haag; N. Tim Gidal used the occasion of another conference to flee to Switzerland; Felix H. Man followed his editor Stephan Lorant to the United Kingdom; Gisèle Freund had to emigrate to France in order to finish her doctoral thesis. Ilse Bing had moved to Paris just prior to these political developments, and Hans Finsler was appointed lecturer of photography at the Zurich school of arts and crafts in 1932. What was left to German photojournalism after this severe loss can be viewed as a level of mediocracy as well as a chance for very young amateurs, who seized the opportunity for careers. These photographers include: Wolfgang Weber, Hilmar Pabel, Bernd Lohse, Wolf Strache, Werner Cohnitz, Max Ehlert, and Erich Stempka, just to name a few. But even these men produced material of a higher quality than the photo-journalism

efforts of the Nazis—even propaganda minister Joseph Goebbels regularly bemoaned the miserable quality of the photographic material presented to him. What happened in Germany in 1933 was to be repeated in Austria in 1938: When the Nazis came into the country, a number of photographers like Wilhelm and Laszlo Willinger had to flee from their homes and businesses.

Photography, of course, was an integral part of the Nazi propaganda machine. As photography was seen as inherently modern in proposition and effect, there was no rejection of modern or even avant-garde styles in the first years of the regime. In 1929, the Stuttgart exhibition *Film und Foto* had set the framework for a common foundation of knowledge about modern German photography; historically, this exhibition must be seen as an important retrospective of the various experimental techniques and styles of German photography to date. When the exhibition traveled to a number of German cities, it was welcomed by critics and public alike, and graphic designers could no longer think of effectively advertising products without using photographs. As a result, modernism was well established at the time of the Nazi regime, and a number of modern designer-photographers continued working without change. Herbert Bayer worked for advertising agencies and curated large exhibitions featuring works that utilized photomontage, serial imagery, and avant-garde leaflets. Bayer's last show accompanied the Berlin Olympic Games and was an enormous success, while it also marked the tolerance of modernism by the Nazis. In early 1938, Bayer left for the United States, where he went on to become a leading designer and photographer.

The fate of another modernist was not as lucky: Else Simon-Neuländer, better known under her brand name Yva, was the most famous fashion photographer in Germany of the 1930s and published in all important magazines. In 1936, she was urged to sell her business to a friend; in 1938, she began work as an X-ray assistant in a Berlin hospital. In 1942, she was deported to the Majdanek concentration camp, where she is suspected to have been murdered. Her last apprentice, Helmut Newton (Neustaedter), however, survived by fleeing to Australia. Many other photographers, including Lotte Jacobi, left their businesses behind, sold them for cheap or gave them away for nothing, using all of their belongings to pay for their emigration. On the other hand, some of these cheaply acquired photostudios allowed other careers to flourish, a phenomenon which continued after World War II.

In many minds, Nazi photography is synonymous with the work of Heinrich Hoffmann. A well-trained portrait photographer with stages abroad, including at the atelier of E. O. Hoppé in London, he opened a small studio in Munich shortly before World War I. In 1921, he met Adolf Hitler and became a personal friend; Hitler eventually transferred to Hoffmann the copyright of his image, resulting in the fact that no one was allowed to take or sell photographs of Hitler without Hoffmann's permission. To this monoculture of imagery came a racist ideology, as spread in photographic books by Erna Lendvai-Dircksen and Erich Retzlaff. The result was an average boredom of the public when looking at photographs, and this would only be overcome by propaganda strategies of individual authorship. As with the communist *Arbeiterfotografie* (Worker Photograpy) movement, the Nazi government tried to stimulate amateur photography by installing local groups, subsiding amateur magazines, and combining sport or travel activities with photography. Leni Reifenstahl is also closely associated with the Nazi movement, especially her film and the photographs adapted from it of the Berlin Games.

The amateurs, however, needed stars to look up to, and by 1933, two were already available: Walter Hege and Paul Wolff. Both were moderately modern in their work; both were extremely productive and actively teaching at workshops and in academies, but their work focused in different directions. Walter Hege was an interpreter of ancient ruins, and Paul Wolff depicted the beauty of everyday life, especially for those few lucky and rich enough to afford driving around Germany in automobiles. In the late 1930s, he was followed by the Austrian Stefan Kruckenhauser with similar images on what was now called the Ostmark. Albert Renger-Patzsch still was recognized as the greatest photographer at the time but did not gain the status of a star during this era as did Hege and Wolff. The most important aim of these photographers and their role in state propaganda was not achieved, however: to inspire a large number of young women and men to become the next generation of propagandists. As a result, World War II began with the Nazis undertaking great efforts to install Propaganda companies (PK) and to enlist such well-known photographers as Hanns Hubmann, Fritz Kempe, Hilmar Pabel, and Lothar Ruebelt. But, despite their being masterfully photographed and printed, these military propaganda pictures had little lasting influence.

Those images that would have interested the German public in a totally different way were not published before 1945: photographs of acts of persecution against Jews, the Sinti and Roma people, political opponents, and all those not able or will-

ing to fit into the racist scheme of the Nazi regime. Most of the images that depict the Holocaust are derived from material seen, taken, and supplied by the perpetrators themselves, thus showing only one side of the truth. Crimes against humanity, as executed openly among the German people, were set into scenes in order to be photographed and recorded in a matter similar to documentary filming. Photographs of concentration camps are rare, and even rarer are images like those by Mendel Grossman of the Ghetto in Lodz, Poland, which had to be smuggled out shortly before he was transported to another camp, where he died. The rarity of these photographs quickly made them icons of the Holocaust, contrasting sharply with the masses of propaganda photographs taken by amateurs and professionals alike, as these few images show the actual horror of people willing to look away from what was done in their name.

After 1945, Germany lay in agony, and so did German photography. Only a few photographers documented the damage and destruction of the country's cities, as Robert Capa had done on his assignment in Berlin in August, 1945. Eva Kemlein worked in Berlin, Hermann Claasen in Cologne, Erna Wagner-Hehmke in Dusseldorf, Karl-Heinz Mai and Renate Roessing in Leipzig, Lala Aufsberg in Nuremberg, and Herbert List and Tom von Wichert in Munich. Many others did not wish to know anything about war and its results. The older photographers who had participated in propaganda and other war crimes now took their motifs from nature, so as to deny that they had helped to destroy a cultivated country. Younger photographers fled to abstraction as a manifestation of their amnesia. In 1949, a group of young photographers was formed which was to become the nucleus of 1950s modernism; its name was *fotoform*, and the more famous members were Peter Keetman, Otto Steinert, and Ludwig Windstosser. Keetman represented the purest form of *fotoform*; Steinert had incredible impact on the German photographic scene as teacher, and Windstosser presented German industry after its remarkable postwar recovery. The group offered membership to two older avant-gardists—Raoul Hausmann, the former *dadasoph*; and Heinz Hajek-Halke, who had played a minor but prolific role in the 1920s.

Hajek-Halke taught on a part-time contract at the Berlin Academy and helped a number of students to find their way, among them characters so diverse as Dieter Appelt and Michael Ruetz. Otto Steinert taught in Saarbrucken until 1959, where he helped important artists like Monika von Boch, Kilian Breier, and Detlef Orlopp start their careers,

but he switched to teaching straight photo-journalism upon moving to Essen. Among his more important students were Hans-Joerg Anders, Henning Christoph, Juergen Heinemann, Bernd Jansen, Dirk Reinartz, Heinrich Riebesehl, Guido Mangold, Rudi Meisel, Peter Thomann, Walter Vogel, Wolfgang Vollmer, and Wolfgang Volz. A few of Steinert's students in the 1960s moved to art photography (e.g., Arno Jansen, André Gelpke, and Timm Rautert).

The situation in Austria after 1945 was slightly different: U.S. propaganda magazines like *Heute* encouraged a number of very young photographers like Ernst Haas and Jewish immigrants like Erich Lessing to create a fresh scene of a life magazine journalism nearly unknown in any other European country. From the same ground, the career of Inge Morath emerged.

There were important exponents of 1960s photojournalism in Germany besides Steinert's students. On one hand, men like Robert Lebeck and Thomas Hoepker pursued their own careers within classic journalism, whereas other photographers like F.C. Gundlach, Walter Lautenbacher, and Charlotte March laid out new goals for fashion photography; even Helmut Newton returned to the German-illustrated papers via France. Advertising and industry instigated a number of photographers to produce masterworks in this field, among them Robert Häusser, Franz Lazi, Will McBride, Karl-Hugo Schmölz, and Walde Huth, and, above them all, Reinhart Wolf. While there were many developments in politics and society during this era, art was not yet a real theme in photography until the mid-1970s. The only movement that quietly blossomed in the 1960s was called *Generative Fotografie*, which indicated a self-referential, extremely abstract form of autopoetically generated images in photographic techniques, including micrography, chemigraphy, and multiple pin-hole photography. This movement was led by Gottfried Jäger and embraced figures as diverse as Hein Gravenhorst, Karl-Martin Holzhaeuser, and Manfred Kage. This movement stimulated early experiments in computer graphics as well, as seen in the work of Herbert W. Franke, Manfred Mohr, and Frieder Nake.

Parallel to the renaissance of interest in classical photography as seen in the art market in the 1970s, there were two chains of development that represent German photography for the next 20 years. One received the name of *auteur* photography, after film theory's use of the term, with Andreas Müeller-Pohle and Wilhelm Schuermann as its main protagonists, following in the footsteps of Steinert students Arno Jansen and Heinrich

Riebesehl, whom they identified as their artistic fathers. The other, more important development can be described as the integration of photography into all existing concepts of art, but used mainly as a means of documenting the artist's own body. Dieter Appelt had been the forgotten forerunner of this movement, but all of those who followed him, from Gerhard Richter to Jürgen Klauke, Katharina Sieverding, and Klaus Rinke with Monica Baumgartl to Anna and Bernhard Johanne Blume, owed a great deal to his efforts and emphasis. Painter Sigmar Polke, who integrated reproduction technologies and photo-chemistry into classical as well as Pop forms of painting, explored new territory that has proven to be extraordinarily influential. All of these artists became teachers at various German art academies but did found stylistic schools of their own.

The *auteur* movement was equally strong in Austria, and some of its proponents like Manfred Willmann, Cora Pongraz, Michael Mauracher, and Margherita Spiluttini gained world fame. On the other hand, there was the Wiener Aktionismus (Vienna Actionism) of performance and body art, which initiated the use of photography in the visual arts on a definitely new level. Protagonists of this development were Peter Weibel, Rudolf Schwarzkogler, Heinz Cibulka, Guenther Brus, and others who did not record their actions themselves but with the help of press photographer Ludwig Hofenreich. This movement forms the background against which more recent artists such as Valerie Export have emerged.

The work of Hilla and Bernd Becher presents an entirely different case. Starting with architectural documentation of vernacular industrial sculptures in—according to the language—a typical German manner, the Bechers' work around 1970 represented the best of Conceptual Art and craft tradition in photography. In 1976, Bernd Becher was appointed professor of photography at the Dusseldorf academy and immediately began to assemble a class in the traditional sense of the word. A number of exhibitions made discernable three generations of Becher students who themselves have gained fame throughout the world now. The first generation is best represented by Candida Höfer, Axel Hütte, and Thomas Struth; the second by Andreas Gursky, Thomas Ruff —now his successor on the Dusseldorf chair—Jörg Sasse, and Petra Wunderlich. The third generation does not yet carry the clear profile of the earlier group, but includes already well-known artists like Laurenz Berges, Johannes Bruns, Christine Erhard, Elger Esser, Claus Goedicke, Heiner Schilling, and Andrea Zeitler.

The success of Bernd Becher's class concept stimulated similar efforts at other academies. Angela Neuke, former student of Martha Hoepffner and Otto Steinert, was installed to a seat at Essen university in 1983 after a long career in photojournalism, and she pursued, until her untimely death in 1997, the set up of a large class of promising designers and photo journalists, among them well-known names like Joachim Brohm, Zóltan Jókay, Volker Heinze, Karin Apollonia Müller, and Markus Werres. On the other hand, since the late 1950s, the Leipzig *Hochschule für Grafik und Buchkunst* (Academy of Graphic and Book Art)—the oldest academy in Germany—had watched closely what happened in the classes of Otto Steinert, his colleagues, and his successors. Nearly every student at this school had to fix his identity against the Western advantages in photo-journalism, which was damned as propaganda in order to install the GDR's own vision. Whereas Gerhard Kiesling, Lotti Ortner-Röhr, Richard Peter junior, Wolfgang G. Schröter, Erich Schutt, and Horst Sturm can clearly be seen as the next generation of German propaganda photographers, others became dissidents of the system and subsequently were not shown again before the late 1980s. Ursula Arnold has to be named here in first place, whereas the roles of, among others, Ulrich Burchert, Arno Fischer, Evelyn Richter, Detlev and Uwe Steinberg remain a little iridescent.

Since 1978, after the installation of the art historian Peter Pachnicke as head of the photography class, interest shifted from straight-forward photojournalism to what was the official function of art in socialist countries: the view on mankind. Christian Borchert and Helfried Strauß broadened the classical fields; Jens Rötzsch and Rudolf Schäfer introduced photographic design to the GDR; Sybille Bergemann and Ute Mahler did the same for fashion. During the 1980s, several GDR photographers earned international fame through magazines and books, among them Ulrich Wüst, who had come from town planning, and a number of performance artists using photography as a means of expression, for example, Kurt Buchwald, Klaus Elle, and Klaus Hähner-Springmühl. Shortly before and after the German re-unification of 1990, a number of Leipzig students formed another nucleus of architectural documentation, by no means minor to the Becher class: Max Baumann, Matthias Hoch, Frank-Heinrich Müller, Peter Oehlmann, Hans-Christian Schink, Erasmus Schröter, and Thomas Wolf were followed by Thilo Kühne, Annett Stuth, and a growing number of young photographers now studying in Leipzig under the new direction of Joachim Brohm, Astrid Klein, and Timm Rautert.

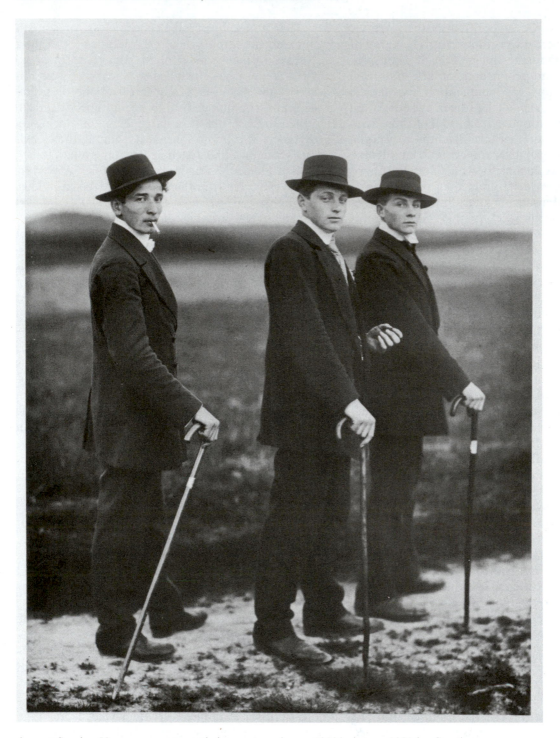

August Sander, Young peasants on their way to a dance, 1913/print ca. 1971 by Gunther Sander from original negative, gelatin silver print, 29.7 × 22.1 cm, Museum Purchase. [*Photograph courtesy of George Eastman House*]

The 1990s saw in Germany the same integration of all fields formerly separated in art, design, and technology. Computer imagery and virtual reality, model building and exact documentation, still and moving images grew into each other and were exhibited as photography only under the conditions of being a two-dimensional, printed, or projected plane. Thomas Demand's work, for example, is shown as photography although he considers himself more a media artist and sculptor. On the other hand, Gudrun Kemsa, trained as sculptor, is equally known as a video artist and as a photographer. Heidi Specker has had a training in photography, but her work can be traced in computer graphics as well. Susanne Brügger's *Map Work* coincides with the return of cartography into Conceptual Art, and Hardy Burmeier uses vernacular photographs of the nineteenth century as a base for his computer works.

Artists of this kind come from a variety of backgrounds which were less distinctive for their work than in former generations. Subsequently, a new type of institution arose, teaching an equal variety of subjects from drawing and painting over photography and philosophy to electronics and economy. Although several academies have taken the first steps of their own transformation in that direction (like the Viennese Academy of Applied Arts), only two new schools have to be named in this field—the *Kunsthochschule für Medien* (Academy of Media) in Cologne, and the *Staatliche Hochschule für Gestaltung* (State Academy of Design) in Karlsruhe, which is directly linked to and situated under the same roof as the *Zentrum für Kunst- und Medientechnologie* (Centre of Art and Media Technology). It is too early to see results of these schools, but there still is going to be a small German notion in works that integrate photography and media technology, the Internet and virtual reality, English language and Chinese or Kanji characters. These artists will act globally and still have their feet on the ground of their home countries, Germany and Austria among them.

ROLF SACHSSE

Further Reading

Stenger, Erich. *Die Photographie in Kultur und Techni*, Leipzig: E.A. Seemann, 1938 (American publication: New York, 1939).

Photography in Germany, 12 (Exhibit catalogue). Stuttgart: Institut für Auslandsbeziehungen, 1981–1991.

Geschichte der Fotografie in Oesterreich, 2 vol., (Exhibit catalogue). Bad Ischl: Oesterr. Fotomuseum, 1983.

FOTOVISION, Projekt Fotografie nach 150 (Exhibit catalogue). Jahren, Hannover: Sprengel Museum, 1988.

Das deutsche Aug Exh. cat. Hamburg Munich: Deichtorhallen/Schirmer/Mosel, 1996.

Honnef, Klaus, Rolf Sachsse, and Karin Thomas, eds. *German Photography*. New Haven, CT and Cologne: Yale University Press/DuMont, 1997.

Positionen künstlerischer Photographie in Deutschland seit 1945 (Exhibit catalogue). Berlin Köln: Berlinische Galerie/DuMont, 1997.

Markus Rasp, ed. *Contemporary German Photography*. Cologne: Taschen, 1997.

frauenobjektiv, Fotografinnen 1940 bis 195 (Exhibit catalogue). Bonn Cologne: Haus der Geschichte der Bundesrepublik/Wicnand, 2001.

JOCHEN GERZ

German

Unlike conceptual artists who radically denied the validity of the image, Gerz uses photography in order to redefine the status of representation in contemporary art and culture. For him, photography and text, through their many forms, are two inadequate, but complementary descriptive systems. As he put it: "What's happening when I am in front of an Ad Reinhardt monochrome? I am constructing a text. What's happening when I am reading? I am creating images as they were a part of my nature."

Jochen Gerz was born in Berlin in 1940. In 1966, he moved to Paris, where he has lived ever since.

While studying in Cologne, London, and Basel, Gerz became interested in poetry. As early as 1959, he was a writer and translator; gradually his texts became more and more visual, until by 1966, the year he settled in Paris, he joined the visual poetry

movement. In 1968, he co-founded, with Jean-Fran-çois Bory, the alternative editorial group Agentzia. Gerz would henceforth explore several artistic paths at the same time, such as literature, painting, sculpture, drawing, and photography, always keenly critiquing the media and desiring to involve the spectator in the creative process. Since 1969, several of his photo/text works have played off the tension between photographs (most often black and white, but in color since 1987) and critical texts.

If Gerz forms columns of lines to supplement illustrations, suggesting a correspondence between text and image, the reader very soon arrives in a no man's land in which he tries to locate the meaning of the two only seemingly related information systems. Although the relation between image and verb is called into question, the meaning, or rather the multiple meanings emerge in the failure of communication and in the concomitant deception of representation. The linearity of verbal text gives Gerz's photographs a particular temporal dimension that re-inscribes them in the field of reality, *not despite but through* fiction. "Time does not allow myth to exist," as Gerz said. That is why memory, the act of recalling the past, plays such an important role in Gerz's work, as a fundamentally aesthetic field. Nevertheless, the object of souvenir ultimately seeps away; it can only be evoked and not seized through photography. What links Gerz's sculpture with his photographic work is this interest on monumentality, as something which is concerned with memory, rather than with power.

Texts and images are used to examine their own function and dysfunction, their mutual analogies as well as their internal dissemblance. His photo-texts resemble a riddle more than having the quality of directing messages for purposes of communication.

With his combinations of images and texts, Gerz departs from the tradition established by John Heartfield. Heartfield created collages presenting social contradictions and power structures; he staged dissonances and focused on contradiction. One doesn't find these kinds of alienation or enlightenment strategies in Gerz's works. His works of art don't present didactics in an aesthetic guise. The information content of Gerz's messages "keels" over, turning them into riddles when trying to understand them.

Following the French symbolist poet Mallarmé, who showed less interest in words than in the white spaces between them, Gerz said: "I'm interested in the non-visual intermediate zone developing from the operation, which is neither text nor image." This intermediate zone illustrates the shift from photographic reality to intellectual abstraction. In *De L'Art n° 1 (About Art n°1)*, 1982–1983, black-and-white landscape photographs are associated with a text about art. A poetic dimension rises up between the metaphorical images on the concept of landscape and the theoretical essay on what art might be. *De L'Art n° 1* is the first of a series of eight works composed always in the same way: texts and photographs complete each other, but they could also be viewed separately. Such works ask questions on the interstice and/or link between the visual and the verbal, their interdependency and their conflicts.

In contrast to politically involved artists of the 60s and 70s who considered art as a weapon to be wielded in the everyday debates in the arena of social policy, Gerz pursues a more radical approach by continually calling communications systems into question, not as neutral instruments but as elements of an existing order. Rather than linking his interrogations with the "representation of politics," he oriented his work to the "politics of representation," that is, its internal structure and ideological forms. For Gerz, aesthetics are intimately related to the social field. As he showed with *Exposition de huit personnes habitant la rue Mouffetard, Paris (Exhibition of eight persons residing Mouffetard road in Paris)*, 1972, art is a space of a potential collective expression.

In 1976, Gerz represented Germany in the Venice Biennale and participated in Documenta 6 (1977) and 8 (1987) in Kassel. In the 1980s, the artist was commissioned to create several monuments in which he would subvert the idea of commemoration, turning spectators into actors: *Monument Against Fascism*, Harburg, 1986; *Bremen Questionnaire*, Bremen, 1990; *2,146 Stones Monument Against Racism*, Saarbrücken, 1990–93; *The Living Monument*, Biron, 1997. In parallel with his artistic work, Gerz has taught as a visiting professor in Germany, France, Canada, and the United States. He is a Senior Research Fellow at Coventry University in England and a Member of the Art Academy in Berlin, and he holds the Honorary Chair at the Braunschweig Art Academy.

VANGELIS ATHANASSAPOULOS

See also: **Conceptual Photography; History of Photography: the 1980s; Photography in France**

Biography

Born in Berlin in 1940, moved to Paris in 1966. Uses various media such as texts, photography, video, installation. Awarded with the German Critics Prize, and Ordre National du Mérite, 1996; Grand Prix National des Arts Visuels of France, 1998; Helmut-Kraft-Stiftung Prize, 1999. Represented Germany in the Venice Biennale, 1976; participated in Documenta 6 and 8 in Kassel. In the 1980s, he was commissioned to create

several monuments in relation to the memory of the public space. Visiting professor at various universities in the United States, Canada, Germany, and France. Lives and works in Paris, France.

Individual Exhibitions

1994 Musée d'art moderne et contemporain de Strasbourg; Strasbourg, France and traveling to Vancouver Art Gallery; Vancouver, British Columbia, Canada

1995 Newport Harbor Art Museum; Newport Beach, California; and traveling to Tel-Aviv University Gallery, Tel-Aviv, Israel; Galerie Guy Ledune, Bruxelles, Belgium; Galerie Chantal Crousel, Paris, France; Neuberger Museum of Art, Purchase, New York

1997 Kunstmuseum Düsseldorf, Düsseldorf, Germany; Museum Wiesbaden, Wiesbaden, Germany; Musée d'art moderne Saint-Etienne, France; Catriona Jeffries Gallery, Vancouver, British Columbia, Canada

1999 ZKM, Zentrum für Kunst und Medientechnologie, Karlsruhe, Germany

2001 Galerie Löhrl, Mönchengladbach, Germany

2002 Musée national d'art moderne, Centre Georges Pompidou, Paris and traveling to Folkwang Museum, Essen, Germany

Group Exhibitions

1970 *Concrete Poetry*; Stedelijk Museum, Amsterdam, Netherlands

1974 *Video*; Musée d'art moderne de la Ville de Paris, Paris, France

1976 *37. Biennale*; German Pavillon, Venice, Italy

1977 *Documenta 6*; Kassel, Germany
 Positions; Louisiana Museum, Humlebaek, Denmark
 Words; Whitney Museum of American Art; New York, New York

1985 *Kunst in der BRD (Art in West Germany) 1945–1948*; Nationalgalerie, Berlin, Germany

1986 *Behind the Eyes: Eight German Artists*; San Francisco Museum of Modern Art, San Francisco, California

1987 *Documenta 8*; Kassel. Germany

1988 *De Facto*; Royal Academy of Arts, Copenhagen, Denmark

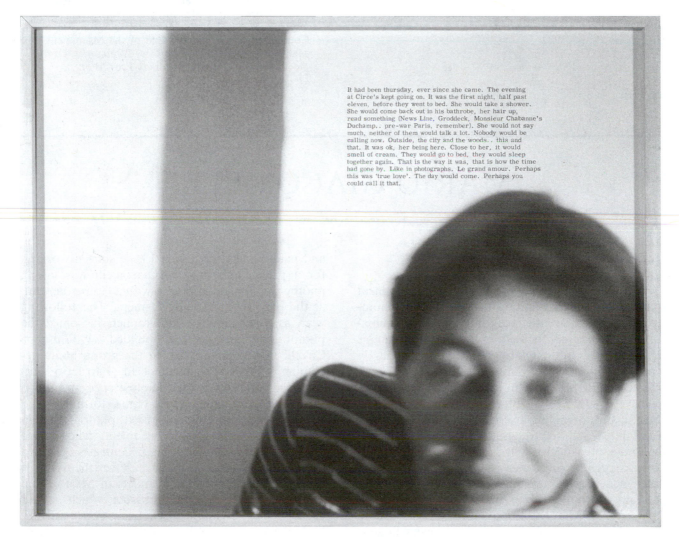

Jochen Gerz, Le Grand Amour (Fictions) #1, 1980, Photo Georges Meguerditchian.
[*CNAC/MNAM/Dist. Réunion des Musées Nationaux/Art Resource, New York*]

1989 *View points on German art*, Musée d'Art Contemporain, Montreal, Quebec, Canada
1990 *Um 1968, Konkrete Utopien in Kunst und Gesellschaft*; Kunsthalle Düsseldorf, Dusseldorf, Germany
1994 *Hors limites, l'art et la vie*; Centre Georges Pompidou, Paris, France
1996 *Face à l'histoire*; Centre Georges Pompidou, Paris, France
1997 *Made in France*, Centre Georges Pompidou, Paris; *Deutschlandbilder*, Martin-Gropius-Bau, Berlin
1998 *Out of Actions: Between Performance and Objects, 1949–1979*; Museum of Contemporary Art; Los Angeles, California
 Premises: Invested Spaces In Visual Arts and Architecture from France 1958–1998; Solomon R. Guggenheim Museum; New York, New York
1999 *Das 20. Jahrhundert (The Century Exhibition)*; Nationalgalerie, Berlin
2000 *Das Gedächtnis der Kunst (The Memory of Art)*; Schirn Kunsthalle, Frankfurt, Germany

Selected Works

Exposition de huit personnes habitant la rue Mouffetard, Paris (Exhibition of eight persons residing Mouffetard road in Paris), 1972
F/T 7, 1973
De L'Art n° 1 (About Art n° 1), 1982–1983

Monument against Fascism, Harburg, 1986
In the Art Nite, 1989
Bremen Questionnaire, Bremen, 1990
2,146 Stones Monument Against Racism, Saarbrücken, 1990–93
The Living Monument, Biron, 1997

Further Reading

Deecke, Thomas, Doris Van Drathen, Peter Snoddy, and Andreas Vowinckel. *Jochen Gerz: Life after Humanism*. Art Books Intl. Ltd., 1998.
Gerz, Jochen. *Life after Humanism*. Stuttgart: Edition Cantz, 1992.
Gerz, Jochen. *Jochen Gerz: People Speak*. Vancouver: Vancouver Art Gallery, 1994.
Holmes, Willard. "Here our look sees itself." *Parachute* 60/1990, Montreal.
Pejic, Bojana. "Art ex Absentia." *Artforum* (April 1990), New York.
Rosen, Myriam. "The emporer's new monument." *Artforum* 3/ (1992), New York.
Schmidt, Hans-Werner et al. *Jochen Gerz, Res Publica, The Public Works 1968–1999*. Stuttgart: Verlag, 1999.
Young, James. "German's Memorial Question: Memory, Counter-Memory, and the End of the Monument." In Martin Morris (Hg.), *German Dis/Continuities*. Durham, North Carolina: Duke University Press, 1998.

MARIO GIACOMELLI

Italian

Mario Giacomelli is one of Italy's most prominent photographers, and among the best-known photographers of the twentieth century. His deeply humanistic photography focused, in the most part, on his native country, although he created notable series on the pilgrimage site of Lourdes, France, and he documented the 1974 famine in Ethiopia. In 1955, he was discovered in Italy by the Italian photographer Paolo Monti, and, beginning in 1963, he became renown in the United States through John Szarkowski of the Museum of Modern Art, New York, where Szarkowski presented a series called *Scanno*, and then later incorporated an image of the photographer in his famous book *Looking at Photographs* (1973).

Born in 1925 in the seaport town of Senigallia in the Marche region of central Italy, Giacomelli grew up in a modest family. When he was nine, his father died. From that time, he dedicated himself to poetry and painting. At the age of 13, he started working for a printer. After 1953, Giacomelli was taking photographs around the area with a Comet Bencini, at the time a very popular camera. The following year, as a self-taught photographer, he joined the photography group Misa founded by Giuseppe Cavalli in Senigallia. Also in the group at its beginning were Vincenzo Balocchi, Ferruccio Ferroni, Pier Giorgio Branzi, Paolo Bocci, and Silvio Pellegrini. Although Cavalli was a formalist who preferred aesthetically composed photographs in gradients of light gray, Giacomelli, whose later work displayed similarly sharp contrasts, profited from his experience with Cavalli. Over the next few years, Cavalli readied the members of Misa to join the photography group La Bussola, which he had founded in 1947 with Ferruccio Leiss, Mario Finazzi, Federico Vender, and Luigi Veronesi. The formalist style during these years stood in contrast to the neo-realists, who, during the postwar period, were begin-

ning to shoot photographs of the country, especially the land and the people of southern Italy, without aestheticizing the image. In literature, representatives of neo-realism include Elio Vittorini and Cesare Zavattini; in film, Vittorio De Sica, Roberto Rossellini, and Luchino Visconti; and in photography, Nino Migliori, Franco Pinna, and Gianni Berengo Gardin. The photographic works were influenced by a reality that their authors had experienced and wanted others to experience, but also showed an influence of American precursors from, for example, the Farm Security Administration and Eugene W. Smith. At the same time (1953–1955), Paul Strand, with his objective viewpoint, was photographing his series *Un paese* in the Italian town Dorf Luzzara in the Po valley. Within this cultural and photographic context, Giacomelli developed an individual style that distinguished him decisively from the others. His photography did not serve as reportage or documentation, but it did help the author to overcome his innermost fears. He conceived the camera as a medium of expression, like the brush is for the painter and the pen for the poet.

In 1954, he bought a used 6 × 9-inch Kobell camera that he modified to produce a 6 × 8½-inch image. He was largely unconcerned about lighting conditions because he used an electronic flash. His mode of expression, whose composition and formal structure he learned while doing graphic work in the printing business, consists of many elements. These include the stark juxtaposition of black and white and a strong, coarse granularity made on photo paper sensitive to contrasts. He also used apparently accidental, formal elements created from consciously "bad" photographic techniques, such as moving the camera and shooting out of focus or resorting to double exposure and extreme development of the negatives. This makes many of his works appear to be a mixture of spiritual and material objects. Other works highlight the tensions created by strong graphic contrasts. The background is often washed out in an overexposed white while the black bodies seem to float. Movement in photography is very important for Giacomelli because it represents life and the passage of time. He developed his own visual language, as he also did in his poetry, and it enabled him to represent scenes that correspond to his vision and perception of the world. The titles of his photography series are usually borrowed from stories or poems by authors who inspired him, such as Cesare Pavese, Edgar Lee Masters, Emily Dickinson, Giacomo Leopardi, and Eugenio Montale. Giacomelli valued the series, which after years he often assembled anew by placing the images in a different sequence. His preferred subjects were poor

and simple people. His photography projects would last some three years because he entered into sympathetic contact with each situation by living with the people in order to eventually work among them. After 1986, he broadened the content of his images with symbolic, artificial elements, such as pigeons, cardboard masks, and dogs made of fur fabric. An example of this is the photography series *Il pittore Bastari* (1992–1993).

Among his most well-known series is *Verrà la morte e avrà i tuoi occhi*—a title inspired by a Pavese poem—which is composed of photographs from 1955–1956, 1966–1968, and 1983. Ruthless and blunt, Giacomelli presents the residents of a home for the elderly in up-close, intimate situations, with the camera flash creating contrasts with their wrinkled skin. In another work, he poses these elderly people, who are dying, against the young, suffering people from Lourdes (1957). Giacomelli took the images in the series *Scanno*—named after the small town in the Abruzzi region of Italy that he visited in 1957 and 1959, five years after Henri Cartier-Bresson—in only a few days. Although he photographed the residents in their daily routines, his eye and technique lend the images the expression of a mystical engagement with the unconscious. The formal oppositions in his photographs of black-clad wo-men standing in front of white walls reflect the inner contrasts of youth and age, tradition and progress, masculinity and femininity. The series *Presa di coscienza sulla natura* is composed of images taken from 1954 to 2000. With an abstract effect, this series displays photographs of cultivated earth, oceans, and beach landscapes, which are photographed in part from an airplane. Giacomelli edited many negatives so that the print better matched his intentions. These kinds of representations show influences of the Italian artist Alberto Burri, whom Giacomelli met in 1968. Although the title of another series, *Io non ho mani che mi accarezzino il volto* (I have no Hands to Caress my Face, from a poem by David Maria Turoldo) (1961–1963), sounds melancholy; these photographs of priests playing in and against a backdrop of snow have a spontaneous, happy, and vital effect. *Caroline Branson* (1971–1973), which was inspired by Edgar Lee Master's *Spoon River Anthology*, is a love story in suggestive images, whose dramatic content represents the loss of ecstasy and the circle of death and rebirth. Giacomelli especially used the surreal effect created by the double exposure of a negative, which suits the presentation of visions of the unseen and unconscious. In *Favola, verso possibili significati interiori* (1983–1984), Giacomelli presents largely abstract images of bent iron rails that encourage

the personal fantasy of the photographer and the viewer to roam free. In doing this, he subscribed to the notion that the message of the image first comes to life in the interpretation of the viewer. In *Ninna nanna*, a collection of photographs taken from 1955 to 1987, the author recalls the memory of childhood in his sadness about the transitoriness and vanity of human creations. His mother's death in 1986 was another trigger for the melancholy and remembrances that he worked into the series *L'infinito* (1986–1988) and *A Silvia* (1987–1990), inspired also by the poetry of Leopardi.

Giacomelli's later series, such as *Io sono nessuno!* (1992–1994), *Bando*, (1997–1999), and *Questo ricordo lo vorrei raccontare* (2000), contain graphic signs, the disappearance of figures, and their shadows. In these works, the author expresses an inner world: alienation and desperation of human individuality, loneliness, the traces of time, transitoriness, and death. Arturo Carlo Quintavalle called Giacomelli's works "informal photographs" and read this as the photographer's self-analysis. Having spent most of his life in his home region, Giacomelli died in his home town of Senigallia in 2000. Many photography collections contain works by Giacomelli. Among them are the Museum of Modern Art in New York; the International Museum of Photography and Film, in Rochester, New York; the Bibliothèque nationale in Paris; the Victoria and Albert Museum in London; the Pushkin Museum in Moscow; and the Centro Studi e Archivio della Comunicazione at the University of Parma.

KATHARINA HAUSEL

See also: **Formalism**

Biography

Born in Senigallia, Italy, August 1, 1925. At thirteen, he began working as an apprentice in a typography business that he later took over. After 1953, he began taking photographs as a self-taught artist. Joined the photography group Misa in Senigallia, Italy, 1954; photography group La Bussola, 1956. Participated in numerous photography competitions in Italy, 1950s–1960s. In 1968, he rejected an invitation by Romeo Martinez, the editor of the magazine *Camera* and a member of the photo agency Magnum, to join Magnum. Prizes: II Mostra Nazionale Castelfranco Veneto, awarded by Paolo Monti, 1955; *Spilimbergo '91*, 1991; International photography prize Città di Venezia, 1992; Pantalin d'Oro, Carrara di Fano, 1994; Cultural Award of the Deutsche Gesellschaft für Photographie, Cologne, 1995. Died in Senigallia, November 25, 2000.

Individual Exhibitions

1959 *Paesaggi e nature morte di Mario Giacomelli*, Biblioteca Comunale, Milan, Italy

1968 George Eastman House, Rochester, New York
1975 Victoria and Albert Museum, London
1980 *Mario Giacomelli*, Centro Studi e Archivio della Comunicazione, University of Parma
1983–85 *Mario Giacomelli: A Retrospective, 1955–1983*, The Ffotogallery, Cardiff, and traveling
1984 *Les Photographies de Mario Giacomelli*, Musée Nicéphore Niépce, Chalon-sur-Saône, France
1987 Pushkin State Museum of Fine Arts, Moscow
1988 Centre National de la Photographie, Paris, France
1989 Foundation Vincent van Gogh, Arles, France
1992 *Mario Giacomelli*, Museo d'Arte Contemporanea, Castello di Rivoli, Turin, Italy
1995 *Mario Giacomelli: Fotografien, 1952–1955*, Museum Ludwig, Cologne, Germany
1998 *Vintage Works, 1952–1958*, Photology, London
2001 *Mario Giacomelli*, Palazzo delle Esposizioni, Rome

Selected Group Exhibitions

1956 *III Mostra internazionale di fotografia*; Venice
1959 *Subjektive Fotografie 3. Internationale de photographies modernes*; Palais des Beaux-Arts, Brussels, Belgium
1960 *Triennale di Milano, Scanno-Fotografie*; Milan, Italy
1963 *Photokina 1963*; Cologne, Germany
 Looking at Photographies: 100 Pictures from the Collection of the Museum of Modern Art; Museum of Modern Art, New York, New York
 Photography 63: An International Exhibition; The George Eastman House, Rochester, New York
1968 *The Photographer's Eye*; Museum of Modern Art, New York, New York
1973 *Looking at Photographs*; Museum of Modern Art, New York, New York
1979 *Venezia '79 la fotografia: Fotografia italiana contemporanea*; Venice, Italy
1983 *Maestri della fotografia creativa contemporanei in Italia*; Pushkin State Museum of Fine Arts, Moscow, U.S.S.R.
1989 *Italia, cento anni di fotografia*; International Monetary Fund, Washington, D.C.
1993 *Immagini italiane*; Aperture, Venice and Naples, Italy, and New York, New York
1994 *The Italian Metamorphosis, 1943–1968*; Solomon R. Guggenheim Museum, New York, New York

Selected Works

Verrà la morte e avrà i tuoi occhi, 1955–1983
Metamorfosi della terra, 1955–1980
Lourdes, 1957
Scanno, 1957–1959
Gente, 1958
Mattatoio, 1960
Io non ho mani che mi accarezzino il volto, 1961–1963
La buona terra, 1964–1965
Caroline Branson, 1971–1973
Favola, verso possibili significati interiori, 1983–1984
Il mare dei miei racconti, 1983–1987
Il teatro della neve, 1984–1986
Ninna nanna, 1985–1987
L'infinito, 1986–1988
Felicità raggiunta, si cammina, 1986–1988
Passato, 1987–1990
A Silvia, 1987–1990

Il Pittore Bastari, 1992–1993
Io sono nessuno, 1992–1994
La notte lava la mente, 1994–1995
Bando, 1997–1999
La mia vita intera, 1998–2000
Questo ricordo lo vorrei raccontare, 2000

Further Reading

Carli, Enzo. *Giacomelli, la forma dentro, fotografie 1952–1995*. Milan: Charta, 1995.

Celant, Germano, ed. *Mario Giacomelli*. Milan: Photology, and Modena: Logos, 2001.

Crawford, Alistair. *Mario Giacomelli, a Retrospective, 1955–1983*. Aberystwyth: Ffotogallery Cardiff and Visual Art Department and University College of Wales, 1983.

Frontoni, Renzo. *Obiettivo Scanno: Cartier-Bresson, Giacomelli, Monti, Roiter, Berengo Gardin, Bucci e altri*. Riccardo Tanturri, ed. Venice: Marsilio, 1997.

Photology presenta *Mario Giacomelli: Prime opere = Vintage Photographs, 1954–1957*, Milan: Photology, 1994.

Quintavalle, Arturo Carlo. *Mario Giacomelli*. Milan: Feltrinelli, 1980.

Taramelli, Ennery. *Mario Giacomelli*. Paris: Contrejour, 1992; 2nd ed., Paris: Nathan, 1998.

Viganò, Enrica. "In ricordo di Mario Giacomelli." *View on Photography* 3, no. 1 (2001).

RALPH GIBSON

American

Ralph Gibson has made significant contributions to photography in the second half of the twentieth century, particularly in the area of fine arts phoographic publishing. As the founder of Lustrum Press in 1969, Gibson put his belief that photographers needed to publish their photographs in an appropriate format into action. He had worked in advertising and design in Los Angeles, where he developed an understanding and appreciation of the possibilities of the photographic book and, realized that, in addition to exhibitions, books could be an effective means of disseminating not only his own photographs, but those of others.

Gibson was born on January 16, 1939 in Los Angeles, California, and grew up in Hollywood. His father was assistant director to Alfred Hitchcock and often took Gibson with him to the sets during the 1940s. The lighting style of the period, which featured sharp contrasts, had a lasting impact on the impressionable young Gibson and would later become a major characteristic of his photographs. Film, which is the illusion of movement created by a series of still photographs, may also have planted the idea of sequence, another of Gibson's defining characteristics. As well, Gibson was influenced by Hitchcock, the master of mystery films, as can be seen in his often moody and mysterious photo-narratives. Later influences included the filmmakers Ingmar Bergman and Jean-Luc Godard, as well as the writers of the *nouveau roman* or new novel, Alain Robbe-Grillet, Marguerite Duras, and Nathalie Saurraute. Gibson also acknowledges his indebtedness to painter Giorgio De Chirico and Surrealism.

After graduating from high school in 1956, Gibson enlisted in the United States Navy, where he received some training as a photographer. Following his discharge in 1960, he enrolled at the San Francisco Art Institute, where he came into contact with Dorothea Lange. He served as her assistant from 1961 to 1962. Returning to Los Angeles in 1963, Ralph Gibson's first serious projects in photography were documentary in nature and influenced by the work of Robert Frank, for whom he served as assistant and cameraman on his films *Me and My Brother* and *Conversations in Vermont*, as well as that of Henri Cartier-Bresson and William Klein, whose styles were in considerable contradiction. What these figures shared and what Gibson responded to was their interest in documenting contemporary urban life. But Gibson had not yet found his own vision. His early series *The Strip: A Graphic Portrait of Sunset Boulevard* (1966) explored the nightlife of youth on Los Angeles' famous boulevard but did not achieve much success.

Gibson's approach to photography changed radically in 1969, when he moved to New York City, established a studio, and founded Lustrum Press, which he directed. While he developed his

own photo books, he published Larry Clark's seminal *Tulsa,* in 1971, showing in harrowing images teenage amphetamine addiction; as well as *Passport,* 1974, which helped establish the reputation of photojournalist Mark Ellen Mark. Gibson's first book was *The Somnambulist,* published in 1970. In contrast to the documentary style in photography in which clarity of information is essential, Gibson described *The Somnambulist* as a "dream sequence." It is the first of three books that form the *Black Trilogy.* Gibson's conceptual approach was subtractive, with importance placed on what was not presented in the photograph; that is, the meaning was generated by what the viewer did not see—the formal qualities of the work, such as the patterns of highlights and shadows implying what Gibson called a "non-specific narrative." Alain Renais' mysterious, black-and-white film, *Last Year at Marienbad* (1961), with the screenplay by Alain Robbe-Grillet, had been especially significant for Gibson. *Deja-Vu,* published in 1973, and *Days at Sea,* 1974, complete the *Black Trilogy. Days at Sea* shows Gibson's often grainy images becoming increasingly abstract; there is also a heightened sense of the erotic that results from the mysterious tableaux and anonymous figures. *The Somnambulist* broke new ground in that it relied very little on text. The book was the ideal medium for Gibson, because he could control the juxtaposition and sequence of the images, leading the viewer to make comparisons and develop a narrative.

In the 1980s, Gibson continued his unique approach in *Syntax* (1983), *L'Anonyme* (1986), and *Tropism* (1987), the latter two books published by Aperture. Gibson has said, "Whatever the mode—from the snapshot to the decisive moment to multimedia montage—the intent and purpose of photography is to render in visual terms feelings and experiences that often elude the ability of words to describe." Gibson provides additional insight when he says, "[A] photographer's need to create becomes 'the event' itself and the photographer finds himself responding to feelings that can only be defined after he has made the photograph."

Preferring the 35-mm Leica M-3 with a 50-mm lens, Gibson has also used 28, 35, and 90-mm lenses. His use of high-speed Tri-X film in bright sunlight, which he also overexposes and underdevelops, results in dense negatives that allow him to achieve the grain and contrast he desires. Although primarily known for his books, Gibson also creates 11 × 14 and 16 × 20 prints for exhibitions.

In 1991, after having established a reputation as a black-and-white photographer, Gibson published *L'Histoire De France,* his foray into color photography, and his fifteenth published monograph. It is an adventure in which he continued to fragment and isolate objects; his use of color is restrained and is carefully integrated into the total composition. As in many others of his books, *L'Histoire* features little text, only an introduction (by Marguerite Duras), chapter titles, and an afterward.

Gibson's series *Ex Libris* (2001), consisting of 109 duotone photographs, expresses his lifelong interest in books and language. For this project, he photographed signs, letter forms, icons, and images representing the history of mankind. Subjects include the Rosetta Stone, the Koran, the Gutenberg Bible, and a wide variety of objects selected from international museums. This series also showcased his first use of 30 × 40-inch Iris prints, and archival, digital inkjet technology.

While Gibson seems to maintain the essence of the medium of photography, he also expands the parameters of both image and technique. His suggestive glimpses of reality create visual riddles that appeal to the unconscious and imagination. By asking the viewer to participate in his act of creation by imagining the narrative, Gibson transports the viewer to a dreamlike world where everything seems pregnant with possibility.

DARWIN MARABLE

See also: **Fine Arts Presses; Robert Frank**

Biography

Born in Los Angeles, California, January 16, 1930. Studied photography while in the United States Navy, Mediterranean Fleet, 1956–1960, and at the San Francisco Art Institute, 1960–1961. Assistant to Dorothea Lange, San Francisco, 1961–1962 and Robert Frank on the films, *Me and My Brother,* New York, 1967–1969 and *Conversations in Vermont,* 1969. Moved to New York in 1969 and founded Lustrum Press. Published *Somnambulist,* the first of the Black Trilogy in 1970, followed by *Deja-Vu* in 1973 and *Days at Sea* in 1974. *L'Histoire De France,* first color photographs, published in 1991. In *Ex Libris* in 2001, continues his lifelong interest in books and language. National Endowment for the Arts Fellowships, 1973, 1975, 1986. John Simon Guggenheim Memorial Fellowship, 1985. Officier, de L'Ordre des Arts et des Lettres de France, 1986 and Commandeur de L'Ordre des Arts et des Lettres de France. Grand Medal of the City of Arles, France, 1994. Lives in New York and France.

Selected Individual Exhibitions

1976 Castelli Graphics, New York
1978 Center for Creative Photography, University of Arizona, Tucson

Selected Group Exhibitions

Selected Works (Books)

The Strip, 1967
Somnambulist, 1970
Deja-vu, 1971
Days at Sea, 1974
L'Histoire De France, 1991
The Spirit of Burgundy, 1994
Ex Libris, 2001

Further Reading

Baldwin, Roger and Ralph Gibson. *Contemporary Photographers*, C. Naylor, ed. Chicago: St. James, 1988.
Gibson, Ralph. "On Content." *Creative Camera* December, 1972.
Deschin, Jacob. "Viewpoint." *Popular Photography* July, 1972.
Lewis, Eleanor, ed. *Darkroom*. New York: Lustrum Press, Inc., 1977.
Heredia, Paula, Director. *Ralph Gibson: Photographer/Book Artist*. 2002 (video).

N. TIM GIDAL

German

Photojournalist Tim Gidal entered the profession at a watershed moment in the history of the medium. Born Ignaz Nachum Gidalewitsch in Munich in 1909, twenty-year-old Gidal published his first photo essay the same year the Deutsche Werkbund launched its influential traveling exhibition of modern photography *Film und Foto* in 1929. The largest exhibition devoted solely to photography to date, "FiFo" (as it became known), celebrated the medium's stylistic diversity and international import at the end of the 1920s. Though Gidal entered the profession too late to be included in this groundbreaking show, he quickly earned a reputation as one of the innovators of the new "objective" style of photojournalism it promoted. The eyewitness objectivity, visual acuity, and passion for social justice for which Gidal became known were evident, even in his earliest photographic essay titled *Greetings, Comrades!*, published in the *Münchner Illustrierte Presse* in June, 1929.

By the end of World War I, photography's perceived objectivity had largely displaced the subjectivity and emotional angst of Germany's wartime journalism and Expressionist painting. In the midst of the nation's mounting obsession with *Sachlichkeit*, or objectivity, photojournalists like Gidal offered the nearly five million purchasers of German-illustrated magazines compelling first-hand accounts of Europe's "golden twenties" and deepening political, social, and cultural strife.

Gidal's own life was deeply affected by the National Socialists' ascent to power in the early thirties. The fourth of five children born to liberal Orthodox Jewish Russian and Lithuanian immigrants, Gidal developed a deep appreciation for his Jewish and Zionist identity. As a young man, he studied history, art history, and economics at the Universities of Berlin and Munich, but he studied photography only informally with his photojournalist brother Georg, before Georg's untimely death in 1931. Gidal's early professional success placed him at the forefront of a growing league of freelance photographers working for the *Dephot* photo agency in the late 1920s, including Kurt Hulton, Felix Mann, Erich Salomon, and Umbo, among others. One of his most influential suppor-

607

ters during this time was a young picture editor for *Weekly Illustrated* named Stefan Lorant, who hired the neophyte photographer for assignments in Munich and London. In the early 1930s, Gidal traveled extensively in Germany, France, Holland, Poland, and Scandinavia before emigrating to Basel, Switzerland in 1933 to complete his doctoral dissertation "Pictorial Reporting and the Press."

Tim Gidal's role as a practitioner, scholar, and historian of photography set him apart from his contemporaries. A humanist in the truest sense of the word, his contributions to the medium's modern history include the publication of more than 30 books, the organization of nearly two dozen major exhibitions, and the tutelage of several generations of students in the United States and Israel. Throughout a career that spanned the better part of the twentieth century, Gidal imparted his genuine compassion for his subject matter and his profound belief in the significance of the photographer's role as an historical eyewitness. Whether documenting a mundane interaction between pedestrians on a street in Tel Aviv or photographing Gandhi's address to the All-India Congress, Gidal maintained an unwavering faith in the dignity of his sometimes ordinary, sometimes extraordinary subjects. Though he professed a healthy respect for photographers who attempted to "express their inner self with the help of the photographic lens," Gidal felt it best to "leave it to the object/subject to express itself with the assistance of [his] camera" (*My Way* preface by Nissan Perez). His images invariably evoke an emotional response, despite Gidal's consistent and exacting professional distance. In Gidal's view, only through the "subjective experiences of the objective facts," could a "genuine" photo-reporter "become a witness to his own time." Although he photographed sensational events, Gidal avoided sensationalism by refusing to photograph violent scenes and by emphasizing the ordinary in the extraordinary and vice versa.

In many early photographs, like "And Yet it Moves," taken in 1929, it is clear that Gidal experimented with the extreme camera angles and subjective manipulations popular with the photographers trained under László Moholy-Nagy at the Bauhaus. Other pictures, such as his 1935 photograph of mannequins in a milliner's shop window, resemble the proto-surrealist photographs of Eugène Atget, who captured the spirit of turn-of-the-century Paris by photographing the defining urban spaces of Parisian life rather than the inhabitants themselves. Still other photos, like an untitled 1930 image depicting a disheveled young couple exchan-

ging a passionate kiss, recall the voyeuristic nightclub photography of contemporaries like Brassaï. There are tightly cropped crowd pictures resembling the work of Weegee and urban snowstorm photos à la Alfred Stieglitz or Edward Steichen. In the end, however, Gidal eschewed both subjective avant-garde techniques and the much-lauded "decisive moment" approach promoted by modern photojournalists like Henri Cartier-Bresson in favor of more objective, unmediated images that convey the expressive personality of his subjects as well as his own intimate understanding of those subjects.

Following the completion of his doctorate in 1935, Gidal produced and directed three short documentary films in Palestine under the title *Eretz Israel* which were screened throughout Germany, France, and Italy in 1936. After the publication of his book *Children in Eretz Israel* that year, Gidal permanently relocated to Eretz, working as a freelance foreign correspondent for Reuters-Photos and as a photographer for the Jewish National Fund and the Hebrew University Hadassah Medical Center. In 1938, he became the first photojournalist to publish a color photo-essay when *Marie-Claire* printed his series *Holy Land*. Gidal traveled to London for the launch of Lorant's *Picture Post* then embarked for India and Ceylon where he produced some of his most famous *Life* magazine and *Picture Post* photo-essays *The All India Congress*, *Travels with Ghandi*, *Village in India*, and *Buddha Procession in Ceylon*. Upon his return to Palestine in 1940, Gidal provided photo-essays of campaigns in North Africa, Burma, and China for the Middle East Eighth Army magazine *Parade*. In 1943, Gidal was wounded on Samos Island in the Aegean Sea and was subsequently assigned to Southeastern Asia under the command of General Mountbatten.

Following his marriage to Sonia Epstein in 1944 and the birth of his son Peter two years later, the Gidal family joined leagues of Nazi-persecuted German Jewish intellectuals and artists when they embarked for New York City. In 1948, Gidal assumed a position on the editorial staff at *Life* magazine while teaching classes in the History of Visual Communication at the New School for Social Research. Over the next two decades, Gidal published more than two dozen books, including *This is Israel* (1948) and a series of 23 children's books co-written by his wife Sonia that depicted children in different cities and villages around the world. Though he continued to photograph, his work as a curator, professor, and author took precedence from the mid-1950s on. His most influential text was a history of photojournalism published in Germany in 1958, translated as *Modern Photo-*

journalism: Origin and Evolution, 1910–1933 in 1972 and still widely cited as an invaluable first-hand account of the development of modern photojournalism. By the time of the book's U.S. release, Gidal had returned to Israel, where he met his second wife, Pia Lis. He spent the next two decades exhibiting and teaching in the Department of Communications at the Hebrew University of Jerusalem, where his scholarship focused almost exclusively on Jewish history in The Holy Land, the Near East, and, finally, in Germany. His textbook *Everyone Lives in Communities* appeared in 1972, and in 1980, Gidal was awarded the Israel Museum's Kavlin Prize for outstanding achievements as a pioneer of photojournalism and teacher/historian of photography. Three years later, he was honored with the Dr. Erich Solomon Prize for Germany in Cologne.

Throughout the 1980s, Gidal (who was by then known as Nachum T. Gidal) worked to compile an illustrated history of Jews in Germany with his second wife Pia, whom he married in 1984. An exhibition of selected works from the book traveled throughout Germany in the mid-eighties, and the book, titled *Jews in Germany from Roman Times to the Weimar Republic*, was released in 1988 and translated in English a decade later. The recipient of numerous awards and honors, Gidal was elected Fellow of the Royal Photographic Society, London and made an Honorary Fellow in 1992, the same year he was named Corresponding Member of the Deutsche Gesellschaft für Photographie. His work is held in the permanent collections of, among other distinguished institutions, New York's Museum of Modern Art, the Los Angeles County Museum of Art, London's Victoria and Albert Museum, the Berlinische Galerie, Paris' Bibliothèque Nationale, Paris; Fotomuseum, Munich and the Ludwig Museum in Cologne. After 87 years as a devoted practitioner, scholar, and humanist whose work was extraordinary in both its scope and significance, Nachum Tim Gidal died in Jerusalem on October 4, 1996. His archive of more than 14,000 prints and negatives was bequeathed to the Israel Museum in Jerusalem.

LEESA RITTELMANN

See also: **Life Magazine; Picture Post**

Biography

Born in Munich, Germany, 18 May 1909. Studied history, art history, literature, and economics at the University of Munich and University of Berlin, Germany, 1928–1933. Received M.A. and PhD for dissertation *Bildberichterstattung und Press* (Pictorial Reporting and the Press), 1935. Photojournalist for *Dephot* 1929–1935; for *Reuters*, Mandate Palestine, 1936; for *Picture Post*, London, 1938–1939; and for *Parade*, Palestine, 1942–1945. Editorial consultant, *Life* magazine, 1949–1954. Lecturer on the History of Visual Communication, New School for Social Research, New York, New York, 1954–1958; Lecturer (later, Associate Professor), Hebrew University of Jerusalem, Faculty of Social Sciences, 1971–1987. Elected Fellow of the Royal Photographic Society, London, 1965. Received Israel Museum's Kavlin Prize for outstanding achievement, 1980. Awarded the Dr. Erich Solomon Prize, Cologne, Germany, 1983. Elected Corresponding Member of the Deutsche Gesellschaft für Photographie, 1992; named Honorary Fellow of the Royal Photographic Society, London, England, 1992. Gidal died in Jerusalem on October 4, 1996 at age 87.

Individual Exhibitions

1937 Steimatzky Gallery; Jerusalem, Israel
1943 Officers' Club; Cairo, Egypt
1971 *Gold Weights of the Ashanti: Nachum T. Gidal Collection*; The Israel Museum; Jersualem, Israel
1975 *Tim N. Gidal in the Thirties*; The Israel Museum; Jerusalem, Israel (traveled to The Photographer's Gallery; London, England in 1976; Lee Witkin Gallery; New York, New York; Berlin, Germany; Basel, Switzerland)
1978 *Tim Gidal: A Retrospective*; Lee Witkin Gallery; New York, New York
1979 *Tim N. Gidal Vintage Prints*; Galerie Nagel, Berlin, Germany (traveled to Galerie Photo Art, Basel, Switzerland)
1981 *Tim Gidal in the Forties*; The Photographers' Gallery; London, England
1984 *Bilder der Dreissigerjahre*; Folkwang Museum, Essen, Germany
 Memories of Jewish Poland; Beth Hatefutsoth; Tel Aviv, Israel
1985 *Tim Gidal: 20th Century Photographer*; Laenderbank; Vienna, Austria
1986 *Kuait, 1942*; Vision Gallery; San Francisco, California (traveled to Lempertz Gallery; Cologne, Germany)
1989 *French Can-Can*; Khan Theater, Jerusalem
1990 *Die Freudianer*; Lucerne, Switzerland (traveled to Nordend Galerie, Frankfurt, Germany; Fotomuseum, Munich, Germany; Hans Albers Museum, Westphalia, Germany)
1992 *Nachum Tim Gidal, Photographs 1929–1991*; The Open Museum, Tefen, Israel
1995 *My Way—Tim Gidal*; Israel Museum Art Gallery; Jerusalem, Israel

Selected Group Exhibitions

1984 *Die Juden in Deutschland von der Römerzeit bis zur Weimarer Republik*; Beth Hatefutsoth, Tel Aviv, Israel (traveled to Fisher Hall; Jerusalem, Israel in 1988)
1985 *Land of Promise: Photographs from Palestine 1850–1948*; New York and Tel Aviv
1993 *Chronisten des Lebens—die Moderne Fotoreportage*; Berlin (traveled to Göteborg, Sweden; Judisches Museum der Stadt Wien, Vienna, Austria)

Selected Works

Tel Aviv, 1935
Nun with Gas Mask, London, 1940, 1940

Gandhi Speaking at All India Congress, Bombay, 1940, 1940
North African Graffiti, 1942
Killed in Action, Burma (alternatively titled *What Price Glory? Burmese Jungle*), 1944
Carl Jung, 1957
India, 1940
Refugee Arrival: Mother finds Daughter, Atlit, 1945, 1945

Further Reading

Gidal Tim. *Beginn des modernen Photojournalismus*. Lucerne, Frankfurt and New York: 1972. Translated by Maureen Oberli-Turner as *Modern Photojournalism: Origin and Evolution, 1910–1933*. New York: Macmillan, 1973.

———. *Die Juden in Deutschland Von der Römerzeit bis zur Weimarer Republik*, Cologne: Könemann, 1997. Translated as *Jew in Germany: From the Romans to the Weimar Republic*, New York: Könemann, 1998.

———. *Henrietta Szold: A Documentation in Photos and Text*. Jerusalem and New York: Gefen Publishing House, 1997.

———. *Land of Promise: Photographs from Palestine 1850 to 1948*. New York: A. van der Marck Editions, 1985.

———. *This Is Israel*. Boni and Gaer, 1948.

———. *Jerusalem in 3000 Years*. New Jersey: Knickerbocker Pr, 1996.

———. *In the Thirties: Photographs by Tim Gidal*, Jerusalem: The Israel Museum, 1975.

———. *My Way: Tim Gidal*, Jerusalem: The Israel Museum, 1995.

———. *Nachum Tim Gidal, Photographs 1929–1991*. Tefen, Israel: The Open Museum, 1992.

———. *Tim Gidal in the Forties*, London: The Photographer's Gallery, 1981.

Hallett, Michael. "A private passion, Tim Gidal." *British Journal of Photography* 3 March 1994, (6963): 22–23, 25.

Horak, Jan-Christopher. "Zionist Film Propaganda in Nazi Germany." *Historical Journal of Film, Radio and Television*, vol. 4, nr. 1, 1984.

Sadler, Richard. "The Way of Tim Gidal." *The Photographic Journal* (1956); 446–447.

Steinorth, Karl. "Zum 85 Geburtstag Nachum Tim Gidal—Pionier des modernen Bildjournalismus." *MFM Fototechnik* (Ludwigsburg, April 1994), vol. 42, no. 4.

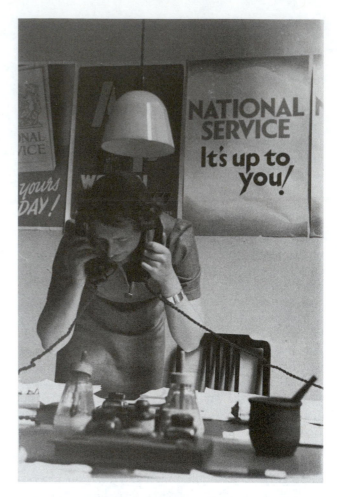

N. Tim Gidal, Worker in a W.V.S. Recruitment Office.
[© *Hulton-Deutsch Collection/CORBIS*]

Turner, Peter. "Tim Gidal." *Creative Camera* (May 1979).

Trow, Nigel. "Tim Gidal, A Visual Ethic." *British Journal of Photography* 1981.

GILBERT & GEORGE

Italian/British

Gilbert Proesch and George Passmore met in 1967 at Saint Martin's School of Art in London where they both studied sculpture. As Gilbert & George they became one of the most important artistic duos of the second half of the twentieth century. Radical in both message and medium, they tried to do away with the highbrow aspect of art. Photography was their prime method to bring art to the people: "We're in the Yellow Pages, under 'Artists.' We are making work, we imagine, for the viewer out there. Artists fall in love with art; we fell in love with the viewer of art. That's the difference." (Bracewell 2001, p. 5)

Proesh was born in the Italian Dolomites and was trained as a wood sculptor in his father's shop. He studied at the Wolkenstein School of Art in Italy, the Hallein School of Art in Austria, and the Munich Academy before moving to London. Passmore attended Darlington Hall College of Art and the Oxford School of Art prior to his London studies. He worked at the Selfridges Department Store and was a barman before he got into Saint Martin's.

According to tradition the two got together as George was the only one who could understand Gilbert's poor English. Presumably their common aversion to the elitist approach to art in general and sculpture in particular at Saint Martin's also played an important role in the decision to go their own way. They became one artist and were since then hardly ever seen separately, neither in real life nor in their art, in which they feature prominently.

At a time when the artistic community was wondering what options were left to explore, Gilbert and George made the radical, but at the same time the only possible choice: they turned life into art and became their own subject matter. They purchased a house, which they named "Art for All," in the working-class neighborhood of Spitalfields in East London and declared that they were "living sculptures." As living (and singing) sculptures they quickly made their name in the late 1960s and early 1970s. In these performances, which could sometimes last for hours, they took the stage dressed in matching business suits with their hands and faces bronzed. If they moved at all, it was in a mechanical and hollow manner.

They appeared interchangeable and stripped from any personality or imagination. In the best known renditions of these sculptures they got drunk or mimed to the music-hall song *Underneath the Arches*. These first performances, representing loss of creativity, had an annoying and unpleasant character. The photographic documentation of some of the "drunk" pieces mimic the off-balance stagger of a drunk; the black and white snapshot-like images are presented willy-nilly across a mounting board, as in *Smashed*, 1973.

Over the years Gilbert and George have expressed themselves through a number of mediums: bookmaking, mail art, drawing, video, painting, and photography, along with their trademark public persona, which always had performance-like qualities. Nevertheless Gilbert and George have consistently referred to their work as sculpture, stretching the traditional definition into a generic term now in wide use in contemporary art. By giving up their separate identities and becoming both artist and artwork, Gilbert and George realized a

notion in the avant-garde of the twentieth century that had long been an ideal, that of erasing the distinctions between life and art. Thus when artist, artwork, and everyday life form a unity, it becomes superfluous and even impossible to make a distinction between genres or mediums. Even so, their use of photography has clearly changed over the years.

At first it served as a way to record their performance sculptures and typically took the form of modest black-and-white documents. Very soon photography became their most important manner of expression, and their large-scale photomontages, bold in both color and subject matter, are a visual language uniquely their own. The artists themselves are the most important and only constant motif in that language. Dressed in their characteristic matching business suits, which they refer to as their "responsibility suits of our art," Gilbert and George conspicuously appear in their work. Other visual elements evolved and varied over the years, but symmetrical compositions, the artists'conservative look, references to art history and the organizing of individual works into series, gave their work a more classical appearance. They not only developed a striking visual language, but created their own conceptual world. Their fundamental ideas, which they codified in various manifestoes, have remained consistent over the decades. Gilbert and George never stopped making fun of the elitist nature of art. Their purpose was to break social and ethical taboos and dissolve the boundary between the private and the public sphere. In doing so, they proved not to be shy of tackling controversial topics such as alcoholism, sex, unemployment, violence, racial tension, homosexuality, and AIDS. Religion, social class difference, and other sacred cows were never safe from the artists.

Between 1970 and 1974 Gilbert and George made a series of charcoal-on-paper sculptures: charcoal drawings featuring natural motifs that covered entire walls. In a 1971 series of triptychs, *The Paintings (with Us in the Nature)*, Gilbert and George put themselves in the midst of an idyllic natural setting. Their photographs of the time were very different. As seen in *Gin and Tonic* (1973) they presented individually framed photos in large patterns. Until 1974 they almost exclusively made black-and-white photographs. Not surprisingly, given their increasingly transgressive subject matter, the first colors to appear in their pictures were strong reds and yellows evocative of blood and urine. Beginning in the 1980s and throughout the 1990s Gilbert and George produced numerous series of exuberant, large-scale montages of photographs. These works are characterized by extremely

bright colors and overlaying black grids, which echo the early patterned compositions. The artists very literally proclaimed themselves subject matter and appeared in almost every picture or included blown up images of their urine, sperm, and excrement, but often featuring natural elements like trees or clouds. These montages were far less realistic and much more humorous and ironic, and often cartoon-like, as exemplified by the 1983 work, *Coming*, which shows the artists looking toward the sky as enlarged and brightly-colored sperm passes by. They also experimented with huge photo-murals consisting of a single composition in framed panels spanning up to 30 feet.

Despite the often difficult subject matter, these montaged works were very well received by both the public and the critics, ensuring the artists an international reputation in the contemporary art world. Gilbert and George have had numerous exhibitions, referred to, fittingly, as one-man shows, all over the world. Their work was shown on three occasions at the international festival of contemporary art, Documenta in Kassel, Germany and was selected for the Venice Biennale. They were short listed for the Turner Prize in 1984 and won the prestigious award in 1986. With their work included in the collections of the most important photography museums and in those of world renowned art institutions, Gilbert and George occupy a unique place in the history of twentieth century photography.

STIJN VAN DE VYVER

See also: **Conceptual Photography; Montage; Photography and Sculpture**

Biography

Gilbert Proesch was born in St. Martin in Thurn, Italy, 11 September 1943. He studied at the Wolkenstein School of Art, South Tyrol, Italy, and Hallein School of Art in Austria, Akademie der Kunst, Munich, Germany, and Saint Martin's School of Art, London, England, 1967.
George Passmore was born in Plymouth, United Kingdom, 8 January 1942. He studied at The Dartington Hall College of Art, England, The Oxford School of Art, England, and Saint Martin's School of Art, London, England, 1965.
Gilbert & George meet and begin collaboration in London, 1967. Begin association with Anthony D'Offay Gallery; London, early 1970s, and Sonnabend Gallery, New York, early 1980s. Awarded Turner Prize, 1984; 1986: Won the Turner Prize. Live and work in London, England.

Individual Exhibitions

2002 *The Art of Gilbert & George*; Fundação Centro Cultural de Belém; Lisbon, Portugal
2000 *Nineteen Ninety Nine 1999*; Museum Moderner Kunst Stiftung; Vienna, Austria

1999 *Gilbert & George 1970–1988*; Astrup Fearnley Museet for Moderne Kunst; Oslo, Norway
1998 *New Testamental Pictures*; Museo di Capodimonte; Naples, Italy
1997 *Gilbert & George*; Musée d'Art Moderne de la Ville de Paris; Paris, France
1993 *China Exhibition 1993*; National Art Gallery; Peking, China (traveled to The Art Museum, Shanghai, China)
1992 *New Democratic Pictures*; Aarhus Kunstmuseum; Arhus, Denmark
1991 *The Cosmological Pictures*; Palac Sztuki; Krakow, Poland (traveled to Palazzo delle Esposizioni, Rome, Italy; Kunsthalle Zurich, Zurich, Switzerland; Wiener Secession, Vienna, Austria; Ernst Muzeum, Budapest, Hungary; Haags Gemeentemuseum, The Hague, The Netherlands; Irish Museum of Modern Art, Dublin, Ireland; Fundacio Joan Miro, Barcelona, Spain; Tate Gallery, Liverpool, England; Wurttembergischer Kunstverein, Stuttgart, Germany)
1990 *Gilbert & George Pictures 1983–1988, Moscow Exhibition*; New Tretyakov Gallery; Moscow, Russia
1987 *Gilbert & George Pictures*; The Aldrich Museum; Ridgefield, Cincinnati
1986 *Gilbert & George, The Complete Pictures 1971–1985*; CAPC, Musee d'Art Contemporain de Bordeaux, (traveled to Kunsthalle, Basel, Switzerland; Palais des Beaux Arts, Brussels, Belgium; Palacio de Valazquez; Parque del Reitrio, Madrid, Spain; Stadtische Galerie im Lenbachhaus, Munich, Germany; Hayward Gallery, London, England; Sonnabend Gallery, New York, New York)
1985 *Gilbert & George*; The Solomon R. Guggenheim Museum; New York, New York
1984 *Gilbert & George*; The Baltimore Museum of Art; Baltimore, Maryland (traveled to Contemporary Art Museum, Houston, Texas; The Norton Gallery of Art, West Palm Beach, Florida)
1983 *Modern Faith*; Sonnabend Gallery; New York, New York
1980 *Photo-Pieces 1971–1980*; Stedelijk van Abbemuseum; Eindhoven, The Netherlands
1977 *Red Morning*; Sperone Fischer Gallery; Basel, Switzerland
 New Photo-Pieces; Art & Project Gallery; Amsterdam, The Netherlands (traveled to Konrad Fischer Gallery, Düsseldorf, Germany)
1975 *Post-Card Sculptures*; Sperone Westwater Fischer Gallery; New York, New York
1973 *Reclining Drunk*; Nigel Greenwood Gallery; London, England
1972 *New Photo-Pieces*; Konrad Fischer Gallery; Düsseldorf, Germany
 The Bar; Anthony D'Offay Gallery; London, England
 The Evening Before the Morning After; Nigel Greenwood Gallery; London, England
 It Takes A Boy To Understand A Boy's Point Of View; Situation Gallery; London, England
1971 *There Were Two Young Men*; Sperone Gallery; Turin, Italy
 The Paintings; Whitechapel Art Gallery; London, England (traveled to Stedelijk Museum, Amsterdam, The Netherlands; Kunstverein, Düsseldorf, Germany; Koninklijk Museum voor Schone Kunsten; Antwerp, Belgium)
1970 *George by Gilbert & Gilbert by George*; Fournier Street; London, England

Art Notes and Thoughts; Art & Project Gallery; Amsterdam, The Netherlands *To Be with Art Is all We Ask*; Nigel Greenwood Gallery; London, England
1969 *Anniversary*; Frank's Sandwich Bar; London, England
Shit and Cunt; Robert Fraser Gallery; London, England

Group Exhibitions

2000 *Out There*; White Cube 2; London, England
1998 *Out of Actions: Between Performance and the Object, 1949–1979*; Museum of Contemporary Art; Los Angeles, California

Photoplay; International Center of Photography and Film, George Eastman House; Rochester, New York
1996 *La Vie Moderne en Europe 1870–1996*; Museum of Contemporary Art; Tokyo, Japan
1995 *Take Me (I'm Yours)*; Serpentine Gallery; London, England
1993 *Contemporary Self-Portraits: Here's Looking at Me*; Centre d'Echanges de Perrache; Lyon, France
1991 *Cruciformed: Images of the Cross Since 1980*; Cleveland Center for Contemporary Art; Cleveland, Ohio; (traveled to Museum of Contemporary Art Wright State University, Dayton, Ohio; Western Gallery, Western Washington University, Bellingham, Washington; Macdonald Stewart Art Center, Guelph, Ontario, Canada)

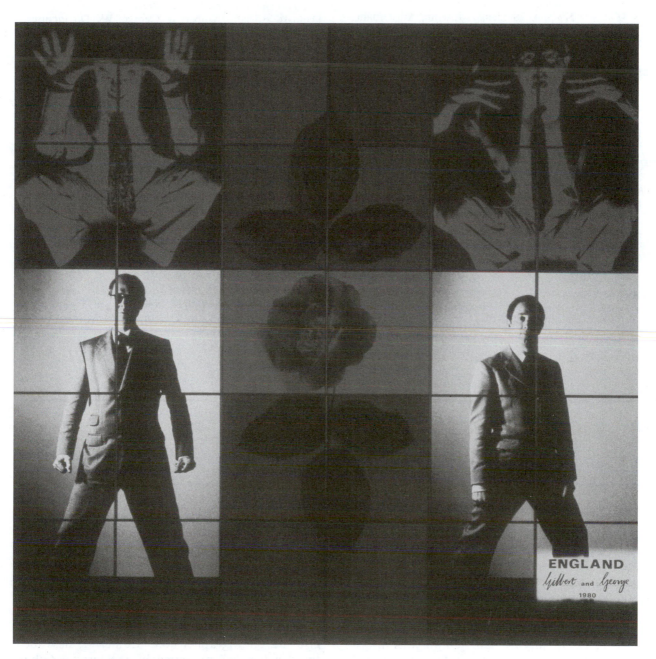

Gilbert & George, England, 1980, Photograph.
[*Tate Gallery, London/Art Resource, New York*]

1989 *Bilderstreit: contradiction, unity and fragmentation in art since 1960*; Ludwig Museum; Cologne, Germany
1983 *Photography in Contemporary Art*; National Museum of Modern Art; Tokyo, Japan
 Trends in Post War American and European Art; Solomon R. Guggenheim Museum; New York, New York
1982 *Aspects of British Art Today*; Metropolitan Art Museum; Tokyo, Japan
 Documenta 7; Kassel, Germany
1981 *British Sculpture in the Twentieth Century*; Whitechapel Art Gallery; London, England
1980 *Kunst in Europa na '68*; Museum voor Hedendaagse Kunst; Ghent, Belgium
 Explorations in the 70's; Pittsburgh Plan for Art; Pittsburgh, Pennsylvania
1978 *Made By Sculptors*; Stedelijk Museum; Amsterdam, The Netherlands
 38th Biennale; Venice, Italy
1977 *Photography as an Art Form*; John and Marble Ringling Museum of Art; Saratoga, Florida
 Documenta 6; Kassel, Germany
 Europe in the 70's; Art Institute of Chicago; Chicago, Illinois
1973 *From Henry Moore to Gilbert & George*; Palais des Beaux Arts; Brussels, Belgium
1972 *Documenta 5*; Kassel, Germany
1971 *The British Avant-Garde*; Cultural Center; New York, New York
1970 *Information*; Museum of Modern Art; New York, New York
 Conceptual Art, Arte Povera, Land Art; Civic Gallery of Modern Art; Turin, Italy
1969 *Conception*; Stadtisches Museum; Leverkusen, Germany
1968 *Snow Show*; St. Martin's School of Art; London, England

Selected Works

The Singing Sculpture, from 1970
Gin and Tonic, 1973

Smashed, 1973
Cherry Blossom (series), 1974
Waiting, 1980
Coming, 1983
We Are, 1985
Bloody People, 1997

Further Reading

Bickers, Patricia. "La Sculpture britannique: generations et tradition." *Artpress* 202 (May 1995) 31–39.
Bracewell, Michael. "Like what you see? Then call Gilbert & George (they're in the phone book)." *The Independent on Sunday Culture*, May 27 2001, 5.
Dannatt, Adrian. "Gilbert & George: We Do Pictures." *Flash Art* Vol. XXVII, no. 178 (October 1994) 63–67.
Farson, Daniel. *Gilbert & George: A Portrait*. London: HarperCollins, 1999.
Farson, Daniel. *With Gilbert & George in Moscow*. London: Bloomsbury, 1991.
Jahn, Wolf. *The Art of Gilbert & George, or, An Aesthetic of Existence*. London: Thames and Hudson, 1989.
Parent, Béatrice, Bernard Marcadé, Wolf Jahn, Rudi Fuchs, Martin Gayford, and Gilbert & George. *Gilbert and George*. Paris: Musée d'Art Moderne de la Ville de Paris, 1997.
Ratcliff, Carter, and Robert Rosenblum. *Gilbert and George: The Singing Sculpture*. New York: A. McCall, 1993.
Ratcliff, Carter. *Gilbert and George 1968 to 1980*. Eindhoven: Van Abbemuseum, 1980.
Ratcliff, Carter. *Gilbert and George: The Complete Pictures, 1971–1985*. New York: A. McCall, 1986.
Richardson, Brenda. *Gilbert and George*. Baltimore: Baltimore Museum of Art, 1984.
Violette, Robert, ed. *The Words of Gilbert and George*. London: Violette Editons, 1998.
Wechsler, Max. "Gilbert & George." *Kunstforum* (April/May 1990) 150–155.

LAURA GILPIN

American

Laura Gilpin biographer Martha Sandweiss described her as "a consummate landscape photographer," while Ansel Adams called her "one of the most important photographers of our time." Especially noted for her images of the Navajo people and portraits and panoramic landscapes that emphasize the quality of light, Gilpin was also a pioneering female photographer. As noted by her biographer, while Gilpin had a keen sense of design and composition, her interest in the cultural significance of the landscape was equally as important, and it is this quality that has assured her work a lasting place in the history of photography.

Sandweiss argues that Gilpin's "interest in landscape distinguishes her from other women photographers and her approach distinguishes her from other male photographers." Whereas anthropologist and photographer John Collier Jr. described the "challenges" presented by the terrain, Gilpin sought an "accommodation" with the landscape.

Through her work, she became acutely aware of how the land was an environment that shaped human activity.

Gilpin was born in Colorado Springs and she began using a camera at age 12. Both her mother and family friend photographer Gertrude Käsebier supported her interest in photography. Educated in eastern boarding schools, Gilpin asserted her regional individuality by wearing a cowboy hat at school. In 1916, she enrolled in the Clarence White School in New York and mastered the Pictorialist style favored by the school's instructors.

A year later, she returned to Colorado and opened a studio specializing in portraits and architectural buildings, and she began photographing the landscapes around eastern Colorado. In 1924, she photographed the Mesa Verde cliffs and ruins and self-published the images as: *Mesa Verde National Park* (1927), and a companion booklet, *The Pikes Peak Region* (1926). Unlike many of her contemporaries who during the Great Depression found employment with government-sponsored programs such as the FSA [see WPA], Gilpin earned her living producing postcards, and a series of lantern slides of archaeological subjects. Her earnings were supplemented by a turkey farm that she ran with her lifelong companion Elizabeth Forster.

Shortly before World War II, her book on the Rio Grande pueblos, *The Pueblos: A Camera Chronicle* (1941), was published, after which she left her work in the Southwest to take a job as a photographer in the public relations department of the Boeing Aircraft Company in Kansas. After the war, she traveled to Yucatán in Mexico and expanded her interest in the architectural heritage of vanished indigenous peoples. The images of her next book, *Temples of Yucatán; A Camera Chronicle of Chichen Itza* (1948), are characterized by a visually powerful explosion of light from a sunburst framed by a sentinel-like portion of *El Castillo* (The Castle). Her next book, *Rio Grande: River of Destiny* (1949), was described as "a human geographical study." In her final book on the Southwest, *The Enduring Navajo* (1968), Gilpin sought to record and convey how the Navaho were accommodating to change in the same way they had accommodated to their physical environment. She had begun photographing this tribe in the 1930s, when Elizabeth Forster worked as a nurse in a Navaho community. At the age of 81, Gilpin was awarded a Guggenheim Fellowship, and from then on until her death at 88, Gilpin worked on recording the ruins of Canyon de Chelly in New Mexico and Arizona. Her photo-graphic archive is at the Amon Carter Museum in Fort Worth, Texas.

Gilpin's artistry has received much merited praise, and she is acknowledged as a premier landscape photographer, her work showing the deep commitment she had to the places she felt exemplified a feeling of spirituality and peace. In recent years, however, her work has come under scrutiny by scholars concerned with issues of cultural appropriation. Martha Sandweiss argues that Gilpin's work was motivated by her outsider status as a White person and that Gilpin was trying to get "close to people whose tradition and history seemed deeper than her own." Like Gilpin, novelist and westerner Willa Cather was also drawn to a culture not her own, and to some of the same locations, in particular to Mesa Verde. In one of Cather's books, the main character asserts that "the relics of the Mesa Verde belong to all people. They belong to boys like you and me that have no other ancestors to inherit from." Sandweiss noted that passages in Cather's *The Professor's House* could have served as text for some of Gilpin's images: "Far above me...I saw a little city of stone, asleep. It was still as a sculpture...it all hung together, seemed to have a kind of composition." Gilpin did offer to illustrate Cather's book but received no reply.

While Gilpin did not agree with characterizations of her work as having unique qualities because of her gender, others have argued that Gilpin's fascination (along with that of Cather's) with the Southwest and its people was based on her outsider status, not only as White woman but as a lesbian. Jonathan Goldberg maintains that both the writer and the photographer shared an interest in "racialized others," and negotiated their lesbian "difference" by immersing themselves in "exotic" cultures as a method of managing their outsider status. He notes, for example, that images of women predominate in both *The Pueblos* and *The Enduring Navaho*, and that this surfeit has had personal and cultural significance, one that is too often underplayed by art critics and biographers, thereby leaving us with a truncated understanding of both Gilpin and her work.

YOLANDA RETTER

See also: **Käsebier, Gertrude; Pictorialism**

Biography

Born: April 22, 1891. Education: Clarence H. White School. Independent professional photographer, from 1915; photographer, Central City Opera House Association, Denver, 1932–1936; chief photographer Boeing Aircraft Company, Wichita, Kansas, 1942–1945; Navaho Indian

photography project, 1946–1948; Canyon de Chelly project, 1968–1979. Teaching: Instructor in Photography Chappell School of Art, 1926–1930; Colorado Springs Fine Art Center, 1930, 1940–1941. Recipient of (selective): Medal International Salon, Madrid, 1935; Award of Merit, Photographic Society of America, 1947; Research Grant School of American Research, Santa Fe, 1971; John Guggenheim Simon Memorial Fellowship, 1975. Died in 1979.

Selected Works

The Prairie, 1917
Round Tower, Cliff Palace, Mesa Verde, Colorado, 1925
Rio Grande Yields Its Surplus to the Sea, 1947
Storm from La Bajada Hill, New Mexico, 1940
Chance Meeting in the Desert, 1950

Selected Publications

The Enduring Navajo. University of Texas Press, 1968
The Rio Grande: River of Destiny. Duell, Sloan & Pearce: New York, 1949
Temples of Yucatan: A Camera Chronicle of Chichen Itza. New York: Hastings House, 1948
The Pueblos: A Camera Chronicle. New York: Hastings House, 1941

Selected Individual Exhibitions

1918 Clarence H. White School, New York
1934 Library of Congress. Washington, D.C.

1946 Museo Arqueológico e Histórico de Yucatán, Mérida, Mexico
1957 Laboratory of Anthropology, Santa Fe, New Mexico
1978 Amon Carter Museum, Fort Worth, Texas

Selected Group Exhibitions

1975 *Women in Photography*. San Francisco Museum of Art, San Francisco, California
1981 *11 photographers of Santa Fe*, Arles, France
1996 *Women of the Clarence White School*. Howard Greenberg Gallery, New York

Further Reading

Davidov, Judith F. "Always the Navaho Took the Picture." In *Women's Camera Work*. Durham: Duke University Press, 1998. 103–155.
Goldberg, Jonathan. *Willa Cather and Others*. Durham: Duke University Press, 2000.
Sandweiss, Martha. "Laura Gilpin and the Tradition of American Landscape Photography." In Vera Norwood and Janice Monk, eds. *The desert is no lady: Southwest landscapes in women's writing and art*. New Haven, CT: Yale University Press, 1987.
Sandweiss, Martha. *An Enduring Grace*. Fort Worth, TX: Amon Carter Museum, 1986.

HERVÉ GLOAGUEN

French

Hervé Gloaguen belonged to the tradition of twentieth-century photo-reporters who defined themselves as socially aware photographers. As a founding member of the Agence Viva in France, he wanted to create a new way of reporting and photographing social events. Active in both color and black-and-white photography, he concentrated on the former without neglecting any genre: natural and urban landscapes, group or single portraits are common in his work.

Born in Rennes in 1937, Gloaguen grew up and was educated in Brittany. His talent for drawing and early interest in photography led him to enter the École des Beaux-Arts de Rennes in 1957. A year later, he was admitted to the École technique de photographie et de cinématographie (ETPC), better known as the École de Vaugirard, in Paris. However, his results were unsatisfactory, and he dropped out of the school after six months.

Now settled in Paris, Gloaguen worked as an apprentice at Photo-Littré, where he learned basic photo laboratory skills. Between 1960 and 1962, he performed his compulsory military service in the Navy and joined its photo and cinema agency at the Fort d'Ivry, near Paris. At this same time, Gloaguen was an amateur jazz musician, which triggered his first Parisian photographs of concerts and theatre shows. He also used short leaves from the Navy to visit and take photographs in Portugal, Spain, and Belgium.

Having completed his military service, he was briefly employed as a photo-reporter and lab assistant by a small photo agency, the Atlantic Press. Through his acquaintance with actors at the Théâtre Mouffetard, he knew Chris Marker, who helped him meet Jacques Dumons, artistic director for the elite French magazine *Réalités*, whose staff photographers were Jean-Philippe Charbonnier and Édouard Boubat. In 1963–1964, on Dumons's recommendation, Gloaguen worked as an apprentice with Gilles Ehrmann, a regular freelance contributor to *Réalités*. Among his first published images in 1965 were eight color photographs presenting the Paris production of Edward Albee's play, *Who's Afraid of Virginia Woolf?*; these illustrate Gloaguen's early experience in color photography and his taste for stage photography.

Between 1965 and 1971, he gained further experience in photojournalism. He kept publishing in *Réalités*, but Électricité de France, the electricity company, also gave him some assignments through its "Création-Diffusion" department in order to illustrate *Contacts électriques*, its newsletter. During this period, he went four times to the United States, traveling to Boston, Dallas, and New Orleans, and exploring the contemporary art scene in New York. In 1966, he met Andy Warhol and Merce Cunningham, whom he photographed. Ugo Mulas had well documented the artistic life of New York in his *New York: Arte e persone* (1967). Gloaguen's idea was to do the same in Paris. Between 1969 and 1972, he photographed the Parisian art scene and published *L'Art actuel en France* (1973), with texts by Anne Tronche. He joined the short-lived Agence Vu in 1971 and, thanks to his new membership, Gloaguen had important encounters with Martine Franck, Richard Kalvar, and Claude Raymond-Dityvon.

In 1972, Alain Dagbert, Martine Franck, François Hers, Richard Kalvar, Guy Le Querrec, Claude Raimond-Dityvon, and Gloaguen created the Viva group. A predeliction for collective action and rebellion had been in France since May 1968. In this context, the inception of Viva was a response to various phenomena. Gloaguen epitomized the emergence of photographers who wanted to include in their photographic work political and sociological content. Together this group shared a moral sense and a critical point of view on photography as a communication device: it was too elitist and manipulated; seldom-covered topics or groups should be thoroughly photographed to reach a wider audience. The photographer's moral intervention, Gloaguen pointed out, must come before the subject's choice, because he or she cannot really control the use of its image. This belief was a driving element for their group.

His *Famille d'Aix-en-Provence* (1972), included in the touring exhibition *Famille en France* (1973–1976), typically illustrates this. No member of the family notices him as he records simple daily actions, such as parents making their bed. In many of Gloaguen's images, protagonists seem unaware of him. He admitted using long focal length lenses rarely. Gloaguen developed in the 1970s his own style, in which the quest for accurate, useful images did not neglect formal qualities and personal involvement. Photographs of daily social life became choreographed records which echo his visual interest in theatre and music shows. In *Squatters à Islington* (ca. 1974), the movements and looks of immigrants animate stable compositions set in a derelict, working-class London district.

Viva unsuccessfully responded to market demands. In addition, personal conflicts within the group did not help it solve management failures. After 1978, Gloaguen gradually distanced himself from the group, although he was still part of it officially, and he further experimented in color photography in Lyons through the support of a grant.

In 1982, Gloaguen joined the Rapho photo agency. His knowledge of color photography helped him publish in both the French and German versions of *GEO* from 1983 to 1990. He benefited from his links with Air Solidarité, a humanitarian nongovernmental organization (NGO), to travel to Africa during the 1980s. His numerous journeys gave him a standing position in the social documentation of this continent, as exemplified, in 1989, when the Rencontres internationales de la photographie in Arles, France welcomed his exhibition *Le miel et le bronze*. One of his greatest photographic and journalistic achievements in the 1980s was his reporting on the international blood market, published by *GEO* in 1987. The worldwide survey of this trade again underlined his interest in denouncing injustice. The United Nations High Commissioner for Refugees (UNHCR) sent him to Canada, Australia, Pakistan, Swaziland, Thailand, and the Central African Republic on assignment to document refugees' lives.

In the 1990s, his photographs were exhibited in Paris and throughout France. In 1995, Gloaguen finished a twenty-year photographic campaign— documenting Roman nightlife in color. His attempt to build an original photographic language in color is well illustrated by this series.

The scope of Hervé Gloaguen's work as a photojournalist is wide and mostly available in print (i.e., in color illustrated magazines or in his books of photographs). These show his attention to French landscape and urbanscape. His work illustrates his

personal interest in both the visual and performing arts, and it documents his concern with photographing multiple aspects of the human condition. In France, some of his photographs are included in the collections of Réattu Museum in Arles and in the Nicéphore Niépce Museum in Chalon-sur-Saône.

PHILIPPE JARJAT

See also: **Photography in France; Martine Franck; François Hers**

Biography

Born in Rennes, France, 11 May 1937. Attended the École des Beaux-Arts de Rennes, the École technique de photographie et de cinématographie (ETPC), Paris, 1957–1959; military service in Ivry, France, 1960–1962. Worked with Gilles Ehrmann as an apprentice 1963–1964. Joined the Agence Vu 1971–1972; founding member of the Agence Viva, 1972. Fondation nationale de la photographie Grant, 1979. Joined Rapho photoagency, 1982. FIACRE (French Ministry of Culture) Grant, 1983.

Individual Exhibitions

1974 *Portraits d'artistes*; Musée d'Art Moderne de la Ville de Paris–ARC; Paris
1982 *Lyon: Portrait d'une ville*; Fondation nationale de la photographie; Lyons
1989 *Afriques*; FNAC; Paris *Le miel et le bronze: Femmes nomades au Niger*; XX^e Rencontres internationales de la photographie; Arles, France (traveled to Crédit Foncier de France; Paris)
1992 *Le marché mondial du sang*; Visa pour l'image Festival; Perpignan, France
1993 *Portraits de femmes*; Keller Gallery; Paris
1995 *De Saïgon à Ho-Chi-Minh Ville (avril-mai 1975): Photographies Hervé Gloaguen*; Centre culturel franco-vietnamien; Paris
1996 *Des avions et des hommes: Photographies en Afrique pour Air Solidarité*; FNAC; Paris
1998 *jazz: Philippe Hartley, peintures-Hervé Gloaguen, photographies*; artshop; Isle-sur-la-Sorgue, France
2000 *À Rome la nuit: Photographies Hervé Gloaguen*; Centre municipal d'activités culturelles; Choisy-le-Roi, France

Group Exhibitions

1973–1976 *Famille en France*; Diaframma Gallery; Milan, Italy (traveled to The Photographers' Gallery, London; Wilde Gallery, Cologne, Germany; Syde Gallery, New Castle, UK; Centaur Gallery, Montreal, Canada)
1975 *VI^e Rencontres internationales de la photographie*; Arles, France
1976 *le groupe Viva: Photographies*; Galerie municipale du Château d'Eau; Toulouse, France
1977 *Photojournalisme*; Galliera Museum; Paris
1978 *European Colour Photography*; The Photographers' Gallery; London
1980 *Jeune photographie*; Fondation nationale de la photographie; Lyons, France

1985 IV^e Biennale internationale de l'image de Nancy; Nancy, France
2001 *Jazz*; Agathe Gaillard Gallery; Paris
2002 *La fotografia tra storia e poesia: fotografie della collezione FNAC*; Centre culturel Français de Milan, Gruppo Credito Valtellinese Gallery, FNAC Gallery: Milan

Selected Works

Illustrated Books

L'Art actuel en France: du cinétisme à l'hyperréalisme, 1973
La Loire angevine, 1979
Lyon, 1982
Droit d'asile, 1986
Jazz, 2004

Reportages

Qui a peur de Virginia Woolf? *Réalités*, no. 230, March 1965, 96–101
Andy Warhol: le mage fantasque des extravagances new-yorkaises *Réalités*, August 1967, 36-41
Tant qu'il y aura du sang *GEO*, no. 98, April 1987, 186–218

Photographs

Louis Armstrong et Velma Middleton, Paris, Palais des Sports, 1961
Louis Armstrong, Paris, Palais des Sports, 1965
Andy Warhol, New York, 1966
Famille d'Aix-en-Provence, 1972
Squatters à Islington, Londres, ca. 1974
Jeune homme, Rome, place Navone, 1995

Further Reading

Gloaguen: 2 ans de travail dans l'intimité de huit artistes contemporains. *Photo*, no. 58, July 1972: 82–89, 108, 110.
Boivin, Jacques. Hervé Gloaguen. *Zoom*, no. 27, 1974: 26–33, 108.
Davis, Sue, ed. *European Color Photography*. London: The Photographer's Gallery, 1978.
Gautrand, Jean-Claude. Le regard des autres: humanisme ou néo-réalisme? In Michel Frizot, *Nouvelle histoire de la photographie*, Adam Biro: Paris, 1994, 613–639.
A Day in the Life of Australia, photographed by 100 of the world's leading photographers. Potts Point (Australia, NSW): DITLA, 1981.
Jeune photographie: 45 bourses, achats, commandes 1976–1980. Lyons: Fondation nationale de la photographie, 1980.
La fotografia tra storia e poesia: fotografie della collezione FNAC. Milan: Mazzotta, 2002.
Photographie actuelle en France, Paris: Contrejour, 1976.
Kismaric, Carole. *Forced out: The agony of the refugee in our time*. London: Penguin Books, 1989.
Nori, Claude. *La photographie française des origines à nos jours*. Paris: Contrejour, 1978.
Nori, Claude. *La photographie française des origines à nos jours*. Paris: Contrejour, 1988.

FRANK GOHLKE

American

Frank Gohlke approaches photography as a literary medium. "Photography," he says, "compresses a multitude of histories into a single frame." He relishes the textual possibilities of the scenes he captures. For him, the process of "unpacking" the potential meanings in an image, and the contemplation of these meanings, is the key project of photography. Light, texture, contrast, and other formal concerns enter into his work in subordinate roles, aids to the articulation of his thematic interests.

The environment, both natural and built, has remained the dominant theme of Gohlke's work since he began in the late 1960s. Early in his career, he was drawn to the wide-open vistas of landscapes in the midwest and western United States. A native Texan, he returned often to photograph prairies, either as nearly "empty" expanses or as hosts to an incongruous variety of architecture. In the more expansive landscapes, we find evidence of the persistent, if subtle, presence of human endeavor—a distant telephone pole or a dirt track—despite the suggestion of infinite emptiness. In the others, he emphasized his concerns for the impact of built structures on the natural environment. Though banal in themselves, the houses and simple farm buildings in these images become catalysts for contemplation when they interrupt otherwise pristine vistas, forcing an understanding of the growing ubiquity of the built environment.

Gohlke strives to create images with deadpan objectivity. The subjects that he selects are dense enough as they stand; he finds no need to further dramatize the inherently compelling narrative of his scenes with provocative angles or radical lighting. This approach early earned him a place in the watershed exhibition, *New Topographics: Photographs of a Man-Altered Landscape*, held at the International Museum of Photography at the George Eastman House in 1975. Most of the photographers in this exhibition, also including Robert Adams, Lewis Baltz, Bernd and Hilla Becher, Joe Deal, Nicholas Nixon, John Schott, Stephen Shore, and Henry Wessel, Jr., shared a social concern for the environment that they expressed photographically in a style merging the goals of 1930s documentary mode projects with the ideals of straight photography—both of which Gohlke had become acquainted with directly from Walker Evans.

Gohlke had met Evans in Connecticut. Having finished his graduate work in English literature at Yale University, he had stayed on in the area to study photography with Paul Caponigro. During this time, he also got to know Evans, who strongly encouraged his decision to become a photographer. Gohlke then moved to Vermont for three years and there established a photography program at Middlebury College.

In 1971, Gohlke moved to Minnesota. Here he encountered the enormity and monumental sculptural presence of the grain elevators that dominated the area where he lived and began a decade-long engagement with the subject. The elevators were emblematic of the incredible productive capabilities of the Midwest, but were also relics of the past. Though they had once embodied the strength of the trade driving the local economy, many of these structures had fallen into various states of ruin by the 1970s. An elegiac tone permeates much of the work of this period, but the images are also laced with an enormous respect for the architectural grandeur of the hulking giants that lined Minneapolis's midway district. For his book, *Measure of Emptiness: Grain Elevators in the American Landscape* (1992), Gohlke selected key photographs from this period and wrote an insightful essay on the significance he found in the subject.

Though closely associated with images of American landscapes, Gohlke has also created several significant bodies of work involving European subjects. In the mid-1980s, for example, he was asked to join an ambitious effort in France to document the country's landscapes. This *Mission Photographique de la DATAR* organized a distinguished group of international photographers whose work was deeply engaged with the landscape. The project was openly based on its famous nineteenth-century predecessor, the *Missions héliographiques*, organized by the *Commission des Monuments historiques* (Commission on Historical Monuments) in 1851 to inventory France's architecture photographically. Tellingly, the impetus for the first project was the realization that France's aggressive modernization efforts under Napoleon III were threatening its architectural heritage. Likewise, the DATAR project responded to the growing awareness that the country's landscapes had suffered gravely from a

century of rampant industrialization. The latter *Mission* published its final report in the form of a thick volume reproducing the photographs produced by the project.

Many of Gohlke's other projects over the following decade echoed his DATAR work in that he focused on a specific geographic area with the goal of establishing its essence at a given point in time. For example, having moved to Massachusetts in 1987, Gohlke began an ongoing project to document the Sudbury River 25 miles west of Boston. The river, once the muse of American Transcendentalist writers Nathaniel Hawthorne, Ralph Waldo Emerson, and Henry David Thoreau, was the subject of local activism to keep it protected—an effort that eventually (1999) led to its becoming part of the national parks system. In 1993, Gohlke had worked with a local art museum (the DeCordova Museum and Sculpture Park in Lincoln, Massachusetts) and the Sudbury Valley Trustees on a project to celebrate the untrammeled beauty of the river. Unlike so much of his work to date, this project focused on the potential for humans to have a light touch in their uses of natural resources—it is the chaotic order of nature that defines Gohlke's Sudbury River and its environs.

Much of Gohlke's work in the 1990s derived from commissions. He photographed Lake Erie for the Gund Foundation in 1997–1998 and participated in the National Millennium Survey in 1999–2000. As well, he was twice invited to work in Italy. First, in 1994 he was invited to photograph the *Parco del Gigante* by the Province of Reggio Emilia, a project that included both an exhibition and a catalogue. Then in 1998 he was asked to participate in a much larger project to photograph the industrial port of Marghera in Venice. The organizers of this second project selected an international roster of photographers whose approaches to the landscape differed considerably. Gohlke's contribution featured his signature black-and-white images of the industrial landscape, but also included views of non-descript interiors of factory control rooms and office areas. These images signal an expansion in Gohlke's interest; they spark contemplation of the impact of built environments on humans rather than on the landscape, and they provoke consideration of how the world we shape in turn shapes us.

This concern informs many of Gohlke's more recent projects as well—works that reflect an interest in the built environment itself. He has an ongoing series that focuses on funeral homes, for instance, in which he studies the exteriors of this specialized architectural form. He also has completed a project with Joel Sternfield in Queens,

New York, that includes exteriors from several different neighborhoods displaying both the haphazard and carefully articulated patterns of urban life. In this later work, as in all of his previous endeavors, Gohlke's images require reading, unpacking as he describes it, to appreciate the vital complexity of his literate photographic output.

J. R. STROMBERG

See also: **Adams, Robert; Baltz, Lewis; Evans, Walker; Nixon, Nicholas; Panoramic Photography; Shore, Stephen**

Biography

Born in Wichita Falls, Texas, 1922. Attended Davidson College, Davidson, North Carolina (1960–1963) and the University of Texas, Austin, where he earned his B.A. in English literature in 1964. Graduate work in English literature at Yale University, New Haven, Connecticut, where he received his M.A. in 1967. Studied photography with Paul Caponigro (1967–1968) while still living in Connecticut, where he met and was greatly influenced by Walker Evans. Taught at Middlebury College, Middlebury, Vermont 1968–1971, founding the photography program. From 1971 to 1987, Gohlke lived and worked in Minneapolis, where he taught variously at the Blake School (1973–1975), the University of Minnesota Extension, Minneapolis (1975–1979), Colorado College (1977–1981), and Carleton College (1980). He also taught at Yale University Graduate School (1981). In 1987, he moved to Massachusetts; began part-time teaching at the Massachusetts College of Art, where he is currently Visiting Professor of Photography. John Simon Guggenheim Memorial Foundation Fellowships, 1975–1976 and 1984–1985; National Endowment for the Arts Photographer's Fellowships, 1977–1978 and 1986–1987; Bush Foundation Artist's Fellowship, 1979–1980; McKnight Foundation/Film in the Cities Photography Fellowship, 1983. Lives and works in Massachusetts.

Individual Exhibitions

1975 *Frank Gohlke Photographs*; Amon Carter Museum, Fort Worth, Texas
1978 *Grain Elevators*; Museum of Modern Art, New York, New York and traveling
1980 University Gallery, University of Massachusetts, Amherst, Massachusetts
1983 *Mount St. Helens: Work in Progress*; Museum of Modern Art, New York, New York
1988 *Landscapes from the Middle of the World, Photographs 1972–1987*; Museum of Contemporary Photography, Columbia College, Chicago, Illinois
1993 *Living Water: Photographs of the Sudbury River by Frank Gohlke*; DeCordova Museum and Sculpture Park, Lincoln, Massachusetts
 Mt. St. Helens as a Public Landscape; Gallery of the School of Architecture and Allied Arts, University of Oregon, Eugene, Oregon
1994 Florida International University, Miami, Florida

1995 *Conversations in the Park*; Reggio Emilia, Ruberia, Italy
1997 *Making Waves: The Sudbury River*; New England Science Center, Worcester, Massachusetts

Group Exhibitions

1975 *New Topographics: Photographs of a Man-Altered Landscape*; International Museum of Photography, George Eastman House, Rochester, New York
1978 *Mirrors and Windows: American Photography since 1960*; Museum of Modern Art, New York
1979 *American Photography of the '70s*; Art Institute of Chicago, Chicago, Illinois
1981 *American Landscapes*; Museum of Modern Art, New York, New York
1982 *An Open Land: Photographs of the Midwest, 1852–1982*; Art Institute of Chicago, Chicago, Illinois and traveling
1985 *Paris-New York-Tokyo*; Tsukuba Museum of Photography, Tsukuba, Japan and traveling
1987 *American Dreams*; Centro de Arte Reina Sofia, Madrid, Spain
1988 *The Second Israeli Photography Biennial*; Mkshkan Le'Omanut, Museum of Art, Ein Harod, Israel
 Tradition and Change: Contemporary American Landscape Photography; Houston Center for Contemporary Photography, Houston, Texas
1989 *Photography Now*; Victoria and Albert Museum, London, England
 Photography Until Now; Museum of Modern Art, New York (traveled to the Cleveland Museum of Art, Cleveland, Ohio)
1993 *Contemporary American Photography*; Jingshan Tushuguan, Guangzhou, China
1995 *From Icon to Irony: German and American Industrial Photography*; Boston University Art Gallery, Boston, Massachusetts
1998 *Expanded Visions: The Panoramic Photograph*; Addison Gallery of American Art, Andover, Massachusetts
1999 *Pictures of Europe*; DeCordova Museum and Sculpture Park, Lincoln, Massachusetts
2002 *Photographers, Writers, and the American Scene*; Museum of Photographic Arts, San Diego, California
 A City Seen: Photographs from the George Gund Foundation Collection; Cleveland Museum of Art, Cleveland, Ohio

Selected Works

Grain Elevator/Midway area, Minneapolis, Minnesota, 1972
Abandoned Grain Elevator/Homewood, Kansas, 1973
Landscape/near Littlefield, Texas, 1975
View Down Two Streets, Wichita Falls, Texas, 1978
Area Clear Cut Prior to 1980 Eruption Surrounded by Downed Trees - Clearwater Creek
Valley - 9 Miles East of Mount St. Helens, Washington, 1981
Eroding Basalt—Near Allanche, Auvergne, France, 1986
Reservoir #3 on the Sudbury River–Framingham, Mass., January, 1990
Porta Marghera, 1996
Breezevale Cove, Rocky River; View North, 1997
Flushing, Queens, 2003

Further Reading

Adams, Robert. "Frank Gohlke." *Aperture* 86 (1982): 40–51.
Enyeart, James, ed. *Visions of Passage: Photographers, Writers, and the American Scene*. Santa Fe, New Mexico: Arena Editions, 2002.
Gohlke, Frank. "Frank Gohlke," *Aperture* 98 (Spring 1985): 28–35.
Gohlke, Frank, and John Hudson. *Measure of Emptiness: Grain Elevators in the American Landscap*, Baltimore, MD: Johns Hopkins Press, 1992.
Gohlke, Frank, et al. *The Sudbury River: A Celebratio*, Lincoln, Massachusetts: DeCordova Museum and Sculpture Park, 1993.
Gohlke, Frank. *Linea di Confine della Provincia di Reggio Emilia, Laboratoriodi Fotografia 7: Frank Gohlke, Parco del Gigante*. Rubiera, Italy: Comune di Rubiera and Provincia di Reggio Emilia, 1995.
Jenkins, William, ed. *New Topographics: Photographs of a Man-Altered Landscape*, Rochester, New York: International Museum of Photography, 1975.
Mescola, Sandro, ed. *Identificazione di un Paesaggio: Venezia-Marghera: Fotographia Transformazioni nella Città Contemporanea*. Milan, Italy: Silvana Editoriale, 2000.
Mission Photographique de la DATAR. *Paysages Photographies*. Paris: Editions Hazan, 1989.
Szarkowski, John. *Frank Gohlke: Mount. St. Helens, 1981–1990*. New York: Museum of Modern Art, 2005.

NAN GOLDIN

American

Nan Goldin's color portraits of her bohemian community in the 1970s turned the intimate family snapshot into an artistic genre and valid photographic art. Reappropriating the family medium of the slide show and the photo album, Goldin creates a visual diary of the private lives of her chosen "family" of gays, lesbians, transgender people, and others outside of mainstream society whom she has photographed consistently over 30 years. Her work with familiar characters known affectionately as "the family of Nan" and her emotional intensity are evocative of cinematic narratives, large

scale, powerful, and intense, a claim which herself makes. Unlike cinema, Goldin insists on the truthful unposed nature of her work, thus aligning herself with photography's fidelity to realism, openly introducing her authorial relationships to the subject, through titles that give her subject's name and the place where the photograph was taken. Goldin has encouraged this reading of her work as autobiographical, famously describing *The Ballad of Sexual Dependency* as "the diary I let people read." She challenges the notion that gender is biological and shows the constructed nature of gender roles, tracking what she calls "the third gender."

Born to an affluent Boston family, Goldin started photographing at age 15 after her elder sister committed suicide, which Goldin stated helped her deal with that tragedy. Goldin left home at an early age and lived with various foster families as a teenager. She attended art school, where she planned to do fashion photography and studied at New England School of Photography with Henry Horenstein, who influenced her snapshot aesthetic. She later attended the Boston School of Fine Arts, where her roommates, the subjects of her first show in 1975, were two drag queens whom she photographed at home and at gay bars. In 1978, she moved to New York City, where she became involved in a thriving art scene emerging around the East Village.

Goldin's work has been associated with the unposed photographs of Larry Clark and the banal "outtakes" of contemporary artist Jack Pierson. Goldin has also been associated with Cindy Sherman, who similarly documents the constructed nature of gendered identity, glamour, and self-presentation. Goldin acknowledges debts to Nobuyoshi Araki, painters Barnett Newman and Mark Rothko (in her use of empty spaces and her visual clarity), as well as to sixteenth-century painter Caravaggio's sensual portraits. Within the history of photography, she has been associated with the portraiture of August Sander and Diane Arbus; however, unlike these two photographers, Goldin is part of the group she documents and uses her images as a form of emotional connection, rather than distance. This claim to "insider documentary" also allows her to disavow criticisms of voyeurism and exoticism. As Goldin has stated, "I'm not crashing. This is my party. This is my family, my friends." She also takes self-portraits, further blurring her role as photographer vis-à-vis her subjects.

Goldin's work initially was presented as evolving slide shows for downtown audiences composed of those who participated in the fringe culture lifestyles she documented. Her *Ballad of Sexual Depen-* *dency* series, made between 1978 and 1996, was her first large slide show and comprises over 700 images set to an eclectic soundtrack. It later was published as a book. Her photographing of her community of her friends enabled those who became familiar with her work to follow her subject, even allowing the viewer to follow the breakdown of relationships, death from AIDS or addiction, and addiction recovery, such as in the five-panel series *Gilles and Gotscho, 1992–1993*. Goldin was also unscathing in her self-portrayal, as her own drug and alcohol abuse landed her in the hospital in late 1988.

Goldin's break with the photographer's presumed neutral gaze is vividly evident in her book *The Other Side*. This series documents the intimate relationships and communities of transsexuals, depicting them at nightclubs and at events like Wigstock and other gay pride events. Like the *Ballad of Sexual Dependency*, Goldin presented these photographs as slide shows at weekly dinner parties.

Goldin challenged the traditional values of art and portrait photography with her 1996 Whitney Museum, New York, retrospective *I'll Be Your Mirror*. One of the few female photographers to have been featured in a solo exhibition at the Whitney, it represented a turning point in Goldin's career and her entry into the mainstream contemporary art world. The photographs shown in this exhibition, demonstrate her preferred settings: interior spaces in which private dramas are played out, particularly cluttered kitchens and bathrooms, rumpled beds, downtown bars, nightclubs, and other gathering places. These photographs are always acutely attuned to the intricate negotiations between people and their surroundings. Among Goldin's strengths is her use of color as a catalyst for amplifying the motional tenor of the moment. In one of her better known images, *Nan and Brian in Bed, NYC 1983*, the scene is illuminated with an orange glow that captures the mood of a painful and dying relationship as Goldin captures herself lying behind her lover on the bed, distant and alone. *Nan One Month after Being Battered, NYC 1984* is a startling portrait of painful self-confrontation, her lipstick garishly echoing the blood from her injured eye. Nan's images are acutely aware of the politics of looking and the power dynamics involved in the seer and the seen. By immersing the viewer in the lives of people not normally seen on the big screen, Nan humanizes them, telling their story and her own with vivid clarity and careful sympathy.

In *All By Myself-Beautiful at Forty, 1953–1995*, Goldin expands the theme of autobiography as a narrative form. A moving sequence of 83 self-por-

traits set to singer Eartha Kitt's "Devil's Playground," the series suggests a confrontation with maturity and aging and incorporates more exterior shots than featured in her earlier series, including cityscapes and landscapes empty of people.

Her photographs are snapshot-like but technically sophisticated in composition, using strong depth of field, mise-en-scène-like mirrors and glistening light fixtures. Consistent throughout her oeuvre is the power of setting to express emotionality, as she uses color to ascribe meaning to the shabbiest apartment, a mirrored nightclub, or in her more recent work, landscapes infused with trauma, such as "Red Sky Outside my Window, NYC, 2000" from her series *Elements*. Goldin uses photography as a means of recording an individual's psychological state, emphasizing the medium's ability to express more than the objective "truth." Now centered in Europe, she is still exploring relationships in her recent *Heart Beat, 2000–2001*, with 228 slides which track five couples in domestic scenes. In this series, the artist is more peripheral to the relationships and desire that she depicts than in her earlier work, where the boundaries between artist and subject were blurred.

DANIELLE SCHWARTZ

See also: **Araki, Nobuyoshi; Arbus, Diane; Clark, Larry; Documentary Photography; History of Photography: the 1980s; Portraiture; Representation and Gender; Sander, August; Sherman, Cindy; Vernacular Photography**

Biography

Born 12 September 1953, Washington, D.C. and raised in Boston, Massachusetts. Attended New England Conservatory of Art at night in 1972; studied with Henry Horenstein. Earned BFA from Tufts University/School of the Museum of Fine Arts, Boston, 1977. Taught at Harvard University, New Haven, Connecticut; did photographic campaign for Matsuda; curated exhibition for Artist's Space. Brandeis Award in Photography, 1994; National Endowment of Arts Fellowship, 1991; Louis Comfort Tiffany Foundation Award, 1991; DAAD, Artists-in-Residence Program, Berlin, 1991; Mother Jones Documentary Photography Award, 1991; Camera Austria Prize for Contemporary Photography, Graz, 1989; Maine Photographic Workshop Book Award, 1987; Englehard Award, Boston School of the Museum of Fine Arts Alumni Traveling Fellowship, Boston 1986. Lives and works in Paris.

Selected Works

David at Grove Street, Boston, 1972
Picnic on the Esplanade, Boston, 1973
Nan and Brian in Bed, NYC, 1983

Nan One Month after Being Battered, NYC, 1984
Cookie and Vittorio's Wedding: The Ring, NYC, 1986
Self-portrait with eyes turned inward, Boston, 1989
Gina at Bruce's dinner party, NYC, 1991
At the bar: Toon, C, and So, Bangkok, 1992
Self-portrait on the train, Germany, 1992
'Gotscho + Gilles. Paris, 1992–1993
All by Myself – Beautiful at Forty, 1953–1995 (slide show)
Joana and Aurele making out in my living room, NYC, 1999
Red sky from my window, NYC, 2000

Selected Slide Shows

1979 Mudd Club, New York
1981 The Kitchen, New York
 Artist's Space, New York
 White Columns, New York
1982 Club 57, New York
1983 Bowery Project, Collaboration with Max Blagg, New York
 Tin Pan Alley, New York
1984 C.E.P.A. Gallery, Buffalo
 Moderna Museet, Stockholm
1985 Edinburgh 39th International Film Festival, Edinburgh
 Whitney Museum of American Art, New York
1986 Image and Sound Film Festival, The Hague, Netherlands
 St. Marks Poetry Project, New York, New York
 Berlin Film Festival, Berlin, Germany
 "The Real Big Picture," (video installation) Queens Museum, New York
1987 Stedelijk Museum, Amsterdam, Netherlands
1987 Philadelphia Museum of Art, Philadelphia, Pennsylvania
 Centro de Arte Reina Sofia, Madrid, Spain
 Hirshhorn Museum and Sculpture Garden, Smithsonian Institution, Washington, DC
 Les Rencontres d'Arles, Arles, France
1988 Fotofest, Rice Media Center, Houston, Texas
 Ferguson Theater, Art Institute of Chicago, Chicago, Illinois
 Sackler Museum, Harvard University, Cambridge, Massachusetts
1989 ICA Theatre, London, England
 Warm Gallery, Minneapolis, Minnesota
 Savoy Theatre, Helsinki, Finland
1990 SF Camerawork, San Francisco, California
1991 Museum of Modern Art, New York, New York
1992 Museum des 20.Jahrhunderts, Vienna, Austria
1993 Fotografiska Museet, Moderna Museet, Stockholm, Sweden
 Fundacio "La Caixa," Barcelona, Spain
 Parco Gallery, Tokyo, Japan
1994 The Kitchen, New York, New York
 International Center of Photography, New York. New York
1995 San Francisco Museum of Modern Art, San Francisco, California
 Centre d'Art Contemporain, Geneva, Switzerland
1996 Tate Gallery, London, England
 Wexner Center for the Arts, Columbus, Ohio

Selected Individual Exhibitions

1973 Project, Inc. Cambridge, Massachusetts
1977 Hudson Gallery (with David Armstrong), Boston, Massachusetts

1985 *Currents*, Institute of Contemporary Art, Boston, Massachusetts
1988 Indiana University Gallery, Bloomington *Couples*, Pace/MacGill Gallery, New York
1996 *Nan Goldin: Children 1976–1996*, Mathew Marks Gallery, New York, New York
　Nan Goldin: Self Portrait, Tokyo Love, Centre de la Vieille Charité, Marseille, France
1996 *Nan Goldin: I'll Be Your Mirror*, Whitney Museum of American Art, New York, New York, (also Kunstmuseum, Wolfsburg, Germany; Stedelijk Museum, Amsterdam, Fotomuseum Winterthur, Switzerland, Kunsthalle Wien, Vienna, Austria)
1999 *Nan Goldin*, National Gallery of Iceland, Reykjavik, Iceland
2001 *Nan Goldin*: *Le feu follet*, Centre Georges Pompidou, Paris, France
2003 *Nan Goldin*, Musee d'art contemporain de Montreal, Montreal, Canada

Group Exhibitions

1979 Pictures/Photographs, Castelli Graphics, New York, New York
1980 *Times Square Show*, Co-Lab, New York, New York
1985 *Self Portrait Show*, Museum of Modern Art, New York, New York
　Biennial Exhibition, Whitney Museum of American Art, New York, New York
1990 *An Army of Lovers*, PS 122, New York, New York
1991 *Devil on the Stairs: Looking Back on the 80s*, Institute of Contemporary Art, Philadelphia, Pennsylvania
　Pleasures and Terrors of Domestic Comfort, Museum of Modern Art, New York, New York
1992 *New Visions in Photography*, Whitney Museum of American Art, New York, New York
1995 *Public Information: Desire, Disaster, Document*, San Francisco Museum of Modern Art, San Francisco, California

1995 *Biennial Exhibition*, Whitney Museum of American Art, New York, New York
　Féminin Masculin: Le Sexe de l'Art, Centre Georges Pompidou, Paris
1996 *Hospice: A Photographic Inquiry*, Corcoran Gallery of Art, Washington DC
1997 *Defining Eye: Women Photographers of the 20th Century*, The Saint Louis Art Museum, St. Louis, Missouri (traveled to The Museum of Fine Arts, Santa Fe, New Mexico; Mead Art Museum, Amherst, Massachusetts; The Wichita Art Museum, Wichita, Kansas)
　Rrose is a Rrose is a Rrose: Gender Performance in Photography, Solomon R. Guggenheim Museum, New York, New York

Further Reading

Goldin, Nan. *The Other Side*, edited with David Armstrong and Walter Keller. New York: D.A.P., 2000; also Scalo Publishers, 1993.
Goldin, Nan. *The Ballad of Sexual Dependency*. Millerton, New York: Aperture, 1986.
Goldin, Nan. *Nan Goldin, The Devil's Playground*. New York: Phaidon, 2002.
Costa, Guido, ed. *Nan Goldin* 55. London: Phaidon Press, 2001.
Gagnon, Paulette. *Nan Goldin*. Montreal: Musee d'art contemporain de Montreal, 2003.
Kotz, Liz. "Aesthetics of Intimacy." In *The Passionate Camera: Photography and Bodies of Desire*, edited by Deborah Bright. New York: Routledge, 1998.
Fridling, Melissa Pearl. "Nan Goldin's Retrospective and Recovery: Framing Feminism, AIDS and Addiction." In *Recovering Women: Feminisms and the Representation of Addiction*. Boulder: Westview Press, 2000.
Townsend, Chris. "Nan Goldin: Bohemian Ballad." In *Phototextualities: Intersections of Photography and Narrative* Ed. Alex Hughes and Andrea Noble. Albuquerque: University of New Mexico Press, 2003.
Goldin, Nan, and Taka Kawachi, eds. *Nan Goldin: Couples and Loneliness*. Kyoto: Korinsha Press, 1998.

EMMET GOWIN

American

Emmet Gowin can seem like two photographers. One captured images of his rural family life in the late 1960s and 1970s, images deeply rooted in an earthbound and intimate knowledge of place and person. The other captured images from his world travels in the 1980s and 1990s, images often uprooted in an airborne and detached comprehension of untainted and irreversibly tainted landscapes. If

there was no readily apparent evolution from one subject matter to the other, there is nevertheless subtle unity to this eminent photographer's body of work. Partly achieved through technical adventurousness, refined composition, and ethereal calm, this unity is animated by Gowin's faculty for the ineffable: "the fact that something is unsayable, that you are emotionally restricted from saying or even recognizing consciously what your own spirit is struggling with, energizes one's work" (Interview

with John Paul Caponigro, *Camera Arts*, Dec./Jan. 1998–1999).

Born in Danville, Virginia, in 1941, Emmit Gowin was raised by devout parents, his father a Methodist minister, his mother a Quaker. During his high school years, he was inspired by Ansel Adams's pictures and began to take photographs. In 1960, he attended the Danville Technical Institute as a business major. In 1961, he enrolled at the Richmond Professional Institute (now Virginia Commonwealth University) to study painting and photography, earning a B.A. in 1965. During these college years, in 1964, he married Edith Morris and formed a close tie with her family in Danville. Edith, along with their sons, Elijah and Isaac, and her extended family became a subject of his photographs in the late 1960s and 1970s.

Gowin attended the Rhode Island School of Design, receiving his M.F.A. in 1967, and these years, 1965–1967, proved crucial to his artistic development. While he experimented with 35-mm photography, influenced by the work of Henri Cartier-Bresson and Robert Frank, he also studied with Harry Callahan, who encouraged his use of larger picture formats, seen in images such as *Nancy, Danville, Virginia*, 1965. And, much as Callahan had, Gowin focused on his wife as a subject; his early portraits of her clearly demonstrate their intimate and deep bond, although some, such as *Edith, Danville, Virginia*, 1971, capturing Edith urinating while standing, were shocking to many when first exhibited. Much like Sally Mann's work of about a decade later, Gowin's depictions of childhood and intimate family life often reveal more about the viewers who find them disturbing than about the photographer or the subjects of the photos. During this period, in 1966, he visited Walker Evans in New York, and, with Callahan's assistance, he met, and later developed a friendship with Frederick Sommer, who influenced his technique and thinking.

From 1967–1971, Gowin taught photography at the Dayton Art Institute in Ohio, and in 1971 his photographs were reproduced in *Album* and *Aperture*. He became widely known for pictures of his rural domestic life, which combine unflinching innocence and snapshot spontaneity with inspired composition and technical experiment. Gowin reflects on images such as *Nancy and Twine Construction, Danville, Virginia*, 1971: "through the lives of new relatives, my more whole family, I returned to the mood that finds solemnity in daily life. As a child, one has the time for such pastimes as sunlight on water or the weave of the porch screen and the openings and closings of those doors. I wish

never to outgrow that leisure" (*Emmet Gowin: Photographs*, Philadelphia Museum of Art, 1990). Gowin augmented the mood of pictures of Edith and his family in Danville through experiments with circular lenses:

> About the circular pictures: I had quite forgotten that it was the nature of the lens to form a circle and in 1967 my only lens was a short Angulon intended for a small camera. I'd been given an old Eastman View 8 × 10 and brought the two together out of impatience and curiosity. After a while, I recognized the wonderful exaggeration near the edge. I began to use the camera with this lens, but for several years I would trim these prints so that the circle was disguised. Eventually I realized that such a lens contributed to a particular description of space and that the circle itself was already a powerful form.

(Emmet Gowin: Photographs, Knopf, 1976, p. 101)

During the 1970s, Gowin began to travel extensively, particularly in Great Britain, Italy, and Jordan, and to photograph both cultivated and uncultivated landscapes. He became established in the academic and arts worlds, and in 1973, he accepted a teaching position at Princeton University. While residing with his wife and children in Newtown, Pennsylvania, he gave lectures and workshops at the Museum of Modern Art, New York, and Yale University, and over time, throughout the United States, Europe, and Japan. His workshops and writing often focused on the darkroom techniques, such as selective and over-all bleaching, combination developing, toning, and contour mapping that distinguish his images. He received prestigious honors, such as the John Simon Guggenheim Memorial Fellowship and the National Endowment for the Arts Fellowship. As his renown as a teacher and mentor grew, he brought Frederick Sommer to be a visiting Senior Fellow at Princeton.

In the 1980s, Gowin began to take aerial landscape photographs, both of natural geologic features and of altered landscapes. In 1980, a fellowship from the Seattle Arts Commission brought him to Washington, where he photographed the aftermath of the Mount St. Helens eruption, creating images such as *Spirit Lake, Mount St. Helens, Washington*, 1980. Over many years, he returned to Washington to photograph Mount St. Helens and, also in Washington, the Hanford Nuclear Reservation. He photographed from an airplane using a gyroscopically stabilized Hasselblad camera, originally developed by NASA to record space flights. In 1982, at the invitation of his former Princeton student, Queen Noor al Hussein, he visited Jordan and pho-

tographed the astonishing facades carved into rock at Petra.

Throughout the 1980s and 1990s, Gowin continued to employ aerial photography to record the impact of humanity upon the landscape. In images such as *Pivot Irrigation Near the One Hundred Circle Farm and the McNary Dam on the Columbia River, Washington*, 1991, he evokes the simplicity and majesty of human survival relying on the depletion of finite resources. Gowin observes, "The astonishing thing to me is that in spite of all we have done, the earth still offers back so much beauty, so much sustenance"(*Emmet Gowin: Changing The Earth*, Yale University Press, 2002, p. 158). He has photographed widely divergent landscapes with a similar sensibility, including military test sites, Kuwait after the Gulf War, and smokestack industries in the Czech Republic. While bearing witness to the degradation of the land, these are images of stunning photographic beauty created with the difficult and time-consuming split-tone process that brings subtle color to black-and-white prints. In 2002, the Yale University Art Gallery (in association with the Corcoran Gallery of Art) organized a nationally touring exhibit of his aerial photographs. The associated book, *Emmet Gowin: Changing The Earth*, was dedicated to his mentors Harry Callahan and Frederick Sommer.

JEFFREY B. EDELSTEIN

See also: **Aerial Photography; Callahan, Harry; Sommer, Frederick**

Biography

Emmet Gowin was born in Danville, Virginia in 1941. He received his B.A. in 1965 from the Richmond Professional Institute (now Virginia Commonwealth University) and his M.F.A. in 1967 from the Rhode Island School of Design. After teaching at the Dayton Art Institute in Ohio, 1967–1971, he joined Princeton University in 1973, as Professor of Photography in the Council of the Humanities, Princeton University. He has taught workshops throughout the United States, Europe, and Japan. Began association with Pace/MacGill Gallery, New York, mid-1980s. His honors include a John Simon Guggenheim Memorial Grant (1974) and two National Endowment for the Arts Fellowships (1977 and 1979), and awards from the Southeastern Center for Contemporary Art (1983), the Seattle Arts Commission (1980), the 1983 Governor's Award for Excellence in the Arts from the State of Pennsylvania, the 1992 Friends of Photography Peer Award, and the Pew Fellowship in the Arts for 1993–1994. Gowin lives in Newtown, Pennsylvania, with his wife Edith.

Individual Exhibitions

1968 The Dayton Art Institute; Dayton, Ohio
1969 School of the Art Institute of Chicago; Chicago, Illinois
1971 George Eastman House; Rochester, New York
1973 The Corcoran Gallery of Art; Washington, D.C.
1982 Light Gallery; New York, New York
1983 Corcoran Gallery of Art; Washington, D.C.
1986 *Petra and Mount St. Helens;* Pace/MacGill Gallery, New York, New York
1990 *Emmet Gowin/Photographs: This Vegetable Earth Is but a Shadow*; Philadelphia Museum of Art, Philadelphia, Pennsylvania; traveled to Detroit Institute of Arts, Detroit, Michigan; Minneapolis Institute of Arts, Minneapolis, Minnesota; Virginia Museum of Fine Arts, Richmond, Virginia; Friends of Photography, Ansel Adams Center, San Francisco, California; Los Angeles County Museum of Art, Los Angeles, California; Museum of Contemporary Art, Chicago, Illinois; and Columbus Museum of Art, Columbus, Ohio
1992 *Emmet Gowin/Photographs*; Espace Photographie Marie de Paris; Paris, France
 Photographs: Landscape in the Nuclear Age; organized by American Center of the American Embassy and the City of Fukuoka; traveled 1992–93 to Osaka, Kyoto, Saporo, Yokohama, and Tokyo, Japan
1996 *Photographs from the Pew Fellowship: Jerusalem, Kansas, and the Nevada Test Site*; Pace/Wildenstein/MacGill Gallery, New York, New York

Group Exhibitions

1969 *Vision and Expression*; George Eastman House, Rochester, New York
1971 *Thirteen Photographers*; Light Gallery, New York, New York
1977 *Mirrors and Windows: American Photography since 1960*; Museum of Modern Art, New York, New York
1997 *Unmapping the Earth*; '97 Kwangju Biennale, Kwangju, Korea
1999 *Transmutation: Silver Prints*; Bowdoin College Museum of Art, Brunswick, Maine
 The Model Wife; Museum of Photographic Arts, San Diego, California
2000 *Emmett Gowin and Students*; Alfred University, Alfred, New York
2003 *The New Sublime*; Northlight Gallery, Herberger College of Arts, Arizona State University; Tempe, Arizona
2004 *In the Center of Things: A Tribute to Harold Jones*; Center for Creative Photography, University of Arizona; Tucson, Arizona

Selected Works

Nancy, Danville, Virginia, 1969
Nancy and Dwayne, Danville, Virginia, 1970
Nancy and Twine Construction, Danville, Virginia, 1971
Edith, Danville, Virginia, 1971
Edith and Elijah, Newtown, Pennsylvania, 1974
Spirit Lake, Mount St. Helens, Washington, 1980

Pivot Irrigation near the One Hundred Circle Farm and the McNary Dam on the Columbia River, Washington, 1991
Old Hanford City Site and the Columbia River, Hanford Nuclear Reservation near Richland, Washington, 1986
Effluent Holding Pond, Chempetrol Mines, Bohemia, Czech Republic, 1992

Further Reading

Ackley, Clifford S. *Private Realities: Recent American Photography.* Boston: Museum of Fine Arts, 1974.
Bunnell, Peter C. *Emmet Gowin: Photographs, 1966–1983.* Washington, DC: The Corcoran Gallery of Art, 1983.
Chahroudi, Martha. *Emmet Gowin: Photographs.* Philadelphia: Philadelphia Museum of Art, 1990.
Gowin, Emmet. *Emmet Gowin Photographs.* New York: Alfred A. Knopf, 1976.
Gowin, Emmet. *Emmet Gowin: Aerial Photographs.* Princeton: Art Museum, Princeton University, 1998.
Reynolds, Jock. *Emmet Gowin: Changing the Earth.* New Haven, Connecticut: Yale University Art Gallery, 2002.
Shaw, Louise, Virginia Beahan, and John McWilliams, eds. *Harry Callahan and His Students: A Study in Influence.* Atlanta: Georgia State University Art Gallery, 1983.

DAN GRAHAM

American

Dan Graham has been a leader among late twentieth-century conceptual artists in the United States and Canada. His early photography was an important foundation for his later installation-based artwork about public and private space. He is also a critical theorist who contextualizes his work using complex theoretical and philosophical propositions in essay format.

Graham's first, most widely recognized photographic project consisted of a group of straightforward photographs of houses in Jersey City, New Jersey, accompanied by an essay. The work was titled *Homes for America* and was published in the December 1966–January 1967 edition of *Arts Magazine.* The photographs showed houses from various angles, the occupants of the houses, and the activities taking place within the homes.

The basic look of these early photographs by Graham is part of an anti-aesthetic movement among conceptual art photographers of the period. The straightforward, deadpan snapshot look compares to the work of Edward Ruscha, for example, who showed the west coast version of pre-fabricated housing in his book, *Some Los Angeles Apartments* (1965). Graham's alienated shots of the outside of the buildings also likens to the work of the German photographers who so influenced conceptual photography, Bernd and Hilla Becher, however at a much less refined formal level. For general purposes, Graham's photographs are technically simple, but in their casual appearance, they effectively transmit the ordinariness of subjects they document.

The artist's interest in tract housing compares to other documentary photographers. Walker Evans was one of the first to make record of lower-income living conditions when he and others like him worked for the Farm Security Administration. Graham's intentions, however, are considerably less straightforward. Without the text, the photographs look like documentary work, but taken together with the article, they reek of criticism, their deadpan, drab appearance a commentary on the lives of those whose environments they represent. The article consisted of commentary on the tract housing units, comparing their size, color, and locations. The houses were analyzed and studied like scientific information but made to seem like a lifestyle limited by the products of mass production. Graham's somewhat intrusive images of the goings-on inside the strangers' homes are also somewhat sardonic. The ambiance of Jersey City becomes a field day for his flip, aesthetic review.

Graham was also cognizant of the presentation of his photographs. He placed his images instantly into a magazine, as opposed to offering prints for sale at a gallery. He allows the photographs to be reproduced in mass quantity and be made available to a wide audience for a low cost. The result is that he demonstrates the ease of reproduction of the photographic medium, even for an artist, who would be expected to be more concerned with the uniqueness or value of an original. He also places

the images in a strategic design within the article. The photographs and text are arranged in long rows, which mime the conditions of tract housing. At one of his earliest exhibitions, at the Finch College Museum of Art, New York, the photographs were featured as a slide projector presentation.

Following the *Homes for America* project, Dan Graham created a diverse oeuvre of artwork and theory. He began by using commonly available resources such as advertising, music, and television, to communicate a critical art perspective. One of his most notable examples of this type is a work titled, "Figurative." Here, Graham documented a strip of paper from a calculator or cash register. The paper has a series of unrelated numbers in a consecutive series. Graham printed the strip of paper next to text that read "Figurative by Dan Graham," and the work was displayed in an issue of Bazaar magazine by means of his purchasing space as an advertisement. Here, Graham played on the viewers' expectations for commercial imagery. The intention of the artist seems incomprehensible, save for that of provoking the viewer of the magazine into a re-consideration of the validity of mass-produced imagery.

The use of photography to accompany other art projects is very important to Graham. He has made many site-specific structures and installations. The site-specific works he makes are typically temporary. The photograph plays an important role in making a record of the event and work. This approach compares to the work of Robert Smithson, a contemporary to Graham in the 1960s and 1970s who created large site-specific conceptual works that were temporary and unavailable to most except through photographs. The photograph becomes the manner in which many people experience the work, and thus its simplicity is due to the fact that it is expected to serve as a factual, objective document that can communicate a more complex, frequently subjective work of art.

Graham has also used film and video since the 1970s for installations and performance works that actively engage the viewer. He frequently poses experiences of simultaneous subjectivity and objectivity, playing with notions of time, and of private and public space. His deconstruction of the experience of viewing art has involved closed-circuit video systems within architectural spaces. Using mirrors and surveillance, Graham suggests the experience of being viewed while one is also viewing. The transmission of an idea through the structure of information is frequently important to Graham. While he spends considerable time constructing his elaborate installations and video works, he also produces a great amount of theoretical writing, which accompanies the works and has equal if not greater importance. Issues of contemporary social phenomena preoccupy Graham and his writing. He has produced conceptual theoretical essays on punk music, suburbia, and public architecture. His work is a product and also critique of a mass-mediated society. His photographs and artwork frequently function within mass media or in dialog with those systems.

RACHEL WARD

See also: **Becher, Bernd and Hilla; Conceptual Photography; Farm Security Administration; Walker, Evans**

Biography

Born in Urbana, Illinois, 1942. His work is part of the collections at Moderna Museet, Stockholm; Centre Georges Pompidou, Paris; and The Tate Gallery, London. Acknowledged by Coutts Contemporary Art Foundation Award, 1992; Skowhegan Medal for Mixed Media, Skowhegan School of Painting and Sculpture, New York, 1992; and others. He lives and works in New York.

Individual Exhibitions

1969 John Daniels Gallery, New York, New York
1971 Anna Leonowens Gallery, Nova Scotia College of Art and Design, Halifax, Nova Scotia
1972 Lisson Gallery, London, England
 Protech-Rivkin Gallery, Washington, D.C.
 Galleria Toselli, Milan, Italy
1973 Galerie MTL, Brussels, Belgium
 Gallery A 402, California Institute of the Arts, Valencia, California
 Gallery Rudolf Zwirner, Cologne, Germany
1974 Galerie 17, Paris, France
 Royal College of Art, London, England
 Performance and Films, Epson School of Art, Surrey, England
1975 Lucio Amelio, Modern Art Agency, Naples, Italy
 John Gibson Gallery, New York, New York
 Palais des Beaux-Arts, Brussels, Belgium
 International Cultural Centrum, ICC, Antwerp, Belgium
 Otis Art Institute Gallery, Los Angeles, California
1976 New Gallery, Institute of Contemporary Art, London, England
1977 *Video-Architecture Projects, Photographs*, Galerie Rene Block, Berlin, Germany
 Stedelijk Van Abbemuseum, Eindhoven, The Netherlands
 Video Piece for Two Glass Buildings, Leeds Polytechnic Gallery, Leeds, England
1978 Corps Museum of Modern Art, Oxford, England
1979 *Architectural Models and Photographs*, Galerie Paola Betti, Milan, Italy
1980 *Gallery Projections, Architectural Proposals, Photographs*, Galerie Rüdiger Schöttle, Munich, Germany
 Museum of Contemporary Art, Lisbon, Portugal
 Museum of Modern Art, New York, New York
1981 Renaissance Society at the University of Chicago, Chicago, Illinois
 Two Viewing Rooms, Museum of Modern Art, New York, New York

Dan Graham, Bedroom Dining Room Model House, 1967, Chromogenic development prints,
Collection Museum of Contemporary Art, Chicago, Gerald S. Elliot Collection. Original in color.
[*Photograph © Museum of Contemporary Art, Chicago*]

1982 Plan B, Tokyo, Japan
1983 *Pavilions*, Kunsthalle, Bern, Switzerland
1985 Art Gallery of Western Australia, Perth, Australia
1986 Storefront for Art and Architecture, New York, New York
 Sculpture, Pavilions & Photographs, Galerie Rüdiger Schöttle, Munich, Germany
1987 ARC/Musée d'Art Moderne de la Ville de Paris, Paris, France
 Museo Nacional Centro de Arte Reina Sofia, Madrid, Spain
 Fruitmarket Gallery, Edinburgh, Scotland
 Photographs 67–87, Galerie Hufkens-Noirhomme, Brussels, Belgium
1989–90 *The Children's Pavilion*; (a collaborative project with Jeff Wall), Marian Goodman Gallery, New York, New York; Santa Barbara Contemporary Arts Forum, Santa Barbara, California; Galerie Roger Pailhas, Marseilles, France; Fonds Régional d'Art Contemporain Rhône-Alpes, Lyons, France; Galerie Chantal Boulanger, Montreal, Quebec
1990 *Photographs 1965–1985*, Marian Goodman Gallery, New York, New York
 Zeichnungen 1965-69. Fotografien 1966–78; Galerie Bleich-Rossi, Graz, Austria
1992–93 *Walker Evans/Dan Graham*; Witte de With Center for Art, Rotterdam, The Netherlands; Musée Cantini, Marseilles, France; Westfälisches Landesmuseum, Münster, Germany; Whitney Museum of American Art, New York, New York
2001–02 Museu Serralves, Porto, Portugal; ARC/Musée d'Art Moderne de la Ville de Paris, Paris, France; Kroeller-Müeller Museum, Otterlo, The Netherlands; Kiasma, Helsinki, Finland; Westfälisches Landesmuseum, Münster, Germany

Group Exhibitions

1966 *Projected Art*; Finch College Art Museum, New York, New York
 Language to be Looked at-Words to be Seen; Dwan Gallery, New York, New York
1969 *Konzeption-Conception*; Stadtisches Museum, Leverkusen, Germany
1970 *Information*; The Museum of Modern Art, New York, New York

 955,000; Vancouver Art Gallery, Vancouver, British Columbia
1979 *Concept, Narrative, Document*; Museum of Contemporary Art, Chicago, Illinois
1982 Documenta 7; Kassel, Germany
1988 *1967: At the Crossroads*; Institute for Contemporary Art, University of Pennsylvania, Philadelphia, Pennsylvania
1989–90 *Image World: Art and Media Culture*; Whitney Museum of American Art, New York, New York
 L'Art Conceptuel en Perspective; Musée Nationale d'Art Moderne, Paris, France; Caja de Pensiones, Madrid, Spain; Musée d'Art Contemporain, Montreal, Quebec; Deichtorhallen, Hamburg, Germany
1992–91 *Passage de l'Image*; Museum of Modern Art, San Francisco, California; Sala de Exposiciones de la Fundacion "la Caixa," Barcelona, Spain; Power Plant, Toronto, Ontario; Wexner Center for the Arts, Ohio State University, Columbus, Ohio

Selected Works

Schema, 1966
Homes for America, 1966
Yesterday/Today, 1975

Further Reading

Charre, Alain, ed, *Dan Graham*. New York: Distributed Art Publishers, 1995.

Graham, Dan, et al. *Dan Graham: Catalogue Raisonne*. Berlin: Richter Verlag, 2001.

Graham, Dan. *Two-Way Mirror Power: Selected Writings by Dan Graham*, Alexander Alberro, ed. Cambridge, Massachusetts: MIT Press, 1999.

Graham, Dan. *Interviews*, edited by Hans Dieter Huber, translated by John S. Southard, New York: Distributed Art Publishers, 1997.

Graham, Dan. *Rock My Religion*, Brian Wall, ed. Cambridge: MIT Press, 1993.

Moure, Gloria, ed. *Dan Graham*, Barcelona: Fundació Antoni Tàpies, 1998.

Pelzer, Birgit, Mark Francis, and Beatriz Colomina, eds. *Dan Graham*, London: New York: Phaidon, 2001.

Zevi, Adachiara, ed. *Dan Graham: selected writings and interviews on art works, 1965–1995*, Roma: Libri di Zerynthia, 1996.

PAUL GRAHAM

British

Few British photographers of the twentieth century have been as prolific as Paul Graham. Since 1979, he has exhibited in group and in solo exhibitions on an almost annual basis throughout Britain, Europe, and North America, and he has been the recipient of some of photography's most presti-

gious awards. His work is also to be found in the collections of museums and galleries such as the Victoria and Albert Museum, London; the Museum of Modern Art, New York; and institutional and private collections across Europe, the United States, and Japan.

Born in Stratford, England in 1956, Graham attended Bristol University from 1974–1978. Graduating with a Bsc. in Microbiology, Graham had no formal education in photography but had his first solo exhibition at the Arnolfini, Bristol in 1979. His series *House Portraits* from this period was included in the group exhibition *Houses and Homes* in 1982. The austere color photographs of new housing developments display from an early stage the tension between Graham's photographic and political influences, a characteristic of much of his work. The composition and use of photographic objectivity, references the work of Walker Evans, and that of Lewis Baltz and those associated with the New Topographics group. However, the choice of subject, the sprawling suburban housing estates that formed what are commonly referred to as New Towns, stems not only from the economic phenomenon of the built environment but also the superficial construction of the communities that lived there.

In 1982, Graham took up a teaching position at Exeter College of Art, where he was Lecturer in Photography until 1984. In 1983, he received an Arts Council Publication Award, and in the same year he published *A1-The Great North Road*, which toured several galleries in England as an exhibition under the same title. The photographic series of garages, service-stations, and cafes dotted along the main arterial route from the north to south of England examined the alienation of traveling individuals from the built environment they passed through on their journeys.

In 1984, Graham left Exeter College of Art to become Lecturer in Photography at West Surrey College of Art and Design, where he taught from 1984–1987. In 1985, he received a Greater London Arts Association Award and in 1986 the second of his four Arts Council Publications Awards. During the same year, he published and toured a body of work under the title *Beyond Caring*. The series depicted the waiting rooms of London DHSS unemployment offices. While his previous work had concentrated on the alienation of the individual from the built environment around them, this series focused on the institutional spaces where individuals had to confront the mechanisms of state that affected their everyday lives. This series was a departure from his earlier work and was

very much in the vein of social documentary. Unlike much British documentary from this period, however, Graham used color photography, a format that brought criticism from photo journalists and documentary photographers who held on to the altruistic ideals of traditional black-and-white documentary photography.

Graham's work does not fall easily into the prescribed genres of photographic practice, an aspect that is evident in his body of work on Northern Ireland, *Troubled Land*. In this series, Graham photographed those spaces where Nationalist and Unionist communities of Northern Ireland laid claims to territory by using painted curb stones and political graffiti. The series made references to both the genres of landscape and conflict photography. Graham has been one of the few visiting photographers to take a critical approach to Northern Ireland, and his work is often cited as an influence on Irish photographers who have taken the dominant representations of Northern Ireland in the popular media as a departure point for their own work.

Troubled Land was published as a book in 1987 in what was to prove a busy and successful year for the photographer. Early in the year, he received the Young Photographers Award from the International Centre of Photography, New York; the Channel 4/Arts Council Video Bursary, London; and a commission from the Hayward Gallery, London. Throughout the year, he also participated in solo and group exhibitions in Europe, North America, and Japan.

In 1988, Graham was awarded the W. Eugene Smith Memorial Fellowship, USA, and the following year was made Fellow of Photography by the Museum of Photography, Film, and Television, Bradford, England. In 1990, he published and exhibited a second body of work on Northern Ireland under the title *In Umbra Res*. The series moved away from the broad compositional representation of territory in *Troubled Land*, to informal studies of people and objects, which were used metaphorically and metonymically to describe the conflict. The photographs were exhibited as diptyches and triptyches to form a narrative within the broader scope of the work, a strategy used in the series *New Europe*, exhibited the following year.

Throughout 1990–1995 Graham regularly photographed in Japan and continued to work on his *Television Portrait* series. In 1992 and 1995, he was again recipient of an Arts Council Publications Award. In 1995, a series of his work on Japan was published as a book, *Empty Heaven*. Again using a combination of portraits and ob-

jects, the work examined the fragile concealment of aspects of Japanese culture. During the same year, he was awarded the Charles Pratt Memorial Fellowship, USA.

Graham continued to photograph and exhibit regularly throughout the mid and late 1990's, and in 1996 his work up to that date was published by Phaidon as part of the publisher's Contemporary Artists Series. In 1999, a new body of work was published, *End of An Age*, and in 2000 a catalogue, *Paintings*, was also produced. In 2001, Graham represented Britain in the 49th Venice Biennale. Photographing in the United States, he is still based in London.

JUSTIN CARVILLE

See also: **Baltz, Lewis**

Biography

Born Stratford, England 1956. Graduated Bristol University, Bsc. in Microbiology, 1978; no formal education in photography. First solo exhibition at Arnolfini, Bristol, 1979. Photographed throughout Britain 1979–1984. Lecturer in Photography, Exeter College of Art 1982–1984; received Arts Council Publication Award, 1983. Lecturer in Photography, West Surrey College of Art & Design, 1984–1987. Received Greater London Visual Arts Association Award, 1985. Photographed in Northern Ireland, 1984–1986. Received Arts Council Publication Award and Greater London Council Publications Award, 1986. Photographed in Britain and Northern Ireland, 1986–1988. Received Young Photographers Award from the International Center of Photography, New York, 1987; Hayward Gallery Commission, London, 1987; Channel 4/Arts Council Video Bursary, 1987. 1988, continued to photograph in Northern Ireland. Awarded Eugene Smith Memorial Fellowship, USA, 1988. Photographed in Germany, Spain, and across Europe, 1988–1990. Made Fellow in Photography, Museum of Photography, Film & Television, Bradford, 1989. Continued to photograph in Europe and Japan, 1990–1996. Received Arts Council Publications Award, London, 1992; Arts Council Publications Award, London, 1995; awarded Charles Pratt Memorial Fellowship, USA, 1995.

Individual Exhibitions

1979 *Paul Graham*; Arnolfini, Bristol, England
1980 *Paul Graham*; Ikon Gallery, Birmingham, England
1983 *A1 – The Great North Road;* The Photographers' Gallery, London and traveling
1986 *Beyond Caring*; The Photographers' Gallery, London and traveling
1987 *Paul Graham*; Cornerhouse, Manchester, England and traveling
 Beyond Caring; Kodak Gallery, Tokyo
1988 *Paul Graham*; Museum Het Princessehof, Leeuwarden, Netherlands
1989 *Paul Graham*; Centre Regional de la Photographie, Douchy, France
1990 *Paul Graham*; Anthony Reynolds Gallery, London

 In Umbra Res; National Museum of Photography, Film & Television, Bradford, England
1991 *Germany/November 1990*; Aschenbach, Amsterdam
1993 *New Europe*, Fotomuseum Winterthur, Winterthur, Switzerland and traveling
 Television Portraits; Esther Schipper, Köln, Germany and traveling
1994 *Television Portraits*; Claire Burrus, Paris and traveling
1995 *Empty Heaven*; Kunstmuseum, Wolfburg, Germany
1996 *Hypermetropia*; Tate Gallery, London
1996 *Empty Heaven*; Galleri Tommy Lund, Odense, Denmark
1998 *Paul Graham*; Galerie Bob van Orsouw, Zurich, Switzerland
2001 *End of an Age*; Galleria Marabini, Bologna, Italy

Group Exhibitions

1982 *Houses and Homes*; Arnolini, Bristol
1984 *Britain in 1984*; The Photographers' Gallery, London
 Strategies-Recent Developments in British Photography; John Hansard Gallery, Southhampton
1986 *Force of Circumstance*; PPOW Gallery, New York
 The New British Document; Museum of Contemporary Photography, Columbia College
 British Photography; Houston Foto Fest, Houston
 Modern Colour Photography; Photokina, Frankfurt
1987 *Inscriptions and Inventions: British Photography in the 1980's*; British Council touring exhibition to Belgium, Luxembourg, France, Italy and Germany
1987 *Critical Realism*; Castle Museum, Nottingham and touring
 New Photography 3; Museum of Modern Art, New York
 New British Photography; Modern Arts Museum, Tampere, Finland
 Recent Histories; Hayward Gallery, London
 Future of Photography; Corcoran Gallery of Art, Washington D.C.
 Mysterious Co-incidences; The Photographers' Gallery, London
 Attitudes to Ireland; Orchard Gallery, Londonderry, Ireland
1988 *British Landscape*; XYZ Gallery, Ghent, Belgium
1988 *A British View*; Museum fur Gestaltung, Zurich Switzerland
 Selected Images; Riverside Studios, London
 Towards A Bigger Picture: British Photography in the 1980's; Victoria and Albert Museum, London
1989 *The Art of Photography 1839 – 1989*; Museum of Fine Arts, Houston and traveling
 Through the Looking Glass-Independant Photography in Britain 1946-1989; Barbican Art Gallery, London and traveling
1990 *Conflict Resolution Through the Arts: Focus on Ireland*; Ward Nasse Gallery, New York
1991 *British Photography from the Thatcher Years*; Museum of Modern Art, New York
 The Human Spirit: The Legacy of W. Eugene Smith; The International Center of Photography, New York and traveling
 The Art of Advocacy: Aldrich Museum of Contemporary Art, Ridgefield, Connecticut
1993 *On the Edge of Chaos*; Louisiana Museum, Humlebaek, Denmark
 The Legacy of W. Eugene Smith; San Jose Museum of Art, San Jose, Caifornia

Photographs from the Real World; Lillehammer Bys Malerisamling, Lillehammer, Norway and traveling

1996 *Colorealismo*; Galleria Photology, Milan, Italy

1996 *Prospect*; Schirn Kunsthalle Frankfurt and Kunstverein Frankfurt, Germany

1996 *Die Klasse*; Museum für Gestaltung, Zurich, Switzerland

1997 *Pittura Britannica*; Museum of Contemporary Art, Sydney, Australia and traveling

1998 *Rencontres Internationales de la Photographie*; Arles, France

1999 *Art Life 21*; Spiral/Wacoal Art Centre, Tokyo, Japan
Ursula Rogg vs Paul Graham; Galerie Andreas Binder, Munich
Common People; Fondazione Sandretto Re Rebaudengo, Guarene, Italy

2000 *Some Parts of This World: Helsinki Photography Festival*; Finlands fotografiska museum, Helsinki, Finland
The British Art Show; Edinburgh, UK and traveling
Invitation to the City; Centre Bruxelles 2000, Brussels, Belgium

2001 *49ᵗʰ Venice Biennale*; Venice, Italy
Neue Welt; Frankfurter Kunstverein, Frankfurt, Germany

Where are We? Questions of Landscape; Victoria and Albert Museum, London

Selected Works

House Portrait #3, 1979
Drivers Discussing Redundancies, Morley's Café, Markham Moor, Nottinghamshire, November, 1981
Great North Road Garage, Edinburgh, November, 1981
Republican Coloured Kerbstones, Crumlin Road, Belfast, 1984
Waiting Room, Poplar DHSS, East London, 1985
Untitled (wire on post), Belfast, 1988
Television Portrait, Cathy, London, 1989
Untitled, Germany 1989 (Man Shielding Eyes; Star of David; Woman in Discotheque) Triptych, 1989
Yuko, Tokyo, 1992
Hypermetropia, 1996

Paul Graham, Untitled #6, Man in a White Shirt, Atlanta, 2002, From the series American Night, Lightjet C Print, 91 × 71.5″. Original in color.
[*Courtesy: Greenberg Van Doren Gallery*]

Further Reading

Graham, Paul. *A1-The Great North Road*. London: Grey Editions, 1983.

Graham, Paul. *Beyond Caring*. London: Grey Editions, 1986.

Graham, Paul. *Troubled Land*. London: Grey Editions 1987.

Graham, Paul. *In Umbra Res*. Bradford: National Museum of Photography, Film & Television, and Manchester: Cornerhouse Publications, 1990.

Graham, Paul. *New Europe*. Winterthur: Fotomuseum and Manchester: Cornerhouse Publications, 1993.

Graham, Paul. *God in Hell*. London: Grey Editions, 1993.

Graham, Paul. *Empty Heaven*. Wolfsburg: Kunstmuseum and Zurich: Scalo Books, 1995.

Graham, Paul. *Paul Graham*. London: Phaidon Press, 1996.

Graham, Paul. *End of an Age*. Zurich: Scalo Books, 1999.

Graham, Paul. *Paintings*. London: Anthony Reynolds Gallery; Zurich: Galerie Bob van Orsouw and New York: Lawrence Rubin/Greenberg Van Doren, 2000.

SID GROSSMAN

American

Sid Grossman stated that "the function of the photographer is to help people understand the world around them." As a dedicated social documentary photographer, he created images with an uncompromising concern for the human condition. Even though he printed imaginative and expressive works expanding the medium's limits during his career, since his death he has been shrouded in controversy and obscurity, a victim of the McCarthy era and changes in photographic tastes.

Grossman was a key personality in The Photo League, an influential organization for professional and amateur photographers in New York City. A founding member, Grossman was also a teacher and Director for the League's school from 1938 to 1949. His legacy includes hundreds of inspired students (Dan Weiner, Walter Rosenblum, Arthur Leipzig, Lisette Model, Leon Levinstein, among many others) who passed through his progressive classes, both in New York and, later, at his Provincetown School of Photography. Grossman also mingled with other photographers at the League, including Paul Strand, Dorothea Lange, Berenice Abbott, Weegee, and Ansel Adams. Strongly influenced by the Depression-era Farm Security Administration photographers and the documentary hero Lewis Hine, Grossman believed photography should serve a social purpose. Most of his street scenes show working-class Americans and the disenfranchised enduring and surviving hard times.

Like many Photo League photographers, Grossman photographed the underprivileged America he knew from his own childhood. His parents were Jewish immigrants living in the Lower East Side; after his father deserted the family, his mother supported four children as a cook. Grossman attended high school in the Bronx, took classes at the City College of New York, and joined the Film and Photo League. The following year, in 1936, he helped found the new splinter group, The Photo League. Largely self-taught, Grossman concentrated on freelance documentary work while also employed by the Works Progress Administration (WPA) as an outdoor manual laborer. Grossman's first photographic project for the League began in 1938, when he collaborated with Sol Libsohn on the *Chelsea Document*. Many League members worked in activist groups, photographing economically disadvantaged neighborhoods throughout Manhattan in an effort to visualize and understand an area's problems, solutions, and overall character. Grossman participated in many other projects, both in and out of the League; in 1939, he created *Negroes in New York*, a Federal Art Project/WPA assignment. As a freelance photographer over the years, he also infrequently earned commercial assignments from various magazines and businesses, such as *Fortune, Esquire, Mademoiselle*, and Lord and Taylor.

By the late 1940s, Grossman began experimenting boldly with smaller cameras and pushed beyond the clear, focused "realism" of traditional documentary by combining people-oriented content with the daring use of angles, surfaces, and light. He increasingly allowed his camera to blur truncated figures in dramatic motion and tilted planes. The grit and grain of these prints enhanced the images' mood, blended his documentary philosophy with a more modernist snapshot aesthetic, and expanded definitions of doc-

umentary expression. Whether focusing on beach scenes at Coney Island, street festivals in Little Italy, or the cultural life of Harlem or Central America, Grossman sought vibrant images displaying a concern for humanity's struggles to survive and endure.

Grossman's life and work also perfectly exemplify the difficulties encountered by politically engaged documentary photographers from the Depression to the cold war years. During his travels to the midwest (Oklahoma, Missouri, and Arkansas) in 1940, Grossman photographed folksingers, farmers, and union activists, creating clear, unaffected, "straight" black-and-white images of the people he met. He also attracted the attention of the FBI, which apparently initiated surveillance of the League because of Grossman's associations with known Communists during this trip. By 1945, when Grossman worked in photo labs for the US Army Air Corps in Central America, he was investigated by the Army Intelligence Bureau because of alleged Communist activities.

Then, in December 1947, Photo League members were surprised to find the organization publicly blacklisted by the US Attorney General in a list of "totalitarian, fascist, communist and subversive organizations." Membership soared as photographers joined in support and defense of the League. But in 1949, during Angela Calomiris's testimony against Communist leaders at the Foley Square Trials, she suggested that The Photo League was a subversive organization and specifically named Grossman as the man who introduced her to the Communist Party. As an informant for the FBI, Calomiris worked at the League (and other groups), gathering incriminating information for the federal government. She also distrusted documentary photographers' penchant for images of social injustice; this propagandistic "Red slant," as she called it, reinforced anti-American ideals.

Ironically, as Grossman entered his most productive, successful, and experimental years (working concurrently on five series, *Folksingers, Coney Island, New York Recent, Mulberry Street,* and *Legion,* 1946–1948), he faced staggering difficulties. After the listing and naming, Grossman's career disintegrated; from 1949, when he quit the League, until his death in 1955, he earned (according to his widow Miriam Cohen) just one commercial assignment. Such accusations kept him, as well as others in the League, from being hired for freelance jobs. With membership dwindling in the wake of federal investigations, The Photo League folded in 1951.

As tastes changed and pressures mounted, many photographers turned away from social realism and sought more subjective, interior realms. While images visualizing the downtrodden may have been celebrated during the Depression, in prosperous post-war America some viewed the same content and concern with suspicion. Grossman, too, started investigating new subjects and styles. During the last years of his life (1949–1955), Grossman photographed in Provincetown, Massachusetts, where he and his family spent their summers in retreat. He taught private classes, studied with Abstract Expressionist Hans Hofmann, and expanded his photographic vocabulary yet again. His work (as seen in *Journey to the Cape,* 1959) radically shifted, including more formally engaged abstractions and non-documentary subjects. They testify not only to Grossman's stylistic diversity but also to the effects of repressive cold war politics on art.

LILI BEZNER

See also: **Documentary Photography; Farm Security Administration; Hine, Lewis; History of Photography: Postwar Era; Photo League; Works Progress Administration**

Biography

Born Sidney Grossman in New York City to Morris and Ethel Glickstein Grossman, 15 June, 1913. Attended City College of New York, ca. 1932–1935; studied painting with Hans Hofmann, Provincetown, ca. 1949–1953; art classes, New School for Social Research, 1949. Joined Film and Photo League, ca. 1934–1935; founding member, The Photo League, 1936; resigned, 1949. Teacher and Director, Photo League school, 1938–1949 (also taught classes at Henry Street Settlement, Harlem Art Center, his own Provincetown School of Photography, and his own New York apartment). Worked in Central American photo labs for Public Relations Section, US Army Air Corps, 1945–1946 (*Cantina, Black Christ, Ballet Russe* series). *Folk Singers, Coney Island, Foreign Legion, Recent New York, Mulberry Street* series, 1946–1948. *New York City Ballet* series, ca. 1951–1955. Married Marion Hille, 1941 (divorced ca. 1949); married Miriam Echelman, 1949; son Adam born 1954. Died of heart disease, 31 December, 1955.

Individual Exhibitions

1961 *Sid Grossman: Parts I and II* (two retrospectives), Image Gallery, New York
1981 *Sidney Grossman: Photographs 1936–1955,* Museum of Fine Arts, Houston, Texas
1987 *Sid Grossman: A Retrospective,* Howard Greenberg Gallery/Photofind, New York, New York
1994 *Sid Grossman Vintage Photographs 1936–1955,* Howard Greenberg Gallery, New York, New York

Selected Group Exhibitions

1939 *Pictorial Photographers of America,* Museum of Natural History; New York, New York

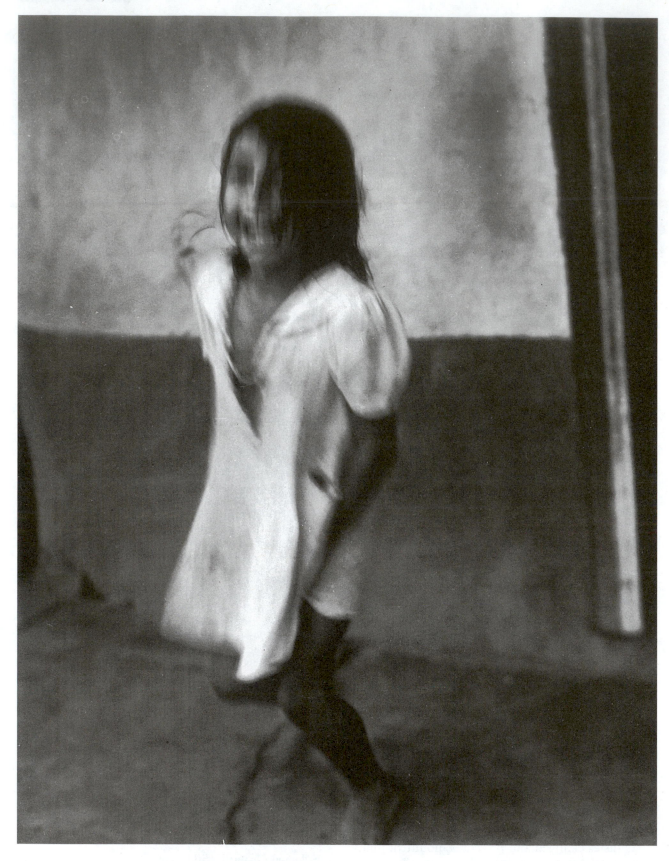

Sid Grossman, Aguadulce, Guatemala circa 1943, silver print.
[© *Miriam Grossman Cohen Courtesy Howard Greenberg Gallery, New York City*]

Photographing New York City, New School for Social Research; New York, New York

Instructors' Exhibition, The Photo League; New York, New York (in member and instructor shows through 1949)

1940 *Membership Exhibition*, American Artists Congress; New York, New York

Chelsea Document, The Photo League; New York, New York (later at Chelsea Tenants' League and Hudson Guild)

A Pageant of Photography, Palace of Fine Arts; Golden Gate International Exposition, San Francisco, California

Image of Freedom, Museum of Modern Art; New York, New York

1942 *New York At War* project, The Photo League; New York, New York (later shown at headquarters of Local 65 of the United Retail and Wholesale Employees and at Madison Square Garden during the International Women's Exposition)

1943 *Air Force Photo Exhibition*, Rockefeller Center; New York, New York

1944 *Photography Today*, ACA Gallery; New York, New York

1948 *In and Out of Focus*, Museum of Modern Art; New York, New York

This is the Photo League, The Photo League; New York, New York

1951 *Realism in Photography*, ACA Gallery; New York, New York

1952 DeCordova and Dana Museum; Lincoln, Massachusetts (mural-size prints of *Gulls* series)

1978 *Photographic Crossroads: The Photo League*, National Gallery of Canada; Ottawa (traveled to the International Center of Photography, New York, New York; Museum of Fine Arts, Houston, Texas; and Minneapolis Institute of Arts, Minneapolis, Minnesota)

Selected Works

Barry, Les. "The Legend of Sid Grossman." *Popular Photography* 47, no. 5, 1961

Bezner, Lili Corbus. "Coming in from the Cold: Sid Grossman's Life in the League." In *Photography and Politics in America: From the New Deal into the Cold War*, Baltimore and London: The Johns Hopkins University Press and The Center for American Places, 1999

Bloom, Suzanne. "Sidney Grossman - Images of Integrity." *ArtWeek* 12, no. 12, (1981)

Documentary Photography. New York: Time-Life Books, 1972

Journey to the Cape, photographs by Sid Grossman, text by Millard Lampell, editors Miram Cohen, Sy Kattelson, Charles Pratt, and David Vestal. New York: Grove Press, 1959

Livingstone, Jane. *The New York School: Photographs 1936–1963*. New York: Stewart, Tabori, and Chang, 1992

Negroes in New York, 1939. (photographs by Sid Grossman), Museum of the City of New York at www.mcny.org

Tucker, Anne. "Sid Grossman: Major Projects." *Creative Camera* 223/224 (1983)

Tucker, Anne. *Sidney Grossman: Photographs 1936–55*, Exh. cat. Houston: Museum of Fine Arts, 1981

Vestal, David. "Sid(ney) Grossman." In *Contemporary Photographers*, New York: St. Martin's Press, 1982

Further Reading

Calomiris, Angela. *Red Masquerade: Undercover for the FBI*. New York: J.B. Lippincott, 1950.

Dejardin, Fiona M. "The Photo League: Left-wing Politics and the Popular Press." *History of Photography* 18, no 2, (1994).

The Photo League, 1936–1951. New Paltz: College Art Gallery, College at New Paltz and State University of New York; New York: Gallery Association of New York State and Photofind Gallery, n.d.

Photo Notes 1938–1950, ed. Nathan Lyons, Rochester, New York: Visual Studies Workshop, 1977.

Stange, Maren. *Symbols of Ideal Life: Social Documentary Photography in America, 1890–1950*. Cambridge: Cambridge University Press, 1989.

Tucker, Anne. "A History of the Photo League: The Members Speak." *History of Photography* 18, no. 2 (1994).

Tucker, Anne. "The Photo League." *Ovo Magazine* 10, no. 40/41 (1981).

Tucker, Anne. "The Photo League." *Creative Camera* 223/224 (1983).

Tucker, Anne W., Clare Cass, and Stephen Daiter. *This Was The Photo League: Compassion and the Camera from the Depression to the Cold War*. Chicago: Stephen Daiter Gallery, 2001.

GROUP F/64

Over a period of roughly four years in the early and mid-1930s a small group of photographers and arts enthusiasts met in an Oakland, California, studio to look at each other's work and share ideas about photography as an art form. They named themselves "Group f/64" after a small camera lens aperture to symbolize their collective commitment to clear photographic seeing. Their identifying label and its attendant practices and ideals intentionally refuted the painterly works

produced by Pictorialist photographers who dominated artistic photography during the first quarter of the twentieth century. While Group f/64 was neither unprecedented nor unique at the time, this informal association, as much a social gathering as an avant-garde movement, nonetheless holds a significant and frequently reconsidered place in the evolution of photographic aesthetics.

Among the photographers involved in Group f/64 were Ansel Adams, Imogen Cunningham, Brett and Edward Weston, and Willard Van Dyke, the group's most vocal spokesperson. Others who participated and exhibited in the handful of Group f/64 exhibitions were Sonya Noskowiak, John Paul Edwards, Alma Lavenson, Consuelo Kanaga, Henry P. Swift, and Preston Holder. Late in the group's lifespan, Peter Stackpole, William Simpson, and Dorothea Lange were invited to take part in the group. (Although Lange, who received technical assistance from Adams for her work with the Farm Security Administration, never took up their offer, it is significant that her photographs and her social documentary style appealed to this group of modernists.)

Characteristics of Group f/64 Photographs

Group f/64's major contemporaneous exhibition was held at the M. H. de Young Memorial Museum in San Francisco in November and December of 1932. Museum director Lloyd La Page Rollins was an advocate of photography and had previously exhibited the work of several of the f/64 photographers. Later exhibitions of f/64 work (prior to the group's dissolution) took place at small galleries run by Ansel Adams and Willard Van Dyke in the Bay Area.

Writing in 1992, Therese Heyman characterized the Group f/64 work displayed at the de Young:

> Seen together, the images established a varied but singular point of view. For the most part, objects were seen closely, framed by the sky or similarly neutral backgrounds. Nothing was moving, and there was great attention to the finely detailed surface textures of the subjects. There was little in the photographs to suggest either the modern industrial world or the troubles of the times....We find images of still life, bits of landscape, posts, bones, and sky, a few industrial buildings, portraits, and nudes or figure studies. The subjects were ordinary in the sense that they were encountered frequently, and yet most had a commanding presence when photographed.
>
> (Heyman 1992, 23–25)

Typically the photographs were made using large-format cameras that produced 4 × 5 or 8 × 10-inch

negatives. With their clear-focusing lenses (as opposed to the blurring and softening optics often employed by Pictorialists seeking painterly images) closed down as far as possible (f/32, f/45, f/64, and f/90 being among the smallest apertures available), these cameras recorded a wealth of detail and tone on black-and-white sheet film negatives. Willard Van Dyke described the Northern California environment of the early 1930s in a way that makes the Group f/64 working habits seem organically engendered. At the time, Van Dyke wrote in *Camera Craft*, before the atmospheric smog characteristic of the latter part of the century settled in upon the Bay Area, there was "a marvelous California light—the skies were so blue and the air was so crisp and clean and there was a kind of hard brilliance that we accentuated by using very sharp lenses and very small apertures." But historian Naomi Rosenblum cautions that although f/64 members sometimes referred to their work as uniquely American—specifically, western American—and revolutionary, the fact that "the beneficent California climate contributed a special flavor to this late-blooming branch should not obscure the international character of the modernist tree from which it issued" (Rosenblum 1992, 34)—a tree which had been growing since the turn of the century.

Precedents and Background for Group f/64

In the early decades of the twentieth century, and particularly in the years between the two World Wars, there was an international ground-swell for change and evolution in photographic art. Then approaching the centennial of its announcement to the public, the medium and its practitioners were undergoing a retrospective self-consideration; the new photographers sought to ascertain, examine, and utilize what in the making of a picture was unique to photography. In 1923, a Czech cultural periodical called *Disk* published the following slogan, which summarizes the emerging attitude and clearly anticipates Group f/64: "Photograph: Objective truth and documentary clarity above all doubts" (quoted in Hambourg, Maria Morris, and Christopher Phillips, *The New Vision: Photography Between the Wars*, New York: Metropolitan Museum of Art, 1989, p. 78). In Europe, magazines were often the venue for the new photography. Hard-edged, crisply focused images were taking the editorial and advertising space formerly claimed by illustrators and painterly photographs. "Visual essays" and photo-reportage began to appear, taking advantage

of photography's unique visual language. The course of avant-garde discovery sometimes led down paths tending toward the unconventional and the abstract (see the disorienting views of Alexander Rodschenko and László Moholy-Nagy), but it also included the startlingly frontal formalism of Albert Renger-Patzsch and Karl Blossfeldt, whose work complimented that of the painters in the *Neue Sachlichkeit* (usually translated as "new objectivity") movement, and Man Ray, whose concentration on objects was surreal in its precision. August Sander made the transition from painterly portraiture to the objective "exact photography" he advertised in the late 1920s. The ruling principle of the new vision was that it was rooted in twentieth century technology.

Writing in a 1963 *Artforum* review, Margery Mann suggests that the emerging modernism of photographic exactitude may have had a revolutionary, social genesis. She describes the interest in clarity as "the completely honest penetration of reality," and asserts that the photographs and photographers emerging during the early 1930s "represent a break with the past; they see the world afresh because the country was in dire straits. Problems required solutions; traditional ways of thinking were not to be trusted." She was specifically addressing Group f/64 in California, but her ideas had parallels across the country and across the ocean. Among the artists exemplifying the new photography in the United States, anticipating f/64's emergence, were: Paul Strand, who made precisely detailed, close-up images of industrial objects, street people, and his wife Rebecca throughout the 1910s and 1920s; Ralph Steiner; and Paul Outerbridge, Jr., whose crisp images of clothing placed him among the leaders of a shift in advertising imagery towards the elegant simplicity and factual clarity of the Precisionist style and away from Pictorial sentimentality and soft-focus excess, as represented in publications by the photographs of Baron Adolf de Meyer and Edward Steichen's early commercial work.

The aesthetic credo of Group f/64 was directly anticipated in the United States in a 1930 exhibition organized by Lincoln Kirstein at the Harvard Society for Contemporary Art. About the work in his show Kirstein wrote "[it] attempts to prove that the mechanism of the photograph is worthy and capable of producing creative work entirely outside the limits of reproduction or imitation, equal in importance to original effort in painting and sculpture." (Hambourg 1989, 44–45) In his exhibition Kirstein presented work by artists who had received support and endorsement from Alfred Stieglitz, including Strand and Charles Sheeler, and other photographs by Berenice Abbott, Walker Evans, Ralph Steiner, Eugène Atget, Tina Modotti, Edward Weston, László Moholy-Nagy, Man Ray, Edward Steichen, and Doris Ulmann, among others. Kirstein was influenced by and included examples of press photography, scientific and cartographic images, and medical X-rays. The democratic inclusion of photographs outside the usual definition and practice of "art," with a particular focus on images published in popular periodicals, was a defining feature of the important *Film und Foto* exhibition held in Stuttgart, Germany, in 1929 that Kirstein carried forward in his show. Many of the photographers Kirstein displayed at Harvard also appeared in the German exhibition.

Relationship to Pictorialism, Stieglitz

Much of Group f/64's activity took place at 683 Brockhurst Street, a studio in Oakland that, ironically, was formerly occupied by Anne Brigman, a leading Pictorialist photographer; Willard Van Dyke had been an assistant for Brigman, and rented her studio from her after she moved to Southern California. Following the de Young exhibit, and after the departure of Rollins from his museum post in April 1933 created a need for a new advocate of f/64-style photography, Van Dyke started running a gallery out of the Brockhurst Street location. He referred to the gallery as "683," very conscious of the presence and importance of "291," Alfred Stieglitz's New York gallery (founded in 1905) that fashioned itself as the world headquarters of modernist art and photography.

All precedents and parallels notwithstanding, the members of Group f/64 considered themselves and their aesthetic philosophy revolutionary. They rejected Pictorialism out of hand, and, in part because of their resolute attachment to the West Coast, also resisted the standards represented by Alfred Stieglitz in his eastern stronghold. The struggle with Pictorialism was carried out in public, largely in the pages of *Camera Craft* magazine in a series of written exchanges between 1933 and 1935 by Van Dyke, Adams, and William Mortensen. Prior to editor Sigismund Blumann's May 1933 review of Group f/64's exhibition at the de Young, the San Francisco-based *Camera Craft* had been a popular magazine dedicated to the reigning style of Pictorialism, largely voiced by Mortensen. But when Ansel Adams was invited

to write a series of articles that first appeared in the magazine in January 1934, *Camera Craft* acknowledged the emergence of a forceful new attitude in photography, and its pages hosted a new chapter in the debate over the true nature of photography. The program of Group f/64 simultaneously shifted from the studio and the gallery to the printed page; as the exhibition of f/64 work tapered off, its aesthetic doctrine was being formulated, transcribed, and disseminated for posterity.

Debates over what is authentically "photographic" did not originate with Group f/64 and Pictorialism. Even within the Stieglitz circle, arguments about what deserves to be called a photograph abounded. In 1904, Sadakichi Hartmann, one of the Photo Secession's leading exponents, wrote an article titled "A Plea for Straight Photography." Hartmann took a number of highly regarded Secessionists to task for excessive manipulation of their photographs. Unlike Mortensen, Stieglitz never positioned himself as the spokesperson or leader of a particular school of photography. During f/64's lifetime, correspondence between Stieglitz, Adams, and Weston suggests a cautious, nuanced respect developing between the writers, though Stieglitz did not rush to exhibit and, thereby, publicly endorse the new, hard-edged work from the west. Ultimately, Adams was the only Group f/64 photographer to show with Stieglitz; his 1936 exhibition in New York was Stieglitz's first show of photographs since a Strand show nineteen years earlier.

Straight Photography and the Great Depression

The Group f/64 photographers were not all born straight. Many began making photographs in the dominant Pictorialist style. In the early 1920s, both Imogen Cunningham and Edward Weston were making soft-focus photographs of nudes, set in groups or singly in natural scenes with the lighting and dramatic effects characteristic of a painterly attitude. But by the middle of the decade both had made sharply focused, full-range prints that were clearly committed to modernist goals. Ansel Adams took a bit longer to foreswear the Pictorialist label; his 1931 exhibition of atmospheric prints at the Smithsonian, *Pictorial Photographs of the Sierra Nevada Mountains*, marked the end of his soft-focus period.

While often rigidly applied as the signal criterion of straight photography, the term "purity" actually has varying interpretations in regards to Group f/64's approach to photography. While the group was philosophically opposed to extensive manipulation resulting in images resembling paintings more than photographs, they were not, individually or collectively, opposed to more subtle corrective measures within the photograph. Dodging, burning, cropping, and enlarging were permitted and practiced. Imperfections resulting from chemicals or particles on negatives could be retouched and removed from prints. Adams used filters in front of his lens, as well as underexposure and overdevelopment, to ensure negatives rich in detail and tonal range. Edward Weston regularly arranged vegetables and shells to create a pleasing still life arrangement for his photographs. In general, the goal was to remove traces of the photographic process that would interfere with direct communion with the objects and scenes pictured.

This principled commitment to clarity and to the information-bearing capacity of photographs linked them, technically at least, to the social reform mission of the Farm Security Administration and its massive documentary photography project. Though the economic hardships of the Depression were slow to reach California, by 1935 the severe conditions had taken hold in the west. Group f/64 photographers faced a dilemma, which, while related to realism, could not be resolved with debate or darkroom work. Only individual levels of social consciousness could resolve the question of photography's role in the face of overwhelming social problems. Prior to this challenge, f/64's images had revealed only passing interest in social issues. Consuelo Kanaga's close-up portraits of young, beatific black faces were notable for their beauty as richly toned prints; Kanaga, however, was interested primarily "in the way black-and-white photography could make social statements, and only in passing did she consider photography as a fine art" (Heyman 1992, 29). This tension began to unravel the sense of purpose shared by the Group f/64 photographers.

After witnessing Willard Van Dyke's evolving commitment to social activism, developing as a result of Van Dyke's connections to Dorothea Lange, Ansel Adams wrote to Edward Weston that Van Dyke was becoming more "a sociologist than a photographer. His photography seems to be turning into a means to a social end, rather than something in itself." Although Adams admired Lange's emotional imagery and her ability to make evocative images that truly recorded the time (and would later collaborate with her on a project documenting the Japanese internment camp in Manzanar), he could not abide her unwill-

ingness to commit to fine printing techniques. While the tools and approaches were much the same, the ends diverged sharply. As Oren writes, "As the Depression wore on it became difficult to sustain Group f/64's timeless, optimistic view of American materiality against the narrative pressure of a more stoic, social documentary view" (Oren 1991, 123). Van Dyke and Kanaga leaned in Lange's direction, the pursuit of photography as a vehicle for truth and reform (Van Dyke eventually became a filmmaker, producing propaganda pieces for the Works Progress Administration reform effort). Adams, the Westons, and others of their f/64 colleagues maintained their focus on photography as art for art's sake.

Dissolution and Legacy of Group f/64

In the wake of the division between the activist and the aesthetic ends of straight photography, and in the face of increasingly dire economic conditions for Bay Area art galleries, Group f/64 came to a quiet end in 1936. Its legacy endures; by its collective activity Group f/64 lent prominence to the concept of straight photography and helped define just what constitutes "purity" in photographic practice. Through debate and visual counterpoint with Mortensen and Pictorialism, f/64 staked out new territory for photographic art. These clear, sharp images were among those that ushered in new standards for art photography in the post-Stieglitz era. Although there was minimal social mission inherent in Group f/64's practice, its commitment to unadorned reality validated and opened the door to artistic acceptance for the work of FSA photographers, and documentarians before and after. Michael Oren situates the group's legacy in terms that ring of spiritual purity and humility.

Group f/64 may be seen as part of an essentialist movement whose traditionally American preoccupation with the hard edges of material details reaches back to the Transcendentalists, who saw in such details evidence of God's immanence. Anecdotal qualities, whether of Mortensen's or Lange's type, would have vitiated such pretensions (Oren 1991, 123).

The 1932 de Young exhibition was revisited in major exhibitions in 1963, 1978, and 1992. Group f.64 member Henry Swift facilitated the first, at the San Francisco Museum of Art (later the San Francisco Museum of Modern Art). During his lifetime Swift used his income as a stockbroker to purchase prints from the other members; his widow added to the collection and donated it to the Museum of Art in 1962. Using the original checklist and the Swift collection as guides, the curators of the later shows (Jean S. Tucker at the University of Missouri-St. Louis and Therese Thau Heyman at The Oakland Museum, respectively) recreated the 1932 exhibition as accurately as possible, given the limitations of a checklist that sometimes offered only a general description of a print's subject, rather than a standard, accepted title. These periodic reassessments underscore Group f/64's importance as a primer and a touchstone for straight photography.

While some of the technical particularities of f/64's straight approach have been subsumed into camera club quality critique factors (e.g., sharp and proper focus, good highlights and shadow detail, strong, dramatic pictures that create immediate interest, sometimes using one strong element of interest), and the Group's concentration on natural forms may have evolved into the work of countless nature photographers wielding macro-focus lenses fitted out with ring lights for full revelation of, as Edward Weston put it, "the thing itself," the intrinsic fascination with photographic beauty that characterized Group f/64 has continued to inspire photographers to come to grips with whatever photography's tools have to offer in terms of unique visual, aesthetic qualities.

GEORGE SLADE

See also: **Abbott, Berenice; Adams, Ansel; Atget, Eugène; Blossfeldt, Karl; Cunningham, Imogen; Farm Security Administration; History of Photography: Interwar Years; History of Photography: Twentieth Century Pioneers; Man Ray; Modernism; Modotti, Tina; Moholy-Nagy, László; Outerbridge, Jr., Paul; Photo-Secession; Renger-Patzsch, Albert; Sander, August; Steichen, Edward; Sheeler, Charles; Stieglitz, Alfred; Strand, Paul; Ulmann, Doris; Weston, Edward**

Further Reading

Colson, James B. "Stieglitz, Strand, and Straight Photography." In Oliphant, Dave, and Thomas Zigal, eds., *Perspectives on Photography: Essays on the Work of Du Camp, Dancer, Robinson, Stieglitz, Strand, and Smithers at the Humanities Research Center*, Austin, TX: Humanities Research Center, The University of Texas at Austin, 1982.

Dater, Judy. *Imogen Cunningham: A Portrait*. Boston: New York Graphic Society, 1979.

Hambourg, Maria Morris, and Christopher Phillips. *The New Vision: Photography Between the Wars*. New York: Metropolitan Museum of Art, 1989.

Heyman, Therese Thau, ed. *Seeing Straight: The f/64 Revolution in Photography*. Oakland, CA: The Oakland Museum, 1992.

Heyman, Therese Thau. "A Rock or a Line of Unemployed: Art and Document In Dorothea Lange's Photographs." In Heyman, Sandra S. Phillips, and John Szarkowski,

Dorothea Lange: American Photographs. San Francisco: San Francisco Museum of Modern Art, 1994.

Mann, Margery. "The Henry F. Swift Collection of Photographs by the f/64 Group, San Francisco Museum of Art." *Artforum* 2, no. 5 (November 1963) 53.

Newhall, Nancy. *Ansel Adams: The Eloquent Light*. San Francisco: The Sierra Club, 1963; revised second edition, Millerton, New York: Aperture, 1980.

Oren, Michael. "On the 'Impurity' of Group f/64 Photography." *History of Photography* 15, no. 2 (Summer 1991) 119–127.

Rosenblum, Naomi. In Heyman, Therese Thau, ed., *Seeing Straight: The f/64 Revolution in Photography*, Oakland, CA: The Oakland Museum, 1992, p. 34.

Tsujimoto, Karen. *Images of America: Precisionist Painting and Modern Photography*. San Francisco: San Francisco Museum of Modern Art, 1982.

Tucker, Jean S. *Group f/64*. St. Louis: The University of Missouri-St. Louis, 1978.

White, Minor, ed. *Aperture* 11, no. 4 (1964) [Imogen Cunningham issue].

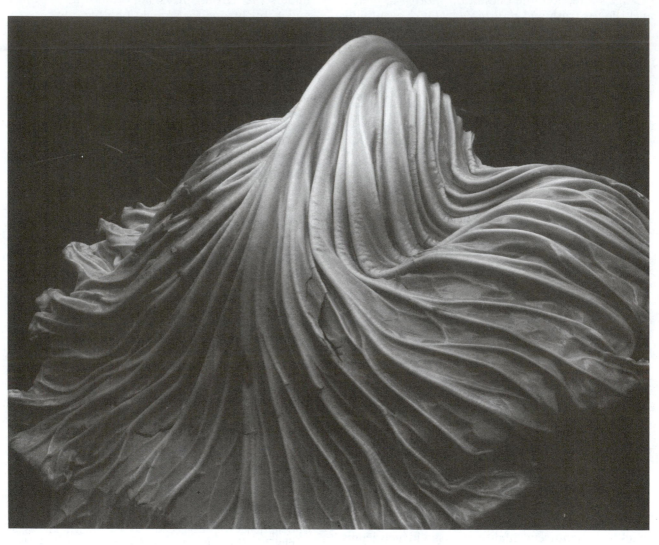

Edward Weston, Cabbage Leaf, California, USA, 1931, Gelatin silver print, 7 9/16 × 9 7/16″.
[*Gift of T.J. Maloney. © 1981 Center for Creative Photography, Arizona Board of Regents. Digital Image © The Museum of Modern Art/Licensed by SCALA/Art Resource, New York*]

ANDREAS GURSKY

German

During the 1990s, Andreas Gursky became one of the most prominent photographers in Germany. His large-format color photographs are distinguished by their precise composition, detailed depth of field, and overall structure that avoids any central vantage point. He is interested in how social and political culture structures people's lives at leisure or at work, in the world of fashion, sport, business, or finance.

Gursky was born in Leipzig, East Germany, in 1955 to a third-generation family of photographers. He grew up in West Germany, where his parents had moved the year he was born. As soon as he could walk, he came into contact with photographers, as well as photographic techniques and their application to the advertising industry. This may have encouraged his decision to pursue his studies at the famed Folkwangschule in Essen, which at the time was the most renowned school of photography in Germany. The school was directed and greatly influenced by the founder of subjective photography, Otto Steinert, who trained photographers in an applied aesthetic that corresponded to his own; and the students worked primarily in small-format photography, in prints rich in contrasting black and white. Although Gursky began his studies the year of Steinert's death in 1978, the aesthetic taught at the school was slow to move from the principles established by Steinert. During this time, Gursky dedicated himself to black-and-white photography reportage with a Leica 35 mm camera. Among the young instructors who had taken over teaching from Steinert, Gursky profited most from the sustained influence of Michael Schmidt, who familiarized him with his own opinions and with the latest developments in photography coming from America.

After four semesters at the Folkwangschule, Gursky followed the advice of his photographer friend Thomas Struth and applied to the Academy of Art in Düsseldorf. There he entered the photography class directed by Bernd Becher and his wife, Hilla. With this step, Gursky turned away from applied photography and to the study of photography as a free art form. In the class he met Candida Höfer, Tata Ronkholz, Thomas Ruff, and Petra Wunderlich; Thomas Struth and Axel Hütte had just finished their studies. The Becheresque principles of style served as a model for this generation and even the following generation. The Bechers taught students to focus on only one theme, one point of view, and one perspective, as well as to decontextualize the subject by excluding as much as possible, any elements that defined time—all essential components of the Bechers' work. The Bechers also influenced Gursky's aesthetic, which in the 1980s focused on common clichés such as people strolling on a Sunday afternoon, playing soccer, or going on a packaged vacation. These themes allowed him, as observer, to maintain a constant distance, and thus his photographs preserved little of the reality of the scenes he shot, making them stand for the general state of things in the industrial world. The precise observation, the fixation on a singular idea of the image, and the patient execution belong not to a medium applied to the world for a functional purpose but to one that is an independent expression and an attitude toward life. Taking in the Bechers' understanding of photography, Gursky put aside the 35 mm camera, which made possible quick-reaction shots and the capture of fleeting moments; from then on he worked with large- and medium-format cameras, no longer in black and white, but exclusively in color. In technique and composition, his photographs from the 1980s demonstrate the influence of American color photographers such as Stephen Shore, William Eggleston, and, above all, Jeff Wall. A characteristic of his photography that crystallized over time is the distant, elevated position of the observer that faded out the defining condition of the frame and led to a floating perspective. Human beings formed by the structures of their world become unrecognizable and appear as part of a single mass that submits, whether in leisure or work, to the same occupation. Mountain climbers, swimmers, skiers, theater audiences, and party or rock-concert goers are as equally subservient as stockbrokers and industrial workers. "I observe human species under the open sky from the perspective of an extraterrestrial being. To make clear that my interest rests in the species and not the individual, I have abstracted people into tiny figurines" (*Gespräch mit B. Bürgi* Zurich, 1992, p. 10).

Though human actors still appear in earlier landscapes, which suggest a kind of narration—*Sonntagsspaziergänger, Ratingen*, 1984 (Walking on Sunday, Ratingen); *Neujahrsschwimmer*, 1988 (New Year's Swimmer); *Angler, Mühlheim*, 1989 (Fisherman, *Mühlheim*)—in the evolution of his work, human beings appear at ever greater distances or seem mediated by traces of modern civilization. Even the titles emphasize the factual—*Restaurant, St. Moritz*, 1991; *Börse, New York*, 1991—to the point of denying additional information. Furthermore, everyday objects remain the focus of his camera but are presented as optical phenomena. Surfaces and colors seem to be thoroughly structured elements of the photographs' composition that confuse or even completely destroy the spatial perspective, something that the floating viewpoint and the distance from that object serve to promote. It also seems to pull the floor from under the feet of the observer. Parallel to the development of his increasingly abstract style was the size of his prints, which from 1988 to 2000 went from .36 × .185 meters to the maximum size of a roll of photographic paper, 1.8 meters high and 5 meters long (*Tote Hosen*, 2000 [Nothing Doing]). In their presentation and reception, these unusual large formats are very similar to painting; as part of the everyday environment, they become the object of another image. This is not to say that Gursky's work conforms to painting in its pictorial manner; the photographs exploit painterly characteristics by transforming given factual objects into objects of monumental size, by cutting photography from any recognizable reference of the object photographed, and also by suggesting in its content a kind of color-field painting, as well as a color scheme that is negated on the flat shiny surface of the photographic paper.

In 1992, Gursky began to use digital technology to in part create his imagery. His first efforts consisted of minor retouching, but soon he was using the computer to construct the image, allowing a further confusion of perspective and vantage point. Yet Gursky holds to creating the final print photographically, using a photo-editing program to transform, assemble, and touch up scanned negatives. He then creates a new negative, which creates the final enlarged print.

Unlike many photographers, Gursky does not work in series. Although certain staging arrangements that create themes of images appeal to him, each photograph is based on a single, precise idea that elicits an individual image. The scenes in the photos depict the self-evident character of everyday life as well as oddities closely observed, both of which

Gursky turns into an abstract pattern. None of his images is temporary or spontaneous. Rather, his trained observing eye seeks out a theme that must form itself into a visual concept, something that often requires a long time to transform—in photographic terms—into a single manageable work and leads to the production of only a few images per year.

MAREN POLTE

See also: **Documentary Photography; Farm Security Administration; Hine, Lewis; History of Photography: Postwar Era; Hütter, Axel; Photo League; Photography in Germany and Australia; Ruff, Thomas; Schmidt, Michael; Steinert, Otto; Struth, Thomas; Wall, Jeff; Works Progress Administration**

Biography

Born in Leipzig, Germany, on January 15, 1955. From 1978 to 1981, he studied photography at the Folkwangschule, a comprehensive high school, in Essen. Further study of photography, Kunstakademie Düsseldorf, 1981–1987; in 1985 he apprenticed with Bernd Becher. Became associated with Galerie Johnen & Schöttle, Cologne, 1988. Bremer Kunstpreis, 1991; Citibank Private Bank Photography Prize, 1998; International Center of Photography Infinity Award for Art, 2001. Living in Düsseldorf.

Individual Exhibitions

1987 Düsseldorf Airport, Düsseldorf, Germany
1988 Galerie Johnen & Schöttle, Cologne, Germany
1989 Museum Haus Lange, Krefeld, Germany
1990 303 Gallery, New York, New York
1991 Kunsthalle Zurich, Switzerland
1993 Monika Sprüth Galerie, Cologne, Germany
1994 *Andreas Gursky: Fotografien, 1984–1993*, Deichtorhallen Hamburg, Germany and traveling
1995 *Andreas Gursky: Images*, Tate Gallery, Liverpool, England
1997 Matthew Marks Gallery, New York, New York
1998 *Currents 27: Andreas Gursky*, Milwaukee Art Museum, Milwaukee, Wisconsin, and traveling
1998 *Andreas Gursky: Fotografien, 1984–1998*, Kunstmuseum Wolfsburg, Germany and traveling
1998 *Andreas Gursky: Fotografien 1984 bis heute*, Kunsthalle Düsseldorf, Germany
2001 *Andreas Gursky*, Museum of Modern Art, New York, New York and traveling

Group Exhibitions

1985 *Studenten der Kunstakademie Düsseldorf*, Künstlerwerkstatt Lothringer Strasse, Munich, Germany
1989 *Erste Internationale Foto-Triennale*, Villa Merkel, Esslingen, Germany
1989 *In Between and Beyond: From Germany*, Power Plant, Toronto, Canada
1990 *Der klare Blick*, Kunstverein Munich, Germany
1991 *Aus der Distanz*, Kunstsammlung Nordrhein-Westfalen, Düsseldorf, Germany

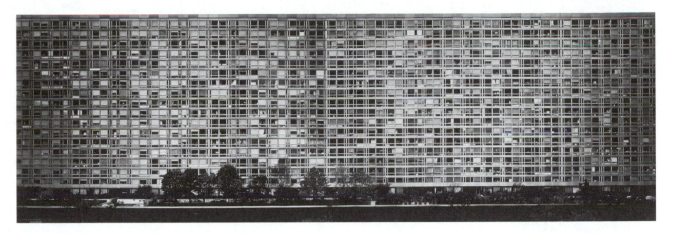

Adrea Gursky, Paris, Montparnasse, 1993.
[*Tate Gallery, London/Art Resource, New York*]

1992 *Distanz und Nähe*, organized for international tour by the Institut für Auslandsbeziehungen, Stuttgart, Germany

1993 *Die Photographie in der deutschen Gegenwartskunst*, Museum Ludwig, Cologne, Germany

1994 *The Epic and the Everyday: Contemporary Photographic Art*, Hayward Gallery and the South Bank Centre, London, England

1995 *Fotografie nach der Fotografie*, Aktionsforum Prater-insel, Munich, Germany

1998 *Citibank Private Bank Photography Prize 1998*, The Photographers' Gallery, London, England

1998 *Das Versprechen der Fotografie: Die Sammlung der DG Bank*, Hara Museum of Contemporary Art, Tokyo, Japan and traveling

1999 *Reconstructing Space: Architecture in Recent German Photography*, Architectural Association, London, England

2000 *How You Look at It*, Sprengel Museum, Hannover, Germany, and traveling

Selected Works

Schwimmbad, Teneriffa, 1987
Bochum, Uni, 1988
Ruhrtal, 1989
Salerno, 1990
Paris, Montparnasse, 1993
Hongkong and Shanghai Bank, Hongkong, 1994
Atlanta, 1996
Rhein, 1996
Chicago Board of Trade II, 1999
Shanghai, 2000
Tote Hosen, 2000

Further Reading

Bürgi, Bernhard, ed. *Andreas Gursky*. Cologne: Walther König, 1992.

Felix, Zdenek, ed. *Andreas Gursky: Photographs, 1984–1993*. Munich: Schirmer/Mosel, 1994.

Galassi, Peter. *Andreas Gursky*. New York: Museum of Modern Art, 2001.

Syring, Marie-Luise, ed. *Andreas Gursky: Photographs from 1984 to the Present*. Munich: Schirmer/Mosel, 1998.

JOHN GUTMANN

American

John Gutmann had two advantages working as a photojournalist in America in the 1930s. As a German immigrant, he saw American life and culture through the eyes of an outsider. Also, his background in painting and familiarity with modernism merged and influenced his photographic visions. Although Gutmann photographed in America from 1933 on, his photographs were virtually unknown until the 1970s, when the art world accepted photography as a serious art form.

John Guttman was born May 28, 1905 in Breslau, Germany (now Wroclaw, Poland) into a financially comfortable Jewish family, where he was exposed to the arts at an early age. He had a special affinity for the visual arts and entered the State Academy for Arts and Crafts in Breslau,

where he was a master pupil of Otto Müller, the Expressionist painter, who had been a member of die Brücke. Gutmann graduated with a B.A. in 1927, and also studied philosophy and the history of art at Silesian Friedrich Wilhelms University, Breslau. He then moved to Berlin and completed an M.A. in art from the State Institute for Higher Education and continued to study at the Alexander von Humboldt University and the Berlin Academy of Arts. As he was establishing a reputation as a painter, the oppressive power of Nazism dramatically increased. In 1932, he lost a teaching position because he was a Jew, then decided to emigrate.

Upon the advice of a friend, Gutmann decided he would settle in San Francisco. Thinking that it would be impossible to earn a living as a painter there, he bought a Rolleiflex camera and, with the aid of a manual, taught himself the bare essentials of photography. After convincing the Berlin news agency Presse-Foto that he was a professional photographer, he signed a contract. He then set sail on a Norwegian freighter and arrived in San Francisco on New Year's Day, 1933. For several years, Gutmann supported himself as a photojournalist for Presse-Foto, and did not yet view himself as an artist.

The work of the California-based Group f/64 photographers and the federally-funded Farm Security Administration photographers prevailed during the 1930s, but Gutmann distinguished himself through particularly well-composed and enigmatic images. He was simultaneously taken aback and invigorated by American popular culture, and unlike his contemporaries, he approached his subjects not to reveal their social contexts or anthropological realities, but to satisfy his outsider's curiosity and delight himself.

His illustrations for magazines through which he supported himself were far more than documents. With his artistic training Gutmann approached his subjects thoughtfully and imbued his photographs with multiple levels of meaning. Although familiar to Americans, the subjects that fascinated him—the street, automobile culture, signs, ethnic minorities, women, graffiti, and the American people during the Great Depression—were viewed through the eyes of a newcomer. Yet his work has proven to be a valuable source of information for cultural anthropologists in that he documented that which no other captured—not the downtrodden struggling to survive, but the masses of Americans who were participating in life and enjoying themselves despite the hard times.

On a cross-country trip in 1936–1937 for Pix, Inc., a New York photo agency, Gutmann discovered a treasure trove of surrealistic images at the New Orleans Mardi Gras. *The Game*, showing a stylish, riding-habit-clad threesome strolling down a littered street acknowledging the camera through their Mardi Gras masks, and *Jitterbug*, showing a dancing masked couple, are simultaneously real and unreal. He also captured what might seem to be ordinary sights, such as a vertical car park in Chicago, but photographed them at an angle and exposure that turns the scene into a Surrealistic wonderment. Gutmann was struck by the plethora of signs and graffiti which was nonexistent in Germany. This aspect of American culture so fascinated him throughout most of his life that he resumed this interest as late as 1987 in his series, *Signals*, where letters, numbers, and fragments of words were photographed against a black background.

In 1936, Gutmann began a position teaching painting, drawing, and art history at San Francisco State College (SFSC; now San Francisco State University), which he held until his retirement in 1973. World War II interrupted his teaching while he served with the Army Signal Corps and the Office of War Information in the China-Burma-India theatre as a still and motion picture cameraman. After the war, Gutmann resumed his teaching position, and in 1946 he founded the creative photography program at SFSC, one of the first of its kind in America. He designed the facilities and taught beginning and advanced photography. He also exposed Bay Area audiences to experimental films, documentaries, and classical short films through his film series, *Art Movies*, held at the college. He continued to work on assignments for Pix, Inc., and his photographs were published in *Time, Life, Look*, and numerous other national and international magazines.

During his decades of teaching, however, Gutmann's photographs were largely unknown to the faculty and students at SFSC. Yet Gutmann's legacy to photography on the West Coast is measured by more than just his extraordinary body of work from the 1930s. His contact with European Modernism had brought a sophistication to his various activities which has had lasting implications for the San Francisco artistic community. In 1959, Gutmann hired Jack Welpott to teach photography on a full-time basis at SFSC, and Welpott went on to expand the department into one of the few successful university-level photography programs in America in the 1960s and 1970s.

In 1972, the year before Gutmann retired from teaching, he began a review of his thousands of

negatives and reprinted many of the 1930s negatives. After amassing a portfolio of 100 images, he went to New York in 1974 at the age of 67 and secured an exhibition at Light Gallery; Gutmann's photographs were rediscovered. His exhibition, *The Face of the Orient*, had been mounted at the M.H. de Young Memorial Museum in San Francisco in 1947, and now 27 years later, the San Francisco Museum of Modern Art mounted a second major solo exhibition titled, *As I Saw It*. Thereafter and until his death in 1998, Gutmann's photographs were exhibited widely in both the United States and Europe and acknowledged for their unique and enduring qualities. *The Photography of John Gutmann: Culture Shock* organized by the Iris & B. Gerald Cantor Center for Visual Arts at Stanford University, Palo Alto in 2000 featured his classic images and traveled across the United States, cementing his reputation.

John Gutmann never considered himself a great photographer or a great artist. About his work, he said:

> I believe a good picture is open to many individual and subjective associations. Ambiguity is an essential part of life. I believe that art is life, and in that sense I am not desperately trying to make art; rather, I am interested in recording the marvelous extravagance of life.

DARWIN MARABLE

See also: **Farm Security Administration; Group f/64; Social Representation; Welpott, Jack**

Biography

Born in Breslau, Germany (now Wroclaw, Poland) on May 28, 1905. Immigrated to the United States in 1933, and naturalized in 1940. Self-taught photographer. Education: the State Academy of Arts and Crafts, Breslau, B.A. in 1927; studied art with Otto Mueller, and also studied the history of art and philosophy at Silesian Friedrich Wilhelms University, Breslau; State Institute for Higher Education, Berlin, M.A., 1928; and post-graduate studies at Humboldt University, Berlin and the Berlin Academy of Arts. Photographer with Presse-Foto Agency, Berlin, 1933–1936; Pix, Inc., New York, 1939–1963. Professor, San Francisco State College (now San Francisco State University), 1938–1973. Still and motion picture cameraman, United States Army Signal Corps and Office of War Information in China, Burma and India, 1943–1945. Married Gerrie von Pribosic, a painter, 1949. Distinguished Teaching Award, California State Colleges, 1968. John Simon Guggenheim Memorial Fellowship, 1979. Died, San Francisco, California, June 12, 1998.

Selected Individual Exhibitions

1938 *Colorful America*, M.H. de Young Memorial Museum, San Francisco

1947 *The Face of the Orient*, M.H. de Young Memorial Museum, San Francisco
1974 Light Gallery, New York
1976 *As I Saw It*, San Francisco Museum of Modern Art
1985 *Fotografias 1934–39*, Il Jornades Fotografiques, Valencia, Spain
1988 *Talking Pictures: Signs, Tattoos & Graffiti*, Fraenkel Gallery, San Francisco
1989 *John Gutmann: Beyond the Document*, San Francisco Museum of Modern Art
1997 *John Gutmann: Parallels in Focus*, Art Department Gallery, San Francisco State University
2000 *The Photography of John Gutmann: Culture Shock*, Iris & B. Gerald Cantor Center for Visual Arts at Stanford University, Palo Alto, California (traveled to Museum of Contemporary Art, Los Angeles; San Antonio Museum of Art, San Antonio, Texas; Henry Art Gallery, University of Washington, Seattle; 2001, Frances Lehman Loeb Art Center, Vassar College, Poughkeepsie, New York

Selected Group Exhibitions

1941 *Image of Freedom*, Museum of Modern Art, New York
1976 *Photography and Language*, La Mamelle, San Francisco (also Camerawork, San Francisco)
1979 *Amerika Fotografie, 1920–40*, Kunsthaus Zürich, Zurich (toured Europe)
1980 *Avant-Garde Photography in Germany, 1919–39*, San Francisco Museum of Modern Art (traveled to Akron Art Institute, Ohio; Walker Art Center, Minneapolis; Baltimore Museum of Art; Columbia College, Chicago;

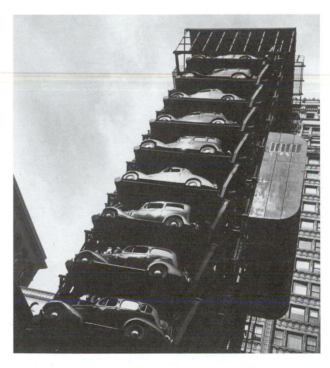

John Gutmann, Elevator Garage, Chicago, 1936, Gelatin silver print.
[*Collection Center for Creative Photography, The University of Arizona* © *1998 Arizona Board of Regents*]

International Center of Photography, New York; Portland Art Museum, Oregon)

1984 *Photography in California, 1945–1980*, Museum of Modern Art, San Francisco (traveled to Akron Art Museum, Ohio; The Corcoran Gallery of Art, Washington, D.C.; Los Angeles Municipal Art Gallery, Barnsdall Park; Herbert F. Johnson Museum of Art, Cornell University, Ithaca, New York; The High Museum of Art, Atlanta; Museum of Folkwang, Essen, West Germany; Musee National d'Art Moderne, Centre Georges Pompidou, Paris; Museum of Photographic Arts, San Diego

1985 *L'Autoportrait á l'Age de la Photographie*, Museé Cantonal des Beaux-Arts, Lausanne, Switzerland (toured Europe)

1989 *Picturing California: A Century of Photographic Genius*, Oakland Art Museum, Oakland

Selected Works

Death Stalks the Fillmore, 1934
Strange Visitors, 1934
Out of the Pool, San Francisco, 1934
Inside the First Drive-In Theatre, Los Angeles, 1935
The News Photographer, San Francisco City Hall, 1935
The Marble Steps of Baltimore, 1936

Elevator Garage with Parking Lot, Chicago, 1936
The Game, 1937
Jitterbug, New Orleans, 1937
"Yes, Columbus Did Discover America!" San Francisco, 1938
High, 1987

Further Reading

Humphrey, John. *As I Saw It: Photographs by John Gutmann*, Exh. cat. San Francisco: San Francisco Museum of Modern Art, 1976.

Kozloff, Max. "The Extravagant Depression: John Gutmann's Photographs of the Thirties." *Artforum*, November, 1982.

Marable, Darwin. "The Marvelous Extravagance of Life." *The World & I Magazine*, March, 1990.

Phillips, Sandra. *The Photography of John Gutmann: Culture Shock*. New York: Merrell Publishers, 2000.

Sutnik, Maia-Mari. "John Gutmann." *Contemporary Photographers*, C. Naylor, (ed.), Chicago: St. James, 1988.

Thomas, Lew, ed. *The Restless Decade, John Gutmann's Photographs of the Thirties*, Essay by Max Kozloff, New York: Harry N. Abrams, Inc., 1984.

Trachtenberg, Alan. "The Restless Decade: John Gutmann." *Exposure*, Fall, 1985.

ERNST HAAS

Austrian

Ernst Haas is celebrated as one the century's great innovators in color photography. His ability to transform mundane and everyday objects or occurrences into images of rare beauty with symbolic and poetic resonances has been much imitated over the years. Haas himself was unconcerned by these attempts to imitate his style, but would always encourage people to find their own vision and way of seeing the world through the medium of photography. Elliott Erwitt, a fellow member of Magnum Photos, who readily admits to having little interest in color photography commented:

> He has been incredibly copied since the beginning....It was certainly new—nobody had done it before and nobody has stopped doing it since....The trouble is that most of Ernst's imitators over the years have been photographically vulgar and obvious, and in a way that's reduced his work retroactively, which is a shame. He just does it better than all of them.

(Elliott Erwitt, *American Photographer* Dec. 1983)

Ernst Haas was born in Vienna in 1921 to a middle-class family. His father was a government official and an amateur photographer, while his mother was always keen to nurture the creative talent she saw in her son through drawing, painting, and music. Always keen to further his studies, Haas had to contend with the new order in Hitler's Austria where he often found himself obstructed and discouraged from pursuing further education due to his Jewish ancestry. This would not stop the young Ernst Haas, who having survived the war found part-time work in a photographic studio, as well as teaching a basic photography course at the American Red Cross center. It was here that he was introduced to the work of Edward Weston, whom he cites as an early influence, whose work sang to him in poetic style that he had never before experienced in photography.

Having exhibited his work at the Red Cross headquarters, and with the backing of Warren Trabant, editor of the German language magazine *Heute*, Haas began to receive regular magazine assignments. It was at this point that his widely acclaimed photoessay of the returning Austrian prisoners of war from Russia was published. This led to offers of employment from *Life* magazine and an invitation from Robert Capa to join the newly formed photographic agency Magnum in Paris.

True to his own lifelong beliefs in having the freedom to create his best work rather than to be driven by the powerful magazine editors of the time, Haas

declined *Life* magazine's offer and joined Magnum. This introduced him to other great photographers of the time such as Henri Cartier-Bresson, from whom he learnt about "the decisive moment" and how to use his discerning eye to build up, then break down the compositional elements in his photographs. Werner Bischoff, who became a great friend, also contributed to Haas's growing interest in humanistic work. In a letter to Wilson Hicks, the magazine's picture editor, Haas explains his decision not to join *Life*'s staff: "There are two kinds of photographers, the ones who take pictures for a magazine, and the ones who gain something by taking pictures they are interested in. I am the second kind."

This was an ethos that would remain prominent in Haas's work throughout his career. It would also be intrinsic to his best work including his visceral colour photography of New York, Paris, and Venice as well as his groundbreaking work in "motion" photography. His early New York photography was published on 24 pages over two issues of *Life*, an unprecedented use of colour photography. His "motion" work of bullfights in Spain in the 1950s was also highly acclaimed as a new way of seeing. Haas described his intentions in a statement prepared for his 1962 exhibition at the Museum of Modern Art, New York, the first solo exhibition of colour photographs in the museum's history:

> To express dynamic motion through a static moment became for me limited and unsatisfactory. The basic idea was to liberate myself from this old concept and arrive at an image in which the spectator could feel the beauty of the fourth dimension which lies much more between moments than within a moment.

Haas visited the United States for the first time on photojournalism assignments for *Vogue*, *Life*, *Paris-Match*, and the *New York Times Magazine*, among others, in 1951. *Life* published the groundbreaking color photoessay "Images of a Magic City," that chronicled Haas's observations of New York City in 1953; Haas had been spending more and more time in the United States, traveling in the Southwest photographing his "Land of Enchantment" photoessay and serving as the American Vice-President of Magnum. He moved permanently to New York in 1965. His career continued to build on its already considerable success. Haas was in demand by large corporations and teaching organisations alike. In typically paradoxical manner he managed to maintain both areas to the highest levels of quality. He shot for corporations such as Ford, Volkswagen, Chrysler, Leica, and Mobil Oil in addition to being one of three photographers to photograph the "Marlboro Man"

advertising campaigns from the early 1970s–1980s. He became involved in Hollywood films, including "The Misfits" and "West Side Story." He also began to run workshops and seminars on photography. In the 1970s and throughout the 1980s, he increasingly used audio-visual equipment to display his work in new ways. Instead of using a single slide projector he would use two projectors dissolving images into each other to a background of music. Once again he delighted in the paradox he provoked from his audience—some spellbound and others unable to watch it all. Having been involved with a four-part PBS television series on photography in 1962, he became involved in directing workshops at the Maine Photographic Workshops in the early 1970s.

Ernst Haas's photographs were also published in book form, including *Creation*, which sold over 250,000 copies, a photographic representation of the creation of the world inspired by his involvement as second director on the film "The Bible." Other books included *In Germany*, *In America*, and *Himalayan Pilgrimage*, a highly spiritual and personal photographic account of the Himalayan region.

There are few places or subjects that Haas did not photograph in his lifetime, from America to Japan, from portraits to landscapes. He always photographed according to his own style and convictions, always experimenting, much imitated but never imitating others. He was among the first of his generation to stride down the path of colour photography, transforming what he saw to challenge his audience, a path since followed by countless others. Following Haas's death from a stroke in 1986, the American Society of Magazine Photographers established the annual Ernst Haas Award for Creative Photography and the Maine Photographic Workshops begins the Ernst Haas Photographic Grant, funded by Kodak. The Ernst Haas Memorial Collection was established at the Portland Museum of Art in Portland, Maine in 1999.

JAMES CHARNOCK

See Also: **Bischoff, Werner; Capa, Robert; Life Magazine; Magnum Photos; "The Decisive Moment"**

Biography

Born in Vienna, Austria, 2 March 1921. Studies medicine, transfers to Graphic Arts Institute but is forced to leave before finishing either course due to his Jewish ancestry, 1940–1941. Works part-time in a photographic studio, begins experimenting with abstract photography, teaches basic photography courses at the Red Cross, 1943–1945. "Returning Prisoners of War" photoessay published in

Heute and then *Life* magazines, 1949. Joins Magnum Photos, 1949. Marries Countess Antoinette Wenckheim, 1951. Honour Roll, American Society of Magazine Photographers, 1952; Leavitt Award, American Society of Magazine Photographers, 1954; The Art Directors Club Medal Special Award, The Art Directors of New York, 1958. Medal for Architectural Photography, The American Institute of Architects, 1962. Honorary Master of Science in Professional Photography, Brooks Institute, Santa Barbara, California, 1985. Hasselblad Foundation International Award in Photography and 1986 Leica Gold Medal of Excellence, 1986. Died in New York, 12 September 1986.

Individual Exhibitions

1960 *Ernst Haas*; Photokina, Cologne

1962 *Ernst Haas: Color Photography*; Museum of Modern Art, New York, New York

1964 *Ernst Haas/Color Photography*; Steinberg Hall, Washington University, St. Louis, Missouri
 Poetry In Color; The IBM Gallery, New York, New York
 The Art of Seeing; travelling exhibition organised by Kodak shown Mexico, England, France, Germany, Austria, Spain, Holland, Belgium, Finland, Southeast Asia, Japan, and Brazil

1971 *Angkor and Bali: Two Worlds of Ernst Haas*; Asia House Gallery, New York, New York and travelling

1972 *Ernst Haas-Nachkrieg* (After the War); Museum des 20 Jahrhunderts, Vienna Austria
 Ernst Haas: Die Schopfung (The Creation); Photomuseum, Munich, Germany
 Ernst Haas: Heimkehrer (Returning Soldiers); Burgenländische Landesgalerie, Eisenstadt, Austria

1973 *Ernst Haas: Die Schopfung* (The Creation); Osterreichisches Museum, Vienna, Austria

1975 *Ernst Haas: Postwar Photographs 1945–1949*; Austrian Institute, New York, New York

1976 *Ernst Haas: An American Experience*; International Center of Photography, New York, New York, and Port Washington Public Library, Port Washington, New York

1976 *Ernst Haas*; La Fotogaleria, Madrid, Spain

1978 *In Deutschland* (In Germany); Photokina, Cologne, Germany

1985, 1982 *Ernst Haas: Heimkehrer*; (Returning Soldiers) Galerie Fotohof, Salzburg, Austria

1986 *To See, To Be*; Rochester Institute of Technology, Rochester, New York
 1921 Ernst Haas 1986; Museum des 20 Jahrhunderts, Vienna, Austria

1992 *Ernst Haas in Black and White*; International Center of Photography, New York, New York

1992 *American Photographs 1950–1975*; Howard Greenberg Gallery, New York, New York

1996 *Ernst Haas (1921–1986)*; Neue Galerie der Stadt Linz, Linz, Austria

1999 *Contour and Colour: Ernst Haas an Exhibition of Colour Photography*; Connolly's London, London, England

2000 *Ernst Haas: New York*; Soho Triad Fine Arts, New York, New York

Selected Group Exhibitions

1947 *Heimkehrer* (Returning Prisoners); American Red Cross Headquarters, Vienna, Austria

1951 *Memorable Life Photographs*; Museum of Modern Art, New York, New York

1955 *The Family of Man*; Museum of Modern Art, New York, New York

1959 *Photography at Mid-Century*; George Eastman House, Rochester, New York

1960 *The World As Seen By Magnum Photographers*; Takashimaya Department Store, Tokyo, Japan

1967 *Photography in the 20th Century*; National Gallery of Canada, Ottowa and travelling

1972 *Photography into Art: An International Exhibition of Photography*; Camden Arts Centre, London, England

1973 *The Concerned Photographer 2*; The Israel Museum, Jerusalem and traveling

1975 *Color Photography: Inventors and Innovators*; Yale University Art Gallery, New Haven, Connecticut

1978 *Mirrors and Windows: American Photography Since 1960*; Museum of Modern Art, New York, New York

1979 *Photographie als Kunst 1879–1979/Kunst als Photographie 1949–1979*; Tiroler Landesmuseum, Innsbruck, Austria

1980 *Photography of the 50s*; International Center of Photography, New York, New York

1982 *Color As Form*; International Museum of Photography and Film, George Eastman House, Rochester, New York

1984 *La Photographie Creative*; Pavillion des Arts, Paris, France

1985 *Photographs from the Magnum Archives 1932–1967*; Pace/McGill Gallery, New York, New York

1994 *Magic Moments: 40 Years of Leica Photography*; and traveling
 Appeal to This Age, The Photography of the Civil Rights Movement 1954–1968; Howard Greenberg Gallery, New York, New York

1995 *Postwar Europe, 1945–1965. Art After The Flood*; Barcelona, Spain

1997 *Masters in Photography: Alfred Eisenstaedt, Ernst Haas, André Kertész, Eugene Smith, Roman Vishniac*; Uma Gallery, New York, New York
 Photographing Austria; Leica Gallery, New York, New York

2000 *Reflections in a Glass Eye, Works from the International Center of Photography*; International Center of Photography, New York, New York

Selected Works

Homecoming Prisoners, Vienna, 1947
White Sands, New Mexico, 1952
Locksmith's Sign, New York, 1952
Fishermen Along the Seine, Paris, 1954
Shadow of a Gondolier, Venice, 1955
Suerte de Cappa, Pamplona, Spain, 1956
Monument Valley, Utah, 1962
Snow Lovers, USA, 1964
Albuquerque, New Mexico, 1969
Abalone Shell, California, 1970
The Art of Seeing with Ernst Haas, BBC Educational Broadcasting Corporation, 1962

Further Reading

Campbell, Bryn. *Ernst Haas: the Great Photographers*. London: Collins, 1983.

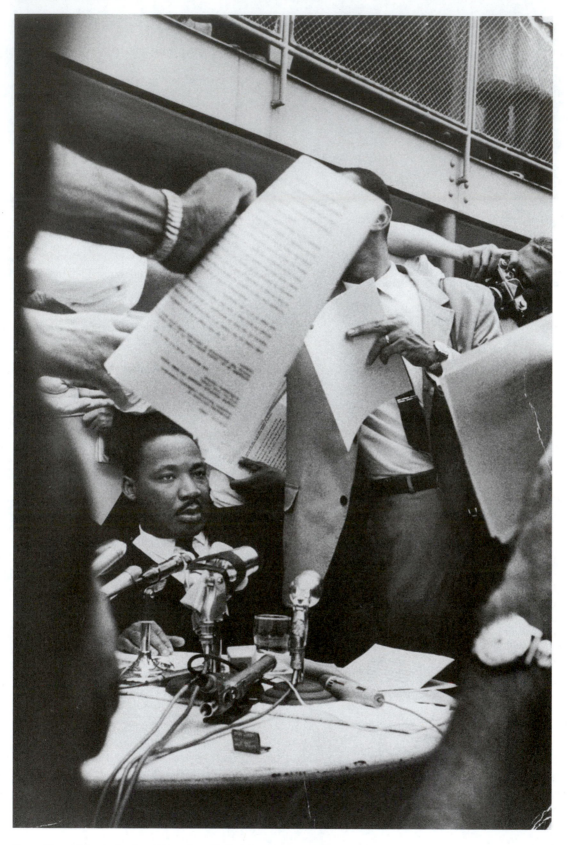

Ernst Haas, Martin Luther King, Jr., Civil rights statesman, Photograph, gelatin silver print, 34.3 × 22.4 cm, 1963.
[*National Portrait Gallery, Smithsonian Institution/Art Resource, New York*
© *Ernst Haas Estate*]

Haas, Ernst. *The Creation*, New York: Viking Press, 1971; New York: Penguin Books, 1976; Dusseldorf: Econ Verlag, 1971; New York: Viking Press, Revised 2nd Edition, 1983.

Haas, Ernst. *In America*. New York: Viking Press, 1975.

Haas, Ernst, *In Germany*. New York: The New York, 1977; Dusseldorf: Econ Verlag, 1976.

Haas, Ernst, and Gisela Minke. *Himalayan Pilgrimage*. New York: Viking Press, 1978.

Haas, The Estate of Ernst and Bondi, Inge, and Ruth A. Peltason, eds. *Ernst Haas Colour Photography*. New York: Harry N. Abrams Inc., 1989.

Haas, Alexander and Jim Hughes. *Ernst Haas in Black and White*. Boston: Bulfinch Press, 1992.

BETTY HAHN

American

Betty Hahn's work is characterized by her relentless experimentation with technical processes and subject matter, and the endearing sense of wit and humor so pervasive in her pictures. These same qualities keep her from being typecast as a "modernist" or "feminist" or some other category of photographer constrained to a particular ideology. Her work is recognizable in that it has no one "signature" appearance. Hahn has experimented with different cameras—plastic toy cameras, 35-mm cameras, the 20 × 24-inch Polaroid camera—and different photographic and non-photographic processes, including gum bichromate prints on paper and fabric, collotypes, cyanotypes, cibachromes, as well as gelatin silver prints, and woodcuts, serigraphy (silkscreening), lithography, trapunto (a stuffed quilting technique), and ceramics—to realize her aesthetic ideas. She was a pioneer in the 1960s and 1970s, along with such figures as Bea Nettles, Robert Heinecken, and Thomas Barrow, in working with various non-silver methods at a time when straight black-and-white photography, much of it documentary, was the only kind of art photography taken seriously.

Hahn was born in Chicago in the fall of 1940 and attended Catholic schools during most of her youth. She showed artistic talent from an early age, and many of the recurring themes and motifs which form her aesthetic signature—horses, flowers, crime, and mystery—first surfaced when she was a young girl. A drawing of two horses Hahn rendered when she was 10 years old was published in *Children's Playmate Magazine*, and she received about 200 fan letters as a result. In 1954, she read Sir Arthur Conan Doyle's *The Complete Sherlock Holmes*, beginning her interest in crime and mystery. And when she was 17, she received her first award, the Hallmark Honor Prize, for a small watercolor landscape. Unlike many adults, Hahn never narrowed her wide-ranging childhood interests, and she made her career out of experimenting with both subject and process.

Her formal art education took place at Indiana University in Bloomfield, Michigan, where she completed both her Bachelor of Arts and Master of Fine Arts degrees in 1963 and 1966, respectively, under the guidance of Henry Holmes Smith. Smith had worked with László Moholy-Nagy, whose work in the 1920s and 1930s had pushed many aesthetic and technical boundaries. Smith encouraged Hahn to do the same, and in 1965 she made her first gum bichromate prints. Without imitating Smith's work, or that of Andy Warhol or Robert Rauschenberg, two artists she admired and whose images influenced her, she developed her own unique style.

After graduate school, she taught design and photography at the National Institute for the Deaf at Rochester Institute of Technology, and later in 1970, transferred to RIT's School of Photographic Arts and Sciences, where she taught until 1975. In the winter of 1976, Betty Hahn was hired by Van Deren Coke to teach photography in the Department of Art and Art History at the University of New Mexico in Albuquerque. The department faculty then included Tom Barrow, Rod Lazorik, and the already famous historian of photography, Beaumont Newhall. She retired in 1997.

Hahn has drawn and continues to draw upon her travel experiences, domestic situations, daily circumstances, and art history for her subjects. Though her techniques may change from project

653

to project, familiar themes appear and reappear. Since 1970, she has rendered flowers, gardens, and botanical studies in needlepoint and watercolor, and also as Polaroids, monotypes, silkscreens, and gum bichromate prints. She has also made color lithographs, embellishing many of these with whatever materials are at hand including spray paint, felt-tip markers, and instant coffee. In pursuing her interest in themes of crime and mystery, she has followed and documented a stranger throughout streets in London in *Observations of British Intelligence*, 1981; collected and photographed household items destroyed by her Borzoi puppy in *Crime in the Home* 1982; and constructed simulated crime scenes that she then recorded in *Scenes of Crime* 1979. Hahn has also given new life to images appropriated from other sources, masterfully illustrated in her long-running *Lone Ranger* series, which she began in 1974. Initially inspired by an image that she found in a stationery store—an 8 × 10-inch glossy black-and-white Hollywood still photograph—she has altered the iconic figures of the Lone Ranger and his companion Tonto using silkscreen, duo tones, Van Dyke prints, and photolithography. Many of the finished works are colorful and humorous. Silver stars and toy bullets, flocking, Sanka brand instant coffee, and pastels adorn various works in this series. Her titles for these images, *Who Was That Masked Man? I Wanted to Thank Him, Starry Night*, and *Phantom Stallion*, to name just a few, are as unique as her alterations, and they reflect her wry sense of humor.

David Haberstich, curator of photography at the National Museum of American History, Smithsonian Institution, and graduate student classmate at Indiana University, has summarized Betty Hahn's aesthetic sensibility and her career up to the present. Writing for the monograph that accompanied Hahn's 1995 retrospective, he stated that:

> ...there is a beauty and unity in Hahn's work that renders it a satisfying, multifaceted, intricately interconnected exposition of photography, its traditions, its role in our lives and its surprising affinities with other arts. More than any other artist, in my mind she summarizes, recapitulates, almost embodies, the history of photography.
>
> (Steve Yates, David Haberstich, Dana Asbury, *Betty Hahn: Photography or Maybe Not*, Albuquerque: University of New Mexico Press 1995, 17)

Betty Hahn continues to live and to work in Albuquerque, New Mexico.

MICHELE PENHALL

See also: **Camera: An Overview; Camera: Diana; Coke, Van Deren; Heinecken, Robert; László; Manip**ulation; **Moholy-Nagy; Newhall, Beaumont; Non-Silver Processes; Print Processes; Rauschenberg, Robert**

Biography

Born Betty Jean Okon in Chicago, Illinois on 11 October 1940. She received a Bachelor of Arts degree in 1963 and a Master of Fine Arts degree in 1966, both from Indiana University, where she studied under Henry Holmes Smith. In 1967, she moved to Rochester, New York and met Roger Mertin, Bea Nettles, Tom Barrow, and Nathan Lyons. Hahn taught photography and design to deaf students at the National Institute for the Deaf, Rochester Institute of Technology in 1969. She was hired as a visiting artist by Van Deren Coke in January 1976 at the University of New Mexico, and in August that year accepted a full-time tenured position there to teach photography. She retired from the University in 1997. Her numerous awards include: a grant from the New York State Council on the Arts in 1975; National Endowment for the Arts fellowships in 1978 and 1983; Honored Educator award from the Society for Photographic Education in 1984 and 2000, a fellowship from the Visual Arts Research Institute at Arizona State University in 1987; a Polaroid fellowship in 1988. Betty Hahn lives and works in Albuquerque, New Mexico.

Selected Works

Road and Rainbow, 1971
Soft Daguerreotype, 1973
Who Was That Masked Man? I Wanted To Thank Him 1974–1979
Passing Shots, 1975–1986
Cut Flowers, 1978–1987
Botanical Layouts, 1978–1980
Crime and Intrigue Series, 1979–1982
Shinjuku, 1984
B Westerns, 1991

Selected Individual Exhibitions

1973 Witkin Gallery; New York, New York
1995 *Betty Hahn: Photography or Maybe Not*; a thirty-year retrospective organized by the Museum of Fine Arts, Santa Fe, New Mexico. Traveled to the International Museum of Photography and Film, George Eastman House in Rochester, New York, the Marble Palace in St. Petersburg, Russia and Granada, Spain

Selected Group Exhibitions

1967 *Photography Since 1950*; International Museum of Photography at George Eastman House, Rochester, New York
1969 *The Photograph as Object*; National Gallery of Canada, Ottawa
1970 *The Camera and the Human Façade*; Smithsonian Institution, Washington, D.C.
 Photography: New Acquisitions; Museum of Modern Art, New York, New York
1971 *Contemporary Photographs*; Museum of Modern Art, New York, New York

The Multiple Image; Massachusetts Institute of Technology, Cambridge, Massachusetts

1972 *Photography Invitational*; Nova Scotia College of Art and Design, Halifax, Nova Scotia

Photography Into Art; Camden Arts Centre, London, England

Historical Processes, Baltimore Art Museum, Baltimore, Maryland

1973 *Light and Lens*; Hudson River Museum, Yonkers, New York

New Images 1839–1973; Smithsonian Institution, Washington, D.C.

1975 *Woman of Photography*; San Francisco Museum of Modern Art, San Francisco, California

A Pictorial History of the World; Kansas City Art Institute, Kansas City, Missouri

Sélections; Festival du Photographie, Arles, France

Women of Photography; Sidney Janis Gallery, New York, New York

1976 *American Family Portraits: 1730–1976*; Philadelphia Museum of Art, Philadelphia, Pennsylvania

1978 *Photography: New Mexico*; American Cultural Center, Paris, France

23 Photographers/23 Directions; Walker Art Gallery, Liverpool, England

Mirrors and Windows: American Photography Since 1960; Museum of Modern Art, New York, New York

1979 *Attitudes: Photography in the 1970s*; Santa Barbara Museum of Art, Santa Barbara, California

20 × 24 Polaroid Color Photographs; Light Gallery, New York, New York

Art for the Vice-President's Residence; Washington, D.C.

1980 *Five Still-Lifes*; Robert Freidus Gallery, New York, New York

The Magical Eye: Definitions of Photography; National Gallery of Canada, Ottawa

1981 *Erweiterte Photographie*; Fifth International Biennale, Vienna, Austria

Marked Photographs; Robert Samuel Gallery, New York, New York

1982 *The Alternative Image*; Kohler Arts Center, Sheboygan, Wisconsin

1983 *Women and Their Models*; Catskill Center for Photography, Woodstock, New York

1984 *Photographic Alternatives*; Hong Kong Art Centre, Pao Sui Loong Galleries, Hong Kong

1985 *Expanding the Perimeters of 20th-Century Photography*; San Francisco Museum of Modern Art, San Francisco, California

The American West: Visions and Revisions; Fort Wayne Museum of Art, Fort Wayne, Indiana

1987 *Photography and Art: Interactions Since 1946*; Los Angeles County Museum of Art, Los Angeles, California

1988 *Reclaiming Paradise: American Women Photograph the Land*; Tweed Museum, *Passages in Time*; Los Angeles Center for Photographic Studies, Los Angeles, California

Art Networks; Houston FotoFest, Houston, Texas

1989 *The Cherished Image: Portraits from 150 Years of Photography*; National Gallery of Canada, Ottawa, Canada

Fantasies, Fables, and Fabrications; Delaware Art Museum, Wilmington, Delaware

1990 *Artists Who Love Nature: From Barbizon School to Contemporary Photographers*; The Green Museum, Osaka, Japan

Art of Albuquerque; The Albuquerque Museum, Albuquerque, New Mexico

The Collector's Eye; Museum of Fine Arts, Santa Fe, New Mexico

1991 *Photography from New Mexico*; MOSFILM Studio Gallery, Moscow, Russia

Patterns of Influence; Center for Creative Photography, Tucson, Arizona

Photography from New Mexico; Vision Gallery, San Francisco, California

1992 *The Modernist Still-Life Photographed*; and traveled to Pakistan, India, Jordan, Saudi Arabia, Egypt, Algeria, Morocco and Greece

1993 *Flora Photographica: The Flower in Photography from 1835 to the Present*; Vancouver Art Gallery, Vancouver, British Columbia

New Acquisitions; Denver Art Museum, Denver, Colorado

Intentions and Techniques; Lehigh University Art Gallery, Bethlehem, Pennsylvania

1994 *Flowers*; Witkin Gallery, New York, New York

Paper Chase; Raw Space Gallery, Albuquerque, New Mexico

Further Reading

Yates, Steve, Dana Asbury, David Haberstitch, and Michele Penhall. *Betty Hahn: Photography or Maybe Not*. Albuquerque: University of New Mexico Press, 1995.

Green, Jonathan. *American Photography*. New York: Abrams, 1984.

Bloom, John. "Interview with Betty Hahn." *Photo Metro* August 1987: 8–17.

Hoy, Anne. *Fabrications*. New York: Abbeville, 1987.

Schwable, Conrad, and John Summers. "Betty Hahn's Lithographs." *Tamarind Papers 3*, No. 2. Albuquerque: Tamarind Institute, 1980.

HEINZ HAJEK-HALKE

German

Best known for his production and promotion of abstract *Lichtgrafik* (light graphics), German photographer Heinz Hajek-Halke experimented with nearly every photographic style and technique developed in the twentieth century. Well regarded by his fellow practitioners, he remained a somewhat more obscure figure to the general public until the 1990s, when a renewed historical interest in the arts, politics, and culture of Germany's Weimar republic sparked a resurgent interest in his career. Though he enjoyed early success with his experimental montage, reportage, advertising, industrial, and botanical photographs, Hajek-Halke's major contribution to modern photography remains his development of a unique abstract pictorial idiom in the form of camera-less photographs produced after the Second World War.

Hajek-Halke aligned himself with experimental photographers like László Moholy-Nagy, Man Ray, and Herbert Bayer and was perhaps this group's most tireless promoter of the camera's unique aesthetic possibilities. He eschewed the straight or "objective" style of photography practiced by German contemporaries like August Sander and the Group f/64 school in the United States, in favor of highly mediated montages and abstract imagery produced via creative darkroom experimentation. More than a mere practitioner of this experimental style, Hajek-Halke was an equally passionate photographic educator whose popular books *Experimentelle Fotografie* (1955) and *Lichtgrafik* (1964) had an international influence in part due to text translations into three languages. Rather than conceal his innovative techniques, Hajek-Halke deliberately revealed his working methods in detailed captions noting his exacting darkroom procedures. For example, the caption for the photograph *Tanaquil* in his 1955 book reads:

> Exposure mounting.—3 negatives: 1) picture of clouds, 2) agaric (top view), 3) picture of nude, glass negative, was sooted on the back and cleaned with dry brush only insofar as was needed, for the desired pictorial effect.—2 exposures, the enlarger being set differently for each.
>
> (Hajek-Halke, *Experimentelle Fotografie* 1955, unpaginated)

Among Hajek-Halke's most important works were his experimental "light graphic" images made without a camera. More than mere photograms, these images evolved from the photographer's combination of various chemical and mechanical techniques. Hajek-Halke regularly combined non-traditional materials such as wire, glass, dirt, varnish, and fish bones with darkroom procedures like solarization, double exposure, montage, and even the occasional smoking or burning of a negative. Many of the resultant images, like *Friedhof der Fische*, of 1939, retain recognizable forms while an equal number are more fully abstract. In the former, one recognizes the influence of Bauhaus photographer Walter Peterhans's evocative subject matter and the abstract forms of Moholy-Nagy's photograms. In the latter, the weight of the medium's inherent objectivity strains against the subjectivity of the unidentifiable forms to create images that are at once assertive and immediate yet suspended in a kind of dreamy, timeless alchemy.

Born in Berlin in 1898, Hajek-Halke spent the majority of his childhood in Argentina before returning to Germany in 1910 at age 12. Although his father—an academic painter and caricaturist—discouraged him from pursuing a career in the visual arts, in 1915 Hajek-Halke enrolled as a painting student at Berlin's Königlichen Kunstschule. His initial career as a film poster designer was interrupted by his active service in the First World War. At the war's end, the young photographer resumed his studies at the Berlin Museum of Arts and Crafts under the Czech Vienna Secessionist graphic artist Emil Orlik before traveling to Hamburg where he produced publicity photos for a chemical-pharmaceutical firm. Hajek-Halke returned to Berlin in 1923 to work as a picture editor, printer, and draftsman at the Dammert publishing house, but it was not until his 1924 apprenticeship in the studio of famous Berlin photographer, Yva, that he began to seriously explore the expressive potential of the photographic medium through collage and montage. From the mid-1920s through the early 1930s, Hajek-Halke worked as a freelance photojournalist for Berlin's Presse-Photo agency while pursuing his own experimental fine art photography. During this time, he also collaborated with photojournalist Willi Ruge and Bruno Schulz, editor of the journal

Deutsche Lichtbild, who hired Hajek-Halke to create layouts and montages for his publication.

Hajek-Halke was enamored with the subject of the female nude throughout his career and this subject constituted the first of his published photos in the late 1920s. One of his most renowned, *Defamation* (1926–1927), features a bird's eye view of a nude model's torso, cropped, enlarged, and diagonally superimposed across a busy Berlin street. In the lower left, three top-hatted men engaged in discussion are balanced by three smaller figures just visible in the upper right. It is difficult to discern if the cryptic title refers to the modern defamation of the once "natural" landscape represented by the model's organic form, to the conversation of the top-hatted trio in the lower corner, or to the photographer's refusal to follow the rules of "straight" photography. In *Defamation*, the model's rounded curves are reiterated in the tires of the cars at the top of the scene and in the men's hats, yet her organic form seems otherwise out of place, writ large amidst an urban modernity that literally passes over and by her. Thus, if Hajek-Halke is to be viewed as ahead of his time for his atypical technical innovation, it is perhaps equally important to note that his frequent formal opposition of presumably "natural" female forms with all things cultural, modern, or intellectual marked him as a man entirely *of* his time.

Like so many artists who remained in Germany throughout the Third Reich, the degree of Hajek-Halke's complicity with, and resistance to, the Nazi regime is difficult to ascertain in historical retrospect. Although he joined the National Socialist Party in 1933, Hajek-Halke shortened his last name to "Halke" later that year and moved to Lake Constance in the Bodensee region in a move that some historians have viewed as a kind of transgressive "inner exile." Proclaiming his outrage at the fact that Hitler's Propaganda Ministry requested him to falsify documentary photographs, Hajek-Halke turned his attention to the less politically-charged field of zoological macro-photography. At the same time, however, he won a gold medal at the 1933 International Photography exhibition and continued to write how-to articles for amateur photographer periodicals in the field of small animal macro-photography. During his years at Lake Constance, Hajek-Halke developed a passion for natural science with a particular interest in herpetology. In the mid-1930s, he contributed photographs and essays to a Natural Science newspaper and traveled to Brazil to conduct research at the Butantan Snake Farm. Though he considered emigrating to Brazil, Hajek-Halke returned to Germany in 1938 and to more politically sensitive work

creating aerial photographs for the Dornier-Werken airplane manufacturing firm in Friedrichshafen. This work was interrupted by World War II and, ultimately, by the photographer's internment as a French prisoner of war in 1944–1945.

As was the case for many German photographers in the 1930s, Hajek-Halke lost all his equipment in the war and as a result, channeled his postwar energy into the founding of a snake-breeding farm that produced snake products and medical leeches for the pharmaceutical industry. He began renewed attempts at painting but was quickly drawn back into his lifelong interest in experimental photography. Hajek-Halke joined Otto Steinert's avant-garde fotoform group in 1950 and in 1955, was appointed as a Lecturer in Graphic Design and Photography at West Berlin's Academy of Fine Arts, a post he held for more than a decade.

In his critically acclaimed 1955 book, Hajek-Halke noted that its purpose was to "stimulate the interested viewer and show him as concrete pictures those things which he can perceive at any time in his closest surroundings" (Hajek-Halke, *Experimentelle Fotografie* 1955, unpaginated preface). When considered in tandem with his expressed desire to resume the photographic experiments of the 1920s' Dessau Bauhaus, it is clear that Hajek-Halke's later work represents the successful synthesis of his early experimental imagery with his World War II era experience in aerial photography and scientific macro-photography. In the decades preceding his death in 1983, Hajek-Halke's continued aesthetic innovation and dedication as a teacher won him many awards, including the Cultural Prize for German Photography and the coveted David Octavius Hill Medal. His work has been acquired by New York's Museum of Modern Art, Germany's Folkwang Museum, Kestner Museum, Berlin Kunstbibliothek, and France's Pompidou Center, among others.

In 1964, art historian Franz Roh described the process of viewing Hajek-Halke's photographs as necessarily challenging. He noted in the introduction to *Lichtgrafik*,

> One is disposed... not only to accept them in detail, since they contain both macro- and microscopic statements, as it were. Bold chiaroscuro configurations are impinged upon by smaller flourishes, by light of increasing and diminishing intensity. The most diverse linear particles of light and form are permeated by every conceivable nuance of shading. The eye is led by stages from the purest white, via light, cloudy opacities, to a wide range of medium greys and an abundance of blacks—a profusion which effectively avoids the purely decorative.

> (Hajek-Halke, *Lichtgraphik*, 1964 unpaginated preface)

As a photographer who remained (and served) in Germany throughout both world wars and whose complicity with the Third Reich remains unclear, a summary of Hajek-Halke's personal biography requires a similarly nuanced attention focused upon the details of his life and his broader contributions to the medium.

LEESA RITTELMANN

See also: **Aerial Photography; Montage; Multiple Exposures and Printing; Photogram; Photography in Germany and Austria**

Biography

Born in Berlin, Germany, 1 December 1898. Childhood in Argentina, returns to Berlin 1910. Studied painting at Berlin's Königliche Kunstschule, 1915–1916 and 1919–1923. Active service in WWI, 1917–1919. Studies with Berlin photographer Yva, 1924. Photographer for *Presse-Photo* and *Deutsches Lichtbild*, 1925; Joins National Socialist Party, 1933; Aerial photographer at *Dornier-Werke*, Friedrichshafen, 1939–1944; Joins Senckenberg Society for Natural Science, 1936; Freelance photographer, 1947; Joins Otto Steinert's fotoform group, 1950–1951. Professor of Graphic Design and Photography, West Berlin Hochschule für Bildende Künste, 1955–1970. Awarded Gold Medal, Internationalen Presseausstellung, Rome, 1933; Kulturpreis, Society of German Photographers, 1965; David-Octavius Hill Medal and Honorary Membership in the Society of German Photographers, 1973. Appointed Associate Member of the International Institute of Arts and Letters, Franklin Institute for the History of Art, 1956. Died in West Berlin, 1983.

Individual Exhibitions

1951 *Subjektive fotografie*; Staatlichen Schule für Kunst und Handwerk (State Art and Crafts School); Saarbrücken, Germany

1956 *Lichtgrafik*; Franklin Institut, Lindau, Germany, traveled to German Society for Photography; Cologne, Germany

1957 *Lichtgrafik*; Staatliche Landesbildstelle; Hamburg, Germany

1958 Werkkunstschule; Bielefeld, Germany

1959 *Fotografia Sperimentale di H-H*; Biblioteca Communale; Milan, Italy

1960 *German Light-Graphics by Hajek-Halke*; National Museum of Modern Art; Tokyo, Japan

1965 *Lichtgrafik*; Galerie am Dom, Frankfurt, Germany

1966 *Lichtgrafik*; Galerie Clarissa, Hannover, and Galerie Seestrasse, Ludwigsburg, Germany

1967 *Lichtgrafik*; Carleton University, Ottowa, Ontario, Canada; University of Montreal, Montreal, Quebec, Canada, and Het Sterckshof, Antwerp, the Netherlands

1978 *Heinz Hajek-Halke*; Galerie Werner Kunze, Berlin, Germany

1997 *Heinz Hajek-Halke: Der große Unbekannte Photographien 1925–1965*; Haus am Waldensee, Berlin, Germany

1998–1999 *Heinz Hajek-Halke—Zum 100. Geburtstag*; Galerie Eva Poll, Berlin, Germany

2001 *Hajek-Halke*; Galerie Priska Pasquer, Cologne, Germany

2002 *Heinz Hajek-Halke (1898–1983)*; Centre Pompidou—Musee National d'Art Moderner, Paris, France

Group Exhibitions

1954 *Foto-Grafik*; Sauermondt-Museum, Aachen, Germany (traveled to Museum für Angewandte Kunst, Vienna, Austria 1956)

1957 *herbert bayer/hajek-halke*; Kunstgewerbemuseum, Zurich, Switzerland

1970 *Fotografie-Fotografik-Lichtgrafik*; Landesbildstelle, Berlin, Germany

1978 *Die Freiheit des Fotografen—Montagen/Collagen/Lichtgrafiken*; Fotomuseum im Stadtmuseum, Munich, Germany

1984 *Subjektive Fotografie, Images of the 50s*; Museum Folkwang, Essen, Germany (traveled to the San Francisco Museum of Modern Art, San Francisco, California)

1999 *Lichtseiten*; Kunstverein Ludwigshafen, Ludwigshafen, Germany

2000 *Das Experimentelle Photo 1930–1960*; Galerie Argus Fotokunst, Berlin, Germany

2002 *Photographie*; Kunsthaus Lempertz, Berlin, Germany

Selected Works

(Üble Nachrede) Defamation, 1926–1927

Das Piano—Doppelbelichtung (Piano—Double Exposure), c. 1927

Das Eva-Chanson, c. 1929

Banjo-Spieler (Banjo Player), c. 1930

Stehender Akt (Standing Nude), 1933

Schwarz-weisser Akt (Black and White Nude), 1936

Friedhof der Fische (Fish Cemetery), 1939

Initiation (für Franz Roh, 7.1.63), 1963

Akt im Spiegel (Nude in Mirror), c. 1930

Die Wartende (Waiting), 1958–1963

Kamakura, 1958–1963

Das Diluviale Aquarium (The Diluvial Aquarium), 1958–1963

Further Reading

GDL-Edition Heinz Hajek-Halke. Leinfelden, 1978.

Hajek-Halke, Heinz. "Biographie in Bruchstücken." In *Foto Prisma* no. 1, Düsseldorf, (January 1952).

Hajek-Halke, Heinz. *Experimentalle Fotografie. Lichtgrafik*. Bonn: Athenaeum Verlag, 1955.

Hajek-Halke, Heinz. *Lichtgrafik*. Düsseldorf and Wien: Econ-Verlag GmbH, 1964.

Hajek-Halke, Heinz. "Vom Photogramm zum Photoherbarium." In *Photoblätter* 12.Jg., no. 1, Berlin, (January 1935).

Heinz Hajek-Halke: Der große Unbekannte. Photographien 1925–1965. Exh. cat. Berlin: Haus am Waldsee, 1998.

Heinz Hajek-Halke. 1898–1983. Exh. cat. Paris, Göttingen, Centre Georges Pompidous, 2002.

Honnef, Klaus, et al. *Heinz Hajek-Halke: Die Ersten Dreissig Jahre*, 2005.

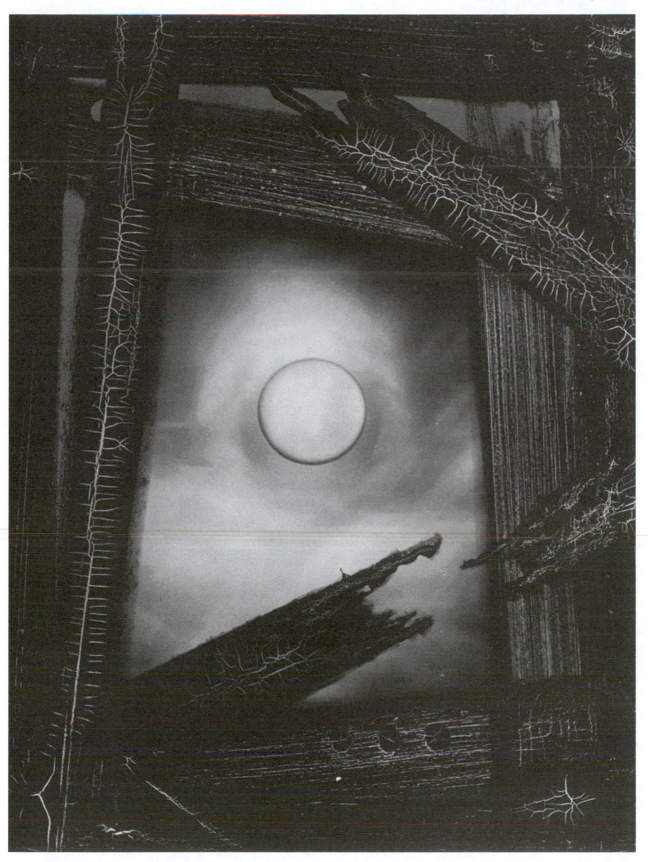

Heinz Hajek-Halke, Ohne Titel, 1950–1968, Photo: Georges Meguerditchian.
[*CNAC/MNAM/Dist. Réunion des Musées Nationaux/Art Resource, New York*]

Honnef, Klaus, and Gabriele Honnef-Harling, eds. *Von Körpern und anderen Dingen Deutsche Fotografie im 20. Jahrhundert*. Heidelberg: Galerie der Hauptstadt Prag, 2003.

Roters, Eberhard. *Heinz Hajek-Halke. Fotografie, Foto-Grafik, Licht-Grafik*. Berlin: Galerie Kunze, 1978.
Der Nachlass von Heinz Hajek-Halke. Cologne: Galerie Rudolf Kicken, 1994.

PHILIPPE HALSMAN

American

Blending technical precision with "psychological portraiture," Philippe Halsman made unique, rich photographs of mid-twentieth-century icons. His photographs of actors, politicians, artists, academics, and other luminaries adorned the pages of the big American picture magazines from 1941 to 1979. He had the unmatched number of 101 *Life* covers to his credit. During the height of his career his work was so widely admired that in a 1958 poll conducted by *Popular Photography*, Halsman was named one of the "Ten Greatest Photographers." Beginning in 1941, Halsman explored surrealism in a decades-long collaboration with the Spanish surrealist artist Salvador Dali. The collaboration led to startling photographs, perhaps the most recognized and elaborate of which is *Dali Atomicus*. In this dream-like photograph, Dali, a canvas, a chair, two cats, and a splash of water all appear to defy gravity by hanging suspended in midair.

Born in 1906 in Riga, Latvia, Halsman was raised by his father, a dentist, and his mother, a school principal. Young Philippe had an upper-middle-class, Jewish upbringing with education in the arts and in several languages. His first foray into photography was in 1921, when he began using his father's old 9 × 12-cm view camera to photograph family and friends. He completed a Bachelor of Arts degree in 1924 and then from 1924 to 1928 studied electrical engineering at the Technische Hochschule in Dresden, Germany. While studying in Dresden, he began to work as a part-time freelance photographer. In 1928 while the family vacationed in the Austrian Alps, a hiking accident resulted in his father's death. Anti-semitism in the area at that time contributed to the accusation, trial, and conviction of Philippe for the death of his father. In 1930, after serving two years in prison, Halsman was freed due to the efforts of important intellectuals, including Albert Einstein and Thomas Mann. Halsman rejoined his family in

Paris in 1931. He studied briefly at the Sorbonne in 1931, writing French poetry, before pursuing photography on his own. In 1932, he started his own portrait studio in the Montparnasse section of Paris.

From an early point in his development as a portrait photographer, Halsman's approach was to reveal and capture something about the private inner person that was not normally seen by the public. This brought depth and life to his portraits. Later in his career, Halsman often wrote about "psychological portraiture":

> If the photograph of a human being does not show a deep psychological insight it is not a true portrait but an empty likeness. Therefore, my main goal in portraiture is neither composition, nor play of light, nor showing the subject in front of a meaningful background, nor creation of a new visual image. All these elements can make an empty picture a visually interesting image, but in order to be a portrait the photograph must capture the essence of its subject.
>
> (Halsman 1972, 7)

Halsman's technical approach evolved from his desire to render clear, precise images showing emotion. Careful lighting rendered images with dramatic highlights and shadows. From the start of his career, Halsman focused sharply, eschewing the more fashionable soft-focus technique. He needed large negatives for great detail. The classic 9 × 12-cm view camera that he began his career with was capable of all of this but was slow. The turning point came after a discouraging sitting with Andre Gide, a writer who Halsman "admired above any other." Halsman decided he needed a camera capable of quickly capturing the emotion on his subject's face before it disappeared. The Leica, Rolleiflex, and Hasselblad, which allowed simultaneous viewing and photographing, were all tools that Halsman used, but their negatives were still too small to satisfy him. Halsman's compromise was to design a 9 × 12-cm twin-lens reflex (TLR) camera, built in 1936 by the grandson of the first camera maker. In 1946 he

refined his camera to the TLR 4×5-inch Fairchild-Halsman, built for him by the Fairchild Corporation.

Between 1932 and 1940, Halsman achieved recognition in Paris as one of the top portrait photographers. He shot extensively for magazines such as *Vogue* and *Vu*, in fashion and portraiture. At that time he sought out and photographed many notable figures of French art, literature, and theatre. But Halsman's life in Europe came to an end in 1940 with Hitler's march on Paris. His wife and children had visas and were able to leave for New York, but Halsman had to flee south from Paris as a refugee. He was only able to obtain an emergency visa to the United States due to the assistance of First Lady Eleanor Roosevelt, Thomas Mann, and Albert Einstein, among others.

In New York with his family, Halsman started anew. A portfolio that he shot for Connie Ford in 1941 gained recognition and got him a first assignment on hats with *Life*. The photography he then went on to make while working on freelance assignments for *Life* and other big American picture magazines of the time, such as *Look* and *The Saturday Evening Post*, gave his work the widespread exposure that assured him great lasting, popular success. His portraits, from the 1940s through the 1970s, ran the gamut of notables, from the Duke and Duchess of Windsor to actor Marlon Brando, from Albert Einstein to sex symbol Marilyn Monroe. In striving to capture the essence of his many famous subjects, Halsman succeeded in creating some of the most recognized and celebrated portraits ever taken of them.

Halsman and others have written on how he evoked a psychological response from his sitters. Halsman's pathos-filled portrait of Albert Einstein in 1947 came about during a conversation with the scholar that turned to Einstein's feelings about his role in creating the atomic bomb. In contrast, for his vulnerable yet seductively confident 1952 photo of Marilyn Monroe in a corner, Halsman used a very different approach. Positioning her in the corner, he and his assistants flirted with her to get Monroe's responses. A signature method for catching subjects off guard that Halsman asked of many of his sitters was to have them jump. His theory of "jumpology" and photos of notable people jumping appear in *Philippe Halsman's Jump Book*.

Besides his considerable achievements as a photographer, Halsman was one of a handful of people influential in the creation of the American Society of Magazine Photographers (ASMP), crucial in setting standards for the trade. He was elected president in 1945. In 1962, he formed the Famous Photographers School with Richard Avedon, Alfred Eisenstaedt, Irving Penn, and others and became one of its guiding faculty.

With the end of World War II, and the attainment of U.S. citizenship, Halsman was again able to travel. In 1951, he returned to Europe and photographed leading figures such as painters Marc Chagall and Henri Matisse. He was then asked to join Magnum Photos as a contributing member so that his work could be distributed by the agency outside of the United States. In 1960, he went to the Soviet Union to photograph the leading luminaries there. In 1966, he traveled to Switzerland to photograph writer Vladimir Nabokov.

In 1979, the last year of Halsman's life, his photographic achievements received widespread exposure in the form of a major retrospective exhibition at the International Center of Photography in New York City. The exhibition toured throughout the United States until 1986. In 1998, another major retrospective was launched, this time at the National Portrait Gallery by the Smithsonian Institution. *Halsman: A Retrospective* was published to coincide with the exhibition. The exhibition toured the United States, Britain, and France through 2002.

See also: **Life Magazine; Magnum Photos; Popular Photography; Portraiture; Surrealism**

Biography

Born in Riga, Latvia, 2 May 1906. Received U.S. citizenship in 1948. Attended Vidus Skola in Riga, 1922–1924, received B.A.; attended Technische Hochschule in Dresden, Germany, 1924–1928, studied electrical engineering; attended the Sorbonne in Paris, 1931; self-taught in photography. Instructor in Famous Photographers School, Westport Connecticut, 1969–1979; President, American Society of Magazine Photographers, New York, 1945, 1954. Recipient "World's Ten Greatest Photographers Award," *Popular Photography*, New York, 1958; Newhouse Award, 1963; Golden Plate Award, American Academy of Achievement, 1967; Life Achievement Award, American Society of Magazine Photographers, 1975. Died in New York City 25 June 1979.

Individual Exhibitions

1979 International Center of Photography, New York, New York, and traveling
1980 Foto Galerij Paule Pia, Antwerp, Belgium
1985 Galerie zur Stockeregg, Zurich, Switzerland
1998 National Portrait Gallery, Smithsonian Institution, Washington, D.C., and traveling in United States and Europe
2001 *Philippe Halsman: 100 Photographs*; Burke Gallery, Plattsburgh State Art Museum, Plattsburgh, New York

Group Exhibitions

1936 *Exposition Internationale de la Photographie Contemporaine*; Musee des Arts Decoratifs, Paris, France

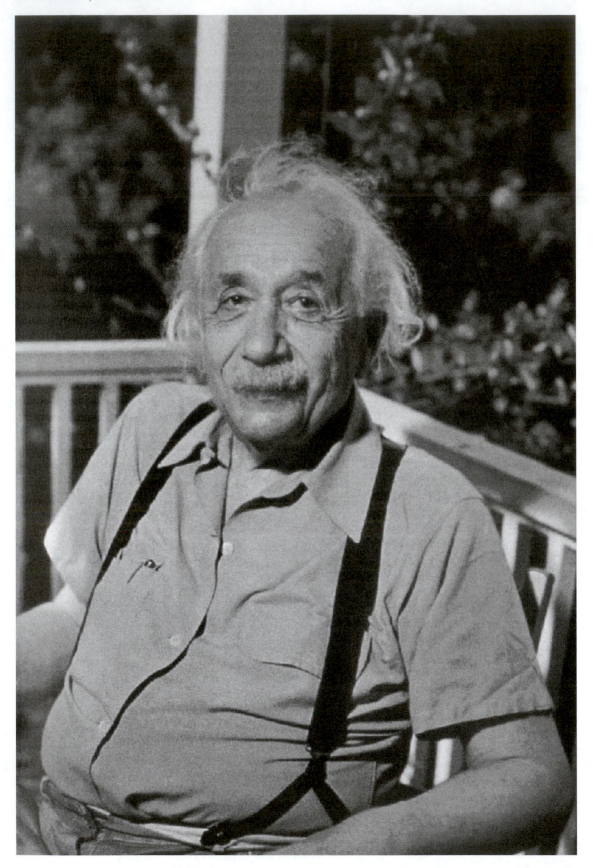

Philippe Halsman, Albert Einstein in his home, 1947.
[© *Philippe Halsman/Magnum Photos*]

1951 *Memorable Life Photographs*; Museum of Modern Art, New York, New York

1965 *12 International Photographers*; Gallery of Modern Art, New York, New York

1978 *Photos from the Sam Wagstaff Collection*; Corcoran Gallery of Art, Washington, D.C., traveling (United States and Canada)

1979 *Fleeting Gestures: Dance Photographs*; International Center of Photography, New York, traveling (United States and Europe)

 Life: the First Decade 1936–1945; Grey Art Gallery, New York University, New York, New York (toured the United States)

1980 *Photography of the 50s;* International Center of Photography, New York, New York, and traveling

1982 *Lichtbildnise: Das Portrat in der Fotografie*; Rheinisches Landesmuseum, Bonn, Germany

1983 *Photography in America 1910–1983*; Tampa Museum, Tampa, Florida

1984 *Sammlung Gruber*; Museum Ludwig, Cologne, Germany

2003 *Jump! Photographers Get off the Ground*; National Gallery of Australia, Canberra, Australia, traveling

Selected Works

Andre Gide, 1936
Albert Einstein, 1947
"Dali Atomicus," 1948
Marc Chagall Venice, 1951
Marilyn Monroe, 1952

Further Reading

Halsman, Philippe. *Dali's Mustache*. New York: Simon & Schuster, 1954, and reissued in Paris: Flammarion, 1994.

Halsman, Philippe. *The Frenchman*. New York: Simon & Schuster, 1949.

Halsman, Philippe. *Halsman Portraits*. New York: McGraw-Hill, 1982.

Halsman, Philippe. *Halsman on the Creation of Photographic Ideas*. New York: Ziff-Davis, 1961.

Halsman, Philippe. *Halsman: Sight and Insight*. Garden City, NY: Doubleday, 1972.

Halsman, Philippe. *Philippe Halsman's Jump Book*. New York: Simon & Schuster, 1959.

Halsman, Philippe. "Psychological Portraiture." *Popular Photography* 51 (December 1958).

Halsman, Philippe, Jane Halsman Bello, Steve Bello, and Mary Panzer. National Portrait Gallery. *Philippe Halsman: A Retrospective*. Boston: Bulfinch Press, 1998.

Halsman, Yvonne, and Philippe Halsman. *Halsman at Work*. New York: Harry N. Abrams, 1989.

Spencer, Ruth. "Philippe Halsman." *British Journal of Photography* 10 October (1975).

HIROSHI HAMAYA

Japanese

Hiroshi Hamaya is one of the great names of photojournalism in Japan, of a similar stature to Ken Domon and Ihee Kimura. His strongest contribution to twentieth century photography, however, is his series of aerial views of wild and dramatic landscapes, including pioneering shots of Mt. Everest. Born in Tokyo, Hamaya began his career in photography in 1931. In 1933, he worked in a photography department of an aviation laboratory, where it might be assumed that he acquired his taste for aerial photography. Self-taught, he became a freelance photographer in Tokyo in 1937, his pictures capturing both the changes of the city and the changes of the people during the inter-war years. After the defeat of Japan in World War II, Hamaya focused on the country's reconstruction with modern urban architecture. It was during this period the elements of Hamaya's mature style began to be codified, with two major publications attesting to this new aesthetic: *Yukiguni* (*Snow Country*), 1956 and *Urah Nihon (Japan's Back Coast)*, 1957. Yet his photographic thinking and his original style only emerged some years later.

Yukiguni is a work of long gestation. In 1939, Hamaya was sent to Takada in the Niigata area in order to make a report about a military camp. During his first stay, he met an ethnologist, Keizo Shibusawa, who impressed Hamaya with his knowledge and rigorous sense of observation. Applying this knowledge, Hamaya visited this region over a ten-year period, centering his interest for the most part on a village called Kuwadoridani, near Takada. His choice of subject matter encompassed a broad sampling of photographic topics: candid studies of villagers, daily life, farm work, and scenic views of the area covered in snow. In this manner, he describes the life in the village during various commemorations and ceremonies, like the winter Festival of Fire, also showing the relation between the peasants and their divinities. The pictures reveal the deep respect that links the

villagers and farmers to their land in an area covered by snow four months of the year. Yet what this series truly revealed can only be understood in an immediate Japanese post-war context where it can be seen as a reply to the rapid modernization and the American occupation. Because the villagers of Kuwadoridani are isolated, they do not benefit from the technical progress, changes of mentality, or Americanization of the urban spaces. But neither are their time-honored traditions disturbed. Hamaya used an original technique of oscillating between larger, almost abstract, views that describe the life of the people and intimate, close-up shots of individuals such as *Woman Planting Rice*, 1955. This photograph depicts a woman passing through a rice field. A formal analysis of this picture can elicit the interpretation that farmers are being left by the wayside, but it can also be read as a quest for more traditional values, a quest for identity, and a specific form of awareness. This oscillating between the documentary and personal reflection are a unique character of early works by Hamaya.

Hamaya next passed many years taking pictures of villages along the West coast of Japan. Much like an ethnologist, he records work in the fields, rituals, the way of living, and the organization of rural society. These pictures were collected in *Urah Nihon (Japan's Back Coast)* of 1957. Hamaya further developed and deepened his themes, bringing to the fore the relations between the villagers and the historic and geographic frame of the places where they live, in lives punctuated by seasons and ceremonies. Hamaya's realism and his focus on agriculture, fishing, and traditional folklore provide a counterpoint to the migration of people to great urban centers in the massive modernization of Japan of the 1940s and 1950s.

With these two collections, Hamaya secured his reputation in Japanese photography circles. Further success arrived when works from these series were selected for the exhibition *The Family of Man* at the Museum of Modern Art, New York in 1955, which also toured Japan. Hamaya secured another milestone in Japanese photography with his entry to Magnum Photos in 1960, the first Japanese photographer to join this Paris-based agency. Although Hamaya traveled extensively on photojournalistic assignments, his strongest work remained that which was realized in his native land. In 1960, he published a series of pictures entitled *Okori to Kanashimi no Kiroku (Record of Anger and Sadness)*, through which he stands up against the Japanese government at the time of the Japan-U.S Security Treaty (ANPO).

During the 1960s, however, portraits of Japanese life gradually disappear from his work, although he returned to the theme in 1976 with a series devoted to the life of Japanese women in the Showa era. He increasingly turned to what might be called natural architecture portraits, taking up aerial photography that results in a set of color, panoramic views of Japan as published in collections entitled *Nihon Rettö (The Japanese Archipelago)* and *Landscape of Japan*, 1960–1964. Through aerial photography Hamaya turns his gaze to the world landscape, shooting in America, Canada, Greenland, Australia, Algeria, Turkey, Western Europe, and most dramatically, in Nepal with his extraordinary series of black-and-white aerial views of the Himalayas. These photographs are featured in two publications: *Aspects of Nature* (1980) and *Aspect of Life* (1981), and are more than landscapes. They are better described as portraits of nature, wherein Hamaya, with his lens, sculpts mineral and vegetal components into a natural architectural order.

Although the aerial work on a formal level is strikingly different than Hamaya's earlier photographs, the consistent thread is the photographer's reliance on the notion of place. In the aerial works, Hamaya seeks out places seeming to become, or at the opposite end of the spectrum, are still wild. He expresses strength through images of mountains or, volcanoes in which nature is the sole law. More than straightforward panoramas, his photographs, as in those of icy landscapes or deserts, present an abundance of details that require the viewer to create order through observation and rational thought, much as humans create order through their actions on nature.

A modest man, Hamaya often downplayed his achievements, but was eloquent when he stated:

> [I feel] photography is less creative than painting: sometimes I tell myself that I'm not a very creative person...but at the same time I know that photography is more a matter of finding than of creating. We wander round the world trying to find things and to decide they are important.
>
> (Interview with Frank Horvat, November 1988, *Entre Vues*, Paris: Nathan, 1990)

Hamaya died in 1999 at his home in Kanagawa Prefecture.

THOMAS CYRIL

See also: **Aerial Photography; Domon, Ken; Magnum Photos; Photography in Japan**

Biography

Born 1915, Ueno district, central Tokyo. Freelance photographer based in Tokyo 1937–1945. Member of Tohosha group, 1941–1942. Relocated to Takada, Niigata Prefecture, 1945–1952; based in Oiso, Kanagawa Prefec-

Hiroshi Hamaya, Woman planting rice, Toyama, 1955.
[© *Hiroshi Hamaya/Magnum Photos*]

ture, 1952 until his death. Awarded Prize of the Year of the Japan Photographic Society, 1958. Contributing photographer for Magnum Photos from 1960. Hasselblad Foundation International Award in Photography and Honorary Member, Royal Photographic Society of England, 1997. Died 1999.

Individual Exhibitions

1946 *Document of the Heavy Snowfall in Takada City*; Izumoya Department Store, Takada, Japan

1947 *Seven Artists in Echigo*; Daishi Bank Hali, Takada, Niigata Prefecture, Japan

1957 *The Red China I Saw*; Takashimaya Department Store, Tokyo

1959 *Ook Dit is Japan*; Leiden Museum, Leiden, Netherlands

1960 *The Document of Grief and Anger*; Matsuya Gallery, Tokyo, Japan

1969 *Hamaya's Japan*; Asia House, New York, New York

1970 *Nature in Japan, Photokina '70*; Cologne, Germany

1981 *Hiroshi Hamaya: 50 Years of Photography*; Takashimaya Department Store, Wako Hall and Fuji Photo Salon, Tokyo, Japan

1982 *Form of the Earth*; Takashimaya Department Store, Tokyo, Japan

1986 *Hiroshi Hamaya: Fifty Years of Photography*; International Center of Photography, New York, New York

1989 *Hamaya Hiroshi*; Kawasaki City Museum, Kawasaki, Japan

1997 *Hamaya Hiroshi, Sixty-Six Years of Photography*; Metropolitan Museum of Photography, Tokyo, Japan

Group Exhibitions

1955 *The Family of Man*; Museum of Modern Art, New York, New York

1959 *Biennale Internationale di Fotographia*; Venice, Italy

1960 *The World as Seen by Magnum*; Takashimaya Department Store, Tokyo, Japan

1965 *12 Photographers*; Museum of Modern Art, New York

1972 *The Concerned Photographer*; Smithsonian Institution, Washington, D.C.

1979 *Japanese Photography Today and its Origin*; Gallery of Modern Art, Bologna, Italy

Japan: A Self-Portrait; International Center of Photography, New York, New York

1980 *The Imaginery Photo Museum*; Kunsthalle, Cologne, Germany

1984 *Sammlung Gruber*; Museum Ludwig, Cologne, Germany

1986 *Beautés du Japon: Coutumes populaires, folklore et modes de vie*; Mairie du 9ème arrondissement, Paris, France.

1989 *Europalia 89, Japan-Belgium*; Museum of Photography, Charleroi, Belgium

2003 *Japon: un renouveau photographique*; Hôtel de Sully, Paris, France

Selected Works

Yuki Guni (Snow Country), 1956

Urah Nihon (Back Regions of Japan), 1957

The Red China I Saw, 1958

Children in Japan, 1959

Okori to Kanashimi no Kiroku (Record of Anger and Sadness), 1960

Landscape of Japan, 1964

The Mount Fuji: A Lone Peak, 1978

Summer Shots: Antarctic Peninsula, 1979

Aspects of Nature and Aspects of Life, 1981

Women in the Showa Era, 1985

Further Reading

Gruber, Renate, and L. Fritz Gruber. *The Imaginary Photo Museum*. New York: Harmony Books, 1981.

Tada Tuguo, *I grandi fotografi: Hiroshi Hamaya*, no. 14, Milan: Fabri, 1982.

Ryuichi, Kaneko, and Iizawa Kohtaro. *Twelve Photographers in Japan 1945–1955*. Yamaguchi, Japan: Yamaguchi Prefectural Museum, 1990.

Kineo, Kuwabara, Hiraki Osamu, and Mitsuhashi Sumiyo. *Century of Photography: Hiroshi Hamaya: Sixty-six Years of Photography, 1931–1990*. Tokyo: Metropolitan Museum of Photography, 1997.

HANS HAMMARSKIÖLD

Swedish

Hans Hammarskiöld, along with his contemporaries in the 1940s and 1950s, contributed to significant changes in Swedish photography, bringing it from styles that relied on conventions of the past to more contemporary photographic expressions. His body of work includes a rich representation of nature as well as cityscapes, fashion, and industrial photographs that feature distinctive lighting with a rich contrasts of tones.

Born in 1925 in Stockholm, Hans Hammarskiöld is largely self-taught in photography. While studying at secondary school, Ostra Real, from

1936 to 1944 in Stockholm, he discovered photography and became fascinated with its possibilities. He spent a great deal of time taking pictures and developing prints in the darkroom. After high school, Hammarskiöld spent six months as an assistant to Sven Thermænius, a well-known cinematographer. In 1947, Hammarskiöld bought his first camera, a Rolleiflex, and, in 1948 became an apprentice photographer at portrait Studio Uggla, where he studied under Rolf Winquist, an outstanding Swedish portraitist of the time.

Hammarskiöld's photographic career really began in Stockholm in 1949, at an exhibition titled *Unga fotografer* (Young Photographers), a show organized by a group of contemporary photographers. The photographers who made up this group wished to separate themselves from both the subject matter and style of the photographic establishment made up of the generation of pre-war photographers. These photographers celebrated what the younger generation saw as an outdated, romanticized view of the Swedish national identity.

One of Hammarskiöld's images from this time, *Barcelona 1949*, shows his digression from the portraiture style he had adapted from Winquist, the movement in this image differing considerably from the style he had been learning as an apprentice. It also displays the sharp contrast of tones with deep blacks and bright whites, a significant departure from the modulated grays prevalent in Swedish photography at the time. In *Frost, 1949*, Hammarskiöld also diverges from convention in focusing on one detail of nature, rather than shooting an over-all scene. This technique becomes a characteristic of his photography over the years, and this image of grains of grass with a leaf in the upper left-hand corner is the first of his many photographs of nature, and more specifically of the magical beauty of frost.

In 1950, Hammarskiöld focused on architecture and fashion and worked for a year at Sten Didrik Bellander's studio. At the time, Bellander's studio was a common meeting place where young photographers frequently congregated.. Hammarskiöld had his first individual exhibition at Rotohallen in Stockholm in 1951, and he won the newspaper "Svenksa Dagbladet" prize that same year.

During the early 1950s, Hammarskiöld traveled to the United States, which strongly influenced his developing photographic style. Hammarskiöld set off to discover what was happening abroad during this transitional time for postwar Europe and met leading photographers in New York such as Edward Steichen, W. Eugene Smith, and Irving Penn.

Edward Steichen, director of photography at the Museum of Modern Art (MoMA) in New York at the time, became an important influence for Hammarskiöld as Anna Tellgren illustrates in *Tio Fotografer, Self-perception*, and *Pictorial Perception*. They formed a lasting friendship, and Steichen encouraged the young photographer. Hammarskiöld's work was included in two of Steichen's exhibitions at MoMA: Postwar *European Photography* (1953) and *The Family of Man* (1955). Hammarskiöld would later take several striking portraits of the great photographer, including *Edward Steichen 1968*.

In 1955–1956, Hammarskiöld joined Condé Nast in London, working for *Vogue* magazine. His contributions included fashion stories, portraits, advertising, food, and interior photography. In addition to this commercial work, Hammarskiöld wandered around London taking captivating images of the city. *Battersea Bridge, 1955* and *Chelsea Embankment, 1955* portray an enigmatic quality of London, with dramatic lighting and dark silhouettes structuring the images. These photographs were exhibited at the Institute of Contemporary Arts in London in 1957.

At this time, Hammarskiöld was also taking black-and-white, highly contrasted but intimate portraits of his family. In his finely composed photographs of his pregnant wife, *Caroline, 1955* and his daughter, *Suzanne, 1961*, Hammarskiöld used accentuated lighting and sharp contrasts. During this time Hammarskiöld took his remarkable portraits of the American poet of Swedish origin Carl Sandburg, resulting in *Sandburg, 1959*. The image features distinctive lighting, adding sharpness and clarity to this elegant portrait.

Returning from London in 1957 to work in Stockholm, Hammarskiöld became and remains a freelance photographer. In 1958, he was one of the 10 founding members of "Tio Fotografer" (Ten Photographers). The group included Hammarskiöld, Sten Didrik Bellander, Harry Dittmer, Sven Gillsätter, Rune Hassner, Tore Johnson, Hans Malmberg, Pal-Nils Nilsson, Georg Oddner, and Lennart Olson, many of whom were among the young photographers who exhibited their work together back in 1949. Ten years later, after many of them had been abroad as a result of their postwar isolation from the world of photography outside of Sweden, the group formed itself officially. Like Hammarskiöld, a few of the group had spent time in the United States while some traveled within Europe, notably to Paris. The reunited group established an agency called Tiofoto in 1959.

Between 1958 and 1968, Hammarskiöld produced picture stories, food photography, still-life, portraits, and industrial photography. He also prepared illustrations for many books.

In 1967, on assignment for a Swedish company, Hammarskiöld started creating "Pictoramas." These are color visual multimedia shows using up to 36 different projectors and often synchronized with music. Hammarskiöld also photographed artists and their work, such as American sculptor Claes Oldenburg and the great Russian dancer Rudolf Nureyev. He published a book of holographs with Swedish artist and poet Carl Fredrik Reuterswärd in 1969 titled *Laser*.

Throughout his career, Hammarskiöld has taken photographs of nature, frequently focusing on details that result in images which are fairly abstract. In *Gotlandsstrand, 1973*, a feather is lit up in the foreground with the shining sun in the background, separated by the ocean and unique rock formations. The line of the translucent feather adds a decorative quality to the image found in many other of his images such as "The Royal Palace, Stockholm, 1970." The swan's curved white neck frames part of the image, again presenting a graphic aspect of the image with intense black-and-white contrasts. Hammarskiöld's many photographs of nature celebrate its beauty and complexity. In Jan Cederquist's text, *Hans Hammarskiöld, Photographer* (1979), Hammarskiöld is quoted:

> I'm very concerned about what we're doing to nature today. As a photographer I could try influencing opinions by showing ugly deforestations areas, animals killed by pesticides and the like. But I prefer doing it the opposite way. To show the beauty and magic of nature. To try to make people see and feel what's really at stake.

Hammarskiöld still illustrates books today, taking many pictures of nature, working mainly in color since 1984. He has illustrated 25 books, and his photographs have been published internationally. His work is also found in collections across the world, including MoMA, the Library of Congress, and the Bibliothèque nationale de France in Paris.

KRISTEN GRESH

See also: **Condé Nast; History of Photography: Postwar Era; Olson, Lennart**

Biography

Born in Stockholm, 17 May 1925. Attended Ostra Real, 1936–1944; self-educated in photography; assistant to cinematographer Sven Thermænius, 1947; apprentice at Studio Uggla under portraitist Rolf Winquist, Stockholm, 1948. Photographer, Bellander Studio, Stockholm, 1950; *Vogue* magazine, Condé Nast Publications, London, 1955–1956; freelance photographer (fashion, architecture, and nature) in Stockholm, since 1957; founding member of "Tio Fotografer," Stockholm, 1958; freelance multimedia shows since 1967; illustrated 25 books since 1950s. Living in Stockholm, Sweden.

Individual Exhibitions

1951 Rotohallen; Stockholm, Sweden
1956 *London*; Institute of Contemporary Arts; London, England
1958 *London*; Artek; Stockholm, Sweden
1962 *Scandinavian Design Cavalcade*; Svensk Form; Stockholm, Sweden
1979 *Retrospective*; Camera Obscura; Stockholm, Sweden
 Retrospective; Douglas Elliott Gallery; San Francisco, California
1981 Stephen White Gallery; Los Angeles, California
1984 Vision Gallery; San Francisco, California
1985 *Stockholm*; Bloomingdale's; New York
1987 Gotlands Fornsal; Visby, Sweden
1989 *Barn, barnbarn*; Upplands Konstmuseum; Uppsala, Sweden
1993 *Subjectivt sett*; Fotografiska Museet; Stockholm, Sweden
2002 *Reflexer-bilder från ett halvt seke*; Waldemarsudde; Stockholm, Sweden

Group Exhibitions

1949 *Unga fotografer* (*Young Photographers*); Rotohallen; Stockholm, Sweden (1950, traveled to New York)
1951 *Jeunes Photographes de Suède*; Galerie Kodak; Paris, France
 Subjektive Fotografie; State Art and Crafts School; Saarbrücken, Switzerland
1952 *Weltaustellung de Photographie*; Lucerne, Switzerland
1953 *Postwar European Photography*; Museum of Modern Art; New York and traveling
 Svensk Fotokonst 1948–1951; Gothenburg Konstmuseum; Gothenburg, Sweden
1954 *Svensk fotografi av idag, svartvitt*; National Museum of Stockholm; Stockholm, Sweden
 Subjektive Fotografie 2; Saarbrücken, Germany
1955 *Fotografi 55*; Svenska Fotografernas Förbunds jubileumsutställning; Stockholm, Sweden
 The Family of Man; Museum of Modern Art; New York and traveling
1958 *Fotokunst*; Lunds Konsthall; Lund, Sweden
1962 *Svenskarna sedda av 11 fotografer*; Moderna Museet; Stockholm, Sweden
1970 *Tio Fotografer*; Bibliothèque Nationale; Paris, France
1971 *Contemporary Photographs from Sweden*, Library of Congress; Washington, D.C.
1978 *Tusen och En Bild/1001 Pictures*, Moderna Museet; Stockholm, Sweden
1982 *The Frozen Image: Scandinavian Photography*; Walker Art Center; Minneapolis, Minnesota
1984 *Six Swedish Photographers*, LACPS; Los Angeles, California
1985 *"Subjektive Fotografie," Bilder der 50er Jahre*; Museum Folkwang; Essen, Germany

Selected Works

Barcelona, 1949
Frost, 1949
Edward Steichen 1968, 1968
Battersea Bridge, 1955
Chelsea embankment, 1955
Caroline, 1955

Suzanne, 1961
Sandburg, 1959
Gotlandsstrand, 1973
The Royal Palace, Stockholm, 1970

Further Reading

Bellander, Sten Didrik, and Hans Hammarskiöld. *Vi fotografera barn*. Stockholm: Wahlström & Widstrand, 1950.

Cederquist, Jan. *Hans Hammarskiöld, Photographer*. Stockholm: Camera Obscura, 1979.

Eskildsen, Ute, Manfred Schmalriede, and Dorothy Martinson. *Subjektive Fotografie, Images of the 50s*. Essen: Museum Folkwang, 1984.

Freeman, Martin, ed. *The Frozen Image: Scandinavian Photography*. Minneapolis and New York: Walker Art Center and Abbeville Press, 1982.

Hammarskiöld, Hans, and Carl Fredrik Reuterswärd. *Laser*. Stockholm: Wahlström & Widstrand, 1969.

Hammarskiöld, Hans, and Tony Lewenhaupt. *Nära Linné*. Stockholm: Bra Böcker, 1993.

Hammarskiöld, Hans, Anita and Wasterber Theorell. *Stockholms fasader 1875–1914*. Stockholm: Gedins Förlag, 1993.

Hard, Ulf, Sune Junsson, and Ake Sidwall. *Tusen och En Bild/1001 Pictures*. Stockholm: Moderna Museet, 1978.

Jonsson, Rune. *Hans Hammarskiöld Fotograf*. Helsingborg: Fyra Förläggare AB, 1979.

Tellgren, Anna. *Tio Fotografer. Självsyn och bildsyn (Ten Photographers: Self-perception and Pictorial Perception)*. Stockholm: Informationsförlaget, 1997.

Wigh, Leif. *Subjectivt sett*. Stockholm: Fotografiska Museet/Moderna Museet, 1993.

HAND COLORING AND HAND TONING

The practise of applying colour by hand onto monochromatic photographs was common from almost the very beginnings of photography until well into the mid-twentieth century, by which time commercially viable colour processes had been developed and replaced the need to add colours to a black and white print. To consider the use and need for hand colouring it is important to appreciate the expectancies of photographers in the early nineteenth century. It was soon after the advent of the Daguerreotype and Calotype that photographers questioned their art's inability to render natural colours. Despite several attempts by a succession of inventors throughout the 1800s, it would not be until 1907 that the Lumiere brothers were successful in creating and manufacturing their Autochrome process. Yet the cumbersome nature and expense of early color processes ensured that hand-coloring persisted.

The technique flourished especially as a service offered by the portrait photographer. By the end of the nineteenth century, many establishments offered not only delicate coloured additions to the portrait but sometimes would completely over-paint the photograph in oils, watercolour, or crayons to such an extent that the resulting hybrid generally presented the visual characteristics of both painting and photograph with the aesthetic qualities of neither. Often the best colourists had been miniature portrait painters whose craft had been superseded by the advent of the photograph. These painters found their skills were in demand for applying colour to glass plates or prints and retouching—removing technical defects and improving the appearance of the subject. Many photographers who had higher aspirations than the family portrait found such practise derisory to the seriousness of their work.

Travel photographers aiming their work at the popular market often coloured their prints as well as the lantern slides used in their lectures. Burton Holmes, an American photographer active between the 1880s and 1950s, was a well-known producer of coloured glass slides to the popular market. In later years Holmes's slides were hand painted to such a high standard by a team he himself trained that the results compared favorably to slides produced by modern colour film (Colebeck, 14).

The humble picture postcard was initially coloured by hand in the late nineteenth century. Stencils were produced to allow block colours to be applied selectively by teams of workers in factories throughout the world. As the popularity of postcards grew, this labour-intensive method was mostly replaced by machinery by the late 1920s.

Whether by hand or machine, colouring had initially been used to replicate a natural rendition; it also eventually created its own aesthetic, one largely asso-

ciated with the glamour and film industries. By the 1930s, reproductions in popular magazines were often from hand-coloured photographs. Hollywood film stars were seen delicately coloured at a time when the movies in which they starred were shot in black and white. Even after the invention of Techni-colour, the cinema industry in the 1940s and into the 1950s still employed hand colourists, primarily to work on movie stills and publicity shots. As films were often shot under controlled lighting in the studio, the still photographer with slower lenses than the film cameraman would produce their work in monochrome, with the publicity departments reproducing their prints from hand-coloured photographs.

It was common in the 1930s for portrait photographers to supply clients with hand-coloured prints. The methods of colouring varied depending on the intensity of colour required. Normally, a sepia-toned print was used as the warmth of the base provided a better rendering to the colours of the inks, dyes, and paints used, and also ensured none of the print would be seen as black and white. Many books offered both the professional and amateur photographer advice on the technique of hand colouring while simultaneously expressing a general mistrust of this practice, especially for the serious photographer.

Public taste for colour, even in its crudest form, had induced portrait photographers to offer to their customers coloured photographs which, sometimes, are far removed from works of art. However, specialists in such work may plead extenuating circumstances; for example, severe competition (Clerc, 463).

The mediums recommended by this and other volumes had different characteristics and results depending on the qualities of the print. Coloured dyes adhered best to glossy prints while smoother matte papers responded better to water colours. Pastel crayons were suitable especially if the user had an understanding of sketching, though the complications suggested by the amount of formulae required to treat the print prior to working with oil paints would deter all but the most dedicated. The air brush was employed for its smoothness in applying colour, usually after areas of the print had been masked off, and brushes of various sizes used to highlight detail.

As colour films became cheaper and thus more widely used, the need for hand colouring receded. Designers still used selective hand colouring in advertisements and especially fashion magazines well into the 1950s, often using blocks of colours in a similar method to the picture postcards of the turn of the century. Though occasionally still used, and replicated now by computer retouching, it is the distinctive and recognisable look of the hand-coloured print that is its use and value long after colour photography has become the norm, employed occasionally, in most instances purely for its nostalgic appeal.

Mike Crawford

See also: **Vernacular Photography**

Further Reading

Clerc, L.P. *Photography: Theory and Practise*. London: Pitman & Sons, 1930.

Colebeck, Annie. *Handtinting Photographs*. London: Macdonald & Co., 1989.

Coote, Jack H. *The Illustrated History of Colour Photography*. Surrey: Fountain Press, 1993.

Heinish, Heinz and Bridget Heinish. *The Painted Photograph, 1839–1914*. PA, University State Press, 1994.

Langford, Michael. *The Darkroom Handbook*. London: Edbury Press, 1981.

ERICH HARTMANN

American

Erich Hartmann's strongly composed vision of documentary photography not only led him to join Magnum Photos in 1952, but to successfully apply his vision to other realms with sensitivity and insight as a self-named working photographer. His concise style brought him commercial projects where he exercised and experimented with the documentary genre. One of his most poignant projects was to document the deserted Nazi concentration camps decades after the war, challenging his ability to capture the essence of objects and place. This may appear as a counterpoint to much of the work he was known for in the technology field, yet he developed a specialty in bringing out the essence of seemingly inanimate objects, such

as computer components, revealing their power and expression. Hartmann who exhibited in Austria, Holland, Germany, Italy, and Japan, was firmly committed to the Magnum collective, serving on the board and as president, and is attributed to being the first to bring the techniques of photojournalism to corporate assignments.

The first child of a prosperous, middle-class Jewish couple, Hartmann was born in 1922 in Munich, and made his first photo in 1930. He fled Germany with his family to Albany, New York, when he was 16 years old. There, he worked in a textile mill and attended evening high school and night classes at Siena College. Hartmann served in the U.S. Army in England, took part in the invasion of Normandy, and after the war he served in Civil Affairs as an interpreter in Belgium and Germany. In 1946, he moved to New York City, married Ruth Bains, and began working for two years as an assistant portrait photographer before turning freelance. After meeting Robert Capa in 1951, he was invited to join Magnum Photos a year later and continued to develop his documentary focus. Although he never formally trained as a photographer, he was influenced by the work of photographer and prominent art director Alexey Brodovitch, Berenice Abbott, and Belgium photographer Charles Leirens at the New School for Social Research, and Werner Bischof and the Farm Security Administration photographers such as Ivan Massar and Clyde ("Red") Hare.

As a freelance photographer based in New York City, Hartmann generated photo essays and reports for major magazines in the United States, France, Germany, Italy, and Japan. His photo essays were published in major magazines including mainstream news and business magazines such as *Fortune, Life, Time, Newsweek, Business Week, The New York Times Magazine, Paris-Match, Die Zeit, Stern,* travel and leisure publications such as *Venture, Vogue, Travel and Leisure, Connoisseur,* and science publications such as *GEO,* and included general interest and topics related to high technology, genetics, electronics, and scientific themes. Hartmann also developed corporate and advertising clients, including Litton Industries, Pillsbury, RCA, Ford Motor Company, IBM, Boeing, and Schlumberger. Hartmann took both color and black and white on assignment depending on the project. He also carried with him a 35 mm camera loaded with black and white film, and a couple of extra rolls that he shot to document his life on assignment and personal aspects of his life. Hartmann was an early colorist and for a period of time specialized in laser photographs that were exhibited in Europe and the United States. He mastered a technique that allowed him to alter angles of the photograph without distorting the object.

In the fine-arts area, Hartmann had his first one-man show "Sunday Under the Bridge" at the Museum of the City of New York in 1956, and he continued exhibiting worldwide throughout his career, both independently and in Magnum Photos presentations.

Membership in Magnum Photos developed and influenced Hartmann's style and working method but he developed a more personalized approach. While from 1955 to 1961 his main assignments were photo-essays for top magazines, he turned to corporate and institutional projects that showed a uniquely human face in science and industry. The documentation of satellite production done for the European Space Agency and many other *"high technology stories"* he has told reveal his "precision" of composition and concern for documentary authenticity. His fascination with how technology embodies also the beautiful led him to intimate portraits of precision-manufactured components. "It was a certain kind of view, that was no longer dependent on posing everything. And I came upon this from being interested in presenting objects in a way they hadn't been looked at before."

As a working photographer Hartmann explored varied themes in numerous countries, later exhibiting social aspects of what he found there. For example, his "Mannequin Factory" exhibition came from an assignment—some of the images evoking a metaphor for the dehumanizing horrors of our time. And his last major projects provide a glimpse of the photographer's personal philosophy.

From 1969 onwards Hartmann lectured students at different institutions in the United States, including lectures at the University of Syracuse and New York University and in Europe. He had a deep commitment and sense of responsibility to help develop young photographers and always had an intern working with him. Hartmann's longtime association with Magnum provided mutual support from colleagues such as Elliott Erwitt, Eve Arnold, and Inge Morath, who was a strong supporter of his later project, "In the Camps."

While "In the Camps" deviates from his usual subject matter, it maintains Hartmann's ability to allow the objects to speak for themselves. In the haunting images of Nazi concentration camps as they were in 1995, even devoid of people, the camps speak loudly of the horrors they contained. Hartmann photographed these places as an indebtedness to escaping them and "to fulfill a duty that I could not define and to pay a belated tribute with the tools of my profession." With "In the Camps" the feeling from these penetrating images and the essence of its meaning evokes the human tragedy

that took place, and it is a powerful reminder. A second project that was completed after Hartmann's death, "Where I Was," offers an autobiographical look at his career and the photographs he took along the way. Reminders of his concise style and recurring fascination with laser light and reflected abstractions can be seen, displaying the depth in his accomplished journalistic and technical skills. The observations of the world around him and of people's relationship with their environments reveal a multifaceted, reflected view of the ordinary.

Hartmann the working photographer was surrounded by high technology and technical ways of looking at objects around us, while at the same time he was a self-proclaimed "commonplace" photographer who had a way of looking at the ordinary with unusual angles and perspectives. Following his death in 1999, he was recognized for his contribution to photography and young photographers that he nurtured and supported and with the naming of the Erich Hartmann Arts Centre at the United World College of the Adriatic in Duino, Italy, in February 2000.

JANET YATES

See also: **Capa, Robert; Magnum Photos**

Biography

Born in Munich, Germany, 29 July 1922. Immigrated with family to United States, 1938, naturalized 1943. Served in U.S. Army 1943–1945. Self-educated in photography. Freelance photographer from 1950. Lecturer at Syracuse University, International Fund for Concerned Photographers, New York University, University of Maryland, Summer Academy in Salzburg. Received Newhouse Medal, Syracuse University, New York; Art Directors Award, New York, 1968, 1977; Photokina Award, 1972; CRAF International Award of Photography; member of Magnum Photos from 1952, served on Board 1967–1986, President 1985–1986. Died New York City, 4 February 1999.

Individual Exhibitions

1956 *Sunday Under the Bridge*; Museum of the City of New York, New York
1962 *Our Daily Bread*; New York Coliseum, New York, New York, and traveling
1971 *Mannequin Factory*; The Underground Gallery, New York, New York, and traveling
1973 *Europe in Space*; The Photographers' Gallery, London, England
1976 *Carnet de Routes' Natures Mortes*; Photogalerie, Paris, France
1977 *Photographs with a Laser*; AIGA Gallery, New York, New York, and Amsterdam, the Netherlands
1978 *Play of Light*; Neikrug Gallery, New York, New York
1981 *Vu du Train (Train Journey)*; Galerie Olympus, Paris, France, and traveling
1983 *Macroworld*; Galerie Olympus, Paris, France, and traveling

1984 *Erich Hartmann Slept Here*; Residenz, Salzburg, Austria, and New York, New York
1985 *The Heart of Technology*; Galerie Olympus, Paris, France, and traveling
1987 *Washington*, Magnum Gallery, Paris, France
1988 *Veritas*; Cathedral of St. John the Divine, New York, New York
1991 *High Technology*; Olympus Gallery, Berlin, Germany, and traveling
1995 *In the Camps*; Gallery at the Arc de Triomphe, Paris, France, and traveling
2000 *Where I Was*; Galerie Fotohof, Salzberg, Austria, and traveling

Group Exhibitions

1955 *Subjektive Fotografie 2*; State Art and Crafts School, Saarbrücken, Germany
1959 *Photography at Mid-Century*; George Eastman House, Rochester, New York
1960 *Photography in the Fine Arts – II*; Metropolitan Museum of Art, New York, New York
 The Sense of Abstraction in Contemporary Photography; Museum of Modern Art, New York, New York
1965 *Photography In America 1850–1965*; Yale University Art Gallery, New Haven, Connecticut
1967 *International Exhibition of Photography: The Camera as Witness*; Montreal Expo, Montreal, Canada
1972 *Photokina*; Cologne, Germany
1979 *This Is Magnum*; Takashimaya Department Store, Tokyo, Japan
1980 *Magnum*; Galerie Le Cloître Hotel de Ville, St. Ursanne, Switzerland
1989 *In Our Time: The World As Seen By Magnum Photographers*; Minneapolis Institute of the Arts, Minneapolis, Minnesota, and traveling
2002 *Magnum Photographers: The Classic Years 1941–1985*; Andrew Smith Gallery, San Francisco, California

Selected Works

Rhode Island/Man Pointing, Reflected in a Puddle, 1949
Woman Preparing Dough for Bread, 1956
Shapes of Sound, IBM Voice Recognition Study, 1960
Dover-Calais Ferry, 1967
Cystosine Flask, 1981
Mannequin Factory, 1969
Prisoner's Uniform. Forest of Below, 1995
Family Therapy, Veritas, 1991

Further Reading

Magnum Photos. St. Ursanne: Switzerland and Paris, 1980.
Auer, Michel, and Michèle Auer, eds. *Photographers Encyclopedia International*. CD-ROM, 1997.
Hartmann, Erich. *In the Camps*. New York and London: N. W. Norton Company, 1995; *Stumme Zeugen* (German), *Dans le silence des camps* (French), *Il silenzio dei campi* (Italian) Contrasto, 1997.
Hartmann, Erich, and Georges Bardawil. *Au Clair de la Terre; l'Europe des satellites, hommes et techniques*. Arcade, Brussels, 1972.
Hartmann, Erich. *Our Daily Bread*. Minneapolis, MN: Pillsbury, 1962.

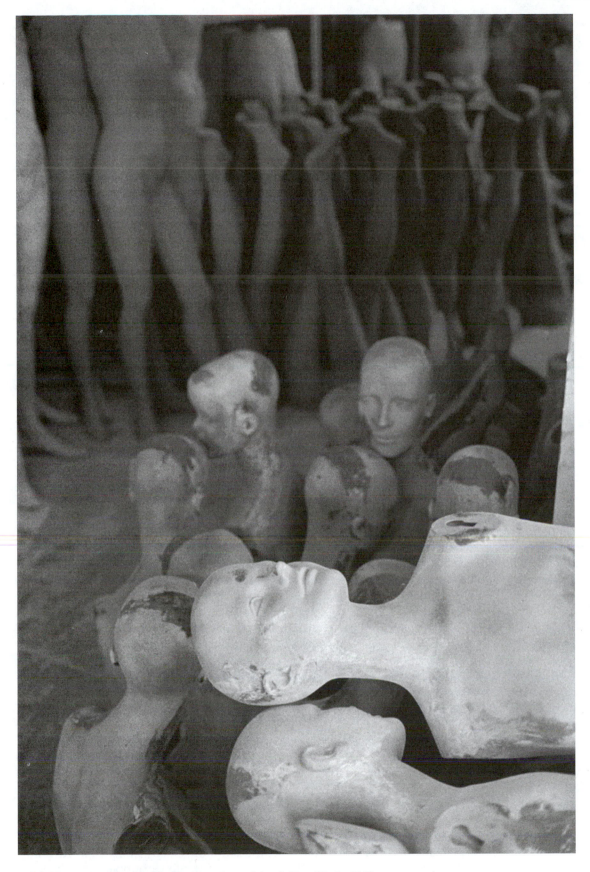

Erich Hartmann, Mannequin Factory, Long Island, New York, 1969.
[© *Erich Hartmann/Magnum Photos*]

Naggar, Carole. *Dictionnaire des Photographes*. Paris, 1982.

Pocock, Philip J. *The Camera as Witness: International Exhibition of Photography/Regards Sur La Terre Des Hommes: Exposition Internationale De Photographie*. Toronto: Southam, 1967.

Schwalbert, Bob. "*Inner Circuit.*" *Camera Arts* 3, no. 3 (1983).

Smith, Gibbs M., Billy Jay, and H. Gernsheim. *Photographers Photographed*. 1983.

JOHN HEARTFIELD

German

Helmut Herzfeld's Anglicization of his name to John Heartfield in the summer of 1916 was in protest to a nationalistic slogan being repeated around Germany, "May God Punish England" (*Gott Strafe England*). The decision to change his name as a form of protest is an example of a life and career that was devoted to, and motivated by, socially conscious action. Not a photographer himself, Heartfield spent his life using photography as a form of politically motivated art. The early part of his career was spent with the Berlin Dada group in which he and his close friend, the painter George Grosz, pioneered the technique of "photomontage." Strictly speaking, photomontage is a technique that creates a new artwork by appropriating and combining pieces from existing photographs. However, it is not uncommon to see a photomontage made with a combination of photographs and other materials, whether text, drawing, or found object. Heartfield and the other members of the Berlin Dada group used photomontage to create disruptive, often nonsensical artworks inspired by the brutality and senseless violence of World War I. In fact, Heartfield and his brother, Weiland Herzfelde (who added an "e" to his name, at the same time Helmut changed his name) were both drafted for service in the war. Heartfield served from 1914 to 1916 when he, by all accounts, staged a nervous breakdown in order to ensure his discharge from the military. Early photomontage was also meant to critique the forces of business and commerce as well as the Expressionist art movement. From Heartfield's Dada period onward, he diverged from his use of photomontage in his art.

Heartfield's work changed a great deal as he moved away from his earliest Dada-influenced pieces and toward photomontages more explicitly in reaction to current events. This shift was connected to his increasing involvement with the German Communist Party. The 1924 photomontage entitled *Ten Years Later: Fathers and Sons*, inspired by the ten year anniversary of the beginning of World War I, was his first piece that made explicit reference to contemporary events. In it, a row of skeletons appears to be suspended above a group of very young boys dressed as soldiers marching to war. In the foreground looms a German general, positioned to lead the young soldiers. Both a remembrance of the dead and a warning against future wars, this piece provoked strong reactions when it was displayed, enlarged, and surrounded by various mementos of the war, in the front window of his and Weiland's bookstore and publishing house, Malik Verlag. At one point, it attracted such a crowd that the police had to be called in to restore the flow of traffic outside the storefront.

Heartfield continued to use photomontage as a means of political critique for the balance of his career. Like many politically motivated artists, he did not seek distribution through the traditional channels of museums or galleries—though it did eventually find him in some small degree—but rather in posters, postcards, and on book and magazine covers, mostly those published through Malik Verlag. His work as a book jacket designer was also his primary means of financial support. The majority of Heartfield's work appeared initially in the magazine *Arbeiter-Illustrierte-Zeitung*, or *A-I-Z* (The Workers' Illustrated Newspaper). The Communist-affiliated magazine, aimed primarily at German workers, was founded in Berlin in 1925 but, like Heartfield himself, was forced to relocate to Prague in 1933 when Hitler came to power. *A-I-Z* was remarkable for two reasons: (1) unlike other similarly-aimed periodicals of the time, it used photography in an innovative way, and (2) it is one of the few examples outside of the former Soviet Union of avant-garde art that success-

fully reached a mass audience. Though Heartfield contributed photomontages to *A-I-Z* as early as 1930, his contributions were more frequent and substantial after his flight from Germany. He became an editor of the magazine for a time, and was frequently provided space for commentary on current events. In 1938, shortly before Germany invaded Czechoslovakia, the magazine ceased production and Heartfield fled to England under threat of extradition back to Germany. He also published works in the magazine *VI—Volks Illustrierte* (People's Illustrated).

An apt example of Heartfield's work during this period is *Adolf—the Superman. Swallows gold and spouts junk* (1933) (*Adolf, der Übermensch: Schluckt Gold und redet Blech*). This photomontage, one of his better known works, appeared in *A-I-Z* and subsequently received a form of mass distribution via large reproductions posted throughout Berlin. The image is one of Hitler, mouth open as if to speak. His chest cavity appears to be an X-ray, so that his ribs are visible, as are the gold coins that form his spine and fill his stomach. Both the subject matter and formal features of this photomontage illustrate many of the important aspects of Heartfield's mature work. The majority of his pieces produced for *A-I-Z* were directed specifically against Hitler and the Nazis. The use of the title—which is as much a caption, and a part of the work itself, as it is a title—to explicate and reinforce the meaning of the images is a feature that becomes more prevalent during this period. Finally, the combination of images from conventional (often journalistic) photography with those that have been manipulated to create a visual disruption was a common technique in Heartfield's photomontages.

Once in England, although Heartfield continued to support himself as a commercial artist and a book jacket designer, he also continued his anti-Nazi work. His work was included in the group exhibition *Living Art in England*. A version of *Kaiser Adolf: The Man Against Europe* appeared on the front page of *Picture Post* in September 1939, but in 1940 Heartfield was interned as a person of German nationality. This not only restricted his artistic output, it also adversely affected his health. In 1950, he was able to repatriate to Germany and settled first in Leipzig, later in East Berlin. He there returned to his former work as a designer of stage sets, book jackets, and political posters. Once back in Germany, he received a number of honors and awards, such as his nomination by Bertolt Brecht to the German Academy of Arts in 1956. However, like Heartfield, Brecht was an outsider in the post-World War II German art and political scene. The milieu of the German art that remained was much different than it had been in the

interwar period. Avant-garde artistic techniques such as photomontage were held suspect in favor of social realism. Finding himself a committed artist without an organization to be committed to, Heartfield's later life provided an example of the conundrum of the Western artist who would attempt to make political art outside the gallery system.

Yet John Heartfield's work has endured and continues to inspire generations of politically motivated artists. His photomontage style has also had a deep impact on advertising photography, particularly in the juxtapositions of startling imagery with sociopolitical commentary. He particularly inspired Andy Warhol, who emerged from an advertising background to become one of the most influential artists of the twentieth century.

SCARLETT HIGGINS

See also: **Agitprop; History of Photography: Interwar Years; Manipulation; Montage; Photography in Germany and Austria; Propaganda**

Biography

Born Helmut Herzfeld in Berlin-Schmargendorf, Germany, 19 June 1891. Studied at Royal Bavarian Arts and Crafts School, Munich, Germany, 1907–1910; Arts and Crafts School in Berlin-Charlottenberg, 1912–1914. Commercial artist for paper manufacturers Bauer Brothers, Mannheim, 1911–1912. Military service, 1914–1916. Founded periodical *Neue Jugend* and publishing house Malik Verlag with his brother, Wieland Herzefelde, 1916–1918. During same period, also directed scientific documentaries for UFA in Berlin and designed scenery for films. With his brother and George Grosz, edited satirical magazines *Jedermann sein eigner Fussball* and *Die Pleite*; with Grosz and Raoul Hausmann edited *dada 3*, 1919–1920. Scenic director of the Max Reinhardt Theatres in Berlin, 1921–1923. Editor of satirical magazine, *Der Knüppel*, 1923–1927. Designed photomontages for *Arbeiter Illustrierte Zeitung* (AIZ) and book covers for the Malik Verlag and other publishers, 1929–1933. Designed book covers and illustrations for the publisher Lindsay Drummond and Penguin Books, 1941–1950. Received offer of lectureship on satirical graphics at Humboldt University in East Germany, 1948. Designed scenery and posters for the Berliner Ensemble and Deutsches Theater in Berlin, 1950. Received full professorship at the Deutsche Akademie der Künste, 1960. Won first prize for a mural at Werkbund Exhibition in Mannheim, 1914. Nominated by Bertolt Brecht to the German Academy of Arts, GDR, 1956. German National Prize for Art and Literature, 1957. Medal for Fighter against Fascism, 1933–1945, 1958. Peace Prize of the GDR, 1961. Died in Berlin, 26 April 1968.

Individual Exhibitions

1932 While visiting the USSR, exhibits in Moscow
1920 Exhibits in Strasbourg
1934 Narodnig galerie; Prague, Czechoslovakia

1935 Maison de la Culture, Paris, France
1938 ACA Gallery; New York
1940 Illegal exhibition; Basel, Germany
1946 Exhibits in Amsterdam, the Netherlands
1957 *John Heartfield and the Art of Photomontage*; Deutsche Academie der Künste, Berlin, Germany (traveled to Erfurt, Halle)
1958 Exhibitions in Moscow, Peking, Shanghai, and Tientsin
1965 *John Heartfield*; Ernst Múzeum, Budapest, Hungary
1969 *John Heartfield 1891–1968, Photomontages*; Institute of Contemporary Arts, London, England
 John Heartfield; Ausstellung der Deutschen Akademie der Künste zu Berlin, Berlin, Germany
1972 Deutsche Akademie der Künste; Berlin, Germany
1976 *John Heartfield*; Staatliche Museen zu Berlin, National-Galerie, Berlin, Germany
 Galerie Rönessance Röne Minde; Zurich, Switzerland
 One Man's War Against Hitler; Arcade Gallery; Bond Street, London, England
1980 *Grosz/Heartfield: the artist as social critic*; University of Minnesota, Minneapolis, Minnesota
1981 *Daumier & Heartfield: politische Satire im Dialog*; Staatliche Museen zu Berlin, Berlin, Germany
1986 *John Heartfield: Photomontages of the Nazi period*; Patrick & Beatrice Haggerty Museum of Art, Marquette University, Milwaukee, Wisconsin
1989 *"Benütze Foto als Waffe!": John Heartfield, Fotomontagen*; Ausstellung der Stadt-und Universitätsbibliothek Frankfurt am Main aus Anlass des Jubiläums; Frankfurt, Germany
 Hurray, the butter is gone!: John Heartfield's photomontages of the 1930s; Presentation House Gallery, North Vancouver, British Columbia
1992 *John Heartfield, AIZ: Arbeiter-Illustrierte Zeitung, Volks Illustrierte, 1930–1938*; Kent Gallery, London, England
1993 *John Heartfield: Photomontages*; Museum of Modern Art, New York, New York
1994 *Neged Hitler!: fotomontaz'im, 1930–1938*; Muze'on Yisra'el, Olam Spertus, Israel

Selected Works

Das Spiel Der Nazis Mit Dem Feuer (The Nazis Playing with Fire), *A-I-Z*, February 28, 1935
Auch ein Propagandaminister (Also a Propaganda Minister), *A-I-Z*, August 22, 1935
Die drei Weisen aus dem Sorgenland (The Three Magi from the Land of Sorrow), *A-I-Z*, January 3, 1935
Hitlers Friedenstaube (Hitler's Dove of Peace), *A-I-Z*, January 31, 1935

Hitlers bester Freund (Hitler's Best Friend, *A-I-Z*, August 15, 1935
Hitler erzahlt Marchen II (Hitler tells Fairy Tales II), *A-I-Z*, March 5, 1936

Selected Group Exhibitions

1920 *International Dada Fair*; Burckhard Gallery, Berlin, Germany
1928 *Film und Foto*; International Werkbund, Stuttgart. Also, first ABRKD exhibition, *Kapital und Arbeit*; Berlin; and Novembergruppe exhibition, Berlin, Germany
1934 International Caricature Exhibition; Mánes Gallery, Prague, Czechoslovakia
1937 *50 Years at Mánes*; Mánes Gallery, Prague, Czechoslovakia
1939 *Living Art in England*; London Gallery, Cork Street, London, England
1946 *Militant Art*; Basel, Germany
1966 "Der Malik-Verlad 1916–1947"; Berlin, Germany

Further Reading

George Grosz, John Heartfield, and the Malik-Verlag, Boston: Ars Libri, Ltd., 1994.
Coles, A. *John Heartfield, 1891–1968*. Birmingham: Ikon Gallery, 1975.
Evans, David. *John Heartfield, AIZ: Arbeiter-Illustriete Zeitung, Volks Illustrierte, 1930–1938*. New York: Kent, 1992.
Evans, David, and Sylvia Gohl. *Photomontage: A Political Weapon*. London: G. Fraser, 1986.
Grosz, George, and John Heartfield. *Grosz/Heartfield, the Artist as Social Critic*. New York: Holmes & Meier, 1980.
Heartfield, John. *John Heartfield 1891–1968; Photomontages Exhibition Held at the Institute of Contemporary Arts, 6 October–8 November 1969*. London: Arts Council of Great Britain.
Heartfield, John, and Weiland Herzfelde. *Photomontages of the Nazi Period*. London: Gordon Fraser Gallery [for] Universe Books, and New York: Universe Books, 1977.
Herzfelde, Wieland. *John Heartfield: Leben und Werk*. Dresden: Verlag der Kunst, 1962, revised edition, 1971.
Herzfelde, Weiland, Wolfgang Simon, and John Heartfield. *Der Malik-Verlag, 1916–1947*. Leipzig: Zentralantiquariat der Deutschen Demokratischen Republik, 1985.
Kahn, Douglas. *John Heartfield: Art and Mass Media*. New York: Tanam Press, 1985.
Weiss, Murray. *John Heartfield: Photomontages of the Nazi Period*. Milwaukee, WI: Patrick and Beatrice Haggerty Museum of Art, Marquette University, 1986.
Willett, John. *Heartfield versus Hitler*. Paris: Éditions Hazan, 1997.

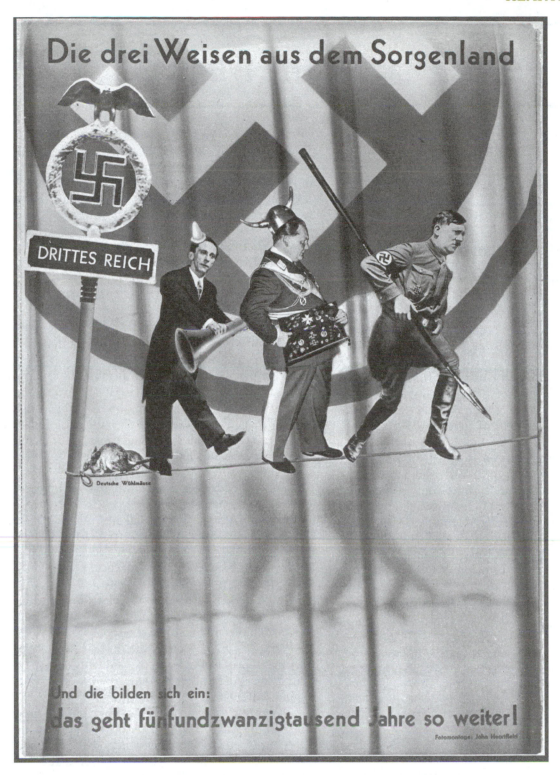

John Heartfield (Helmut Herzfelde), Die drei Weisen aus dem Sorgenland (The three magi from the Land of Sorrow), from "AIZ, Das Illustrierte Volksblatt," January 3, 1935, p. 16, rotogravure print, rephotographed montage with typography, 37.9 × 26.9 cm, Museum Purchase, ex-collection Barbara Morgan.
[*Photograph courtesy of George Eastman House*]

DAVID MARTIN HEATH

Canadian, born United States

David Martin Heath, photographer and teacher, began photographing in the early 1950s and in 1957 moved to New York City where he developed his own dark, lyrical style of "street photography" while working as a photo assistant to earn a living. His deep commitment to the art of photography propelled him to publish the seminal book, *A Dialogue with Solitude*, in 1965, which was the outcome of two successive Guggenheim fellowships in 1963 and 1964. His photographs explore the human psyche, delving deeply into the most intimate moments of his subjects, and communicate these emotions on both very personal and universal levels. His subjects include the wide array of emotions found in children, the relationships between men and women of all ages, and the character of solitude and fragility. Using a variety of media from 35 mm to Polaroid instant film, Heath's studio is the street where he photographs human nature and the human condition. His influences came from not only photography and the arts, but from philosophy, religion, and childhood experiences. Fundamentally, his photographs are best viewed not as single images, but as sequences: series of emotions, thoughts, and responses to what he is seeing in his environment, presented in poetic relationships to each other to elicit an effective and affective sense of his vision.

> What I have endeavored to convey in my work is not a sense of futility and despair, but an acceptance of life's tragic aspects. For out of acceptance of this truth: that the pleasures and joys of life are fleeting and rare, that life contains a larger measure of hurt and misery, suffering and despair—must come not the bitter frustration and anger of self-pity, but love and concern for the human condition.

(Heath 2000, Preface)

Born in Philadelphia on 24 June 1931, Heath was abandoned by his parents at the age of four years old and grew up in foster homes and orphanages until quitting school at the age of 16 to pursue a job as a photo finisher. After his service at the end of the Korean War, he returned to the United States with an even keener interest in photography and pursued post-secondary education in the Philadelphia and Chicago areas. Heath was influenced and inspired by the photo essays in the magazines of the 1940s and 1950s, and was particularly moved by Ralph Crane's 1947 *Life* magazine essay "Bad Boy's Story" concerning orphans and foster children, which addressed his personal experience.

In 1957, Heath left Chicago for New York City, where he attended a class with W. Eugene Smith at the New School for Social Research in 1959 and a workshop in Smith's loft in 1961. Inspired by the photographs of his teacher, he realized the power that photography had as a means of artistic expression. Heath worked as an assistant to commercial photographers during the late 1950s and early 1960s and attempted to build a career around photojournalism. However, his desire was to be a creative photographer. His photographs were exhibited first in the 7 Arts Coffee Gallery in New York, and he was given his first major one-man show by the Image Gallery in 1961. In 1964, his photographs were published by *Contemporary Photographer* (Winter 1963/1964) published by Lee Lockwood, himself a photojournalist. During the 1960s, he exhibited with major museum and university art galleries, including the Museum of Modern Art, New York, the George Eastman House, Rochester, New York, and Yale University in New Haven, Connecticut.

His street photographs of the 1950s and 1960s were influenced more by the work of Robert Frank, which stressed the ambiguity possible in the single image and its relationship to other images in a sequence. His photographs—tragic, comic, and poetic—are imbued with a sense of solitude of the individual. "Disenchantment, strife and anxiety enshroud our times in stygian darkness" (Heath 2000).

Recognized as one of the seminal photography books of the 1960s, *A Dialogue with Solitude* remains the central body of work by which Heath is recognized. The 82 photographs, taken over a ten-year span from his service in Korea to his time in Philadelphia, Chicago, and New York City, achieve the unified and meaningful statement that he sought in his work. Arranged in 10 sections and designed to be viewed in sequence, the photographs investigate the human condition—from isolation, loneliness, despair, and destruction to laughter and love. John Szarkowski, Director of Photography at the Museum

of Modern Art, has said that Heath's photographs "combined the freedom and spontaneity of the small-camera approach with a rare formal intensity and precision. His pictures possess stability, simplicity and great emotional force." The book is a moving, eloquent statement of both hope and despair.

Through his teaching, Dave Heath has quietly influenced a wide range of photographers and is the direct antecedent of photographers who turn their cameras on subjects that have a deep personal connection to their lives, such as Larry Clark and Nan Goldin. Heath taught at the Dayton Art Institute, Ohio, and Moore College of Art in Philadelphia, Pennsylvania in the late 1960s before moving to Toronto to teach at the Ryerson Polytechnical Institute from 1970 to 1996. Having a deep affinity with the work of Diane Arbus, and having been greatly affected by her suicide in 1972, he continued to photograph, but redirected his investigation to new mediums—most particularly those of the instant Polaroid, slide sound projections, and journals, which he continues to work on today.

Dave Heath presently lives in Toronto, Canada, where he is represented by Michael Torosian (Lumiere Press) who recently re-issued *Dialogue with Solitude* (2000). Howard Greenberg Gallery in New York City also represents him. Heath's photographs can be found in numerous collections, including the Museum of Modern Art, New York; the Art Institute of Chicago; the International Museum of Photography, George Eastman House in Rochester, New York; and the National Gallery of Canada in Ottawa.

VINCENT CIANNI

See also: **Frank, Robert; Street Photography**

Biography

Born in Philadelphia, Pennsylvania, 24 June 1931; Served in the U.S. Army during the Korean War, 1952–1954; studied at Institute of Design, Illinois Institute of Technology, Chicago, 1955–1956; moved to New York City and worked as an assistant, 1957; first solo exhibition at Image Gallery, 1961. Instructor in Photography at the School of the Dayton Art Institute, Ohio, 1966–1967; Moore College of Art, Philadelphia, Pennsylvania, 1967–1969; Ryerson Polytechnic Institute, Toronto, Canada, 1970–1996. John Simon Guggenheim Memorial Fellowship, 1963, 1964; Canada Council Grant, 1981. Currently lives in Toronto, Canada.

Selected Works

Korea, 1953
Vengeful Sister, Chicago, 1956
Sheila and Arnie at 7 Arts Café, 1958
Couple Kissing, c. 1961
Cleveland, Ohio, April 1966

Individual Exhibitions

1958 7 Arts Coffee Gallery, New York, New York
1961 Image Gallery, New York, New York
1963 *A Dialogue with Solitude*; Art Institute of Chicago, Chicago, Illinois, and traveled to George Eastman House, Rochester, New York
1964 *David Health/Paul Caponigro*; Heliography Gallery, New York, Judson Memorial Church, New York City, New York
1968 Phoenix College, Phoenix, ArizonaFocus Gallery, San Francisco, California
1979 *Songs of Innocence*; Walter J. Phillips Gallery, Banff, Alberta
1981 *A Dialogue with Solitude and SX-70 Polaroid Works*; National Gallery of Canada, Ottawa, Ontario
1982 *Omnia Vanitas*; International Center of Photography, New York, New York
1983 Rhode Island School of Design, Providence, Rhode Island
1988 *Dave Heath: Work from the 50s and 60s*; Photofind Gallery, New York, New York
1994 *A Dialogue with Solitude*; Minneapolis Art Institute, Minneapolis, Minnesota
2001 *Dave Heath*; Howard Greenberg Gallery, New York City (in conjunction with the re-issue of *A Dialogue with Solitude*)

Selected Group Exhibitions

1958 *Group Exhibition*; New York Public Library, Hudson Park Branch, New York, New York
1963 *A Bid for Space IV*; Museum of Modern Art, New York, New York
 Photography 63: An International Exhibition; George Eastman House, Rochester, New York
1965 *Photography in America 1850–1965*, Yale University Art Gallery, New Haven, Connecticut
 Photographs from the George Eastman House Collection 1900–1964; New York World's Fair, Queens, New York
1966 *American Photography: The Sixties*; Sheldon Memorial Art Gallery, University of Nebraska, Lincoln, Nebraska
 Contemporary Photographers II; George Eastman House, Rochester, New York
1967 *Contemporary Photography Since 1950*; New York State Council for the Arts, Rochester, New York
 Photography in the Twentieth Century; The National Gallery of Canada, Toronto, Ontario
1974 *Ryerson: A Community of Photographers*; Royal Ontario Museum, Toronto, Ontario
1978 *Mirrors and Windows*; Museum of Modern Art, New York, New York
1980 *The Magical Eye*; National Gallery of Canada, Ottawa, Ontario
1990 *Street Engagements: Social Landscape Photography of the 60s*; International Museum of Photography, George Eastman House, Rochester, New York

1993 *Magicians of Light: Photographs from the Collection*; National Gallery of Canada, Ottawa, Ontario

1994 *The Family*; Canadian Museum of Contemporary Photography, Ottawa, Ontario

Further Readings

Borcoman, James. "David Heath: A Dialogue With Solitude." *Journal of the National Gallery of Canada.* Ottawa: The National Gallery of Canada: October 5, 1979.

Borcoman James. *Magicians of Light: Photographs from the Collection of the National Gallery of Canada.* Ottawa: National Gallery of Canada, 1993.

Davis, Keith. *An American Century of Photography.* New York: Hallmark/Abrams, 1999.

Doty, Robert. *Photography in America.* Whitney Museum of American Art, New York City: Random House, 1974.

Heath, Dave. *A Dialogue With Solitude.* New York: Community Press, 1965.

Heath, Dave, and Robert Frank. *A Dialogue With Solitude.* Toronto: Lumiere Press, 2000.

Lyons, Nathan. *Photography in the Twentieth Century.* New York: George Eastman House of Photography and Horizon Press, 1967.

Szarkowski, John. *Mirrors and Windows.* New York: Museum of Modern Art, 1978.

Torosian, Michael. *Extempore.* Toronto: Lumiere Press, 1988.

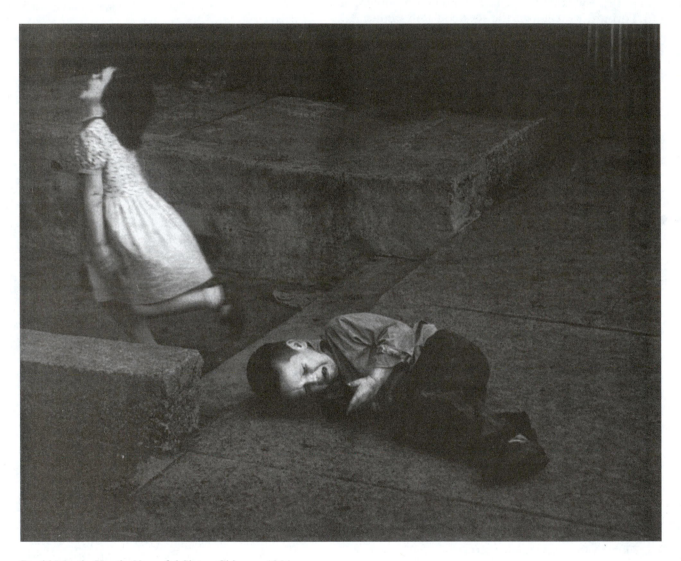

David Martin Heath, Vengeful Sister, Chicago, 1956.
[© *Courtesy Lumiere Press*]

ROBERT HEINECKEN

American

Robert Heinecken is a pioneering figure in contemporary photography and somewhat of a paradox, as he is a photographer who has rarely taken a picture. Although not as well known as many of his contemporaries his influence has been significant, both for his creative work and his role as an educator. Putting forth some of the earliest ideas about "photo-sculpture"—three-dimensional structures upon which photographs were presented, exploring notions about mass media and popular culture, and exploring the form now known as artists' books, Heinecken's work was an integral part of the aesthetic pressure-cooker that was Southern California in the 1960s and 1970s. In the early 1960s he founded the photography program at the University of California at Los Angeles (UCLA), eventually mentoring dozens in the graduate program, many of whom have gone on to significant careers, including photographers David Bunn, Patrick Nagatani, Jo Ann Callis, John Divola, and Ellen Brooks, video artist Scott Rankin, and author and teacher James Hugunin.

Born in 1931 in Denver, Colorado, the only child of a Methodist minister, a missionary from a family of missionaries, Heinecken attended public schools in Colorado and as a boy took informal art lessons. The family relocated to Los Angeles and then Riverside, California, where Heinecken attended high school and a community college, continuing his interest in art. His early adulthood was rebellious; enrolling in UCLA, he was put on probation and dropped out after less than two years of study. To avoid the draft for the Korean War, he enlisted in the U.S. Navy as a Naval Aviation Cadet. Although barely meeting the minimum height requirement (years later admitting he stuffed his boots with newspaper), he found the discipline of the military helpful. Eventually he was commissioned as a Second Lieutenant in the U.S. Marine Corps as a jet fighter pilot, where he trained other pilots and achieved the rank of Captain.

After discharge Heinecken returned to UCLA where he met Edmund Teske, who was working as a figure model, and became associated with Linda Connor and Jack Welpott, who was the first MFA candidate in photography accepted into the graduate program. He also met the influential artist Wallace Berman, also a poet and small-press publisher. His interest in American visual culture began early; he presented an audio-visual program at Aspen Design Conference in 1963 on the topic. It was in 1965 that he attended the meeting in Rochester, New York, that led to the formation of the Society for Photographic Education, where he met Nathan Lyons, Carl Chiarenza, Jerome Liebling, Van Deren Coke, Minor White, and Beaumont Newhall, all of whom were to become important friends as well as colleagues.

Although chiefly associated with California, in the mid-1980s Heinecken began living alternative years in Chicago, serving as a guest instructor at the School of the Art Institute. The motivation for this was his relationship with photographer Joyce Neimanas, whom he had met in mid-1976 when serving as a guest instructor at Columbia College. Heinecken quickly became an integral part of Chicago's important photography community, which included SAIC colleague Kenneth Josephson. His seminal photo-installation *Waking Up In New America* was presented at the Art Institute of Chicago in 1987. Heinecken continued to teach at UCLA until his retirement in 1991 after which he was appointed Professor Emeritus; in 1996 he relocated to Chicago full-time.

Although Heinecken is thought of and identifies himself as a photographer, his only use of a camera was the Polaroid SX-70, with which he created the artists' book and series *He:/She:* in the mid-1970s. His career is not without controversy; a continuing motif is pornography, and his work has been criticized as being misogynist, as typified by the 1973 mixed-media work *Lingerie for a Feminist Suntan #3*. This work challenges feminist teachings that the male gaze is harmful and exploitative in any and all of its forms with a prickly humor that most likely confirmed his detractors' opinions. Consisting of a life-size photograph of a voluptuous nude woman, actual bra and panties are displayed on a hanger attached to the work. The areas usually covered by this clothing are hand-colored with a wash of brown; the rest of her body is pale.

Heinecken's ideas about sculpture and photography helped initiate the seminal 1970 exhibition at the Museum of Modern Art, New York, *Photogra-*

phy into *Sculpture* in which his so-called "puzzle pieces" (images adhered to blocks of wood that could be refigured) were included. In 1969, his audacious act of screening grisly Vietnam war photographs over the existing images in the pages of a number of *Time* magazines, and placing them back on the newsstand where they were sold has become legendary and inspired a rich vein of investigation into the commercial print medium. Exemplifying this interest is one of Heinecken's best-known series, the folio *Are You Rea* (1966–1968). To create these works, the artist used magazine pages as "negatives," which produced prints that merge images from both sides of the original pages.

These often disturbing images fused text and image as well as image and image, indicating another of Heinecken's interests, the relationship of image and text which culminated in *The S.S. Copyright Project "On Photography"* of 1978. Using a method that is now very familiar to us through the paintings of Chuck Close, this large-scale work features in one panel the image of writer Susan Sontag created through a montage of black-and-white snapshots of the artist, his friends, his California studio, his car, his everyday life, and what he has called "waste photos found in the UCLA lab" almost carelessly stapled onto a board. The other panel creates Sontag's likeness through photographs of the text of her book, *On Photography*, variously exposed to achieve a range of dark and light. A text panel aggressively placed between these two images begins "An intense comparison of these two pictures intends to throw light on a few serious on-going dilemmas which have plagued photography since its inception in 1833 and its re-discovery in 1977." a sarcastic reference to the publication date of Sontag's volume. Everything photography is about and everything that it does to the eye and mind is somewhere in this work.

In the 1990s, Heinecken turned to more personal themes, including a cycle of photomontages using the image of the Hindu god Shiva. He had discovered later in life his maternal grandmother had been Indian, and the attributes of this god of destruction and creation allowed him to extend his investigations into the nature of photographic imagery and its uses in and impact on contemporary culture. He has exhibited widely and internationally and is in the collections of most major museums in the United States.

LYNNE WARREN

See also: **Artists' Books; Coke, Van Deren; Conceptual Photography; Connor, Linda; Josephson, Kenneth; Liebling, Jerome; Newhall, Beaumont; Sontag, Susan; Teske, Edmund; The Museum of Modern Art; Welpott, Jack; White, Minor**

Biography

Born October 29, 1931, Denver, Colorado. Educated in Denver, Los Angeles, and Riverside, California, public schools. 1949–1951, Attends Riverside Junior College, receiving A.A. degree with emphasis in art. 1951–1953, Attends University of California, Los Angeles, drops out. 1953, Enlists in U.S. Navy as Naval Aviation Cadet, receives Pilot Wings in 1954, discharged Captain in the U.S. Marine Corps in 1957; member of USMC Active Reserve until 1966. Marries Janet M. Storey in 1955, three children. Re-enrolls in UCLA in 1957, receiving B.A. in 1959, serves as teaching assistant. Receives M. A. in 1960, and is appointed Instructor, Department of Art. 1962 initiates photography curriculum in fine-arts context and appointed Assistant Professor. 1970s active teaching workshops, including Ansel Adams Workshops at Yosemite National Park; meets photographic model Twinka Thiebaud and begins relationship. 1976, meets photographer and future wife Joyce Neimanas in Chicago; Culver City studio and contents destroyed in fire. 1977, National Endowment for the Arts Photographers Fellowship. Separates from family, divorced 1980. 1980, Receives Guggenheim Fellowship. 1980s begins teaching at the School of the Art Institute of Chicago. 1991, Retires from UCLA; appointed Professor Emeritus in the Department of Art, relocates to Chicago 1996. 1997, Kiyosato Museum of Photographic Arts, Kiyosato, Japan acquires The Robert Heinecken Collection of approximately 900 contemporary photographs and related items collected by Heinecken from friends and colleagues. 1999, Completes extended interviews for UCLA Oral History Program. Archives transferred to the Center for Creative Photography, Tucson, Arizona.

Selected Works

Refractive Hexagon, 1965
Are You Rea portfolio, 1966–1968
Cream 6, 1970
Different Strokes, 1970/97
Lingerie for a Feminist Suntan #3, 1973
Cliché Vary, Lesbianism, 1974
Cliché Vary: Autoeroticism, 1974
Cliché Vary: Fetishism, 1974
He:/She:, 1974–1978
Space/Time Metamorphosis #1, 1975
Space/Time Metamorphosis #2, 1976
The S.S. Copyright Project "On Photography," 1978
Case Study in Finding an Appropriate TV Newswoman (A CBS Docudrama in Words and Pictures), 1984
"Shiva, King of Dancers" Manifesting as a Transvestite, 1992

Individual Exhibitions

1960 Art Galleries at the University of California, Los Angeles, California
1965 Long Beach Museum of Art, Long Beach, California

1972 *Robert Heinecken: Photographic Work*; Pasadena Art Museum, Pasadena, California
1973 Light Gallery, New York, New York
1977 International Museum of Photography, George Eastman House, Rochester, New York, and traveling
1979 Forum Stadtpark, Graz, Austria
1980 Werkstadt für Fotographie, West Berlin, Germany
1983 *Robert Heinecken: Food, Sex and TV*, Fotoforum, Universität Kassel, Kassel, West Germany
1987 *Television/Source/Subject: Photographic Works and Installations by Robert Heinecken*, Art Institute of Chicago, Chicago, Illinois

1989 *Robert Heinecken 1962–1989;* Pace/MacGill Gallery, New York, New York
1990 Gallery MIN, Tokyo, Japan
1999 *Robert Heinecken: Photographist, a Thirty-Five Year Retrospective;* Museum of Contemporary Art, Chicago, Illinois, and traveling

Group Exhibitions

1967 *Contemporary Photography Since 1950*; George Eastman House, Rochester, New York

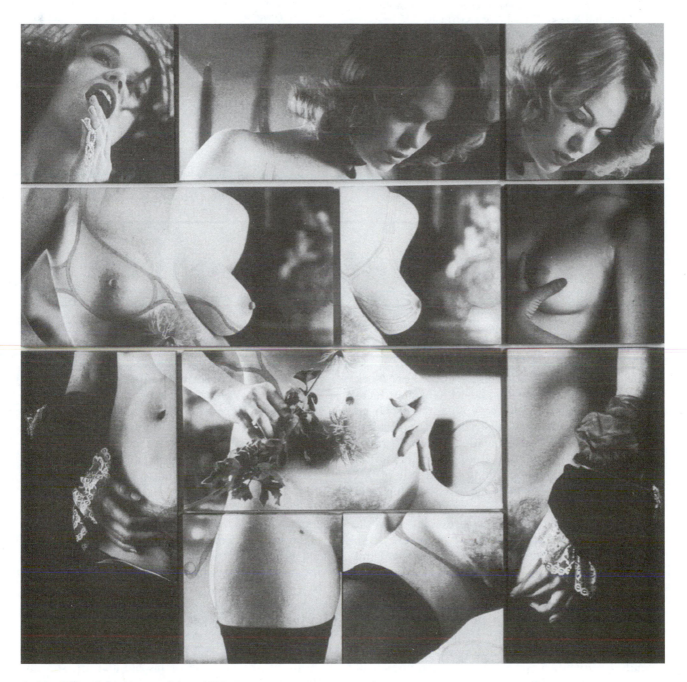

Robert Heinecken, Autoeroticism, 1975.
[© *Robert Heinecken, Courtesy of Pace/MacGill Gallery*]

1968 *Photography as Printmaking;* Museum of Modern Art, New York, New York

1970 *Photography into Sculpture*; Museum of Modern Art, New York, New York

1974 *Artists' Books*; Moore College of Art, Philadelphia, Pennsylvania, and University of California Art Museum, Berkeley, California

 Photography in America; Whitney Museum of American Art, New York, New York

1978 *Mirrors and Windows: American Photography Since 1960*; Museum of Modern Art, New York, New York, and traveling

1981 *Photo Recycling: Photo oder Die Fotografie im Zeitalter ihrer technischen Reproduzierbarkeit*; Fotoforum, Universität Kassel, Kassel, West Germany

1983 *Big Pictures by Contemporary Photographers*; Museum of Modern Art, New York, New York

1987 *L.A. Hot and Cool: Temperaments and Traditions*; M.I.T. List Visual Arts Center, Cambridge, Massachusetts

1989 *On the Art of Fixing a Shadow: One Hundred and Fifty Years of Photography*; National Gallery of Art, Smithsonian Institution, Washington, D.C., and traveling

1993 *Proof: Los Angeles Art and the Photograph, 1960–1980*; Laguna Art Museum, Laguna Beach, California, and traveling

Further Reading

Durant, Mark Alice, and Amy Rule. *Robert Heinecken: A Material History*. Tucson, AZ: Center for Creative Photography, 2003.

Enyeart, James L., ed. *Heinecken*. Carmel, CA, and New York: Friends of Photography/Light Gallery, 1980.

Lyons, Nathan, ed. *The Persistence of Vision*. Rochester, NY: George Eastman House, 1967.

Coke, Van Deren, Henri Barendsi, Darwin Marable, et al. *Light and Substance*. Albuquerque: The University of New Mexico, 1973.

"Robert Heinecken." In *Great Photographers*. Alexandria, VA: Time-Life Books, 1983.

Robert Heinecken: Food, Sex and TV. Kassel, West Germany: Edition Fotoforum, Universität Kassel, 1983.

Walsh, George. "Heinecken, Robert." In *Contemporary Photographers*. New York: St Martin's Press, 1982.

Warren, Lynne, A.D. Coleman, et al. *Robert Heinecken: Photographist*. Chicago: Museum of Contemporary Art, 1999.

NANCY HELLEBRAND

American

Nancy Hellebrand is a photographer whose work has moved from the black-and-white social documentary photography of people that she began in the early 1960s to more abstract black-and-white studies of faces and bodies made in the early 1980s to her most abstract nature studies in color, begun in the late 1980s and continuing to the time of this writing. Although her photography, printing, and even subject matter have changed dramatically from the time of her earliest to her latest work, Hellebrand's work as a whole seeks to reveal the truth or essence of her subjects as she sees them and as she wishes them to be seen.

Hellebrand began her college education as an art major. Her discovery of photography as the artistic medium she would follow occurred during her first year of college at USC in 1963 with a course being taught there by Bernie Kantor. As she pursued social documentary photography, her choice of black-and-white 35-mm seemed a somewhat natural choice. Another photography course Helleb-

rand took in New York with Alexey Brodovitch in 1964 was crucial to Hellebrand's development of a personal vision. Brodovitch influenced her by stressing that when photographing, one's personal view should take precedence over known orientation to subject. Following one's impulses was of more artistic merit than portraying the strictly familiar.

While pursuing her bachelor's degree, from 1964–1965 Hellebrand apprenticed to David Attie, a commercial photographer. From 1966–1967 she was a studio manager for John Cochran, a fashion photographer. In 1967, Hellebrand opened a photography studio in New York, shooting commercial, editorial, and informal portraits in black-and-white 35-mm. She also taught photography at Parson's School of Design, New York in 1970. In 1971, Hellebrand received her B.A. in English Literature from Columbia University. In that year, she closed her studio and moved to London to study photography privately under Bill Brandt until 1974. Bill Brandt influenced Hellebrand chiefly by the example of his life and art, showing Hellebrand that a lifestyle devoted to the pursuit of art was highly desirable and extremely worthwhile.

From 1971 through 1974, Hellebrand produced a series of medium format black-and-white photographs of Londoners in their homes. The portraits that she captured culminated in a solo exhibition for Hellebrand at London's National Portrait Gallery in 1974, and a book, *Londoners at Home*, published in the same year. Her portraits, representing a variety of Londoners of varying ages, sexes, occupations, and classes, all convey a common sense of the desperation of her subjects. For instance, the photograph shown on the cover and plate #7 in *Londoners at Home*, entitled "Young girl (13 years old)," portrays a seated female who is trying to appear to be a grown woman. Her extended hand with engagement/wedding band upon it, holding a burning cigarette, would seem to illustrate that she is indeed a woman. One could merely accept the image the young girl is projecting, except that her self-conscious expression and stance belie it. Coupled with that, the completely empty space Hellebrand has left around the girl further diminishes her façade of womanhood.

Many of Hellebrand's other photos from *Londoners at Home* show a hodgepodge of possessions in her subjects' homes that Hellebrand carefully included to reflect some truth about their owners. Photographing with a medium-format camera and wide-angle lens corrected for distortion, Hellebrand got very close to her subjects and took in just as much of their home's surroundings as she wanted to convey her ideas. In choosing challenging existing light in what were obviously poorly or unevenly lit and shadowy apartments, Hellebrand made an artistic decision to emphasize the real over the artificial. Despite the great degree of stillness that must have been required on the part of her subjects, they still appear to look real—natural in their surroundings.

In 1974, Hellebrand returned to Philadelphia and began exhibiting her work at Light Gallery in New York. She taught photography at Philadelphia College of Art in 1975 and at Bucks County Community College from 1975 to 1988. The early 1980s marked the beginning of a transitional period for Hellebrand's photography, moving away from the documentary approach toward people she'd pursued for roughly 20 years and toward an abstract approach. As her focus changed, so too did her medium. Using an 8 × 10-inch view camera, Hellebrand made extreme close-up portraits of faces and bodies. In carefully cropping within camera on certain parts of peoples faces and bodies, she made abstractions out of them. In the mid-1980s, Hellebrand photographed landscapes in 8 × 10, producing small platinum prints. A series of photographs of handwriting Hellebrand took in the late 1980s marked her turning point from documentation to abstraction. This work, inspired by Hellebrand's interest in calligraphy, was taken from samples of handwriting, greatly enlarged, toned brown, and printed on matte paper.

Hellebrand's artistic path, her shift from people to nature and from more conventional documentary to more experimental abstract, runs concurrent with her spiritual belief of Sufism as it relates to developing one's higher perception of reality beyond mere appearances. Her images of nature are not so much an expression of their object as they are an expression of her vision of nature and her interpretation of the divine within it. Hellebrand began to photograph in color and print digitally in the early 1990s, beginning with landscapes. In the late 1990s, she shot tree branches moving in the wind. Her untitled *Water Series #754*, an image taken from running water, is representative of the work she has done from 2002 to 2004, digitally photographing water and clouds and then manipulating the results. She has changed the apparent forms of nature, enhancing their color, texture, and contrast until her large-scale giclee prints (a digital process) appear very much like pastel drawings.

Hellebrand's work has appeared in many group shows, including major shows at the International Center of Photography and the Museum of Modern Art, in New York. Besides Hellebrand's 1974 solo exhibition at the National Portrait Gallery in London, she has had two major solo exhibits in 1984 and 1989 at Pace/MacGill Gallery, New York. Her work can be seen in many public collections, notably in the Museum of Modern Art in New York, the National Portrait Gallery in London, and the Philadelphia Museum of Art. Hellebrand has been the recipient of fellowships from the John Simon Guggenheim Memorial Foundation and the National Endowment for the Arts.

Tony De George

See also: **Abstraction; Brandt, Bill**

Biography

Born in Philadelphia, Pennsylvania, 1944. Attended University of Southern California, Los Angeles, 1962–1963; attended Boston University, Boston, Massachusetts, in 1963–1964; received B.A. in English Literature from Columbia University, New York in 1971. Studied photography at USC in 1963; studied photography briefly with Alexey Brodovitch in New York in 1964; studied photography with Bill Brandt in London, 1971–1973. Adjunct Professor at Parson's School of Design, New York, 1970; Adjunct faculty at Philadelphia College of Art, Philadelphia, Pennsylvania, 1975; Associate Professor of Art at Bucks County Community, Newtown, Pennsylvania, 1975–1986; Visiting critic at Yale Univer-

sity, New Haven, Connecticut, 1986–1987; Photography faculty at Yale University Summer Program, Norfolk, CT, 1987. John Simon Guggenheim Memorial Foundation Fellowship, 1984; National Endowment for the Arts, Photography Fellowship.

Individual Exhibitions

1974 *Londoners at Home, Photographs by Nancy Hellebrand*; The National Portrait Gallery, London, England
1984 *Nancy Hellebrand*; Pace/MacGill, New York, New York
1989 *Nancy Hellebrand Handwriting*; Pace/MacGill, New York, New York
2002 *Waters Rising*; Locks Gallery, Philadelphia, Pennsylvania
2004 *Water, Vapor*; Rosenfeld Gallery, Philadelphia, Pennsylvania

Group Exhibitions

1973 *Women Photographers*; The National Film Theatre, London, England
1975 Group Show, Light Gallery, New York, New York
1983 *Big Pictures by Contemporary Photographers*; Museum of Modern Art, New York, New York

1987 *National Endowment for the Arts Anniversary Exhibition*; Museum of Modern Art, New York, New York *Legacy of Light*; International Center of Photography, New York, New York
1990 *Contemporary Artists*; Philadelphia Museum of Art, Philadelphia, Pennsylvania
1991 *Philadelphia Art Now: Artists Choose Artists*; Institute of Contemporary Art, Philadelphia, Pennsylvania
1995 *Large Bodies*; Pace/MacGill, New York, New York

Selected Works

Young Girl (13 years old), 1972
Joy, 1982
Untitled, Water Series #754 (taken from 2002–2004, undated)

Further Reading

Chiefetz, Dan, and Nancy Hellebrand. *Theater in My Head.* Boston: Little, Brown and Company, 1971.
Edwards, Owen. "Multiple Personalities." *American Photographers* (December, 1985).
Grundberg, Andy. "About Face." *Modern Photography* (November 1983).

Nancy Hellebrand, Colorado Stream, #754, 2004. Giclee print, 36 × 48″.
[© *Nancy Hellebrand*]

Hellebrand, Nancy. *Londoners at Home: Photographs by Nancy Hellebrand.* London: Lund Humphries; distributed in U.S. by Light Impressions.

Hellebrand, Nancy. *Nancy Hellebrand "Writing" Catalogue.* New York: Pace/MacGill Gallery, 1989.

Hellebrand, Nancy. "Nancy Hellebrand: More than a Face." *Aperture* no. 91 (1983).

"Nancy Hellebrand: Londoners at Home." *Creative Camera* no. 124 (October 1974).

NIGEL HENDERSON

British

Nigel Henderson was an innovative artist working with photography who said of his work "I've never thought of myself as a photographer" and "I use the camera to draw." He had little interest in documentary photography or the fine print, preferring to transform reality using collage and a range of experimental print techniques. His collages, which he hoped would "stick a little bit in peoples' craw," relied on ephemera, neglected fragments, splashes, and marks, chance and contradiction, to produce what he described as an "expressive document," which was frequently laden with personal symbolism.

As a young man growing up in London in the 1930s, Henderson met many of the foremost European artists, intellectuals, and writers of the period and his work was shaped by these contacts. Although he has been seen as both a pop artist and a member of the New Brutalist movement of the 1950s, and his work has parallels with the mark-making of Abstract Expressionism, he himself acknowledged that his strongest influences were Dadaism and European Surrealism.

Henderson was born in 1917 in St. Johns Wood, London. His parents came from very different social backgrounds and divorced when he was seven. It was through his mother's involvement in the art worlds of London and Paris that, as a teenager and young man, Henderson met members of the Bloomsbury Group, T.S. Eliot, Bertoldt Brecht, Marcel Duchamp, Max Ernst, and other prominent artists and writers. He initially studied biology at Chelsea Polytechnic but left without completing the course and worked as an assistant at the National Gallery in London from 1936–1939. At about this time, he started painting seriously and experimenting with collage and, through his mother's friendship with the American collector, Peggy Guggenheim, showed early work in her gallery, Guggenheim Jeune.

He was 22 when war broke out and he became a pilot in Coastal Command, an experience which both enchanted him and left him "very, very jumpy" after five years of war. Imagery from his years of flying and time in the biology lab were both to find their way into his later work. In 1943, he married Judith Stephens, an anthropologist and niece of Virginia Woolf, and after the war they moved to the East End of London where she was working on a research project. Henderson received an ex-serviceman's grant to study at the Slade School of Art where he met the sculptor Eduardo Paolozzi, who became a great friend and collaborator on a range of projects.

By the late 1940s, Henderson was recovering from his war experience by walking the streets around his home in Bethnal Green, a working class area of almost Dickensian poverty. Later he said that

> I was consciously sometimes looking for chunks, bits of typification of Englishness—including the cliche 'British Oak' and all that and I still won't avoid it, it meant something to me. I think of these notions of the steadiness of the English character—and the war brought it out—and I found it very impressive, playing cricket in the street for instance was something I'd longed romantically to do.

In 1949, while a student at the Slade School of Fine Art, he took up photography initially in order to record the, to him, alien and fascinating world of Bethnal Green as source material for his work. In three years of photographing the area he created a remarkable visual record of a place and time. It was his only major documentary project and, like his collaged work, is redolent with a nostalgia for a culture about to disappear and a fascination with the ambiguity of reality.

When he began taking pictures Henderson enrolled on a technical course but found it unsympathetic and eventually taught himself photography. He also

started experimenting in his bathroom darkroom, making photograms, double exposures, distorted and folded paper prints, and drawing on glass negative plates. He sometimes hand coloured these complex images. As he saw it "if you encounter photography for yourself in a way you're going to reinvent photography for a while." These works were a starting point from which his later collages were to develop.

In the 1950s, he worked briefly for *Vogue* and the *Architectural Review* but gave up the idea of commercial photography when he was asked to teach photography at the Central School of Art and found teaching a "great stimulus" and a shared enthusiasm. After his move to Essex in 1954 he continued teaching, first at Colchester School of Art and later at Norwich School of Art, where he became Head of Photography in 1965. The Paolozzis had also moved to Essex and together the two couples set up Hammer Prints Ltd., a successful textile and ceramic design company.

In the 1950s, Henderson was part of the Independent Group based at the Institute of Contemporary Arts and was regarded as a key and influential figure of the period, in particular by his contemporaries. With his friends, Paolozzi and architects Alison and Peter Smithson, he was involved in two major and controversial exhibitions: *Parallel of Life and Art* at the Institute of Contemporary Arts in 1953 and *This Is Tomorrow* at the Whitechapel Art Gallery in 1956 for which the group made the installation *Patio and Pavilion*. A number of works by Henderson from this exhibition are now owned by the Tate.

However, although he was a prolific artist, Henderson professed a lack of interest in a career as an artist and was motivated by what he described in 1978 as a "very strong amateur passion. It's a very rude word now for some reason and I'm sorry because I like the word. It means doing things for the love of it. I can't see anything wrong with that." After his move out of London he exhibited less and was almost unknown to a generation of art lovers. It was only after his death in 1985 that his work gradually began to be exhibited again and recognised as a significant and influential contribution to the development of British art in the 1950s.

SHIRLEY READ

See also: **Manipulation; Montage**

Biography

Born in London, April 1 1917. Studied biology, Chelsea Polytechnic 1935–1936. Assistant to Dr Helmut Ruhemann, picture restorer, National Gallery, London, 1936–1939.

Pilot in Coastal Command, 1939–1945. Married Judith Stephens, 1943. Studied at the Slade School of Art, London, 1945–1949. Photographed the East End of London and made experimental imagery, 1949–1951. Photography tutor, Central School of Arts and Crafts, London, 1951–1954. Stressed photographs purchased by Brooklyn Museum of Art, New York, 1952. Parallel of Life and Art, exhibition organised with Paolozzi and architects Peter and Alison Smithson, Institute of Contemporary Arts, London, 1953. Moved to Essex, 1954. Co-founded Hammer Prints with Paolozzi, 1955. *This Is Tomorrow*, Whitechapel Art Gallery, London, with Paolozzi and the Smithsons, 1956. Teaching, Colchester School of Art, Essex, 1957–1960. Exhibited Cambridge University, 1960. Head of Photography, Norwich School of Art, 1965. Three works acquired by Tate Gallery, London, 1974–1975. Mural, University of East Anglia, 1975. Retrospective, Kettle's Yard, Cambridge, 1977. Died in Essex, 1985.

Individual exhibitions

1954 *Photo-Images*; Institute of Contemporary Arts, London
1960 *Nigel Henderson*; School of Architecture, University of Cambridge
1961 *Nigel Henderson: Recent Work*; Institute of Contemporary Arts, London
1977 *Nigel Henderson: Photographs, Collages, Paintings*; Kettles Yard, Cambridge
 Nigel Henderson: Paintings, Collages and Photographs; Anthony d'Offay Gallery, London
1978 *Nigel Henderson: Photographs of Bethnal Green 1949–1952*; Midland Group, Nottingham
1982 *Nigel Henderson*; Norwich School of Art, Norwich
1983 *Nigel Henderson*; Graves Art Gallery, Sheffield
 Nigel Henderson—Head-Lands: Self Portraits and Imagined Landscapes 1960–1983; Serpentine Gallery, London
 Nigel Henderson; John Hansard Gallery, Southampton
1989 *Nigel Henderson 1917–1986: Collages*; Birch & Conran, London
2001 *Nigel Henderson: Parallel of Life and Art*; Gainsborough House, Sudbury, Suffolk and touring

Group exhibitions

1938 *Collages, Papiers-Colles and Photomontages*; Guggenheim Jeune, London
1951 *Growth and Form*; Institute of Contemporary Arts, London
1953 *Wonder and Horror of the Human Head*; Institute of Contemporary Arts, London
 Post War European Photography; Museum of Modern Art, New York
 Parallel of Life and Art; Institute of Contemporary Arts, London
 Group Show, 22 Fitzroy Street, London
1954 Triennale Milan
 Collages and Objects; Institute of Contemporary Arts, London
1956 *This is Tomorrow*; Whitechapel Art Gallery, London
1957 *Eduardo Paolozzi and Nigel Henderson*; Arts Council Gallery, Cambridge
 Hammer Prints Ltd: An Exhibition and Sale of Ceramics and Textiles etc. designed by Eduardo Paolozzi and Nigel Henderson; Studio Club, London

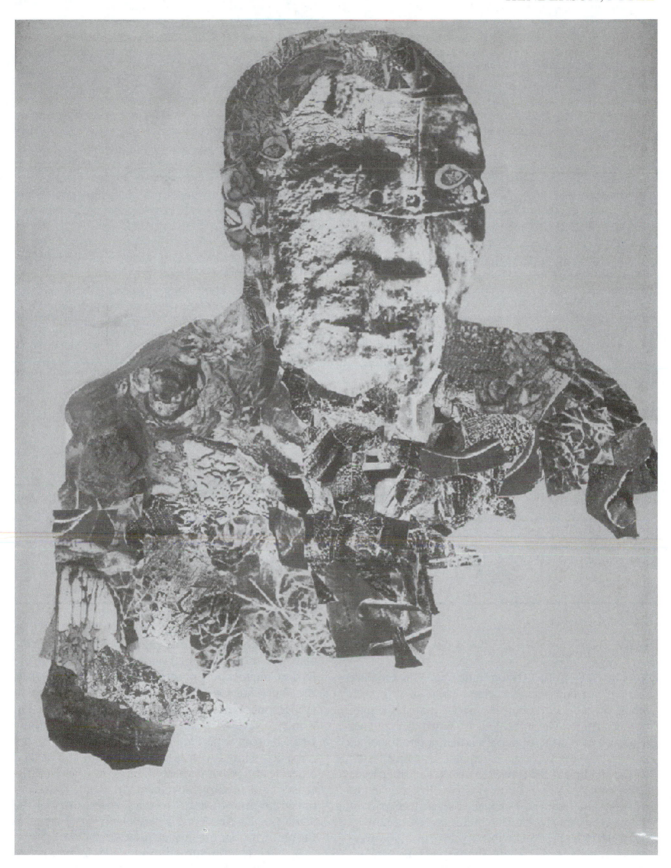

Nigel Henderson, *Head of a Man*, 1956, Photographic collage on board, 159.7 × 121.6 cm.
[*Tate Gallery, London/Art Resource, New York*]

1976 *Just What is it? Pop art in England 1947–1963:* York Art Gallery, York, United Kingdom

The Human Clay; Hayward Gallery, London

Pop art in England: Beginnings of a New Figuration 1947–1963; Kunstverein in Hamburg, Hamburg, Germany

1981 *Constructed Images;* Falmouth School of Art, Cornwall

1983 *Portraits and Lives;* John Hansard Gallery, Southampton, United Kingdom

1984 *Headhunters;* Arts Council of Great Britain touring exhibition

The Forgotten Fifties; City of Sheffield Art Galleries

1986 *Contrariwise: Surrealism and Britain 1930–1986;* Glynn Vivian Art Gallery, Swansea, United Kingdom

1987 *Conversations;* Darlington Arts Centre, Devon

British Pop Art; Birch & Conran, London

This is Tomorrow Today; The Clocktower Gallery, ICA, New York

1990 *The Independent Group: Postwar Britain and the Aesthetics of Plenty;* Institute of Contemporary Arts, London and touring

1992 *New Realities: Art in Western Europe 1945–1968;* Tate Gallery, Liverpool, United Kingdom

1995 *Photographers' London: 1839–1994;* Museum of London, London, United Kingdom

1997 *From Blast to Pop: Aspects of Modern British Art, 1915–1965;* David and Alfred Smart Museum of Art, University of Chicago, Chicago, Illinois

Documenta X; Kassel, Germany

1998 *Head First: Portraits from the Arts Council Collection;* Arts Council Collection touring exhibition

Young Meteors: British Photojournalism 1957–1965; National Museum of Photography, Film and Television, Bradford, United Kingdom

2001 *Open City: Street Photographs 1950–2000;* Museum of Modern Art, Oxford, United Kingdom

As Found; Museum fur Gestaltung, Zurich, Switzerland

Creative Quarters: The Art World in London 1700–2000; Museum of London, London, United Kingdom

Selected works

Milk Bottle, 1949–1951
Prints Inventive, 1949–1951
Photographs of Bethnal Green, 1949–1952
Self Portrait, 1953
Head of a Man, 1956
Lovely Linda, series c. 1977
Willy Call-Up, 1979

Further Reading

Haworth-Booth, Mark. "Nigel Henderson: A Reputation Reassessed." *Creative Camera* no. 3 (April–May 1990).

Henderson, Nigel. *Nigel Henderson: Photographs of Bethnal Green 1949–1952.* Nottingham: Midland Group, 1978.

Hoffman, David, and Shirley Read. "Nigel Henderson." *Camerawork* no. 11, (September 1978).

Roberts, John. "Nigel Henderson at the Serpentine." *Studio International* 196, no. 1000 (July 1983).

Walsh, Victoria. *Nigel Henderson: Parallel of Life and Art.* London: Thames & Hudson, 2001.

Whitford, Frank. *Nigel Henderson: Photographs, Collages, Paintings.* Cambridge: Kettle's Yard Gallery, 1977.

FLORENCE HENRI

Swiss

Born in New York City on June 28, 1893, Florence Montague Henri was the eldest child of a French father, Jean Marie François Henri, and a German mother, Anne Marie Schindler. When her mother died two years later, Florence's father, a director of an oil company whose position required extensive travel, left the children in the care of relatives. Her sister René stayed with an aunt in London while Florence went to live with her mother's family in Silesia, then part of Germany, where she remained until the age of nine.

By 1902, Henri was living in Paris in a boarding school run by nuns, where she began taking piano lessons. In 1905, she moved to London and lived there with her aunt and in Sandown on the Isle of Wight, at the time a thriving center and gathering place for musicians. In London, she studied at the Earl's Court Road Conservatory under Percy Grainger. When her father died in 1907, leaving her with a modest but comfortable inheritance, Henri moved to Rome to live with her father's other sister, Anny Gori. Through her family associations, Henri became acquainted with Filippo Marinetti and several other leading avant-garde figures of the Futurist artistic and literary movement. In Rome, she continued her music studies at the Conservatory of the Santa Cecilia Academy, where Henri met Ferruccio Busoni, who became her mentor.

In 1909, Henri returned to England, living for two years in a boarding school run by the Sisters of Mary in Richmond. She continued taking piano lessons

and by 1911 played pieces by Grieg, Liszt, and Franck at concerts in Bechstein Hall (later named Wigmore Hall). By 1912, Henri moved to Berlin to continue her music studies as the pupil of Egon Petri, and then Busoni. With the outbreak of war in 1914, Henri, unable to leave Berlin and to receive money from her inheritance in England, had to make a living playing the piano at the silent cinema. Perhaps due to this difficult situation and her own highly self-critical view of her ability to compete against the piano masters, Henri decided to abandon music and took up painting instead. In the beginning, she executed traditional drawings of figure studies and landscapes. Towards the end of the war, she met the writer and art historian Carl Einstein, who became a mentor and close companion for many years. Einstein was associated with the Cubist circle in Paris.

In Berlin, Henri studied in the atelier of Johannes Walter-Kurau, where she met Margarete Schall, a fellow painting student who became a close friend. Berlin was a rich source of modern art activity; the city's galleries exhibited the works of Fernand Léger, Robert Delaunay, Pablo Picasso, Vasily Kandinsky, Umberto Boccioni, Gino Severini, Kasimir Malevich, and László Moholy-Nagy. Quite probably, all of these impulses convinced Henri to move to Paris to further her study of art. By 1924, she had taken up residence in Paris, determined to learn more about modern art. Between 1925 and 1927, she enrolled at the Académie Moderne, where she studied with Léger, Amédée Ozenfant, and at the Académie Montparnasse with André Lhote. In the fall of 1925, her work was shown along with others from the Académie Moderne in the *Exposition Internationale L'Art Aujourd'hui*, the first international exhibition of avant-garde art in Paris since the war. Henri's paintings were shown side by side with works by proponents of Cubism, Futurism, Purism, Constructivism, Orphism, Synchronism, and Surrealism.

While living in Paris, Henri traveled frequently to Berlin and along the way visited her friend Margarete Schall in Essen. Through Schall, she met students and faculty members of the Bauhaus in Dessau. In 1927, Henri enrolled in a summer session as a non-matriculating student studying with Moholy-Nagy, Kandinsky, and Paul Klee. Although photography was not yet part of the Bauhaus curriculum, Moholy-Nagy and others used photography as part of their teaching method, finding the camera an ideal art-making device for the machine age. Through her experience with Moholy-Nagy, Henri learned all the current camera techniques: double and multiple exposures, montage, photograms, micro-photographs, and negative prints. Equally influential to Henri's training in photography was her friendship with László's wife, the photographer Lucia Moholy, who made significant portraits of Henri.

Henri soon recognized the medium's capacity as a pictorial language and outlet for creative expression. Upon returning to France, Henri began to develop a large body of photographic work based upon her Bauhaus experience and an extension of the formal and structural aesthetics of Cubism, Purism, and Constructivism. These non-objective principles forged an alternative to the then-dominant French art movement Surrealism. Henri transcended the avant-garde of one art form to that of another.

Henri's greatest experimentation with geometric abstraction occurred during the period between 1929–1930, the years in which she was most closely involved with the artists and critics associated with *Cercle et Carré* founded by Belgium poet, writer and art critic Michael Seuphor. *Cercle et Carré* was an avant-garde group of international architects, painters, sculptors, writers, and intellects which published a review of abstract art under the same name. Henri was one of two photographers whose work appeared in the group's magazine. Another Paris-based organization equally devoted to geometric abstraction, *L'Art Contemporain*, featured her work in their publication—the only photographer in a review devoted to art, poetry, and theory.

In her photographic work, Florence Henri exploited the dialogue between realism and abstraction, but always maintained a recognizable subject. She was concerned with transparency and movement, and she explored spatial extension and fragmentation in her utter modern vocabulary.

Her still life and abstract compositions achieved by balancing abstraction with a pure and essential subject were created in the spirit of the machine age. She viewed space as if it were elastic, distorting figure and ground and altering planes through the use of mirrors and lenses. Henri chose mainly a few primary elements of essential form. One of the most frequently repeated forms in her imagery is that of the sphere—either as a perfectly round ball(s) or in such natural forms as an apple.

In her portrait work featuring mainly artists, Henri was primarily concerned with women. She helped to redefine and shape mainstream ideas of womanhood revealing forceful and independent types whose features appeared as abstract rhythmic patterns. Her compositional format—filling the picture plane with close-up shooting and tight cropping and immediacy of the subject—was influenced by Lucia Moholy and followed the formal strategy of New Vision (*Neue Sehen*) portraiture. Henri constructed an image of the new modern woman, evoking at times the serious introspective mood and even

the quiet painful melancholy that permeated some of her portraits of women as well as those of herself.

When her inheritance dwindled with the stock market crisis of 1929, Henri explored the field of commercial art and found that photography served a profitable means of livelihood. She began photographing the luxury goods optimally featured in fashion magazines. Among her clients were the perfumery Lanvin, Au Bon Marché department store, and Columbia Records. She applied her brand of modernism by placing emphasis on the articles versus a functional narrative. In an advertisement featuring Selcroix table salt, Henri applied photomontage setting the product against a seascape.

In her studio work for fashion advertising, Henri understood the link between fashion and modernity and the important role contemporary apparel played in shaping a new female identity. Shooting from above or at an angle, she contrasted bold geometric patterns against the model's form as part of the composition. Likewise, Henri's female nudes are thoroughly modern. Her figure and nude compositions evince a luxuriant sensuality set within a dream-like atmosphere.

Henri's street photographs reveal her continued search for form and composition. She sought out nature, but the human form set within her nature remained an abstract entity. She saw urban life in terms of complex formal relationships that emphasized texture, structure, and chiaroscuro. In her vision of urban scenes, such as life along the Seine, Henri remained always analytic versus descriptive, emphasizing the spatial ambiguity of figure and ground.

During World War II, Henri, like Picasso, Georges Braque, and Lhote among others, stayed in Paris. Her intellectual and professional life was severely disrupted by the dissolution of the artistic circles that had supported her creativity. Likewise, during the war her photographic production was curtailed because photography film and paper became scarce and expensive. After the Nazi Occupation of France, photography was forbidden altogether. After the war, Henri produced photographic portraits on occasion, but primarily returned to painting. She also found a new interest in quiltmaking to which she could apply principles of modernism in color and design. Henri died in 1982 in France, at a time when her considerable achievements were being recognized by a new generation of photographic historians and collectors.

MARGARET DENNY

See also: **László, Moholy-Nagy; Modernism; Montage; Multiple Exposures and Printing; Photogram; Surrealism**

Biography

Born June 28, 1893, New York, New York; naturalized Swiss citizen. Moved between Silesia, London, Paris, and Rome from the ages of two to 14 to live with family members following the death of her mother (1895) and father (1907). Studied piano in London at the Earl's Court Road Conservatory under Percy Grainger (1905–1907). Studied piano at the Conservatory of the Santa Cecilia Academy in Rome under mentor Ferruccio Busoni. (1907–1909) Performed Grieg, Liszt, and Franck at concerts in Bechstein Hall in London (1911). Studied music in Berlin (1912) with Egon Petri and Ferruccio Busoni. Remained in Berlin during the war. Discontinued playing piano; took up painting. Attended Berlin Academy of Fine Arts and studied art in Munich (1918–1920); in Berlin, studied at the atelier of Johannes Walter-Kurau. Married briefly to Swiss Karl Anton Koster (1924). Enrolled in summer session at Bauhaus Dessau (1927). Studied with László Moholy-Nagy, Vasily Kandinsky, and Paul Klee. Learned photographic process and experimentation with Moholy-Nagy and his wife Lucia Moholy. Moved to Paris and began an intense period of photographic experimentation. (1927) Henri photographs, two ball-and-mirror compositions and a self-portrait, featured in Moholy-Nagy essay published in the Dutch journal *i10* (December 1928). Photographs exhibited in *Fotografie de Gegenwart* (Contemporary Photography) in Museum Folkwang, Essen and *Film und Foto* in Stuttgart and traveling. Introduced to Michel Seuphor and became part of a small group of international avant-garde artists and writers known as Cercle et Carré. Opened commercial photographic studio and instructed students in photography, Gisèle Freund among them. Entered into world of commercial advertising illustration (1929). Died July 24, 1982, La Bérangeraie, Laboissière-en-Thelle (Oise), France.

Individual Exhibitions

1930 Studio 28; Paris, France
1930 Galerie Laxer Norman; Paris, France
1933 *Photoausstellung Florence Henri*; Museum Folkwang Essen, Essen, Germany (traveled to the Galerie La Pleide; Paris, 1934)
1974 Galleria Martini & Ronchetti; Genoa, Italy
1975 Martini & Ronchetti Gallery; New York, New York
1976 Galleria Milano; Milan, Italy
 Galleria Pan; Rome, Italy
 M. L. D'Arc Gallery; New York, New York
1977 Galleria Martini & Ronchetti; Genoa, Italy
1978 University of Parma, Italy
 Musée d'Art Moderne de La Ville de Paris, France.
 Galleria Narciso; Turin, Italy
1979 Galleria G7; Bologna, Italy
 Aspetti di un Percorso, Banco di Chicari; Genoa, Italy
 Villa Romana; Florence, Italy
 The Photographers' Gallery; London, England
1981 *Florence Henri. 70 Photographies 1928–193*; Musée d'Art et d'Histoire, Geneva
1982 *Florence Henri's Vintage Photographic Work*; Prakapas Gallery, New York
1987 San Francisco Museum of Modern Art, San Francisco, California

Selected Group Exhibitions

1925 *L'Art d'Aujourd'hui;* Syndicat des Anti-Quaires, Paris
1929 *Photgraphie der Gegenwar;* Museum Folkwang Essen
 Film und Foto: Internationale Ausstellung des Deutschen Werkbunde; Stuttgart, Germany and traveling
1930 *Modern European Photography;* Julien Levy Gallery, New York, New York
1937 *Foto '37;* Stedelijk Museum, Amsterdam, Netherlands
1970 *Photo Eye of the 20s;* Museum of Modern Art, New York, New York (traveling U.S.A.)
1975 *Women of Photography: An Historical Survey;* San Francisco Museum of Modern Art, San Francisco, California (traveling, U.S.A., 1975–1977)
1980 *Avant-Garde Photography in Germany 1919–1939;* San Francisco Museum of Modern Art, San Francisco, California (traveling U.S.A., 1981–1982)
1981 *Germany: The New Vision;* Fraenkel Gallery, San Francisco, California
1982 *Lichbildnisse: Das Portäit in der Fotografie;* Rheinisches Landesmuseum, Bonn, Germany
Lege et l'Espirit Moderne; Musée d'Art Moderne de La Ville, Paris, France
1983 *Bauhausfotografie;* Institut für Auslandbeziehung, Stuttgart, Germany and traveling

Further Reading

Armstrong, Carol. "Florence Henri, a photographic series of 1928: Mirror, mirror on the wall." *History of Photography* 18 (Autumn, 1994): 223–229.

DuPont, Diana C. *Florence Henri: Artist-Photographer of the Avant-Garde.* San Francisco: San Francisco Museum of Modern Art, 1990.

Fagiolo, Maurizio. *Florence Henri: una riflessione sulla fotographia.* Turin: Martano, 1975.

Florence Henri. Milan: Electa, 1995.

Florence Henri. Genoa and New York: Martini & Ronchetti Gallery, December 1974.

FRANÇOIS HERS

Belgian

François Hers was born in 1943 in Brussels. He is not a photographer per se but rather an artist who uses photographs to intervene in the field of art. His career can be summed up as a search for a new status for art in contemporary society defined as a new relationship between artists, their works, and society. His choice of photography as a medium and his (relatively limited) personal photographic practice are the direct product of this intellectual, philosophical, and political position. His ambition, after his art studies, was to reclaim the freedom and relevance for art that he felt the modernity of early twentieth century figure Marcel Duchamp had gained and lost afterwards, and go beyond the figure of the solitary and all-powerful artist as avant-garde hero. His search for a new relevance and legitimacy for art was inscribed in a great utopia of collective involvement of all—and not simply artists—in art as consumer society invaded 1960s Europe.

In 1966, one of Hers's first projects was to design a commissioned mural for a company by asking the workers to take pictures or to borrow prints from their family albums to tell their life stories. One hundred of the most representative images chosen by the workers made up the final mural.

His later practice was that of a photographer using photographs for larger projects, often institutional ones, and much less that of an image maker. Indeed he often states that his participating in group exhibitions is merely for him a way to keep in touch with the world of art, but that his main concern is to modify its deep structure and modes of intervention. In 1972, he co-founded Viva, a cooperative of photographer-authors modeled after Magnum Photos. The second half of the 1970s saw him traveling widely and making various reportages leading in 1981 to a book and exhibition, *Intérieurs,* and in 1983 to *Récits.*

This was followed in 1983 by his initiating one of the major photographic realizations of the decade in France, the Mission photographique de la DATAR (Photographic Mission of the Direction for Territorial Planning). Hers, with the support of the director of the government agency for planning and development, Bernard Latarjet, set up an ambitious program of public commissions. The Mission, combining the documentary and accumulative spirit of the Farm Security Administration and the philosophy of Hers's concept of commission, contracted with

photographers over a period of six years (1983–1989). The central idea was to represent the nature of the French territory today and the relationship inhabitants have with it. Every contract was negotiated with the photographer both technically and artistically so that the result would be an artistic statement as well as a source of meaning for the understanding and the appropriation of what had become the buzz words of the times: space and territory. Obviously not all works succeeded in fulfilling this mission; the choice of photographers and the rather literal influence of the American New Topographics style (as exemplified by Lewis Baltz or Frank Gohkle) limited the artistic impact it could have had. As a project, however, it was a milestone in the rediscovery of the complex aspect of commissioning and it was a seminal experiment for various other collective photo projects focusing on community.

In 1990, Hers tried to open up his concept of commission to any person or group—and not simply classic public or private patrons—wishing to commission a work of art by securing funding from the Fondation de France. The Fondation de France, created in 1969, finances innovative projects on societal issues not otherwise funded. In a manifesto called "the Protocole," Hers defined the role of the "mediator": half producer, half architect. The mediator negotiates the project between artist and commissioner; she or he organizes, structures, and helps formalize the conception, realization, and eventual dissemination or exhibition of the work.

Hers sees himself as this mediator. His photographic practice is now wholly contained in this institutional role. He occupies an interesting, albeit very marginal, place on the French photography scene. Inheritor of the utopias of the 1960s and 1970s, deeply committed to a democratic ideal of access of all not to consumption but to co-production of art works without compromising the high requirement of art, his action tries to

François Hers, "Interiors," first photo in the series, 1981, Photo: Philippe Migeat.
[*CNAC/MNAM/Dist. Réunion des Musées Nationaux/Art Resource, New York*]

maintain the vital link of creation at a time when, on the one hand, contemporary art is more esoteric than ever and, on the other, consumerism triumphs in mass culture.

JEAN KEMPF

See also: **Farm Security Administration; Photography in France; Visual Anthropology**

Biography

Born in Brussels 1943. Co-founder of Viva, 1972. "Interiors," Centre Georges Pompidou, Paris, 1981. 1983–1989: Directs the Mission photographique de la DATAR. 1990: manages the "new patrons" project for the Fondation de France. Director, Hartung Foundation, 1984. Living in Antibes and Paris, France.

Individual Exhibitions

1981 *Interieurs;* Centre Georges Pompidou, Paris, France

Group Exhibitions

1986 *Chambres d'amis;* Ghent, Belgium

Further Reading

Intérieurs. Bruxelles: Editions des archives d'architecture moderne, 1981.

Hers, François, Jean-François Chevrier, and Roman Cieslewicz. *Récit.* Jumet: Graphing, 1983. Published in English as: *A Tale.* London: Thames and Hudson, 1983.

[Mission photographique de la DATAR]. *Paysages, photographies.* Paris: Hazan, 1989.

Le Protocole. Dijon: Presses du réel, 2002.

http://www.nouveauxcommanditaires.org (accessed June 19, 2005).

JOHN HILLIARD

British

Conceptual artist John Hilliard first began to use photography as a student during the 1960s. Initially, the camera was a means to document his temporary site-specific installations, but Hilliard soon recognized that the metonymic power of the photographic image deserved more serious examination. In realizing that the camera was not simply a neutral device for recording fact, the artist began exploring the language and history of the medium of photography. He established a challenge to expose the myth of photographic truth, a form of rigorous visual and intellectual inquiry emblematic of Conceptual Art and Minimalism in the late 1960s. Hilliard started questioning the selective methods of image making and confronted the ways photographic meaning could be manipulated.

By the early 1970s, after time spent traveling in the United States and further guided by critical theory and semiotics, Hilliard began to work exclusively with photography. A representative work from these early years of inquiry, *Camera Recording Its Own Condition*, 1971, is a sequence of seventy black-and-white images presented in a grid-like quasi-scientific fashion, showing the reflection of a camera at the moment the photograph is taken. Each image differs slightly, as Hilliard changed both the speed and aperture, thus creating a range of legibility from light to dark, depending on the over- or under-exposure of the image. At the center of the grid, an image suggests itself as the "correct" exposure. Such self-referential imagery indicates Hilliard's concern with the mechanics of photography, actions that paradoxically reveal the intervention of the photographer in the camera's supposedly objective realm.

Similarly, in *Causes of Death*, 1974, Hilliard scrutinized the photographer's subjective editing process through a series of four black-and-white images of what appears to be a sheet-covered dead body prone on a rocky landscape. While obviously depicting the same subject from the same angle, each photograph is cropped a little differently to create a new context of meaning for each image, suggesting a different cause of death. Other projects by Hilliard from this fertile period in the 1970s—concerning a consideration of focus, film speed, and technical darkroom decisions with regards to paper and developing—again exposed the fallibility of photography as an objective or evidentiary medium.

As Hilliard pursued this line of inquiry further, he began experimenting with color photography through the 1980s, which led to a repositioning of his critique from the investigation of classic representational practices in photography to a semiotic examination of imagery in popular culture. As a result, much of Hilliard's work from the last two decades presents a critical comment on the ubiquitous transmission of images through commercial advertising in newspapers, magazines, and cinema. Oftentimes, his visual statements on the effects of mass consumerism can be seen in very direct ways, as found in "East/West, 1986." In this large photowork, Hilliard presents a dynamic juxtaposition of a positive and negative version of a highly stylized profile portrait of what appears to be a sophisticated Asian woman. Here, the artist provokes consideration of issues of identity, mirroring, and cultural assimilation.

Hilliard developed a rich, colorful, saturated style during the 1990s, presenting tableaux images with erotic and sometimes violent narratives, and glossy surface effects which emulate or at least reference the seductive power of advertising. For the most part, these images remain vague, as the artist uses devices that obstruct the full view of the subject. In "Miss Tracy, 1994," a female nude lies prone on a bloodied sheet, but the majority view of the woman's body is abstracted by an opaque rectangle. Only the periphery or "frame" of the subject remains in focus. Hilliard continues his experiment in the construction of ambiguity and the manipulation of narrative means. Formally, his presentation draws attention to the surreal nature of photographic space—the relationship between the picture plane, and the spaces before and beyond—and to the traditional acceptance of the transparency of a photograph.

While he has continued to produce work with a formal vocabulary that disrupts a seamless gaze of the subject, in more recent years Hilliard's work has become larger in scale, almost to the point of mural form, through printing his photographs on canvas and vinyl. As well as the visual impact of a larger size, such images must also be understood as a direct formal critique of surface. A clear example of this strategy can be found in *Nocturne*, 1996, an image of an interior wall in an abandoned house, covered for the most part with wallpaper and graffiti. Yet the central focus of the image is blocked by a rectangle of an enlarged, close-up detail of the decorative wallpaper. The visual riddle of *Offence*, 1997, works in a similar fashion. Here, a couple in the front seat of a car peer through the windshield, but their view out (and consequently the audience's gaze in) is obstructed by a white rectangular police sign indicating the car has been clamped. The lighting, dress, and demeanor

of the couple suggest a distressing incident may have occurred, and the stern police warning "Stop! Do not attempt to move it!" further adds to the confused nature of the scene. Here again, the artist has successfully manipulated the narrative through elements of cropping, framing, and obstruction.

Speaking about his working practices in 1997, Hilliard explained that his usual procedures involve a progression through a series of rough drawings, diagrams, and writings, in an almost cinematic or storyboard fashion. From this collection of visual and textual language, Hilliard then affects a rigorous process of selection to arrive at a particular photographic composition. Such strategies of assiduous analysis have persisted throughout his career, and his professional success in teaching during the last 20 years must also be recognized alongside his credentials as an active artist with a strong exhibition record. Significant faculty positions in London, at the Camberwell School of Art, and currently at the Slade School of Art, further highlight his reputation. And while never automatically associated with a particular artistic or aesthetic group, Hilliard's distinct formal and intellectual examination of photography places him alongside the likes of theorist and photographer Victor Burgin in the history of late twentieth-century British photography.

SARA-JAYNE PARSONS

See also: **Burgin, Victor; Conceptual Photography**

Biography

Born in Lancaster, England, 1945; Lancaster College of Art, 1962–1964; St. Martin's School of Art, London, 1964–1967; travel scholarship to the United States, 1965; Northern Arts Fellow in Visual Art, Newcastle-Upon-Tyne, 1976–1978; David Octavius Hill Memorial Award, 1986. Teaches at the Slade School of Fine Arts; living in London.

Individual Exhibitions

1969 Camden Arts Centre, London
1970 Lisson Gallery, London
1974 Museum of Modern Art, Oxford, United Kingdom; Galleria Toselli, Milan, Italy
1976 Galerie Hetzler & Keller, Stuttgart; Galerie Durand-Dessert, Paris; Robert Self Gallery, Newcastle-Upon-Tyne, United Kingdom
1977 Badischer Kunstverein, Karlsruhe, Germany; Galerie Durand-Dessert, Paris; Galerie Paul Maenz, Cologne, Germany
1978 Studio Paola Betti, Milan; John Gibson Gallery, New York; Lisson Gallery, London Laing Art Gallery, Newcastle-Upon-Tyne, United Kingdom
1979 Ikon Gallery, Birmingham; Galeria Foksal, Warsaw, Poland; Galerie Durand-Dessert, Paris
1982 Amano Gallery, Osaka, Japan; Ryo Gallery, Kyoto, Japan

1984 Frankfurter Kunstverein, Frankfurt; Kettle's Yard Gallery, Cambridge, United Kingdom; Institute of Contemporary Arts, London

1987 Sprengel Museum, Hannover, Germany; Galerie Durand-Dessert, Paris

1989 Renaissance Society at the University of Chicago Galerie Le Réverbère, Lyon

1993 Musée des Beaux-Arts, La Chaux-de-Fonds, France

1995 Art Affairs, Amsterdam

1997 Kunsthalle Krems, Austria; Kunstverein Hannover, Hannover, Germany

1998 Arnolfini Gallery, Bristol, United Kingdom

Group Exhibitions

1971 *Prospect 71*; Kunsthalle, Düsseldorf, Germany

1972 *The New Art*; Hayward Gallery, London, United Kingdom

1977 *Malerei un Photographie im Dialog*; Kunsthaus Zürich, Zurich, Switzerland

1979 *Art As Photography, Photography As Art*; Institute of Contemporary Arts, London, United Kingdom

1982 *Aspects of British Art Today*; Metropolitan Museum, Tokyo, Japan

1985 *Hand Signals*; Ikon Gallery, Birmingham, United Kingdom

1987 *Blow-up–Keitgeschichte*; Württembergischer Kunstverein, Stuttgart, Germany; Haus am Waldsee Berlin; Kunstverein Hamburg; Frankfurter Kunstverein; Kunstverein Hannover; Kunstmuseum Luzern, Lausanne, Switzerland

1988 *John Hilliard, Barbara Kruger, Ken Lum, Richard Prince, Jeff Wall*; Galleri Contur, Stockholm

1989 *Through the Looking Glass*; Barbican Art Gallery, London, United Kingdom

1993 *Moving into View*; South Bank Centre, London, United Kingdom

1995 *Contemporary British Art in Print*; Scottish National Gallery of Modern Art, Edinburgh; Yale Center for British Art, New Haven, Connecticut

1996 *Victor Burgin, Dan Graham, Rodney Graham, John Hilliard*; Lisson Gallery, London, United Kingdom

1998 P.S.1 Institute of Contemporary Art, New York

Selected Works

60 Seconds of Light, 1970
Camera Recording Its Own Condition, 1971

Causes of Death, 1974
East/West, 1986
Miss, Tracy, 1994
Debate (18% Reflectance), 1996
Nocturne, 1996
Offence, 1997
Confusion, 1997

Further Reading

Analytische Photographie. John Hilliard. Karlsruhe, Germany: Badischer Kunstverein, 1977.

Archer, Michael. "Interview with John Hilliard." *Audio Arts* (Amsterdam), 7 no. 3 (1985).

Brooks, Rosetta. "Through the looking glass, darkly: photographs by Yves Lomax, Susan Trangmar and John." *Aperture*, no. 113 (Winter 1988).

Durden, Mark. "The Beyond and the Ridiculous." *Art Monthly*, no. 207 (June 1997).

Elemental Conditioning. Oxford: Museum of Modern Art, 1974.

From the Northern Counties. London: Lisson Gallery, 1978.

Green, David. "Monochrome Art: full of things which absorb light: photography and monochrome painting." *Creative Camera*, no. 358 (June/July 1999).

Hatton, Brian. "Victor Burgin, Dan Graham, Rodney Graham, John Hilliard." *Art Monthly*, no. 199 (September 1996).

Hilliard, John. *John Hilliard.* Salamanca, Spain: Ediciones Universidad de Salamanca, 1999.

Hoffman, Justin. "Fotographie Digital." *Kunstforum International*, no. 109 (1987).

John Hilliard. Cologne: Kölnischer Kunstverein, 1983.

John Hilliard. New Works 1981–1983. Cambridge: Kettle's Yard Gallery, University of Cambridge: 1984.

John Hilliard. London: Institute of Contemporary Arts, 1984.

John Hilliard. Chicago: Renaissance Society, University of Chicago, 1989.

Roberts, John, ed. *The Impossible Document: Photography and Conceptual Art in Britain, 1966-76.* London: Camerawork, 1997.

Reardon, Valerie. "John Hilliard: Arnolfini, exhibition." *Art Monthly*, no. 222 (December 1998/January 1999).

Through The Looking Glass. Photographic Art in Britain 1945–1989. London: Barbican Art Gallery: 1989.

Wallace, Marina. "John Hilliard." *Art Monthly*, no. 204 (March 1997).

LEWIS HINE

American

One of the towering figures in twentieth century photography, Lewis Wickes Hine's photographs of immigrants, child labor, and industrial workers are, along with Eugène Atget's photographs of Paris and August Sander's study of his fellow Germans, one of the major achievements of photography in the first third of the last century. Hine died impoverished and in relative obscurity, however,

on November 4, 1940 in Dobbs Ferry, New York, a few miles from his home in Hastings-on-Hudson. This was ten months after the death of Sara Ann (Rich) Hines, his wife of 35 years.

Born on 26 September 1874 in Oshkosh, Wisconsin, from necessity, Hine worked in various manual labor jobs in Oshkosh for seven years following his graduation from high school in 1892 and the death of his father in the same year. He managed to study sculpture and drawing during this period of his life and studied for a year at the University of Chicago, but it was his relocation to New York City in 1901 that set the course towards his important photographic career.

In 1903, Hine taught himself the basics of photography at the urging of Frank A. Manny, the director of the Ethical Culture (Fieldston) School in Riverside, New York, where Hine taught nature studies and geography. Hine's initial interest in photography was as another tool to be used in his job as a teacher. and it was at the urging of Manny that Hine began to photograph immigrants at Ellis Island in New York Harbor, the work beginning with school field trips meant to counter the racist and generally anti-immigrant stereotypes common among the middle class and upper classes. Following what must be regarded as one of the richest apprenticeships in the history of photography in completing this extraordinary study in 1909, Hine became a professional photographer. His approach to photography remained instrumental throughout his career, guided by his ideas about society and education, which were rooted—rather loosely—in the politics of the Progressive Movement and concretely in the ideas of John Dewey (with whom Hine may have taken a course while at the University of Chicago) and his training in the new discipline of sociology. In any case, it is clear from his degree in education from New York University, received in 1905, and from his studies in sociology at Columbia University in 1907, but above all from the evidence of his photographs, that the influence of Dewey's ideas outweighed any others.

In 1905, Hine met Arthur Kellogg, an important social reformer, to whom he sold some of his Ellis Island images. In 1907, he also photographed for the massive sociological study, The Pittsburgh Survey. Somehow he managed to photograph a series on Washington, D.C. slums for the reformist magazine, The Survey, that same year. This led to his freelancing for and eventual hiring by the National Child Labor Committee (NCLC) in 1908, which published The Survey and which assigned Hine to photograph and collect data on tenement homeworkers. As a full-time investigator and photographer for NCLC, Hine resigned his teaching position at the Ethical Culture School, "changing [his] educational efforts from the classroom to the world."

He continued his photography of labor, moving to concentrate on child labor, which he continued until 1917. During that period he traveled tens of thousands of miles mostly in the southern, eastern, and southeastern states photographing children working in mines, mills, sweatshops, and every sort of factory, which employed them for 10 to 14 hour days, six days a week of relentless, deadening, cheap labor. The photographs and the data were used in publications, lantern slide illustrated lectures, and to successfully lobby Congress, which enacted the first laws regulating child labor. Looking at these magazines and at photographs of the lobby boards, Hine also influenced notions of sequence, serial presentation, and the rudiments of photojournalism.

By training, education, and inclination, Hine was a cultured and witty man, far more sophisticated about contemporary and modern art than his contemporary Alfred Steiglitz was about the art inherent in the documentary traditions of photography. It is those traditions arising from the combination of social expectations (what are photographs for and how the viewer understands them) and the then new technology of photo-mechanical reproduction that reached a critical juncture in Hine's work.

Aspects of, among many others, the work of nineteenth century photographers Mathew Brady and Timothy O'Sullivan provide a context for measuring Hine's contribution. Preceding Hine by a generation, Jacob Riis's muckraking photographs seem to overlap some of Hine's concerns; however, among many differences the most important are that Riis hired professional photographers for much of the work credited to him, and unlike Hine, Riis photographed types. From his early work at Ellis Island to his last important project, photographing the construction of the Empire State Building, Hine's photographs are about the individual person or group of people seen individually, if in a social context. Following Hine, and more fruitfully linked to him is Paul Strand. Strand, a student at the Ethical Culture Fieldston School, and a member of the camera club Hine directed there, is rightfully recognized as an originator of Modernism in photography, but Strand's social concerns and socialist politics rooted in the Progressive politics of the School are given short shrift by photo writers following the anti-political lead of Steiglitz.

Hine named—and in some significant way created—what he called "Social Photography," or what is now more commonly called documentary photography. It should be noted that this use of the term documentary was first applied to films and did

not come into common use until 20 years after Hine began to photograph. As the social and didactic content of Hine's photographs dim with the passage of time—while their value as historic documents grows—the elegance of the work remains. Contemporary viewers might care to use Walker Evans's formulation, "documentary style" for the best of Hine's photographs.

In 1918, Hine quit his position with the NCLC when they, feeling the struggle to regulate child labor was successful, reduced his salary. He took a job with the American Red Cross and photographed the aftermath of World War I in France, Greece, and the Balkans, returning to the United States in 1919 where he organized exhibitions for the American Red Cross Museum, which had been founded in Washington, D.C. that year. He also photographed Red Cross-sponsored rural health programs. After 1919, Hine was not associated with any organization, and he began to call himself an "interpretive photographer." Until he was commissioned to photograph the construction of the Empire State Building in 1930, Hine's only income was from freelance work. He organized exhibitions of his work, including *Interpretation of Social and Industrial Conditions Here and Abroad*, which was shown at the National Arts Club and the Civic Club, both in New York City, in the fall of 1920. He continued to supply photographs to *The Survey* throughout the 1920s, but the Progressive movement continued a decline precipitated by WWI. During this time, Hine returned to Ellis Island for new work there as well as taking assignments from unions and advertising agencies, but his main project was the celebration of the industrial worker, including photographs taken while documenting the construction of the Empire State Building. This culminated in the only book of his work published in his lifetime, *Men at Work* in 1932; it garnered considerable acclaim. These photographs, like all of Hine's work, focused on the human individual within, this time, the literal framework of the steel. A portfolio of photographs of loom workers in textile mills was exhibited at the 1933 World's Fair in Chicago and published that year as *Through the Loom* as well as in *The Survey*. In the same year, an assignment photographing the Tennessee Valley Authority dam projects at Wilson and Muscle Shoals in Alabama ended when his photographs were published without crediting him. By 1938, he could no longer earn a living from his photography.

In his last years, Hine twice unsuccessfully applied to the Guggenheim Foundation for grants, but more shamefully, in retrospect, is Roy Stryker's refusal to hire Hine for any Farm Security Administration work,

considering him "past his prime." As Hine slipped further and further into poverty, he was getting increasing recognition for his photographs beyond their utility from the critic Elizabeth McCausland, the young art historian, Beaumont Newhall, and above all from photographers, especially Berenice Abbott, and the young documentarians in New York's The Photo League. In 1939, a retrospective of Hine's work was successfully mounted at the Riverside Museum under the sponsorship of an umbrella group ranging from the New York City comptroller, his long-time supporter the sociologist and editor, Paul Kellogg, Berenice Abbott, and even Alfred Steiglitz, no doubt with the encouragement of Paul Strand.

After Hine's death in 1940, his son Corydon gives the Hine's archive to The Photo League. Upon its dissolution, Walter Rosenblum, acting on behalf of the League's membership, donated the archive to the George Eastman House in Rochester, New York.

RICHARD GORDON

See also: **Documentary Photography; History of Photography: Nineteenth-Century Foundations; Modernism; Newhall, Beaumont; Riis, Jacob; Social Representation; Steiglitz, Alfred; Strand, Paul**

Biography

Lewis Wickes Hine born in Oshkosh, Wisconsin, 26 September 1874. Attended University of Chicago, 1900; relocates to New York City to teach at Ethical Culture (Fieldston) School, 1901. Given camera by ECS principle, Frank A. Manny, begins photographing Ellis Island immigrants. Receives Pd. M. degree from New York University, 1905; attended Graduate School of Arts and Sciences, Columbia University, 1907. Staff photographer for National Child Labor Committee and photographer and art director for their magazine *Charities and Commons* (later *The Survey*), 1908–1917. Establishes studio in upstate New York, advertising his services as "Social Photography by Lewis W. Hine," 1912. Photographer for American Red Cross, 1917–1919. Awarded Art Directors Club of New York, medal of photography, 1924. Works for government and corporate clients 1921–1939. Died in Dobbs Ferry, New York, 4 November 1940.

Individual Exhibitions

1920 *Interpretation of Social and Industrial Conditions Here and Abroad*; Civic Arts Club and National Arts Club, New York, New York
 Woman's Club, Hastings-on-Hudson, New York
1931 Yonkers Museum, Yonkers, New York
1939 Riverside Museum, New York, New York, and traveled to Des Moines Fine Arts Association Gallery, Des Moines, Iowa, and New York State Museum, Albany, New York
1967 *Lewis W. Hine: A Traveling Exhibition*; George Eastman House, Rochester, New York
1969 *Lewis W. Hine: A Concerned Photographer*; Riverside Museum, New York, New York

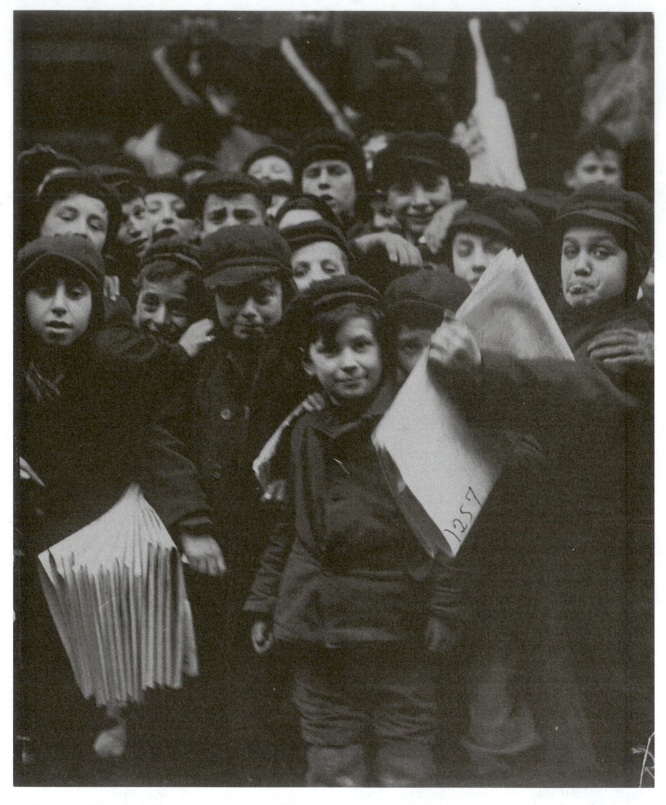

Lewis Wickes Hine, Newspaper boys in New York, Photo: Jean Schormans.
[*Réunion des Muséees Nationaux/Art Resource, New York*]

1972 Stanford University Museum of Art, Stanford, California
1973 Witkin Gallery, New York, New York
 Lunn Gallery, Washington, D.C.
1977 *Lewis Hine, 1874–1940: A Retrospective of the Photographer*; The Brooklyn Museum of Art, Brooklyn, New York
1999 *Lewis Wickes Hine: The Final Years*; The Brooklyn Museum of Art, Brooklyn, New York
2000 *Let Children Be Children, Lewis Wickes Hine's Crusade Against Child Labor*; Lore Degenstein Gallery, Susquehanna University, Selinsgrove, Pennsylvania, traveling exhibit from The International Museum of Photography, George Eastman House, Rochester, New York

Selected Works

Young Russian Jewess, Ellis Island, 1905
Spinner Girl (or *Cotton-Mill Worker*), c. 1908
Factory Boy, Glassworks, 1909
Doffer Family, Mrs. A. J. Young and her Nine Children, Tifton, Georgia, January, 1909
Italian Immigrant, East Side New York City, 1910
Breaker Boys in Coal Chute, South Pittson, Pennsylvania, January 1911
River Boy, Beaumont, Texas, November, 1913
Power House Mechanic, 1920
Child Picking Cotton, 1929
Steamfitter, 1921
Men At Work, 1932

Further Reading

Gutman, Judith Mara. *Lewis W. Hine Two Perspectives*. ICP Library of Photographers, NY: Grossman Publishers, 1974.
Kaplan, Daile. *Photo Story: Selected Letters and Photographs of Lewis W. Hine*. Washington, DC: Smithsonian Books, 1992.
Kaplan, Daile. *Lewis Hine in Europe, The Lost Photographs*. New York: Abbeville Press Publishers, 1988.
Goldberg, Vicki. *Lewis Hine Children At Work*. Munich, London, New York: Prestel, 1999.
Langer, Freddy. *Lewis Hine: The Empire State Building*. Munich, London, New York, Prestel, 1998.
Rosenblum, Nina. *America & Lewis Hine*. A film biography. Daedalus Productions, 1984.
Trachtenberg, Alan. *Reading American Photographs Images as History: Mathew Brady to Walker Evans*. New York: Hill and Wang, 1989.
Trachtenberg, Alan, Naomi Rosenblum, and Walter Rosenblum. *America & Lewis Hine Photographs 1904–1940*. Millerton, NY: Aperture, 1977.

HIRO

Yasuhiro Wakabayashi, known more commonly as Hiro, has not achieved widespread recognition in the art world, but is one of the most creative and sought-after commercial photographers in the late twentieth century. His work cannot be simplified as mere advertising, as his aim is always to create highly unique and provocative images. Whether shooting product still lifes, celebrity portraits, or fashion spreads, he succeeds in elevating his commercial photography to the aesthetic status of high art.

Due to political circumstances, Hiro's early life was characterized by instability and upheaval. He was born in Shanghai, China, in 1930 to Japanese parents. His father, a linguist, was working on a Chinese–Japanese dictionary. Hiro did not see his parents' homeland until the age of six, when they were forced to flee to Nagano during the Sino-Japanese war. The family was then shuffled between China and Japan multiple times as relations between the two nations grew increasingly antagonistic. The family almost immediately returned to China, however, this time settling in Peking. As a young teen, Hiro was drafted into the Japanese army of occupation and bore witness to torture and atrocities. In 1945, as the Chinese army entered to re-take the city, the Wakabayashis were forced into an internment camp. After a few months they were able to depart once again for Japan and re-settled in Tokyo, where Hiro finished high school.

Following World War II, Hiro came into contact with American soldiers in Japan and became increasingly fascinated with America. He was particularly attracted by the design of the products the soldiers brought with them, from military machinery to beverage cans. By tutoring American officers in Japanese he came into contact with Western magazines, and was motivated to experiment with photography himself. He began shooting around Tokyo with a Minoltaflex. The American magazines Hiro had discovered had such an impact on him that in 1954 he chose to depart for New York City with a very specific objective in mind: to

become a photography assistant to either Richard Avedon or Irving Penn.

The young photographer had such talent and determination that he soon met his goal. Within two years of his arrival on American shores, Hiro succeeded in being hired as Avedon's assistant. When Avedon went off to Paris on assignment he asked Hiro to stay in New York and practice taking commercial still lifes. The two exchanged correspondence across the Atlantic, with Avedon alternately praising and sharply criticizing Hiro's work. Quick to recognize the immensity of his talent, in 1958 Avedon named Hiro an associate at the studio.

A second major influence on Hiro's photography was Alexey Brodovitch, renowned art director for *Harper's Bazaar*. In 1956, Hiro began studying photography at the New School for Social Research with Brodovitch, who provided him with aesthetic direction and career development. Impressed with Hiro's work, Brodovitch tested his readiness for publication with a deceptively simple assignment: he asked him to photograph a Dior shoe. Hiro labored for weeks before totally satisfying Brodovitch's expectations, at which point he was finally allowed to begin working on assignments for *Harper's Bazaar*.

Hiro developed his own aesthetic standards according to Brodovitch's dictum that one should click the shutter only when the camera reveals something that has never before been seen. This emphasis on originality and innovation has remained with Hiro throughout his career, and is manifested in the frequently startling nature of his compositions. He has a remarkable ability to generate surprise through his choices in composition and his evocative use of hyper-saturated color. By draping a ruby and diamond necklace over the hoof of a steer, or allowing a tarantula to creep up a model's foot, he uses unexpected juxtapositions that recall the strategies of surrealist art.

Though his images never shy from audaciousness, Hiro's technique is highly controlled and calculated. He is as known for his intensity, control, and patience as he is for his imagination. Approaching his medium with a scientific precision, he is a consummate perfectionist with a tendency to value preparation over spontaneity. In the studio he is also a great experimenter, particularly with lighting. He obsesses over the nature and quality of light, and has utilized strobes, colored gels, infrared film, and neon to generate various effects. His interest in cinematography led him to experiment with a movie camera, not out of a desire to be a filmmaker, but in order to apply the appearance of moving pictures to still photographs. In the studio, he developed complex techniques to convey a sense of motion. This filmic, shifting focus can be observed in some of his portraits, which have an interior focus but blurred edges.

In many ways, Hiro's abilities and aesthetics are particularly appropriate to commercial photography. His love of innovation and novelty are perfectly suited to the aims of advertising and the capitalist sensibility that drives it. His ostentatious color, animated forms, and clarity of vision likewise make his images enormously appealing and seductive, signs of the pleasures of excess. Yet his depiction of products and commerce is not simplistically celebratory. He has also used the medium of advertising to make a critique about conspicuous consumption, as in 1972, when he created a cosmetics advertisement featuring a close-up of a woman's mouth as she gobbled pharmaceuticals.

Although he has never fully garnered a reputation as an art photographer, Hiro has a strong body of work that he created independently for non-commercial purposes. In 1962, on a return trip to Japan, he took black and white portraits of strangers cramped into subway cars, their bodies pressed uncomfortably against the glass windows of the train doors. The series succinctly conveys the claustrophobia and anxiety of urban existence. In 1990, he published the book *Fighting Birds/Fighting Fish*, featuring black-and-white photographs of illegal cock fights and vibrant color photographs of Siamese fighting fish. With these images, Hiro elegantly conveys the choreography of the animals' warlike gestures. More recently he turned his camera to human subjects, and created black-and-white images of babies. Rather than sentimentalizing the innocence of infancy, he instead radically frames the compositions around fragments of the infants' bodies to underscore their strange, almost alien quality.

SHANNON WEARING

See also: **Fashion Photography; Penn, Irving; Portraiture**

Biography

Born Yasuhiro Wakabayashi in Shanghai, China, 3 November 1930. Attended New School for Social Research, New York, 1956–1958. Photography assistant to Rouben Samberg, 1954–1955, to Richard Avedon, 1956–1957, and to Alexey Brodovitch, 1958–1960; Associate, Avedon Studio 1958–1971; Freelance magazine photography 1958-present; Staff Photographer, Harper's Bazaar, 1966–1974. Received Gold Medal, Art Directors Club of New York, 1968; Photographer of the Year Award, American Society of Magazine Photographers, 1969; Newhouse Citation, Syracuse University, 1972; Society of Publication Designers Award, 1979; Certificate of Excellence, American Institute of Graphic Arts, 1980 and 1981; Award of Excel-

lence, International Editorial Design Competition, 1982; Photographer Award, Photographic Society of Japan, 1989; Art Directors Club 70th Annual Exhibition Merit Award, 1991. Living in New York City.

Individual Exhibitions

2000 *Hiro/2000*; Maison Européenne de la Photographie; Paris, France

Selected Group Exhibitions

1959 *Photography in the Fine Arts*; Metropolitan Museum of Art; New York, New York

1968 *One Hundred Years of Harper's Bazaar*; Hallmark Gallery; New York, New York

1977 *Fashion Photography*; George Eastman House; Rochester, New York, and traveling

1985 *Shots of Style*; Victoria and Albert Museum; London, England, and traveling

1990 *Photographie: de la réclame á la publicité*; Centre Georges Pompidou, Paris, France

1990 *The Indomitable Spirit*; International Center of Photography; New York, New York

1991 *Appearances*; Victoria and Albert Museum; London, England

1994 *Fashion Photography: Avedon, Hiro, Penn*; Art Basel 25 '94 Galerie Zur Stockeregg, Zurich, Switzerland

Selected Works

Shinjuku Station 27, Tokyo, Japan, 1962
Harry Winston Necklace, New York City, 1963
Donna Mitchell, Craters of the Moon, Idaho, 1968
Popping Pills, New York City, 1972
Apollo Spaceflight Training Suits, Houston, Texas, 1978
Foot Series 6, New York City, 1982
Fighting Birds 35-39, Baltimore, Maryland, 1988
Child 26, New York City, 1991

Further Reading

Avedon, Richard, ed. *Hiro: Photographs*. Boston: Little, Brown and Company, 1999.

Edwards, Owen. "Is This Man America's Greatest Photographer?" *American Photographer*, vol. 8 (January 1982).

Hiro. *Fighting Fish/Fighting Birds: Photographs*. Essay by Susanna Moore. New York: Harry N. Abrams, 1990.

Woodward, Richard B. "Hiro." *Graphis*, vol. 48 (March/April 1992).

HISTORY OF PHOTOGRAPHY: NINETEENTH-CENTURY FOUNDATIONS

To fully understand the twentieth-century history of photography, it is necessary to return to photography's beginnings, to the contextual environment of its "invention" in France and England and to important precedents. Although historians document through texts as early as the fifth century BC the phenomenon of light projected through a small opening (aperture), creating variable patterns on a surface, photography's "pre-history" really began in the Renaissance with two basic photographic concepts: the ideas of the "frame" and of the "box."

The "frame" is an important editing device allowing two-dimensional representation of three-dimensional space (a drawing, a painting, later a photograph) and depends largely on principles of linear perspective developed in 1435 by the Italian

painter Leone Alberti in *On Painting*. The "box" combines the light source, aperture, and surface into one entity, the "camera obscura." This Renaissance drawing device conceived by Leonardo da Vinci (about 1500) and described by Giovanni della Porta in Natural Magic (1553), is literally a "dark room" with one wall (opposite a tiny opening) becoming the vertical section of a cone of light: the frame (called "Alberti's window"). The camera obscura improved through time becoming smaller and more portable; optics were added (the idea attributed to Daniello Barbaro in 1568), and mirrors to "right the image."

Thus, a cumulative effort of many centuries of ideas and innovations allowed the inventors of photography, Joseph-Nicéphore Niépce, Louis

Daguerre, William Henry Fox Talbot, and Hippolyte Bayard to draw on this "pre-history," to add to the mix through trial and error, the latest nineteenth-century chemistry and achieve what historians refer to as the "historical moment"—a permanent image taken by a camera (camera obscura). At least four such "moments" declared the invention of photography. The first photograph, amazingly still extant, was by Joseph-Nicéphore Niépce taken from a window on his estate at "Le Gras," near Chalon-sur-Saone, in France, dated 1827. The emulsion (bitumen of Judea familiar to graphic artists) was coated onto a pewter plate and the camera exposure lasted about eight hours, as evident from the recorded shadows. It was a photograph (heliograph); but it was not a viable process. That would come later with the achievements of Niépce's partner, Louis Daguerre, a commercial artist of some renown. Unfortunately, Niépce died before Daguerre discovered, probably by accident, the key to his positive process: mercury vapor as a developing agent. The historic announcement of the invention of the daguerreotype (a copper/silver plate) was made in January 1839, and was greatly facilitated by Franqois Arago of the Chamber of Deputies who convinced the French government to purchase the patent and provide Daguerre a substantial annuity of 6,000 francs.

Daguerre's announcement gave rise to another historical moment across the Channel from France, where the distinguished English scientist, William Henry Fox Talbot, hurriedly gathered his photographs, many exposed in tiny cameras, and his experimental evidence of a very different negative/positive paper process, the Talbotype, and announced before the Royal Society the invention of photography ("Photogenic Drawing") in England, also in 1839.

While nationalistic politics fed the declarations of invention in France and England, still another inventor, an unsung hero, waited at the request of the French government to announce what was, in a strange way, a combination of both processes. Hippolyte Bayard invented a positive paper process of photography, more like Talbot's than Daguerre's, perhaps with more significance to art history, since he immediately exhibited some of the most aesthetically interesting images of the time. Along with architecture and genre subjects, Bayard's enigmatic self portraits, including *Self-Portrait as a Drowned Man (1840)*, an allusion to David's *Death of Marat*, borrowed on satire to reproach the French government for his lack of recognition. These photographs helped establish France as a center of photographic art and

provided a home for Talbot's English paper process, the Talbotype or calotype, for even Bayard switched to the more sophisticated calotype.

Prior to the dissemination of the daguerreotype process, with its greatest expansion in the United States (9,000 instruction manuals and considerable equipment sold in 1839), and the calotype process, with its greatest achievements in France, there was another development in Scotland, in the early body of photographs produced by Hill and Adamson. Although the French had declared the daguerreotype patent-free except in rival England, Talbot maintained his expensive patent on the calotype, delaying its expansion in his own country. He offered it patent-free, however, to his friend, Sir David Brewster, in Scotland, where eventually it was given to the artistic team of David Octavius Hill and Robert Adamson, a partnership that produced over 2,500 calotypes, mostly portraits, allegories, and tableaux beginning in 1843. This perhaps overshadowed Talbot's own considerable contribution of photographs printed in his book *Pencil of Nature* (1844), calotypes of architecture and genre scenes, many taken at his estate at Lacock Abbey. Photography's "historical moment" in England was best represented in about four-and-a-half short years by an extensive portfolio of photographic art in Scotland, a great start for the medium.

Despite this achievement, the calotype flourished better in France and has been characterized as a collective aesthetic occurring between 1845 and 1870 according to Andre Jammes and Eugenia Janis in *The Art of French Calotype* (1983). Unlike the daguerreotype, used primarily in the commercial portrait studio, the paper calotype lent itself to a long tradition of print-making and drawing, and was an efficient reproducible art (numerous prints from one negative). The "lack of aura" attributed to one-of-a-kind art, would later challenge photography's legitimacy in the twentieth century according to Walter Benjamin in *The Work of Art in the Age of Mechanical Reproduction*. Furthermore, since the calotype looked like art (it was championed by Lady Eastlake, an early writer on photography), it was easy for critics and intellectuals to include the calotype with more established arts in a never-ending desire to have photography imitate painting and hold its own as "high art." Hippolyte Bayard's positive paper prints hung next to works by Titian and Rembrandt, in the Martinique benefit exhibition, in Paris, in 1839—possibly the very first photography exhibition.

The early French calotypists, Hippolyte Bayard, Louis Blanquard-Evrard, and Gustave Le Gray experimented with and improved the aesthetic potential and longevity of the medium, by improving the tonal range, the richness of blacks, the vari-

ety of papers, and waxing the negative. The waxing process developed to improve emulsion absorption was attributed to Le Gray, a photographer and teacher with his own art school. The production of lasting portfolios to preserve the delicate calotypes and facilitate their distribution was attributed mostly to Blanquard-Evrard. The photo critic, Francis Wey, stated, "Our albums are our salons."

The nationalistic fervor of the Second Empire prompted Napoleon III to modernize Paris, following the French Revolution (1789–1793), and to attempt to restore the glory of French architecture. For the first time, photographic documentation played a role in restoration, as did the influence of Romanticism on all literary and visual output. Romanticism influenced the use of the calotype over the daguerreotype to document the great medieval cathedrals across France, despite the detail, sharpness, and tonal range that could be achieved with the daguerreotype; ironically, it was considered of too small a scale and too impersonal ("cold tinge, shiny surface"). Government grants for photographic restoration, the "Missions Heliographiques" (1851) were provided to the early calotype artists: Hippolyte Bayard, Henri Le Secq, Edward Baldus, Gustave Le Gray, and O. Mestral. Charles Négre, calotypist and student of Le Gray, later explained this romantic viewpoint:

> Being a painter myself....whenever I could dispense with architectural precision, I indulged in the picturesque, in which case I sacrificed a few details when necessary, in favor of an imposing effect that would give a monument its real character and also preserve the poetic charm that surrounds it.

(Jammes 1983, 62)

If the project failed as architectural documentation—even the ongoing lithographic survey, "Voyages Pittoresques," provided more details than the calotype photographs—it gave these fine calotype photographers recognition and respectability, as Daguerre had had with government support.

The calotype was also used for documentation in Egypt, the Holy Land, and other locations. Maxime du Camp, accompanied by writer Gustave Flaubert, made calotypes as early as 1850 on an expedition to Egypt; Charles Marville documented Paris prior to Eugène Atget, and photographed in Germany in 1853; and Edward Baldus, using both the calotype and the wet-plate process, documented cathedrals, early railroads, and the devastating Rhône floods of 1856.

While members of the science community seized on the new wet-plate collodion attributed to Frederick Scott Archer, in 1851, advocates in the art community fought furiously for the retention of the calotype. The art journals of this period, *La Lumiére*, for the *Société Haliographique* and *The Bulletin* for the *Société, Française* favored the calotype, while *Le Propagateur* and *Cosmos* came out in favor of the collodion. The new technology triumphed and in 1851 the collodion era emerged.

Collodion, initially developed for medical use, had the properties for even suspension of silver producing a superior glass negative especially when printed on albumen paper. Therefore, collodion/albumen became the standard used for over 30 years. Unfortunately the glass negatives had to be exposed and processed while moist, requiring a portable darkroom in the field. Although faster, the collodion process was still incapable of recording action.

Louis Daguerre's process had an immediate universal appeal, especially in the United States. In 1839, Samuel Morse, painter and inventor of the Morse code, purchased a daguerreotype system. Experimenting with John Draper, New York University chemistry professor, the two initiated a period in the United States that became the longest, most advanced, and lucrative commercial practice of daguerreotypy in the world. Other innovators, Henry Fitz and John Plumbe working in Boston, Robert Cornelius and the Langenheim brothers in Philadelphia, and others, offered services such as toning, coloring, size options, and elegant frames. They applied steam power and the new German system of labor (assembly line) to their mini-factories and competed to reduce prices. Two of the finest establishments to evolve out of this experimental period in the United States were Southworth and Hawes in Boston, who learned from Daguerre's representative in the U.S., François Gouraud, and Mathew Brady in New York City and later Washington, D.C., who studied under Morse and Draper.

Southworth and Hawes represent the highest quality of skill and variety of daguerreotypy ever produced, rivaled only by Mathew Brady in the United States and, possibly, by Antoine Claudet and Richard Beard in England, and Jean-Sabatier-Blot in France. Beard patented a coloring process that made daguerreotypes as precious as the hand-painted, ivory miniatures they replaced. Brady, prior to his reputation as American Civil War photographer, began by making jewelry cases, learned the daguerreotype, and opened his first of several studios on lower Broadway, New York City, in 1844, across from the famous P. T. Barnum American Museum. He realized that photographing the famous was a means to success. Brady's most important early daguerreotype edition, *The Gallery of Illustrious Americans*, featured prominent Americans

such as naturalist John James Audubon, politician Henry Clay, and others. This edition of daguerreotypes, one-of-a-kind positives, were reproduced as lithographs by the famous lithographer, François d'Avignon. And this shrewd venture helped build his reputation as "Brady of Broadway."

Brady also photographed renowned actress Jenny Lind, performing for P. T. Barnum and the celebrated wedding of another Barnum star attraction, the midget, Tom Thumb, held at New York's Grace Church. Brady established his last and most luxurious studio, the National Portrait Gallery, across from this church where he continued making celebrity portraitures including Edward, Prince of Wales, and presidential candidate, Abraham Lincoln, who said: "Brady and the Cooper Institution [where he delivered a speech] made me president." Photographs taken by Brady personally are few due to eye problems. He had to rely on his brilliant operators, Alexander Gardner, who managed Brady's Washington, D.C. studio, Timothy O'Sullivan, George Barnard, and others whose work was produced under the Brady name, a practice that continued during the Civil War. Gardner and O'Sullivan finally broke with Brady to produce portfolios of the war under their own names: "Gardner's Photographic Sketchbook of the War," (which included work by O'Sullivan) and Barnard's "Photographic Views of Sherman's Campaigns."

War photography was introduced with the advent of the wet-plate process, subsequently replacing illustrators and sketch artists in the field with photographers and their portable dark rooms. Alexander Gardner, specializing in photographs of Lincoln, documented the "Hanging of the Lincoln Conspirators," shortly after the assassination. As one of the first "photojournalistic events" it was too ghastly for the public, and illustrations, but not the actual photographs, were published to record the event.

Known for the first photographs of war in the Crimea, in 1855, pre-dating Brady by some six years, Roger Fenton, the English photographer, holds a special place in the nineteenth century. His career spanned an important middle period connecting the invention of Talbot's calotype, the advent of collodion, the commercial "view" business, and finally war photography. In spite of his reluctance to regard photography as high art, Fenton preceded and laid the foundation for the return of art photography in England during first, the Pre-Raphaelite period, and second, the Pictorialist period.

Fenton had visited France in the 1840s. He was very impressed by salon life, befriended the calotype artists, and had studied painting with Paul Delaroche. In 1847, he joined the English Calotype Club,

which had only 12 members due to Talbot's restrictive patent. He founded the Photographic Society of London, in 1853, which later became the Royal Photographic Society and, even established a darkroom in Windsor Castle for Prince Albert. Both Queen Victoria and Prince Albert were strong advocates of photography.

The Crimean War forced Fenton to perfect his new collodion skills under horrible conditions. Sent to Balaklava Harbor at the request of Agnew's Publishing of Manchester, England, and Prince Albert, he recorded the chaos of war and the aftermath of battle, which prompted John Szarkowski, in *Photography Until Now*, to refer to photographs of the terrain as "bare, moon-like landscapes." Fenton photographed for only four months, producing 360 plates, mostly portraits of officers. In 1855, he contracted cholera and was replaced by James Robertson and Felice Beato.

In some ways, the Crimean and American Civil Wars marked the ends of two remarkable careers in photography. Mathew Brady's very nineteenth-century mission and destiny nearly destroyed him; first, when he was almost killed during the battle of Bull Run, and later, when his venture ended in bankruptcy. There was little interest in buying his photographs after the war although, eventually, some 7,000 plates were purchased at discount by the United States Library of Congress. Roger Fenton, having recovered from war and cholera worked for the British Museum and made camera "views," then with little explanation, abruptly ended his photographic career in 1862. Fenton's "views" were some of the best of the genre. His closest competition, Francis Frith and Company, lasted an amazing 111 years. The view business prospered during the wet-plate era with such companies as Francis Frith in England, George Washington Wilson in Scotland, the Alinari Brothers in Italy, Adolphe Braun in France, Bonfils of Beirut, and others, providing eclectic, romanticized, often trivialized documentation of people, places, and events that, nonetheless, are important to the historic photographic record.

The collodion process provided studios with other commercial offerings to augment the portrait and view business. The tintype (Ferrotype, 1856), a collodion positive image on metal, was a cheaper yet far inferior version of the gradually disappearing daguerreotype; the Ambrotype (1854), a collodion positive image on glass, attributed to the American James Ambrose Cutting; and the stereograph (1849) attributed to Sir David Brewster of Scotland, made with a stereoscopic camera such as the Dancer, the Quinet, and the Disderi offered, with the aid of a stereoscope, the phenomenon of three-dimensional

views. The "carte de visite" (1857) attributed to A.A. Disderi in France offered inexpensive multiple portraits, an idea quickly copied by all the large portrait studios, including Brady's of New York. Such innovations greatly expanded photography's commercial possibilities, and, except for the Ambrotype, were extremely popular, some into the twentieth century.

The best studios, such as Mathew Brady in the United States and A.A. Disderi and Etienne Carjat in France survived through fierce competition to prosper in the late nineteenth century. They produced some of the finest portrait work as well as a sensitive record of each country's political and artistic leaders. Another Frenchman, Gaspard Félix Tournachon, or Nadar, was the first in France to photograph from a balloon and to photograph underground with artificial lights, but more importantly, to expand and transform his satirical political cartoons (the Panth, on Nadar) into a highly successful and unique portrait business. His singular style with simple lighting and an emphasis on character when applied to photographing celebrities, created a model for many portraitists and fashion photographers in the twentieth century.

Roger Fenton, who spent a lifetime as an advocate for photography left this pursuit at a time when art photography suddenly reemerged among the elite in English society. Various photographers aspiring to high art, during the 1850s and 1860s, aligned themselves with their English brethren, the Pre-Raphaelite painters, John Millais, Georges Watts, and Dante Gabriel Rossetti. They used the photographic medium to fabricate popular allegorical themes from literature and the Bible. Neither collage nor allegory was new to photography, but they had not been used to this extent. Oscar Rejlander was one of the earliest Pre-Raphaelite photographers, who made thirty separate negatives of models and through multiple printing created an amazing collage, measuring 16 × 31 inches, called *Two Ways of Life*, an allegory based on the famous Raphael painting *The School of Athens*. One of Rejlander's ways of life in the allegory featured overt nudity, appropriate to the theme but not to a Victorian audience. He was criticized for this but only after winning first prize in the Art's Treasure's Exhibition in Manchester, in 1857, and having the work purchased by Queen Victoria.

Henry Peach Robinson, a painter, illustrator, and photographer also produced allegories using multiple printing techniques which were less ambitious than Rejlander's. "Fading Away," which featured a healthy fourteen-year-old girl facing the moment of her death, was criticized as too morbid, probably because the photographs made the scene look too real. However, some in Victorian society thought the photograph "an exquisite sentiment" providing a glimpse into nineteenth-century Romantic sensibility. Robinson also published a famous "how-to" book, *The Pictorial Effect in Photography*, in 1869, complete with instructions and illustrations to produce photographs following methods used by the Pre-Raphaelite painters.

The collodion process lured two more in England to art photography, Lewis Carroll and Julia Margaret Cameron. Carroll, the writer of *Through the Looking Glass*, and *Alice in Wonderland*, was also a math lecturer at Oxford in England. He had a fascination, possibly obsession, with very young girls, especially Alice Lidell, the model for Alice in Wonderland, her sisters, and others, and decided to photograph them, often in allegorical costume and pose. Some of these photographs were nude studies, which again aroused Victorian criticism, which contributed to Carroll's laying down his camera and stating that the negatives in question would be destroyed at his death. The photographs that have survived showed a strong sensitivity to the subject and an almost fastidious practice of craft typical of all of Carroll's endeavors.

Julia Margaret Cameron was of the privileged class; she took up photography late in life as a hobby that became a consuming passion. Cameron was close to her mentor, and Pre-Raphaelite painter, George Watts, and attempted many allegories based on the Bible and on the King Arthur legends. Her portraits of Alfred Lord Tennyson, Charles Darwin, Henry Wadsworth Longfellow, and others, are exceptional and convey a unique style that is close-up and abstract, with harsh lighting. Although Cameron was a strong role model for women in photography, a medium dominated by men, it is perhaps misleading to characterize her as an early example of feminism by today's definitions. In her autobiography, *Annals of My Glass House*, she stated: "When I have had such men before my camera my whole soul has endeavored to do its duty towards them in recording faithfully the greatness of the inner as well as the features of the outer man." Cameron is best known for illustrating Tennyson's "The Idylls of the King." Somewhat less known are her sensitive portraits of women in which the poses, the titles, and the delicacy of these enigmatic pictures reveal another aspect of her complex oeuvre.

Allegorical photography aligning itself with Pre-Raphaelite painting resulted in some of the most ambitious and contrived art photography ever produced. And it had its critics. One of these, Peter Henry Emerson, was a physician with an English mother and an American father. He was a distant relative of Ralph Waldo Emerson, American essayist, who, shortly after learning the camera, stated

that he: "took several photographs that were destined to revolutionize photography and make my name in photographic circles." This prophesy was not far off the mark. His famous textbook entitled *Naturalistic Photography for Students of the Arts* (1889), considered an antithesis to Robinson's own book, *Pictorial Effect in Photography*, advocated the straight use of the camera without any manipulation of process or consideration of allegorical subject matter. "Naturalistic Photography" appears to be a revolutionary statement, yet within the context of art history, Emerson's images although not in the style of the Pre-Raphaelites were in the style of the "Naturalists" of the "Rustic" New English Art Club and of the French artist, Jules Bastien-Lepage.

Emerson produced a series of portfolios taken in the East Anglia region of England. He began the series in 1886 with *Life and Landscape in the Northfolk Broads* and ended it in 1895 with *Marsh Leaves*, which is considered his best work. Although making claims to be working with photographic reality, he idealized the peasants he photographed, often posed them in highly stylized compositions, and insisted on "soft focus" for atmospherics.

By the time Emerson's career declined, in 1891—he dramatically renounced his own thesis stating: "The Death of Naturalistic Photography"—he had already influenced, art photography's next phase. Pictorialism, from 1888 to 1912, was a universal style of aesthetic photography meant to evoke feeling and to elicit beauty over fact.

By the 1880s, photography had become a less complicated process with the development of the dry-plate. Practitioners proliferated, especially art photographers. Naturalism continued to have its supporters, in the work of Frank Sutcliffe in the English coastal town of Whitby, but Impressionism, Post-Impressionism, Symbolism, and Tonalism also influenced the Pictorialist photographers toward the turn of the century.

To the members who formed the "Linked Ring," a group trying to raise photography to high art in imitation of painting, in 1892, Pictorialism was a radical break with the photography that preceded it. The Ring started as an English gentlemen's club, (women were not admitted until 1900), and some of its members were Herschel Hay Cameron (Julia Cameron's son), Frank Sutcliffe, Frederick Evans (a distinguished architectural photographer), James Craig Annan, and others. They created their own exhibition spaces and "linked" their endeavors with Pictorialists in other countries. The *Linked Ring* advanced the camera club movement that still exists today. The Vienna Camera Club of 1891 with Pictorialist Henrich Kuehn, the Paris Photo Club of 1894 with Pictorialist Robert Demachy, and the

New York Photo-Secession of 1908 with Pictorialist Alfred Stieglitz, Edward Steichen, and others, were some of these "links." Stieglitz, who may have had the greatest influence on the style, the direction of, and the institutionalization of art photography in the twentieth century, ironically received his first of 150 photographic awards from Peter Emerson.

Pictorialism featured some of the finest images in black and white and color (platinum, photogravure, gum bichromate, etc.) ever attempted by photographers. Of special note is the refinement of the gum bichromate process by Robert Demachy in France. This beautiful and complex photographic process formed a color bridge between the first hand-painted daguerreotype and the invention of the autochrome process by the Lumiére brothers, in 1907.

Pictorialism also influenced documentary photography. Following the American Civil War, Brady photographers (now independent), Timothy O'Sullivan, Alexander Gardner, and others such as the U.S. Army photographer, A. J. Russell, took their wet-plate skills on the road. The U.S. government and private corporations such as the railroads, paid photographers to document the American West. The geological survey expeditions in the United States (also in Canada) were some of the most difficult assignments photographers undertook with their large wooden cameras and darkroom wagons. From 1867 to the early 1880s, these public and private surveys provided information on geology, settlement, indigenous people, and natural resources. These survey photographs remain some of the most magnificent images ever made of this vast and unspoiled territory.

The most important of the government surveys were: the Clarence King 40th Parallel Survey from California to the Great Salt Lake, with photographer Timothy O'Sullivan (who briefly joined the Darien Expedition to Panama in 1870); the Lt. Georges Wheeler Survey West of the 100th Meridian ascended the Colorado River, with O'Sullivan and William Bell in 1871; the Francis Hayden Survey from 1870–1878 to the Yellowstone region and south to New Mexico and Arizona, with William Henry Jackson; the John Wesley Powell Survey of 1871–1882 to the Grand Canyon, Virgin, and Zion regions and the Upper Rio Grande Valley, with E. O. Beaman, James Fennimore, and Jack Hillers; and the California State Josiah Whitney Surveys of the 1860s to Yosemite, with Carlton Watkins.

Timothy O'Sullivan's photographs were some of the earliest and least romanticized images of the land. However, geologist King, looking for evidence of the theory of "Catastrophism" through God's interaction with earth, may have influenced O'Sullivan's choice of views. The Hayden surveys to Yel-

lowstone with William Henry Jackson included landscape painters Sanford Gifford and Thomas Moran. Together they planned their "picturesque" views. Some of Jackson's views were also destined for sale through Anthony's of New York. The aestheticization of the land, the expanding commercialism, and the easy access to the West following the "meeting of the rails" (the much photographed Promontory Point in Utah connecting East with West) brought closure to this period, but not before the portfolios of Jackson and Moran convinced the U.S. Congress to designate Yellowstone a national park.

Carlton Watkins of the Whitney surveys, had a forty-year career, starting as a studio photographer in San Jose, California. Although he is best known for his Yosemite photographs (1860s into the 1880s), his work took him from Mexico to Canada, and included documents of the early mining and lumber industries, legal land disputes, and California missions—tens of thousands of images many of which were exhibited in California and in New York. Of all the survey photographers, Watkin's personal style and complexity of composition perhaps best situates him as a figure transitional to the twentieth century art genre, "Landscape Photography." Watkins's work also helped paved the way for the designation of Yosemite as a national park.

Not all survey work was of the land. The photographers O'Sullivan, Hillers, Jackson, and later Edward Curtis, Carl Moon, and Adam Vroman also photographed the rapidly disappearing tribes of Native American. A very large collection of portraits survives, made mostly by Curtis, who began publishing portfolios on Southern tribes, in 1908 and completed this work with Volume 20, on the Alaskan Inuit, in 1930. By his death in 1952, at the age of 84, Curtis had made over 40,000 negatives, 2,200 photogravures, thousands of pages of text, and also wax cylinders of tribal languages.

Most photographs of Native Americans were "captivity portraits," those taken shortly after battle, "assimilation" photographs, showing Native Americans in government schools such as Carlisle, Hampton, etc., or "novelty" photographs, extreme poses of Indians often with implements of the dominant culture, such as automobiles, airplanes. These were just some of the ways that photographers represented the "other." Most photographs, including those of Curtis, romanticized the Native Americans as "noble savages" living in a world created by James Fennimore Cooper. Curtis occasionally over-posed his subjects or was not careful with their dress or artifacts in his portraits, but he was sympathetic to their plight and consistent in his approach to photographing, which he referred to

as "The Twenty Five Cardinal Points." If anything, Curtis is guilty of applying the Pictorialist style to his ethnographic photographs.

Eadweard Muybridge, an Englishman living in the United States, was another survey photographer who made landscape and panoramic views in California and elsewhere during this period, but his finest work was as a photographer and inventor. Accepting a private commission to photograph a galloping race horse called Occident, Muybridge succeeded in making the first "action" photograph and is credited with the invention of the camera shutter. With this device he produced a series of motion studies using people and animals then continued this work with funding from the University of Pennsylvania and the American painter, Thomas Eakins. These motion studies culminated in the book *Animal Locomotion* (1887). When these studies were shown in a zoo-praxiscope, an early movie projector, Muybridge became the inventor of the motion picture.

Toward the end of the century, one of the largest waves of immigrants arrived in New York Harbor and other ports, creating unprecedented social problems. To address these there emerged a new social science and a new category of photography, "social documentary." From 1882 to 1887, during one of the worst economic depressions in American history, half of the population of New York City, mostly immigrants, was unemployed and living in poverty. Among them, was Jacob Riis, an immigrant from Denmark, living in desperate conditions in police lodgings—the same lodgings he would later, as a journalist, expose through photographs and eliminate altogether with the help of Police Commissioner, Theodore Roosevelt. Riis used his camera as a "weapon," as a tool for social reform by publishing, in the newspapers, his photographs of squalid living conditions. His first of many books of photographs, *How the Other Half Lives*, was published in 1890 using the new half-tone printing process and together with written exposés and lantern slide lectures was to make a large impact on improving the life of the poor and the exploited.

Jacob Riis's successor, Lewis Hine, also reflected part of a larger new social science emerging during the Progressive Era beginning in 1890 that took a scientific approach to understanding poverty not as a "sin" but as an economic condition. Hine, was a photography teacher at the progressive Ethical Culture Center, in New York. He also worked as a photographer for the Pittsburgh Survey, a new sociological investigation, and the National Child Labor Committee (NCLC) and used his camera to expose the exploitation of children in their working environments. Lewis Hine's social documentary

photography set the stage for another group of photographers, the Historic Section of the Farm Security Administration (FSA), who worked during the Great Depression of the 1930s.

Photography had always been a technological art, and now as the century was drawing to a close, the wet-plate had finally gone the way of the daguerreotype and calotype. From 1880, it was gradually replaced by the dry plate process, using not collodion but gelatin and not requiring an instant darkroom. It was only a matter of time before gelatin would allow the glass plate itself to disappear, for roll film to come into being, and the hand camera to achieve popular commercial success.

There were, however, a few holdovers still using the glass-plate cameras. Eugène Atget started photographing Paris late in life after a somewhat unfulfilled career as an actor. He saw the changes occurring in his beloved city as modernity laid its claim on the boulevards and buildings and, like Charles Marville before him, thought he could preserve through photography what was still ancient and sacred. Atget continued to use his large wooden plate camera well into the twentieth century, and long after the Kodak had made everyone a potential photographer. Atget's work (over 10,000 plates) collected by Man Ray's assistant, Berenice Abbott, although primarily done on commission and in subject categories for sales has, over the years, been championed by the modernists, especially the Surrealists who were inspired by the haunting, empty cityscape populated by dolls and hats in shop windows—human surrogates functioning in another reality.

Paul Martin was one of the first photographers to use the latest hand camera, Fallowfield's Facile Detective camera, a noisy wooden, movable dry plate camera. Prior to this, the most portable cameras were the stereos used by nearly all large format photographers. Martin, a working class Frenchman who lived in England, photographed and exhibited his work through camera clubs and magazines. Using his Fallowfield camera he made some of the most modern, candid, and often serendipitous street photographs and night shots of a genre that began with the French calotypist, Charles Négre in the 1850s, continued with the London portfolio of John Thomson, the genre scenes of Frank Sutcliffe, and the turn-of-the-century work of Alice Austen in Lower Manhattan, New York City. Martin also made some sculpture pieces of fishmongers, very modern photo "cut-outs." Although offered a free Kodak, Martin, like Atget, continued to use his precious wooden camera.

In a shrewd, risky entrepreneurial venture, George Eastman of the Eastman Dry-Plate Company of Rochester, New York (1880) created an innovative portable hand camera. The preferred name for these first hand held cameras was the "detective camera," taken from popular literature. The cameras were novelty items disguised in walking canes, waistcoats, hats, and guns—few worked very well. The functional, inexpensive Kodak camera was designed with a short focal length lens of f/9, a shutter operated by pulling a string, and a roll of paper negative film of one hundred round frames. It included with the camera purchase, factory processing and reloading. The advertising read, "You press the button, we do the rest." Not just the film but the entire camera was sent back to the company following exposure. Unique, modern, and instantly popular, even the name "Kodak," was a designed acronym. The twentieth century had arrived.

PETER KLOEHN

See also: **Abbott, Berenice; Atget, Eugène; Camera Obscura; Eastman Kodak Company; Farm Security Administration; Film; Hine, Lewis; Impressionism; Linked Ring; Man Ray; Photo-Secession; Pictorialism; Riis, Jacob; Steichen, Edward; Stieglitz, Alfred; Surrealism; Szarkowski, John; War Photography**

Further Reading

After Daguerre: Masterworks of French Photography (1848–1900) from the Bibliothéque Nationale. New York: The Metropolitan Museum of Art in association with Berger-Levrault, Paris, 1980.

Andrews, Ralph W. *Curtis' Western Indians.* New York: Bonanza Books, 1962.

Barger, Susan M. *Bibliography of Photographic Processes in Use Before 1880: Their Materials, Processing and Conservation.* Rochester, N.Y.: Rochester Institute of Technology, 1980. (Bibliography).

Barger, Susan M. and William B. White. *The Daguerreotype: Nineteenth-Century Technology and Modern Science.* Washington/London: Smithsonian Institute, 1991.

Bartram, Michael. *The Pre-Raphaelite Camera: Aspects of Victorian Photography.* London: Widenfield and Nicolson, 1985.

Caffin, Charles H. *Photography as a Fine Art: The Achievement and Possibilities of Photographic Art in America.* 1901. Reprint, with introduction by Thomas F. Barrow. Dobbs Ferry, NY: Morgan & Morgan, Inc., 1971.

Coe, Brian. *Cameras: From Daguerreotypes to Instant Pictures.* New York: Brown Publishers, Inc., 1975.

Collier, Jr., John and Malcolm Collier. *Visual Anthropology: Photography as a Research Method, Revised and Expanded Edition.* Albuquerque: University of New Mexico Press, 1986.

Crawford, William. *The Keepers of Light: A History & Working Guide to Early Photographic Processes.* Dobbs, Ferry, NY: Morgan & Morgan, 1979.

Doty, Robert. *Photo-Secession: Stieglitz and the Fine Arts Movement in Photography.* New York: Dover Publications, 1978.

Edwards, Elizabeth, ed. *Anthropology & Photography: 1860–1920.* New Haven and London: Yale University

Press in association with the Royal Anthropological Institute, London, 1992.

Emerson, Peter Henry. *Naturalistic Photography for Students of the Arts*. London: Sampson Low, Marston, Searly and Rivington, 1889. Reprint: New York: Arno Press, 1975.

Fox, William L. *View Finder: Mark Klett, Photography, and the Reinvention of Landscape*. Albuquerque: University of New Mexico Press, 2001.

Frizot, Michel, ed. *A New History of Photography*. (original French ed. Paris: Bordas, 1994). K" ln: K"nemann Vwelagsgesellschaft mbH, 1998 (English transl.)

Galassi, Peter. *Before Photography: Painting and the Invention of Photography*. New York: The Museum of Modern Art, 1981.

Gernsheim, Helmut and Alison Gernsheim. *Roger Fenton, Photographer of the Crimean War*. 1954. Reprint. New York: Arno Press, 1973.

Goldberg, Vicky, ed. *Photography in Print: Writings from 1816 to the Present*. Albuquerque: University of New Mexico, 1988.

Haas, Robert B. *Muybridge, Man in Motion*. Berkeley: University of California Press, 1976.

Hannavy, John. *Masters of Victorian Photography*. New York: Holmes & Meier Publishers, Inc., 1976.

Horan, James D. *Mathew Brady, Historian with a Camera*. New York: Crown Publishers Inc., 1955.

Horan, James David. *Timothy O'Sullivan, America's Forgotten Photographer: The Life and Work of the Brilliant Photographer Whose Camera Recorded the American Scene from the Battlefields of the Civil War to the Frontiers of the West*. Garden City, NY: Doubleday, 1966.

Harker, Margaret. *The Linked Ring: The Secession Movement in Photography in Britain, 1892–1910*. London: Heinemena, 1979.

Jammes, Andre, and Janis, Eugenia Parry. *The Art of the French Calotype: With a Critical Dictionary of Photographers, 1845–1870*. Princeton, N.J.: Princeton University Press, 1983.

Jeffrey, Ian. *Photography: A Concise History*. Reprint. London: Thames and Hudson Ltd., 1989.

Jenkins, Reese V. *Images and Enterprises: Technology and the American Photographic Industry, 1839–1925*. Baltimore and London: The Johns Hopkins University Press, 1975.

Lemagny, Jean-Claude and Rouille, Andre, (eds.). *A History of Photography: Social and Cultural Perspectives*. New York: Cambridge University Press, 1987.

Lo Duca (Joseph-Marie). *Bayard*. (1943). Reprint. New York: Arno Press, 1979.

Naef, Weston J. and James N. Wood. *Era of Exploration: The Rise of Landscape Phtography in the American West, 1860–1885*. Buffalo, N.Y.: Albright-Knox Art Gallery; New York: The Metropolitan Museum of Art, 1975.

Newhall, Beaumont. *The Daguerreotype in America*. 3rd rev. ed. New York: Dover Publications, 1976.

Newhall, Beaumont. *The History of Photography: From 1839 to the Present*. 5th ed. New York: The Museum of Modern Art, 1988.

Newhall, Beaumont, ed. *Photography: Essay & Images*. New York: Museum of Modern Art, 1980.

Palmquist, Peter E. *Carlton E. Watkins: Photographer of the American West*. Albuquerque: University of New Mexico Press, 1983.

Pirenne, M.H. *Optics, Painting & Photography*. Cambridge: Cambridge University Press, 1970.

Roger Fenton. With an Essay by Richard Pare. *The Masters of Photography Series*. Number Four. New York: Aperture Foundation Inc., 1987.

Rosenblum, Naomi. *A World History of Photography*. rev. ed. New York: Abbeville Publishing Group, 1984.

Rudistill, Richard. *Mirror Image: The Influence of the Daguerreotype on American Society*. Albuquerque: University of New Mexico Press, 1971.

Scharf, Aaron. *Pioneers of Photography: An Album of Pictures and Words*. By arrangement with the British Broadcasting Corporation. New York: H.N. Abrams, 1976.

Snyder, Joel. *American Frontiers: The Photographs of Timothy H. O'Sullivan, 1867–1874*. Millerton, NY: Aperture, 1981.

Szarkowski, John. *Looking at Photographs*. New York: The Museum of Modern Art, 1973.

Szarkowski, John. *Photography Until Now*. New York: The Museum of Modern Art, 1989.

Trachtenberg, Alan, ed. *Classic Essays on Photography*. New Haven, CT: Leete's Island Books, 1980.

Weaver, Mike. *Julia Margaret Cameron, 1815–1870*. Boston: Little Brown and Company, 1984.

Welling, William. *Photography in America: The Formative Years, 1893–1900*. New York: Thomas Y. Crowell Company, 1978.

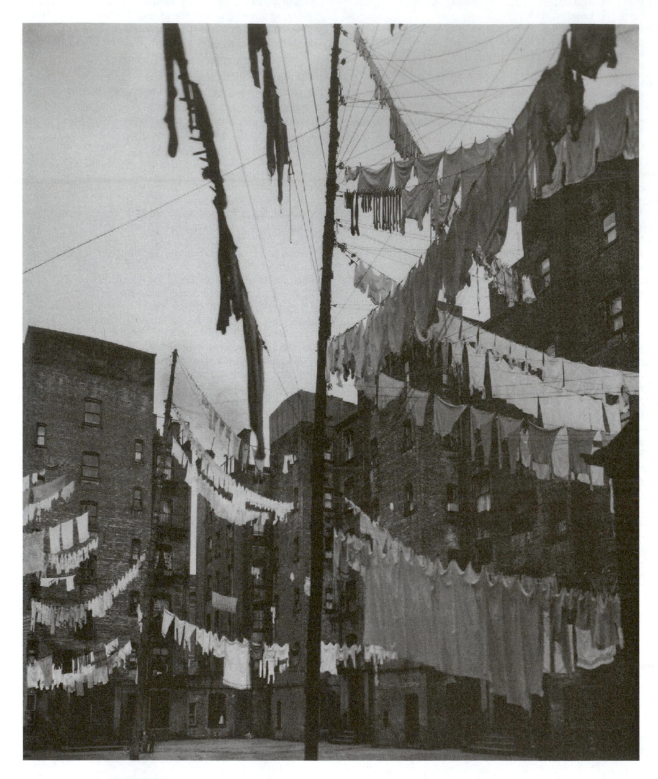

Berenice Abbott, 3 Court of First Ave. Photography Collection, Miriam and Ira D. Wallach
Division of Art, Prints and Photographs.
[© *Berenice Abbott/Commerce Graphics Ltd., New York City. The New York Public Library/
Art Resource, New York*]

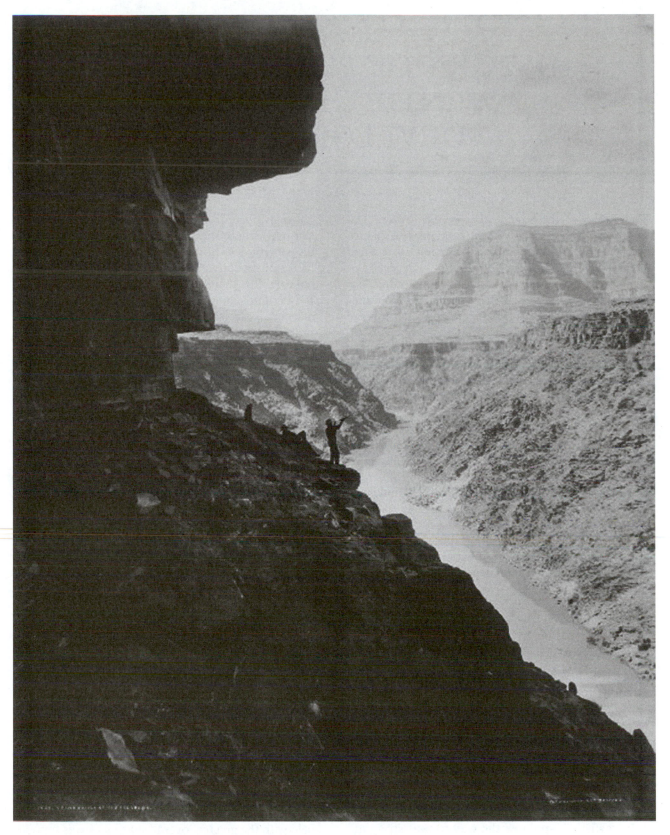

William Henry Jackson, Grand Canyon of the Colorado, ca.1880, Smithsonian American Art Museum, Washington, DC, Museum purchase from the Charles Isaacs Collection made possible in part by the Luisita L. and Franz H. Denghausen Endowment.
[*Smithsonian American Art Museum, Washington, DC/Art Resource, New York*]

HISTORY OF PHOTOGRAPHY: TWENTIETH-CENTURY DEVELOPMENTS

By the end of the nineteenth century, a myriad of technical advances had placed cameras and photographs in the hands of millions. George Eastman had successfully mass-marketed Kodak cameras and ingeniously provided for efficient developing. The half-tone process had at last enabled photographs to be published along side of text. Artistically-minded photographers were challenging moribund photographic societies and gathering together to pursue the artistic side of the medium. In the United States, Alfred Stieglitz broke with the Camera Club of New York. Members of this "Photo-Secession," (founded in 1902) included, among others, Gertrude Käsebier, Clarence White, Alvin Langdon Coburn, George Seeley, and Stieglitz's ally, Edward Steichen. The fifty issues of the quarterly *Camera Work* magazine, published by Stieglitz between 1903 and 1917, multiple printing documented the pictures and convictions of the Photo-Secession. Considered among the most sumptuous art magazines ever produced, it contained superb reproductions of photographs. In addition to *Camera Work*, the Photo-Secessionists showed work at gallery 291, named from its street number on Fifth Avenue, New York City, also known as the Little Galleries of the Photo-Secession. Stieglitz showed not only photographs there but also, from 1906 on, avant-garde modern art, some of which was selected in Paris by Steichen.

Straight Photography

After 1900, the notion of style was contested among aesthetically minded photographers. The dominant style of much twentieth century photography was called "straight," to distinguish it from the blurred, vague look of Pictorialism, which had held sway in the last half of the nineteenth century. Stieglitz's own style of the 1890s—less vague and less ostensibly "artistic"—pointed the way to the "straight." The new photography was crisp and looked more purely a product of the camera. There was less darkroom manipulation to the negative, and many photographers used an approach called "previsualization," where the finished picture is composed in the viewfinder. Some of those who had begun as Pictorialists converted to this new approach, most notably Edward Weston, whose trip to Ohio in 1923 and his encounter with the Armco Steel plant marked a decisive shift towards a sober, brittle style. Edward Steichen, too, one of the most romanticizing Pictorialists up to about 1920, made a soul-searching effort to learn and adapt to straighter approaches. In the early 1920s, Stieglitz made a series of cloud pictures entitled *Equivalents*, which, despite their everyday subject, were intended to convey the artist's deepest feelings.

Stieglitz championed straight photographers such as Paul Strand whose works were featured exclusively in the last two issues of *Camera Work* in 1916 and 1917. His candid pictures of street people taken with a modified camera and his close-ups of machinery and architecture demonstrated how the straight style could produce documents filled with ideas and feelings. Strand settled in France in 1950, thereafter traveling extensively—to the Hebrides, Italy, Ghana, and Egypt—and produced several books of photographs. Stieglitz continued to be a dynamic force for artistic photography in the 1920s and was the proprietor of the Intimate Gallery, and another gallery called An American Place—the title of which reiterated his faith in the expressive aspirations of a distinctly American creative spirit—until his death in 1946. Many aspiring photographers—several of whom would become famous—made the pilgrimage to visit Stieglitz and ask for his advice. After his death, his long-time partner, the painter Georgia O'Keeffe, saw to it that his collection and his own photographs entered important museum collections.

Group f/64, named for one of the aperture's smaller settings, which produced the maximum depth of field with the greatest overall sharpness, was founded in 1932 as an informal collection of like-minded straight photographers. These included Edward Weston, Imogen Cunningham, Sonya Noskowiak,

and Ansel Adams. Using a classic view camera and using natural light exclusively, they made 8 × 10-inch negatives, stopping their lenses down very far to achieve the greatest depth of field. Vivid detail was achieved by contact printing on glossy papers. Retouching or enlarging in any measure was considered taboo. This aesthetic extended to the exhibition of their prints as well. Eschewing decorative frames, they mounted their prints on simple white card stock sparsely spaced on gallery walls. This became standard for the exhibition of photographs throughout the twentieth century. Adams combined his convictions about the straight approach with his passion for the outdoors. After being made aware of photography after visiting the 1915 Panama-Pacific Exposition in San Francisco, Adams avidly hiked and photographed the mountains and spaces of California and the West. Closely linked to the environmental organization the Sierra Club and its concerns, his images of the Sierra Nevada range and of Yosemite produced classic pictures of twentieth century photography. His famous "Zone System," a sophisticated procedure he advocated for determining precise lights and darks, might be seen as the technical expression of the straight photographers' heightened concern for craft.

Straight photography appeared in Europe in a variety of manifestations, and for many reasons. In Germany, the "straight" approach was embodied in the *Neue Sachlichkeit* (New Objectivity) movement, also the name of a soberly realistic contemporary painting style. In photographs of everyday things, Albert Renger-Patzsch made important images in the early and mid-1920s. The title of his well-known book, *The World is Beautiful* (1928), signaled his interest in the straightforward depiction of everyday subjects. Similarly, Karl Blossfeldt's detailed close-ups of plant forms achieved a monumentality of design. The Cologne-based professional portraitist August Sander made countless images of diverse sitters, emphasizing their ethnic, class, and social identities in the first half of the twentieth century. He imagined a vast catalogue of all different types of sitters that was to be called *People of the Twentieth Century. Face of Our Time* (1929) was the first manifestation of this project. The Nazis confiscated it for its liberality, but later observers have been suspicious of Sanders's treatment of "types."

The Influence of Avant-Garde Art

Avant-garde artists became interested in the expressive and design aspects of photography in the first decades of the twentieth century. This, in turn, led photographers to experiment freely with the medium. There was renewed interested in camera-less photographs, made by placing objects on photographic paper and exposing the arrangement to light. Though they had been made long before—even during the dawn of the medium itself—these images were now of interest for their pictorial qualities. Several artists discovered them at the same time. The Dada artist Christian Schad made his "schadographs" beginning in 1919. Man Ray produced his proto-Surrealist "rayographs" in Paris, in 1921. The Hungarian Constructivist László Moholy-Nagy, inspired by Schad and with the assistance of his photographer wife, Lucia, made his own abstract "photograms." Overall, photograms have become a staple of photographic education.

Another new medium was photomontage, which involved pasting objects on photographs or in cutting and assembling photographs into one picture. Again, this had its roots in earlier practices, such as the combining of watercolor and photographs in the Victorian period and in the combination printing of figures such as Oscar Gustav Rejlander and Henry Peach Robinson. The most important montagists hailed from Germany. Hannah Höch produced culturally aware montages made from ephemera—newspaper, advertising, and vernacular photography. Raoul Haussmann, like Höch, was associated with Dadaism, and also made jarring photomontages. This hybrid medium was also of great interest to the Surrealists, who admired the weird juxtapositions in those made by Max Ernst and others. They also utilized new treatments of photography, including solarization, multiple printing, and bas-relief (*paraglyphe*), a technique used by Raoul Ubac which produced a three-dimensional effect. Man Ray's Surrealist photos often made strange transformations of the female body.

Constructivists like Moholy-Nagy and El Lissitzky were less interested in the preposterous meanings than in combining images in the interest of new spatial and light effects. The most prolific of all was the Soviet Alexander Rodchenko, who produced myriad prints, posters, books and other projects. Their daring designs made the Stalin regime keep careful watch. German-born John Heartfield (born Hertzfeld) used photomontage in biting political satires. Wittily combining photographs of politicians with bizarre elements in absurd situations, and given lacerating titles, Heartfield's antifascist imagery appeared in illustrated workers' magazines (such as the *Arbeiter Illustrierte Zeitung*) between 1929 and 1938 in Berlin and Prague.

The Bauhaus, a progressive German arts-and-crafts school was the first in which photography was taught as an integral part of a comprehensive

715

arts curriculum. Teachers such as Moholy-Nagy, Gyorgy Kepes, and Herbert Bayer used photography to expand their students' vision. They prized the negative as an end in itself, used the photogram as a teaching tool, and took pictures from unorthodox viewpoints. For Moholy-Nagy, the photograph was a necessary tool for the advancement of an enhanced appreciation of things. He delighted in all manner of technical imagery including X-rays, photomicrographs, and motion photography. In his influential book, *Painting, Photography, Film* (1925), Moholy extended his conviction that photography was an essential part of the modern sensibility. This was a motif in teaching and publications. After the Nazis threatened the Bauhaus, Moholy-Nagy fled first to England, then to Chicago, where he founded the New Bauhaus (later the School of Design and the Institute of Design) bringing his venerable Constructivist-inspired notions of photography's utility to a generation of artists, designers, and photographers.

Documentary Photography

Although photographs had been made to document all manner of things in the nineteenth century, it was not until the 1930s that they came to be admired for their aesthetic value alone. Additionally, technological advances such as miniature cameras as the 35 mm format was initially known, quick shutters, and faster film, changed both the process and the resulting documentary imagery.

In many ways, the photographs of Eugène Atget span both centuries. He made some 10,000 pictures in an attempt to document the entirety of picturesque Paris: its denizens, its alleys, parks, and old buildings. Atget sold them to architects, set designers, and artists and worked in relative obscurity until being "discovered" by Man Ray, and by his assistant, Berenice Abbott. She saved his entire body of work upon his death in 1927; today it is housed in the Museum of Modern Art, in New York. Similarly, a group of enigmatic photographs of New Orleans prostitutes by the amateur E. J. Bellocq (c. 1912) were discovered. They were later printed by Lee Friedlander. In the twentieth century, the appreciation for photography elevated the status of many previously unrecognized talents. Such was the case with James VanderZee, whose decade-long career in New York City as a professional photographer was recognized as producing a veritable documentary portrait of the Harlem Renaissance.

Most documentary photography in the twentieth century has been socially concerned. As a teacher at the progressive Ethical Culture School in New York, and as a trained sociologist, Lewis Hine was genuinely interested in social justice, and used his pictures to affect change. Beginning in 1905, he began taking pictures of Ellis Island immigrants. To make his most important body of work, he traveled to mines and textile mills to document children at work. These images were then used to change child labor laws.

The economic crisis of the American Depression provided the impetus for a major documentary project. Under the direction of Roy Stryker, an economics professor, a group of photographers under the aegis of the Farm Security Administration (FSA) was sent to rural America to document the effects of poverty. Another part of its mission was to justify in pictures the successes of President Franklin D. Roosevelt's New Deal programs. Photographers such as Arthur Rothstein, Walker Evans, Dorothea Lange, Russell Lee, and Ben Shahn were sent to the hardest hit areas of the country, often to the Dust Bowl, where farmers were being driven from their land by the harsh weather and blighted economy. Stryker often briefed photographers before they went into the field. They sent their rolls of film back to Washington, D.C., for developing. Today, thousands of their photographs—which were used at the time in posters, advertising, and in all manner of public forums—are housed in the Library of Congress. Although each photographer had a certain style, overall, FSA photographs show a heightened sense of compassion and often a concern for pictorial values. Photography also played a large part in the collaborative projects associated with the time. These include Walker Evans's pictures for James Agee's book on Alabama sharecropper families, *Let Us Now Praise Famous Men* (1941), and Margaret Bourke-White and Erskine Caldwell's book on the South, *You Have Seen Their Faces* (1937).

The New York-based Photo League (1930–1951) was a group of liberal photographers and filmmakers committed to depicting the urban poor. They produced important projects such as the *Harlem Document*, but aroused suspicion during the McCarthy era for their left-wing politics. In England, at nearly the same time, a project called Mass-Observation also sought to understand national identity by accruing documentary information. Founded in 1936 by the journalist and poet Charles Madge, and including the participation of filmmakers and natural scientists, it sought to amass raw data about daily life and about Britain's status quo. Ordinary people took countless photographs of their lives and provided information about their

reactions to all sorts of events and conditions. Humphrey Spender made evocative images of industrial towns disguised as a worker.

Photojournalism

Photography and the press have always been intrinsically linked. Even before the technology existed to reproduce photographs in mass-produced publications—originally, actual photographs were bound into books—drawings made from photographs were printed. The halftone process, widely used after 1900, enabled photographs to be published along side of text. With the widespread use of miniature cameras such as the Ermanox (1924) and the Leica (1925), photojournalism came into its own. These new cameras made photographers highly mobile, and enabled them to inconspicuously move close to the action. They utilized natural light, had wide-aperture lenses, and fast exposure times. The development of the flash in the twentieth century represented a great advance over the cumbersome, explosive, and smoky flash powder previously utilized. The synchroflash coordinated the flash with the shutter of the camera. Later, multiple flashes allowed photographers to arrange a room with many light sources, creating a more natural effect, and simply wait for an appropriate moment to shoot. Flashbulbs and electronic flashes were other twentieth-century innovations.

A new style of photography evolved which emphasized informality and spontaneity. Images now conveyed news. Photographically illustrated publications became wildly popular in the 1920s and 1930s. Germany led this phenomenon with publications such as the *Müncher Illustrierte Presse* (1928), though France's *Vu* (1928) and, later, Henry Luce's *Life* and *Look* (begun in 1936 and 1937, respectively), in America, were also widely read. Margaret Bourke-White's industrial photographs first appeared in *Life*, as did those of Alfred Eisenstaedt. Pictures of politicians, events, and interesting sites held viewers in thrall and became important in shaping popular opinion. The photoessay—sequenced pictures accompanying an informational text—was a form that was invented to suit these new picture magazines. Over time, every manner of human-interest story was expressed in this form. Innovative editors, such as Stefan Lorant, editor of the *Müncher Illustrierte Presse*, oversaw both image-making and stories. Photographers were part of a team that included an editor, researcher, and writer. Over time, effective formulae for photoessays were established. Pictures were sequenced on the page before the addition of text, and opening paragraphs established a context for the imagery that followed. In 1934, Lorant fled the Nazis. In London he established important picture magazines such as *Picture Post* (1938) and *Weekly Illustrated* (1934). The spontaneous and natural look of the photographs he printed, many by émigré photographers, impacted photojournalism around the world. Certain photographers, such as Felix H. Man and W. Eugene Smith, became well known for their images that became part of memorable photoessays. Picture magazines provided important experiences for photographers and editors in the twentieth century. Andreas Feininger, for example, who had worked for *Life*, later made several books of design-conscious imagery. The influential Alexey Brodovitch, art director of *Harper's Bazaar* from 1934–1958, helped shape the style of magazine layouts, and that of important photographers as well.

Photojournalists became adept at capturing significant and newsworthy moments. This led to an appreciation of the aesthetic of spontaneity in its own right. The Hungarian-born André Kertész made beautifully composed images notable both for their composition as well as their perceptiveness. Henri Cartier-Bresson, working in France, conceived of an entire approach based on capturing, as he said, the "decisive moment," the name of an important book of his images (1952). He described the process of the patient readiness to snap preconceived shots as a "fencer making a lunge." He was a founder of Magnum Photos in 1946 with David Seymour ("Chim") and Robert Capa. This photographer's collaborative, which maintained a staff of roving cameramen taking pictures to sell to press agencies, was the result of a desire for greater control over their pictures.

Since photography's invention, war has provided the subject for countless pictures. The sites and soldiers of the Crimean War and the American Civil War were extensively photographed. Actual scenes of battle, however, could not be taken because of cumbersome equipment. But by 1930, smaller cameras, roll film, and the dictates of the press made the experience of war inherently photographic. Governments, too, used photography for aerial reconnaissance and to monitor troop movements, as well as for propaganda purposes. Combat photographers faced great technological challenges and life-risking situations. Robert Capa became a pioneering combat photographer. His blurry images of moments from the Spanish Civil War and from D-Day conveyed the franticness of battle. Joe Rosenthal's image of American soldiers raising a flag on the Iwo Jima battlefield (1945) became an icon of American patriotism. In Britain during

World War II, a host of talented press photographers made memorable images of Blitz damage, including George Rodger, one of Magnum's founders. Powerful pictures of the human cost of war were made by the Soviet photographer, Dmitri Baltermants. Lee Miller, a former assistant to and model for Man Ray, accompanied American forces and produced startling pictures of the liberation of the German concentration camps. David Douglas Duncan photographed the war in Korea. Don McCullin and Larry Burrows made graphic pictures of the wounded in Viet Nam in the 1960s. War photographs assumed the power to change public opinion. Thus, governments have exerted control over their publication.

Fashion Photography and Portraiture

Although nineteenth-century photographers made images of fashionably dressed sitters, fashion photography was not a distinct genre. Because photographs could now be published, because of sophisticated retail strategies, and because the motion picture industry used photographs to sustain interest in its stars, fashion photographers became important in the 1920s and 1930s. Designers, magazines, and department stores all depended on them. Baron Adolph de Meyer, a Pictorialist, made images of aristocratic beauties, as did George Hoyningen-Huene, while Edward Steichen made unforgettable images of Hollywood stars and cultural figures. Man Ray produced Surrealist-inflected fashion photographs in the 1930s. In England, Cecil Beaton came to represent the very ideal of the urbane fashion photographer.

Several portraitists became renowned for their perceived ability to capture the personalities of their sitters. In the first half of the century, Steichen, Beaton, Yousef Karsh, and Gisèle Freund documented important sitters. Phillip Halsman, Irving Penn, Richard Avedon, David Bailey, Herb Ritts, and Annie Leibovitz have done the same in later decades, their works straddling the border between rote documents and artworks. Pictures by these photographers were most often collected in books, which might be seen as a continuation of the nineteenth-century predilection for compiling images of famous sitters. Since the 1970s, the portrait tradition has been ironized by the witty photographs of William Wegman, who photographed his pet dog in situations formerly reserved for serious portraiture.

Science and Technology

Twentieth-century scientists and photographers were interested in capturing motion in ever-smaller increments. Eadweard Muybridge and Jules Larey had been pioneers in the previous century. With the development of super-quick shutters and film, scientists such as Harold Edgerton amazed viewers with images of bullets captured in mid-trajectory and the beautiful symmetries of water droplets. X-rays, aerial photography and astronomical photography, and infrared photography were also refined in this period, as was the ability to photograph images seen through electron microscopes. In general, as it had in the past, photography proved to be an indispensable tool of modern science. Concurrently, older forms of the medium, such as the tintype and the stereograph, disappeared.

As the twentieth century drew to a close, and with the dawning of the technological era, photographs were breaking free of the traditional camera and darkroom altogether. Digital photography, the transcription of the subject directly to disc or drive, was the result of a marriage with computers. By the 1980s, scanners and software had been developed to store and convincingly alter pictures, thereby calling into question the inherent veracity of the photograph. The abandonment of any traditional developing, the meaninglessness of a photographic "original," and the ease with which digital imagery is transmitted through Internet systems has irrevocably changed the fundamental nature of the medium.

Color

Color photography matured in the twentieth century. Previously, color in photographs—outside of the singular and isolated experiments of isolated inventors—was achieved by the actual application of colored pigments to the photograph's surface. The first practical color process was the Autochrome process, invented in 1907 by the French Lumière brothers (Auguste and Louis). It produced a positive color transparency, not a print on paper, by using a color screen, actually a glass plate covered in dyed starches, through which light registered colors on a layer of emulsion. Alfred Stieglitz, John Cimon Warburg (1867–1931), and Jacques Lartigue all made autochromes. However, the process was expensive, ephemeral, produced unique examples, and did not encourage experimentation.

Advances did not come until the 1930s when Leopold Mannes and Leopold Godowsky, Jr., working at Kodak Research Laboratories, invented Kodachrome film. The following year, the Agfa Company of German, arrived at the Agfacolor negative–positive process. Like the Kodachrome process, it made possible reversal film, which produced color transparencies suitable for projection (as slides) and for reproduction (as prints). In 1942, Kodak introduced Kodacolor film, which, after years of refinement, became the most popular color photography process of all.

Camera artists at mid-century cautiously made works in color, some courted by Kodak and other companies to demonstrate its practicality and expressiveness. Important early practitioners of color processes include Paul Outerbridge, Jr., Madame Yevonde, and Helen Levitt. The Austrian Ernst Haas, a Magnum photographer, made remarkable colored abstract and blurred motion works at mid-century. In 1958, the Belgian Pierre Cordier began making his abstract "chimigrammes," color photograms made chemically on photosensitive paper. In America, in the 1960s and after, photographers such as William Eggleston and Nan Goldin explored color, especially the warm end of the tonal range. The nature photographer Eliot Porter captured the shimmering surfaces of the outdoors and produced books sponsored by the Sierra Club. The chromogenic print, or C-print, as it is known, is a further stage in the development of color processes and has been a choice of artistic photographers. Ektachrome is an example of this process, which relies, like much color photography, on layers of variously color-sensitized emulsions.

The instantaneous Polaroid process, invented by Edwin Land and marketed after 1948, is an example of a dye diffusion print that produces a unique positive print. The SX-70 process produced finished prints within the camera itself. It was eagerly taken up by amateurs. Photographers in the 1960s and 1970s, such as Maria Cosindas and Lucas Samaras, made works of startling originality sometimes by manipulating (rubbing and scratching) the emulsion process as the image develops. Still, many photographers resisted what they saw as the gaudy tones of color photography, which had long been associated with amateurs and used for advertising and reproduced in popular magazines. Until the last two decades of the century, the dominance of black-and-white photography for artistic expression was unchallenged. Additionally, the cost of reproducing color photographs in monographs and other publications has been, until recently, prohibitively expensive. By 1990, however, color photography—in prints of monumental scale and bright tones—had become an important aspect of contemporary art, much of which includes photography. Sandy Skoglund made bright dye-destruction prints from shots taken of her elaborately staged painted sets. Indeed, many heralded contemporary artists, including the generation who emerged in Germany in the late 1980s, including Andreas Gursky and Thomas Struth, work exclusively in large color photography formats.

Post-War Photography

The readership of picture magazines declined in the 1950s and 1960s because of the popularity of television and the ease of travel. As amateur photography flourished, the need for professional photography—portraiture, architectural photography, journalistic imagery, and the like—began to wane. By this time, the public recognized a split between the pragmatic uses of the camera, and more expressive/aesthetic pursuits. Important museum exhibitions of photography became a regular occurrence in the twentieth century. They often gave legitimacy and names to various movements and groups. The *Film und Foto* exhibition in Stuttgart, Germany, in 1929, included about one thousand images, mostly "straight" and Constructivist, from photographers around the world.

By mid-century, the straight approach to photography was being transformed into highly subjective, even mystical statements. Minor White wished his symbol-laden imagery to convey profoundly personal, symbolic content. He was also instrumental in the institutionalization of fine art photography in the United States. He was a founder of *Aperture* magazine (1952), a publication devoted to superbly printed artistic photography, and also became an important teacher. Aaron Siskind explored the abstract imagery of paint-spattered walls, old billboards, and pavements. Harry Callahan's work was less abstract but just as formal in its spare sense of line. Both became influential teachers, first at the Institute of Design (Chicago) and later at the Rhode Island School of Design.

Until the 1950s and 1960s, totally abstract photography was uncommon, although abstract photograms were made by the Constructivists and by the followers and students of Moholy-Nagy. In 1917, Alvin Langdon Coburn had made kaleidoscopic abstract photographs, "Vortographs," with the aid of a mirrored box. Francis Bruguiere also made images filled with abstract light effects around the same time. In the 1940s, photographers such as Frederick Sommer made horizon-less images of the Ari-

zona landscape. Resembling contemporary abstract paintings, they were admired by the Surrealists.

After 1950, a number of photographers working in America became interested in societal conditions. They documented figures in their surroundings in a laconic, unsentimental way. After training as a photojournalist, the Swiss émigré Robert Frank traveled across the country taking informal photos of lonely spaces and isolated individuals. The resulting book, *The Americans* (France, 1958; America, 1959), with its foreword by the Beat writer Jack Kerouac, seemed to articulate the alienation many felt during the Cold War.

A movement in photography known as "Social Landscape," dominated photography in the 1960s and 1970s. It was named for important exhibitions, one of which was *Toward a Social Landscape* (1966, George Eastman House), organized by the photographer-curator Nathan Lyons. Discontent with American popular culture in the post-war period, questioning the conventions of good picture making, and influenced by Frank's *The Americans*, photographers such as Bruce Davidson and Garry Winogrand took random-seeming pictures of the often inscrutable behavior of individuals and groups. In England, Raymond Moore and Tony Ray-Jones worked from a similar outlook. Lee Friedlander's imagery often included himself, and reflected the isolated individual on the street and in hotel rooms. Diane Arbus's photographs, some of which appeared in *Esquire* magazine, portrayed society's outcasts, the disabled, and the grotesque antics of public behavior. Her bizarre pictures are thought to express the outrage associated with contemporary societal pressures and with the celebration of a radical individuality in this period. Bruce Davidson's series of ghettos and New York City gang teenagers, and Danny Lyon's civil rights protestors, prisoners, and motorcyclists are seen as part of the "New Journalism" style of photography prevalent in the 1960s and 1970s. It was thought to be the pictorial equivalent of the hard-hitting reportage of contemporary journalists such as Norman Mailer, Tom Wolfe, and Hunter Thompson. In a similar vein, Mary Ellen Mark made moving but unsentimental photographs of homeless children.

European photography between the 1920s and 1960s was marked by imaginative uses of documentary photography. Although there were progressive photos published in the flourishing picture magazines, many photographers also published influential books of their works. Brassaï (the pseudonym of Gyulas Halász) became well known for his book, *Paris de nuit (Paris at Night)* (1933), which documented the city's picturesque and haunting night-life. Another photographer working in Paris, Robert Doisneau made lighter, more satirical documents of Paris and its strollers. Much European photography reveals a social aspect. In Mexico, Manuel Álvarez Bravo made Surrealist-inspired documents of peasant life; Tina Modotti, Edward Weston's one-time partner, photographed peasants with a revolutionary political outlook. In Germany, Otto Steinert was influential in reintroducing an experimental spirit to photography in the post-war period. He was a founder of a movement called "Subjective Photography" and led an important group called "fotoform" in the early fifties. The Swiss Werner Bischoff made socially conscious color imagery of poverty-stricken peoples. Josef Sudek of Czechoslovakia is renowned for his still lifes and images of Prague. From a younger generation, Jan Saudek makes innovative works that recall nineteenth-century pictures. Mario Giacomelli's images of Italian village life are noteworthy. Japanese photographers have kept apace of western developments and have brought an original aesthetic to their pictures. Eikoh Hosoe's imagery is more artistic than Takayuki Ogawa, who is known for socially realistic works.

Contemporary Photography

A different approach to the landscape was represented in a highly influential 1975 exhibition entitled "New Topographics: Photographs of a Man-altered Landscape" mounted by the International Museum of Photography and Film, George Eastman House. Among the images represented were those by Robert Adams, Lewis Baltz, and the German couple, Hilla and Bernd Becher, which soberly depicted features of the industrial landscape, or the banal spaces and housing projects of the American West. They seemed to be a reaction to the highly subjective documentary work that was made in the 1950s and 1960s. In a similar spirit of coolness, the handful of photographers spearheaded by Mark Klett who conducted the Rephotographic Survey Project (RSP) between 1977 and 1979 precisely documented 122 nineteenth-century western survey sites.

After 1970, photographers manipulated the print as an object in its own right. Recalling the nineteenth-century fondness for manipulating negatives, photographers now explored all manner of manipulations. Along these lines, Jerry Uelsmann made fantasy-filled combination prints in the 1960s. Robert Heinecken and Ray K. Metzker made ingenious series and collages from photographic fragments. Duane Michals explored the series in themes

that often hint at the otherworldly. The Starn twins (Doug and Mike) tore and reassembled photographs with tape. Artists such as David Hockney and Gilbert & George made large-scale, multi-image collages. Photographs are integral components of the paintings of Anselm Kiefer and Sigmar Polke where they often relate to recent German history.

Although the 1960s witnessed a taste for harsh documentary photographs, some images provoked scandals in the later part of the century. Les Krims's 1970 image of a legless man on a pedestal provoked a viewer to hold the son of the gallery director hostage until it was removed. An exhibition that included some of the graphically sexual images of Robert Mapplethorpe provoked conservative members of Congress to call for their censorship and for a rethinking of government funding for the arts in general. The homoeroticism of some of the works was linked to the AIDS epidemic, from which Mapplethorpe himself later died. Andre Serrano gained notoriety for an image of a crucifix immersed in urine (1987). Joel-Peter Witkins's photographs have shocked many viewers; his antique-looking images of bizarre tableaux often include amputees and severed heads. Jock Sturges was brought to trial for his images of nude girls; Sally Mann's pictures of her own nude children have sparked a less heated debate.

Feminist concerns and issues of identity were expressed by photographers working in the latter decades of the century. Cindy Sherman's self-portraits explore women's roles while Astrid Klein's collages, which use the conventions of advertising photography and language, challenge assumptions about gender. Similarly, in the 1990s, photo-artists such as Lorna Simpson and Carrie Mae Weems have critiqued cultural stereotypes about race and about the female body.

Institutionalizing Photography

Museums began establishing their own distinct photography departments as well, with one of the earliest departments at the Museum of Modern Art, in New York (1940). In 1955, the Museum of Modern Art (MoMA) mounted *The Family of Man*, a blockbuster exhibition arranged according to universal themes of love, work, and birth. Including 500 works by nearly 70 photographers shooting in countries throughout the world, it was the most visited photography exhibition ever; its catalogue became the best selling photography book of all time. It was arranged by Edward Steichen, then head of the photography department,

and was meant to reaffirm humane values in the post-war period.

In the twentieth century, photography became the subject of serious intellectual inquiry. Figures such as Walter Benjamin, Roland Barthes, Susan Sontag, and John Berger have written important philosophical and cultural examinations of the medium. Authors and poets have also integrated photography and its effects into their writing. The century also saw the advent of pioneering historians of photography such as Heinrich Schwartz, Helmut and Alison Gernsheim. Nancy and Beaumont Newhall encouraged artistic photography in their time and established departments of photography in museums and universities alike. Beaumont Newhall wrote an enduring history of photography, *The History of Photography: From 1839 to the Present* in 1937, based on a landmark exhibition of the same name at MoMA. Important curator-writers such as John Szarkowski, also at MoMA, curated significant shows and shaped opinion about the direction of contemporary photography for several decades. Organizations for amateurs and professionals proliferated in the twentieth century. Camera clubs, exhibiting societies, and workshops sprang up in cities around the world. A broad range of magazines and instructional books conveyed professional, aesthetic, and technical information. After World War II, galleries devoted exclusively to photography were established. The market for photography soared in the 1970s as historians and museums determined a canon for its history.

MARK POHLAD

See also: **Adams, Ansel; Bauhaus; Becher, Hilla and Bernd; Brownie; Callahan, Harry; Capa, Robert; Cartier-Bresson, Henri; Dada; Digital Photography; Documentary Photography; Duncan, David Douglas; Edgerton, Harold; Evans, Walker; Farm Security Administration; Fashion Photography; Frank, Robert; Group f/64; Heartfield, John; Hine, Lewis; Höch, Hannah; Infrared Photography; Institute of Design; Life Magazine; Lissitzky, El; Magnum Photos; Man Ray; Mapplethorpe, Robert; Moholy-Nagy, László; Montage; Multiple Exposures and Printing; Museum of Modern Art; Newhall, Beaumont; Photogram; Photo League; Photo-Secession; Pictorialism; Porter, Eliot; Portraiture; Renger-Patzsch, Albert; Sander, August; Sherman, Cindy; Solarization; Steichen, Edward; Stieglitz, Alfred; Stryker, Roy; Surrealism; Szarkowski, John; War Photography; Weems, Carrie Mae; Weston, Edward; White, Clarence; White, Minor**

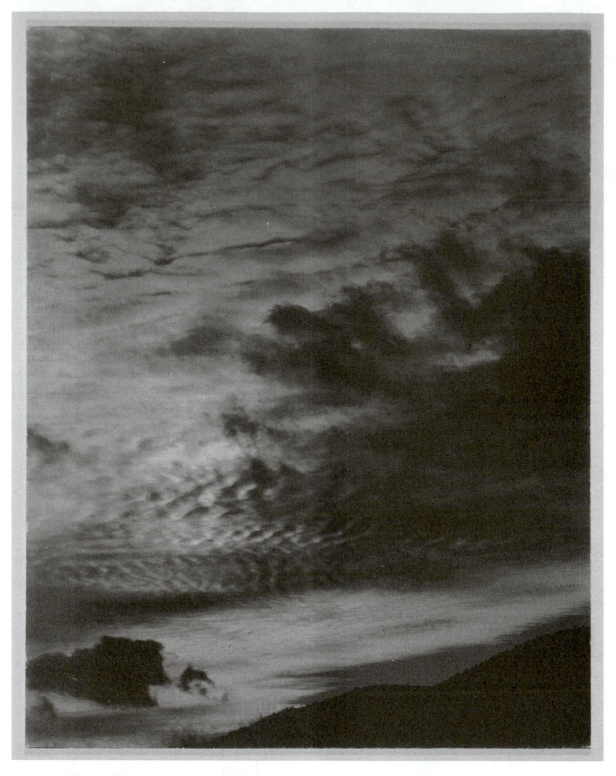

Alfred Steiglitz, Equivalent, 1929, gelatin silver print, 11.8 × 9.3 cm, Part purchase and part gift of An American Place, ex-collection Georgia O'Keeffe.
[*Photograph courtesy of George Eastman House*]

Hugo Erfurth, Frans Blei, 1928, oil pigment, 22.2 × 16 cm ($8^3/_4 × 6^5/_{16}''$).
[*The J. Paul Getty Museum, Los Angeles*]

Brassaï (Guyla Halasz), "Bijou" of Montmartre. 1932 or 1933, Gelatin-silver print, $11^7/_8 ×$
$9^1/_8''$ (30.2 × 23.2 cm). David H. McAlpin Fund.
[*Digital Image © The Museum of Modern Art/Licensed by SCALA/Art Resource, New York*]

Edward Weston, Torso of Neil, 1925, Platinum/palladium print, $9^1/_8 \times 5^1/_2''$, Purchase.
[© *1981 Center for Creative Photography, Arizona Board of Regents. Digital Image © The Museum of Modern Art/Licensed by SCALA/Art Resource, New York*]

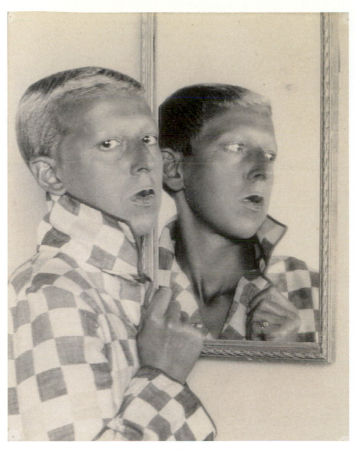

Claude Cahun, Self-portrait, 1928.
[*Réunion des Muséees Nationaux/Art Resource, New York*]

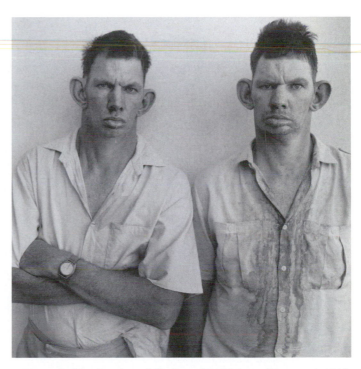

Roger Ballen, Dresie and Casie, twins, Western Transvaal, 1993.
[© *Roger Ballen*]

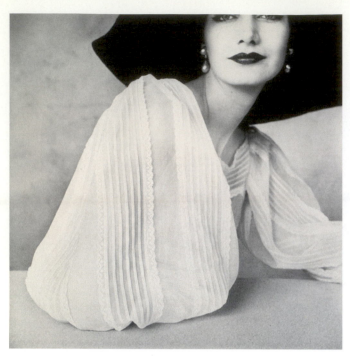

Irving Penn, Large Sleeve (Sunny Harnett), New York, 1951, 13⁹/₁₆ × 13⁹/₁₆″ (34.5 × 34.4 cm), gift of the photographer.
[*Digital Image © The Museum of Modern Art/Licensed by SCALA/Art Resource, New York*]

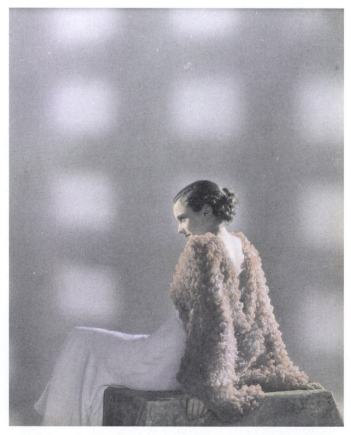

Dora Maar, Untitled (fashion photography), Photo: Jacques Faujour
[*CNAC/MNAM/Dist. Réunion des Musées Nationaux/Art Resource, New York*]

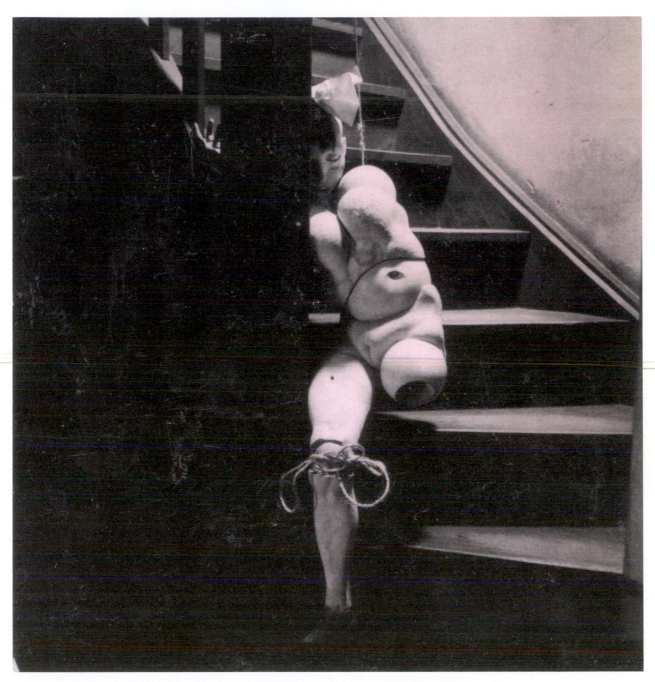

Hans Bellmer, The Joy of the Doll, Page No. 9 of the maquette. Photo: Philippe Migeat.
[*CNAC/MNAM/Dist. Réunion des Musées Nationaux/Art Resource, New York*]

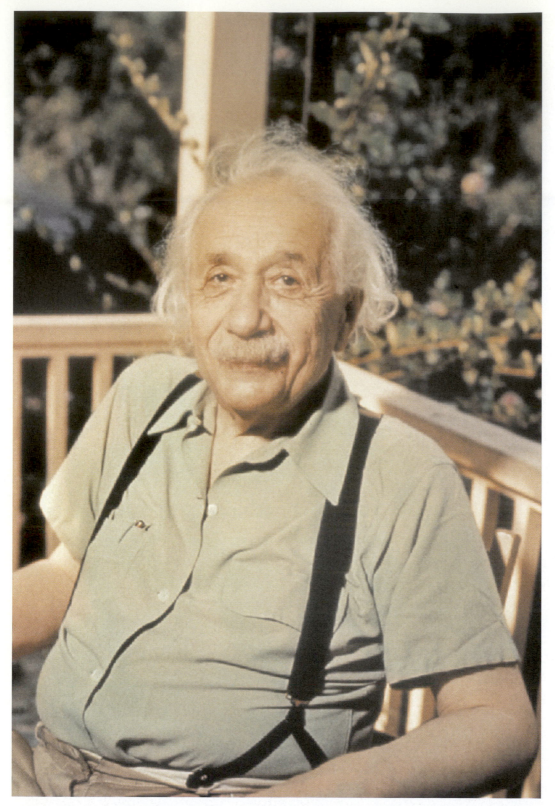

Philippe Halsman, Albert Einstein in his home, 1947.
[©*Philippe Halsman*/*Magnum Photos*]

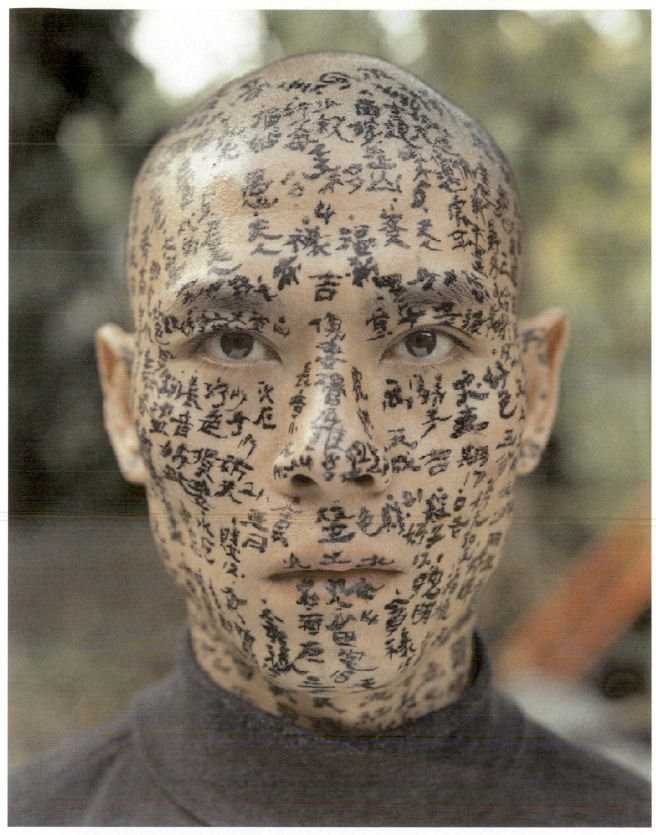

Zhang Huan, from Family Tree, 2000, C-Print, 40 × 50″.
[*Courtesy of the artist and Aura Gallery*]

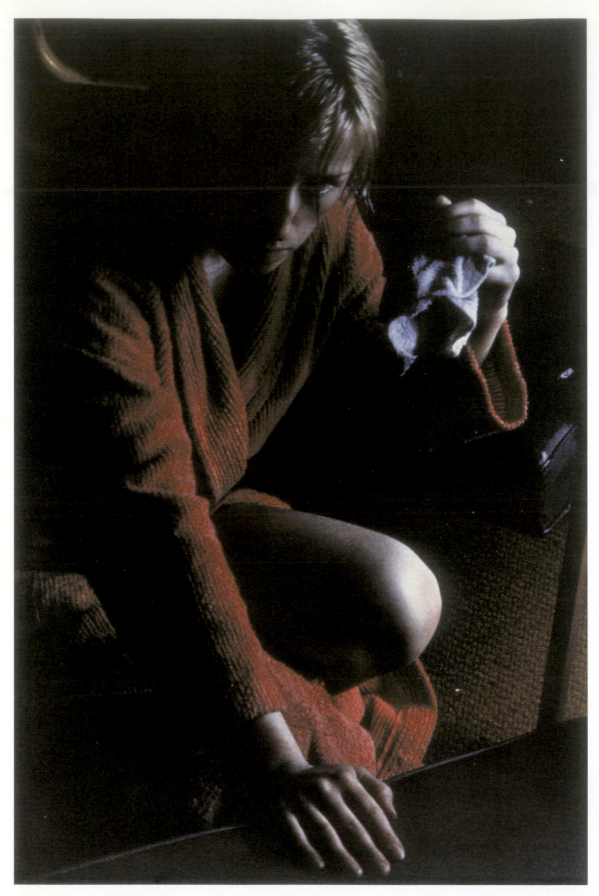

Cindy Sherman, Untitled, 1982.
[*Tate Gallery, London, Great Britain, Courtesy of the artist and Metro Pictures*]

Further Reading

Coke, Van Deren. *Avant-Garde Photography in Germany, 1919–1939*. New York: Pantheon Books, 1982.

Daniel, Pete, Merry A. Foresta, Maren Stange, and Sally Stein. *Official Images: New Deal Photography*. Washington, D.C.: Smithsonian Institution, 1987.

Druckery, Timothy, ed. *Electronic Culture: Technology and Visual Representation*. New York: Aperture, 1996.

Galassi, Peter. *American Photography, 1890–1965*. New York: Harry N. Abrams, Inc., Museum of Modern Art, 1995.

Grundberg, Andy, and Kathleen Gauss. *Photography and Art: Interactions Since 1946*. New York: Abbeville Press, 1987.

Hambourg, Maria Morris, and Christopher Phillips. *The New Vision: Photography Between the World Wars: The Ford Motor Company Collection at the Metropolitan Museum of Art*. New York: Harry N. Abrams, 1989.

Homer, William Innes. *Alfred Stieglitz and the Photo-Secession*. Boston: A New York Graphic Society Book, Little, Brown and Company, 1983.

Phillips, Christopher, ed. *Photography in the Modern Era: European Documents and Critical Writings, 1913–1940*. New York: Metropolitan Museum of Art, and Aperture, 1989.

Sontag, Susan. *On Photography*. New York: Farrar, Straus, and Giroux, 1977.

Teitelbaum, Matthew, ed. *Montage and Modern Life, 1919–1942*. Cambridge and London: MIT Press, and Boston: The Institute of Contemporary Art, 1992.

Trachtenberg, Alan, and Lawrence W. Levine. *Documenting America, 1935–1943*. Berkeley: University of California Press, 1988.

Williams, Val. *Women Photographers: The Other Observers, 1900 to the Present*. London: Virago Press Ltd., 1986.

HISTORY OF PHOTOGRAPHY: TWENTIETH-CENTURY PIONEERS

Like traditional histories, the history of photography has, until recently, been "heroic." That is, it has focused on the achievement of individuals. Even as photohistory has become wider in its scope and has become more interested in its social and cultural dimensions, it is still important to single out those pioneers whose work and interests embodied crucial changes in twentieth-century photography. Those discussed in this entry—mainly up to the 1980s—introduced a new style, subject, or technique. They may also have championed a new way of thinking about the medium. Their importance can be measured by their influence on others and through their exhibitions, publications, and awards.

Stylistic Pioneers

The most renowned photographers of the century introduced new styles and subjects. In the first few years of the twentieth century, Robert Demachy (1859–1936) was an expert of the gum bichromate and oil processes, important Pictorialist techniques. He advocated heavy manipulation of the negative, to make photos more artworthy, describing this aesthetic in books and magazines. Hugo Henneberg (1863–1918), Heinrich Kühn (1866–1944), and Hans Watzek (1848–1903) were leaders of the Pictorialist movement in Austria and formed a group known as the Trifolium. They produced many pastoral, Impressionistic images. Clarence White (1871–1925) was a key member of Alfred Stieglitz's Photo-Secession and an important teacher of Pictorialist principles. His elegant images of his turn-of-the-century family were influential. The school that White established (in 1916) trained many subsequent photographers.

Alfred Stieglitz (1864–1946) was a one-man propaganda machine for artistic photography, and was a leader in camera clubs and organizations in the years around the turn of the century. He was the nexus for a clique of artistic photographers, which he called the Photo-Secession. He championed a new style of photography in opposition to the prevailing Pictorialist aesthetic. Called "straight," it was more crisp and eschewed any manipulation to the negative. He was also the publisher of a lavish photography magazine, *Camera Work*, which established a precedent for quality and aesthetics. He was proprietor of the first and most important gallery of artistic photography in America, the Little Galleries of the Photo-Secession (later, simply *291* for its address on Fifth Avenue, in New York). Finally, inasmuch as

723

291 and *Camera Work* eventually showed important modernist artworks of all kinds—paintings, drawings, sculptures—Stieglitz acted as a champion of modernism in general and thus linked the mission of photography with that of the fine arts. Stieglitz's *Equivalents*, sky photographs done in the early 1920s, were powerful examples for aesthetic-minded practitioners later in the century.

Edward Steichen (1879–1973) was a romantic-minded Pictorialist photographer and a tireless lieutenant for Stieglitz's Photo-Secession and *Camera Work* magazine. Besides taking some of the most memorable images of the era, he also made masterful portraits of famous figures. He became a well-known commercial photographer in the 1920s and 1930s and, as an officer in the Navy during World War II, was responsible for tactical aerial photography. His later career is marked by his organization (as director of the Department of Photography, Museum of Modern Art [MoMA], New York) of the 1955 *Family of Man* exhibition.

Women also made strong contributions to Pictorial photography. The pioneering woman photographer Gertrude Käsebier (1852–1934) was a founding member of Stieglitz's Photo-Secession and is renowned for her images of mother and child. Alice Boughton's (1865–1943) long career was devoted to portraiture cast, like Käsebier's, in a Pictorialist style. Another pioneering female photographer was Anne (Annie) W. Brigman (1869–1950), a Photo-Secessionist whose female nudes set in California mountain landscapes were unique.

Though his most important works were made in a Pictorialist mode, Alvin Langdon Coburn (1882–1966) is credited with making some of the first purely abstract photographs in the medium's history, sometime around 1916. Shooting through a kaleidoscopic mirror device on his camera, he called the resulting pictures "Vortographs," after the English abstract movement Vorticism. He also photographed the geometry of the New York City. Francis Bruguière (1879–1945) also conducted abstract and experimental effects in photography as seen in his 1920s images of cut paper shapes.

Alexandr Rodchenko (1891–1956) was dedicated to the social and aesthetic mission of Russian Constructivism. Besides taking important photographs, Rodchenko was an influential graphic designer, painter, and filmmaker. He was connected with many major culture figures of his time. He is remembered for his images of parades, construction sites, sports, and the circus often taken from unconventional points of view. Another Constructivist photographer and designer was El Lissitzky (1890–1940) who used photomontage and photographic exhibitions to promote the principles of good design and utopian ideals.

Academically trained as an artist, and influenced by the natural philosophy of his day, Karl Blossfeldt (1865–1932) is known for his close-up photos of plant forms. These were published in the book *Urformen der Kunst* (*Archetypes of Art*) (1928), an important example of the 1930s art style known as *Neue Sachlichkeit* (*New Objectivity*). The work of Albert Renger-Patzsch (1897–1966) is also linked to this style by virtue of his close-up images of machine parts, plants, shells, and other design-inherent subjects. His book, *The World is Beautiful* (1928) featured a hundred of his own images. The photographer/painter/filmmaker and designer, László Moholy-Nagy (1895–1946) was a leader in his philosophy of photography, in the advanced nature of his own pictures, and in his teaching. His book, *The New Vision: From Material to Architecture* (1930), was a key landmark in *Neue Sehen* or "New Vision" photography. An impassioned, intellectual teacher, from 1923 Moholy-Nagy taught light and color at the renowned design school, the Dessau Bauhaus. After emigrating to America, he founded the New Bauhaus (later the Institute of Design) in Chicago in 1937. Moholy-Nagy's own photography is comprised of abstract "photograms," photomontages, and daringly formal photographs. The geometric, semi-abstract photographs of Florence Henri (1895–1982) seem to embody Moholy-Nagy's principles.

Associated with the Dada and Surrealist groups of the 1920s and 1930s, Man Ray (1890–1976) used photography to make important avant-garde art, e.g., his "Rayographs," as he called his camera-less pictures. Lee Miller (1907–1997), Man Ray's model in the 1920s, became an important photographer in her own right and was witness and participant to many of Man Ray's innovations (e.g., solarization). In the 1920s and 1930s, Man Ray also produced innovative fashion photography. Man Ray's career spanned New York and Europe, photography and the fine arts, and the world of fashion and Hollywood.

Similarly, Bill Brandt (1904–1983) brought a lyrical surrealist vision to images of the English working class and, later, to distorted female nudes. Working in Man Ray's studio for three months, Brandt developed a taste for formal experimentation. His books, *The English at Home* (1936) and *A Night in London* (1938) were instrumental to subsequent generations of socially concerned photo-documentarians.

Hungarian émigré Brassaï's (1899–1984) images of the nightlife of Paris have become so well known that many visitors' experience of that city has been shaped by them. He photographed the café deni-

zens, homeless, and participants in the sex trade. His *Paris de Nuit* (1933) was acclaimed as an instant classic. Trained as an artist, painter Pablo Picasso, sculptor Alberto Giacometti, and writer Jean-Paul Sartre were among his notable friends.

California-based Edward Weston (1886–1958) was among the most influential photographers of the century for his style and for his persona. Following Stieglitz's lead, Weston embraced the "straight" style of photography—his conversion while shooting an Ohio steel plant in 1922 has become legendary—in which the subject is shown in sharp detail. He also advocated "previsualization," that is, imagining the finished picture before the shutter is released. Around 1930, Weston was a founder of Group f/64, a loose, short-lived association of his friends and followers, in which many of his own principles were applied. In 1937, he was awarded the first John Simon Guggenheim Memorial Fellowship in photography. His relationships with other photographers, his circle of California writers and artists, and his three photographer sons (Brett, Neil, and Cole) make him a singular figure. His *Daybooks*, journals that he maintained from 1923 to 1943, describing his method and outlook, are unique resources in twentieth-century photohistory.

Ansel Adams (1902–1984) is regarded as the preeminent landscape photographer of the American West. He was a devoted member of Group f/64 and, through a series of influential books, came to be regarded as a technical expert. His intricate "Zone System" became an ideal for determining correct exposures. In advocating for the Sierra Club before Congress, he exemplified how a photographer could make a difference in terms of conserving the land he photographed. His politically-conscious images of the WWII internment camp for Japanese Americans at Manzanar, California, are now seen as important documents of the era. Adams was also a tireless organizer, helping to establish the department of photography at the Museum of Modern Art (1940), and the department in what is now the San Francisco Art Institute (1946). Imogen Cunningham (1883–1976) was also a progressive west coast photographer and a founding member of Group f/64. Her close-ups of plant forms and later nudes are well known. She won a Guggenheim award in 1970, and at age 92 she began her final project, *After Ninety*, a collection of portraits.

Paul Strand (1890–1976) is considered one of the most important photographers of the century, mainly for his socially compassionate and uncompromisingly "straight" images, yet has proven to have influenced countless photographers practicing in various styles and genres. Stieglitz heavily promoted his formal images at gallery *291* and in the pages of *Camera Work* magazine. Strand also made landmark avant-garde films that were formally daring (e.g., *Manhattan*, with Charles Sheeler, 1920) and socially conscientious (e.g., *The Plow that Broke the Plains*, with Pare Lorentz, 1936). His book collaboration with photohistorian Nancy Newhall, *Time in New England* (1950), where historical literature is coupled with photographs taken on location, is considered a model of the genre. Images taken during his extensive travels, which occupied Strand for the rest of his life, appeared in influential books.

In his images of New Orleans, the Mississippi river, and the ruins of the antebellum South, Clarence John Laughlin (1905–1985) projected a haunting romance on regional subjects. Similarly, Wright Morris (1910–1998) produced photographically illustrated novels (e.g., *The Inhabitants*, 1946), most of them set in the Midwest, in which the pictures and text exist separately. Images of old farm structures or lonely landscapes are set beside texts describing characters and rural life.

Moving into the post-war era, Harry Callahan's (1912–1999) spare images of his wife, Chicago streets, and watery landscapes remain highly influential. In 1976, he was the subject of a major exhibition at the MoMA and became the first photographer to represent the United States at the 1978 Venice Biennale with a one-man exhibition of his work. He has influenced many photographers, first as a teacher at the Institute of Design, in Chicago (later the Illinois Institute of Technology) from 1946 to 1961, then at the Rhode Island School of Design, until 1977. He is often regarded as part of a teaching partnership with Aaron Siskind (1903–1991). Siskind was a socially conscious photographer in the 1930s, having been a member of New York's progressive Photo League. There he worked on projects such as *Harlem Document* and met like-minded photographers such as Walter Rosenblum (b. 1919). By the 1960s, Siskind had adopted the abstract imagery—graffiti, peeling paint, faded signs—for which he has become known.

Minor White's (1908–1976) formal, mystical images inaugurated a heightened subjectivism for photography in the 1950s and 1960s. Highly educated himself, he became an important teacher, and for some, a guru. He was a founder and editor of *Aperture* magazine, and from 1953 to 1957 curator of exhibitions at the George Eastman House (now the International Museum of Photography at George Eastman House). A dedicated teacher, he held posts at the Rochester Institute of Technology

and at the Massachusetts Institute of Technology. The exhibitions he organized (e.g., *Light*. 1968) were notable for their conceptualism.

Wynn Bullock's (1902–1975) finely printed images of landscapes and nudes-in-landscapes from the 1950s and 1960s had a philosophical bent to them. The poetic black-and-white imagery of Paul Caponigro (b. 1932) is similar. He has taught in many institutions and has been the subject of solo exhibitions at many major museums.

Beaumont Newhall (1908–1993) was, for all intents and purposes, the most important (particularly in the United States) photohistorian of the twentieth century. As a photographer, curator, and author he worked at many important institutions and with many important photographers. The many editions of the textbook that grew from the catalogue of a seminal 1937 exhibition at the Museum of Modern Art became the standard history of the subject until late in the twentieth century. His wife, Nancy Parker Newhall (1908–1974), was an invaluable assistant and published seminal documents and treatments of photohistory.

Pioneering Fashion and Portrait Photographers

The work of certain fashion and portrait photographers has been recognized as artworthy and influential. Cecil Beaton (1904–1980) was the prototype of the aristocratic society portraitist. Talented in many areas, his fashion imagery and celebrity photographs are widely known. He was also a prolific writer (particularly about his own career), a cartoonist, painter, and a film and theatrical designer. Besides his work for magazines such as *Harper's* and *Vogue*, he transformed himself into a war photographer in the 1940s and later became official photographer to the Royal family. Horst P. Horst (1906–1999) is remembered for the fashion and advertising images he made during his long tenure as a Condé Nast photographer.

The Canadian portraitist, Yousuf Karsh (1908–2002) photographed many important figures in the twentieth century. Images such as his famous *Winston Churchill* (1941) appeared in magazines and were later collected into picture books. Gisèle Freund (b. 1908) made definitive portraits of early and mid-twentieth-century writers and intellectuals, some in color. Arnold Newman (b. 1918) became well known for his pictures of, as he said, "people in their natural surroundings," mostly artists, scientists and politicians.

Irving Penn (b. 1917) helped raise fashion photography to the status of art. A student of the influential editor/art director, Alexey Brodovitch (1898–1971), by the late 1940s, Penn was photographing for *Vogue*. His work evolved from motion images set in outdoor locations, to isolated portraits with blank backgrounds. His sitters range from a broad mix of cultures, ethnicities, and classes. Richard Avedon (1923–2004) also studied under Brodovitch and became an important fashion photographer, particularly for *Harper's Bazaar*, in the post-war era. His work also came to use blank backgrounds. His protégé, Hiro (b. 1930) used color effectively and embraced a more collective kind of production than had been used by masters of photography before.

Herb Ritts (1952–2002) photographed celebrities and models in a way that looked back to classic Hollywood photos. Annie Liebovitz's (b. 1949) self-aware portraits of actors and musicians appeared in magazines and collected in books. Beginning in the 1970s, William Wegman (b. 1943) applied the conventions of celebrity and fashion portraiture to his pet (Weimaraner) dogs to produce witty, irreverent images that have become landmarks of late modern photography.

Defining the Documentary

Documentary photographers made inroads in terms of subject matter and in their relationship to their subjects. Their work ranges from "ethnic" subjects to images that reference provocative social issues. Arnold Genthe's (1869–1942) photographs of San Francisco's Chinatown are regarded as important documents of that community. Devoting himself to documenting the vanishing tribes and customs, between 1907 and 1930 Edward Sheriff Curtis (1868–1952) published his enormous multivolume, *The North American Indian*, the century's most exhaustive ethnographic survey. Though the resulting images are now seen as heavily contrived, they are important as art and information.

Photographing his countrymen outside of Cologne in 1910, the German photographer August Sander (1876–1964) began work on "*Man of the Twentieth Century*," which was to be a catalogue of the various types and classes that made up society. In 1929, his book, *Anlitz der Zeit* (*Face of Our Time*), the first installment in the massive project, was published. It was suppressed by the Nazis for its wide range of "undesirable" types.

Lewis Hine's (1874–1940) series of immigrants in Ellis Island (1905) and the photographs he took while working as an investigator and reporter for the National Child Labor Committee (1908–1916) are pioneering works of social documentary. His resourcefulness in gaining access to factories and sweatshops is legendary. Hine's "photointerpretations" as he called them, were used on pamphlets,

posters, and in articles and exhibitions. They were also used as evidence in governmental hearings about child labor.

Berenice Abbott's (1898–1991) book, *Changing New York* (1939), is a landmark of artistic urban and architectural documentation. The images she made to illustrate scientific laws are also important. Abbott took great pains to see that the contents of Eugène Atget's (1857–1927) studio were preserved.

Not a photographer himself, Roy Stryker (1893–1976) was nevertheless the guiding sensibility behind the Farm Security Administration (FSA), which sponsored a massive documentary project during the Depression. An economics professor, he directed such photographers as Russell Lee (1903–1986), Dorothea Lange (1895–1965), Ben Shahn (1898–1969), Jack Delano (1914–1997), Arthur Rothstein (1915–1985), Walker Evans (1903–1975), and others. He gave them assignments and suggested shooting scenarios, research, and travel plans. Stryker was also responsible for disseminating and promoting their imagery as they related to Franklin D. Roosevelt's New Deal programs (of which the FSA itself was one). Stryker's insistence on capturing the deleterious effects of the Depression in human terms runs throughout the FSA body of pictures. The pioneering female documentarian, Marion Post Wolcott (1910–1990) portrayed rural areas in a sentimental vein in her work for the FSA. *Migrant Mother* (1936), by Dorothea Lange, an image of a worried mother surrounded by her children, has become an icon of the Great Depression in America. Lange's feeling for the speech of her subjects is seen in the captions of her book collaboration with Paul S. Taylor, *An American Exodus: A Record of Human Erosion* (1939).

Walker Evans is regarded as the most purely artistic of the Depression-era photographers. He may be said to have been a romantic documentarian; his works speak both to the living conditions of his sitters and to picture making itself. His appreciation for writers and literature can be seen in his book projects, which include *Let Us Now Praise Famous Men* (with James Agee, 1941). His solo exhibition at the MoMA, *American Photographs* (1938), was a landmark. In the same vein, the laconic, Cold War-era photographs of Robert Frank's (b. 1924) *The Americans* (France, 1958; U.S., 1959) influenced an entire generation of photographers. Another pioneering figure who had been mentored by art editor Alexey Brodovitch, Frank made images for pictorial magazines and documented his travels. The Guggenheim Fellowship he won in 1955, the first given to a European-born photographer, enabled him to make the images for *The Americans*.

In 1952, Roy DeCarava (b. 1919) became the first African-American artist to receive a Guggenheim Fellowship. He contributed the pictures for a collaboration with the writer Langston Hughes, *The Sweet Flypaper of Life* (1955), a unique book documenting everyday life in Harlem. DeCarava ran a gallery devoted to artistic photography, A Photographer's Gallery in New York City, one of the first artists' cooperatives and the first to have an African-American proprietor. In the early 1960s, DeCarava ran the Kamoinge Workshop for young black photographers, also the first of its kind. The African-American Gordon Parks (b. 1912) is a pioneering documentarian best remembered for his images of the Black experience. A late participant in the FSA, Parks made photographs for the Standard Oil Company before becoming a *Life* photographer in 1948. His images and essays devoted to urban African Americans are celebrated, and he has been the subject of many exhibitions.

Garry Winogrand (1928–1984) was a pioneer of the documentary style that came to be known as "Social Landscape." Influenced by Walker Evans's *American Photographs* and by Robert Frank's *The Americans*, Winogrand's most innovative work shows awkward societal relationships enacted in public spaces. Slightly later, Robert Adams (b. 1937) and Lewis Baltz (b. 1945) became exemplars of "New Topographics" photography. They made straightforward, ostensibly banal images of suburban sprawl in the west and/or images of man-made structures in an almost clinical manner. Other photographers sometimes linked to this style include Hilla (b. 1934) and Bernd Becher (b. 1934), and Joe Deal (b. 1947). Bill Owens (b. 1938) has also devoted his career to images of suburbia.

Also of significant influence to later generations of photographers in both their choice of subject matter (subcultures or neglected populations) and gritty, seemingly candid style were Americans Danny Lyon (b. 1942), Bruce Davison, and Larry Clark. Lyon made powerful series of society's outlaws—bikers, prisoners, and political radicals. Davidson (b. 1933) also produced personally inflected photo-essays about urban populations. His *East 100th Street* (1966–1968) is a representative example. Larry Clark (b. 1943) embodied the photographer who lived the life of his subjects. His *Tulsa* (1971) frankly documented the culture of violence and drugs of the city's underworld. Figures that followed in this documentary genre include Mary Ellen Mark (b. 1940), who became intimate with her subjects' lives and was sponsored by not-for-profit groups to publish her images of homeless children and prostitutes. Nan Goldin (b. 1953) applied the snapshot aesthetic to the colorful char-

acters of her life—her family, friends, drag queens, addicts, and lovers.

War Photographers

War photographers have risked their lives to document the many wars of the twentieth century. Over time, cameramen aimed to get closer to the action and make more graphic pictures. By the later part of the century, their works had the power to shape public opinion.

Robert Capa (1913–1954) was the preeminent war photographer of the twentieth century. His willingness to get close to combat—he was killed by a landmine in Indochina—established a precedent for subsequent war photographers. His battlefield imagery of the Spanish Civil War and the Allied landing on the beaches of Normandy is particularly well known. With Henri Cartier-Bresson and others, he founded the Magnum Photos cooperative agency, which became a symbol and model for photographers taking collective action to retain control of their own work.

A highly decorated Marine in the South Pacific during WWII, David Douglas Duncan (b. 1916) became known as the "Legendary Lensman" for his battle photographs. Duncan was the first photographer to be given a solo exhibition by the Whitney Museum of American Art, New York. Larry Burrows (1926–1971) exemplified the conscientious photojournalist willing to risk his life—he died in a helicopter crash—for his images, having spent nearly a decade in Vietnam photographing the effects of war. Don McCullin (b. 1935) has taken images of devastation and injury in Vietnam, Congo, Lebanon, Biafra, and Londonderry. His book *Hearts of Darkness* (1981) amounts to a document of violent conflict in the twentieth century.

Photojournalists

The imagery of photojournalists appears in newspaper and illustrated magazines. Pioneers are those whose works are recognized for their art and/or for those whose subjects are unique. Editors have played a prominent role in determining subjects and layout.

Frances Benjamin Johnston (1864–1952) has been called the first woman press photographer. Associated especially with the nineteenth century, she worked well into the twentieth, producing straightforward pictures for the popular press, for government assignments, and of American sites and architecture over a long, productive career.

Alfred Eisenstaedt (1898–1996) and Erich Salomon were pioneering photojournalists; their pictures and behavior defined the modern photojournalist. Working with small-format cameras, they infiltrated newsworthy events shooting candid images of politicians, natives, and celebrities. In 1935, Eistenstaedt went to America where he became a staff photographer for *Life* magazine, a post he would hold for more than forty years. The imagery of Andreas Feininger (1906–1999), a long-time photographer for *Life* (1943–1962), is laced with experimental techniques. Felix Man (1893–1985) also made countless news photographs for pictorial magazines such as the *Müncher Illustrierte*, *Picture Post*, and *Life*. Werner Bischof (1916–1954) was widely known as a photojournalist of renown for compassionate travel images. He became a member of the influential collaborative, Magnum, in 1949, and was sent on assignment to cover famines as well as the Far East.

Margaret Bourke-White (1904–1971) was a pioneering female photojournalist between the late 1920s and the 1950s. Her images were widely seen in Henry Luce's new picture magazines, *Fortune* and *Life*. She became something of a heroine, taking assignments in such places as the Soviet Union and India. The monumentally formal aspect of her work, such as the *Fort Peck Dam* (1936), which graced the first cover of *Life*, as well as her exotic travels, influenced later photojournalists.

Henri Cartier-Bresson (1908–2004) is famous both as a photojournalist and as an artist of the camera. His "decisive moment" aesthetic, watching for the perfectly composed incident, has been widely imitated. Cartier-Bresson photographed for several magazines, and came into contact with many important photographers and artists of his day (he had been trained by a painter). After being captured by the Nazis during the war, he escaped and became part of the Resistance. In 1947, he founded the Magnum agency with Robert Capa, David ("Chim") Seymour (1911–1956), and others. Cartier-Bresson's one-man exhibition at MoMA in 1946 launched his international career.

To Paris from his native Hungary in 1925, André Kertész (1894–1985) was a freelance photographer working for many European magazines and newspapers. His aesthetic journalistic style was very influential on later photographers. He was particularly adept at capturing humane situations with a heightened sense of composition. Inspired by Surrealism, his important series, *Distortions*, are images of female nudes seen in a distorting mirror.

W. Eugene Smith (1918–1978) is regarded as a master of the photo-essay form. After being wounded while a war correspondent for *Life*, Smith dedicated himself to illustrating dramatic stories of human drama (for example, *The Spanish Village*, April 9, 1951), in *Life* magazine.

John Heartfield (née Helmut Herzfeld, 1891–1968) subverted the notion of the candid photojournalist altogether. He made politically subversive photomontages, most of which were published in the magazine *AIZ* (*Arbeiters Illustrierte Zeitung*), that mercilessly lampooned the militarist German government. They are unique in the history of photohistory and in the history of art. Although Weegee (Arthur H. Fellig, 1899–1968) was not the first crime photographer, he was certainly the most archetypal. His picture book, *Naked City* (1945), comprised of lurid crime-scene images, became something of a bestseller and was the basis of a movie and a television series.

Pioneers of Motion and Color

Several photographers made inroads with new techniques, which allowed them to photograph their subjects in ways never before seen.

With their links to the Italian Futurist movement (*Futurismo*), and the notion of "futurist photodynamism," brothers Arturo and Anton Giulio Bragaglia are famous for applying the principles to the medium of photography. In the 1930s, the electrical engineer Harold Edgerton's (1903–1990) advances in rapid strobe lighting (sometimes to one millionth of a second) produced stop-action images that were as beautiful as they were scientific, popularizing both photography and scientific research. His pictures regularly appeared in *Life* magazine. They were also displayed at a 1937 MoMA exhibition. The Albanian-American Gjon Mili (1904–1984) trained as an electrical engineer at MIT where he knew Harold Edgerton. He later collaborated with him and made artistic motion images of his own. Barbara Morgan (1900–1992) is best remembered for her dance photographs, for which she is regarded as a master. Instead of taking pictures during performances, she worked with dancers—Martha Graham and Merce Cunningham among them—to capture dramatic moments in the dance.

Eliot Porter (1901–1990) is important for the aesthetic and scientific value of his color nature photographs. Trained as a biologist, his works were praised by Stieglitz. He became connected with the Sierra Club and throughout his long career has produced several books of his lavishly colored pictures. Helen Levitt (b. 1913) was originally influenced by Cartier-Bresson's "decisive moment" aesthetic and took pictures of New York and Mexico City streets. She was awarded two Guggenheim awards (1959, 1960) to make color photographs, and these figure largely in her reputation. Although figures like Paul Outerbridge had used color processes as part of their art, William Eggleston (b. 1939) is considered one of the first mature practitioners of color photography. The images he made in the late 1960s and 1970s of his native Tennessee are at once beautifully composed and evocative of social issues. Trained as a painter, and having worked with Robert Frank, the color photographer Joel Meyerowitz (b. 1938) became well known in the late 1970s for his pastel-hued Cape Cod landscapes, views of St. Louis, and Florida. Marie Cosindas (b. 1925) is a pioneering color photographer, and one of the most celebrated women photographers of the 1960s and 1970s. She also was an early experimenter with instant film, often heightening its color for more vivid effects. She was given solo exhibitions in 1966 at MoMA and at the Boston Museum of Fine Arts, the first for a living Boston photographer.

Pioneers of Home and Nation

Several photographers in the twentieth century produced bodies of work that have become recognized as singularly representative of their respective countries.

Martin Chambi (1891–1973) was Peru's most renowned photographer. His pictorial images from the 1920s through the 1950s of landscapes, natives, workers, and professionals in their costumes comprise a unique and invaluable record of that society. The African portrait photographer Seydou Keïta (1921–2001) made an invaluable record of Mali culture through the works he produced in his studio.

The photographer Manuel Álvarez Bravo (1902–2002) captured the street life and political strife of his native Mexico. He had been encouraged by photographer Tina Modotti (1896–1942) to show his pictures to her lover, Edward Weston. A young film actress, Modotti became Edward Weston's lover and subject of his early images. In the 1920s and 1930s, she produced her own works, which utilized Weston's crisp, straight approach but in the service of Mexican, anti-fascist subjects.

Ken Domon (1909–1990) was arguably the century's most influential documentary photographer in Japan. In his images of ancient monuments and Japanese life (including Hiroshima victims), he advocated a new, crisp style in opposition to the then prevailing Pictorialist style. He was also an important organizer, the founder of the Shudan Photo group (1950), and was important for showing the works of western photographers in Japan. The Japanese Eikoh Hosoe (b. 1933) is important in his own country and abroad. His 1960 *Man and*

Woman series was groundbreaking both for its subject and for the gender implications it explored. This was further explored in his book, *Embrace* (1971). Hosoe has published books of dancers, has been an important advocate of artistic photography, and has taught internationally. Kikuji Kawada (b. 1933) was a freelance photographer in the 1950s and founded the Vivo group with Hosoe and others. His works relate to indigenous subjects—the Japanese flag, soldiers, the Hiroshima monument—and are compiled in books (e.g., *The Map*, 1965).

Roman Vishniac (1887–1990) is known for his atmospheric documentation of European Jews in the immediate pre-WWII era. Josef Sudek (1896–1976) was Czechoslovakia's most renowned photographer and made memorable images of urban landscapes and lyrical images of banal objects. Jaromir Funke (1896–1945), also relentless innovator and experimenter, and Sudek were founders of the Czech Photographic Society and are regarded as masters in that country.

Pioneers and Provocation

Some twentieth-century photographers are famous for the controversy their works provoked. This was mainly due to the then-disturbing nature of their subjects. Lisette Model (1906–1983), for instance, is famous for her quirky portraits of human imperfection. To New York in 1938 from a background in art, and encouraged by Alexey Brodovitch, Model utilized a snapshot aesthetic. Teaching at the New School for Social Research in New York around 1950, she influenced young photographers. One of these, Diane Arbus (1923–1971), photographed unique individuals in bluntly frontal fashion. Arbus sought out and photographed invalids, twins, pet owners, transvestites, and eccentrics of all types. Before committing suicide in 1971, she had been awarded Guggenheim Fellowships in 1963 and 1966. Arbus was the first major American photographer—and the first woman photographer—to be represented at the Venice Biennale. Ralph Eugene Meatyard's (1925–1972) haunting images of dilapidated architecture and masked figures of the late 1950s and 1960s share a brooding, gothic quality. Les Krims (b. 1942) is recognized for his bizarre portfolios of the 1970s (e.g., *The Incredible Case of the Stack O'Wheats Murders*) in which he stages comic scenarios in the style of police photographs. His work became notorious when, during an exhibition of his images in Tennessee, the son of the gallery director was kidnapped until his pictures were taken down.

The work of Robert Mapplethorpe (1946–1989) includes images of flowers, of bodybuilders, celebrities, and homosexual and sadomasochistic imagery. He was a major figure in what would come to be known as the "culture wars" of the late 1980s and early 1990s. Conservative politicians, regarding his work as indecent, called into question the entire system of government sponsorship of the arts. This led to greater restrictions being placed on the National Endowment for the Arts. Tragically, Mapplethorpe's work must also be seen as related to the first wave of consciousness of the AIDS epidemic since he himself died of the disease. Andres Serrano also shocked viewers in 1987 with an image of a crucifix seen through urine. Joel-Peter Witkin (b. 1939) is known for his bizarre subjects—amputees, corpses, and fetish images—arranged in macabre tableaux and printed in techniques reminiscent of early processes.

Sally Mann's (b. 1951) images of nude children, mainly members of her own family, provoked controversy apart from their nature as probing character studies. Jock Sturges's masterfully printed images of nude girls, usually shown in beach locations, were at times confiscated as pornography.

Late-Century Pioneers

Lee Friedlander (b. 1934) is known as a pioneering Social Landscape photographer, but with an interest in photographic vision and in the mechanics of picture making. His works often include pictures within pictures. In the 1970s and 1980s, he devoted himself to images of American historical sites and landscapes. Kenneth Josephson (b. 1932), too, explores the nature of the photograph itself and the presence of the photographer in even more conceptual ways. Emmet Gowin (b. 1941) photographed his wife, Edith (Morris), in the familiar spaces of their native Virginia. His works have a gentle pathos and are noted for their sense of time.

Duane Michals (b. 1932) is associated with the expressive use of the artistic photo-sequence in the late 1960s and 1970s. Often containing an element of fantasy, they have a narrative, almost filmic quality. Jerry Uelsmann (b. 1934) is regarded as a pioneer in multiple printing. Beginning in the 1960s, he produced fantastic, surreal images that defied logic and, considering their date, sought to expand consciousness. Uelsmann is also recognized as a teacher of note.

With his roots in performance art, Lucas Samaras (b. 1936) made a lasting impression with a series of self-portraits (*Autopolaroids*, 1971). Shortly after, he began experimenting with the instant Polaroid SX-70 process, manipulating images while they were still developing (*Photo-Transformations*, 1975). And while

technically her photographs are not innovative, Cindy Sherman is considered a major figure of late-century photography for redefining the artist's self-portrait and being largely responsible for the widespread acceptance of photography as contemporary art; her most important works, *Untitled Film Stills* (beginning in 1977), feature herself as a subject in sophisticated scenarios that evoke the feeling of remembered pictures. They draw on cultural history—films, literature, news imagery, popular culture. Sherman's imaginative self-representation raises issues of gender and identity.

MARK B. POHLAD

See also: **Abbott, Berenice; Adams, Ansel; Arbus, Diane; Atget, Eugène; Bauhaus; Becher, Bernd and Hilla; Blossfeldt, Karl; Bourke-White, Margaret; Brandt, Bill; Brassaï; Bravo, Manuel Álvarez; Bruguière, Francis; Callahan, Harry; Caponigro, Paul; Cartier-Bresson, Henri; Chambi, Martin; Clark, Larry; Cunningham, Imogen; Dada; Davidson, Bruce; DeCarava, Roy; Domon, Ken; Edgerton, Harold; Eggleston, William; Evans, Walker; Frank, Robert; Futurism; Goldin, Nan; Group f/64; Heartfield, John; Institute of Design; Käsebier, Gertrude; Keïta, Seydou; Lange, Dorothea; Laughlin, Clarence John; Surrealism; Man Ray; Meyerowitz, Joel; Moholy-Nagy, László; Museum of Modern Art; Newhall, Beaumont; Penn, Irving; Photo-Secession; Porter, Eliot; Renger-Patzsch, Albert; Sander, August; Shahn, Ben; Sherman, Cindy; Siskind, Aaron; Steichen, Edward; Stieglitz, Alfred; Strand, Paul; Stryker, Roy; Surrealism; Weegee; White, Clarence; White, Minor; Winogrand, Garry**

Further Reading

Davis, Keith F. *An American Century of Photography, From Dry-Plate to Digital: The Hallmark Photographic Collection.* Kansas City, MO, and New York: Hallmark Cards, Inc. in association with Harry N. Abrams, Inc., second edition, 1999.

Debroise, Olivier. *Mexican Suite: A History of Photography in Mexico.* Translated and revised by Stella de Sá Rego. Austin, TX: University of Texas Press, 2001.

Lahs-Gonzalez, Olivia and Lucy Lippard. *Women Photographers of the 20th Century.* St. Louis, MO: St. Louis Art Museum, 1997.

Newhall, Beaumont. *The History of Photography.* New York: The Museum of Modern Art, 1982.

Rosenblum, Naomi. *A History of Women Photographers.* New York: Abbeville Press, 1994.

Rosenblum, Naomi. *A World History of Photography.* 3rd ed. New York: Abbeville Press, 1997.

Thomas, Ann. *Beauty of Another Order: Photography in Science.* New Haven, CT: Yale University Press, 1997.

Warner, Mary. *Photography: A Cultural History.* New York: Prentice Hall and Harry N. Abrams, 2002.

Weiermair, Peter and Gerald Matt, eds. *Japanese Photography: Desire and Void.* Zurich: Edition Stemmle, 1997.

Willis, Deborah. *Reflections in Black: A History of Black Photographers 1840 to the Present.* New York: W.W. Norton, 2000.

HISTORY OF PHOTOGRAPHY: INTERWAR YEARS

Photography as it was practised in Europe, the United States, and Japan during the period from 1918 to 1941 closely parallels the hopes, doubts, and fears of Western societies confronted with the future of the great project of the Enlightenment and its democratic ethos. Seeds planted earlier fully bloomed for better or for worse in that ideologically intense period, which experienced the development of utopian totalitarianisms in Europe and the success and extraordinary failures of financial capitalism, thus questioning the theoretical models of the modern State. In those years, the world was still a coherent and fairly simple place where old powers reigned, even though the catastrophe of the Great War, World War I, was already shifting the center of gravity towards the United States, but not yet towards the rest of the world, which still remained more or less under forms of imperial domination. Such a situation explains the violent oppositions in the culture of the period, as well as its surprising vitality: widely believed was the idea that only culture could save man from himself, and more pre-

cisely, or a new culture that would take into account the physical *tabula rasa* of the war. The society that emerged sealed the central presence of the machine in modern life, and photography would become the perfect instrument and expression of that mechanical modernity. It fully entered the visual art scene while expanding dramatically in the worlds of information, industry, and commerce. All the future developments and issues of photography date back to those interwar years, which produced some of the most interesting and complex works—a fact that latter-day authors tend to neglect.

Photography was by then practised the world over and by more and more segments of the population—in South America, Australia, Asia, and Africa—although much remains to be done to document those local practices. For all intents and purposes, however, the history of the medium was still almost exclusively written in Europe, North America, and Japan, if only because these were the centers of industrial power. Issues were, however, notably different in Europe and the United States, and despite comparable forms, the photographic expressions of the two continents diverged.

The first characteristic of interwar photography was its cross-fertilization, with the powerful internationalization that took place after the Great War and until the early 1930s with the rise of the Nazi State in Germany and its subsequent expansion in central Europe.

Circulation

The Europe of the aftermath of the war was one of the circulation of artists—and photographers in particular—and of the establishment of a few art capitals: Berlin, London, Paris, and Prague. In Paris, a particularly interesting concentration of emigrant photographers produced a rich creative ambiance, although it never took the form of "schools," either formal or informal. The most active and influential photographer was certainly Man Ray (1890–1976), an American expatriate who came to Paris in 1921. Later on arrived André Kertész (1894–1985) and Brassaï (1899–1984) from Hungary, Florence Henri (1893–1982), born in the United States, and Ilse Bing (1899–1998) from Germany, as well as Lisette Model (1906–1983) from Austria.

In Germany, the Bauhaus (1919–1933) encouraged the bridges between all forms of expression and disseminated its theories in Europe through its students. One of the most emblematic figures of these (trans)continental migrations was László Moholy-Nagy (1895–1946) who left Hungary for Austria, before becoming one of the theoreticians of the Bau-

haus and reconstructing it in Chicago in 1937 as the Institute of Design. His photographic and theoretical work as well as his teaching condensed all the formal and intellectual experiments of the period, compelling him to explore and invent the language of the future—with the camera—to paraphrase his often quoted statement that the new illiteracy would be visual (*Painting, Photography, Film*, 1925–1927).

But the most open center was Prague, which inherited both the French influence and that of the Bauhaus, as well as the American avant-garde. In Prague, the camera really became the instrument of modernity with Jaroslav Rössler (1902–1990) and his abstract compositions, Jaromir Funke (1896–1945) with his surrealistic images and photographs of industrial objects, Josef Sudek (1896–1976), who mixed classicism and surrealistic innovation—not unlike Eugène Atget and the early Walker Evans—and of course Frantissek Drtikol (1883–1961) who experimented in the 1920s and early 1930s with the nude, mixing genres and forms in a most original way.

The influence of European photographic developments was also felt in Japan. The *Film und Foto* exhibition (1929) in Stuttgart traveled to Tokyo and Osaka, and Japanese photographers acclimated European and especially German modernism, experimenting in framing and manipulation of the image, away from the more traditional practices—portraiture, genre scenes, and Pictorialism—at a time when Japan was undergoing a cultural revolution of unprecedented magnitude.

Photographers in the United States kept in close touch with European developments, and participated in considerable numbers in *Film und Foto*. Some figures such as Berenice Abbott, who made Atget known and was deeply influenced by the Bauhaus aesthetic, spent significant time in Europe and was friendly with many European artists. On the whole, however, the United States developed a different course, because of the divergent conceptions of the place of the artist in society and perhaps more importantly of the very nature of society and the place of the machine in it.

The Cultural Revolution in Europe

Photography between the wars cannot be reduced to avant-garde practices and to New Vision (*Neue Sehen*) or New Objectivity (*Neue Sachlichkeit*)—two loose but powerful terms covering experimental practices in Germany, France, Italy, and the Soviet Union. More classical, post-Pictorialist, or simply poetic and pastoral images were made, printed, exhibited, and appreciated (see Kurt Hielscher's *Deutschland*, 1924), and stimulated a growing body of serious amateurs. There was also a powerful continuation of portraiture, the best-known

practitioner being August Sander (1876–1964), as well as Hugo Erfurth (1874–1948) who made portraits of artists, politicians, and leaders of the time.

The movement was made possible by Dadaism and Futurism—which had started the upsetting of traditional values in art during World War I—and would in turn feed Surrealist image-making (Jacques-André Boiffard, Hans Bellmer, Raoul Ubac, and Man Ray). But it is to be seen in the context of German expressionism and Soviet Constructivism that gave it its real aim and ideology. The issue was clearly to change how people saw the world in order to prepare them for the new and better times to come, and in some cases—in the Soviet Union—to construct a modern industrial society out of a rural one. As the photographic image became omnipresent in the media, both in news and advertising, it turned into an instrument of learning and ultimately of active propaganda. Far from "pure art," the European practice of the period was committed and in some sense "total" as the 1928 title of an article by Johannes Molzahn in *Das Kunstblatt* proclaimed: "Nicht mehr Lesen, Sehen" (Not mere reading, seeing!).

Formally, avant-garde practice of the time can be characterized by the change—and often break up—of point of view and the creation of a new experience of the commonplace and trivial: high- or low-angle shots, extreme close ups, and fragmentation of subjects often leading to total abstraction. This "vision" is intimately connected with industrial objects including buildings.

The object triumphed in the 1920s as it occupied all the aspects of daily life (Aleksandr Rodchenko, Albert Renger-Patzsch, Moholy-Nagy, Germaine Krull, Hans Finsler, Umbo). Renger-Patszsch's programmatic book for the new vision, *Die Welt ist Schön,* (*The World is Beautiful*) of 1928 was in fact supposed to be called *Die Dinge* (*Things*). As for the human figure, it did not quite escape the effects of the mechanical eye in the distortions of André Kertész and Bill Brandt, and perhaps first and foremost in the renewal of the nude, transformed by a Drtikol and a Maurice Tabard, or Umbo's mannequins and Bellmer's disarticulated and uncanny dolls.

The other direction was that of the photomontage, multiple exposure, and the cameraless photography with the photogram. Photograms—shadows of objects on photographic paper—were extensions of X-ray photography and could very well have been re-invented in the twentieth century by Moholy-Nagy or Man Ray, both beginning to practice the form in 1921. This double "origin" is significant of its expressive as well as instrumental function. Passively objective traces of common objects, photograms construct at the same time a strange and mysterious world that begs interpretation or at least opens the image to wide narrative associations. The superimposition and the creative use of "mistakes," particularly that of amateur and vernacular practice, produced in the hands of El Lissitsky, T. Lux Feininger, Herbert Bayer, Man Ray, Rodchenko, Tabard, Moholy-Nagy, and others, images which were either akin to automatic writing or more inducive to meditation on a dream-like world, made up of improbable meetings or conjunctions, combining once again the reality of the objects and their surreal connections. All these techniques aimed at shifting the center of representation from simple being-ness—that is, the weight of the presence of the object itself—to one of association and structure producing meaning.

Photomontage, an extension of collage practised since the nineteenth century, took on a new vitality in the 1920s, boosted by Dadaism, Cubism, and the development of the poster, and more generally, graphic design as it came to be used as a visual message. In that respect, it can be seen as a manner of integration of the image into language, constructing statements as a mechanic constructs a machine. Mixed and hybrid in essence, the photomontage became an activity in itself, culminating with the *Fotomontage* exhibition of 1931. With authors such as Kurt Schwitters, Rodchenko, Moholy-Nagy, and numerous lesser-known or anonymous artists, it was one of the central practices of the New Vision although now it tends to be seen as a secondary practice. It formed the basis for the budding art of graphic design, which bloomed in central Europe and the Soviet Union. Poster design, political and commercial advertising, and magazine layout provided the best outlets for expressions of photomontage (*Die Neue Linie, Vu, Regard*). More polemic forms, such as John Heartfield's, hinted at the political force of photography, its power on "the masses" and thus its potential revolutionary nature. This direction, however, was ambiguous and the power of the visual image made its use by totalitarian states, notably the Soviet Union of the mid-1920s, then Italy, and eventually Germany in the early 1930s, particularly easy.

USA: The Nature of Photography

American photographers had quite different concerns. They kept in close touch with European developments—and sometimes emulated them, especially the most obvious stylistic figures of Constructivism (Abbott, Evans) or New Objectivity (Paul Strand, Charles Sheeler, Margaret Bourke-White, Evans), but their position and issues were different, especially as regards the role of the photographer in society. This would explain the development of the medium in the United States in the post-World War II years, and its relative supremacy.

The Great War had obviously a much reduced impact on American society as it did not produce the *tabula rasa* effect—the Great Influenza epidemics of 1918 may have been in fact more traumatic—and periodization tends to be slightly different. The powerful efflorescence of a strongly material and industrial culture was, on the other hand, paramount. The involvement of artists in commercial work, their questioning of their place in society, and the "relevance" of their work, all combined to focus the debate on the nature of photography—and especially its autonomy in the field of visual arts, a major difference from European practice. Despite concerns with the growing materialism of the 1920s and the existence of a strong documentary tradition, the project for most American artistic photographers of the interwar years remained internal to the medium.

The mutation of American photography away from Pictorialism towards "pure" or "straight" photography began in the mid-teens, can be best followed by the debate among the group surrounding Alfred Stieglitz—its galleries, exhibitions, and publications (see the articles by Marius de Zayas "Photography," *Camera Work* 41, January 1913, and "Photography and Artistic-Photography," *Camera Work* 42–43, April–July 1913, in which this Mexican artist and friend of Stieglitz theorized the "truth function" of photography) and Clarence White who formed a school, organized shows, and published *Pictorial Photography in America* (1920–1929). The two groups were separated by strong egos and a different relation to commercial assignments and money—the financially independent Stieglitz advocated absolute detachment from the constraints of commissions or the market while predictably White, who had to earn a living, more pragmatically trained commercial photographers. But the work they inspired is in fact quite complementary, and it evidences the various reactions to and difficult integration in artistic discourse of mass culture.

After the late 1910s, Alfred Stieglitz kept his strong intellectual presence especially through his own production, in particular the O'Keeffe portraits, the "Equivalents" series and the views of New York. His own practice did not necessarily closely follow the strict "purist" aesthetics he advocated but displayed a deep and original understanding of the place of the eye in the modern sensibility.

The portraits of Georgia O'Keeffe began in 1918 and continued until the mid-1930s. Intimately linked to the history of the couple, open-ended and totalizing, they constitute a truly photographic project, playing on time, gaze, and alterity/difference. The "cloud" series, or *Songs of the Sky* and then *Equiva-lents* as it came to be known (1922–1930) are images of clouds without reference to the surrounding landscape, essentially made with a 4 × 5-inch camera. It is a clear manifestation of symbolist theory, freeing the image from any "referential" value (except for the meteorologist...) and concentrating on the emotion produced by the transcendental and the infinite (Davis 121). The series of New York buildings Stieglitz made in the 1930s, mostly from his window, as well as the Lake George images, although more direct in its form, develop an idea of the intensely spiritual but essentially personal relationship with the world, neither intellectual nor simply sensual.

This approach marks a real distance with European photography of the times, which had moved towards high Modernism, and reinforces the connection with what Edward Weston was doing in California. Weston, who had practiced pictorial photography since 1911 in Los Angeles, turned to "pure" photography in the early 1920s after meeting the Stieglitz group. He subsequently went to Mexico (with Tina Modotti) before returning to California in 1926. His style and subject matter increasingly emphasized the forms of objects as rendered through a continually sharper use of the optical qualities of the camera and the print. His famous series of vegetables, nudes, and Western landscapes form a coherent stylistic body of work aiming at being essentially photographic and at recording the "quintessence of the object." They are steeped in a philosophy borrowing largely from Transcendentalism and sustaining a mystical ideal of "depiction of timeless and universal life rhythms." (Davis 134).

Weston is also important for his institutional activities. He was asked to prepare the West Coast selection of the 1929 *Film und Foto* exhibition in Stuttgart and received in 1937 and 1938 the first John Simon Guggenheim fellowships granted to a photographer. In 1932, he formed around him a group of photographers, among whom were Ansel Adams, Imogen Cunningham, and his son Brett, called Group f/64 and devoted to direct, pure photography extending from the lens to the print.

The print was to be Ansel Adams's main field of expertise. Adams, who was training to become a pianist, turned to photography under the influence of Paul Strand and devoted his energy to making perfect negatives and prints, and creating a form of mystical realism that was to make him, in the World War II and post-war years, the master American landscape photographer.

The technical expertise that Adams refined in printing is an interesting characteristic of the interwar period in the United States as opposed to a freer, less "crafty" approach to the medium in Eur-

ope. Weston and Strand, as well as Stieglitz, paid great attention to the making and the selecting of their prints conceived as real and unique art objects. Its roots are no doubt numerous—in American machinism, maybe even in a certain conception of the work ethic—but can be easily ascribed to the autonomization of the medium.

The most direct exponent of Stieglitz's theory well into the century was probably Paul Strand (1890–1976), whose pictures were featured in the last issue of *Camera Work* in 1917, for many marking the break in America with the outmoded Pictorialist style. He developed Stieglitz's concept of straight photographic practice and was probably as adamant about it. He was also a fierce critic of Materialism and of an American society caught in the ideology of the machine and of science ("Photography and the New God," *Broom*, 1922). He wanted to substitute for it a society where contemplation and its main player, the artist, would bring a fully human dimension to life. In that respect, although his philosophy was very similar to that of Stieglitz or Weston, his photography, from the early modernist studies of fences (1917) or his famous *Blind* (1916) to the portraits of peasants and common people, and his numerous images of buildings in the United States and abroad, show a much greater human concern.

His friend and partner on a short film venture, *Manhatta* (1921), Charles Sheeler (1883–1965), had fewer qualms as regards industrial power and technology. His images of the Ford Plant at River Rouge (1927) or of the deck of an ocean liner (1929), of a steam locomotive (1939), or of a turbine (1939), that he treated both as a painter and as a photographer, are clear manifestations of a form of industrial sublime (Davis 153). The line is thin between the complex work of Sheeler and the multitude of images by lesser known although no less competent photographers who displayed a fascination for the machine age. Machines, cars, tools, industrial buildings, factories, and bridges, were the heroes of the age, and found their zealots beyond the walls of the gallery in photographer-star Margaret Bourke-White and in publications such as Henry Luce's *Fortune*.

Photographic life was active in the United States in that period—witness regular exhibitions (Davis 130–131) and the activities of camera clubs. Pictorialism was largely dead by the 1920s but would not completely disappear and in fact would merge quite easily with the "documentary" aesthetic of the 1940s ("humanistic photography" as it was sometimes called). Quite clearly, however, American photography was, by then, developing its own *sui generis* form of New Objectivity.

Walker Evans best exemplified the invention of this American form of photographic realism. His first images, made on his return from Paris (1927) and in Cuba (1933), display an essential modernistic style that makes them comparable with those of contemporary German and central European photographers. Form, and the multitudes of surprises and "puns" allowed by the city environment, were essential in those early photographs. Evans, however, by the time he was hired by the photographic department (historical section) of the Resettlement Administration (later Farm Security Administration), had moved towards a more comprehensive vision. Subjects appear more clearly in their entirety and tended to draw the spectator towards their existence, more than towards the photographer's choice. Focusing on the vernacular architecture and folk art with a penchant for the old and dilapidated and photographed with a large view camera (up to 8×10-inch), Evans developed a melancholy—or at least interrogative—gaze on the American scene, leading to the publication of one of the most influential books of the decade, *American Photographs* (1938), which accompanied the first solo photographer exhibition at the Museum of Modern Art, New York. Because of his association with a government information agency and his work on contemporary subjects and scenes, Walker Evans has long been discussed in terms of the documentary nature and function of his images. The debate is particularly sterile in his case. Indeed, together with Sheeler and Strand, Evans may be seen as bridging in photography the gap between art and society: neither commenting upon the latter (whether positively as commercial photographers do, or more negatively as documentary or press photographers), nor evading it (as Stieglitz), Evans defined a place and a stance, the frontal gaze, at the same time committed with its bodily presence but also detached, neither participant, nor observer. This proposition was to characterize much of American photography in the years to come.

The Human Condition

The decades that saw the development of totalitarian regimes on the failures of exhausted monarchies and imperial systems, and that experienced a mere decade later, a massive, global, and apparently endless recession that undermined the very pillars of democracy, could not remain blind to the role and vision of the artist in society. Simultaneously, politicians became aware of the possibilities of the medium in furthering their agenda, be it liberal as

in the United States or totalitarian as in the Soviet Union, Italy, and Germany.

This concern took different forms. Photojournalism, for want of a better word, was one of them and went beyond the simple news photograph. Documentary photography tackled projects of a larger nature.

This started in Germany, with the *Berliner Illustrirte Zeitung* and the *Münchner Illustrierte Presse*, which developed "picture stories" and commissioned images from photographers such as Erich Salomon (1886–1944) or Felix H. Man (1893–1985) (a series on Italian dictator Mussolini's daily life). Few were trained photographers but many had studied the humanities in university. The taking of power by the Nazi party in 1933 led to the disbanding of the creative groups around the magazines and the dissemination of operators and editors throughout Europe, thus giving birth to a wide variety of illustrated publications elsewhere. The form also reached the United States, with the creation of *Fortune* (1930), *Life* in 1936 by Henry Luce, and *Look* in 1937. France had its own, with *Match* (1926) and Lucien Vogel's *Vu* (1928), a more politically committed publication. *Vu* hired photographers such as Kertész, Germaine Krull (1897–1985), Brassaï, and Robert Capa (1913–1954). In his magazine work Kertész explored daily life in the city and in the country, with a general tone of criticism towards the dehumanizing trend of modern life, but mostly emphasizing the paradoxes and strange encounters in an ironic manner close to surrealism. Brassaï, for his part, specialized in night life and the underworld, looking at the city as a large stage where characters pass. In England, Bill Brandt chronicled English life (*The English at Home*, 1936) as well as London by night (*A Night in London*, 1938).

More systematic, and less geared towards the press, larger documentary works are one of the distinctive marks of the period. Documentarians used the collection power of the photographic image, which had already been perceived in the great surveys of the nineteenth century, and coupled it with new increased means of dissemination.

In Germany, after the Great War, near Cologne, a professional photographer named August Sander began what he planned to be a survey of the German people of the period. The project was so vast and comprehensive that it took years to complete and was published in various installments. His aim was precisely to reflect the society of the twentieth century (one of the names of the series was "Men of the Twentieth Century") thanks to the "purity" of the camera. He set up a simple protocol that he stuck to methodically, posing the sitter in his work environment, positioning the subject to face the photographer, and capturing the subject's full body. The survey was organized according to the occupation of the sitter, the only identity provided by the caption.

But collective operations were the most important ones and the survey that had the deepest effect on the future of photography was undoubtedly that of the Farm Security Administration in the United States. More than its hiring of Walker Evans, Dorothea Lange (1895–1965), or Ben Shahn (1898–1969), and its training of several young men and women who were to become major players in the field of humanistic photography in the post war years, the FSA, under the direction of Roy Stryker (1893–1976), was significant in its structured and coherent attempt at constructing a full picture of American society of the era. This was accomplished not by using portraits of its people, but by showing them in their daily environment and, if necessary, expressing, by visual means the "essence" of the situation. Placing the responsibility on the shoulders of the photographer/reporter and his necessary honesty, and presenting the result in the form of an organized file of images and documents, the FSA inaugurated a new relationship between the photographer and the world. Stryker's commitment was not one of his own opinion but one of his own conviction, that of the faith in the people and the fundamental need for a democracy to give a voice to their existence. Such a complex interplay makes the work of the FSA the great laboratory of the modern image, and the place where all the contradictions of representation in a mass culture are at play.

The Effect of Technique

Most of the developments already cited would not have been possible without radical evolutions in the technical capabilities of the camera, film, and printing processes. The creation of the small camera, Oscar Barnack's Leica (c. 1925), using cinema film and made possible by the improvement in lenses and fine-grain developers, enlarged the field of the "photographable" with its maniability, its unobtrusiveness, and the possibility to create multiple exposures. As with all epistemological breaks, it took a while to percolate, and was first taken up—understandably—by non-professional photographers. Inevitably, alongside the technical perfection sought by some—especially American—photographers, a new type of image, grainier, rougher, with harsher contrasts, more stylized, and "wrenched from the world" as it were, became accepted. Practical and affordable color film also made its debut. Color photography remained for the most part limited to the world of advertising because of cost, but

demand for it was high and such popular magazines as *National Geographic* made a policy of publishing as much color as it could. By the mid-1930s, and despite the Depression, the first color transparency films were released by Agfa and Kodak (1936).

The 1920s and 1930s also experienced the birth of modern advertising, in the United States and to a more limited extent in Europe and Japan (Davis 555–580). Advertising made heavy use of the photographic image, absorbing much of the creative energies and ideas of the period. Most major photographers—with perhaps the exception of Stieglitz—worked at some point in their careers for commercial publications. The photograph invaded the entire public sphere, even book covers. More and more photography books, entirely or partially composed of photographs, were published. They formed one of the major sources of dissemination of the work of many practitioners and gave birth to a new form of art (Davis 172–173, Frizot 570). The 1920s and 1930s were indeed the decades of graphic art, poster, and book design. Serious photography criticism ensued (with the publications of articles in specialized magazines and histories of photography), and by the mid-1930s several important exhibitions had taken place in Europe and the United States, thus establishing the photograph as an art among others.

Such evolution spurred the development of an audience of trained viewers—more and more often practitioners themselves, albeit within the very limited sphere of the family snapshot. The public of all classes became more familiar with as well as more aware of the power and the potential of the photograph. This expansion of popular practice and of popular consumption of photography formed the intellectual, cultural, and economic base for the development of postwar photography.

JEAN KEMPF

See also: **Agitprop; Bauhaus; Camera: 35 mm; Dada; Documentary Photography; Farm Security Administration; Futurism; Group f/64; Institute of Design; Life Magazine; Modernism; Multiple Exposure and Printing; Museum of Modern Art; National Geographic; Photogram; Propaganda; Surrealism; Works Progress Administration**

Further Reading

Ades, Dawn. *Photomontage*. New York: Thames & Hudson, 1986.

Baqué, Dominique. *Les Documents de la modernité. Anthologie de textes sur al photographie de 1919 à 1939*. Nîmes, France: Jacqueline Chambon, 1993.

Bunnell, Peter. *Degrees of Guidance: Essays on Twentieth-Century American Photography*. Cambridge and New York: Cambridge University Press, 1993.

Davis, Keith. *An American Century of Photography*. Kansas City, MO: Hallmark, 1999.

de Zayas, Marius. "Photography and Artistic-Photography." *Camera Work* April–July 1913, 42–43.

de Zayas, Marius. "Photography." *Camera Work* January 1913, 41.

Evans, Walker. *American Photographs*. New York: Museum of Modern Art, 1938.

Fiedler, Jeannine, ed. *Photography at the Bauhaus*. Cambridge, MA: MIT Press, 1990.

Frizot, Michel, ed. *A New History of Photography*. Cologne: Könemann, 1998.

Hight, Eleanor M. *Picturing Modernism: Moholy-Nagy and Photography in Weimar Germany*. Cambridge, MA: MIT Press, 1995.

Krauss, Rosalind and Jane Livingston. *Amour Fou: Photography and Surrealism*. New York: Abbeville Press, 1985.

Moholy-Nagy, László. *Painting, Photography, Film*. Cambridge, MA: MIT Press, 1987.

Philips, Christopher, ed. *Photography in the Modern Era: European Documents and Critical Writings, 1913–1940*. New York: Metropolitan Museum of Art and Aperture, 1989.

Renger-Patszsch, Albert. *Die Welt ist Schön*. Munich: K. Wolff, 1928.

Rouillé, André and Jean-Claude Lemagny. *A History of Photography: Social and Cultural Perspectives*. Cambridge and New York: Cambridge University Press, 1987.

Stange, Maren. *Symbols of Ideal Life: Social Documentary Photography in America. 1890–1950*. Cambridge and New York: Cambridge University Press, 1989.

Strand, Paul. "Photography and the New God." *Broom*, 1922.

HISTORY OF PHOTOGRAPHY: POSTWAR ERA

There is one thing the photograph must contain, the humanity of the moment. This kind of photography is realism. But realism is not enough—there has to be vision and the two together can make a good photograph. It is difficult to describe this thin line where matter ends and mind begins.

(Robert Frank 1962)

At the end of World War II, the world's vision of itself had been shattered, and it had to reconceptualize the idea of "humanity" in order to face new issues and concerns that were arising in the postwar era. Photography, which, in the interwar years, had been highly experimental, even in some of its practical and commercial applications, also changed to fit the new times. During WWII, photojournalism, with Europe as its primary arena, had captured the horrors and traumas of the war. In the postwar years (roughly 1945–1959), the recognition that photographers could use their cameras not just to record events, but to influence the way in which the public responded to these events, changed the way in which the art of photography was conceived. Insurrection in India, poverty in the United States, the war in Korea, and the new social elite in Europe were just a few of the subjects that would come to dominate the work of postwar photography. These new subjects, combined with the more critical support and sponsorship of photographers, led artists to realize that they could shape attitudes and history through their concerns and a commitment to the medium. The concept of the independent photographer as a lone individual with a personal vision, and not connected or obliged to anyone, took shape during these years in which the photographer began to explore the world and the self. These years are remembered as a time when photographers such as Robert Frank, William Klein, and Minor White among others, would carve out an important niche in the new world order, initiating a wide variety of developments.

There are three main shifts that occurred in the photographic world after 1945. The first was physical. Up to and during WWII, Europe, especially the capitals of France and Germany, had been the lively and energetic nexus of the photographic and artistic world. It was known as *the* place artists went if they were serious and wanted to fully develop their talents. The onslaught of war only emphasized the importance of going overseas, and many Americans left their homeland in the late 1930s and early 1940s to go abroad and follow the events in Europe, Africa, and Asia. After the war, European photography continued to be important as we can see in the postwar work of such talented men as Henri Cartier-Bresson and Robert Doisneau, but the center of the photographic world had shifted its focus west to the United States as expatriates returned home and American photographers began to experiment with light and form. European photographers, aroused by this demographic shift, also left their homeland to search out new subject matter in America, which had happened only infrequently prior to WWII.

The second shift that occurred was stylistic, and grew out of the renewed interest in what is called "straight photography." It was originally conceived by art critic Sadakichi Hartmann who, although he highly praised the 1904 exhibition of the Photo-Secession at the Carnegie Institute, in Philadelphia, Pennsylvania, called for a return to a photography that was untouched and left as the eye had originally seen it. "To work straight" according to Hartmann was to "[r]ely on your camera, on your eye, on your good taste and your knowledge of composition..." In other words, the goal should be to produce "photographs that look like photographs" as opposed to the more abstract photography that was prevalent in the first half of the twentieth century. The postwar photographers answered Hartmann's call as is evidenced in many images of the time by artists such as Paul Strand, Ansel Adams, Robert Capa, and Ruth Orkin.

The third shift was social. The "humanist movement," as it is now called, was perhaps the greatest innovation in the postwar years and hit its apex in the photographic work of the 1950s. Up to the end of the 1940s, photographers had primarily worked for the sake of society, to inform it, if not to improve it, or to declare some sort of personal truth as we see, for example, in the work of Alfred

Stieglitz. Up to the 1950s, photographers, especially in the United States, attempted to promote some sort of social message. After the 1950s, photographers in the United States continued to focus on and question nature and society, but there was a turn toward a more personal viewpoint. Many famous names from the war, such as Margaret Bourke-White, continued to work, but they shifted from photojournalism to a more humanistic approach. Individualism was encouraged and the image of the solitary photographer traveling alone around the country became the stereotypical image of the artist/photographer.

Thus conceptions of subject, method, and style began to radically shift in the late 1940s. The mood of this moment is perhaps, surprisingly, encapsulated in the development of tabloid journalism from the 1930s to the 1940s in the work of the man who is perhaps the most famous of these photographers, Arthur Fellig, more commonly known as "Weegee." The Austrian-born photographer is best remembered for his macabre images of New York City in the late 1930s and 1940s, which culminated in the publication of his book *Naked City* in 1945. The book includes photographs of murder victims as well as of the curious crowds that gathered on the streets of New York during and after the war years. Weegee's obsession with the grotesque side of urban life led to his stark but memorable photographs of life in seedy bars and the alleys behind them, filled with prostitutes, famous gangsters, conspicuous dwarfs, freaks of all sorts, and their voyeuristic onlookers. Weegee had a fascination for photographing the other end of the spectrum as well. His images of the rich and famous—Frank Sinatra, Louis Armstrong, Jayne Mansfield—are also well-remembered. Perhaps the most distinctive characteristic for which Weegee is known is that he slept with a police radio next to his bed (and also had one in his car) and was often the first to arrive at a crime scene. This was the basis for the rumor about how he must have used a "Ouija" board to divine the future—hence, one theory for how he got his name.

Most important is Weegee's style, which is fundamental to an understanding of how photography after 1945 materializes in the work of artists such as William Klein and Robert Frank. Weegee's signature was a strong flash with a starkly contrasting black and white image. His style is often confrontational with a flash going off in the face of those he was in pursuit of. Given that most of his images are of night scenes in the city, this brash lighting only adds to the uncanny atmosphere of his portrayals of New York nightlife. Transvestites being taken into the police station, women crying outside

a burning building, automobile crashes, and dead bodies revealed a different side of America than was generally seen. Yet not all of Weegee's photographs involve death and destitution. There are also images filled with joy, humor, and a touch of the burlesque, such as the memorable image of water-soaked children gathered in the sunny summer street watching warily as a policeman turns off the fire hydrant—perhaps their only form of amusement—in *Police End Kids' Street Shower—Under Orders, August 18, 1944*. Weegee also celebrates the diversity and paradoxes of the United States in his vibrant images of church gatherings and jazz concerts in Harlem and intimate shots stolen of people sleeping or kissing in movie theaters. Thus, although he would never gain the artistic prominence of the photographers he inspired in the 1950s, Weegee's artistry and influence is notably present in the next generation.

One of the artists that represents the bridge between the photojournalism of Weegee's era and the more individualistic aspects of the late 1940s and early 1950s was William Klein. Although his work was starkly different than the brazen images of Weegee, Klein's work is considered to border on the grotesque and to echo the black-and-white photos in *Naked City*. Although American, Klein was first a sculptor, and began his career in France, where he worked in the studio of Fernand Léger while also concentrating on other media such as painting and abstract photography. Returning to New York in the 1950s, Klein quickly gained a reputation for his "bad" photographs of city life. This was further emphasized when he was noticed by American *Vogue* and hired as a fashion photographer in 1954. Uncomfortable with the workings of a photo studio, Klein took his models out onto the streets of New York, where he developed a unique look and pioneered the creative use of the wide-angle lens.

In the pages of *Vogue* and in his own work, Klein violated all of the rules of photography by deliberately distorting and blurring his figures, and his subject matter was also extreme images of children with toy guns pointed at the camera. His "in your face" style became a trademark and would be something we would later observe in, for example, the efforts of Diane Arbus. Yet although his images seem random and hasty, one can find a certain symmetrical balance to them. Klein's genius is summed up in his publication *New York, New York* (1956), which draws on all of his talents (and the influences of Weegee).

Another photographer who made the transition between WWII and the postwar era is Robert Capa. Known for his photography of the Spanish Civil

War and WWII in Europe, Hungarian born Capa's (born Endre Friedmann) career lasted up to the moment he was killed by a landmine in Indochina in 1954. Capa, who considered himself to be a journalist rather than an artist, was the quintessential mid-century photographer. He was both a straight photographer and a humanist and had an eye for amazing portraiture. Paradoxically, he first entered the world of photography for economic rather than artistic reasons as a darkroom assistant. Yet, influenced by his relationships with some of the great photographers of his time, such as Cartier-Bresson and André Kertész, Capa became one of the most sought-after photographers of the 1930s and 1940s. Technically speaking, Capa was never a master in the darkroom. His editors remarked that he seemed to have installed a device on his camera that intentionally scratched his film. Thus, although Capa never did quite master the technical side of his art, such as the use of his flash, his style and ability to capture the emotion of a moment are virtually unsurpassed in the photographers of his generation.

After WWII, Capa continued to photograph and make an impact on the world of photography both artistically and professionally. As a man of his era, Capa understood that "professionalism" was becoming more individualistic in late-1940s Europe, where the art world was still buzzing with energy. The photographers who were working and living in Paris banded together in 1947 to create Magnum Photos. Named for its dictionary definition as a "two-quart bottle of spirits," "Magnum" was an agency formed to support a commitment to "concerned" photography and to serve as an international forum for professional photographers and a training ground for young up-and-coming artists. Owned and operated by the artists themselves, the agency's founding members included Robert Capa (who was at the center of the activity) and Henri Cartier-Bresson. Their goal was to improve the lives of photographers and at the same time to allow full artistic license. It was meant to be a collective enterprise in which photographers could develop individually and be free to roam the world and choose their own subjects.

While he was still establishing Magnum, Capa continued to travel the world. He created a portfolio of images from the USSR in 1947, the building of the newly founded State of Israel in the late 1940s, the social elite of Europe in the 1950s, and haunting images of Japan and Indochina in 1954. Capa was also capable of capturing the essence of everyday life of the rich and famous: his photos of Picasso and his family at the Golfe-Juan in 1948 are best remembered in the photo of the artist holding an umbrella over Françoise Gilot while walking on

the beach, and another of him cradling his young son in his arms. We find the same atmosphere present in Capa's photos of Matisse at his studio in Nice and Alfred Hitchcock at work on a film set.

Although Capa was influenced by Cartier-Bresson's theory of "the decisive moment," the two had very diverse approaches to their subject matter. While Cartier-Bresson was noted for his "cool detachment" from his subjects, Capa became intimate with the people he photographed and immersed himself in the whole experience. This commitment to his subjects is tragically marked by the fact that while marching with the Vietnamese army near Thaibinh on a last-minute assignment for *Life* magazine in May of 1954, Capa was killed climbing a dike. His last images show the very spot where he lost his life moments later.

Women also made an impact on postwar photography and one of these was another photographer who had become famous during WWII—*Life* photojournalist Margaret Bourke-White. Though Bourke-White gained a reputation for such firsts as being the first female photographer to fly on a bombing mission during the war, and the first western photographer allowed to enter the Soviet Union, some of her most impressive and touching images were created after 1945. For example, she was sent to India and Pakistan to capture the turbulence of the era and from this produced one of the most striking photos ever taken of Gandhi, *Monhandras Gandhi at His Spinning Wheel* (1946). For that photo she was asked to first learn the art of the chakra, the spinning wheel, in order to better understand the man. She successfully spun some wool and was let in and allowed three photos. The first two failed technically and her only shot turned out to be *the* one. Whenever Gandhi later saw her he would joke, "There's the torturer again." She was also the last one to interview Gandhi before his assassination. In the early 1950s, she went on to photograph other important social issues such as South Korea and apartheid South Africa where she documented the life of poor blacks living behind barbed wire such as in *Shantytown Dweller* (1950) and *Gold Miners* in Johannesburg (1950).

The shift from the 1940s to the 1950s was not just noted in the work of individual photographers such as Bourke-White and Klein but was perhaps best illustrated in one of the most important artistic events of the 1950s. *The Family of Man* exhibition that took place at the Museum of Modern Art (MoMA) in 1955 influenced and defined the shape of the future of photography. Billed by its promoters as "the greatest photographic exhibition of all time" it was organized by Edward Steichen and was a compilation of

503 images by 273 photographers from 68 countries selected out of over 2 million photographs submitted from all over the world. The title was taken from a poem by Carl Sandburg who wrote in his introduction that "Everywhere is love and love-making, weddings and babies from generation to generation keeping the Family of Man alive and continuing... alike and ever alike we are...." Steichen wanted to explore photography's universal themes such as love, childhood, family, work, play, suffering, and death. He aimed to convey the dynamism of photography and how it could help explain "man to man" and act as "a mirror of the universal elements and emotions in the everydayness of life—as a mirror of the essential oneness of mankind throughout the world."

The exhibition was seen as an international and communal effort to heal the wounds still left over from WWII and it toured Europe (including Russia), Africa, and Asia. It was an attempt to disseminate the ideas of these commonalities and included photographs from the Farm Security Administration, the National Archives, and files from *Life* Magazine. Images included scenes from middle America, the Indian subcontinent, Java, Europe, Cuba, Pakistan, and the Belgian Congo. Well-known names such as Bill Brandt, Robert Capa, Robert Doisneau, Ruth Orkin, Irving Penn, Dorothea Lange, and Allan and Diane Arbus graced the pages of the exhibition catalogue, which is sprinkled with philosophical quotes from such diverse personalities as Montaigne, Thomas Jefferson, and a Sioux Native American.

The Family of Man exhibition said many things about mid-century photography but one of the most interesting was the discourse it prompted regarding the shift in the treatment of the African American as a subject from before and after WWII. The exhibition included images of African Americans by photographers such as Consuelo Kanaga, Helen Levitt, W. Eugene Smith, and Wayne Miller, in whose work we see portraits of intimacy between family members, children playing in the streets, and the American jazz scene.

One of these is often defined as one of the least-known American photographers, though Consuelo Kanaga's (1894–1978) career spanned 50 years and she is now credited with having pushed the subject of the African American towards a less romanticized and more realistic viewpoint. A photographer during the Depression, by the 1940s, Kanaga focused her camera on the power of the individual subject most likely inspired by the photographs of the Appalachian residents made in the 1920s, and 1930s by Doris Ulmann. Equally indebted to the Photo-Secessionists (Stieglitz and Steichen) Kana-

ga's work blended commercial photography and social documentary with a hint of abstraction. Her balance between aesthetics and social issues explores this interaction between the camera and the subject that was such a central theme in the postwar era. Perhaps Kanaga's most significant contribution to postwar photography developed from her trips to Tennessee and Florida in the late 1940s and early 1950s. In the marshlands of Florida she took her most memorable image of an African American migrant worker protecting her two small children with her arms. The photograph "She is a Tree of Life to Them" was so named by Edward Steichen when he placed it in *The Family of Man* exhibition in 1955. Kanaga said that this striking image was influenced by Sargent Johnson, an African American sculptor from San Francisco.

Another group of photographers who rose to prominence after WWII were African-Americans, who played a significant role in the way that the world viewed them as both subject and artist in the postwar years. Along with other great names such as Richard Saunders and Gordon Parks, Roy De-Carava is now remembered as one of the most influential photographers of the mid-century whose collection of work spans three decades and gives us some of our most memorable images of DeCarava's native Harlem. In a time when the art world was dominated by the White male, African-Americans were kept on the sidelines and had worked largely in journalism and commercial photography, the most well-known being James VanDerZee who was a studio and portrait photographer. Yet things rapidly changed after 1950 and this was partly due to DeCarava.

DeCarava began his career as a painter who worked early on as a commercial artist. In 1947, having exhausted the medium, he turned to photography as a mode of expression. He liked the directness of the camera. With help from Edward Steichen, DeCarava became the ninth photographer ever to be awarded a Guggenheim Fellowship and in 1955 co-authored his famous book *The Sweet Flypaper of Life* with poet Langston Hughes. The book won much critical acclaim and marked a turning point in African-American photography as an art form. With DeCarava we find sensitive portrayals of life in Harlem with images that are often mere shadows of form. His photos reflected the move away from the harsh political motifs of the 1930s and a general postwar shift towards a more personal, more abstract view of things. Perhaps his most notable contribution to African-American photography is DeCarava's representation of the Black community, and of greats such as singer Billie Holiday and

musician John Coltrane, which communicated a newly found independence that has continued in postwar African-American photographic art.

Three other photographers who carried the photography of the 1940s into the 1950s and influenced photographers for many years to come were Harry Callahan, Aaron Siskind, and Minor White. Harry Callahan's career began in the mid-1940s. He was a self-taught photographer who was greatly influenced by Adams, Stieglitz, and László Moholy-Nagy (at Chicago's Institute of Design, where Callahan taught in the 1950s) but who forged his own identity and style that was much more personal than many of his peers. Having worked in the darkroom at General Motors Photography Department during the war, it was during a four-month period in New York in 1946 that he met Nancy and Beaumont Newhall who were impressed by his work and showed it in the 1946 exhibition *New Photographers*. His photographs followed in the tradition of modernist experimentation of the 1920s and 1930s but have a much more humanistic and personal quality. Callahan's talent shows in his incredibly fine images such as *Cattails against Sky* (1948) and *Weed against Sky, Detroit* (1948), but his most famous and profound photographs are of his favorite models, wife Eleanor and daughter Barbara. Very intimate works, some of the photographs show his wife nude in a domestic interior such as in *Eleanor, Chicago 1948*, others are of her emerging from still water, in shadow, or are "snapshots" of his family going about their daily lives.

New Yorker Aaron Siskind (1903–1991) is remembered as one of the most noteworthy mid-century photographers whose art is centered primarily on one subject: the picture plane, a subject that is also known as one of the most important aesthetic issues in modern art. Although he was actively engaged in the world of documentary photography in his early years of work, from the moment of his first exhibition in New York in the late 1940s his contribution to modern art only grew. Practicing in the tradition of the "straight" photographers he is associated with New York School Painting and his subject matter is reminiscent of the surfaces of a painting by Franz Kline or Clyfford Still. Rather than taking traditional subject matter as his central concern, Siskind often focused his camera on a wall and engaged with the picture plane. Geometrical forms and flat planes became his object of study. Although he produced well-known images such as *Terrors and Pleasure of Levitation* (1954) and facades of Chicago streets, Mexican pyramids, and abstract designs on walls in Rome, he is relatively unknown compared to other

photographers of his time. Yet his impact was great. A radical by nature, his work did for photography what abstract expressionists such as Kline and de Kooning did for their own medium. In addition he was a great teacher who was in residence at the Chicago Institute of Design alongside Harry Callahan in the 1950s–1970s and later went on to the Rhode Island School of Design.

Minor White was perhaps the most influential photographer of these three men and of the postwar era. Having worked for the Works Progress Administration (WPA) during the Great Depression, White is remembered for his haunting images of the natural world but also as one of the founding members of *Aperture* quarterly and as a great teacher who helped advance the careers of many burgeoning artists. White's meticulous "straight" photographic style was formed during his exchanges with such masters of the prewar era as Edward Weston, Alfred Stieglitz, and Ansel Adams. His conversations with Stieglitz, in particular, spurred his "meditations" about photography as a way to translate visual form into something he called the "suprasensual." For White, the photograph was a "mirage" and the camera was a "metamorphosing machine."

> To get from the tangible to the intangible...a paradox of some kind has frequently been helpful. For the photographer to free himself of the tyranny of the visual facts upon which he is utterly dependent, a paradox is the only possible tool. And the talisman paradox for unique photography is to work "the mirror with a memory" as if it were a mirage, and the camera a metamorphosing machine, and the photograph as if it were a metaphor.... Once freed of the tyranny of surfaces and textures, substance and form can use the same to pursue poetic truth.

White developed the theory of the "accidental," and his essay *Found Photography* is a profound description not only of his approach, but of his spiritual process. While he saw photography as something sacred and spiritual, White was also a master technician which just added to the exquisiteness of his craft. Photographs such as *Pacific, Devils Slide, California, 1947* and the stunningly majestic *Barn and Clouds, In the Vicinity of Naples and Dansville, NY, 1955* are perhaps some of the most outstanding illustrations of his aesthetic theory in practice.

Apart from Minor White, Swiss-born photographer Robert Frank is probably the most influential of the postwar era. Unlike the abstract planes of Siskind or the intimate familial portraits of Callahan, Frank's work framed the mundane moments of loneliness, boredom, racial strife, and the banal, everyday life of America in the 1950s. On his arri-

val in New York in 1946 Frank found work with *Harper's* and *Junior Bazaar*. After *Harper's* closed its doors a year later he left New York and traveled through the Americas to Peru and Bolivia before returning to Europe in 1949. For the next five years he continued to travel between Europe and the United States and published his stunning yet somber collection of images in the book *Black and White Things*.

The postwar photographic era perhaps culminated in Robert Frank's landmark project—*The Americans* (1959). This is probably the most influential single photo book published between 1945 and 1959. Having begrudgingly returned to the United States in 1953, Frank spent the years 1955–1956 traveling across America on a Guggenheim Fellowship, capturing scenes that revealed an America driven by racial conflict, politics, loneliness, and boredom. Using a 35-mm manual Leica he shot 500 rolls of film, which unfold for us his version and vision of America in the 1950s. His images are of public space and public life—streets, post offices, Woolworth's, cafes, small hotels, bus stations, parks, hospitals, elevators, diners, and gambling casinos. His subject matter runs the gamut from 4th of July picnics to cowboys to interstate highways. Even the design of the text was somewhat revolutionary. Reflecting Walker Evans's book *American Photography*, Frank's book was sparse and the photographs were only printed on the right-hand side of the pages. The left-hand side was blank except for the page numbers. Thus, from Frank we get a vision of a foreigner's response to his adopted country that is a kind of "anguished visual poetry rather than graphic art." Jack Kerouac, author of *On the Road*, wrote in the introduction to the book "he sucked a sad poem right out of America onto film, taking rank among the tragic poets of the world." Frank is merely a "poetic" observer whose photographs revel in the voyeuristic rather than participatory pleasure of the image. It was not just his choice of subject but his unique style that included closely cropped scenes, that also draws the eye. In addition, Frank is known for frequently photographing directly into the glare of the light, and often framed his subjects off-center or on a tilted horizon. This skewed sense of balance along with his use of the small, handheld 35-mm camera greatly influenced the way that photographers worked from that time on. Thus, Frank deliberately breaks the rules of "good" photography. Yet in doing so he also closes off a great and productive era in postwar photography but, more importantly, looks ahead to the 1960s and 1970s in which photographers such as Richard Avedon, Diane Arbus, and Garry Winogrand will carry on his tradition in their own vision.

In Europe, the important group *fotoform* became the nucleus of 1950s modernism; Peter Keetman, Otto Steinert, and others showed both the continuity and disruption with the previous photographic styles, especially in Germany. "*Subjektive Fotografie,*" a style that focused on abstraction, design, and close observation was emerging, codified in a series of three exhibitions in the early 1950s.

Around the world, in Japan, which had its own postwar era, but also in countries not directly affected by the World War, there was a general boom in photography as societies increasingly modernized and standards of living increased. Japan's postwar photographers, including Ken Domon, Hiroshi Hamaya, Kikuji Kawada (whose famous black and white picture of the Japanese flag, laying on the ground, soaked and wrinkled, is a symbol of an essential part of Japanese reconciliation with their war years), Shomei Tomatsu, and others reflected the introspection and independence that characterized western photographers. Photojournalism and social depiction predominated as Japan's postwar photographers dealt with the aftermath of their defeat and the devastating physical and psychological consequences of the atomic bombs dropped on Nagasaki and Hiroshima.

In the USSR and countries under communist rule, policies dictating "official" styles constrained photographic innovation even as they codified photographic genres such as Socialist Realism.

STEPHENIE YOUNG

See also: **Adams, Ansel; Arbus, Diane; Bourke-White, Margaret; Brandt, Bill; Callahan, Harry; Capa, Robert; Cartier-Bresson, Henri; DeCarava, Roy; Doisneau, Robert; Domon, Ken; Frank, Robert; Hamaya, Hiroshi; History of Photography: Interwar Years; Institute of Design; Kawada, Kikuji; Keetman, Peter; Klein, William; Levitt, Helen; Life Magazine; Magnum Photos; Museum of Modern Art; Newhall, Beaumont; Penn, Irving; Siskind, Aaron; Socialist Photography; "The Decisive Moment"; Ulmann, Doris; War Photography; Weegee; White, Minor; Winogrand, Garry**

Further Reading

Barth, Miles. *Weegee's World*. New York: Bulfinch Press, 1997.

Frank, Robert. *The Americans, 1959*. New York: Pantheon, 1986.

Frank, Robert, Sarah Greenough, Philip Brookman, Martin Gasser. *Robert Frank: Moving Out*, Washington: National Gallery of Art, 1994.

Peter Keetman, Schallplatte, 1948.
[© *Fotomuseum im Munchner Stadtmuseum. Photo reproduced with permission of the artist*]

Head Millstein, Barbara. *Consuelo Kanaga: An American Photographer*. Brooklyn: Brooklyn Museum in association with the University of Washington Press, 1992.

Kennedy, Anne, and Nicholas Callaway, eds. *Eleanor: Photographs by Harry Callahan*. Carmel,CA: Friends of Photography, 1984.

Klein, William. *Paris + Klein*. New York: Distributed Art Publishers, 2003.

The Family of Man. Exhibition Catalogue. Intro. Edward Steichen. New York: Museum of Modern Art, 1935.

Maddow, Ben. *Faces: A Narrative History of the Portrait in Photography*. Boston: Little Brown & Co., 1977.

Newhall, Beaumont. *The History of Photography: From 1839 to the Present*. New York: The Museum of Modern Art, 1982.

Orvell, Miles. *American Photography: Oxford History of Art*. New York: Oxford University Press, 2003.

Rubin, Susan Goldman. *Margaret Bourke-White: Her Pictures Were Her Life*. New York: Harry N. Abrams, 1999.

HISTORY OF PHOTOGRAPHY: THE 1980S

A medium linked with low art and popular culture, photography has historically been considered a secondary form of artistic expression. Despite the early efforts of the Pictorialists, photography continued to be associated with documentary, informational, and commercial contexts. Its status started to change in the late 1950s and during the 1960s, when the medium was progressively introduced into the international contemporary art scene and began to be more widely collected, both publicly and privately. This process culminated in the 1980s and photography acquired a double status: on the one hand, it became a luxury object, invested with considerable aesthetic and economic value; on the other, it continued to address broader public functions through its "popular" forms that came to dominate mass communication. And most interesting, these two seemingly opposing statuses were conflated by many of the most successful artists of the era. Other artists confronted photography as both an object of aesthetic delectation and a vehicle of more traditional social concern, expanding tendencies that had shaped photography in earlier decades.

By the middle of the 1980s, photography had accomplished "all that was first set out in its mid-nineteenth century agenda: general recognition as an art form, a place in the museum, a market (however erratic), a patrimonial lineage, an acknowledged canon." (Solomon-Godeau, 85) More specifically, the considerable growth of the art market contributed to the fetishist dimension of photography, transforming it into saleable and often over-valued merchandise. Indeed, in the 1960s an increasingly active market had devel-

oped that coincided with Robert Rauschenberg's and Andy Warhol's introduction of photography into painting and as leading artists, into the mainstream of contemporary art practice. Moreover a mass of documentation—of conceptual art, land art, performance and body art, mail art—appeared in galleries in the late 1960s and 1970s and made their habitués accustomed to seeing photographs and eventually to buying them. Thus a new market developed, one whose prices were geared more toward high-priced painting than to traditional photography.

As the market grew in the 1980s, private collectors constituted its most influential force and dominated art-world consensus. Contemporary curator and critic Dan Cameron summed up the unique situation in 1986:

> If the art world five years ago seemed to be dominated by the galleries—an adjustment that contrasted, for example, to the central role of critics during the 1960s—it now appears that patronage itself is becoming the all-important factor in determining the type of international impact an artist is going to have. Whereas until recently artists and dealers talked about the number of works sold from an exhibition, now the emphasis is clearly on who bought them.

> (*Art and Its Double*, p. 30)

Beyond market peculiarities, the 1980s were characterized by a fervent polemic—an artistic as well as a theoretical one—around photography. The widespread use of technical and reproducible imagery in the fine arts is considered as one of the main distinguishing features of postmodernism, which em-

erged full-blown in the decade and distinguished it from modernism's formalist aesthetics that are embedded in the idea of the unique object. Historically, although there was "modernism" in photography, in the larger application of this term in the art world, photography was often seems as the proverbial second-class citizen because it was a highly reproducible medium. In this way, photography appeared to resist classification according to traditional aesthetic categories, and instead called for the revision and re-actualization of these categories. Hence the paradox: if there is some specificity in the photographic image, it consists in its elusiveness and its capacity to shift from one category to the other, that is, precisely, in its lack of specificity. In that sense, photography could be apprehended either as a record of some exterior reality, or as an interiorized vision revelatory of the photographer's own inner being. In most of cases, it was both at the same time.

For Rosalind Krauss, "the photographic...had come to affect all the arts." (Michelson, 1987, introduction) Photography was central not only to advanced art but to society as well. Photography critic Abigail Solomon-Godeau wrote:

As photography has historically come to mediate, if not wholly represent, the empirical world for most of the inhabitants of industrialized societies (indeed, the production and consumption of images serves as one of the distinguishing characteristics of advanced societies), it has become a principal agent and conduit of culture and ideology.

(Solomon-Godeau 1984, 76)

Although the decade is characterized by a wide diversity of styles and uses of the photographic medium, a primary distinction can be made between artists who used photography among other forms of expression (without being exclusively photographers) and those who came to be called "pure photographers."

Many artists of the first group, and especially those who combined photography with texts, had largely internalized art theory and assimilated into their own art making. Following a conceptualist and post-conceptualist realm, such photographers tried to demonstrate the distance that separates photography and its referent, despite their common identification.

Photography had been thus regarded as a particular semiotic system, the understanding of which, far to be obvious, depends on visual and cultural codes. Informed by French structuralism and semiotic theories (Roland Barthes, Jean Baudrillard, Jacques Derrida, and Michel Foucault), as well as by psychoanalysis (Jacques Lacan) and phenomenology (Maurice Merleau-Ponty and Louis Althusser), artists renewed and expanded the conceptualist critique of representation. From that point of view, photographic images were texts to be deciphered rather than works of art to be admired. For Rosalind Krauss, the photograph is "a meaninglessness surround which can only be filled in by the addition of a text." ("Notes on the Index: Seventies Art in America," p. 66).

Two seminal essays by Roland Barthes, "*The Death of the Author*" and "*From Work to Text*," served as references for the artists. According to Barthes:

We know now that a text is not a line of words releasing a single 'theological' meaning (the 'message' of the Author-God) but a multi-dimensional space in which a variety of writings, none of them original, blend and clash. The text is a tissue of quotations drawn from the innumerable centers of culture....Succeeding the Author, the scriptor no longer bears within him passions, humors, feelings, impressions, but rather this immense dictionary from which he draws a writing that can know no halt: life never does more than imitate the book, and the book itself is only a tissue of signs, an imitation that is lost, infinitely deferred.

(Barthes 1977, 146–147)

Not only did the captioned photograph incorporate verbal texts into visual art more than ever before, but captioning so linked the visual with the verbal that the visual was turned into a text. In "*Notes on the Index: Seventies Art in America*," Krauss characterized the photograph as an "index," an imprint of something tangible in the physical world. According to her, indexes are "marks or traces [of that] to which they refer, the object they signify. Into the category of the index, we would place physical traces (like footprints), medical symptoms...." Photography would belong to that same category of motivated signs.

Among the artists who investigated the textual dimension of photography, Victor Burgin is maybe the most representative. Burgin's work is a constant questioning of the photographic medium as a sign-producing device capable to influence social behavior. Photography is for Burgin an apparatus of power, an ideologically motivated representation that has to be deconstructed, as can be seen in *Office at Night*, 1985–1986. Burgin's work is informed by psychoanalytical theory, using it to investigate the mechanisms of visual representation as well as the return of the repressed in the cultural sphere. But for Burgin photography is, above all, a process of production. "Such a process, through the technical manipulation of materials, mediates reality and constitutes an ideological intervention in the world. This awareness corrects the ingenuous

acceptance of the camera as an incorruptible instrument of truth."

A whole generation of what became known as conceptual photographers (or "media artists", as critic Irving Sandler calls them) emerged from of the California Institute of the Arts (CalArts) in Los Angeles. An influential figure was John Baldessari, who first used the term "post-studio art" to designate those practices, very fashionable in the late 1970s, which exceeded straight painting or sculpture. Opening formalist aesthetics to the examination of art's potential social and political engagement, Baldessari's art and teaching were informed by production and presentation strategies culled from disciplines outside the traditional confines of fine art, such as commercial photography and mass media imagery. Baldessari, a generation older than many of his students who received early fame, was himself finally recognized as an important artist in the 1980s with works such as *The Little Red Cap*, 1982 and *Hanging Man with Sunglasses*, 1984.

Once the stability of traditional artistic categories was successfully challenged by photography in the late 1970s into the 1980s, attention was transferred to the politics of image making by photographic as well as by more traditional means. Indeed, postmodernism emerges as a dominant fine arts ideology at the same time as political and social dimensions appear widely in art-making as both methodology and subject matter. More important, photography and the critical thinking that accompanied it in the 1980s are so interwoven that the full impact of works often cannot be understood without reference to their theoretical contexts.

In the preface of *The Anti-Aesthetic: Essays on Postmodern Culture*, Hal Foster makes an important distinction between two kinds of postmodernism: a postmodernism of resistance and a postmodernism of reaction. According to Foster, the former "seeks to deconstruct modernism and resist the status quo," while the latter repudiates modernist tradition in order to celebrate those normative structures that perpetuate cultural conservatism and its interests. (p. xii) If conceptual photographers and media artists were the tenants of the former type of postmodernism, the latter was associated with painting, dominated the art-world of the 1980s.

Photography was valued over painting by those who promoted deconstruction theory because of its perceived "relevance," that is, its capacity to function as a critical agent capable of raising questions about contemporary society, its values, and its symbols. Painting, and more specifically neo-expressionist painting that emerged in the late 1970s and early 1980s and that was rooted in the heroic gesture of the artist in search of transcendence, was considered by oppositional postmodernists as regressive and ahistoric, promoting a conception of the artwork as a luxury commodity, ready to be exchanged in the marketplace.

Perhaps as a result of this reaction against neo-expressionism, the 1980s in the United States saw the emergence of the tactics of appropriation or simulation. These strategies were also a reaction to the dominant ideology of the mass media. Artists like Sherrie Levine, Barbara Kruger, Richard Prince, or Martha Rosler sought to deconstruct myths of American culture as they shaped or were manifested in everyday life by willfully 'rephotographing' famous photographs and signing them as their own or through using found, anonymous imagery.

As an art director in the 1970s, Barbara Kruger worked for Condé Nast publications, whose legendary art directors had nurtured and shaped many of the premier photographers of the twentieth century. This experience provided her a sense of how magazines manipulate their readers through photography as well as graphic skills that she employed in her subsequent art work. As she noted, "It's the magazine's duty to make you their image of their own perfection." Employing collage and photomontage, techniques used by avant-garde artists of the 1920s and 1930s including Hannah Höch and John Heartfield, Kruger re-inscribed these visual strategies in a contemporary context, focusing on representation as an instrument of power and a regulator of sexual difference. In works such as *"Untitled" (Your gaze hits the side of my face)*, 1981 and *"Untitled" (Buy me I'll change your life)*, 1984, Kruger demonstrates how photography can serve as a means of addressing questions about language, sexuality, representation, commodities, and the relationships among them, expanding the perspectives and possibilities of feminist art. Pre-existing images, lifted from their original contexts and reproduced in black and white, are open to new interpretations. Thus Kruger demonstrates that the meaning of a photograph lies on its social use and context more than on what is inherent in the image.

As can be seen in Kruger's work, much of the most important artistic production of the 1980s is directly concerned with photography's capacity for creating and imposing social stereotypes. Many artists explored the visual potential offered by mass imagery and advertising, blurring the limits between high art and popular culture by use of photography. Another paradigmatic artist of the 1980s is Richard Prince. Prince also began his career working at a commercial photography concern, the clippings department of Time-Life publications. In the base-

ment archives of the publisher of the famous picture magazine, he had access to literally thousands of images. In 1977, he began re-photographing photographs from advertisements. By separating images from their media context—that is, from their intended significations—Prince enabled them to take on other meanings. Saturated blow-ups of everyday commercial imagery, his Ektacolor prints explored photography's capacity to transform reality into fiction and fiction into reality. Prince became particularly associated with fragmented representations of the Marlboro Man, as in *Untitled (Cowboy)* of 1989. Enlarged and cropped, these images became free-floating signifiers of the mythology of American masculinity, subtly displacing the visual and imaginary relationship between the viewer and the artwork.

Another important artist of this tendency is Cindy Sherman, who emerged in the 1980s not only as an acclaimed photographer but as one of the decade's top contemporary artists. Sherman's *Untitled Film Stills* (started in the late 1970s and continued during the 1980s) are a set of black-and-white photographs in which the artist has costumed herself to suggest the female types available in the Hollywood movies of her childhood. Associating femininity with masquerade, she addresses directly the way mass media inscribe women into stereotypical models of representation, distributing roles and creating characters. Thus, Sherman establishes a sort of dictionary of photographic poses, through which the veracity of the staged image, as well as the codes required for its reading, are seriously called into question.

While Sherman works exclusively within the photographic medium, she is not considered a photographer in the sense of traditional photographic practice. Within the realm of "pure photography," as exemplified by figures like Helmut Newton and Henri Cartier-Bresson who inherited the tradition of the straight photography of the 1920s and 1930s, the theoretical debates also raged. Pure photography focused on what made photography different from any of the other arts—its "truth" to appearances and its peculiar physical and formal qualities. The most eminent spokesman for this formalist conception of photography was John Szarkowski, the director of photography at the Museum of Modern Art, New York, who more than any other individual in America had established photography as a high art, defining its terms of discourse and creating its canon, until being challenged by *October* magazine and its deconstructionist aesthetics in the 1980s. As Irving Sandler writes, Szarkowski had been to photography what formalist champion Clement Greenberg had been to painting. Szarkowski's thesis was that photography is a unique medium, which, as it evolved, progressed self-consciously toward its own essence. This essence was theorized in terms of inherent properties such as time, the frame, detail, and the vantage point. In seeking to identify photography's "values, traditions, masters and masterworks," as Solomon-Godeau put it, Szarkowski felt that photography was "purified of its worldly entanglements, distilled into a discrete ensemble of 'photographic pictures,'" in short, treated with reference to itself only. Reflecting on his contribution, Szarkowski commented: "I think I took the risk of allowing photography to be itself and show itself without being couched in the rubric of philosophical or moral positions." (Sandler 1996, 348) Szarkowski's formalism was challenged again and again through the forum of *October* particularly as it prompted him to dismiss the directions photography took in the 1980s.

October's contributors were not the only ones who called into question this purist, documentary conception of photography. Many photographers rejected this stance as well as Vilém Flusser's assertion that photography is the last step before the complete dematerialization of the image. These artists, often called impure photographers, focused on the particular materiality and tactility of photographic emulsions. In contrast to pure photographers, these artists minimized photography's traditional or "straight" role as a veristic window on the world. They loosened up and expanded technique, cultivating the grain in their images, utilizing blurred focus, cropping, wide-angle distortions, and exploring color. Some of these photographers also began, harking back to the aesthetics of the Pictorialists, to manipulate the surface, emulating the idiosyncratic "touch" of the painter and to enlarge the formats, so that their photographs could compete with wall-size canvases.

Artists like Joel-Peter Witkin and Giordano Bonora (*Untitled*, 1986) especially exemplify the furthering of the Pictorialist tradition of creating a unique, painting-like works with subject matter that evokes spectral or allegorical associations. Witkin, like Mike and Doug Starn, Paolo Gioli, and Italian artist Natale Zoppis, among others, used brushwork, stacked multiple images, and manually colored their prints, enhancing photography's visual presence.

An important part of postmodern art theory saw in photography a significant shift from production to reproduction, the seminal article of Walter Benjamin "The Work of Art in the Age of Mechanical Reproduction," the often-cited support for this viewpoint. In this view, inherent in the nature of a photograph, the modernist boundaries between "high" and "low" cultural forms are breached or

obscured. Although there is no critical consensus about postmodernism, as Solomon-Godeau points out, "the properties of photographic imagery which have made it a privileged medium in postmodern art are precisely those which for generations art photographers have been concerned to disavow". (Solomon-Godeau 1984, 76) On the other hand, impure photographers rejected the identification of photography with mechanical reproduction (and the subsequent denial of the original), prizing unique prints or limited editions of their work. In such a way, they aspired to the "aura" of the traditional, one-of-a-kind, and handmade work of art, defending the tradition in which the uniqueness of the process as well as the originality of the idea makes each print unrepeatable.

Examining the aesthetic divisions of photography that emerged in the 1980s, writer Susan Weiley proposed that

> the more accurate distinction lies between photographers whose work invites intimate viewing, as in a book, and those who intend the work for a wall.... Work has shifted from the intimacy of being held in the hand toward something that has to be seen on the wall, at a distance. It's a major difference.

(Weiley 1980, 149)

While this distinction is somewhat helpful in sorting out the influential currents of the decade, the personal and intimate was not restricted to book formats or traditional small-scale black-and-white photographs typical of 1950s icons Harry Callahan or Robert Frank, nor was the public and distanced to be found solely on gallery and museum walls. Artists like Christian Boltanski took an interest in the intimacy of the photograph as a personal souvenir, producing both intimate artists' books as well as huge installations. In Boltanski's work, photography allows the creation of a fictional past, demonstrating that our personal identities are more and more structured by photographs, which tend finally to take the place of our memories, as in *Monument*, 1987. The format in which these photographs appear matter not as much as the intimate manner in which the artist presents them, often in grotto-like settings with the illumination of bare light bulbs or even candles. Others, such as Jeff Wall, using photograph's fictive abilities to "create" cultural and societal memories, relied on presentations associated with public spheres, such as advertising light boxes, while also successfully presenting these large-scale, backlight transparencies in book form, demonstrating the continuing, inherent flexibility of the medium.

The photo-paintings that emerged at the beginning of the 1980s and quickly became a favorite, if not dominant form in contemporary art through the end of the century originated with such artists as Jeff Wall. Using references to the history of paintings as well as to media imagery, Wall plays off the historical presumptions about photographs capturing or presenting reality while paradoxically creating fictions and the thin lines that separate these presumptions. Early works, such as *The Thinker*, 1986, based on Auguste Rodin's famous bronze, refer directly to great works in the history of art. In later works Wall explored the literary and filmic aspects in his art. The majority of his pieces contain references to art history, the media, and socio-economic problems, typical of postmodernism, and putting forth the concept that recasting tradition into contemporary visual culture may be one of the true distinguishing features of the decade.

Robert Mapplethorpe's work is also iconic 1980s imagery and is emblematic of the fact that underground, alternative, marginal, and marginalized cultures were favored topics for photographers during the decade. Mapplethorpe's most notorious images create a photo-document of the New York gay scene. But like Cindy Sherman, he made a series of self-portraits in which he appears disguised: as a horned devil, drag queen, terrorist with a machine gun, gangster, and so on. Although extremely personal and often shocking, his work has the stylishness and finish of high-fashion photography, essentially dehumanizing his models. Through quotations of old master paintings and fine art photography of historic figures such as Man Ray or George Platt Lynes, he aestheticized often repellent subjects, creating highly charged, seductive images whose sheer beauty served as a foil for their unrestrained sexuality. As Hal Foster put it:

> new social forces—women, blacks, other 'minorities,' gay movements, ecological groups, students...have made clear the unique importance of questions of gender and sexual difference, race and the Third World...in such a way that the concept of class, if it is to be retained as such, must be articulated in relation to these new terms."

(1983, 17)

Nan Goldin's *The Ballad of Sexual Dependency*, which examined the social milieu of those considered outsiders, was one of the most influential photographic series of the 1980s. Often working within the loose narrative structure of series of related images, Goldin photographed intimate scenes of her closest friends. Expressing a highly personal viewpoint, Goldin also frequently featured a reli-

gious motif as seen in *Self-Portrait in Blue Bathroom*, 1980, where the bathtub suggests ritual cleansing, and the artist's image in the mirror is framed by the blue of St. Mary, another tendency that harkened back to an earlier time, especially the turn of the twentieth century. Andre Serrano's overt use of Christian iconography caused a firestorm of controversy in the late 1980s, sparking the so-called "cultural wars" in America.

Sexuality and its complex relations with the photographic act of seeing are also at the center of Nobuyoshi Araki's work. Araki presents the female body with an erotic intensity as in his *Tokyo Story* series, 1980–1988. Undressed, bound, and staged in domestic environments, it becomes the object of both exhibitionist and voyeuristic instincts. Playing with the conventions of documentary and fashion photography as well as pornography, Araki uses his photographs as a means to exorcise his phantasms, offering along the way an incisive portrait of contemporary Japanese urban culture, proving that in the 1980s, the human body, naked or dressed, does not necessarily only implicate sexuality. In the 1980s, sexuality becomes yet another area for discourse on social issues, politics, or aesthetic theory.

The use of the human body, while a central motif in 1980s photography, was not monolithic in the nature of its representations. In stark opposition to Mapplethorpe's cold vision of perfect physique, John Coplans focused on the deterioration and vulnerability of the flesh, using his own body. As Elizabeth Fraiberg wrote, Coplan's photography "is the stuff of Mapplethorpe's worst nightmares." (Fraiberg 1990, 28) Coplans use of large scale and fragmented images presented in series brought forth a number of earlier tendencies associated with art photography of the 1960s and 1970s.

It is Lucas Samaras, working since the 1960s, who has probably most fully explored the limits of the documentary form through his use of Polaroid photography in a number of series in which he presents the intimacies of his own everyday life. Using the ability of Polaroids to both instantly offer up their image as well as their ability to be physically manipulated, Samaras enriched an historically humble medium with a personal literature that challenges presumptions about its immediacy and "popular" character. The highly personal, humble use of photography exemplified by Goldin and Samaras or Francesca Woodman, among others, also saw its opposite in another hugely influential tendency of the 1980s, that of the cold, distanced, analytic social document.

The most characteristic example is the work of Bernd and Hilla Becher, which is principally an objective recording of architectural relics of the industrial age. (*Industrial Facades #4*, 1978–1995) yet which in presenting "typologies" fit well within the postmodern theoretical structures advanced during the 1980s. Bechers' conception of photography influenced a great number of photographers, who had worked since the 1970s but burst forth on the international scene in the 1980s, among them Andreas Gursky, Thomas Ruff, and Thomas Struth. The Bechers, whose photographs had achieved prominence within the conceptual and minimal art movements, taught at the Staatliche Kunstakademie (State Art Academy) in Düsseldorf, where Gursky and others assimilated their rigorous method and its implications. Teasing an eccentric geometry out of each of his subjects, Gursky reorders the world according to his own visual logic, accumulating myriad details to offer a sense of harmonic coherence. His pictures typified by *Hong Kong Stock Exchange*, 1994, may be described as modern-day versions of classical history painting in that they reproduce the collective mythologies that fuel contemporary culture: travel and leisure (sporting events, clubs, airports, hotel interiors, art galleries), finance (stock exchanges, sites of commerce), material production (factories, production lines), and information (libraries, book pages, data).

Ruff and Struth also exploited and expanded the Becher's use of photography as a neutral medium in the service of an objective representation of reality. The mechanical and coldly descriptive appearance of their images is reminiscent of August Sander's sociological use of photography to record "types" in the 1920s and 1930s. Yet this generation of artists realized that photography's "neutrality" and "objectivity" are not a reality, rather a commonly-held belief. In their typically large-scale, color photographs, these artists present images that often seem more real than reality itself.

Another important photographer to emerge out of the historical traditions of photography in the 1980s is Martin Parr. A photojournalist in temperament and by training, Parr produced several startling color series that extended and redefined this tradition, including *The Last Resort*, 1986–1988, and *The Cost of Living*, 1988. In these photographs that unite a growing political awareness with a preoccupation with the domestic and mundane, Parr created dynamic, colorful images that, ranging in subject from crumbling British seaside towns to international hubs of consumer culture, offer witty, unblinking insights into contemporary life.

But aesthetic tendencies or even aesthetic fad and fashion aside, photography, unlike painting and other traditional media, is primarily a fruit of

science and its industrial applications. Its expressive potentialities, before being a matter of conscious choice and personal vision, depend on technology. In that sense, one of the reasons of photography's success in the 1980s is the fact that it became available to a growing number of people. The visual possibilities offered by the technological progress of photographic procedures gradually disengaged photography from its traditional subjugation to reality. Artists used various techniques, including large format Polaroid photography, advanced electronics, multimedia, and digital imaging, to create works that question issues of historical verity as well as the conflict between reality and imagination.

During the 1980s, a system called DX coding was introduced for 35-mm film. The cassettes in which the film is encased were imprinted with an auto-sensing code enabling certain cameras to automatically set the film speed; this information can also be used by processing laboratories to accurately develop the film. In 1980, Sony demonstrated the first consumer camcorder, and in 1984 Canon demonstrated the first electronic (digital) still camera. In 1985, Minolta marketed the world's first auto-focus SLR system (called "Maxxum" in the United States). In 1987, both Kodak and Fuji introduced inexpensive disposable cameras, the Kodak Fling and Fuji Quicksnap. Both were sold in foil wrappers ready-loaded with film, the complete camera being given to the film processor after exposure. Canon went on to introduce the RC-760 still video camera in 1987 and the Q-PIC floppy disc camera in 1988, which led to the introduction and widespread acceptance of digital cameras in the 1990s.

Such are the issues that preoccupied photographers in the 1980s: the technical particularities of the medium which, along with industrial evolution and the advent of digital technology, deeply transformed its aesthetic premises; the role and function of photography in the broader social and cultural context of post-industrial societies; the place of human subjectivity inside them, that of the body, its intimacy, disguises, mutations and mythologies; quotation and play with the typologies and historical conventions of the medium; coexistence of past and present and the shifting relations between fact and fiction. In this way photography is constantly taking effect between the private and the public sphere. Among the many exhibitions that seemed to showcase these tendencies, we can retain *Image Scavengers: Photography*, mounted in 1982 by the Institute of Contemporary Art at the University of Pennsylvania in Philadelphia; *Appropriation and Syntax: The Uses of Photography in Contemporary Art*, mounted in 1988 at the Brooklyn Museum of Art in New York; *20th Century Photographs from the Museum of Modern Art*, photographs selected by John Szarkowski and Susan Kismaric, mounted in 1982 at The Museum of Modern Art in New York; and *New American Photographs*, mounted in 1987 at the Harvard University Art Museums.

The 1980s witnessed a particularly vital and inventive period when the reciprocal influences of artistic and commercial photography effected a clear change in the way that artists as well as the public apprehended photography. If the photographic experimentation in the field of fine arts opened the way to advertising and other mass media, permitting them to revise and renew their communicational strategies, the artistic recycling and appropriation of "low" forms of photography offered to artists an inexhaustible universe of new topics. From now on, not only commercial photography can be considered as a form of art, but, more importantly, artistic photography can be analyzed in terms of communication and visual marketing.

Be that as it may, it is clear that the photographic production of the 1980s cannot be apprehended through compartmentalized stylistic categories. Artists knowingly called into question such arbitrary divisions that confine and close off the art-discourse, showing that photography is much more complex and rich than it appears to be, a multidimensional and ambiguous object. Indeed, toward the end of the decade, the watchwords were hybridization and interbreeding, topics that would be further elaborated in the 1990s.

VANGELIS ATHANASSOPOULOS

See also: **Appropriation; Araki, Nobuyoshi; Barthes, Roland; Becher, Bernd and Hilla; Body Art; Boltanski, Christian; Burgin, Victor; Conceptual Photography; Coplans, John; Deconstruction; Flusser, Vilém; Goldin, Nan; Gursky, Andreas; Image Theory: Ideology; Krauss, Rosalind; Mapplethorpe, Robert; Modernism; Parr, Martin; Photographic "Truth"; Photography and Painting; Postmodernism; Prince, Richard; Representation and Gender; Representation and Race; Ruff, Thomas; Semiotics; Serrano, Andre; Sherman, Cindy; Solomon-Godeau, Abigail; Starn, Mike and Doug; Struth, Thomas; Wall, Jeff; Witkin, Joel-Peter; Woodman, Francesca**

Further Reading

Barthes, Roland. "The Death of the Author." In *Image-Music-Text*. Translated by Stephen Heath, New York: Hill and Wang, 1977.

Bürger, Peter. *Theory of the Avant-Garde*. Translated by M. Shaw, Minneapolis: University of Minnesota Press, 1984.

Burgin, Victor. *Thinking Photography*. London: Macmillan, 1982.

William Wegman, Frog/frog II, color Polaroid, 1982, 21 × 24″.
[*Reproduced with permission of the artist*]

Crimp, Douglas. "The Photographic Activity of Post-Modernism." *October* no. 15, Winter 1980.

Eauclaire, Sally. *American Independents: Eighteen Color Photographers.* New York: Abbeville Press, 1987.

Foster, Hal, ed. *The Anti-Aesthetic: Essays on Postmodern Culture.* Port Townsend, WA: Bay Press, 1983.

Fraiberg, Elizabeth. "John Coplans: The Aboriginal Man." *Q: A Journal of Art* May 1990, 28.

Heartney, Eleanor. *Postmodernism.* London: Tate Publishing, Ltd., 2001.

Krauss, Rosalind. *The Originality of the Avant-Garde and Other Modernist Myths.* Cambridge, MA: MIT Press, 1985.

Lawson, Thomas. *A Fatal Attraction: Art and the Media.* Chicago: Renaissance Society at the University of Chicago, 1982.

Michelson Annette, et al. eds., "Introduction." *October: The First Decade, 1976–1986.* Cambridge, MA: MIT Press, 1987.

Owens, Craig. *Beyond Recognition: Representation, Power, and Culture.* Berkeley: University of California Press, 1992.

Sandler, Irving. *Art of the Postmodern Era: From the Late 1960s to the Early 1990s.* New York: Harper Collins, 1996.

Solomon-Godeau, Abigail. "Photography after Art Photography." In *Art After Modernism: Rethinking Representation.* ed. Brian Wallis, New York: The New Museum of Contemporary Art, /Boston: David R. Godine, 1984.

Sontag, Susan. *On Photography.* New York: Delta Books, 1977.

Szarkowski, John. *Photography until Now.* New York: Museum of Modern Art, 1989.

Szarkowski John. *American Landscapes: Photographs from the Collection of the Museum of Modern Art.* New York: The Museum of Modern Art, 1981.

Tomkins, Calvin. *Post- to Neo-: The Art World of the 1980s.* London: Penguin Books, 1989.

Traub, Charles, ed. *The New Vision: Forty Years of Photography at the Institute of Design.* Millerton, NY: Aperture, 1982.

Weiley, Susan. "The Darling of the Decade." *Art News* April 1989.

HANNAH HÖCH

German

Hannah Höch entered the art world as a creative force with the radical-leaning Berlin Dada circle, which formed shortly before the end of World War I. She was generally regarded as responsible for appropriating the photomontage technique from folk culture and making it an avant-garde art form in a way that perfectly fit the anarchic spirit of the Dada movement. Her works frequently contained distinctly personal iconography, but ultimately took part in the political discourses of the Weimar Republic, including those involving ideas of utopia, debates over technocracy in German society, and the construction of women's identities.

Born in 1889 in the Thuringia region of Germany, Höch was the daughter of an insurance company manager and an amateur painter and housewife. As the family's eldest child, she took care of her younger siblings and was largely kept from attending school. She was nearly 22 when she was finally able to enroll in the Kunstgewerbeschule in Berlin. There, she studied glass with Harold Bengen. The outbreak of World War I forced her brief return home, where she worked for the Red Cross. In 1915, she returned to Berlin to study graphics with Emil Orlik at the Staatlichen Lehranstalt des Kunstgewerbemuseums. She met and became involved with the Austrian artist Raoul Hausmann in the same year. Their romantic liaison brought her into contact with many figures of the avant-garde, including the Futurists. Later, when the Berlin Dada circle unofficially formed in 1917, after the arrival of Richard Huelsenbeck from Switzerland, she also met the political dissidents George Grosz and John Heartfield, who published incendiary pamphlets under the name Malik Verlag.

Between 1916 and 1926, Höch worked three days a week for the Ullstein Verlag, which published the popular illustrated magazines *Die Dame, Berliner Illustrierte Zeitung,* and *Die praktische Berlinerin.* At Ullstein, Höch designed pattern books appearing in these journals, which targeted female audiences. Her work for Ullstein, taken in conjunction with the politicized intellectualism she took part in as a member of the Dada movement, eventually informed the ideological content of much of her art.

During a trip to Gribow on the Baltic Sea in 1918, Höch saw souvenir postcards depicting officer's uniforms onto which photographs of heads had been pasted. The medium used to create the images was photomontage, a technique existing since the nine-

teenth century. Höch was consequently stimulated to experiment on her own. As the illustrated magazine industry exploded during the Weimar years, Höch used portions of images collected from periodicals like those in which her own ornamental patterns appeared to create her photomontages. An inveterate collector, she kept scrapbooks and filled boxes with clippings, filed according to the object represented. Höch also frequently incorporated fragments of her own photographs and watercolors into her work.

Between 1918 and 1922, Höch remained closely affiliated with the Dadaists, from their explosive self-introduction into the art world through a radical performance at the usually decorous Berlin Secession of 1918 to the 1921 Dada evenings staged by Hausmann and Kurt Schwitters in Prague. In 1920, Höch participated in the First International Dada Convention held in Dr. Otto Burchard's gallery in Berlin, an event that marked the apex of Dada's artistic preeminence in Germany. Among several of her works exhibited was her renowned critique of the Weimar Republic, *Schnitt mit dem Küchenmesser*. Her 1922 work, *Meine Haussprüche*, is said to mark her break with Hausmann and the nihilism of Dada. The work manifests a sympathetic turn towards Constructivism in her compositional adherence to a vertical–horizontal axis.

Unlike John Heartfield, who extracted images from their sources with meticulous attention to outline and who subsequently rephotographed his montages so that each would appear as a seamless whole, Höch allowed the edges of her collaged images to be apparent. Because of the clipped-off contours, the juxtaposition of incongruous sizes, the visibility of picture seams, and the resulting grotesque appearance of her figures, Höch's works have been characterized by historians as violent. This brutality served her underlying messages, which frequently dealt with the continued subjugation of women in a culture undergoing seismic political shifts.

Always at issue for Höch was society's belief in the credibility of the photograph. Unknown to many readers, magazines and newspapers routinely manipulated the images that accompanied news articles in order to make them more dramatic. Höch's photomontages utilized similar methods of fabrication, yet allowed the evidence of the manipulation to be seen. With their cobbled appearance, her pictures constantly remind the viewer that they are artificial constructions. By emulating the level of control expended by fashion magazines to assemble ideal "realities," she both subverted and commented on the mechanisms of the media, revealing the didactic power of illustrated magazine content and the insidious implications this power had for women's self perceptions and political situation.

Höch continued to create small format photomontages through the mid-1930s. She was immensely productive, exhibiting frequently, creating highly political series like *From an Ethnographic Museum*, and even publishing a book critiquing consumer culture entitled *Scheingehacktes* with her companion, the Dutch poet Til Brugman, in 1935. Through Brugman, she met the artists Piet Mondrain, Theo Van Doesburg, and Hans Arp, all with whom she became close friends. The National Socialist's Degenerate Art campaign of 1937, which successfully isolated artists and prevented their collaboration, halted Höch's exhibition possibilities and her productivity. In 1942, she moved to a small house on the outskirts of Berlin near Heiligensee, working and exhibiting intermittently until her death in 1978.

SAVANNAH SCHROL

See also: **Dada; Futurism; Heartfield, John; History of Photography: Interwar Years; History of Photography: Twentieth-Century Pioneers; Manipulation; Montage; Photography in Germany and Austria; Propaganda**

Biography

Born Johanne Höch in Gotha (Thuringia), 1 November 1889. Enrolled in the Berlin Kunstgewerbschule, 1912. Returned home to work with Red Cross, 1914. Studied at the Staatliche Lehranstalt des Kunstgewerbemuseums in Berlin, 1915. Became companion of Raoul Hausmann, 1915. Accepted part-time position at Ullstein Verlag, 1916. Experiments with photo collages after encountering medium during trip to Baltic Sea, 1918. Left Hausmann and broke with Dadaists, 1922. Began relationship with Dutch poet Til Brugman and settled in The Hague, 1926. Established contacts with Piet Mondrain and other de Stijl artists, 1926. Denounced as cultural Bolshevik by National Socialist, Wolfgang Willrich, 1937. Married pianist Kurt Matthies, 1938. Divorced Matthies, 1944. Lived in isolation on Heiligensee near Berlin, 1942. Died in Berlin on 31 May 1978.

Individual Exhibitions

1929 Kunsthuis de Bron, The Hague
 Rotterdamische Kring, Rotterdam
 Kunstzaal Van Lier, Amsterdam
1934 *Fotomontazi*; Brno, Czechoslovakia
 Fotomontage van Hannah Höch; Kunstzaal d'Audretsch, The Hague
1945 Galerie Gerd Rosen, Berlin
 Museum of Modern Art, New York
1957 *Hannah Höch, Collagen*; Galerie Gerd Rosen, Berlin
1959 *Hannah Höch, Collagen, 1956–1959*; Galerie Gerd Rosen, Berlin
1964 *Hannah Höch; Galerie Nierendorf*, Berlin

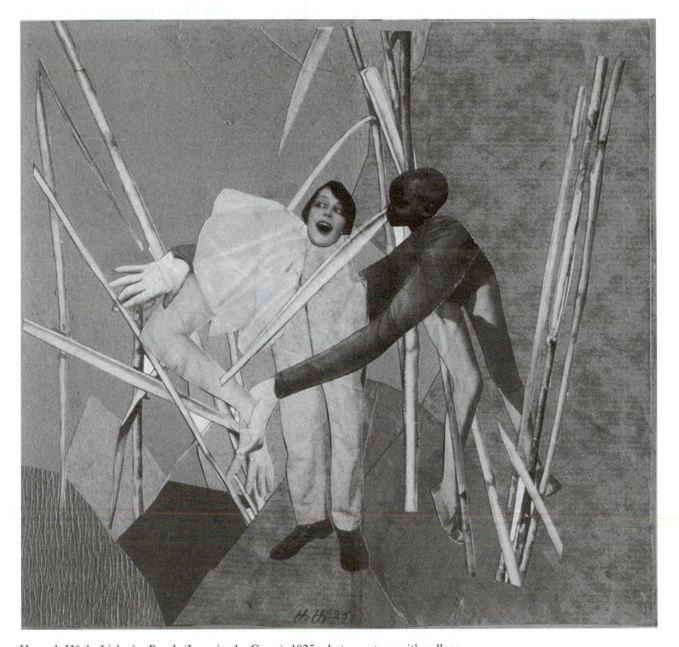

Hannah Höch, Liebe im Busch (Love in the Grass), 1925, photomontage with collage, 9 × 8½".
[*Collection of the Modern Art Museum of Forth Worth, Museum Purchase, The Benjamin J. Tillar Memorial Trust*]

1971 *Hannah Höch: Collagen aus den Jahren 1916–1971*; Akademie der Künst, Berlin

1976 Retrospective Exhibition; Museé d'Art Moderne de la Ville de Paris and the Nationalgalerie Berlin, Staatliche Museen Preussischer Kulturbesitz, Berlin
 Hannah Höch; Muzeum Sztuki w Lodzi, Lodz, Poland

1980 *Hannah Höch zum neunzigsten Geburtstag: Gemälde, Collagen, Aquarelle, Zeichnungen*; Galerie Nierendorf, Berlin

1983 *Hannah Höch, 1889–1978: Oil Paintings and Works on Paper*; Fischer Fine Art Limited, London

1984 *Hannah Höch, 1889–1978*; L.A. Louver Gallery, Venice, California

1985 *Collages, Hannah Höch, 1889–1978*; Institute for Foreign Cultural Relations, Stuttgart

1990 *Hannah Höch, 1889–1978: ihr Werk, ihr Leben, ihre Freunde*; Berlinische Galerie, Berlin

1993 *Hannah Höch: Gotha 1889–1978 Berlin*; Museen der Stadt Gotha, Gotha

1997 *The Photomontages of Hannah Höch*; Walker Art Center, Minneapolis, Minnesota, and traveling

Group Exhibitions

1919 *Erste Berlin Dada Ausstellung*; Graphischen Kabinett of I.B. Neumann, Berlin
1920 Novembergruppe Exhibition, Berlin
　　 Erste Internationale Dada-Messe; Dr. Otto Burchard's, Berlin
1921 Novembergruppe Exhibition, Berlin
　　 Grotesken; Berlin Secession, BerlinAnti-Dada-Merz-Tournee, Prague
1922 Novembergruppe Exhibition, Berlin
　　 Grotto for Merzbau, Hannover
1923 Novembergruppe Exhibition, Berlin
　　 Juryfreie Kunstaustellung; Berlin
　　 Grotto for Merzbau, Hannover
1924 *Allgemeine Deutsche Kunstausstellung*; traveling in the Soviet Union
1925 Deutsche Kunstgemeinschaft; Berlin Stadtschloss, Berlin
　　 Juryfreie Kunstaustellung; Berlin
1926 Novembergruppe Exhibition, Berlin
　　 Deutsche Kunstgemeinschaft; Berlin Stadtschloss, Berlin
1928 *Onafhankelijken Group Exhibition*; The Hague
　　 Kölnischen Kunstverein; Essen, Germany, and traveling
1930 *Grosse Berliner Kunstaustellung*; Berlin
　　 Novembergruppe Exhibition, Berlin
1931 *Fotomontage* exhibition; Staatliche Kunstbibliothek, Berlin
　　 Frauen in Not; Haus der Juryfreien, Berlin
　　 Grosse Berliner Kunstaustellung; Berlin
1932 *Exposition Internationale de la Photographie*; Palais des Beaux Arts, Brussels
　　 Collage Exhibition; Philadelphia Museum of Art, Philadelphia, Pennsylvania
1933 *Exposition Internationale de la Photographie*; Palais des Beaux Arts, Brussels
1980 *Conrad Felixmüller and Hannah Höch*; Berlinische Galerie, Berlin
1994 *Three Berlin Artists of the Weimar Era: Hannah Höch, Käthe Kollwitz, Jeanne Mammen*; Des Moines Art Center, Des Moines, Iowa, and traveling

Selected Works

Schnitt mit dem Küchenmesser Dada durch die letzte weimarer BierbauchkulturepocheDeutschlands (Cut with the Kitchen Knife Dada through the Last Weimar Beer Belly Cultural Epoch of Germany), 1919–1920
Meine Haussprüche (My House Sayings), 1922
Hochfinanz (High Finance), 1923
Liebe im Busch, 1925
Die starken Männer (The Strong Men), 1931
Deutsches Mädchen, 1930

Further Reading

Adriani, Götz, ed. *Hannah Höch*. Cologne: Du Mont Buchverlag, 1980.
Apel, Dora. "'Heroes' and 'Whores': The Politics of Gender in Weimar Antiwar Imagery." *The Art Bulletin* 1 September 1997.
Höch, Hannah. *Hannah Höch 1889–1978: Ihr Werk, Ihr Leben, Ihre Freunde*. Berlin: Berlinische Galerie and Argon, 1989.
Höch, Hannah. *Eine Lebenscollage*. 2 vols. Bearbeitet von Cornelia Thater-Schulz, Berlin: Berlinische Galerie and Argon, 1989.
Lavin, Maud. *Cut with the Kitchen Knife: The Weimar Photomontages of Hannah Höch*. New Haven, CT: Yale University Press, 1993.
Lavin, Maud. "Strategies of Pleasure and Deconstruction— Hannah Höch's Photomontages in the Weimar Years." In *The Divided Heritage: Themes and Problems in German Modernism*. Irit Rogoff, ed., Cambridge: Cambridge University Press, 1991.
Makela, Maria. "Hannah Höch." In *Three Berlin Artists of the Weimar Era: Hannah Höch, Käthe Kollwitz, and Jeanne Mammen*. Louis R. Noun, ed., Des Moines, IA: Des Moines Art Center, 1994.
Ohff, Heinz. *Hannah Höch*. Berlin: Gebr. Mann, 1968.
Pagé, Suzanne. "Interview with Hannah Höch." In *Hannah Höch: Collages,Peintures, Aquarelles, Gouaches, Dessins*. Paris and Berlin: Museé ArtModerne de la Ville de Paris and Nationalgalerie Berlin Staatliche MuseenPreussischer Kulturbesitz, 1976.
Serger, Helen. *Hannah Höch: 1889–1978*. New York: La Boetie, 1983.Walker Art Center, eds. *The Photomontages of Hannah Höch*. Minneapolis, MN: Walker Art Center, 1996.

HORST P. HORST

American

The formal portrait of designer Coco Chanel, Paris, 1937 and the famous 'Mainbocher Corset,' Paris, September 15, 1939, are among the twentieth century's best known fashion photographs. Both were made within two years of each other by the photographer, Horst P. Horst. Displaying an intuitive understanding for form, grace, femininity, and elegance, the elegantly composed, dramatically lit

photographs exemplify Horst's style and capture the spirit of the 1930s. Horst himself conveyed the sophistication of the era: he was handsome, charming, and gregarious. He and photography were the perfect match for a "wonderful life," which gave him entrée to homes, gardens, and soirees. He said "I like taking photographs, because I like life. And I like photographing people best of all, because most of all I love humanity."

During a career spanning over half a century, Horst P. Horst gave us the definitive portraits of such diverse twentieth century figures such as fashion icons the Duchess of Windsor, Consuelo Balsan, The Baroness Pauline de Rothschild, and Elsa Schiaparelli; movie stars and singers Marlene Dietrich, Mistinguett, and Mary Martin; artists Salvador Dali, Jean Cocteau, and Cy Twombly; writer Gertrude Stein; and a host of others. Each of these portraits capture the personality and style of the sitter while at the same time conveying enduring qualities that has allowed it to become a classic. Horst said of Schiaparelli "she was daring and knew how to show it successfully," a phrase that accurately describes him as well.

Born in 1906 in Weissenfels-an-der-Saale in Germany, the son of a merchant, Horst originally came to Paris to study architecture with Le Corbusier. After meeting George Hoyningen-Huene, already established as the French capital's premier portrait and fashion photographer, he turned instead to photography. The 1930 Huene photograph *The Divers* of a young Horst, muscular and handsome in an Izod bathing suit, paired with a female model at the end of a diving board, is a watershed image, a signal of the androgyny and the drama that characterized the worlds of high society and art of the 1930s.

Horst's earliest photographic works echo Huene's cool classicism. But his dramatic lighting, circular backlighting, and use of the silhouette, were his own innovations and rapidly were established as his signature. Within a few years, Horst developed a more ornamental style. He may not have revolutionized fashion photography, but he certainly perfected it. He had a preference for a richly packed studio, a continued use of props, and complicated lighting effects. His trompe l'oeil (a photograph within a photograph) shots were among his most original. In 1936, Horst was at the height of his interest in placing his models in an elaborate studio "set," frequently designed by one of his friends, such as the interior decorators Jean-Michel Frank or Emilio Terry. Horst recalled that the Paris studio was equipped with about 20 large floodlights and spotlights. He preferred to use the spotlights to emphasize the important points of a dress.

Horst flourished in the 1930s, and photographed prolifically in a style that embraced theatricality and classicism simultaneously. A favorite model was Lisa Fonnsagrives (later Lisa Penn), and it was his work with Lisa that demonstrated a gradual shift in approach. He eliminated props, relying on his mastery of studio lighting. Lisa was also the subject of some of his most successful nude studies, which convey the graphic inventiveness power of his compositions. This power can be seen in the classic *Vogue* cover of June 1, 1940. He posed the athletic and statuesque Lisa to create letters that spell out the magazine's title. These stylized gestures were based in part on his observations of dance; like a choreographer, Horst knew the graphic and emotional power of these gestures arrested at their peak.

Horst moved with the "fashionable set" in Paris in the 1930s. Amongst his closest friends were Coco Chanel, the eccentric and brilliant artist Christian Berard, the Vicomtesse de Noailles, Gertrude Stein, Luchino Visconti, and Janet Flanner. While he consistently photographed his friends, his photographs of Coco Chanel are particularly well known. Asked to photograph Chanel for *Vogue*, he found she hated the picture. Ready to pose several days later, she showed up with a bag of her jewelry, which was laid out on a table so that she could choose which piece to wear. She became absorbed in thinking about a love affair that was ending; this was the image Horst captured. It became her favorite image for years. He continued to have great success with his fashion work, which was formally inventive, ingenuously lit, often with a slight surrealistic edge. This sense of the strange and the dramatic is beautifully evoked in *Dali's costumes for the Ballet Russe de Monte Carlo production of Massine's Bacchanale, executed by Chanel*, which appeared in *Vogue* on October 15, 1939.

In 1962, when the ingenious Mrs. Diana Vreeland came to *Vogue* as editor-in-chief, she commissioned Horst to do a report on the Edwardian Consuelo Vanderbilt Marlborough Balsan and her collection of French works of art, beginning a new phase of Horst's career. Horst and his companion, the writer Valentine Lawford, set off around the globe, reporting on the lives of the "tres chic." In this work he pioneered the use of the small format camera and natural light for society portraiture and fashion photography, originating "lifestyle photography," an amalgam of formal portraiture, an unspoken narrative, and the capturing of the aura

that surrounds celebrity. Barbara Plumb in her introduction to the book *Interiors* wrote:

> Whomever Horst photographed, he beguiled. It was magic to watch him at portrait sittings. When the rapport had jelled, he would ask for a Dubonnet or a Campari, depending on his mood, and then start clicking away with his Rolleiflex or Hasselblad. Even the stiffest and most fidgety of subjects overcame any natural shyness and fear of the camera in Horst's presence because he made each one feel appreciated and beautiful. The whole process was so much like a seduction that often other people in the room felt like intruders—or voyeurs.

One knows upon viewing these works that these were seamless collaborations between sitter and photographer, both of whom were enjoying their task at hand.

What ultimately characterizes Horst's photography is his conception of beauty. He studied classical poses, Greek sculpture, and classical painting. He devoted meticulous attention to details such as the positioning of hands, arms, and feet during the process of being photographed. The Detolle corset for Mainbocher featured in American *Vogue*, September 15, 1939, is an undisputed masterpiece of fashion photography. This haunting photograph marked Horst's farewell to Paris, soon to be occupied by Nazi Germany. Horst said

> I left the studio at 4:00 A.M., went back to the house, picked up my bags, and caught the 7:00 A.M. train to Le Harve to board the Normandie....For me, this photograph is the essence of that moment. While I was taking it, I was thinking of all that I was leaving behind." Years later he said, "We all felt that war was coming....And you knew that whatever happened, life would be completely different after. I had found a family in Paris, and a way of life.

Horst immigrated to the United States in 1935 and became a naturalized citizen. He continued to photograph well into his 80s, and died Nov. 18, 1999, at his home in Florida.

<div align="right">Diana Edkins</div>

See also: **Condé Nast; Fashion Photography; History of Photography: Interwar Years; Hoyningen-Huene, George; Photography in France**

Biography

Horst P. Horst was born Horst Bohrmann August 14, 1906, in Weissenfels-an-der-Saale in Germany. He was the son of a Garman hardware-store owner. After his education at the Schulpforta, followed by a short period in Switzerland and Capri, he was sent by his parents to work for a Hamburg export firm. He soon returned to study at Hamburg's Kunstgewerbeschule, a well-known school of applied arts under the direction of Walter Gropius from 1926–1928. While there he wrote to Le Corbusier

and was invited to be a student-apprentice at the architect's atelier in Paris in the late 1920s. In Paris he met George Hoyningen-Huene and became his photographic model and lifelong friend. He started his career at *Vogue* helping out with sets at the *Vogue* studio in Paris. He began taking pictures himself and continued working for Condé Nast Publications in Paris as staff photographer, 1932–1935. He took over as chief photographer in *Vogue*'s Paris studio when Huene left to join *Harper's Bazaar*. Horst spent part of each year in Paris and the remainder in New York. He made New York and Oyster Bay his permanent residence. He specialized in fashion, portraits, travel, and later with Valentine Lawford houses, gardens, and lifestyle photography. Immigrated to the United States in 1935 and was naturalized in 1942. He served in the U.S. Army from 1942–1945 as a technical Sergeant. He remained a fashion and still life photographer for Condé Nast Publications well into his 80s. Died November 18, 1999, Palm Beach Gardens, Florida.

Individual Exhibitions

1984 *Horst and His World*; International Center of Photography, New York, New York, and traveling
1991 *Horst: 60 Ans de Photographie*; Musée des Arts de la Mode, Paris, France
1996 *Horst*; International Center of Photography, New York, New York
2001 *Horst: Portraits 60 Years of Style*; National Portrait Gallery, London, England

Selected Group Exhibitions

1985 *Shots of Style*; Victoria and Albert Museum, London, England
1987 *Fashion and Surrealism*; Fashion Institute of Technology, New York, New York
1992 *On the Edge: The First One Hundred Years of Vogue*; New York Public Library, New York, New York
2002 *Dressing Up: Photographs of Style and Fashion*; Worcester Art Museum, Worcester, Massachusetts
2003 *Women*; Photography Monika Mohr Galerie, Hamburg, Germany
2004 *Photo – Icons*; Arte Fino, Zurich, Switzerland
2003 *Explorei icons of modern photography*; HackelBury Fine Art Limited, London, England
2003 Invito alla Fotografia; Galleria Carla Sozzani
2004 Platinum; Galleria abOrigena, Milan, Italy
2004 *Das Wunder Mensch/Parameter of Life*; Museum Moderner Kunst, Passau, Poland

Selected Works

Greek Statute, Paris, 1932
Noel Coward, Paris, 1934
George Hoyningen-Huene, Paris, 1934
Fashions: Hat, Talbot; Suit, Robert Piguet, Paris, 1936
Coco Chanel, Paris, 1937
Serge Lifar and Olga Spessivtzeva in Bacchus, Paris
Duchess of Windsor, Paris, 1937
Lisa Fonssagrives in forehead corsage, Lanvin, 1938
Lisa Fonssagrives signing "I love you" in black felt tricorn Balenciaga hat and Boucheron gloves, Paris, August 1, 1938
Electric Beauty, Paris, 1939

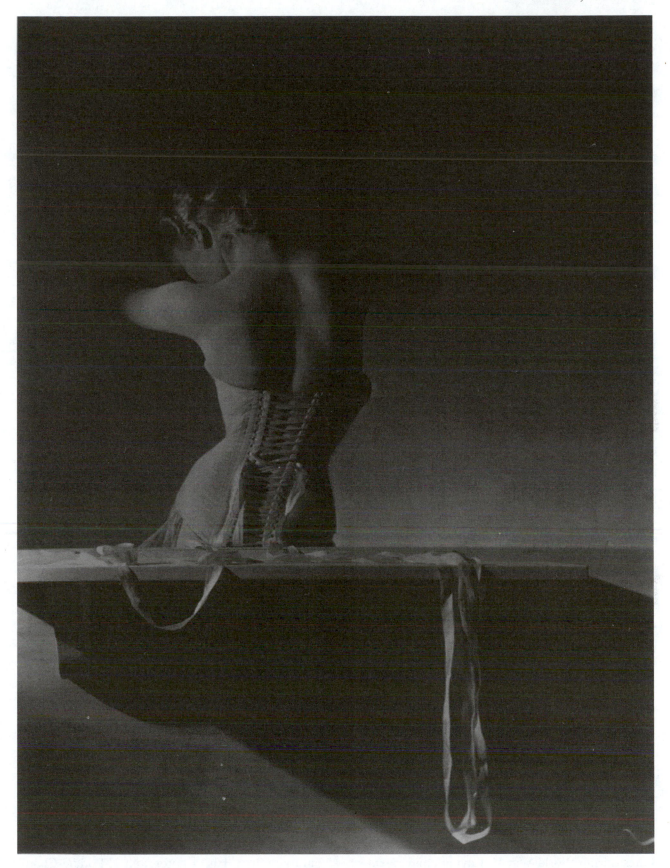

Horst P. (Paul) Horst, Mainblocher Corset, Vogue, 1939.
[*CNAC/MNAM/Dist. Réunion des Musées Nationaux/Art Resource, New York*]

"*From Paris—The new Detolle corset with back lacing, Mainbocher,*" Paris, 1939

Salvador Dali costumes for the Ballet Russe de Monte Carlo production of Massine's Bacchanale, executed by Coco Chanel, Paris, October 15, 1939

Lisa Fonssagrives in Malayan Turban by Lilly Daché, New York, 1939

Mrs. Stanley G. Mortimer (born Barbara Cushing) and Mrs. Desmond Fitzgerald modeling matador hats, New York, 1940

Lisa Fonssagrives, V.O.G.U.E., 1940

Lisa Fonssagrives, turban, 1940

Evening clothes by Schiaparelli, New York, 1940

Marlene Dietrich in Mainbocher, 1942

Salvador Dali, 1943

Carmen, New York, 1946

Gertrude Stein and Horst, Paris, 1946

Jean Cocteau, Venice, 1947

Jean Marais, Venice, 1947

Birthday Gloves, New York, 1947

The New American Foot, New York, 1948

Maria Callas, New York, 1952

Jacqueline Bouvier and Lee Radziwell, New York, 1958

Cy Twombly, Rome, 1965

W.H. Auden, New York, 1970

Robert Wilson, director-author, New York, 1977

Diana Vreeland, New York, 1979

Paloma Picasso, Paris, 1979

Fashion, Calvin Klein, New York, 1983

Stockings, New York, 1987

Further Reading

Beaton, Cecil, and Gail Buckland. *The Magic Image.* London: 1975 and Boston: 1975.

Booth, Pat. *Master Photographers: The World's Great Photographers on Their Art and Technique.* London: 1983.

Diamonstein, Barbara Lee. *Visions and Images: American Photographers on Photography.* New York: 1981.

Duncan, Nancy Hall. *The History of Fashion Photography.* New York: 1979.

Horst, Horst P. *Horst: Portraits.* London: National Portrait Gallery, 2001.

———. *Horst: Interiors.* Barbara Plumb, ed. Boston: Little Brown &Co., 1993.

———. *Form.* Altadena, CA: Twin Palms, 1992.

———. *Horst: Sixty Years of Photography.* Text by M. Kazmaier. T.J. Tardiff and L. Shirmer, eds. New York: Rizzoli, 1991.

———. *Horst: Photographs 1931–1986.* Milan/London: Idea/Art Data, 1985.

———. *Return Engagement: Faces to Remember, Then and Now.* With text by James Watters. New York: Clarkson N. Potter, 1984.

———. *Horst His Work and His World.* New York: Alfred A. Knopf, 1984.

———. *Horst: Fashion Theory.* Carol di Grappa, ed. New York: 1980.

———. *Salute to the Thirties.* With George Hoyningnen-Huene. New York: The Viking Press, 1971 and London, 1971.

———. *Vogue's Book Of Houses, Gardens, People.* With text by Valentine Lawford. New York: The Viking Press and London, 1963.

———. *Patterns from Nature.* New York: J.J. Augustin, 1946.

———. *Photographs of a Decade.* New York: J.J. Augustin, 1944.

Lawford, Valentine. *Horst: His Work and His World.* New York: 1984.

Gruber, Fritz L. *Beauty: Variations on the Theme Woman by Masters of the Camera-Past and Present.* London: 1965, and New York: 1965.

Gruber, Fritz L. *Fame: Famous Portraits of Famous People by Famous Photographers.* London: 1960, and New York: 1960.

Lawford, Valentine. *Horst: His Work and His World.* New York: 1984.

Liberman, Alexander. *The Art and Technique of Color Photography.* New York: Simon and Schuster, 1951.

EIKOH HOSOE

Japanese

Eikoh Hosoe is among the most important practitioners in the history of modern Japanese photography. Born Toshihiro Hosoe in 1933, the son of a Shinto priest, he was only 12 years old when Hiroshima and Nagasaki were bombed by the United States during World War II, leaving unprecedented physical and psychological destruction. Hosoe acquired his first camera at the age of 18 and began to capture the transformations of a terror-ravaged Japan; he changed his name to Eikoh to mark the beginning of a new era. His easy mastery of English provided opportunities, especially later in his career.

Hosoe's early interest was in documentary-style photography. His photograph "Poddie-Chan" (1951) of a young American child (taken at the

Grant Heights U.S. Army Base in Tyoko during the postwar occupation) won first prize in the student section of the Fuji Photo Contest of 1952. Inspired by the result, he enrolled at the Tokyo College of Photography but soon abandoned his interest in documentary ideals. While at the College, Hosoe was a key contributor to a new expressive style espoused by the *Demokrato* (Life) group that collaborated during the postwar era. Other members included Ay-O, On Kawara, Masuo Ikeda, Tatsuo Fukushima, and the spiritual leader Shuzo Takiguchi. Hosoe began to experiment and created photographs that were extremely dramatic and—a move which has continued throughout his adult life. His photographs around this time attempted to evoke the dark, post-nuclear face of Japan as a way of understanding changes and exploring personal expression. The strong contrasts made possible by black-and-white photography have also been a consistent interest for the artist, who has only ventured into color photography once.

Hosoe graduated in 1954 to become a freelance photographer. His book *35mm Photography*, a technical guide, was published a year later, and favorable sales allowed him to travel throughout Japan. During 1956, Hosoe mounted his first solo show at Konishiroku Gallery, entitled *An American Girl in Tokyo*, a fictional photo essay with text that depicted a story of ill-fated love between an American girl and a Japanese man. While commercially unsuccessful, the story recounted in the exhibition was made into a radio drama, and the series was published in *Photo Salon* magazine.

The most profound moment of Hosoe's early career, however, occurred in 1959, when he saw a performance by the young dancer and founder of *Butoh* dance, Tatsumi Hijikata. Hijikata adapted Yukio Mishima's novel *Kinjiki* (*Forbidden Colors*, 1952–1953), creating a scandal through his exploration of the homoerotic themes of the book. At this time, Hosoe helped to found the commercially successful photo agency VIVO, an organization formed from a group called Eyes of Ten, and he also staged his second solo exhibition, *Otoko to onna* (*Man and woman*), which shocked Japanese audiences and earned him international attention. The exhibition included very large, fragmented nude portraits of Hijikata and the people in his dance troupe, which Hosoe refers to as "photographic theatre." That same year, on a beach in Chiba, Hosoe and Hijikata made the experimental, anti-nuclear war film *Navel and Atomic Bomb*. Hosoe has also made several other films during his career, such as *Judo* (1964) and *Modern Pentathlon* (1964) for the Tokyo Olympic Games. Both artists

returned to Chiba the following year to develop a new series titled *Embrace*. By chance, however, Hosoe also discovered Bill Brandt's *Perspectives of Nudes* (1961) and abandoned the *Embrace* project for 10 years for fear of imitating the British master.

Also at this time, Hosoe won the "Most Promising Photographer Award" of the Japan Photo Critics' Association, and he began one of the most important and successful working relationships of his career with Mishima, who was impressed by Hosoe's work with Hijikata. One of their first collaborative projects was a series of photographs of Mishima, which Hosoe created for the writer's book of critical essays, *The Attack of Beauty* (1961–1963). Mishima was among the first modern Japanese writers to attract critical attention in the West; his novels often addressed the tension between Western and Japanese cultures. During this time, Hosoe took another series of portraits of Mishima, which were published as the book *Barakei* (1963), translated into English as *Killed by Roses*. Hosoe's photographs reveal the tension Mishima embodied between pre- and post-war Japan as well as the body and the mind. The series has been described by Hosoe as a "subjective documentary." The artist's directorial role in the project is most evident in works such as *Ordeal by Roses #32* (1962) and *Ordeal by Roses #5* (1962) which depict Mishima with a rose in his mouth and tied up with a hose—symbolizing a masochistic balance of eroticism and menace. During this time, Hosoe married Misako Imai.

While highly regarded for this literary work, Mishima—Hosoe's most celebrated collaborator—was equally famous for his preoccupation with the human body, its beauty and degeneration. He longed for the patriotism of Imperial Japan and was explicit about the cultivation of the perfect physical form. His ultimate act of will was by committing *seppuku* (ritual suicide) in 1970.

Mishima's death coincided with the launch of the revised version of *Barakei*, which Hosoe postponed the release of until the following year. The English translation had also been changed to *Ordeal by Roses* at Mishima's request. The photographs in *Barakei* evidence the stylistic innovations of postwar Japanese photographers and reveal a level of photographic manipulation not seen until much later in other parts of the world. Many writers, such as frequent Hosoe commentator Mark Holburn, regard this publication as the artist's masterpiece.

Other well-known series, such as *Kamaitachi* (The weasel's sickle, 1965–1968), *Simmon: A Private Landscape* (1971–), and *Kimono* (1963), are private studies and metaphors for a changing Japanese society. The later works are cinematic and intensely dramatized,

playing on sexual discoveries, legends, and myths that relate to Hosoe in his personal life. During the 1970s, Hosoe began to show his work outside Japan, most often in America, as well as holding photography workshops at home and abroad. In 1972, Hosoe met Cole Weston, son of Edward Weston whose work he had admired since the early 1950s, and agreed to translate the *Daybooks of Edward Weston* into Japanese.

Throughout his career, Hosoe has used the human form, and the nude in particular, to explore issues of identity and the spiritual self, although there is no history of the nude in Japanese art photography until early in the twentieth century. Hosoe's photographs during the mid 1980s of the work of Spanish architect Gaudi reveal his belief that Gaudi's curvilinear flourishes have the sensuality of flesh. His book, *The Cosmos of Gaudi*, was published in 1984—although Hosoe had studied Gaudi's work since 1964—and included drawings and poems by Joan Miró. It was not until 1991 that Hosoe attained gallery representation through Howard Greenberg/Photofind Gallery, New York. Hosoe's most recent series include *Luna Rosa* (1990–1996) and *People Concerned with the Works*. Today, Hosoe remains an important figure in photography through his teaching and workshops (he has been Professor of Photography at the Tokyo Institute of Polytechnics since 1975). A retrospective of Hosoe's work, *Eikoh Hosoe: META* toured the United States throughout the 1990s.

KATE RHODES

See also: **Nude Photography; Photography in Japan; Weston, Edward**

Biography

Born Yonezawa, Japan, 18 March 1933. Attended Tokyo College of Photography, Tokyo, 1952. Taught photography workshops at Phoenix College, Arizona, and Columbia College, Chicago, 1973–1974; taught at the Ansel Adams Workshop in Yosemite, California, 1973–1975; taught workshops in Arles, France 1976, 1979, 1983. Established *The Photo Workshop School* in Tokyo, 1974–1977; Professor of Photography, Tokyo Institute of Polytechnics, Tokyo 1975–. Gave workshops in platinum printing, New York, 1987; received first prize in the student group of the Fuji Photo Contest, 1952; joined the artists' group Demokrato, 1953; helped to found the photo agency VIVO, 1960. Most Promising Photographer Award of Japan Photo Critics Association, 1961; Photographer of the Year Award, Japan Photo Critics Association; Award for *Barakei* from Photo Critic Society, Japan, 1963. Living in Tokyo, Japan.

Individual Exhibitions

1956 *An American Girl in Tokyo*; Konishiroku Gallery; Tokyo
1960 *Man and Woman*; Konishiroku Gallery; Tokyo
1968 *An Extravagantly Tragic Comedy*; Nikon Salon; Tokyo and Osaka
1969 *Man and Woman*; Smithsonian Institute; Washington, D.C.
1974 *Eikoh Hosoe*; Light Gallery; New York
1975 *Simmon: A Private Landscape*; Light Gallery, New York; Spectrum Gallery, Barcelona
1977 *Gaudi*; Nikon Salon; Tokyo and Osaka
1979 *Eikoh Hosoe: Retrospective*; Photographers' Gallery; Melbourne*Eikoh Hosoe: Kamaitachi*; Silver Image Gallery; Ohio State University, Columbus; Studiengalerie des Salzburg College; Austria, Portfolio Gallery; Lausanne, Switzerland
1980 *Ordeal by Roses* and *Kamaitachi*; FNAC Forum; Paris, Paule Pia Gallery; Antwerp, Belgium, Nikon Gallery; Zurich, Photo Art; Basel, Switzerland
1982 *Eikoh Hosoe Retrospective 1960–1980*; Museum of Modern Art; Paris and Rochester Institute of Technology; New York
　　The Human Figure 1960–1980; at George Eastman House; Rochester, New York
1984 *The Cosmos of Gaudi*; Espace Printemps; Ginza, Tokyo (traveled Japan until 1989)
1985 *Color Works*; Gallery Shunju; Tokyo
　　Ordeal by Roses; Burden Gallery; New York
1986 *Homage to Gaudi*; Printemps Ginza; Tokyo
1988 *Photography: The World of Eikoh Hosoe*; Ikeda Museum of 20th Century Art; Ito, Niigata Municipal Art Museum
1990 *Photography: The World of Eikoh Hosoe*; Museum of Modern Art; Osaka, Tokyo Art Hall, Tokyo
　　Eikoh Hosoe: Meta; Houston Foto Fest, Texas; Center for Creative Photography, Tucson, University of Massachusetts, Amherst, Massachusetts
1991 *Eikoh Hosoe: Meta*; Midtown Gallery, International Center of Photography, New York. Continues to travel through 2001
1993 *Before Awakening: Toward the End of the Century*; ICAC Weston Gallery, Tokyo.
2000 *Eikoh Hosoe Photographs: Ordeal by Rose—the shadow of Yukio Mishima*; Eslite Gallery; Taipei
2000 *Eikoh Hosoe: Photographs 1950–2000*; Yamagata Museum, Yamagata Prefecture and traveling

Selected Group Exhibitions

1957 *The Eyes of Ten*; Konishiroku Gallery; Tokyo
1962 *NON*; Ginza Matsuya; Tokyo
1963 *Contemporary Japanese Photography, 1961–1962*; National Museum of Modern Art: Tokyo
1966 *Ten Photographers*; National Museum of Modern Art; Tokyo
1967 *Photography in the 20th Century*; National Gallery of Canada; Ottawa (toured Canada and U.S. 1967–1973)
1974 *New Japanese Photography*; Museum of Modern Art; New York
1975 *Contemporary Japanese Photography: from the end of the war to 1970*; Tokyo, Nagoya, Osaka

1977 *Neue Fotografie aus Japan*; Museum of Modern Art; Graz

Eyes of Japanese Photographers; Helsinki

1979 *Japanese Photography: Today and its Origin*; Galleria d'Arte Moderna; Bologna (traveled to Milan, Brussels, and London)

1981 *Astrazione e Realta*; Galleria Flaviana, Locarno, Italy

1984 *Die japanische Photographie*; Hamburg

1985 *Black Sun: The Eyes of Four*; Museum of Modern Art, Oxford (traveled to Philadelphia Museum of Art; Philadelphia)

2000 *World Without End: Photography and the twentieth century*; Art Gallery of New South Wales, Sydney

Selected Works

Poddie-Chan, Grant Heights, Tokyo, 1951
Otoko to onna (Man and Woman) #20, 1960
Otoko to onna (Man and Woman) #24, 1960
Barakei (Ordeal by roses) #5, 1962
Barakei (Ordeal by roses) #32, 1962
Kamaitachi #8 (The weasel's sickle), 1965
Kimono #4, 1963

Embrace #47, 1970
Simmon: A Private Landscape, 1971
The Cosmos of Gaudi, Sagarada Familia, Barcelona, Spain, 1977

Futher Reading

Holburn, Mark. *Eikoh Hosoe*. New York: Aperture Masters of Photography, Aperture Foundation, Inc., 1999.

Holburn, Mark. *Beyond Japan*. London: Barbican Art Gallery, 1991.

Holburn, Mark. *Black Sun: The eyes of four. Roots and innovation in Japanese photography*. Millerton, New York: Aperture, 1985.

Holburn, Mark. "Eikoh Hosoe and Yukio Mishima: The Shadow in the Time Machine." *Art Forum International* 21, no. 6 (1983).

Marable, Darwin. "Eikoh Hosoe." *History of Photography* 24, no. 1, (2000).

Szarkowski, John, and Shoji Yamagishi. *New Japanese Photography*. New York: Museum of Modern Art, 1974.

Thomas Ann, W. "Eikoh Hosoe: Killed by roses." *National Gallery of Canada Journal* no. 45, (January, 1984).

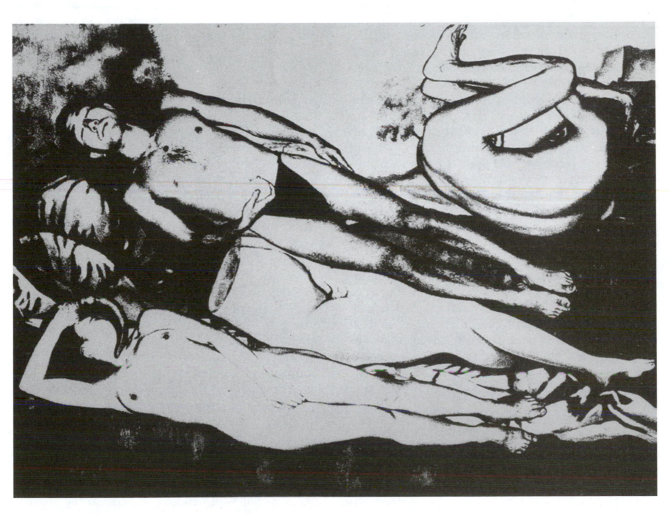

Eikoh Hosoe, Untitled, number 17 of the series "ba.ra.ke.i".
[© *Rights Reserved, CNAC/MNAM/Dist. Réunion des Musées Nationaux/Art Resource, New York*]

GEORGE HOYNINGEN-HUENE

American

A leading fashion photographer between the World Wars, George Hoyningen-Huene brought an austere elegance to haute couture with sharp, polished images often bearing strong classical overtones. His work appeared in the principal fashion magazines of the time and had a significant impact, not only on contemporaries like Horst P. Horst and Cecil Beaton, but also on later photographers, including Irving Penn, Richard Avedon, and Herb Ritts.

Hoyningen-Huene was born to nobility in Saint Petersburg, Russia in 1900, and refinement and luxury were the mainstays of his childhood. His father was a baron, in charge of the czar's equestrian activities, and his mother was an American socialite. His early years were divided between the imperial court, a country estate in Estonia, and family tours of Europe. His appreciation for Renaissance and Classical art developed out of his European travels and was reinforced by frequent visits to the Hermitage. Despite a passion for history and archaeology, he was a mediocre student, excelling only in his drawing lessons.

With World War I and the Russian revolution, his family went into exile, first in Britain, then on the French Riviera. In 1918, Hoyningen-Huene joined a British expeditionary force fighting in Russia, where he witnessed famine and death firsthand. Upon his discharge, he moved to Paris to work as a film extra and perfect his drawing skills under the tutelage of cubist artist André Lhote before starting as an illustrator in his sister's fashion design studio, Yteb. His easy manner, exacting eye, and social pedigree assured him access to the highest echelons of the fashion world, and by 1925 his drawings were appearing in *Harper's Bazaar*. He signed an exclusive contract with Condé Nast a year later and designed photo backdrops for French *Vogue* before finding the opportunity to work behind the lens.

Too restless behind the drafting table, Hoyningen-Huene took quickly to the collaborative spirit of the photography studio, contributing photographs to *Vogue* and *Vanity Fair*. Edward Steichen, *Vogue's* head of photography and a major force in fashion at the time, heavily influenced Hoyningen-Huene's early photographic style in stressing a modernist crispness with hard, modulated light that emphasized smooth lines, sculptural form, and fine detail. Hoyningen-Huene adeptly incorporated these traits into his work, as seen in *Lee Miller, Coiffure by Callon*, 1930, (Lee Miller was later to become a well-known photographer herself), where a plain backdrop and reflected light center attention on the nuances of the model's hairstyle and dress.

Despite his debt to Steichen, Hoyningen-Huene worked beyond these technical basics to develop his own style, adding a classical flavor derived from his extensive knowledge of art history. In costuming and form, the languid *Lisa Fonssagrives, Evening Dress by Vionnet*, 1938, pays homage to the neoclassicism paintings of Jacques Louis David, while the smooth male torso in *Beach Fashion*, c. 1930, suggests a fragment of Greek sculpture much like that found in Hoyningen-Huene's later *Fallen Statue, Isle of Delos*, c.1943.

An equally significant component of Hoyningen-Huene's Condé Nast work was his taste for gender indeterminacy, especially in his swimwear shoots, where he often depicted androgyny and role reversal. This aspect of his style derived in part from his close ties to the Surrealists—he was friends with Man Ray and Jean Cocteau, among others—but also likely drew on his own experiences as a homosexual in 1920s Paris. In *Bettina Jones, Beachwear by Schiaparelli*, 1928, a woman leans beside a seated man, coolly peering down at him over her cigarette smoke as though she has cornered her next conquest. Hoyningen-Huene's most famous image, *Swimwear by Izod* (also known as *Divers*), 1930, addresses sexual ambiguity through simplified formal composition. With remarkably similar bodies, hairstyles, and swimsuits, a man and woman turn their backs to the camera, and, as her legs perfectly overlap his, their symmetry suggests they are merely two sides of a single being.

In addition to his fashion layouts, Hoyningen-Huene gained a reputation as a celebrity portraitist, making images of people as diverse as the movies' Tarzan, Johnny Weissmuller, and fashion designer Coco Chanel. He had a special talent for movie

stars, however, as he was able to convey anything from charming affability—as in *Cary Grant*, 1934—to iconic inaccessibility, which he captured in his portrait of the expatriot American dancer and performer, *Josephine Baker*, 1929.

Hoyningen-Huene's personal life overlapped with his work in his relationship with Horst P. Horst, who was his apprentice, model (as in *Beach Fashion* and *Swimwear by Izod*), and lover. One of the most fruitful relationships in the history of fashion photography, the two men worked and traveled together in the early 1930s, even building a house together in Tunisia. Horst's own photography would be deeply marked by what he learned from Hoyningen-Huene—occasionally to the point of virtual indistinguishableness—and so it appeared only natural that, when Hoyningen-Huene left Paris in 1935 to join *Harper's Bazaar* in New York, it was Horst who succeeded him at French *Vogue.*

Working for *Harper's Bazaar* brought significant changes to Hoyningen-Huene's style as he strove to meet a different editorial style. Not only did he work in color more frequently, but he often left the studio to shoot outdoor assignments and even agreed to participate in advertising campaigns. While these changes demonstrated his considerable adaptability, they also revealed the fragility of his carefully controlled aesthetic. The photographs from this period sometimes seem cluttered and even tentative, losing the concise elegance of his Paris work as they deviate more toward the pretty than the powerful.

With growing discontent over the demands and limitations of magazine work, Hoyningen-Huene sought new subjects for his camera, taking extended trips to Africa in 1936 and Greece in 1937. Beginning with the book *African Mirage*, from 1938 to 1946 he published several works based on his travels, combining photography with literary texts and essays. Despite some stunning portraits, like the enshrouded young man in *Tunisia*, 1936, these projects evinced a preference for landscapes and architecture, and Hoyningen-Huene adjusted his methods accordingly. Seeking basic geometrical patterns and the play of planes, he produced monumental views with strong lines and cutting shadows, as in *Valley Temple of Khaf-Re, Egypt*, 1943.

Given these changing interests, at the end of World War II, Hoyningen-Huene decided to leave the fashion world entirely, moving to Hollywood in 1946. Always attracted to the cinema, he had produced and directed several short movies over the years, and with the encouragement of his friend and lover, film director George Cukor, he found work with the studios as a "color coordinator." The position was particularly nebulous in the still-nascent color motion picture industry, and it suited Hoyningen-Huene's appetite for new creative and collaborative challenges, allowing him to combine his interests as he worked in production design, costume design, and even cinematography to develop the overall aesthetic of productions like *A Star is Born* (1954), *Let's Make Love* (1960), and *A New Kind of Love* (1963). He supplemented this film work with occasional publicity portraits of Hollywood stars and taught photography at the Art Center School. Never returning to full-time photography, he died of a heart attack in Los Angeles in 1968.

STEPHEN MONTEIRO

See also: **Condé Nast; Fashion Photography; History of Photography: Interwar Years; Horst, Horst P.; Man Ray; Miller, Lee; Penn, Irving; Ritts, Herb; Steichen, Edward**

Biography

Born in Saint Petersburg, Russia, 4 September 1900. Studied at the Imperial Lyceum in Saint Petersburg; tutored in drawing by André Lhote, Paris. Chief photographer for French *Vogue*, Paris, 1926–1935; photographer for *Harper's Bazaar*, Paris and New York, 1935–1945; photography instructor at the Art Center School, Pasadena, California, 1947; production consultant on movie studio films, Hollywood, California, 1946–1963. Recipient of the Photokina photographic award, Cologne, Germany, 1963. Died in Los Angeles, California, 12 September 1968.

Individual Exhibitions

1970 *Huene and the Fashionable Image*; Los Angeles County Museum of Art; Los Angeles

1977 *Photography by Hoyningen-Huene*; Sonnabend Gallery; New York

1980 *Eye for Elegance: The Photography of George Hoyningen-Huene*; International Center of Photography; New York, and traveling

1984 *Hoyningen-Huene*; Staley-Wise Gallery; New York

1984 *Hoyningen-Huene*; The Chrysler Museum; Norfolk, Virginia

Group Exhibitions

1928 *Salon Indépendant de la Photographie*; Salon de l'Escalier; Paris

1929 *Film und Foto*; Stuttgart, Germany

1963 *Photokina*; Cologne, Germany

1965 *Glamour Portraits*; Museum of Modern Art; New York, and traveling

1974 *1930s Portraits and Fashion Photographs*; Sonnabend Gallery; New York

1975 *Fashion 1900–1939*; Victoria and Albert Museum; London

1977 *History of Fashion Photography*; International Museum of Photography; Rochester, New York

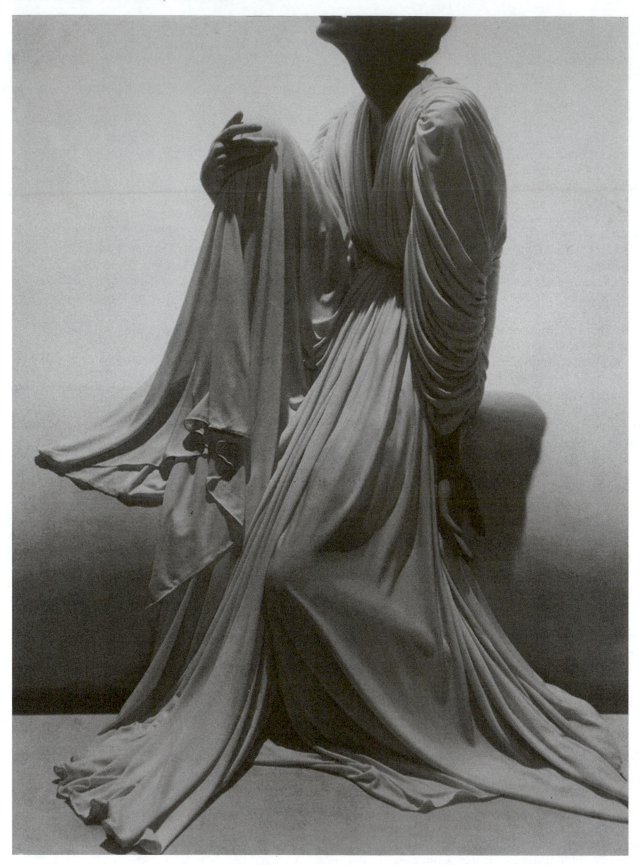

George Hoyningen-Huene, Robe de grès, 1936, Photo: Georges Meguerditchian.
[*CNAC/MNAM/Dist. Réunion des Musées Nationaux/Art Resource, New York*]

1980 *Fashion Photographers*, Hastings Gallery; New York
1980 *Masks, Mannequins and Dolls*, Prakapas Gallery; New York
2001 *The Look: Images of Glamour and Style*, Museum of Fine Arts; Boston, Massachusetts

Selected Works

Bettina Jones, Beachwear by Schiaparelli, 1928
Josephine Baker, 1929
Lee Miller, Coiffure by Callon, 1930
Swimwear by Izod, 1930
Beach Fashion, c. 1930
Agneta Fischer Modeling Evening Gloves, 1931
Toto Koopman, Evening Dress by Augustabernard, 1933
Cary Grant, 1934
Tunisia, 1936
Lisa Fonssagrives, Evening Dress by Vionnet, 1938
Valley Temple of Khaf-Re, Egypt, 1943
Fallen Statue, Isle of Delos, c.1943

Further Reading

Ewing, William A. *The Photographic Art of Hoyningen-Huene*. London: Thames and Hudson, and New York: Rizzoli, 1986.
Ewing, William A. *Eye for Elegance: George Hoyningen-Huene*. New York: Congreve, 1980.
Horst, Horst P. *Salute to the Thirties*. London: Bodley Head, and New York: Viking, 1971.
Hoyningen-Huene, George. *African Mirage: The Record of a Voyage*. London: Batsford, 1938.
Hoyningen-Huene, George. *Hellas: A Tribute to Classical Greece*. New York: J.J. Augustin, 1943.
Hoyningen-Huene, George, and Alfonso Reyes. *Mexican Heritage*. New York: J.J. Augustin, 1946.
Pucciani, Oreste, ed. *Hoyningen-Huene*. Los Angeles: Friends of the Libraries, University of Southern California, 1970.

GEORGE HURRELL

American

The name George Hurrell is synonymous with the exacting art of Hollywood glamour portrait photography. His technique involved precise lighting and careful retouching of his negatives to produce the flawless beauty, drama, and sensual allure characteristic of his highly influential style. It was Hurrell who was instrumental in creating "the look" of many legendary stars of Hollywood's Golden Age, often bolstering their careers and the success of their films with his sophisticated, mesmerizing photographs.

Raised in Cincinnati, Ohio, young George Hurrell had developed an interest in drawing and painting and later discovered photography as a way to reproduce his paintings. At the age of 16, he moved to Chicago to study painting, first at the Art Institute of Chicago and then at the Academy of Fine Arts, but he left the program in 1922. In the same year, he found a job hand coloring photographs for a commercial studio and moved from studio to studio until the portrait photographer Eugene Hutchinson hired him in 1924. While working for Hutchinson, Hurrell learned the techniques of lighting, negative retouching, airbrushing, and darkroom work.

Growing impatient with work at the Hutchinson studio and wanting to escape the cold Chicago winters, Hurrell drove west and settled in an artists' colony at Laguna Beach, California, in 1925. Although he still harbored a desire to paint, he found a lucrative business photographing artists, their paintings, and the circle of rich and famous who frequented the bohemian set in Laguna Beach. Establishing a reputation for fine portraiture among the crowd, he eventually moved to Los Angeles in 1927. There, he got his first opportunity to photograph an actor when the socialite and aviatrix Poncho Barnes recommended the young photographer to her friend, the actor Ramon Novarro.

Impressed with Hurrell's photographs of Barnes, Novarro commissioned a series of portraits. Thrilled with the results and unimpressed with lackluster studio photographers he had worked with in the past, Novarro showed his new stills to other actors at Metro-Goldwyn-Mayer (MGM) film studios. The photographs caught the eye of actress Norma Shearer. Shearer wanted the leading role in *The Divorcée* but was unable to convince her husband, MGM production chief Irving Thalberg, that she had enough sex appeal for the part. She hired Hurrell to create a new image for her. Hurrell trans-

formed the actress into a sultry siren and created the photographs that would land her the role. Thalberg and Shearer were so impressed with Hurrell's work that MGM studio's publicity department hired the photographer in 1930. For the next two years, Hurrell photographed every star at MGM, including Joan Crawford and Jean Harlow, his work setting a new standard for portraiture in Hollywood.

Hurrell's success was attributed to a photographic expertise that developed from the perfection of several techniques he had learned over the years. His formula for portrait lighting included attaching a spotlight to a boom arm, which could be carefully positioned to cast highlights on the subject's hair. He then added a softer key light placed slightly above and in front of the subject's face emulating natural light, and he illuminated the background with a floor lamp. Hurrell carefully adjusted the lighting to add dimension and drama to his photographs. In addition, he developed a retouching process, with the help of an assistant, that was so refined his subjects were asked not wear makeup during their sessions. Powdered graphite was applied to the negatives with a blending stump to accentuate the skin's highlights. This technique, in addition to the careful printing of his negatives, would yield a smooth, flawlessly luminous, yet lifelike quality to his subject's skin tone. Remarking about Hurrell's style, actress Loretta Young commented, "[your skin] looked like you could touch it."

From 1930 through the 1950s, Hurrell's career as a photographer flourished, but guided by a restless spirit; he worked at various studios as well as running an independent freelance business. By 1932, life at MGM for him was troublesome; after a disagreement with the head of publicity Howard Strickling, he left to set up his own studio on Sunset Boulevard. Hurrell's business prospered as stars flocked to his studio for portraits. After six years, the photographer moved to Warner Brothers, helping establish the careers of stars Bette Davis, Humphrey Bogart, Errol Flynn, and James Cagney. His talents for portraiture were needed during World War II, and Hurrell found service with the First Motion Picture Unit of the U.S. Army Air Force, where he shot training films and photographed generals at the Pentagon. He returned to Hollywood after the war, but soon found that the old style of glamour photography was out of fashion. Hurrell worked on the east and west coasts shooting advertising and fashion layouts through the 1950s, and he started a television production company with his wife, Phyllis, in 1952. He settled in Southern California permanently in 1956 returning to the film industry as a unit still man.

Recognition for his life's photographic work came in the 1960s and continues to the present day. Hurrell's first exhibition, *Glamour Poses*, opened at the Museum of Modern Art, New York, in 1965. Throughout the 1970s, he published numerous commemorative books and special-edition prints of his work. His reputation for creating glamour associated with the golden years of Hollywood was acknowledged by later generations of actors and actresses, and he continued to photograph stars including Liza Minelli, Paul Newman, and Robert Redford in his characteristic style. After his retirement in 1976, Hurrell continued to shoot portraits, adding to his portfolio the faces of Hollywood stars such as Sharon Stone, Brooke Shields, and John Travolta. Among his last assignments during the early 1990s were portraits of Warren Beatty and Annette Bening for the movie *Bugsy*, and singer Natalie Cole for the cover of the her album *Unforgettable*. In the last years of his life, Hurrell worked with producer J. Grier Clarke and producer-director Carl Colby on *Legends in Light*, the first television documentary of his life and work. George Hurrell died of cancer in 1992.

NANCY BARR

See also: **Fashion Photography; Lighting and Lighting Equipment; Museum of Modern Art; Portraiture**

Biography

Born Covington, Kentucky, 1 June 1904. Attended Art Institute of Chicago, 1920. Assisted portrait photographer Eugene Hutchinson, Chicago, 1924. Freelance photographer for Metro-Goldwyn-Mayer Film Studios 1930–1932. With 20th Century-Fox while running his own studio, 1932–1934. Worked for Warner Brothers, 1935–1938. Staff photographer at the Pentagon, 1942–1946. Employed by Walt Disney Studios, 1954–1956. Freelance production and publicity still photographer for movies and television, 1960–1975. Retired, 1976. Died Van Nuys, California, 17 May 1992.

Individual Exhibitions

1965 *Glamour Poses*; Museum of Modern Art; New York, New York
1977 Victoria and Albert Museum; London, England
1978 *The Hurrell Style*; Laguna Beach Museum; Laguna Beach, California
　　Dreams for Sale; Municipal Art Gallery; Los Angeles, California
1980 *The Hurrell Style*; Palm Springs Desert Museum; Palm Springs, California
1987 Cincinnati Museum of Art; Cincinnati, Ohio
1988 *Glamour and Allure: The Hollywood Photographs of George Hurrell*. Organized by the Smithsonian Institution Traveling Exhibitions (traveled nationally)

1990 New York Public Library; New York, New York

1991 *Imaging Myths: George Hurrell*; George Eastman House; International Museum of Photography Rochester, New York.

1998 *Unseen Hurrell: Classics and Rediscovered Photographs from the Collections of the Margaret Herrick Library at the Academy of Motion Pictures Arts and Sciences*; (traveled to Museum of Photographic Arts, San Diego (1998); Tacoma Art Museum, Tacoma Washington (2001))

 Grand Illusion: Celebrity Portraits by George Hurrell; Museum of Photographic Arts; San Diego, California

 George Hurrell: Hollywood and Beyond; Orange County Museum of Art; Newport Beach, California

2001 *George Hurrell: Portraits of Hollywood Stars*; Palm Springs Desert Museum; Palm Springs, California

 Seeing Stars; George Hurrell; Charles H. MacNider Art Museum; Mason City, Iowa

2002 *The Lost Photographs of George Hurrell*; Hollywood Entertainment Museum; Hollywood, California

Group Exhibitions

1980 *Southern California Photography 1900–1965: An Historical Survey*; Los Angeles County Museum of Art; Los Angeles, California

 The Great Hollywood Portrait Photographers; Museum of Modern Art; New York, New York

1983 *Hollywood Portrait Photographers, 1921–1994*; National Portrait Gallery; Washington, D.C.

1987 *Intimate Encounters: Photographic Portraits from the Collection*; California Museum of Photography; Riverside, California

1988 *Masters of Starlight: Photographers of Hollywood*; Los Angeles County Museum; Los Angeles, California

1989 *Candid and Studied: The Mexican Photographs of George Hurrell and Macduff Everton*; Carnegie Art Museum; Oxnard, California

1996 *Portraits: An Examination of Identity*; Museum of Contemporary Photography, Chicago, Illinois.

1999 *Beauty or Truth: Hollywood Photography by Clarence Sinclair Bull, George Hurrell, and Weegee*; Bayly Art Museum, University of Virginia; Charlottesville, Virginia

2000 *Shooting Legends: Hollywood by Halsman and Hurrell*; Norton Museum of Art; West Palm Beach, Florida

 Marlene Dietrich: A Legend in Photographs; Organized by the Goethe-Institut (traveling worldwide)

2001 *Made in California: Art, Image, and Identity, 1900–2000;* Los Angeles County Museum of Art; Los Angeles, California

Selected Works

Ramon Novarro, 1929
Norma Shearer, 1929

Joan Crawford, 1932
Jean Harlow, 1932
Bette Davis, 1938
Jane Russell, 1946
Natalie Cole, ca. 1991
Sharon Stone, ca. 1993

Futher Reading

Christy, George and Gene Thornton. *The Portfolios of George Hurrell*. Santa Monica, Graystone Books, 1991.

Stine, Whitney. *50 Years of Photographing Hollywood: The Hurrell Style*. New York: Greenwich House, 1976.

Vieira, Mark A. *Hurrell's Hollywood Portraits: The Chapman Collection*. New York: Harry N. Abrams, Inc., Publishers, 1997.

George Hurrell, Portrait of Shirley Temple.
[© *Bettmann/CORBIS*]

AXEL HÜTTE

German

Axel Hütte, with Thomas Struth, Andreas Gursky, Thomas Ruff, and Candida Höfer, is a prominent representative of the so-called "New German Photography," the "Düsseldorf School," or the "Becherschüler"—labels that refer to a group of German photographers who came into prominence during the 1980s and who all studied with Bernd Becher at the Düsseldorf Academy of Art. Influenced by both the detached documentary style of German prewar *Neue Sachlichkeit* or New Objectivity and the self-reflexive attitude of conceptual art, these photographers depict the late twentieth century environment by means of prints—often large—that are characterized by compositional simplicity and the clarity and sharp details typical of the large-view camera.

Apart from an impressive series of black-and-white portraits in the late 1980s and early 1990s, Hütte aimed his camera chiefly at architecture, cities, and landscapes. His early 1980s black-and-white series of inner courtyards, entrance halls, and stairwells of London public housing projects of the early and mid-twentieth century testifies to this. Hütte presents these spaces as anonymous and deserted monofunctional zones, revealing both the weaknesses of the urban social reform programs that created them and the ruthless spatial politics of the Thatcher-era that neglected them. These photographs of worn-out architecture contribute to an artistic tradition that reaches back to nineteenth-century realism, which featured wastelands, back streets, and backyards prominently. At the same time, however, Hütte combines this unspectacular, everyday generic architecture with unmistakably classical overtones by referring both to the renaissance image of the *città ideale* and nineteenth-century topographical or architectural photography. This effect is achieved by milky white skies, a geometrical clarity, and an emphasis on the perspectival recession of the architectural space, which shows some similarities with Strüth's street series. Yet Hütte makes the viewer more aware of the picture frame. The photographical perspective consciously takes up a position *vis-à-vis* the urban scenography.

This sophisticated framing and fragmentation of (urban) space is equally prominent in his 1990s color photographs of bridges and subway exits.

In his pictures of steel bridges, the grid of cross-beams and girders demarcates and traverses the image. As a result, the surrounding landscape becomes a two-dimensional icon and is translated into a collage-like abstract image. In the photos of Berlin subway stations, this interest in industrial architecture is combined with a fascination for the rhythmical play of glass surfaces and their varying degrees of transparency.

Hütte, however, is mostly known for his landscapes. One of the highlights of his career to date is his series of pictures of the Italian countryside made in the early 1990s. Hütte shows that the Italian landscape is a long-standing cultural construction that developed in relation to an age-old imagery of *vedute* and *capricci* of scenery with architectural fragments and ruins. Although unmistakably depicting a contemporary landscape by means of a modern medium, he refers to this wealthy tradition. His landscape perception is colored by stereotypes and pictorial conventions such as the division of the picture into fields of color and the use of *repoussoir* elements, stressing the spatial tension between foreground and background. This is achieved by partially blocking the view with an architectural construction, which can be ancient crumbling walls as well as recently built suburban areas. In other cases, Hütte uses the familiar frame motif in order to contain the landscape within the structure of a classical loggia or a simple, utilitarian concrete or steel shelter.

The low horizons, the subtle hues, and the attention to the fragility of the structural elements of the landscape also turn up in his late 1990s impressive natural landscapes photographed on diverse continents. In contrast with his Italian series or other Mediterranean views, in his later work Hütte depicts spectacular mountain tops, glaciers, deserts or dense jungles. With these images of the virgin nature of extreme landscapes, Hütte, unmistakably, refers to the romantic notion of the sublime. Nevertheless, he does not create nostalgic images of a natural world, which, in contemporary society, is first and foremost an exotic product of tourism—a phenomenon that always has been closely connected with (photographical) image production. Hütte knows that the viewer is aware that his images are artificial con-

Axel Hütte, Furka, Suisse, 1995, Photo: Jean-Claude Planchet.
[*CNAC/MNAM/Dist. Réunion des Musées Nationaux/Art Resource, New York*]

structions made by means of a technical apparatus and the endless patience of the artist. Sometimes, he reminds us of that fact by stressing the act of framing—especially in his diptychs, in which the same landscape is framed differently. Hütte succeeds in lending a certain modern quality to these seemingly innocent images by focussing on the vulnerability of the landscape. Atmospheric conditions are stressed. Often, the landscape is presented as an almost imperceptible realm. The view in his Italian *vedute* is blocked by an architectural structure; his mountain tops are equally obfuscated in fog, and his jungles are completely grown thick. With their almost monochrome surfaces, geometrical simplicity, and their suggestion of boundless extensions, these landscapes answer to the modernist space of abstract art and modern architecture favouring infinity, transparency, and dematerialization—qualities evoked in the deep blue monochromes of Hütte's recent nocturnal cityscapes as well.

STEVEN JACOBS

See also: **Architectural Photography; Gursky, Andreas; Photography in Germany and Austria; Ruff, Thomas; Struth, Thomas**

Biography

Born in Essen in 1951. Studied sociology at the University of Cologne (1973–1975) and photography with Bernd Becher at the Academy of Art in Düsseldorf (1973–1981). DAAD scholarship for London, 1982; scholarship for the German Study Centre in Venice, 1985; Karl-Scmidt-Rotluff Scholarship, 1968–1988. Herman Claasen Prize 1993. Lives and works in Düsseldorf.

Selected Individual Exhibitions

1984 Galerie Konrad Fischer; Düsseldorf, Germany
1988 Regionalmuseum; Xanten, Germany
1992 Museum Künstlerkolonie; Darmstadt, Germany
1993 Harmburger Kunsthalle; Hamburg, Germany
1993 Kunstraum; München, Germany
1995 Rheinisches Landesmuseum; Bonn, Germany
1997 Fotomuseum; Winterthur, Switzerland
1997 Musei Civici Rubiera; Reggio Emilia, Italy
2000 *Fecit*; Museum Kurhaus Kleve; Kleve, Germany
2001 *As Dark as Light*; Huis Marseille; Amsterdam, Holland
2004 *Terra Incognita*; Palacio de Velàzquez; Madrid, Spain

Selected Group Exhibitions

1979 *In Deutschland*; Rheinisches Landesmuseum; Bonn, Germany
1988 *German Art of the Late 80s*; The Institute of Contemporary Art; Boston
1990 *Der klare Blick*; Kunstverein; Munich, Germany
1991 Museum of Contemporary Photography; New York
1992 *Distanz und Nähe*; Neue Nationalgalerie; Berlin, Germany
1993 *Industriefotografie Heute*; Sprengel Museum; Hannover, Germany
1994 *La Ville*; Centre Georges Pompidou; Paris, France
1997 *Alpenblick: Die zeitgenössische Kunst und das Alpine*; Kunsthalle; Vienna, Austria
1998 *At the End of the Century: 100 Years of Architecture*; Solomon R. Guggenheim Museum; New York
1998 *Landschaft: Die Spur des Sublimen*; Kunsthalle; Kiel, Germany
1999 *Reconstructing Space: Architecture in Recent German Photography*; Architectural Association; London
2000 *Ansicht, Aussicht, Einsicht: Architecturphotographie*; Museum Bochum; Germany
2001 *In Szene gesetzt*; ZKM; Karlsruhe, Germany
2002 *Heute bis Jetzt*; Museum Kunst Palast; Düsseldorf, Germany

Selected Works

London Series, 1982–1984
Portraits, 1985–1995
Bridges, 1990s
Berlin Subway Exits, 1990s
Italian Landscapes, 1989–1996
Landscapes and Fog, 1994–2003
Nocturnal Cities, 1998–2003

Further Reading

Breuer, Gerda. *Axel Hütte: London. Photographien 1982–1984*. Munich: Schirmer/Mosel, 1992.

Covallo, Elvira, ed. *Axel Hütte: Theorea*. Munich: Schirmer/Mosel, 1996.

Gerhold, Roman Ronald. "Axel Hüttes Architekturphotographie oder Architektur der Photographie." In *Ansicht, Aussicht, Einsicht: Architecturphotographie*, edited by Monika Steinhauser and Luger Derenthal. New York: Richter Verlag, 2000.

Hofmann, Barbara. "Axel Hütte." In *Heute bis Jetzt: Zeitgenössische Fotografie aus Düsseldorf (I)*, edited by Rupert Pfab. Munich: Schirmer/Mosel, 2002.

Honnef, Klaus, ed. *Axel Hütte: Landschaft*. Munich: Schirmer/Mosel, 1995.

Olivares, Rosa. "Terra Incognita." In *Terra Incognita*. Munich: Schirmer/Mosel, 2004.

Schneede, Uwe M. *Axel Hütte: Italien*. Munich: Schirmer/Mosel, 2004.

IMAGE CONSTRUCTION: PERSPECTIVE

Strictly speaking, perspective refers to the illusion of three dimensional space created in a two dimensional image by lines converging toward a single point, and the apparent decrease in the size of objects that occupy space further from the camera. In classical perspective, the size of an object is in a more or less standard hierarchy of depiction, from those in the foreground to those meant to be in the midground and background of a painting; in other words, in a traditional painted or drawn scene the viewer can perceive those things that are "closer" by the size relationships presented among all objects in a scene. In a photograph, however, the size of objects in the foreground and background of a photograph can change greatly with variances in distance between camera and subject. As the camera moves in close, the subject appears larger in the image while the objects in the background remain about the same size. As the camera is drawn away, the subject appears smaller or the same size as the objects in the background.

In photographs, there is not only the illusion of depth, but there are also different kinds of depth established by the type of lens on the camera and the distortions created by the lens and camera angle. Changing a lens without changing the camera-to-subject distance will not affect single point perspective, because the sizes of all objects in the image will change by the same amount. But the lens will change the perspective on how much space there seems to be between the objects from foreground to background. A long focal length or telephoto lens compresses the space in perspective and makes objects in front of, or behind each other, seem closer together. A classic example is when shot from behind through a telephoto lens, the pitcher in a baseball game appears reduced in size relative to the distance the viewer "knows" separates him from the batter and catcher and which normally would cause the pitcher to loom larger than those at home plate, even as the distance between the pitcher and home plate appears greatly truncated.

A wide-angle lens has the opposite effect of making objects seem farther apart than they really are. This effect should be familiar by the warning placed on the slightly convex mirrors used as rear-view mirrors in automobiles: "Caution: objects are closer than they appear." A wide-angle lens will also distort the shape of objects by making them seem to stretch out away from the center of the image. Vertical elements may lean to the side, or spherical shapes may appear to be elliptical, especially near the corners of the frame. This dis-

tortion is increased if the camera is aimed down or away from the center of the image. It is also increased as the camera moves closer to the subject, and decreased as the camera moves back from its subject to a greater distance. The human form, especially the face, becomes especially distorted by this effect in wide-angle lenses, particularly when the camera is close to its subject. For this reason, photographers often choose a longer focal length lens for portraiture, figure studies, and fashion photography, unless this distortion is part of the photographer's intent. The portraits and nudes of British photographer Bill Brandt during the 1950s created groundbreaking images of the human figure using the distortion of wide-angle lenses to make his subjects appear emotionally intense, mannered, and painterly.

Perspective, as it applies to the way horizontal lines in an image recede and move closer together as they move into the background, will be exaggerated with a wide angle lens, and increased as the camera moves in closer. This same effect that occurs with vertical lines of building is often seen as undesirable, because it is a frequent problem in the photography of architecture, where good perspective is important. Swings and tilts of a large format view camera back and lens are frequently used to correct this kind of perspective distortion. Digital tools may also be used to make corrections, but will change the shape of the rectangular image and require cropping the image to a smaller size.

The width and breadth of the space in a photograph may be extended with a panorama perspective to include more space, from left to right, than is actually possible in a single photograph. In extremely wide panoramas, there may even be more than one set of converging lines, creating multiple perspectives in a single image. This can be achieved with a special panorama camera designed for this purpose. Panorama images can also be made with digital image stitching tools in leading photographic software packages.

When the camera is located beyond the common positions of the human body, oblique, radical perspectives are possible. The "bird's eye view" may be accomplished from a high vantage point looking down. This perspective may sweep out high across a landscape with a smooth, gradual transition between foreground, middle ground, and background; or, it may be more extreme, with the camera pointed directly down on its subject in a smaller space.

The "worm's eye view" occurs when the camera is located near the ground and pointed upward at an extreme angle. Widely attributed to Russian Constructivist Alexander Rodchenko, this perspective was inspired by the Russian Revolution to invent new ways of looking at the world. Rodchenko felt this new change in political and social conscience deserved equally new visual perspectives to alter the viewer's perception of what is possible, visually and conceptually, in an image. Designers experimenting with cameras at the Bauhaus, such as the Hungarian architect László Moholy-Nagy, also worked with new forms of perspective, inventing camera angles and framing strategies that varied from conventional expectations of what a photograph could be.

This experimental spirit in perspective came early in the twentieth century with the exciting new cultural changes brought about by early twentieth century modernism, but it was also a response to the freedom offered by newly designed hand cameras. Until 1888, all photographs were made from extremely large glass plate cameras limited to the perspectives offered from the static location of a tripod, and limited in use to the expertise of skilled photographers. The hand camera made it possible for laymen and practitioners of other disciplines to experiment with photographic perspective as a means of exploring ideas of their own, and it freed them from the physical limitations of large view cameras. The results of these early experiments in perspective are now integrated into both commercial and artistic photographic practice.

Contemporary photographers continue to experiment with perspective. Photographer John Pfahl has done an extensive series of "altered landscapes" in which he has used string and other strips of material in the photograph to "draw" in the photograph. In the final print these interventions in the landscape appear both as three-dimensional and two-dimensional figures, because they play on the illusions offered by tricks of scale and dimension in a three dimensional space compressed into a two dimensional medium.

While the photograph is a medium that has always been known for its accuracy in representing reality, the relationships of objects or forms in a photograph from a given point of view, or a given lens, can vary within a very broad range of possibilities. The singular point of view, however, remains constant. Today, some theorists would argue that this central, singular viewpoint suggests the individualism of entrepreneurial capitalism, and thus constitutes a set of pictorial conventions that affirm a political ideology. Some artists might argue to the contrary, that this condition is what makes photography capable of expressing a succinct humanitarian and emotional point of view.

Either way, perspective is important to how the camera makes "reality" an interpretive process.

Perspective can alter the perception and the viewers' experience of what is possible within the terms of photographic space and vision. In response to social, cultural, and political points of view, it can alter the intellectual interpretation of the image. Understanding perspective is critical to understanding how to master the expressive control of photographic technique and the communication of ideas through photography.

LANE BARDEN

See Also: **Bauhaus; Camera: An Overview; Lens; Modernism; Moholy-Nagy, László; Perspective; Pfahl, John**

Further Reading

Adams, Ansel. *The Camera.* Boston: New York Graphics Society, 1991.

London, Barbara and John Upton. *Photography.* 6th ed. Reading, MA: Addison-Wesley Educational Publisher, 1998.

London, Barbara and Jim Stone. *A Short Course in Photography: An Introduction to Black-And-White Photographic Technique.* 4th ed. New Jersey: Prentice Hall, 2001.

Stroebel, Leslie. *View Camera Technique.* Boston: Focal Press, 1993.

IMAGE THEORY: IDEOLOGY

Since its establishment as both a practical and fine-arts application, an ideology about photography's nature has been developed that contains varying sets of dictums describing what should be considered legitimate or even ideal in photography, as an art and as a craft. This set of assumptions has alternately bound and freed photographers to create images for societal consumption. The consumption of the images is itself within another set of assumptions, with political considerations looming large, as a medium so widespread and having such a clear impact on society cannot fail to have deep political implications.

The phrase that served as the title of William Henry Fox Talbot's pioneering 1844 book *The Pencil of Nature* remains at the center of all ideological discussions about photography. From the idea of photography being a means by which the existing world is faithfully depicted two main questions arise. The first question asks if photography is an objective medium; the second question deals with photography's status as a means of artistic expression. These questions both arise, however, from the chemical, optical, mechanical nature of photography which seems, in a commonsense view of things, to endow the medium with a "natural" or "automatic" (objective) manner of reproduction.

Photography's early success owes much to the needs of nineteenth century society of such a process. Even if the "natural" and "automatic" part of photography worked against its successful recognition as an art form, photography was able to produce the kind of images western artists, using devices such as the camera obscura, had been searching for since the fourteenth century. The scientific or natural part of the photographic process was seen as a way to escape human subjectivity, a very desirable idea in the nineteenth century as astonishing strides in the sciences were made.

As the camera was developed and refined in the late nineteenth century, especially with lenses modeled on the human eye, the camera and the eye were seen as functioning very much in the same way. The resulting ideology was that photography was perceived as tantamount to human vision, that is, human vision "frozen" in time and neutral in its capturing of the image. In this sense photography could be considered a universal language, an idea that can be found in many nineteenth and early twentieth century texts on the subject.

Yet defining photography as at base neutral and "scientific" did not resolve whether or not it could be considered art; in fact, paradoxically, its very "objective" nature allowed some artists to theorize that by hand-manipulating these optical, chemical, mechanical processes, true artistry could arise, a viewpoint at the base of the Pictorialist movement of the late nineteenth and early twentieth centuries.

Anyone could capture an image; few could successfully manipulate that captured image to be on a par with painting or printmaking as a unique, soulful expression of a creative individual.

Yet as early as the 1920s, many artists and theorists began to question this ideology, especially in light of the revolutionary political events of the day, including World War I and the communist revolutions. In the great disruptions of society in Europe and elsewhere, it quickly became apparent that photographs were malleable. The context in which the image was seen was recognized to be how the photograph's meaning was determined The rise of the illustrated press in Germany and later America, the use of photographs in advertising, and the burgeoning of the cinema, universally described as but an illusion of light, quickly spread the idea of photography as a subjective medium that showed no more "truth" than any other. In fact, its ability to mimic what seemed to be the "real world" yet be unreliable as fact gave rise to an entire new image theory: that of photographic images as paradoxical. Many were content to let photography do what it did well—more or less effortlessly capture images from the everyday world (as evidenced by the huge commercial success of products for the amateur market)—and give photography its due as a supporting player in the drama of fine arts production.

"Photographic vision," the notion that the human "eye" was now being influenced by that of the camera lense was first expressed with the rise of Modernism and the *Neue Sehen* (New Vision) movement in the 1920s. This notion arose out of the interplay between the practical applications of photography and the aspirations of some of its practitioners that it be recognized as an art medium equal to all others, but on its own terms. What photography was able to depict that the human eye could not capture undeniably influenced various modern art movements, from Impressionism to Cubism. Yet photography's expressive qualities remained in doubt even as its subjectivity became increasingly apparent, especially to its practitioners and theorists.

As a major component of advertising and propaganda, photography's subjectivity became harder and harder to deny, yet popular audiences for the medium remained vulnerable to photography's claim to objectivity. Its optical–mechanical qualities were still recognized as scientific; what changed was a recognition that all human activity was inescapably subject to human manipulation and interpretation, a legacy of such post-World War II philosophies as Structuralism and Deconstruction. Considering each photograph as a cultural artifact, that is, a product of a particular society and culture with its own particular set of codes, directly opposed the earlier notion of photography as a universal language. This a more politically driven critique than it might seem; as with photography their target is, from a Marxist point of view, what could be called the ideological superstructure of society.

The question of photography's objectivity did not arise once and then become settled. The issue has been rethought and revisited in various ways during various eras. The shift from artisan activities to the commercial press in early twentieth century paralleled but did not define the reaction against Pictorialism that unfolded in the fine-arts photography realm as early as the first decades of the century. The "objectivity," which would become the distinctive mark of mid-twentieth century photography, had its roots in the *Neue Sachlichkeit* (New Objectivity) movement of the 1930s, a product of post-World War I society. The images that resulted from the ideology of this movement were paradoxical; many were so experimental or abstract that the average viewer may not see them as objective in any sense. Yet the philosophy held that in producing images that could be made only via photographic means (whether with a camera or through non-camera means such as photograms), true objectivity could be achieved, as the process was freed from the subjectivity of the human eye and experience.

The quest for objectivity took a much different path among American art photographers of the 1930s, exemplified by Ansel Adams and Edward Weston. These photographers believed that through the use of view cameras, small apertures and the care in exposing, developing, and printing that led to the zone system, objectivity was achieved through sheer technical skill. These decisions, which produced photographs that were considered at the same time objective and beautiful, in fact restricted photographic practice to a small part of what photography was capable of achieving. The belief that crystal sharp, black-and-white images that displayed the full range of tones from black to white were in fact the best, most factual representations of the real world showed the power of ideology. These images in many ways could not be further from "real," as they deleted color, assumed that human vision is clear, sharp, and able to focus simultaneously on foregrounds and backgrounds, and presented images with degrees of perspective often beyond human vision. Yet Weston's and Adams's ideology shaped the perception of what is an objective image in virtually all types

of photography, especially architectural, advertising, and industrial photography, and set the standard for what was acceptable as a fine-arts photograph for decades.

The tension between the subjective nature of photography and those who believed the medium had authentic applications toward objectivity reemerged in Europe around World War II with photographers like those who would found Magnum Photos (including Henri Cartier-Bresson and Robert Capa) or *Life* magazine photographer W. Eugene Smith. These photographers, enamored of the possibilities of small format cameras, which could use available light and come close to the subject without the subject's being aware of the photographer, dictated an entire school of photographic endeavor. This movement had many rules that claimed to be signals of whether a photograph could be "trusted" as straightforward, unmanipulated, and solely reliant on a combination of the medium's optical-mechanical characteristics, shaped only by an alert guide. These rules included that the image should not be cropped, leading to the famous black border Cartier-Bresson included in his photographs to prevent publishers from cropping them, as these photographers had great conflicts with publishers arising from the way photographs would appear in the printed page. Yet this idealism had its practical limitations: W. Eugene Smith worked extensively on his prints, bleaching, dodging, and burning until he got the desired effect. The ability of the photographic negative to be manipulated to compensate for less-than-ideal conditions at the point of its exposure by no means is antithetical to the idea that photographs are objective. Yet as these very techniques are most often employed to smooth over the differences between the way photography can capture images and the way the human eye and brain process visual information, would indicate that photographs in fact are not, and perhaps cannot be, objective. A further confusion about authenticity and objectivity happens with montage, which presents disparate images as one. Now easy to achieve with digital techniques, this technological advance will create new ethical problems for photographers.

In the late twentieth century, ideological concerns about the photograph as an objective record resided mostly in the area of photojournalism, as postmodernism codified the position that all images are subjective given that they are human creations consumed in various cultural contexts. An example is that in the late 1990s the considerable success of Brazilian photographer Sebastião Salgado, also a Magnum photographer, led some to criticize him for posing or otherwise interacting with his subjects against the traditions of photojournalism in which the photographer should be an observer, not a participant. Yet Salgado also follows the ideology of the social documentarians of the early twentieth century, such as Jacob Riis or Lewis Hine, whose social and political agendas superceded the ideologies of fine-arts image making. Yet the debate that Salgado engendered demonstrates the continuing synergy between these two areas—the developing and perpetuating of image ideologies useful to photographer-artists interested in aesthetic expression and those useful to larger societal goals.

Today's photography is a very broad field with applications in almost every aspect of modern life whether using chemical or digital means. The often subtle or even arcane arguments within photography as a fine-art activity continue to have an impact on its larger practice. And the practice of photography in other realms continues to inform the fine-arts ideologies. The development in the last decades of the twentieth century of a fine-arts aesthetic based on vernacular forms such as the snapshot or the photo album shows these ideologies continued to be defined by those that arose at photography's inception.

NUNO PINHEIRO

See also: **Barthes, Roland; Camera Obscura; Deconstruction; Ethics and Photography; Group f/64; Image Construction; Krauss, Rosalind; Lens; Modernism; Photographic Theory; Photographic "Truth"; Pictorialism; Propaganda; Representation; Semiotics; "The Decisive Moment"; Visual Anthropology**

Further Reading

Allard, Sir Alexander. *Jacob A. Riis, Photographer and Citizen.* New York: Aperture, 1993.

Barthes, Roland. *Camera Lucida, Reflections on Photography.* New York: Hill & Wang, 1981, and London: Jonathan Cape, 1982.

Bolton, Richard, et al. *The Contest of Meaning.* Boston: MIT Press, 1989.

Bourdieu, Pierre. *Un Art Moyen.* Paris: Minuit, 1965.

Debray, Régis. *Vie et Mort de L'Image.* Paris: Gallimard, 1992.

Freund, Gisèle. *Photographie et Société.* Paris: Seuil, 1974.

Pinheiro, Nuno. "Fotografar a Outra Metade, Estética e Política." In Vaz, Maria João, Eunice Relvas, and Nuno Pinheiro, eds. *Exclusão na História*, Oeiras: Celta, 2000.

Sontag, Susan. *On Photography.* New York: Farrar, Straus & Giroux, 1973, and London: Allen Lane, 1978.

IMPRESSIONISM

Impressionism in photography is inextricably intertwined with naturalistic photography and Pictorialism, or art photography. In 1889, Dr. Peter Henry Emerson published a book entitled *Naturalistic Photography for Students of Art* in which he argued for the establishment of photography as a legitimate art reliant on the specific techniques of the discipline. In part, Emerson's text was a reaction to Henry Peach Robinson's *Pictorial Effect in Photography* (1869), a highly influential publication that advocated a beautiful, artistic photography based on the emulation of painting. Such pictorial effects were often achieved through the careful staging of subject matter and unrestrained manipulation of the photograph itself. Emerson vigorously objected to such contrived photography and its overt concern with the aesthetic of the finished product. Rather, Emerson argued for naturalism, which he defined as "the true and natural expression of the impression of nature by an art." Emerson reasoned that beauty already exists in nature; thus, "all suggestions for the work [must be] taken from and studied from nature" (Emerson 1889, 23).

In addition to opposing the aesthetic aims of Pictorialism as practiced by Robinson, Emerson objected to the seemingly opposite scientific mentality that sought to render all aspects of the photographic subject in focus. For Emerson, the goal of naturalist photography had nothing to do with the exact recording of nature. Rather, Emerson argued, the photographer should use the camera to convey the image perceived by the human eye. Relying on physiological studies of the human eye and scientific explanations of human sight, Emerson claimed that the eye does not perceive the entire field of vision with perfect clarity; only the central object appears sharp and in focus, while the foreground and background of the image appear slightly blurred. Thus, the goal of the naturalist was to remain true to human perception, to capture the essence of the scene as viewed by the human eye. To achieve this end, Emerson suggested that the photographer shoot only naturally occurring (not manufactured) scenes and make all but the central object of the photograph slightly out of focus.

Emerson's call for pure, naturalistic photography—an honest photography using simple equipment and non-staged compositions to imitate human perception—proved quite influential, providing a middle-ground between the aesthetic sentimentality of Robinson's Pictorialism and the supposed objectivity of scientific photography. Yet, Emerson's proposal of intentional blurring in the photograph opened the way for a less precise type of photography that, ironically, and to Emerson's dismay, fostered another form of photographic Pictorialism—impressionism.

With respect to painting, the term "impressionism" derived from a Claude Monet painting entitled, *Impression: Sunrise*, of 1872. Monet's hazy image of the port of Le Havre offered a representation of the momentary experience arising from a transient impression rather than the precise detail of the scene. From then on, the word impressionism has been used to describe this artistic movement, understood as both an extension of and a departure from preceding realist painting. Thus, an understanding of impressionism requires an awareness of the inherent qualities of realism.

The development of realism is most often traced to the art and literature of nineteenth century France. The hallmarks of realism commonly included a broadened notion of history, an expanded range of experience, and a concentrated field of vision in temporal and emotional terms. For realist artists, historical, royal, and/or religious subjects were replaced by common and contemporary subjects available for immediate observation. The acceptability of this new subject matter corresponded to more general trends involving the post-enlightenment rise of scientific activity and the preceding romantic era. The aim of realism was to give truthful, objective, impartial representations of the real world, based on the rigorous contemplation of contemporary life. This ambition stemmed from the desire of artists in the late eighteenth and early nineteenth century to rid themselves of emotional subjectivity arising from preconceived and formulaic methods of artistic production. The realists' chosen tool was that of the developing basis of science and empirical research: "objective" study and observation. Realists, such as the painter Gustav Courbet or the positivist Auguste Comte, intended to present objects and events without prejudice, not in accordance with subjective or insti-

tutional notions. The French author Hippolyte Taine challenged people to look—really *look*—at their surroundings:

> Give up the theory of constitutions and their mechanism, of religions and their system, and try to see men in their workshops, in their offices, in their fields, with their sky, their earth, their houses, their dress, tillage, meals, as you do when landing in England or Italy, you remark faces and gestures, roads and inns, a citizen taking his walk, a workman drinking

(Linda Nochlin, *Realism: Style and Civilization* 1971, 23)

Thus, fidelity to reality, despite the problematic nature of what exactly constitutes a truthful perception of reality, became a primary aspect of the realist endeavor.

Similar to realist painters, impressionist artists were also guided by the notion of fidelity to reality. As did their predecessors, impressionists dedicated themselves to the representation of scenes as immediately perceived. This insistence on contemporary subject matter observed first hand functioned for both realist and impressionist artists as an objection to established and institutional artistic conventions. Yet, the impressionists significantly differed from the realists in their understanding of fidelity to reality and the artistic techniques employed to render that reality. Rather than abide by the realist tendency to create seemingly objective and detailed reproductions of a scene, impressionists focused on representing an actual experience derived from the fleeting moment of observation. Furthermore, as was Emerson a few years later, impressionists were likewise influenced by scientific discussions of human vision and perception. They too recognized that the human eye does not see colors and objects as distinct entities, but rather perceives them with respect to the colors and objects with which they are juxtaposed. In addition, ever-changing atmospheric qualities of light and air, not to mention the motion of the subject, affect the overall image of any given scene. With these issues in mind, impressionists focused on capturing the play of light and color that activated an image, not reproducing an exact likeness of the objects in that image. The resulting aesthetic involved the hazy and somewhat imprecise representation of the scene as the painter had experienced it during his act of creation. Thus, more so than crisp delineation of detail, impressionist painters attempted to accurately convey the subjectively perceived essence of a precise moment.

The impressionists' emphasis on the perceived essence of a scene was somewhat similar to Emerson's prescriptions for naturalist photography. It is not surprising, then, that impressionism also had its

photographic adherents. George Davison (1854–1930), a young devotee of the concepts of naturalism, took Emerson's suggestions for "differential focusing" to another level. Emerson never intended for a photograph to be completely out of focus; yet, Davison recognized the aesthetic potential inherent in the unfocused image. In 1890, Davison delivered a lecture entitled "*Impressionism in Photography*" in which he argued that the degree of focus of a photograph should be determined by the photographer's intent. If the goal of the photographer was to objectively record his subject, then clarity of detail necessitated total focus. If the photographer had more artistic intentions, he was then free to render his subject at will in order to achieve an aesthetically pleasing outcome. As an example of an artistic image, Davison offered his own award-winning photograph, *The Onion Field* (1890), a blurred and imprecise representation of an old farmstead captured with pinhole photography.

Such out-of-focus photography, often in replication of impressionist painting, quickly became popular, due in part to its ability to convey a romantic and ephemeral atmosphere. To achieve impressionistic representations of their subjects, generally natural landscapes, ambitious photographers adopted a variety of techniques. In pinhole (essentially lense-less) photography, the camera lens was replaced by a small hole through which light could shine on light-sensitive material, resulting in a more diffused and less precise image. Another technique involved the use of a soft-focus lens; blurring resulted from the exploitation of imperfections in the camera lens itself, providing a "softer" representation of the subject or scene. To achieve impressionistic images, other photographers printed their images on rough-surfaced paper or even fabric, and employed diffusion filters during the printing process. In addition, the introduction of the gum bichromate process in 1894 allowed photographers to physically manipulate their images, using a variety of methods to both erode and/or layer upon a light sensitive gum arabic mixture that coated the photographic paper. All of these techniques, used alone or in combination, aided photographers in the creation of impressionist photographs, pictures that were often consciously modeled on the works of impressionist painters.

Not all were thrilled by the pictorial effects of impressionist photography; Emerson, for example, lambasted Davison as an untrained amateur and accused him of misappropriating the original concepts of naturalism for the development of a "fuzzy school" of photography. Yet, the denouncements of critics did little to stop the spread of impressionist

photography and various pro-impressionist groups emerged, beginning in 1892 with the Linked Ring Brotherhood. Earlier that year, H.P. Robinson, along with Davison, resigned from England's premiere photographic institution, the Royal Photographic Society. As advocators of photography as a fine art, Robinson and Davison sought to distance their work from the scientific photography promoted by the Photographic Society. Robinson then founded the Linked Ring and invited a number of photographers, including Alfred Stieglitz and Frederick H. Evans, to become members of this exclusive, new London-based organization dedicated to the propagation of photography as a fine art. Ten years later, building upon the model of the Linked Ring, Stieglitz initiated the Photo-Secession in the United States. While not all members of the Linked Ring and Photo-Secession produced impressionist images, they were dedicated to the establishment of photography as a fine art and, with this in mind, adopted a mentality that embraced the sentiment of impressionist photography to convey an accurate, albeit subjective, momentary perception of reality. In the ever-present struggle to establish photography as a legitimate art, the attitude and techniques fostered by impressionism allowed the work of serious photographers to stand apart from that of both scientists and the increasing numbers of amateurs infiltrating the field. Impressionism offered photographers the freedom to work in accordance with individual artistic aspirations and to present a personal and emotionally charged representation of the world.

Impressionism in photography was a relatively short-lived movement. By 1910, a clear preference emerged for a photography governed by its own conventions, not modeled on the aesthetics of painting. With the increasing acceptance of photography as a fine art in its own right, a number of photographers turned to purely photographic techniques to create their works, leaving behind the conscious emulation of impressionist painting.

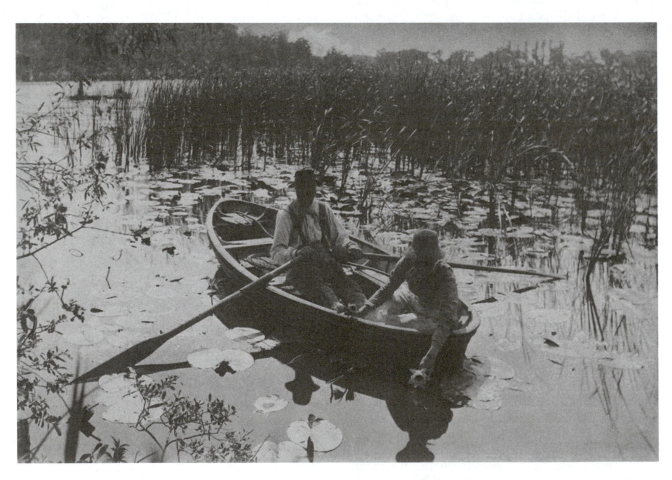

Peter Henry Emerson, Gathering Water Lilies from Life and Landscape on the Norfolk Broads, 1886, Platinotype, 7⅞ × 11⁷⁄₁₆ ", Gift of William A. Grigsby.
[*Digital Image © The Museum of Modern Art/Licensed by SCALA/Art Resource, New York*]

Today, the diffused aesthetic of impressionist photography frequently appears in the work of commercial and nature photographers. In these genres, a hazy or imprecise representation can prove helpful in a number of ways. For example, the calculated blurring of an image can infuse the image with atmospheric emotion ranging from glowing optimism to misty gloom, while simultaneously de-emphasizing less enticing details of a model or product. In addition, the photographer can convey activity by panning the camera in tandem with a moving subject. In conjunction with a relatively low shutter speed, this technique will render the subject in focus and the remainder of the scene out of focus. The use of special lenses can create impressionist images, as well. A long lens (useful for photographing subjects at a distance) and/or shallow depth of field will also allow selective focus, as will certain combinations of aperture and shutter speed settings. A soft-focus lens can be used to soften details, such as facial wrinkles of models, resulting in a smoother and more idealistic image. Alternatively, once the photography is taken, the final image may be altered during the developing process in any number of ways, from the layering of diffusion filters to computer-based digital manipulation. In short, contemporary photographers have recourse to a countless array of techniques to achieve impressionist effects, and can rely on impressionist effects to evoke an infinite range of emotions.

A. KRISTA SYKES

See also: **Camera: Pinhole; Evans, Frederick H.; History of Photography: Nineteenth-Century Foundations; Lens; Linked Ring; Photo-Secession; Pictorialism; Representation**

Further Reading

Coe, Brian. "George Davison: Impressionist and Anarchist." In *British Photography in the Nineteenth Century.* Edited by Mike Weaver. Cambridge and New York: Cambridge University Press, 1989.

Emerson, Peter Henry. *Naturalistic Photography for Students of Art.* London: Sampson Low, Marston, Searle & Rivington, 1889; New York: Arno Press, 1973.

Herbert, Robert L. *Impressionism: Art, Leisure, and Parisian Society.* New Haven, CT, and London: Yale University Press, 1988.

Newhall, Beaumont. *The History of Photography from 1839 to the Present.* New York: Museum of Modern Art and Bulfinch Press, Little, Brown and Company, 1982; 5th rev. ed. 1994.

Nochlin, Linda. *Realism: Style and Civilization.* NY: Penguin Books, 1971.

Rewald, John. *The History of Impressionism.* New York: Museum of Modern Art, 1946; 4th rev. ed. 1973.

Robinson, Henry Peach. *Pictorial Effect in Photography.* London 1869; Pawlet, Vermont: Helios, 1971.

Tausk, Peter. *Photography in the 20th Century.* London: Focal Press, 1980.

Thomson, Belinda. *Impressionism: Origins, Practice, Reception.* London and New York: Thames & Hudson, 2000.

INDUSTRIAL PHOTOGRAPHY

Twentieth-century industrial photography is a subset of documentary photography, focused on production and abundant supply. Its own subsets include environments of productivity, or industrial zones; tools and machinery for industrial production, or capital goods; workers, work teams, and foremen; and the interrelationship of these components under the aegis of entrepreneurial, corporate, or governmental control. An enormous storehouse of images, escalating in quantity and complexity of interpretation from ca. 1900 through the 1950s, it is primarily an American phenomenon with its roots in the transportation revolution that replaced canals, packet boats, and steamers with railways, large cargo ships, and ore boats; in the power revolution which replaced steam with electricity; and in the engineering revolution which replaced shop-based, rule-of-thumb engineering with laboratory-based, university trained planning, drafting, and theory. Industrial photography may be said to reflect an American system of manufactures, wherein any image pertaining to a specific archive is interchangeable with another, and that the archive itself only makes sense when considered to be an

index of the production process that transforms raw materials into industrial products, then distributes them to outlets for sales or back into production for further stages of fabrication.

American industrial imagery, particularly engineered tall structures such as cranes, derricks, and skyscrapers, became of supreme interest to industrializing European countries during the interwar years of the 1920s and 1930s, engineering an international Machine Style and a European variant photography known as *Neue Sachlichkeit* (New Objectivity). New Objectivity photography was, however, contained within the architectural, crafts, and fine arts disciplines as taught in the Weimar Bauhaus, an experiment in utopian living and production that did not survive the massive military preparations and suppressions on the eve of World War II. It was not industrial photography per se.

As codified in the postwar industrial zones and factories in the 1950s and 1960s on both sides of the Atlantic, industrial photography has factual/historical and metaphorical relationships to progress. The factual/historical relationship entails records or inventories of processes and machinery that relate to the monitoring, managing, and improving of production. The metaphorical relationship is more obtuse and entails "pictorial stories" of industry that relate to the instilling of an aura of productivity. A late-1960s German text defines this metaphor as marketing of the "prestige variety":

> The new photographic style does justice to this development by trying to bring out the spirit of our age, to interpret...the rhythm of modern industry, the precision, the many interlocking functions on the mechanical, electrical, chemical, and biological level as an integrated whole....The technical characteristics of such plants attract the photographer with a flair for pictorialism as much as they provide the technologist with the information he needs....
>
> (Giebelhausen 1967, 36)

The following chronological summary exposes the factual and metaphorical components of industrial photography as dynamic fields of operation and representation. It considers the evolving industrial landscape. In order to explain these dynamics, large projects rather than individual pictures or photographers are foregrounded, although their trajectories may intersect individual careers and styles. Pictures are viewed as industrial artifacts in production and as archives in distribution.

> Archival projects manifest a compulsive desire for completeness, a faith in an ultimate coherence...an empiricist model of truth prevails. Pictures are atomized, isolated in one way and homogenized in another.
>
> (Sekula 1987, 118)

The summary concludes around 1950. Succeeding decades are most accurately represented as post-industrial, with industrial imagery and zones skewed to more personal and ironic approaches defined and maintained within academic forums and the art world. As Kim Sichel has explained

> The cultural power of the machine as a beacon of the future has been radically changed. In recent decades, photography's relationship with the machine world has also changed, evolving from a tool for preaching to a more tentative, ironic, and historicizing record...a more self-referential stance.
>
> (Sichel 1995, 1, 9)

1900–1920: Industrial Zones

Industrial photography became a defined field at the turn of the century. Before this time numerous photographs were taken of individual proprietorships, shops, and dense industrial areas. These cannot be defined as industrial zones or "works" because they lack coherence and comprehensiveness; in their jumbled heterogeneity they float free of coordinates or connecting links, save those of the proprietors or engineers, prominently posed in the pictures, who were responsible for their construction or operation. Coordinates were provided through burgeoning transcontinental railroad systems and the concomitant expansion of factory districts and building types along the rights of way. By 1900 major railroad lines crisscrossed and even overlapped the country, converging in parallel grids or huge arcs at urban gateways and urban freight yards—the new "metropolitan corridors." These grids and arcs, followed by the overhead lines of electrified trolleys and locomotives, are both the "text" and organizing elements of photographs taken along the New York/New England seaboard; at the Brooklyn Bridge; and in Chicago, Cleveland, St. Louis, and other expanding corridors. Alfred Stieglitz's *Hand of Man* and *In the New York Central Yards* (1902 and 1893, respectively), feature these grids and convergences.

At the same time, the "control of communication" and the establishment of managerial hierarchies in large railroad companies were also reflected in the photographic codification of industrial building types. Besides monumental bridges,

photographs of industrial installations include monumental terminals; trackside maintenance structures; power stations; suburban depots; any number of factories, iron and steel works, and petroleum installations; as well as loading and unloading devices along wharves and docks. Whether or not they appertain to the new oligopolies and monopolies being formed in these years, each structure appears as a singular artifact *and* as a component of a coherent engineered order. Its own components (roof lines, smokestacks, trusses, suspension cables, cranes, towers) read clearly so as to be easily identified and cross-referenced. Trains, ore boats, and other ships also loom large, yet do not disorient the viewer as they are pictured head-on, horizontally, or zeroing diagonally into deep space.

Just as "system," "efficiency," and "survey" were the buzzwords of the new engineering theory, "consolidation" characterizes these dynamic industrial images. The Detroit Photographic Company, which marketed prints and postcards, consolidated the practices and inventories of William Henry Jackson and numerous other independent photographers. Along with the stereo views of the Keystone View Company, Underwood & Underwood, and other national distributors, Detroit Photographic's images marketed a visual archive of urbanism as industrialized order to an industrializing public (metropolitan workers and shoppers). They show residues of "grand style"—clear compositional boundaries between the genteel observer and the industrial zone. However, their equally grand exploitation of the long, panoramic format, for example, the four-part panorama of Bethlehem Iron Company (1891), indicates linear expansion and implies boundless diversification.

The drama of these new zones—their smoke, steam, and thrusts—is also forcefully presented in photography. It is indebted to paintings, prints, illustrated stories extolling industrial escapism, and Pictorialist photography. Stieglitz's snapshots of the New York Central yards, Alvin Langdon Coburn's smoky, artfully smoke-stacked views of Pittsburgh steel installations, and Clarence White's studies of mid-western canal and eastern shipbuilding zones show the visceral impact of the spreading "hand of man." Pictorialism was instrumental in creating a symbolic language of process, material transformation, looming form, and cavernous space that Margaret Bourke-White and others would infiltrate into the next generation. Where industrial photography and industrial Pictorialism substantially differ is in the notion of the archive itself, which implies a huge quantity, a need for storage, mass distribution, and the submersion of the artist into the arterial tracks of engineered and romantic commerce. Pictorialism vaunted the single print by the singular artist.

Archival and industrial strategies and images come together in the photographic document of 1904–1914, the construction of the Panama Canal. Ernest Hallen, the official photographer of the U.S. government's Isthmian Canal Commission, made over 10,000 negatives covering every aspect of the project. His most advanced work positions the observer right in front of huge concrete structures or within the canal cut. Ulrich Keller notes that these intersections produced not only an "awesome body of information," but also "the systematic documentation of a given industrial production process by a specially appointed photographer who remains on the job for months, if not years." (Keller 1983, viii) The "awesome information" strategy extended into the corporate 1920s; studied, systematic communication would define federally controlled projects of the 1930s.

1920–1930: Incorporated Structures

By the 1920s and in the fully developed industrial corporation, the production and distribution of images were fully professionalized by executive managers and engineers. A departmentalized hierarchy of communication strategies replaced the multiple founts of image-making of previous decades, and photography came into its own to represent them. Members of the higher executive strata utilized this imagery to communicate with one another horizontally, reinforcing their hard-won status of policy-makers and gatekeepers.

Decontextualization was the mode of address, and it was accomplished via a variety of image types: aerial views of industrial installations as well as urban industrial districts; perspectives of factory interiors; close-ups of machines; and close-up portraits of executives. These were perfected by photographers whose prominence was keyed to their ability to adapt their techniques and styles to various industrial jobs and clients. Success was also keyed to exposure in the key archival publications of the day. Corporate stockholder magazines, portfolios, and advertisements were the basis of this exposure as publicity managers generated the commissions. Re-publication in business culture magazines (*Fortune* and *Vanity Fair*), in university textbooks (*American Economic Life*), and in multi-volume pictorial histories (*The Pageant of America*) further standardized and ensured the life of these image types.

Margaret Bourke-White's photographs of Cleveland's iron and steel district and its major industry, Otis Steel (1927–1929), followed by their re-publication in *American Economic Life* and in *Fortune*'s "Hard Coal" (February 1931); "Iron Ore" (April 1931); "Raw Materials in Costly Motion" (July 1931); and "Mill on the Lake" (September 1931), among other portfolios, effectively decontextualized and systematized romantic Pictorialism. Structures and workers were enshrouded in clouds, fog, or smoke, or captured as silhouetted apparitions piercing the darkened sky. Far from being considered pollutants, smoke and steam enhanced the illusions snatched from nature, contributing to the symbolization of power as it was magnified in the corporate nexus. As practiced by Herb Rittase, Ewing Galloway, and the many anonymous corporate photographers whose work appeared in *Fortune*, this type of imagery exponentially increased the body of formats and styles derived from early twentieth-century romantic and engineering-based prototypes. Thus choreographed buildings, vehicles, and machines were re-visualized as mysterious, ineffable presences—metaphors for the controlling executive presences who, ensconced in their financial district offices, had literally decontextualized themselves from the scene.

Top executives saw themselves and their territories as abstractions: auratically bathed in light, shadow, and/or atmosphere; decontextualized via tight cropping and the close-up; and further abstracted in indeterminate space. The photographic programs of leading-edge image disseminators General Electric and Ford companies show these strategies clearly. Examples in the General Electric's archives include power stations, dynamos, and transformers photographed either with or without workers as scale figures. General Electric reproduced these as cut-outs or montages on a blank field, with captions such as "$4600 buys this 1667, kv-a. Transformer, 99% efficient, 13 feet high." (Ripley, 1929) Ford's image program included the photographs of Charles Sheeler, who covered the new River Rouge plant. Sheeler's photographs update the industrial grid with the planar complexities of Cubist painting, transmitted through Stieglitz's gallery 291 and its journal *Camera Work. Criss-Crossed Conveyors* (1927) was reproduced in *Vanity Fair* with the caption, "By Their Works Ye Shall Know Them." In Ford's company magazine *Ford News*, Sheeler's *Ladle Hooks* (1927) was elevated to the level of a religious icon; it received the publicists' appellation "the Cathedral of Industry." According to Terry Smith, "[This is a]n industry without producers, process, or product...an industry of image, look, an abstract domain, a suitably clear background for the pure act of consumption of the sign to be sold." (Smith 1993, 115–16.) This was the ultimate abstraction of the industrial zone.

1930–1940: Governmental Power

During the Depression years of the 1930s, industrial photography followed major building projects and these were located in the federal sector. The key federal projects involving industrial photography were power stations, in particular hydroelectric dams constructed in the Far West. "The huge scale of the new power stations and their potential for transforming society made them more imposing than anything that had preceded them." (Nye, 1994, 133)

Photographers were retained by the U.S. government to document these projects from inception to completion. As public money was involved, the intent of these photograph campaigns was rhetorical and propagandistic: to prove fiscal responsibility, to survey managerial control and worker safety, to put a closure to the satisfactory surmounting of engineering challenges, and to supply the burgeoning image agencies (for example, the Newspaper Enterprise Association and *Life* magazine) with grandiose publicity scaled to emphasize social as well as economic value. The industrial photographers of the 1930s were expected to know not only image-making strategies, but also the various technical processes involved with construction. As differentiated from the photographers of the contemporaneous Farm Security Administration photographic project, industrial photographers on federal construction sites were permitted to "draft" their own shooting programs so long as they adequately covered the project to which they had been assigned. Image types were codified in line with their rhetorical and engineering-oriented functions: overall views, taken over time; details showing the technical intricacies of construction components; routines of work; equipment and machinery; construction milestones, often embellished or re-staged for dramatic effect; and "fine art" views.

Ben Glaha, an engineering draftsman hired to document the Hoover Dam project, exemplifies 1930s industrial photography. His views of the dam site along the Colorado River have the grandiosity and abstraction of Bourke-White's *Mountains of Ore* (1927–1929), but heroic titles (reflecting heroic corporate identities) have been replaced with engineering data: "The Downstream Face of

the Dam and a Portion of the Power Plant as Seen from the Low-Level Catwalk. Top Forms on Dam at Elevation 1,055. October 2, 1934." His structural and mechanical engineering details have the decontextualization, planar gridding, and complexity of Sheeler's River Rouge conveyors, but heroic slogans (reflecting corporate advertising campaigns) have been replaced by information: "Detail of Roof Slab and Beam Reinforcement in Canyon Wall Valve-House Structure. June 1, 1935." And in his fine-art views, taken as engineering documents and then printed for display and framing in federal offices in Washington, the controlling eye of the executive manager has visually been replaced by that of the machine. This is exemplified in the monumental claw-like shapes and shadows climbing up and arching over "Portion of 287.5 Kv. Transofmers, Roof Take-off Structures for Units N-1 to N-4 Inclusive, from Ramp at Elevation 673.0. April 12, 1938." Glaha commented that "drawings of this type are often beautiful....It is the beauty of precision, the beauty that becomes evident when nonessentials are stripped away—in other words, the beauty of pure function." (Ben Glaha, quoted in Vilander, 1999, 55) This was the ultimate streamlining of the industrial project.

After 1940: Industrial Re-Mapping

The didactic functions and messages of industrial photography were an established lexicon by the 1940s. What became apparent during and after World War II was that the focus of American progress had shifted: from the industrial metropolis to the industrial district with its factories; thence to the power plants being constructed in remote, rural locations; and finally to the vehicles and highways that transported materials, products, goods, and people to all of these sites of production. One aspect of post-World War II industrial photography is its linkage to an emergent highway culture, a culture of space bisected by highways, criss-crossed by junctions, bounded by billboards, and anchored by tourist villages that rapidly merged with nearby towns. The "strip," the ubiquitous jumble of establishments just outside so many city limits that photography from the 1950s through the 1980s would scrutinize, was not far behind.

The major industrial photography project of this eminently modern era was the archive amassed by Standard Oil of New Jersey (SONJ) under the direction of Roy Stryker. Intended to bolster the huge petroleum company's image through the production and dissemination of thousands of pictures (SONJ was under fire because of accusations of possible wartime collusion with the Germans), the project amassed 85,000 photographs, thousands of which were kept in circulation. Some made their way into newspapers and magazines, including SONJ's *The Lamp* and *Photo Memo* and the popular periodicals *Life, Look,* and *Saturday Evening Post.* Others were enlarged into the relatively new form of the photo mural and sent to cultural and educational organizations. Still others formed the visual texts of fine art exhibitions, including *In and Out of Focus* at the Museum of Modern Art, New York.

What is important about this culminating industrial archive is not its image styles, image types, or even its short-lived success as propaganda, but rather the overall scale and reach of the program and its thorough professionalization. Whether the subject of a pictorial sequence is an oil installation and its high-technology machinery, such as the series devoted to the fluid catalytic cracker in Linden, New Jersey, or a SONJ-dominated locale, such as the series on St. Martinville, Louisiana, or three SONJ towns in Texas, the content is the restructuring of the continental map as nodes of industrial activity separated by huge spatial voids. These nodes extend the notion of industry from the workplace to the town and finally to the family home itself. Photography makes this extended industrial landscape "real."

Esther Bubley, Russell Lee, Harold Corsini, Edwin and Louise Rosskam, Gordon Parks, Todd Webb, John Vachon, John Collier, Jr., Berenice Abbott, Charlotte Brooks, and Elliott Erwitt were the SONJ photographers. They worked as freelancers. Some were veterans of 1930s documentary projects and others made their first mark here. In that they were working with a by-then fully professionalized photographic language, they can be considered the first "industrial photographers." From this point on, industrial photography would be mainstreamed "to help sell products, to influence public opinion, and to educate and entertain employees." (Zielke and Beezley 1948, v) It comes as no surprise that the aforementioned text, dividing industrial photography into "pictorial," "human," "news," and "how-to" interests, came out in the apex years of SONJ-distributed imagery. Thereafter, the how-to books proliferated, and the field plateaued.

GERALDINE WOJNO KIEFER

See also: **Abbott, Berenice; Aerial Photography; Architectural Photography; Bauhaus; Bourke-White, Margaret; Coburn, Alvin Langdon; Erwitt, Elliott; Farm Security Administration; Lee, Russell;**

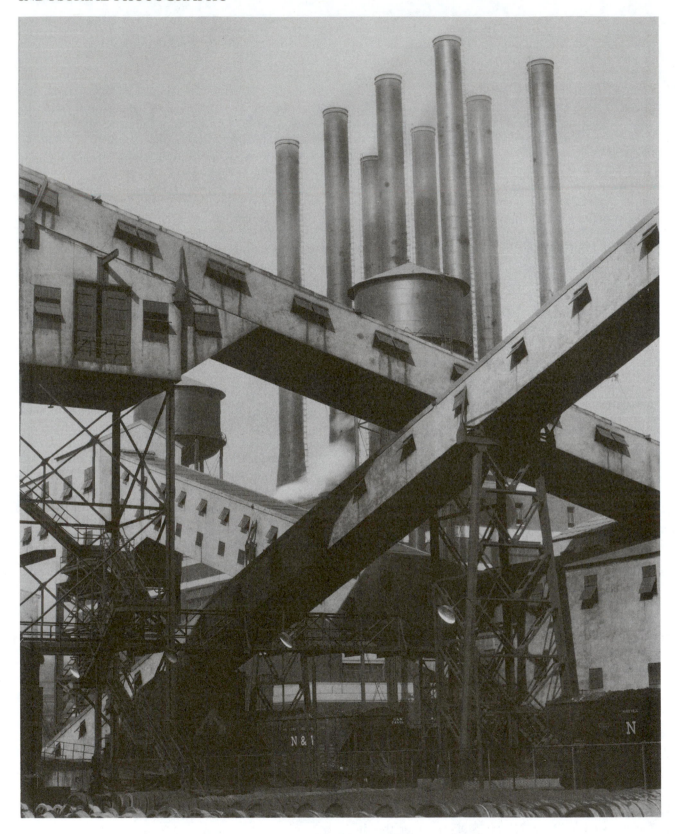

Charles Sheeler, Ford Plant, Detroit, Michigan, 1927, Gelatin-silver print, 9⅛ × 7½″, Gift of Lincoln Kirstein.
[*Digital Image © The Museum of Modern Art/Licensed by SCALA/Art Resource, New York*]

Life Magazine; Look; Pictorialism; Propaganda; Sheeler, Charles; Stieglitz, Alfred; Stryker, Roy; White, Clarence

Further Reading

Doezema, Marianne. *American Realism and the Industrial Age*. Cleveland, Ohio: The Cleveland Museum of Art, 1980.

Giebelhausen, Joachim. *Photography in Industry*. Ed. E.F. Linssen. Munich: Nikolaus Karfp, Verlag Grossbild-Technik GMGH, 1967.

Hales, Peter Bacon. "American Views and the Romance of Modernization." In *Photography in Nineteenth-Century America*. Ed. Martha A. Sandweiss. New York: Harry N. Abrams, Inc., 1991.

Hambourg, Maria Morris. *The New Vision: Photography between the World Wars, Ford Motor Company Collection at the Metropolitan Museum of Art*. New York: The Metropolitan Museum of Art, 1989.

Hurley, F. Jack. *Industry and the Photographic Image: 153 Great Prints from 1850 to the Present*. New York: Dover Publications, Inc., 1980.

Keir, Malcolm. *The Epic of Industry*. Vol. 5 of *The Pageant of America: A Pictorial History of the United States*. Ed. Ralph Henry Gabriel. New Haven: Yale University Press, 1926.

Keller, Ulrich. *The Building of the Panama Canal in Historic Photographs*. New York: Dover Publications, Inc., 1983.

———. *The Highway as Habitat: A Roy Stryker Documentation, 1943–1955*. Santa Barbara, California: University Art Museum, 1986.

Kiefer, Geraldine W. "From Entrepreneurial to Corporate and Community Identities: Cleveland Photography." In *Transformations in Cleveland Art, 1796–1946*, by William H. Robinson and David Steinberg. Cleveland, Ohio: The Cleveland Museum of Art, 1996, pp. 198–215.

Lemann, Nicholas. *Out of the Forties*. Washington and London: Smithsonian Institution Press, 1981.

Neubart, Jack. *Industrial Photography*. New York: Amphoto, 1989.

Nye, David E. *American Technological Sublime*. Cambridge, MA, and London: The MIT Press, 1994.

———. *Consuming Power: A Social History of American Energies*. Cambridge, MA, and London: The MIT Press, 1998.

———. *Image Worlds: Corporate Identities at General Electric*. Cambridge, MA, and London: The MIT Press, 1985.

Ripley, C.M. *Facts about General Electric*. Schenectady, NY: General Electric Company, 1929.

Sekula, Allan. "Photography between Labour and Capital." In *Mining Photographs and Other Pictures, 1948–1968: A Selection from the Negative Archives of Shedden Studio, Glace Bay, Cape Breton, Photographs by Leslie Shedden*. Ed. Benjamin H.D. Buchloh and Robert Wilkie. Halifax: The Press of the Nova Scotia College of Art and Design and the University College of Cape Breton Press, 1983, pp. 193–268.

Sichel, Kim. *From Icon to Irony: German and American Industrial Photography*. Seattle and London: University of Washington Press, 1995.

Smith, Terry. *Making the Modern: Industry, Art, and Design in America*. Chicago and London: The University of Chicago Press, 1993.

Stilgoe, John. *Metropolitan Corridor: Railroads and the American Scene*. New Haven and London: Yale University Press, 1983.

Taylor, A. Faulkner. *Photography in Commerce and Industry*. London: Fountain Press, 1962.

Vilander, Barbara. *Hoover Dam: The Photographs of Ben Glaha*. Tucson: The University of Arizona Press, 1999.

Wilson, Richard Guy, Dianne H. Pilgrim, and Dickran Tashjian. *The Machine Age in America, 1918–1941*. New York: Harry N. Abrams, Inc., 1986.

Zielke, Moni Hans and Franklin G. Beezley. *How to Take Industrial Photographs*. New York and Toronto: McGraw-Hill Book Company, Inc., 1948.

INFRARED PHOTOGRAPHY

Pioneering astronomer Sir William Herschel made the discovery of infrared light in 1800. Interested in viewing the sun through a large telescope and recognizing that this cannot be done by direct means, he began a search for filters that would accomplish this. Herschel discovered certain colored filters passed little light, yet produced a great deal of heat. Other filters passed lots of light, but little heat. He speculated that different rays had different heating capacities and that the rays from the infrared, literally meaning "below the red" were responsible for the maximum heating effect. In an elegant experiment he proved his theory. Many refinements of this discovery followed, principally by Ritter and Ampere. From the 1870s on a great deal of scientific experimentation with sensitizers took place, including those chemicals that extended the sensitivity into the infrared

range. Modern photographic infrared films were perfected by the early 1930s, and initially the applications of the films were for scientific and military purposes. Gradually these films gained popularity with artists and photographers, and they are readily available in most camera stores.

Infrared Film

Infrared films are made by adding certain sensitisers to the film emulsion during the coating process. This "allows" the film to "see" the infrared spectrum. The question is "exactly what does this film see?" The answer is that it depends on what filter is used with the film. Without any filter the film works as a coarse grain, green sensitive (orthochromatic) emulsion, and it is sensitive to the entire visible light spectrum. By adding filters, starting with yellow (#12) and going to orange and red (#25) or the infrared only filter (#87) the film can "see" deeper and deeper into the infrared range. The filters actually subtract or block the visible light depending on the color of the filter and therefore reveal more of the remaining infrared light. The question is often asked if the infrared films can record heat and the answer is that they cannot "see" heat. The reason is that the infrared films record the infrared portion of the light spectrum *reflected* from the subject being photographed, not the thermal energy that the subject contains.

Light Spectrum

There are different theories that describe the light spectrum. The one that makes the most sense for photographers is the wave theory. This theory holds that light is a wave and that you can measure the length between the tops of the waves, similar to waves in the ocean. The distance here is very short, shorter than of one millionth of a meter. We call these nanometers and the visible light spectrum sits between 300 and 700 nanometers. Ultra violet is about 300 nm, while red is 700 nm. Beyond 730 nm is the infrared range, and its length is generally defined as being between 730 to 1400 nm. The commercially available films range in sensitivity from 750 nm to 900 nm. Thus it becomes important to select the right film for a given purpose or infrared effect. Kodak films are generally sensitive up to the 900 nm range. Ilford SX-200 has a range up 750 nm, while Konica films reach into the low 800 nm range. Since nanometers are analogous to horsepower in an engine, the higher the number the more infrared the film is potentially capable of recording. The difference in the results then becomes the filter that you apply in taking the photograph. The

stronger the filter, the more of the infrared information that you will record on your film.

Exposure

Infrared films do not have standard exposure sensitivity such as an ASA or ISO. The reason is that the film is sensitive to the amount of infrared radiation that is reflected from the subject that you are photographing. So where does infrared radiation come from? The sun is a massive source of infrared, but as we all know, the amount of sunlight present can vary depending on many factors, including weather conditions, pollution in the air, time of day, and season of the year. Other good sources of infrared light are tungsten bulbs and strobe lights.

Some light meters and camera meters can read infrared very well, others do not do so well, and unfortunately none have an explanation or warn-

Konica 750 in the 2¼" film size	ASA 32 without the filter
Kodak Infrared High Speed HIE – 35mm	ASA 125 without the filter
Ilford SX200	ASA 200 without the filter

ing in the directions that come with the meter. Fortunately, the amount of infrared light that is present is proportional to the amount of light from the above sources.

The following are some recommended settings for camera light meters that have proven valuable and should serve as a starting point.

The method of taking an infrared photograph is to take a meter reading without the filter on the camera, set the proper exposure, and then put the filter on the lens.

Infrared Light and Lenses

There is another element to consider with infrared and that is the wavelength itself. The lenses on almost all cameras are made to focus the visible light spectrum. Optically the lens must bend the different rays (read different wavelengths) so that only one image is formed on the film inside the camera. This is quite an optical feat and some older lenses could not do this. With infrared we find that the wavelengths are even longer than the visible light waves and that the normal rules no longer apply. These waves in effect form an image behind the camera when the camera is focused on the visible wavelengths. In order to make an infrared image that is in sharp focus, we must actually

"un-focus" the camera. Most 35 mm cameras have a small mark or dot on the lens barrel that indicates where the infrared focus point is, thus making our job a little easier. But there is another way to help solve the focus problem. It is called depth-of-field. By using an f-stop of f/8 or smaller aperture the focus problem of infrared films is almost eliminated. As a practical matter you can expose at f/8 or f/11 and let the meter determine the shutter speed. This will work well for about 90% of the situations involving 35 mm cameras. Focusing with sheet film and a view camera is somewhat different. The recommendation here is a normal focus though the ground glass and then extending the bellows about ¼″. Again, using depth-of-field or smaller apertures will help to eliminate the focus difference.

Processing and Handling

This is something else that is different from normal black-and-white films. The Konica and Ilford films can be handled in subdued light, but the Kodak film must be loaded and unloaded in total darkness. That means in a darkroom or with a changing bag. Processing the film requires some care as well. Infrared films tend to react strongly in the highlight areas and can easily be overdeveloped.

Why Use Infrared Films?

Philosophically speaking, the film literally records light waves that cannot be seen. Extending this, we are recording objects or people that are not there. That is not quite true, but then a photograph is an illusion anyway. It does put the viewer on notice that something different is going on. It is an approach of isolating the image and subject in a special way, and it declares the artist/photographer's intentions. An infrared photograph almost always conveys a strong sense of drama. One of the distinguishing features of infrared photographs is that all vegetation in bright light turns "white" in the finished print. Skin tones take on an alabaster look. Infrared film can open up a whole new world of seeing for the photographer.

Since the 1930s infrared film has been used among fine art photographers in addition to its scientific applications. While widely explored by amateur photographers, its use by professionals remains limited. Weegee, for example, used infrared film and infrared flash to photograph movie audiences. Edward Steichen used it to make some of his World War II photographs. Minor White completed a series of infrared landscapes in the mid-1950s using large format infrared film, including the image *Barn and Clouds in the Vicinity of Naples and Dansville, New York*, 1955. The lesser-known photographer António José Martins employed infrared film in his Arctic landscapes. Since the time of these pioneers, infrared film has played a role for its aesthetics in the history of the medium.

PETER LE GRAND

See also: **Astrophotography; Film; Film: Infrared; Filters; Light Meter; Periodicals: Professional; Steichen, Edward; Weegee; White, Minor**

Further Reading

Clark, Walter. *Photography by Infrared*. London: Chapman & Hall, Ltd, and New York: John Wiley & Sons, Inc., 1946.

Paduano, Joseph. *The Art of Infrared Photography*. Dobbs Ferry, NY: Morgan & Morgan, Inc., 1984.

Applied Infrared Photography. Publication M-28, Eastman Kodak Company, Rochester, NY, 1972.

Scientific Imaging Products. Publication L-10, Eastman Kodak Company, Rochester, NY, 1989.

INSTANT PHOTOGRAPHY

Instant photography has many possible origins. The idea of a photographic process that would produce a positive image in a short amount of time had antecedents in the nineteenth century with direct positive print processes like the daguerreotype, the ambrotype, and the speedily produced tintype (or ferrotype), and with combined photographic processing systems like the collo-

dion-plate Dubroni camera system, where the plate was both exposed and developed in the watertight interior chamber of the camera. In the twentieth century, technologies like the photobooth (patented in 1925) and the more recent digital camera allow the photographer or subject to view the photograph shortly or immediately after it is taken, but since these processes rely on a separate printing process (albeit in the case of the photobooth, one contained within the mechanism) they resist classification as "instant photography." True instant photography, then, originated with the innovations of scientist and Polaroid founder Edwin H. Land, and its basic principles are best articulated in his own words. In his 1947 article "A New One-step Photographic Process," Land described the goal of instant photography as essentially:

> ...a camera and a photographic process that would produce a finished positive print, directly from the camera, immediately after exposure. From the point of view of the user, the camera was to look essentially like an ordinary camera, the process was to be dry, the film was to be loaded in one of the usual ways, the positive print was to look essentially like a conventional paper print, and the print was to be completed within a minute or two after the picture was taken

(Land 1947, 61)

Land's first instant camera, the Model 95 Polaroid Land Camera, went on sale in 1948 and was technologically revolutionary on a number of levels. The collapsible camera was at once sturdy, relatively compact, and large enough to accommodate $3\frac{1}{4} \times 4\frac{1}{4}$ films. The camera was designed to house two rolls—one of photosensitive film and the other of positive paper—which were pressed together as the film was extracted from the mechanism protecting the developing and printing emulsions. But the real innovation of Land's "one-step photography" system was the film's entirely contained self-processing system. As the exposed Land film was pulled from the camera, it was pressed between a pair of steel rollers. The rollers ruptured a "reagent pod" of developing chemicals and spread them between the negative and positive layers. The viscous chemical mixture initiated a diffusion transfer process (developing both negative and positive images simultaneously) and stabilized the image. In less than one minute the negative layer could be peeled away and discarded leaving a richly detailed finished positive print.

Despite some minor alterations in its early years (a shift from sepia to more professional looking black and white films and improvements in the print stabilization process) the Land Camera was an unmitigated success with professionals and amateurs alike. Given the ability to view the finished photograph and the photographic subject side by side, Land saw his one-step system as not only an entertaining approach to snapshooting but also a way to take better photographs, putting the power of aesthetic production in the hands of the everyday consumer. Thus while Land was ever focused on making his instant cameras as mechanically streamlined and operationally foolproof as possible, he was also consistently concerned with instant photography as an artistic medium. Just one year after the Model 95 was introduced to the public Land met landscape photographer Ansel Adams and promptly hired him to work for Polaroid as a consultant. Adams was instrumental in the development and marketing of Land films, specifically with professional photographers in mind. In his lifelong collaboration with Polaroid, Adams used his Land Camera and the larger format 4×5 Polapan Land films he helped to inspire to create masterfully detailed and composed black and white landscapes of the American southwest, and penned the *Polaroid Land Photography Manual* (1963). In the foreword to this text, however, Adams diverges somewhat from Land's democratic vision of the citizen-artist by stressing the distinction between the Land Camera's popularity as a gadget for everyday photographers and its sophistication in the hands of the skilled professional to whom the book was addressed. In the mid-to-late century, however, professional photographers' main use of the instant process was as a proofing method to determine proper exposure of studio set-ups.

A restless innovator, Land continued to tinker with the one-step process, making the film speed and the development process faster and the films more stable. In 1963, Polaroid introduced Polacolor instant color films, and in 1972, Land achieved another major breakthrough with what he termed "absolute one-step photography" embodied in the revolutionary Polaroid SX-70 camera. Designed specifically with everyday snapshot photographers in mind, Land saw the SX-70 as a solution to all of the "problems" of the Land Camera and thus reinvented virtually every aspect of extant instant photographic technology. Far more compact than earlier models, the SX-70, when collapsed, was designed to fit snugly into a man's coat pocket. The camera was also fully automatic, motorized (no pulling to extract the film was required), and employed a radical new "garbage free" film technology for which no timing, peeling, or coating of the film was required. The negative and positive layers of each frame of film were contained in a

plastic card with a clear window in front. As the image developed and stabilized, opacifiers protecting the image became slowly transparent until the finished print was revealed. The particular intrigue of the SX-70—one which landed the SX-70 and its inventor on the cover of *Life* magazine—was taking a picture and watching the image appear before your very eyes. And because of this particularly novel feature, the SX-70 also laid claim to a new kind of photographic practice: the photograph that was taken so that the photographer, and often the subject as well, could watch it develop. In contrast to the sophistication and control offered to the user of the Land Camera, the SX-70 offered remarkable ease of use, mechanical simplicity, and a certain "magical" quality. Of course, the ingenious design of the SX-70 had its drawbacks as well. Land's democratic desire to create a camera for anyone and everyone marked as problems many of the design features that might have given more aesthetically minded photographers more creative control. And while some art photographers have found aesthetic uses for the SX-70 (see below), for the most part, the technology defined and reflected a distinctly vernacular usership.

While the Land Camera and the SX-70 stand out as particular milestones, the technological history of instant photography includes a broad range of products and applications. Since the introduction of the SX-70, Polaroid has emphasized the shift in the instant photography demographic from the professional photographer to the amateur snapshooter by producing a variety of inexpensive cameras featuring plastic lenses and novel features, like the stripped down Pronto! (introduced in 1976), the brightly colored Cool Cam (1988), and the I-Zone, still being manufactured at the turn of the twenty-first century, which produces postage-stamp-sized color photos with a sticker backing. But Land also found ways to employ his instant photographic process to develop a variety of other technologies, from instant slide films and instant overhead transparency films to the ground-breaking but ill-fated Polavision, an instant, color, motion picture system. And Polaroid was by no means the only company to produce technology for instant photography, although most have relied heavily on the SX-70 design. Minolta, Konica, Keystone, and Fuji all designed instant cameras to be compatible with Polaroid films. The Polaroid Corporation put its proprietary relationship to instant camera and film technology to the test in 1976 when it filed suit against Eastman Kodak Company in a landmark patent case and won. After ten long years of litigation, Kodak, who had managed to corner over a quarter of the U.S. market on instant photographic technology in the early 1970s with its Kodak Instant system, was found to have infringed upon seven of ten Polaroid patents covered in the suit and ordered to stop manufacturing and selling their instant cameras.

Since the 1980s, the Polaroid Corporation has been in decline and the popularity of instant photography is currently much challenged by the growing sophistication of digital image technology. However, instant photography may yet maintain a foothold in the photographic technology market for its broad range of practical and aesthetic uses. Because of its immediacy and the control it offers the photographer over the image, the instant photograph has played a role in a variety of professional contexts including medical imaging, document copying, identification, insurance, and professional photography. In addition, and in keeping with Land's goal of bridging the gap between art and vernacular photography through instant technology, Polaroid has actively and effectively encouraged instant photography's role in the realm of art production and maintains a large archive of artwork produced with their cameras. The success of this enterprise reflects an aesthetic engagement with the particular formal and technical character of the medium. The quality of images produced with Land film, for example, is superb, as the instant negative is necessarily the same size as the positive print and therefore equivalent to standard medium and large format films. While Ansel Adams pioneered the use of Polaroid instant film for his highly detailed landscapes, contemporary artists like Chuck Close have maintained this practice, using 20 × 24-inch Polaroid prints as maquettes for his large photorealist portrait paintings. William Wegman has also created a number of striking 20 × 24-inch images of his famous Weimaraner dogs.

Other artists have been drawn to the particular visual effects of the amateur-oriented SX-70 films. Andy Warhol liked to use the contrasty photos produced by his Polaroid Big Shot to create his commissioned silkscreen portraits of the 1970s and 1980s, and Walker Evans, a lifelong detractor of color photography, became enamored with the vivid, jewel-toned masterpieces he created with the SX-70 in the last years of his life. The unique design of instant film also offers a wealth of technical possibilities for aesthetic experimentation to those willing to scratch, peel, and manipulate their instant images. Instant photography manuals offer guidelines for Polaroid photo transfers, negative separation, peeling away the white titanium oxide backing to alter the colors, and pressing into the developing emulsion to distort the image. Using this latter technique,

multi-media artist Lucas Samaras is well known for his abstractly expressionistic "autopolaroids" and "photo-transformations." The SX-70 has also been productively used by Robert Heinecken, especially in his "He:/She:" series of the 1970s that combine trenchant texts with snapshot-like images. Various Polaroid processes have been explored by Marie Cosindas, who creates jewel-like color compositions using the instant process, and Rosamond Purcell, who began experimenting with PIn the late years of the twentieth century, David Levinthal and American photographers Joyce Tenneson and Ellen Carey have explored the process; Levinthal creating quirky set-ups with toys, Tenneson affecting portraits, and Carey striking layered images and abstractions.

Despite this variety of aesthetic and practical applications, instant photography is, even today, best known for its social function as a medium for personal or snapshot photography. Land's goal of "absolute one-step photography" was always a democratic one and the SX-70 and its descendants have had a unique role in the realm of vernacular photographic practice. The instant camera produces a photograph unlike any other, and one that accentuates the core facets of the snapshot image. Instant photography embodies an air of playfulness and mystery but also an inherently incidental quality. The instant photograph, particularly in the vernacular mode, feels at once precious, because it is unique and not easily reproduced, and yet disposable, not worth reproducing. It trades on its immediacy, not its posterity. The novelty of the photographic process, where one takes a picture just to see it develop, calls attention to the role of amateur photography as not only a means of documentation but also a leisure activity in its own right in many contemporary cultures. But the photograph's instantaneousness is perhaps most significant because of the way that it condenses the meaning of a variety of snapshot practices into a single moment. The instant photograph not only documents a moment to be reviewed and remembered later but also becomes present in that moment. Gratification is instant and intimate as the Polaroid is inevitably passed around to be viewed and discussed. If the photograph is an unflattering one, the subject may immediately discard it. If it is a good snapshot, it can be injected into the social narrative right away, uniting its viewers as the network through which the photograph circulates. And as incidental as the instant snapshot may be, it holds the nostalgic charge of both a photographic record and a physical memento, an affective potency that digital photography may never quite achieve.

CATHERINE ZUROMSKIS

See also: **Adams, Ansel; Close, Chuck; Evans, Walker; Heinecken, Robert; Levinthal, David; Polaroid Corporation; Vernacular Photography; Wegman, William**

Further Reading

Adams, Ansel. *Polaroid Land Photography Manual: A Technical Handbook*. New York: Morgan & Morgan, Inc., 1963.

Land, Edwin H. "A New One-step Photographic Process." *Journal of the Optical Society of America*, 37, no. 2 (1947).

———. "Absolute One-step Photography." *The Photographic Journal*, 114, no. 7 (1974).

Olshaker, Mark. *The Instant Image: Edwin Land and the Polaroid Experience*. New York: Stein and Day, 1978.

Sealfon, Peggy. *The Magic of Instant Photography*. Boston: CBI Publishing Company, Inc., 1983.

Sullivan, Constance. *Legacy of Light*. New York: Alfred A. Knopf, 1987.

Wensberg, Peter C. *Land's Polaroid: A Company and the Man Who Invented It*. Boston: Houghton Mifflin Company, 1987.

Lucas Samaras, Panorama, 11/26/84, Polaroid print assemblage, 1984, 10⅞ × 36⅛ ʺ (27.6 × 291.6 cm), Museum purchase.
[*Smithsonian American Art Museum, Washington, DC/Art Resource, New York*]

INSTITUTE OF DESIGN

The Institute of Design (New Bauhaus) began as an outpost of experimental Bauhaus education in Chicago and became one of the most important schools of photography in twentieth-century America. It was the home to such photographic luminaries as László Moholy-Nagy, Harry Callahan, and Aaron Siskind, and the inspiration to students who would become some of the best fine-art photographers in the country. The Institute of Design (or ID) also educated generations of photographers who would in turn become teachers, thus ensuring a lasting legacy of ID principles and pedagogy. The pictures that have emerged from the teachers and students there set new standards for photographic exploration, using photography's own means to expand its possibilities.

The New Bauhaus and School of Design, 1937–1946: Moholy's Experiment

The school began when a group of Chicago industrialists, the Association of Arts and Industries, decided to found a school that would be based on Bauhaus principles. In 1937, they contacted Walter Gropius, the former head of the German Bauhaus and then teaching at Harvard University, to ask him to be the new school's first director. He declined, but suggested his good friend and colleague László Moholy-Nagy, who had also taught at the Bauhaus. Moholy-Nagy living in London at the time, agreed, and boarded a ship to the United States to head up what would be called the New Bauhaus.

In 1937, Moholy-Nagy was already one of the most versatile artists of the twentieth century. A painter, sculptor, photographer, filmmaker, typographer, and set designer, he also had extensively published his theories on photography and film. His greatest artistic goals were to harness light as a medium in and of itself, and to this end he made photograms, films, plexiglas light sculptures, and what he called the Light-Space Modulator—a moving machine whose shimmery and perforated surfaces reflected and refracted light in constantly changing ways. His experience at the Bauhaus had been to teach its Foundation Course, a workshop in which students explored the properties of various materials through innovative and experimental pro-blems. The Bauhaus was radical in its hands-on approach, which—in direct contrast to traditional academic art education, whose pedagogy was based on imitation of the masters—put students in direct contact with materials and techniques. More than an art school, the Bauhaus positioned itself as integral to the fabric of daily life; it aimed to combine art and technology to the service of society. Moholy-Nagy brought these ideas and methods with him when he came to Chicago to start his new school.

In October 1937, the New Bauhaus was opened to great expectations in the art and industrial communities of Chicago. Housed in the former Marshall Field mansion on Chicago's historic Prairie Avenue, the school had been modernized in keeping with its mission of educating the whole person and providing the tools for a new vision appropriate to a new age. The school offered both day and evening classes, and in the first year, over 60 students attended either full- or part-time (among these were Nathan Lerner, and in the second semester, Arthur Siegel). The classes were structured as a series of workshops in which all students took the foundation, or Basic Workshop, in the first year, which exposed them to numerous fields, and over the next three years pursued a more specialized course of study in such workshops as Color, Sculpture, Architecture, or Light. It was in the Light Workshop that photography was taught; also included in this category was film, typesetting, advertising, and light studies. György Kepes, a photographer and painter who had known Moholy-Nagy since their days together in Berlin, was hired to lead the Light Workshop. When he was delayed in getting to the States, however, the class was begun by his assistant Henry Holmes Smith, who had been an active commercial photographer and would go on to teach photography for decades.

Although photography was not taught as a separate discipline, all students there came into contact with photographic processes and exercises, just as all students participated in the various other workshops. In the Basic Workshop, exercises approached materials and visual problems from the position of experimentation; Moholy-Nagy and his faculty urged students to try new ideas and welcomed unforeseen results. Students began by making tactile charts of

various textures, wooden hand-sculptures intended to feel good in the palm rather than look exciting on a pedestal, and innovative designs in wood and paper that transformed materials from two dimensions into three. The point of all these exercises was to experience the world afresh, as a child would. Similarly, the Light Workshop approached photography as a step-by-step process in which students would come to understand intimately the principles of photography and especially of light.

Light workshop exercises began with the photogram, a cameraless picture made by placing an object or casting shadows directly onto a piece of photographic paper while exposing it to light. Moholy-Nagy and Kepes believed it was the key to all photography, because it revealed the photographic paper's infinite range of tones and its essential sensitivity to light. From a practical point of view, the photogram required no cameras or equipment (no small help in a time of limited funds) and got students into the darkroom right away for processing skills. Students then progressed to light modulators, in which they manipulated white pieces of paper to reveal the play of light and tonal gradations over the paper's varied surfaces; students were encouraged to see the world itself as a light modulator and understand photographic subject matter in terms of gradations of black, white, and gray. Eventually, they would work with multiple exposures and superimposed images; negative prints and solarization; prisms and mirrors to explore reflection, refraction, and distortion; and "virtual volume," in which an object such as a string or wire produced the appearance of a three-dimensional volume when spun around during a lengthy exposure. Nathan Lerner pioneered the "light box," a controlled environment in which the effect of light on various objects could be studied, and other students began working with this technique as well. Most of the photographs of this early period are characterized by the intense exploration of the properties of photography in careful studio set-ups, and by the application of these discoveries to portraiture and still-lifes.

The New Bauhaus lasted only one year. Because of financial difficulties and apparent philosophical conflicts, the Association of Arts and Industries elected not to re-open the school in the fall of 1938. This did not deter Moholy-Nagy and his faculty and students, however, and a new school, The School of Design in Chicago, opened in February 1939 at 247 East Ontario Street, in an abandoned bakery below the old "Chez Paree" nightclub. Moholy-Nagy convinced the faculty initially to teach for free, subsidizing the school with his own earnings and with the support of the enlightened arts patron Walter Paepcke, president of the Container Corporation of America and later founder of the Aspen Institute. Many of the students from the New Bauhaus enrolled. Henry Holmes Smith had left the program when the school did not re-open, but Kepes continued to lead the Light Workshop, now assisted by student Nathan Lerner as well as technicians Leonard Nederkorn and Frank Levstik. Other photographers who would teach at the School of Design on a full- or part-time basis included James Hamilton Brown, William Keck, Edward Rinker, and Frank Sokolik.

The curriculum that had been innovated in the New Bauhaus was carried over to the School of Design, and while students did not specialize in photography, all students came into contact with it. (Some, like Homer Page and Milton Halberstadt, who enrolled in fall 1940, would go on to careers as photographers.) Photography still began with the basics of photograms and light modulators and progressed through various forms of experimentation. As more practicing and commercial photographers taught classes, however, photography also began to move slowly out of doors, and students conducted exercises in such formal qualities as texture and repeating forms. During this time Moholy-Nagy and Kepes also publicized their special photographic pedagogy in articles in *Popular Photography* such as "Making Photographs without a Camera" (Moholy 1939) and "Modern Design! With Light and Camera" (Kepes 1942); Kepes and Lerner also collaborated on an entry on "The Creative Use of Light" in the *Encyclopedia of the Arts*. In the summer of 1940, the school held a special summer session at Mills College in Oakland, California, in which most of the faculty participated and which attracted numerous new students to the school. In 1941, a traveling exhibit of photographs by students and faculty of the school called *How to Make a Photogram*, designed by Moholy-Nagy, Kepes, and Lerner and circulated by the Museum of Modern Art, New York, began a six-year tour of schools and museums and gave the school's photographic program further publicity.

In 1944, the school changed its name once again, to the Institute of Design, and gained college accreditation. With the waning of World War II and the introduction of the G.I. Bill, more and more students attended the school, and increasingly, they were interested in photography. Moholy-Nagy began offering special photography courses to veterans, and by the spring of 1945, 20 students were enrolled in night photography classes and eight in the specialized course. That fall, the school moved to 1009 N. State Street, and enrollment swelled to nearly 500.

(The school moved once again in the fall of 1946, to 632 N. Dearborn, where it remained for nine years.) Needing more faculty, and realizing the potential of the photography program, Moholy-Nagy hired Arthur Siegel in 1946 to begin a four-year photography course (Kepes had left the school in 1943). To inaugurate the new program, Siegel organized a six-week seminar in photography in the summer of 1946. "The New Vision in Photography" featured the country's top photographers and curators, including Berenice Abbott, Erwin Blumenfeld, Gordon Coster, Beaumont Newhall, Ed Rosskam, Frank Scherschel, Paul Strand, Roy Stryker, and Weegee. With workshops, slide presentations, lectures, and films, the symposium revealed the state of the field and helped put the Institute of Design on the cultural map. Where photography had once been an integral part of the design curriculum, now it was being recognized as having its own history and practices.

Sadly, Moholy-Nagy would not remain to shepherd the school through this major change; the previous year, he had been diagnosed with leukemia, and he died on November 24, 1946. But the school he founded would live on to have an enormous impact on photography in the United States. Already, the Institute of Design had revolutionized the way photography was taught and practiced in very important ways: photography was acknowledged as an essential component of modern vision; it was part of an education that involved all the arts and strove to shape the whole person; it was understood as part of a study of light and its properties; and it was taught experimentally, with a hands-on, Bauhaus workshop approach. Furthermore, the school introduced the European avant-garde to Chicago, effectively changing the geography of photography in America; photography previously had been dominated by artists in New York and the San Francisco Bay Area, but henceforth Chicago would also be recognized as one of the important American centers of photography.

The Institute of Design, 1946–1961: Callahan, Siskind, and the Shift Toward Individual Expression

The year 1946 marked a significant shift for photography at the Institute of Design, as it separated thoroughly from the design program and began its own specialized course of instruction, one that would eventually be marked by an individual subjectivity and a sense of personal expression. Not only had Moholy-Nagy, the school's founder and link to the European Bauhaus, died, but the nascent program veered away from the study of photography as pure experimentalism. The new head of photography, Arthur Siegel, had attended the New Bauhaus in its first year, but had gained most of his photographic experience working for government organizations; he would later freelance for the premiere American picture magazines and do commercial work. His contacts were more professional than avant-garde, and his outlook more practical than theoretical. Well read and acerbic, Siegel was a charismatic teacher with very strong opinions. Perhaps his most lasting contribution to the school was his teaching of the history of photography; his introduction of the class helped ensure that photography there became understood as a separate discipline with its own unique past.

Siegel immediately hired his friend Harry Callahan, whom he had met in Detroit. An avid, largely self-taught photographer, Callahan had only been making pictures for a few years and had no teaching experience, but he proved to be the perfect fit for the new direction the Institute of Design was taking. Callahan was the model of a working photographer, making pictures every day regardless of mood or inspiration. His try-anything approach to formalism encompassed multiple-exposure, extreme contrast, and "light drawing" with lengthy exposure, as well as straight-on architectural photography, portraiture, and still-lifes of weeds and grasses. During his time at the school, Callahan worked on some of his most well-known series, such as 8×10 "snapshot" portraits of his wife Eleanor and daughter Barbara, pictures of women on the street lost in thought, weeds against the snow, and Chicago facades. Callahan's combination of experimentalism and humanism had impressed Moholy-Nagy, who had approved his hiring in the summer of 1946, and it would later be the primary influence upon numerous students.

Callahan embraced the existing photographic exercises he was handed as part of the photography curriculum, and added several of his own. Still beginning with photograms and light modulators, he moved on to documentary problems, such as having students photograph people on the street after talking to them, and the "evidence of man" assignment (photographing humanness without actually showing people); technical issues, such as the 90% sky problem, which taught students how to get a clean negative, and "near and far," a focus problem; and formal issues, such as sequences or street numbers or the alphabet as found out in the world. As curious as any student, he would often go out and try the problem himself as soon as he had assigned it. In contrast to Siegel, Callahan was taciturn and sometimes inarticulate as a teacher;

his method was to teach by example, and with very few, well-chosen words.

As some of the original faculty, like Frank Levstik and Frank Sokolik, departed in the late 1940s, Callahan and Siegel filled their posts with a variety of part-time teachers. Gordon Coster, Ferenc Berko, and Wayne Miller all taught at the school during this period, and were especially valued for their documentary experience and classes. Students increasingly were taking their cameras out into the city, away from the studio and its controlled experimentation, and found Chicago rich in subject matter; student pictures from this period often focus on children, local architecture, and street scenes. One of the first four-year photography students in 1946 was Art Sinsabaugh, who graduated from the program in 1949; upon graduation, he was hired by Callahan to teach, and eventually ran the evening photography program through 1959. His early reticulated and solarized pictures, then still typical of ID student work, could not have predicted his later long, narrow prairie landscapes made with a banquet camera. Another student of Callahan's was Yasuhiro Ishimoto, who attended from 1948 to 1952. Although Callahan did not show his own photographs to students at that point, his influence was profound, and can still be felt in Ishimoto's compassionate portraits of children on Maxwell Street or pictures of cars in snow.

In 1949, two important changes occurred: Siegel resigned from the faculty at the Institute of Design, leaving Callahan to become the head of the photography department, and the ID, ever short of funds and needing greater support, merged with the Illinois Institute of Technology. In merging with IIT, the ID gained institutional backing but lost some of its independence. Although Siegel would return to teach sporadically throughout the 1950s, his absence was felt, and Callahan knew he needed another strong personality to help him direct the photography program. He made an inspired choice, one that would mark the beginning of a teaching team so complementary and influential as to be legendary in photographic education: in 1951, he hired Aaron Siskind.

At the time, Siskind was living in New York, where he had gained a significant reputation in art circles as a photographer. Originally a teacher—he taught English for 21 years in New York's public schools—he had only recently taken up photography full-time, and was trying to find a way to support himself and continue his photographic career. He was also a close associate of the Abstract Expressionists, and often exhibited with them; his photographs of painted and graf-

fiti-covered walls shared a similar two-dimensional formalism. The wall pictures were something of a departure for Siskind, however, whose initial interest in photography had been directed toward his political activism. Throughout the 1930s, he had been a member of the leftist Film and Photo League, where he oversaw group documentary projects such as "Portrait of a Tenement" and "Harlem Document." In Chicago, he continued his work on painted and graffiti-covered walls, and documented Chicago's architecture and urban facades as well as leading students in more socially-oriented projects. One of his most memorable series from the period is "Pleasures and Terrors of Levitation," an extensive series of divers at the Oak Street Beach, their figures silhouetted against the white sky like a new alphabet.

Siskind was in many ways Callahan's opposite: where Callahan was shy and found teaching at times agonizing, Siskind was a natural teacher, his years in the city schools having accustomed him to speaking in front of a group. Callahan remained devoted to his wife, Eleanor, throughout his life, whereas Siskind married several times and was a notorious womanizer. Callahan was quiet but centered, Siskind gregarious and outspoken. Somehow, though, the two formed an extremely compatible and effective team, and students recall them as almost a single entity. (Although there were other photography teachers sporadically at the ID in the 1950s—among them, Lyle Mayer, Keld Helmer-Peterson, Arthur Siegel, and, when Callahan was on leave in France during the 1957–1958 academic year, Frederick Sommer—Callahan and Siskind were the leaders of the program.) Callahan gravitated toward the beginning students, teaching them the foundation problems, and Siskind gradually took on the more advanced students, guiding their individual projects. When the graduate program began, both men met with the students to advise them on their master's theses.

Together Callahan and Siskind shaped the new undergraduate curriculum. Callahan increasingly emphasized working in series, so students could follow an idea in a sustained manner; this would eventually lead to the master's thesis. Siskind developed some new assignments to add to the evolving batch from the school's early days. The "copy problem," in which students attempted to duplicate exactly the tones of another print, taught technical skills, while his "significant form" problem sent students to Chicago's conservatories to photograph plants in distilled form. But it was Siskind's experience on group documentary projects that would have some of the most impact in the 1950s.

He began leading collaborative student projects to photograph local public housing developments, the elderly, and an extended record of the buildings of Louis Sullivan. "The Sullivan Project," as the latter came to be known, began in the fall of 1952, and involved students such as Len Gittleman and Richard Nickel. The students documented Sullivan buildings throughout Chicago and the Midwest, exhibited the photographs, and planned to publish a book; although the book never happened, Nickel made the project the subject of his 1957 master's thesis and worked to preserve the buildings. In 1956, Callahan and Siskind outlined the undergraduate curriculum in an article in *Aperture* called "Learning Photography at the Institute of Design." They described the course of study over four years, from undertaking the foundation course, then clarifying technique, then experiencing the photographic disciplines or traditions (such as portraiture, journalism, architecture, and so on), and finally engaging in a planned project. Their goal, as they stated it, was "from within the framework of a broad professional education to open an individual way." This was the beginning of a marked departure for photography at the Institute of Design; it became at once more vocational and more personally expressive.

In the spring of 1950, a few students had approached Callahan asking to continue on in a graduate capacity, but the school offered no further study in photography. Callahan convinced IIT to allow a graduate degree, and, later with Siskind, guided the students in producing a concentrated series, or body of work. In 1952, the first Master's of Science degrees in photography were granted to Marvin Newman, Jordan Bernstein, and Floyd Dunphey; Newman's thesis was an exploration of the series form itself. The thesis project became the model for future graduate study at the ID, and indeed for advanced photographic inquiry throughout the country. Many students would go on to conduct sustained photographic projects and received master's degrees at the Institute of Design, and many of these would institute similar programs in schools across the United States.

Some key events in the late 1950s shaped the way the ID's photographic program evolved. In 1955, the school selected a new director, Jay Doblin; that same year, it moved from Dearborn Avenue on the north side to Crown Hall, on IIT's south-side campus. Doblin, a commercial designer whose appointment was protested by most of the faculty and students because of his business orientation, had little interest in artistic photography. At the same time, however, he allowed the small program to continue without much interference from the administration, and this relative isolation provided Callahan and Siskind with a great deal of freedom. The move to Crown Hall physically integrated the ID with IIT but removed the school from the city's center of activity. The photography program also began to gain some a national reputation through the stature of Callahan and Siskind as well as such publications as their *Aperture* essay; *The Student Independent*, a 1957 student-produced portfolio in an edition of nearly 500; and the ID's first book, *The Multiple Image: Photographs by Harry Callahan*, published in 1961.

In 1961, *Aperture* also published an issue devoted to the graduate photography program at the ID, with an introduction by Arthur Siegel and featuring the thesis photographs of Joseph Jachna, Kenneth Josephson, Ray K. Metzker, Joseph Sterling, and Charles Swedlund. Among the top students in the program, all five would go on to successful photographic and teaching careers. Jachna explored water in his thesis, while Josephson studied the multiple image in different forms, Metzker documented Chicago's Loop, Sterling focused in on the American teenager, and Swedlund presented an experimental approach to the nude. Although quite different in subject matter and approach, all shared a certain ID style—contrasty black and white and based in a graphic sensibility—and a goal of personal expression through sustained inquiry. In a shift away from Moholy's original idea of photography as part of an integrated curriculum, it had now become a separate discipline, and experimentation was now put to the service of picture-making. The most important change at—and contribution of—the ID in this period was the emphasis on individuality and subjectivity in photography, and the development of the series and body of work. More change would occur in the 1960s, with the departure of Harry Callahan and a changing academic and political climate.

The Institute of Design, 1961–1978: The Siskind and Siegel Years

In 1961, Callahan left the Institute of Design to join the faculty at the Rhode Island School of Design, and Siskind became the head of the Photography Department. During the 1960s and into the 1970s, there were many important changes at the school. An increasingly large number of students joined the graduate program and earned master's degrees in this period, and the photography program, under Siskind's leadership and eventually that of Arthur

Siegel, grew more and more independent from ID and IIT. Both the artistic and political climate changed dramatically during these years, and had their effect on photographic practice at the school. And it was during this period that students were trained in large numbers to become photography teachers, directing photographic programs at new and established institutions across the country and propagating an ID philosophy and pedagogy to new generations of students.

Siskind was the primary draw for students who came to study at the ID in the 1960s. Although he was assisted by former student Joseph Jachna, who taught from 1961 to 1969, and various other teachers for much shorter periods—Reginald Heron, Frederick Sommer, Wynn Bullock, Joseph Sterling, Charles Swedlund, and Ken Biasco—he more or less embodied the program. Classes consisted of seminars and critiques in which students presented their thesis work to Siskind, and additional meetings were as likely to be at a student-faculty party as in a classroom. The ID and IIT administration allowed the program a great deal of independence, and photography became increasingly isolated from the other departments at the school. But although the focus was now on the graduate thesis project, students still began with the foundation as initiated by Moholy-Nagy and modified by Callahan and Siskind.

The 1960s witnessed the rise of environmentalism, free love, hallucinogenic drugs, and the anti-war and civil rights movements. The times were manifested photographically in a renewed interest in photographic landscapes, nudes, psychedelic experimentation, and politically grounded documentary photographs. ID students were affected by the times in varying degrees, but it is clear that photography there, as around the country, began to look different from that of the preceding generation. At the ID, students began to move beyond the solitary frame, using such techniques as collage or inserting photographs in their photographs, printing entire strips of film as a single image, and uniting two or more frames or negatives into a joined picture. The nude (both male and female) became a subject of intense exploration, a screen upon which different experimental techniques were projected. Students increasingly inserted themselves into the photograph, bypassing a detached abstraction or documentation in favor of a more self-conscious approach to photography. A select list of the almost 50 photographers receiving master's degrees in the 1960s includes Barbara Crane, Reginald Heron, and Thomas Porett (1966); Thomas Barrow, Kurt Heyl, Thomas Knudtson, William Larson, Art Sin-

sabaugh, and Judith Steinhauser (1967); Rosalyn Banish, Barbara Blondeau, Keith Smith, and Geoffrey Winningham (1968); and Kenneth Biasco and Linda Connor (1969). Their thesis projects followed, in reach and scope, the standard laid out in the 1950s: sustained investigations of a particular topic or technique, they originated from the foundation course assignments and expanded upon them with individual vision.

Siskind was retired by the school in 1970, and returned to teach classes in 1971 before joining Callahan at the Rhode Island School of Design. Four years before his departure, however, he had rehired Arthur Siegel to help teach the graduates, and Siegel once again became head of the photography program in 1971, where he remained until his death in 1978. With his training as a student at the New Bauhaus in 1938, experience founding the photography department in 1946, and commitment to teaching there sporadically throughout the 1950s, Siegel was the last remaining link to Moholy-Nagy's program. As irascible and brilliant as ever, he was also the last in a line of charismatic photography teachers. Other faculty and visiting lecturers taught photography for short periods at the school in the 1970s, and included Patricia Carroll, Alan Cohen, Jonas Dovydenas, John Grimes, Arthur Lazar, David Phillips, David Plowden, David Rathbun, Alex Sweetman, and Garry Winogrand (whose small-format, edgy street photography would have a lasting effect on student work).

The 1970s witnessed a massive rise in graduate enrollment, with over 80 master's degrees awarded. A necessarily incomplete list would include Barry Burlison, Eileen Cowin, Antonio Fernandez, Elaine O'Neil, Judith Ross, and Robert Stiegler (1970); Calvin Kowal, Esther Parada, Lynn Sloan, and Warren Wheeler (1971); Douglas Baz, Patricia Carroll, Alan Cohen, Francois Deschamps, and Charles Traub (1972); Andrew Eskind and James Newberry (1973); David Avison, John Grimes, and Lewis Kostiner (1974); and many others in the second half of the decade. A notable change was the rise of cinematography and animation, both of which were attracting students in schools across the country. Cinema, long a favorite medium of Moholy-Nagy, had been an active part of the photography program since as early as 1942, and many students and teachers had made films independently or as part of a class during the 1950s and 1960s. In the late 1960s, students began to earn degrees with thesis projects in cinematography, and after 1971, cinema became separate from still photography. Under teachers such as Larry Janiak, students produced short, experimental, and

documentary films that emerged from their solid foundation in photography.

One of the most striking phenomena during this period was the impact the Institute of Design had on graduate photographic education nationwide. As the country began to devote more funds and efforts toward higher education in the 1960s and 1970s, new colleges began to sprout up and old ones expanded their art departments. The ID, at this time, was one of the few institutions to train photography teachers, and an extraordinary number of its graduates went on to head or found photographic programs. In the process, the ID's graduates exported its unique pedagogy: problem-based learning, with emphasis on a significant body of work, rooted in the European avant-garde and tempered by American individual subjectivity.

After Siegel died in 1978, the school's last link to the New Bauhaus was gone. By then, the ID was already heading in some different directions, away from the kind of photography that had been practiced for its first four decades. Film and animation were eventually cut from the curriculum, and, under the direction of John Grimes, the school began early on to investigate digital technologies. Grimes hired such teachers as David Plowden, Patty Carroll, and Jay Wolke to continue the instruction of photography, and after 1985, the two possible areas for specialization became computer imaging and documentary photography. The graduate program continued through the early 1990s, but the undergraduate program in photography was eliminated in 1994, and the concomitant loss of faculty eventually shrank the master's program as well; the last strictly photographic theses were completed in 2001. Photography has now been absorbed, as a tool of visual communications, into the graduate design program as a whole—in a way, returning the school and the program to Moholy-Nagy's original goals of a more integrated education.

ELIZABETH SIEGEL

See also: **Abbott, Berenice; Architectural Photography; Bauhaus; Blumenfeld, Erwin; Callahan, Harry; Connor, Linda; Digital Photography; Documentary Photography; Industrial Photography; Ishimoto, Yasuhiro; Josephson, Kenneth; Manipulation; Modernism; Moholy-Nagy, László; Multiple Exposures and Printing; Museum of Modern Art; Newhall, Beaumont, Plowden, David; Nude Photography; Photogram; Sandwiched Negatives; Siskind, Aaron; Solarization; Sommer, Frederick; Strand, Paul; Street Photography; Stryker, Roy; Winogrand, Garry**

Further Reading

Banning, Jack, Adam Boxer, et al. *The New Bauhaus School of Design in Chicago: Photographs 1937–1944.* New York: Banning & Associates, 1973.

Daiter, Stephen. *Light and Vision: Photography at the School of Design in Chicago, 1937–1952.* Chicago: Stephen Daiter Photography, 1994.

Findeli, Alain. *Le Bauhaus de Chicago: L'œuvre pédagogique de László Moholy-Nagy.* Sillery, Québec: Editions du Septentrion, 1995.

Grimes, John. "The Role of the Institute of Design in Chicago." *Photographies* (Paris) 3 (December 1983).

Grundberg, Andy. "Photography: Chicago, Moholy and After." *Art in America* 63 (September 1976).

Hahn, Peter, and Lloyd Engelbrecht, eds. *50 Jahre Neue Bauhaus Nachfolge: New Bauhaus in Chicago.* Berlin: Argon, 1987.

Pohlad, Mark B.,"A Photographic Summit in the Windy City: The Institute of Design's 1946 'New Vision in Photography' Seminar." *History of Photography* 24, no. 2 (Summer 2000).

Rice, Leland D. and David W. Steadman, eds. *Photographs of Moholy-Nagy from the Collection of William Larson.* Claremont, CA: The Galleries of the Claremont Colleges, 1975.

Selz, Peter. "Modernism Comes to Chicago." In *Art in Chicago, 1945–1995,* London and New York: Thames and Hudson, 1996.

Solomon-Godeau, Abigail. "Armed Vision Disarmed: Radical Formalism from Weapon to Style." *Afterimage* 19 (January 1983).

Traub, Charles, and John Grimes. *The New Vision: Forty Years of Photography at the Institute of Design.* Millerton, NY: Aperture, 1982.

Travis, David, and Elizabeth Siegel, eds. *Taken By Design: Photographs from the Institute of Design, 1937–1971.* Chicago: The Art Institute of Chicago, 2002.

Wingler, Hans M. *The Bauhaus: Weimar, Dessau, Berlin, Chicago.* Translated by Wolfgang Jabs and Basil Gilbert, Cambridge, MA: MIT Press, 1969.

THE INTERNET AND PHOTOGRAPHY

In the last years of the twentieth century, the proliferation of digital photographic technologies converged with rapidly expanding access to the global networking of computers. The result, for both professional and amateur photographers, is a transformed medium whose online component has encompassed, merged, expanded, and altered previous practices. Sending photographs at electronic speed has become commonplace. Photography's past as well as its present output has been scanned into the system, producing an unprecedented number of images for scholarly, personal, and commercial use. Museums, galleries, and photography festivals now display their collections to global audiences. Photojournalism in online newspapers and magazines has the currency of broadcast news while offering a range of display options impossible to achieve in print. Camera stores, film-processing labs, and photo pornographers have set up shop in the virtual world. Thousands of websites provide both professional and amateur commentary on the descriptive, historical, interpretive, and technical aspects of the medium.

Online photography is the product of a second stage in the development of computer connectivity. The first stage, the founding of the internet, began with a proposal made by the Rand Corporation in 1962 to find a means of linking military computers. It was only in 1969 that four computers were able to "talk" to each other. What we now call the internet is a product of the Transmission Control Protocol/Internet Protocol (TCP/IP) established in 1983. The Protocol allowed for the connection of an infinite number of computers in a global network, each identified by its Internet Protocol (IP) number. While creators of the internet saw it as having limited academic, business, or military applications, its origins coincided with the advent of desktop computing. As a result, the 1,000 computers linked to the internet by the end of 1984 grew to an estimated 1 million interconnected machines in 1992.

The second stage of computer connectivity was marked by the invention of the World Wide Web by Timothy Berners-Lee in 1991. The web operates within the internet to link informational "sites" rather than physical computers. It was made far more useful in 1993, when a University of Illinois student, Marc Andreesen, released Mosaic, the first web browser. Mosaic, which would later become Netscape, allowed users to find websites on the basis of the information within them, sparking a second growth spurt in computer connectivity. The number of sites grew from 600 in 1993 to 1 million in 1997. At the end of 2004, it was estimated that there were more than 20 million sites on the web accessible to more than 900 million people.

While the internet in its first decade was used largely for the transmission of text (e.g., email), both the worldwide web and the browsers designed for it could accommodate images. At first, these images were provided by industrial scanning equipment and could only be housed within relatively large servers. Access to images, given the computer and modem speeds of the day, was frustratingly slow. But the exponential increases in computer speed and memory and the introduction of broadband connections during the 1990s provided an incentive for an increasing number of images on the web. Conversely, the growing availability of images inspired consumers to buy ever faster computers with ever larger memories and to connect them to ever faster online services.

The startling improvements in computer speed, capacity, and connectivity were complemented by the advent of the digital camera. Digital imaging techniques had been developed by NASA and a number of independent laboratories (e.g., the Image Processing Institute at the University of Southern California) as early as the 1960s. But it wasn't until 1990 that Kodak proposed the current set of standards for digital photography. The following year, Kodak sold the first digital camera to be manufactured according to those standards, a Nikon F-3 equipped with a 1.3 megapixel sensor. From 1994–1996, consumer digital cameras, designed for interface with a home computer, were marketed by Apple, Kodak, Casio, and Sony. Like computers, the capacity of digital cameras increased rapidly, while their price fell, and by the end of the 1990s, peripherals such as scanners and photo printers also became available to home consumers.

Half a decade after the convergence of digital photography and online technologies, photography itself is the subject of websites dedicated to a wide variety of activities pertaining to the medium. Local

photographers and photo supply shops have their own websites while many of the major photographic companies maintain elaborate sites dedicated to their products and their history. Personal websites offer family photographs, amateur art photography, and self-styled commentary on the technology and aesthetics of the medium. Chatrooms and newsgroups, maintained by internet service providers, offer discussions of the medium and its specialized components. Students of photography may find a variety of photography courses, ranging from collections of tips from self-styled experts to university-based curricula. Established photography journals such as *The British Journal of Photography*, the American *Popular Photography*, and the French *ReVue Photography* offer online editions. Entirely online "zines," like *Online Photography*, and *Digital Photography and Imaging International* offer news and how-to articles, as well as links to the work of lesser-known photographers.

As photography-oriented websites grew in number and diverged wildly in quality, photography enthusiasts began posting lists of what they had found to be the most worthy links. One of the first of these "portal" sites, *Bengt's Photo Page*, was created in Sweden by Bengt Hallinger in 1996. As of this writing, it continues to offer a vast number of links to online photo exhibitions, digests, how-to articles, magazines, user groups, and a set of links to digital photography news groups. Charles Daney's *Photography Pages* provides a slightly different though no less extensive selection of links. *Still Journal* provides articles and reviews and a "portal to the art, technique, history and culture of photography."

Amateur photography websites proliferate, especially those of local camera and photography clubs. Vernacular uses take many forms, including the "Are You Hot" website, wherein an individual can post a photo, presumably his or her own, and be evaluated by others. Professional organizations, such as the Society for Photographic Education, feature extensive and informative websites to communicate with their members.

Photojournalists, who were among the pioneers in the use of digital cameras, have continually expanded the uses to which internet photography has been put. Digital images are instantly transmitted worldwide to editors who have an unprecedented range of options in editing and presenting them. Newspaper and magazine websites offer photo essays, often with voice-over commentary as well as photo galleries that contain collections of images not shown in the print edition or held over well beyond its run. One of the first uses of these galleries came with the death of Princess Diana in 1997—though by the turn of the century, this practice had become a standard item on the websites of most major publications. The events of September 11, 2001, depicted in extensive archival sites in journals worldwide, created photographic coverage of a single event unprecedented in terms of the number of posted images and their accessibility.

Traditional photo agencies, such as Magnum Photos or Alinari, moved quickly into the digital age, developing detailed sites for interested individuals, professional researchers, and commercial visitors.

The internet and world wide web also facilitated sales of archival photographs, providing an impetus for the creation of ever larger and more accessible photo archives. Among the largest of these commercial archives is TimePix (with archival images from *Time, Life, People, Fortune,* and *Sports Illustrated* as well as the million-image Mansell collection). Other online suppliers of archival images include WireImage, PhotoDisc, and Microsoft's digital photography company, Corbis which, in 1995, purchased the Bettmann Archive's 17 million images to achieve a collection of some 70 million photographs. Many of the larger circulation newspapers and magazine have online "stores" marketing their own photo archives.

With the spread of the internet as an educational tool, other photography collections make samples of their holdings and their exhibitions available online for research and teaching purposes. George Eastman House and the Library of Congress have been leaders in this practice, the Library currently offering over 300,000 of its 5 million images accessible online. Other institutions, such as the International Museum of Photography, the New York Public Library, the University of California at Riverdale Museum of Photography, and Museé de l'Elysée Lausanne Museum provide a diverse selection of historical photographs and current exhibitions. Local and regional archives also make use of the internet, either individually or collectively, as exemplified by sites such as *British Columbia Historical Photographs Online*. The internet has also spawned its own, entirely online photography museums. One of the earliest and most extensive is the *American Museum of Photography*, founded by William B. Becker in 1996 based on his personal 5,000-image collection of historical photographs.

In addition to these general collections, the history of photography is well served by a number of additional online resources. Among these are Robert Leggat's *History of Photography* site, founded in 1997 as an overview of the subject and, of course, *PhotoHistorians*, a site maintained by Professor

William Allen at Arkansas State University with hypertext links to hundreds of individuals interested in the history of the medium. Professor Andrew Davidhazy at the Rochester Institute of Technology posts a site with links to the many areas of photography history in which he has an interest. The *Midley History of Photography* site is a collection of articles and unpublished materials by R.D. Wood on the history of early photography. Early photography is also well documented, including sites maintained by *Maison Nicéphore Niépce, The First Photograph* site posted by the Harry Ransom Research Centre of the University of Texas, Austin, and the *Daguerreian Society*. Mike Ware's *Alternative Photography Pages* contains an encyclopedia of historical processes while a single process is covered in exemplary detail on *Stanford University's Albumen* site. Examples of other specialized histories include the late Peter Palmquist's *Women in Photography* site, the extensive *History of Photography in Japan*, and the detailed corporate timeline published by Kodak on its website. Organizations such as The Royal Photographic Society, The Photographic Historical Society of Rochester, New York, and la Société française de photographie provide useful portals, not only to their own members but also to other photography organizations.

Specialized interests in photography are also well served by the internet. Virtually any genre in photography can be quickly accessed through formal or informal groups' postings on the web. Sites for architectural photography, aerial and panoramic photography, glamour and fashion photography, and industrial photography are particularly prominent.

As it has evolved into a marketing tool, the internet has also become a primary means for the buying, selling, and trading of antique cameras, both in the large auction sites such as eBay and in more specialized sites. The German site, *Classic Cameras*, provides an introduction to the development of the camera along with worldwide links to individuals buying, selling, and trading old cameras. Two other sites also offer this latter function as well as links to other classic camera sites: *The Classic Camera Website* and Don Colucci's *Antique and Classic Camera Website*. A singularly non-commercial escape from the online antique camera world is the virtual tour of *Canon's Camera Museum* in Japan.

In less than a decade, online photography has evolved its own unique forms of photographic exhibition. Fritz Nordengren's site, *Behind the Viewfinder—A Year in the Life of Photojournalism*, is an exchange of work and ideas by ten diverse photojournalists who, along with Nordengren, engaged in a very public communication beginning in January of 1998. Sites like *Photo.net* and *Qiang Li's Photo Critique Forum*, in addition to offering familiar commercial portal links, offer a forum whereby individuals critique one another's photographs.

Finding photographic images on the internet became increasingly easy, as most search engines, notably Google, created special image-only searches. Searches turn up both fine arts photographs and any number of amateur postings, creating unique "virtual galleries" with every search.

The sum total of the services made possible by the convergence between photography and the internet has yielded a profound change in how the visual world is accessed by that one sixth of the world's people with access to the internet. It's clear that online photography has contributed to the so-called digital divide, the growing difference in informational access between that one sixth of the population and the five sixths without computer access. The computer has become a kind of gatekeeper for social inclusion, and it will likely be the work of the twenty-first century to first determine and then moderate the computer's shaping of the visible world.

RENATE WICKENS

See also: **Archives; Camera: Digital; Corbis/Bettmann; Digital Photography; Life Magazine; Professional Organizations**

Further Reading

Berners-Lee, Tim. *Weaving the Web: The Original Design and Ultimate Destiny of the World Wide Web*. San Francisco: Harper, 1999.

Druckrey, Timothy, ed. *Electronic Culture: Technology and Visual Representation*. New York: Aperture, 1996.

Howard, Philip N., and Steve Jones, eds. *Society Online: The Internet in Context*. Thousand Oaks, California: Sage Press, 2004.

Kember, Suan. *Virtual Anxiety: Photography, New Technologies and Subjectivity*. Manchester, New York: University of Manchester Press, 1998.

Lister, Martin, ed. *The Photographic Image in Digital Culture*. London: Routledge, 1995.

Mitchell, William J. *The Reconfigured Eye: Visual Truth in the Post-Photographic Era*. Cambridge, Mass: MIT Press, 1992.

Warschauer, Mark. *Technology and Social Inclusion: Rethinking the Digital Divide*. Cambridge, Mass: MIT Press, 2003.

Whittaker, Jason. *The Cyberspace Handbook*. London: Routledge, 2004.

Websites

(Accessed December, 2004)
Albumen *http://albumen.stanford.edu/*

INTERPRETATION

To interpret a photograph is to make sense of it for oneself and to learn what it means to others. For many viewers, photographs seem to be transparent, obvious, like looking at actual persons, things, and events in the world, and in little need of interpretation as images. Because photographs are made from light reflecting off of people, places, and objects in the world, they have attributes of what C. S. Peirce called "indexical" qualities. The photographic sign is caused by what it signifies, or in Roland Barthes's definition, a photograph is "that which has been." Thus, given this causal connection to reality and an inherited Renaissance style of realistic depiction, people often view snapshots, news photographs, advertising images, and art photographs as transcriptions of reality rather than as opinionated and influential constructs bearing situated knowledge and invested expressions. Photographs are factual, fictional, and metaphorical, and need to be interpreted. The interpretation of art, for Arthur Danto, entails seeing the work as being about something, projecting a point of view by rhetorical means, requiring interpretation within a cultural context.

In Ernst Gombrich's and Nelson Goodman's view, there is no innocent eye, and by implication, no innocent camera, or viewer. According to Goodman,

the eye functions not as an instrument self-powered and alone, but as a dutiful member of a complex and capricious organism. Not only how but what it sees is regulated by need and prejudice. It selects, rejects, organizes, discriminates, associates, classifies, analyzes,

constructs. It does not so much mirror as take and make; and what it takes and makes it sees not bare, as items without attributes, but as things, as food, as people, as enemies, as stars, as weapons.

(Goodman 1976)

An interpretation of a photograph is a thoughtful response in language to its subject matter, medium, form, and the context in which it was made and in which it is seen. Interpretations, like photographs, are constructs. When we interpret we do not merely report meaning, we build it and then report it; interpretation is a process of discovery and invention.

To interpret is to make meaningful connections between what we see and experience in a photograph and what else we have seen and experienced. Richard Rorty says that "reading texts is a matter of reading them in the light of other texts, people, obsessions, bits of information, or what have you, and then seeing what happens." Jonathan Culler prods interpreters to

> ask about what the text does and how: how it relates to other texts and to other practices; what it conceals or represses; what it advances or is complicitous with. Many of the most interesting forms of modern criticism ask not what the work has in mind but what it forgets, not what it says but what it takes for granted.

To interpret a photograph is to ask and answer such questions as: What is this that I see? How was it made? What is it about? What does it represent or express? What did it mean to its maker? What did it mean to its intended viewer? What is it a part of? What are its references? What is it responding to? Why did it come to be? How was it made? Within what tradition does it belong? Interpretations are built by individuals and shared. Eventually cumulative answers to interpretive questions, offered publicly by informed interpreters, most often art historians, critics, curator, and photographers themselves, are received as conventional understandings that are generally shared in scholarly venues by a community of like-minded interpreters and then passed on as what are essentially canonical understandings, in short, the accepted view by which subsequent interpretations are made. Such conventional interpretations of photographs are recorded in history of photography courses, encyclopedias, exhibition catalogues, and especially in historical texts.

Socially minded interpretations broaden conventional interpretations by examining the social implications and consequences of images. Allan Sekula, for example, advocates that we "regard art as a mode of human communication, as a discourse anchored in concrete social relations, rather than as a mystified, vaporous, and ahistorical realm of purely affective expression and experience." Socially interpretive questions include answers to these kinds of questions: What ends did the image serve its maker? What purposes, pleasures, or satisfactions did it afford its maker and its owner? Whom does the image address? Whom does it ignore? How is it gendered? What problems does it solve, allay, or cause? What needs does it activate or relieve?

To interpret an image is also to make personal sense of it by asking and answering such questions as: What does this image mean to me? Does it affect my life? Does it change my view of the world? A requirement for an interpretation by some scholars is that it changes one's life. Rorty, in the Pragmatist tradition, argues that there should be no difference between interpreting a work and using it to better one's life: A meaningful interpretation is one that causes one to rearrange one's priorities and to change one's life. In the phenomenological tradition, for Hans Gadamer and Paul Ricoeur, the purpose of interpretation is to make the artwork one's own. Ricoeur asserts that interpretation involves appropriation by which the interpreter makes what is interpreted one's own through the endeavor to make sense of it in the light of his or her personal experience. Because an artwork has an existence of its own, Ricoeur adds the requirement that the work interpreted must be understood as well as appropriated.

Feelings guide interpretations. As Goodman argues, "The work of art is apprehended through the feelings as well as through the senses. Emotional numbness disables here as definitely if not as completely as blindness and deafness." Israel Scheffler negates the false dichotomy between thinking and feeling: "Reading our feelings and reading the work are, in general, virtually inseparable processes....Emotion without cognition is blind, cognition without emotion is vacuous."

Conventional, social, and personal interpretations are not mutually exclusive and ought to correctively enhance one another. A conventional interpretation that ignores social implications of what it interprets is lacking in complexity and relevance. A social interpretation, however, that ignores conventional knowledge of what it interprets risks lack of correspondence to relevant facts of origin. A personal interpretation that is uninformed by conventional knowledge and social insights is most likely too personal to be relevant to what is being interpreted.

As Umberto Eco asserts, texts have rights: All images set limits as to how they can be interpreted. The rights of an image are established in part by

the internal textual coherence of the image that sets itself firmly against any uncontrollable urges of the interpreter for social betterment or personal meaning. Nevertheless, "photographs' rights" are often and seamlessly overridden by the printed words that accompany them, or by the contexts in which they are shown: a Lennart Nilsson photograph made for scientific meaning of an intra-uterine fetus can readily be supplanted by placing it on placards in demonstration for or against abortion rights. In practice, photographs mean through use. Responsible interpretative endeavors can rectify misuses of images.

If one wants a plausible interpretation of a photograph, one cannot just fix on one or two elements of the photograph and forget about the rest of the elements in the image and in its causal environment. There is a range of interpretations any work will allow that is socially constituted by consensual agreement of pertinent practitioners. As Eco asserts, certain readings prove themselves over time to be satisfactory to the relevant community of interpreters. For Eco, "certain interpretations can be recognized as unsuccessful because they are like a mule, that is, they are unable to produce new interpretations or cannot be confronted with the traditions of the previous interpretations."

It is not the goal of interpretation to arrive at a right interpretation, but rather interpretations that are reasonable, informative, convincing, enlightening, satisfying, and that allow interpreters to continue on their own. Contrarily, weak interpretations might simply be inane, far-fetched, unresponsive, unpersuasive, irrelevant, boring, or trivial. Nor is it the goal of interpretation to arrive at a single, cumulative, and comprehensive singular interpretation. Images are not the kinds of things that reduce to singular meanings, and informed interpreters of images are not the kind of responding individuals who are looking for simple, single meanings. There are many different interpretive answers to the different questions interpreters ask. Multiple interpretations are valuable in that they direct a viewer's attention to an aspect of an image that the viewer might not otherwise see and ponder. Good interpretations inspire other interpretations and engender further discourse.

Some interpretations are better than others. Interpretations can be evaluated by criteria of coherence, correspondence, and completeness. Coherence is an external and independent criterion asking that the interpretation make sense in itself, as a text. The criterion of correspondence asks that the interpretive text match what is seen in and known about the image being interpreted. Interpretations ought also to account for all that is included in the image and what contextual knowledge is available about its origins.

Interpretations of an image ought not to rely exclusively on or be limited to what the maker of the image meant the image to mean. As Israel Scheffler argues,

> human creation is always contingent, always experimental, always capable of yielding surprises—not only for others, but for the human creator himself. The product humanly made is never a pure function of creative purpose and foreseeable consequences of the maker's actions. The human maker does not fully own his own product.

Intentionalists, however, believe that an image does have a meaning and the meaning is determined by the maker of the image. A significant limitation of Intentionalism is that it commits one to the view that there is a singular meaning of a work, and a single correct interpretation of it, namely, the maker's meaning.

In opposition to Intentionalists, Conventionalists maintain that meanings that can be reasonably attributed to an image are based on the linguistic, cultural, and artistic conventions at work when the image was made. Nor does it make sense to limit what a photograph might mean based on what its maker says it means. To rely on the artist's intent for an interpretation of an artwork is to put oneself in a passive role as a viewer. Reliance on the artist's intent unwisely removes the responsibility of interpretation from the viewer; it also robs the viewer of the joy of interpretive thinking and the rewards of new insights into images and the world. Thus the maker's intent might play a part in interpretation, but ought not determine a work's meaning.

Interpretations can discourage further interpretations. Karen-Edis Barzman refers to these as "master readings" that have "a dependence on so much erudition that the reader is disarmed and even daunted at the moment of reception, a moment in which asymmetrical power relations between writer and reader are at least implicitly affirmed." Such interpretations position the viewer asymmetrically as a passive recipient of fixed meaning (the interpreter's), harmfully deny the plurality of interpreters, and suffocate thought.

> They presume to read authoritatively for their audiences, universalizing their own situated perceptions, fixing meaning with the stamp of finality, and thus rhetorically denying their readers the possibility of intervening interpretations themselves.

TERRY BARRETT

See also: **Barthes, Roland; Ethics and Photography; Image Theory: Ideology; Photographic "Truth";**

Representation; Sekula, Allan; Social Representation

Further Reading

Barrett, Terry. *Interpreting Art*. New York: McGraw Hill, 2003.

Barthes, Roland. *Camera Lucida*. New York: Hill & Wang, 1981.

Barzman, Karen-Edis. "Beyond the Canon: Feminists, Postmodernism, and the History of Art." *The Journal of Aesthetics and Art Criticism* 52, no. 3 (1994) 330.

Batchen, Geoffrey. *Burning with Desire*. Cambridge: Harvard, 1997.

Bolton, Richard, ed. *The Contest of Meaning*. Cambridge, MA: MIT Press, 1989.

Danto, Arthur. *The Transfiguration of the Commonplace*. Cambridge, MA: Harvard, 1981.

Eco, Umberto, with Richard Rorty, Jonathan Culler, and Christine Brooke-Rose. *Interpretation and Overinterpretation*. Stefan Collini, ed. Cambridge University Press, 1992, 92, 111, 115, 150.

Goodman, Nelson. *Languages of Art*. Cambridge, MA: Hackett, 1976.

Scheffler, Israel. *In Praise of the Cognitive Emotions*. New York: Routledge, 1991, 7.

Sekula, Allan. *Photography Against the Grain*. Halifax: The Press of the Nova Scotia College of Art and Design, 1984, 53.

Wells, Liz, ed. *The Photography Reader*. London: Routledge, 2003.

YASUHIRO ISHIMOTO

American, Japanese

Yasuhiro Ishimoto's work embodies a unique mixture of Japanese, American, and European influences. Born to Japanese parents in San Francisco in 1921, he has worked as a Japanese citizen since 1961, using a number of traditional Japanese themes. As further proof of his impeccable Japanese credentials, he was included in the canonical *Photography and The National Museum of Modern Art, Tokyo 1953–1995* exhibition curated by Masuda Rei at the National Museum of Modern Art, and he was named a Man of Cultural Distinction by the Japanese government in 1997. This belated identification of his work as a part of the modern Japanese photographic tradition has overshadowed the pivotal influence of the Bauhaus in his photographic education and obscured the importance of the formative years that he spent in the United States.

Although born in the United States, Ishimoto returned to Japan at age three with his parents to begin his schooling. Being born in the United States granted him automatic citizenship, and in 1939, when he graduated from high school, he returned to the United States to go to college. He began studies in agriculture at the University of California, but in 1942 his plans were interrupted by the outbreak of World War II. Despite being a citizen, he was interned in Armach, Colorado with other Japanese Americans. Although this forcible confinement could have been traumatic, he claims that, as a young man, he was easily able to endure the fieldwork, and the enforced break in his college studies gave him time for contemplation that he would otherwise have lacked.

At the end of the war, Ishimoto began studies in architecture at Northwestern University, Evanston, Illinois. Soon, however, after reading László Moholy-Nagy's *Vision in Motion*, he transferred to the celebrated photography program at Chicago's Institute of Design. This program had been founded in 1937 by Moholy-Nagy as The New Bauhaus, and, by his death in 1946, it had incorporated many of the same tenets of design faith that the original Bauhaus in Dessau had espoused. Although he was under the tutorship of the inspirational Harry Callahan and supervised by Aaron Siskind, Ishimoto soon developed his own method of working and won the Moholy-Nagy Prize in 1951 and then again in 1952.

After graduating from the Institute of Design in 1952, Ishimoto returned to Japan. His big break came shortly thereafter, when one of his photographs was selected to be part of the monumental 1955 *The Family of Man* exhibition being put together by Edward Steichen at the Museum of Modern Art in New York. The picture, of a young girl loosely tied to a tree in a game of hide-and-seek,

captures an exhilarating childhood moment in which the adult gaze of the audience gets caught between constraint and play, sexuality and innocence. The world tour of *Family of Man* brought his work to a global audience and provided him with the opportunity to publish a 1958 collection of his work in Japan as *Aru Hi Aru Tokoro* (*Someday Somewhere*).

Shortly after the *Family of Man* exhibition, in 1956, Ishimoto married Shigeru, to whom he remains married. The couple returned to Chicago in 1958, living there until 1961 when they moved to Japan, where Ishimoto applied for and received citizenship. While in Chicago, however, Ishimoto had put together two series of pictures that illustrate the three major influences on his work: the city life of Chicago, traditional Japanese art, and the principles of the New Bauhaus.

In the years after his book *Aru Hi Aru Tokoro* won the 1958 New Talent Prize of the Japanese Photography Critics' Association, he compiled two other books: *Chicago, Chicago*, a lyrical portrayal of life in Chicago at the end of the 1950s, and *Katsura*, an architectural anatomy of the seventeenth-century Imperial detached palace (or "Villa") at Katsura. Although the subjects of *Chicago, Chicago* and *Katsura* are quite different from one another, depicting different eras in different countries, Ishimoto drew on the Bauhaus aesthetic in capturing them. On the one hand, Ishimoto presents life in Chicago according to the principles of Moholy-Nagy's *Vision in Motion*, observing and structuring the inner life of his fellow humans through their interactions with the new technology. On the other hand, he presents the Imperial design of the Villa at Katsura as if it were a result of Bauhaus geometrical design theories *avant la lettre*.

Along with Moholy-Nagy, Ishimoto can count Hiroshige, the nineteenth-century painter, and Bashō, the Japanese Haiku poet of the seventeenth century, as major influences. Each of them, in their respective disciplines, was a master of the genre representing each of the customary stations along the Tokkaido—the major road linking the capital at Edo (modern-day Tokyo) to the Emperor in Kyoto. From Hiroshige, he took elegance and an ability to catch a moment in time; and from Bashō, a contemplative delight in tiny details. Rather than coach stops at guest houses along a road, Ishimoto's stations of the Tokkaido are the 29 "JR" station stops between Tokyo and Kyoto on the publicly-owned *Yamanote-sen* of the national Japanese Railway. The poignant pictures in *Yamanote-sen 29* are a further illustration of his ability to grasp a historical design in the context of modern technology.

The same elegance and contemplative regard found in *Yamanote-sen 29* are also found in the sequences of clouds, footprints, and crushed leaves that comprise an increasing proportion of his work in the 1990s. Ishimoto had addressed these subjects earlier in his career, but he has dwelt on them—pushing them to abstraction—even as the patient clarity of his earlier work was helping him become accepted as one of the main talents in twentieth-century Japanese photography. His influence on the younger generation of Japanese photographers and especially on members of the VIVO (Esperanto for "life") group has so far come from this earlier phase. Most notable among the members of that group who were affected by the intimate moments he found in the city were Ikko Narahara, Eikoh Hosoe, and Kukuji Kawada.

Ishimoto continues to take and print photographs. Since before his studies at the Institute of Design he has printed his own pictures, a practice that explains why his gelatin silver prints are never larger than 11×14 inches—the largest size he can print in his darkroom. Along with re-envisioning his classic series in his 1983 color pictures of the Katsura palace, or his collection *Chicago, Chicago 2* of the same year, Ishimoto re-investigates his old negatives, allowing him to rediscover his former triumphs and fashion new insights from them.

DAN FRIEDMAN

See also: **Bauhaus; Callahan, Harry; Institute of Design; Moholy-Nagy, László; Photography in Japan; Photography in the United States: the Midwest; Siskind, Aaron**

Biography

Born in San Francisco, 14 June 1921 to Japanese parents; moved to Japan in 1924. Graduated from Kochi Prefectural Agricultural High School, 1939; traveled to United States, 1939. Studied agriculture at the University of California, Los Angeles; interned in Japanese-American camp, 1942–1944. Enrolled in architecture program at Northwestern University, Evanston, Illinois, 1946. Studied with Harry Callahan and Aaron Siskind 1948–1952 at Institute of Design (ID), Chicago. Won prize in young photographers' contest sponsored by *Life* magazine; ID's Moholy-Nagy Prize 1951, 1952. Returned to Japan, 1953. Married Shigeru, 1956, Won New Talent Prize of the Japanese Photography Critics' Association for his book *Aru Hi Aru Tokoro* (*Someday, Somewhere*) in 1958. Lived and photographed in Chicago, 1958–1961. Returned to Japan and won Camera Art Award for "Face of Chicago" in 1962. Obtained Japanese citizenship, 1969. Mainichi Art Award for his book *Chicago, Chicago*, 1969. Received the Annual Award of the Japan Photography Association and the Ministry of Education's Art Encouragement through the Selection

of Excellence Award, 1978. Japanese government awarded him Medal of Honor with Purple Ribbon in 1983, Order of Cultural Merit in 1993, and Man of Cultural Distinction in 1997. Lives in Tokyo, Japan.

Individual Exhibition

1953 Museum of Modern Art, New York
1954 Takemiya Gallery, Tokyo
1960 Art Institute of Chicago, Chicago, Illionois
1961 Museum of Modern Art, New York
1962 *Chicago, Chicago*, Nihonbashi Shirokiya Department Store, Tokyo
1977 *Mandala of Two Worlds*, The Seibu Museum of Art, Tokyo
1981 *The Eleven-Faced Goddess of Mercy of Kokoku*, Seibu Otsu Hall, Otsu
1982 *Chicago, Chicago* and *Someday, Somewhere*, Photo Gallery International, Tokyo
1983 *Chicago, Chicago II* and *Yamanote-sen 29 (Yamanote-Line 29)*, Photo Gallery International, Tokyo
1984 *Katsura: Space and Form*, Seibu Otsu Hall, Otsu
1986 *Machi-Hito – Katachi (City – People – Form)*, Photo Gallery International, Tokyo
1988 *HANA*, Photo Gallery International, Tokyo
1989 *KATSURA*, Photo Gallery International, Tokyo
1990 *The Photography of Yasuhiro Ishimoto: 1948–1989*, Yurakucho Art Forum, Tokyo
1992 *Fallen Leaves and Crushed Cans*, Photo Gallery International, Tokyo
1994 *Yasuhiro Ishimoto: KATSURA and Recent Works*, Recontres Internationales de la Photographie, Arles, France
1995 *Recent Works: Never the Same* and *Ise Shrine*, Photo Gallery International, Tokyo
1996 *Joy of Color*, Photo Gallery International, Shibaura
1996 *Yasuhiro Ishimoto: Remembrance of Things Present*, National Film Center, The National Museum of Modern Art, Tokyo
1997 *Yasuhiro Ishimoto: The Chicago Years*, Laurence Miller Gallery, New York and, Photo Gallery International, Tokyo
1998 *Yasuhiro Ishimoto: Flow*, Photo Gallery International, Tokyo
1998 *KATSURA*, Photo Gallery International, Shibaura
1998 *Yasuhiro Ishimoto: Chicago and Tokyo*, Tokyo Metropolitan Museum of Photography, Tokyo
1999 *Yasuhiro Ishimoto: A Tale of Two Cities*, Art Institute of Chicago, Chicago, Illinois
1999 *Yasuhiro Ishimoto: The Mandalas of the Two Worlds at the Kyoo Gokoku-ji*, The National Museum of Art, Osaka

Group Exhibitions

1953 *Contemporary Photography—Japan and America*, The National Museum of Modern Art, Tokyo
1955 *The Family of Man*, Museum of Modern Art, New York
1956 *Contemporary Photography—Japan and France*, The National Museum of Modern Art, Tokyo
1960, 1961, 1963 *Contemporary Japanese Photography*, The National Museum of Modern Art, Tokyo
1967 *Photography in the 20th Century*, National Gallery of Canada, Ottawa (toured Canada and United States, 1967–1973)
1974 *New Japanese Photography*, Museum of Modern Art, New York

1977 *The Photographer and the City*, Museum of Contemporary Art, Chicago
1979 *Japanese Photography Today and Its Origin*, Galleria d'Arte Moderna, Bologna (traveled to the Palazza Reale Milan; Palais des Beaux-Arts, Brussels; and the Institute for Contemporary Arts, London)
1980 *The New Vision: Forty Years of Photography at the Institute of Design*, Chicago Cultural Center, Chicago, Illinois
1984 *The Art of Photography: Past and Present, from the collection of the Art Institute of Chicago*, The National Museum of Art, Osaka
1988 *Eight Japanese Photographers*, Photo Gallery International, Tokyo
1990 *Tokyo: A City Perspective*, Tokyo Metropolitan Museum of Photography, Tokyo
1991 *Innovation in Japanese Photography in the 1960s*, Tokyo Metropolitan Museum of Photography, Tokyo
1991 *Photographs in Japan 1955–1965*, Yamaguchi Prefectural Museum, Yamaguchi
1991 *SITE WORK: Architecture in Photography since Early Modernism*, Photographers' Gallery, London
1995 *Photography and The National Museum of Modern Art, Tokyo 1953-1995*, National Film Center, The National Museum of Modern Art, Tokyo
1996 *1953 Shedding Light on Art in Japan*, Meguro Museum of Art, Tokyo
1996 *Together Again*, Gallery 312, Chicago, Illinois
1996 *When Harry Met Aaron: Chicago Photography 1946–1971*, The Museum of Contemporary Photography, Columbia College, Chicago, Illinois
1996 *Modern Photography*, Yokohama Museum of Art, Yokohama
1997 *City Images in Photography from the Museum Collection*, National Film Center, The National Museum of Modern Art, Tokyo
1998 *Waterproof*, EXPO '98, Lisbon
1999 *The World and the Ephemeral*, Recontres Internationales de la Photographie, Arles, France

Selected Works

"untitled" [girl tied to tree], 1955
Aru Hi, Aru Tokoro (Someday, Somewhere), 1958
Chicago, Chicago, 1958
Chicago, Chicago 2, 1983
Katsura Villa, 1983
Ise Shrine, 1995

Further Reading

Crane, Susan, ed. *Museums and Memory*. Stanford, California: Stanford University Press, 2000.
Putzar, Edward. *Japanese Photography 1945–1985*. Tucson, Arizona: Pacific West, 1987.
Westerbeck, Colin. *Yasuhiro Ishimoto: a tale of two cities*, with Arata Isozaki and Fuminori Yuloe. Chicago, Illinois: Art Institute of Chicago, 1999.
Otsuji, K., and F. Yukoe. *The Photography of Yasuhiro Ishimoto*. Tokyo: Seibu Museum of Art, 1989.
Szarkowski, John, and S. Yamagishi. *New Japanese Photography*. New York: Museum of Modern Art, 1974.
Ichikawa, Masanori, and Rei Masuda. *Yasuhiro Ishimoto, remembrance of things present: 14 Feb–30 Mar*. Tokyo: National Film Center, the National Museum of Modern Art, 1996.

GRACIELA ITURBIDE

Mexican

Now aligned with the most notable names in Mexican art, Graciela Iturbide's photographs are political, emotional, and often surprising. Though only in mid career, her place in the history of photography has been firmly established as the foremost Mexican photographer after her mentor, Manuel Álvarez Bravo. Her work emphasizes that photography more than captures the main events of the twentieth century; it looks closely at the everyday and the unusual of the contemporary world. Iturbide has more than 20 years of experience, ranging from her first project, a study of the Seri Indians in Northern Mexico (1981), to a retrospective of her work at the Philadelphia Museum of Art (1997–98). Her photography is memorable and striking because she is not limited by artificial borders. Rather, her art emphasizes that there are no minor subjects and that each moment and each act are integral to understanding the fast-paced contemporary world and the relations between the old and the new, the indigenous and the foreign, the traditional and the technological.

Born in Mexico City in 1942 as the oldest of 13 children, she remembers how she made her first contact with photography by looking through family photo albums. She married in 1962 and gave birth to three children, but after the 1970 death of her six-year-old daughter, she decided to take her life in a different direction, and she studied photography at Mexico City's National Autonomous University from 1969–72 in the Department of Cinema. It was during this time that she spent a year as assistant to Mexican photographer Manuel Álvarez Bravo, who also became her greatest inspiration. The importance of this relationship is reflected in the light, shadow, and subject matter of her work. Like her mentor, she is not concerned so much with creating distinctions between social hierarchies, but instead her photographs often concentrate on the forgotten, the impoverished, and the heterogeneous nature of modern life.

After a trip to Europe where she met Henri Cartier-Bresson, she returned to Mexico and became very active in the Mexican art world, and in 1978 she was a founding member of the Mexican Council of Photography. Her opportunity to make an important contribution to the history of photography came in 1979, when renowned Mexican artist Francisco Toledo asked her to do a series of photographs of his hometown, Juchitán, Oaxaca, in southern Mexico. Juchitán is known throughout Mexico for its matriarchal society and for women of such strength and loveliness that they are often referred to as having bewitching powers. Iturbide photographed this indigenous Zapotec community and documented the powerful and multi-faceted role of these women as healers, community leaders, and merchants. In this series, she captured some of the most powerful images of the Mexican indigenous and was awarded the first prize at France's prestigious people "Mois de la photo" in 1988.

Iturbide is passionately interested in the role of women in the community, and the overwhelming physical presence of her subject matter from the *"Juchitán"* series is felt in photographs such as *Our Lady of the Iguanas* (Nuestra Señora de las iguanas) 1980) depicting a Juchitán merchant wearing a headdress of live iguanas, a common sight in the Isthmus of Tehuantepec. In these photographs, she transforms the everyday into the mystical, the surreal, the enchanting. It is clear to see how, like her predecessors such as Rufino Tamayo and Frida Kahlo, Iturbide's work directly addresses the relation between history and the present, between the indigenous and the modern world. Her photographs often reveal the mixture of the pre-Hispanic, the Catholic, and the modern. Each image is a conscious dissection of the impact that technology and contemporary society have made on traditional cultures in Mexico and other regions of the world and the ways these cultures are surviving the New World Order. In photographs such as *Angel Woman* (Mujer Angel) 1979, which portrays a Seri Indian walking into the Sonoran desert with a boom box, and *The Store* (La tienda) 1982, which highlights the on-going impact of the Spanish Conquest on the local culture in Ecuador, she portrays the realities of contemporary Latin America. In addition, her photographs from the Juchitán such as *Chickens* (Pollos) 1979. demonstrate that she does not turn away from stark scenes that transgress sexuality, gender roles, and the harsh reality

of everyday life in Mexico's indigenous regions but celebrates their importance.

Iturbide's work exudes the rich influences that have swept into her variegated subject matter, and the reflections of master photographers such as Edward Weston, Alfred Stieglitz, Paul Strand, and Margaret Bourke-White are evident throughout her images. At the same time, her portraits of Oaxacans reflect the influence of the dramatic and surreal style of Joel-Peter Witkin, but with the subtlety and sensitivity to their subjects of Diane Arbus's work and the confrontational nature of Robert Mapplethorpe. The influence of one of her greatest inspirations—the Italian-born photographer Tina Modotti—is also evident. Modotti was a socially committed photographer who lived in Mexico for a large part of her life and concentrated on photographing workers and political movements between World War I and World War II. Like much of Modotti's photography, Iturbide's heterogeneous photographic subjects reflect her social commitment to using photography for making a difference in the way the world sees. She integrates herself into the community and photographs as she sees, and in that way finds the beauty or the horror of her subject matter and passes this on to the viewer. She is intimate with her subject matter and, rather than forming a critical opinion, she lets it speak for itself.

Iturbide has an international following and has traveled and photographed communities in Cuba, Peru, Panama, Russia, and Madagascar in the same provocative style found in her work from Mexico. She has undertaken photographic journeys to the southern United States and to India, and she has been invited to speak throughout the world, including Puerto Rico, South Korea, and the esteemed Beaux Arts School in Paris, France. She currently resides in Mexico City.

STEPHENIE YOUNG

See also: **Arbus, Diane; Bravo, Manuel Álvarez; Bourke-White, Margaret; Cartier-Bresson, Henri: Mapplethorpe, Robert; Modotti, Tina; Photography in Mexico; Social Representation; Stieglitz, Alfred; Strand, Paul; Weston, Edward; Witkin, Joel-Peter**

Biography

Born in Mexico City, 16 May 1942. 1969–1972, attended Centro Universitario de Estudios Cinematográficos at the Universidad Nacional Autónoma de México. 1970–1971, worked as assistant to Manuel Álvarez Bravo. 1983, received production grant from the Consejo mexican de Fotografía; 1986, awarded prize from the UN-International Labor Organization; 1987–1988, received the W. Eugene Smith Award; Guggenheim Fellowship, 1988; Grand Prize, Mois de la Photo in Paris, 1988; Hugo Erfurth Award, Germany, 1989; International Grand Prize in Hokkaido, Japan, 1990; Rencontres Photographiques award, 1991. Invited by Médecins sans frontières to photograph in Madagascar, 1991. Currently living in Mexico City.

Individual Exhibitions

1980 *Graciela Iturbide*; Casa del Lago, Mexico City; Casa de la Cultura, Juchitán

1982 *Graciela Iturbide*; Musée national d'Art moderne, Georges Pompidou Center, Paris, France

1985 *Juchitán;* Casa de la Cultura, Juchitán, Mexico and traveling

1987 *Graciela Iturbide*; Centro di Ricerca per l'Immagine Fotografica, Milan, Italy

1988 *Juchitán pueblo de nube;* Side Gallery, Newcastle, England and traveling

1989 *Juchitán de la mujeres*; Galería Juan Martin, Mexico City, Mexico

1990 *External Encounters, Internal Imaginings: Photographs by Graciela Iturbide*; San Francisco Museum of Modern Art, San Francisco, California

1990 *Graciela Iturbide*; Ernesto Mayans Gallery, Santa Fe, New Mexico

1990 *Neighbors*; Museum of Photographic Arts, San Diego, California

1991 *Visiones: Graciela Iturbide*; Le Mois de la Photo à Montreal, Maison de la Petite Patrie, Montreal, Canada

1991 *Recontres internationales de la Photographie* (retrospective); Chapelle du Méjan, Arles, France

1991 *Graciela Iturbide*; Museum of Photography, Seattle, Washington

1992 *Graciela Iturbide*; Galéria Visor, Valencia, Spain

1993 *En el nombre del padre*; Galería Juan Martín, Mexico City, Mexico and traveling

1993 *Graciela Iturbide*; Sala de Exposición de Telefónica, Madrid, Spain

1993 *Graciela Iturbide*; Chicago Cultural Center, Chicago, Illinois

1994 *Graciela Iturbide*; Universidad de Salamanca, Salamanca, Spain

1995 *Graciela Iturbide*; I Kwangju Bienniale, Kwangju, Korea

1996 *Graciela Iturbide: La forma y la memoria*; Museo de Arte Contemporáneo de Monterrey, MARCO, Monterrey, Mexico

1997-8 *Graciela Iturbide: Images of the Spirit* (retrospective); Philadelphia Museum of Art, Philadelphia, Pennsylvania

Group Exhibitions

1994 *Mexico de las Mujeres*; Galeria Arvil, Mexico D.F.

1995 *Tres fotografas mexicanas*; Galeria Jose Clemente Orozco, Mexico City, Mexico

1996 *El Volcan*; Center of Modern Art, Canary Islands, Spain

1996–1997 *Photography in Latin America: A Spiritual Journey*; Brooklyn Museum of Art, New York

1997 *Skulptur im licht der fotografie*; Vienna, Austria; Duisburg, Germany; and Fribourg, Switzerland

2000 *Reflections in a Glass Eye: Works from the International Center of Photography Collection*; International Center of Photography, New York

Selected Works

México, D.F. (Mexico City), 1972
Pollos (Chickens), Juchitán, Oaxaca, 1979
Mujer Angel (Angel Woman), Sonora, 1979
Nuestra Señora de las Iguanas, (Our Lady of the Iguanas), Juchitán, Oaxaca, 1980
La tienda (The Store), 1982
Magnolia, Juchitán, Oaxaca, 1986
Cholas con Zapata y Villa en East L.A., (1986)
Cementerio (Cemetery), Juchitán, Oaxaca, 1988

Further Reading

Harris, Melissa, ed. *Aperture: On Location With: Henri Cartier-Bresson, Graciela Iturbide, Barbara Kruger, Sally Mann, Andres Serrano, Clarissa Sligh*. New York: Aperture Foundation, 1995.
Iturbide, Graciela. *External Encounters, Internal Imagings: Photographs by Graciela Iturbide*. San Francisco: San Francisco Museum of Modern Art, 1990.
Iturbide, Graciela. *Images of the Spirit*. New York: Aperture Foundation, 1996.
Iturbide, Graciela. *Juchitán de las mujeres*. Intro and text by Elena Poniatowska. Mexico: Ediciones Toledo, 1989.
Iturbide, Graciela. *La forma y la memoria*. Monterrey, Mexico: Museo de Arte Contemporaneo de Monterrey, 1996.
Iturbide, Graciela. *Sueños de pape*. Mexico: Fondo de Cultura Economica, 1985.
Medina, Cuahhtemoc. *Graciela Iturbide* (Phaidon 55S). New York: Phaidon Press, 2001.

IZIS (ISRAEL BIDERMANAS)

French, born in Lithuania

Izis Bidermanas is one of the most important French photographers, who unfortunately has been greatly underestimated. His career started at the end of World War II, when he portrayed his resistance comrades in Limoges. By the time he was included in the popular 1955 exhibition, *The Family of Man*, at the Museum of Modern Art, New York (MoMA), he had joined the staff of *Paris-Match*, specializing in photographs of painters, artists, and writers. He published several photography art books collaborating with artists and poets from Paris and its poorer quarters, discovering astonishing formal relations between objects and people. After leaving *Paris-Match* in 1969, he worked as a freelance photographer until his death in 1980.

He was born in Marijampole in Lithuania on January 17, 1911. Although Bidermanas had shown interest in painting at an early age, he left school at age 13 to be an apprentice to a portrait photographer in that city. After living the life of a gypsy, wandering the countryside to photograph, he ended up, penniless and speaking no French, in Paris in 1930 at age 19. As apprentice to a portrait photographer, Bidermanas had learned techniques of soft focus and retouching, both of which he later rebelled against, calling them untruthful. In Paris, he worked first in a laboratory, retouching photographs and printing. He was employed by the photographer Arnal and later directed a small photography shop in the 13th arrondissement in Paris, before opening his own studio in 1934 and producing portraits.

During World War II he became a member of the resistance movement, photographing his comrades and working as a photo researcher. After the war he became a French citizen (1946) and worked as a freelance photographer before joining the staff of *Paris-Match*. Remaining with the magazine for over 20 years, he focused on photographs of painters, poets, and writers. He was known to stroll the city of Paris as a dreamer, searching for moments, which "aroused his curiosity, moved him or made him reflect."

Following the German invasion of France in 1940 Bidermanas, as a Jew, was forced to flee and hide; he supported himself retouching photos. It was during this time he took on his pseudonym, Izis. He ended up in the Limoges in 1944, fighting as a soldier during the liberation of the town and where he

made portraits of the French underground resistance fighters. It was this intense experience that caused him to radically alter his style. He asked if he could photograph his comrades of the Resistance; they showed up nicely washed and dressed. As this completely changed the image he desired, he asked them to don their filthy, war-stained clothing that he might capture the heroes of Limoges.

These photographs caused a stir when they were exhibited in Limoges under the title "Ceux de Grammont," and they caused him to be noticed upon his return to Paris, where he met with Laure Albin-Guillot, known as the "muse of portraiture" and one of the leaders of the École de Paris, the photographer Brassaï, and Emmanuel Sougez, founder of the photo service *L'Illustration* and an important promoter of young photographers. He met and photographed Dora Maar at this time, producing a notable portrait of her smoking a cigarette in a masculine manner. Izis mounted his first exhibition in 1946, but quickly realized he could not support himself without returning to studio work, and opened another studio at 66, rue de Vouille in 1947, which he maintained until 1954.

When he became associated with *Paris-Match* in 1949, he had the occasion to photograph Paris's leading artistic and literary figures. He met the painter Marc Chagall, well-known for his joyful, mystical Jewish subjects and became friends. Chagall later allowed him as the only photographer to document his work on the ceiling of the opera in Paris, photographs he later published in a book.

In 1951 he met poet and screenwriter Jacques Prévert, with whom Bidermanas jointly created several beautiful art books, including *Charmes of Londres* (1951) following a three-week stay in London, with handwritten texts by writer and playwright Jacques Audiberti to poet and writer André Virel, One of his best-known photographs, shot in the East End slums, shows a man blowing bubbles. In 1951, Izis provided 59 more photos for the publication *Grand bal du printemps*; these books are now highly sought-after for both Izis's poetic images and the texts they contain.

In 1955, Izis participated in the international exhibition *The Family of Man*, a worldwide success that featured the type of humanistic photography that was so characteristic of that era in France. His work became internationally known at this time, although he rarely left Paris. He did complete memorable images during sojourns in Israel as well London in the early 1950s. In 1965 his childhood interest in circuses and friendship with Marc Chagall resulted in the publication *Le Cirque d'Izis*, with lithographs by the painter and circus photographs by Izis.

Izis was dismissive of methods and devices, such as light meters or flashguns, which he thought would destroy the atmosphere he searched to capture and recreate in his prints. He was not very prolific, often waiting a considerable time to capture the right image, and employing his trusty old Rolleiflex in all his photography.

Throughout his career, Izis was interested in individuals rather than showing people as part of an event. He photographed what made him curious, moved him, or made him think. Prévert compared him to one who goes out strolling in dreams.

As the meaning of his photographs is often rather more suggestive than explicit, his documentary photography belongs to the so-called metaphorical documentation. His motifs often resemble a riddle and require poetic understanding. His books, especially "*Paris des poètes*" (1977) demonstrate the artist's sometimes surrealist working methods. In 1978, he became an honorary member of the Rencontres d'Arles. He died on May 16, 1980.

The Hotel de Sully honored Izis with a retrospective in 1988. While his archive belongs to his widow, his photographs have been exhibited internationally and are included in the collections of several photography museums and photography departments within general museums such as the Bibliothèque Historique de la Ville de Paris, Bibliothèque nationale de Paris, Musée Reattu, Arles, France, Musée du Limoges, France, Museum of Modern Art, New York, and the Art Institute of Chicago.

NATHALIE NEUMANN

See also: **Photography in France**

Biography

Born in Marijampole, Lithuania, 17 January 1911. Apprenticed to a studio photographer, 1924; immigrated to Paris and opened own studio 1930. Persecuted as a Jew, fled to Southern France, 1940; took on his pseudonym Izis. Fought for the liberation of Limoges, 1944; returned to Paris, working freelance, 1946; correspondent for *Paris-Match,* 1949–1969; freelance photojournalist until his death. Died in Paris, France, 16 May 1980.

Individual Exhibitions

1944 *Ceux de Grammont*; Musée de Limoges; Limoges, France
 Limoges en Novembre; Musée de Limoges; Limoges, France
1955 *Izis*; Art Institute of Chicago; Chicago, Illinois
1957 *Izis*; Limelight Gallery; New York, New York
1966 *Cirques d'Izis*; Musée de Limoges; Limoges, France
1972 *Izis (Israel Biderman)*; Museum of Tel Aviv; Tel Aviv, Israel
1975 Galérie Agathe Gaillard; Paris, France

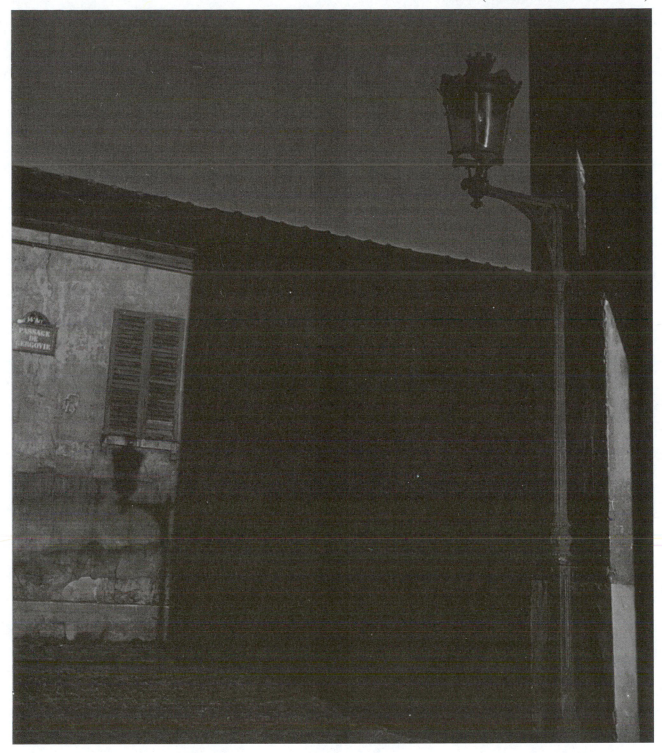

Izis (Israel Bidermanas), Passage de Gergovie.
[© *Louise Izis, CNAC/MNAM/Dist. Réunion des Musées Nationaux/Art Resource, New York*]

1977 Galerie Nagel; West Berlin, Germany
 Fête à Paris; Carlton Gallery; New York, New York
1978 Rencontres Internationales de la Photographie; Arles, France
1979 *Izis*; FNAC, Paris and traveling

1984 *40 eme anniversaire de la liberation: Les Maquisards*; Pavillon du Verdurier; Limoges, France
1988 *Izis—Retrospective Paris, Mois de la Photo*; La Caisse Nationale des Monuments Historiques et des Sites, Paris, France

1989 *L'emotion partagée*; Musée de la Photographie; Charleroi, France

1990 *Izis*; Musée Nicéphore Niépce; Chalon-sur-Saône, France

1993 *Izis photographie Chagall. La création du monde*; Joods Historisch Museum; Amsterdam, the Netherlands

Group Exhibitions

1951 *Five French Photographers*; Museum of Modern Art; New York, New York

1954 *Great Photographs*; Limelight Gallery; New York, New York

1955 *The Family of Man*; Museum of Modern Art, New York, New York and traveling

1957 *Salon National de la Photographie*; Bibliothèque nationale de France; Paris, France

1972 *Boubat/Brassaï/Cartier-Bresson/Doisneau/Ronis/Izis*; French Embassy; Moscow, USSR

1976 *Other Eyes: Photographs Taken on the British Isles, by Izis and Others*; Arts Council of Great Britain, London and traveling

1986 *Crosscurrents II*, San Francisco Museum of Modern Art; San Francisco, California

Selected Works

Portrait of Dora Maar, 1946
Jacques Prévert, 1949
May 1st, place Victor Basch, Paris, 1950
Whitechapel, London, 1950
Ile Saint-Louis, Paris, 1946
Rue Hautefeuille, Paris, 1951
Planting Trees in Israel, 1953

Further Reading

Publications by Izis

Paris des rêves. Lausanne: La Guilde du Livre, 1950. With Jacques Prévert, as *Paris Enchanted*, London, 1952.

Le Grand bal du printemps. With Jacques Prévert. Lausanne: La Guilde du Livre, 1951.

Charmes de Londres. With Jacques Prévert. Lausanne: La Guilde du Livre: 1952, as *Gala Day: London*, London 1952.

Paradis terrestre. With Colette. Lausanne: La Guilde du Livre, 1953.

People of the Queen. London, 1954.

Israël. Preface by Andre Malraux; cover and inset by M. Chagall. Lausanne: Editions Clairefontaine, 1955.

Le Cirque d'Izis. Mark Chagall and Jacques Prévert. Monte Carlo: Suaret, 1965.

The World of Chagall. London/Paris: Text and captions by Roy McMullen, 1969.

Turner, P. *Other Eyes*. London: Hayward Gallery, 1976.

Paris des poètes. Texts by Louis Aragon, et al. Paris: Nathan, 1977.

Publications on Izis

Borhan, Pierre. *Retrospective Izis*. Paris: Hotel de Sully, 1988.

Izis de Paris et d'ailleurs. Paris (catalogue of the CNMHS), 1988.

Mois de la Photo. Paris (catalogue of the month of photography), 1988.

Izis: photographies 1944–1980. Introduction by Marie de Thézy: Paris/London Tokio, Ed. de La Martinière, 1993.

Izis Photographs Chagall. Amsterdam (catalogue of the Joods Historisch Museum), 1993.

de Thezy, Marie. *Izis—Photos 1944–1980*, Paris, 1993.

J

J. PAUL GETTY MUSEUM

Located on the heights of Los Angeles's hills of Santa Monica, the Getty houses two renowned photography collections at the J. Paul Getty Museum and at the Getty Research Institute. Oil tycoon J. Paul Getty (1892–1976) first established the museum in 1953 as an educational establishment dedicated to his collection of European painting, decorative arts, and classical antiquities. In 1976, his substantial bequest funded one of the most expansive acquisition strategies of the 1980s, enlarging the museum and establishing the research institute. The two collections at these institutions represent two different discourses in photography—its establishment as an art form and reconciliation with its nineteenth-century functions. Both establishments have purchased a number of American and European private collections, providing historical reflections on photography's varied developments, beginning from 1839 through the modernist era.

J. Paul Getty's substantial bequest, reportedly nearing $2.3 billion, reached the Getty Trust in 1982 and decisions were made to create new departments for the museum (illuminated manuscripts, prints and drawings, sculpture, and photography) and to create additional organizations that underscored existing programs in education, con-

servation, and scholarship. With this expansion the J. Paul Getty Museum was joined by the Getty Research Institute for the History of Art and the Humanities, the Getty Conservation Institute, the Getty Information Institute, the Getty Education Institute for the Arts, and the Getty Leadership Institute for Museum Management. These organizations now form "the Getty," located in a contemporized design of a classically inspired structure built by leading architect Richard Meier. Initially located in Malibu, the Getty opened at its spectacular new site in Santa Monica in 1997 and received widespread, international exposure.

Since its inception, photography competed for artistic authority and acceptance into museums. Although major institutions such as the Metropolitan Museum of Art and the Museum of Modern Art in New York, and the George Eastman House (now International Museum of Photography and Film) in Rochester, New York, began collecting as early as 1928, photography was still relegated to a second class status within most art museums. Following the Museum of Modern Art's landmark exhibition *The Family of Man* in 1955, photography permeated a public audience. Even so, the Getty was a latecomer to the collecting of photography. This was ameliorated considerably by the Getty trust, which

allowed the museum a huge advantage in the art market during the 1980s at the time it was being affected by contemporary art developments around performance art and conceptual and color photography. Individuals who had amassed photography collections from 1839 though the 1950s became the Getty's source for rare and valuable objects.

In the photography department's formative years, Weston Naef, Chief Curator of Department of Photographs, stated his intentions: "I want to work slowly and systematically toward forming the most comprehensive collection of photographs of all schools, all periods, up until and through the 1930s." (Schreiber, 1984, 93, 95) Yet the collection seemingly was established overnight. This occurred when in 1984, the art dealer Daniel Wolf was introduced to Naef and John Walsh, the director of the J. Paul Getty Museum. Daniel Wolf had first approached Naef with the collections of legendary Detroit and New York-based curator and collector Samuel Wagstaff and Chicago-based Arnold Crane. Wagstaff's collection included 18,000 objects and represented many important nineteenth century figures. Arnold Crane's collection represented early French and British materials and important twentieth-century modernist photographers such as Man Ray, László Moholy-Nagy, and Walker Evans. After securing these two collections, additional purchases were made including early European photography (Bruno Biscofberger of Zurich), portions of the Albert Renger-Patzsch archive (Jürgen and Ann Wilde of Cologne), and 1920s and 1930s Czech photographs (William Schurmann of Aachen).

While unusual at the time, the acquisition of these materials under the auspices of a private dealer that were in fact for a public museum caused a seismic shift in attention from the East to the West coast. By the official announcement of the department's creation in September 1984, the museum had acquired some 30,000 objects, reportedly costing $20 million.

Acquisition strategies at the J. Paul Getty Museum are qualified by thematic divisions: How We Live, Mythology, Natural World, People and Occupations, Religion, Science and Industry, and Where We Live. These divisions shape public reception, relying mostly on the ideas of cultural developments. In the Department of Photographs, the diversity of photographic systems and objects, including stereographs, graphic illustrations of photography's influence, original negatives, prints by various techniques, card photographs, and cased objects such as daguerreotypes and ambrotypes, highlights the international phenomenon of photographic processes that shaped artistic developments. Wagstaff's collection provided the substance for the department's first

exhibition, *Hanging Out: Stereographic Prints from the Collection of Samuel Wagstaff, Jr. at the J. Paul Getty Museum* (1985). *Experimental Photography: Discovery and Invention* (1989) was a later exhibition and symposium that brought together photography's major figures who first attempted to connect photography's scientific endeavors of the nineteenth-century with the fathers of modernist photography, such as Alfred Stieglitz. Beaumont Newhall, Larry Schaaf, Nancy Keeler, Eugenia Parry-Janis, and John Szarkowski were among the symposium's participants, whose presentations constituted a related publication. Other exhibitions have ranged from examinations of nineteenth-century permutations, such as *Palette of Light: Handcrafted Photographs, 1898–1919* (1994), to monographic exhibitions of the masters of photography: Eugène Atget, Gertrude Käsebier, Albert Renger-Patsch, Walker Evans, Doris Ulmann, Edward Weston, Dorothea Lange, Manuel Álvarez Bravo, and Frederick Sommer.

The exhibitions reflect a dedication to scholarship and dissemination of communal knowledge that is culturally biographic. The depth and diversity of their collection allows for exploration of acknowledged masters that increases understandings of their timely contributions. Walker Evans, widely acclaimed for his photographs from the 1930s and 1940s of America's rural communities, exemplifies the museum's conscientious research. The exhibitions, *Walker Evans: The Getty Collection* (1995), *Walker Evans: Signs* (1998), and *Walker Evans, Cuba* (2001) revealed his ability to not only document America but to intuitively identify the structures that subtly characterize the growth of industry. *The American Tradition and Walker Evans: Photographs from the Getty Collection* (2001) actively demonstrated this strength of the collection. Work chosen from 1850 to 1940 exhibited Evans with predecessors and contemporaries to discuss the insight photographers gave to changes in advertising and immigration that transformed rural towns and urban cities. This smaller exhibition of rare photographs complemented a larger exhibition that the museum hosted, *Walker Evans & Company: Works from the Museum of Modern Art*. The J. Paul Getty Museum also holds the work of nineteenth century English pictorialist photographer Julia Margaret Cameron, and has exhibited and published this work extensively.

The educative role of the J. Paul Getty Museum is realized through symposiums and colloquiums around important ideas that bring together eminent authorities to engage in discussions and debates on contemporary topics involving the collection and the artists. An important component of

the Getty's educational program is their publication *In Focus*, an alternative form of catalogue for many of their monographic exhibitions. The standard format is pocket-sized with over 100 pages and consists of 50 images, artist's chronology, and transcriptions of round-table discussions that include important figures in photography. Among the titles in this series are *André Kertész* (1994), *Alfred Stieglitz* (1995), *Eugène Atget* (2000), *August Sander* (2000), and *Dorothea Lange* (2002).

In contrast to the museum, the Getty Research Institute (GRI) for the History of Art and the Humanities offers a collection that critically engages the function and employment of photography. Photography acquisitions in the Special Collections and Visual Resources department are also purchased from individual collectors, but the agenda is shifted from a modernist approach to interests in the vernacular. The collection is divided into seven areas: Ritual, Performance, and Spectacle; Cross-Cultural Exchange; Processes of Conception and Production; Visual Communication and the Culture of Images; Art and Science; History of Collecting and Display; and Cultural and Social Debates. Headed by Curator of Special Collections, Frances Terpak, the divisions examine the complexities of the nineteenth-century and photography's participation by examining the materials of the period, which includes archival photographs, rare books and albums, and mechanical devices.

The approach at GRI is interdisciplinary and expansive. *Framing the Asian Shore: Nineteenth-Century Photographs of the Ottoman Empire* (1998) was composed from a purchase of 6,000 photographs from French collector Pierre de Gigord. The exhibition contextualized the photographs in postcolonialist terms, examining the Western image of the Orient. Other materials that described Eurocentric interests were included as well, such as maps, early prints, ceramic tiles, and Romantic literature. Exchanges between scientific technology and visual perception are growing aspects of the collection as well. *Devices of Wonder: From the World in a Box to Images on a Screen* (2001) connected visual entertainment devices from the seventeenth-century through to the twentieth-century and displayed many of photography's precursors such as a physionotrace, crank magic lanterns, and a portable camera obscura. In addition to Western devices, the department has increased holdings in Latin American photography. Purchases have resulted in a two-part exhibition that traced Mexico's revolutionary history through to its modernist era, *Mexico: From Empire to Revolution* (2000). The exhibition featured the work of Augustin Victor Casasola,

Manuel Ramos, and a series of documentary photographs that captured the historic shooting of Emperor Maximilian, photographs that served as Édouard Manet's inspiration for his realist painting *The Execution of Emperor Maximilian of Mexico* (1867). The collection of Mexican photography complements the J. Paul Getty Museum in its large holding of photographs by Manuel Álvarez Bravo, whose work is often connected to both Mexico's documentary tradition, which stems from the Revolution and to modernist and surrealist movements.

Since 1984, the museum has extended its collection to include practices since the 1930s and 1950s, moving into the areas of Pop Art and color photography. *The Hidden Witness: African Americans in Early Photography* (1995) was an important exhibition in this respect. The objects drew from a recent acquisition of Jackie Napoleon Wilson's collection of African American photography composed of daguerreotypes, albumen prints, and *carte-de-visites* from the Civil War era. Although the exhibition featured nineteenth-century work, contemporary artist Carrie Mae Weems was commissioned to create a photographic installation that spiritually responded to *The Hidden Witness*. The collaboration received wide acclaim and laid the groundwork for later comparative exhibitions such as *Nadar/Warhol: Paris/New York* (1999) and *William Eggleston and the Color Tradition* (1999).

The Getty makes a difference by weaving together the presentation, enjoyment, study, and conservation of the visual arts in order to increase the public's knowledge and sensitivity, expand its awareness and creativity, sharpen its understanding and caring—all with the conviction that cultural enlightenment and community involvement in the arts can help leap to a more civil society.

These last lines of the Getty's mission statement are a summation of institutional aims of the photography collections at the Getty. Overall, the keys to their collections are informational. At both institutions, the departments offer study rooms, which are available by appointment, to view the collections and foster research. A grant program exists explicitly for this purpose. On another level, photography is used in a conventional sense on the internet through the Getty Center's Photo Study Collection Database, which represents a physical department at GRI. Containing over 250,000 object entries, the photographs document works in the collection (Antiquities, Medieval, Decorative Arts, Sculpture, Painting, and Prints) as well as donated and acquired images by photographers of archaeological sites and other humanities interests. Their website, *www.getty.edu* underscores their collections—a

conglomerate of works dedicated to accessing examples of the human endeavor.

SARA MARION

See also: **Archives; Museums; Museums: United States; Weems, Carrie Mae**

Further Reading

Boxer, Sarah. "The Hill Where Elitists and Populists Meet: Photo Collections and the Getty Center." *The New York Times*, (March 15, 1998): 39–40.

Deal, Joe. *Between Nature and Culture: Photographs of the Getty Center* (1999).

"Dearth of Art History." *Art Review*, vol. 53 (July/August 2001): 75.

Failing, Patricia. "A Nonreligious Monastery for Art Historians." *Artnews*, vol. 85, no. 1, (January 1986): 70–74.

In Focus Boxed Set: André Kertész, László Moholy-Nagy, Man Ray: Los Angeles: The J. Paul Getty Museum, 1999.

The J. Paul Getty Museum: Handbook of the Collections. Los Angeles: J. Paul Getty Museum, 1997.

The J. Paul Getty Trust Report, 2000–2001. Los Angeles: The J. Paul Getty Trust, 2001.

Joyce, Patrick. "More Secondary Modern than Postmodern." *Rethinking History*, vol. 5, no. 3 (2001): 367–382.

Keller, Judith. *Walker Evans: The Getty Museum Collection,* Los Angeles: J. Paul Getty Museum, 1995.

Kuspit, Donald. *Albert Renger-Patzch: Joy Before the Object.* Los Angeles: J. Paul Getty Museum, 1993.

Masterpieces of the J. Paul Getty Museum: Photographs. Los Angeles: The J. Paul Getty Museum, 1999.

Nilson, Lisbet. "Moving West: In One Swell Coup, the Psychic Center of the Photo Market Shifts to Malibu." *American Photographer*, vol. 14 (January 1985): 56–63.

Paradise, Joanne. "Document: The Collections of the Getty Research Institute." *Burlington Magazine*, vol. 140, no. 1143 (1998): 425–432.

Schreiber, Norman. "Pop Photo Snapshots: Goody for Getty," *Popular Photography*, vol. 91 (September 1984): 93, 95.

Walsh, John and Deborah Gribbon. *The J. Paul Getty Museum and Its Collections: A Museum for the New Century.* Los Angeles: The J. Paul Getty Museum, 1997.

LOTTE JACOBI

American

Lotte Jacobi created some of the most striking and enduring original photographic portraits of the twentieth century. Although many of her subjects were celebrities, including actors and dancers, her works were not mere glamour shots. Jacobi captured not only the sitter, but the essence of his or her creativity through her direct approach and bold compositions, leaving a legacy that has shaped our perception of the artistic circles that emerged during the years between World War I and World War II in Berlin.

Born in Thorn, West Prussia, Germany (now Torún, Poland) in 1896, Johanna Alexandra Jacobi (Lotte was a nickname that caught on at home) was the fourth generation of her family to take up photography. Her great-grandfather, Samuel Jacobi, a glazier, began making daguerreotypes in the 1840s, having purchased equipment, a license to practice, and instructions from Daguerre while visiting in Paris. Growing up in Posen, Germany, the oldest of three children, Jacobi studied art history and literature at the Academy of Posen (1912–1916). At the age of 18, she aspired to become an actress,

the theater being one of her many interests, but she kept returning to her roots in photography. She made her first pictures using a pinhole camera made by her father, Sigismund Jacobi.

In 1916, Jacobi married Fritz Honig, and the couple had a son, John Frank, the following year. The marriage only lasted four months; after a long separation, their divorce became final in 1924, and Jacobi retained custody of her son. The following year, she enrolled her son in school in Bavaria, and Jacobi attended the Bavarian State Academy of Photography in Munich, where she learned film and photography, and the University of Munich (1925–1927), where she studied art history.

After completing her formal training, Jacobi moved to Berlin, where her family had operated a photographic business since 1921. Following an apprenticeship with her father, Lotte became the director of Jacobi Studio of Photography from 1927–1935, photographing some of the most prominent German citizens, including Bertolt Brecht, Albert Einstein, Käthe Kollwitz, and Kurt Weill. The Jacobi Studio made photographs for print media; John Heartfield was a customer from 1929–

1932. Jacobi made photographs for Heartfield, some for his montages and some for book covers.

During the 1930s, the theater and the arts became her primary subjects; she extended her interest to include dance and eventually film. Film and dance were important components of her early studies and influenced her photography stylistically. Liquid forms and fluid motion became a hallmark of her works associated with dancers and actors. To accomplish her indoor work without a flash, she began to use a 9 × 12-cm Ermanox, one of only nine such cameras made during 1928–1929. During this period, she reluctantly switched from the use of glass plate negatives to celluloid film.

Pursuant to her love for the theater, Jacobi began a series of theater portraits, appearing during and after dress rehearsals when it was permissible to photograph the actors. Portraits of stage actors Peter Lorre, Franz Lederer, and Lotte Lenya, which have become her iconic photographs, are some of the most original and modern images, even by today's standards. Jacobi's portrait style, characterized by experimentation with abstraction—unusual perspectives, cropped-heads, and high or low-angle shots—places her work firmly among the German school of photography known as the *Neue Sachlichkiet* (New Objectivity) and the experimental works of Russian photographer and graphic artist Alexandr Rodchenko.

Jacobi's works, like those by the New Objectivity practitioners, are beautiful formalist images that appear intended for press advertising and today help define the visual style of the Weimar Republic. In 1930, her work appeared in a modernist exhibit in Munich, *Das Lichtbild*, organized by Max Burchartz, and mounted the following year in Essen. Although she worked closely with avant-garde photography methods, Jacobi always privileged the expressive content of her images over formal aesthetics.

While still in Europe, a client in Berlin arranged for Jacobi to travel to the Soviet Union from the fall of 1932 to January, 1933. Her work from this four-month sojourn reflects her response to the diversity of people, places, and geography. Much of her early work prior to her coming to the United States has been lost.

Of Jewish heritage on both sides and upon the death of her father in 1935, Jacobi with her son John fled the inhospitable climate of Nazi Germany, and they settled in the United States; she became a naturalized citizen in 1940. Once in New York, she opened a portrait studio with her sister Ruth at the corner of Sixth Avenue and 57th Street in October, 1935. She eventually flourished in a succession of studios on her own in New York City from 1935–1955 and maintained a gallery during 1952–1955. In 1938, she was the first woman to photograph on the floor of the New York Stock Exchange during trading hours. She held an instant celebrity status as a refugee witness of German culture before the rise of the Nazi Party. Her photographs appeared in the Sunday *Herald Tribune* shortly after her arrival.

Jacobi's portraits made in America are equally captivating as those from her German period, possessing the immediacy of the moment and the presence of the person portrayed. The images reveal the photographer's willingness to observe her subject rather than direct the proceedings; the sitters appear to have been caught slightly unaware. Photographing luminaries Albert Einstein, First Lady Eleanor Roosevelt, actor Paul Robson, and painter Marc Chagall among others, Jacobi achieved naturalism in her portraiture work by instilling a relaxed atmosphere. She explained her approach to portraiture:

> My style is the style of the people I photograph. In making portraits, I refuse to photography *myself*, as do so many photographers.
>
> (Wise 1978, p.8)

While photographing her subjects, often in the sitter's own surroundings, Jacobi converses casually, uses existing light, and waits for her subjects to come into their own. Jacobi penetrates her subject's self-conscious, translating the sitter's personality to the permanent image. In 1939, when *Life* magazine did an essay on Einstein, he insisted that Jacobi be one of the photographers.

Shortly after arriving in America, she met German publisher and fellow émigré Erich Reiss, and the couple married in 1940. Reiss took over the accounting and management of Jacobi's studio in New York. Reiss died in 1951.

In America, Jacobi's oeuvre took on many shifts in style, moving from objectivity to photogenic drawings called "light abstractions." In 1946, when her husband Erich Reiss became ill, and as a form of therapy, she suggested they both began a course in photograms taught by Leo Katz at the Atelier 17, an artistic center in New York City. Jacobi's unique vision of an already explored process translated to her capturing fragile abstract patterns on light-sensitive paper created by moving objects and lights. Katz called her camera-less work made in the 1950s "photogenics." To achieve the abstracted patterned effect, she used candles, flashlights, glass, cellophane, and paper cut in odd shapes.

A collection of photographs Jacobi made in the 1930s and 40s, a documentary of New York City, remained an important personal project but one that was never exhibited.

In 1955, Jacobi moved to rural Deering, New Hampshire with her son John and his wife Beatrice; she continued photographing, exhibiting, and teaching. In the later part of her life, she found time to explore untapped interests in beekeeping, gardening, and politics. The University of New Hampshire at Durham awarded her an Honorary Degree in 1973, and the University holds The Lotte Jacobi Archive comprised of 47,000 negatives, several hundred study and exhibition prints, three portfolios, as well as letters, catalogues, documents, and other printed material. She died in Concord, New Hampshire, in 1990.

MARGARET DENNY

See also: **Heartfield, John; History of Photography: Postwar Era; Photography in Germany and Austria; Portraiture**

Biography

Born in Thorn, West Prussia, Germany, August 17, 1896; naturalized American citizen, 1941. Attended the Academy of Posen (1912–1916) where she studied art history and literature, the Bavarian State Academy of Photography in Munich for film and photography, and the University of Munich (1925–1927), where she studied art history. Attended the University of New Hampshire, Durham, 1961–1962; studied graphics, art history, French, and literature; Atelier 17, Paris, etching and engraving, 1962–1963. Married Fritz Honig in 1916, divorced, 1924; son, John Frank Hunter. Married the publisher Erich Reiss in 1940 (he died in 1951). Director of Jacobi Studio of Photography, Berlin, from 1927–1935; operated a portrait studio in New York City from 1935–1955, a gallery from 1952–1955; proprietor of Jacobi Studio and Gallery, Deering, New Hampshire, 1963–1970. A founder of the Department of Photography, Currier Gallery of Art, Manchester, New Hampshire, 1970, (Honorary Curator of Photography, 1972–1978). Awarded an Honorary Degree in 1973 at the University of New Hampshire at Durham. Recipient: Silver Medal, Royal Photography Salon, Tokyo, 1931; First Prize, British War Relief Photography Competition, *Life* Magazine, New York, 1941; First Prize, New Hampshire Art Association, 1970; New Hampshire Governor's Award for the Arts, 1980; Erich Salomon Prize, West Berlin, 1983. Died in Concord, NH, May 6, 1990.

Individual Exhibitions:

1937 Jacobi Studio, New York
1952 Ohio University College, Athens, Ohio
1953 University College of Education, New Paltz, New York
1959 Currier Gallery of Art, Manchester, New Hampshire (traveling retrospective)
1964 303 Gallery, New York (retrospective)
1965 Middlebury College Library, Middlebuty, Vermont
1966 *Two Photographers*, Gropper Galleries, Cambridge, Massachusetts (with Marie Cosindas)
1972 Staatliche Landesbildstelle, Hamburg, Germany

1973 Folkwang Museum, Essen, Germany and traveling
1974 Light Gallery, New York
1977 Danforth Museum, Framingham, Massachusetts
1978 University of Maryland, Baltimore, Maryland
1979 *Lotte Jacobi: Begegungen*, Münchner Stadtmusuem, Munich, Germany

Selected Group Exhibitions:

1930 *Das Lichtbild*, Munich, Germany and traveling
1937 *Dance Photographs*, Brooklyn Museum of Art, New York
1948 *In and Out of Focus*, Museum of Modern Art, New York
1955 *Subjektive Fotografie 2*, State School of Arts, Saarbrucken, Germany
1958 *Subjektive Fotografie 3*, State School of Arts, Saarbrucken, Germany
1960 *Sense of Abstraction*, Museum of Modern Art, New York
1975 *Women of Photography*, San Francisco Museum of Art, San Francisco, California and traveling
1979 Re*collections: 10 Women of Photography*, International Center of Photography, San Francisco, California, NewYork and traveling
1980 *Avante-Garde Photography in Germany 1919-39*, San Francisco Museum of Modern Art, San Francisco, California and traveling
1979 *Fotogramme—die lichtreichen Schatten*, Fotomuseum im Stadtmuseum, Munich, Germany and traveling
1987 *Photography and Art 1946-86*, Los Angeles County Museum of Art, Los Angeles, California

Selected Works

From *Lotte Jacobi*, edited by Kelly Wise, Danbury New Hampshire: Addison House, 1978

Portraits

Kurt Weill, Composer, Berlin, 1928
Franz Lederer, Actor, Berlin, ca. 1929
Marinetti, Italian Poet, Berlin, 1929
Georg Grosz, Artist, Berlin, ca. 1929
Käthe Kollwitz, Painter, Sculptor, Berlin, ca. 1930
Peter Lorre, Actor, Berlin, ca. 1932
Thomas Mann, Writer, NJ ca., 1936
Albert Einstein (sailing), Huntington, Long Island, 1937
Albert Einstein, Physicist, Princeton, NJ, 1938
Alfred Stieglitz, Photographer, New York, 1938
Marc Chagall, Artist, New York, 1942
Berenice Abbott, Photographer,New York, c. 1943
Nancy Newhall, Curator, New York, 1943
Eleanor Roosevelt, New York, 1944
William E. DuBois, Historian, Writer, and wife, *Shirley Graham*, Writer, New York, ca. 1950
Lorenz Hart, Lyrics Writer, New York, ca. 1950
Paul Robson, Actor, Singer, New York, ca. 1952
Robert Frost, Poet, Ripton, VT, 1959
Minor White, Photographer, Teacher, Deering, NH, ca. 1962
Pablo Casals, Cellist, Marlboro, VT, 1967

Cities and Travel

Tajik woman Stalinabad, 1932
View of Moscow and the Kremlin, January, 1933
London, 1935
Central Park by Night, New York, around 1940
View of Manhattan from the Squibb Building, New York, around 1940

Theatre and Dance

Claire Bauroff, Dancer, Berlin, ca. 1928
Head of a Dancer, (Niura Norskkaya) Berlin, ca. 1929
Lotte Lenya, Actress, Berlin, ca. 1930
Pauline Koner, Dancer, New York, ca. 1937

Photogenics

Most "photogenics" were made in New York between 1946 and 1955 and are untitled

Further Reading

Beckers, Marion and Elisabeth Moortgat. *Atelier Lotte Jacobi, Berlin/New York*. Berlin: Das Verborgenes Museum, 1997.
Goldberg, Vicki. "Lotte Jacobi." *American Photographer* 2 (March 1979): 22–31.
Lotte Jacobi: A Selection of Vintage and Modern Photographs, Beverly Hills, CA: Stephen White Gallery, 1986.

Lotte Jacobi, Robert Lee Frost (1874–1963), poet. Photograph, gelatin silver print, 17.5 × 24.5 cm.
[*National Portrait Gallery, Smithsonian Institution/Art Resource, New York*]

Lotte Jacobi: Photographs, introduction and notes by Peter Moriarty, Boston: David R. Godine, 2002.
Lotte Jacobi: Theatre & Dance Photographs. Woodstock, VT: Countryman Press, 1982.
Lotte Jacobi: Portraits & Photogenics, Baltimore: University of Maryland, Baltimore County Library, c 1978.
Lotte Jacobi Papers located at the Diamond Library, University of New Hampshire, Durham.
Wise, Kelly, ed. *Lotte Jacobi*. Danbury, New Hampshire: Addison House, 1978.

SUNIL JANAH

Indian

Photojournalist Sunil Janah was born in 1918 in Dibrugarh in the northeast Indian state of Assam, and educated at St. Xavier's and Presidency colleges in Calcutta. A gift of a camera from his grandmother at age 11 and inspiration from a family friend engaged in the profession of photography launched his career as one of the most prolific photographers of pre- and post-independence India. Janah captured, through his lens, images of some of India's most tumultuous and calamitous times. In the 1940s alone, his photographs recorded the Bengal famine of 1943; the South India famine of 1945 (with Margaret Bourke-White); India's peasant, labor, and independence movements; and the communal violence and mass dislocations that accompanied the Partition of India.

Janah's photographic interests started with the pictorial, photography being a hobby secondary to his interest in literature. Eventually, he combined the two interests to launch a lifelong career in photojournalism.

Janah joined the Communist Party of India in 1943 and briefly served as the photo editor on the party's newspaper *The People's War*. He probably envisioned the deliverance of India from British imperialism in a socialist system of governance. It was through his involvement in the Communist Party, substantiated by his photographic represen-

tation of ordinary working people—factory workers, miners, fisher folk, men tilling fields, and women transplanting rice or picking tea leaves, that he participated in the anti-colonial and anti-imperialist struggle and rallied for a socialist state in post-independence India.

In 1943, the diversion of Indian food grains to the British army on the Eastern Front of World War II, the British seizure and destruction of barges that prevented the transport of grains to outlying regions of Bengal, and the involvement of manipulative grain brokers all combined to precipitate the worst human calamity in India's economic history. Janah's potent images of the Bengal Famine of 1943, followed by the images of the 1945 famine affecting South India, in particular Rayalseema and Mysore, permanently encapsulated an historical portrayal of a man-made disaster in an exploited nation reeling under imperialist dominance. Janah photographed emaciated people waiting in line for food, groups of skeletons and hungry dogs gnawing at dead bodies, reminding viewers of similar images by Felice Beato in the aftermath of the Mutiny of 1857.

Janah also accompanied American photographer Margaret Bourke-White (1904–1971) as an interpreter and reporter during her travels in India, providing insider reports. Together, they captured the 1945 Famine as well as some of the most vivid terror-filled images of the violence that marred India's progress to freedom. Bourke-White's images were published in *Life* magazine and in her book *Halfway to Freedom* (1949).

Political events and personalities formed a core subject of Janah's photographs. In addition to portraits of Mahatma Gandhi and Jawaharlal Nehru, Janah also photographed historic moments between Gandhi and Mohammad Ali Jinnah during their talks on the future of India, Gandhi in Calcutta trying to pacify warring Muslims and Hindus during the partition riots of 1946–1947, uprisings against British rule and their brutal suppression, and the communal violence itself, that was unleashed in Calcutta on the eve of India's independence. Particularly horrifying are his images of the bodies of political demonstrators piled in a heap after being shot by police in Bombay in the aftermath of the Naval (R.I.N.) Mutiny, and of bloated bodies on the streets following the Calcutta riots. The Partition itself has been poignantly captured in his depiction of a barbed wire fence implying the creation of separate Hindu and Muslim nations.

During 1947–1967, Janah worked as a freelance photographer in Calcutta, serving also, from 1958 to 1964, as the Head of the Department of Photography at the School of Printing Technology, Calcutta.

Between 1967 and 1979, Janah worked from Delhi. His work during this entire period, from 1947–1979, included assignments from commercial firms as well as from the Government of India and associated agencies, such as the Damodar Valley Corporation and the India Tourism Development Corporation.

In 1957, Janah documented the United Nations' aid in the Southeast Asian nations of Burma, Malaysia, and Thailand, where he photographed rice and rubber plantations and tin mines. He also fulfilled assignments for the U.N. Organization in Geneva and Paris.

In the post-independence era, in the 1950s and 1960s, India executed a series of five-year economic plans based on industrial projects involving the construction of dams and steel plants. Janah maintained a detailed photographic inventory of the changes that represented India's modernity. Notable in this regard are photographs such as those of boatmen rowing a loaded country boat on the Hooghly River, against the background of a Calcutta skyline dominated by modern buildings, and of tribal women workers carrying loads below the giant upright steel pylons of a power plant under construction. Almost as if to counteract the rapid forces of industrialization that threatened India's natural life and beauty, Janah traveled extensively to photograph the people of India—its workers, its peasants, and its tribal people residing in remote areas. Some of his photographs vividly portray their shrunken bodies during natural disasters, while others express their intrinsic grace.

Particularly as regards tribes, Janah felt amazed at the ease with which they appeared before a camera, a gadget unknown to most of them. In eastern and central India, he photographed the Santals, Oraons, Bhumias, Hos and Hajangs of Bengal and Bihar, the Gadabas, Saoras and Juangs of Orissa, the Chakmas of Tripura, and the Murias and Bison-horn Marias of Bastar. In the west and south, he photographed the Bhils of Rajasthan, the Warlis of the Western Ghats and the Todas of the Nilgiris. In the northeast, Janah photographed the Kukis of Manipur, the Nagas of Nagaland, the Abors, Daflas and Mishmis of Arunachal Pradesh, the Miris of the Brahmaputra valley, and the Kacharis, Khasis, Garos and Mikirs of Assam and Meghalaya. Janah's photo-documentation of these tribes preserved pristine images of lives that are constantly changing under the threat of economic and industrial development. Through Janah's camera, the traditional and the modern, the rural and the urban converged to produce a holistic image of an emergent modern nation.

Subsequently, Janah spent more of his time photographing India's monuments and archaeological remains, its dance forms, and its natural beauty. His photographs are a record of India's evolution from political subjugation to independence, from famine to economic recovery and industrialization, from tradition to modernity. Poised between images of the past and present, of the Taj Mahal and Bombay's Victoria Terminus railway station, the temples and sculpture of Khajuraho and Orissa and the modern office blocks of Delhi, Janah's photographs present a priceless visual continuum of India's past and present.

Janah did much of his early photography using a Rolleiflex that had to be held at waist level in order to view the image projected on the ground-glass screen on top of the camera. This positioning may have enhanced the dramatic effect of his composition. He mostly took his photographs in natural light, often under difficult physical conditions. With age, his vision has declined. Although he continued, until very recently to be active in his darkroom, he now spends much of his time working on writing his reminiscences to accompany a retrospective publication of his photographs. Janah, now 86, lived with his wife Sobha in London from 1980 to 2003, and now resides in Berkeley, California.

Janah was awarded the Padma Shri in 1972 by the Government of India in recognition of his outstanding achievement in his field.

Janah's works have been exhibited extensively in India and abroad, including Calcutta, Delhi, Mumbai, Havana, Berlin, London, Prague, Bucharest, Sofia, New York, Philadelphia, and San Francisco.

Janah published three books: *Tribals of India* (2nd ed; OUP, 2003), *Dances of the Golden Hall* with Ashoke Chatterjee (Indian Council of Cultural Relations, 1979), and *The Second Creature* (Signet Press, 1948). His photographs have illustrated several others, including most of the illustrations in books such as *Mahatma Gandhi* by Jawaharlal Nehru, *India Brandt* by Arthur Lundkvist, *Kama Kala* by Mulk Raj Anand, and *Indian Temple Sculpture* by A. Goswami. The BBC and ITV in the United Kingdom and Doordarshan in India have produced short documentaries on the life and works of Sunil Janah.

MONOLINA BHATTACHARYYA

See also: **Bourke-White, Margaret; Portraiture; Social Representation; Visual Anthropology**

Biography

Born in Assam, India in 1918. Photographer and journalist for the Communist Party of India, 1943–1947, working as the photo editor of the CPI paper People's War/People's Age, 1943–1946. Recorded (a) the Bengal-Orissa famine of 1943–1944; (b) the South India famine of 1945 (with Margaret Bourke White); (c) India's peasant, labor and independence movements; and (d) India's partition. Freelance photojournalist, Calcutta, 1947–1967, and in Delhi, 1967–1979. Work included assignments from the Government of India and associated agencies, such as the Damodar Valley Corporation and the India Tourism Development Corporation, India's agricultural, mining and metal industries, and development projects. Continued photographing and recording: India's urban, rural and tribal life; political and cultural luminaries; classical dance; temple architecture and sculpture. Worked for the United Nations organization in Burma, Malaya and Thailand in 1957, and in Geneva and Paris in 1958–1959. Head of the Department of Photography at the School of Printing Technology, Calcutta, from 1958 to 1965. In 1972, awarded the Padma Shri by the Govt. of India, for outstanding achievement in his field. In 1980, moved to London. Continued writing and darkroom printing work on exhibitions and books. Also continued taking photographs in the United Kingdom, Europe, and North America into this century, until rendered unable by increasing loss of vision.

Individual Exhibitions

1965 Calcutta, 1952 and 1953, and New Delhi
1972 Berlin, Rostok and London
1975–76 Prague, Bucharest and Sofia
1984 London at the South Bank and at the Barbican; and Oxford, at the Oxford Museum of Modern Art (along with the paintings of the poet Rabindranath Tagore, on the 125th anniversary of the poet's birth)
1985 New York Overseas Press Club
1987 Oxford, Wolverhampton and several other cities in the Midlands, United Kingdom
1991–92 New Delhi, Calcutta and Bombay, (Retrospectives)
1992 Havana Bienelle at Havana, Cuba
1994 Merida, Mexico
1996 New Delhi—by the Indira Gandhi National Centre for the Arts (IGNCA).
1997 Preston at the Harris Gallery, and London at the Nehru Centre
1998 Gallery At 678, New York
2000 Kalart Gallery, San Francisco

Group Exhibitions

1982 *Festival of India*, at The Photographers Gallery, London
1990 *Fotofest 1990*, Houston, Texas
1997–98 *India—a Celebration of Independence*, an exhibition organized by the Philadelphia Museum of Art and Aperture Foundation at Philadelphia, London, Milan, Virginia, New Delhi, Mumbai (Bombay) and Chennai (Madras)

Further Reading

Sunil Janah's Homepage: *http://members.aol.com/sjanah*.
Goldberg, Vicki. *Looking at India's Upheaval from the Inside (and the Side)*. New York.

Times, August 21, 1998. Exhibition Review: *Sunil Janah: Photographing India, 194–1978*, Gallery At 678, New York, 1998.

Janah, Monua. *Sunil Janah: Inside India, 1940–1975, Historical and Cultural Background*. http://members.aol.com/sjanah/exsf00/histcult.htm.

Ramachandran, V.K. "Documenting Society and Politics." *Frontline* Volume 15, No. 19, September 12-26, 1998. Also available online: *http://www.flonnet.com/fl1519/15190690.htm*.

Guptara, Prabhu. *Sunil Janah—Prabhu Guptara talks to a pioneer Indian photojournalist*. Ten-8, No. 21, 1987.

Sunil Janah, The Second Creature. Calcutta: Signet Press, 1948. (Design and layout by Satyajit Ray).

———. *Dances of the Golden Hall*, Indian Council of Cultural Relations, New Delhi, 1979 (text by Ashoke Chatterjee, introduction by Indira Gandhi and foreword by Yehudi Menuhin).

———. *The Tribals of India*. Calcutta: Oxford University Press, 1993. (2nd ed. 2003.).

PHOTOGRAPHY IN JAPAN

The history of Japanese photography is necessarily understood in relation to Western developments, yet it is important to avoid being overwhelmed by the seemingly endless stream of images that flow from Japan. As well, it is important to decode long-standing Western fantasies about Japanese representation. Yet the preeminence of Japanese photography in areas such as equipment manufacturing during the second half of the twentieth century and the Japanese love of the photographic medium stand as unique features in world photographic history.

Photography was brought to Japan by Dutch travelers between 1839 and 1840; in other words, photography was introduced to Japan virtually from the beginning. In 1848, at the beginning of the Tokugawa period (1848–1868), photographic equipment is mentioned in a document written by a Nagasaki merchant named Toshionojo Ueno. At that time, Nagasaki was the only city where Dutch and Chinese ships were allowed. Soon after, Japan was shaken by violent political and military conflicts, rendering photographic experimentation difficult. The first recorded Daguerreotype was realized by Eliphalet Brown, Jr. in 1854 at the time of the second expedition of Admiral Perry, who had been sent by the United States government to force commercial exchange between Japan and the United States. Brown had been mandated to create an illustrated report, but unfortunately most of these photographs disappeared in a fire in the United States two years later.

The Meiji Restoration of 1968 saw the nation's capital moved to Tokyo (renamed from "Edo"), and for the first time, Western ideas and products were freely allowed into Japan. Thus, for this period of Japanese photography, it is not surprising that the most renowned photographers are Westerners. Felice Beato, who had been the first European to work in China, exploited the growing market for Japanese art in the West and created many delicately hand-colored works published in two albums: *Views of Japan with Historical and Descriptive Notes* and *Native Types*. Baron Raimund von Stillfried-Ratenicz, originally an Austrian painter and direct competitor to the Italian Beato, set up a studio with a number of Japanese assistants, ultimately buying out Beato's studio. The native pioneers of Japanese photography, Hikoma Ueno in Nagasaki, Renjo Shimooka (1823–1914) in Yokohama, and Kimbei Kusakabe (1841–1934) are less well known. Hikoma Ueno is credited with setting up the first native-run studio. Kimbei Kusakabe had trained with both Beato and Stillfried, and he founded his own studio in 1877. It is Renjo Shimooka who is often dubbed the "father of Japanese photography." Although their studios catered to a great extent to Western tourists, they allowed the diffusion of photography in the Japanese society. Landscapes proved popular subjects aside from the portraits that were their main trade, and they largely combined Western conventions while enhancing some details with color. Because most of these productions were intended for the Western market, they fulfilled Western expectations of the Land of the Rising Sun as a place of pastoral beauty and elegant, exotic people. The misty mountainscape, gentle geisha, or the fierce Samuri were popular images.

At the turn of the nineteenth century, there were well over a hundred photography studios operating

in Japan, but the expansion of the field had been limited by the fact that all photographic equipment had to be imported at great cost, as there were no native manufacturers. This sitiuation changed in the early years of the century, with the Cherry Portable camera debuting in 1903. A forerunner of Konica, this modest dry-plate camera marked the beginning of the Japanese camera industry, which was soon to become a dominant force. The Fujii Lens Seizo-sho factory was founded in 1908, equipped with modern manufacturing equipment imported from Germany, and consolidated in 1917 into Nippon Kogaku Kogyo K.K., a forerunner of Nikon, considered one of the finest lines of cameras in the twentieth century. For the amateur market, an affordable pocket-sized camera called the Minimum Idea was introduced in 1911. Its huge popularity can be surmised from the founding, two years later, of the Minimum Photo Club.

During the Meiji era, photography had been linked to the aristocracy and the upper class, both as patrons and subject matter. At the turn of the century, however, newspapers begin to publish photographs; the first Japanese photojournalists covered the Boxer Rebellion in China in 1900 and the Russian-Japanese war in 1904–1905. Important pioneering photographers of this period were Reiji Ezaki and Kenzo Tamoto, who studied with Hikoma Ueno and created the well-known work, *Ainu woman harvesting seaweed* (ca. 1900), and paved the way for a more realistic photographic style.

Great expansion in the field took place during the Taisho era (1912–1926). With Emperor Taisho's succession to Emperor Meiji, Japan was finally fully emerging on the international scene. Despite the boom of the Minimum Idea camera, photography was still largely an artistic medium, remaining under the influence of painting in the dominant Western style known as Pictorialism. Japanese Pictorialists include: Teiko Shiotani, Hakuyo Fukumori, Ori Umesaka, and Yasuzo Nojima, who, like their western counterparts Robert Demachy, Julia Margaret Cameron, and Gertrude Käsebier, concentrated on techniques to enhance texture, create half tones, and soften outlines. In Japan, painting and photo are so closely linked that the term which is used is *shashin-ga*, which could be translated as "photographic painting."

Until 1920, the division of style common in painting was applied to photography: on one hand, the *Nihonga* style or Japanese painting and on the other hand, the *Yoga* style, which means Western painting. The Fukuhara brothers, Shinzo and Roso, who were a major force in the early days of modern photography in Japan, and Kiyoshi Nishiyama are key figures of this period. They were the first to breach this stylistic partition, associating the spare but atmospheric characteristics of the Nihonga tradition with a clearer pictorial vision, as exemplified by the emerging Modernists in the West such as Paul Strand or Edward Weston. In 1921, Shinzo Fukuhara, who had traveled and photographed extensively in the West, formed *Shashin-Geijyutsu-sha* along with his brother Roso and Isao Kakefuda and Motoo Ootaguro, and founded the magazine *Shashin Geijutsu* (Art Photography). Shinzo also served as first chairman of the Japan Photographic Society. These photographers did not free themselves entirely from Pictorialism, as can be seen in Shinzo's *Paris et la Seine*, 1922. Roso Fukuhara, however, achieved a more Modernist vision in his works.

A number of illustrated news and popular magazines appeared during the 1920s, providing venues for photography, including *Kokusai Shashin Joho*, *Kokusai Jiji Gappo* (later named *Sekai Jiji Gappo*), and *Kokusai Gappo*. Photography magazines included *Geijutsu Shashin Kenkyu*, *Photo Times*, and *Amateur*. The first major photography curriculum at the college level, the Konishiroku Shashin Senmon Gakko photo school, was established in Tokyo. Renamed Tokyo Shashin Senmon Gakko in 1926, the school currently exists as the Tokyo Institute of Polytechnics. This program joined the already exisiting photography department, founded in 1915, of Tokyo Bijutsu Gakko (Tokyo Art School).

During the Taisho period, the history of Japanese photography also saw a major milestone with the introduction and subsequent widespread use of the small format, roll-film camera. A leading example was the Kodak Vest Pocket, introduced by Eastman Kodak in 1912, and available in Japan around 1915. This camera spawned the *Vesu-tan* group, who experimented with lens effects and printing techniques that were relatively simple and did not require a professional studio to achieve. In 1925, the Konishiroku Honten Company introduced the highly popular Pearlette camera as an imitation of the Vest Pocket. The consequence was a major expansion of amateur photography associated with Japanese practice. The 1920s also saw the founding and expansion of numerous photographic clubs and associations. Along with Shinzo Fukuhara's Nihon Shashin-kai (Japan Photographic Society), founded 1924, the Zen-Nihon Shashin Renmei (All-Japan Association of Photographic Societies) formed from the consolidation of numerous smaller clubs. This organization published the influential *Asahi Camera* magazine.

Advances in equipment manufacturing continued. Asahi Kogaku Goshi Kaisha, the forerunner of Asahi Optical Company, Ltd., the maker of Pentax cameras, had been established in Tokyo in 1919 as a manufacturer of opthalmic lenses. By 1934, it had become a major supplier of camera lenses for manufacturers such as Konishiroku and Minolta. The forerunner of Olympus Optical Co., Ltd., Takachiho Seisaku-sho, had also been established in 1919, as a microscope manufacturer. It made its first photographic lens in 1936. Photographic papers were being widely manufactured by this era as well. In 1928, the forerunner of Minolta Camera Company was founded. Along with several other lens manufacturers producing innovative products, Nippon Kogaku Kogyo K. K. manufactured its first Nikkor lens, which in 1936 was first mounted on the Hansa Canon camera. The forerunner of Canon, Inc. was established in 1933 as Seiki Kogaku Kenkyusho (Precision Optical Instruments Laboratory), introducing the Hansa Canon in 1935. In 1934, the Fuji Photo Film Company was established. That same year, the "Super Olympic," the first 35mm camera made in Japan, was produced.

In the first half of the 1930s, at the beginning of the Showa period (1926–1989), Japanese photography saw the impressive burgeoning of the medium also characteristic of the interwar years in Europe. Along with the influence of European avant-gardes, there was the development of press photography or photojournalism, and the advent of modernist design and advertising. Building on the expansion of artistic thought and practice of the 1920s, institutions that could form the basis for an academic movement, a counter-culture, and an avant-garde were in place. Photography followed the race for development of Japanese society in general, and reflected the changing conditions and the new sensibilities of individuals. During this period, marked by two major disasters—the 1923 Tokyo earthquake and the devastation of the atomic bombing of Hiroshima and Nagasaki in 1945—the medium entered into a stage wherein there was the uneasy coexistence of opposing expressions: the traditional Pictorial-influenced realism, and experimental practices.

In the 1930s, photography bloomed in the illustrated press, which in part was inspired by the picture stories of *Life* magazine, which began publication in 1936. Yonosuke Natori was the first Japanese photographer to be published in *Life*, with his images of Japanese soldiers. The photojournalists, however, were opposed to *shinko shashin* (new or modern photography), whose adherents mixed Pictorialism with aspects of the European avant-garde. Modernism represented a decisive rupture, a rejection of a pictorialist aesthetic that many Japanese photographers were reluctant to make. Fueled by technical advances, however, the modern movement included significant experimentation, which led artists to discover new possibilities.

Those who practiced *shinko shashin*, or the new photography, included Kiyoshi Koishi, Nakaji Yasui, Iwata Nakayama, Yasuzo Nojima, and Ihee Kimura; they were particularly influenced by the German movement *Neue Sachlichkeit* (New Objectivity), and the teachings eminating from the Bauhaus schools in Dessau and Berlin. They were able to experience firsthand the European avant-gardes via the *Film und Foto* exhibition, organized in 1929 at Stuttgart, Germany and presented in 1931 in Tokyo and Osaka. This exhibition showed the works of László Moholy-Nagy, Albert Renger-Patzsch, and many others. The *Photo-Times* magazine, founded in 1924, had also begun to publish new trends in foreign photography in the 1930s.

Innovations proposed by the *shinko shashin* philosophy were spread via three important clubs, each reflecting the personality of their founders: Kiyoshi Koishi with the Naniwa Shashin Club of Osaka, Nakaji Yasui with the Tanpei Shashin Club, and Iwata Nakayama with the Ashiya Camera Club. Another group, Zen 'ei Shashin Kyokai (photographic avant-garde), was in part inspired by Surrealism. In parallel, the Realist Movement appeared with, among others, Ihee Kimura, Shoji Ueda, Yonosuke Natori, and Hiroshi Hamaya.

An important magazine that supported the expression of the modern photography movement, *Koga*, published 18 issues between May, 1932 and December, 1933. Graphic design and typography as innovative as the photographs that appeared were published by the magazine's principals, Yasuzo Nojima, Iwata Nakayama, Nakaji Yasui, and Ihee Kimura. The first issue consisted of a manifesto that urged photographers "to smash into pieces the concepts of traditional art." Works by *Koga's* three founders are characteristic of the *shinko shashin* movement. Nojima, the head of the magazine and the oldest of the three, had practiced a Pictorialist style for more than 20 years, as exemplified by the 1910 photograph *Troubled. Waters.* Around 1930, he made a radical move to experimental forms, as seen in *Untitled, Model F* of 1931. While he specialized in nudes and portraits, Nojima consistently tried to go beyond the rules of these genres. Kimura was the first to use a 35-mm Leica to produce snapshot-like photographs of the daily life of the working classes of Tokyo. His photo-

graphic style is characterized by a floating space, an emphasis on texture that suggests a zen spirit in the conception of his photographs, as can be seen in *Portraits of Literary Artists* of 1933. Nakayama had worked in portrait studios in New York and Paris, where he came into contact with what was called "Pure Photography," as exemplified by Paul Strand or Albert Renger-Patzsch. When he returned to Japan, he worked on photograms and multiple exposures.

During the short life of *Koga*, several essays on theoretical and experimental topics were published, further disseminating these ideas among Japanese photographers. Publication ceased in 1933 for financial reasons and because Ihee Kimura decided to pursue photojournalism. The modern or new photography movement revealed the fluid situation of Japanese photography in the 1930s. The most important club, the Naniwa Shashin Club, which had been a leader of Pictorialist style for 20 years, moved, for a short period, to the promotion of experimental works.

Several smaller groups in the Kansai area (Osaka and Hyogo) were dedicated to experimentation. The Tanpei Shashin Club, created by Bizan Ueda and Nakaji Yasui in February 1930, attracted Osamu Shiihara and Tershichi Hirai, who practiced styles very strongly influenced by the German New Objectivity. Shoji Ueda, a mainstay of the Naniwa Club, was particularly inspired by Moholy-Nagy's *Malereï, Fotographie und film*, and was one of the first Japanese photographers to develop a highly personal aesthetic, photographing his family as models in his ongoing *Dunes* series. Sutezo Otono and Ei-Q (Sugita Hideo) were the first photographers to explore the possibilities of photogram, a technique pioneered by Moholy-Nagy and Man Ray. Ei-Q worked on a plastic approach to photography, combining painting and photography.

Also, Surrealism had been important in Japan because it gave birth to a new photographic style in the late 30s. Gingo Hanawa, Yoshio Tarui, and Terushichi Hirai created the avant-garde group *Zoei Shudan*. They used techniques such as photograms and multiple exposures and printing to describe imaginary worlds. The photomontage work of Gingo Hanawa that explored themes of dream and illusion and which he dubbed "Complex Pictures," is created with a collage technique, allowing a broader definition of photography. With his *Hansekai* series, Kiyoshi Koishi proved that he had integrated and digested avant-garde techniques, employing them as tools to elaborate his own photographic universe.

However, Pictorialism continued to exert attraction on young photographs after 1930, carrying this style much beyond its general practice in the West. Sakae Tamura and Giro Takao, two young photographers of this period who had been published in *Photo Times*, created pictorialist pictures, modeled on Impressionist painting and infused with subjectivity, that were considered as works that forecast Surrealism.

Established figures such as Ihee Kimura, Shoji Ueda, and Yonosuke Natori, with their adaptations of Social Realism, a style practiced in Europe and America especially during the Great Depression, took up the visual vocabulary and the themes of the German illustrated press. But in the mid-1930s, the Japanese government, marching inexorably toward militarization, took over these themes to make fearsome weapons of propaganda in magazines such as *Front* or *Nippon*. Propaganda, along with a film shortage and government crack-down on the manufacture or importation of photographic equipment as World War II began, cut significantly into photographic production. Censorship was also practiced. Ken Domon's protest against censorship published in *Nihon Hyoron* in 1943 resulted in the banning of the magazine, and the last months of World War II saw the destruction of thousand of so-called "compromising negatives." The war era also saw the consolidation or cessation of publication of many photography magazines as part of the general contraction in the field.

As with every aspect of Japanese life, the dropping of the two atomic bombs by the United States in the waning months of the War are an inescapable reality and watershed for Japanese photography. The tragedy of Nagasaki and Hiroshima is immortalized by the photographic accounts in the hours and the days that followed the bombings by Yoshito Matsushige and Mitsugi Kishida in Hiroshima and Army photographer Yosuke Yamahata in Nagasaki, along with some pictures by a young student, Toshio Fukda, Seizo Yamada, and Eiichi Matsumoto. From these rare documents ensued many reflections about destruction and what history cannot erase. Initially, there was a ban on publishing any photographs of the atomic bomb destruction by the U.S. occupation; this ban was lifted in 1952. But as late as 1965, Kikuji Kawada published a collection called *Bijutsu Shuppansha (Maps)* in which he mixed close-up shots of stains, bumps, and cracks on walls of the Atomic Dome of Hiroshima with pictures of dead soldiers. Through the combination of these disparate elements, close-up shots of objects and numerous signs, Kawada evoked the defeat of Japan during

World War II. His famous black-and-white picture from this series of the Japanese flag, lying on the ground, seeming soaked and wrinkled, is a symbol of an essential part of Japanese history.

The general devastation caused by World War II as well as the economic reality of a bankrupt country also devastated the Japanese photographic equipment industry. Many manufacturers, having had their resources diverted to the war effort, found it difficult to rebuild in the bleak postwar years. The Nikkor lenses, however, after having been introduced to eminent war photographer David Duncan Douglas, who was then in Japan, became the lenses of choice for international war correspondents and photojournalists, one step towards the preeminence of Japanese photo equipment in the postwar era.

Photographers tried to report the terrible events of the war while looking to the reconstruction of the mental and physical landscape of the country. Ken Domon, who with Shigeru Tamura and Hiroshi Hamaya had formed *Seinen Hodo Shashin Kenkyukai* (Young Documentary Photo Research Club) in 1938 to practice a socially aware documentary style, published his powerful series *Hiroshima* in 1958. A work about memory and the inability to completely bury the past, this series was unique in post-war Japanese photography as the country modernized and looked to a future shaped by science and technology. This accession to modernity is evident in two events: the 1964 Tokyo Olympic Games and the 1970 Osaka World's Fair. As part of reflection about modernization, Japan discovered, in the 1950s and 1960s, such Western photographers, as Henri Cartier-Bresson, Robert Doisneau, Brassaï, Robert Frank, and W. Eugene Smith, who realized one of the most heartrending photographs of Japan, *Tomoko Kamimura in Her Bath*, 1971 from a photo-series that chronicled the disastrous mercury poisoning caused by a manufacturing plant in the fishing village of Minamata.

In 1950, Ken Domon founded the *Shudan* group, which exhibited such leading international photojournalists as Margaret Bourke-White, W. Eugene Smith, Henri Cartier-Bresson, and Bill Brandt. Following the tenets of the German movement "Subjektive Fotografie," the first signs of a revival of photographic subjectivity appear while the popularity of the practical applications of photography greatly increases. Post-war Japanese photographers generally were unconcerned by technical issues; American-born Yasuhiro Ishimoto, trained by Harry Callahan and Aaron Siskind at the Chicago Institute of Design, visited Japan in 1953 for a five-year stay and brought with him the lessons of the New Bauhaus, greatly influencing the emerging post-war generation. He permanently relocated to Japan in 1961 and became a Japanese citizen. Ishimoto was the only Japanese to be included in the massive *The Family of Man* exhibition organized in 1955 by the Museum of Modern Art in New York and which circulated in Japan in 1956 to an audience of over a million people.

Post-war Japanese photography largely developed around three axes: documentary photography, personal photography, and commercial photography. Ken Domon led the movement for documentary forms with an influential essay in which he defined "realism" photography, published as instructions for potential entrants to the monthly contests held by the international magazine *Camera*, for which he served as a juror. Another important practitioner was Shomei Tomatsu, who with his series *Nagasaki, 11:02* (the time the atomic bomb was dropped) pays tribute to the survivors of Nagasaki. Ihee Kimura and Hiroshi Hamaya, professional photographers before the war, increasingly considered photography as a medium to discover, capture, and transmit a social reality. Hamaya documented folklore, traditions, and rituals that were threatened with being swept away in the rush to modernization. Hamaya developed his photographic thinking through two major publications: *Yukiguni (Snow Country)* of 1956 and *Urah Nihon (Japan's Back Coast)*, 1957. Ihee Kimura, inspired by Cartier-Bresson's philosophy of "the decisive moment," continued his snapshot aesthetic in documenting the average Japanese citizen in the street, at work, or engaging in other aspects of everyday life. Kimura's importance to Japanese postwar photographic history is reflected by the naming of a prestigious prize awarded annually by *Asahi Camera* magazine.

Relationships to history, the history of a place, religious experience, and the construction of bonds which unite people and their divinities are also found in the photography of Yoshio Watanabe. A leading architectural photographer, in 1953 he was authorized to take pictures of the ritual of razing and rebuilding the Ise Jingu Shrine, an ancient Shinto temple in the Mie Prefecture made of wood, which takes place every 20 years. The documenting of this reconstruction was a milestone both for Watanable and Japanese photography.

Personal photography is based on the I-Novel, and based on the idea that photography can become an individual expression, a notion that came late to Japan. These photographers were younger, emerging as professionals after the War. The most representatives artists in this arena are Daido Moriyama, who was influenced by William Klein; Nobuyoshi Araki,

who was the first to use and popularize the term "I-photography"; and Masahisa Fukase, who completed series about solitude and madness, such as the *Yoko* series, 1964–1975. Other postwar figures, such as Eikoh Hosoe and Ikko Narahara (known also as simply "Ikko"), explored other personal paths.

In his 1956 series *Man and His Land*, Ikko draws a parallel between two communities, the small village of Kurogami on the island of Kyushu, destroyed by an erupting volcano; and the artificial island of Hajima, which was built around a coal mine. The photographs presented a pessimistic view wherein man is subject to both nature's hostility and social oppression. Ikko continued working with the photoessay form but expanded his practice to other experimental art mediums in the 1970s and 1980s. Eikoh Hosoe dramatized a relationship between himself and a young American girl he met in a base as he was looking to improve his English in a photo narration *An American Girl in Tokyo* (1956), using a photojournalistic technique to create a work of fiction. Hosoe was hardly the only Japanese photographer to dwell on implications of the U.S. occupation of Japan, which officially ended in 1952 but saw U.S. troops stationed on Japanese soil to the end of the century. Shomei Tomatsu, who has established himself as one of Japan's leading postwar figures with his 1958 series *Chewing Gum and Chocolate*, documented the preoccupation of Japanese people wishing to save their traditions and culture from Americanization.

From 1957 to 1959, critic Tatsuo Fukushima organized seminal exhibitions called *Jūnin no me*, which means "The Eyes of Ten People." The 10 exhibitors were Eikoh Hosoe, Yashuhiro Ishimoto, Kikuji Kawada, Shun Kawahara, Ikko Narahara, Masaya Nakamura, Akiro Sato, Akira Tanno, Shomei Tomatsu, and Toyoko Tokiwa. Six of these colleagues, Hosoe, Kawada, Narahara, Sato, Tanno, and Tomatsu, created the important agency VIVO to support and distribute their style of photojournalism while pursuing their personal work.

Significant advances in photographic technology continued as Japanese manufacturers innovated and improved their products. By 1962, Japan had displaced West Germany as the world's top producer of cameras. In the early 1960s, the Nikonos camera, the first underwater camera not requiring a bulky housing, was introduced. The Pentax SP was introduced in 1964 as the first single-lens-reflex camera featuring a through-the-lens exposure system, which was soon to become standard in SLR cameras. The next year, the first Japanese cameras incorporating electronic shutters were introduced, and Canon created the world's first camera with a quick-loading feature for 35-mm film, also to become a standard feature.

In the second half of the 1960s, a new generation of artists, including Daido Moriyama, Hiromi Tsuchida, Yutaka Takanashi, Masahisa Fukase, and Issei Suda questioned the conception of modern art based on the creation of an original world inspired by the personality and the aesthetic sense of the artist. In November of 1968, Yutaka Takanashi, Takuma Nakahira, Koji Taki, and Takahiho Okada published the magazine *Provoke*. The pictures of these photographers are characterized by a fragmentation without any aesthetic order and by violently contrasted images. Although very short-lived, publishing only three issues, with runs never exceeding 1,000 copies, *Provoke* became a seminal opus of post-war Japanese photography. Indeed, *Provoke* carried radical photographic theory and unpolished images described as *are-bure-boke* (rough, blurred, out-of-focus) as described by photohistorian Anne Wilkes Tucker.

Nobuyoshi Araki first emerged as a major force in Japanese photography when he was awarded the first ever and now prestigious Taiyo-sho Award in 1961. A photo essay called *Satchin* that followed children out on the street in Tokyo was the first in an almost continuous documentation of everything that comes before Araki's lens, including subject matter many consider goes beyond the erotic to pornographic, making him a prototypical figure of Japanese photography in the West.

During most of the postwar period, the nude in photographs was considered objectionable, and the government banned the depiction of pubic hair, to the point that officials impounded nude photographs of Edward Weston scheduled for a 1976 exhibition. Kishin Shinoyama was one of the few Japanese to explore this genre fully, with his 1969 series *Death Valley*, *Twin*, and *Brown Lily*. The *Death Valley* nudes are striking abstractions of the body arranged against the dramatic landscape of the famous California desert. Shinoyama also made his mark with a collection of photographs of Yukio Mishima. In September 1970, before his suicide by hara-kiri, which became an international event, the novelist posed for Shinoyama, acting out for the camera his ideas for his own death. Two pictures in particular became very famous: the first one shows the transformation of Mishima into a Saint Sebastian motif, his wrists tied to the branch of a tree while arrows pierce his side and armpit. In the second one, Mishima is lying on the ground, a short saber stuck in his abdomen, while the photographer stands behind him, brandishing a longer saber, waiting for a signal to behead Mishima.

Mishima claimed to be protesting against the loss of values in Japanese society to the advances of technology and capitalism. Those pictures, like those from the 1963 collection *Barakei (Killed by Roses)* of Eikoh Hosoe, once more questioned the modern history of Japan and its relationship with Western art history.

With the beginning of the Heisi period in 1989 with the death of Emperor Hirohito and the succession of Emperor Akihito, while domestically Japan experienced a severe recession which caused the closing of several magazines and photo galleries, a new breed of Japanese photographer had emerged, dealing with international artistic issues and achieving international recognition while staying true to the deep traditions of Japanese photography. Yasumasa Morimura became known internationally with work that explored this set of themes. In large-format color images, Morimura used himself, costumed and made-up, to imitate the major paintings of Western art history, such as *Daughter of Art History: Princess A*, of 1990, which is inspired by Velasquez's portrait of l'Infante Margarita of 1656. Morimura also realized a self-portrait, *Doublonnage (Marcel)*, in 1988, in which he represents himself as a new Rrose Sélavy, the portrait of French avant-garde artist Marcel Duchamp in the guise of his female alter-ego that was immortalized by Man Ray in 1920–21. Although working within postmodern precepts at the end of the twentieth century, Morimura's method creates a continuity between painting and photography, a salient issue at the turn of the nineteenth century.

Hiroshi Sugimoto, another internationally renowned figure, has meditated on time and space since 1978. Made with a wooden cabinet 8 × 10-inch Durdorf and Sons view camera and long time exposures modulated by filters to create a film speed comparable to nineteenth century films, Sugimoto pictures contain a disturbing poetry initially more collected by those in the West than in Japan. Photographing in ongoing series the elaborate U.S. movie palaces of the 1920s and 1930s, drive-in theaters, natural history museums, wax museums, and seas and oceans, the Zen spirit that infuses Sugimoto's work seems uniquely Japanese.

Toshio Shabata is another prototypical Japanese photographer who has established a wide reputation in the West with his extraordinary, large-scale landscape studies, often showing the earth contained or otherwise interrupted by man's engineering feats. His 1999 exhibition *Quintessence of Japan* established his reputation as one of Japan's leading contemporary photographers.

Japanese photographers historically had been almost entirely male; in the 1980s and 1990s, young Japanese women finally began to emerge as creative forces, chief among these figures is Mariko Mori. Like her colleague Yasumasa Morimura, identity is one of Mori's favorite themes., She also integrates into her photographic compositions elements from Shintoist Buddhism: (*Mirror of the Water*, 1996; *Pure Land, Entropy of Love* and *Burning Desire*, 1998). She often represents herself as a sort of hybrid creature of human and machine, a character who has perhaps stepped out of the *manga*, and *anime* forms so popular in Japan during these years. Mori is also a technical innovator, working with holographic imagery and three-dimensional video. Since 1995, Mariko Mori has worked on a project, *Beginning of the End*, that combines space and time. At each stop during her extensive travels, the artist takes photographs using a 360° camera, the artist herself present in the middle of the image, held within transparent capsule. Made up of 13 panoramic images, *Beginning of the End*, is divided into three groups that depict the past (Angkor, Teotihuacán, La Paz, Bolivia, Gizeh), the present (Times Square in New York, Shibuya in Tokyo, Piccadilly Circus in London, and Hong Kong), and the future (represented by ambitious development projects La Défense in Paris, the city of Shangai, the Docklands in London, Odaiba in Tokyo, and the construction boom of post-Cold War Berlin).

The high school student Hiromix (Toshikawa Hiromi) became a phenomenon in Japan with her Nobuyoshi Araki-inspired photo diary style as young women became a greater and greater influence on the creation and consumption of photographs. A 1998 exhibition *An Incomplete History*, attempting to capture the history of female photographers during the 130-year history of the medium, began a two-year tour of the United States. It featured nine photographers, most of whom had been largely overlooked, including Eiko Yamazawa, Osaka's first woman photographer who ran her own studio from the 1930s to the 1950s; Tsuneko Sasamoto, known as Japan's first female documentary photographer; Miyako Ishiuchi, who did a pioneering series of male nudes; and Michiko Kon, a younger artist known for her still lifes.

In the 1990s, Japanese photography saw greater institutionalization, with the opening of the permanent quarters of the Toyko Metropolitan Museum of Photography, the founding of the Kiyosato Museum of Photographic Arts and the Shoji Ueda Museum of Photography, and numerous other photography programs. The widespread use of dis-

posable cameras and other easy-to-use equipment, such as the auto-focusing camera developed in Japan, further cemented the longstanding fascination with the medium. Photography entered the digital age with the manufacture of products that further expanded amateur use, such as camera phones, automatic vending machines dispensing photo stickers that created the Print Club (Purinto Kurabu) craze, and other devices, with the Internet allowing almost instantaneous circulation of images.

THOMAS CYRIL

See also: **Araki, Nobuyoshi; Domon, Ken; History of Photography: Interwar Years; Hosoe, Eikoh; Ishi-** moto, Yasuhiro; Kawada, Kikuji; Morimura, Yasumasa; Pictorialism; Shibata, Toshio; Sugimoto, Hiroshi; "The Decisive Moment"; Toyko Metropolitan Museum of Photography

References

PhotoGuide Japan website: http://photojpn.org.
The History of Japanese Photography. Houston and New York: Museum of Fine Arts, and the Japan Foundation, 2003.
The Founding and Development of Modern Photography in Japan, Tokyo: Tokyo Metropolitan Culture Foundation and Tokyo Metropolitan Museum of Photography, 1995.

HAROLD JONES

American

Harold Jones's career in photography has spanned more than 40 years. He has been involved with the industry in its many facets—as a museum curator, gallery director, director of a photographic archive, a teacher of studio photography at the college level, and as a professional photographer. As an undergraduate student at the Maryland Institute of Art in Baltimore in the early 1960s, Jones studied both painting and photography. When applying to graduate programs, he produced a portfolio of black-and-white photographic self-portraits that were painted over half their surface. At the time, he did not know of anyone else working in this manner, and did not know how to refer to this collection of hybrid images. Fortunately for him, his prospective graduate advisor, Van Deren Coke, liked the work and took Jones on as a student at the University of New Mexico in Albuquerque.

Following his graduate work, Jones spent several years as an assistant curator at the George Eastman House in Rochester, New York, but left in 1971 to become the first director of the Light Gallery in Manhattan. Tennyson Schad, owner of the Light Gallery, hired Jones to operate what was then only the second major gallery devoted to the sale of art photography in New York City. The Witkin Gallery had opened in 1969 and sold nineteenth-and twentieth-century photographs, but the Light Gallery focused on the work of contemporary photographers, including Harry Callahan, Aaron Siskind, Frederick Sommer, and, later, Robert Mapplethorpe. The gallery's success was attributed to Tennyson Schad's willingness to show young, unknown photographers and to trust his staff and directors in their artistic decisions. While Jones left in 1975 to become the first director at the Center for Creative Photography, Light Gallery continued to impact the contemporary photography scene until it closed in 1987.

The Center for Creative Photography at the University of Arizona in Tucson was established in May of 1975 to house the purchased archives of Ansel Adams, Wynn Bullock, Harry Callahan, Aaron Siskind, and Frederick Sommer. As the center's first Director, Jones oversaw the earliest programs at the center, which included publication of a journal, in-house and touring exhibitions, and continued collections acquisition. In 1977, Jones left the center, but he stayed in Tucson, to start a program of photography instruction at the University of Arizona. The photography of Harold Jones is difficult to categorize, and there are no generalizations that satisfactorily describe his varied body of work. His original dual training in painting and photography led to a practice that Jones referred to as "photodrawings"— gelatin silver prints that are worked with a variety of hand-colored surfaces. Over the years, Jones used ink, food coloring, and oil paints as well as a

variety of chemical toners, often in combinations that were thought to be incompatible. The resulting images are unique and cannot be duplicated. Jones' hand-colored effects range from subtle to direct and are the result of continuing experimentation. Initially, he felt ambivalence about altering the surfaces of his prints, feeling that it was an impure practice, but ultimately he concluded that the making of the photograph was the first phase of drawing, and surface treatments and coloring constituted the second phase.

In addition to experimenting with hand-coloring, Jones's approach is varied even within his unaltered prints. Jones has worked with both multiple and long-duration exposures to capture people in motion, or to suggest apparitions. Rather than creating intimate or psychologically probing studies, Jones uses as his subjects everyday objects arranged in compositions that require viewing and re-viewing. Jones has described his delight in the process in which a person moves beyond a superficial reading of a photograph to a closer inspection. His images reinforce the idea that a world continues beyond the picture plane, that one is seeing a fragment of a larger whole. While he often photographs everyday objects, such as the supports of a water tower, or laundry hanging on a folding rack, they are often taken from an unusual vantage point or cropped in unexpected ways. These varied approaches can produce a range of effects from humor to mystery. Sometimes Jones creates formal compositions that submerge the meaning of the objects shown. When the objects displayed can be discerned, however, they appear neither mundane nor banal. Jones' compositions and juxtapositions provoke questions whose answers are often not found within the edges of the photograph.

In addition to his work as a photographer, since 1977 Jones has been instructing students at the University of Arizona on the art of photography. As a professor, Jones teaches introductory and photo-techniques courses and also provides instruction in documentary photography and self-portraiture. The University of Arizona photography department includes several studio photography instructors. The department promotes a philosophy of creating photographs that communicate significant personal substance by building on a broad background in the visual arts at large and through a specific knowledge of the cultural, historical and visual aspects of photography.

REBECCA SENF

See also: **Adams, Ansel; Callahan, Harry; Center for Creative Photography; Coke, Van Deren; Galleries; Hand Coloring and Hand Toning; Manipulation; Mapplethorpe, Robert; Multiple Exposures and Printing; Siskind, Aaron; Sommer, Frederick**

Biography

Born Morristown, New Jersey, 29 September 1940. Received a diploma in painting from the New School of Fine and Industrial Art, Newark, New Jersey, 1963; Maryland Institute of Art, Baltimore, Maryland, BFA in photography and painting, 1965; University of New Mexico, Albuquerque, New Mexico, MFA in photography and art history, 1971. Advertising Chairman, Gallery 61, Newark, New Jersey, 1962–1963; Wedding Photographer, Udel Studios, Baltimore, Maryland, 1964; Official School Photographer, Maryland Art Institute, Baltimore, Maryland, 1964; Portrait Photographer, Jordan Studios, Baltimore, Maryland, 1965–1966; Gallery and Technical Adviser, Quivera Bookshop and Gallery, Corrales, New Mexico, 1966–1967; Assistant, University of New Mexico Art Museum, Albuquerque, New Mexico, 1966–1968; Assistant Curator, Exhibitions, George Eastman House, Rochester, New York, 1968–1969; Associate Curator, Exhibition and Extension Activities, George Eastman House, Rochester, New York, 1969–1971; Visiting Lecturer, Photography, University of Rochester, New York, 1970–1971; Visiting Lecturer, Photography, Cooper Union, New York City, New York, 1971–1972; Director, Light Gallery, New York City, New York, 1971–1975; Adjunct Associate Professor of Art History, Queens College, New York City, New York, 1974–1975; Director, Center for Creative Photography, University of Arizona, Tucson, Arizona, 1975–1977; Director, Photography Program, Department of Art, University of Arizona, Tucson, Arizona, 1977–1985, 1991–1993, 1994–1995; Assistant Professor of Art, Department of Art, University of Arizona, Tucson, Arizona, 1977–1981; Associate Professor of Art, Department of Art, University of Arizona, Tucson, Arizona, 1981–1993; Professor of Art, Department of Art, University of Arizona, Tucson, Arizona, 1993–present; Director, Graduate and Undergraduate Programs, Department of Art, University of Arizona, Tucson, Arizona, 1999–present. Fellowship, George Eastman House, Rochester, New York, 1967; National Endowment for the Arts Photographers Fellowship, 1977. Living in Tucson, Arizona.

Individual Exhibitions

1969 University of California at Davis; Davis, California
1970 Rochester Photographic Workshop; Rochester, New York
 Barnes Gallery, Loomis Institute; Windsor, Connecticut
1972 Madison Arts Center; Madison, Wisconsin
1973 University of Massachusetts; Boston, Massachusetts
1974 Soho Photo Gallery; New York City, New York
1976 Spectrum Gallery; Tucson, Arizona
 Light Gallery; New York City, New York
1977 Kresge-Art Center, Michigan State University; East Lansing, Michigan
1978 *Lightning*; Neal Slavin Studio; New York City, New York
 Harris 125 Gallery, University of Southern California; Los Angeles, California
1980 Light Gallery; New York City, New York

1982 *Harold Jones: Photo-Drawings*; Center for Creative Photography; Tucson, Arizona

1984 *Recent Photo-Drawings*; B.C. Space; Laguna Beach, California

1988 *Main Space*; Blue Sky Gallery, Oregon Center for Photographic Arts, Inc.; Portland, Oregon

1989 *Harold Jones*; Dinnerware Artist's Cooperative Gallery; Tucson, Arizona

1991 *Harold Jones Tucson Photographs*; Photo Picture Space Gallery; Osaka, Japan

1996 *Harold Jones*; Jewish Community Center Fine Arts Gallery; Tucson, Arizona

2000 *Seeing 60*; Joseph Gross Gallery, Department of Art, University of Arizona; Tucson, Arizona

Selected Group Exhibitions

1970 *Photosynthesis*; Oakland College of Arts and Crafts; Oakland, California

1972 *60s Continuum*; International Museum of Photography, George Eastman House; Rochester, New York

1973 *New Images 1839–1973*; Smithsonian Institution; Washington, D.C.

1974 *New Images in Photography*; Lowe Art Museum, University of Miami; Coral Gables, Florida

1977 *The Great West: Real/Ideal*; University of Colorado; Boulder, Colorado (subsequently Smithsonian Institution traveling exhibition; toured the United States)

1979 *Attitudes: Photography in the 1970s*; Santa Barbara Museum of Art; Santa Barbara, California

1980 *Mondo Arizona*; Joseph Gross Gallery; University of Arizona, Tucson

1981 *Contemporary Hand-Colored Photographs*; de Saisset Art Gallery, University of Santa Clara; Santa Clara, California

Harold Jones and Frances Murray; Gallery Atelier 696; Rochester, New York

1983 *Arboretum*; Boulder Center for the Visual Arts; Boulder, Colorado (traveled to Shwayder Gallery, University of Denver School of Art; Denver, Colorado and Auraria Higher Education Complex; Denver, Colorado)

1984 *The Alternative Image II*; Kohler Arts Center; Sheboygan, Wisconsin

1985 *Extending the Perimeters of Twentieth Century Photography*; San Francisco Museum of Modern Art; San Francisco, California

1986–87 *Arizona Biennial*; Tucson Museum of Art; Tucson, Arizona

1988 Tyler Art Gallery, State University of New York at Oswego; Oswego, New York

1990–91 *Arizona Photographers: The Snell and Wilmer Collection*; Center for Creative Photography; Tucson, Arizona (traveled to Coconino Center for the Arts; Flagstaff, Arizona)

1991 *Andres, Jones and Nash*; Dinnerware Artist's Cooperative Gallery; Tucson, Arizona

1995 *Scratching the Surface*; The Museum of Fine Arts; Houston, Texas

1997 *97 Arizona Biennial*; Tucson Museum of Art; Tucson, Arizona

1998 *The Northlight 25th Anniversary Exhibition*; Northlight Gallery, Arizona State University; Tempe, Arizona

1999 *Harold Jones/Pam Marks*; Davis-Dominguez Gallery; Tucson, Arizona

Selected Works

T. Ascension, 1969
John's Glass, 1976
Patio, 1977
Self-Portrait with Water, 1978
Crow, Ueno Park, Tokyo, 1988
Rose, 1993

Further Reading

"Harold Jones: Photographs in Balance." *Artweek* 30 October 1976.

Cauthorn, Robert S. "Harold Jones photographs: Exhibit Focuses on Two Decades of Work." *The Arizona Daily Star* 17 December 1988.

Cheseborough, Steve. "Photography Exhibit an Unusual Pairing." *The Arizona Republic* 2 October 1993.

Lyons, Nathan, ed. *Vision and Expression*. New York: Horizon Press, 1969.

Snyder, Norman, ed. *The Photography Catalog*. New York: Harper and Row, 1976.

Stevens, Nancy. "Harold Jones, Leaving the Light." *The Village Voice* 16 June 1975.

The Alternative Image II. Exh. cat. Sheboygan, Wisconsin: John Michael Kohler Arts Center, 1984.

PIRKLE JONES

American

Pirkle Jones was an integral part of the California photographic community, chronicling its people, politics, and landscape. Jones, however, was not a native of California; he was born in 1917 in Shreveport, Louisiana. In 1946, after serving in World War II, Jones entered the first class in photography at the California School of Fine Arts (now the San Francisco Art Institute) in order to study with Ansel

Adams. Adams had founded the program and taught many classes there. Jones worked as Adams' assistant from 1947 until 1953 and the two photographers forged a lifelong friendship. Jones has spent much of his 60-year career as a teacher of photography, primarily at the San Francisco Art Institute; he joined the school's faculty in 1952, and remained there until his retirement in 1997. Jones has also drawn inspiration from his associations with some of the other luminary American photographers of the twentieth century—Edward Weston, Minor White, Imogen Cunningham, and Dorothea Lange. Jones is perhaps best known for two collaborative documentary projects: *Death of a Valley*, with Lange; and *A Photographic Essay on the Black Panthers*, co-created with his wife—writer, photographer, and poet, Ruth-Marion Baruch.

Jones is noted for the breadth of his work, which includes landscapes, architectural photographs, portraiture, cultural impressions, and politically charged social documentary photographic essays. While his career was shaped by his proximity to a community of great artists, Jones developed his own idiosyncratic photographic vision. Though the body of his work is difficult to characterize, nature is certainly one of the dominant themes. Jones's technically masterful images of waterfalls, trees, marshes, and rocks are not solely intended as photographic illustrations of the environment, but rather as impressions of his own relationship to nature, which in its untouched state has sacred overtones. This idealization of the land, which issues from the Adams tradition of landscape photography, is used to instill nostalgia. For it is through this more arcane and Edenic "before" that Jones suggests the negative impact of human development upon landscapes and customary ways of life. In his social documentary photography, Jones similarly plays the dual roles of artist and witness. One senses Jones's personal commitment to and passion for his subject matter, his images often expressing his point of interest and his point of view. His sensitive and acute observations of human behavior are emotionally charged and visually poetic.

Jones's first major project motivated by social consciousness was conceived in 1956 when Dorothea Lange approached him to collaborate on a photographic essay commissioned by *Life* magazine. This piece documented the final year of Berryessa Valley in California, which was about to be flooded after the completion of the Monticello Dam. While the assignment was never published by *Life*, it was later reproduced as a single issue of *Aperture* magazine in 1960 under the name *Death of a Valley*. Lange and Jones chronicled the community's last year before their forced relocation. The pictures look with a vivid sense of nostalgia

and empathy at a small town, small farm way of life. Images of the orchards in bloom; pears, grapes, and grain being harvested; pastoral sunbathed countryside; quaint homes; and well-seasoned locals are contrasted with melancholic scenes of profound loss, dispossession, destruction and dislocation: severed power lines, burning structures, and tractors scarring the once-fertile earth. The essay and the subsequent exhibition remain powerful testaments to the price of progress. The series received popular and critical acclaim, and it figures among the highlights of Jones's career. Two years after the *Death of a Valley* project, Jones collaborated with Ansel Adams to document the construction of the Paul Masson Winery in Saratoga, California. Completed in 1963, as both a publication and a touring exhibition, *The Story of a Winery* illustrated the growth of a new industry, telling the story of winemaking from the early budbreak on the vine to the final product in the glass.

Jones's most enduring creative partnership was with Ruth-Marion Baruch. Over the course of their marriage, Jones and Baruch produced a number of photographic milestones, the first occurring in 1961 when the pair was drawn to a small, forgotten town located on the banks of the Sacramento River. *Walnut Grove: Portrait of a Town* documents a small, racially diverse community in transition. While the town's fertile soil and location made it a thriving business gateway and agricultural hub, the introduction of a freeway which bypassed Walnut Grove led to the town's decline. The location gave Jones another opportunity to visually explore the manner in which development has changed a town's habitation and landscape.

Perhaps Jones's greatest photographic legacy is the landmark series *A Photographic Essay on the Black Panthers*. Eventually gaining the trust of the party leaders, Jones and Baruch were granted unprecedented access to the group's inner circle. Portraits of Panther leaders Kathleen and Eldridge Cleaver, Huey Newton, Bobby Seale, and Stokely Carmichael appear alongside other photos of participants at Panther rallies and demonstrations in Oakland and San Francisco during 1968. Jones and Baruch also captured more intimate moments—images of members' family gatherings and the young recipients of the Panther's Breakfast for Children Program. Jones's and Baruch's photographs clearly humanize their subjects, connecting the activists' struggles with universal themes of family and hope for a better future. The project intended to create a better understanding of the organization; images projecting dignity, pride, and sincerity were used to temper the violent reputation

for which the group became infamous. Kathleen Cleaver, commenting on the series 35 years after its first public appearance, wrote:

> The photographs Ruth-Marion Baruch and Pirkle Jones took amidst such tumultuous events show the sensitive humanity that animated the young revolutionaries in the Black Panther Party. Although we typically were portrayed in the mass media as thugs, menacing criminals, or subversives, their work radically contrasted the propaganda of the time.

(Cleaver 2002)

A Photographic Essay on the Black Panthers became a politically controversial and widely exhibited series of photographs, drawing 100,000 visitors to its inaugural venue at the de Young Museum in San Francisco, and appearing as *The Vanguard: A Photographic Essay on the Black Panthers* when the images with accompanying text were published by Beacon Press in 1970.

One year after embarking on the Panthers series, Jones was drawn to a California houseboat community known for its artistic and free-spirited residents. In *Gate 5, Sausalito*, Jones connects to the essential humanity of those alternative lifestyle seekers, celebrating their iconoclastic natures through captured moments of personal observation. Jones's work since the mid 1970s displays a Weston-like penchant for finding order among the seemingly chaotic. In Jones's *Flea Market* photos, symmetry is present amongst disorder, beauty amongst the bric-a-brac. The *Rock, Salt Marsh* and *Mount Tamalpais* series signal Jones's return to more nature-oriented and landscape-dominated imagery. Finding a middle path between verisimilitude and abstraction, the natural environments pictured by Jones issue from his introspective creative process and promote similar contemplative moments in viewers.

The Santa Barbara Museum of Art held the first retrospective of Jones's work in 2001. *Pirkle Jones: Sixty Years in Photography* showcased 120 of his photographs. In 2003, six years after the passing of Ruth-Marion Baruch, Jones donated 160 vintage prints from the original exhibitions of *A Photo Essay on the Black Panthers* (1968) and *Walnut Grove: Portrait of a Town* (1961) to U.C. Santa Cruz. The photographs, along with Jones's and Baruch's complete archive, will be housed in the Special Collections of the university library.

CARLA ROSE SHAPIRO

See also: **Adams, Ansel; Documentary Photography; Lange, Dorothea; Weston, Edward; White, Minor**

Biography

Born in Shreveport, Louisiana, 2 January 1914. From 1936 to 1940, participated in pictorial photography salons organized by the Camera Pictorialists. Served in the U.S. Army in 1941, stationed in the South Pacific. After World War II, he was accepted into the first photography class offered at the California School of Fine Arts in San Francisco (now the San Francisco Art Institute [SFAI]), where he studied with Ansel Adams. Married poet and photographer Ruth-Marion Baruch in 1949. Professional assistant to Ansel Adams in San Francisco from 1949–1953. Instructor at the California School of Fine Arts from 1952–1958. Formed, with several other artists, the Bay Area Photographers in 1955. In 1960, *Aperture* published *Death of a Valley*, a collaboration between Jones and Dorothea Lange which documented the Berryessa Valley in California. With Ansel Adams, completed the project, *The Story of a Winery* in 1963. Collaborated with Ruth-Marion Baruch in 1968 on *A Photographic Essay on the Black Panthers*. Returned to teaching at the SFAI in 1970 until his retirement in 2001. In 1997, established the Pirkle Jones and Ruth-Marion Baruch Endowment in support of their Photography Archives Endowment at Special Collections, University Library, U.C. Santa Cruz. Currently lives and works in Mill Valley, California. Other awards: Photographic excellence award, National Urban League, New York, 1961; Fellowship Grant in Photography by the National Endowment for the Arts, 1977; Award of Honor at the San Francisco Arts Festival, 1983.

Individual Exhibitions

1952 Ansel Adams Studio, San Francisco, California
1956 *Building and Oil Refinery*, San Francisco Academy of Sciences, San Francisco, California
1960 *California Roadside Council Exhibition*, Sacramento
1960 (with Dorothea Lange) *Death of a Valley*, San Francisco Museum of Modern Art; Oakland Museum, California; The Art Institute of Chicago; Napa Public Library, California
1963 (with Ansel Adams), *The Story of a Winery*, Smithsonian Institute, Washington, D.C.; traveled throughout the U.S. from 1963 to 1966
1964 (with Ruth-Marion Baruch), *Walnut Grove: Portrait of a Town*, San Francisco Museum of Modern Art, San Francisco, California
1968 (with Ruth-Marion Baruch), *A Photographic Essay on the Black Panthers*, de Young Museum of Art, San Francisco; Studio Museum in Harlem, New York; Hopkins Centre, Dartmouth College, Hanover, New Hampshire; U.C. Santa Cruz, California
1968 *Portfolio Two*, California Redwood Gallery, San Francisco, California
1969 *Photographs by Pirkle Jones*, Underground Gallery, New York City, New York
1970 *Gate 5*, Sausalito, Focus Gallery, San Francisco, California
1971 *Pirkle Jones Portfolio*, San Francisco Museum of Modern Art, SanFrancisco, California
1977 *Photographs of Ansel Adams, Dorothea Lange, Charles Sheeler, and Edward Weston*, San Francisco Art Institute Library, San Francisco, California

1977 *Works of Annette Rosenshine*, San Francisco Art Institute Library, San Francisco, California

1982 *Pirkle Jones*, The Art Institute of Chicago, Chicago, Illinois

1983 *Historical Photographs*, San Francisco Art Institute Library, San Francisco, California

1984 *Vintage Years Through 1980*, Vision Gallery, San Francisco, California

1994 *Berryessa Valley: The Last Year*, Vacaville Museum, Vacaville, CA and Napa Valley Museum, Napa Valley, California

2001 *Pirkle Jones: Sixty Years in Photography*, Santa Barbara Museum of Art, Santa Barbara, California

Selected Group Exhibitions

1954 *Perceptions*, San Francisco Museum of Modern Art, San Francisco, CA

1955 *Pictorial Image*, George Eastman House, Rochester, NY

1955 *Subjektive Fotographie*, Saarland Museum, Saarbrücken, West Germany

1956 *These Are Our People*, United Steel Workers of America, Pittsburgh, PA

1956 *This Is the American Earth*, California Academy of Sciences, San Francisco, CA

1958 *Images of Love*, Limelight Gallery, New York City, NY

1960 *Photography at Mid-Century*, George Eastman House, Rochester, N.Y. (traveled to Walker Art Gallery, Minneapolis, MN; de Young Museum of Art, San Francisco, CA; Wadsworth Athenaeum, Harford, CT; Addison Art Gallery, Andover, MA; Boston Museum of Fine Art, MA)

1961 *Photographs and Etchings: The World of Copper and Silver*, Metropolitan Museum of Art, New York

1967 *Photography for the Art in the Embassies Program*, Focus Gallery, San Francisco, CA

1967 *Photography in the Twentieth Century*, National Gallery of Canada, Ottawa (toured Canada and the U.S. 1967–1973)

1968 *Photographs From the Permanent Collection*, Museum of Modern Art, New York City, NY

1969 *Recent Acquisitions, Contemporary Photographers*, Art Institute of Chicago, Chicago, IL

1975 *The Land: Twentieth Century Landscape Photographs*, Victoria and Albert Museum, London (traveled to National Gallery of Modern Art, Edinburgh; Ulster Museum, Belfast; National Museum of Wales, Cardiff)

1975 *Marin County Spectrum: The Camera Work of Marin County Photographers*, Lamkin Camerawork Gallery, Fairfax, CA

1976 *Court House*, Seagram House, New York (traveled to Museum of Modern Art, New York City; Art Institute of Chicago, IL; American institute of Architects, Washington, D.C.; San Francisco Art Institute, CA; Camden Arts Centre, London)

1978 *New Acquisitions*, University of New Mexico Art Museum, Albuquerque, NM

1980 *Bay Area Photographer 1954–1979*, Focus Gallery, San Francisco, CA

1980 *Rock Series and Salt Marsh Series*, San Francisco Art Institute, San Francisco, CA

1982 *Fifteen Outstanding Photographers*, Carmel Photoart Gallery, Carmel, CA

1984 *Photography in California 1945–1980*, San Francisco Museum of Modern Art (traveled to Akron Art Museum, Akron, Ohio; The Corcoran Art Gallery, Washington, D.C.; Los Angeles Municipal Art Gallery, Barnsdall Park, Los Angeles; Herbert F. Johnson Museum of Art, Cornell University, Ithaca, NY; The High Museum of Art, Atlanta, GA; Museum Folkwang, Essen, Germany; Musee National d'Art Moderne, Centre Georges Pompidou, Paris, and the Museum of Photographic Arts, San Diego, CA)

1986 *The Monterey Photographic Traditions; The Weston Years*, Monterey Peninsula Museum of Art, Ca; Fresno Art center, Fresno, CA; Triton Museum of Art, Santa Clara, CA; the Sierra Nevada Museum of Art, Reno, NV

1988 *Master Photographs from "Photography in the Fine arts Exhibition, 1959–1967,"* International Center of Photography, New York

1988 *Picturing California: A Century of Genius*, Oakland Museum, Oakland, CA

1990 *Legacy: 15 Protégés of Ansel Adams*, Arkansas Art Center, Little Rock, AK

1991 *Patters of Influence: Teacher/Student Relationships in American Photography Since 1945*, Center for Creative Photography, University of Arizona, Tucson

1992 *This is the American Earth: A Silver Celebration of the Twenty-Fifth Anniversary of the Friends of Photography*, Ansel Adams Center, San Francisco (and venues throughout the United States and Canada)

1992 *Watkins to Weston: 101 Years of California Photography 1849–1950*, Santa Barbara Museum of Art, Santa Barbara, CA; Crocker Art Museum, Sacramento, CA; Laguna Art Museum, Laguna Beach, CA

1994 *Friends and Contemporaries: Documentary Photography in Northern California, Lange in Context*, San Francisco Museum of Modern Art, San Francisco, CA

1997 *Summer of Love: Revolution & Evolution*, Ansel Adams Center for Photography, San Francisco, CA

2000 *Made in California: Art, Image, and Identity, 1900–2000*, Los Angeles County Museum, Los Angeles, CA

2001 *Capturing Light Masterpieces of California Photography, 1850–2000*, Oakland Museum of California

Selected Works

Grape Picker, Berryessa Valley, 1956

Oak Tree, Marin County, 1952

Oak Tree, Marin County, 1978

Man Lifting Tomato Box, Walnut Grove: Portrait of a Town, 1961

Black Panther Demonstration, Alameda County Court House, Oakland, 1968

Plate Glass Window Shattered by Oakland Policemen, 1968

Black Panther Guard, Marin City, 1968

Kathleen Cleaver, Communications Secretary, De Fremery Park, 1968

Black Panthers from Sacramento, Free Huey Rally, 1968

Further Reading

Adams, Ansel. "Pirkle Jones: Photographer." *U.S. Camera Magazine* October 1952: 40–42.

Holmes, Robert. "Pirkle Jones." *British Journal of Photography* 17 October, 1980: 1040–1041.

Jones, Pirkle. *Pirkle Jones: California Photographs.* New York: Aperture, 2001.

Jones, Pirkle, and Ruth-Marion Baruch. *The Vanguard: A Photographic Essay on the Black Panthers.* Boston: Beacon Press, 1970.

Jones, Pirkle, and Ruth Garner Begell, eds. *Berryessa Valley: The Last Year.* Vacaville, California: Vacaville Museum, 1994.

Jones, Pirkle, and Dorothea Lange. "Death of a Valley." *Aperture* 8, no. 3, (1960): 127–165.

Katzman, Louise. *Photography in California 1945–1980.* New York: Hudson Hills Press/ San Francisco Museum of Art, 1984.

Mezey, Phil. "Masters of the Darkroom": 'In Tandem,' an Interview with Ruth Marion-Baruch and Pirkle Jones." *Darkroom Photography* 1, no. 7, (1979): 22–26.

Newhall, Nancy. "Pirkle Jones Portfolio." *Aperture* 4, no. 2, 1956: 49–57.

Warren, Dody. "Perceptions: A Photographic Showing from San Francisco." *Aperture* 2, no. 4. 1954: 11–33.

Wride, Tim B. "Reconciling California: The Rediscovery of Pirkle Jones." In *Pirkle Jones: California Photographs.* New York: Aperture, 2001: 98–120.

Pirkle Jones, Unidentified Migrant Worker Brought to the Valley for the Last Harvest, from the Series Death of a Valley; 1956, printed 1960, gelatin silver print; 11 ⅞ × 10 ¼″ (30.18 × 26.04 cm), San Francisco Museum of Modern Art, Gift of anonymous donor in memory of Merrily Page. [© *Pirkle Jones*]

KENNETH JOSEPHSON

American

When the journal *Aperture* published Kenneth Josephson's thesis pictures in 1961 in a special issue devoted to five graduating students, it was a sign that he was a photographer to watch, a photographer with the courage to experiment. Josephson's thesis subject was the "Exploration of the Multiple Image," and though his subsequent body of work does not exclusively focus on the "multiple image," his career, so to speak, does. While his finished photographs largely take the form of silver prints, his career has included work as a street photographer, filmmaker, conceptual photographer/artist, and professor of photography. Since the early sixties, his diverse, prolific output has contributed to changes in the perceptions of photography that occurred simultaneously with photography's acceptance by the art market and most museums.

Josephson was born in Detroit, Michigan in 1932. He took his first photographs around the age of 12 and soon was processing his own film and prints independently. After high school, he studied at the Rochester Institute of Technology (RIT) from 1951–1953 and was trained in the technical aspects of photo-chemistry and commercial photography until he was drafted into the Army. He served for two years in West Germany, printing photographs for the U.S. Army. Upon his return to civilian life, Josephson resumed his studies at RIT, where he was a student of Minor White and Beaumont Newhall, eventually graduating with a B.F.A. in 1957. Upon his return to Detroit, he married and took a position as a photographer for the Chrysler Corporation.

After the death of his wife Carol in 1958, Josephson relocated to Chicago and began graduate studies at the Institute of Design (ID) of Illinois Institute of Technology, where Harry Callahan and Aaron Siskind were teaching. ID had been started by László Moholy-Nagy in 1937 as the "New Bauhaus," and it educated students in modernist aesthetics that stressed a formalist methodology and encouraged experimentation. Whether it was because of his talented instructors, the innovative curriculum, or such fellow students as Joseph Jachna, Ray Metzker, Joseph Sterling, and Charles Swedlund, his career took off as his talents in photography became noticed. In 1960, he received his M.S. from ID and was offered a position as the first photography instructor at The School of the Art Institute of Chicago (SAIC). In 1962, he was one of the founding members of the Society for Photographic Education (SPE). In 1964, Josephson was included in *The Photographer's Eye* at the Museum of Modern Art, New York, which traveled around the world, and by 1966 he had his first solo exhibition in Stockholm at the Konstfackskolan.

Josephson easily adopted the "straight" style taught by Callahan and Siskind, now known as "Chicago School" and identified by crisp details, dramatic lighting, and abstract design. He was trained in multiple printing, montage, collage, and about the photograph as fine art and as a physical object, but since 1960 has basically followed the same practice, summed up in the following:

> The heart of the method is this: A clue from one photograph would develop into an idea for another. At times the subject matter suggested a method of working and vice versa. Sometimes I would seek out some specific subject matter with a planned picture in mind, but as I became involved with the subject a very different picture would result.... The best procedure for me to follow is to involve myself completely with a number of problems, then move from one to another, and return to each for the purpose of re-evaluation. This time lapse period was the most important factor of this procedure.
>
> (White, Minor, ed., "Five Photography Students from the Institute of Design, Illinois Institute of Technology," *Aperture* 9, 2 (1961), n. pag. Ill.)

Polapans 1973, a black-and-white print of a light bulb with four polaroids taped below, is a fitting example of his method, first because his subject *is* photography, second because each Polaroid glows brighter and nearer, and third because of the witty image of the bulb representing the idea.

His *Multiple Image* method allowed him to alternate between conceptual, nude, still-life, and "street" photography. Part of the time, he concentrated on high contrast photographs of pedestrians in the shadows of Chicago's elevated trains dabbled with bright light. At other times, he crossed over between series combining a nude image as part of a larger image, such as *Sally, 1976*. Since 1964, he has been placing "Images within Images" and photographing "Marks and Evidence," names given by Josephson to two of his series. Since 1967, he has been intervening in his photographs by placing such things as his arm, shadow, or reflection in the frame before shooting. Repeatedly questioning the assumed givens of photography and reality became his preferred subject, requiring the viewer to figure out his pictures.

Josephson was one of the early pioneers of Conceptual art. For example, before the English artist Richard Long photographed a trace left by his walking on grass and called it art, Josephson photographed a similar trace he found by chance see *Wisconsin*, 1964. Since 1968, he has collaged postcards, black-and-white and color photographs often fragmenting space, such as *Illinois*, 1970, pre-dating the multi-perspective collage work of David Hockney. The technique of collage was only a step away from assemblage, and after 1970 Josephson made three-dimensional objects which included photographs, such as *Anissa's Dress*, 1970.

Without a doubt, Josephson's photography deals with intellectual issues; however, a significant yet subtle aspect of his work is its humorous, sometimes surreal, content, which deals with the paradoxes of everyday life, with the gap between the second and third dimensions, and with the medium of photography itself. For example, his "History of Photography" series (begun 1970) takes a look at signature works by renowned photographers from an often humorous point of view, such as *Chicago*, 1978, a version of Edward Steichen's 1926 portrait of Gloria Swanson, which shows, instead of the movie siren's veiled face, bare buttocks beneath a lacy veil. Other examples are found in conceptual works such as *The Bread Book*, 1973, an artists' book composed of shots of the fronts and backs of each of the slices in a loaf of bread, bound in the order in which the loaf was cut. And last, but not least, his transformational, still-life photographs of paper bags and books from the early 1960s and 1988.

In 1972, he received a Guggenheim Fellowship, and in 1975 and 1979 National Endowment for the Arts fellowships that gave him the opportunity to travel. In the late 1970s he traveled in India, expanding his "street" series to include another culture and acknowledging his continuing interest in the intuitive work of Garry Winogrand and Henri Cartier-Bresson. After 1984, Josephson became interested in

landscape and traveled to England, France, and Italy adding more images to his landscape series, demonstrating the influence of Eugène Atget and Edward Weston.

In 1997, Josephson retired from The School of the Art Institute of Chicago, where he taught for 37 years and influenced generations of photographers. He has exhibited widely in the United States and abroad, and his work is included in collections throughout the United States, Canada, Sweden, and France.

CHRISTIAN GERSTHEIMER

See also: **Artists' Books; Atget, Eugène; Callahan, Harry; Cartier-Bresson, Henri; Conceptual Photography; Institute of Design; Long, Richard; Moholy-Nagy, László; Museum of Modern Art; Newhall, Beaumont; Siskind, Aaron; Weston, Edward; White, Minor; Winogrand, Garry**

Biography

Born in Detroit, Michigan, July 1, 1932. Attended Rochester Institute of Technology, 1951–53 and 1955–57; drafted into United States Army and stationed in Germany, 1953–1955: attended Institute of Design, Illinois Institute of Technology, 1958–1960; founding member Society for Photographic Education, 1962, first professor of photography at The School of the Art Institute of Chicago, 1960–1997; Visiting Professor, University of Hawaii, Honolulu, 1967; John Simon Guggenheim Memorial Fellowship, 1972, Visiting Professor, Tyler School of Art, Philadelphia, 1975; National Endowment for the Arts Grant, 1975 and 1979; Visiting Professor, University of California, Los Angeles, Fall 1981-Spring 1982; Ruttenberg Arts Foundation Grant, Chicago, 1983; Lives in Chicago, Illinois.

Individual Exhibitions

1966 Konstfackskolan, Stockholm
1971 Art Institute of Chicago and New York Visual Studies Workshop, Rochester and traveling
1974 University of Iowa Museum of Art, Iowa City
 291 Gallery, Milan College of Marin Art Gallery, Kentfield, California
1976 Cameraworks Gallery, Los Angeles
 Galerie der Bruecke, Vienna
1977 Gallery II, Perdue University, Lafayette, Indiana
 Reicher Gallery, Barat College, Lake Forest, Indiana
1978 *Kenneth Josephson: The Illusion of the Picture*, Fotoforum der Gesamthochschule, Kassel, Federal Republic of Germany
1979 Open Eye Gallery, Liverpool, England
 Photographers' Gallery, London
 P.P.S. Galerie, Hamburg, Germany
1981 Delpire Gallerie, Paris
 Young Hoffman Gallery, Chicago
1982 Orange Coast College Photography Gallery, Costa Mesa, California
1983 Vision Gallery, Boston

Swen Parson University, Northern Illinois University, Dekalb, Illinois
 Kenneth Josephson, The Museum of Contemporary Art, Chicago, Illinois
1984 The Friends of Photography, Carmel, California
 Baker Gallery, Kansas City, Missouri
1991 *Kenneth Josephson*, Rhona Hoffman Gallery, Chicago, Illinois
1996 *Kenneth Josephson*, Ecole Regionale des Beaux-Arts de Saint-Entienne, France
1999 *Kenneth Josephson: A Retrospective*, Art Institute of Chicago, Chicago, Illinois; Whitney Museum of American Art, New York.
2001 *Kenneth Josephson Photographs*, Yancey Richardson Gallery, New York
 Land/Cityscapes, Allen Priebe Gallery, University of Wisconsin, Oshkosh, Wisconsin

Group Exhibitions

1958 *The Face of America*, U.S. State Department, traveling
1961 Venice Biennale, Italy
1962 *Three Photographers*, George Eastman House, Rochester, New York
1964 *The Photographer's Eye*, Museum of Modern Art, New York and traveling 1965
1967 *The Portrait in Photography: 1848–1966*, Fogg Art Museum, Harvard University, Cambridge, Massachusetts
1970 *The Universal Eye*, Eastman Kodak Pavilion, Expo '70, Osaka, Japan and
 Unique/Multiple: Sculpture/Photographs, Museum of Modern Art, NewYork
 Contemporanea, Parcheggio di Villa Borghese, Rome
1974 *Ken Josephson, Bernard Plossu, Charles Spink*, Sunset Center, Carmel, California
 20th Century American Photography, Nelson-Atkins Art Gallery, Kansas City, Missouri
1975 *For You, Aaron, Photographs by Four Former Students of Aaron Siskind: Jachna, Josephson, Metzker, Sterling and Swedlund*, The Renaissance Society at the University of Chicago
1976 *Photo/Synthesis*, The Herbert F. Johnson Museum of Art, Cornell University, Ithaca, N. Y.
1977 *The Great West, Real/Ideal*, University of Colorado, Boulder and traveling
 The Photographer and the City, Museum of Contemporary Art, Chicago
 Malerei und Photographie im Dialog von 1840 bis Heute, Kunsthaus, Zurich
 The Target Collection of American Photography, Museum of Fine Arts, Houston, Texas
1978 *Portfolios by Twelve Artists*, Vienna Secession, Vienna, Austria.
 Mirrors and Windows: American Photography since 1960, Museum of Modern Art, New York and traveling
 Tusen och en bild, Moderna Museet, Fotografiska Museet, Stockholm
 Photography as Art, Visual Studies Workshop, Rochester, New York
1979 *American Photographs of the Seventies*, Art Institute of Chicago, Illinois
1980 *The New Vision: Forty Years of Photography at the Institute of Design*, Light Gallery, New York, New York
 Nude: Theory, Gallerie Fiolet, Amsterdam

The Imaginary Photo Museum, Photokina, Cologne, Germany

Absage das Einzelbild, Museum Folkwang, Essen, Germany

Rencontres, Rencontres Internationales de la Photographie, Arles, France

1981 *American Children*, The Museum of Modern Art, New York

Artist's Books: A Survey 1960–1981, Ben Shahn Center for the Visual Arts, William Patterson College, Wayne, New Jersey

Crane, Jachna, Josephson, Larson, Metzker/ An Exhibition of Photographs, Fine Arts Center Gallery, University of Arkansas, and traveling

ORD to LAX, Los Angeles Center for Photographic Studies, Los Angeles

1982 *Work by Former Students of Aaron Siskind*, Center for Creative Photography, University of Arizona, Tuscon

20th Century Photographs from the Museum of Contemporary Art, Seibu, Museum of Art, Tokyo and traveling

Photo-Collage, Contemporary Arts Museum, Houston, Texas

1983 *Harry Callahan and His Students: A Study in Influence*, Georgia State University Art Gallery, Atlanta

1984 *Exposed and Developed*, National Museum of American Art, Smithsonian Institution, Washington D.C.

Creative Photography, Bibliothèque nationale de France, Paris

1985 *American Images: Photography, 1945–1980*, Barbican Art Gallery, London

Art, Design and the Modern Corporation, National Museum of American Art, Smithsonian Institution, Washington D.C.

1986 *Staging the Self: Self-Portrait Photography, 1840's–1980's*, National Portrait Gallery, London and traveling

1987 *Photogaphy and Art: Interactions Since 1946*, Los Angeles County Museum of Art and traveling

Photographs Beget Photographs, Minneapolis Institute of Art Minneapolis, Minnesota and traveling

Modern Photography and Beyond, National Museum of Modern Art, Kyoto

1988 *Josephson, Jachna, and Siegel: Chicago Experimentalists*, San Francisco Museum of Modern Art, San Francisco

1989 *150 ans de photographie: Certitudes et Interrogations, 1839–1989*, Musee de la photographie, Charleroi, Belgium

Symbol and Surrogate: The Picture Within, University of Hawaii Art Gallery, Honolulu and traveling

1992 *Three Decades of Midwestern Photography*, Davenport Museum of Art, Iowa

1993 *Industrial Effects: Twentieth-Century Photographs from The Art Institute of Chicago*, Art Institute of Chicago

1994 *An American Century of Photography: From Dry-Plate to Digital, The Hallmark Photographic Collection*, Nelson-Atkins Museum of Art, Kansas City and Traveling

1996 *When Aaron Met Harry: Chicago Photography, 1945–1971*, Museum of Contemporary Photography, Columbia College, Chicago

Together Again: Ishimoto, Jachna, Josephson, Metzker, Sterling, Swedlund, Gallery 312, Chicago

Art in Chicago, 1945–1995, Museum of Contemporary Art, Chicago

2002 *Taken by Design: Photographs from the Institute of Design, 1937–1971*, Art Institute of Chicago and traveling

Kenneth Josephson, Stockholm, 1967, Gelatin silver print, Collection Museum of Contemporary Art, Chicago, Illinois Arts Council Purchase Grant.
[*Photograph © Museum of Contemporary Art, Chicago. © Kenneth Josephson. Courtesy of Rhona Hoffman Gallery, Chicago, Illinois*]

Selected Works

Matthew, 1965
Drottingholm, Sweden, 1967
New York State, 1970
The Bread Book, 1973
Washington, D.C. 1975, from the series Archaeological Series, 6 Inch Contour Gauge, 1975
Self-portrait, 1963
Stockholm, 1967
Flags, 1969
Sally, 1976

Further Reading

Frizot, Michel, ed. *A New History of Photography*. Paris: Konemann, 1999.

Green, Jonathan, and James Friedman. *American Photography: A Critical History 1945 to the Present*. New York: 1984.

Kelly, Jain. *Nude Theory*. New York: Lustrum Press, 1979.

Lemagny, Jean-Claude, and Andre Rouille, eds. *Histoire de la Photographie, A History of Photography: Social and Cultural Perspectives*. Paris: Bordas, 1986; Cambridge University Press, 1987.

Travis, David, and Elizabeth Siegel, eds. *Taken By Design*. Chicago: The Art Instituteof Chicago, 2002.

Warren, Lynne, and Carl Chiarenza. *Kenneth Josephso*. Chicago: Museum of Contemporary Art, Chicago, 1983.

Witkin, Lee D., and Barbara London. *The Photography Collector's Guide, first edition*. New York: 1979.

Wolf, Sylvia. *Kenneth Josephson: A Retrospectiv*. Chicago: The Art Institute of Chicago, 1999.

Krantz, Claire Wolf. "Stolen Captured: Robert Heinecken, Kenneth Josephson." *New Art Examiner* vol. 27, no. 5 (2000): 32–7.

White, Minor, ed. "Five Photography Students from the Institute of Design, Illinois Institute of Technology." *Aperture* 9, 2 (1961): n. p. (ill.).

K

YOUSUF KARSH

Canadian

Yousuf Karsh rose to international renown in 1941 as the photographer of the defiant World War II British Prime Minister Winston Churchill. Already famous as a studio portraitist in Canada where he had lived since leaving his native Armenia, he quickly became the portrait photographer of choice for political leaders, celebrities, and artists. By the end of his long career, Karsh had achieved a rare stature: His portraits had become the images by which many public figures are best remembered—Churchill's pugilistic stare; writer Ernest Hemmingway in a rugged knit sweater; painter Georgia O'Keeffe in raking light beneath a rack of antlers. His pursuit of the inspirational in his sitters reflects the tradition of public portraiture that conveys authority and eminence, a style not associated with the fine-arts aspirations of many twentieth century photographers. This traditional style, however, supported Karsh's humanist belief that the good in mankind can be captured in a photograph. In his portraits, he reflected his conviction that,

> There is a brief moment when all that there is in a man's mind and soul and spirit may be reflected through his eyes, his hands, his attitude. This is the moment to record. This is the elusive 'moment of truth.'

(Karsh 1963, 95)

Yousuf Karsh was born in Mardin, Armenia, in 1908 and with his family fled Turkish persecution to Syria in 1922. The teenaged Karsh continued on alone to Canada in 1924, sponsored by his uncle George Nakash, a studio portrait photographer in Sherbrooke, Quebec. After barely six months of high school he began working full-time with his uncle, providing income which allowed him to help support his family in Syria. In his uncle's studio he learned the language and repartee between photographer and client, and found this human dimension to photography deeply appealing.

In 1928, Karsh's uncle sent the young man to Boston to apprentice with master society portrait photographer John H. Garo. There, he was exposed to Garo's prominent circle of visitors and learned the importance of light, shadow, and form. He stayed on in Boston after completing the apprenticeship, then returning to Canada, and relocating to the capital Ottawa in 1932 to be at the crossroads of visiting dignitaries. While in Boston, Karsh had studied the reproductions of great classical portraitist painters at the Boston Public Library and had been immersed in late pictorialism as he explored the realm of celebrity portrait photography. The soft focus and atmospheric effects in *Turban*, 1936, displays the romantic idealism present in his early photographs. Karsh began mastery

of the black-and-white printing process in Garo's studio and continued perfecting the process to support the subtle range of texture and light in his photographs. During this period Karsh was associated with the Ottawa Little Theatre where he met actress Solange Gauthier, whom he married in 1939. There he was also exposed to new potential in lighting and directing subjects that brought a more dramatic and chiseled sculpting of images, such as *Romeo and Juliet*, 1933, which suited newspaper and magazine reproduction. By the mid-1930s, Karsh had developed a style that demonstrated his talent in shaping light, producing a stylish, more-angular composition than was fashionable in the conservative post-colonial era Ottawa where he had settled. His association with the Little Theatre also led to a commission from the theatre's patrons, Lord and Lady Bessborough, representatives of the King of England in Canada.

During these early years, as he became known across Canada as *Karsh of Ottawa*, he experimented with photography and entered international salon exhibitions. Karsh also built his reputation through society sittings and photographing personalities visiting Ottawa, such as character actress Ruth Draper, singer and activist Paul Robeson, and British royalty Lord Louis Mountbatten. Through Canada's leader, William Lyon Mackenzie King, he was appointed to photograph Winston Churchill and captured the image by which the world remembers this pugnacious, fearless leader.

Karsh traveled again to London in 1943 where he photographed dozens of personalities that were first published in English popular illustrated magazines and the book *Faces of Destiny*, 1946, beginning his portfolio of international celebrities. In 1944, he undertook the first of many *Life* magazine assignments, portraying some 70 Washington, D.C. personalities. In the following year, he photographed the participants of the pre-United Nations San Francisco Conference, adding to his collection of what he called "people of consequence." Karsh also received his first advertising assignments during this period, in which he promoted Kodak film and made portraits of distinguished musicians for RCA Victor. Karsh continued to photograph celebrities and travel around the world adding royalty, heads of state, Nobel Prize laureates, and spiritual leaders, and amassed an evocative volume of portraits. Karsh's images were widely published in magazines and he produced a series of books that in addition to the pictures, recounted his experience with each sitter creating an impression about his subjects that was larger than the words or pictures alone. Some of his best-known portraits were made in the 1950s, including *Georgia O'Keeffe*, 1956, and *Ernest Hemingway*, 1957. Karsh constantly traveled, accompanied by his second wife, Estrellita Nachbar, whom he married in 1962, preferring to photograph his subjects in their own environments even though his initial success had been as a studio artist.

Although primarily known as a celebrity photographer, Karsh undertook two key assignments to portray everyday people for industrial commissions and the Canadian news magazine *Maclean's*. The industrial profiles bestowed a heroic, dignified status on front-line workers, presenting strong, inspirational portraits, such as *Rear Window (Gow Crapper)*, 1951, for Ford of Canada and equally compelling portraits for Canada's Atlas Steel. The factory setting presented compositional and lighting challenges that Karsh met through combining negatives from various exposures. A profile of Canada's cities assigned by *Maclean's* required Karsh to personify the country, swelling with post-war prosperity. The series sketched the regions and captured the public's conception of its identity, not surprisingly often using portraits of people to illustrate the geography of the country, such as *Farmer by His House*, ca. 1952.

The majority of Karsh's photography was in black and white and developed by inspection with his own formula for gold-toned prints that are especially archival. The color photographs he produced, mainly in the 1940s and 1990s, were dye transfers realized through a printer in New York. The unique and impressive style that Karsh developed in this period influenced countless photography students, and he also touched many students while serving as a visiting professor at numerous universities in North America.

Over his 60-year career Karsh photographed more than half of the International Who's Who Millennium list of the "100 most influential figures of the twentieth century" and was also the only photographer included in the list. Karsh's images have been widely disseminated in publications and have appeared on stamps around the world. He received the Companion of the Order of Canada and countless honors, including degrees from more than 13 universities. In 1987, the National Archives of Canada purchased Karsh's archives of negatives, color transparencies, and over 50,000 original prints. Karsh's images are in collections around the world and have been exhibited internationally, including in Japan, Australia, Argentina, Canada, and the United States, and a definitive retrospective in Berlin in 2000. Karsh died in Boston, Massachusetts, July 13, 2002 at 94-years-old.

JANET YATE

See also: **Life Magazine; Photography in Canada; Pictorialism; Portraiture**

Biography

Born in Mardin, Armenia, 23 December 1908. Immigrated to Quebec, Canada, 1924. 1928, apprenticeship under John H. Garo of Boston, Massachusetts. Established studio in Ottawa, 1933, that remained open until 30 June 1992. 1939, marriage to actress Solange Gauthier. 1941, achieved international fame with portrait of British Prime Minister Winston Churchill. 1962, marriage to second wife. Canada Council Medal, 1969; Honorary Fellow of the Royal Photographic Society of Great Britain, 1970; Master of Photographic Arts, Professional Photographers of Canada, 1970; Member of the Royal Canadian Academy of Arts, 1975; Companion of the Order of Canada, 1990; Master of Photography, International Center of Photography, 1990; Gold Medal of Merit, National Society of Arts and Letters, 1991. Died in Boston, Massachusetts, 13 July 2002.

Individual Exhibitions

1951 *The Men of Ford of Canada*; Canadian National Exhibition; Toronto, Canada
1951 *Celebrities by Yousuf Karsh*; George Eastman House, Rochester, New York
1952 *Photographs by Yousuf Karsh*; Art Institute of Chicago, Illinois
1959 National Gallery of Canada, Ottawa, Canada
1967 *Men Who Make Our World*; Expo '67 World's Fair; Montréal, Canada
1983 *Celebration of Karsh's 75th birthday*; Museum of Photography, Film and Television; Bradford, England, and traveling
1983 *Karsh: A Fifty-Year Retrospective*; International Center of Photography; New York, New York, and traveling
1984 Photographic Museum, Helsinki
1988 *Karsh: A Birthday Celebration*; Barbican Centre of London; London, England, and traveling
1989 *Karsh: The Art of the Portrait*; National Gallery of Canada; Ottawa, Canada
1992 *American Legends*; International Center of Photography; New York, New York, and traveling
1996 *Karsh: The Searching Eye*; Museum of Fine Arts, Boston, Massachsetts, and traveling
1998 *90th Birthday Celebration*; National Gallery of Canada; Ottawa, Canada
1999 *Karsh: Faces of the Twentieth Century*; National Portrait Gallery of Australia; Canberra, Australia
2000 *Karsh*; Nagoya/Museum of Fine Arts Boston; Nagoya, Japan
2000 *Yousuf Karsh: Helden aus Licht und Schatten*; Deutsches Historisches Museum; Berlin, Germany
2003 Naples Art Museum, Naples, Florida
2004 *Yousuf Karsh: Industrial Portraits*; Art Gallery of Windsor; Windsor, Canada

Group Exhibitions

1967 *Photography in the 20th Century*; National Gallery of Canada; Ottawa, Canada, and traveling

1973 Santa Barbara Museum of Art, California (with Margaret Bourke-White)
1977 *Fotografische Künstlerbildnisse*; Museum Ludwig; Cologne, Germany
1979 *Photographie als Kunst 1879–1979/Kunst als Photographie 1949–1979*; Tiroler Landesmuseum; Innsbruck, Austria, and traveling
1980 *The Imaginary Photo Museum*, Kunsthalle; Cologne, Germany
1982 *Lichtbildnisse: Das Porträt in der Fotografie*; Rheinisches Landesmuseum; Bonn, Germany
1984 Sammlung Gruber, Museum Ludwig, Cologne, Germany
1999 *Reflections on the Artist: Self-Portraits and Portraits*, National Gallery of Canada, Ottawa

Selected Works

Romeo and Juliet (The Tomb of the Capulets), 1933
Turban (Betty Low), 1936
Winston Churchill, 1941
Joan Crawford, 1948
Albert Einstein, 1948
Rear Window (Gow Crapper), 1951
Farmer by His House, ca. 1952
Pablo Casals, 1954
Audrey Hepburn, 1956
Georgia O'Keeffe, 1956
Ernest Hemingway, 1957
Ossip Zadkine, 1965

Further Reading

Borcoman, James, et al. *Karsh: The Art of the Portrait.* Ottawa: National Gallery of Canada, 1989.
Karsh, Yousuf. *Faces of Destiny.* Chicago: Ziff-Davis Publishing, and London: George G. Harrap, 1946.
Karsh, Yousuf. *Portraits of Greatness.* New York: Thomas Nelson and Sons, and Toronto: University of Toronto Press, 1959.
Karsh, Yousuf. *In Search of Greatness.* Toronto: Toronto Press, and New York: Alfred P. Knopf, 1962.
Karsh, Yousuf. *Karsh: A Sixty Year Retrospective.* Boston: Bulfinch Press and Boston Museum of Fine Arts, 1996.
Karsh, Yousuf. *Karsh.* Nagoya: Nagoya/Boston Museum of Fine Arts, 2000.
Karsh, Yousuf, and John Fisher. *Canada: As Seen by the Camera of Yousuf Karsh and Described in Words by John Fisher.* Toronto: Allen, 1960.
Karsh, Yousuf, and Jerry Fielder. *Karsh: A Biography in Images.* Boston: Museum of Fine Arts Publications, 2003.
Vorsteher, Dieter, and Janet Yates, eds. *Yousuf Karsh: Helden aus Licht und Schatten.* Berlin: G + H Verlag, 2000; as *Yousuf Karsh: Heroes of Light and Shadow.* Toronto: Stoddart Publishing, 2001.

GERTRUDE KÄSEBIER

American

Gertrude Stanton Käsebier was one of the leading photographers of the early years of the twentieth century, a fact made more remarkable by her gender. At a time when women were often held back from artistic aspirations, Käsebier was remarkably successful, although her goal of being an artist aside was initially put aside to marry and raise a family. One indication of the high esteem in which her work was held was its being featured in the inaugural issue of the Photo-Secession journal, *Camera Work*, in January 1903, by the renowned photographer Alfred Stieglitz. Even before this, Stieglitz wrote in his journal, *Camera Notes*, that Käsebier was "the leading portrait photographer in this country [United States]." She is particularly known for her portraits, including those of mothers and children as featured on a U.S. postal stamp in the "Masters of Photography" series in 2002.

Gertrude Stanton was born 18 May 1852, to a Quaker family in Fort Des Moines, Iowa. Her parents, like thousands of Americans in the mid-nineteenth century, crossed the plains in a covered wagon. After an eight-year stay in Iowa, John Stanton, seeing opportunity in the Gold Rush, established a saw mill in Eureka Gulch, Colorado Territory, but his death in 1864 left his wife Muncy, Gertrude, and son Charles to fend for themselves. The family moved back to New York City where Muncy Stanton later operated a boarding house, and Gertrude was to meet her future husband, Eduard Käsebier.

As a child, Käsebier showed artistic inclinations, but they were never encouraged, and she had no formal training. She credited her grandmother as having been an inspiration to her with her artistry in patchwork quilts, and said her first primer with its colorful pictures caused her to want to be a painter. Gertrude attended the Moravian Seminary for Women in Bethlehem, Pennsylvania, living with her maternal grandmother, but left to marry Eduard Käsebier in 1874 on her 22nd birthday. Shortly after her marriage, Käsebier had applied to Cooper Union, an art school in New York City, but was turned down. When she attended the Pratt Institute in Brooklyn after her children were grown in the late 1880s photography was not then considered art, and Käsebier thus received no academic training in the medium.

Her first success with photography was through a competition sponsored by *The Monthly Illustrator* in 1892. She won a $50.00 prize, but gave the money away because, according to William Innes Homer, "her teachers chastised her for taking the photographic medium seriously, and, in deference to their views, she came to believe she had done something wrong...."

In 1893, she was the chaperone of an art class (as she was likely the oldest student) that went to study *en plein air* at an art colony in Crdcie-en-Brie, a provincial village in France. On a rainy day when she could not paint from nature, she turned to her camera to do indoor portraiture. Thereafter Käsebier focused intently on photography, studying with a chemist in Germany, who helped her with the technical aspects. Eventually returning to Brooklyn, Käsebier apprenticed herself to photographer Samuel Lifshey where she learned the business aspects of photography.

Käsebier made a concerted effort to borrow poses and techniques from antique portraits, and consciously set out to elevate photographic portraiture to the status of fine art. In his 1903 essay in *Camera Work*, "Mrs Käsebier's work—An Appreciation," noted art historian and critic Charles H. Caffin extolled the virtues of her work, profuse in regard to the merits of her artistic portraits, which he believed were especially sensitive in regard to the character of the sitter. Although Käsebier claimed to have psychic powers, in fact she worked extremely hard to achieve this quality, spending several hours with each sitter until she felt she knew him or her well enough for the likeness to be a biography. As her friend, the writer Mary Fanton Roberts [Giles Edgerton] explained, "Her real work is done with the sitter—not in the dark room." She was against retouching because she believed it detracted from the character of the sitter, and she only did it when pressure was applied by her client. Käsebier claimed retouching made "people look like peeled onions."

She established her first portrait studio at 273 Fifth Avenue in New York in 1897, and in 1898 opened a summer studio at a house known as Long

Meadow in Newport, Rhode Island. There Käsebier mingled freely with the wealthy and socially connected, and she established some important professional relationships. The photographer Baron de Meyer admired her work and spent time with her; the prominent Boston photographer F. Holland Day went to visit, accompanied by Frances Lee, who became one of Käsebier's favorite models, appearing in some of her most best-known pictures.

Käsebier also made a number of portraits of Native Americans. The experiences she had had, especially with the Sioux, as a youngster in Eureka Gulch prepared her for this later photographic work. When she undertook this work in the East, Native Americans were not accessible to her so she wrote to William Frederick Cody (Buffalo Bill) requesting that he allow some of the "braves" from his Wild West Show to be photographed by her. It is said that one of the sitters was so frightened he covered himself with his blanket and Käsebier practically had to trick him into a relaxed attitude. The resulting portrait is *The Red Man*, circa 1898.

This work was included among the five photogravures featured in *Camera Work's* first issue, along with complimentary articles by Caffin and Frances Benjamin Johnson. Käsebier had been part of the group dedicated to promoting photography to the status of fine art that in 1902 formed the Photo-Secession. However, the formal elements displayed by Käsebier were characteristic of the painting movement of the late nineteenth century known as Symbolism: flatness of imagery, decorative patterning in the manner of Japanese prints (well illustrated in her sensitive portrait of the celebrated Sioux activist and musician, *Zitkala-Sa, 1898*), simplicity of composition, and overall harmony of design.

Käsebier worked primarily with platinum prints, although she did begin using a gum bichromate process in 1901. Her photographic debut had taken place in 1898 at the first Philadelphia Photographic Salon where she exhibited ten works: portraits, studies related to the mother-and-child theme, and one nude. The next year she was appointed to the jury. It was in this salon that she exhibited a Madonna and child, which she called *The Manger*; it sold for $100.00, setting a record for the highest price paid for an art photograph at that time. Her work in a similar spirit, *Blessed Art Thou Among Women*, the image that subsequently appeared a postage stamp, is perhaps her best-known. One of the most prestigious exhibition spaces in which her work was shown was the Little Galleries of the Photo-Secession, popularly referred to as 291 (Fifth Avenue address), owned and operated by Alfred Stieglitz, with whom she had a close but tempestuous relationship. Käsebier was elected to membership in both the prestigious Camera Club (1900) in New York and The Linked Ring (1900) in London. Also in 1900, photographer Clarence H. White recognized her as "the foremost professional photographer in America." She had won numerous awards and had exhibited throughout the United States, Europe, and South America. By 1910, the year of her husband's death, the most fruitful period of Käsebier's photography had passed, as taste shifted away from Pictorialism. She moved from her home in Oceanside, Long Island, to 342 West Seventy-first Street in Manhattan where she also maintained her studio. Also in 1910, Käsebier became President of the Women's Federation of the Professional Photographers Association of America. In 1912, she resigned from the Photo-Secession, and early in this decade she gave up photography. In 1916, Käsebier helped found the Pictorial Photographers of America. She continued to exhibit and kept her studio open until 1927, but by then her daughter Hermine was doing most of the work. When Käsebier died in 1934, Pictorialism was definitely out of favor, and Käsebier's work was considered out-of-date.

MARIANNE BERGER WOODS

See also: **de Meyer, Baron; Family Photography; History of Photography: Nineteenth-Century Foundations; History of Photography: Twentieth-Century Pioneers; Linked Ring; Pictorialism; Photo-Secession; Photo-Secessionists; Portraiture; Stieglitz, Alfred**

Biography

Born Gertrude Stanton 18 May 1852 in Fort Des Moines, Iowa. 1874, married Eduard Käsebier; three children, Frederick William, Gertrude Elizabeth, and Hermine Mathilde. 1889, enrolls in art course at the Pratt Institute in Brooklyn, New York. 1893, travels to France and abandons painting for photography. 1897, establishes portrait studio on Fifth Avenue in New York. 1899, exhibits at Camera Club of New York; works published in Photo-Secession journal, *Camera Work*, in January 1903. 1900, elected to membership in Camera Club of New York and Linked Ring Brotherhood, London. 1902, cofounder of the Photo Secession. 1907, photographed sculptor Auguste Rodin and his work in Paris. 1910, husband dies, moves from Oceanside, Long Island, to Manhattan where she maintains studio; becomes president of Women's Federation of the Professional Photographers Association of America. 1912, resigns from the Photo-Secession. Died in New York City October 13, 1934.

Solo Exhibitions

1899 Camera Club of New York
1929 Department of Photography at the Brooklyn Institute of Arts and Sciences, Brooklyn, New York

Gertrude Käsebier, The Manger, 1899, Platinum print, 31.8 × 25.4 cm (12½ × 10").
[*Smithsonian American Art Museum, Washington, DC/Art Resource, New York*]

1979 *A Pictorial Heritage: The Photographs of Gertrude Käsebier*, Delaware Art Museum and The Brooklyn Museum of Art, New York
1992 *Gertrude Käsebier: The Photographer and Her Photographs*, Museum of Modern Art, New York, New York

Group Exhibitions

1896 Boston Camera Club
1897 Pratt Institute, Brooklyn, New York
1898 1st Philadelphia Photographic Salon
1901 The New School of American Photography, London and Paris
1902 *American Pictorial Photography*, National Arts Club, New York
1903 Jubilee Exhibition, Hamburg, Germany
1904 Photo-Secession shows at Corcoran Art Gallery, Washington, D.C., and the Carnegie Institute, Pittsburgh, PA
1905 Little Galleries of the Photo-Secession, New York
 Lewis and Clark Exposition, Portland, OR
 Vienna Camera-Klub
1906 Joint exhibition with Clarence White, Little Galleries of the Photo-Secession
 Photo-Secession Exhibition, The Pennsylvania Academy of Fine Arts, Philadelphia
 Photo-Club de Paris, Paris, France
 Photographic Salon, London
1907 New English Art Galleries, London
1908 Photo-Club de Paris
1909 International Photographic Exposition, Dresden
 International Exhibition of Pictorial Photography, National Arts Club, New York
1910 International Exhibition of Pictorial Photography, Albright Art Gallery, Buffalo, New York
1914 Royal Photographic Society, London
1929 Department of Photography, Brooklyn Institute of Arts and Sciences, New York
1988 *Fine Day: An Exhibition Featuring Photographs by Alice Austen, Frank Eugene, Gertrude Käsebier and Others*, Alice Austen House, Staten Island, New York
 After the Manner of Women: Photographs by Kasebier, Cunningham, and Ulmann, J. Paul Getty Museum, Los Angeles, California
1991 *Gertrude Käsebier and Helen Levitt*, Museum of Modern Art, Metropolitan Museum of Art Traveling Exhibition

Selected Works

The Red Man, ca 1898
Zitkala-Sa, 1898
The Manger, 1899
Blessed Art Thou Among Women, ca. 1900
Portrait of Miss N, 1903
Silhouette Portrait of a Boy in Profile, ca. 1905
The Silhouette (Gerson Sisters), 1906

Further Reading

Anonymous. "Some Indian Portraits." *Everybody's Magazine* 4 (January 1901).
"The Käsebier File: Rediscovery in Progress." *American Photo* 3 (May June 1992).
Armstrong, Carol. "From Clementiana to Käsebier: the Photographic Attainment of the 'Lady Amateur.'" *October* 91 (Winter 2000).
Bayley, R. Child. "A Visit to Mrs. Käsebier's Studio." *Wilson's Photographic Magazine* 40 (February 1903).
Caffin, Chades H. "Gertrude Käsebier and the Artistic Commercial Portrait." In *Photography as a Fine Art*, 1903.
"Mrs. Käsebier and the Artistic-Commercial Portrait." *Everybody's Magazine* 4 (May 1901).
"Mrs. Käsebier's Work—An Appreciation." *Camera Work* 1 (January 1903).
Cleland O'Mara, Jane. "Gertrude Käsebier: The First Professional Woman Photographer 1852–1934." *The Feminist Art Journal* (Winter 1974–1975).
Dow, Arthur W. "Mrs. Gertrude Käsebier's Portrait Photographs—From a Painter's Point of View." *Camera Notes* 3 (July 1899).
Edgerton, Giles (pseud. Mary Fanton Roberts). "Photography as an Emotional Art: A Study of the Work of Gertrude Käsebier." *The Craftsman* 12 (April 1907).
Green, Rayna. "Gertrude Käsebier's 'Indian' Photographs: More Than Meets the Eye." *History of Photography* 24 (Spring 2000).
Holm, Ed. "Gertrude Käsebier's Indian Portraits." *The American West* 10 (July 1973).
Johnston, Frances Benjamin. "Gertrude Käsebier, Professional Photographer." *Camera*.
———. "Gertrude Käsebier." *Camera Work* 20 (October 1907).
———. "Mrs. Käsebier." *American Amateur Photographer* 15 (February 1903).
———. "Mrs. Käsebier's Prints." *Camera Notes* 3 (July 1899).
Lohmann, Helen. "Gertrude Käsebier—Photographer." *Abel's Photographic Weekly* 3 (20 February 1909).
———. "Rediscovering Gertrude Käsebier." *Image* 19 (Summer 1976).
Tighe, Mary Anne. "Gertrude Käsebier Lost and Found." *Art in America* 65 (March 1977).
"Gertrude Stanton Käsebier." In *Notable American Women, 1607–1950*, vol. 2. Cambridge, MA: 1971.
Michaels, Barbara L. *Gertrude Käsebier. The Photographer and Her Photographs*. New York: Harry N. Abrams, 1992.
Photography. New York: The Metropolitan Museum of Art/The Viking Press, 1978.

KIKUJI KAWADA

Japanese

Kikuji Kawada was born in 1933 in Ibaraki Prefecture and studied economics at the Rikkyo University of Tokyo between 1948 and 1955. Kawada then took up photography, working for the publishing house Shinchosha until 1959; a self-taught photographer, he never stopped learning new techniques of shooting and printing. His first solo exhibition, titled *Sea*, took place at the Fuji Photo Salon in Tokyo in 1959. With *Sea*, Kawada explored one of his favorite topics: The history and the stories of Hiroshima through its ruins and landscapes of desolation. Yet Kawada is not limited to landscape documentation, and two series, *Bijutsu Shuppansha* (*Maps*) of 1965 and *The Last Cosmology* of 1979–1997 brought him to international attention. The former series also examines the effects of World War II on the Japanese landscape, the latter documents eclipses of the moon and the sun. Focusing on luminous marks, *The Last Cosmology* offers to viewers an almost abstract picture where changes in atmosphere are detected as pure visual sensations the viewer must perceive.

In Japan, Kawada belonged to a group, with Ikko Narahara, Shomeï Tomastu, and Eikoh Hosoe, that allowed the emergence of a new photographic style that countered the photographic realism that had held sway among Japan's photographers since the 1930s. This new style allowed the photographs to elaborate their own visual form rather than following strict conventions. Between 1957 and 1959, Kawada participated, with Yashihiri Ishimoto, Shun Kawahara, Akiro Sato, Akira Tanno, Shomeï Tömatsu, Toyoko Tokiwa, Masaya Nakamura, Ikkö Narahara, and Eikoh Hosoe in many exhibitions called "Jünin no me," which means "the eyes of ten persons." Within this group, six members (Kawada, Satö, Tanno, Tömatsu, Narahara, and Hosoe) created an organization they called VIVO, which in the universal language Esperanto means "life." These photographers shared the desire to be free of the canons of the photojournalism aesthetic by creating original, creative images. While exemplifying this goal, VIVO functioned more as an organization that offered members exhibition and publishing opportunities than a polemical group. After the dis-

solution of VIVO in 1962, an important exhibition of their work was mounted, which marked the new direction in the history of photography in Japan that VIVO members achieved.

In 1960 and 1961, Kawada traveled extensively around Japan and became a teacher at the Tama Art University. His 1961 exhibition, *Maps*, at the Fuji Photo Salon established him as a major figure. These pictures are witnesses to the pain and suffering the Japanese people endured in World War II and in the devastation of the atomic bomb attacks on Hiroshima and Nagasaki, and their will to remember the past. In 1965, Kawada published a collection taken from this exhibition, called *Bijutsu Shuppansha* (*Maps*), where he mixed close-up shots of stains, bumps, and cracks on walls of the 'atomic dome' of Hiroshima with pictures of dead soldiers. Through these close-up shots of many signs and objects, Kawada evokes the defeat of Japan during World War II. His famous black-and-white photograph of the Japanese flag, crumpled, spoiled, worn, and folded is particularly symbolic of the war era and its aftermath. The flag was an essential emblem used by the military government in the 1930s and 1940s to assist in imposing a nationalist policy. As shown by Kawada's picture, it also signifies the defeat of Japan. Yet, this image also evoked the will of Japan's reconstruction so that the national emblem would proudly fly again.

Kawada pictures give specific testimony, as do Ken Domon's publications (*Hiroshima, Kenbunsha*, in 1958) and those of Shomeî Tomatsu (*11:02 Nagasaki Shashin Dojinsha*, in 1966). This publication is a key for understanding Kawada's works. Indeed, Kawada does not focus on an object for its own sake, he chooses it as a vector. With a subtle interaction of framing and light, Kawada confers to the object a symbolic power to make it travel through stratums of interpretation.

In his pictures, Kawada combines many levels of meaning to create different approaches to reality. This tendency was accentuated in the series *Seinaru Sekai* (*Damned Atavism*) in 1971 and *Ludwig II no Shiro* (*Castle of Ludwig II*) in 1979. The first series is based on and meant as a commentary on a Tatsuhiko Shibusawa essay entitled "Essays about Baroque Art," and the two series together portray a

fantasy world full of chimeras and frightening creatures inspired by medieval Western churches, gardens, or New York City's Wax Museum. In a similar vein, Kawada has also photographed the fantastical architecture and objects in the Sacred Grove of Bomarzo outside Rome, the Tiger Balm Garden in Hong Kong, and the Boboli Gardens in Florence. With these series, Kawada established his style and his photographic vision by accentuating contrasts that play with various levels of symbolism. He also evokes a perverted world where the sacred becomes grotesque, the grotesque allowing Kawada to evoke a parallel between Japan and the Occident and to set up an inquiry about the relationships between the cultures in the history of these forms.

This theme was explored, but in a more deeply psychological manner, in his series *Los Caprichos* of 1986 in which Kawada explored and extracted the dementia and madness hidden in the boredom and the banality of daily life. In 1996, Kawada received two major awards for his entire work, the annual award from the Photographic Society of Japan and an award from the International Photographic Festival of Higashikawa.

Beginning in 1999, Kawada employed digital means to compose photo-montages as well as exploring digital photography and new printing techniques. These manipulated pictures portray different objects related to consumer society, like cars (*Car Maniac*, 1998) or the urban environment. With his collection *Eureka*, he devised an imaginary city using elements such as monuments or highways extracted from other cities, continuing his interest in the incoherence, the instability, and loss of landmarks of modern life. His images are also meditations on the hidden face of society in which he establishes a parallel between the city and the behavior of city dwellers. According to Kawada, the city, it plan, and the restraints of urbanism are the best reflection of our consciences.

THOMAS CYRIL

See also: **Digital Photography; Domon, Ken; Hosoe, Eikoh; Photography in Japan**

Biography

He was born in 1933 in Ibaragi Prefecture. He graduated from the Department of Economics, Rikkyo University, 1955. He was a staff photographer at the Shinchosha Publishing Company, 1955–1959. He turned freelance in 1959. After leaving Shinchosha, he organized and co-founded the VIVO photographers agency with E. Hosoe, S. Tomatsu, I. Narahara, and others, 1959. He has since worked as a freelance photographer. In 1966, he made a tour of Europe and visited both Europe and Southeast Asia. He received the Annual Award, The Photographic

Society of Japan in 1996, the Domestic Artist Prize, and Higashikawa Award at the Higashikawa International Photography Festival in 1996.

Individual Exhibitions

1959 *The Sea*, Fuji Photo Salon, Tokyo
1961 *The Map*, Fuji Photo Salon, Tokyo
1968 *Sacré Atavism*, Nikon Salon, Tokyo
1976 *Kikuji Kawada Photographs*, Shadai Gallery, Tokyo
1984 *Nude Museum and Ludwig II Collection*, P.G.I., Shibaura, Japan
1986 *Los Caprichos*, Photo Gallery International, Toranomon, Tokyo
1995 *The Last Cosmology*, Tower Gallery, Yokohama, Japan
1996 *The Last Cosmology*, Mitsubishi-Jisho Artium, Fukuoka
The Last Cosmology, Higashikawa International Photography Festival, Higashikawa, Japan
1998 *Car Maniac*, P.G.I., Shibaura, Japan
1999 *The Globe Theater*, Internationale Fototage Herten, Herten

Group Exhibitions

1957 *The Eyes of 10 Photographers*, Konishiroku Photo Gallery, Tokyo
1962 *Non*, Matsuya Department Store, Ginza, Tokyo
1963 *Contemporary Japanese Photographs*, National Museum of Modern Art, Tokyo
1974 *New Japanese Photography*, Museum of Modern Art, New York
1977 *Neue Fotografie aus Japan*, Kulturhaus der Stadt, Graz, Austria
1978 *VIVO: Contemporary Photography*, Santa Barbara Museum of Art, Santa Barbara, California
1979 *Japan: A Self-Portrait*, International Center of Photography, New York
1982 *38 Japanese Photographers*, Zeit-Foto Salon, Tokyo
1986 *The Works with Polaroid 20×24*, Shibuya Seibu Seed Hall, Tokyo
Japon des Avant-Gardes 1910–1970, Centre Georges Pompidou, Paris
1988 *8 Japanese Photographers*, Photo Gallery International, Tramonom, Tokyo
1989 *Europalia 89, Japan-Belgium*, Museum of Photography, Charleroi, Belgium
1990 *Eye of deja-vu*, Heineken Village Gallery, Tokyo
1991 *Photographs in Japan 1955–1965*, Yamaguchi Prefectural Museum of Art, Yamaguchi, Japan
Beyond Japan: A Photo Theatre, Barbican Art Gallery, London
Innovation in Japanese Photography in the 1960s, Tokyo Metropolitan Museum of Photography, Tokyo
1995 *Works by 25 Photographers in Their 20s*, Kiyosato Museum of Photographic Arts, Yamanashi
Objects, Faces and Anti-Narratives-Rethinking Modernism, Tokyo Metropolitan Museum of Photography, Tokyo
Japanese Culture: The Fifty Postwar Years, Meguro Museum of Art, Tokyo
1998 *Realism in Postwar Japan 1945–1960*, Nagoya City Art Museum, Nagoya, Japan
Corridor of the Gaze/Theatrical Tableaux, Tokyo Metropolitan Museum of Photography, Tokyo

Kikuji Kawada, The Japanese National Flag, from the series The Map, 1960–1965, Photo:
Christian Bahier and Philippe Migeat.
[*CNAC/MNAM/Dist. Réunion des Musées Nationaux/Art Resource, New York*]

Under/Exposed, Stockholm Photography Festival, Stockholm

Waterproof, Expo '98, Lisbon, Portugal

1999 *Exploring Photography: From the Museum Collection*, National Film Center, The National Museum of Modern Art, Tokyo

Master Works, Master Photographers, Tokyo Metropolitan Museum of Photography, Tokyo

Contemporary Photographic Art from Japan, Neuer Berliner Kunstverein, Berlin

2003 *Japon: un renouveau photographique*, Hôtel de Sully, Paris

Selected Works

The Map, 1965

The Japanese National Flag, Shinjuku, Tokyo—from The Map Series, 1959–1965

Ludwig II no shiro (Castle of Ludwig II), 1979

Last Cosmology, 1979–1997

Nude, 1984

Car Maniac, 1995–1998

Eureka, 1999

Further Reading

Attilio, Colombo, and Doniselli Isabella. *Japanese Photography: Today and its Origin.* Bologna: Grafis Edizioni, 1979.

Kohtaro, Iizawa, and Kasahara Michiko. *Objects, Faces and Anti-Narratives: Rethinking Modernism.* Tokyo: Metropolitan Museum of Photography, 1995.

Ryuichi, Kaneko, and Nakamura Hiromi. *Zeitgenössusche Fotokunst aus Japan.* Heidelberg: Umschau Braus, 1999.

Ryuichi, Kaneko and Iizawa Kohtaro. *Illusion: Japanese Photography.* Stockholm: Riksutställningar, 2001.

Tucker, Anne Wilkes. *The History of Japanese Photography.* New Haven, CT, and Houston, TX: Yale University Press and Museum of Fine Arts, Houston, 2003.

PETER KEETMAN

German

The terms "*fotoform*" and "subjective photography" are well-known synonyms for West German photography of the 1950s. Among the most enigmatic representatives of this photographic style is Peter Keetman, who influenced subsequent generations of photographers with his formally composed, purist images.

Keetman was born on April 27, 1916, in Wuppertal-Elberfeld. His father, an enthusiastic amateur photographer, gave the eight-year-old Keetman a camera. In 1935, the father also sent him to study at the Bavarian State Instructional Institute of Photography, which today is the State Academy of Photographic Design in Munich.

In 1937, Keetman finished his studies with the apprentice exam in commercial photography. He worked in the studio of Gertrud Hesse in Duisburg, Germany, then in 1939 he moved to Aachen and joined the industrial photographer Carl-Heinz Schmeck, who worked mainly for firms in heavy industry. In 1940, Keetman was drafted for military service and was severely wounded.

In 1947, he resumed his master's studies with Hanna Seewald in Munich at the State Instructional Institute of Photography. After completing his master's in 1948, with fellow student Wolfgang Reisewitz, he audited a course taught by the photographer and artist Adolf Lazi, who had just established a private instructional institute of photography in Stuttgart. In the context of an exhibit called *Die Photographie 1948* (Photography 1948)—one of the very first photo exhibitions in postwar Germany—Lazi also showed works from Peter Keetman.

Repelled by the propagandistic use of photography in the period of National Socialism, young photographers, among them Keetman and Reisewitz, as well as Siegfried Lauterwasser, Toni Schneiders, Ludwig Windstosser, and their mentor Otto Steinert, formed the group fotoform; they created a community of shared interests, planned group exhibits, and participated together in other exhibits. The collective goal of the group's members was not to make photography that served the represented object—in the sense of an objective reflection of reality—but to reorient photography toward the creative possibilities of the medium and toward the creation of an inherently valued art product.

The following year the young group presented works at the first Photo-Kino exhibition in Co-

logne (called Photokina after 1951). One review described the explosive force of the fotoform exhibition as an "atomic bomb in the manure pile of German photography."

In 1950, under the overall control of Otto Steinert, a worldwide photography movement developed from fotoform called "subjective photography" that existed until the fall of 1991. In his many exhibits of subjective photography, Steinert borrowed from the organizational impulse of fotoform, and, in internationalizing and popularizing the group, he altered it. The other members gradually withdrew from the stage and worked as commercial, industrial, portrait, and theater photographers.

Keetman received enormous publicity from the success of his shows. He participated in nearly every important exhibition of the 1950s and 1960s, and his works appeared in almost every photography journal.

After the 1950s, Keetman made a living on commissioned works, industrial reports, and photography for illustrated volumes of art textbooks. He also dedicated himself to illustrating books on urban and rural landscapes, such as *Munich* (1955) and *Bavarian Lake Country* (1958), which were very successful. These commissions also stimulated his free photographic work. One of his best-known series was published in the book *Volkswagen: A Week at the Factory*, which collected a series of photographs made within the Wolfsburg VW assembly line in 1953.

He always took time to systematically investigate the photographic potential of objects. He would examine the representability of an object in a long series of trials. The image always aimed to capture the essential structure of the object. He also made countless landscape prints, mainly in the upper Bavarian area of Chiemgau, that are distinguished by their concentration on line and on graphic qualities. Keetman's technical experiments with movement studies in the 1950s were also commercially valued. His *Lichtpendelm-Schwingungsbilder* (Light Pendulum—Images in Oscillation), in which a moving light source traces curves over the photo paper, was used in advertising.

Keetman's artistic work is concerned with interpreting the energies that give objects shape and drawing out the essential forms, themes, and subjects. To accomplish this, he uses all the possibilities for representing an object that the technology of photography offers. His perception of things suggests the natural world, in whose structural composition he sees a model for comprehending all things in life.

Keetman's photography avoids any narrative impulse and has no formal foregrounding construction. It concentrates on the energy of the things themselves. In this sense, his works more closely belong to the "informal"—the most radical answer to the new freedom of the postwar period. The concept of the informal was first raised by Michel Tapié in 1951 and is not bound solely to a rejection of any figuration or content, but also suggests the greater meaningfulness of matter in relation to form, and thus the self-shaping powers inherent in all matter. This is the last radical essay into traditional art and onto the plane of metaphysical experience. The artistic rendering of this experience that flows directly from the artist in the process of painting or drawing sets a natural limit for the camera. Nevertheless, it is amazing that attempts are made in photography to reach a similar experience by eliminating the fact of the camera—so that one attempts to retrace self-shaping powers to the photographic materials.

As Keetman wrote in 1950, the eye for detail leads to a new natural order and form: nature is the master instructor of simplicity and truth; these two are symbols for photography.

RUDOLF SCHEUTLE

See also: **Schneiders, Toni**

Biography

Born in Wuppertal-Elberfeld, Germany, April 27, 1916. Attended Bayerische Staatslehranstalt für Lichtbildwesen (today: Staatliche Fachakademie für Fotodesign), Munich; Duisburg, 1935–1937 and 1947–1948. Assistant to Gertrud Hesse, 1937; assistant to Carl-Heinz Schmeck, 1939. Course work with Adolf Lazi, Stuttgart, 1948. Founding member of the group fotoform, 1949. Industrial reports; freelance commercial photography; many book publications. After 1969, honored member of Bund Freischaffender Foto-Designer (Society of Independent Photo Designers), Germany. David Octavius Hill Medal from the Gesellschaft Deutscher Lichtbildner (Society of German Transparency Photographers). Lives in Marquartstein, Bavaria.

Selected Individual Exhibitions

1981 Fotomuseum im Münchner Stadtmuseum, Munich
1982 Benteler Galleries, Houston, Texas
1986 Galerie voor Industriele Vormgeving, Amsterdam, Netherlands
1988 Galerie Zur Stockeregg, Zurich, Switzerland
1988 Fotohof Gallery, Salzburg, Austria

Selected Group Exhibitions

1948 *Exposition Art Photographique, Ausstellung Photographischer Kunst*, Neustadt an der Hardt, Germany
1948 *Die Photographie 1948*, Stuttgart, Germany

Selected Works

Ammonshorn, 1950
Spiegelndetrofen, 1950
Zellulare formen, 1950
Faschingsdekoration, 1955
High Board, 1957
Berkiser Werke, 1959

Further Reading

Misselbeck, Reinhold. *Deutsche Lichtbildner*. Cologne: Dumont Buchverlag, Museum Ludwig, 1987.
Pohlmann, Ulrich, and Rudolf Scheutle, eds. *Lehrjahre Lichtjahre: Die Münchner Fotoschule, 1900–2000*. Munich: Fotomuseum im Münchner Stadtmuseum, 2000.
Sachsse, Rolf, ed. *Peter Keetman: Eine Woche im Volkswagenwerk*. Berlin: D. Nishen, 1985.
Schmoll gen. Eisenwerth, J. A., ed. "Subjektive Fotografie": *Der deutsche Beitrag, 1948–1963*. Stuttgart: Institut für Auslandsbeziehungen, 1989.
Steinert, Otto, ed. *Subjektive Fotografie 2*. Munich: Brüder Auer, 1955.
Zwischen Abstraktion und Wirklichkeit: Fotografie der 50er Jahre. Ludwigshafen: Kunstverein, 1999.

Peter Keetman, Volkswagen-Werk, 1948.
[© *Fotomuseum im Munchner Stadtmuseum. Photo reproduced with permission of the artist*]

SEYDOU KEÏTA

Malian

Seydou Keïta is Mali's best known photographer. He operated a highly successful portrait photography studio in the capital city of Bamako, during the decades surrounding Mali's independence from France in 1960. However, his international recognition and place in the world history of photography did not arrive until the 1990s.

Born in Bamako, Keïta spent the early years of his life as an apprentice carpenter to his father. When he was 14 years old, his uncle returned from a trip to Senegal with a Kodak Brownie, which he gave to Keïta. He started by taking photographs of his family and friends. Although he continued to work as a cabinet maker, and had no official training in photography, Keïta began photographing professionally in 1939. He learned to develop and print from a local studio operator and photo shop owner, Frenchman Pierre Garnier, as well as photographer Mountaga Demblélé, who also loaned him use of his darkroom. In 1948, Keïta opened his own studio in a lively part of the city. Around the same time he bought a 13 cm × 18 cm box camera, which produced sharp contact prints without the need of an enlarger.

As a commercial portrait photographer, Keïta has said repeatedly that his only concern was to satisfy his customers by presenting them clearly and in their best possible light. Working in black and white, using both natural and artificial light, Keïta's portraits reflect this obligation to flatter his sitters—sometimes resulting in characteristically unusual compositions, such as bust-length portraits shot at three-quarters or other angles. His output is also a reflection of the social and political changes in Bamako at this time. The city enjoyed rapid urbanisation and development at the end of the Second World War, with workers streaming in from surrounding regions. Keïta's photographs catered to a burgeoning middle class in the bustling new urban centre (at that time a city of about 100,000 people), including office clerks, shopkeepers, politicians, and employees of the colonial government (such as schoolteachers and soldiers). As a photographer, Seydou Keïta's role was to make his subjects look like they belonged to the middle class of Bamako, to make them feel modern and *Bamakois*.

Following World War II, people in Bamako, especially young men, began to wear European clothes, which were viewed as stylish and fashionable. To meet this demand, Keïta had several European suits available in his studio, including a beret, as well as accessories (watches, fountain pens, watch-chains, plastic flowers, a radio, a scooter, a bicycle, and an alarm clock). Some young sitters consciously imitated characters they identified with from American B-grade films. Keïta understood the importance of picturing external signs of wealth and beauty in his women sitters; he would show off their large earrings and ornate hairstyles as well as their long, slender fingers that were a sign of high social standing. Although largely taken on the bare ground in his courtyard, Keïta also used cloth backdrops with decorative patterning. Sometimes the backdrop matched the clothes, but Keïta claimed this was mere coincidence. Between 1949 and 1952 he used his own fringed bedspread, but later changed the backdrop every two to three years. Today, these various fabrics are used as a reference to date his work.

Keïta soon became well known for his portraits and was never short of work. His studio was well located in the centre of the city. During slow periods, two former apprentices from his days as a carpenter took samples of his work to the train station to invite business. In interviews, Keïta spoke of the lines of people who used to wait in front of his studio, especially on Saturday evenings and Muslim holidays. As Keïta noted, "To have your photo taken was an important event."

Following Mali's independence from the French, Keïta became the country's official photographer for the new socialist government in 1962. The government job offered prestige and, presented to him as his patriotic duty, he reluctantly closed his studio. He covered the main events of Mali's first 15 years of independence—presided over by President Mobido Keïta and then ruled by the National Liberation Military Committee—such as official visits and meetings with heads of state. However, Keïta's pictures from this period are in government archives and thus far, inaccessible.

Keïta retired in 1977, but to his surprise was 'rediscovered' and then celebrated by the Western world in the 1990s (together with the younger

Bamako photographer Malick Sidibé). Although there are several stories related to the discovery of Keïta, a 1991 exhibition *Africa Explores: Twentieth Century African Art* at the Museum of African Art in New York proved crucial in bringing his work to the attention of the international art world. French curator of contemporary African art André Magnin relates the story of seeing Keïta's portraits in that exhibition. Although Keïta was uncredited, in 1993 Magnin tracked him down in Bamako with the help of photographer Françoise Huguier, and gained access to tens of thousands of negatives covering the period from 1948 to 1962, which now form the only available source of Keïta's work (negatives from 1935 to 1947 have been lost).

In 1994, the Fondation Cartier pour l'art contemporain (Cartier Foundation for Contemporary Art) in Paris organised a one-man exhibition as part of the 'Mois de la Photo' in Paris, which brought Keïta's work to the attention of both specialists and the general public. Since this time, his work has been shown all over the world. André Magnin's monograph *Seydou Keita* (Scalo, 1997) further popularised his work, and Keïta even came out of retirement to photograph fashion for magazines such as *Harper's Bazaar* in 1998.

Keïta's photographs have been displayed in the West as large exhibition prints to meet the formal demands of the art gallery. This dramatic recasting of their original form and function has given the images a new life. However, it is important to remember their original postcard size, as intimate documents at the threshold between private and public life, shared between friends, lovers, and family. For contemporary Western viewers, the formal beauty of the black-and-white studio portraiture and Keïta's lack of exposure to Western publications gives them a freshness of vision. More strikingly, the images attract because of the dignified poses of the sitters, and their clear desire to cast themselves in the manner in which they wished to be defined. Although the names and professions of many of the sitters have been lost, their aspirations are communicated in a way that makes them emotionally and visually compelling. In contrast to photographs produced by Western observers, Keïta's portraits are the result of an African photographer controlling the camera to create images of African subjects for an African audience. Thus, in Keïta's photographs, Bamako is imagined as the city at the birth of modernity in West Africa.

DANIEL PALMER

See also: **Photography in Africa: Central and West; Portraiture**

Biography

Born Bamako, Mali, c. 1921. Given first camera aged 14, but no official training in photography. Began photographing professionally in 1939, and opened portrait photography studio in Bamako in 1948. Made thousands of commercial portraits in the period 1948–1962. Became Mali's official photographer following independence from the French in 1962, covering its first 15 years of independent rule. Retired in 1977, but rediscovered by the Western art world to great acclaim in the 1990s. Died Paris, November 22, 2001, while undergoing treatment for cancer.

Selected Individual Exhibitions

1994 *Seydou Keïta: Portraits de 1949 à 1964*, Fondation Cartier pour l'art contemporain, Paris
1995 *Seydou Keïta*, Centre Nationale de la Photographie, Paris
1996 *Seydou Keïta, photographer: Portraits from Bamako, Mali*, National Museum of African Art, Smithsonian Institution, Washington, D.C.
2001 *Seydou Keïta*, Sean Kelly Gallery, New York
 Seydou Keïta: Portraits from Mali, Presentation House Gallery, North Vancouver, Canada
2002 *Mali Portraits by Seydou Keïta*, The William Bennington Museum of Art, University of Connecticut, Storrs, Connecticut

Selected Group Exhibitions

1993 *24th Rencontres Internationales de la Photographie*, Arles, France
1994 *Premières Rencontres de la Photographie Africaine*, Bamako, Mal
1995 *Big City Artists from Africa*, Serpentine Gallery, London
 Self Evident, Ikon Gallery, Birmingham
1996 *In/sight: African Photographers, 1940 to the Present*, Solomon R. Guggenheim Museum, New York
1997 *Seydou Keïta and Malik Sidibé*, Fruitmarket Gallery, Edinburgh
 Trade Routes: History and Geography: 2nd Johannesburg Biennale, Johannesburg, South Africa
1998 *Roteiros, Roteiros, Roteiros, Roteiros, Roteiros: XXIV Bienal de São Paolo*, São Paolo
1999 *L'Afrique Independente*, Partobject Gallery, Carrboro, North Carolina
2000 *Africa: Past-Present: Malick Sidibé, Seydou Keita, P. K. Apagya, Depara, C.A. Azaglo and Ojeikere*, Fifty One Fine Art Photography, Antwerp, Belgium
2001 *You Look Beautiful Like That: The Portrait Photographs of Seydou Keïta and Malick Sidibé*, The Fogg Art Museum, Harvard University Art Museums, Cambridge, Massachusetts and traveled to UCLA Armand Hammer Museum of Art, Los Angeles, California
 XVI International Video and Multimedia Arts Festival, Musée d'art Moderne de la Ville de Paris, Paris, France
2002 *Portraits of Pride—Seydou Keïta, Malick Sidibé and Samuel Fosso*, Galleri Enkehuset, Stockholm
 The Short Century: Liberation and Independence Movements in Africa, 1945–1994, P.S.1 Contemporary Art Center, Long Island City, New York and traveling

Selected Works

Keïta's photographs are largely untitled.

Further Reading

Diakhaté, Lydie. "The Last Interview: Seydou Keita 1921–2001." *Contemporary African Art* (Fall/Winter 2002): 17–23.

Diawara, Manthia. "Talk of the Town." *Artforum* 36 (February 1998): 64–71.

Enwezor, Okwui, Olu Uguibe, and Octavia Zaya. *In/sight: African Photographers, 1940 to the Present*. New York: Guggenheim Museum, 1996.

Lamunière, Michelle. *You Look Beautiful Like That: The Portrait Photographs of Seydou Keïta and Malick Sidibé*. Cambridge, MA: Harvard University Art Museums, 2001.

Magnin, André, ed. *Seydou Keita*. Zurich: Scalo, 1997.

Mercer, Kobena. "Home from Home: Portraits of Places in Between." *Self Evident*. Birmingham, England: Ikon Gallery and Autograph, 1995.

Storr, Robert. "Bamako: Full Dress Parade." *Parkett* 49 (May 1997): 24–34.

Seydou Keita, Malian Men with Musical Instruments.
[© *Contemporary African Art Collection Limited/CORBIS*]

ANDRÉ KERTÉSZ

American, born in Hungary

Though he developed his photographic style in post-war Paris amidst a flurry of avant-garde activity, André Kertész never aligned himself with any particular artistic movement. While somewhat influenced by the Constructivist and Surrealist tendencies of his period, he always remained true to his own sensibilities, which valued humanity, emotion, and the value of observation. Brassaï, Henri Cartier-Bresson, and W. Eugene Smith would all name him as a major influence of their work.

André Kertész's life followed a westward trajectory from old world to new world, during which he was always guided by his ambition for photography. Born Kertész Andor in 1894 in Budapest, he grew up in a middle class family that was Jewish, but not strictly religious. At the age of 14 Kertész lost his father to tuberculosis. He and his two brothers were subsequently raised by their mother and taken under the wing of their uncle, who they followed to the Budapest stock exchange for employment. Kertész became inspired by the images he discovered in Hungarian magazines as a youth, and was the only member of his family to develop an active interest in art. Upon the completion of his schooling in 1912, he eagerly launched his career as a photographer with the purchase of his first camera.

Kertész found his early subject matter in the streets of Budapest and its rural surroundings. He was particularly drawn to the more marginalized members of society, like the gypsies and peasants who existed on the fringes of Hungarian society. While such subjects were shared by the Hungarian pictorialist photographers, Kertész's aesthetic sensibilities significantly diverged from those predecessors. The Pictorialists tended to wrap their compositions in a layer of haze and romanticize their lower-class subjects. Kertész's approach was more akin to a realist tradition, more interested in observation and reportage than in perpetuating a nostalgic mythology. This straightforward portrayal of the underclasses also hints at social critique, though he was never overtly political. The fun-

damental loyalty to documentary photography that Kertész developed early on would remain with him throughout his career.

In 1914, Kertész was recruited by the Austro-Hungarian army to fight in the First World War, and his camera accompanied him on the front lines. Two years later, while recovering from wounds in an army hospital, he took some of his first "distortion" photographs of soldiers swimming in the hospital pool. Unfortunately, most of the negatives from the war were later destroyed during the Hungarian Revolution.

Following his tenure as a soldier, Kertész returned to Budapest and resumed his job at the stock exchange, but photography came to occupy more of his time. In 1917, his photographs began to be published in such Budapest publications as *Erdekes Ujság (Interesting News)* and the satirical magazine *Borsszem Jankó*. It was around this time that he met Elizabeth Saly, a coworker at the stock exchange, who began appearing in his pictures in 1919. A student of art and dance, she would eventually become his lifelong partner.

Kertész can be characterized by a certain stubbornness in his working method, which led to certain difficulties in his career. He was denied a silver medal in a 1924 exhibition sponsored by the Hungarian Amateur Photographers' Association. He was punished for refusing to conform to salon conventions, insisting on submitting silver prints rather than the traditional bromoil prints. Shortly thereafter his efforts were validated when *Erdekes Ujság* published one of his war-era night photographs on the cover—his first cover photograph.

While Kertész accumulated photographic successes, the political circumstances in Budapest became distinctively uninviting under Admiral Horthy's anti-Western, anti-Semitic nationalist policies. Such a repressive climate, compounded with Kertész's artistic goals, provided plenty of impetus for a decisive move to Paris in 1925, whereupon Andor became André for good.

Kertész's immigration was aided by a press card, and he immediately launched his career as a freelance photojournalist, taking pictures for a variety of French, German, British, and Italian publications. He lived in Montparnasse, a thriving locale for artists and bohemians, and established himself amongst the community of Hungarian expatriate artists whose social headquarters was the Café du Dôme. He became casually acquainted with the few other eminent photographers in Paris, Germaine Krull, Berenice Abbott, and Man Ray. He also befriended such luminaries as poet Michel Seuphor, painter Piet Mondrian, and his fellow countryman

Brassaï, who was then working as a journalist and would credit Kertész for inspiring his own interest in photography. Kertész paid a momentous visit to Mondrian's studio in 1926, during which he took portraits of the artist and still lifes of various items in the apartment. A photograph from this visit depicts Mondrian's glasses and pipe on a table and plays on the abstract geometry for which their owner was so renowned.

Kertész brought something of his Hungarian aesthetic to his Paris photographs—a lighthearted, sometimes satirical approach to capturing moments in the daily lives of Parisians. Though he occasionally experimented with cropping, he did not frequently manipulate his negatives otherwise. He found the city to be a rich enough subject matter to warrant straight observation. However, his occasionally disorienting framing and interest in abstract forms hinted at his association with the avant-garde. He generally favored oblique angles over frontal views and often utilized high viewpoints, creating images at times suggestive of László Moholy-Nagy's highly experimental "new vision" photography or Alexandr Rodchenko's Constructivism.

The Sacre du Printemps Gallery hosted Kertész's first solo exhibition in March 1927. The exhibition connected Kertész's work to "*l'esprit nouveau*," the term coined by Guillaume Apollinaire nine years earlier in his call for a postwar formalistic "return to order," and later adopted by Le Corbusier and Amédée Ozenfant's Purism movement. Michel Seuphor and the poet Paul Dermée were responsible for reviving the term, and chose Kertész as their principal photographer when they published a magazine called *Documents internationaux de l'esprit nouveau* in April 1927, a platform for their interest in abstraction and the International Style. Kertész's contributions to the *Premier Salon Indépendant de la Photographie* in 1928 revealed his penchant for aestheticizing everyday objects and his interest in abstract formalism. Such tendencies are demonstrated by his picture of a fork resting against the curve of a plate, a composition distinguished by its play of line and shadow. Yet his work never reduces its subjects to total abstraction. There is a certain sensitivity to his approach, as well as a loyalty to his subjects and their connotations.

An artistic breakthrough of sorts occurred in 1928 when Kertész purchased his first Leica camera. The ease of portability of the recently developed instrument suited Kertész's aesthetic and fostered spontaneity and experimentation in his work. His interest in capturing chance encounters—or "the decisive moment" that would become the trademark of Henri Cartier-Bresson—is demo-

nstrated in a 1928 photograph taken in Meudon, in which a man carrying a large wrapped package approaches the camera as a locomotive rumbles across a bridge at the top of the composition.

Aside from being frequently published in the literary journals of avant-garde circles, Kertész's photography also reached a more mainstream audience through pictorial magazines specializing in human interest stories. He was one of the most important contributors to the new magazines *Vu* and *Art et Médicine*, and became a pioneer of the photo essay.

Kertész had a brief marriage from 1928–1930 to Rosza Klein, a Hungarian woman who later became a photographer herself, under the pseudonym Rogie André. In 1930, he visited Budapest for the first time since his departure, and rekindled his relationship with Elizabeth Saly. She went to Paris to live with Kertész the following year, and they were married in 1933. She resumed her role as his frequent model, appearing in photographs amongst palm-reading gypsies, in Parisian cafés, and posing with André himself.

It was around this time that Kertész began exploring one of his most renowned themes, the *Distortions*. These experiments began as assignments for *Vu*; in 1929 he took photographs of a fortune teller in the transmogrifying sphere of her crystal ball, and a year later took portraits of his friend Carlo Rim in a circus mirror. He developed this technique further with a series of distorted nudes commissioned by the mass magazine *Le Sourire*. In these *Distortions*, women's bodies are morphed into grotesque creatures with nebulous shapes—bodies that refuse to be contained or easily defined.

These compositions hint at an affinity with Surrealism, and Kertész did occasionally publish in journals associated with the movement, including André Breton's *Minotaure*. However, Kertész never pledged allegiance to Surrealism or any other movement, and maintained his loyalty to what he called "naturalism." Despite his experimentation with distorted images and unusual juxtapositions, Kertész was never interested in manipulating the photographic process itself, which distinguishes him from the techniques employed by his contemporary, Man Ray. When elements of Surrealism appear in Kertész's work, they most often derive not from the artist's hand, but from the simple observation of daily life. This impulse appears in the 1937 photograph of a repairman's arm reaching between the blades of a ventilator. Though the image displays the kind of jarring juxtaposition typical of Surrealism, and closely resembles a montage, it is in fact an unmanipulated snapshot of the real world.

At this point Kertész turned more attention to the publication of books, and his first, a collection of portraits of children entitled *Enfants*, was published in 1933. He would go on to publish several more books of his photographs, including *Nos Amies les Bêtes* in 1936, *Day of Paris* in 1945, and *On Reading* in 1971.

In October 1936, André and Elizabeth Kertész sailed for New York City for what was intended to be a two-year experiment with America. He opted to leave Paris for essentially the same reasons he fled Budapest 11 years earlier: an increasingly repressive political environment and the promise of making a better living as a photographer. Through a Hungarian relative, Kertész was offered a one-year contract with Keystone Studios, a motion picture agency with a New York office. Upon arriving he was disappointed to find a paucity of reportage assignments, and had to settle for working in the studio on commercial photography.

By early 1937, Kertész had already dissolved his contract with Keystone and decided to try his luck with American magazines. He began working for Alexey Brodovitch, an acquaintance from Paris who was now the art director at *Harper's Bazaar*, a Hearst publication. He also took society portraits for Hearst's *Town and Country* and freelanced for two Condé Nast publications, *House and Garden* and *Vogue*.

In 1938, he attempted to break into *Life* magazine with an assignment focusing on the New York waterfront. Kertész took a number of successful compositions, from bird's-eye views of the harbor to more intimate shots of workers on tugboats, but none of the photographs were ever published, for reasons still uncertain. Despite this setback, Kertész continued to submit work to other magazines such as *Coronet*, which was more inclined to respect photography as a valid, autonomous art form rather than as mere illustration for text. However, since *Coronet* did not hire staff photographers, but bought pictures from various artists through agencies, Kertész was unable to make a living from this publication alone. One of Kertész's main obstacles in acquiring magazine work was his manner of working. American editors preferred photographers who took multiple roles of film and offered a large pool of images from which to select. Kertész, by contrast, was much more economical, opting to submit a small number of very fine images, and thereby assuming the role of editor for himself.

Amidst his career struggles, Kertész maintained a certain degree of visibility as an artist, continuing to exhibit works and publish books of his photographs. In December 1937, Kertész had his first solo exhibi-

tion in America in the gallery of *PM* magazine, a trade publication geared toward the advertising industry. Nine months previously he was included in a major exhibition at the Museum of Modern Art, New York, entitled *Photography 1839–1937*, and in 1941 the Museum acquired his photograph of a schoolhouse in Armonk, New York, when it was included in their exhibition *Image of Freedom*.

Perhaps the greatest blow of Kertész's career occurred in 1939, when wartime circumstances resulted in him and Elizabeth being declared enemy aliens by the U.S. government. Residents holding "enemy" passports were discouraged from photographing outdoors out of fear that photography might be used to undermine national security. Since Kertész was essentially forbidden from street photography, which had always been his primary means of expression, he withdrew from publishing work altogether.

This reclusion lasted until 1944, when André and Elizabeth became naturalized American citizens. Photographic assignments began to pick up, and Kertész soon began doing projects for *Fortune*, including a series of photographs of factory workers in various industrial cities. Also in 1944, he respectfully declined an offer from Moholy-Nagy to teach photography at the New Bauhaus (Institute of Design) in Chicago, ever preferring the role of the amateur to that of the intellectual. Five years later he secured an exclusive contract with *House and Garden*, which supplied him with a stable income and opportunities for travel in America and Europe.

After 13 years with Condé Nast, he broke his contract with the company and retired from magazine photography. He would continue to take pictures throughout his later years, frequently dedicating his images to the memory of Elizabeth, who died of cancer in 1977. As he aged, his camera retreated from the street and retired indoors to his apartment, but often with a gaze toward the outside world. Many of his last photographs were taken through the window of his apartment overlooking Washington Square, and he did a great number of still life compositions by setting up little household objects and sentimental souvenirs on windowsills.

SHANNON WEARING

See also: **Abbott, Berenice; Brassaï; Cartier-Bresson, Henri; Condé Nast; Documentary Photography; History of Photography: Interwar Years; Life Magazine; Man Ray; Manipulation; Museum of Modern Art; Photography in France; Surrealism; "The Decisive Moment"**

Biography

Born in Budapest, Hungary, 2 July 1894. Received baccalaureate from the Academy of Commerce, Budapest in 1912, but self-educated in photography. Worked at Budapest Stock Exchange 1912–1914 and 1918–1925; Served in Austro-Hungarian Army, 1914–1918; Published in various Budapest magazines as a freelance photographer, beginning 1917; Freelance photographic reportage for multiple European magazines following move to Paris, 1925; Studio work for Keystone Studios, 1936; Freelance photographic work for American magazines published by Condé Nast, Hearst, and Luce, 1937–1949; Exclusive contract with Condé Nast, 1949–1962. Received silver medal at Exposition Coloniale in Paris, 1930; Gold medal at IV Mostra Biennale Internazionale della Fotografia, Venice, 1963; made honorary member of American Society of Magazine Photographers, 1965; guest of honor at the Miami Conference on Communication Arts, University of Miami, Coral Gables, Florida, 1965; John Simon Guggenheim Memorial Fellowship, 1974; guest of honor at VI Rencontres Internationales de la Photographie, Arles, 1975; appointed Commander of the Order of Arts and Letters by the French government, 1976; recipient of Mayor's Award of Honor for Arts and Culture, New York, 1977 and 1981; Medal of the City of Paris, 1980; First Annual Award of the Association of International Photography Art Dealers, 1980; Honorary Doctorate of Fine Arts from Bard College, Annandale-on-Hudson, New York, 1981. Died in New York, New York, 28 September 1985.

Individual Exhibitions

1927 Galerie Au Sacre du Printemps; Paris, France
1937 *André Kertész, an Exhibition of 60 Photographs*; PM Gallery; New York, New York
1946 Art Institute of Chicago; Chicago, Illinois
1962 Long Island University; New York, New York
1963 *André Kertész, Photographies*; Bibliothèque nationale de France; Paris
 IV Mostra Biennale Internazionale della Fotografia; Venice
1964 *André Kertész, Photographer*; Museum of Modern Art; New York, New York
1971 Moderna Museet; Stockholm, Sweden
1972 The Photographers' Gallery; London, England
1975 VI Rencontres Internationales de la Photographie; Arles, France
1978 Musée National d'Art Moderne; Centre Georges Pompidou; Paris, France
1980 University of Salford; Salford, England
 Photographs of a Lifetime; Israel Museum; Jerusalem, Israel
11981 Cornell Fine Arts Center, Rollins College; Winter Park, Florida
1982 *André Kertész: Master of Photography*; The Chrysler Museum; Norfolk, Virginia
1985 *André Kertész of Paris and New York*; Art Institute of Chicago, Chicago, Illinois and traveling
 André Kertész: A Portrait at Ninety; International Center of Photography; New York, New York and traveling
1987 *André Kertész: Diary of Light 1912–1985*; International Center of Photography; New York, New York

1990 *André Kertész, ma France*; Palais de Tokyo; Paris, France and traveling

1992 *André Kertész, Form and Feeling*; Queensland Art Gallery; Brisbane, Australia, and traveling

1994 *André Kertész and Hungary*; Magyar Fotográfiai Múzeum; Kecskemét, Hungary, and traveling

 André Kertész: A Centennial Tribute; J. Paul Getty Museum; Los Angeles, California

 André Kertész, le Double d'une Vie; Pavillon des Arts; Paris, France and traveling

Group Exhibitions

1928 *Premier Salon Indépendant de la Photographie*; Comédie des Champs-Elysées; Paris, France

 Galerie l'Epoque; Brussels, Belgium

 Internationale Foto Salon; Amsterdam and Rotterdam, the Netherlands

1929 *Fotografie der Gegenwart*; Folkwang Museum; Essen, Germany

 Film und Foto; Stuttgart, Germany

1930 *Das Lichtbild*; Munich, Germany

 Primer Salon Anual de Fotografia; Buenos Aires, Argentina

1931 *Das Lichtbild 1931*; Essen

1932 *Exhibition of Modern Photography*; Royal Photographic Society of Great Britain; London, England

 Modern European Photography; Julien Levy Gallery; New York, New York

1934 *Groupe annuel des photographies*; Galerie de la Pléiade; Paris, France

 The Modern Spirit in Photography and Advertising; Royal Photographic Society of Great Britain; London, England

1937 *Photography 1839–1937*; Museum of Modern Art; New York, New York

 Pioneers of Modern French Photography; Julien Levy Gallery; New York, New York

1941 *Image of Freedom*; Museum of Modern Art; New York, New York

1967 *The Concerned Photographer*; Riverside Museum; New York, New York, and traveling

1977 *Documenta 6*; Kassel, Germany

1978 *Sympathetic Explorations: Kertész/Harbutt*; Plains Art Museum; Moorhead, Minnesota

1989 *The Art of Photography: 1839–1989*; Royal Academy of Arts; London, England

 L'Invention d'un Art; Musée National d'Art Moderne, Centre Georges Pompidou; Paris, France

Selected Works

Wandering Violinist, 1921

Satiric Dancer, 1926

Lajos Tihanyi, 1926

Mondrian's Glasses and Pipe, 1926

Meudon, 1928

Fork, 1928

Distortion #91, 1933

Arm and Ventilator, 1937

East Walk of Conservatory Pond, Central Park, 1944

Further Reading

Borhan, Pierre, ed. *André Kertész: His Life and Work.* Boston: Bulfinch Press, 1994.

Corkin, Jane, ed. *André Kertész: A Lifetime of Perception.* New York: Harry N. Abrams, 1982.

Ducrot, Nicolas, ed. *André Kertész: Sixty Years of Photography, 1912–1972.* New York: Grossman, 1972.

Kertész, André. *Day of Paris.* New York: J. J. Augustin, 1945.

Kertész, André. *Hungarian Memories.* Boston: Little, Brown and Co., 1982.

Kismaric, Carol. *André Kertész.* Millerton, NY: Aperture, 1977.

Phillips, Sandra S. *André Kertész of Paris and New York.* Chicago: The Art Institute of Chicago, 1985.

WILLY KESSELS

Belgian

The varied output and wide-ranging career of Willy Kessels reflected many of the twentieth century photography's significant aesthetic developments. Like many of his contemporaries, Kessels had a career in the visual arts before he became a photographer. An architectural draftsman, furniture designer, and sculptor, Kessels was one of the protagonists of Belgian avant-garde art and modern architecture during the 1920s. Architecture and the urban environment play an important role in his photographic oeuvre, which developed from 1929 onwards. In fact, Kessels' architectural photography is an indispensable visual archive of Belgian modernism. In Brussels he photographed many of the buildings by leading architects such as Henry Van de Velde, whose portrait he also made. The generally moderate nature of Belgian architectural

modernism, which hesitates between functionalism, neoplasticism, and Art Deco, is perfectly matched by Kessels's photography, which is characterized by what might be called a subdued constructivist aesthetic. Although often employing bird's eye views, diagonal compositions, and oblique framings, his images never feature the radical fragmented structures and spatial disorientations of Russian and German avant-garde photography. Kessels presented modern buildings as pristine but stable objects, where the sculptural mass is stressed by a subtle balance of light and shade.

His middle-of-the-road modernism is reflected in his urban motifs as well. His bird's eye view of the *Square du Petit Sablon* (1930) stresses the gentle curves of a park and demonstrates an affinity to Alvin Langdon Coburn's famous *The Octopus* (1912), a bird's-eye view of a snow-covered park rather than to László Moholy-Nagy's more abstract and dynamic depictions of the urban landscape. His picture of Brussels' *Grand'Place* (1930), taken from the tower of the town hall, contains two obligatory constructivist characteristics: the bird's eye view and a predilection for pronounced shapes that bisect and structure the image, providing it with contrasting patterns of light and dark. In this case, however, the graphic elements are gothic tracery instead of modern iron or steel work, and the vertical view shows a village square rather than a hectic metropolis. The disjointed rhythms of scale and the kaleidoscopic effects, so characteristic of avant-garde depictions of the metropolis, are absent even in his urban montages. *Habitations individuelles* (1932), the photomontage of modernist dwellings he made for the book *Bruxelles-Atmosphère*, shows a relatively coherent structure and a compositional stability not seen in the work of his peers.

In the early 1930s, Kessels participated in two important photo exhibitions organized by the surrealist E.L.T. Mesens: *Internationale de la photographie* and *Deuxième exposition internationale de la photographie*. Both exhibitions were held at the Brussels Palais des Beaux-Arts and featured works of the leading photographers and international avant-garde artists of the day. Kessels was represented with a characteristic selection, which, along with his architectural and urban photography, included nudes and various commercial commissions. His nudes, although often betraying classical aesthetic conventions and pictorialist influences, contain unconventional viewpoints and framings and traces of darkroom experimentation, such as solarization. His advertising photography for, among other clients, hotels, furniture manufacturers, construction firms, and pharmaceutical firms, was a significant contribution to the rapid prolifera-

tion of the illustrated press during the 1930s—in Belgium represented by magazines such as *Le Soir illustré*, *Les Beaux-Arts*, *Reflets*, and *Variétés*. Kessels' advertising photographs, which he regularly combined with his own graphic design, are often pretexts for his experiments with composition and various lighting techniques. Some of these commercial commissions are among his best works, especially those that combine a kind of *Neue Sachlichkeit* (New Objectivity) sobriety with avant-garde techniques. In his still-life compositions made for advertising purposes, Kessels often imbues everyday objects with magical qualities, resulting in almost surrealist effects such as *Saint-Nicolas chez Barbebleu* (1937), his reportage of a doll factory published in the magazine *Reflets*.

Another highlight of his career is the still life photographs he took for *Misère au Borinage* (1933), the documentary film made by Joris Ivens and Henri Storck that deals with the notorious poverty, misery, and social injustice in the coal mining region of the Belgian Borinage. The pictures from this series that were made with a large-format camera are sharply focused and replete with detail, as can be seen in portraits of miners and their families. These photographs are reminiscent of the work of predecessors Jacob Riis, Lewis Hine, and peers such as the American Farm Security Administration photographers of the 1930s. Others, made with a small format camera, are characterized by a slight blur, evoking a pictorialist interest in atmospheric effects. This can be seen in the pictures of unemployed labourers scrambling for bits of coal on the slopes of slag-heaps.

With this important contribution to the aesthetics of realism, Kessels presents himself as a politically engaged photographer. In the mid-1930s, however, Kessels exchanged the unmistakably leftist overtones of the Borinage pictures for ultra-right-wing leanings. Some of the Borinage pictures took on entirely different meanings when they appeared in a pamphlet distributed by *Rex*, one of Belgium's fascist movements—a fact which illustrates the highly complex and ambivalent relationships between modern art, photography, ideology, and politics during the 1930s. Kessels sympathized with the Flemish nationalist and ultra-right-wing movement *Verdinaso*, for which he shot a propaganda film. He also made a portrait photograph of its leader Joris Van Severen and during the Second World War, after the collapse of the Verdinaso movement, he photographed several leaders of the Belgian collaboration.

After the war, Kessels turned his camera to the scenery and inhabitants of the valley of the river Scheldt, which he had discovered during the early 1940s. His deeply humanistic portraits of local

farmers and fishermen, the pictures of Emile Verhaeren's tomb on the river's bank, and the many tranquil riverscapes and landscapes are vaguely reminiscent of pictorialism, and constitute a parochial, even sentimental view of his native region. In addition, Kessels undertook a broad range of darkroom experiments, such as photograms, solarizations, double exposures, and scratching on the negative, resulting in abstract organic forms and demonstrating an affinity with the contemporary movement Subjektive Photographie.

These two bodies of work seem completely disconnected from Kessels's turbulent personal life. Shortly after the war, Kessels was convicted of collaboration with the Nazi occupiers of Belgium and imprisoned. Even as late as 1996, these events still stirred controversy: a retrospective exhibition in Charleroi was censored and never opened to the public. Undoubtedly, Kessels' war past has been in large part a cause of his relative obscurity.

STEVEN JACOBS

See also: **Architectural Photography; Coburn, Alvin Langdon; Farm Security Administration; Hine, Lewis; History of Photography: Interwar Years; Manipulation; Moholy-Nagy, László; Photogram; Pictorialism; Riis, Jacob; Solarization**

Biography

Born in Dendermonde, Belgium, 26 January 1898. Briefly studied architecture in the Saint-Lucas School and the Royal Academy of Fine Arts, both in Ghent. After working as an architectural draftsman, furniture designer, and sculptor, he became a self-educated photographer in 1929. Wins the *Prix de publicité Pétrole Hahn* on the occasion of the *Deuxième exposition internationale de la photographie* in Brussels. Member of the jury of the *Festival international du Film* at the occasion of the 1935 Universal Exhibition in Brussels. In 1947, sentenced to four years imprisonment as a result of collaboration during World War II. Died in Brussels, 10 February 1974.

Individual Exhibitions

1984 *Langs de Schelde: Fotografie van Willy Kessels*; Provinciaal Museum Emile Verhaeren, Sint-Amands-aan-de-Schelde, Belgium
1990 *Rencontre internationales de la photographie*; Arles, France
1997 *Amnésie, Responsabilité et Collaboration*; Palais des beaux-arts, Brussels, Belgium

Selected Group Exhibitions

1932 *Internationale de la photographie*; Palais des Beaux-Arts, Brussels, Belgium
1933 *Deuxième exposition internationale de la photographie et du cinéma*; Palais des Beaux-Arts, Brussels, Belgium
1936 *Nu artistique*; Antwerp
1964 *Corrélations*; Kasteel Nijenrode, Breukelen, the Netherlands
1965 *Corrélations*; Salle Magritte, Knokke, Belgium
1997 *Le temps menaçant: Années 30 en Europe*; Musée d'art moderne de la ville de Paris, Paris, France

Selected Books (illustrated by Kessels)

1930 Albert Guislain, *Découverte de Bruxelles*, Brussels: Editions l'Eglantine
1930 Reportage on unemployment in Brussels in the journal *AZ*
1932 Albert Guislain, *Bruxelles Atmosphères 10–32*, Brussels: Editions l'Eglantine
1932 Roger Avermaete, *Synthèse d'Anvers*, Brussels: Editions l'Eglantine
1944 Bert Peleman, *Schoon Scheldeland*, Brussels: De Burcht
1955 Bart Peleman & Filip de Pillecyn, *De eeuwige Schelde*, Louvain: De Clauwaert Boekengilde
1967 *Sint-Niklaas en het land van Waas*, Antwerp: Nederlandse Boekhandel

Selected Works

La Grand'Place de Bruxelles, 1930
Square du Petit Sablon, Bruxelles, 1930
Habitations individuelles, ca. 1932
Portrait of *Henry Van de Velde*, 1932
Still photographs for *Misère au Borinage*, 1933
Publicity photograph for *Pétrole Hahn*, 1933
Portrait of *Joris Van Severen*, ca. 1936
Saint-Nicolas chez Barbebleu, 1937
Nu cathédrale, 1966

Further Reading

De Naeyer, Christine. *W. Kessels*. Charleroi: Museé de la photographie, 1996.
Kessels, Willy. *Amnésie, responsabilité et collaboration: Willy Kessels photographe*. Exh. cat. Brussels: Palais des Beaux-Arts, 1997.
Leplus, François, and Alain Paviot. *Willy Kessels*. Paris: Galerie Alain Paviot, 1990.
Samoy, Achiel G. *Een levensschets: Willy Kessels kunstfotograaf*. Ghent: Handelsdrukkerij Het Volk, 1974.

EDMUND KESTING

German

Edmund Kesting was a painter, photographer, and art educator. He founded two private art schools and an artists' group, and was intimately involved in the avant-garde movement of the 1920s. The sentence "A painter looks through the lens," was taken from an article in the late 1930s, and the title of a book edited by Kesting in 1958, aptly demonstrates how he conceived of himself as a mediator between painting and photography. He propagated the close connection between these two art forms and saw himself literally as a "light painter," an artist drawing with light.

Born in 1882 in Dresden, Kesting very early showed his artistic and musical talents. After his intermediary exams, he attended a school of commercial arts and joined the *Dresdner Kunstakademie* in 1915. In 1919, still a student himself, he founded with painter Carl Piepho the private school of design *Der Weg* (The Path) and taught there. In 1926, he established a branch of this school in Berlin. Both schools had to be closed down in 1933 with the advent of the Hitler regime, and, classified as an "*entarteter*" (degenerate) artist by the Nazis, Kesting was banned from painting and exhibiting.

In the 1920s, Kesting mainly worked as a painter, inspired by expressionism as well as dadaism and constructivism. Due to his encounter and ensuing friendship in the beginning of that decade with poet, musician, and essayist Herwarth Walden, who founded the artists' group and art gallery the *Der Sturm* (The Storm), Kesting came into close contact with a number of avant-garde figures. From 1923 onwards he participated in all major exhibitions of that circle. Under that influence, Kesting produced a number of paper collages he called "*Schnittgraphiken*" (cut graphics). Deeply impressed by the works of the Russian Constructivists Alexandr Rodchenko, El Lissitzky, and Wassily Kandinsky, Kesting increasingly incorporated elements of constructivism into his paintings.

Kesting first came into touch with photography during his experimental works with photograms in 1923. Artists like László Moholy-Nagy and El Lissitzky, who themselves were experimenting with the medium, enhanced his interest in photography. He saw himself as one of these innovators when he self-consciously stated that "a small circle of photographing painters decided the fate of photography, and I am one of them, too." In contrast to other constructivist photographers, however, Kesting saw photography not so much as a creative medium in the sense of the artists associated with the movement *Neue Sachlichkeit* (The New Objectivity), but rather as an artistic form with which he expected to master the classic repertoire of expression and design in a modern way. Thus, photography was simultaneously creative and apparative to him.

Kesting started experimenting with the technique of multiple exposure around 1926–1927. The first samples are portraits of his wife Gerda Müller-Kesting and of sculptures of the *Dresdner Zwinger*. It was by accident that he came upon the idea of consciously using this technique in his work. Although Kesting is sometimes seen as the founder of this "sandwich technique," this credit actually goes to the Swedish painter Oscar Gustav Rejlander, who preceded him in creating doubled images and constructed scenes by means of multiply exposed negatives.

Kesting used to see portrait photography as a great challenge, and he worked on it mainly until 1937 and during the last decade of his work period. His models were initially his family—wife and child—and later increasingly friends, relatives, pupils of the *Weg* school as well as artists, writers, and other VIPs. He persistently used multiple exposure and thereby tried to visualise the mental and lively aspects of the portrayed personalities. The literal "multi-layeredness" of his pictures and the concentration on shades of light, the modelling of light and shadow, were his means to convey and transfer meaning. Kesting almost exclusively used this technique inside the studio; outdoor multiple exposures are rare.

His portraits can be classified into dominant categories: one type is the montage of profile and half figure photographs, another the combination of (half) profile and silhouette pictures. A third group consists of photographs of women in mirrors or with veils.

From 1930 to around 1936, Kesting also did dance photography, emphasising the movement and rhythm of the bodies. He enlarged his reper-

toire of forms by including combinations of whole bodies with facial silhouettes, inspired especially by Mary Wigmann's pupil Gret Palucca.

In the middle of the 1930s, mainly for financial reasons, Kesting turned towards architectural and advertising photography. In this course, he photographed the entire Green Vault of the *Dresdner Kunstsammlungen*. His object and advertising photography, while sometimes being reminiscent of the cool and emotionless style of *Neue Sachlichkeit*, do betray that Kesting was not at home in this field: they lack the necessary technical perfection. Kesting worked mainly for the firms Minos (photography) and Auto-Union (cars).

Kesting's most impressive series, a photomontage of the devastated centre of his native city of Dresden in 1945, shortly before the end of the war, is "*Der Totentanz von Dresden*" (Dance of the Dead in Dresden), in which dancing skeletons are set into the ruins of the city. In his use of this traditional painterly motif, *Der Totentanz* has a unique place in post-war German photography of the devastation of World War II.

Kesting's activities as a painter saw a new upswing after the war, when he founded the artists' group "*der ruf*" (The Call). In 1946, he led the workshop "*Photographie und Film*" at the *Staatliche Hochschule für Werkkunst* at the *Hochschule für Angewandte Kunst* in Berlin-Weißensee. As a result of his position on formalism and socialist realism in the German Democratic Republic, Kesting was forced to leave his teaching position in 1953. The department of photography was dissolved. Kesting was employed at the *Deutsche Hochschule für Film und Fernsehen* three years later. During these years he experimented with photochemical painting. Furthermore, he again took up portraiture, photographing artist friends from West Berlin as well as the cultural and political establishment of East Germany.

Kestings's works are scattered all over the world. Numerous early plates are lost, and many of Kesting's prints from these are not extant either, and are known only in reproductions. Many of his photographs have posthumously been dated and registered by his wife, since Kesting himself did not care much about systematic registering of his work. He saw photography as a "forward-looking work."

FRANZISKA SCHMIDT

See also: **Architectural Photography; History of Photography: Twentieth-Century Pioneers; Manipulation; Moholy-Nagy, László; Montage; Multiple Exposures and Printing; Photogram; Photography in Germany and Austria; Portraiture**

Biography

Born 27 July 1892 in Dresden-Löbtau. Study at the *Kunstgewerbeakademie* Dresden in the subjects wood sculpture, carpentry, decorative painting, and restoration, 1911–1916; *Akademie der Bildenden Künste*, Dresden (drawing), 1915; served as a wireless operator in the German Army in France, 1915–1918; continuation of his studies at the *Akademie der Bildenden Künste*, Dresden, 1918–1922. Autodidactic studies of photography, from 1917. Founded the private art school "Der Weg— Schule für Gestaltung" (The Path—School of Design), which was inspired by the European avant-garde, especially constructivism, 1919; met Herwarth Walden and came into close contact with the group of artists *Der Sturm*, Berlin, 1921–1923; marriage with Gerda Müller, former pupil of the "*Weg*" school, 1922; founded the second "*Weg*" school in Berlin, 1926; increased interest in photography, prompted by Moholy-Nagy and El Lissitzky, from 1926; works with photomontage (sandwich technique), from 1929; photographer for advertising (photo and car industries), 1932; prohibition to paint and publish, declared as "*entarteter Künstler*" (degenerated artist) by the Nazis, 1933–1945; confiscation of works by Kesting, 1937; commercial assignments for optical industries in Dresden and portrait photogaphy. Founded and organised the group of artists "*der ruf*" (The Call), Dresden 1945; supervision of the workshop "*Photographie und Film*" at the *Staatliche Hochschule für Malkunst* in Dresden, 1946; professor at the class of photography at the *Hochschule für Angewandte Kunst* in Berlin-Weißensee, 1948–1953; dismissal in the course of the debate on socialist realism, 1953; appointment at the *Deutsche Hochschule für Film und Fernsehen* in Potsdam-Babelsberg, 1956; experiments with "chemical paintings," 1955. Died in Birkenwerder, East Germany, 21 October 1970.

Selected Individual Exhibitions

1916 Kunsthandlung Emil Richter, Dresden, Germany
1919 *Edmund Kesting*; Galerie Ernst Arnold, Dresden, Germany (paintings)
1923 *Edmund Kesting*; Galerie "*der Sturm*," Berlin, Germany
1931 Kunstschule "*der Weg*," Dresden, Germany
1936 Kunstausstellung Kühl, Dresden, Germany
1959 *Edmund Kesting*; Kunstausstellung Kühl, Dresden, Germany (Zeichnungen und Aquarelle)
1962 *Edmund Kesting—Malerei, Grafik, Fotografik*; Städtische Kunstsammlung, Karl-Marx-Stadt (today Chemnitz), Germany; travelling to Weimar and Stralsund, Germany
1964 *Edmund Kesting—Malerei, Grafik, Fotografik*; Bunte Stube, Ahrenshoop, Germany
1966 *Edmund Kesting—Arbeiten aus fünf Jahrzehnten*; Kunstausstellung Kühl, Ahrenshoop, Germany
 Edmund Kesting; Galerie Wort und Werk, Leipzig, Germany
1967 *Edmund Kesting*; Rathaus, Birkenwerder, Germany
1969 *Edmund Kesting. Porträt, Grafik, Fotografik*; Städtische Kunstsammlungen, Görlitz, Germany
1972 *Der Weg—Neue Schule für Kunst*; Galleria del Levante, Mailand and Munich, Italy, and Germany
1980 *Edmund Kesting—Malerei, Aquarelle, Zeichnungen, Druckgrafik 1907–1968*; Galerie am Sachsenplatz, Leipzig, Germany

1982 *Edmung Kesting zu Ehren des 90. Geburtstages*; Kunstausstellung Kühl, Dresden, Germany

1983 *Der Gründer der "Weg-Schule" Dresden/Berlin 1919–1923*; Galerie Stolz, Köln, Germany

Edmund Kesting. Malerei, Grafik, Fotografie. Manuelle und maschinelle Bildgestaltung; Kulturhaus Hans Marchwitza/Filmmuseum der DDR, Potsdam, Germany

1988 *Edmund Kesting. Gemälde, Zeichnungen und farbige Blätter, Graphik, Photographien*; Staatliche Kunstsammlungen, Dresden, Germany

1992 *Edmund Kesting, Zum 100. Geburtstag, Gemälde, Arbeiten auf Papier, Fotografien*; Galerie Döbele, Dresden, Germany

Selected Group Exhibitions

1916 Galerie Arnold, Dresden, Germany

1920 Dresdner Künstlervereinigung, Lennéstraße, Dresden, Germany

1921 Dresdner Künstlervereinigung, Lennéstraße, Dresden, Germany

1924 *I. Allgemeine Deutsche Kunstausstellung*, Moscow, Saratow and Leningrad, Russia, and traveling

1926 *International Exhibition of Modern Art*; Brooklyn Museum, Brooklyn, New York

Internationale Kunstausstellung, Dresden, Germany

1927 *Grosse Deutsche Kunstausstellung*, Berlin, Germany

"das junge deutschland"; Schloß Bellevue, Berlin, Germany

1928 *Große Deutsche Kunstausstellung*; Berlin, Germany

1930 *Das Lichtbild. Internationale Ausstellung*; München, Germany

1932 *Dresdner Sezession*; Kunstverein, Dresden, Germany

Internationale Hygieneausstellung, Dresden, Germany

1933 Dresdner Künstlervereinigung, Deutscher Künstlerverband and Dresdner Sezession, Schloß and Lennéstraße, Dresden, Germany

1936 *Mezinarodni vystava fotografia*, Manes Gallery, Praque

1946 *1. Allgemeine Deutsche Kunstausstellung*; Nordhalle, Dresden, Germany

1948 *Dresdner Künstler*; Museum der Bildenden Künstler, Leipzig, Germany

1959 *Künstlerische Fotografie in Dresden von den Anfängen bis in unsere Zeit*; Staatliche Galerie Moritzburg Halle, Germany

1961 *Der Sturm—Europäische Avantgarde 1912–1932*; Schloß Charlottenburg, Berlin (West), Germany

1970 *Deutsche Avantgarde 1915–1935*; Köln

The non-objective world 1914–1924; Tate Gallery, London, Great Britain

1972 *Der Weg*; Galleria del Levante, Mailand and Munich, Italy and Germany

1977 *Edmund Kesting—Subjektive Fotografie der 20er und 30er Jahre*; Galerie Werner Kunze, Berlin, Germany

Medium Fotografie, Staatliche Galerie Moritzburg Halle, Germany

Malerei und Fotografie im Dialog; Kunsthaus, Zürich, Switzerland

1978 *Das Experimentelle Photo in Deutschland 1918–1940*, Galleria del Levante, Mailand and Munich, Italy and Germany

1980 *Avant-Garde Photography in Germany 1919–1939*, San Francisco Museum of Modern Art, California (travelled to Akron Art Institute, Ohio; Walker Art Center, Minneapolis, Baltimore Museum of Art, Maryland; Columbia College, Chicago; International Center of Photography, New York; Portland Art Museum, Oregon)

1982 *Photographie in Dresden—Zeugnisse internationaler Entwicklung in Dresdner Sammlungen*, Kupferstich-Kabinett, Staatliche Kunstsammlungen, Dresden, Germany

1983 *Fotogramme—die lichtreichen Schatten*, Fotomuseum im Münchner Stadtmuseum, München, Germany

1984 *Künstler fotografieren—fotografierte Künstler*; galerie oben, Karl-Marx-Stadt (today Chemnitz), Germany

1987 *Künstler um Palucca*; Staatliche Kunstsammlungen, Dresden, Germany

1988/89 *Expressionismus. Die zweite Generation (1915–1925)*; Los Angeles Country Museum of Art, Kunstmuseum Düsseldorf and Staatliche Galeie Schloß Moritzburg

1990 *Tanz: Foto. Annäherung und Experimente 1880–1940*; Museum des 20. Jahrhunderts, Wien, Austria

1991 *Herwarth Walden 1878–1941*; Berlinische Galerie, Berlin, Germany

Selected Works

Totentanz von Dresden, 1945

Further Reading

By Kesting

Kesting, Edmund. "Bildbauwerke. Abbilden, Sehen, Schauen, Erleben. Proportion in Natur und Kunst." In *Der Weg. Aus den Lehrwerkstätten*, no. 1 (1926).

Kesting, Edmund' "Das Organische in der Kunst." In *Dresdner Sezession 1932. 1. Ausstellung im Sächsischen Kunstverein Dresden 1932, Dresden*, 1932.

Kesting, Edmund. "Über photographisches Gestalten." in *das lichtbild. internationale ausstellung*, München: 1930.

Grohmann, Will, and Edmund Kesting. *Dresden, wie es war*. Berlin (West): 1956.

Kesting, Edmund. *Ein Maler sieht durch's Objektiv*. Halle: 1958.

Kesting, Edmund. *Kloster Chorin*. Leipzig: 1962.

Holzhausen, Walter, and Kesting, Edmund. Prachtgefäße, Geschmeide, Kabinettstücke. Goldschmiedekunst in Dresden, Tübingen: 1966.

On Kesting

Billeter, Erika, ed. *Malerei und Photographie im Dialog*. Bern: 1977.

Brix, Karl, and Heinrich L. Nickel. *Künstlerische Fotografie in Dresden von den Anfängen bis in unsere Zeit*. Exh. cat. Halle: 1959.

Brix, Karl. *Edmund Kesting. Malerie, Grafik, Fotografik*. Exhibition catalogue, Karl-Marx-Stadt (Chemnitz): Städtische Kunstsammlungen, 1962.

Derenthal, Ludger. *Bilder der Trümmer—und Aufbaujahre. Fotografie im sich teilenden Deutschland*. Marburg: 1999.

Edmund Kesting. Exh. cat. Stuttgart: Galerie Döbele GmbH, 1992.

Edmund Kesting. Exh. cat. Potsdam: Kulturhaus Hans Marchwitza, 1983.

Edmund Kesting. Exh. cat. Dresden: Staatliche Kunstsammlungen Dresden, 1988–1989.

Edmund Kesting. Zum 100. Geburtstag, Gemälde, Arbeiten auf Papier, Fotografien. Exh. cat. Galerie Döbele, Stuttgart 1992.

Hüneke, Andreas, Gerhard Ihrke, Alfred Neumann, and Ulrich Wallenburg, eds. *Medium Fotografie.* Leipzig: 1979.

Lang, Lothar. Edmund Kesting in Leipzig. In Weltbühne, 75. Jg. 1980, 1.4.1980.

Werner, Klaus. *Edmund Kesting. Ein Maler fotografiert.* Leipzig, 1987.

YEVGENY KHALDEI

Ukranian

Yevgeny Khaldei was a photojournalist who is best known for his photographs of World War II. His photographs are humanistic images that document the war from the Russian perspective. As an employee of a Soviet news agency, Khaldei ensured that his photographs were acceptable to the Communist regime. Khaldei was often not credited as the author of his photographs and never given royalties for their use in publications.

Khaldei began his career as a contributor to his factory newsletter with images representing laborers in the Soviet Realist style. This was followed by contributions to various city and regional publications. In 1935, he sent photographs to Fotokhronika of Soyuzfoto, a precursor of TASS, and was invited to Moscow to take a course in photography where he studied with Semyon Fridlyand, Arkady Shaikhet, and Max Alpert and learned a humanistic approach to photojournalism. He began working for TASS in 1936.

From 1941–1945, Khaldei followed the Red Army as a war photographer for TASS. He used a Leica camera throughout the war. He photographed soldiers preparing for battle as in *Murmansk*, 1942; soldiers in the midst of liberating a country in *Vienna*, April 1945; and at leisure such as the light-hearted photograph *Sailor's Leisure, Murmansk*, 1941. In these works and others, Khaldei used formal qualities such as well-balanced compositions and dramatic lighting to make the event appear monumental. Khaldei is also noted for his images of women such as female snipers as in *Liza the Sniper, Novorossiisk*; Soviet women pilots represented in *Women Pilots* (called "night witches" by the Germans because they fought at night); crossing guards as in *Road to Berlin*, May 1, 1945; and many images of innocent bystanders. He also photographed the victims of war such as the *Murdered Jews in a Synagogue, Budapest*, and a *Jewish Couple, Budapest*, 1945, whose yellow stars he removed from their coats. Khaldei contributed to the drama of some of his photographs such as *Outskirts of Vienna*, 1945, an image of soldiers walking over a Nazi flag in front of a burning home, by setting fire to the home which belonged to a concentration camp commandant. Other photographs like *Life Again, Sevastopol*, May 1944, depicting young sunbathers against the ruins of the city, were considered too frivolous to publish at the time.

As the end of the war approached, Khaldei had seen the famous photograph of Americans raising the flag at Iwo Jima by Joseph Rosenthal and set out to create his own flag-raising images. He hired his family friend, Israil Solomonovich Kishitser, to make three flags for him which he made from red tablecloths. Khaldei photographed the first flag being raised at the airport, and the second flag being raised at the Brandenburg gate. The third flag was raised over the Reichstag on May 2, 1945. At the request of TASS, Khaldei removed the watches on the solider holding up the flag bearer. They were concerned that it would be perceived as a sign of looting or consumerism.

Khaldei also captured the atrocities of war such as the realistic image, *Executed Russian POWs in Rostov Prison*. His images involving war criminals are equally dramatic such as *Suicide of a Nazi Family, Vienna*, 1945, which records a Nazi officer who killed himself and his family. He recorded the final defeat of the Germans in his many photographs of the victory parade in Red Square, Moscow, on June 24, 1945.

After the war, Khaldei photographed the conference at Potsdam and trials at Nuremburg. Khaldei photographed numerous images of Joseph Stalin,

Winston Churchill, and Harry S. Truman at the peace conference. He seems to have captured the character of Stalin in works such as *Truman and Stalin, Potsdam*, July 1945, and *Potsdam*, July 1945. In the latter image, Khaldei placed Stalin in the center of a picture so that he is the focus of attention. He also stands out in his white suit. At Nuremburg, Khaldei photographed the war criminal and, especially, Hermann Goering at the trials, who was extremely angry that the soldiers allowed a Russian to photograph him.

In 1947, Robert Capa was visiting Russia, but was not able to leave the country with his undeveloped film. Khaldei processed the film for him. Capa, stunned by his lack of equipment, gave Khaldei a Speed Graphic camera.

In 1948, Khaldei was dismissed and given no reason by TASS. According to the Nakhimovskys, his employment may have ended due to anti-Semit-

ism or time he spent alone photographing Josip Broz Tito, who recently broke with Stalin, in his office.

After his dismissal from TASS, Khaldei continued to work as a photographer producing works such as portraits of composer Dimitry Shostakovich and cellist Mstislav Rostropovich in 1951. In 1959, he was hired by the Russian newspaper *Pravda* and photographed Russian life. He was forced out for being Jewish in 1976.

Khaldei only began to be recognized towards the end of his life through awards, exhibitions, and publications. In 1995, he was awarded a medal from the French Ministry of Culture. Colgate University Professor Nakhimovsky can be credited with bringing attention to the photojournalist in the United States through organizing the exhibition *The Lens of the Beholder: Photographs of the Soviet Empire* (Picker Art Gallery from October 29–December 15, 1995) and writing *Witness to*

Yevgeny Khaldei (Jewgeni Chaldej), Ruinen im Zentrum Berlins.
[*Courtesy of Deutsches Historisches Museum, Reprinted by permission of Voller Ernst*]

History: The Photographs of Yevgeny Khaldei in 1997. This was followed by the exhibitions *A Witness to History: Yevgeny Khaldei, Soviet Photojournalist* at the Jewish Museum, New York from January to April 13, 1997, and *Russia in Black and White: The Photojournalism of Yevgeny Khaldei*, Jewish Museum, San Francisco from February 24 to July 17, 1997.

JENNIFER OLSON-RUDENKO

Biography

Yevgeny Khaldei was born on March 10, 1917, in Yuzovka (later Stalino, later Donetsk), Ukraine. In 1918, Khaldei's mother was killed in a pogrom against the Jewish community, and the family took up residency with his grandparents. After completing four grades, Khaldei went to work cleaning the insides of steam engines in order to help support himself. In 1936, Khaldei began working for TASS news agency. In 1937, he was drafted and served as a guard on the Finnish border. He continued to work for TASS serving as a war correspondent from 1941–1945. In 1941, his family, along with the other Stalino Jews, was killed by the Nazis. On October 31, 1945, he married Svetlana and she bore him a daughter, Anna. In 1948, he was dismissed by TASS. In 1959, Khaldei was hired by the Russian newspaper *Pravda*. In 1976, he was dismissed for being Jewish. He died on October 6, 1997 in Moscow.

Selected Works

Sailors' Leisure, Murmansk, 1941
Murmansk, 1942
Liza the Sniper, Novorossiisk, 1943
Women Pilots ("night witches"), 1943
Life Again, Sevastopol, 1944 May
Executed Russian POWs in Rostov Prison, 1944 May
Sky Over Sevastopol, 1944 May
Outskirts of Vienna, 1945
Murdered Jews in a Synagogue, Budapest, 1945
Jewish Couple, Budapest, 1945
Road to Berlin, 1945 May 1
Victory Flag Over the Reichstag, 1945 May 2
Suicide of a Nazi Family, Vienna, 1945
German Prisoners of War, Berlin, 1945 May
Victory Parade, Red Square, Moscow, 1945 June 24
Marshal Zhukov, Red Square, Moscow, 1945 June 24
Truman and Stalin, Potsdam, 1945 July
Potsdam, 1945 July
Dimitry Shostakovich, 1951
Mstislav Rostropovich, 1951

Further Reading

Khaldei, Yevgeny. *Von Moskau nach Berlin: Bilder des russischen Fotografen Jewgeni Chaldej.* Berlin: Nicolaische Verlagsbuchhandlung, 1995, and Berlin: Parthas, 1999.
Nakhimovsky, Alexander and Alice Nakhimovsky. *Witness to History: The Photographs of Yevgeny Khaldei.* New York: Aperture, 1997.

CHRIS KILLIP

British

In the television series of the book *Another Way of Telling*, the artist and writer John Berger begins the second episode of the series with a discussion of a photograph of a young skinhead sitting on a brick wall crying. Berger remarks that it is no accident that the young man is framed by the bricks in the photograph; indeed, he states that there is something in common with what is happening to the youth and the bricks that surround him. Berger's comments point not only to the metaphorical role of the objects in the photograph but also to the role of the photograph in telling the story of the individual and the place he is in. The photograph *Boy Sitting on Wall, Jarrow 1976*, is from Chris Killip's series *In Flagrante*, one of the most significant bodies of photographic work on the north-east of England, an area of Britain that has periodically been photographed since the 1920s with the rise in popularity of the photo-essay through magazines such as *Picture Post*.

Born in Douglas on the Isle of Man in 1946, Killip who is largely self-taught in photography, began his career as an assistant to the advertising photographer Adrian Flowers in Chelsea, London, between 1963 and 1965. After several years working as a freelance photographer's assistant in London, Killip returned briefly to his hometown on the Isle of Man between 1969 and 1971 before once more returning to the British mainland in 1972, this time to the North of England whose landscape and people became the subject of his most widely celebrated work.

It was during the intervening years back on the Isle of Man that Killip's work was to take a direction that would have a significant effect on his subsequent work on the North of England throughout the 1970s and 1980s. Having encountered the work of photographers such as Paul Strand, Walker Evans, and August Sander at the Museum of Modern Art while on assignment in New York in 1969, Killip gave up commercial photography to return home and photograph the Island as he experienced it. The result was not of a body of work that expressed his own personal story of life on the island but rather a narrative that told the story of the changing social relations between the islanders and their environment as he experienced it during social upheavals brought about by changing population demographics and the influx of wealthy financial services workers onto the island. Although his photographs of the island and its inhabitants appeared in a number of photo-essays between 1969 and 1973, the complete body of work was not published as the book *Isle of Man* until 1980.

In the years between photographing and publishing his work on the Isle of Man, Killip began to photograph in the north-east of England. In 1972, he received a commission from the Arts Council of Great Britain for the touring exhibition *Two Views-Two Cities* and during the same year, he also exhibited in the Photographers' Gallery in London in the group show *Four Photographers*. Killip's work on the North-East during these early years was also supported by a number of major awards throughout the early and mid-1970s. He received an Arts Council of Great Britain Photography Award for the year 1973–1974 and between 1975–1976 he was the recipient of the Northern Arts Photography Fellowship. In 1977, Killip was also awarded an Arts Council of Great Britain Major Bursary Award.

It would be wrong to portray Killip during this period as journeyman photographer, traveling throughout and photographing north-east England. Killip was also very much to the fore of a fledgling photographic culture during this period, making a significant contribution to bringing photography to a wider public audience. Between 1976 and 1980, he served as a member of the Photography Committee of Northern Arts in Newcastle-Upon-Tyne, making awards to other young photographers. During this time, 1977–1979, he was also a member of the Photography Committee of the Arts Council of Great Britain.

Killip's role in supporting photography was not just confined to an administrative role sitting on Arts Council committees. In 1976, he was a founding member of the influential Side Gallery in Newcastle-Upon-Tyne. Between 1976 and 1984, Killip played an active role as an exhibition curator and advisor before serving as Director of the Side Gallery between 1977–1979. During his eight-year association with the Side Gallery, Killip curated and co-curated a number of exhibitions that brought past and contemporary documentary photography to the attention of the arts community of the north-east. Amongst those from the past were exhibitions of work by Lewis Hine, August Sander, Weegee, and nineteenth century figures Thomas Annan and E.J. Belloq. Exhibitions of contemporary documentary photographers included the work of familiar names such as Martine Frank, Robert Doisneau, Don McCullin, and Gilles Peress as well as young British photographers Chris Steel-Perkins and Trish Murtha.

After two years as Photographic Consultant to the *London Review of Books* between 1979 and 1981, Killip spent the next decade concentrating on his photographic work while at the same time participating in exhibitions throughout Europe, North America, and the Southern Hemisphere. The many years spent photographing the North of England culminated in the publication in 1988 of *In Flagrante*, recognised as one of the most significant and influential bodies of British documentary of the twentieth century. If his photographic influences are predominantly North American, the direction and subject matter of this work was very much shaped by the political and ideological effects on the society of that period. Margaret Thatcher's Conservative laissez-faire economic policies brought about rapid de-industrialisation throughout North England, the results of which where etched on its landscape and the faces of those who remained there. Killip's work is not the campaigning social documentary that is the norm for such subject matter: indeed, he was to acknowledge in the brief introductory text that the images said more about his experiences than those photographed. As Berger was to remark on the standard photographs of such subject matter:

> *In Flagrante* does not belong to this tradition. Chris Killip is admittedly aware that a better future for the photographed is unlikely. The debris visible in his photos, the debris which surrounds protagonists, is already part of a future which has been chosen—and chosen, according to the laws of our particular political system, democratically.
>
> (Berger 1988)

Having received the Henri Cartier-Bresson Award in 1989, Killip was awarded an honorary Master of Arts by Harvard University, Cambridge, Massachusetts in 1994. Between 1994 and 1998, Killip had held the Chair of the Department of Visual and Environmental Studies and had been Director of

the Carpenter Center for the Visual Arts at Harvard University, where he is currently a Professor of Visual and Environmental Studies.

JUSTIN CARVILLE

See also: **Berger, John; Documentary Photography**

Biography

Born in Douglas, Isle of Man 1946. Self taught in photography but moved to London to become an assistant to photographer Adrian Flowers 1963–1965. Works as freelance assistant in London 1965–1969; returns to the Isle of Man to work as photographer 1969–1971. Works as photographer in England 1972–1976; commissioned to photograph two cities by the Arts Council of Great Britain for the exhibition "Two Views-Two Cities" 1972; Receives Arts Council of Great Britain Photography Award 1973–1974; Northern Arts Photography Fellowship 1975–1976. Founder member and exhibition curator and advisor Side Gallery, Newcastle-Upon-Tyne, England 1976–1984; becomes member of Photography Committee, Arts Council of Great Britain 1977–1979; receives Arts Council of Great Britain Major Bursary Award 1977. Director, Side Gallery, Newcastle-Upon-Tyne, England 1977–1979; Photographic Consultant, *London Review of Books*, 1979–1981. Commissioned by London Review of Books for cover portraits 1980–1987; Photographs throughout north-east of England 1980–1991; Commissioned by Pirelli Ltd. to photograph workforce for exhibition 'Working at Pirelli' 1989; Henri Cartier-Bresson Award, Paris 1989. Visiting Lecturer, Department of Visual and Environmental Studies, Harvard University, Cambridge Massachusetts USA 1991–1993; Honorary Master of Arts, Harvard University 1994; Professor, Chairman Department of Visual and Environmental Studies 1994–1998; Director, Carpenter Centre for Visual Arts, Harvard University 1994–1998; Professor, Department of Visual and Environmental Studies 1998–present.

Individual Exhibitions

1973 *Two Views-Two Cities*; Huddersfield City Art Gallery, Bury St. Edmunds Art Gallery, England, and travelling

1977 *North-East of England*; Side Gallery, Newcastle-Upon-Tyne; and tour of Northern Arts region

1980 *Isle of Man*; Side Gallery, Newcastle-Upon-Tyne, England, and travelling

1983 *Askam and Skinningrove*; Side Gallery, Newcastle-Upon-Tyne, England, and tour of Northern Arts region

1984 *Seacoal*; Side Gallery, Newcastle-upon-Tyne, England, and tour of Northern Arts region

1984 *Chris Killip*; Photo Gallery, Johannesburg, South Africa

1985 *Another Country*; (with Graham Smith), Serpentine Gallery, London England, and travelling.

1986 *Chris Killip*; Art Institute of Chicago, Chicago, Illinois

1988 *On The Edge Of The City*; (with the painter Ken Currie), Manchester City Art Gallery, England

1988 *In Flagrante*; Victoria and Albert Museum, London, England, and travelling

1989 *Chris Killip*; Fotografiska Museet, Stockholm, Sweden

1990 *Working at Pirelli*; Victoria and Albert Museum, London, England

1991 *Chris Killip Retrospective*; Palais de Tokyo, Paris, France

1996 *The Last Art Show*; Bede Gallery, Jarrow, England

1997 *Chris Killip: Photographs, 1971–1996*; Manx Museum, Douglas, Isle of Man

2000 *Chris Killip, 60 Photographs*; The Old Post Office, Berlin, Germany

Group Exhibitions

1972 *Four Young Photographers*; Photographers' Gallery, London, England

1978 *Personal Views 1860–1977*; British Council Touring Exhibition

1980 *From Object to Object*; Arts Council of Great Britain touring exhibition

1981 *Old and Modern Masters of Photography*; Victoria and Albert Museum, London, England

1982 *Strategies—Recent Developments in British Photography*; John Hansard Gallery, Southampton, England

1982 *The Sea Project*; Photographers' Gallery, London, England

1982 *Lichbildnisse: Das Porträt*; Rheinischeslandes Museum, Bonn, Germany

1983 *International Photography Festival*; Malmö, Sweden

1985 *British Eyes*; Centre Nationale de la Photographie, Paris, France

1985 *Human Interests: Fifty Years of British Art About People*; Cornerhouse, Manchester, England

1985 *The Miner's World: Miners in Photography and Literature*; The Midland Group, Nottingham. Impressions Gallery, York; and D.L.I. Museum, Durham, England

1986 *British Contemporary Photography: Coming of Age*; FotoFest, Houston, Texas

1987 *Photoworks from Great Britain*; Forum Stadtpark, Graz, Austria

1987 *Three British Photographers*; Consejo Mexicano de Fotografia, Mexico City, Mexico

1987–1998 *Towards A Bigger Picture*; Victoria and Albert Museum; Tate Gallery, Liverpool, England

1988 *Britische Sicht! Fotografie aus England*; Museum für Gestaltung, Zürich, Switzerland

1988 *Matter of Facts: Photographie Art Contemporain en Grande Bretagne*; Musée des Beaux Arts, Nantes and Musée d'Art Moderne, Saint-Etiennes; Caves Sainte Croix, Metz, France

1989 *The Art of Photography 1839–1989*; Museum of Fine Art, Houston, Texas; Australian National Gallery, Canberra, Australia, and travelling

1989 *Photography Until Now*; Museum of Modern Art, New York, New York and Cleveland Museum of Art, Cleveland, Ohio

1989 *Through the Looking Glass: Photographic Art in Britain 1945–198*; Barbican Art Gallery, London, England

1990 *British Photography from The Thatcher Years*; Museum of Modern Art, New York, New York

1990 *Arbete Pågår*; Hasselblad Center, Göteborg, Sweden

1991–1992 *Shocks to the System*; Royal Festival Hall, London, England, and travelling

1993 *Encontros de Fotografia*; Coimbra, Portugal

1994 *Documentary Dilemmas*; British Council, European Touring Exhibition

1994 *Streetstyle*; Victoria and Albert Museum, London, England
1995 *20 Modern British Photographs*; Victoria and Albert Museum, London, England
1996 *Picturing Modernity*; San Francisco Museum of Modern Art, San Francisco, California
1999 *Some Photographs, an Independent Art*; Victoria and Albert Museum, London, England
2000 *Modern Starts*; Museum of Modern Art, New York, New York
2001 *Open Ends*; Museum of Modern Art, New York, New York

Selected Works

Boy Sitting on Wall, Jarrow, 1976
Seacoalers, 1976
Workers, Pirelli Factory, 1989
Jarrow, England, 1998

Further Reading

Badger, Gerry. "We Are Making a New World: Chris Killip 'In Flagrante.'" In Peter Turner and Gerry Badger, eds. *Photo Texts*. London: Travelling Light, 1988.

Badger, Gerry. *Chris Killip*. London: Phaidon 55.
"Chris Killip Photographs Fondation Cartier pour l'art contemporain 1975–1976 in the North East." *Creative Camera* 155 (1977) entire issue.
Davis, Sue. "Chris Killip." *Camera International*, No. 9, Spring (1986): 40–49.
Haworth-Booth, Mark. "Chris Killip: Scenes from Another Country." *Aperture*, 103, Summer (1986): 16–31.
Killip, Chris. *Isle of Man*. Text by John Berger. London: Zwemmer/AC of GB, 1980.
Killip, Chris. *In Flagrante*. Text by John Berger and Sylvia Grant. London: Secker & Warburg, 1988.
Kismaric, Susan, ed. *British Photography from the Thatcher Years*. New York: The Museum of Modern Art, 1990.
Osman, Colin, and Peter Turner. "Chris Killip: Isle of Man Portfolio." *Camera International Year Book 1975*, London: Coo Press, 1975.
Royal Academy of Arts, London. *The Art of Photography 1839–1989*. New Haven and London: Yale University Press, 1989.

AART KLEIN

Dutch

Without any formal education Aart Klein became one of the most important Dutch photographers of his generation. He is best known for his graphic approach to photography.

> My photography is called black-and-white photography, but in fact it's the other way around: white on black. That is because if you don't do anything, you get a black image. Things only happen when you open the shutter: then you make a drawing in white.
>
> (Marsman 1996)

This statement, by far his most famous, reveals his distinct vision and underlines how much he valued the technical aspect of photography.

Aart Klein was born in 1909 in Amsterdam. At the age of 21, he took a job as an office clerk at the Polygoon photo press agency. In the nine years that followed, he moved up from administrative assistant to one of the agency's most important photo-

graphers. Negatives of this period, his learning years, are lost, however. During the World War II years he held various jobs, including press photographer and an official photographer for the city of Amsterdam taking wedding photos. In 1943, he was forced to work in Germany by the Nazi occupiers taking portraits. On a leave back in Amsterdam he went underground. With the Donia Group, a resistance cell, he took pictures that were sent to the Allied forces in England. Later, he registered his country's liberation with a group of photographers called Particam, or Partisan Cameras.

In 1946, Aart Klein and Sem Presser, on assignment for the Dutch Ministry of Information, captured the state of post-war Germany in the book *Zoo leeft Duitschland. Op de puinhopen van het Derde Rijk* (How Germany Lives. On the Ruins of the Third Reich).

After the war, Klein, with his colleagues Maria Austria, Henk Jonker, and Wim Zilver Rupe from Particam, founded a photo agency using their lib-

eration name. This name, at Klein's initiative, was later changed to Particam Pictures. The Particam crew showed a distinctive style due to Klein's technical skills. They were able to avoid the use of flash by slightly heating the developer, which produced a much more sensitive film. Being able to photograph in darkened theaters or situations allowed the Particam photographers to corner the market in all kinds of stage photography, and the group had a virtual monopoly for theatre, opera, ballet, cabaret, and circus photography. Klein began showing his works in photographic exhibitions around this time, including in "Foto '48" at the Stedelijk Museum, Amsterdam.

In 1953, the Netherlands was confronted with the worst natural disaster in its history, known as the Big or Great Flood. During an extremely strong storm in the Atlantic, dikes were breached and the North Sea flooded the southern part of the country. Onethousand, eight-hundred and thirty-five people were killed, 47,000 houses were destroyed, and 139 kilometers of dikes were damaged. Together with Ed van der Elsken and photojournalist Dolf Kruger, among others, Klein's work showed his country and the world the tragedy that had especially affected agricultural areas. His pictures of the flooding were published in the newspaper *De Spiegel*.

Because of his formal approach to composition, Klein was included in the landmark *Subjektive Fotografie II* exhibition in 1954, but the Dutchman never really let go of reality to move toward the abstraction demonstrated by many of the other photographer who showed on that occasion. His work always retained recognizable elements and was never fully abstract. Even so, Klein's work was never as popular as that of many of his photojournalist or fine-arts contemporaries, making him somewhat of an outsider.

A subject that Klein especially mastered was birds in flight; he had the remarkable ability to position the birds seemingly exactly where he wanted them to capture the most dramatic images. This talent provoked one of his assistants to remark that Klein always carried a few birds in his pocket. Klein, however, was merely very patient and would wait for what Henri Cartier-Bresson called "the decisive moment," that is, until the composition matched what he had in mind. But unlike the French master, for Klein the work was not finished with the snap of the shutter. He worked hard in the darkroom to achieve his desired contrast so that they achieved their distinctive graphic appearance. Works such as *Zebra*, 1957, showing a zebra from the rear, exemplify this practice. The zebra's stripes are sharply etched across the picture plane, creating a pattern that almost obscures the organic shape of the animal.

The work conducted by Klein in the darkroom can be fruitfully compared to the efforts of his countryman, painter Piet Mondriaan, when he developed his trademark abstract style. In a famous 1912 series of paintings that documents his move to abstraction, Mondriaan purged the naturalistic image of an apple tree until he was left with a set of geometrical shapes. In the same way, Klein repeatedly adjusted the level of contrast until his pictures were pure and clean, emphasizing the straight lines and planes he looked for when he was shooting.

In 1956, Klein left Particam Pictures and set up his own studio. It was in this period, Klein combined his preferences for landscape and industrial photography and made, at his own initiative, his most famous works on the Delta engineering project, published in two books: *Delta. Poort van Europa* (Delta. Gateway to Europe) and *Delta. Stromenland in beweging* (Delta. Land of Streams in Motion). This project, which allowed Klein to continue the theme of the struggle against water, which so shapes the Dutch psyche that he explored in the aftermath of the Big Flood, was aimed to prevent flooding. It consisted of the creation of major infrastructure in the splendid natural setting of the southern part of the Netherlands. Klein once again looked for the vast planes of the landscape and the rhythmic qualities of the dikes and bridges. With a great deal of patience, vision, and technical skill, he created a distinct look at the massive interventions in the landscape meant to prevent a disaster like the one he witnessed a decade earlier. Although Klein always looked for subjects that matched his style, it is wrong to look at his pictures as mere graphic tricks. His work displays his belief in progress and offers a very personal and optimistic view.

In the years that followed the completion of the Delta photographs, Klein worked for the newspaper *Algemeen Handelsblad* and for Dutch companies such as Shell and Philips. Not surprisingly, these and other companies welcomed the optimistic spirit of his photography. Besides, his style fitted the modern industrial architecture and the visual taste of the 1960s and 1970s. Later on, he frequently went abroad, with travel grants and on assignment for different government agencies.

While Klein was not active as a photographer at the end of his life, it was at that time his influence and importance were recognized and appreciated. In 1982, he received the Capi-Lux Alblas Prize. In 1986, a major retrospective exhibition was mounted in Breda, the Netherlands. In 1996, Aart Klein received Fund for the Visual Arts, Design and Architecture's oeuvre prize. When Aart Klein died in 2001 at the age of 92 his pictures of the 1953 flooding and the

subsequent Delta works were a part of his country's collective memory.

STIJN VAN DE VYVER

See also: **Photography in France**

Biography

Born in Amsterdam, The Netherlands, 2 August 1909. Associated with Polygoon agency 1930–1939; co-founds Particam Pictures and The Netherlands Association of Press Photographers, 1945; co-editor of *De Fotojournalist*, 1945–1946; goes into independent business, 1956; teacher of photography at the Utrecht School of Graphics, 1958–1959. Receives Capri-Lux Prize, 1982: receives oeuvre prize from the Foundation for Visual Arts, Design and Architecture, 1986. Member of the board of the GKf-fotografen, 1956–1960. Died in Amsterdam, the Netherlands, 31 October 2001.

Individual Exhibitions

1964 *Bilder ohne Worte*; Staatliche Landesbildstelle, Hamburg, Germany

1972 Bibliothèque nationale de France, Paris, France
1973 Stedelijk Museum, Amsterdam, The Netherlands
1986 *Retrospective Aart Klein*; De Beyerd; Breda, The Netherlands

Group Exhibitions

1948 *Foto 48*; Stedelijk Museum; Amsterdam, The Netherlands
1953 *Post-War European Photography*; Museum of Modern Art; New York, New York
1954 *Subjective Fotografie II*; Staatlichen Schule für Kunst und Handwerk (State Art and Crafts School); Saarbrücken, Germany
1975 *The Land: 20th Century Landscape Photographs Selected by Bill Brandt*; Victoria and Albert Museum, London, England, and traveling
1977 *Ralph Gibson, Aart Klein & Bill Brandt*; Vrije Universiteit; Amsterdam, The Netherlands
1981 *Foto in Vorm*; Stedelijk Museum; Amsterdam, The Netherlands
1984 *Subjektive Fotografie, Images of the 50s*; Museum Folkwang; Essen, Germany, traveled to the San Francisco Museum of Modern Art, San Francisco, California
1995 *The Illegal Camera 1940–1945*; Amsterdams Historisch Museum; Amsterdam, The Netherlands, traveled to

Aart Klein, Delta construction site Haringvlietdam, The Netherlands, 1966.
[© *Aart Klein/Nederlands fotomuseum*]

Museum of the Great Patriotic War, Moscow, Russia; The Jewish Museum, New York, New York; The Field Museum, Chicago, Illinois; The Houston Holocaust Museum, Houston, Texas; Mead Art Museum, Amherst College, Amherst, Massachusetts; The Janice Charach Epstein Gallery, Jewish Community Center of Metropolitan Detroit, West Bloomfield, Michigan; Centro Português de Fotografia, Porto, Portugal

1998 *The Netherlands: Land out of Sea*; Maly Manezh; Moscow, Russia

2000 *De Noordzee*; De Nieuwe Kerk; Amsterdam, The Netherlands

2003 *Zwart-wit Kleur*; Amsterdams Historisch Museum; Amsterdam, The Netherlands

De Ramp van '53 door het oog van de media; Nederlands fotomuseum; Rotterdam, The Netherlands

Panorama Amsterdam 1862–2003; Fotografiemuseum Amsterdam FOAM; Amsterdam, The Netherlands

2004 *Onbedoelde Fotografie*; Amsterdams Centrum voor Fotografie; Amsterdam, The Netherlands

Selected Works

Antwerp De Zwanegang (street), 1949
Zebra, 1957
American War Cemetery, 1960
Oysterbed, 1961
Scheepswerf NDSM, 1961
Rodmen, 1961

Further Reading

Eskildsen, Ute, Robert Knodt, and Christel Liesenfeld. *Subjektive Fotografie: Images of the 50s*. Essen: Museum Folkwang, 1984.

Groenman, Sjoerd, and Aart Klein. *Delta; Poort van Europa*, Amersfoort: Roelofs van Goor, 1962.

Groenman, Sjoerd, Klaas Graftdijk, and Aart Klein. *Delta. Stromenland in beweging. Land im Fluss. Currents to future. Desafio al mar*. Amersfoort: Roelofs van Goor, 1967.

Haveman, Mariëtte. "Met een meeuw in zijn tas. De foto's van Art Klein." *Kunstschrift* no. 1 (1999).

Hekking, Veronica, and Flip Bool. *De illegale camera 1940–1945, Nederlandse fotografie tijdens de Duitse bezetting*. Naarden: V + K Publishing, 1995.

Leeflang, S.A., W. Hijmans, and Aart Klein. *Professioneel profiel—Philips*, Eindhoven: Philips Nederland N.V., 1970.

Marsman, Eddie. "Aart Klein, maker van bouwwerkjes." *Foto* no. 11 (2001).

Marsman, Eddie. "Aart Klein." *Foto* no. 7/8 (1996).

Nesna, Hans, Aart Klein, and Sem Presser. *Zoo leeft Duitschland. Op de puinhopen van het Derde Rijk*. Amsterdam: Scheltens & Giltay, 1946.

Terreehorst, Pauline. *Aart Klein, fotograaf*. Utrecht: s.n., 1986.

Terreehorst, Pauline. *Aart Klein: Kleur in zwart/wit*. Amsterdam: Boekhandel De Verbeelding, 1990.

van Veen, Anneke, ed. *Foto's voor de Stad, Amsterdamse documentaire foto-opdrachten*. Amsterdam: Gemeentearchief Amsterdam, 1992.

ASTRID KLEIN

German

The German photo artist Astrid Klein became well known in the 1980s with her large scale black-and-white photo works—she uses this term to distinguish her intentions from traditional photography. In almost all her works Klein uses existing text and graphic material, altering it greatly through various manipulations including greatly enlarging it, overlaying grids or other markings, including masking and stencilling, and using positive and negative images. By unhinging pictures and words from their original context, these materials lose their relationship to reality. The concept of a photograph as a reproduction of reality, that is, the ability to map a real item onto a picture, is given up and transferred into fiction through distancing. She is also a sculptor and writer.

Born in Cologne in 1951, Klein studied at the Academy of Art and Design in Cologne. At the beginning of her artistic career she created small-sized gouaches on backgrounds. It was in the late 1970s that she dedicated herself to photography, and along with German photo artist Rudolf Bonvie, embarked on a project to work out the specifics of the medium as a pictorial application independent of traditional photographic usages. Later, her interest was directed toward an analysis of the journalistic use of pictures, as reflected in her use of photo material from mass media. Klein can therefore be seen as connecting to a generation of artists, which, in the 1960s and 1970s, dealt with the unpleasant realism of the mass-media-based photography. Among these artists, were Jürgen Klauke, who was teaching at the Fachhochschule Köln in the mid-

1970s, and the Czech-born Katharina Sieverding, who creates politically-charged, large-scale self-portraits, by whom Klein was greatly influenced. Klein's first solo exhibition took place in 1980 at the Künstlerhaus Hamburg; further exhibitions quickly followed in Cologne, Berlin, and Düsseldorf.

At the beginning of the 1980s, she created the work *Marche ou crève* (March or Die) (1981). It is a five-panel photo work, showing Black women of the Third World who hung themselves to escape (according to the press reports from which Klein obtained her image) the changes of the modern world. The viewer's reception of the work is directed by the interplay of text and picture—a technique that the artist gradually downplays in her later work. In the course of the 1980s, Klein departed increasingly from straightforward, easily intelligible texts. Her works become more complex and abstract, particularly through her use of a multiplicity of experimental photographic methods. She presented images in both negative and positive, worked with double exposure, the overlay of negatives, photo or light drawing, etching into the emulsion, and inserting paper cut-outs into the photographic print. Thus she picks up the technique of the photogram (or Rayogram), which was used in the 1920s by such experimental artists as Man Ray.

In silhouette, seven dogs are arrayed across the picture plane of a large photo panel that was part of the installation *Endzeitgefühle* (End Time Feelings) (1982) in an abandoned Hamburg factory. Their black forms were inscribed on a photo of a factory wall with a boarded-up door not unlike the wall upon which it was fixed, and acted like projected shades, racing wildly, perhaps from a horrifying past, into an unknown apocalyptic future. A version of this work was also placed in a subway station in Hamburg in 1986. The setting underlines the threat, darkness, and end-time mood of the central theme of this work. In *Endzeitgefühle*, Klein takes up the political discourse of the 1980s, but her terminology serves as a more timeless statement. This work is in contrast to earlier works combining picture and text excerpted from the contemporary press, and marks a turning point in Klein's career.

She began managing the transformation of the images she selects and the uncoupling of the material from its original context, through greatly enlarging the found elements. Thus, raster, the pattern of lines created by a signal coming through the cathode ray tube of the television, common in mass-media illustrations, appear. This becomes apparent in works as *eingeebnet, eingeordnet, begradigt* (Levelled, Arranged, Straightened) and *Gedanken abgetrieben* (Thought Aborted) both of 1984.

By 1986, Klein had become a visiting professor at the Hochschule für Bildende Künste in Hamburg. Invitations to exhibit in London, Toronto, and many other cities in Europe and overseas followed. She received a number of German grants and scholarships, including the Förderpreis der Stadt Köln (1984), the Karl Schmidt-Rottluff Stipendium (1987), and the Kaethe-Kollwitz-Preis of the Akademie der Künste (1997), as well as the Kunstköln-Preis (2001). The awards are evidence of the importance and appreciation of Astrid Klein's work. Since 1993 she has been professor of fine arts at the Hochschule für Grafik und Buchkunst, Academy of Visual Arts Leipzig. In 1998, she became a member of the Akademie der Künste in Berlin.

In 1994, the work *Auswege* (Ways Out) arose, consisting of a wall installation that shows the motif of women in light-coloured dresses who walk along a narrow way repeated 11 times. Referring back to a work of the same title from 1983, the piece relies on the device presenting a spatial dimension into the picture that alters the architecture of the space to create the narrative of the piece. The path that is taken by the women in the photographs serves as a connecting element.

fremd (Foreign) (1994), a collaboration with Rudolf Bonvie, consists of seven individual components presented within the exhibition space. The viewer is also included in the pictures by mirrors that carry the writing *fremd* in different languages. Here, as in Klein's early works, picture and text are combined, but by the foreign languages the legibility is made more difficult and the information is not referred compellingly to a contemporary problem. The political aspect, however, is not to be ignored.

Klein's interest in the context of the exhibition space shows up also in the installation which she created in 2001 for the Bundestag in Berlin. The installations of fluorescent tubes, following the course of steps in the Jakob-Kaiser-Haus, bear quotations from Thomas Hobbes' *Leviathan* (1651), who postulated the necessity for contractual arrangements in his political philosophy as basic condition for the existence of a society.

Running through Astrid's Klein work is the examination of the relationship of text to picture, wrenching this almost ubiquitous manifestation of photography out of its everyday realms and placing it into images in which these relationships can be reconsidered. This is not only a device that allows her to analyze society's relation to art, but to muse on the political implications of art and photography.

MIRIAM VOSS

See also: **Conceptual Photography; History of Photography: the 1980s; Photography in Germany and Austria**

Biography

Born in Cologne, Germany, 1951. Studies at the Fachhochschule für Kunst und Design, Cologne 1973–1977; visiting professor at the Hochschule für Bildende Künste, Hamburg 1986. Since 1993, professor of Fine Arts at the Hochschule für Grafik und Buchkunst, Academy of Visual Arts Leipzig. Foundation of the label "Public Domain" (video and audio edition) 1997; member of the Akademie der Künste, Berlin, 1998. Scholarship of the Deutsch-Französisches Jugendwerk 1980; scratch scholarship of the Kunstfonds e.V., Bonn 1982; grant of the Land of North Rhine-Westphalia 1983; Förderpreis der Stadt Köln, 1984; Förderpreis Glockengasse, Köln; Karl Schmidt-Rottluff Stipendium, 1987; BDI Preis für gestaltete Räume (ARS VIVA); stage design for Kalldewey Farce (Botho Strauss) at the Schauspielhaus, Dortmund 1991; Krupp-Stipendium of photography, 1992; Käthe-Kollwitz-Preis of the Akademie der Künste, 1997; scholarship holder of the Kunststiftung Baden-Wuerttemberg; KUNSTKÖLN-Preis, Köln. Living in Cologne.

Individual Exhibitions

1980 *Astrid Klein*; Hamburg Künstlerhaus; Hamburg, Germany
1984 *Aus Deutschland*; Kunstmuseum; Luzern, Switzerland-
Von hier aus: zwei Monate neue deutsche Kunst in Düsseldorf; exhibition centre; Düsseldorf, Germany
 Astrid Klein—Utopien denunzieren; Wuerttembergischer Kunstverein; Stuttgart, Germany
1985 *Astrid Klein—Rudolf Bonvie*; Kunsthalle; Bielefeld, Germany
 Astrid Klein; Produzentengalerie; Hamburg, Germany
1987 *Astrid Klein—Photoworks 1984–1987*; Gimpel Fils; London, Great Britain
1988 Art Space; San Francisco, California (with Katharina Sieverding)
1989 *Astrid Klein: Photoarbeiten 1984–1989*; Kestner-Gesellschaft; Hannover, Germany and traveling
1991 *Astrid Klein*; Galerie Rudolf Zwirner; Cologne, Germany
 Astrid Klein; Ezra and Cecile Zilkha Gallery; Wesleyan University; Wesleyan, Connecticut
1992 *Astrid Klein*; Fine Arts Gallery; University of British Columbia, Vancouver
 Astrid Klein; Produzentengalerie; Hamburg, Germany
1994 *Astrid Klein*; Saarland Museum; Saarbrücken and Kunsthalle; Nuremberg, Germany
1997 *Astrid Klein: Käthe-Kollwitz-Preis 1997*; Akademie der Künste; Berlin, Germany (with Martin Kippenberger)
2001 *Astrid Klein: Neue Arbeiten*; KunstRaum Klaus Hinrichs; Trier, Germany
 Astrid Klein: Auswege II, 1983/94; Neues Museum; Staatliches Museum für Kunst und Design in Nuremberg, Germany
2002 *Astrid Klein–experience error–Neue Arbeiten*; Produzentengalerie; Hamburg, Germany

Group Exhibitions

1977 Forum Junger Kunst; Museum; Bochum, Germany
1982 *Halle 6*; Kampnagel Fabrik; Hamburg, Germany
 Mit Fotografie; Museum Ludwig; Cologne, Germany
1985 *Kunst mit Eigen-Sinn*; Museum des 20. Jahrhunderts; Vienna, Austria
 1945–1985. Kunst in der Bundesrepublik Deutschland; Nationalgalerie Berlin, Germany
 Extending the Perimeters of 20th Century Photography; San Francisco Museum of Modern Art; San Francisco, California
1986 *Reste des Authentischen. Deutsche Fotobilder der 80er Jahre*; Museum Folkwang; Essen, Germany
1987 *Documenta 8*; Kassel, Germany
 Art from Europe; Tate Gallery; London, Great Britain
1989 *Blickpunkte*; Musée d'Art Contemporain; Montréal, Canada
 In Between and Beyond—From Germany; Power Plant Museum; Toronto, Canada
 1. Internationale Foto-Triennale; Esslingen, German
 Inszenierte Wirklichkeit; Museum für Kunst und Kulturgeschichte der Stadt Dortmund; Dortmund, Germany
1992 *Photography in Contemporary German Art: 1960 to the Present*; Walker Art Center; Minneapolis, Minnesota, and travelling
1993 *Photographie in der deutschen Gegenwartskunst*; Museum Ludwig; Cologne, Germany
1997 *Deutschlandbilder—Kunst aus einem geteilten Land* und *Positionen künstlerischer Photographie in Deutschland seit 1945*; Martin-Gropius-Bau; Berlin, Germany
1999 *Das 20. Jahrhundert—Ein Jahrhundert Kunst in Deutschland*; Hamburger Bahnhof, Berlin, Germany, and traveling
 ZOOm—Ansichten zur deutschen Gegenwartskunst; Sammlung Landesbank Baden-Wuerttemberg; Stuttgart, Germany
2000 *Remake Berlin*; Neuer Berliner Kunstverein; Berlin, Germany
 Kennen wir uns?; Kunsthalle Nuremberg, Germany
2001 *wertwechsel—zum wert des kunstwerks*; Museum für Angewandte Kunst; Museen der Stadt Köln; Cologne, Germany
2003 *Keep on Looking*; Kunst Haus Dresden; Städische Galerie für Gegenwartskunst; Dresden, Germany

Selected Works

Marche ou crève, 1981
Endzeitgefühle, 1982
Auswege, 1983/1994
Eingeebnet, eingeordnet, begradigt, 1984
Verführung—Sklaverei, 1988
Auswege, 1994
Fremd, 1994

Further Reading

Art from Europe. Works by Ulay and Marina Abramovic, René Daniels, Marlene Dumas, Astrid Klein, Pieter Laurens Mol, Andreas Schulze, Rosemarie Trockel. Exhibition catalogue. London: The Tate Gallery; London: Tate Gallery Publications, 1987.
Casper, Lutz, and Stephan Schmidt-Wulffen. *ZOOm—Ansichten zur deutschen Gegenwartskunst.* Exhibition

catalogue. Sammlung Landesbank Baden-Württemberg, Stuttgart: Hatje Cantz Verlag, 1999.

Garrels, Gary, ed. *Photography in Contemporary German Art: 1960 to the Present*. Exhibition catalogue. Minneapolis: Walker Art Center, 1992.

Gillen, Eckhart, ed. *Deutschlandbilder: Kunst aus einem geteilten Land*. Exhibition catalogue for the Berliner Festspiele GmbH and the Museumspädagogischen Dienst Berlin, DuMont Buchverlag, Köln 1997.

Güse, E.-G., and E. W. Uthemann, eds. *Astrid Klein*. Exhibition catalogue. Saarbrücken: Saarland Museum Saarbrücken and Nuremberg: Kunsthalle, Ostfildern: Cantz-Verlag, 1994.

Haenlein, Carl. *Astrid Klein. Photoarbeiten 1984–1989*. With texts by Noemi Smolik, and Carsten Ahrens. Exhibition catalogue. Hannover: Kestner-Gesellschaft, 1989.

Rein, Ingrid. "*Astrid Klein. Fotografie als verhüllende Enthüllungen*." In *Künstler. Kritisches Lexikon der Gegenwartskunst*. Edited by Lothar Romain and Detlef Bluemler, Munich: WB Verlag, 1988.

Watson, Scott. *Astrid Klein: Träger, New Photoworks*. Exhibition catalogue. Vancouver: Fine Arts Gallery, University of British Columbia, 1992.

WILLIAM KLEIN

American

William Klein is an eclectic artist, initially a painter and graphic designer, and a renowned photographer and filmmaker. Appreciated since the 1950s for the striking novelty of his images in Europe and Japan that followed the publication of his now legendary book about New York, *Life Is Good and Good for You in New York* (1956), his importance to contemporary photography was late in being established in the United States. Today, however, he is recognized as one of the most important practitioners of twentieth-century photography, who helped establish the genre known as snapshot photography or street photography. The use of the wide-angle lenses to distort the image, fast film, extreme contrast, grainy printing, and blurry and streaked imagery is Klein's photographic language.

William Klein was born in New York in 1928. He studied sociology at City College of New York, and in 1946, enlisted in the United States Army, where he worked as an army newspaper cartoonist. When he was discharged in 1948, he found himself in Paris and decided to stay, living there until 1954. These were the years of his artistic formation. After attending the Sorbonne, he briefly studied painting with Fernand Léger. Abstraction was the prevailing aesthetic in Europe at that time, but it was the teaching of Léger that had its greatest impact on how Klein learned to relate to the art world: there should be no barriers between the various artistic mediums and styles. Léger provided the example: while best known as a painter, he also did set design, costume design, mur-

als, and films. This attitude had its origins in the avant-garde movements of Russian Constructivism, the Dutch movement De Stijl (The Style), and Dada, as well as from the teachings of the German Bauhaus.

In 1952, an Italian architect, Mangiarotti, after viewing Klein's exhibition of abstract paintings at the Galleria del Milione in Milan, asked him to realize a mural made with sliding and revolving panels. Klein painted the panels with abstract shapes and then photographed the panels in motion. This led to his first experiments in the darkroom with a kind of rayograph or photogram, where he placed geometrical shapes on photographic paper and exposed them to light.

In 1954, Alexander Liberman, art director of *Vogue*, was in Paris. He saw an exhibition of Klein's abstract photographs and offered him a job at *Vogue* as a fashion photographer. Back in New York, Klein began his personal project: a photographic diary of his return to his native city. The photographs he took in the streets of New York did not convince prospective American publishers. They seemed too raw and violent; Klein's aesthetic was in direct contradiction with the rules of what was then considered good photography. The canons that had been imposed by Henri Cartier-Bresson were those of a clean and balanced image, built on the average tones. The persons were taken at a distance or secretly. Klein meant to contradict explicitly every rule dictated by Cartier-Bresson: to the average tones he opposed a strong black-and-white contrast, to a clean and defined printing contrapposed a grainy one obtained through the blowup processes. Klein chose a popular model

for his photographs, the images published in the daily newspaper, *New York Daily News*. In fact, grainy printing nearly succeeded in obtaining a typographical effect. Also, the way he went catching photographs in the crowd was the same as a paparazzo in search of a scoop, stealing smiles or tears in a hurry, nearly in motion. His images seem to have a cinematic soul, most of them look like photograms selected from a movie, as we can see in *Dance in Brooklyn*.

The first publication of the series exited in Paris in 1956 with the Dada-like title: *Life Is Good for You in New York. William Klein Trance Witness Revels.* William Klein took care of every aspect of this book and of the following ones: design, typography, covers, and texts. The book was meant to be a photographic story with chapters.

In New York he could not find a publisher for his books, but he found a very well-paid job and, for ten years (1955 to 1965), worked as a fashion photographer at *Vogue*. Klein's pictures brought new revolutionary ideas in the fashion world as well. In contradiction with the sharpness and clearness of Irving Penn's and Richard Avedon's photographs, he shot images with his Rolleiflex to reframe and manipulate in the darkroom. Instead of a telescopic lens, he introduced the wide-angle lens, and the streets, instead of the studio, were his favorite settings.

While Klein photographed fashion in New York, Europe and Asia looked to him for his stronger and subversive images, those shot in the streets of New York. *Rome* (1958), *Moscow* (1959–1961), and *Tokyo* (1961) were his following publications.

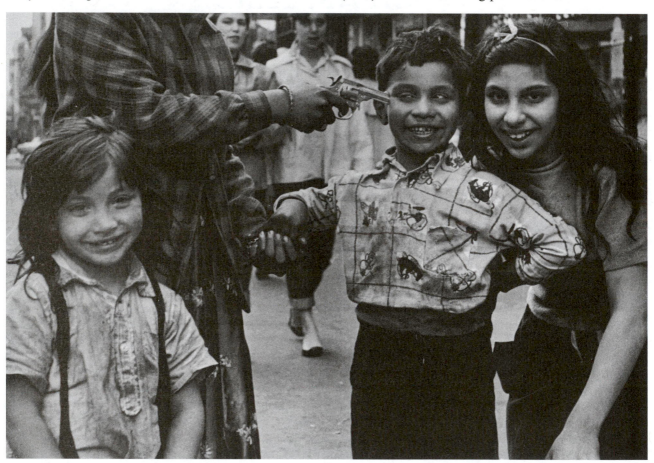

William Klein, Gun 2, near the Bowerey, New York, 1955/print 1985, gelatin silver print, 23.4 × 34.6 cm, Museum Purchase: Lila Acheson Wallace Fund.
[*Photograph courtesy of George Eastman House,* © *William Klein. Courtesy Howard Greenberg Gallery, New York City*]

In 1965, Klein left Vogue and professional photography and took up filmmaking. His most famous works are *Who are you Polly Magoo?*, *Cassius the Great*, *Loin du Vietnam,* and, released in 2000, *The Messiah.*

At the beginning of his photographic career in 1956, William Klein won the Prix Nadar for the book *New York.* At Photokina 1963, he was voted one of the greatest artists in the history of photography. In 1978, he was honored at the International Festival of Arles. In 1980–1981, the Museum of Modern Art organized an exhibition of his early works, which redefined the role of the photographer inside the New York School of Photography.

William Klein lives and works in Paris as a filmmaker and, part-time, as a still photographer.

ROBERTA RUSSO

See also: **Cartier-Bresson, Henri; History of Photography: Postwar Era; Liberman, Alexander; Manipulation; Photogram; Social Representation; Street Photography**

Biography

Born in New York, 19 April 1928. Studied sociology at City College of the City of New York. Was enlisted in the United States Army as an army newspaper cartoonist, 1946–1948. Attended the Sorbonne in Paris, 1948; studied painting with Fernand Léger, 1948. Worked for *Vogue,* 1955–1965. 1958, takes up filmmaking. Award Nadar, 1956. Grand Prix de la Photographie, France, 1986. Kultur Preis, Germany, 1987. Guggenheim Award, USA, 1988. Commander of Arts and Letters, France, 1989. International Prize Hasselblad Foundation, Sweden, 1990. Agfa Bayer, Germany, 1993. Millennium Medal, Royal Photographic Society, Great Britain, 1999. Living in Paris, France.

Individual Exhibitions

1951 Gallery Dietrich-Lou Cosyns; Brussels
1951 Galleria del Milione; Milan
1953 Gallery Apollo; Brussels
 Salon des Réalités Nouvelles; Paris
1956 La Hune; Paris
1960 Vista Books; London
1961 Fuji Photo Salon; Tokyo
1965 Jaegers; London
1967 Stedelijk Museum; Amsterdam
1978 Fiolet Gallery; Amsterdam
 Apeldoorn Museum; Apeldoorn
 Massachussetts Institute of Technology; Cambridge
1979 National Foundation of Photography; Lyon
 Canon Gallery; Geneve
1979 Canon Gallery; Basel
 Salford International Exhibition; Manchester
 Museum of Modern Art; New York
1981 Light Gallery; New York
 Light Gallery; Los Angeles

1983 Centre Georges Pompidou; Musée National d'Art Moderne; Paris
1986 *Photographs by William Klein: Recent Acquisitions*; UCR/California Museum of Photography; Riverside, California
1995 *William Klein New York 1954–1955*; San Francisco Museum of Modern Art; San Francisco, California
1996 *New York 1954–1955*; Maison Européenne de la Photographie; Paris
1997 *New York 1954–1955*; Palace of Exhibitions; Rome
2000 *Old and New Work*; Carla Sozzani Gallery; Milan
2001 *Painted Contacts*; Charles Cowles Gallery, New York

Group Exhibitions

1963 *Thirty Photographers of the Century*; Photokina; Cologne
1977 *10 Fashion Photographers*; International Museum of Photography and Film at the George Eastman House; Rochester; and Brooklyn Museum, New York; San Francisco Museum of Modern Art; Cincinnati Art Institute; Museum of Fine Arts, St. Petersburg, Florida
1978 International Festival, Arles
 10 Photographers from Atget to Klein; Massachusetts Institute of Technology; Cambridge
1980 *Photography of the 50s*; International Center of Photography; New York, traveled to Center for Creative Photography, University of Arizona, Tucson; Minneapolis Institute of Arts; California State University, Long Beach; Delaware Art Museum, Wilmington
1981 *French Photography: A Selection, 1945–1980*; Zabriskie Gallery; Paris
1982 *50 Years of Vogue*; Musée Jacquemart André; Paris
1985 *The New York School, Photographs, 1935–1963, Part I & Part II*; Corcoran Gallery of Art; Washington, DC
1986 *The New York School, Photographs, 1935–1963, Part III*; Corcoran Gallery of Art; Washington, D.C
1987 *Photography and Art 1946–1986*; Los Angeles County Museum of Art; Los Angeles, California
1997 *American Photography 1890–1965 from the Collection*; Museum of Modern Art; New York
2000 *William Klein, Helmut Newton, Irving Penn, David Seidner*; Maison Europienne de la Photographie; Paris.
2001 *Open City: Street Photographs since 1950*; The Museum of Modern Art; Oxford, England; and Hirshhorn Museum and Sculpture Garden, Washington, D.C.

Selected Works

New York, 1956; 1996
Rome, 1958–1959
Moscow, 1964
Tokyo, 1964
Mister Freedom, 1970
Close Up, 1989
Torino 90, 1990

Further Reading

Caujolle, Christian. *William Klein.* Paris: Centre national de la photographie, Photo Poche, 1985.

Galassi, Peter, and Luc Sante. *American Photography 1890–1965 from the Museum of Modern Art, New York*. New York: The Museum of Modern Art, 1997.

Harrison, Martin. *In & Out of Fashion* London: Jonathan Cape, and New York: Random House, 1994.

Heilpern, John. *William Klein: Photographs, etc*. New York: Aperture, 1981.

Jenkins, Bruce, and Jonathan Rosenbaum. *The Films of William Klein*. Minneapolis: Walker Art Center, 1988.

Jouffroy, Alain. *New York 54–55*, Paris: JM Bustamante, and Bernard Saint-Gènes, 1978.

Jouffroy, Alain. *William Klein*. Milan: Editions Fabbri, 'I Grandi Fotografi', and Paris: Editions Filipacchi, 1982.

Livingston, Jane. *The New York School: Photographs, 1936–1963*. New York: Stewart, Tabori & Chang, 1992.

Naggar, Carole. *William Klein: Photographe*. Paris: Centre Georges Pompidou, Éditions Herscher, 1983.

Phillips, Sandra S. *Life is Good & Good for You in New York: Trance Witness Revels/William Klein*. San Francisco, California: San Francisco Museum of Modern Art, 1995.

MARK KLETT

American

Mark Klett is among the most accomplished landscape photographers in the ranks of twentieth century American photography. His unique photographs incorporate elements of a nineteenth century tradition, while critically examining many of the twentieth century's most poignant environmental concerns. Throughout his work, Mark Klett focuses on the experience of contemporary travelers in the American West, while demonstrating how that experience differs from the mythologized histories of this same land. Klett is an educator, artist, and historian who has influenced a generation of photographers and inspired a new sensibility for those interested in landscape and culture.

Klett's introduction to photography began with an early interest in science. In 1974, he received a B.S. in geology from St. Lawrence University in Canton, New York. After graduating he studied photography with Nathan Lyons at the Visual Studies Workshop in Rochester, New York, receiving his M.F.A. in 1977. During graduate school Klett spent summers working for the United States Geological Survey (USGS) in Wyoming and Montana. This combination of experiences would prove to be a seminal period that would define his mature work as an artist.

Upon completing graduate school, Klett helped to organize the Rephotographic Survey Project (RSP), a project in which a series of nineteenth century photographs of the American West were rephotographed by a team of artists. Supported by an National Endowment for the Arts (NEA) grant, he worked with Gordon Bushaw, Rick Dingus, JoAnn Verburg, and the art historian Ellen Manchester to document over 100 sites that were previously photographed by photographers such as Timothy O'Sullivan and William Henry Jackson, who traveled with nineteenth-century explorers and surveyors. The work of the RSP photographers was published as *Second View: The Rephotographic Survey Project* (1982). This project had a significant impact on Klett's work as an emerging artist, teaching him to carefully consider the boundaries between science and art, past and present, and to successfully integrate these concerns into his photographs.

When Klett's work with the RSP was nearly complete, he took a position with the Sun Valley Center for the Arts and Humanities in Sun Valley, Idaho. This position meant that Mark Klett would now settle in an area where he was most at home, making the move to Idaho in 1978. His work began to look at a personal experience with the western landscape, allowing the beauty and austerity of nineteenth century photography to inform his new photographs. His photographs from this period are diaristic in their style and mark the beginning of hand-written text on the face of each print. Since 1979, Klett has used a Polaroid material to produce his photographs. This material, Type 55 P/N film, was crucial to the exacting work of the RSP photographers for its ability to produce both a positive and a negative without the use of traditional developing agents. It became an integral part of Klett's work, acting as both a practical and stylistic element to his photographs.

In 1981, he received a Ferguson Award from the Friends of Photography. Klett used the award money to travel and work in Nepal. In 1986, he worked with the artist Linda Connor to publish a portfolio entitled *Nepal*. Klett's gelatin silver prints, most measuring 16 × 20 inches, were printed to show the development marks left by the Polaroid film—a reference to the wet-plate negatives made during the nineteenth century, and a conscious nod to the photographers whose work he studied so intently. After returning from Nepal, Klett accepted a position with the Photography Collaborative Facility at Arizona State University (ASU) in Tempe, Arizona. It was in the desert southwest that he began to explore the land as a resident. This deeper identification with the desert helped solidify his understanding of the desert's ecosystem, seasons, light, and cultures. This is clearly seen in photographs where he captures the drought of cacti, the sprawl of humanity, or the blinding light of midday. In images such as *Checking the Road Map, Crossing into Arizona, Monument Valley, 6/22/82*, we see the momentary pause of new residents who seem less concerned with their present location than they are with their ultimate destination. This kind of experience is exactly what Klett focuses on regarding life in the twentieth-century West. Klett writes: "The longer I work, the more important it is to me to make photographs that tell my story as a participant, and not just an observer of the land."

Within the history of landscape photography, Mark Klett's photographs are often noted for the many ways in which they challenge a long-standing artistic tradition. His unconventional practices within the field of photography include the choice to print on matte surface paper, the inclusion of an irregular border from the Polaroid negative, and his addition of text in the finished photograph. Further, he has defied the landscape tradition of utilizing a full tonal range by photographing during the brilliant light of midday, yielding a palette of middle grays seldom seen in the work of his contemporaries. Klett's photographs question the assumption that a landscape must contain drama to achieve aesthetic success. His titles, often witty or descriptive, are written directly on the face of each print in his signature silver ink, making his work instantly recognizable and emphasizing the photograph's presence as an object and his role in its creation. Klett consistently includes the date on which the photograph was taken as an integral component of his title. This serves to remind the viewer that a photograph exists within the larger context of human history, and that it too has a history unto

itself. Titles such as *Fallen Cactus, New Golf Course, Pinnacle Peak, Arizona, 3/4/84* suggest a moment in time when the "permanence" of a golf course was first given life, ironically, through the death of an iconic desert plant. Klett's first monograph *Traces of Eden: Travels in the Desert Southwest* (1986) appears as an early example of his working style and demonstrates his fluidity between the disparate media of black and white and color.

In the 1990s, Klett completed a series of rephotographic projects, albeit smaller than the original RSP. In 1990, he created a 13 panel panorama of San Francisco that was originally photographed in 1878 by Edweard Muybridge. The two works were published back to back as a nine-foot-long accordion book *One City/Two Visions: San Francisco Panoramas, 1878 and 1890* (1990). Working with a similar project in 1991, Klett made a series of photographs documenting the changes in and around Oklahoma City since 1889. This work, published as *Photographing Oklahoma: 1889–1991* (1991), contains archival photographs made during the nineteenth century that are then juxtaposed with his own work. In 1992, he began a new body of rephotographic work in Washington, D.C. The project resulted in the publication of *Capitol View, A New Panorama of Washington, D.C.* (1994).

Throughout Mark Klett's career he has used both color and black-and-white film. Much of his color work from the 1980s and early 1990s was printed with the dye transfer process, creating a print known for its rich, saturated palette, and archival longevity. After the disappearance of dye transfer materials in 1994, Klett began to explore the emergence of computer technology to produce both color and black-and-white work. Working with digital cameras as well as digital output to explore this technology, his work has remained on the leading edge of current technology. In 1997, he launched a website containing the work of a long term project entitled *Third View*. In the Third View project he has utilized the assistance of graduate students to document many of the sites that were the subject of the original RSP photographers. Field diaries, video, and sound are used to create a dynamic addition to the photographs in this new series. The website is found at *www.thirdview.org/*.

Throughout his career, he has made use of images for commercial purposes as well as aesthetic ones. Mark Klett's photographs can be found in publications such as *Condé Nast Traveler, Westways, Harpers*, and *Outside* magazine among others. Commercial work has helped to maintain his status in the photographic community in the United States and abroad. His photographs are

held internationally in over 50 museum collections and have been exhibited in nearly 70 individual and 200 group exhibitions worldwide.

SCOTT DAVIS

See also: **Connor, Linda; Digital Photography; Dye Transfer; Friends of Photography; History of Photography: Nineteenth-Century Foundations; History of Photography: the 1980s; Lyons, Nathan**

Biography

Born in Rochester, NY, in 1953. Attended St. Lawrence University, Canton, NY, B.S., 1974; completed graduate studies with Nathan Lyons at the Visual Studies Workshop in Rochester, NY, 1977. Chief Photographer for the Rephotographic Survey Project, 1977–1979; Assistant Director of Photography at Sun Valley Center for the Arts, Sun Valley, Idaho, 1978–1981; Fine Arts Specialist, Arizona State University, Tempe, AZ, 1982–1996; Regents Professor of Art, Arizona State University, Tempe, AZ, 1996–present. Received Emerging Artist Fellowship from the NEA in 1979; Ferguson Award, Friends of Photography, Carmel, CA, 1980; NEA Fellowships in 1982, 1984; Awards in the Visual Arts Fellowship, 1986; Brandeis University Creative Arts Award, 1990; Kraszna Krausz Award for Best Books in Photography, 1992; Japan/U.S. Creative Artist Fellowship, Friends of Photography, 1993; Distinguished Research and Creative Activity Award, Arizona State University, 1999; Buhl Foundation Fellowship, 1999. Living in Tempe, Arizona.

Individual Exhibitions

1979 Mind's Eye Gallery, Idaho State University; Pocatello, ID
1980 Silver Image Gallery; Seattle, WA
1981 Sun Valley Center for the Arts and Humanities; Sun Valley, ID
1982 Moore College of Art; Philadelphia, PA
1983 Colorado Mountain College; Breckenridge, CO
1984 Art Institute of Chicago; Chicago, IL
1985 University of New Mexico Art Museum; Albuquerque, NM
1986 University of Missouri; Kansas City, MO
1987 Phoenix Art Museum; Phoenix, AZ
1988 Afterimage Gallery; Dallas, TX
1989 Milliken University; Decatur, IL
1990 Pace/MacGill Gallery; New York, NY
1991 Oklahoma City Art Museum; Oklahoma City, OK
1992 Museum of Contemporary Photography; Chicago, IL
1993 Photo Gallery International; Tokyo, Japan
1994 National Museum of American Art, Smithsonian Institution; Washington, D.C.
1995 Pace Wildenstein MacGill Gallery; New York, NY
1996 Lisa Sette Gallery; Scottsdale, AZ
1997 Galerie Fotohof; Salzburg, Austria Museum
1998 Photo-eye Gallery; Santa Fe, NM
1999 The Huntington; San Marino, CA
2000 Palm Beach Photographic Center; Palm Beach, FL

Group Exhibitions

1977 *Contemporary Color Photography*; Indiana University Art Museum; Bloomington, IN
1978 *Color Invitational*; Rochester Institute of Technology; Rochester, NY
1979 *...from the Visual Studies Workshop*; group exhibition traveling through New York State; sponsored by the Gallery Association of New York
1980 *U.S. Eye*; Photography Exhibition, sponsored by the U.S. Olympic Committee for the winter games in Lake Placid, NY
1982 *Color as Form: A History of Color Photography*; Corcoran Gallery of Art; Washington, D.C., traveled to the George Eastman House; Rochester, NY, and Creative Photography Lab; Massachusetts Institute of Technology; Cambridge, MA
 New Landscapes; Friends of Photography; Carmel, CA
1983 *Mountain Light*; International Center for Photography; New York, NY
1985 *New Landscapes*; University of Tasmania; Hobart, Australia
1986 *The Poetics of Space, Contemporary Photographic Works*; Museum of Fine Arts; Santa Fe, NM
1987 *Visions of the West: Two Views from Two Centuries*; Museum of Photographic Arts; San Diego, CA
 American Landscape Photography; Australian National Gallery; Canberra, Australia
1988 *Tradition and Change: Contemporary American Landscape Photography*; Houston Center for Photography; Houston, TX
1989 *L'Oeil de la Lettre*; Centre National de la Photographie; Paris, France
 Decade by Decade; Center for Creative Photography; Tucson, AZ, traveled to the Phoenix Art Museum; Phoenix, AZ
 Night Light, An Exhibition of 20th Century Night Photographs; Nelson-Atkins Museum of Art; Kansas City, MO
1990 *On the Art of Fixing a Shadow, One Hundred and Fifty Years of Photography*; Los Angeles County Museum of Art; Los Angeles, CA, traveled to the Art Institute of Chicago; Chicago, IL
1991 *Motion and Document, Sequence and Time*; National Museum of American Art, Smithsonian Institution; Washington, D.C
 American Photography since 1920; Sala de Exposiciones de la Fundacion "la Caixa"; Barcelona, Spain
 Night Visions; Museum of Photographic Arts; San Diego, CA
1992 *Between Home and Heaven*; National Museum of American Art; Washington, D.C.
 The Political Landscape; University Art Museum, University of New Mexico; Albuquerque, NM
1994 *Eadweard Muybridge et le Panorama Photographie de San Francisco*; Musee Carnavalet; Paris, France
 Critical Landscapes; Tokyo Metropolitan Museum of Photography; Tokyo, Japan
1995 *Terras do Norte*; Encontros de Fotografia, Universidade de Coimbra; Coimbra, Portugal
1996 *Crossing the Frontier: Photographs of the Developing West, 1849 To the Present*; San Francisco Museum of Modern Art; San Francisco, CA
 Perpetual Mirage; Whitney Museum of American Art; New York, NY

1997 *Under the Dark Cloth: The View Camera in Contemporary Photography*; Museum of Photographic Arts; San Diego, CA

1998 *Imag(in)ing Mars*; Center for Creative Photography, Tucson, AZ

Digital Frontiers: Photography's Future at Nash Editions; International Museum of Photography and Film, George Eastman House; Rochester, NY

1999 *Innovation, Imagination: 50 Years of Polaroid Photography*; Friends of Photography, San Francisco, CA

The Altered Landscape; Nevada Museum of Art, Reno, NV

2000 *Breathless! Photography and Time*; Victoria and Albert Museum; London, UK

Made in California: Art, Image, and Identity, 1900–2000; Los Angeles County Museum of Art, Los Angeles, CA

Reflections in a Glass Eye: Works from the International Center of Photography; International Center of Photography, New York

Selected Works

Second View: The Rephotographic Survey Project; 1984
Traces of Eden: Travels in the Desert Southwest; 1986
Headlands: The Marin Coast at the Golden Gate; 1989
One City/Two Visions: San Francisco Panoramas, 1878 and 1990; 1990
Photographing Oklahoma: 1889–1991; 1991
Revealing Territory; 1992
Desert Legends: Re-storying the Sonoran Borderlands; 1994

Further Reading

Castleberry, May. *Perpetual Mirage: Photographic Narratives of the Desert West*. New York: Whitney Museum of American Art, 1996.

Foresta, Merry, Stephen Jay Gould, and Karal Ann Marling. *Between Home and Heaven: Contemporary Ameri-

Mark Klett, Checking the Road Map, Crossing Into Arizona, Monument Valley, 1982.
[*Courtesy of the artist*]

can Landscape Photography. Albuquerque: University of New Mexico Press, 1992.

Fox, William L. *View Finder: Mark Klett, Photography, and the Reinvention of Landscape*. Albuquerque: University of New Mexico Press, 2001.

Goin, Peter, ed. *Arid Waters: Photographs from the Water in the West Project*. Reno: University of Nevada Press, 1992.

Jenkins, William. *New Topographics: Photographs of a Man-Altered Landscape*. Rochester: International Museum of Photography at George Eastman House, 1975.

Klett, Mark. *Beyond Wilderness (Aperture 120)*. New York: Aperture, 1990.

Phillips, Sandra S. *Crossing the Frontier: Photographs of the Developing West, 1849 to the Present*. San Francisco: Chronicle Books, 1996.

Pool, Peter E., ed. *The Altered Landscape*. Reno: University of Nevada Press, 1999.

Read, Michael, ed. *Ansel Adams, New Light: Essays on his Legacy and Legend*. San Francisco: The Friends of Photography, 1993.

Reisner, Marc. *Cadillac Desert: The American West and Its Disappearing Water*. New York: Viking Books, 1986.

PHOTOGRAPHY IN KOREA

The word "photography" is translated as *sa-jin* in Korean, a name given by a group of Chosun dynasty diplomats who visited Beijing in the 1860s and took pictures at one Russian photographer's studio. Each syllable has a distinct meaning and the two combine to define the term. The first part, *sa* means precise representation, while the second one, *jin* means essence or true quality of an object. The meaning of *sa-jin* thus differs from that of the English term "photography," which emphasizes the exact reproduction of the surface of the object being photographed. Instead, the word *sa-jin* underscores the understanding of Korean people on photography, through which, they believe, not only the outer surface, but also the inner quality of an object can be transmitted.

Modern photography was introduced in Korea during the 1880s, 40 years after its invention by Daguerre. This delay was a result of the foreign policy of the Chosun dynasty, which banned all forms of contact with Western culture before 1876. During the 1880s, some people including Kim Yong-won, Ji Un-young, and Hwang Chol learned the technique of photography and opened their studios in Korea. However, even with their activities, photography was far from being accepted by the general public due to expensive equipment and the shamanic taboo circulated in the society.

The Act of Hair-Cut (*danbal-lyong*) executed in 1895 played a key role in the distribution of photography among the public. Faced with the mandate of cutting their long hair, the symbol of filial piety, Korean literati and other Koreans wanted to leave the visual record of their long-haired appearance.

Photography provided an easy and detailed medium, which satisfied their demand, and from this period onward, commercial photography has been a successful venture in Korea. Competition among photography studios contributed to the development of photographic techniques and lowered the price of pictures. Furthermore, some even wanted to learn the practice of photography as a leisure activity. In order to meet the demand, the YMCA opened a course for amateur photographers, while a few private institutions offered short-term night classes.

After Korea was colonized by Japan in 1910, the photography industry in Korea was mostly dominated by Japanese photographers. With the help of improved techniques and equipment along with the support from the Japanese Government General in Korea, Japanese photographers had a virtual monopoly on photography production. In response to this situation, a group of Korean photographers organized Kyong-sung (currently Seoul) Photographers' Association in 1926. Instead of maintaining the traditional focus on studio portraiture, they expanded their field of subjects with various techniques and new materials.

Amateur photographers began to appear in significant numbers during the 1930s; the introduction of the portable, inexpensive, and less complicated camera equipment then available attracting a wider public to the medium. By 1937, there were 70 amateur photography clubs with up to 1,000 members in Korea. However, their activities were soon the target of suppression from the Japanese government. During the Second World War, on the

grounds of national security, the Japanese government restricted the activities of Korean photographers. They were not allowed to take pictures from buildings higher than 50 meters, and film could not be purchased without official permission.

When Korea regained its autonomy at the end of World War II in 1945, photographers in Korea organized groups and conducted various activities. In 1945, a group of amateur photographers founded Chosun Photo Art Study Group (Choson Sajin Yesul Yonguhui). Their members arranged the first salon exhibition of art photography, which was the first nationwide photography competition in Korea. During this period, the public was primarily interested in photography as 'art,' yet the term 'art photography' was not clearly defined. Instead, the tendency was to refer to photography by amateurs as art photography.

During the Korean War in the early 1950s, many war correspondents, both foreign and Korean, actively recorded the vivid situation of the war, which ultimately introduced the concept of 'realism' to Korean photography. Also beginning from the early 1950s, photographers began to participate in international photography competitions. Although few were successful in these during the 1950s, by the late 1960s, photographic works submitted for international competitions by Korean photographers earned more than 4,000 awards in about 50 competitions. Due to their participation at these international competitions, Korean photographers had ample chances of contact with the latest Western photographic trends. In the meantime, photography became available to a wider public. For example, *The Family of Man* exhibition organized by the Museum of Modern Art, New York, when shown at the Kyongbok-gung Museum in Seoul in April 1957, attracted more than 300,000 visitors.

In the 1960s, media photography played an important role during the democratic movement in Korea. During the April 19th Student Uprising, when people protested against the autocracy and corruption of the government, photographers risked their lives to record the brutal forces used by the government to suppress the protests. These pictures were published in various newspapers, which eventually brought about the fall of the corrupt government. So-called media photography found its function and responsibility during this political upheaval. Along with art photography, journalistic or realistic media photography now constituted one of two major trends of photography in Korea.

Photography began to be adopted in commercial advertising relatively late in Korea, beginning only in the late 1960s. The primary concern of the new government during the 1960s and 1970s was 'modernization.' The economy was changing from a traditional, agriculture-based system to an industrial one. Advertising photography was the outcome of the period when mass-production engaged mass-consumption. In addition, the introduction of color film and auto-focus cameras after the 1960s made photography more accessible to a wider population. Due to the successful economic development after the late 1970s, photography became a popular leisure activity among the general public. The digital revolution came as a boon to amateur Korean photographers in the 1990s, aiding the exchange of ideas and images, and numerous amateur photographers post their works on their personal websites.

Postwar and contemporary Korean photographers who have made reputations both in Korea and outside include Choi Min-shik, who most commonly focuses on human subjects; Lim Young-kyun, who takes landscapes that capture the rhythms of ordinary life; Jeong-Hee Park, also a landscape photographer; Kim Ga-jung, who takes nudes; Kim Woo-young, a nature photographer who photographed the Himalayas; photojournalist Siwoo Lee, known for his photographs of landmine victims; and Jungjin Lee, a female photographer who served as an assistant to Robert Frank during her studies in New York. Suh Jai-Sik published the popular books, *The Beauty of Korea* and *The Beauty of Seoul*, featuring his expansive color photographs. The arrest and subsequent jailing of photojournalist Seok Jae-hyun in China for allegedly taking photographs of North Koreans attempting to escape that country, made international headlines at the close of the century.

J. P. PARK

See also: **Photography in Japan**

Further Reading

Bennett, Terry. *Korea: Caught in Time*. U.K: Garnet, 1997.
Ch'oe, In-Jin. *Han'guk Sajinsa: 1631–1945* (A History of Korean Photography). Seoul: Nunpit, 1999.
——. In-Jin *Han'guk Sinmun Sajinsa* (A History of Korean Newspaper Photography). Seoul: Yolhwadang, 1992.

Ch'oe, Chun. *Han'guk Sinmunsa* (A History of Korean Newspaper). Seoul: Ilchogak, 1983.
Kim, Minsu, and Ch'oe Minji. *Iljeha Minjok Unron Saron* (Korean Journalism of the Japanese Colonial Period) Seoul: Ilwol sogak: 1978.
Stroebel, Leslie, Ed. *The Focal Encyclopedia of Photography*. 2nd ed. Boston: Focal Press, 1993.

JOSEF KOUDELKA

Czechoslovakian

A documentary and landscape photographer, Josef Koudelka first came to international prominence as the anonymous Czech photographer who chronicled the 1968 Soviet invasion of Czechoslovakia. Koudelka, already earning a reputation as a photographer of Gypsies and theatrical life at the time of the Russian military intervention, subsequently became a political exile. As a wanderer who cherishes solitary independence, he has become a specialist in desolate photographs of outcasts like himself. Much of his work depicts vanishing lifestyles and such sore points of contemporary life as environmental destruction.

Koudelka was born in the tiny village of Boskovice, in the province of Moravia in Czechoslovakia in 1938. Introduced to photography as a teenager by a friend of his father's, Koudelka began photographing his family and surroundings with a 6 × 6-inch Bakelite (plastic) camera. In 1961, he earned a degree in aeronautical engineering from Technical University in Prague and also acquired an old Rolleiflex. Koudelka then embarked on a career as an engineer in Prague and Bratislava at the same time that he began developing his photographic career.

Koudelka credits the Czech photographer and critic Jiri Jeníček with encouraging him to put together his first exhibition, in 1961. At this show, Koudelka encountered Czech photography critic and curator Anna Fárova, who became a friend and collaborator. While completing his military service in Bratislava, Koudelka met the Roma poet Desider Banga and began photographing the Roma people using one of the first wide angle lenses that came to Czechoslovakia. This East German lens with a focal length of 25 mm enabled Koudelka to work in small spaces and achieve a full depth of field even with bad light. In the 1960s, the Roma were undergoing forced attempts to assimilate them within the Czech state. Although Koudelka found taking these photographs to be difficult, he found inspiration in the music played in their settlements and in the support of the Roma themselves.

By chance, Koudelka also became involved with Czech theater. He began to take freelance photographs of performances for the magazine *Divadlo* (Theater) in 1961. The first performance that he photographed was Bertold Brecht's *Mother Courage* and he continued to work for *Divadlo* until leaving Czechoslovakia. He later explained why he stopped doing theatrical work:

> By [photographing theater] the same way I photograph real life, I learned to see the world as theater. To photograph the theater of the world interests me more....With the gypsies, it was theater, too. The difference was that the play had not been written and there was no director—there were only actors....It was the theater of life.... All I had to know was how to react.
>
> (Koudelka 2002, 122)

In 1968, Alexander Dubcek, the new leader of Czechoslovakia, initiated a reform program to create "Communism with a human face." The resulting freedom of speech and press, freedom to travel abroad, and relaxation of secret police activities led to a period of euphoria known as the Prague Spring. Encouraged by Dubcek's actions, many Czechs called for far-reaching reforms including neutrality and withdrawal from the Soviet bloc. To forestall the spread of reforms, the Soviet army invaded Czechoslovakia in August 1968. Koudelka recorded this invasion. His pictures were smuggled out of the country with the help of Farova and

published with the initials P.P. (Prague photographer) to spare his family any possible reprisal. The highly dramatic pictures showing Russian tanks rolling into Prague and the Czech resistance became international symbols and won "anonymous Czech photographer" the Overseas Press Club's prestigious Robert Capa Gold Medal. The photographs would not be published under Koudelka's name until 1984, following his father's death.

Koudelka left Czechoslovakia on a three-month exit visa in 1970 to photograph gypsies in the West. He did not return after the expiration of the visa and became stateless. England granted him political asylum that same year. Introduced to the photographer's cooperative Magnum Photos by Elliot Erwitt, Koudelka became an associate in 1971 and a full member in 1974. Despite numerous offers of work, Koudelka refused most assignments. In constant movement, he preferred to wander around Europe in search of pictures of a world that he felt was rapidly disappearing.

In 1986, Koudelka began working with a Linhof panoramic camera. The wide format for portraying the city and countryside had long interested him. Even his early work includes attempts to achieve a panoramic view, with either horizontal or vertical cropping from originally square negatives. Koudelka used panorama to photograph the changes wrought by the construction of the Channel Tunnel in France in 1988, the fall of the Berlin Wall in 1988–1991, and the war in Beirut, Lebanon in 1991.

This new camera also enabled Koudelka to make a series of apocalyptic photographs about the catastrophic state of the countryside. After becoming a French citizen in 1987, he was able to go back to the current Czech Republic for the first time in 1990. The visit led to *Black Triangle*, a study of his native country's landscape wasted by industrialization and environmental catastrophes. Monumental, painterly compositions of superbly balanced and expressively provocative panoramic shots show how oversized technological instruments have transformed the land into a ravaged and unkempt stage devoid of human presence.

Koudelka has been the recipient of major awards such as a grant from the British Arts Council to document the disappearing Roma life in England (1976). He also received an official invitation from the French Ministry to document urban and rural landscapes in France (1986). The grants sustained him through long-term projects in black and white that led to the publication of several books including *Gypsies* (1978) and *Exiles* (1988), which was shot at the edges of Europe in Ireland, Spain, Por-

tugal, and Greece. His most recent publication is *Lime Stone* (2001), which continues Koudelka's emphasis on landscapes devastated by people.

CARYN E. NEUMANN

See also: **Magnum Photos; Panoramic Photography; Photography in Russia and Eastern Europe**

Biography

Born in Boskovice, Moravia, Czechoslovakia (Czech Republic), 10 January 1938. Graduated from Technical University, Prague, with a degree in aeronautical engineering, 1961. Completes military service in Bratislava, Czechoslovakia, 1962. Works as an aeronautical engineer in Prague and Bratislava, 1961–1967. Member of the Union of Czechoslovak Artists, 1965–1970. Union of Czechoslovak Artists Annual Award for Theater Photography, 1967. Leaves Czechoslovakia, 1970. Granted asylum in England, 1970. Member of Magnum Photos, 1971–. Prix Nadar, 1978. United States National Endowment for the Arts Photography Grant, 1980. Leaves England to reside in France, 1980. Still stateless, he travels throughout Europe, 1980–1987. Naturalized in France, 1987. Grand Prix National de la Photographie, 1989. Hugo Erfurth Prize, City of Leverkusen, Germany and Agfa-Geveart AG, 1989. Prix Romanes, 1989. Henri Cartier-Bresson Award 1991. Chevalier de l'Ordre des Arts et des Lettres, 1992. The Hasselblad Foundation International Award in Photography, 1992. Centenary Medal, Royal Photographic Society, 1998.

Individual Exhibitions

1961 *Fotographie—Josef Koudelka s texty Karla Valtery*; Semafor, Prague
1968 *Josef Koudelka*; Divadlo za branou, Prague
1969 *Theatre Photography 1965–1970*; Aldwych Theatre, London
1975 *Josef Koudelka*; Museum of Modern Art, New York
1975 *Josef Koudelka*; Carlton Gallery, New York
1976 *Josef Koudelka*; Art Institute of Chicago, Chicago
1977 *Gitans: La fin du Voyage*; Galerie Delpire, Paris
1977 *Josef Koudelka*; Victoria and Albert Museum, London
1980 *Camera Obscura*; Stockholm
1981 *Josef Koudelka*; Carpenter Center for the Visual Arts, Harvard University
1988 *Josef Koudelka*; International Center of Photography, New York
1988 *Josef Koudelka, Exil*; Centre cultural français, Berlin Ost
1991 San Francisco Museum of Modern Art; San Francisco
1991 *Josef Koudelka, Mission Photographique Transmanche*; New Mosque, Thessalonica, Greece
1992 Villa Medici, Rome
1995 *Gitanos*; Centro de la Imagen, Mexico City
1996 *Periplanissis, Following Ulysses' Gaze*; Zapeion Megaron, Athens
1996 *The Black Triangle*; Stenersen Museum, Oslo
1998 *Josef Koudelka: Transmissions from Behind the Iron Curtain: Theatre Photography 1964–1970/Invasion 1968*; Lyttleton Circle Foyer, Royal National Theatre, London

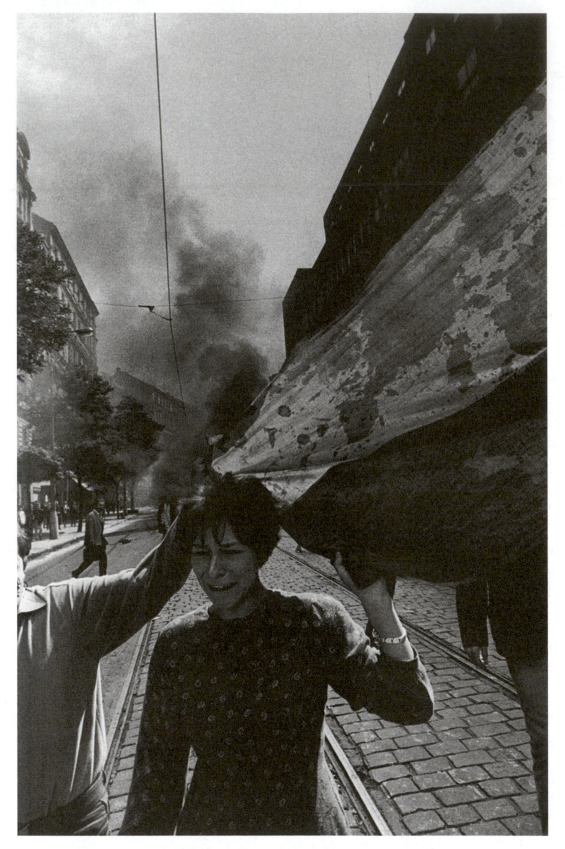

Josef Koudelka, Invasion of Warsaw Pact troops, The Czechoslovakian national flag, Prague, August 1968.
[© *Josef Koudelka/Magnum Photos*]

1998 *Renaissance: Wales*; National Museums and Galleries of Wales, Cardiff
1998 *Contacts: Wales*; Cardiff Bay Arts Trust, Cardiff
2000 *Chaos*; The Snellman Hall, Helsinki

Group Exhibitions

1971 *Photographs of Women*; Museum of Modern Art, New York
1973 *Two Views: 8 Photographers*; The Photographers' Gallery, London
1974 *Celebrations*; Hayden Gallery, Massachusetts Institute of Technology, Cambridge
1980 *Old and Modern Masters of Photography*; Victoria and Albert Museum, London, traveling
1983 *Personal Choice: A Celebration of Twentieth Century Photographs*; Victoria and Albert Museum, London

Further Reading

Cuau, Bernard. *Josef Koudelka*. Paris: Centre national de la photographie, 1984.
Horvat, Frank. *Josef Koudelka in Entre Vues*. Paris: Nathan, 1990.
Koudelka, Josef. *Chaos*. Paris: Nathan-HER/Delpire, 1999.
Koudelka, Josef. *Exiles*. New York: Aperture, 1988.
Koudelka, Josef. *Gitans: La fin du Voyage*. Paris: Delpire Editeur, 1977.
Koudelka, Josef. *Gypsies in the British Isles*. London: Arts Council of Great Britain, 1976.
Koudelka, Josef. *Josef Koudelka*. Prague, Czech Republic: Torst, 2002.
Koudelka, Josef. *Lime Stone*. Paris: La Martinire, 2001.
Koudelka, Josef. *Prague 1968*. Paris: Centre National de la Photographie, 1990.

MAX KOZLOFF

American

Critic, photographer, curator, Max Kozloff is a leading figure in the field of photography and photographic criticism. Born in Chicago, Illinois on June 21, 1933, Max Kozloff began his training as an art historian. In 1953, he attended the University of Chicago, where he received his Bachelor of Arts degree and then his Master of Arts degree in Art History in 1958. Kozloff also studied at the Institute of Fine Arts of New York University from 1960–1964. In 1967, he married the artist Joyce Kozloff. They have a son, Nikolas. Kozloff was an art critic for *The Nation* from 1961–1969, the New York editor of *Art International* from 1961–1964, and served as Executive Editor of *Artforum* from 1974–1976. In 1976, as both a personal and political choice, Kozloff expanded his interest from the field of art criticism to writing on and practicing photography.

Kozloff's work as a critic has gone well beyond the medium of photography and is influential on artists, art historians, and the art world. He has written critically on a diverse range of artists including photographers Peter Hujar, Duane Michaels, and Weegee and the nineteenth century painter Jean-Baptiste-Siméon Chardin and contemporary painter Jasper Johns. His many collections of essays focus on photography, museums, and modern art, and include *Lone Visions, Crowded Frames, Cultivated Impasses, Social Graces, The Privileged Eye, Renderings: Critical Essays on a Century of Modern Art*, and *Photography and Fascination*. Besides street photography and Jewish photographers, his area of expertise in writing about photography includes portraiture and photojournalism.

Kozloff taught at the California Institute of Arts, Valencia, from 1970–1971 and at Yale University in 1974 as well as the School for the Visual Arts, New York. It is his career as a lecturer, however, that has allowed his ideas to be widely disseminated; his 2000 lecture series at The School of Visual Arts in New York was on his book of collected writings, *Cultivated Impasses: the Waning of the Avant-Garde, 1960–1980*, which examines the complex debates that animated the art world of the 1960s and 1970s. In this volume, Kozloff re-examines the traditions of twentieth century modernism from the viewpoint as a 1970s art critic covering every type of art from the period, from conceptual art to body art to multi-media installations.

While focusing on avant-garde movements in much of his writing, as a photographer Kozloff has commented that he sees himself working in the tradition of Eugène Atget, his subject matter often store windows and the streets. Kozloff has written on "fortuitous encounters" as the premise of street

photographer, and in a 2000 interview with Vicki Goldberg, Kozloff remarked on his evolution:

> What's guided me all along has been the hope of achieving a kind of intelligible obscurity. I first noticed it when I started photographing store windows, around 1976. These windows are particularly compromised surfaces, since they simultaneously let us see into their contents while interrupting them with reflections, at some illusory remove of the world around us. The model was Atget. There was something innately pictorial about this experience, which evaporated in the round, and left only my flat transcription of it. The spectacle provided by store windows was, in pictorial terms, of double exposure, of disintegration, of seeing and not seeing. Confusing and frustrating as this situation was, it taught me about the larger equivocations of the visible world. The photograph became a kind of dream.

While a regular exhibitor on the New York scene, Kozloff's 1998 joint exhibition with his wife Joyce Kozloff, *Crossed Purposes*, at the List Gallery, Swarthmore College, Pennsylvania, toured the United States. Featuring Joyce Kozloff's map paintings alongside a survey of Max Kozloff's color street photography, *Crossed Purposes* focused on Kozloff's celebration of the rich diversity of urban life, especially festivals and street fairs. Much of Kozloff's work centers on the notion, in his words, of "chance intimacies," and these photographs capture not only the aesthetics of the setting, but also demonstrate Kozloff's intellectual and emotional commitment to social change and activism. At the same time, his photographs often have a tender poignancy, provoking discussion about evidence, perception, and subjectivity in photography.

Additionally, Kozloff has curated many critically praised exhibitions, including the 2002 *New York: Capital of Photography* at The Jewish Museum, which examined how street photographers have come to define urban perception as the characteristic visual experience of modernity. Corresponding with his own interests in street photography, this exhibition presented a survey of over 100 images of the genre spanning the twentieth century. As well, the exhibition sought to examine the photographer's response to the city in the context of a Jewish sensibility, beginning with the work of Alfred Stieglitz and his circle up to works by contemporary photographers. Kozloff's most recent book, also examining work, *New Yorkers: As Seen by Magnum Photographers*, was published by Powerhouse Books in 2003.

In a 1997 reflection, Kozloff concisely encapsulates his view on photography and criticism and the ways in which they interact and crossover, both in his own work and in life:

> An educated eye, a sociopolitical critique, a self-affirming consciousness: these are strong assets of any criticism. Only let them be combined with and worked through each other, so that they may be mutually informed yet moderate by their competing interests. Let them reach toward, rather than shun the photographic image. Let it be realized that the pictures themselves may have an unexpected impact, but won't bite. The age of the image needs a reaffirmation of photographic criticism as a separate field concerned with filtrates of memory, rich in portents of art, yet based in the material witness of life.

Kozloff is the recipient of many awards, including a Pulitzer Award for Criticism and a Fulbright Fellowship in 1962; the Frank Jewett Mather Prize for Art Criticism and the Ingram-Merrill Foundation Award in 1965; a Guggenheim Fellowship in 1969 and the NEA Fellowship for Art Criticism in 1972. In 1984, Kozloff received a national Endowment for the Arts Criticism Fellowship. In 1990, he was awarded the International Center of Photography's Writing Award. Kozloff continues to practice photography and criticism in New York today.

MELISSA RENN

See also: **Portraiture; Street Photography**

Biography

Born in Chicago, Illinois on June 21, 1933. Attended the University of Chicago, where he received both his BA in 1953 and his MA in Art History in 1958. Studied at the Institute of Fine Arts of New York University, 1960–1964. In 1967, he married the artist Joyce Kozloff. Art Critic, *The Nation*, 1961–1969; New York Editor, *Art International*, 1961–1964; Executive Editor of *Artforum*, 1974–1976. Pulitzer Award for Criticism, 1962; Fulbright Fellowship, 1962; Frank Jewett Mather Prize for Art Criticism, 1965; Ingram-Merrill Foundation Award, 1965; John Simon Guggenheim Memorial Fellowship, 1969; National Endowment for the Arts Fellowship for Art Criticism, 1972 and 1984; International Center of Photography's Writing Award, 1990. Lecturer at Art Institute of Chicago, University of New Mexico, Albuquerque (1978), California Institute of Arts, Valencia (1970), Queens College of City University of New York (1973), and Washington Square College of New York University (1961). Taught at California Institute of Arts, 1970–1971; Yale University in 1974. Living in New York City.

Selected Individual and Group Exhibitions

1977, 1970, 1980 *Max Kozloff*, Holly Solomon Gallery, New York
1982 *Max Kozloff*, Marlborough Gallery, New York

1993 *Max Kozloff*, P.P.O.W. Gallery, New York
1996 *Max Kozloff*, National Center for the Performing Arts, Bombay, India
1998 *Crossed Purposes*, joint exhibition with Joyce Kozloff, List Gallery, Swarthmore College, Pennsylvania and traveling

Further Reading

Goldberg, Vicki. "An Interview with Joyce and Max Kozloff—Contemporary Artists." *Art Journal* v. 59, no. 3 (Fall 2000) 96–103.
Goldberg, Vicki, ed. *Photography in Print: Writings from 1816 to the Present*. New York: Touchstone, 1981.
Kozloff, Max. "Critical Reflections." *Artforum* v. 35, no. 8 (April 1997) 68–69, 108, 113.

Kozloff, Max. *Cultivated Impasses: Essays on the Waning of the Avant-Garde, 1964–1975*. New York: Marsilio, School of Visual Arts, 2000.
Kozloff, Max. *Lone Visions, Crowded Frames: Essays on Photography*. Albuquerque: University of New Mexico Press, 1994.
Kozloff, Max. *New Yorkers: As Seen by Magnum Photographers*. New York: Powerhouse Books, 2003.
Kozloff, Max. *New York: Capital of Photography*. New York: Jewish Museum, 2002.
Kozloff, Max. *Photography and Fascination: Essays*. Danbury, N.H.: Addison House, 1979.
Kozloff, Max. *The Privileged Eye: Essays on Photography*. Albuquerque: University of New Mexico Press, 1987.
Kozloff, Max. *Renderings: Critical Essays on a Century of Modern Art*. New York: Simon & Schuster, 1968.
Liese, Jennifer. "May 1973." *Artforum* v. 41, no. 9 (2003) 42.

ROSALIND KRAUSS

American

Rosalind Krauss is a leading contemporary art historian and critic of the late twentieth century. She is Meyer Shapiro Professor of Modern Art and Theory at Columbia University, with which she has been associated since 1992. She received her Bachelor of Art's degree from Wellesley College in 1962. She developed her knowledge of modern painting and sculpture with the aid of the influential art historians Clement Greenberg and Michael Fried and began writing criticism in the 1960s. She received her Ph.D. from Harvard University in 1969 with a dissertation on the sculptures of David Smith. She explains in the preface of her first book, *Terminal Iron Works: the Sculpture of David Smith* (MIT Press, 1971): "It was during this period of intense study of modernist works of art that my own conviction about the quality of American sculpture was strengthened."

Even though her critical work was originally firmly anchored in American art, her interests and her approach found an attentive audience in France. Formed in the tradition of American formalism and convinced that the history of modern art could not be pursued apart from its criticism, Rosalind Krauss joined the editorial board of *Artforum* magazine in the 1960s. She distanced herself from the heritage of American formalism without ever renouncing it and left *Artforum* to start *October* magazine in 1976. This journal quickly became an important tool for a transatlantic critical dialogue.

Initially specialized in the history and criticism of the plastic arts, Rosalind Krauss became more and more interested in photography. As she herself has explained, this interest follows the logical direction taken by modern art itself in its ever-expanding use of the real as material instead of simply subject matter. Her questioning of the photographic concept comes from the development of her personal critical experience about art. As she often does in her critical approach, she starts a dialogue between seemingly heterogeneous concepts, like photography and impressionist painting, and reconceptualizes a whole field making one the condition of the other. There would not have been, in this case, an impressionist movement without the capability of thinking in photographic terms: "photography teaches the distance between perception and reality." Even though she applies photographic concepts to the intellection of the development of modern art, Rosalind Krauss suggests that photography and the history of photography should not be approached through the discourse of art history as photography belongs to the sphere of the archives and not the sphere of the museum. She settles, for example, the questions about the unity of the body of work of Eugène Atget by seeing it as an archival

collection rather than an "oeuvre." This way, she eliminates the need for spurious artistic justifications for the many repetitions of a same subject in different photographs. As an archival practice, photography is automatically justified in its cataloguing of a subject matter through time.

The growing importance of photography in the critical evaluation of her field is self evident in her fourth book, *The Originality of the Avant-Garde and Other Modernist Myths* (1985). In 1990, the Macula Editions in Paris compiled twelve previously published articles with a new introduction under the title, *Le Photographique, pour une théorie des écarts*.

In the line of Roland Barthes and Walter Benjamin, Krauss establishes photography, or more precisely, the photographic, as a theoretical tool with which she can re-examine a variety of artistic productions. She poses as essential for the re-evaluation of our apprehension of art objects the indexical quality of photography. As a sign which has a relationship with its referent based on a physical association, photography functions in the same mode as impressions, symptoms, traces, or clues. As such, photography differs completely from other modes of reproduction that could be qualified as iconic, where resemblance establishes the relationship with the referent. This semiological specificity of photography is used by Krauss as a theoretical tool to look at other works of art in the way they function as signs. She interprets the importance that the work of Marcel Duchamp took in the 1960s as the exemplary modernist practice through the recognition of a pivotal point in the conception of painting and sculpture. The work of Duchamp develops pictorial and sculptural practices that function as indexes rather than icons, providing a new interpretation of what constitutes an aesthetic image. It is precisely this substitution of modes, the indexical for the iconic, in the work of Duchamp that led Rosalind Krauss to talk about photography and to understand through photography how Duchamp influenced the American artists of her generation.

Besides her work as a critic and theoretician, Rosalind Krauss has curated exhibitions, many of them on contemporary sculpture. In the area of photography, she originated the exhibition *L'Amour Fou: Surrealism and Photography*, at the Corcoran Art Gallery, Washington, DC, in 1985. She authored a book on Cindy Sherman in 1994, and her 2000 book *Bachelors* examines female artists including photographers Claude Cahun, Sherman, and Francesca Woodman.

YVES CLEMMEN

See also: **Atget, Eugène; Barthes, Roland; Deconstruction; Semiotics; Sherman, Cindy; Woodman, Francesca**

Biography

Born in Washington, DC, November 30, 1940. Attended Wellesley College, B.A., 1962; Harvard University, Ph.D., 1969. Associate editor of the *Artforum*, 1971–1976; editor of *October Magazine*, 1976–. Associate Professor of Art History, Massachusetts Institute of Technology, 1965–1971; lecturer, Princeton University, New Jersey, 1972–1974; Professor, Hunter College, New York, 1975–1990; Meyer Shapiro Professor of Modern Art and Theory, Columbia University, 1992–. John Simon Guggenheim Memorial Fellowship, 1971; the Frank Jewett Matter Award for distinction in art criticism, 1972. Lives in New York.

Selected Works

The Originality of the Avant-Garde and Other Modernist Myths. Cambridge, MA: MIT Press, 1985. (Paperback edition 1986)

Le Photographique: pour une Théorie des Écarts. Histoire et théorie de la photographie. Paris: Macula, 1990

Cindy Sherman, 1975–1993. With an essay by Norman Bryson, New York: Rizzoli, 1993

The Optical Unconscious. October Books. Cambridge, MA: MIT Press, 1993. (Paperback edition 1994)

Francesca Woodman, Photographic Work. Exhibition catalogue. With Ann Gabhart and essay by Abigail Solomon-Godeau. Wellesley, MA: Wellesley College Museum, 1986

Further Reading

Carrier, David. *Rosalind Krauss and American Philosophical Art Criticism: From Formalism to Beyond Postmodernism*. Westport, CT: Praeger, 2002.

Kraus, Rosalind, Jane Livingstone, and Dawn Ades. *L'amour fou: Photography and Surrealism*. Washington, DC: Corcoran Gallery of Art; New York: Abbeville Press, 1985.

Squiers, Carol, et al. *Over Exposed: Essays on Contemporary Photography*. New York: New Press, 1999.

BARBARA KRUGER

American

Barbara Kruger's 1993 reflection—"I had to figure out how to bring the world into my work"—succinctly captures the socially engaged language and ethical-political dimensions that have characterized her art works from their beginnings in the early 1970s. She also alludes to the fact that her works commonly appear in sites other than art galleries and museums and thus is able to reach a broader audience: billboards and other public placements, newspaper pages, magazine and book covers, t-shirts, and matchbooks, among them. Her emergence coincided with that of other artists influenced by post-structuralist theory and semiotics, as well as the contemporary art movements Conceptualism and Feminism. Her peer group included Dara Birnbaum, Mary Kelly, Cindy Sherman, and Victor Burgin. These artists shared a common interest in photography from popular culture and media; others of this generation like Kruger, became known for their practice of "appropriation" or scavenging of pre-existing images, including Richard Prince, Sherrie Levine, and Ross Bleckner. These engagements, or interrogations of photography, challenged prevailing fine art and documentary photography traditions. These artists' works critically engaged how forms of power were related to visual images, and how media culture was exerting increased social and public influence. Kruger's overriding theme is to play with contemporary stereotypes and clichés, using the iconic power of selected images as a point of departure.

Kruger's experience as a graphic designer was critical to her artistic development both in the forms her work takes and her desire to address the popular audience. Kruger was born in Newark, New Jersey, in 1945. After graduating from Weequahic High School, she attended Syracuse University, New York, majoring in art, from 1964–1965; and then went on to Parsons School of Design, New York, from 1965–1966, where she studied photography with Diane Arbus, and the graphic designer, painter, and former art director of *Harper's Bazaar*, Marvin Israel. In 1966, Kruger began working as a designer at *Mademoiselle* magazine, where she became senior designer until 1970; she continued for many years to be a freelance picture editor with *House and Garden* and *Aperture*.

Kruger's earliest works were fiber-based hangings with mixed media such as paint, glitter, and ribbons. These pieces were exhibited in New York at the Whitney Museum of American Art 1973 Biennial, and at Artists Space in 1974. In 1979, Kruger began using photography, and self-published *Picture/Readings*, which along with other series, *Hospital, Public Sector/Private Space*, and *Remainders*. These works took the form of photo/texts; initially she took her own black-and-white and color photos and authored her own, sometimes extensive, texts. The rephotographing of found images collaged with concise texts began in 1978 with *Untitled (Business)*, and subsequent *Untitled (Perfect)*, 1980, and *Untitled (Deluded)*, 1980, which initiated the pared down plays and contrasts between word and image that are so distinctive to her work. With *Untitled (Your comfort is my silence)*, 1981, and *Untitled (Your gaze hits the side of my face)*, 1981, Kruger began framing her works in vibrant red lacquer, as well as employing Futura bold italic fonts, in texts that had a directness of address that have become her signature style. Her participation in Documenta VII, Kassel, Germany, and the Venice Biennial, both in 1982, and the 1983 Whitney Biennial, coincided with her entry into the commercial gallery system, with Larry Gagosian Gallery in Los Angeles in 1982, Annina Nosei Gallery in New York from 1983–1986, and then as the first woman artist with the Mary Boone Gallery beginning in 1986.

During this period she was active in placing works on billboards and buses, and realized public projects in Providence, Rhode Island; Minneapolis, Minnesota; and Atlanta, Georgia. In the late 1980s, she mounted billboard projects in Australia, and was active with the group Art Against Aids and lent her talents to other public health issues. In addition, Kruger has, since the 1970s, been active as a teacher, curator, and writer/critic. She began writing her column on television and popular culture, "Remote Control," as well as other commentaries and reviews for *Artforum* in 1979; Remote Control was assembled as a book in 1993. The multiple sites of exhibition and formats of display for her art works, her various contributions as a

designer, critic, editor, and curator, combined with her feminist and other social engagements, led critic David Deitcher to describe her as a "crossover artist," whose varied artistic and social commitments made it impossible to separate these usually separate realms of activity and knowledge.

The photographic images which Kruger crops and overlays with type are selected from as wide a variety of sources as photography itself encompasses, including commercial photographs from manuals, photo magazines, and archives. Critic Carol Squiers has described Kruger's choice of images as being "peripheral images, the workhorse photographs of advertising and magazine illustration." The directness of address in Kruger's texts invites the viewer to reflect on the process of how images produce meaning. For example, in *Untitled (Buy me I'll change your life)*, 1984, and *Untitled (I shop therefore I am)*, 1987, Kruger employs the language of consumer culture, and highlights the blatant ways that advertising functions as an interface between consumer and commodity. Squiers also underlines how Kruger's work complicates the boundaries between commercial, editorial, and artistic photographs:

> She manipulates, modulates, and recodes the address of obscure and sometimes hilarious images, playing received wisdom, treacly clichés, and militant critique against visuals whose original function is often puzzling at best.

In the 1990s, Kruger began incorporating video and sculpture into her work, and has explored the genre of installation. However, her signature strategy of found images combined with terse text continues to be Kruger's primary way of working. Seventy-one works spanning 1978 to 1999, as well as documentation of Kruger's public projects and billboards, were included in her 1999 retrospective at the Museum of Contemporary Art, Los Angeles, which constitutes her most comprehensive exhibition and catalogue to date. The startling simplicity of Kruger's photo montages is testimony to the powerful capacity of images to draw on deep and already circulating social meanings. Combined with concise and deliberate texts, Kruger's photo-based works self-reflect on the powerful role of the image in popular culture and society.

MONIKA KIN GAGNON

See also: **Agitprop; Arbus, Diane; Artists' Books; Burgin, Victor; Conceptual Photography; Deconstruction; Feminist Photography; History of Photography: the 1980s; Prince, Richard; Semiotics; Sherman, Cindy; Structuralism**

Biography

Born in Newark, New Jersey, 26 January 1945. Attended Syracuse University, New York, 1964–1965; Parson's School of Design, New York, 1965–1966, studied with Diane Arbus and Marvin Israel. Designer at *Mademoiselle* magazine, Condé Nast Publications, New York, 1966–1970; and freelance picture editor, including *House and Garden* and *Aperture*. Visiting artist at the University of California at Berkeley (1976), Wright State University, Ohio, Ohio State University, the Art Institute of Chicago, and California Institute of the Arts. Lives in New York City and Los Angeles.

Selected Individual Exhibitions

1979 *Picture/Readings*; Franklin Furnace Archive, New York
1982 *No Progress in Pleasure*; Hallwalls/CEPA Gallery, Buffalo, New York
1983 *We Won't Play Nature to Your Culture*: Works by Barbara Kruger; Institute of Contemporary Arts, London (Traveled to Watershed Gallery, Bristol, England; Le Nouveau Musée, Villeurbanne, France; Kunsthalle, Basel, Switzerland [in collaboration with Jenny Holzer])
1985 *New American Photography: Barbara Kruger, Untitled Works*; Los Angeles County Museum of Art, Los Angeles
1985 *Striking Poses: Barbara Kruger*; Contemporary Arts Museum, Houston
1987 *Barbara Kruger*; Mary Boone Gallery, New York
1988 *The Temporary/Contemporary*; National Art Gallery, Wellington, New Zealand
1989 Museo d'Arte Contemporanea, Castello di Rivoli, Turin, Italy
1989 Galerie Bebert, Rotterdam, The Netherlands
1990 Kölnischer Kunstverein, Cologne, Germany
1991 Projekt Gadetegn 1991; 117 billboards displayed in metropolitan Copenhagen, Denmark [Public Project]
1996 Museum of Modern Art at Heide, Melbourne, Australia
1999–2000 Museum of Contemporary Art, Los Angeles, and traveling to the Whitney Museum of American Art, New York

Selected Group Exhibitions

1977 *Narrative Themes/Audio Works*; Los Angeles Institute of Contemporary Art, Los Angeles, traveled to Artists Space, New York
1978 *Artists Books: New Zealand Tour 1978*; National Art Gallery, Wellington, New Zealand, traveled to Govett Brewster Art Gallery, New Plymouth, New Zealand; and Auckland City Art Gallery, New Zealand
1981 *5th Vienna International Biennale: Erweiterte Fotografie*; Wiener Secession, Vienna, Austria
1981 *19 Emergent Artists: 1981 Exxon Series*; Solomon R. Guggenheim Museum, New York
1982 *XL La Biennale di Venezia*; Venice, Italy
1982 *Documenta 7*; Kassel, Germany
1982 *Image Scavengers: Photography*; Institute of Contemporary Art, University of Pennsylvania, Philadelphia
1983 *Whitney Biennial: Contemporary American Art*; Whitney Museum of American Art, New York
1984 *Difference: On Representation and Sexuality*; The New Museum, New York
1985 *Biennial Exhibition: Contemporary American Art*; Whitney Museum of American Art, New York

1985 *Ecrans Politiques*; Musée d'Art Contemporain de Montréal, Montreal, Canada

1985 *Kunst mit Eigen-Sinn*; Museum für moderner Kunst Stiftung Ludwig Wien, Vienna, Austria

1986 *Jenny Holzer & Barbara Kruger*; The Israel Museum, Jerusalem

1987 *Documenta 8*; Kassel, Germany

1988 *From the Southern Cross: A View of World Art, c. 1940–1988*. The Biennial of Sydney; Art Gallery of New South Wales and Pier ⅔, Walsh Bay, Sydney, Australia, traveled to National Gallery of Victoria, Melbourne, Australia

1989 *Bilderstreit: Widerspruch, Einheit und Fragment in der Kunst seit 1960*; Museum Ludwig, Cologne, Germany

1989 *A Forest of Signs: Art in the Crisis of Representation*; The Museum of Contemporary Art, Los Angeles

1989 *Magiciens de la Terre*; Musée National d'Art Moderne, Centre Georges Pompidou, Paris

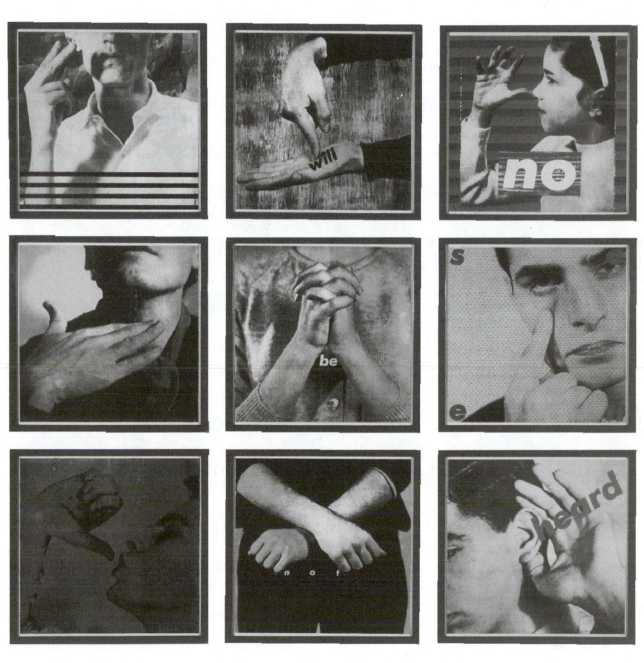

Barbara Kruger, Untitled (We will no longer be seen and not heard), 1985, Lithograph on papersupport, 9 panels, each: 520 × 520 mm.
[*Tate Gallery, London/Art Resource, New York*]

1990 *The Decade Show: Frameworks of Identity in the 1980s*; Museum of Contemporary Hispanic Art, New York

1991 *Beyond the Frame: American Art, 1960–1990*; Setagaya Art Museum, Tokyo, traveled to Museum of Art, Osaka, Japan; and Fukuoka Art Museum, Fukuoka, Japan

1993 *The Mediated Image: American Photography in the Age of Information*; University Art Museum, University of New Mexico, Albuquerque

1993 *Photoplay: Obras de The Chase Manhattan Collection*; Center for the Fine Arts, Miami, Florida, traveled to six locations in Latin America from 1993–1994

1998 *Fast-Forward Trademarks*; Kunstverein Hamburg, Hamburg, Germany

1998 *In the Flesh (Multi-media Event)*; The Living Art Museum, Reykjavik, Iceland

1998 *The Promise of Photography—The DG Bank Collection*, traveled to Hara Museum of Contemporary Art, Tokyo; Kestner-Gesellschaft, Hanover, Germany; Centre National de la Photographie, Paris; Akademie der Künste, Berlin; and Schirn Kunsthalle Frankfurt, Frankfurt, Germany

1999 *The American Century: Art & Culture 1900–2000 (Part II: 1950–2000)*; Whitney Museum of American Art, New York

Selected Works

Barbara Kruger. Exh. cat. New York: Mary Boone Gallery, 1987

Barbara Kruger. Exh. cat. Wellington, New Zealand: National Art Gallery, 1996

Barbara Kruger. Exh. cat. Melbourne, Australia: Museum of Modern Art at Heide, 1988

Barbara Kruger. Exhibition. Los Angeles: The Museum of Contemporary Art, 1999

Kruger, Barbara, and Phil Mariani, eds. *Remaking History*, Albany, CA: Bay Press, 1989

Kruger, Barbara. *Remote Control: Power, Cultures and the World of Appearances*. Cambridge, MA: MIT Press, 1993

Linker, Kate. *Love for Sale: The Words and Pictures of Barbara Kruger*. New York: Henry N. Abrams, 1990

Slices of Life: The Art of Barbara Kruger. Exhibition catalogue. Champaign, Illinois: Krannert Art Museum, 1986

We Won't Play Nature to Your Culture: Works by Barbara Kruger. Exhibition catalogue. London: Institute of Contemporary Art, 1983

Further Reading

Buchloh, Benjamin, H.D. "Allegorical Procedures: Appropriation and Montage in Contemporary Art." *Arforum* 21, no. 1 (September 1982): 43–57.

Crimp, Douglas, and Paula Marincola. *Image Scavengers: Photography*. Philadelphia: Institute of Contemporary Arts, 1982.

Deitcher, David. "Barbara Kruger: Resisting Arrest." *Artforum* xxix (February 1991): 84–92.

Floyd, Phylis. "Barbara Kruger." In *Dictionary of Women Artists (Volume 2)*, Chicago: Fitzroy Dearborn Publishers, 1997, 808–809.

"Forty Years of Aperture: A Photographic History." *Aperture* 129 (Fall 1992): 1–79.

Goodeve, Thyrza Nichols. "The Art of Public Address." *Art in America* 85, no. 11 (November 1997): 92–99.

Mitchell, W.J.T. "An Interview with Barbara Kruger." *Critical Inquiry* xvii (1991): 434–448.

Nixon, Mignon. "You Thrive on Mistaken Identity." *October*, no. 60 (1992): 58–81.

Owens, Craig. "The Discourse of Others: Feminists and Postmodernism." In *The Anti-Aesthetic: Essays on Postmodern Culture*. Edited by Hal Foster. Port Townsend, WA: Bay Press, 1983; London: Pluto Press, 1985.

Squiers, Carol. "Barbara Kruger." *Aperture* 138 (Winter 1995): 58–67.

———. "'Who Laughs Last?': The Photographs of Barbara Kruger." In *Barbara Kruger*. Los Angeles: The Museum of Contemporary Art, 1999.

GERMAINE KRULL

Dutch, born in Germany

Although she had a long career and worked in numerous genres, it was Germaine Krull's experimental photography from the 1930s that secured her reputation. Krull is counted among the most influential photographers of the classical avant-garde. Her choice of subjects was uncompromising, and her style of representation was completely new for the time—a style both ·independent and schooled. Krull's contacts in Germany, Holland, and France made her a key figure in the artistic exchange between some of the most active centers of artistic renewal, and her closeness to artists and intellectuals such as Walter Benjamin, Jean Cocteau, Florent Fels, and André Malraux also contributed to her success and fame. With the recommendation of her friend, the artist Robert Delaunay, she was the only female photographer represented at the 1926 Salon d'Automne in Paris, a

show that substantially influenced modern photography in France. Its impact can be seen in the works of Ilse Bing, Pierre Boucher, Brassaï, Henri Cartier-Bresson, René Jacques, Pierre Jahan, François Kollar, Roger Parry, Roger Schall, Maurice Tabard, and René Zuber. Krull is no less important than Alexandr Rodchenko from the USSR or Albert Renger-Patzsch from Germany.

Born in 1897, Germaine Krull came to know much of Europe because her parents moved the family so many times during her childhood. Her independent-minded father schooled her at home until her parents divorced in 1912. In 1915, she applied to enter university but was unsuccessful because she lacked a high school diploma. She then applied to a school of commercial photography in Munich that was still heavily influenced by German-American Pictorialist Frank Eugene, who had taught there until 1913. After completing her studies, she worked as a portrait photographer from her own studio. In her nudes and in photographs that she published in 1918 along with photographs by Josef Pécsi and Wanda von Debschitz-Kunowski, she followed pictorial conventions.

In the intellectual circles of Munich, Krull had close contact with liberal and left-wing thinkers. By 1919, she had become attracted to revolutionary communism in the Soviet Republic, and in 1921, she participated in the Third World Congress of the Communist International in Moscow, though she did not photograph any of the political events. In 1923, she opened a studio in Berlin with Kurt Hübschmann (alias Kurt Hutton), who matched her photographic ambitions and met her demanding standards. The two created a number of nude series over the next few years. In a sequence of lascivious photographs of nude couples from 1924 titled "Les Amies," Krull tended toward an unencumbered improvisation (although the subjects were posed) that created a distance from Pictorialism that distinguishes her later work. At this time she also began shooting street photography, though few of these photographs made their way into the press.

In 1923, she met the Dutch filmmaker Joris Ivens. In 1925, she moved with him to Amsterdam, and there she came into contact with the Dutch avant-garde movement that arose around the journal i 10. Together with Ivens, who at the time was very much under the influence of Soviet filmmaker Sergei Eisenstein, Krull tried stylistic innovations in film and photography. In 1925, this resulted in urban landscape portraits of Antwerp, Rotterdam, and Amsterdam from both a bird's-eye and a worm's-eye view. Her photographs of the docks were pioneering and one of the high points of her work.

Krull found one of her most important subjects in industrial complexes, where she photographed smokestacks, cranes, ship masts, and iron bridges. The industrial structures in these photographs often melt into confusing geometric patterns. Her photography never indulged in compositional finesse; on the contrary, her photographs seem to capture the momentary and the careless. Krull emphasizes falling lines and creates confusion by foreshortening perspective, layering the depth of certain image surfaces, focusing on obscuring details, and altering the horizon line. She captures the speed of the perpetually moving eye, similar to the way László Moholy-Nagy did at the time, but without his tendency toward constructivist abstraction. She was not interested in his theories about photography, but, like him, she sought to capture the new theme of the city in a subjective form of perception.

In 1928, she published her masterpiece, Métal. It contains photographs taken after 1923 of machines and industrial structures from various locations. In 1926, Krull moved to Paris, where she quickly made contact with progressive artists, most notably Eli Lotar in 1927, for whom she left Ivens. Critical to her increasing fame was Robert Delaunay, who exhibited her work along with his own at the Salon d'Automne in 1927. If Krull's description corresponds to actual facts (something not yet confirmed), then this was the very first avant-garde photography exhibit in France. A photo series of the Eiffel Tower that she made in 1927 was enormously successful; the images reappeared years later in illustrated books and photography anthologies. They were also integrated into Métal.

This paean of a book foregrounds the details of machinery to the point where their function as technology is unrecognizable, with double exposures obscuring them even further; she makes them appear like animated creatures. Krull's photographs are more expressive and more disturbing, and at the same time more casual, than what the Neue Sachlichkeit or "New Objectivity" of the time had to offer. Similar garish effects were prominent in Krull's works from her time in Amsterdam and Paris. Her aim was an alienation effect that was half expressionistic, half surreal, and played with light and shadow to have an impact of the fantastic on the objects photographed. In visualizing the world of machines, she put into play these effects, and out of the denaturalized world of industrial wonders there arose images filled with pathos. When she took photographs of everyday subjects, the same effects gave the objects a poetic meta-existence. Around 1930, with the same style, she photographed Parisian boulevards, arcades, and market

halls. A number of these photographs recall the work of Eugène Atget, something noted by Walter Benjamin (see his famous "Kleine Geschichte der Photographie" from 1931).

At this time Krull also worked as a successful commercial photographer. After 1926, she ran her own studio, and it supplied German magazines with dramatically illuminated fashion photography. She worked as a journalist for French newspapers, doing this without losing her interest in experimental photography, especially collages, multiple exposures, and photo montages. The portraits from her time in Paris have a vividness that results from her use of deep shadows. After 1929, street photography grew in reputation, and she toned down her style. A nude photo from 1930 emphasizes a simplicity that was more reminiscent of Edward Weston and Imogen Cunningham than of the art photography of Paris. During the 1930s, she made photo illustrations for crime novels and travel books in addition to planning a photographic novel.

After 1928, Krull's works were shown at the famous Salon de l'Escalier, where modern photography first made its breakthrough in France, and at all the important photo exhibits in the following years. One of the introductory volumes in a series about contemporary photography was dedicated to her work, and in 1931, Edward Burra wrote to a female friend that he did photography "by the Germaine Krull method" (Mellor 1978, 123–125). She already had an international reputation as a pioneer of modern photography, but war and emigration hurt her leadership role. Her ability to change styles, her aversion to theoretical reflection, and her part-time occupation with commercial photography may have contributed to her being forgotten for so long.

In any case, Germaine Krull soon gave up photography. During World War II, she was certified by the Allies as a war correspondent and she photographed in Italy, Germany, and France, publishing works in *Libération*, and *Rafale*. She also photographed as a war correspondent in Indochina, and moved to Bangkok after the war, where she opened a hotel. Living and traveling in the East from 1947 to the early 1960s, she continued to make photographs but without any special stylistic character. Her later photography from Asia goes through the same evolution as photography in both Western Europe and the United States. It shows a turn away from formalism and toward the "humanist" values of mirroring the outside world. In the early 1960s, André Malraux commissioned her to document the art memorials of Thailand and Indochina.

Late in life, before returning to Germany in 1983, she lived in northern India among Tibetan refugees, including the Dalai Lama, with whom she became close. However, she never again entered the popular consciousness with her photography. It was at Documenta 6 in Kassel, Germany, that her prewar avant-garde works were rediscovered, but a retrospective of semiabstract photographs that appeared the same year in Bonn did not have the intensity of her earlier works.

WOLFGANG BRUECKLE

See also: **Architectural Photography; Brassaï; Fashion Photography; History of Photography: Interwar Years; Modernism; Moholy-Nagy, László; Multiple Exposures and Printing; Portraiture; Renger-Patzsch, Albert; Street Photography; Tabard, Maurice; War Photography**

Biography

Born to German parents in Wilda-Poznań, Poland, November 29, 1897. Childhood in East Prussia, Italy, France, Switzerland, and Austria. Moved to Bavaria, Germany, 1912. Studied at Bayerische Staatslehranstalt für Licht-bildwesen (the Instructional and Research Institute for Photography) in Munich, 1915. Completed exams for Master's of Photography, 1917. Opened studio in Munich, ca. 1918. In the same year her first photography publication. Traveled to Berlin, Hungary, and the USSR and was arrested numerous times for her political activities for Communist groups, 1919–1922. Opened a studio in Berlin, 1923. Contact with the Dutch avant-garde, travel, and residence in Amsterdam, 1924–1925. Moved to Paris, 1926. Worked for magazines and participated in several international photo exhibits. Moved to Monte Carlo and opened a studio, 1935. Travel to Brazil, 1941. Until 1944 organized for the French liberation the photo agency of the Services d'Information de la France Combattante (Radio Brazzaville). Moved to Algeria to the Office Française d'Information Cinématographique. Participated in the invasion of southern Italy started at Naples. Continued work as a war correspondent in Ceylon, 1944. Settled in Bangkok, 1946. Became part owner and manager of the Hotel Oriental, 1947. After a short stay in Paris, moved to India, 1967. Returned to Germany, 1983. Died in Wetzlar, Germany, July 31, 1985.

Individual Exhibitions

1943 Centre de l'Information de la France Combattante, Algiers, Algeria
1967 *Germaine Krull, 1927–1967*, Musée du Cinéma, Paris, France
1968 Alliance Française, Delhi, India
1977 *Germaine Krull: Fotographien 1922–1966*, Rheinisches Landesmuseum, Bonn, Germany
1978 Galerie Agathe Gaillard, Paris, France
1980 Galerie Wilde, Cologne, Germany
 Stedelijk Museum, Amsterdam, The Netherlands

1983 Galerie Wilde at International Art Fair, Cologne, Germany

1988 *Germaine Krull: Photographie, 1924–1936*, Musées d'Arles, Rencontres Internationales de la Photographie, Arles, France

1999 *Avantgarde als Abenteuer: Leben und Werk der Photographin Germaine Krull*, Museum Folkwang, Essen, Germany, and traveling U.S. as *Germaine Krull: Photographer of Modernity*

Selected Group Exhibitions

1928 *Premier Salon Indépendant de la Photographie*, Salon de l'Escalier; Paris, France

1929 *Film und Foto: Internationale Ausstellung des Deutschen Werkbundes*; Ausstellungshallen und Königbaulichtspiele, Stuttgart, Germany

1932 *Exposition Internationale de la Photographie*, Palais des Beaux-Arts, Brussels, Belgium, traveled through Holland

1977 *Documenta 6*, Museum Fridericianum, Kassel, Germany

1978 *Paris—Berlin, 1900–1933: Rapports et contrastes France—Allemagne*, Centre National d'Art et de Culture Georges Pompidou, Paris, France

1979 *Film und Foto der 20er Jahre*, Württembergischer Kunstverein, Stuttgart, Germany, traveled through Germany and to Zurich, Switzerland

1982 *Lichtbildnisse: Das Porträt in der Fotografie*, Rheinisches Landesmuseum, Bonn, Germany

1983 *A propos du corps et de son image*, Centre Culturel, Bretigny, France

1985 *Das Aktfoto: Ansichten vom Körper im fotografischen Zeitalter*, Fotomuseum im Stadtmuseum, Munich, Germany

1986 *Shots of Style*, Victoria and Albert Museum, London, England, traveled through Great Britain

1991 *Le Pont transbordeur et la vision moderniste*, Marseille, France

1994 *Photographische Perspektiven aus den Zwanziger Jahren*, Museum für Kunst und Gewerbe, Hamburg, Germany
 Fotografieren hieß teilnehmen: Fotografinnen der Weimarer Republik, Museum Folkwang, Essen, Germany

1998 *Les Femmes photographes*, Hotel Sully, Paris

Selected Works

Jean Cocteau, 1925
Pont Transbordeur, Marseille, 1926
Métal, 1927 (book)
Eiffel Tower, 1928
Gabon, Porter, 1943

Further Reading

Auclair, Marcell. "Tour Eiffel, soeur aînée des avions." *L'Art vivant*, Oct. 1, 1928.

Boelema, Ida. "'La Vie mène la danse': De vroege jaren van Germaine Krulls volgens haar memoires." *Jong Holland* 3 (1995).

Bouqueret, Christian. *Germaine Krull: Photographie, 1924–1936*. Arles: Musée Réattu, 1988.

Gallotti, Jean. "La Photographie est-elle un art? Germaine Krull." *L'Art vivant*, July 1, 1929; repr. in Baqué, *Les documents de la modernité*.

Herz, Rudolf and Dirk Halfbrodth. "Germaine Krull." In *Revolution und Fotografie: München 1918–1919*, Berlin: Nishen, 1988.

Honnef, Klaus. *Germaine Krull: Fotografien, 1922–1966*. Bonn: Rudolf Habelt Verlag, Rheinisches Landesmuseum, 1977.

Langlois, Henri. *Germaine Krull*. Paris: Cinémathèque Française, 1967.

MacOrlan, Pierre. *Photographes nouveaux, Germaine Krull*. Paris: Gallimard, 1931 (with reprintings of contemporary reviews and essays).

Mellor, David. "London—Berlin—London: A Cultural History: The Reception and Influence of the New German Photography in Britain, 1927–1931." In *Germany, the New Photography, 1927–1933: Documents and Essays*. Edited by David Mellor, London, 1978, 123–125.

Saunier, Charles. "Le Métal: Inspirateur d'art." *L'Art vivant* May 1, 1929.

Sichel, Kim. *Germaine Krull, Photographer of Modernity* Cambridge, MA: MIT Press, 1999, as *Avantgarde als Abenteuer: Leben und Werk der Photographin Germaine Krull*, Munich: Schirmer/Mosel, 1999.

L

DOROTHEA LANGE

American

One of the twentieth century's best-known photographers, Dorothea Lange was devoted to illustrating the human condition, creating one of the most widely-reproduced and studied images in photography, *Migrant Mother* of 1936. Although best-known for her work with the Depression-era Farm Security Administration, Lange's passion for her photography and her subject matter lasted throughout her career.

Born Dorothea Nutzhorn in 1895 in Hoboken, New Jersey (she later took her mother's maiden name), young Dorothea knew she wanted to be a photographer. At age seven she contracted polio, leaving her with a lifelong limp, which she felt marked her life—enabling her to understand what it was like to be an outsider. During her teenage years, Lange attended a public school in New York City and spent much of her time observing the everyday life around her. After high school, while studying to be a teacher, Lange announced that she wanted to become a photographer and embarked on a self-apprenticeship.

She eventually worked as an assistant in several portrait studios, notably that of Arnold Genthe, and befriended many photographers who helped her to learn the technical aspects of photography. In 1917, she studied with Clarence White, the well known Photo-Secessionist, at Columbia University. A year later, after travels and with few resources, Lange found herself in San Francisco. Here she met artist Roi Partridge and his wife, photographer Imogen Cunningham, who would remain lifelong friends (and whose son Rondal Partridge would later become her apprentice). Shortly thereafter she opened a portrait studio (1919) and was soon established as a prominent portrait photographer, her aesthetic sense having been influenced both by Genthe and White. Lange married painter Maynard Dixon in 1920 (whom she would divorce in 1935).

Lange remained a portraitist for the first 15 years of her career; her clients were mainly from the industrial and commercial worlds. Her pictures were often done with a soft focus and were frequently side profiles or taken at untraditional angles with natural lighting such as in *Harry St John Dixon, 1922* or *Dorothy Wetmore Gerrity, 1920*.

Although she was a sought after portraitist, Lange changed her photographic subjects after the stock market crash in 1929 and the ensuing Great Depression. Lange was compelled by the social crisis to document what was going on, and she took to the streets to photograph the people around her and their reactions to the economic decline. This change of direction was significant and she, from this point on, dedicated herself to photographing the trou-

bling conditions of the dispossessed. One of Lange's first images of this unrest is a photograph of a breadline near her studio, which became one of her most famous images, *White Angel Breadline, 1933*. The unshaven man with his hands clenched in front of him, leaning against a wooden railing, his back to the crowd waiting for his ration of food, creates an overwhelming sense of isolation, a feeling that will be omnipresent in Lange's images to come. Lange's images begin to shift from her portraiture technique, in which the individual is taken out of their context, to a style that focuses on the relationship between the subject and their environment such as *Dust Bowl Refugees Arrive in California, 1936*.

Lange continued to photograph the social turmoil of the Great Depression in the streets near her portrait studio while she received her first exhibition in 1934 at Willard Van Dyke's Brockhurst Gallery in Oakland, California. Lange had made portraits of Van Dyke and his colleagues Ansel Adams and Edward Weston all of whom were associated with the Group f/64, a group of West Coast photographers. Although Lange did not join the group, she was in contact with several members.

At this first showing of her work, Lange's photographs were noticed by Paul Schuster Taylor, an economics professor at Berkeley. He asked her to take photographs for his articles dealing with social research and reform. Lange and Taylor collaborated and together began their mission to publicize the plight of thousands of Americans for the California Emergency Relief Administration. Their initial work resulted in field reports made up of Taylor's interviews with workers, Lange's photo essays and Taylor's analysis depicting the frightening reality of the migrant agricultural workers in California. Taylor's sociological approach to their subjects would have an important influence on Lange's developing style of photography as well as the thinking of Roy Stryker at the FSA.

After photographing the conditions of migrant workers in the Imperial Valley, Lange wrote to Stryker,

> ...what goes on in the Imperial is beyond belief. The Imperial Valley has a social structure all its own and partly because of its isolation in the state those in control get away with it. But this year's freeze practically wiped out the crop and what it didn't kill is delayed—in the meanwhile, because of the warm, no rain climate and possibilities for work the region is swamped with homeless moving families.

Taylor and Lange were married in 1935 and continued their professional partnership until Lange's death in 1965.

In 1935, Lange was hired by Roy Stryker of the Resettlement Administration's Photographic Division, which would become the Farm Securities Administration (FSA) in 1937. Part of Roosevelt's New Deal, this governmental operation developed programs intended to help impoverished farmers. The FSA hired photographers to document rural America and Lange, along with Walker Evans, Ben Shahn, Carl Mydans, Russell Lee, and others, became part of this project to show America at work and document the deteriorating social situation. Today, these photographs hold an important place in the history of documentary photography representing a pervasive public state of misery. The FSA images carry on a documentary tradition begun by Jacob Riis and Lewis Hine around the turn of the twentieth century, but add a new dimension to documentary photography in the intimacy of the portraits, which is most notable in the work of Lange.

Lange threw herself into her work with the FSA, as she did with all her endeavors, and began traveling and surveying the countryside to document rural poverty. Lange also became a social observer of the migrating farmer population. She interviewed her subjects and took extensive notes, as Taylor had done on their projects together, creating a context for her images. Lange continued to work for the FSA on and off until 1940, despite her sometimes difficult relationship with Stryker and the budgetary problems within the administration. Conflict with Stryker was frequently linked to the fact that she did not have any control over her images once the negatives were sent to Washington.

Many of the images from Lange's FSA period have become icons of the Great Depression and the state of despair of the American people at the time. Her compassionate portraits of poverty stricken people such as *Migrant Worker in San Joaquin Valley, California, 1936*, *Migrant Workers in Rural California, 1938*, and *Migrant Cotton Picker, Eloy, Arizona 1940* convey the desolation of rural America. Her intimate and powerful portraits of women alone or with children have become symbols in American pictorial history: *Mother and Child, Yakima Valley, Washington, 1939*, *Woman in High Plains, Texas Panhandle, 1938*, *Mother and Children on the Road, Tulelake, Siskiyou County, California, 1939* and of course, the most famous *Migrant Mother, 1936*. Lange's great skill was her ability to engage her subjects; this engagement along with her frequent use of close ups evoke compassion from the viewer.

In her photograph, *Hoe Culture, Alabama, 1936*, Lange focuses on the hands and torso of her subject,

reminiscent of the modernist technique of using a part to represent the whole. In *Heading Towards Los Angeles, California, 1937,* Lange photographs two men walking on a desolate road. Lange shows the injustices of society by framing her image with these men to the left of the picture and a billboard advertisement to the right that shows an image of a man reclined in a chair accompanied by, "Next Time, Try the Train, RELAX, Southern Pacific." This ironic juxtaposition using figures and text powerfully depicts the misfortune of the people she saw around her.

Lange and Taylor eventually published many of these images in 1939 in a book titled, *An American Exodus: A Record of Human Erosion.* This project was intended by Lange and Taylor to be a document—a photographic and textual representation—conveying the underlying causes of the rural poverty. According to Henry Mayer in *The Making of a Documentary Book*

> While public opinion sought causes of this shift in the misfortunes of nature—drought and dust storms—the authors of *An American Exodus* passionately insisted that deeper causes lay in a moral callousness about the social effects of mechanization and in political indifference to the poor and the voiceless.
>
> (p. i)

After working for the FSA, Lange, who believed in the social and political importance of her photographs, began working for the Bureau of Agricultural Economics. Shortly thereafter, in 1941, Lange was the first woman to be awarded a John Simon Guggenheim fellowship.

The following year, Lange worked for the War Relocation Authority, the government agency responsible for forcing 110,000 Japanese Americans into internment camps after the bombing of Pearl Harbor. She and Ansel Adams both took many pictures of the internment camp in Manzanar, California. Lange's sensitive representations of the people at the camps confirm her conviction against this government program; her powerful images of displaced children such as *Japanese American Children, Hayward, California, 1942* and *Pledge of Allegiance, San Francisco, California, 1942* communicate her disapproval of the project.

Lange later photographed for the Office of War Information and was assigned to report on the minority groups on the West Coast. She again collaborated with Ansel Adams on recording the wartime expansion of the "boom-town" of Richmond, California, as military vessel construction filled their shipyards.

During the postwar period, Lange suffered from health problems that kept her from photographing on a regular basis for several years. When she was able to work again, she did a photo essay with Adams on the Mormons for *Life* magazine, and *Life* then sent her to Ireland to do a story titled, *Irish Country People.*

In 1953 and 1954, Lange participated actively in the preparation of the *The Family of Man* exhibition, held at the Museum of Modern Art (MoMA) in 1955 and which subsequently traveled extensively around the world. During this time, she advised and exchanged ideas about the exhibition with Edward Steichen, with whom she had a long lasting and close friendship. Ultimately, eight of Lange's images were included in this seminal exhibition.

At this time Lange also worked on a story for *Life* magazine on the daily life of a public defender in Oakland. Lange focused on the faces, expressions, and gestures of the public defender as well as all those in the courthouse such as in *The Witness, Public Defender, Oakland, California, 1955–1957. Life* did not end up publishing the story but it was published by newspaper supplement *This Week* in 1960.

In the 1950s Lange began to take more and more photographs of her own family. She also accompanied Taylor, who had become an economic consultant for rural questions in developing countries, on various assignments. They traveled to Asia, South America, and Egypt where Lange continued to photograph, emphasizing the features and gestures of her subjects. Lange's close up portraits are direct and honest, a style that dates back to her FSA days, such as the portrait, *Palestinian, 1958.*

In 1962, many of Lange's FSA images were shown in Steichen's exhibition at the MoMA, *The Bitter Years.* In 1965, one of her last projects was a book of many of her images of women titled, *The American Country Woman,* a book intended to show the courage and purpose of many of her subjects.

In 1964 and 1965, Lange was involved in selecting works from her entire career, without limiting the photographs to her well known Depression-era images for the retrospective at MoMA, which appeared in 1966. Lange died of cancer on October 11, 1965, weeks after choosing the last images for her retrospective. Her images have been exhibited and published worldwide and her archives, including negatives, prints, books, letters, contact sheets, and notes are held at the Oakland Museum of Art in California.

KRISTEN GRESH

See also: **Adams, Ansel; Cunningham, Imogen; Documentary Photography; Evans, Walker; Farm Security Administration; Group f/64; Hine, Lewis; Lee, Russell; Life Magazine; Museum of Modern Art; Office of**

War Information; Shahn, Ben; Steichen, Edward; Stryker, Roy; Weston, Edward; White, Clarence

Biography

Born in Hoboken, New Jersey, 26 May 1895. Attended Training School for Teachers, New York, 1914–1917; assistant in different photography studios such as Arnold Genthe, 1912–1917; studied at Clarence White School, Columbia University, New York, 1917. Opened portrait studio, San Francisco, 1919; portrait photographer, San Francisco, 1919–1934; 1934–1935; became associated with economist Paul Schuster Taylor working on plight of migrant agricultural workers; married 1935. Farm Security Administration photographer (known as Resettlement Administration until 1937) under Roy Stryker, San Francisco, 1935–1939; publication of *American Exodus* with Paul Taylor, 1939; photographer for United States Bureau of Agricultural Economics, 1940; photographer for U.S. War Relocation Agency, San Francisco, 1942; Office of War Information, 1943–1945; freelance photography for *Life* and other magazines, 1953–1957; instructor of photography at California School of Fine Arts, 1957–1958; freelance photographer, Asia, South America, Middle East, 1958–1962. Guggenheim Foundation Grant, 1941. Died in Marin County, California, 11 October 1965.

Individual Exhibitions

1934 Brockhurst Photography Gallery; Oakland, California
1960 *Death of a Valley*; San Francisco Museum of Art, San Francisco, California and traveling
1961 Bibliotheca Communale; Milan, Italy
1966 *Dorothea Lange Retrospective*; Museum of Modern Art, New York, New York and traveling
1967 *Dorothea Lange*; Amon Carter Museum, Fort Worth, Texas
1971 Oakland Art Museum; Oakland, California
1973 Victoria and Albert Museum; London, England
1978 Oakland Art Museum; Oakland, California
1998 *Dorothea Lange*; Patrimoine Photographique, Hôtel de Sully, Paris, France
2002 *About Life: The Photographs of Dorothea Lange*; J. Paul Getty Museum, Los Angeles, California

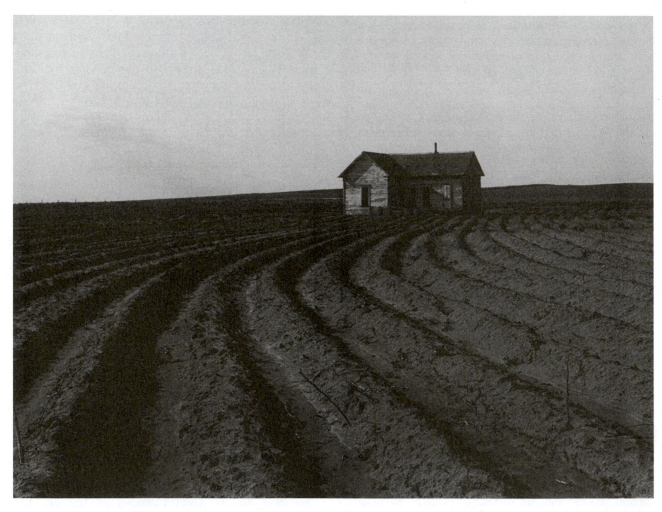

Dorothea Lange, Tractored Out, Childress County, Texas, 1938, Gelatin-silver print, 14¹³⁄₁₆ × 20¾″.
[*Digital Image © The Museum of Modern Art/Licensed by SCALA/Art Resource, New York*]

Group Exhibitions

1955 *The Family of Man*; Museum of Modern Art, New York, New York, and traveling
1962 *The Bitter Years: Farm Security Administration Photographs 1935–1941*; Museum of Modern Art, New York, New York, and traveling
1979 *Executive Order 9066*; Whitney Museum of Art, New York, New York, and traveling
1979 *Photographie als Kunst 1879–1979/Kunst als Photographie 1949–1979*; Tiroler Landesmuseum Ferdinandeum, Innsbruck, Germany, and traveling
1980 *Amerika: Traum und Depression 1920–1940*; Kunstverein, Hamburg, Germany, and traveling
1995 *Women Come to the Front: Journalists, Photographers and Broadcasters During World War II*; Library of Congress, Washington, D.C.
1996 *Points of Entry: A Nation of Strangers, Reframing America, and Tracing Cultures*; Jewish Museum, New York, New York
2000 *Visualizing the Blues: Images of the American South*; Ogden Museum of Southern Art, New Orleans, Louisiana

Selected Works

Dorothy Wetmore Gerrity, 1920
Harry St John Dixon, 1922
White Angel Breadline, 1933
Dust Bowl Refugees Arrive in California, 1936
Hoe Culture, Alabama, 1936
Migrant Worker in San Joaquin Valley, California, 1936
Migrant Mother, 1936
Migrant Workers in Rural California, 1938
Woman in High Plains, Texas Panhandle, 1938
Mother and Child, Yakima Valley, Washington, 1939
Mother and Children on the Road, Tulelake, Siskiyou County, California, 1939
Heading Towards Los Angeles, California, 1937
Migrant Cotton Picker, Eloy, Arizona, 1940
Japanese American Children, Hayward, California, 1942

Pledge of Allegiance, San Francisco, California, 1942
The Witness, Public Defender, Oakland, California, 1955–1957
Palestinian, 1958

Further Reading

Bezner, Lili Corbus. *Photography and Politics in America—From the New Deal into the Cold War*. Baltimore and London: The John Hopkins University Press, 1999.
Borhan, Pierre, ed. *Dorothea Lange: The Heart and Mind of a Photographer*. Boston: Bulfinch Press, 2002; and *Dorothea Lange: Le Coeur et les raisons d'une photographe*. Paris: Editions de Seuil, 2002.
Coles, Robert, and Heyman, Therese. *Dorothea Lange: Photographs of a Lifetime*. New York: Aperture Foundation, 1982.
Heyman, Therese Thau, ed. *Celebrating a Collection: The Work of Dorothea Lange*. Oakland: Oakland Museum of Art, 1978.
Heyman, Therese Thau, Sandra Phillips, and John Szarkowski. *Dorothea Lange: American Photographs*. San Francisco: San Francisco Museum of Modern Art/Chronicle Books, 1994.
Hurley, F. Jack. "The Farm Security Administration File: In and Out of Focus." *History of Photography* 17, no. 3 (1993).
Lange, Dorothea and Paul Taylor. *An American Exodus: A Record of Human Erosion*. New York: Reynal and Hitchcock, 1939. New edition, by Sam Stourdzé, Paris: Editions Jean-Michel Place, 1999.
Levin, Howard and Katherine Northrup, eds. *Dorothea Lange: Farm Security Administration Photographs, 1935–1939*. Glencoe: The Text-Fiche Press, 1980.
Meltzer, Milton. *Dorothea Lange: Life through a Camera*. New York: Puffin Viking Penguin, 1985.
Meltzer, Milton. *Dorothea Lange: A Photographer's Life*. New York: Farrar/Straux/Giroux, 1978.
Ohrn, Karin Becker. *Dorothea Lange and the Documentary Tradition*. Baton Rouge: Louisiana State University Press, 1980.
Partridge, Elizabeth, ed. *Dorothea Lange: A Visual Life*. Washington and London: Smithsonian Institution Press, 1994.

JACQUES HENRI LARTIGUE

French

In 1963, after almost 60 years of taking photographs daily and pasting the images into albums, Jacques Lartigue publicly exhibited his personal photographs in New York at the Museum of Modern Art (MoMA). At the same time, he changed his name to Jacques Henri Lartigue. A meeting in 1962 with John Szarkowski, the Director of the Department of Photography at the MoMA, meant that Lartigue was to become one of the most well-known and admired amateur photographers in the later twentieth century. Lartigue was born in Courbevoie into one of France's wealthiest families in 1894. He began photographing at age six using his father's camera, and received his own in 1902. Lartigue recorded the world around him in great detail, both in photographs and in corresponding diaries. The wealth and connections of his family meant that from a young age Lartigue was granted access to some of the most important people and events of the time, and his photographs have become valued

as the representation of the end of France's *belle époque*. Lartigue's photographs, while taken to preserve his memories, now function as documents that record an era rather than simply a life.

Most of Lartigue's early photographs record events and people at his home. Lartigue's first photograph is a fairly typical family portrait that he took on a 13 × 18-cm plate camera in 1902. His aunt, uncle, and cousin stand at the left of the group, and his parents along with his brother Maurice (Zissou) and another child named Marcelle, who holds a kitten, stand at the right of the group. His aunt leans forward to steady his cousin who sits on a tricycle. The photograph was taken outdoors and the windows of the family home are visible behind the people. Although he was to take many photographs of the people close to him, this is one of the few straight portraits that Lartigue took. Many of his pictures of people capture them in less typical poses, often in movement.

Lartigue's father continued to give his son new cameras and by 1904 he was able to take snapshots with his Gaumont Block Notes camera. The faster shutter speed of this camera allowed Lartigue to capture movement. Movement seemed to appear everywhere in the Lartigue household. He photographed his nanny, Dudu, throwing a ball into the air, and Zizi, his cat, leaping into the air for a toy. In another photograph, a family member hurls a cushion out of a second-story window. Siblings, cousins, and even adults appear engaged in playful action. These action photographs are significant, for they demonstrate a young boy's extraordinary ability to anticipate and capture a moment. In one particularly remarkable photograph, *My Cousin Bichonnade, Paris*, 1905, Lartigue captured his cousin running down an outdoor staircase. She makes her hands into fists and raises them to chest level. Her left knee juts forward and both her feet, which have left the ground, are almost hidden by her long skirt. It appears as if Bichonnade is flying. The notation in the album below the photograph reads "Photo taken with Spido-Gaumont 6 × 13″ (Lartigue, Album 1905, folio 44 recto, reproduced in Centre Pompidou, *Jacques Henri Lartigue, L'Album d'une vie/A Life's Diary*, n.p.).

Flight was one of Lartigue's obsessions. In 1906 he wrote in his diary: "There's one thing all of us want to do...it's an idea we all dream and talk about...to get up into the air! In my sleep I can fly...I fly all the time. I can't get enough of it. But once awake, I'm a little boy again" (Diary, Rouzat, 1906; quoted in *Diary of a Century*). Lartigue spent much time recording some of the first flights and flight-related experiments in France. There are photographs of the family constructing his brother's glider, as well as balloon races in the Tuileries gardens, and an image of a small Zissou, dwarfed by the huge "Colonel Renard" dirigible. Lartigue watched and photographed many of the early airplane experiments that were conducted at the Issy-les-Moulineaux airfield. The names of significant figures in the history of French aviation appear in his diary and in the captions below his photographs: Gabriel Voisin, Amérigo, Léon Delagrange. Not only do these photographs record some of the first airplanes, they are also beautiful compositions that express a young man's fascination with flight at a time when it still seemed unreal. *Mathieu in a Farman, Issy-les-Moulineaux, January 1911* shows a flat, almost empty airfield. At the very top of the frame a plane floats, sideways, its silhouette like an eagle. It hangs there as if by magic. In the lower half of the frame we see a couple walking their baby in a pram, and all three turn their heads to watch a biplane leave the ground. In *Audemars in a Blériot aeroplane, Vichy, September 1912*, a sea of hats tilts upwards to watch a small, primitive-looking plane that swoops in from just above the tops of the trees. By taking the photograph from within the crowd, Lartigue captured the sense of wonder and excitement that must have come with these early flights.

The young Lartigue was also captivated by another invention of the era—the automobile. In addition to the many family photographs depicting his father's cars, or family members dressed in riding outfits, Lartigue also photographed automobile races. As with the photographs of family members playing around his home, Lartigue focused on capturing movement. Here, at the races, the challenge was to capture speed. Lartigue did this remarkably well in his most well-known photograph *Delage Automobile, A.C.F. Grand Prix, Dieppe Circuit, June 26, 1912*. A car races so fast out of the picture frame that its wheels become distorted ovals. The onlookers appear to lean in the other direction, expressing tension between the speed of the car and the immobility of the people. Everything in the image is blurred except the body of the car and its driver and passenger. While many of Lartigue's other images capture the excitement of the races by showing the track, the crowd, and groups of cars, none captures speed so perfectly.

In addition to depicting the inventions of the early twentieth century, Lartigue also photographed the fashion of that period. In a series of photographs taken in 1911 and 1912 on the fashionable, bourgeois streets of Paris—Avenue de Bois de Boulogne and the Avenue des Acacias—Lartigue caught the image of society's *élégantes*. The women are dressed

in remarkably elaborate clothing: a long fur jacket with silk tassels; hats shaped like dirigibles, festooned with feathers; piles of ermine wrapped around shoulders and hands, trailing down over a velvet embroidered and fur-trimmed skirt; lace collars, sleeves, and bodices. While some of the women look at the camera, many turn their heads trying to avoid the camera's gaze. Indeed several of the women appear unaware that Lartigue photographs them. Some are photographed from behind, lending the images a voyeuristic quality. When the women do realize they are being photographed, the expressions on their faces range from suspicion and dismay to coy haughtiness. In 1910, the 16-year-old Lartigue wrote in his diary about taking photographs of Paris's fashionable women:

> *She*: the well-dressed, fashionable, eccentric, elegant, ridiculous, or beautiful woman I'm waiting for. You can spot her from far away, in the midst of all the other people, just as you can immediately spot a golden pheasant when it's surrounded by chickens...My camera makes such a noise that the lady jumps...almost as much as I do. That doesn't matter, except when she is in the company of a big man who is furious and starts to scold me as if I were a naughty child. That really makes me very angry, but I try to smile. The pleasure of having taken another photograph makes up for everything! The gentleman I will forget. The picture I will keep.

(Diary, Paris, 29 May 1911, quoted in *Diary of a Century*)

The hunting references are clear. For Lartigue, photographing was a kind of sport that enabled him to capture a moment or a person and preserve it for himself.

Photographing women was something Lartigue continued to do for the rest of his life. In 1919, he married Madeleine (Bibi) Messager, the daughter of composer and Opéra director André Messager. On their honeymoon, Lartigue made some of his most intimate images. In one photograph, *Honeymoon at the Hôtel des Alpes, Bibi and Me in the Mirror's Reflection, Chamonix, January 1920*, the camera looks through an open door at Bibi sitting in the tub. To the left of the door, Lartigue's image is reflected in a mirror above an armoire. At the right of the frame the couple's clothes hang on a clothes stand and newspapers are scattered across a table. It is a domestic scene that is both happy and poignant, for Lartigue is only present in his reflection. This is a telling photograph of a man who described himself as distant and self-absorbed. Lartigue photographed all three of his wives as well as actresses, friends, models, and lovers.

Despite his passion for photography, Lartigue earned his living as painter. By 1922, he was exhibiting his paintings at the Galerie Georges Petit in Paris, and by the mid-1930s he was well known as an artist. He also worked as a consultant on several films and as an interior decorator. Lartigue's profile in the art world along with his privileged status as a member of a bourgeois family meant that he was able to photograph several famous artists and performers. In the 1920s he made a series of photographs of women, including performers Josephine Baker and Gaby Basset, entitled *Portraits with Cigarettes*. He was friends with the artist Van Dongen and photographed him many times over the years. He photographed Picasso in his studio in 1955. These images, however, are not typical portraits. One photograph of Picasso, for example, shows the artist from behind, dressed only in a pair of shorts, closing the door to his studio in Cannes. It is not a heroic portrait. Two pages from one of Lartigue's albums from 1955 show the hands of both Picasso and of Jean Cocteau. Picasso wears the same shorts as in the picture of his studio, but here we see only the top of his leg, the bottom of his shorts and one hand resting prone against his leg. By contrast, the photograph of Cocteau shows the torso of a man in a suit, his hand animated, gesturing, while another hand in movement, belonging perhaps to the photographer, obscures most of his face.

After Szarkowski "discovered" Lartigue, he became known as a photographer. That same year his photographs were featured in an issue of *Life* magazine and eight years later, in 1970, Richard Avedon edited a book entitled *Diary of a Century* that presented many of Lartigue's photographs along with corresponding diary entries. It was only at this late stage in his life, after photographing daily from the age of six, that Lartigue worked as a photographer. He worked on several magazine commissions and, in 1974, Valéry Giscard d'Estaing, president of France, asked Lartigue to take his official photograph. When Lartigue replied that he was not an official photographer, d'Estaing stated that was why he wanted Lartigue to take his portrait.

When Lartigue was in his 80s, he donated his photographic collection—his 130 albums, all his negatives, cameras, and diaries—to the nation of France. Since then, the Donation Jacques Henri Lartigue has mounted many traveling exhibitions, which have made his photographs even more popular. While the popularity is due in part to the subject matter and the photographs' status as records of early twentieth century life, it also reflects Lartigue's uncanny ability to capture an image at the best possible moment and to seemingly preserve it forever.

LINDA M. STEER

907

LARTIGUE, JACQUES HENRI

See also: **Family Photography; Life Magazine; Museum of Modern Art; Photography in France; Szarkowski, John**

Biography

Born in Courbevoie, France, 13 June 1894. Received first camera in 1902. Amateur photographer for most of his life. Trained as a painter at the Académie Julian in Paris in 1915. First solo photography exhibition at the Museum of Modern Art in New York in 1963. Died in Nice, France 13 September 1986.

Individual Exhibitions

1963 *The Photographs of Jacques Henri Lartigue*; Museum of Modern Art, New York, New York
1966 Photokina; Cologne, Germany
1971 Photographers' Gallery; London, England, and traveled to Open University, Bucks; Graves Art Gallery, Sheffield; Art Center, Nottingham; Plymouth Art Center, Devon; City Museum, Bristol; Central School of Arts, London; Oldham Art Gallery, Lancashire; Liverpool Polytechnic, Liverpool; Darlington Hall Arts Center; Marseille; Le Havre; Museum für Kunst und Gewerke, Hamburg, Germany

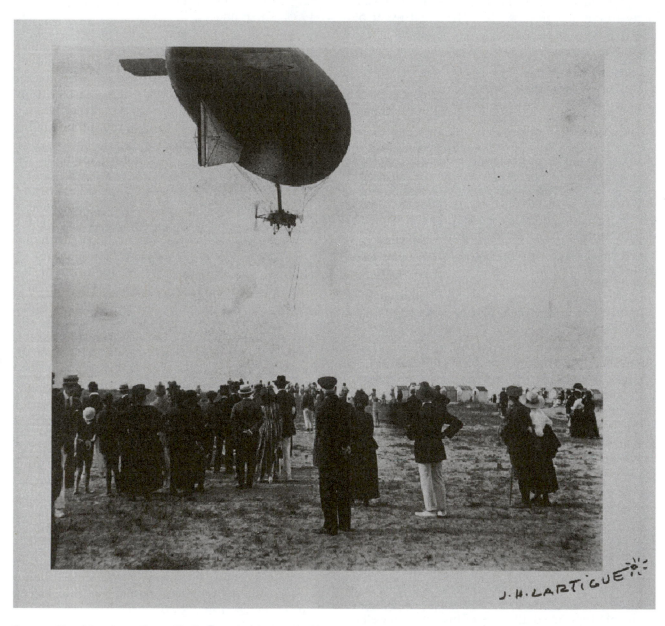

Jacques Henri Lartigue, Deauville (ballon airship), 1919, Photo: H. Lewandowski.
[*Réunion des Musées Nationaux/Art Resource, New York*]

1975 *Lartigue 8x80*; Musée des Arts Décoratifs de Paris, Paris, France

1980 *Bonjour Monsieur Lartigue*; Galeries Nationales of the Grand Palais, Paris, France, and traveling

1981 *Vingt années de découverte à travers l'oeuvre de Jacques Henri Lartigue*; Grand Palais des Champs-Elysées, Paris, France

1982 *Bonjour Monsieur Lartigue*; International Center of Photography, New York, New York, and traveled to 14 locations across the United States

1984 *Le passé compose*; Musée Réatu, Arles, Grand Palais de Champs-Elysées, Paris, France, and traveling world-wide

1990 *Volare*; Galerie Eralov, Rome, Italy

1994 *Lartigue Centenary*; The Photographers' Gallery, London, England

 Lartigue a cent ans; Rencontres Internationales de la Photographie, Arles, France

1995 *Rétrospective d'un amateur de genie*; Bunkamura Museum of Art—Shibuya, Tokyo, Japan

2003 *Jacques Henri Lartigue, L'Album d'une vie*; Centre Georges Pompidou, Paris, France

Group Exhibitions

1955 *"Gens d'Images" exhibition*; Galerie d'Orsay, Paris, France

1956 Galerie d'Orsay; Paris, France

1971 *Récents enrichissements des collections photogrpahiques du Cabinet des Estampes*; Bibliothèque nationale de France, Paris, France

1973 *Friends of Photography*; Carmel, California

1975 *The Land: 20th Century landscape, photographs selected by Bill Brandt*; Victoria and Albert Museum, London, England

Selected Works

My First Photograph, 1902
My Nanny Dudu, Paris, 1904

My Cat Zizi, Paris, 1904

In My Bedroom, Collection of My Racecars, Paris, 40 rue Cortambert, 1905

My Cousin Bichonnade, Paris, 1905

Zissou Dressed as a Ghost, Villa "Les Marronniers," Châtelguyon, July 1905

Avenue du Bois de Boulogne, Paris, 1911

Mathieu in a Farman, Issy-les-Moulineaux, January 1911

Audemars in a Blériot Aeroplane, Vichy, September 1912

Delage Automobile, A.C.F. Grand Prix, Dieppe Circuit, June 26, 1912

Honeymoon at the Hôtel des Alpes, Bibi and Me in the Mirror's Reflection, Chamonix, January 1920

Bibi, Marseille, October 1928

Renée, Paris, 1931

Hand of Picasso, 1955

Hand of Jean Cocteau, 1955

Official Photograph of President Valéry Giscard d'Estaing, 1974

Further Reading

Borhan, Pierre, and Martine D'astier. *Les Envols de Jacques Lartigue et les débuts de l'aviation*. Paris: Association des Amis de Jacques Henri Lartigue, 1989.

Centre Pompidou. *Jacques Henri Lartigue, L'Album d'une vie/A Life's Diary*. Paris: Centre Pompidou, 2003.

Lartigue, Jacques Henri. *Diary of a Century*. Edited by Richard Avedon. New York: Viking Press, 1970.

———. *Jacques Henri Lartigue, Photographer*. London: Thames and Hudson, 1998.

———. *Lartigue: Album of a Century*. Edited by Martine D'Astier, Quentin Bajac, and Alain Sayag, translated by David Wharry. New York: Harry N. Abrams, 2003.

———. *Mémoires sans Mémoire*. Paris: Editions Robert Laffonte, 1975.

———. *L'Oeil de la mémoire: 1932–1985*, Paris: Carrère, 1985.

PHOTOGRAPHY IN LATIN AMERICA: AN OVERVIEW

The history of photography in Latin America is rich and diverse. The work of Latin American photographers often reflects the key historical, social, political, and aesthetic forces at work in the region. A variety of people and groups brought the photographic medium to Latin America in the nineteenth century: foreign invaders, such as the French forces seeking to place Maximillian on the throne in Mexico; amateur artists looking for inspiration, such as Adela Breton; settlers searching for a way to earn a living, such as the German Guillermo Kahlo, the father of the renowned artist Frida Kahlo; and numerous foreign companies seeking profits and needing to illustrate their operations to investors.

During the nineteenth century, Latin American photography more closely followed artistic and journalistic trends from outside the region. European institutions, audiences, and aesthetics played significant roles in this early Latin American photography. However, by the early twentieth century,

909

Latin American photography became more complex and syncretic. It often portrayed the many problems and contradictions of societies that combined indigenous, colonial, and modern industrial elements.

In the early twentieth century, documentary photography grew in importance in Latin America. Already by the late nineteenth century, Latin Americans had become increasingly interested in visual records of contemporary events, as was seen, for example, in the many combat photographers who recorded the region's conflicts. Documentary photography became more widespread as travel became easier with construction of roads and rail lines. Also, the appearance of illustrated periodicals such as *Caras y Caretas* in Argentina and *El Cojo Ilustrado* in Venezuela created more demand for photographs.

The beginnings of documentary photography can perhaps best be seen in Mexico and Brazil during the late nineteenth century. In Mexico, documentary photography prospered under the dictatorship of Porfirio Díaz. This photographic style suited the needs of the dictatorship, showing off public works, parades, and orderly citizens, all in line with the positivism of the era. In Brazil, Marc Ferrez, the best-known nineteenth-century Latin American photographer, recorded economic development and modernization starting in the 1860s and continuing into the early twentieth century.

It was during the period of the Mexican Revolution that began in 1910 when documentary photography matured in Mexico. The best example of an early Mexican photojournalist is Agustín Victor Casasola, who left an archive of more than 600,000 plates. He photographed some of the key revolutionary leaders such as Emiliano Zapata and Pancho Villa. Casasola, who sometimes traveled with troops, showed the human side of the conflict and focused on the life of ordinary soldiers. He often photographed women, both soldiers and those accompanying the men. Casasola's photographs also demonstrated the horrors of war, as seen in his images of executions. His work shows how photography can be used to aid in the construction of political history and national identity.

The early twentieth-century also saw the flourishing of portraiture in Latin America, a trend that began in the late-nineteenth century and was part of a world-wide phenomenon. These early portraits often depicted members of a new urban society that was growing in size, power, and wealth. This trend can be seen in the work of photographers such as Melitón Rodríguez and Benjamín de la Calle in Colombia, Alejandro Witcomb in Argentina, Romualdo García in Mexico, and Eugene Courret in Peru.

As might be expected in a region in which Catholicism predominates, many early Latin American photographers used their medium to examine the place of the Catholic Church. Among the most notable early examples is the work of Juan José de Jesús Yas, who was born in Japan, moved to Guatemala in 1877, and converted to Catholicism. Starting in the 1880s and continuing until the second decade of the twentieth century, he frequently photographed the clergy, churches, and ritual objects. Missionaries in the remote parts of Latin America also used photography to document and legitimate a European presence among indigenous populations. Missionaries used their cameras to record the lives, rituals, and cultures of native inhabitants and the transformations that took place with the arrival of so-called "civilization."

In the post-World War I period, there were limited options for photographers in Latin America. Relatively few photographers were able to both earn a living and maintain any sense of artistic vision. There was no counterpart to the photographic experimentation that took place in Europe and the United States, as seen in the work of photographers such as Alfred Stieglitz. Furthermore, the nihilism and pessimism of the European avant-garde was not present in Latin America, as the region did not experience the same death and destruction. Rather, themes such as pan-Americanism and *Indigenismo* permeated Latin American photography.

Despite the limited opportunities for photographers in general in the post-WWI period, the 1920s did see the emergence of the so-called Cuzco School. Centered in Cuzco, the photographers associated with this school—Native Americans from the highlands of Peru—produced images that were modern and ethnographic. These men used old equipment and earned a living as traditional village studio photographers, working under difficult economic situations. Furthermore, each of them came from the same social and ethnic groups as many of their subjects. None of them became rich nor famous in their lifetime. It was only later in the twentieth century that these men were recognized as important photographers.

The most well-known of the Cuzco School photographers is Martín Chambi. Chambi, the son of peasants from the village of Coaza, began working during the 1920s. He began his career as an apprentice for a photographer working for a British mining company. He later moved to Cuzco, where he made a modest living as a studio photographer. Chambi also traveled widely and produced thousands of documentary photographs. His body of work was influenced by the *indigenismo* ideology prevalent at

the time in Peru. He was also associated with the nationalist APRA political party. Chambi's work brings his subjects to life, even in ordinary scenes and without defying the conventions of conservative Peruvian society. He meticulously posed his photographs, so much so that they satisfied his upper-class clients who were unaware that he was satirizing their status and class power. Unfortunately, Chambi died virtually unknown in 1973.

In addition to Chambi, the other Latin American master who emerged from the first half of the twentieth century was the Mexican Manuel Álvarez Bravo. Álvarez Bravo began taking photographs in the mid-1920s. Originally more interested in painting, music, and literature, in 1922, Álvarez Bravo met the photographer Hugo Brehme and decided that he, too, would become a photographer. Then in 1927, Álvarez Bravo met Tina Modotti, who led him to find a personal tone for his images. Edward Weston came to admire Álvarez Bravo's work, which opened the doors to the international photographic community. Álvarez soon became internationally famous, exhibiting in Paris in the 1930s along with Henri Cartier-Bresson. His work possesses a great poetic quality. Furthermore his images offer a wide range of interpretations, as there is often more than meets the eye in what seem like ordinary photographs. Like the Mexican muralists of the time, Álvarez Bravo incorporated Mexico's indigenous past into his images.

There were relatively few women involved in photography in the early twentieth century. The first to make a significant contribution was the Italian-born Tina Modotti, who first went to Mexico in 1923, where she lived off and on until she died there in 1942. Modotti was a student of Edward Weston. She is known for her photographs of Mexican street and village life, exploring everyday problems of the people. For example, she produced images of workers' demonstrations. Modotti emphasized what she called "photographic quality," which meant taking "sincere photographs" without manipulation. Modotti had an important influence on other Mexican photographers such as Manuel Álvarez Bravo and Lola Álvarez Bravo.

Lola Álvarez Bravo was another important female photographer in Mexico in the first half of the century. Many of her images reflect the surrealist movement. She also produced portraits, especially of painters and writers involved in the vibrant art scene of Mexico City in the 1930s and 1940s. Among her subjects was the artist Frida Kahlo. Alvarez Bravo was able to capture Frida's free spirit in a way that no male photographer had been able to do.

A third female photographer of note in Mexico was the Hungarian-born Kati Horna, who came to Mexico in 1939 seeking political asylum. Horna settled in Mexico City for the rest of her life. Like Álvarez Bravo, she was part of the surrealist movement. Horna also earned a living as a newspaper photographer.

In Buenos Aires, Argentina, a number of female photographers also made significant contributions. In particular, the German-born Annemarie Heinrich and Greta Stern rose to prominence. Both women arrived in Buenos Aires in the 1930s and both became known for their artistic portraits, a distinctive characteristic of the Buenos Aires photography scene. Their clients were often well-known artists from theater, dance, and cinema. No artist who visited the Colon Theater in the Argentine capital failed to visit their studios. These glamorous photographs of the famous performing artists developed in Buenos Aires to a greater extent than anywhere else in the region.

The role of Latin American photography changed with the Cuban Revolution of the 1950s. From the early days of the revolution, Cuban photographers recorded the events of the guerrilla war against the dictator Fulegncio Batista. Not only did photographers document events, they also portrayed the leaders of the revolution. Iconography played an important role in Latin American photography of the period. Fidel Castro's image became known worldwide and could be seen in publications such as *Life*. Che Guevara became a popular icon in large part due to Alberto Korda's photograph of the revolutionary leader with a black beret with a revolutionary star on it.

In many ways, the photographs of the Cuban Revolution followed the tradition of epic photography begun during the Mexican Revolution with the works of photographers such as Casasola. In the post-Cuban Revolution period, Latin American photography was given a sort of revolutionary imperative. That this was the case can be seen in Fidel Castro's unannounced visit in 1984 to the Third Colloquium of Latin American Photography being held in Havana. The Cuban leader reminisced about the role of photography and images during the revolution. Furthermore, with the creation of the Cuban news agency Prensa Latina, a Third World alternative to international news organizations, a new space was opened for Latin American photojournalists.

One of the results of the Cuban Revolution was that it forced photographers—as well as those in almost any other occupation—to choose sides. Either one was committed to the ideals of social revolution or one was labeled as a frivolous and decadent artist who simply produced art for art's sake.

The Cuban Revolution was not the last time that photography was used for political purposes. Rebels in El Salvador during the 1980s continued the tradition. However, the Salvadorans also added a new twist to traditional documentary photography. They made the genre more pragmatic and media-savvy. The 1980s was a decade of media events, and in places like El Salvador, where conflict was rampant, a good photograph could be just as important as a military victory.

In 1978, Latin American photographers staged the First Colloquium of Latin American Photography in Mexico City. Subsequent meetings would be held in Mexico City in 1981 and Havana in 1984. The events brought a new prominence to Latin American photography. In the wake of the Cuban Revolution and influenced by more recent events such as the Sandanista Revolution in Nicaragua, leftist political rhetoric dominated the meetings. The Colloquium was accompanied by an exhibition called *Hecho en Latinoamerica* (*Made in Latin America*). The exhibition clearly had a point of view, as photography was seen as an anti-imperialist tool. Some used the term "liberation photography," in reference to Liberation Theology, which was so prevalent at the time. One critic described the exhibit as "documentary and humanistic with an occasional tinge of exoticism and leftist politics." While some Latin American photographers did produce alternative styles of images, they were largely unrepresented at the Colloquium.

The Colloquium was also important in that it helped to internationalize Latin American photography. It led to a series of international exhibitions that helped to bring Latin American photography to a global audience for the first time. Also important is the fact that for the first time, some of these exhibitions were based on extensive curatorial surveys. Generally, Latin American curators had lacked the funds to conduct such a survey.

While the Colloquium had emphasized the political and social nature of Latin American photo-

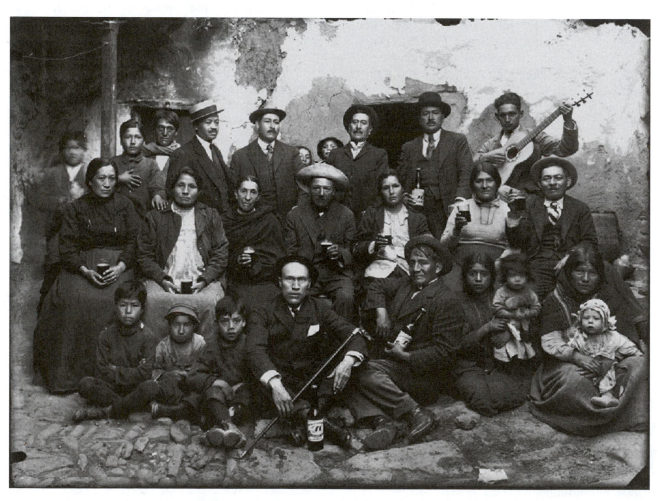

Martín Chambi, Fiesta Familiar, Cusco 1930, placa de vidrio, 13 × 18 cm.
[*Courtesy of Julia Chambi López y Teo Allain Chambi, Archivo Fotográfico Martín Chambi, Cusco, Peru*]

graphy, by the end of the twentieth century, the medium had taken many forms. While traditional themes of social justice and magical realism continued, many other forms of experimental photography prospered. Among them was the avant-garde work of Luis González Palma and Mario Cravo Neto. Others such as Pedro Meyer, Graciela Iturbide, and Flor Garduño produced documentary fine art. Overall, by the end of the century, the Latin American photography scene was as diverse and vibrant as anywhere in the world.

RONALD YOUNG

See also: **Bravo, Manuel Álvarez; Chambi, Martín; Documentary Photography; Modotti, Tina; Photography in Central America; Photography in Mexico;** **Photography in South America; Portraiture; Weston, Edward**

Further Reading

Billeter, Erika. *A Song to Reality: Latin American Photography, 1860–1993*. Barcelona and New York: Lunwerg, 1998.

Hopkinson, Amanda. "'Mediated Worlds': Latin American Photography." *Bulletin of Latin American Research* 20:4 (2001): 520–527.

Levine, Robert M. *Images of History: Nineteenth and Early Twentieth Century Latin American Photographs as Documents*. Durham and London: Duke University Press, 1989.

Levine, Robert M. ed. *Windows on Latin America: Understanding Society through Photographs*. Coral Gables, FL: North-South Center, University of Miami, 1987.

Watriss, Wendy, and Lois Parkinson Zamora, eds. *Image and Memory: Photography from Latin America, 1866–1994*. Austin, TX: The University of Texas Press, 1998.

CLARENCE JOHN LAUGHLIN

American

For most of his career as an active photographer (1930–1967), Clarence John Laughlin remained outside the mainstream of American photographic practice. Laughlin's first love was writing, and his interest in photography began with the notion that the images could add another layer of understanding to his words. Although the bulk of his work is straightforward black and white photography made with a 4 × 5-inch view camera, it is the relatively small number of pictures involving staged tableaux, collage, multiple printing, and other techniques that often put him at odds with those who practiced and championed straight photography in the United States. It was his insistence that the captions written to accompany the pictures were integral elements of the photographs, and needed to be displayed with them that in part created a reputation that he was a cantankerous individual. It was not until the late 1960s, when Laughlin had ceased to photograph consistently, that his work began to be seriously considered as a unique and important voice in the photographic history of the twentieth century.

Laughlin's pact with the written word was hardly superficial. His father encouraged him to read at an early age, but when the elder Laughlin died in 1918, Clarence left school to help support his mother and crippled sister. He continued to read, especially American fiction and the writings of the French Symbolist poets. At his death in 1985, his personal library numbered some 30,000 volumes. He was likewise self-taught as a photographer.

Laughlin's work is organized around a series of 23 themes or groups, the core of which was established early in his career. By the time of his first museum exhibition in 1936 at the Delgado Museum of Art (now the New Orleans Museum of Art) the group structure was firmly in place. The groups serve not only as a road map for the progression of his work, but as a key for understanding the philosophical organization of it. The groups addressed some prosaic themes, such as *The Louisiana Plantations* and *American Victorian Architecture*, but also ventured into areas that were less easily defined, such as *Poems of the Interior World* and *The Mystery of Space*.

The photographs of his American contemporaries (including Ansel Adams, Edward Steichen, Alfred Stieglitz, Paul Strand, and Edward Weston) were known to Laughlin, but he found little in theirs that reflected his own concerns of photography. He

saw much more correspondence with his own vision in the photographic work of the Europeans Hans Bellmer, and Eugène Atget, the expatriate Man Ray; the paintings of Russian refuge Eugene Berman; and the constructions of the eccentric American artist Joseph Cornell. Laughlin's active collecting of books and other literature of the Surrealist movement, along with his 1940 exhibition at the New York gallery of Julien Levy has often caused him to be considered part of that movement, but he was never officially associated with them. Bolstering a Surrealist affinity is a unique group of pictures called *The Color Experiments*. These were created between 1943 and 1946 using the materials of the dye-transfer process, at times in combination with gelatin silver camera images or photograms, and sometimes employing elements of drawing, collage, and frottage.

Laughlin initially used the subject matter of his native Louisiana to forge his approach to what he called "the third world of photography, the world beyond documentation and purism." His earliest books, *New Orleans and Its Living Past* (1941) and *Ghosts Along the Mississippi* (1948), respectively, synthesize urban and rural milieus, suffusing the characteristic architecture of each place with both symbolism and nostalgia. His fascination with the lessons that could be learned from the architecture of the past were set in sharp contrast against what he felt was the mechanized pace of modern life, and the soulless architecture that often accompanied it. With the outbreak of World War II, Laughlin began an even more symbolically charged set of pictures (*Poems of the Interior World*) that he hoped would expose the folly and madness of global war. Work on the series of over 300 prints and accompanying captions continued throughout the 1940s, and must be regarded as among his most ambitious projects.

From the late 1940s until he ceased photographing in 1967, Laughlin worked more outside of Louisiana than within his native state. He traversed the western part of the United States, usually on commissions to photograph new architecture or to deliver lectures, and began to record the vanishing inventory of Victorian-era architecture in major cities. Chicago is perhaps best represented in the over 5,000 negatives that form this project, but extensive work was carried out in Milwaukee and Lake Geneva, Wisconsin, Galveston and San Antonio, Texas, and Los Angeles and San Francisco, California. For this project, in some ways an extension of his earlier architectural work in Louisiana, Laughlin seemed anxious to record every detail of the buildings and abandoned the overt symbolism he had favored in the 1930s and 1940s. These photographs present the buildings as a catalogue of relics, a precious heritage doomed by the misguided policies of urban renewal.

Failing health and other obligations curtailed Laughlin's career as an active photographer after 1967. Though he had long looked to Europe (especially France) as a source of inspiration, Laughlin didn't travel abroad until 1965. On that trip he photographed briefly in England and France, forming the last of his categories, *Fantasy in Europe*.

For the last 20 years of his life Laughlin re-evaluated his accomplishments in photography. This process included creating a master index of his negatives and refining the arrangement of the groups. He also worked on writing projects, organized exhibitions of his work, and actively sought a home for his archive. In 1968, the University of Louisville Photographic Archives purchased his negatives and a set of prints. In 1973, the Philadelphia Museum of Art produced the retrospective exhibition, *The Personal Eye*, accompanied by a book of the same name published by *Aperture*. In 1981, his voluminous archive of correspondence, master prints, and manuscripts were acquired by the Historic New Orleans Collection. And in 1983, the portion of the work at the University of Louisville was combined with the archive in New Orleans. Less than two years later Laughlin died in New Orleans after a series of debilitating ailments. His ashes were interred in Père-Lachaise Cemetery in Paris.

JOHN H. LAWRENCE

See also: **Adams, Ansel; Architectural Photography; Atget, Eugène; Bellmer, Hans; Dye Transfer; Levy, Julien; Man Ray; Manipulation; Photogram; Photography in the United States: the South; Steichen, Edward; Stieglitz, Alfred; Strand, Paul; Surrealism; Weston, Edward**

Biography

Born near Lake Charles, Louisiana, 14 August 1905. Moved with family to New Orleans in 1910, where he was educated in local schools until the ninth grade. Continued his education with selected night courses during the 1920s. Self-educated in photography beginning in 1930. From 1936–1941 was a photographer with the U.S. Army Corps of Engineers. Had a trial period of employment at *Vogue* magazine, 1941. Appointed Assistant Photographer in the National Archives in Washington, D.C., 1942. Military service in World War II was as a photographer with the U.S. Signal Corps (New York) and Office of Strategic Services (Washington, D.C.), 1943–1946. From 1946–1965 earned his principal living by photographing contemporary architecture, writing magazine articles about photography, circulating exhibits of his own work, lecturing throughout the United States on his photographic theories. Received a Carnegie Corporation grant through

the Library of Congress in 1952 to continue photographing antebellum southern architecture. Named an Associate of Research at the University of Louisville, Louisville, Kentucky, 1968. Awarded an honorary doctor of humane letters by Tulane University, New Orleans, Louisiana, 1976. Died in New Orleans, Louisiana, 2 January 1985.

Individual Exhibitions

1936 *Photographs by Clarence John Laughlin*; Isaac Delgado Museum of Art, New Orleans, Louisiana
1940 *Photographs by Clarence John Laughlin, Series I: Images of the Lost, Series II Poems of Desolation*; Julien Levy Gallery, New York, New York
1946 *The Camera as a Third Eye*; Philadelphia Museum of Art, Philadelphia, Pennsylvania
1948 *Ghosts Along the Mississippi*; Phillips Gallery, Washington, D.C.
1968 *Clarence John Laughlin, Photographs of Victorian Chicago*; The Corcoran Gallery of Art, Washington, D.C.
1973 *Clarence John Laughlin: The Personal Eye*; Philadelphia Art Museum, Philadelphia, Pennsylvania
1976 *The Transforming Eye*; International Center of Photography, New York, New York
1980 *An Exhibition of Selected Photographs of Historic Louisiana Architecture by Clarence John Laughlin*; Jacob Aron Room Special Collections Division, Howard-Tilton Library, Tulane University, New Orleans, Louisiana
1985 *Other Ghosts Along the Mississippi*; The Historic New Orleans Collection, New Orleans, Louisiana
1985 *Clarence John Laughlin*; Robert Miller Gallery, New York, New York
1991 *Clarence John Laughlin: Visionary Photographer*; Nelson-Atkins Museum, Kansas City, Missouri
1997 *Haunter of Ruins: The Photographs of Clarence John Laughlin*; The Historic New Orleans Collection, New Orleans, Louisiana

Group Exhibitions

1950 *Photography Mid Century*; Los Angeles County Museum of Art, Los Angeles, California
1980 *Southern Eye Southern Mind; A Photographic Inquiry*; Pink Palace Museum, Memphis, Tennessee
1982 *Edward Weston and Clarence Laughlin: An Introduction to the Third World of Photography*; New Orleans Museum of Art, New Orleans, Louisiana
1983 *Subjective Vision: The Lucinda W. Bunnen Collection of Photographs*; The High Museum of Art, Atlanta, Georgia
1984 *A Century of Vision: Louisiana Photography 1884–1984*; University Art Museum, University of Southwestern Louisiana, Lafayette, Louisiana

Selected Works

Birds in Hyperspace, 1935
Self-Portrait of the Photographer as Joshua, 1939
Elegy for Moss Land, 1940
The Unending Stream, 1941
The House of Hysteria, 1941
The Masks Grow to Us, 1947
Receding Rectangles, 1947
The Language of Light #3, 1952
The Improbable Dome, 1964

Further Reading

Coleman, A. D. *The Lucinda W. Bunnen Collection, Subjective Vision in Photography*. Atlanta, GA: The High Museum of Art, 1983.
Davis, Keith, with Nancy C. Barrett and John H. Lawrence. *Clarence John Laughlin: Visionary Photographer*. Kansas City, MO: Hallmark Cards, Inc., 1990.
Laughlin, Clarence John, and David Cohn. *New Orleans and Its Living Past*. Boston: Houghton-Mifflin Company, 1941.
Laughlin, Clarence John. *Ghosts Along the Mississippi*. New York: Charles Scribner's Sons, 1948.
Laughlin, Clarence John, and E. John Bullard. *Edward Weston and Clarence John Laughlin: An Introduction to the Third World of Photography*. New Orleans, LA: The New Orleans Museum of Art, 1982.
Lawrence, John, and Patricia Brady, eds. *Haunter of Ruins: The Photography of Clarence John Laughlin*. Boston: Bulfinch Press, 1997.
Leighten, Patricia. "Clarence John Laughlin: The Art and Thought of an American Surrealist." *History of Photography* 145 (April–June 1988).
Williams, Jonathan. *Clarence John Laughlin: The Personal Eye*. Millerton, NY: Aperture, 1973.

Clarence John Laughlin, Old Grocery Store in New Orleans.
[© *CORBIS*]

ROBERT LEBECK

German

Robert Lebeck stands among the great German photojournalists. In more than a half century of work—20 years of which he spent with the German magazine *Stern*—he has produced photographs of significance and authenticity, consistently managing to capture people and powerful situations in photographs.

Lebeck was born in Berlin in 1929. He grew up with his grandparents in the town Jamlitz near Berlin, and in 1943 at the height of World War II he became a soldier. He was subsequently captured and became a prisoner-of-war. When the war ended, he was released from an American prison camp and went on to earn a high-school diploma in Donaueschingen, Germany. Then, in Zurich and later at Columbia University in New York, he studied ethnology. He traveled throughout the United States, working as an usher, as kitchen help, and with the railroad. The skills he acquired in the United States were to serve him well as a photojournalist. In the United States he chanced upon U.S. magazines such as *Life* and *Look* and was fascinated by their variety and quality:

> I only later learned that the magazines in Germany before the Hitler period were as world renowned as the American magazines of the 1950s. From their reputation I came to understand what qualified as a good photo essay and what it meant to respect photojournalism. And I did all of this without realizing that I would choose this career.

> (Steinorth 1993, 6)

In 1952, he returned to Germany and received a job with the U.S. Army in Heidelberg. The next year, his wife gave him his first camera. The leading German photojournalist and fashion photographer Herbert Tobias (1924–1982), who was returning to Heidelberg from Paris, taught Lebeck how to develop film and make enlargements. His first photo, of Chancellor Konrad Adenauer in Baden-Baden, was published in July 1952 in the *Rhein-Neckar-Zeitung*, a newspaper in Heidelberg. The following year Lebeck worked for various newspapers in Heidelberg.

When Winston Churchill received the Karlspreis award from the city of Aachen in 1956, no journalists were permitted to attend the closed dinner festivities. Lebeck disguised himself among the kitchen workers and photographed the great leader at the banquet; Scotland Yard confiscated the film. The next day Lebeck was again prepared and hid behind a curtain as members left the reception. When Adenauer suddenly asked for a photographer, Lebeck was ready.

By the middle of the 1950s, new magazines had begun to make up a significant portion of the press. Among them was *Kristall*, out of Hamburg, where Lebeck had his breakthrough in 1960, traveling for three months across Africa. It was the year that the European powers bestowed independence on their last colonies. There, as the state of Zaire (now Congo) declared its independence and the Belgium King Baudouin and President Joseph Kasavubu drove along the boulevard in an open car, Joseph Kasavubu took the king's sword from the car's backseat. Lebeck was the only photographer who recorded the scene.

In 1966, Lebeck went to Hamburg to work for *Stern*, which had become the biggest weekly magazine in West Germany. He was always there at the focal point of events. In 1963, he was at the coronation of Pope Paul VI. Lebeck photographed Cardinal Ottaviani laughing as he kissed the pope's hand; he would have so much preferred being named pope. This image has become an icon of photojournalism. "It shows what it means to be there when the event takes place," Lebeck said.

He made a gripping photograph at American politician Robert Kennedy's funeral as the coffin was carried from the ceremony into the night. When Ayatollah Khomeini, the Iranian revolutionary leader, returned to Tehran from Paris after 15 years of exile, Lebeck sat with him in the plane. His photographs of Khomeini's arrival in Tehran suggested the coming of war, which the Islamic revolution would begin only a few months later in the name of Allah.

These photographs reveal the photographer's special skill at recording situations in the second that history and a decisive historical moment melt together. Also important is that Lebeck ignored all the prevailing rules of photography, which makes clear that such photographs require the total sensory perception of a watchful and decisive eye. Although Lebeck's photography exhibits a light-

ning-quick determination of subject, detail, light, and perspective, it also demonstrates a perfect staging of the scene that lends the momentary situations a meaning far beyond the event.

Despite competition from television and the changes brought about by digital photography, Lebeck does not view the future of photojournalism with pessimism:

> The most important thing, and the reason I believe in the future of still photography, is that still photos remain longer in one's memory. Georg Stefan Troller once formulated this observation in a vivid way and gave a series of very illuminating examples. It is curious that when one thinks of photographic images, one thinks of still photographs. Troller knew what he was talking about, because he had made many provocative films for television. No one seems to remember precisely, but Troller once explained that the photo appears to capture time, to vanquish time, to subdue the duration of time, and photography is an act that challenges transitoriness and because of this exhorts our passionate participation. In my opinion, one cannot better phrase the reasons to speak of a future for photojournalism.

(Steinorth 1993, 11)

Lebeck is internationally known not only as a photographer but also as a collector. At the end of the 1960s, he began collecting nineteenth-century photographs. According to Lebeck, he purchased his first daguerreotype in the United States in 1967 and started collecting postcards of photographic journalism. Soon his interests widened from the pioneers of photography to the amateurs with artistic ambitions. At important auctions in the 1970s, a collector with little money but an eye for quality could procure striking examples of the history of photography. He had a special interest in new discoveries, tracking down unknown and forgotten photographic works and undervalued treasures. With an unconventional way of proceeding and an eye for quality photographs, Lebeck has made a substantial international contribution to the history of photography. In 1993 the city of Cologne purchased his complete collection of more than 11,000 photographs.

RUDOLF SCHEUTLE

See also: **Photography in Germany and Austria**

Biography

Born in Berlin, Germany, March 21, 1929. Soldier in World War II, 1944; high school in Donaueschingen, 1945–1948; ethnology studies in Zurich, 1948–1949, and at Columbia University in New York, 1949–1951. Return to Germany, employee at U.S. Army headquarters in Heidelberg, 1951. Freelance photojournalist for newspapers in Heidelberg, 1952–1955; editor of *Revue*, 1955–1960; photojournalist for *Kristall*, 1961–1962; photojournalist for *Stern*, 1962–1963; photojournalist for *Stern* in New York, 1966–1968; editor in chief of *Geo*, photojournalist for *Stern*, 1979–1995. Exhibit Sammlung Lebeck: Fotografie des 19. Jahrhunderts (The Lebeck Collection: Photography of the Nineteenth Century) in Berlin, 1982; awarded the Dr.-Erich-Salomon-Preis from the German Society for Photography, 1991. Moved to southern France, 1994. Exhibits *Alles Wahrheit! Alles Lüge! Photographie und Wirklichkeit im 19. Jahrhundert. Die Sammlung Robert Lebeck* (Everything Is Truth! Everything Is Lies! Photography and Reality in the Nineteenth Century: The Robert Lebeck Collection), *Agfa Foto-Historama* at the Wallraf-Richartz Museum/Museum Ludwig, Cologne, 1997. Lives as a freelance photojournalist in southern France.

Individual Exhibitions

1962 *Tokio—Mokau—Leopoldville*; Museum für Kunst und Gewerbe, Hamburg, Germany
1983 *Augenzeuge Robert Lebeck: 30 Jahre Zeitgeschichte*; Stadtmuseum, Kiel, Germany
1991 *Robert Lebeck: Fotoreportage*; Couvert de Mines, Perpignan, France, and Museum Ludwig, Cologne, Germany
1993 *Robert Lebeck—Fotoreportage Churchill in Bonn*; Historisches Museum der Pfalz, Speyer, Germany
1995 *Die Porträts*; Palais Palffy, Vienna, Austria

Group Exhibitions

1996 *Das deutsche Auge*; Deichtorhallen, Hamburg, Germany
1998 *Signaturen des Sichtbaren: Ein Jahrhundert der Fotografie in Deutschland*; Galerie am Fischmarkt, Erfurt, and Rheinisches Landesmuseum, Bonn, Germany

Further Reading

Böttger, Tete, ed. *Robert Lebeck: Vis-à-vis*. Göttingen: Steidl, 1999.

Robert Lebeck, Ein Kongolese entreisst Konig Boudouin von Belgien den Degen, Leopoldville, 1960.
[© *Fotomuseum im Munchner Stadtmuseum. Photo reproduced with permission of the artist*]

Dewitz, Bodo von, and Roland Scotti. *Alles Wahrheit! Alles Lüge! Photographie und Wirklichkeit im 19. Jahrhundert: Die Sammlung Robert Lebeck*. Cologne: Verlag der Kunst, 1997.

Lebeck, Robert. *In Memoriam: Fotografien auf Gräbern*. Dortmund: Harenberg, 1980.

———. *Afrika im Jahre Null*. Hamburg: Kristall, 1961.

———. *Romy Schneider: letzte Bilder eines Mythos*. Schaffhausen: Edition Stemmle, 1986.

———. *Begegnungen mit Grossen der Zeit*. Schaffhausen: Edition Stemmle, 1987.

———. *Porträts*. Göttingen, 1995.

———. *The Mystery of Life*. Stern-Portfolio, no. 14, Hamburg, 1999.

———. *Rückblenden: Erinnerungen eines Fotojournalisten*. Munich: Econ, 1999.

Steinorth, Karl, and Meinrad Maria Grewenig, eds. *Robert Lebeck: Fotoreportagen*. Stuttgart: Cantz, 1993.

RUSSELL LEE

American

Russell Lee is an American photographer best known for his documentary work on the Great Depression and the Dust Bowl, which was undertaken for the Farm Security Administration (FSA) between 1936 and 1942. Because of his detailed photographic observations of American social realities of the late 1930s, Lee was described by Roy Stryker, the FSA director, as "a taxonomist with a camera."

The son of Burton and Adeline Lee, Russell was born in Ottawa, Illinois in 1903. His childhood was marred by his parents' divorce and his mother's premature death. Lee was entrusted to the care of several legal guardians, including his grandparents and his great uncle. He attended Culver Military Academy in Indiana, where he graduated in 1921, and then enrolled at Leigh University in Pennsylvania, earning a degree in chemical engineering in 1925. In spite of this scientific education and a promising career making composition roofing with the Certainteed Products Company, based in Marseilles, Illinois, Lee's marriage to painter Doris Emrick in 1927 introduced him to the world of art. Dissatisfied with his job, Lee resigned from the Certainteed Products Company in 1929 and moved first to San Francisco, where he started painting, and subsequently to the Woodstock Art Colony, New York. From 1931 to 1936, Lee painted portraits and landscapes in Woodstock and his first 35 mm camera was bought as a drawing aid. Yet Lee soon found out that his talent was with photography rather than painting. He started documenting the lives of the people in the Woodstock surroundings during the Depression and later focused on New York, detailing the effects of the economic crisis on the urban context. His scientific knowledge allowed Lee to experiment with the photographic medium and its technical aspects. In particular, the use of flash became a distinctive feature of his photographs, enabling Lee to capture detailed shots of interiors.

In 1936, Roy Stryker invited Lee to join the photographic team of the Resettlement Administration (RA), which was later renamed Farm Security Administration (FSA). Part of the New Deal programs to help farmers during the Depression years, the RA and the FSA used their photographic section to gain support for their projects. The aim of the photographic staff, which in addition to Lee included Ben Shahn, Dorothea Lange, Arthur Rothstein, Jack Delano, and Walker Evans, was to show to the nation the predicament of agricultural workers in the 1930s. During his six years with the FSA, Lee traveled extensively throughout the United States, recording the rural and the urban social realities of the Depression. His most famous work consisted of two series of photographs of San Augustine, Texas, taken in 1939, and Pie Town, New Mexico, 1940. Lee's photographs, like those of his FSA colleagues, were widely disseminated through national newspapers, magazines, and even books, such as Richard Wright's *12 Million Black Voices* (1941). This successful photo-documentary volume on African American history featured both Lee's rural images and his grim depiction of black Chicago slums. Lee's FSA photographs have been praised as social documents. Yet, like other FSA photographers,

Lee has also been subjected to criticism. Maren Stange, for example, has argued that the FSA documentary style, which Lee fundamentally contributed to codify, ultimately suppressed the radical potential of the photographed subjects, testifying "both to the existence of painful social facts and to the reformers' special expertise in ameliorating them, thus reassuring a liberal middle class that social oversight was both its duty and its right." During his tenure with the FSA, Lee divorced from his first wife and in 1939 married Dallas journalist Jean Smith. The couple soon started to work together and Jean Lee often followed her husband in his travels, writing captions and short essays for his photographs.

During the Second World War, Lee, who had left the FSA in 1942, worked for the Overseas Technical Unit of the Air Transport Command (ATC). The new unit's task was to photograph the routes and the airfields flown by the ATC, thus providing American pilots with images of the often unknown airspace in which they would fly. In 1944, Lee was promoted to major and the following year he received the Air Medal for his contribution to the unit.

At the end of the war, Lee returned to his life-long project of illustrating American social realities. In 1946, the Department of the Interior commissioned Lee to document the health, housing, and safety conditions of coal miners throughout the United States. Lee's photographs, which amounted to more than 4,000, were part of a survey promoted by the Department of the Interior and the United Mine Workers. They portrayed the lives of coal miners showing their daily activities, the interiors and exteriors of the mines, and their accommodations. Many of these photographs were published in 1947 in the final report of the survey, *A Medical Survey of the Bituminous Coal Industry*, which contributed to important changes in the work and health regulations of the mining industry. That same year, Lee, together with many of his former FSA colleagues, was again under the direction of Roy Stryker working for Standard Oil New Jersey (SONJ) in an effort to improve the corporation's public image. After SONJ, Lee continued to work in the field of industrial photography throughout the 1950s and was hired by several important companies such as Arabian-American Oil Company (Aramco) and Jones and Laughlin Steel. Parallel to this body of industrial photographs, Lee collaborated with Texan political and cultural institutions to record post-war Texas life and its different social conditions. Lee's subjects were extremely varied and ranged from the living conditions of Spanish-speaking population to state mental institutions, from portraits of Texan politi-

cians to those of literary authors. Though Lee's reputation is closely connected to the American soil, in 1960, he was in Italy for two and a half months taking over 4,000 photographs for a special issue of *Texas Quarterly* on that country. Throughout the 1950s and 1960s, Lee's work appeared in *Fortune*, *The New York Times Magazine*, *Magnum*, and *The Texas Observer*.

After a retrospective exhibition organized by the University of Texas at Austin in 1965, Lee accepted a position as the first photography instructor at the University of Texas. Teaching became the focus of Lee's career until his retirement in 1973. He died in Austin on August 28, 1985.

LUCA PRONO

See also: **Delano, Jack; Documentary Photography; Evans, Walker; Farm Security Administration; History of Photography: Interwar Years; Industrial Photography; Lange, Dorothea; Rothstein, Arthur; Shahn, Ben; Stryker, Roy**

Biography

Born in Ottawa, Illinois, 21 July, 1903. Died in Austin, Texas, on August 28, 1985. Attended Culver Military Academy in Indiana, and Leigh University in Pennsylvania, but self-educated in photography. Joined the photographic team of the Resettlement Administration (RA)/Farm Security Administration (FSA) in 1936 for six years. Worked for the Overseas Technical Unit of the Air Transport Command (ATC) during World War II. After the war he was hired by state departments and important private corporations such as Standard Oil New Jersey (SONJ), the Arabian-American Oil Company (Aramco), and Jones and Laughlin Steel. Instructor of photography at The University of Texas, 1965–1973. Died in Austin, Texas, 28 August 1985.

Exhibitions

1938 *First International Photographic Exposition*; Guild of Photographic Dealers, Grand Central Place, New York
1955 *Family of Man*; Museum of Modern Art, New York, New York
1962 *The Bitter Years: 1935–1941*; Museum of Modern Art, New York, New York
1964 *The Photographer's Eye*; Museum of Modern Art, New York, New York
1965 *Russell Lee: Retrospective*; University Texas Art Museum, Austin, Texas
1965 *Photography in America 1850–1965*; Yale University Art Gallery, New Haven, Connecticut
1976 *Masters of the Camera: Stieglitz, Steichen and Their Successors*; International Center of Photography, International Museum of Photography, New York, New York
1978 *Russell Lee*; George Eastman House, Rochester, International Museum of Photography, New York

Further Reading

Hurley, Jack. *Russell Lee: Photographer*. Dobbs Ferry, NY: Morgan & Morgan, 1978.

Stange, Maren. *Bronzeville: Black Chicago in Pictures, 1941–1943*. New York: New Press, 2003.

——. *Symbol of Ideal Life: Social Documentary Photography in America, 1890–1950*. Cambridge, MA and New York: Cambridge University Press, 1989.

Wroth, William. *Russell Lee's FSA Photographs of Chamisal and Penasco, New Mexico*. Santa Fe, NM: Clear Light Publications, 1985.

ANNIE LEIBOVITZ

American

Simultaneously an artist, a photojournalist, and a commercial photographer, Annie Leibovitz has played a seminal role in the business of image making in the late twentieth century. Her works, which have appeared in American and European magazines including *Time, Stern, Paris-Match, Rolling Stone, Vanity Fair,* and *Vogue* among others, document society's preoccupation with celebrity and appearance. The methods by which she has been able to articulate the essence of star personae have revealed her to be a keen interpreter of popular culture. An unwitting pioneer of the women's movement, Leibovitz blazed her own trail to success in a largely male-dominated industry, and she has continued to help redirect perceptions of female identity.

The daughter of an air force officer and a professional dancer, Leibovitz was born in 1949 in Westport, Connecticut. She enrolled in the San Francisco Art Institute in 1967 and began to study painting during a period when Minimalism and Post-Painterly Abstraction were considered the only viable expressive means. Feeling a greater affinity for realism, Leibovitz began to investigate other modes of artistic expression. Her study of painting, however, provided her with a strong sense of composition that has informed her photographic work.

During the summer of 1968, Leibovitz joined her parents on Clark Air Force Base in the Philippines, where her father was stationed. Her mother had the opportunity to go to Japan and took Leibovitz with her. On the trip, Leibovitz bought her first professional camera, a Minolta SRT101, and began taking amateur shots, which she developed herself in the base's hobby shop. Upon her return to the Art Institute, she began taking night courses in photography.

While in school, Leibovitz studied with Ralph Gibson, who introduced her to the works of Henri Cartier-Bresson, Dorothea Lange, and Robert Frank. Initially, she was drawn less to portraiture than to studies of locations and environments. This was an interest sparked by *Life* magazine's early photo essays, entire articles expressed principally through pictures captured by a single roving journalist such as *Life*'s long-time photo editor Walker Evans.

In 1970, Leibovitz approached the two-year old San Francisco-based youth and rock magazine *Rolling Stone* with a picture she had taken of beat poet Allen Ginsberg. Art director Robert Kingsbury bought the portrait and introduced Leibovitz to founding editor Jann Wenner. In 1971, Leibovitz received a bachelor of fine arts degree from the San Francisco Art Institute. After a short independent assignment in Europe, which she took specifically to hone her skills, Leibovitz returned to *Rolling Stone* seeking a position and was subsequently hired on a $47.00 weekly retainer.

Leibovitz became chief photographer of *Rolling Stone* in 1973 and by 1974, had photographed most of the era's foremost rock artists and many of its major political figures. She often collaborated with writer Tim Cahill, taking photographs as he gathered story material. Her initial work consisted of candid shots taken while following subjects engaged in specific activities. An example of this portraiture type can be found in a body of work created in 1975, when Leibovitz served as the official concert photographer for the Rolling Stones. She traveled with the band, capturing many facets of their tour, both onstage and off. Her best-known image from this period, however, is that of the nude John Lennon embracing the fully clothed Yoko Ono, taken on the day of Lennon's murder.

Since the mid-1980s, Leibovitz's portraits have become elaborately staged productions, highlighting a sitter's celebrity persona or referencing an object or deed that has made the sitter famous. Rejecting the conventional close-up view, Leibovitz has preferred the 35-mm lens, which allows for the inclusion of contextual and conceptual details, like props. Before photographing her subjects, she has admittedly studied them from various perspectives, considering them in political, psychological, and sociological terms before determining her conceptual and compositional approach. This stylistic change, emphasizing the contrived over the candid, reflects her 1983 move to New York-based Condé Nast Publications, which produces the glossy fashion magazines *Vanity Fair* and *Vogue*.

Leibovitz's mid-career work also saw a brief return to her early role as photojournalist. In 1985, she became the official photographer for the World Cup Games in Mexico and in 1994, she documented the aftermath of the sieges of Sarajevo, Bosnia. Atlanta's Olympic Games Committee commissioned Leibovitz to make portraits of participating athletes in 1996. This assignment yielded both a book and a traveling exhibition.

In 1991, Leibovitz became the second living and only female photographer to have a retrospective exhibition at the National Portrait Gallery in Washington, D.C. In the same year, she brought suit against Paramount Pictures in a closely watched artist's rights case for their irreverent appropriation of her nude portrait of the pregnant actress Demi Moore for an advertising campaign promoting *Naked Gun 33⅓: The Final Insult*. The image at issue contained a model's similarly posed pregnant body, topped with actor Leslie Nielsen's head. Paramount was acquitted of copyright infringement charges based on the doctrine of Fair Use.

In 1999, Leibovitz published a collaborative work entitled *Women* with critic and essayist Susan Sontag. The book contains over 70 photographs of women, ranging from the world renowned to the unknown and cutting across ethnic and socio-economic boundaries. An exhibition of the same name, containing over 50 of the book's images, each made of four separate Iris prints constituting portraits of enormous size, has traveled to various venues nationally. The brainchild of Susan Sontag, the book was intended to redefine conventional conceptions of femininity and has affirmed Leibovitz's trademark interest in the mutable concepts of identity and image.

SAVANNAH SCHROLL

See also: **Cartier-Bresson, Henri; Evans, Walker; Frank, Robert; Gibson, Ralph; Lange, Dorothea; Life Magazine; Portraiture; Sontag, Susan**

Biography

Born in Westport, Connecticut, 2 October 1949. Traveled to Japan and bought first camera, 1968. Lived on kibbutz in Israel and took part in archeological dig of King Solomon's temple, 1969. Received bachelor of fine arts degree from San Francisco Art Institute, 1971. Appointed chief photographer for *Rolling Stone* magazine, 1973. Official concert tour photographer for Rolling Stones, 1975. Contributing photographer for *Vanity Fair* magazine, 1983. American Society of Magazine Photographers Photographer of the Year Award, 1987. Clio Award and the Campaign of the Decade Award from *Advertising* magazine for her American Express "portraits" campaign, 1987. Founded Annie Leibovitz Studio in New York City, 1990. Infinity Award from International Center for Photography, 1990. Currently lives and works in New York City.

Selected Individual Exhibitions

1991 *Annie Leibovitz: Photographs*; National Portrait Gallery, Smithsonian Institution, Washington, D.C., and traveling
1998 *Annie Leibovitz Retrospective*; Center for Modern and Contemporary Art, Veletrzni Palace National Gallery, Prague, Czech Republic, and traveling through Eastern and Central Europe
 Olympic Portraits; Olympic Museum, Lausanne, Switzerland, and traveling
1999 *Women*; Corcoran Gallery of Art, Washington, D.C., and traveling
2000 *Nudes: Mark Morris Dance Group*; Edwynn Houk Gallery, New York, New York, and traveling

Selected Group Exhibitions

1989 *150 Years of Photography: Leibovitz, Mapplethorpe, Newman, Slavin, Weber, Beaufrand, De la Ville, Scannone, Sigala, Vogeler*; Museo de Arte Contemporáneo de Caracas, Caracas, Venezuela
1990 *5 × 5: Leibovitz, Ritts, Newman, Weber, Mapplethorpe, De la Ville, Sigala, Scannone, Vogeler, Beaufrand, Díaz, Giovanni, Ospina, Galvis, Gómez-Pulido*; Fundación Museo de Arte Acarigua-Araure, Bogotá, Colombia
2000 *Picturing the Modern Amazon*; New Museum of Contemporary Art, New York, New York
2000 *Picturing Women*; Steven Scott Gallery, Baltimore, Maryland

Selected Works

American Soldiers and the Queen of the Negritos, Clark Air Force Base, the Philippines, 1968
Mick Jagger, Buffalo, New York, 1975
Patti Smith, New Orleans, Louisiana, 1978

John Lennon and Yoko Ono, New York City, 1980
Whoopi Goldberg, Berkeley, California, 1984
Demi Moore, 1991
Jennifer Miller, New York City, 1996
Eileen Collins, Johnson Space Center, Houston, Texas, 1999

Further Reading

Bowman, Kathleen, and Larry Soule. *New Women in Media.* Mankato, MN: Creative Education, 1976.

Harris, Mark Edward. *Faces of the 20th Century: Master Photographers and Their Work.* New York: Abbeville Press, 1998.

Leibovitz, Annie. *Dancers.* Washington, DC: Smithsonian Institution Press, 1992.

————. *Olympic Portraits.* Boston: Bulfinch Press, 1996.

————. *Photographs.* Introduction by Tom Wolfe. New York: Pantheon Books, 1984.

————. and Ingrid Sischy. *Photographs, Annie Leibovitz, 1970–1990.* International Center for Photography and National Portrait Gallery, eds. New York: Harper Perennial, 1992.

————. *Women.* Introduction by Susan Sontag. New York: Random House, 1999.

Lousiana Museum of Modern Art, eds. *Stardust: Annie Leibovitz 1970–1999.* Humlebæk, Denmark: Louisiana Museum of Modern Art, 2000.

Marcus, Adrianne. *The Photojournalist: Mary Ellen Mark and Annie Leibovitz.* Los Angeles: Alskog, Inc., 1974.

Nickerson, Camilla, and Neville Wakefield, eds. *Fashion: Photography of the Nineties.* New York: Scalo, 1998.

JEAN-CLAUDE LEMAGNY

France

Jean-Claude Lemagny has played multiple roles in the world of fine-art photography. His extensive academic achievements include a License in History and Geography, a Certificate in French Literature, a Certificate in Art of the Middle Ages, a Superior Studies Diploma in the History of Art, and an Aggregation in History, which is a prestigious professional qualification as a teacher. In 1963, he was named Chief Curator for the Department of Prints and Photographs at the Bibliothèque nationale de France (BNF). His first responsibilities at the BNF included cataloguing art books and eighteenth century French engravings. In 1968, he became responsible for the contemporary photography collection. He was also a professor at L'Ecole du Louvre, teaching classes in eighteenth century engraving. In 1998, Lemagny retired as official curator of photography and was named an Honorary General Curator of the BNF.

An articulate and prolific writer, Lemagny produced hundreds of articles and several major books on exhibitions, individual photographers, movements, or themes in photography. He both organized and participated in numerous conferences and colloquiums on photography in France and around the world, attending untold numbers of openings and receptions for photography. By invitation from other institutions, he often guest curated exhibitions or wrote accompanying text for catalogues. He participated in the first meetings with Lucien Clergue to organize the Rencontre Internationale d'Arles, an international photography event that began in 1970. This annual event brought thousands of participants each summer to the south of France to participate in a variety of both structured and spontaneous photo activities, including exhibitions, public and private critiques, workshops, and lectures. The streets could be filled for days with people looking at or showing photographs. Though Lemagny was sometimes invited to give an official presentation at Rencontre d'Arles, his presence was more often at his personal initiative. Summer after summer, Lemagny could be found seated at a table, often at the Hotel Arlatan, reviewing photographers' portfolios on a first-come-first-served basis, the line of hopeful artists sometimes stretching for blocks. He would take a break at noon to eat a sandwich and otherwise spent the day looking at and talking about hundreds of photographs.

In his role as Curator of Photography at the BNF, Lemagny considered himself a public servant and wanted to serve. He handled administrative activities of the department, met regularly with contemporary artists, organized monthly exhibitions with texts for the Galerie Colbert, the photography exhibition space for the BNF, and every week was available for consultation to researchers in the Prints and Photographs reading room. He

worked extensive hours to handle such responsibilities, sometimes meeting with artists on Saturdays. The depth and intensity of his involvement in photography made him a valuable source of information about contemporary photographers, photography institutions and activities, and diverse personalities in the art world such as gallery directors, editors, curators, and critics. Because of the demands on his time at the BNF, he once said, "If I truly need to finish some work, I need to stay home." His dynamic, incessant presence in the world of photography in Paris was so strong that he was nicknamed, "The Master."

One of his principle responsibilities at the BNF was to acquire new works for the collection. Meeting regularly with artists, he confronted the problem of limited financial resources and the continuous discovery of new work. Purchasing works directly from the artist or through a gallery or agent, he opted as a matter of policy to disperse available funds to a diversity of potential artist instead of concentrating funds for major purchases of the more established and more expensive works. Over the years he served as photography curator the BNF acquired over 70,000 new photographs. His curatorial efforts establish the collection of the BNF as one of the most important photography collections in the world.

Lemagny was also responsible for the organization of exhibitions from the library's collection. On a monthly basis, BNF photography exhibitions filled the library's Galerie Colbert. The Galerie Colbert was an experiment to create and maintain an exhibition space that coherently reflected the contemporary aspect to works exhibited there. Lemagny organized nearly 100 exhibitions in the Galerie Colbert. Some of these exhibitions were in other sites in Paris and around the world. *Eloge de L'Ombre*, an exhibition and catalogue organized by Lemagny, was presented to the public in 2000–2001 at the Kawasaki Municipal Museum and the Yamaguchi regional Fine-Art Museum in Japan.

The publication in 1992 of *L'ombre et le temps* is a look at this curator's thoughts and visions on photography. Working with other contributors responding to his propositions, this book strives to merge both enthusiastic support and provocative criticism into fertile material for reflection on the state and nature of photography.

In 1994, shortly before retiring as curator of photography, he organized an exhibition and book called *La Matiere, l'Ombre et la Fiction*, (*Matter, Shadow and Fiction*). Both the exhibit and the book

drew from the BNF's collection of contemporary photographs, organizing works by panels based not on author, date, content, theme, or genre but by the photographs' visual compatibility. Lemagny once wrote that any two photographs have more in common one with the other than any photograph could ever have with something seen in it. The presentation provoked both strong support as well as criticism. In 1996, Jean-Francois Chevrier criticized Jean-Claude Lemagny for devoting himself to creative photography while neglecting documentary and informational considerations. The same year, Phillipe Arbaizar wrote of Lemagny's tremendous work and contribution to the world of art photography.

In 1989, Lemagny wrote: "In photography, as in all art, what is of fundamental importance is not finding an idea but exploring matter manifest in forms. It is about sustaining a certain thickness, from within which creativity can circulate."

BRUCE MCAIG

See also: **Archives; Bibliothèque nationale de France; Museums: Europe; Photography in France**

Biography

Born in Versailles, France, 24 December 1931. License in History and Geography, Certificate in French Litterateur, Certificate in Art of the Middle Ages, Diploma of Superior Studies in the History of Art, *Agregation* in History. Awarded the Medal of Algeria, named an Official of Arts and Letters. 1963 to 1998 served as Chief Curator of Photography at the Bibliotheque Nationale de France. Over the last 50 years of the twentieth century, prepared hundreds of exhibitions and texts on photography. Lives in Paris, France.

Selected Works

La photographie creative, 1984
Histoire de la Photographie, by Andre Rouille et Jean-Claude Legmany, 1986. Second edition, 1997
L'Ombre et le temps, 1992
La Matiere, l'ombre et la fiction, 1994
Le Cours du visible, 1999

Further Reading

Bibliothéque nationale, ed. "Bonjour Monsieur Lemagny." In *Nouvelles de la photographie*. Paris: Bibliothéque Nationale, 1996.
Delage de Luget, Marion. *Jean-Claude Lemagny, maitre d'oeuvre*. Paris: DEA d'Arts Plastiques Universite Paris VIII, 2001.
Lemagny, Jean-Claude. *Eloge de l'Ombre*. Tokyo: Tosyo Insatsu Co., Ltd. 2000.

LENS

The photographic camera is a product of convergent evolution, a process where similar forces give rise to analogous though unrelated structures. What is striking about the camera is the way it resembles the eye. Some inventions intentionally mimic nature. In the case of the camera, the mechanism functions like a biological structure, but for several centuries it was developed without a working knowledge of the physiology of vision.

Cameras contain two essential components: a light-tight chamber and an aperture. In a properly constructed camera, the aperture projects the scene in front of it as a visible image within the chamber. Modern cameras use light-sensitive substances to capture, process, and transmit that image. Our visual apparatus functions in a similar manner, as retinas process visual information projected by the pinhole aperture seen within the iris.

Cameras can operate without a lens. These devices are called pinhole cameras because the aperture must be narrow enough to allow only one coherent image into the chamber. Pinholes function by allowing only one ray of light from each point of a visible surface to reach the back of the camera chamber.

Pinhole cameras have the advantage of simplicity and infinite depth of field—every point within the image is in focus—but the size of the aperture sorely limits the intensity of the image. Consequently photosensitive materials require several minutes of exposure. In evolutionary terms, pinhole cameras correspond to the most primitive eyes in nature, for instance those of a nautilus, which also consist of a pinhole and simple retina.

The lens improves the efficiency of cameras by gathering more light. Unlike a pinhole, which approaches the spatial limit of zero, lens apertures can be of finite size, creating a bright image within the apparatus that reduces exposure time. The lens retains the qualities of a pinhole by focusing light from many different directions into a single coherent image. A correspondingly large aperture—in other words, a hole—projects light incoherently, forming a circular beam of illumination, not a visible image.

The lens functions through refraction, or the fact that light bends when it passes through media of different densities. Both the eye and the camera exploit the structural capacity of a lens, one crystalline and the other organic, to focus light and form a coherent, transmittable image within a darkened chamber.

Though some ancient cultures may have discovered some of the properties of lenses, such inquiries, if they happened, lie outside the stream of development that led to the camera. The first reports of lenses in our historic continuum appear in thirteenth century Europe, where lenses were used to correct impaired vision. A Venetian law book from 1300 refers to *roidi da ogli*, "little disks for the eyes," and in 1306 sermon Friar Giordana of Pisa reported that the art of making eyeglasses was scarcely 20 years old.

In the sixteenth century, the lens became married to the camera in its current use of amplifying the intensity of projected images. It was first mentioned in mid-century by the Milanese polymath Girolamo Cardano, who described how the visual effects of the pinhole camera can be enhanced by the insertion of a biconvex lens in the aperture:

> If you want to see the things which go on in the street, at a time when the sun shines brightly, place in the window shutter a biconvex lens. If you then close the window you will see images projected through the aperture on the opposite wall....[ii]

Daniele Barbaro subsequently explained how to focus by altering focal length and depth of field in *La Practica della perspettiva*.[iii] But Giambattiste della Porta was the first person to widely promote the lens. In *Magia Naturalis* he recommends using a biconvex lens to improve images within the *camera obscura*, and his widely circulated text popularized the camera as a tool for painters.

Lensmaking steadily improved after the Renaissance. Optical standards were established during the eighteenth century, and the invention of photography in the nineteenth century created a mass market for lenses. Virtually every camera incorporates a lens. While pinhole cameras are functional, they are impractical for most uses. And, while the biconvex lens used in early photographic cameras sufficed to brighten images, compound lenses were required for the many advances of photography since the nineteenth century.

Lens manufacturing advanced considerably during the twentieth century. The main innovations lay

in three areas: coatings, aspheric geometry, and the creation of compound assemblies. These advances increased the power and utility of photographic lenses, leading to a diverse range of uses that has continued expanding into the twenty-first century.

Coatings minimize flare and other disruptions caused by reflections within the lens assembly. The basic lens is spherical and easily mass produced because calibrating grinding equipment to a circular form is relatively simple. Aspherical lenses often offer superior performance to spherical lenses, but they require sophisticated design and manufacturing resources. Finally, photographic cameras require compound lenses to serve the range of demands placed by modern users. The item we commonly denote as a "lens" is, in fact, an assemblage of convex and concave lenses, bonded with cement and mechanically calibrated to act in concert.

Modern lenses are highly specialized. Photography services a range of disciplines: snapshots, journalism, advertising, prepress production, cinema, television, photomicroscopy, astronomy, and aerial surveillance from street level to satellite. Each of these disciplines and their many subdisciplines requires a specialized lens apparatus.

The spread of digital computers in the 1970s had a major impact on lens production. For seven centuries only a handful of organizations had the capability to produce superior products. Computers allowed more entrants into the industry, and they also supported complex manufacturing processes that were previously difficult or impossible. Combined with advances in materials science, specifically the development of inexpensive and durable optical-grade polymers, digital computers have contributed to the spread of cameras in virtually every context.

Relentless progress has pushed the lens to the point of invisibility while making its cost negligible. In such a situation it is impossible to predict which innovations will take hold, for instance the now standard practice of including cameras in mobile phones. While progress will continue in the established photographic disciplines, the advent of cheap, ubiquitous cameras, and their inclusion in a broadening array of devices, will be the most dynamic area of development in the coming century.

ALI HOSSAINI

See also: **Camera: An Overview; Camera Obscura; Camera: Pinhole; Depth of Field**

Further Reading

Gernsheim, Helmut, and Alison Gernsheim. *The History of Photography from the Earliest Use of the Camera Obscura up to 1914*. London: Oxford University Press, 1955.
Kemp, Martin. *The Science of Art: Optical Themes in Western Art from Brunelleschi to Seurat*. New Haven, CT: Yale University Press, 1990.
Ray, Sidney F. *The Lens and All Its Jobs*. New York: Focal Press, 1977.
Singer, Charles, ed., et al. *A History of Technology, Vol. III.* Oxford University Press: New York, 1958.
Wald, George. "Eye and Camera." In *Scientific American Reader*. NY: Simon & Schuster, 1953, 555–68.

i *A History of Technology, Vol. III.* Ed. Charles, Singer et al. Oxford University Press: New York, 1958.
ii Gersheim 1969, p. 10.
iii Kemp 1990, p. 189.

HELMAR LERSKI

Swiss-Polish

Helmar Lerski was among the most original representatives of the avant-garde active between World War I and World War II. He was a very important link between Pictorialism and what was called *"Neue Sehen"* or New Vision on the one hand, and between photography and film, on the other. Born to Polish immigrants in Strasbourg, then part of Germany, he came to photography only indirectly.

After receiving an education as a bank clerk in Zurich, he immigrated to the United States, and working part-time to make ends meet, eventually established himself as an actor in German-speaking theaters. In 1905, he published a book of aphorisms about free love, a fashionable theme amid the contemporary criticisms of bourgeois institutions. This was his only literary work. He learned photography with the help of his first wife, Emilie Bertha Rossbach, who came from a family of photographers.

Nevertheless, measured by the expectations of pictorial photography of that time, his technical skills were slight. In 1909 he gave up acting, and in 1910 he opened his own studio with his wife. His first published photography dates from the following year, appearing in Milwaukee, Wisconsin-based German-language newspapers. After 1911, at the latest, Lerski took part in one of the Photographers' Association of America conventions. It is uncertain whether he took a teaching position in photography in Austin, Texas, that the university offered him in 1914. In any case, he already had a reputation among the faculty. The influential critic of the time, Sadakichi Hartmann, emphasized the singular artificiality of Lerski's photographs that seemed to reveal a face "masked by mimicry."

In the early American years of his work, the term "Lerski pictures" gained currency. These photographs already show the stylistic characteristics that were to become typical of Lerski's output. In their overall qualities they conformed to the current standards of artistic photography, dominated by the soft-focus, expressive ideals of Pictorialism. But through the manner in which the subject is portrayed, Lerski created a distinct style, one achieved by chiaroscuro light effects and posed gestures, by use of a low vantage point to indicate pathos, making his works comparable to those of nineteenth century master Julia Margaret Cameron. Lerski paid particular attention to lighting, using a clever mixture of side and frontal illumination that he aimed with mirrors.

In 1915, Lerski returned to Germany. In the same year he had a one-man show, which was well received, at a Berlin publishing house, with one critic suggesting that Lerski might be a figure able to liberate photography from its increasingly hidebound traditions. Even at this time it was apparent that he avoided traditional ways of printing and that the theatrical staging of his photographs was something not previously seen. Although he exhibited his photographs again the next year, Lerski then suddenly gave up still photography. In 1916, he found a position as director and cameraman of the photography and technical department of the newly founded WW Film Society of Berlin. The aesthetic of German expressionism, with its reliance on graphic effects, hard contrasts of light and shadow, and dramatic portrayals, suited him well. A press release from the first year that he worked with the film society praised the photographic treatment of the actors' faces as "uniquely specialized...with the entire treasure of his means and form of expression," which was brought out by Lerski's unusual lighting technique. Trade publications cited the quality of his light staging, which Lerski continued to use after the WW Film Society broke up. Over the next few years he worked with screenwriter and poet Béla Balázs and director Berthold Viertel; a 1925 article in *Die Filmwoche* described him as artist, poet, and visionary of the camera.

After another four years of more or less successful film projects (most of which were directed toward a narrow group of intellectuals), Lerski returned to still photography. After 1929 his pictures of personalities from the Berlin art scene began appearing in *Vogue*, *Die Dame*, *Die neue Linie*, *Scherl's Magazin*, *Sport im Bild*, and *Die weite Welt*. Essays praising his earliest work also started to appear. Yet Lerski first secured his great fame as a portrait photographer for a project he worked on privately in his studio. Hiring off the street and from employment agencies, he photographed anonymous models, a practice which excited much attention after these pictures were published. Lerski was represented with these studies in 1929 at the world-famous Film und Foto exhibition. This was followed by a major exhibition of these works, *Everyday Heads*, in 1930, and a book of reproductions was published. Two museums had already purchased some of his prints.

Lerski's photographs presented a completely new project. He did not concern himself with conventional beauty, and photographed physiognomies because of their expressive intensity. The models' faces are photographed up close, tightly cropped, and often from below. Complicated lighting transformed the faces into vivid landscapes against a neutral backdrop. In the dramatically lit atmospheres, and quietly expressive expressions Lerski captured with the intent to produce an introspective, but noble, if not heroic, expression without any particularized psychological revelation; one can trace the influence of German films. Lerski represented not single individuals, but representatives of the collective. His method, however, was completely different from that of his contemporary August Sander, who photographed typical citizens he felt exemplified their professions or positions in society. Lerski portrayed people without any overt symbols or even intimations of their social positions. Only the "true" humanist potential was to come forth in his portraits. If ever the term "expressionistic" applied to photography, it applied to Helmar Lerski.

In his following project, Lerski further pursued his unique vision. In 1931, he worked in Palestine on *Document of the Jewish Race*, a photography series for which he had already secured a French publisher; he planned to have Albert Einstein write

the foreword. The work was supposed to show the "original Jewish type and its many branches" and included photographs of their "milieu," although Lerski's urban and landscape photography never achieved anything like the intensity of his portraiture. Of these, however, only a few ever made it to print; the book project was never completed. In 1932 Lerski immigrated with his second wife to Tel Aviv, where he continued his photography and also took portraits of Arabs. He also turned once again to film but without much success. In 1936, he began to work on a new photo project, *Metamorphosis Through Light*. Within three months he took 175 pictures of a single Jewish worker in the glaring sun, always with the aid of mirrors. By 1930 he had already conceived the idea for this work, which he would later consider his masterpiece. This project pushed to the limit the style that can be found in his earliest photographs and that he perfected in *Everyday Heads*: the transformation of the face into sculpture; the suppression of all physiognomic expression in the interest of pathos; and the attempt to convey mysterious meanings and character that reveal the sublime depths of the human soul. In 1937, Lerski showed a number of photographs in London, presenting them in a succession of projections from transparencies for five weeks—a very unusual form of presentation at the time. In Lerski's exhibitions, the conceptually organized presentation of his works prevailed, more than with other photographers of classical modernism. In this respect, the projects *Everyday Heads* and *Metamorphosis Through Light* pointed to the future.

When World War II made working conditions difficult, Lerski reached back to older materials. In Jerusalem in 1941 he showed *Images of the Human Face*, which was based on his portraits of Jews and Arabs. From the negatives he enlarged individual details that produce a continuous concentration on the speaking aspects of the face. He had already set the stage for this project in an edition of the magazine *Die neue Linie*. In addition, he created portraits of workers and soldiers for the propaganda exhibition Fight and Work for the Jewish support fund Keren Hajesod. He also worked again in film. A number of his remaining photographic works share the same preoccupation with the representation of humanity; for example, he photographed a series of hands that he worked on in 1944 and a series of portraits of wooden puppets illuminated in expressionist lighting. After his return to Zurich in 1948, Lerski again gave up photography. Always an artistic loner, characteristic of the great independence of his style is that he was heralded as an artistic precursor in the exhibition *Subjektive Foto-*

grafie 2 of 1955 by Otto Steinert, and at the same time enjoyed a reputation as a socially critical "humanist" in the then German Democratic Republic in East Germany, one of the few Western avant-garde artists to receive such high recognition. Lerksi died in Zurich in 1956.

WOLFGANG BRUECKLE

See also: **History of Photography: Interwar Years; Lighting and Lighting Equipment; Modernism; Pictorialism; Portraiture**

Biography

Born to Polish parents (birth name: Israel Schmuklerski) in Strasbourg, France, then part of Germany, February 18, 1871. Raised in Zurich, Switzerland, after 1876. Received Swiss citizenship, 1887. Moved to the United States, 1893. Worked as an actor in German-language theaters in Chicago, New York, and Milwaukee. Began learning photography from his wife Emilie Bertha Rossbach and established with her a studio, 1910. Photographs appeared at the yearly meetings of the Photographers' Association of America, 1912–1914. Reputedly taught photography and German at the University of Texas, 1914–1915. Returned to Europe, 1915. Cameraman in many Berlin film studios, 1915–1929. Technical director of Schüfftan-Photography, Deutsche Spiegeltechnik GmbH (Ufa), 1925–1927. Managed a photography studio, 1928–1931. Photo and film work in Europe and the Near East, 1931–1932. Moved to Palestine; worked there as a cameraman and photographer, 1931. Occasional European travels, 1937–1939. Return to Zurich, 1948. Honorary member of the Palestine Professional Photographers' Association, 1939. Died in Zurich, November 29, 1956.

Individual Exhibitions

1915 *Portraits*; Galerie der Grafik-Verlag, Berlin, Germany
1930 *Köpfe des Alltags*; Kunstbibliothek, Berlin, Germany
1934 *Jewish Heads*; Massik Art Shop, Tel Aviv, Palestine
1936 *Dynamic Photography*; Divan Bookshop, Jerusalem, Palestine
1938 *Metamorphosis Through Light*; Academy Cinema, London, England
1941 *Thirty Years of Photographic Works*; Bezalel Jewish National Museum, Jerusalem, Palestine
1942 *Images of the Human Face*; Bezalel Jewish National Museum, Jerusalem, Palestine
1943 *Fight and Work*; Tel Aviv Museum, Tel Aviv, Palestine, and traveled through Palestine, to New York, Johannesburg, South Africa, and London
1945 *Human Hands*; Tel Aviv Museum, Tel Aviv, Palestine
1946 *75th Birthday Exhibition*; Mikra Studio, Jerusalem, Palestine
1948 *Verwandlungen durch Licht*; Kunstgewerbemuseum, Zurich, Switzerland
1951 *Helmar Lerski Photographien*; Schauspielhaus, Zurich, Switzerland
1955 *Photographies de Helmar Lerski*; Musée de l'Etat, Luxembourg
1958 *Bruder Mensch*; Staatliche Landesbildstelle, Hamburg, Germany

1961 *Der Mensch mein Bruder*; Paulskirche, Frankfurt am Main, Germany, and traveling
1982 *Helmar Lerski, Lichtbildner: Fotografien und Filme, 1910–1947*; Museum Folkwang, Essen, Germany, and traveled to Munich, Germany, and San Francisco, California

Selected Group Exhibitions

1912 *Photographers Association of America 32nd Annual Convention*; St. Louis, Missouri, and Philadelphia, Pennsylvania
1913 *Salon of Photography*; Royal Watercolour Society Galleries, London, England
1914 *Salon of Photography*; Royal Watercolour Society Galleries, London, England
1929 *Film und Foto: Internationale Ausstellung des Deutschen Werkbundes*; Ausstellungshallen und Königbaulichtspiele, Stuttgart, Germany
1930 *Gezeichnet oder geknipst?*; Haus Reckendorf, Berlin, Germany
1931 *Die neue Fotografie*; Gewerbemuseum, Basel, Switzerland, and traveled through Switzerland
1932 *Exposition Internationale de la Photographie*; Palais des Beaux-Arts, Brussels, Belgium, and traveled through the Netherlands
1955 *Subjektive Fotografie 2*; Staatliche Schule für Kunst und Handwerk, Saarbrücken, Germany
1962 *Creative Photography, 1826 to the Present Day, from the Gernsheim Collection*; Landeshaus, Münster, Germany, and traveled through Germany and to Detroit, Michigan
1971 *Photo Eye of the 20s*; University of South Florida, Tampa, Florida, and traveled through the United States
1981 *Avant-Garde Photography in Germany, 1919–1939*; San Francisco Museum of Modern Art, San Francisco, California, and traveled through the United States
1994 *Photographische Perspektiven aus den Zwanziger Jahren*; Museum für Kunst und Gewerbe, Hamburg, Germany
1997 *Deutsche Fotografie: Macht eines Mediums 1870–1970*; Kunst-und Ausstellungshalle der Bundesrepublik Deutschland, Bonn, Germany

Works

Photographs

Eleonora von Mendelssohn, Schauspielerin, 1927–1930
The Couturiére, 1929
Untitled, c. 1930
Deutscher Arbeiter, 1928–1931
Deutsche Hausgehilfin, 1928–1931

Books

Köpfe des Alltags, Unbekannte Menschen gesehen von Helmar Lerski. Text by Curt Glaser. Berlin: Hermann Reckendorf Verlag, 1931.
Verwandlungen durch Licht/Metamorphosis Through Light. Text by Andor Kraszna-Krausz, with the documentation of the panel discussion "*Metamorphosis as a Provocation*" from 1982, edited by Ute Eskildsen, Freren: Luca Verlag, 1982 (texts in German and English).

Selected Films

Opium: Die Sensation der Nerven (Germany, 1919, dir.: Robert Reinert); *Nerven* (Germany, 1919, dir.: Robert Reinert); *Das Wachsfigurenkabinett* (Germany, 1924, dir.: Paul Leni); *Der heilige Berg* (Germany, 1926, dir.: Arnold Fanck); *Metropolis* (Germany, 1927, dir.: Fritz Lang); *Die Abenteuer eines Zehnmarkscheins, K 13513* (Germany, 1926, dir.: Berthold Viertel); *Sprengbagger 1919* (Germany, 1929, dir.: Carl Ludwig Achaz-Duisberg); *Avodah* (Palestine, 1935, dir.: Helmar Lerski); *Hebrew Melody* (Germany, produced 1934–1935, no premier date documented, dir.: Helmar Lerski); *Yaddei Hashemesh—Children of the Sun* (Palestine, produced 1939–1940, no production date documented, dir.: Helmar Lerski); *Amal* (Palestine, produced 1940, no production date documented, dir.: Helmar Lerski); *Kupat Cholim* (Palestine, produced 1940–1941, no production date documented, dir.: Helmar Lerski); *Labour Palestine?* (Palestine, produced 1941, no production date documented, dir.: Helmar Lerski); *Balaam's Story* (Palestine, 1946–1950, dir.: Helmar Lerski); *Adamah—Tomorrow Is a Wonderful Day* (Palestine, 1948, dir.: Helmar Lerski)

Writings

Lebt die Liebe! With E. F. Ruedebusch. Berlin: Renaissance-Verlag, 1905. A collection of aphorisms.
Die Photographie ist eine große Sache. Berliner Börsen-Courier. March 11, 1930.

Further Reading

Allan, Sidney. "How to Make Large Heads: A New Phase in Photographic Portraiture." *Wilson's Photographic Magazine* 50, no. 9 (1913).
Brückle, Wolfgang. "Wege zum Volksgesicht: Imagebildung für das Kollektiv im fotografischen Porträt des Nachexpressionismus." In *Bildnis und Image, Das Portrait zwischen Intention und Rezeption*. Edited by Andreas Köstler and Ernst Seidl. Cologne: Böhlau, 1998.
———. "Kein Portrait mehr? Physiognomik in der deutschen Bildnisphotographie um 1930." In *Gesichter der Weimarer Republik: Eine physiognomische Kulturgeschichte*. Edited by Claudia Schmölders and Sander Gilman. Cologne: Du Mont, 2000.
Eskildsen, Ute, and Jan-Christopher Horak. *Helmar Lerski, Lichtbildner. Fotografien und Filme, 1910–1947*. Essen: Fotografische Sammlung Museum Folkwang, 1982 (texts in German and English).
Farner, Konrad. "Maxima humania: Helmar Lerskis 'Metamorphose.'" *Sinn und Form* 14 (1962).
Hahm, Konrad. "Lichtbilder: Zu den Arbeiten von Helmar Lerski." *Die Form, Zeitschrift für gestaltende Arbeit* 4, no. 9 (1929).
Horak, Jan-Christopher. "The Penetrating Power of Light: The Films of Helmar Lerski." *Image* 36, nos. 3–4 (1993).
Lamprecht, Gerhard. *Deutsche Stummfilme 1903–1931*. Berlin: Deutsche Kinemathek, 1970.
Lerski, Anneliese, ed. *Der Mensch—mein Bruder, Lichtbilder von Helmar Lerski*. Texts by Louis Fürnberg, Berthold Viertel, and Arnold Zweig. Dresden: VEB Verlag der Kunst, 1958.
Macpherson, Kenneth. "As Is." In *Germany, the New Photography, 1927–1933*. Edited by David Mellor. Lon-

don: Arts Council of Great Britain, 1978; from *Close Up 3* (1931).

Raum, Stefan. "'Kunstwollen,' Physiognomie und Propaganda: Tausendjährige Photographie." In *Kunst und Kunstkritik der dreißiger Jahre, 29 Standpunkte zu künstlerischen und ästhetischen Prozessen und Kontroversen.* Edited by Maria Rüger. Dresden: Verlag der Kunst, 1990.

Schwarz, Heinrich. "Kunst und Photographie." 1932 lecture given at the Österreichisches Museum für Kunst in Industrie, Vienna. *Fotogeschichte* 4, no. 1 (1984).

Tönnis, G. "Der Einfluß des Dialogs zwischen Fotograf und Fotografiertem auf die Struktur der Portraitfotografie." *Zeitschrift für Kunstpädagogik* 2 (1975).

Viertel, Bertold. "Jüdische Köpfe." *Die Neue Weltbühne* 34 (1938).

DAVID LEVINTHAL

American

Since 1972, David Levinthal has photographed his collection of toy figures, models, and historical figurines, and this unique work has defined him as one of the leading postmodern artists in America. Levinthal uses Polaroid's instant SX-70 and mammoth 20 × 24-inch cameras to photograph his tabletop tableaux. The resulting images expose and critique cultural myths and stereotypes, particularly American cultural stereotypes around racism and sex, as well as historical events around which myth and stereotypes have grown, such as Nazism or the Holocaust. Like his contemporaries, Cindy Sherman, Barbara Kruger, and Laurie Simmons, Levinthal draws much of his inspiration and imagery from the myths and icons that appear in film noir, pulp novels, romance books, pin-up magazines, advertising, and television.

Levinthal exploits the veracity of the photographic medium to create images that question the nature of representation. His photographs of staged tableaux are a groundbreaking example of what many postmodern artists were doing in the late 1970s and 1980s—constructing and staging scenes for the camera. Critic A. D. Coleman referred to this working method as "the directorial mode," underscoring the idea the photographer controls every detail of the scene to be photographed. During these decades, many other artists including Sherrie Levine, Cindy Sherman, Sandy Skoglund, and Joel-Peter Witkin made images of elaborately staged subjects that evoke the feel of reality, because they are photographed in a straight documentary style, but are in fact photographic fictions of artificial moments.

Born in San Francisco on March 8, 1949, Levinthal grew up in a wealthy Jewish family. In 1966, he took a basic photography class his freshman year at Stanford's Free University in Palo Alto. He practiced the West Coast aesthetic of masters Edward Weston and Ansel Adams; he even studied the nude with Adams's contemporary Ruth Bernhard. Levinthal's early work of pinball players and storefronts in Santa Cruz and railway cars in Palo Alto reflect the street photography style popularized by Lee Friedlander and others in the 1960s. After graduating from Stanford with a degree in studio art in 1970, from 1971–1973, he pursued a master of fine art's degree in photography at Yale University, New Haven, Connecticut, where he explored his fascination with American popular culture. Initially, he made close-up photographs of M&M's and Chuckles candies and donuts, which garnered the attention of his instructor Walker Evans. By the winter of 1972, Levinthal had begun photographing toy soldiers engaged in battle on his linoleum floor.

What began as part of Levinthal's MFA thesis developed into a three-and-a-half year collaboration with his friend and fellow classmate Garry Trudeau, who went on to create the cartoon strip *Doonsbury*. This collaboration resulted in Levinthal's first photographic series and the publication of *Hitler Moves East: A Graphic Chronicle, 1941–1943* of 1977, with a text by Trudeau. Inspired by the war photographs of Robert Capa, Levinthal arranged toy soldiers in elaborate artificial settings—using potting soil, flour for snow, even fire—to recreate the Eastern Front and Hitler's invasion of Russia. He photographed with a Rollei SL-66 camera and sepia toned the grainy black-and-

white Kodalith paper to convey the gritty feel of war. To underscore the artificiality of his simulated tableaux, Levinthal employed what would become his hallmark techniques of ambiguous space, dramatic lighting, exaggerated blur, and selective focus to obscure the boundaries between reality and artifice. *Hitler Moves East* is considered a classic and an early example of a postmodern photography book, which influenced others such as Sherrie Levine, who also photographed with toy figures, and Cindy Sherman to stage tableaux and fabricated fictions in their own work.

After graduating from Yale, Levinthal taught at a succession of colleges including the University of Nevada, Las Vegas, 1975–1976. Despite the critical acclaim of *Hitler Moves East*, he felt uncertain about his artistic career and returned to school in 1981 to earn a Management Science degree from the Massachusetts Institute of Technology, Cambridge, Massachusetts. In 1982, he co-founded New Venture, a public relations firm in Menlo Park, California. In 1983, having established financial security, he sold his business, moved to New York City, and was immediately included, along with postmodern photographers James Casebere, Sarah Charlesworth, Laurie Simmons, and others, in his first group exhibition, *In Plato's Cave*, at the prominent Marlborough Gallery.

Inspired by the paintings of Edward Hopper and film noir, between 1984–1986 he produced *Modern Romance*. Working in the tradition of Lucas Samaras, Levinthal used the instant SX-70 Polaroid camera for the first time and created voyeuristic photographs of figures in bedrooms, diners, and on street corners. He also transmitted the scenes to television via video and made photographs of the scenes on the TV screen. During 1987–1989, Levinthal used the mammoth 20 × 24-inch Polaroid instant camera for the first time to photograph *The Wild West*. Inspired by the Western movies and televisions shows he grew up with, this series depicts tiny plastic cowboys and Indians in saloons and on horses to address stereotypes and frontier myths. Resembling film stills, his new photographic format monumentalized the tiny toy figures, promoted shallow depth of field, and created ambiguous scale.

Seduction and sex pervade Levinthal's subsequent bodies of work. For *American Beauties* (1989–1990), he posed voluptuous plastic pin-up girls in bikinis on a beach of white sand but lends an ominous twist to these 1950s glamour girls as they pose against a menacing black sky. Levinthal goes to sexual extremes in *Desire* (1990–1991) to critique the stereotyping of women as submissive sex objects. His use of heavy blur obscures explicit detail, but the plastic Caucasian sex dolls from a Japanese mail order catalog wear black leather, red stilettos, and are blindfolded and bound for S&M. The title of his *XXX* series (2000–2001) signals the adult nature of his photographs of scantily clad and nude women posing like porn stars and strippers. Photographed with the 20 × 24-inch Polaroid camera, the 12-inch plastic dolls look almost lifelike in their pornographic presentation, but they are representations of male fantasies and comment on sexual stereotypes.

During the 1990s, Levinthal created his most controversial work by examining the Holocaust and racism. For *Mein Kampf* (1993–1994) he composed figures of SS officers, Hitler, and nude concentration camp victims in chilling scenarios that retell the brutality and horror of the Holocaust. Even more controversial was his series *Blackface* (1995–1996). Levinthal photographed his extensive collection of black memorabilia, household objects such as mammy cookie jars, lawn jockeys, and Little Black Sambo figurines that stereotype African Americans. For *Blackface*, he avoided blur and used the clarity of the 20 × 24-inch Polaroid camera to photograph these small racial objects in extreme close-up. *Blackface* was to be exhibited at the Institute of Contemporary Art in Philadelphia in 1996, but the institution cancelled the exhibition. Critics of the day questioned whether Levinthal was being complicit or critiquing stereotypes in his *Blackface* series. His other series include: *Die Nibelungen* (1993), *Barbie* (1998–1999, 20 × 24-inch Polaroid), *Netsuke* (2002, SX-70 camera); and *Baseball* (2003, 20-by-24-inch Polaroid).

Levinthal exhibits in museums and galleries internationally, and his work is in the collections of leading museums around the world. Levinthal also produces commercial photographs for Exposure NY's clients such as Absolut Vodka, IBM, *The New York Times Magazine*, *Men's Journal*, *GQ*, *Entertainment Weekly*, *Playboy*, and *Wired* magazines.

ELIZABETH K. WHITING

See also: **Capa, Robert; Constructed Reality; History of Photography: the 1980s; Instant Photography; Kruger, Barbara; Polaroid Corporation; Postmodernism; Representation; Representation and Gender; Representation and Race; Sherman, Cindy**

Biography

Born in San Francisco, California, 8 March 1949. Attended Stanford University, Palo Alto, California,

A.B. in studio art, 1970; Yale University, New Haven, Connecticut, M.F.A. in photography, 1973; Massachusetts Institute of Technology, Cambridge, Massachusetts, S.M. in management science, 1981. Instructor of photography at the University of Nevada, 1975–1976. Became associated with Janet Borden Gallery, New York, 1987. Received Polaroid Corporation Artist Support Grants, 1987–1989; National Endowment for the Arts, Visual Artists Fellowship, 1990–1991; John Simon Guggenhiem Foundation Fellowship, 1995; Prix du Livre de Photographie, Le Prix du Livre-Images, les Rencontres, Arles, France, 1997. Resides in New York, New York.

Selected Individual Exhibitions

1977 Carpenter Center of Visual Arts; Harvard University, Cambridge, Massachusetts
 Hitler Moves East: A Graphic Chronicle, 1941–44; California Institute for the Arts, Valencia, California
1977 International Museum of Photography; George Eastman House, Rochester, New York
1985 *Modern Romance*; Founders Gallery, University of California, San Diego, California
1986 Laurence Miller Gallery; New York, New York
 Clarence Kennedy Gallery; Polaroid Corporation, Cambridge, Massachusetts
1987 University Art Museum; California State University, Long Beach, California
 Desire; Laurence Miller Gallery, New York, New York
1993 The Friends of Photography; Ansel Adams Center, San Francisco, California
 Die Nibelungen; The Vienna State Opera and Galerie H.S. Steinek, Vienna, Austria
 The Wild West; Gene Autry Western Heritage Museum, Los Angeles, California, Southeastern Center for Contemporary Art; Winston-Salem, North Carolina, Pastrays Gallery; Yokohama, Japan
1994 Center for Creative Photography; Tucson, Arizona
 The Photographers' Gallery; London, England
 Bibliothèque nationale de France; Paris, France
1995 University Art Gallery; University of New Mexico, Albuquerque, New Mexico
1997 *David Levinthal: 1975–1996*; International Center of Photography, New York, New York
 Playing with History; Corcoran Gallery of Art, Washington, D.C.
 Philadelphia Museum of Judaica; Philadelphia, Pennsylvania
 Holocaust Museum; Houston, Texas
1999 *Girlfrind! The Barbie Sessions*; San Jose Museum, San Jose, California, and traveling to Norton Museum of Art, West Palm Beach, Florida; The Museum at the Fashion Institute of Technology, New York, New York; Salina Art Center, Salina, Kansas; Birmingham Museum of Art, Birmingham, Alabama; South Carolina State Museum, Columbia, South Carolina
 XXX: New Photographs; Baldwin Gallery, Aspen, Colorado
2001 *Small Wonders: World in a Box*; Detroit Institute of Art, Detroit, Michigan
2002 *David Levinthal: Disquieting Tales from Toyland*; Asheville Art Museum, Asheville, North Carolina
 Blackface; Alexandria Museum of African American Culture, Alexandria, Virginia

Selected Group Exhibitions

1983 *In Plato's Cave*; Marlborough Gallery, New York, New York
1985 BC Space; Laguna Beach, California
1986 *Signs of the Real*; White Columns, New York, New York
1987 *Avant-Garde in the Eighties*; Los Angeles County Museum of Art, Los Angeles, California
 Fabrications; International Center of Photography, New York, New York
1988 *The Constructed Image II*; Jones Troyer Gallery, Washington, D.C.
1989 *Surrogate Selves: David Levinthal, Cindy Sherman, Laurie Simmons*; Corcoran Gallery of Art, Washington, D.C.
 Photography of Invention: American Pictures of the 1980s; National Museum of American Art, Smithsonian Institution, Washington, D.C., and traveling
 Theatergarden Bestiarium; The Institute of Contemporary Art, P.S.1 Museum, New York
1990 *Rethinking American Myths*; Atrium Gallery, University of Connecticut, Storrs, Connecticut
 Devil on the Stairs; Institute of Contemporary Art, Philadelphia, Pennsylvania; Newport Harbor Museum, Newport Beach, California
 Des Vessies et des Lanternes; La Botanique, Brussels, Belgium; Palais de Tokyo, Paris, France
1991 *More than One Photography*; Museum of Modern Art, New York
 Interpreting the American Dream; (James Casebere, David Levinthal, Richard Ross), Galerie Eugen Lendl, Graz, Austria
1992 *American Made: The New Still Life*; Iestan Museum of Art, Tokyo, Japan
1995 *Edward Hopper and the American Imagination*; Whitney Museum of American Art, New York, New York
 Representations of Auschwitz: 50 Years of Photographs, Paintings, and Graphics; Auschwitz-Birkenau State Museum, Oswiecim, Poland
 Taking Pictures: People Speak About the Photographs That Speak to Them; 2International Center of Photography, Midtown, New York, and traveling to The Friends of Photography, San Francisco, California; Washington Project for the Arts, Washington, D.C.; High Museum of Art, Atlanta, Georgia; Milwaukee Art Museum, Milwaukee, Wisconsin; Los Angeles County Museum of Art, Los Angeles, California; Minneapolis Institute of Art, Minneapolis, Minnesota; Fine Arts Gallery, Vanderbilt University, Nashville, Tennessee; Center for Creative Photography, Tucson, Arizona; Louisiana Art and Science Center, Baton Rouge, Louisiana
1996 *The Imaginary Real*; The Museum of Fine Arts, Houston, Texas
 Prospect 96; Schirn Kunsthalle, Frankfurt, Germany
1997 *Devoir de Mémoire*; Rencontres Internationales de la Photographie, Arles, France
 Making it Real; Independent Curators Incorporated, New York, The Aldrich Museum of Contemporary Art, Ridgefield, Connecticut, and traveling to: Reykjavik Municipal Art Museum, Reykjavik, Iceland; Portland Museum of Art, Portland, Maine; Bayly Art Museum, Charlottesville, Virginia; Bakalar Gallery, Boston, Massachusetts; and Emerson Gallery, Clinton, New Jersey
1999 *Images for an Age: Art and History at the Center for Creative Photography*; The University of Arizona, Tucson, Arizona
 MoMA 2000: Open Ends; Museum of Modern Art, New York, New York

David Levinthal, Untitled, from the Wild West series, 1988, Polarois Polacolor ER Land Film,
20 × 24″. Original in color.
[*David Levinthal, courtesy Baldwin Gallery, Aspen, Colorado*]

American Perspectives: Photographs from the Polaroid Collection; Tokyo Metropolitan Museum of Photography, Tokyo, Japan

Made in California, 1900–2000; Los Angeles County Museum, Los Angeles, California

2001 *Diabolical Beauty*; Santa Barbara Contemporary Arts Forum, Santa Barbara, California

True Fictions; Museum Bad Arolsen, Kassel, Germany

Toying with Reality; Houston Center for Photography, Houston, Texas

Nazi, 1933–1999; Patrimonie Photographique, Hôtel Sully, Paris, France

2002 *Contemporary American Photography 1970–2000*; Samsung Museum of Modern Art, Seoul, Korea

New Visions of the American West; Nassau County Museum of Art, New York

Selected Works

Hitler Moves East, 1975–1977
Modern Romance, 1984–1986
The Wild West, 1987–1989
American Beauties, 1989–1990
Mein Kampf, 1993–1994
Blackface, 1995–1998

Further Reading

Levinthal, David. *Netsuke*. Essay by Eugenia Parry. Paris: Galerie Xippas, 2004.

———. *David Levinthal: Modern Romance*. Essay by Eugenia Parry. Los Angeles: St. Ann's Press, 2001.

———. *XXX*. Interview by Cecilia Anderson. Paris: Galerie Xippas, 2000.

———. *Blackface*. Essay by Manthia Diawara. New Mexico: Arena Editions, 1999.

———. *Mein Kampf*. Essay by James E. Young, introduction by Roger Rosenblatt, afterward by Garry Trudeau. Santa Fe, NM: Twin Palms Publishers, 1998.

———. *Barbie Millicent Roberts*. Preface by Valerie Steele. New York: Pantheon, 1998.

———. *David Levinthal: Work from 1975–1996*. Essay and interviews by Charles Stainback and Richard Woodward. New York: International Center of Photography, 1997.

———. *Small Wonder: Worlds in a Box*. Essay by David Corey. Washington DC: National Museum of American Art, Smithsonian Institution, 1995.

———. *Dark Light: David Levinthal Photographs 1984–1994*. Essay by David Allan Mellor. London: The Photographers' Gallery, 1994.

———. *Desire*. Essay by Andy Grundberg. San Francisco, CA: Friends of Photography, Ansel Adams Center, 1993.

———. *Die Nibelungen*. Text by Julien Robson and Andrea Hurton. Vienna, Austria: Wiener, Staatsoper, Galerie H. S. Steinek, 1993.

———. *The Wild West*. Edited by Constance Sullivan, essay by Richard Woodward. Washington, DC: Smithsonian Institution Press, 1993.

———. *American Beauties*. Essay by Rosetta Brooks. Santa Monica, CA: Pence Gallery and New York: Laurence Miller Gallery, 1990.

Levinthal, David, and Garry Trudeau. *Hitler Moves East: A Graphic Chronicle, 1941–1943*. New York: Sheed, Andrews & McMeel, 1977.

CLAUDE LÉVI-STRAUSS

French

Claude Lévi-Strauss was born in Belgium and educated in France. By the mid-1930s, he was beginning to develop a whole new approach to the study of what were then termed primitive cultures. Based on his studies of these cultures, many of which enjoyed very little contact with the modern world, he was also advancing interesting theories regarding kinship configurations. Lévi-Strauss would eventually become known as the father of "structural anthropology," and would join the elite European and American intellectual circles. He held a distinguished post at the University of Paris, counting Roland Barthes, philosopher Michel Foucault, and influential psychoanalyst Jacques Lacan among his colleagues. For Lévi-Strauss structural analysis was a methodology to discern universal human truths that transcended historical time, and he published numerous anthropological tracts that put forth his influential views: *Tristes Tropiques; The Savage Mind* and *The Raw and the Cooked: Mythologies*. As a hobby, and also as a way of documenting his work, Lévi-Strauss began photographing the various tribes with whom he interacted. To illustrate certain points, Lévi-Strauss included some of these photographs in his publications. However, it was not until 1994, with the publication of his photographic memoir, *Saudades Do Brasil* (nostalgia for Brazil), that Lévi-Strauss made his most significant contribution to the field of photography.

Lévi-Strauss rarely discussed the role of photography in his observation of indigenous cultures. In *The View From Afar*, Lévi-Strauss does discuss the power of photography as an artistic expression, particularly as it relates to the art of painting. In a lengthy passage, Lévi-Strauss elucidates the limitations of photography:

> The primary role of art is to sift and arrange the profuse information that the outer world is constantly sending out to assail the sensory organs. By omitting some data, by amplifying or reducing other data...the painter introduces into the multitude of information a coherence... Can it be said that photographers do the same thing? To do so would be to overlook the fact that the physical and mechanical constraints of the camera, the chemical constraints of the sensitive film, the subjects possible, the angle of view, and the lighting, allow the photographer only a very restricted freedom compared with the artist's practically unlimited freedom of eye and hand.

(Lévi-Strauss 248–249)

The limitations of photography do not presuppose the uselessness of the medium, however. Even though the ability to manipulate film is not as great, Lévi-Strauss identified the ability of photography to "capture reality," perhaps more than any other art form. As he later concludes, photography is more objective than other art forms.

Lévi-Strauss felt that photography had a use above and beyond art, however; he believed that the medium provided a valuable supplement to field observation. During his long career, Lévi-Strauss observed many cultures on five different continents. In an attempt to augment his writing, to make the culture "come alive" for the reader, he would sometimes include photographs when describing a tribe. However, Lévi-Strauss recognized that this form of documentation was, in one sense, reliant upon time and place. As he states in his introduction to *Saudades Do Brasil*:

> My negatives are not a miraculously preserved, tangible part of experiences that once engaged all my senses...they are merely their indices—indices of people, of landscapes, and of events that I am still aware of having seen and known, but after such a long time I no longer always remember where or when. These photographic documents prove to me that they did exist, but they do not evoke them for me or bring them materially back to life.

(Lévi-Strauss 1995)

Photographs are no substitute for actual observation, and their inclusion in anthropology must therefore be supplemental, a powerful representation of reality, but a representation nonetheless.

The 180 photographs included in *Saudades Do Brasil* date from the mid- to late-1930s, when the anthropologist made several expeditions to various tribes in the Mato Grasso region of the Amazon. Even though they date from different expeditions and involve different tribes, the set-up of the collection suggests a single expedition starting in Sao Paulo and moving into some of the most remote locations in Amazonia. The Sao Paulo photographs suggest a modern, frenetic city, with cars crowding wide boulevards and people hustling down busy streets. Famous for his studies of "primitive" peoples, in this section Lévi-Strauss turns his eye on the development of mechanization and commercialism in a previously agrarian society. The compilation quickly moves on to more outlying territories; however, even as the horse begins to replace the car in these photographs, there is still evidence of rapid change in these formerly inaccessible locations. The roads in these photographs are all dirt, but they are well-maintained and broad enough for vehicular traffic. The towns have a more primitive look, but in one photograph electrical lines can be seen running to one of the buildings. At this point the compilation enters a third section, as Lévi-Strauss chronicles his visits to the remote Caduveo, Bororo, and Nambikwara tribes. Some of these photographs may be recognized from his other works, but nowhere else had he published such an impressive collection. Lévi-Strauss paints a vivid portrait of traditional and relatively unspoiled tribal life in the Amazon. His camera focuses on all areas of cultural practice, including photographs of subjects fishing, dancing, cooking, eating, grooming, and engaging in strength rituals. He also includes photographs involving native dress, face decoration, and traditional weapons.

Immediately apparent in *Saudades Do Brasil* is the lack of posed subjects. True, there are quite a few close-ups in the collection; however, all of these illustrate some aspect of ornamentation, such as a nasal feather labret or a facial tattoo. Other than these, the other photographs in the collection appear spontaneous, with the subjects going about their daily routines of work, rest, and play. This approach to photography manifests the anthropologist's goal of non-interference. But this compilation is more than just a memoir of peoples from the past, it also represents a new argument by Lévi-Strauss, one which he broaches in his introduction, but really advances through his use of visual images. Lévi-Strauss laments the disappearance of these cultures, and identifies as the culprit the institution of European economic models and the sub-

sequent population explosion. *Saudades Do Brasil* thus acts as a warning, a retrospective on several cultures nearing extinction.

Lévi-Strauss's contributions as an anthropologist and philosopher, however, have had a greater impact on contemporary art and photography than his use of the medium. His ideas have informed Structuralism, which became an essential ingredient in the development of photographic theory in the 1960s and 1970s. Various observations he made, such as "the decision that everything must be taken into account facilitates the creation of an image bank," have been starting points for numerous contemporary artists, including the seminal sculptor and theorist Robert Smithson.

ANDREW HOWE

See also: **Barthes, Roland; Deconstruction; Discursive Spaces; Documentary Photography; Image Theory: Ideology; Representation and Gender; Social Representation; Visual Anthropology**

Biography

Born in Brussels, Belgium, 28 November 1908. Attended the University of Paris, 1927–1932 (studied philosophy and law). Taught secondary school; member of Sartre's intellectual circle; Professor of Sociology at University of Sao Paulo, 1934–1937; visiting professor at the New School for Social Research, New York, 1941–1945; Director of Studies at École Pratiquedes Hautes, University of Paris, 1950–1974; appointed Chair of Social Anthropology, College de France, 1959.

Selected Works

Lévi-Strauss, Claude. *Saudades Do Brasil: A Photographic Memoir*. Trans. Sylvia Modelski. Seattle: University of Washington Press, 1995.

———. *Structural Anthropology, vol 2*. Trans. Monique Layton. Chicago: University of Chicago Press, 1976.

———. *Structural Anthropology*. Trans. Claire Jacobson. New York: Basic Books, 1963.

———. *Tristes Tropiques*. Trans. John Russell. New York: Basic Books, 1961.

———. *The View From Afar*. Trans. Joachim Neugroschel and Phoebe Hoss. New York: Basic Books, 1983.

HELEN LEVITT

American

Perhaps best known for her photographs of children at play on the street corners of New York City, Helen Levitt also made a career out of documenting the social conditions of urban America. Her photographs are striking, dramatic events that tell stories through their captured moments, weaving context into her subjects deftly and subtly. Her collaboration with author James Agee produced some of the mid-century's most striking documentary films, and one book, *A Way of Seeing*. Agee himself admired Levitt's photos very much, describing them as almost a work of literature:

> At least a dozen of Helen Levitt's photographs seem to me as beautiful, perceptive, satisfying, and enduring as any lyrical work that I know. In their general quality and coherence, moreover, the photographs as a whole body, as a book, seem to me to combine into a unified view of the world, an uninsistent but irrefutable manifesto of a way of seeing, and in a gentle and wholly unpretentious way, a major poetic work.

Levitt was born in 1918 in the city that she would later document so passionately. After leaving an unsatisfactory stint at school, Levitt began to work for a commercial photographer and teach herself the basic photographic techniques. But, in 1935, Levitt became so impressed by the images of Henri Cartier-Bresson at the exhibition *Documentary and Anti-Graphic* (which also included work by Walker Evans and Manual Álvarez Bravo) that she bought the same Leica camera that Cartier-Bresson photographed with. Soon after, Helen Levitt met Cartier-Bresson and began to do simple pictures with the basic, 35-mm camera. Levitt's subjects were mostly poor children in New York City, and through techniques she learned from Cartier-Bresson, she captured them unobtrusively. With her right-angle viewfinder, Levitt remained as much on the periphery of her scenes as possible. Those early pictures, which would have been considered in the same tradition of "street photographs" by Walker Evans and Ben Shahn, were instrumental in creating Helen Levitt's style. Evans was, in particular, a huge influ-

ence on Levitt's own photographs. Like Evans, Helen Levitt wanted to remain a bodiless eye, on the edge of her subject's periphery, so that her photographs had an authentic and unrehearsed style.

It was, in fact, her meeting with Walker Evans that fueled the majority of Levitt's career. As her mentor, Evans introduced the young Levitt to his then-collaborator, James Agee, who later would become both her collaborator and strongest admirer. Through her study under Evans, Levitt honed her craft, and created a distinct style that borrowed her mentor's own detached indifference. This style is most clearly evident in her first major photographic collection of her trip to Mexico City with Alma and Joel Agee, James Agee's wife and infant son. Her photographs in Mexico recall Walker Evans's own photographs in *The Crime of Cuba*; though Levitt frequently chose children as her subjects, the photographs of Mexico City are darker and more bleak than any she had taken in New York City. Many of them focused on the rural poor and their stifling living conditions and inadequate surroundings. Many of her Mexico City portraits contain a cinematic movement, captured through several photographs taken in rapid succession. And like Evans's photographs of Cuba, Levitt stopped short of making any absolute political statement, deciding instead to nestle her commentary in ambiguous vessels.

The subtle detail and clarity of her subjects won Levitt her first solo exhibition at the Museum of Modern Art in 1943, a following photography fellowship, and a great reputation in the growing photographic community. Her photographs began to appear with regularity in popular magazines and photo journals of the time alongside her mentors and colleagues, Walker Evans, Ben Shahn, and Margaret Bourke-White. After her return from Mexico City, Agee and Levitt began a lengthy and productive collaboration together. Both artists believed in the power of the ordinary, in the poetry hidden within the mundane world, and their association reflected it. Together, they produced a short book, *A Way of Seeing*, as well as two critically acclaimed documentary films, *The Quiet One* and *In The Streets*. In the academy-award nominated *The Quiet One*, Agee performed the narration for Levitt's film about an emotionally disturbed African American student at a reform school, while the *In The Streets* documented the urban life in the streets of East Harlem in the 1940s.

Her focus on film kept her away from photography for the majority of the next decade, though she briefly studied at the Art Students League in New York, and became interested in the method and production of color photography. She returned to the streets of New York and began, again, to document them through the new color medium she had studied. She was awarded a Guggenheim Fellowship for her efforts and produced a show at the Museum of Modern Art. Unfortunately, the master slides from Levitt's show were stolen from the museum and have yet to be recovered.

Levitt still works and lives in the city she helped to document. A retrospective of her photographs of New York from 1937–1945 was displayed at the Laurence Miller Gallery, and countless people have recently re-discovered the beauty and lyrical simplicity of Helen Levitt. Within the group of 1930s documentary photographers, Helen Levitt stands as a chronicler of the quiet, undiscovered subjects, the overlooked beauty of the mundane. Her photographs of children translate their play into a visceral, shared language. Unlike many of the photographs of the century, Levitt's work makes no overt political statement; her subjects are captured just as they are, without commentary or dialogue with their audience. In fact, through her photographs, an audience looses its identity, becomes the transparent eye of the camera lens and discovers her shared way of seeing.

ANDY CRANK

See also: **Bourke-White, Margaret; Bravo, Manuel Álvarez; Evans, Walker; Shahn, Ben; Street Photography**

Biography

Born in Brooklyn, New York, 1918. Photography Fellowship, Museum of Modern Art, 1946; Guggenheim Fellowship, 1959, 1960; Ford Foundation Fellowship, 1964; New York State Council on the Arts Creative Artist's Grant, 1974; National Endowment for the Arts Photography Fellowship, 1976; John Simon Guggenheim Memorial Fellowship, 1981; Friends of Photography Peer Award for Distinguished Career in Photography, 1987; Outstanding Achievement in Humanistic Photography, 1997; Master of Photography Award, 1997.

Selected Individual Exhibitions

1943 *Photographs of Children*; Museum of Modern Art, New York
1992 *Helen Levitt*; San Francisco Museum of Modern Art, San Francisco, California
1994 *Helen Levitt: Fotografías*; Diputacion Provincial, Granada, Spain
1995 *Helen Levitt: Old, New, and Seldom Seen*; Laurence Miller Gallery, New York, New York
1997 *Mexico City*; Center for Creative Photography, Tucson, Arizona
 Crosstown; International Center of Photography, New York, New York
 Helen Levitt: Vintage New York, 1937–1945; Laurence Miller Gallery, New York, New York

Selected Group Exhibitions

1952 *Helen Levitt and Frederick Sommer*; Institute of Design, Chicago, Ilinois

1955 *The Family of Man*; Museum of Modern Art, New York, New York

1976 *One Hundred Master Photographs*; Museum of Modern Art, New York, New York

1978 *New Standpoints: Photography 1940–1955*; Museum of Modern Art, New York, New York

1982 *Color as Form*; George Eastman House, International Museum of Photography, Rochester, New York

1985 *The New York School: Photography 1935–1963, Parts I and II*; Corcoran Gallery of Art, Washington D.C.

1986 *Photographs from the Permanent Collection*; Metropolitan Museum of Art, New York, New York

1988 *Convulsive Beauty*; Whitney Museum of American Art, New York, New York

1989 *On the Art of Fixing a Shadow*; National Gallery of Art, Washington, D.C.

Photography Until Now; Museum of Modern Art, New York, New York

1995 *American Photography, 1890–1965*; Museum of Modern Art, New York, New York

2000 *Reflections in a Glass Eye: Works from the International Center of Photography Collection*; International Center of Photography, New York, New York

Selected Works

The Quiet One (film), 1949
In The Street (film), 1952
A Way of Seeing, 1965
Photographers on Photographers, 1966
In the Street: Chalk Drawings and Messages, New York City, 1938–1948, 1987
Helen Levitt: Mexico City, 1997
Crosstown, 2001

Further Reading

Mossin, Andrew. "Agee and the Photographer's Art." *Aperture* no. 100 (Fall 1985) : 73–75.

Phillips, Sandra S. *Helen Levitt*. San Francisco, CA: San Francisco Museum of Modern Art, 1991.

———. "Helen Levitt's Cropping." *History of Photography* v. 17 (Spring 1993): 121–125.

Squiers, Carol. "The Unseen Helen Levitt: A Few Words in Private." *American Photo* vol. 3 (May/June 1992): 14.

Strauss, David Levi. "Helen Levitt." *Artforum International* vol. 36 (Oct. 1997): 97.

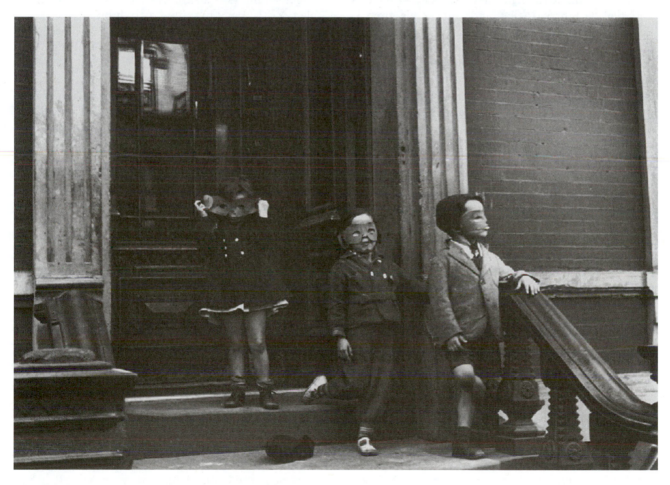

Helen Levitt, Three Kids in Masks on Stoop, NYC, 1940, Gelatin Silver Print.
[*Courtesy Fraenkel Gallery, San Francisco*]

JULIEN LEVY

American

Julien Levy opened his first art gallery in the depths of the Great Depression in the autumn of 1931. As a student at Harvard University, Levy had been among a talented group of young men including Alfred Barr and Arthur Everett "Chick" Austin, who were to become pioneering curators of modern art, who had studied art history with Paul Sachs, and who would go on to be among the most important catalysts for introducing modern art to the United States. Levy met the artist Marcel Duchamp when his father purchased a Brancusi sculpture and the two sailed for Paris together in 1927. Soon after his arrival he met the poet Mina Loy and her daughter Joella, and during his time in Paris, Levy socialized within an art world that included patron of the arts and collector Peggy Guggenheim, photographers Man Ray, Berenice Abbott, and Eugène Atget, and writer Gertrude Stein. Levy imagined the possibility of capturing this energy and aesthetic talent for New York—he married Joella Loy and after the young couple returned to Manhattan, Mina Loy would remain Levy's artistic mentor and professional link to the Paris art scene.

After working for a few years at the Weyhe Gallery, under the direction of print collector Carl Zigrosser, Levy opened the Julien Levy Gallery at 602 Madison Avenue at 57th Street, on 2 November 1931. His first exhibition was meant as a tribute to a man he considered one of his spiritual godfathers, Alfred Stieglitz. During the 1930s, Stieglitz ran his own gallery called An American Place. Levy sought a loan of photographs from Stieglitz for his opening show, but the elder photographer declined, suggesting instead that Levy mount and frame a selection of photogravures from issues of *Camera Work* magazine. Levy's retrospective of American photography featured the best of Pictorialist and early Straight photography with work by Stieglitz, Edward Steichen, Paul Strand, Gertrude Käsebier, Clarence White, Anne W. Brigman, and Charles Sheeler, as well as nineteenth-century images by Civil War photographer and portraitist Mathew Brady. Stieglitz's response to Levy's initial overtures of collaboration suggests his initially skeptical attitude to the younger dealer's efforts to promote photography. However, the two men remained in contact over the next decade, with Levy often visiting Stieglitz at An American Place to share meals, discuss art, and look at photographs together.

One of Levy's most lasting contributions to the history of photography developed from his friendship with Man Ray and Berenice Abbott in Paris. Abbott had befriended the elderly photographer Eugène Atget, and took Levy to his studio where Levy bought a large number of Atget's prints. When Atget died in 1927, Abbott rescued the vast number of negatives and prints in his studio and with the financial help of Levy, sought to promote Atget's remarkable archive of material. Back in New York, Levy mounted an exhibition of Atget's work at the Weyhe Gallery, and then included Atget in several exhibitions at the Julien Levy Gallery. Levy promoted Atget's work to his friend Alfred Barr at the new Museum of Modern Art, but the museum was not yet ready to accept photographs into the collection. Levy's patience with the project to support Atget's archive grew thin, but Abbott's tireless efforts over the next several decades eventually resulted in the purchase of the Atget Archive by the Museum of Modern Art in 1969, and Levy reaped the financial proceeds of half the sale.

The Julien Levy Gallery is best known in art history as the space where a U.S. audience first encountered Surrealism, and although Levy's keen eye and willingness to take aesthetic risks made artists such as Dorothea Tanning, Salvador Dali, Max Ernst, and Joseph Cornell standard fare in his exhibition seasons, Levy never abandoned his deep commitment to promoting photography as a fine art. During the two decades that Levy ran his gallery, he presented a wide range of solo and group photography exhibitions, exploring themes such as the tradition of portrait photography, and drawing important connections between European and American photographers. Henri Cartier-Bresson had his first solo exhibition at the Gallery in 1933, and Lee Miller had her only solo show during her lifetime at the Gallery the same year. Man Ray had his first solo show in New York in April 1932. Walker Evans, known now as a quintessentially

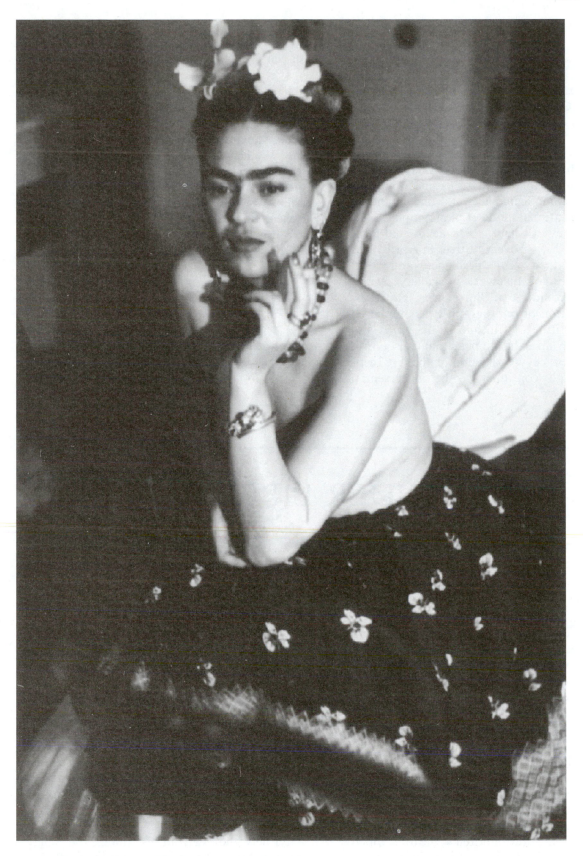

Julien Levy, Frida Kahlo (With Fingers on Cheek Smoking).
[*Philadelphia Museum of Art: The Lynne and Harold Honickman Gift of the Julien Levy Collection, 2001*]

"American" photographer, was included in several exhibitions at the Levy Gallery during the 1930s, suggesting an association with European and surrealist tendencies relatively unexpected in his career. Other photographers shown at the Julien Levy Gallery included George Platt Lynes, Manuel Álvarez Bravo, André Kertész, László Moholy-Nagy, Brett Weston, David Hare, and nineteenth-century masters Nadar and Julia Margaret Cameron. Perhaps taking a cue from his mentor Stieglitz, Levy often presented photography with other media, which enriched and complicated viewers' understanding of the representational mode of photography.

The Julien Levy Gallery closed at its final location at 42 East Fifty-Seventh Street in April 1949. Unfortunately, there is no permanent archive of Levy's collection or his work as gallery owner, dealer, and promoter of Surrealism. However, his large collection of photographs was purchased by the Art Institute of Chicago in the 1970s and was featured in an exhibition at that museum in 1976. The Julien Levy Collection at the Art Institute of Chicago continues to be an essential resource for understanding the growth of American and European photography in the mid-twentieth century.

M. RACHEL ARAUZ

See also: **Abbott, Berenice; An American Place; Archives; Art Institute of Chicago; Atget, Eugène; Bravo, Manuel Álvarez; Cartier-Bresson, Henri; Evans, Walker; Galleries; History of Photography: Interwar Years; Käsebier, Gertrude; Kertész, André; Man Ray; Miller, Lee; Modernism; Moholy-Nagy, László; Museum of Modern Art; Platt Lynes, George; Steichen, Edward; Stieglitz, Alfred; Strand, Paul; Surrealism; White, Clarence**

Further Reading

Levy, Julien. *Memoir of an Art Gallery*. New York: G.P. Putnam's Sons, 1977.

Schaffner, Ingrid, and Lisa Jacobs, eds. *Julien Levy: Portrait of an Art Gallery*. Cambridge, MA: The MIT Press, 1998.

Travis, David. *Photographs from the Julien Levy Collection Starting with Atget*. Chicago: The Art Institute of Chicago, 1976.

ALEXANDER LIBERMAN

American

"Photography is not art"—these are the words of photographer, publishing executive, writer, painter, and sculptor Alexander Liberman. Art or no, from the time he received a vest-pocket Kodak as a gift from his father at the age of eight, photography would have a decisive influence on his life. Liberman had an immense sense of documentary purpose and fervently recorded his family, social circle, and travels. Later, his appreciation for a photograph's straightforwardness and spontaneity would reinvent fashion photography.

Alexander Liberman was born in Kiev, Russia, in 1912 to an upper-class family. In 1917, he moved to Moscow where his father, a timber merchant and economist, advised Vladimir Lenin and his mother founded the first state children's theatre, which became a showcase for Constructivist costume and set design. Liberman's mother had always hoped he would become a painter and encouraged him to use his artistic talent to design sets for the theatre. Unfortunately, it was closed after she refused to adapt *Treasure Island* to the ideologies of the new Soviet republic.

In 1921, Liberman was sent to live with friends in England. Three years later, he joined his parents in Paris, France, where he attended the exclusive Ecole des Roches and received a degree in Philosophy and Mathematics from the Sorbonne in 1930. While in Paris, he became acquainted with many artists—especially Russian émigrés such as Marc Chagall. In 1931, he began to study painting with André Lhote and architecture with Auguste Perret at the Ecole Spéciale. He then transferred to the architecture program at the Ecole des Beaux-Arts and accepted a part-time job with noted artist and designer Cassandre.

After he withdrew from his studies, the progressive editor Lucien Vogel asked him to join the staff of *Vu*, one of the first photographically illustrated magazines, where he worked as art director and

later managing editor. At *Vu*, he became known for his innovative photomontage covers that recalled Russian Constructivism, and he also met photographers Henri Cartier-Bresson, Brassaï, and André Kertész. In 1936, Liberman left the publication to devote himself to painting.

Shortly after Germany invaded France, Liberman escaped to New York where his parents and several acquaintances had already settled. The year was 1941, and Lucien Vogel was already working for Condé Nast and convinced him to hire Liberman at *Vogue*. Although the art director initially dismissed him, Liberman was rehired by Nast himself who was impressed with his gold medal for magazine design from the 1937 International Exposition in Paris. Liberman began designing covers for *Vogue* and was promoted to art director in 1943. He would go on to become editorial director of Condé Nast Publications in 1962, a post he would hold for over 30 years.

In the early 1940s, Liberman stopped painting as he settled into his new life in the United States. His mother reacquainted him with many artists in exile whom they had known in France such as Fernand Léger and Marc Chagall, and he began commissioning illustrations for *Vogue* from artists he admired, including Salvador Dalí, Joseph Cornell, and Marcel Duchamp.

Liberman's acknowledgement of the shift in social attitudes during World War II would have a profound influence on *Vogue* and all of fashion photography. He felt that the new era deserved less whimsical images of women and more candid, original fashion reportage. Liberman highly respected the work of Edward Steichen and his ability to capture the true essence of his subjects. He sought to set a new standard—just as Steichen had revolutionized photography at Condé Nast Publications years earlier. For that reason, he recruited photographers with gritty documentary and experimental sensibilities—Allan and Diane Arbus, Erwin Blumenfeld, Irving Penn, Gordon Parks, William Klein, John Rawlings, and Helmut Newton—and he would later enlist the talent of Richard Avedon and Patrick Demarchelier.

In 1948, Liberman sent Penn, who began as his assistant in 1943, on assignment to Lima, Peru, where he would take the legendary photograph of model Jean Patchett sitting in a café with her elbow on the table, holding her pearls to her lips and staring past the gentleman seated with her. Liberman described Penn's almost accidental image as "a woman caught in an everyday moment—the imperfection of actual life." He regarded the aus-

tere clarity of Penn's photography as characteristically modern, and Penn would later credit Liberman with teaching him to "capture the gesture of a real person."

Actual life to Liberman was about art, and *Vogue* would become a forum for contemporary art. In 1947, Liberman began to make annual visits to France where he photographed the painters and sculptors of the School of Paris such as Picasso, Braque, and Matisse. Several of these artists, like Léger and Chagall, he had known for years. What began as a series of photo essays for *Vogue* became his most acclaimed exhibition at the Museum of Modern Art, New York in 1959 and a successful book entitled *The Artist in His Studio* published in 1960. James Thrall Soby described Liberman's unaffected portraits of these artists in their studios and homes as having an "extraordinary visual sensitivity" and a "rare capacity for psychological insight." He also photographed his contemporaries from the New York School such as Jasper Johns, Robert Raushenberg, and Helen Frankenthaler. Many of these portraits were to be collected in a book titled *Nine Americans*, which remains unpublished. Liberman's portraits of artists comprise a timeless record and key understanding of the artistic process that he felt critical accounts could not achieve alone. Selections of these portraits were included in the exhibition *Portraits of Artists by Alexander Liberman* at the Getty Research Institute in 2003.

Liberman was a man of astonishing versatility, and he was also a prolific painter and sculptor who exhibited regularly since 1954. His sculpture and paintings are in the collections of major museums, such as the Museum of Modern Art, the Corcoran, the Solomon R. Guggenheim Museum, and the Tate Gallery in London. His public sculpture can be seen around the world, including the Storm King Art Center and the Smithsonian's Hirshhorn Museum and Sculpture Garden.

In the 1990s, Liberman published three more volumes of photographs: a tribute to his close friend Marlene Dietrich, his photographs of the Capitoline Hill in Rome, and a collection of images from the course of his life. Alexander Liberman died in Miami in 1999.

ANNE BLECKSMITH

See also: **Arbus, Diane; Avedon, Richard; Blumenfeld, Erwin; Brassaï; Cartier-Bresson, Henri; Condé Nast; Fashion Photography; Kertész, André; Klein, William; Newton, Helmut; Penn, Irving; Steichen, Edward**

Biography

Born in Kiev, Russia, September 4, 1912. Received baccalaureate from the Sorbonne, 1930. Studied painting with André Lhote, 1931. Studied architecture at the Ecole Spéciale and Ecole des Beaux-Arts, 1931–1932. Joins staff at *Vu*, 1933. Won medal for magazine design at the Paris International Exhibition, 1937. Arrives in New York as an exile and began work at *Vogue*, 1941. Promoted to art director of *Vogue*, 1943–1962. Became executive director of all Condé Nast Publications, 1962. Died Miami, Florida, November 19, 1999.

Individual Exhibitions

1959 *The Artist in His Studio*; Museum of Modern Art, New York, New York
2003 *Portraits of Artists by Alexander Liberman*; Getty Research Institute, Los Angeles, California

Selected Works

Cézanne's studio, 1949
Coco Chanel in the Tuileries, 1951
Pablo Picasso in his Studio, Vallauris, France, 1954
Alberto Giacometti in his Paris studio, 1955
Marcel Duchamp's Hands, 1960
Barnett Newman Leaving his White Street Studio, 1968

Further Reading

Delvin, Polly. *Vogue Book of Fashion Photography 1919–1979*. New York: Simon and Schuster, 1979.

Kazanjian, Dodie, and Tompkins, Calvin. *Alex: The Life of Alexander Liberman*. New York: Knopf, 1993.

Liberman, Alexander, ed. *The Art and Technique of Color Photography: A Treasury of Color Photographs by the Staff Photographers of Vogue, House & Garden, Glamour*. New York: Simon and Schuster, 1951.

———. *The Artist in His Studio*. New York: The Viking Press, and London: Thames and Hudson, 1960; London: Thames and Hudson, 1989; New York: Random House, 1988.

———. *Greece, Gods and Art*. New York: The Viking Press, 1968.

———. *Marlene: An Intimate Photographic Memoir*. New York: Random House, 1992.

———. "Steichen's Eye." In *Steichen the Photographer*. New York: The Museum of Modern Art, 1961.

———. "The Stones of Venice." *Horizon Magazine* 5, no. 3 (1963).

Liberman, Alexander, and Brodsky, Joseph. *Campidoglio: Michelangelo's Roman Capitol*. New York: Random House, 1994.

Liberman, Alexander, and Tompkins, Calvin. *Then: Alexander Liberman Photographs 1925–1995*. New York: Random House, 1995.

Rose, Barbara. *Alexander Liberman*. New York: Abbeville Press, 1981.

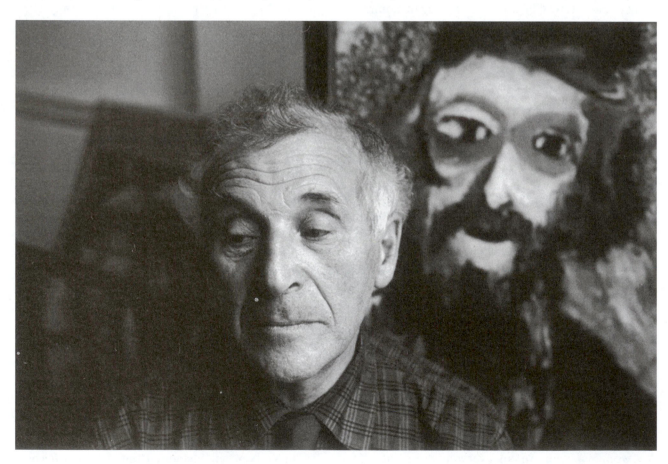

Alexander Liberman, Marc Chagall, 1957, gelatin silver print.
[*Research Library, The Getty Research Institute, Los Angeles*]

LIBRARY OF CONGRESS

The Library of Congress is a unique, multi-faceted institution. Among its many functions, it houses an important collection of historic photographs, along with other visual materials, in the Prints and Photographs Division. To understand the scope of the Library's photographic collections, it is useful to consider the larger context of the Library's diverse collections, services, and programs. It serves as the legislative library and research branch of the U.S. Congress, for example, as well as the copyright agency for the United States; a center for scholarship with research materials in diverse media, representing a comprehensive, international range of subjects in more than 450 languages; a public institution with many general and specialized reading rooms; a government library; a major provider of bibliographic data, products, and services; a sponsor of exhibitions and musical, literary, and cultural programs; a conservation research center; and the largest repository of maps and atlases, printed and recorded music, motion pictures, and television programs in the world.

The Library of Congress was established when the U.S. Congress was preparing to move to its new capital of Washington D.C. On April 24, 1800, President John Adams approved legislation to appropriate $5,000 to purchase "such books as may be necessary for the use of Congress," and on January 26, 1802, President Thomas Jefferson signed the law defining the functions of the Library, creating the position of Librarian of Congress, and giving Congress authority to establish the Library's budget and regulations.

Jefferson believed that the American legislature needed access to information on "all subjects" in many languages in order to govern a democracy, so a comprehensive mandate for the Library's collections was implicit. He argued that there was "no subject to which a Member of Congress may not have occasion to refer." This Jeffersonian concept is the rationale for the broad collecting policies of the Library of Congress, which were most fully realized in the twentieth century. Jefferson's belief in the power of knowledge and its importance to democ-racy also encouraged the Library to share its collections and services extensively with other institutions.

During the early 1850s, as the Library began to expand in size and function, it had to stave off competition from the Smithsonian Institution to serve as the national library. The Smithsonian's librarian, Charles Coffin Jewett, tried to establish a national bibliographical center at the Smithsonian, but his plan was blocked by Smithsonian Secretary Joseph Henry, who preferred that the Smithsonian concentrate on its programs of scientific research and publication. Henry favored the development of a "national" library at the Library of Congress, and in 1854 he dismissed Jewett, agreeing 12 years later to transfer the entire 40,000 volume library of the Smithsonian Institution to the Library of Congress.

The person most responsible for shaping the Library of Congress into an institution of national significance in the Jeffersonian spirit was Ainsworth Rand Spofford, Librarian of Congress from 1865 to 1897. Spofford achieved this goal by linking the legislative and national functions of the Library through the 1897 reorganization of the Library.

In 1876, the U.S. Bureau of Education listed the rapidly growing Library of Congress as one of the two largest libraries in the United States, with its approximately 300,000 volumes. By 1897, when the Library moved from the Capitol into its spacious new building, its collections ranked first among American libraries in size and scope. Over 40% of its 840,000 volumes and 90% of the map, music, and graphic arts collections had been acquired through copyright deposit. Important items deposited with copyright registrations included Civil War photographs by Mathew Brady's studio and some of the earliest motion pictures.

Copyright deposits greatly influenced the development of the Library's collections. When the Library moved into its new building, separate custodial units were established for the special collections formed primarily through copyright deposit— maps, music, and graphic arts. Spofford's successors as Librarian of Congress hired subject special-

ists to develop these and other collections and persuaded Congress to appropriate substantial funds to purchase research materials for all collections. Copyright deposit remained one of the Library's major acquisitions sources throughout the twentieth century, but between 1865 and 1897 it was fundamental in making the Library of Congress a national institution.

Shared acquisitions and cataloging necessitated international bibliographic standards, and the Library met the challenge through the creation in the mid-1960s of the MARC (Machine Readable Cataloging) format for communicating bibliographic data in machine-readable form. This new capability for converting, maintaining, and distributing bibliographic information soon became the standard format for sharing data about books and other research materials. The possibility of worldwide application was immediately recognized, and the MARC structure became an official national standard in 1971 and an international standard in 1973. Although this format was clearly library-oriented, it found favor with the archival community, where it has been extensively used to catalog photographic collections and individual photographs in a variety of institutional settings, including libraries, archives, and historical societies (art museums are notable exceptions to this trend).

The Library of Congress has greatly expanded beyond its initial function as a library devoted to books, so its collections span the traditions of libraries, archives, and museums, including not only conventional printed books but rare and unique books and incunabula, maps, printed ephemera, photographs, motion pictures, and even musical instruments. Although widely acknowledged as the "national" library, it still does not serve as an official national library in the same sense that such institutions exist in other countries.

Photographs in the Library of Congress in Washington are held in the Library's Prints and Photographs Division, along with other works on paper, from printed posters to fine-art prints. The Adams Building of the Library, opened in 1939, contained the Prints and Photographs Division until the massive Madison Building was completed in 1980. The Prints and Photographs Division in this modern facility is easily accessible to researchers. Although the aims of the Library in collecting photographs have tended toward the documentary, they also encompass fine-art photographs, especially since curator Jerald C. Maddox, who served as curator of photography in the pivotal period

from 1966–1987, consciously began forming a collection informally identified as "master" photographs in the 1970s. George J. Hobart became curator of documentary photography in 1968. Other noted photographic professionals who have helped shape the collections and practices of the Prints and Photographs Division throughout its history include:

Hirst D. Milhollen (1906–1970), a specialist in photography for over 40 years, helped obtain the Brady collection, and was appointed curator of negatives in 1950. Noted photographer and legendary archivist Paul Vanderbilt was chief of the Prints and Photographs Division from 1947–1950, and consultant in iconography, 1950–1954. He developed the basic scheme of picture retrieval. Alan Fern, on the staff of the Library for 21 years, was chief of the Prints and Photographs Division, then director for special collections since 1978, until serving as director of the Smithsonian Institution's National Portrait Gallery, 1982–2000. Stephen E. Ostrow succeeded Fern as chief of the Division. Recent photography staff include Beverly Brannan, curator for large documentary collections since 1974, and Verna Curtis, who became Jerald Maddox's successor.

When Merry Foresta began collecting art photographs for the Smithsonian Institution's National Museum of American Art (later called the Smithsonian American Art Museum) in the early 1980s, this initiative represented competition, which led the Library to return to its concentration on the documentary tradition and to de-emphasize its commitment to new acquisitions of "fine-art" photography.

The functions of the Division are separated into three areas: curatorial, cataloguing, and reference. The specialized and skilled members of the cataloguing staff have been highly influential in their field for many years. Typically developing descriptive and technical standards that encompass photographs and non-photographic prints alike, their publications and professional networking, both formal and informal, have promoted professionalism and the standardization of rules, procedures, and nomenclature for prints and photographs throughout the archival, library, and museum communities.

Collections

An overview of some of the Library's photographic holdings provides some impression of their diversity, size, scope, and significance. The more than 725 daguerreotypes in the Prints and Photographs Division include primarily portraits, but fine architec-

tural views and outdoor scenes are found also. In 1926, the Library acquired its first "master" fine-art photographs: two important groups of works from the estate of influential pictorialist Clarence H. White and from his fellow Photo-Secessionist, Gertrude Käsebier. Although the Library had by this time amassed substantial holdings of documentary photographs, these acquisitions marked its recognition of the artistic value of the medium and its intention to develop collections of aesthetic significance in tandem with those of documentary importance.

In the 1930s, photographs by F. Holland Day and Clarence H. White were received from the Alfred Stieglitz estate. For many years the Stieglitz photographs were kept in the rare book room, but eventually curator Jerald Maddox consolidated the photographs into the Prints and Photographs Division.

In the 1930s, the Carnegie Corporation provided funds to establish and support at the Library a national repository for photographic negatives of early American architecture, now called the Pictorial Archives of Early American Architecture. This development had been encouraged by the deposit at the Library in 1929 of several thousand photographic negatives of gardens and architectural subjects by an important architectural photographer (among her other specialties), Frances Benjamin Johnston. This deposit was followed by many others in later years. Supported by grants from the Carnegie Corporation, Johnston was commissioned by the Library to create an archive of her fine photographic records of the rapidly disappearing Southern antebellum architecture, with special devotion to its humbler buildings. Johnston's donation of a body of work set an important precedent for donations of architectural photographs by photographers and their families and sponsors, among them Gertrude Wittemann, Theodor Horydczak, Carol M. Highsmith, and Joseph E. Seagram and Sons.

In 1943, Librarian of Congress Archibald MacLeish announced the purchase of the photographic prints and glass negatives by Arnold Genthe (1869–1942) remaining in his studio at the time of his death. This collection of approximately 10,000 negatives, 8,700 contact prints and enlargements, plus transparencies and color work, is the largest assemblage of Genthe's work anywhere. At about the same time MacLeish established a committee "to insure the proper development" of the Library's photographic archive.

Genthe was an internationally recognized photographer working in the soft-focus pictorialist style. The Library's "electronic collection" contains approximately 16,000 of Genthe's black-and-white negatives, transparencies, lantern slides, and color Autochromes. Its production was part of an initiative by Congress to help the Library to preserve fragile negative collections. Most of Genthe's prints were unprocessed by the end of the century, however, and access to them requires written permission from the Chief, Prints and Photographs Division.

The Library's Prints and Photographs Division has long been almost synonymous with documentary photographs from the era of the Great Depression. In 1940, the Library of Congress Works Projects Administration (WPA) Project began collecting materials produced by the federal art, music, theater, and writers' projects and the Historical Records Survey. In collecting materials from these government-initiated projects, the line between the missions of the Library and the National Archives was blurred, since the National Archives would normally (and more logically) collect original materials produced or commissioned by the federal government.

In 1944, the Library took custody of the Office of War Information collection of nearly 300,000 photographs, including the "photo-documentation of America" file organized by Roy E. Stryker in the Farm Security Administration from 1936 to 1942. The combined photographic archives of two landmark photographic documentation projects carried out successively within two federal agencies, the Farm Security Administration (FSA) and the Office of War Information (OWI), were placed by executive order under the administration of the Library. The FSA-OWI archive was the most comprehensive photographic survey of the lives of ordinary people ever assembled. To the Library's already extensive pictorial coverage of American buildings, cities, and news events it added an unequaled record of a broad spectrum of Americans living and coping with the difficult period of 1935–1943. The famed photographers, who worked on the basis of field assignments from Stryker, included Walker Evans, Dorothea Lange, Russell Lee, Arthur Rothstein, Ben Shahn, Jack Delano, Esther Bubley, Gordon Parks, Marion Post Wolcott, Carl Mydans, and John Vachon. As the scope of the project broadened, the photographers began documenting both rural and urban areas, then turned to Americans' mobilization for war. The total collection, including photographs from outside sources—military, industrial, and news bureaus, contains about 164,000 black-and-white film negatives and transparencies, 1,610 color transparencies, and 107,000 black-and-white photographic prints.

In 1943, Ansel Adams (1902–1984) documented the Manzanar War Relocation Center in California and the Japanese Americans interned there during World War II. In *"Suffering under a Great Injustice": Ansel Adams's Photographs of Japanese-American Internment at Manzanar*, the Prints and Photographs Division at the Library of Congress presented on the World Wide Web side-by-side digital scans of both Adams's 242 original negatives and his 209 photographic prints, allowing viewers to observe his darkroom technique and cropping decisions. Although most of the photographs are portraits, the images also include daily life, agriculture, and sports and leisure activities. Adams donated these prints and original negatives to the Library between 1965 and 1968. In the World Wide Web version, the entire collection appears online for the first time. The online collection also includes digital images of the first edition of *Born Free and Equal*, the book Adams based on his work at Manzanar.

The Panoramic Photograph Collection contains approximately 4,000 images featuring American cityscapes, landscapes, and group portraits. These panoramas offer an overview of the nation, especially for the early twentieth century when the panoramic format was at the height of its popularity. Subjects include: agricultural life; beauty contests; disasters; engineering works such as bridges, canals and dams; fairs and expositions; military and naval activities, especially during World War I; the oil industry; schools and college campuses; sports; and transportation. The images, 1851–1991, cover all the states and the District of Columbia, plus some foreign countries and U.S. territories. The Library's large collection of panoramas was formed largely during the late nineteenth and early twentieth centuries, again in consequence of the copyright privilege. More than 400 photographers are represented in the collection. Postcards and magazines reproduced panoramas as advertisements for real estate and the promotion of the tourist industry. Panoramic photographs were also popular as group portrait souvenirs for people attending conventions, conferences, and company events, when panoramic photographers actively solicited orders from the large number of participants in such wide-format group portraits.

The Theodor Horydczak Collection (mid-1920s–1950s) documents both the architecture and people of the Washington metropolitan area in the 1920s–1940s, including streets and neighborhoods and exteriors and interiors of commercial, residential, and government buildings and interiors. Washington events and activities of national import, such as the 1932 Bonus Army encampment, the 1933 World Series, and World War II preparedness campaigns, are also depicted.

One of the important benefactors of the Prints and Photographs Division was Angelo A. Rizzuto (1906–1967), whose gift of his own photographs was accompanied by a financial gift. Rizzuto had conducted a major photographic survey of Manhattan and planned a publication. In 1969, through Rizzuto's bequest, the Library received the working files for his unfinished book. The 60,000 black-and-white negatives and photoprints offer a detailed record of Manhattan from about 1952 to 1966. The emphasis in Rizzuto's work is on the vast scale of the Manhattan cityscape and the complex interrelationships between people and their environment. Although he supplied minimal caption information, the photographer carefully organized his images chronologically. The collection has not been cataloged and is not available for use except by special petition. Division chief Alan Fern decided to purchase photographs for the collection with Rizzuto's fund, and Jerald Maddox used it judiciously to acquire art photographers' portfolios. The Rizzuto fund also facilitated the acquisition of photographs by Roger Fenton.

The *Look* Collection includes 3.9 million photographs, negatives, and color transparencies (represented by about 10,060 catalog records), ca. 1951–1971. This material is rich in the documentation of American and international events and the lifestyles of celebrities, as well as the "human interest" stories of the less than famous, in which the now defunct *Look* magazine specialized.

The Carl Van Vechten Photographs Collection includes 1,395 photographs, taken from 1932–1964 by this American photographer (1880–1964). The collection is noted for portraits of celebrities, especially figures from the Harlem Renaissance. While the Van Vechten material represents only a portion of the artist's total output, the Library also contains some photographers' complete archives, such as the Toni Frissell collection, which is notable for both her significant World War II contribution and her fashion photography.

Other photographic collections include: the American Red Cross Collection of 50,000 photographs and negatives; the 303 glass-plate negatives among the papers of Orville and Wilbur Wright, which record their work with flying machines, donated in 1949; the Abdul-Hamid II Collection, which portrays the Ottoman Empire during the reign of one of its last sultans, Abdul-Hamid II,

with 1,819 photographs in 51 large-format albums, ca. 1880–1893; and photographs produced and gathered by George Grantham Bain, ca. 1900–1931, for his news photo service, including portraits, worldwide news events, and New York City (about 1,200 photographs may be seen online, selected from the larger collection, with records being added frequently).

Access

The Prints and Photographs Reading Room provides public access to the collections and services of the Prints and Photographs Division and is open to patrons conducting research in the Division's collections. The Prints and Photographs collections of over 13.6 million images, including photographs, fine and popular prints and drawings, posters, and architectural and engineering drawings, is international in scope; however, the collections are naturally rich in images documenting the history of the United States and the activities of citizens.

There is no comprehensive published catalog describing the enormous collection of the Prints and Photographs Division, and intellectual access is complicated. Many materials are cataloged in groups, with no itemized listing, and others are not listed in a catalog, but rather are made available through "browsing" files in the Reading Room. A portion of the holdings is available on the Internet. Of special interest are the over 650,000 items (as of 2001) from several of the Division's collections that are represented by catalog records and accompanying digital images in the Prints and Photographs Online Catalog; new records and digital images are added continuously. Access to the online catalog, as well as to illustrated guides, reference aids, and other information about the Division's collections and services is available through the reading room's home page on the World Wide Web at *http://www.loc.gov/rr/print/*.

The Division has prepared guides, reference aids, and finding aids for particular collections and popularly requested topics, which often list images not yet accessible through the online catalog. There are specialized reference aids, for instance, on "Women's Activities During the Civil War," "Timber Frame Houses," and on the National Child Labor Committee photographs by Lewis Hine. Some of these documents are accompanied by digitized images.

Access to the FSA-OWI negatives is now done electronically via the Library's Web site, and users are often fascinated by the "killed" images which were not printed during the life of the project, whereas access to the prints is through a vertical file in the Prints and Photographs Reading Room and on microfilm surrogates. Many of the prints were sorted into "lots" or groups arranged by assignment or geographic location. Most of the lots were microfilmed in order, after which they were disassembled and refiled according to a decimal classification scheme, involving numbered subject categories, developed by Paul Vanderbilt, who had had prior experience with the collection as an archivist for the OWI. His arrangement of "lots" and the FSA-OWI Reading Room File for the agency was already implemented when the Library received the collection with Vanderbilt as its curator. Vanderbilt apparently intended to interfile images from non-FSA-OWI sources into the large browsing file he had created, but such an expansion was never implemented; in retrospect, most researchers are probably relieved that this very special collection is not encumbered or confused by photographs from other sources. Even picture researchers who are normally more interested in the subject content of pictures than in their provenance or creators realize the historical and practical value of keeping this illustrious FSA-OWI archive separate from other pictures of similar subjects.

Access to the lots by photographer, location, and subject headings is provided by records in a card catalog. The microfilm of approximately 1,800 lots (400 lots were not microfilmed) preserves this initial arrangement by assignment. A published set of 1,637 microfiches reproduces the FSA-OWI Reading Room File: *America 1935 1946: The Photographs of the U.S. Department of Agriculture, Farm Security Administration, and the U.S. Office of War Information, Arranged by Region and by Subject.*

The popular Web-based American Memory Project was established in 1990 to begin sharing portions of the Library's Americana collections in electronic form. Since the Prints and Photographs Online Catalog generally includes only cataloging implemented since the mid-1980s, images organized and described in prior decades are available only by searching manual files in the Prints and Photographs Reading Room. Some images are described at the group level rather than the item level, so many published images credited to the Prints and Photographs Division may not yet be available via the online catalog.

Full use of the collections in the Prints and Photographs Reading Room requires the help of staff familiar with the Division's varied systems of cataloging and finding aids and who supervise the safe, appropriate use of disparate materials. Special

arrangements must be made when patrons wish to view more than 15 original items from the Division's collections (not including documentary photographs, which constitute the bulk of the Division's holdings); unprocessed and/or fragile material requiring supervised handling or special preparation for visits by classes or groups; or when the number of images requested exceeds average use. Researchers sometimes have been frustrated by limitations on access to descriptive information about photographic collections, largely attributable to the Library's chronic backlog of processing and cataloguing (which in turn has been criticized as the result of bureaucratic mismanagement and delay), but the Division's willingness to negotiate physical access to unprocessed materials has been exemplary and much admired. Many repositories will not allow research access until collection materials until processing has been completed. The policy of the Prints and Photographs Division, whether official or unofficial, has been flexibility in working around these limitations with researchers.

The Library does not grant or deny permission for the reproduction of images from its collections. While some may be unrestricted, e.g., when their copyrights have expired and they have entered the public domain, many others in the Prints and Photographs Division clearly are covered by current copyright restrictions; indeed, the very presence of many photographs in the Library was occasioned by their submission with copyright registrations. Patrons are advised to be aware of the kinds of rights and restrictions that might apply, such as copyright, licensing agreements, trademark, donor restrictions, privacy rights, and publicity rights. Since the Library houses the U.S. Copyright Office, its passive attitude toward copyright restrictions and reluctance to vigorously enforce copyright might seem odd, since other repositories frequently refuse to provide copies of materials known to be copyrighted. The Library's attitude, however, is that the burden of adherence to copyright and other restrictions is the responsibility of the user, not the repository, and is consistent with its generally very open policies.

DAVID HABERSTICH

See also: **Adams, Ansel; Archives; Delano, Jack; Documentary Photography; Evans, Walker; Farm Security Administration; Hine, Lewis; Käsebier, Gertrude; Lange, Dorothea; Lee, Russell; Look; Office of War Information; Panoramic Photography; Shahn, Ben; Stieglitz, Alfred; Stryker, Roy; Visual Anthropology; War Photography; White, Clarence; Works Projects Administration**

Further Reading

Adams, Ansel. *Born Free and Equal.* Bishop, CA: Spotted Dog Press, 2001.

America 1935–1946: The Photographs of the U.S. Department of Agriculture, Farm Security Administration, and the U.S. Office of War Information, Arranged by Region and by Subject, Cambridge, England: Chadwyck-Healey; Teaneck, N.J.: Somerset House, 1980.

Cole, John Young. *For Congress and the Nation: A Chronological History of the Library of Congress.* Washington: Library of Congress, 1979.

———. *Jefferson's Legacy: A Brief History of the Library of Congress.* Washington: Library of Congress, 1993.

Collins, Kathleen. *Washingtoniana: Photographs: Collections in the Prints and Photographs Division of the Library of Congress.* Washington: Library of Congress, 1989.

Conaway, James. *America's Library: The Story of the Library of Congress, 1800–2000.* Foreword by James Billington; introduction by Edmund Morris., New Haven, CT: Yale University Press in association with the Library of Congress, 2000.

Fern, Alan, and Milton Kaplan. "John Plumbe, Jr., and the First Architectural Photographs of the Nation's Capitol." *The Quarterly Journal of the Library of Congress* 31 (January 1979): 3–20.

Fern, Alan, Milton Kaplan, and the staff of the Prints and Photographs Division. *Viewpoints: A Selection from the Pictorial Collections of the Library of Congress; A Picture Book.* Washington: Library of Congress, 1975.

Frissell, Toni. *Toni Frissell: Photographs, 1933–1967.* Introduction by George Plimpton; foreword by Sidney Frissell Stafford. New York: Doubleday in association with the Library of Congress, 1994.

Green, Shirley L. and Diane Hamilton. *Pictorial Resources in the Washington, D.C., Area.* Washington: Library of Congress, 1976.

Kusnerz, Peggy Ann. *Picturing the Past: Photographs at the Library of Congress, 1865–1954.* Ph. D. dissertation. University of Michigan, 1992, Ann Arbor, MI: UMI Dissertation Services, 1994.

Melville, Annette. *Special Collections in the Library of Congress: A Selective Guide.* Washington, DC: Library of Congress, 1980.

Rohrbach, Peter T. *Automation at the Library of Congress, the First Twenty-five Years and Beyond.* Washington: Library of Congress, 1985.

Shaw, Renata V., compiler. *A Century of Photographs, 1846–1946, Selected from the Collections of the Library of Congress.* Washington: The Library, 1980.

JEROME LIEBLING

American

Jerome Liebling's photographs are the visual manifestations of his fascination and concerns for people, their places in the world, and their abiding passions. Despite a career of over 50 years of image making, his photographic identity is elusive; it is as difficult to summarize Liebling in a phrase as it is to represent the nuanced range of his photographs in a single example. Neither journalist nor portraitist, Liebling's niche can be provisionally labeled as "documentary humanist." As Sarah Boxer wrote, "Liebling's photographs go beyond the humane—the standard tone of documentary—and reach the human." Though he claims that "My life in photography has been lived as a skeptic," and a note of moral indignation pervades his work, his photographs are neither nihilistic nor cynical. Instead, they seem transcendent, as if the visible, material world is transmuting into something ethereal. Exterior shells, costumes, and carapaces mingle with living forms in his photographs; they instill a keen appreciation of our own corporeal and spiritual existence.

New York City was Liebling's birthplace and first major subject; his earliest important works record children engaged in imaginative games and explorations on the city streets, along with neighborhood and family rituals. He studied photography prior to and following his army enlistment in World War II. His association with Walter Rosenblum at Brooklyn College inspired his participation in the Photo League from 1946 to 1948; the socially conscious activities of the League photographers matched his own sense of the need for photography to address issues of morality and justice. Besides Rosenblum, Paul Strand's photographs and films were important influences, along with others engaged with the progressive humanism of the League. Ad Reinhardt was one of Liebling's design teachers, and his Bauhaus-inspired curriculum left an important mark on Liebling's work. Addressing the pain and suffering he witnessed in wartime Europe became another formative, lasting goal of his photography.

In 1949, he left New York City and began teaching photography in Minneapolis at the University of Minnesota. It was there that his career as a photographer, filmmaker, and teacher was firmly established. Liebling was among the earliest to teach photography in a university setting (and was one of the founders of the Society for Photographic Education in 1962). His legacy at the university and in Minnesota is still strongly felt among a generation of photographers. *Light of Our Past*, a 1983 exhibition in St. Paul, included Liebling and the work of 30 other photographers who came to maturity during Liebling's two decades in Minnesota and who, in most cases, were either formally or informally guided by Liebling. The influence is more intangible than specific, more about a personal, open-ended, and inquiring attitude towards one's subject than a specific way of applying one's tools. Passionate engagement is valued highly, as is a sense of justice and respect.

While his subject matter has been extremely diverse, Liebling's formal approach has been consistent over time, reflecting a purity of vision instilled in him by his exposure to Bauhaus design imperatives. As Naomi Rosenblum explains, "Liebling has made the economy of means that is at the heart of Bauhaus aesthetic doctrine reverberate with emotional intensity" (*Contemporary Photographers* 1982, 455). His photographs are made with a hand-held, medium format camera, allowing both descriptive richness and a mobile, responsive point-of-view. Like August Sander's, Liebling's portrait subjects are usually well described by contextual details like clothing and equipment. Overriding all physical evidence, however, is a gentle yet intense regard that characterizes Liebling's work. In speaking of his portraits he refers to an exchange between photographer and subject, a giving to each other that is critical to the image. The results can feel very intimate. His choices of subjects tend to favor those whose lives are filled by labor. "My sympathies remained more with the folk who had to struggle to stay even, whose voices were often excluded from the general discourse," Liebling wrote in 1997.

He has worked in both black-and-white and color, taking up the latter, with tremendous facility, in the late 1970s. Many of his subjects listed below have been realized in both media. The extended series, often covering many years, is important to Liebling, though more as accumulation of distinct,

time-inflected views than as conventional narrative. Among the subjects Liebling has recorded are: handball players; cadavers; mannequins; agricultural workers; politicians in various guises; slaughterhouse workers in South St. Paul; informal street portraiture in Miami, New York's Brighton Beach, and Minneapolis' Gateway District; street scenes in Spain and London; ruined buildings in the South Bronx; clients of social service agencies; Native American and Shaker communities; mining and manufacturing areas of the Midwest; and the farming landscape of Massachusetts's Pioneer Valley and the physical traces of Emily Dickinson in Amherst. Regional concerns have informed Liebling throughout his career; he has, purposefully and incidentally, made telling portraits of his three long-term homes—New York City, Minnesota, and Massachusetts, where he moved in 1970.

Liebling's motion picture work reflects the importance of serial imagery. He studied film at the New School for Social Research, concurrent with his engagement in the Photo League. He taught photography and film simultaneously while at the University of Minnesota and Hampshire College, Amherst, Massachusetts. His academic colleague in Minnesota, Allen Downs, was a frequent collaborator; their films include *The Tree is Dead* (1955), *Pow-Wow* (1960), and *The Old Men* (1965). Group projects at the university, echoing similar efforts in the Photo League, included documenting the demolition of the Metropolitan Building, a landmark building razed in 1961 as part of a Minneapolis urban renewal campaign. Filmmaker Ken Burns has noted his influence on a generation of Hampshire students.

Alan Trachtenberg, a frequent commentator on Liebling's work, offers a fitting summary:

> Liebling's pictures are often difficult to look at, not easy to take. His work embraces great extremes and demands much in return....Liebling speaks what is on his mind as well as what is in his eyes, and speaks directly to common civic concerns. There is no mistaking that his camera is an instrument of communication.

(Trachtenberg 1982, n.p.)

GEORGE SLADE

See also: **Bauhaus; Photo League; Portraiture; Sander, August; Strand, Paul; Worker Photography**

Biography

Born in New York City, New York, 16 April 1924. United States Army, 1942–1945. Studied design with Ad Reinhardt and photography with Walter Rosenblum and Paul Strand, Brooklyn College, 1942, 1946–1948. Studied film production, direction, cinematography, and script writing, New School for Social Research, New York City, 1948–1949. Professor of Film and Photography, University of Minnesota, Minneapolis, 1949–1969; Professor of Film and Photography, State University of New York, New Paltz, 1957–1958; Professor of Photography and Film Studies, Hampshire College, Amherst, Massachusetts, 1970–1990; Vice President, University Film Study Center, 1975–1977; Editorial Board, *Massachusetts Review*, 1975 to present; Yale University, Walker Evans Visiting Professor of Photography, 1976–1977; University of New Mexico, 1978; Professor Emeritus, Hampshire College, 1990 to present. Massachusetts Arts and Humanities Foundation Fellowship, 1975; John Simon Guggenheim Memorial Foundation Fellowships, 1977, 1981; National Endowment for the Arts Photographers Fellowship, 1979; Massachusetts Council of the Arts Fellowship, 1984; project director for National Endowment for the Arts Survey Grant, 1984; honorary Doctor of Laws degree, Portland School of Art, Portland, Maine, 1989. Living in Amherst, Massachusetts.

Individual Exhibitions

1950 *Jerome Liebling: Photographs*; Walker Art Center, Minneapolis, Minnesota
1951 The Portland Art Museum; Portland, Oregon
1952 *Jerome Liebling, 1950–1951: A Photographic Document of the Minnesota Scene*; University Gallery, University of Minnesota, Minneapolis, Minnesota
1957 Study Room, George Eastman House; Rochester, New York
1958 New York State University; New Paltz, New York
The Minneapolis Institute of Arts; Minneapolis, Minnesota
1960 Limelight Gallery; New York, New York
1963 *Jerome Liebling: Photographs*; Walker Art Center, Minneapolis, Minnesota
Museum of Modern Art; New York, New York
1972 *Po-Lit-I-Cal Pho-To-Graphs: Of, Pertaining To, or Dealing With the Study of Affairs, Structure...: Jerome Liebling*; Hampshire College Gallery, Amherst, Massachusetts
1978 *Jerome Liebling Photographs, 1947–1977*; Friends of Photography, Carmel, California, and traveled to University of California Art Museum, San Diego, California
1979 *40 Photographs*; University of Massachusetts, Amherst, Massachusetts
1980 *Jerome Liebling: Photographs*; Corcoran Gallery of Art, Washington, D.C., and traveled to Viterbo College, LaCrosse, Wisconsin
1982 *Contemporary Color: Jerome Liebling*; Fogg Art Museum, Harvard University, Cambridge, Massachusetts
Jerome Liebling; Photography Gallery, Portland School of Art, Portland, Maine
1987 *Jerome Liebling: Massachusetts*; Smith College Museum of Art, Northampton, Massachusetts
1988 *Jerome Liebling: A Retrospective*; Howard Greenberg/Photofind Gallery, New York, New York
Jerome Liebling Photographs; Blaffer Gallery of Art, University of Houston, Houston, Texas
1990 *Jerome Liebling Photographs*; Hampshire College, Amherst, Massachusetts
1995 *Jerome Liebling*; 292 Gallery, New York, New York
The People, Yes: The Photographs of Jerome Liebling; The Minneapolis Institute of Arts, Minneapolis, Minne-

sota, and traveled to The Photographers' Gallery, London, England

1997 *Jerome Liebling Photographs*; Konica Plaza, Sapporo, Japan

1998 *Jerome Liebling: Photographs of New York City 1947–1997*; Sidney Mishkin Gallery, Baruch College, New York, New York

2001 *Jerome Liebling Photographs: Locally Grown*; Mead Art Museum, Amherst College, Amherst, Massachusetts
Photographs from "The Dickinsons of Amherst"; Mount Holyoke College Art Museum, South Hadley, Massachusetts

Group Exhibitions

1960 *Photography at Mid-Century*; George Eastman House, Rochester, New York

1961 *Faces and Facades: Photographs of the Gateway Area by Jerome Liebling and Robert Wilcox*; University Gallery, Northrop Memorial Auditorium, University of Minnesota, Minneapolis, Minnesota

1962 *American Invitational Photography Exhibition*; DeCordova and Dana Museum, Lincoln, Massachusetts

1963 *Five Unrelated Photographers*; Museum of Modern Art, New York, New York

1966 *Photography Invitational*; Sheldon Memorial Art Gallery, Lincoln, Nebraska

1967 *The Camera As Witness*; International Exhibition of Photography, Expo 67, Montreal, Quebec

1968 *Contemporary Photographs: An exhibition of contemporary photographers for purchase by the U.C.L.A. Art Gallery*; U.C.L.A. Art Gallery, Los Angeles, California
Current Trends in Photographs; Scudder Gallery, University of New Hampshire, Durham, New Hampshire

1976 *Contemporary Photography*; Fogg Art Museum, Cambridge, Massachusetts

1978 *Mirrors and Windows: American Photography Since 1960*. Museum of Modern Art, New York, New York
Photographs from the Collection of Sam Wagstaff; Corcoran Gallery of Art, Washington, D.C.
14 New England Photographers; Museum of Fine Arts, Boston, Massachusetts
Photographic Crossroads: The Photo League; International Center of Photography, New York, New York, and traveled to Minneapolis Institute of Arts, Minneapolis, Minnesota

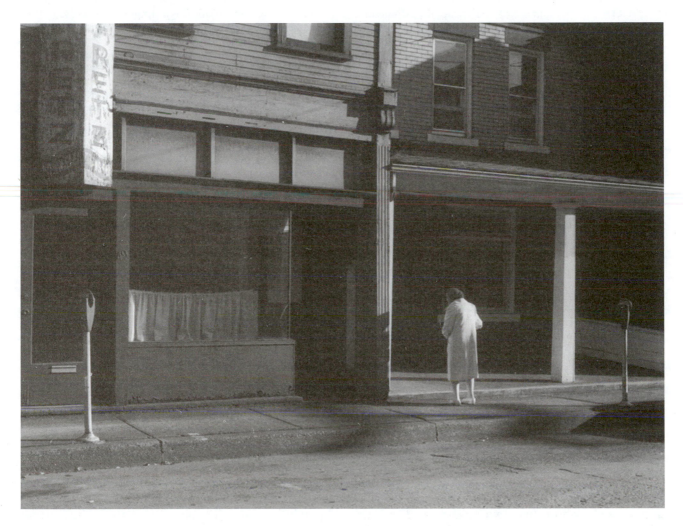

Jerome Liebling, Morning, Monessen, Pennsylvania, 1988.
[*Courtesy of the artist*]

Exhibit One: Eight Massachusetts Photographers; Massachusetts Arts and Humanities Foundation, Boston, Massachusetts

Street Kids, 1864–1977; New York Historical Society, New York, New York

1981 *American Children*; Museum of Modern Art, New York, New York

1982 *Place: New England Perambulations*; Addison Gallery of American Art, Phillips Academy, Andover, Massachusetts

Western Massachusetts in Color, A Survey; Springfield Museum of Fine Arts, Springfield, Massachusetts

1983 *Light of Our Past, 1947–1974: Minnesota Photographic Heritage*; Film in the Cities Gallery, St. Paul, Minnesota

1984 *American Photography 1960–1970*; National Museum of American Art, Smithsonian Institution, Washington, D.C.

1985 *American Images 1945–1980*; Barbican Art Gallery, London, England

1986 *Commitment to Vision*; University of Oregon Gallery, Eugene, Oregon

1994 *American Politicians*; Museum of Modern Art, New York, New York

1995 *Common Lives*; Stichting Fotografie Noorderlicht, Groningen, the Netherlands

1996 *Democratic Processes: American People and Politics*; pARTs Photographic Arts, Minneapolis, Minnesota, and traveled to Hartnett Gallery, University of Rochester, Rochester, New York

1997 *Signs of Age*; Santa Barbara Contemporary Arts Forum, Santa Barbara, California

1998 *Metroscapes: The Gateway Photographs of Jerome Liebling and Robert Wilcox/Suburban Landscapes of the Twin Cities and Beyond*; Frederick R. Weisman Art Museum, University of Minnesota, Minneapolis, Minnesota

2000 *Photography in Boston: 1955–1985*; DeCordova Museum and Sculpture Park, Lincoln, Massachusetts

2001 *Photo League, New York 1936–1951*; Mestre, Galleria Contemporaneo, Venice, Italy

2002 *Changing Prospects: The View from Mount Holyoke*; Mount Holyoke College Art Museum, South Hadley, Massachusetts

This is the Photo League; Columbus Museum of Art, Columbus, Ohio

Selected Works

The Face of Minneapolis, 1966
Jerome Liebling: Photographs 1947–1977 (Untitled 15, Friends of Photography), 1978
Jerome Liebling Photographs, 1982
The People, Yes: Photographs and Notes by Jerome Liebling, 1995
Jerome Liebling: The Minnesota Photographs, 1949–1969, 1997
The Dickinsons of Amherst, 2001

Further Reading

Boxer, Sarah. "The Layers of Time Distilled Into a Moment." *The New York Times*, 22 May 1998.

Burns, Ken. "Freedom of Thought: Jerome Liebling as Teacher." In *The People, Yes*. New York: Aperture, 1995.

Cannon, Mary. "Focus on Fine Art: The Photography of Jerome Liebling." *Minnesota History* 51, no. 8 (Winter 1989).

Liebling, Jerome, ed. *Massachusetts Review* 19, no. 4 (December 1978); as *Photography: Current Perspectives*. Rochester, New York: Light Impressions, 1979.

Livingston, Jane. *Jerome Liebling*. Washington, DC: Corcoran Gallery of Art, 1980.

Richards, Jane. "Every one a hero." *The Guardian* (London) 18 July 1995.

Rosenblum, Naomi. "Liebling, Jerome." In Walsh, George, Colin Naylor, and Michael Held, eds. *Contemporary Photographers*. New York: St. Martin's Press, 1982.

Trachtenberg, Alan. "How Little Do My Countrymen Know." Exh. cat. In *Jerome Liebling Photographs*. 1982, not paginated.

Tucker, Anne W., Clare Cass, and Stephen Daiter. *This Was The Photo League: Compassion and the Camera from the Depression to the Cold War*. Chicago: Stephen Daiter Gallery, 2001.

LIFE MAGAZINE

Life magazine began publication with the 23 November 1936 issue. It was the third in a string of successful magazines developed by publisher Henry Robinson Luce (b. 3 April 1898–d. 28 February 1967), whose first two magazines *Time* and *Fortune* began publication in 1923 and 1930, respectively. Luce predicated his decision to start a picture magazine on his growing belief that photography could communicate the news, tell stories, and elaborate on editorial points of view. He recognized the rhetorical possibilities of photography, noting that he wanted to, "edit pictures into a coherent story—to make an effective mosaic out of the fragmentary documents which pictures,

past and present, are...." For most of the remainder of the twentieth century, *Life* played a major role in expanding the role of photography in U.S. culture. Photography has altered U.S. visual culture profoundly over the last century and *Life*'s refinement of, and consistent use of, the photo-essay has contributed to these changes. Their best-known picture editor, Wilson Hicks, famously noted that pictures, if carefully organized and accompanied by captions, "lend themselves to something of the same manipulation as words." It is hard to overestimate the significance of *Life*'s contribution to the history of photography or to correctly gauge the effects of the magazine's editorializing on American social history. Much of our understanding of the rhetoric of images comes from exposure to the use of photography that *Life* pioneered and some part of what generations of Americans have understood of the world came to them via the magazine.

While the success of *Life* was unprecedented, selling over a million copies each week within four months of its initial publication, the magazine itself did have key models on which to build. Foremost among these, Luce's premier publication, *Fortune*, had for years been using photographs in increasingly essayistic forms. This magazine dedicated to business and culture had also utilized the services of Leica photographers such as Dr. Erich Salomon, whose suites of candid photographs ignited a shift in what *Fortune* was after in its photography. By 1935 the magazine was consistently favoring the use of the lightweight 35 mm cameras for use by its photographers, especially when focusing on people. Their star photographer, Margaret Bourke-White, struggled through the transition to a more humanistic approach to photography that year before signing on to work at *Life*. Her famous cover *Fort Peck Dam* and the accompanying photographs for *Life*'s first issue demonstrated that by 1936 she had mastered the art of candid photography without losing her touch for creating monumentalizing images of industry.

The other major source that Luce relied on for the early development of *Life* was the example of the German illustrated press. For much of the 1920s, first in Germany and then in France and England, European illustrated magazines had demonstrated a great agility in the use of photography as journalism. The *Münchner Illustrierte Presse* and the *Berliner Illustrirte Zeitung*, among others, had long and successful track records when Luce sent Daniel Longwell, the editor in charge of planning *Life*, to Germany to study their illustrated publications. Luce also hired Kurt Korff, the celebrated editor of the *Berliner Illustrirte Zeitung*, who had by then fled Nazi Germany

for New York, to come work with Longwell in the role of advisor. At Korff's recommendation, Alfred Eisenstaedt was hired as one of the main staff photographers at the magazine. Eisenstaedt and Bourke-White's photographic contributions to the early issues of *Life* represent the twin models on which the magazine was predicated: the German illustrated press and Luce's own publication, *Fortune*.

In the summer before he published the first issue, Luce released a prospectus for his new magazine in which he discussed his plans:

> To see life; to see the world; to eyewitness great events; to watch the faces of the poor and the gestures of the proud; to see strange things—machines, armies, multitudes, shadows in the jungle and on the moon; to see man's work—his paintings, towers, and discoveries...to see and take pleasure in seeing; to see and be amazed; to see and be instructed.

During the first two years of *Life*'s publication the editors pursued a program of experimentation with formats. Some of their signature layout features, such as the two-page bleed where one image extends to all four borders of a two-page spread, were developed at this time. As well, they early discovered the sales value of a little sex. Seldom did an issue of *Life* miss the opportunity to include partially clad women, sometimes under cover of a story on Hollywood or thinly veiled as a fashion piece on the season's swimwear. Though this practice opened the magazine to criticism from some fronts, its impact on sales was undeniable.

Life soon realized that they needed more photographers on their staff. In addition to Bourke-White and Eisenstaedt, they began publication with only two other experienced photographers—Peter Stackpole and Thomas D. McAvoy. The editors planned to supplement their staff photographers' photo-essays with news service pictures. They also wished to find people familiar with the growing practice of documentary photography. To this end, as the magazine hired new photographers they sought out people such as Carl Mydans who had trained under Roy Stryker in the Historical Section of the Farm Security Administration (FSA). Stryker taught FSA photographers to work from a script to ensure that they brought home images that supported a particular argument. Documentary became a mode of photographic persuasion that used the rhetoric of realism to gain an authoritative voice on a given subject. Stories were planned in advance and the photographers given lists of desired images to go create. Along with the captions and the context of the magazine's story, the photographs carried

the weight of authenticity that came to characterize this practice. *Life* deserves credit for participating in the development of this form of visual rhetoric, even as its editorial points of view must be clearly understood.

Under Luce's watch, for example, the magazine took an editorial stance in favor of intervention in the European conflicts of the late 1930s. To enlist the support of their readers, they published stories that focused on France's and Britain's need for help. In the wake of Germany's annexation of Austria they ran a 16-page spread in their 28 March 1938 issue on the rise of the Nazi party. The accompanying text opined that Austria was just the first step in Germany's plans for European domination; it further decried the treatment of Jews under the Nazis. With this article, and others like it, the editors of *Life* attempted to shake the magazine's readers out of their lingering isolationist slumber and prepare them for war. Over the next three years, the magazine would steadily endorse the need for American involvement in the European conflict and stress the implausibility that the French Army or the British navy would be able to forestall a German advance westward.

The culmination of the magazine's World War II editorializing came with Luce's famous essay "The American Century," which appeared in the 17 February 1941 issue. Luce used *Life*'s editorial page to argue that Americans must "accept wholeheartedly our duty and our opportunity as the most powerful and vital nation in the world and in consequence to exert upon the world the full import of our influence, for such purposes as we see fit and by such means as we see fit." He looked beyond the war as well to a time when the country would assume its role as de facto leaders of the world. In this light, the international coverage in the magazine took on the quality of surveying an empire, one that Luce argued belonged rightfully to all Americans willing to step up and accept their destiny.

Once the United States entered the war, *Life* endeavored to reinforce the decision and to defend their role in shaping public opinion. In the 15 December 1941 issue, the magazine editorialized that

> *Life's* new-age journalism makes information about *all* the forces that move and shape our lives easy to understand and absorb—and infinitely exciting. In doing this, *Life* helps great masses of people come to grips with the world as it really is—helps them make more intelligent decisions.

Life covered World War II aggressively, sending its best photographers around the world to capture in great detail every battle they could—it even set up a training camp for new war photographers as many of its veterans were already in the field. Bourke-White photographed Red Square in Moscow the night the Germans bombed the Kremlin; Robert Capa was on the beach with the GIs during the invasion of Normandy on D-Day; William Vandivert endured the Blitz of London; and W. Eugene Smith sent back unsparing images of the rigors of the Pacific conflict. Their efforts brought impressive returns. By some estimates, 15% of all American adults read *Life* magazine by the time the conflicts in Europe began.

Life was not without controversy during its rise, both from outside and inside the magazine. From the start, many scholars criticized the magazine's oversimplification of complex subjects (such as Friedrich Nietzsche's philosophy). Others found it culturally philistine. Despite *Life*'s constant commitment to reproducing art—they reproduced over 72 paintings in the first six months of 1950—many modern artists criticized their less-than-adventurous selections. The conservatism of the first decade changed incrementally as evidenced by lavishly illustrated articles on Abstract Expressionism as early as 11 October 1948 and continuing for the following decade. Internally, the problems tended to involve rifts between the editors and the photographers or writers. W. Eugene Smith, who had over 50 photo-essays in *Life* between 1946 and 1952, eventually quit at the height of his success because he had no control over the final layout of his pictures or the content of the captions. He objected strenuously and over a long period, but the editors were unwilling to give up control of the key stage in creating the magazine. Smith resigned in 1954.

Throughout the 1950s and into the 1960s, *Life* maintained a dominant position in the magazine world. One 1950 survey estimated that half of the American population now read at least one copy of *Life* in a three-month period. By 1953, almost 5 million copies were sold each week—which implied that over 26 million actually read the magazine once the "pass-around" factor was considered. Some of the magazine's most memorable stories date to those years, including W. Eugene Smith's "A Spanish Village" (9 April 1951). Despite the advances in television technology, and a growing audience for the programs it carried, *Life* continued to offer one of the most popular formats for the communication of news and events. Television did not have the capability to air news footage in ways compelling enough to steal *Life*'s audience—yet.

With the exponential growth of television—both in terms of people who owned TVs and with what was being offered by the networks—the 1960s

offered the magazine its first declines since its inception. The advances of network news from small, under-financed departments, to large-scale international operations, along with the generous airtime now given to the nightly news, greatly increased their audience. For example, despite having top photojournalists covering the Vietnam War, *Life*'s coverage was dominated by that on television. In turn, advertising revenues started to taper off at the magazine as television offered cheaper advertising when considered in terms of dollars per viewer reached.

Part of *Life*'s success had always been serendipitous; the reasons for its decline would be likewise partially out of its hands. In the 1930s, Luce and his editors were able to capitalize on advances in technology to bring a new type of magazine to the public. In the 1960s it was the broadcast networks' turn at wild popularity. As good as war had always been for the magazine, and the Vietnam war was no exception, even more people turned to nightly news to bring images of the conflict into their homes. In the wake of television's monumental success, and with ever increasing publication costs unmet by dwindling advertising revenue, *Life* ceased publishing as a weekly with the 29 December 1972 issue. Hedley Donovan, then Editor-in-Chief, explained that the magazine had been losing money for four years before deciding to close down. He also held out the promise of a possible return by noting that they had not sold the name. The magazine did produce occasional "Special Event" issues over the next six years and the moderate success of those led the company to try once again to publish *Life*, only now as a monthly.

The new *Life* began with the October 1978 issue and carried on, at times even thriving, until its May 2000 issue. Pictorially, the new *Life* had much in common with its forebear—perhaps too much. Often the magazine seemed dedicated to nostalgia. It did have its high points, though. During the 1980s, *Life* ran emotionally charged stories, such as Donna Ferrato's 1985 piece on domestic violence, which often placed the magazine at the forefront of photojournalism again. And in 1991 the magazine returned to the weekly format as a response to the increased interest generated by the Gulf War. Though short-lived, the experiment was based on the editors' past experiences with increased circulation during wartime. Later in the decade, after returning to the monthly format, *Life* began enjoying profitable years again. The period of economic health lasted until the late 1990s. At that point, the magazine's new editor dismissed approximately a third of the staff, reverted to *Life*'s earlier signature style, and reemphasized photojournalism. These efforts appeared to be working when the announcement of *Life*'s second closing was announced. Despite rising revenues, the costs of printing, paper, and distribution proved overwhelming even for a magazine with the backing that *Life* had. Once again, the publishers dangled the possibility of future special issues.

Tellingly, in 2000 *Life* became available in a limited format as an online journal—*www.lifemag.com*. This digital incarnation of *Life* may prove to be more prophetic than we now realize. The world of photography on paper is losing increasing ground to digital imaging. Perhaps *Life* is once again on the leading edge of how citizens of the world will get their information—the company does continue to control a vast pixilated domain of the world's visual culture.

JOHN STOMBERG

See also: **Bourke-White, Margaret; Capa, Robert; Documentary Photography; Eisenstaedt, Alfred; Farm Security Administration; History of Photography: Interwar Years; Look; Salomon, Erich; Stryker, Roy**

Further Reading

Baughman, James L. *Henry R. Luce and the Rise of American News Media*. Boston: Twayne, 1987.

Elson, Robert T. *Time Inc.: The Intimate History of a Publishing Enterprise*. 3 vols., New York: Atheneum, 1968, 1973, 1986.

Goldberg, Vicki. *Margaret Bourke-White: A Biography*. New York: Harper and Row, 1986.

Hicks, Wilson. *Words and Pictures: An Introduction to Photojournalism*. New York: Harper Brothers Publishers, 1952.

Kozol, Wendy. *LIFE's America: Family and Nation in Postwar Photojournalism*. Philadelphia: Temple University Press, 1994.

Littman, Robert, and Doris C. O'Neil, eds. *LIFE: The First Decade, 1936–1945*. Boston: New York Graphic Society, 1979.

Loengard, John. *LIFE Photographers: What They Saw*. Boston: Bulfinch Press, 1998.

Maddow, Ben. *Let Truth Be the Prejudice: W. Eugene Smith, His Life and Photographs*. Millertown, NY: Aperture, 1985.

Maitland, Edey. *Great Photographic Essays from LIFE*. Boston: Little Brown, 1978.

McGrath, Edward G. *The Political Ideals of LIFE Magazine*. Ph.D. diss., Syracuse University, 1962.

Wainwright, Loudon. *The Great American Magazine: An Inside History of LIFE*. New York: Alfred A. Knopf, 1986.

LIGHT METERS

Light meters (also known as exposure meters) are used to determine the amount of light needed for a given photographic exposure. In many cameras, light meters are often built into the body, and can be made to automatically set the exposure. Handheld light meters are used with cameras without built-in meters, as well as for special metering applications.

The amount of exposure needed on film is determined by the film speed or sensitivity. The light meter is set to this speed to determine the aperture and shutter speed combination that will result in the appropriate amount of density on film. The light meter measures the light intensity of the scene, and then calculates the needed exposure based on the film speed. This exposure is most often given in terms of aperture and shutter speed settings, but can also be rendered in exposure values (EV).

Exposure is a combination of the intensity of the light that reaches the film, and the length of time that light strikes the film. Exposure can be increased and decreased by controlling these two factors. These are controlled by changing the aperture, which controls the brightness, and by changing the shutter speed, which controls the time.

Light meters measure the brightness value of a scene based on the assumption the scene has an average distribution of highlights, midtones, and shadows. The average of these tones is a medium gray, also known as 18% gray. All light meters, regardless of function, rely on 18% as the standard.

Types of Light Meters

The most common form of light meter is the reflected light meter. These meters are most commonly built into camera bodies, but all handheld meters also have reflected metering capability. Reflected meters measure the amount of light being reflected off of the subject and the scene. To take a reflected meter reading, the meter (or the camera) is pointed at the subject or scene to be metered. The meter will then provide readings that will render that scene to the 18% gray standard.

A variation of reflected light meters is the spot meter, which takes a meter reading in a highly specific area, usually about .5–3° of the total scene (as opposed to the 30–50° reading of a standard reflected light meter). Spot meters can be built into a camera system or into handheld meters.

Handheld light meters often have the additional capability of taking incident meter readings. Incident meters evaluate the amount of light falling on the subject. In this manner, the subject's original reflectance values are irrelevant. To take an incident meter reading, the meter is brought to the position of the subject (so that the light falling on the meter is identical to that falling on the subject) and the meter is pointed back toward the lens of the camera. Incident meters use a white dome for a reading, which results in a very wide angle of view (180°). The metered value is calibrated to the 18% gray standard, but it is the light falling on the subject that is placed at this value.

Flash meters are designed to take a light meter reading in the brief burst of light caused by a flash discharge. Flash meters are most often of the handheld variety, and are often capable of both reflected and incident flash meter readings.

Color temperature meters are designed to measure the color temperature of a given light source. Color temperature results in a particular color cast on film that is often not easily detected by the human eye. For example, fluorescent light sources look white to our eye, but render with a greenish cast on film. As every light source has a different color temperature, color temperature meters provide a measurement of that value so that it can be corrected by use of filters while shooting.

Middle Gray

A light meter, regardless of type, assumes that every light source and subject is middle gray, or 18% gray. The 18% gray value is the average of all the possible tones in an image. The assumption that the scene is "average" works fairly well the majority of the time. However, in instances where the scene is not "average," as in an example of a white horse in a field of snow, the meter will render the scene improperly when it places it to 18% gray. The result is a muddy, gray horse and field instead of the white with detail of the original scene. The

solution would be to add two to three stops of exposure to the original meter reading, resulting in greater density on film, which in turn would result in a more appropriate rendition of the original scene.

Other instances when a meter can be "fooled" occurs with scenes that feature high contrast. For example, a scene with a backlit subject will often produce a silhouette of the subject in the photographic print, since the meter will try to average the very light background with the very dark subject. The result is a lack of detail in both areas. The solution would be to get closer to the subject in which the detail is desired, re-meter, and use that setting as the final exposure. The background will still be bright and without detail, but the subject will now be rendered with the desired amount of detail.

Different Meters for Different Scenes

There is no one metering choice for every situation and every scene. Reflected meters are designed to place any subject they are pointing at to 18% gray. The white horse scene mentioned above would render incorrectly if the meter is followed in its exact recommendation. However, knowing the exact tone the meter is to measure can provide an advantage with placement exposure, i.e., placing the tones of the subject based on the middle reading of 18% gray. The white horse scene is the perfect example; knowing the scene would be rendered incorrectly if the meter reading is followed should prompt the photographer to slightly overexpose the scene so that the whites would be white. Reflected meters also have the advantage over incident meters in that they only need to be pointed at the subject. Landscapes and subjects that are very far away are only able to be metered with a reflected meter, because of the impossibility of taking an incident meter reading at such subjects. Reflected meter readings and placement exposure are the building blocks of the Zone System, an exposure and development system developed by Ansel Adams to render the tones of the scene according to the previsualization of the photographer.

Incident meters are used in cases where reflected meters could potentially fail, such as the white horse in a snowy field scene. Since incident meters measure only the light falling on the subject, the subject's original tones are rendered accurately. Incident meters are a poor choice in scenes with complex lighting or ones in which the subject is out of easy reach of the camera.

Metering Systems

Built-in light meters often come with a series of metering features in modern cameras. Most modern SLR cameras come with many metering capabilities. The most common metering features are automatic (in that the exposure is automatically set), and aperture and shutter priority. Aperture and shutter priority can be considered semi-automatic, since they each allow you to choose either an aperture that you want (in aperture priority) or the shutter you prefer (in shutter priority). The camera will then set the corresponding shutter speed or aperture needed to obtain proper exposure.

SLR cameras also often come with features designed to make the metering process more accurate. Most in-camera meters "see" the entire scene inside the viewfinder and calculate the exposure accordingly. However, many modern SLRs can be set so that the meter "looks" to the center (center-weighted) for the exposure, or even more specifically, can be set to look at only a few degrees of a scene at a time (spot metering).

Multi-segmented metering systems, also known as matrix metering systems, divide the scene into a series of segments that are each evaluated independent of one another. The overall pattern is then compared to a series of common patterns inside the camera's memory to give a more accurate exposure. An example of a common pattern would be a darker foreground against a light sky.

CHRISTYE SISSON

See also: **Adams, Ansel; Camera: 35 mm; Camera: An Overview; Exposure; Film; Filters**

Further Reading

Adams, Ansel. *The Camera (Book 1)*. Boston: Little Brown & Co., 1995.
Adams, Ansel. *The Negative (Book 2)*. Little Brown and Co., 1995.
Langford, Michael. *Basic Photography*. New York: Focal Press, 2000.
London, Barbara, and John Upton. *Photography*. 6th ed. New York: Addison-Wesley Longman, 1998.
Meehan, Joseph. *The Photographer's Guide to Using Filters*. New York: Amphoto, 1999.
Schaefer, John. *An Ansel Adams Guide: Basic Techniques of Photography, Book 1*. Boston: Little Brown and Co., 1992.
Stroebel, Leslie and Richard Nakia. *Basic Photographic Materials and Processes*. Saint Louis, Missouri: Butterworth-Heinemann, 2000.

LIGHTING AND LIGHTING EQUIPMENT

A photograph can be created only through the action of light on a sensitized emulsion; thus light is the most basic tool the photographer has to apply and the primary skill the photographer has to master. The application of light to a photographic setting can be one of the more perplexing problems a photographer faces, for as any amateur photographer quickly learns, what is seen with the human eye—which has a remarkable range of perception under all sorts of lighting conditions—is not what will be translated onto a photographic image. When photographing out-of-doors, the basic rule is that the photographer should always have the sun behind him/her, yet the range of conditions out-of-doors is vast and no single rule can be applied. In the absence of sunlight; at night or indoors, the most widely used lighting source is the flash on the camera, either built in as on modern point-and-shoot cameras, or a flash attachment. When using flash, the results often are not what the photographer had in mind; harsh shadows and a flattened perspective are just two of the problems with this kind of lighting. Learning how light behaves can have an enormous pay-off in satisfaction and a major improvement in the resulting picture for amateurs. For professionals, lighting is a stock in trade.

Size of the Light Source

The sun is the most frequently used source in the making of pictures. It is a very steady and reliable source and even on a cloudy day there is usually enough light available to make good photographs. It is during the evenings and nights or indoors that some form of supplemental lighting needs to be used. In the case of professional studio photographers their lighting equipment and the predictability that these lights provide is an essential part of their practice.

When the photographer needs to apply light to a subject or scene, it is essential to consider the relative size of the light source and the relative size of the subject to be photographed. The sun is physically much larger than the earth (by a factor of almost 40 times), but from our vantage point on earth it is a relatively small light source. Although it is brilliant and intense, compared to many structures or objects on earth, it is a relatively small light source. When the light source is relatively small and the subject/object relatively large the following can be expected to happen: the shadows will be strong and deep, the contrast in the photograph will be very high, and every bit of textural detail will be revealed. This can easily be verified on a bright sunny day. The shadows are very strong and can often be captured displaying an almost perfect outline of the objects that cast them.

Under partly cloudy conditions, a new lighting situation arises. The sun now illuminates the cloud, which in turn illuminates the earth, thus the size of the light source has changed. While the sun is still the origin of the light, it is now the cloud that retransmits the light, and its size determines what happens to the shadows and contrast and textural detail. When the relative size of the light source is larger than the relative size of the subject/object to be photographed the following things can be expected to occur: the shadows will be weak or almost non-existent, the contrast in the photograph will be normal or low, and textural detail will not be prominent.

These same lighting situations can be duplicated with almost any form of man-made light. From household light bulbs to extensive strobe systems, all of these can be adapted to what occurs in naturally available light. A simple light modifier can be a white card, where the bulb illuminates the card and the card in turn illuminates the subject. Professional photographers often use white, silver, or gold umbrellas on their strobe equipment to make the light source larger. Sometimes a softbox is used to change the size of the light source. The number of variations is almost endless, and it is what can give a photograph that special "signature" that is often referred to as the style of a certain photographer. Fashion and commercial photographers, such as Horst P. Horst or Annie Liebovitz, often have a

signature style of lighting. Others characteristically utilize flash to create a distinctive lighting environment, Weegee being a famous example.

There are some basic rules that the professionals follow in portrait or people photography. With the emphasis that is placed on youthfulness in our society, most portrait and beauty photographers use very large light sources for their pictures. The reason is that the larger the light source the less prominent any textural detail will be. Textural detail in this instance means wrinkles or slight perceived skin defects and the lighting approach can minimize these defects.

The Key Method of Lighting

One method of thinking about lighting is what is often referred to as the "Key" method. The Key method becomes a necessity when there are two or more light sources used in the picture. The Key method asks a simple question, namely: "What is the character or mood of the picture going to be?" Once the character of the picture has been determined the light source that creates this mood will become the Key light. The Key light will determine the basic exposure and all of the other lights will be balanced to the key light.

Direction of the Light

Where the light comes from is as important as the size of the light source. The character or mood of a photograph is often determined by the angle of the light that illuminates the subject. Top lighting will result in the major portion of the face being cast in deep shadow. A portrait where the light source is small and placed lower than the face will have a disturbing ghoulish effect. A light placed at a 45 degree angle will produce one side of the face that is pleasingly open, but the other side in deep shadow. A light placed behind a person will produce a "halo" effect. All these effects can be modified by use of fill-in lighting or flash, resulting in an almost infinite number of variations of how and where to position the lighting equipment.

A standard method of lighting a portrait is to use a large light source as the main or Key light and a smaller concentrated light coming from the rear towards the camera, but not visible in the picture. The Key light is often slightly above the sitter's head, particularly when the sitter is wearing glasses. This reduces the flare that is often seen in the glasses.

Light Modifiers

There are a variety of ways a light source can be changed or modified. A very common modifier is an umbrella, which is used to create more diffuse light that flattens and evens out the tones that are captured photographically. Umbrellas can be sized from 24 inches to well over 6 feet in diameter. The lining of the umbrella is as important as its size in creating diffused lighting; some feature silver reflective material on the inside, others are lined with white or gold foils. The purpose of these linings is to enlarge the light source. Since the basic shape is circular, the light will be cast on the subject in a circular manner.

A soft box is a square or rectangular box made of fabric and a lightweight frame that also enlarges the light source. A soft box provides a very even source of light over the entire surface of the box, but the quantity of light drops off very rapidly outside of the perimeter of the box.

Grids and snoots are tools used to concentrate light and are often used in portraits on the hair portion of the picture. Barn doors are another method of concentrating light onto the subject.

One of the least expensive modifiers can be a piece of plain white cardboard, often called a fill card, which can be mounted onto the camera, a stand, or simply held in the hand while photographing. The purpose of the card is to reduce a shadow by reflecting light from a strobe or bulb.

Flash can be utilized as fill-in to create a more diffused lighting situation when photographing out of doors, even on bright, sunny days. Strong shadows can be minimized by a flash set to two stops more than the speed of the film being used.

Photographers in the twentieth century have endlessly experimented with lighting environments and techniques, from László Mohogy-Nagy's famous "light modulator" experiments at the New Bauhaus (Institute of Design) in Chicago to Man Ray's experiments with photograms.

PETER LE GRAND

See also: **Camera: An Overview; Camera: Point and Shoot; Horst, Horst P.; Institute of Design; Liebovitz, Annie; Light Meter; Man Ray; Mohogy-Nagy, László; Photogram; Portraiture; Weegee**

O. WINSTON LINK

American

O. Winston Link is known primarily for his extraordinary documentation of the final years of the steam railroad engine and of America's vanishing rural landscape during a five-year period between 1955 and 1960. His lifelong fascination with railroading, combined with the knowledge that the era of the steam engine was indeed passing, had prompted this documentation. When his bold black and white, night-time photographs of trains were first exhibited several decades later in 1983, he was linked evermore with his subject.

Named after two maternal ancestors who served in the United States Congress in the nineteenth century, Ogle Winston Link was born December 16, 1914 in Brooklyn, New York to Earnest Albert Link and Ann Winston Jones Link. Link's father, Al, was an elementary school carpentry teacher and Ann a homemaker. Introduced to various technical activities by his father, Link's career trajectory in the manual arts is attributed to his father's influence. As early as four years of age, Link was enthused by trains when he glimpsed a toy train set in a department store window. On day trips with his father, Link shot New York harbor and other landmarks. Trains were also frequent subjects of his adolescent photography as he haunted rail yards and railroad hubs in New Jersey. A self-taught skilled amateur photographer, Link developed his film at home and printed the photographs with an enlarger that he built.

While attending Manual Training High School in Brooklyn, Link served as the photographer for the yearbook. But from an early age, his father had convinced Link to become a civil engineer, and Link won a scholarship to attend Polytechnic Institute of Brooklyn (now Polytechnic University). His interest in photography was sustained, however, as he served as the photo editor for the yearbook and photographer for the class newspaper. Link supplemented his income by shooting weddings on the weekends.

After earning his degree in 1937, Link was offered a position as publicity director for the public relations firm Carl Byior and Associates; he accepted thinking it would do until he landed a job in his field of engineering. Link applied his technical skills, refined aesthetic, and sense of humor to each assignment he received, mastering the ability to stage a photograph yet make it seem spontaneous and natural, the necessary components of public relations photography. One of his photos for a new type of heat-resistant glass was described by *Life* magazine as a classic publicity picture.

In 1942, he left Carl Byior to work on a research initiative at Columbia University, New York, that advanced the war effort. Deafness in one ear had prevented him from serving in the military; however, he used both his civil engineering knowledge and technical skills in photography on several projects. Link helped develop a device that detected enemy submarines from low-flying planes. He worked on capturing the speed of bullets on film, and documented the commercial research company, Airborne Instruments Laboratory in Deer Park, Long Island. Ignoring the wartime ban on railroad photography, he shot steam engines on the Long Island Rail Road, whose tracks lay adjacent to the laboratory, thus renewing his interest in a favorite subject.

His desire to capture the drama of trains at night inspired him to work with other engineers to develop radio signals that would activate a series of flashes that would illuminate his subject. The project failed because the metal bulk of the trains interfered with the radio signals, which could not activate all of the lights. As well as depicting the afterburner effect of jet airplanes taking off, Link solved other scientific and photographic problems during his years at the laboratory. Although the strobe photography of Harold Edgerton is better known, Link also used strobe lights and adapted them for synchronized flashes, which became a valuable technique that he would brilliantly apply to his most celebrated work.

After the war, Link went into business for himself as a commercial photographer specializing in industrial subjects. First working out of his parents' house, he eventually rented space in Manhattan in 1949. Link's clients included top advertising agents and companies like B.F. Goodrich, Alcoa Aluminum, and Texaco, though he accepted occasional assignments from the *New York Times* and various fashion houses.

While on assignment to take photographs of air conditioning systems for Westinghouse in Staunton, Virginia in 1955, Link drove a dozen miles to Waynesboro to watch a Norfolk & Western train that was passing through. After a rail worker's invitation, Link toured the train yard, repair shop, and refueling facilities, where his enthusiasm mounted until he spotted a steam engine at work. At that time in the mid-1950s, the major railroads had traded their steam engines for diesel-powered engines, but the Norfolk & Western still powered their locomotives by steam.

After returning to New York and excited by the potential of photographing the railway at night, Link submitted a proposal and several prints that he had taken to the head of Norfolk & Western, asking permission to document the trains, people, and property along the railway's route. Link advanced his cause by pointing out the absence of night photographs of trains, though his preference for night shooting stemmed from his desire to control lighting that could not be accomplished in daylight. Given access to the line, Link, along with his assistant (and later biographer) Thomas Garver, filled the time between his commercial assignments by covering the line's route, which wound through Virginia, North Carolina, West Virginia, Kentucky, and Ohio. During the five years that he spent on this venture, financing it completely with his own funds, Link employed a specially designed and coordinated series of flashes at night to depict his subject. Relying upon his scientific training, Link intricately placed lighting in the areas that he wished to film, sometimes taking days to set up for a complex shot in which he simultaneously used three 4 × 5-inch view cameras. Such dramatic images as *NW1/Train No. 2 Arriving at Waynesboro, Virginia*, 1955; *NW 723, Cow 13, Norvel Ryan and his Son Bringing in the Cows, Train No. 3 in the Background, Shawsville, Virginia*, 1955; and *NW 821 Luray Crossing with Y-6 Locomotive and Freight, Luray, Virginia*, 1956, resulted.

Link's charming personality won him friends among the rail workers who rallied when Link requested that engineers back trains up for another shot or create white steam on demand to synchronize with his shots. Understanding the interdependence between people and technology, Link integrated rail workers, as well as people who lived in the surrounding communities, within his images, thus illustrating how the engines affected daily life and how the railroad's active, loud, churlish personality was a member of the community.

Following the running of the last steam engine in May of 1960, Link sought publishers who would be interested in a book-length treatment of the Norfolk & Western photographs. His failure to secure a publishing contract forced him to lock away his negatives and try to market sound recordings that he made of the steam engines. Few of his images were published in national magazines and it was not until 1976 when the Museum of Modern Art, New York, acquired six of his photographs for the permanent collection that any professional interest was expressed in his images. After Alan Ripp's 1982 article in *American Photographer*, solo exhibitions of Link's Norfolk & Western photos were launched in London and in the United States the next year, thus broadening the audience for Link's work. Retiring in 1983 to Mount Kisco, New York, Link was recognized as the only photographer shooting at night during the period from 1940 to 1970. Link's other significant project was documenting the erection of the Verranzo Bridge linking Brooklyn to Staten Island in 1960.

Remarkable for his planning, his ability to set up the shot and envision the outcome, coupled with his commitment to perfection, resulted in Link's depiction of the relationship between industry and humanity. His techniques lent an otherwise innocuous scene the ability to evoke a second and third look from his audience. Most importantly, Link recorded a time and place in America that otherwise would have remained hidden from view. The History Museum and Historical Society of Western Virginia has set up an O. Winston Link Museum in Roanoke, Virginia, to preserve and disseminate Link's remarkable historical and cultural legacy.

REBECCA TOLLEY-STOKES

See also: **Industrial Photography; Photography in the United States: the South**

Biography

Born in Brooklyn, New York, 16 December 1914. Attended Polytechnic Institute of Brooklyn, Brooklyn, New York, B.A., 1937. Tau Beta Phi, 1936. Public Relations Director, Carl Byior and Associates, 1937–1942; research engineer and photographer for the Airborne Instruments Laboratory, Office of Scientific Research and Development, Columbia University, 1942–1945; self-employed industrial and commercial photographer, 1942–1987. Died 30 January 2001 in Katonah, New York.

Individual Exhibitions

1983 *Night Trick*; The Photographers' Gallery, London, England, and traveling
1983 Akron Art Museum; Akron, Ohio
1983 International Center of Photography; New York, New York
1983 Chrysler Museum; Norfolk, Virginia

1983 Museum of Science and Industry; Chicago, Illinois

1983 Houston Center for Photography; Houston, Texas

1983 Museum of Contemporary Photography; Columbia College, Chicago, Illinois

1983 The Madison Art Center; Madison, Wisconsin

1996 *B & W and Color Photographs*; John McEnroe Gallery, New York, New York

1998 *Trains that Passed in the Night: The Railroad Photographs of O. Winston Link*; Sheldon Memorial Art Gallery and Sculpture Garden, Lincoln, Nebraska, and traveling

1998 *Vintage Contact Prints from the Early Years 1937–1952*; Robert Mann Gallery, New York, New York

2003 *Steam Power Railroad Photographs of O. Winston Link*; University of Virginia Art Museum, Charlottesville, Virginia

2004 *Arrested Motion: 1950s Railroad Photographs by O. Winston Link*; Fenimore Art Museum, Cooperstown, New York

Group Exhibitions

1998 *UTZ: A Collected Exhibition*; Lennon, Weinburg, Inc., New York, New York

1998 *Flashback: The Fifties*; Bonni Benrubi Gallery, New York, New York

2000 *O. Winston Link, George Tice*; Robert Klein Gallery, Boston, Massachusetts

2000 *The Steam Locomotives of 20th Century—Naotaka Hirota and O. Winston Link*; Kiyosato Museum of Photographic Arts, Yamanashi, Japan

2002 *Photographs We Know, Iconic Images*; Fahey/Klein Gallery, Los Angeles, California

2003 *Enchanted Evening*; Yancey Richardson Gallery, Chelsea, New York

2003 *Only Skin Deep: Changing Visions of the American Self*; International Center of Photography, New York, New York, and traveling

Selected Works

Hawksbill Creek Swimming Hole, Luray, Virginia, 1956

Hotshot Eastbound, Iager Drive-In, Iager, West Virginia, 1956

Maud Bows to the 'Virginia Creeper' Green Cove, Virginia, 1956

The Birmingham Special Gets the Highball at Rural Retreat, 1957

Ghost Town, Stanley, Virginia, 1957

Silent Night at Seven Mile Ford, Virginia, 1957

Swimming Pool, Welch, West Virginia, 1958

Further Reading

Garver, Thomas H. "Railroad Photographs of O. Winston Link." *American Art Review* 12, no. 5 (2000).

Link, O. Winston. *Ghost Trains: Railroad Photographs of the 1950s*. Norfolk, VA: Chrysler Museum, 1983.

Link, O. Winston, and Thomas H. Garver. *The Last Steam Railroad in America: From Tidewater to Whitetop*. New York: Harry N. Abrams, 1995.

Link, O. Winston, and Rupert Martin. *Night Trick: Photographs of the Norfolk & Western Railway, 1955–1960*. London: Photographers' Gallery in conjunction with the National Museum of Photography, Film & Television, Bradford, and the National Railway Museum, York, 1983.

Link, O. Winston, and Timothy Hensley. *Steam, Steel, & Stars: America's Last Steam Railroad*. New York: Harry N. Abrams, 1987.

LINKED RING

The Linked Ring, also known as the Linked Ring Brotherhood and officially the Brotherhood of the Linked Ring, was a group formed in London in May of 1892. It was composed of photographers interested in furthering their ambition to elevate the practice of photography to that of the other fine arts mediums such as painting or the graphic arts. Though not synonymous with the Pictorialism movement, many of the aims of that movement were the aims of the Linked Ring, especially in establishing high standards of technical quality that was greatly expressive, differentiating themselves from the burgeoning numbers of amateur photographers, and quickly developing commercial applications. Unlike Pictorialism, the associates of the Linked Ring generally aspired to creating photographs that successfully exploited the unique qualities inherent in the medium and not necessarily in subservience to the forms and conventions of painting. The aesthetic aims of the Linked Ring, however, tend to be blurred with those of Pictorialism due to the fact many Pictorialists were involved in this group along with other, later secessionist groups, particularly the American Photo-Secession (founded in 1902).

Chief among the founders were leading nineteenth century photographers Henry Peach Robinson (1830–1901), George Davison (1854/6–1930), and Alfred Maskell (active 1890s), author of the influential publication *Photo-Aquatint, or the Gun-Bichromate Processs*, whose increasingly acrimonious relations with the Photographic Society of London (renamed Royal Photographic Society [RSP] in 1894) and resignation from the Society in 1891 led to the idea of the Linked Ring. Through this organization they could not only better further their ideas, but express their dissatisfaction with the RPS. This venerable institution did not distinguish among the various types of photographic practice, considering all photographs equal. This notion was especially inflammatory in the area of "scientific" versus "artistic" applications. As well, RPS often hired individuals with no experience in the medium, such as sculptors or painters, to jury their prestigious annual exhibitions, and prizes were awarded, despite many feeling it unfair to judge one photograph as "better" than another. The organization was a loose federation of like-minded individuals, and featured no board of directors or officers, and to which members were elected based solely on the existing members' judgment of the artistic value of their work.

Other well-known founders of the Brotherhood were Frank M. Sutcliffe (1853–1941), who captured lush Yorkshire landscapes; Paul Martin (1864–1944), known for his engagingly natural, candid portraits; Alfred Horsley Hinton (1863–1908), a leading landscape photographer who was also a popular judge for photographic exhibitions as well an the editor of the influential and popular magazine *Amateur Photographer*; and Frederick Hollyer (1837–1933) known for his beautiful Platinotype portraits of late-nineteenth century literary and artistic figures.

Chief among the Brotherhood's activities was the establishment of an exhibition that would serve as an alternative to the RPS exhibitions and those of other groups. Called the Photographic Salon, to associate it with the annual painting salons organized in many European capitals, it first appeared in 1893. The eminent Scottish photogravurist J. Craig Annan (1864–1946; elected to the group in 1894) and Frederick H. Evans (elected in 1900) served as the exhibition's first directors. In keeping with Linked Ring ideals, no medals or prizes were awarded. The Photographic Salon was extremely successful and became an important annual event in the world of fine arts photography, later being known as the London Salon.

As well, the Brotherhood published an annual titled *Photograms of the Year*, which like the Photo Club of New York's publication *Camera Notes* and the Photo-Secession's later *Camera Work*, served to spread the image of advanced photographic practice around the world.

Leading American Pictorialist and photographic champion Alfred Stieglitz, who had been elected to membership in 1894 took notice, founding his own group with essentially the same ideals, the Photo-Secession. Leading Pictorialist photographer Gertrude Käsebier, who worked out of a well-respected professional studio in New York, was the first woman to be elected to the Linked Ring in 1900. Another early female member was Canadian Minna Keene (1861–1943); in 1908 Keene was also the first woman elected as a fellow to the Royal Photographic Society.

Though but a loose organization, the Linked Ring exhibited characteristics typical of many groups; internal dissent and rivalries began emerging, especially after 1905. By this time, many of the members of the Photo-Secession had also became become members of the Linked Ring, raising concerns among the originators of the group at the British group being dominated by Americans. At the 1908 Photographic Salon, it was determined a majority of displays were by Americans. Reactions included a "Salon des Refusés" of photographs not admitted to the Salon mounted at the offices of *Amateur Photographer*. Still in the majority, the British members changed the rules for the following year's Salon, leading to the resignation of several influential Americans including Stieglitz and Clarence White. The success of the Salon des Refusés and continuing discord within the Brotherhood led to the Linked Ring being dissolved in 1910. The London Salon of Photography, which mounts an annual exhibition with a continuous history to the present day, has roots in the Linked Ring. In a historical irony, many of photographs by and archives of the founders of the Linked Ring can be found at the Royal Photographic Society.

Lynne Warren

See also: **Evans, Frederick H.; History of Photography: Twentieth-Century Developments; History of Photography: Twentieth-Century Pioneers; Käsebier, Gertrude; Non-Silver Processes; Periodicals: Historical; Photo-Secession; Photo-Secessionists; Pictorialism; Professional Organizations; Royal Photographic Society; Stieglitz, Alfred; White, Clarence**

Further Reading

Doty, Robert. *Photo-secession: Photography as a Fine Art.*, Rochester, New York: George Eastman House, 1960; as *Photo-Secession: Stieglitz and the Fine-Art Movement in Photography.* New York: Dover Publications, 1978.

Harker, Margaret. *The Linked Ring, The Secession in Photography in Britain, 1892–1910.* London: Heinemann, 1979.

The London Salon. www.londonsalon.org (accessed May 17, 2005).

Rosenblum, Naomi. *A World History of Photography.* New York: Abbeville, 1984.

———. *A History of Women Photographers.*, New York: Abbeville Press, 1994.

Royal Photography Society. www.rps.org (accessed May 17, 2005).

Whelan, Richard. *Alfred Stieglitz: A Biography.* Boston: Little, Brown, 1995.

HERBERT LIST

German

Herbert List figures as one of the most important German avant-garde photographers of the 1930s and 1940s. Although List was rightly named one of the most important German photographers in the post-war years, he was nearly forgotten in the 1960s and 1970s. One reason he was again recognized in the 1970s was that his art recommended itself to the concerns of the last years of the twentieth century: formal innovation, the exploration of the self, and he did not fit without contradiction into either *Neue Sachlichkeit* (New Objectivity) or Surrealism—the trends dominating Germany during his formative years.

Central to this new reception of List's works were his surrealistic sill lifes created in the 1930s. Already at that time the critic Egon Vietta had emphasized the metaphysical aspects of List's works and connected them to the works of Giorgio de Chirico, Carlo Carràs, and the painting of the *Pittura Metafisica*. In the unique aura of his puzzling still lifes List positioned objects so that the light endowed them with surreal qualities and metaphysical elements. List himself speaks of a "mysterious marriage" that the objects celebrate with one another, and that he intended "to reveal the magical substance within them."

André Breton and the Paris Surrealists influenced List's early works. List seized on such artistic techniques as double exposure, and he combined objects in a way that recalled the works of poet Comte de Lautreamont. In these works, List does not combine objects that are essentially foreign to each other; he tears objects from a shared context and then they establish a wonderful correspondence with each other. Borrowing from Surrealism, List developed his own formal language using elements of neo-classicism that dominated advertising art and fashion in the 1920s.

List's works from the 1930s show the influence of themes from Greek antiquity. Two themes that move through his entire oeuvre are images of Greece and photographs of young men. List's interest in Greece was nurtured by a humanist education as well as the high esteem Greeks placed on the love of boys; this was the image of ancient Greece promoted by the poet Stefan Georg that Friedrich Gundolf then conveyed to List, whom he met during List's short stay as a student at the University of Heidelberg.

In 1937, List embarked on a trip to Greece that lasted a number of months. There he photographed temples and sculptures of classical Greece as well as the landscape, architecture, and residents of the islands. He composed these photographs so the ruins of antique temples would have a monumental appearance.

His photographs also included everyday objects, such as clothing mannequins he photographed along the streets of Athens, fishing nets, and beach-front bars. He staged these in photographs that can only be described as magic realism. The works were exhibited in the Galerie du Chasseur d'images in Paris and were the first to earn List recognition. He then published photographs in *Harper's Bazaar*, *Verve*, *Photographie*, and *Life*. The publication of the book *Licht über Hellas*

(Light over Greece), which was to be printed in 1939 by the Paris publishing house Arts et Métiers Graphiques, did not happen. In 1945, the plates were destroyed in a printing press in Magdeburg during a bombing campaign. The book finally appeared in 1953.

The male body and its representation is a central theme that can be traced throughout List's entire work. His first photographs were taken on the beaches of the Baltic Sea, and List's photographs often invoke nature as a snapshot of an ideal, timeless, utopian vision of masculinity that celebrate the cult of eternal youth and the beauty of beautiful men. Most of List's photographs of young men were never published when they were taken. In the 1930s and 1940s, photographs of male nudes could have put List in acute danger because his pictures of young male bodies could not be reconciled with the image of the body held by the National Socialists. This is true even though List's perspective and monumentalization adopted the reigning aesthetic of the 1930s and suggests the political climate of the time. In using the ancient Greek image of the body, ancient models of the ideal physique became central to his work. They are recorded in the aesthetic ideal of ancient Greek sculpture and the athletic figures they represent. The play of light and shadow became a decisive element in his compositions. These echoed back to the invigorating effect created in his photographs of store window mannequins and to his series of Viennese wax figure works titled *Präuschers Panoptikum*, which seemed to bring the artificial human figure back to life.

After the war ended, List began work photographing ruins of the destroyed city of Munich, focusing on the baroque and classical structures of a city so renowned for its architecture that it was called "Isar-Athens," or Athens along the Bavarian river Isar. These photographs, made in glistening light, created an aesthetic experience that linked his images of Greece with the ruins of Germany. In the immediate post-war period, this representation of destruction—one wholly deprived of moralizing—met with no interest and no possibility for publication.

Beginning in the 1950s, List turned away from the symbolic arrangements of still lifes and architecture and concentrated on the representation of people. List substituted individual images with the photographic essay. He took photographs showing daily life in places like the Trastevere quarter of Rome or the city of Naples, and these works became his greatest contributions to *Life* magazine. The form of the book also became more important

to his photography. Between 1945 and 1947 List self-published many of his most important photography projects with private publishers. Books he readied for publication include, *Zeitlupe Null* with metaphysical still-lifes, *Augenblicke* with photographs of encounters with people, *Ver Sacrum* with photographs of young men, and the volume of photographs *Panoptikum* with photographs from a wax figure works. However, up to the *Panoptikum*, List's projects were collections of individual photographs. However, in his books *Rome* (1955), *Caribia* (1958), about the island world of the Caribbean, and *Napoli* (1962), the concept of series became the defining element. In the 1950s, List produced reportage projects with emotional themes that displayed his interest in people and the shift in his works to human interest photography. From that point forward List's works conveyed a sensitivity toward humanity and his attention often focused on the lives of simple people. These included the Indians on coffee plantations in Mexico and the black population on the Caribbean islands, their customs and religious rituals. His first experiments with color photography appeared in 1960 in the magazine *Du*.

ESTHER RUELFS

See also: **History of Photography: Interwar Years; Photography in Germany and Austria; Surrealism**

Biography

Born in Hamburg, Germany, 7 October 1903; attended a humanist high school, 1912–1920; 1921 started training in a coffee company in Heidelberg; 1923 entered his father's coffee company; traveled as a student to Brazil, Venezuela, Guatemala, El Salvador, Mexico, and the United States, where he took his first photographs, 1926–1928; acquainted with Andreas Feininger, who encouraged his interest in photography, 1930; headed the family's coffee import company and pursued photography as an amateur, 1930; first publication appeared in the yearbook *Arts et Métiers Graphiques*, Paris, 1935; left Germany and abandoned his career and became a working photographer, going to London, Paris, Athens, and published in *Vogue, Harper's Bazaar, Verve, Life*, 1936–1941; traveled to Greece and worked on the project *Licht über Hellas*, a volume of photographs of Greece, 1939–1941; after the occupation of Greece by the German army he had return to Germany, 1941; as a "non-Aryan" he could not officially work for the German press; worked on a series of portaits of artists and intellectuals, in France he made portraits of Pablo Picasso (1944) and Jean Cocteau (1948); served the German army as a map maker, 1944–1945; lived in Munich and after the war worked as photojournalist, most often for *Du*, 1945–1960; worked temporarily as a photo reporter and art editor for *Heute*, 1946; published various books of human interest photography, 1955; published *Rom, Car-*

ibia 1958, *Napoli* 1962; 1965 gave up photography and turned to collecting Italian drawings from the sixteenth to eighteenth centuries; David Octavius Hill Prize, Gesellschaft Deutscher Lichtbildner (GDL), 1964; member of GDL 1964–1973. Died in Munich, 4 April 1975.

Individual Exhibitions

1937 *Herbert List—Photographies*; Galerie du Chasseur d'images, Paris, France
1940 *Hellas*; Parnassos Galerie, Athens, Greece
1942 *Hella*; Galerie Karl Buchholz, Berlin, Germany
1942 *Hellas*; Athens, Greece, and traveling
1958 Galleria dell'Obelisco, Rome, Italy

1976 *Herbert List: Photographien 1930–1970*; Die Neue Sammlung, Munich, Germany, and traveling
1981 *Fotografia Metafisica: Herbert List*; International Center of Photography, New York, New York, and traveling
1983 *Herbert List; Photographies 1930–1970*; Musée d'Art moderne de la Ville de Paris, Paris, France, and traveling
1986 *Herbert List—Photographs*; Pace/MacGill Gallery, New York, New York
1988 *Hellas*; PPS Galerie FC Gundlach, Hamburg, Germany
1989 *Junge Männer*; Charles Cowles Gallery, New York, New York
1990 *Herbert List: Photo*; Suomen Valokuvataiteen Museo, Helsinki, Finland
1993 Glyptothek München; Munich, Germany, and traveling

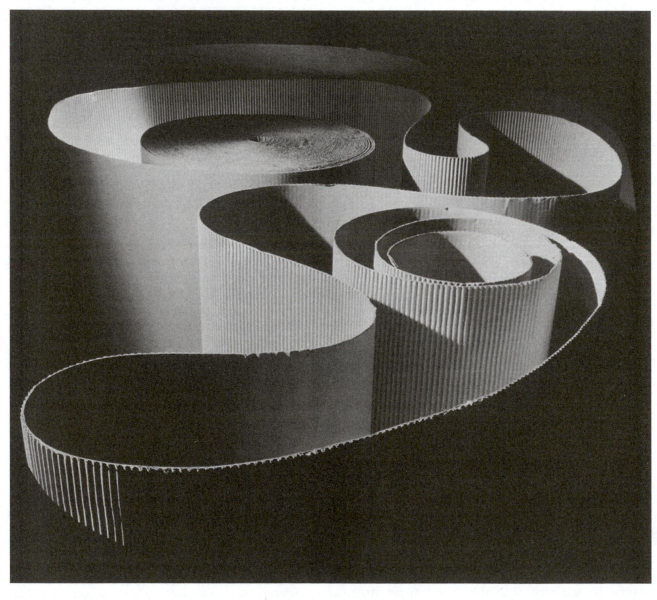

Herbert List, Study.
[© *Rights Reserved, CNAC/MNAM/Dist. Réunion des Musées Nationaux/Art Resource, New York*]

1995 *Herbert List—Memento 1945*; Münchener Stadtmuseum, Munich, Germany, and traveling
1995 *Italien*; Museo Bagatti Valsecchi, Milan, Italy
2000 *Herbert List—Die Retrospektive*; Fotomuseum im Münchener Stadtmuseum, Munich, Germany, and traveling

Group Exhibitions

1935 *Photographie*; Musée des Arts décoratifs, Pavillon de Marsan, Musée du Louvre, Paris, France
1951 *Subjektive Fotografie*; Staatliche Schule für Kunst und Handwerk, Saarbrücken, Germany
1952 *Exposition mondiale de la photo*; Luzern, Switzerland
1954 *Subjektive Fotoografie 2*; Staatliche Schule für Kunst und Handwerk, Saarbrücken, Germany
1955 *The Family of Man*; Museum of Modern Art, New York, New York, and traveling
1964 *World Exhibition of Photography: What is Man?*; Pressehaus Stern, Hamburg, Germany, and traveling
1977 *Fotografische Künstlerbildnisse*; Museum Ludwig, Cologne, Germany
1979 *Photographic Surrealism*; New Gallery of Contemporary Art, Cleveland, Ohio, and traveling
1980 *Avant-Garde Photography in Germany 1919–1939*; San Francisco Museum of Modern Art, San Francisco, California, and traveling
1984 *Subjektive Fotografie, Images of the 50s*; Museum Folkwang, Essen, Germany, and traveled to the San Francisco Museum of Modern Art, San Francisco, California
1985 *Das Aktfoto*; Fotomuseum im Münchener Stadtmuseum, Munich, Germany, and traveling
1987 *The Ideology of Male Beauty*; Vancouver Art Gallery, Vancouver, British Columbia, Canada
1990 *Das Land der Griechen mit der Seele suchen*; Agfa Foto-Historama, Römisch Germanisches Museum, Cologne, Germany
1991 *The Kiss of Apollo*; Fraenkel Gallery, San Francisco, California
1992 *Photographie—Sculpture*; Palais de Tokyo, Paris, France

1995 *Ende und Anfang. Photographie in Deutschland um 1945*; Deutsches Historisches Museum, Berlin, Germany
1997 *Deutsche Fotografie—Machst eines Mediums 1870–1970*; Kunst-und Ausstellungshalle der Bundesrepublik Deutschland, Bonn, Germany
1997 *Die Skulptur in der Fotografie*; Wilhelm Lehmbruck Museum, Duisburg, Germany, and Museum Moderner Kunst Stiftung Ludwig, Vienna, Austria
1999 *Puppen Körper Automaten—Phantasmen der Moderne*; Kunstsammlung Nordrhein-Westfalen, Düsseldorf, Germany

Selected Works

Licht über Hellas, 1953
Rom, 1955
Caribia, 1958
Napoli, 1962
Bildwerke aus Nigeria/Nigerian Images, 1963

Further Reading

Brauchitsch, Boris von. *Das Magische im Vorübergehen—Herbert List und die Fotografie*. Hamburg, Münster: L.I.T. Verlag, 1992.
Derenthal, Ludger. "Die magischen Reste." In *Herbert List—Memento 1945*. München: Fotomuseum im Münchener Stadtmuseum, 1995.
Metken, Günter. *Herbert List—Photographien 1930–1970*. Munich: Schirmer/Mosel, 1980.
Scheler, Max, ed. *Herbert List—Junge Männer*. Santa Fe, NM: Twin Palms Publishers, 1988.
Scheler, Max, ed. *Herbert List—Hellas*. Munich and London: Schirmer Art Books, 1993.
Scheler, Max, ed. *Herbert List—Italien*. Munich: Schirmer/Mosel, 1995; London: Thames and Hudson, 1995; Milan: Giorgio Mondadori, 1995.
Scheler, Max, and Matthias Harder, eds. *Herbert List, die Monographie*. München: Schirmer Mosel, 2000; Paris: Editions Senil, 2000; New York: Monacelli Press, 2000.

RICHARD LONG

British

Richard Long's exhibited and published work is most frequently seen and, arguably, most consistently brought to mind through the medium of photography. Beginning his career in the late 1960s with anonymous, impermanent works that combined walking and different forms of recording and mediating the experience of natural landscape, Long set upon a course of development that he found allowed numerous variables, including the use of photography. His poetic, meditative work was increasingly recognized in Europe and the United States during the following decade. By the mid-1970s he was established as an artist of international standing. In a manner that is characteristically

understated and pertinent, Richard Long has described his work as: "Art made by walking in landscapes. Photographs of sculptures made along the way. Walks made into textworks" (*http://www.richardlong.org/*).

Born in Bristol, England, in 1945, Long attended Bristol School of Art, gaining a Diploma in Art and Design in 1966. He went on to study fine art although not specifically photography at St. Martins School of Art during 1966–1968. He made his first works of art by means of walking in landscape in 1967 including the piece *A Line Made By Walking*. Emerging as part of a new generation of British artists who were to achieve international importance, including Victor Burgin and Gilbert & George, his first major exhibition was staged in the Galerie Konrad Fischer, Dusseldorf, in 1968. He began to make works specifically for gallery installations including *Three Circles of Stones* for *The New Art*, held at London's Hayward Gallery in 1972. Richard Long's work has also been frequently shown in group exhibitions, which showcase different approaches to topography and temporality (for example *Time, Place, Space: Richard Long, On Kawara, Lawrence Weiner* at the Galerie Ghislaine Hussenot, Paris in 1990) or which seek to align him to the Earth Art movement, such as *Magiciens de la Terre*, held at the Centre Georges Pompidou, Paris, in 1988.

Establishing a clear line of influence upon Richard Long's art or attaching him to art movements is a task that yields inconclusive results. This is partly explained by the artist's reticence to say much on the subjects but also because movements such as Earth Art (making art in, and of, the landscape—a movement alternatively know as Land Art) or art practices associated with the production of series or with the combination of image and text, offer only partial insights into a working method that *de facto* is the work, and which is pursued alone and independently. Long, however, is on record for admiring, at an early stage in his career, avant-garde composer and artist John Cage's use of pace, time, and rhythm in works such as *Indeterminacy*. More recently, he has expressed a liking for the work of some of his contemporaries, including American conceptualist Lawrence Weiner. Long also links himself to a long cultural history of walking that includes practices of religious pilgrims and wandering Japanese poets. Because he uses potent and universal symbolic forms in his work such as straight lines, spirals, and circles, Long has frequently been viewed as part of the ancient tradition of constructing ritual earthworks, as well as being seen to be conceptually attuned to the mysticism of both Zen

Buddhism and Shinto. He has incorporated "musical whispers" drawn from the popular music (for example, Bob Dylan's *You Ain't Goin' Nowhere*) in the titling of some of his pieces and in some textworks. His own admirers range widely across the creative arts and include musician and producer Bill Drummond of KLF, as well as numerous visual artists such as fellow British conceptualist Hamish Fulton, an occasional walking companion for Long.

As it has developed, single or serial photographs with descriptive titles attached to the photographic works as texts, have become a key element within Richard Long's art. The majority of these photographs are monochrome prints, but color is used where it is deemed to add meaning to the work, as is the case with the 30 different delicate color modulations that form the series *No Where: A Walk of 131 Miles Within An Imaginary Circle In The Monadhliath Mountains* of 1993. Camera technology is kept simple and straightforward with a preference for the Nikkormat camera.

Photography is important to Long because the speed of execution inherent in the medium allows transient impressions to be registered and also because photography offers the artist yet another form of physical engagement with the world. This latter consideration is an important factor for an artist for whom the idea of touch has been used literally and metaphorically in the form of walking, as well as in the making of landscape artworks, which combine natural materials and the elements.

In the process of making work, these mediations with nature take many different forms in works, which are sometimes created near to home but frequently in far distant, sometimes geographically remote, locations. They include the surface indentations made into the earth by walking, which were photographed for *A 2½ Mile Walk Sculpture* of 1969; the stones thrown in a circle photographed for *Throwing Stones Into A Circle* of 1979; and the artist's body impression, which was photographed for *Sleeping Place Mark* of 1990. Such photographs of works made on site are viewed by the artist to be "the appropriate way for that place to become art in the public knowledge" and therefore to reach an audience (Giezen 1985, 3).

Photographs appear in Long's gallery exhibitions and publications as a means of bringing the work to an audience but, at the same time, they are also intended to function in their own right and are not mere "copies" of what might be experienced when apprehending the artist's sculptures *in situ*. This distancing from the simplistic idea that what is shown in a gallery replicates what would be

encountered on site is carried through to the frequent use of quarry stones obtained from sources near to exhibition locations rather than the use of materials removed from the landscape sites of the sculptures. Far from being "copies" of experiences of apprehending the sculptures (which may or may not still exist) the photographs of the sculptures are now considered by many as the crucial production of meaning in his work. Following on from this, it has been argued that the artist's photographs cannot be easily pulled apart from the creative act itself and are therefore an integral part of it.

Richard Long invariably involves himself in all aspects of the presentation of his work in gallery exhibitions and in publications, many of which are in fact artists' books, a medium that was instrumental in Long's early success. A case in point is *Walking in Circles* shown at London's Hayward Gallery in 1991. Here he worked closely with the exhibition organizer in the selection and installation of the works, and he collaborated with the graphic designer in the production of the book that accompanied the exhibition. Such attention to detail can variously be seen in the *Walking in Circles* publication in the recreation of one of the exhibits as a blind embossed design on the binding, in the titling of the different sections of the book, and in the choice and ordering of the photographs.

Examples of work are in important private collections such as the John Haldane Collection and in numerous art museums and photographic collections of the first rank such as the Museum of Modern Art, New York.

JANICE HART

See also: **Artists' Books; Conceptual Photography; Photography and Sculpture**

Biography

Born in Bristol, England, on 2 June 1945; continues to make this location his home. Attended Bristol School of Art from 1962, gaining a Diploma in Art and Design in 1966. Fine arts study at St. Martins School of Art (now part of the London Institute) 1966–1968; no formal photography training. Begins association with Galerie Konrad Fischer, Dusseldorf, Germany, and Galerie Yvonne Lambert, Paris, France, late 1960s. Becomes associated with Anthony D'Offay Gallery, London, late 1970s. Awarded Kunstpreis Aachen, 1988, and the Turner Prize of the Tate Gallery, London, 1989; Chevalier de l'Ordre des Arts et Lettres, by the French Ministry of Culture, 1990.

Individual Exhibitions

1968 *Richard J. Long: Sculpture*; Galerie Konrad Fischer, Dusseldorf, Germany

1969 *Richard Long*; John Gibson Gallery, New York, New York
 Richard Long—Sculpture; Galerie Yvonne Lambert, Paris, France
1970 *Richard Long*; Dwan Gallery, New York, New York
1971 *Richard Long*; Gian Enzo Sperone, Turin, Italy
 Richard Long; Art & Project, Amsterdam, Holland
 Richard Long; Whitechapel Gallery, London, England
 Richard Long; Museum of Modern Art, Oxford, England
1972 *"Projects" Richard Long*; Museum of Modern Art, New York, New York
1973 *Richard Long*; Stedelijk Museum, Amsterdam, Netherlands
1974 *Richard Long*; John Weber Gallery, New York, New York
 Richard Long; Scottish National Gallery of Modern Art, Edinburgh, Scotland
1975 *Richard Long: River Avon Driftwood; Crossing Two Rivers/Minnesota/Wiltshire*; Art & Project, Amsterdam, Holland
1976 *Richard Long*; Gian Enzo Sperone, Rome, Italy
 Richard Long: River Avon Driftwood; Arnolfini, Bristol, England
 Richard Long; Art Agency, Tokyo, Japan
1977 *Richard Long*; Whitechapel Gallery, London, England
 Richard Long; Gallery Akumalatory, Poznan, Poland
 Richard Long; Kunsthalle, Berne, Switzerland
 Richard Long; National Gallery of Victoria, Melbourne, Australia
 Richard Long; Gallery of New South Wales, Sydney, Australia
1978 *Richard Long*; Halle für internationale neue Kunst, Ink Gallery, Zurich, Switzerland
 Richard Long; Austellungsraum Ulrich Ruckreim, Hamburg, Germany
1979 *Richard Long: The River Avon*; Anthony D'Offay Gallery, London, England
 Richard Long: Sculpturen en Fotowerken; Van Abbemuseum, Eindhoven, Netherlands
1980 *Richard Long*; Fogg Art Museum, Cambridge, Massachusetts
1981 *Richard Long*; Graeme Murray Gallery, Edinburgh, Scotland
 Richard Long; David Bellman Gallery, Toronto, Canada
 Richard Long; Centre d'Artes Plastiques Contemporains de Bordeaux, Bordeaux, France
1982 *Richard Long*; National Gallery of Canada, Ottawa, Canada
1983 *Richard Long Exhibition*; Century Cultural Centre, Tokyo, Japan
1984 *Concentrations 9: Richard Long*; Dallas Museum of Art, Dallas, Texas
1985 *Richard Long*; Malmo Konsthall, Malmo, Sweden
 Il Luogo Buono: Richard Long; Padiglione d'Arte Contemporanea di Milano, Milan, Italy
1986 *Piedras: Richard Long*; Palacio de Cristal, Madrid, Spain
 Richard Long; Solomon R. Guggenheim Museum, New York, New York
 Richard Long; Porin Taidmuseo, Porin, Finland
1987 *Richard Long*; Musee Rath, Geneva, Switzerland
 Richard Long; Centre Nationale d'Art Contemporain, Grenoble, France

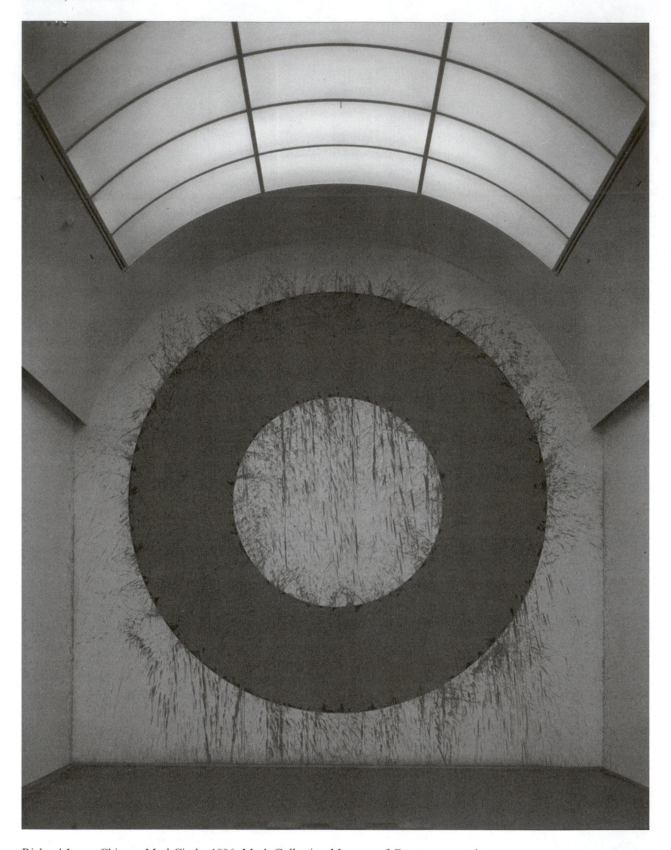

Richard Long, Chicago Mud Circle, 1996, Mud, Collection Museum of Contemporary Art, Chicago, gift of David Meitus.
[*Photograph © Museum of Contemporary Art, Chicago, Courtesy Sperone Westwater, New York*]

1988 *Kunstpreis Aachen: Richard Long*; Neue Galerie-Sammlung Ludwig, Aachen, Germany
1989 *Richard Long*; La Jolla Museum of Contemporary Art, La Jolla, California
1990 *Richard Long*; Tate Gallery, London, England
1991 *Richard Long*; Stadtische Galerie im Stadelschen Kunsinstitut, Frankfurt, Germany
 Richard Long: Walking in Circles; Hayward Gallery, London, England
1992 *Richard Long*; Fundacio Espai Poblenou, Barcelona, Spain
1993 *Richard Long*; Inkong Gallery, Seoul, Korea
1994 *Richard Long*; Kunstammlung Nordrhein Westfalen, Dusseldorf, Germany
 Richard Long; Philadelphia Museum of Art, Philadelphia, Pennsylvania
1995 *Richard Long*; Syningarsalur Gallery, Reykjavik, Iceland
1996 *Richard Long*; Setagaya Art Museum, Tokyo, Japan
 Richard Long; Contemporary Arts Museum, Houston, Texas
 Richard Long; Modern Art Museum, Fort Worth, Texas
1997 *A Road from the Past to the Future: Work by Richard Long from the Haldane Collection*; Crawford Arts Centre, St. Andrews, Scotland
 Richard Long; Benesse Museum of Contemporary Art, Naoshima, Japan
2000 *Richard Long*; Guggenheim Bilbao, Bilbao, Spain

Selected Group Exhibitions

1967 *19:45–21:55*; Dorothea Loehr, Frankfurt, Germany
1969 *Earth Art*; Andrew Dickson White Museum of Art, Cornell University, Ithaca, New York
1974 *Carl Andre, Marcel Broodthaers, Daniel Buren, Victor Burgin, Gilbert & George, On Kawara, Richard Long, Gerhard Richter*; Palais des Beaux-Arts, Brussels, Belgium
1976 *Andre/Le Va/Long*; Corcoran Gallery of Art, Washington, D.C.
1976 British Pavilion; Venice Biennale, Venice, Italy
1978 *Skuptur: Matisse, Giacometti, Judd, Lavin, Andre, Long*; Kunsthalle Bern, Bern Switzerland
1984 *The Critical Eye/1*; Yale Centre for British Art, New Haven, Connecticut

1987 *Wall Works: Richard Long, Michael Craig-Martin, Annette Messager, Marion Mölle, Matt Mullican, Sol LeWitt - Six Artists Working Directly on the Wall*; Cornerhouse, Manchester, England
1989 *Magiciens de la Terre*; Centre Georges Pompidou, Paris, France
1990 *Time, Space, Place: Richard Long, On Kawara, Lawrence Weiner*; Galerie Ghislaine Hussenot, Paris, France
1991 *Bronze, Steel, Stone, Wood: Carl Andre, Ellsworth Kelly, Richard Long—Three Installations of Sculpture*; Anthony D'Offay Gallery, London, England
1993 *Gravity and Grace*; Hayward Gallery, London, England

Selected Works

A Line Made By Walking, England 1967, 1967
A Circle In Alaska: Bering Straight Driftwood On The Arctic Circle, 1977
Throwing Stones Into A Circle, A Six Day Walk In The Atlas Mountains, Morocco, 1979
Sahara Line, 1988
Sleeping Place Mark, A Night Of Grunting Deer, A Frosty Morning, The Seventeenth Night Of A 21 Day Walk From The North Coast To The South Coast of Spain, Ribadesella To Malaga, 1990
Orkney Stones: A Four Day Walk On Hoy 1992, 1992
No Where: A Walk Of 131 Miles Within An Imaginary Circle In The Monadhliath Mountains, 1993

Further Reading

Giezen, Martina. *Richard Long in Conversation: Bristol 19.11.1985*. Noordwijk, Holland; MW Press, 1985.
Haldane, John. Introduction to *A Road From The Past To The Future: Work By Richard Long from the Haldane Collection*. St. Andrews, Scotland: Crawford Arts Centre, 1997.
Kirkpatrick, Colin. Interview with Richard Long. *No Where*. In *Transcript* v. 2, no. 1 (1999): 38–51.
Lobacheff, Georgia. *Interview with Richard Long: Sao Paulo Bienal 1994*. London: The British Council, 1994.
Seymour, Anne. Introduction to *Richard Long: Walking In Circles*. London: Hayward Gallery, 1991.

LOOK

First published in 1937, *Look* magazine was a bi-weekly general interest magazine, one of the first and longest-running pictorial magazines in American publishing history. Gardner Cowles, Jr., son of an Iowa publishing family responsible for several key media acquisitions in the Des Moines area, launched *Look* as a competitor to Time's *Life* magazine (whose publication lifespan mirrors *Look*'s). Because the Cowles media group continued to acquire new publications, *Look* was subsequently published under various company names: Look, Inc. (1937–1945); Cowles Magazines (1946–1965); and Cowles

Communications, Inc. (1965–1971). In its early years (prior to World War II), *Look*'s content consisted primarily of sensational tabloid spreads about celebrities, fashion, sports figures, strange "news" items, and other popular trends. After WWII, the magazine assumed a more family-oriented focus, with regular features, such as fashion, food, sports, and popular entertainment, as well as special features on current health issues, developments in medicine and technology, social issues of the day, and political affairs. When *Look* ceased publication of the magazine in 1971, Gardner Cowles, Jr. gave the entire archive of negatives to the Library of Congress in Washington, D.C.

When *Look* came into the market, in an economy still struggling back to its feet from the Depression of the previous decade, many people were either out of work or underemployed; this was no less true for photographers. *Look* therefore enjoyed a ready pool of potential staff, and employed a substantial number of photographers full-time. In a given year, *Look* maintained a roster of 10 to 12 full-time photographers, in addition to at least as many freelance photographers. Several of the regular staff photographers at *Look* had experience with documentary photography, such as Stanley Tretick and Tony Vaccaro, both of whom served as photographers for the military. Many others had worked for the federal government's Farm Security Administration (FSA) project or the Office of War Information (OWI) projects prior to their tenure at *Look*, among them Russell Lee, Arthur Rothstein, and John Vachon. The success and timing of the FSA project, in particular, may have played a significant role in paving the way for photojournalism publications such as *Look* and *Life*. In America's pre-television era, before the overwhelming ubiquity of visual culture, pictures were still fresh and new. The public response to the images in the FSA collection was tremendous, not only because of the innovation and artistic achievement they represented, but because they communicated in a new way the hardships, character, and personal effort of working people across the country—entirely in pictures. At a time when the country was preparing itself for international combat, it is no wonder that Americans were especially receptive to images that consolidated and magnified the cultural and political climate of that era. The FSA images, in many ways and almost instantaneously, distilled public sentiment by creating a visual lexicon of American culture and character. Whether fortuitously or by design, *Look* was well-positioned to capture this public yearning for symbols, to harness that mixture of escapism and glamour, grit and gumption,

nationalism, and local pride that so characterized mainstream American culture around WWII.

Look's "golden years" (1954–1964), corresponded to a surge in readership across the industry, due largely to economic recovery following the war, as well as the thicket of political issues arising from a new period of social change. *Look* remained competitive by covering the "serious" issues. One of its more notable efforts is the January 1956 issue, whose feature article, titled "The Shocking Story of Approved Killing in Mississippi," carried an exclusive interview with Roy Bryant and J.W. Milam, two men accused (but not convicted) of the murder of Emmett Till just three months prior. During the interview, Roy Bryant and J.W. Milam actually confess to the murder. While *Look*'s reporting drew some criticism (Roy Wilkins, Executive Secretary of the NAACP at the time the story went to print, questioned the veracity of Bryant and Milam's account of Till's activities prior to the murder, while other readers, sharing their comments in letters to the editor, objected to coverage they considered overly-prescriptive and condemning), there is no doubt that, in the minds of mainstream America, this was a bold editorial decision that augmented *Look*'s image as a serious journal of record.

The two- to three-month production cycle at *Look* meant that feature stories were sometimes less than timely or relevant. *Look* endured an embarrassing flap when it published the results of an opinion poll related to the 1964 presidential election just a few weeks after the assassination of John F. Kennedy. *Look*'s desire to inform and stimulate without adversely provoking or challenging its readers imposed another limitation on its effort at hard-hitting news coverage. As a counterbalance, the magazine padded its political coverage with lifestyle and food sections, celebrity profiles and product surveys aimed at a thriving—and increasingly competitive—consumer market: women. *Look*'s increased pitch to the female consumer found its home in regular features such as "For Women Only," which highlighted unconventional and often frivolous "trends" in fashion and leisure, from Vivienne Colle patchwork dresses to jeweled hosiery and two-person ponchos.

Look's shift in content and design to a more family-oriented, consumer-friendly format is widely attributed to the editorial influence of Fleur Cowles, Gardner Cowles' wife and associate editor at *Look* from 1947 on. Fleur (née Fenton) worked for a short time with the Truman Administration before marrying Gardner Cowles and, shortly thereafter, assuming her role on the magazine's staff; it is often noted that her influence began informally—with suggestions in the

form of notes tucked into Gardner Cowles' papers—and was a primer for subsequent positions with *Quick*, another Cowles publication, and her own brainchild, *Flair* magazine, a short-lived but influential art, culture, and lifestyle magazine, featuring innovative design and formatting, sophisticated layouts, and a more fluid organizational structure attributable to Fleur's interest in Surrealism.

Appeals to female readers and the presence of Fleur in a prominent position did not necessarily bridge the gender gap of the era. In an interview with the American Society of Media Photographers (ASMP), Charlotte Brooks, a veteran *Look* photographer, described the mixed blessing of being the only woman photographer on staff for the duration of her 20-year tenure at *Look*. Brooks described a definitively discriminatory work environment, where she was paid less than her male counterparts and assigned to a restricted slate of stories deemed appropriate for women. At the same time, Brooks enjoyed tremendous professional opportunities. As she explained:

> I think it had to do in part with the nature of the assignments. Although I enjoyed everything, the other people used to hate "All-American Cities" and "What is a Teacher?" But I had a marvelous time; I loved all of it. The people involved were interesting people, and it was always so wonderful to be able to go out as Miss Look. I think I got a little bit of a head about that. You were not yourself at all, nobody would know your name, but you represented a powerful organization and it had some meaning.

(American Society of Media Photographers, Charlotte Brooks interview, October 4, 2004)

In general, *Look* photographers, many of whom remained at the magazine until its final days in 1971, enjoyed a considerable degree of creative freedom as the result of *Look*'s production methods. Images were processed as "jobs" rather than "assignments," which meant that photographs that were not selected for a specific story might still be used at a later date. This procedure, in addition to *Look*'s photographic format, afforded its photographers considerable license and authorship in their work, as most were collaborations between photojournalist and writer. *Look* provided steady employment for many professional photographers, offered unprecedented opportunity for young artists, and launched the careers of several notable photographers, among them Stanley Tretick, made famous for his photographs of John F. Kennedy, and fashion photographer Douglas Kirkland, whose portraits included such luminaries as Marilyn Monroe, Marlene Dietrich, and Elizabeth Taylor.

JENNIFER SCHNEIDER

See also: **Farm Security Administration; Lee, Russell; Life Magazine; Office of War Information; Rothstein, Arthur**

Further Reading

Cooperman, Gary S. *A Historical Study of Look Magazine and Its Concept of Photojournalism.* Columbia, MO: University of Missouri-Columbia, 1966.

Cowles, Gardner. *Mike Looks Back: The Memoirs of Gardner Cowles, Founder of Look Magazine.* New York: G. Cowles, 1985.

Cowles Communications. *Records of the Look Years.* New York: Cowles Communications, 1973.

Kozol, Wendy. *Life's America: Family and Nation in Postwar Photojournalism.* Philadelphia: Temple University Press, 1994.

Leonard, George Burr. *Walking on the Edge of the World.* Boston: Houghton Mifflin, 1988.

Schonauer, David. "Lost Shots." *American Photo* 10 (Nov/Dec 1999): 20.

Rothstein, Arthur. *Photojournalism: Pictures for Magazines and Newspapers.* New York: American Photographic Book Pub. Co., 1956.1

A History of Technology, Vol. III. Ed. Charles Singer et al. Oxford University Press: New York, 1958.

URS LÜTHI

Swiss

Born in 1947, Urs Lüthi belongs to the generation of European artists whose aesthetic programs were decidedly influenced by the challenge to traditional thinking about artistic production and distribution that came to a head in the events and aftermath of 1968. In particular, the artistic practices of this generation were fueled by Harold Szeeman's influential 1969 exhibition at the Kunsthalle Bern, *When*

Attitude Becomes Form, which famously brought a number of American post-minimalist artists and European conceptualists together to present a model of art as an idea manifest in an action.

A Swiss national who spent some time working as a graphic artist, Lüthi's long and prolific career culminated in the prestigious invitation to represent Switzerland at the 2001 Venice Biennial. His work, which largely centers around self-representations in a number of media, has been described as both body art and conceptual, and although Lüthi was undoubtedly influenced by movements like Fluxus and Conceptual Art, his work resists strict categorization, and he did not align himself with any particular group or charter. Given to experimentation in a variety of media and presentation, including photography, performance, painting, video, installation, and even graphic design, Lüthi's work has been varied and not always conceived of as coherent, especially in the United States where he has received significantly less attention than in Europe. However, it is indisputable that Lüthi's photographic work—especially his self-portraits—have had an important, if not seminal, role in redefining the use of photography as an autonomous art form in the latter half of the twentieth century. Of crucial concern to his oeuvre are recurrent questions regarding the relationship between truth and representation, or as he suggested in a 1974 statement, the tenuous line between subjectivity and objectivity. For Lüthi, "perhaps the most significant and creative aspect of my work is ambivalence as such...Objectivity is not important to me; all is objective just as all could be subjective" (Lüthi 2001, 9).

It therefore makes sense that Lüthi's earliest artistic investigations led him to an investigation of photography and to the self-portrait in particular, since, in the days before Roland Barthes's seminal reflections on the photographic medium, for example, photography itself was still largely conceived of as a vehicle of truth. On the other hand, the self-portrait had long been historically understood as the artist's means to evidence an interior truth, to make public a very private self. Lüthi's earliest self-portraits, however, were largely in "disguise," as if to suggest the impossibility of a communicable stable subject. In particular, the most famous of his self-portraits pictured him in various poses as a woman, such as the sultry *Self-Portrait* (1971), which suggests comparison to Man Ray's photograph of *Marcel Duchamp as Rrose Sélavy* (1920–1921), or the tellingly titled *I'll Be Your Mirror* (1972), and the famous *Lüthi Also Cries For You* (1970). Not only did these images question traditional gender norms,

they also positioned photography as an art form in its own right. They were printed on canvas, de-emphasized the role of the artist as implicated in self-revelation, and instead constructed a model wherein the artist would serve as a vessel for an externally imposed quest. As he did in a 1970 exhibition in Lucerne entitled *Visualized Thought Processes* (1970), in which he displayed all of his possessions in glass cases alongside postcard displays of his sketches and self-portraits, Lüthi uses these photographs to blur the categories of art and motif, thereby also blurring the function of the artist.

In 1974, Lüthi participated in the seminal *Transformer: Aspect of Travesty* exhibition, curated by Jean-Cristophe Amman, in which he displayed a 20-photograph series of black and white large-scale photographs of his own naked body, clutching a smaller black and white self-portrait. Entitled *The Numbergirl* (1973), this series exceeded the exhibition's intended focus on transsexuality and launched Lüthi's international star. The narrative aspect of the photographic series was something he had also explored in an earlier collaboration with David Weiss and Willy Spiller. *Sketches* (1970), the photographic series that ensued from this collaboration, represents Lüthi and Weiss at play, in various staged poses and configurations.

Throughout the 1980s, Lüthi returned to painting and produced a number of abstract and landscape paintings, many of which he also entitled *self-portrait*, illustrating his continued concern with simultaneously confirming and dispelling the view of art as a perceived repository for personal identity and experience. When he returned to photography, it would be to incorporate photographic images in large-scale installations and series. Turning in the 1990s to enhanced technologies and digital reprocessing, Lüthi began to embrace the methods and means of contemporary advertising, fusing a seemingly kitsch aesthetic into his pursuits of everyday life. First came the exhibition at Galerie Blancpain-Stepczynski in 1993 of *The Complete Life and Work, Seen Through the Pink Glasses of Desire* in which Lüthi exhibited 180 photographs, all printed in a uniform size and shape and in pink, from his life and artwork, further blending the boundaries between art and life and making the image serve as an equivalent sign for each.

In the series *Placebos and Surrogates* (1996–ongoing) and two of its constituent parts, *Run for your Life* (2000) and *Art for A Better Life* (2001), Lüthi contrasts the excesses of a culture that continually promotes wellness propaganda and health as means to achieve happiness with the mundane images of his own life and aging body, continuing to question the relationship between truth and

beauty in an imagerial culture. In this series, large-format photographs of beaches and other traditional places of leisure are mounted on a wall, the frames angled inward so as to appear as if invisible. The images are surrounded by a pink glow, a literal photographic "aura," which reflects off the walls from the edges of the red frames. Around these are hung, for instance, plaques admonishing the viewer to "discover your essence" or "change your life," platitudes from a cultural machine that attempts to brand and market happiness like any commodity. The important aspect of Lüthi's work is that he recognizes that art too may play a role in this commodification—that it too may function as a surrogate for truth. He displays all of his works emblazoned with a photographic representation of his own head, cast in profile like a Greek statue, as both trademark and discursive authority. Likewise, for his 2001 Venice Biennale exhibition, he reissued his famous self-portraits from the 1970s, re-titling them with their original name and the new title: *Trademarks* (1970s/2001). In his long pursuit of thinking about the role of the artist, Lüthi recognizes that these canonical portraits, which have vastly influenced a generation of artists, have become as entrenched as the very assumptions of photographic truth that he started out contesting.

HANNAH FELD

See also: **Conceptual Photography; Constructed Reality; Photographic "Truth"; Representation and Gender**

Biography

Born in Lucerne, Switzerland, 10 September 1947. Attended Kunstgewerbeschule (École des Arts et Métiers) in Zurich from 1963–1964. Since 1994, Professor at the University of Kassel, Kassel, Germany. Represented Switzerland in the 2001 Venice Biennial. Lives in Munich and Kassel.

Individual Exhibitions

1966 Galerie Beat Mäder; Bern, SwitzerlandGalerie Palette; Zurich, Switzerland
1972 Galleria Diagramma; Milan, Italy
1974 Galerie Stadler; Paris, France
 Galleria Schema; Florence, Italy
1975 Museum of Art and History; Geneva, Switzerland
 Galerie Stähl; Zurich, Switzerland
1976 Kunsthalle Basel; Basel, Switzerland
 Nishimura Gallery; Tokyo, Japan
1978 Museum Folkwang; Essen, Germany, Neue Galerie am Landesmuseum Johanneum
1981 *Bilder 1977–1980*; Kunstmuseum Bern, Bern, Switzerland
1984 FRAC Pays de la Loire; Genas, France
1986 Kunstmuseum Winterthur; Winterthur, Switzerland
1990 Helmhaus Zurich; Zurich, Switzerland

1993 *The Complete Life and Work, Seen Through the Pink Glasses of Desire*; Galerie Blancpain-Stepczynski, Geneva, Switzerland
1994 Kunstraum im politischen Club Colonia; Cologne, Germany
1996 *Placebos & Surrogates*; Galerie Blancpain-Stepczynski, Geneva, Switzerland
2000 *Run for Your Life (Placebos & Surrogates)*; Swiss Institute, New York, New York
2001 *Art for a Better Life: From Placebos & Surrogates*; XLIX Venice Biennial, Swiss Pavilion, Venice, Italy

Group Exhibitions

1970 *Visual Thought Processes*; Kunstmuseum Luzerne, Lucerne, Switzerland
1974 *Transformer*; Kunstmuseum Luzerne, Lucerne, Switzerland, and traveled to The Kitchen, New York, New York; Institute of Contemporary Art, Philadelphia, Pennsylvania; and Contemporary Art Center, Cincinnati, Ohio
1975 *Body Art*; Galerie Stadler, Paris, France
1976 *Art as Photography*; Fotoforum Kassel, Kassel, Germany
1977 *Identity, Identification*; Palais des Beaux-Arts, Brussels, Belgium
 Documenta 6; Kassel, Germany
1978 Sydney Biennale; Sydney, Australia
 Artitudes; Contemporary Art Gallery, Musée de Nice, Nice, France
1981 *Westkunst*; Centre Georges Pompidou, Paris, France
1983 *Art and Photography*; Berlin National Gallery, Berlin, German
1984 *Contiguities*; Palais de Tokyo, Paris, France
1985 *Medium Photographies*; Oldenburger Kunstverein, Oldenburg, Germany
1987 *Androgyne*; Neuer Berlin Kunstverein, Berlin, German
1989 *The Invention of an Art*; Centre Georges Pompidou, Paris, France
1992 *Manifesto*; Centre Georges Pompidou, Paris, France
1995 *Beyond Limits*; Centre Georges Pompidou, Paris, France
1996 *Masculine-Feminine*; Centre Georges Pompidou, Paris, France
1999 *The Truth of Photography*; Hara Museum of Contemporary Art, Tokyo, Japan, and traveled to National Center of Photography, Paris, France; Art Academy, Berlin, Germany
 Tomorrow Forever-Photography in Ruins; Kunsthalle Krems, Krems, Austria
2000 *Ich est etwas anderes—Art at the End of the Twentieth Century*; Sammlung Nordrhein-Westfalen, Düsseldorf, Germany

Selected Works

Sketches (with Willy Spiller and David Weiss), 1970
Lüthi Also Weeps for You, 1970
Manon as a Self-Portrait by Urs Lüthi, 1971
I'll Be Your Mirror, 1972
The Numbergirl, 1973
The Complete Life and Work, Seen Through the Pink Glasses of Desire, 1993
Placebos & Surrogates, 1996–
Run for Your Life, 2000

Trademarks for Venezia from Placebos & Surrogates, 1970s/2001
Art for a Better Life: From Placebos & Surrogates, 2001

Further Reading

Ammann, Jean-Cristophe, ed. *Urs Lüthi*. Exh. cat. Basel: Kunsthalle Basel, 1976.

Butler, Susan. "Once Upon a Place and Time." *Creative Camera* (Oct.–Nov. 1999): 22–27.

Lüthi, Urs. *Urs Lüthi 1900*. With essays by Marie-Louise Lienhard, Beat Wyss, Hannes Bohringer. Zurich: Helmhaus, 1990.

Lüthi, Urs. *Run For your Life* (*Placebos & Surrogates*). With text by Helmut Freidel et al. Lenbachhaus Munich and Swiss Institute New York. Ostfildern: Hatje Kantz, 2000.

Lüthi, Urs. *Art for a Better Life; From Placebos + Surrogates: XLIX Venice Biennial*. With essays by Max Wechsler, Michelle Nicol, and Jeiner Georgsdorf. Lucerne: Edizioni Periferia, 2001.

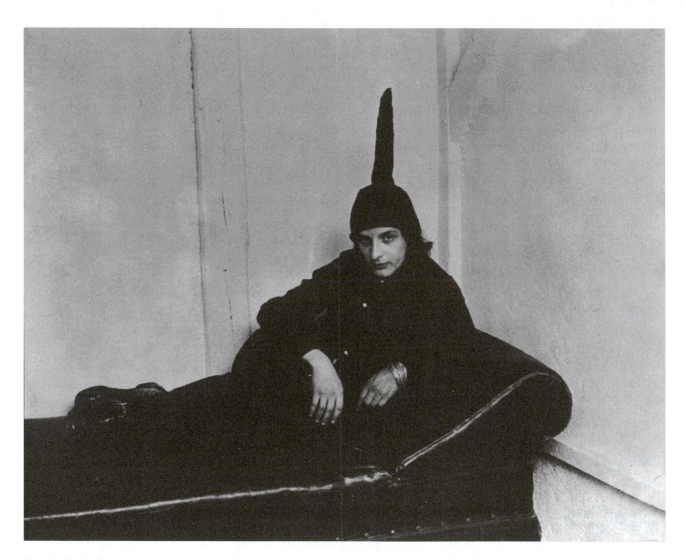

Urs Lüthi, Self portrait.
[© *Rights Reserved, CNAC/MNAM/Dist. Réunion des Musées Nationaux/Art Resource, New York*]

GEORGE PLATT LYNES

American

George Platt Lynes was an accomplished fashion photographer during his lifetime, most sought after for his technically virtuosic commercial work for *Harper's Bazaar*, *Vogue*, and other popular magazines. He was sought after as well as for his engaging portraits of some of the most influential literary figures of his day, including dance critic and ballet impresario Lincoln Kerstein, and poets W.H. Auden and Marianne Moore. The images for which he today commands a great deal of attention, however, are his Surrealist-inspired homoerotic nudes (*Male Nude on Faux Skin Rug*, 1953) and mythological studies (*Birth of Dionysus*, 1936–1939). Lynes was formed, for the most part, by the expatriate era of the 1920s and 1930s and the artistic luminaries he encountered in his frequent trips to Europe. More specifically, the intellectual and emotional attachment he sustained throughout his lifetime with Monroe Wheeler, the head of New York's Museum of Modern Art (MoMA) Exhibitions and Publications departments during this time, and with Gertrude Stein, were the most important influences that would steer him towards his achievement and as one of the most significant, yet almost forgotten, photographers of the twentieth century.

George Platt Lynes was born in 1907 in East Orange, New Jersey, the son of a clergyman. Educated at private schools and briefly at Yale University, Lynes made his first trip to France in 1925 where he met artists Jean Cocteau and Pavel Tchelichev and writers Andre Gide and Gertrude Stein, with whom he corresponded for the next ten years, and all of whom he later photographed. He returned stateside that same year and published a series of literary pamphlets including Stein's *Description of Literature* and Ernest Hemingway's first play, *Today is Friday*, with cover designs by Cocteau and Pavel Tchelichew. Lynes began photographing in 1927, under the mentoring of a local professional photographer in Englewood, New Jersey, and opened The Park Place Book Shop in 1928. Accompanied by Monroe Wheeler and writer Glenway Wescott, he made his second trip to France in 1928, during which he was probably introduced to the work of expatriate photographers Man Ray,

George Hoyningen-Huene, Germaine Krull, Paul Outerbridge, Jr., and Berenice Abbott. Lynes began experimenting with "double exposures and other controlled accidents in the surrealist manner, however, there is little to suggest that Lynes subscribed fully to the tenets of surrealism." (Crump 1993, 140).

In 1931, Lynes met and was encouraged by Julien Levy, with whom he collaborated on a series of Surrealist-influenced still-lifes. Levy included work by Lynes in the *Surrealism* exhibition at the Wadsworth Athenaeum, Hartford, Connecticut, and in the seminal *Surréalisme* exhibition at the Julien Levy Gallery in New York in 1932. Lynes had his first solo exhibition at the Leggett Gallery, New York in 1932. Levy also exhibited his work in conjunction with Walker Evans later that year, as well as in the influential exhibition, *International Photographers*, at the Brooklyn Museum of Art. Lynes opened a portrait studio in New York City in 1932 and quickly became known for his portraits and fashion photographs. The same year, Levy and Lincoln Kirstein, Lynes's friend since prep school, included his work in *Murals by American Painters and Photographers* at MoMA, its first exhibition to include photography. In 1934, he had his second solo exhibition at the Julien Levy Gallery and in 1936, he was included in the controversial *Fantastic Art, Dada, and Surrealism* show at MoMA (see *The Sleepwalker*, 1935). Over 200 of Lynes's portraits and photographs were shown at the Pierre Matisse Gallery in New York City in 1941.

Alexey Brodovitch, who as art director for *Harper's Bazaar*, began giving Lynes fashion assignments because of his ability to solve difficult artistic problems that studio lighting offered. Lynes acted as official photographer to Lincoln Kirstein's American Ballet Company (later the New York City Ballet) documenting George Balanchine's productions until the early 1940s in the tradition of Baron Adolph de Meyer and Hoyningen-Huene. Lynes also photographed choreographer and dancer Frederick Ashton and the principal dancers in the operetta *Four Saints in Three Acts*, 1934 (Crump 1993, 141).

Lynes's mythological series, completed between 1937 and 1940, legitimized the male nude in the

surrealist tradition. The images, representing the myths of Dionysis, Pan, Orpheus, and Eros, and others, were eroticized male nudes. These, along with his more straightforward male nudes, make up the bulk of the work he did between the late 1930s and early 1950s. Lynes utilized the same manipulation of light and composition as in his fashion and portrait studies. In many cases, the figures are posed in scenes that suggest narratives. In others, the concentration is on the gesture and the pose, and in still others, the emphasis shifts to the model's direct engagement with the viewer. There exists little differentiation in the way Lynes photographed both the male and female nude. In both, the emphasis on the musculature of the figure and the eroticism of the form, has been suggested as a direct result of his communication with sex researcher Alfred C. Kinsey, the most noted collector at the time of Lynes' erotic images. Lynes pursued his relationship with the Kinsey Institute as a repository for what he considered his most important work (Miller 1994).

Lynes moved to California in 1945 to become director of *Vogue*'s Hollywood studios. He made many portraits of film stars at this time but found this work debilitating. He returned to New York after three years and spent the remainder of his life doing fashion photography and continuing his personal work, although he never regained the notoriety that he had before his move to the West Coast. Lynes was unable to exhibit most of his creative work during his lifetime for fear that its homoerotic qualities would endanger his career. He destroyed a large portion of these photographs, and few of the remainder were made public until Lynes was the subject of a major retrospective at the Art Institute of Chicago in 1960 and *George Platt Lynes: Photographs from the Kinsey Institute* in 1993. Various monographs followed including, *George Platt Lynes: Photographs 1931–1955*, Twelvetrees Press, 1981; *George Platt Lynes: Ballet*, Twelvetrees Press, 1985; and *George Platt Lynes, Photographs from the Kinsey Institute*, 1993. Lynes died nearly impoverished in 1955.

VINCENT CIANNI

See also: **Abbott, Berenice; de Meyer, Baron Adolph; Fashion Photography; Hoyningen-Huene, George; Krull, Germaine; Levy, Julien; Man Ray; Museum of Modern Art; Outerbridge, Jr., Paul; Portraiture; Surrealism**

Biography

Born in East Orange, New Jersey, 15 April 1907. Privately educated. Enters Yale University, 1925. Makes first trip to Europe, meets lifetime companions Glenway Wescott

and Monroe Wheeler, 1925. Publishes the *As Stable Pamphlets*, Englewood, New Jersey, 1925. Opens Park Place Book Shop, Englewood, New Jersey, 1926. Exhibits his celebrity portraits at Park Place Book Shop, continues traveling to Europe, teaching himself photography, 1928. Julien Levy arranges to include Lynes in *Surréalism* exhibition, Wadsworth Athenaeum, Hartford, Connecticut, 1931. First important exhibition Julien Levy Gallery in tandem with Walker Evans, 1932. Opens first New York City studio, 1933. Begins publishing fashion and portrait work in *Town and Country*, *Harper's Bazaar*, and *Vogue*, 1934. Documents American Ballet (now New York City Ballet), 1935. Surrealistic composition *The Sleepwalker* included in *Fantastic Art, Dada and Surrealism*, 1936. Photographs mythology series, 1937–1940. Disillusioned with New York and his private life, Lynes closes his studio and leaves for Los Angeles to head *Vogue* magazine's Hollywood studio, 1945. Return to New York, 1948. Meets sex researcher Alfred Kinsey who purchases photographs for Kinsey Institute, Bloomington, Indiana Institute, 1950. Publishes his male nudes in homoerotic magazine *Der Kries* using the pseudonyms Roberto Rolf and Robert Orville, 1951–1954. Declares bankruptcy, 1954. Diagnosed terminally ill with cancer; last portrait with Monroe Wheeler, May, 1955. Died in New York, New York, 6 December 1955.

Selected Works

Frederick Ashton and the principal dancers of Four Saints in Three Acts, 1934
The Sleepwalker, 1935
Portrait of Jean Cocteau, 1936
Yves Tanguy, c. 1938
Birth of Dionysus, 1936–1939
Cyclops, 1936–1939
Female Nude, 1940
Male Nude Hanging, 1940
Portrait of Tennessee Williams, 1944
Portrait of Jared French, 1945
Portrait of Lincoln Kirstein, 1948
Fashion Study for Vogue, 1948
Maria Tallchief in Firebird, 1949
Nicholas Magallenas and Francisco Moncion in Orpheus, New York City Ballet, 1950
Female Nude, 1950
Male Nude as "dying slave," 1952
Male Nude on Faux Skin Rug, 1953

Individual Exhibitions

1932 *Portrait Photography by George Platt Lynes*; Leggett Gallery, New York, New York
1992 *Fifty Photographs by George Platt Lynes*; Julien Levy Gallery, New York, New York
1941 *Two Hundred Portraits by George Platt Lynes Plus an Assortment of Less Formal Pictures of People*; Pierre Matisse Gallery, New York, New York
1973 *George Platt Lynes, Portraits 1931–1952*; Art Institute of Chicago, Chicago, Illinois
1988 Sonnebend Gallery; New York, New York
1996 Nicholas Wilder Gallery; Los Angeles, California

1997 *George Platt Lynes, Photographic Visions*; Institute of Contemporary Art, Boston, Massachusetts

1998 Robert Miller Gallery; New York, New York
Stephen Wirtz Gallery; San Francisco, California

1978 *George Platt Lynes: Photographs from the Kinsey Institute*; Grey Art Gallery and Study Center, New York, New York; Centro per l'Arte Contemporanea Luigi Pecci, Prato (Florence), Italy

1994 *George Platt Lynes: Photographs from the Kinsey Institute*; Henry Radford Hope School of Fine Arts Gallery, Indiana University, Bloomington, Indiana

Selected Group Exhibitions

1931 *Surrealism*; Wadsworth Atheneum, Hartford, Connecticut

1932 *Surrealisme*; Julien Levy Gallery, New York, New York
Walker Evans and George Platt Lynes; New York, New York
Murals by American Painters and Photographers; Museum of Modern Art, New York, New York

1936 *Fantastic Art, Dada, and Surrealism*; Museum of Modern Art, New York, New York

1937 *Review Exhibition*; Julien Levy Gallery, New York, New York

1967 *Twentieth Century Portraits*; Museum of Modern Art, New York, New York

1985 *Seventeen American Photographers*; Los Angeles County Museum of Art, Los Angeles, California

1977 *Photographs from the Julien Levy Collection*; The Witkin Gallery, New York, New York

1989 *Photographic Surrealism*; The New Gallery of Contemporary Art, Cleveland, Ohio
The Male Nude: A Survey in Photography; Marcuse Pfeiffer Gallery, New York, New York

1989 *The New Vision: Photography Between the World Wars, Ford Motor Company Collection at the Metropolitan Museum of Art*; Metropolitan Museum of Art, New York, New York

1999 *Selections from the Collections of the Kinsey Institute*; The Kinsey Institute, Bloomington, Indiana

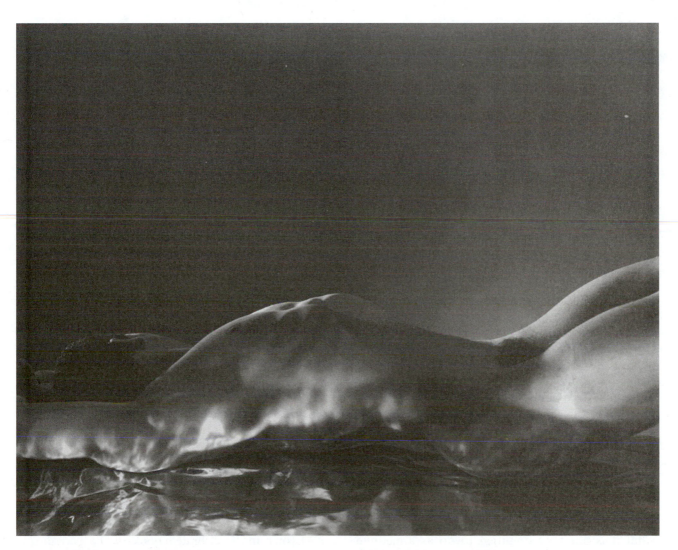

George Platt Lynes, Untitled, male nude in 'water' reflection, circa 1950, gelatin silver print.
[*Photograph by George Platt Lynes. Courtesy of John Stevenson Gallery*]

Further Reading

Becherer, Joseph P. *Selections from the Collection of the Kinsey Institute*. Bloomington, IN: Kinsey Institute, 1990.

Crump, James. *George Platt Lynes, Photographs from the Kinsey Institute*. Boston: Little, Brown and Company, 1993.

Feinblatt, Embria. *Seventeen American Photographers*. Los Angeles: Los Angeles County Museum of Art, 1948.

Kirstein, Lincoln. *George Platt Lynes Portraits, 1931–1952*. Chicago: Art Institute of Chicago, 1960.

Lynes, George Platt. *The New York City Ballet Photographs taken by George Platt Lynes: 1935–1955*. New York: City Center of Music and Drama, 1957.

Miller, Barbara L., and Robert L. Cagle. "Out of the Kinsey Archives: Reevaluating the Photographic Works of George Platt Lynes." *The Ryder Magazine*, Indiana University (September 9–23, 1994).

Pohorilenko, Anatole, and James Crump. *When We Were Three: The Travel Albums of George Platt Lynes, Monroe Wheeler, and Glenway Wescott, 1925–1935*. Santa Fe, NM: Arena Editions, 1998.

Prokopoff, Stephen. *George Platt Lynes: Photographic Vision*. Boston: Institute of Contemporary Art, 1980.

Woody, Jack. *George Platt Lynes: Photographs 1931–1955*. Pasadena, CA: Twelvetrees Press, 1981.

Woody, Jack. *George Platt Lynes: Ballet*. Pasadena, CA: Twelvetrees Press, 1985.

DANNY LYON

American

A self-taught photographer, Danny Lyon began taking photographs at the age of 17. Raised in Forrest Hills, New York, a middle class neighborhood just outside Manhattan, Lyon went on to the University of Chicago where he majored in history. By the time he received his Bachelor of Art degree in 1963 Lyon had already begun work on one of the most important series of his career, that on the civil rights movement. In 1962, he had joined the Student Non-violent Coordinating Committee (SNCC) as a photographer documenting the U.S. civil rights movement. This association began a career as a photojournalist and a filmmaker that has spanned five decades.

Coming of age during the socially conscious 1960s, Lyon's documentary photography and film work grew from a deep commitment to social issues. An innovator in the immersive and social approach to documenting marginalized communities, Lyon's belief in photography's accessibility and its potential for social change coupled with his working method have made him one of the most original photographers of the late twentieth century. From the beginning of his career, Lyon has maintained that documentary images should not be isolated from the context of their making. He has said that "Photography works best when it does what it is uniquely qualified to do as a medium: reproduce the real world." Along with his peers Bruce Davidson, Leonard Freed, Roland L. Free-

man, and Mark Ellen Mark, he sought through his photography to raise awareness of issues of tolerance and social justice.

Lyon's documentary projects investigate social groups and their surroundings by his joining the group and photographing it from within. He has produced moving accounts of groups as diverse as bikers, prison inmates, Native Americans, and Mexican immigrants. Lyon's own Jewish, east coast background never stopped him from immersing himself in communities different from his own. As the first staff photographer for the Atlanta based, predominantly African American organization, SNCC, Lyon worked with this group from 1962 to 1964. During that time Lyon's ideas regarding the usefulness of photography for social good were perfectly in line with the organization's needs for documentation of the student-led movement within the civil rights movement. His images of lunch counter sit-ins and demonstrations were striking and often showed the violence and risk involved in the struggle. His photographs were reproduced in the press, as well as in SNCC fundraising brochures, and were compiled in his own book called *The Movement* (1964). A later edition entitled *Memories of the Southern Civil Rights Movement* (1992) included additional text by Lyon and others that put the student contributions to the civil rights movement in context.

Lyon's most celebrated book of the period, *The Bikeriders*, was produced just after his time in the south. Published in 1968, *Bikeriders* probed the dan-

gerous and exciting life of motorcycle riders from the perspective of the Chicago Outlaw Motorcycle Club. Lyon became a proud member of the Outlaws, traveling with them, sharing their lifestyle, and photographing them from 1963 to 1967. His next book, *Conversations with the Dead* was published in 1971. Over a period of 14 months Lyon was allowed access to the Texas prison system. His photographs explored the lives of those incarcerated in six Texas prisons. The publication included texts taken from prison records and convicts' writings, particularly the letters of Billy McCune, a convicted rapist whose death sentence was commuted to life in prison. While many of Lyon's books have had a great influence on the social documentary tradition, *The Bikeriders* and *Conversations with The Dead* became seminal examples of the new style of modern photojournalism.

Lyon's subsequent books are distinctive in their inter-weaving of photographs, text, interviews, and sometimes fiction. As published works, each project combined Lyon's searing photographic images with his and his subject's first person observations, giving the reader a fuller picture of the complex world Lyon often spent years investigating. This format contrasted sharply with the more traditional photo book model of the time, where image and text occupied distinct areas of a publication. Lyon, however, has maintained this practice throughout his career, even though he believed that it made many museums reluctant to show his work.

In the late1960s, Lyon embarked on a major series documenting the destruction of an area of lower Manhattan through urban renewal. Photographing buildings over a 12-block area, Lyon captured the end of an architectural era and also made portraits of some of its inhabitants. Dozens of Manhattan's nineteenth century buildings were soon to be demolished to make way for renovations to the Brooklyn Bridge and the construction of the World Trade Center. After this series was published as *The Destruction of Lower Manhattan*, Lyon worked sporadically for the federal government as a photographer. From 1972 through 1974 he completed a number of assignments for the Environmental Protection Agency's DOCUMERICA project. During this time he photographed extensively in Texas including the Rio Grande Valley and the Chicano barrios of South El Paso and Houston. In 1974, he photographed the Bedford-Stuyvesant section of Brooklyn, New York. Like his earlier documentary studies of marginalized groups, Lyon's images from these assignments mirror his concerns of community. They depict ethnic neighborhoods struggling under the pressure of outside forces, including federally driven policies such as urban renewal. Lyon's

humanistic approach is revealed in sequences of images that not only record ethnic communities before they are destroyed, but also express an intimacy and respect for the individuals he has come to know through the process of documenting them.

While not nearly as well known as his still photography, Lyon has pursued documentary filmmaking since the late 1960s. Over the years he has gained recognition as a skilled and thoughtful filmmaker. His films include *Soc. Sci. 127* (1969), *Little Boy* (1977), *Los Ninos Abandonados* (*The Abandoned Children*, 1975), *Born to Film* (1982), and *Media Man* (1994). Working simultaneously in film and still photography, Lyon has recorded many of the same Latino and Native American communities in both mediums. In 1979, a decade after being awarded a Guggenheim Foundation Fellowship in photography, he was awarded another in film.

During the 1980s, Lyon became increasingly interested in mixing autobiographical themes into his work. As a result, old family photographs, his own images of his wife and children, as well as autobiographical texts became familiar elements in works such as the 1982 film *Born to Film*, and the books *I Like to Eat Right on The Dirt* (1989), and the autobiographical monograph *Knave of Hearts* (1999). In 1990, a major traveling retrospective of his work entitled *Danny Lyon: Photo Film. 1959–1990* was mounted by the Folkwang Museum in Essen, Germany, and the Center for Creative Photography in Tucson, Arizona.

While his work has been included in countless group and solo exhibitions through out North America and Europe, Lyon's philosophy about the power and responsibility of documentary image-making are best expressed in his book projects. The importance of photography's accessibility and its potential for social and political change have been the driving force that has lead him to work extensively in the American South, the Southwest, Mexico, Haiti, and Cuba. In keeping with his interest in democratizing the photographic image, Lyon has created a website (www.BleakBeauty.com) which not only displays his work for a broad audience but also provides a discussion forum and an outlet for his political views:

When activist photography appeared on the scene in the early 1960s we assumed that a revolution was at hand... The marriage of the B&W photograph with the offset printing press was a marriage made in heaven; for the realistic picture could be reproduced and available to thousands for a reasonable amount of cash. This happy marriage should have spawned dozens of picture-magazines helping to radicalize America and putting the

power of the press into thousands of individual hands. This did not happen. Instead the explosion of interest in photography spurned few magazines, but hundreds of art galleries instead.

Lyon's personal involvement as a witness to the struggles he records has made him a unique figure in American photography. He has been an unapologetic subjective reporter, pursuing a type of advocacy in documentary practice and expressing his views on the failures of society and the endurance of disenfranchised communities. He has also been a champion of the photographic book as a distinct and democratic form of expression where text and image have equal importance in illuminating the photographer's vision.

LISA HENRY

See also: **Documentary Photography; Photographic "Truth"; Representation and Gender; Social Representation**

Further Reading

Lyon, Danny. *The Bikeriders*. San Francisco: Chronicle Books, 2003.

———. *Bushwick*. Rozel: Le Point du Jour editeur, 1996.

———. *Conversations with the Dead*. Austin, TX: Holt, Rinehart and Winston, 1971.

———. *The Destruction of Lower Manhattan*. New York: Power House Books, 2005. *Pictures from the New World*. Millerton, New York: Aperture, 1981.

———. *I Like to Eat Right on the Dirt*. Clintondale, NY: Bleak Beauty Books, 1989.

———. *Indian Nations: Pictures of American Indian Reservations in the Western United States*. Santa Fe, NM: Twin Palms Publishers, 2002.

———. *Knave of Hearts*. Santa Fe, NM: Twin Palms Publishers, 1999.

———. *Merci Gonaives*. Clintondale, NY: Bleak Beauty Books, 1988.

———. *Memories of The Southern Movement*. Chapel Hill, NC: University of North Carolina.

———. *The Paper Negative*. Clintondate, NY and Bernalillo, NM: Bleak Beauty Books, 1980.

NATHAN LYONS

American

Since the mid-1950s, Nathan Lyons has contributed significantly to the discipline of photography. As a photographer, curator, director, teacher, writer, editor, and lecturer, his influence has been felt in the field for nearly five decades. Leroy F. Searle writing for *Afterimage* in the Jan/Feb 2004 issue recalls:

> When I first met Nathan Lyons, I anticipated something midway between a legend and a rumor—entirely appropriate for someone who...had created a full-fledged graduate program in photography affiliated then with SUNY-Buffalo...he moved the program from the George Eastman House to an old woodworking factory, enlisting every new class of graduate students into remodeling... and turning the Visual Studies Workshop into one of the most remarkable institutions in the contemporary history of American art and culture, whose graduates, faculty, and friends are, without much exaggeration, the Who's Who of American Photography.

Born January 10, 1930 in Jamaica, New York, Lyons, a self-taught photographer, became interested in the medium in 1945 at the age of 15. After having graduated from Haaren High School, New York in 1947, he enrolled for two years in the Manhattan Technical Institute where he studied architectural drafting, and then went on to major in Business Administration at Alfred University, New York from 1948–1950. In 1950, Lyons enlisted in the U.S. Air Force as a photographer, was involved in the Photo Intelligence Unit in Korea from 1951–1953, and then remained for a year as a staff news writer and public relations photographer. He returned to Alfred University in 1954 and majored in English literature, graduating in 1957 with a Bachelor of Arts. That same year he was hired by the George Eastman House in Rochester, New York, a museum of photography and cinematography founded in 1947, to be the Director of Information and Assistant Editor of the magazine *Image*. His first curatorial project was in 1959 when Lyons organized the traveling exhibition, *Seven Contemporary Photographers*. He has since gone on to immerse himself completely in photography. He founded *Afterimage*, a nonprofit, bimonthly journal of photography, independent film, video, and alternative publishing, and was editor of the magazine from its start in March

1972 through to 1977. In 1983, he organized Oracle, now an international organization of directors and curators of photographic institutions that meets annually to discuss a variety of issues and topics related to photography.

Lyons's various accomplishments are all based on his identity as a scholar. As the author and editor of numerous books and exhibition catalogues, his writings have sought to define the capabilities of the image-making process specific to photographic practice. In doing so, he has encouraged the development of a history of photography as well as stimulated a "discussion of photography as an expressive medium," as Lyons wrote in the catalogue essay to his 1967 exhibition for Eastman House, *Photography in the Twentieth Century*, 1967. The exhibition consisted of photographs from the George Eastman House's collection, including work by Diane Arbus, Bill Brandt, Harry Callahan, Robert Capa, Mario Giacomelli, Eikoh Hosoe, Ray K. Metzker, Lisette Model, Duane Michels, Frederick Sommer, Edward Steichen, and Jerry Uelsmann, to name just a few who were included and who demonstrate the range of possibilities in and approaches to photography. This exhibition was one of many he organized during his time as Associate Director and Curator of Photography at the George Eastman House until 1969, when he left to become the founding Director of the Photographic Studies Workshop (now Visual Studies Workshop), a media arts center and one of the first alternative organizations of its kind in the country.

Considering his own personal, photographic projects, Lyons carefully organizes his photographs by presenting them as diptychs, juxtaposing image next to image in sequences, thereby revealing how meaning is constructed and how interpretation is structured by sets of juxtapositions. Since 1956, he has been engaged in creating sequences of images with words appearing in the frame and playing an important role in the formation of meaning.

In 1962, Lyons set aside his view camera for a 35 mm camera, and has thought of the work produced after this year as eventually forming a trilogy starting with *Notations in Passing*, published in 1974, his first attempt at creating photographic sequences that set the pace for his approach and provided an introduction to his visual vocabulary. For several years he was involved in recording the urban and suburban landscapes as well as documenting the man-made in the rural environment. Meditative in its presentation, *Notations* possesses a rhythm that captures the poetics of human intervention in the landscape. There are no essays or texts accompanying the images, except for one word, "Introduction," printed at the start of the book. In retrospect, this serves as an apt beginning for what was to come in subsequent years in his career as a photographer.

His second photographic project in the "trilogy" is *Riding 1st Class on the Titanic!*, which took 13 years to complete and reflects many of the same concerns as Robert Frank's *The Americans*. From 1974 to 1987 Lyons photographed storefront windows, graffiti, bumper stickers, and billboards, among others urban displays. The title of the book is taken from an inscription that appears in one of the photographs, which captures a graffiti-sprayed wall.

Lyons's most recent publication, *After 9/11*, published by Yale University Art Gallery, is a visual record of the varied responses and reactions by Americans to the devastating tragedy of the terrorist attack that led to the collapse of the World Trade Center. Lyons engaged in recording the collective response in cities and towns across the United States, including New York. Over the course of 13 months he photographed man-made compositions he discovered in the landscape that mimicked the American flag. The flag is present in a number of these photographs, but when not included, Lyons frames the scene and presents it in a horizontal format so as to construct an image that represents and takes the form of the American flag.

Lyons's photographs have been included in a number of exhibitions and are in the permanent collections of the Addison Gallery of American Art, Andover, Massachusetts; Amon Carter Museum, Fort Worth, Texas; Center for Creative Photography, Tucson, Arizona; International Center of Photography, New York; Museum of Fine Arts, Houston, Texas; Museum of Modern Art, New York; and the San Francisco Museum of Modern Art, California, to name just a few. He has lectured extensively on photography and photographic education, and continues to teach workshops at the Visual Studies Workshop, such as *Image, Sequence, Series*, which examines narrative and non-narrative structures employed as a strategy in photographic practices. In 2001, he left his position as Director of the Visual Studies Workshop, but continues his involvement as Director Emeritus at the Workshop and as a member of the Board of Directors. He is also Distinguished Professor Emeritus at SUNY Brockport, New York. Whether he is photographing, writing, curating, lecturing, or editing Lyons's perceptive, intuitive, and full engagement with the world around him, and therefore the world of images, results in an honest response to his environment and a body of photographic work that as Adam D. Weinberg wrote "provide[s] a contin-

uous line of thinking, a guidebook to a life, a 'guidebook' that has influenced the thinking of a generation of photographers.''

MARISA C. SÁNCHEZ

See also: **Afterimage; Professional Organizations**

Biography

Born in Jamaica, New York, 10 January 1930. Attended Haaren High School, New York, 1943–1947; studied architectural drafting, Manhattan Technical Institute, New York, 1948–1950; majored in Business Administration at Alfred University, New York, 1948–1950; enlisted in the United States Air Force, 1950; served in Photo Intelligence Unit, 1951–1953, and as staff news writer and public relations photographer. Majored in English literature, Alfred University, New York, 1954–1957, B.A.. Amateur photographer, New York, 1946–1950; freelance photographer, New York, 1954–1957. Director of Information, George Eastman House, Rochester, New York, 1957–1958; Assistant Editor *Image* magazine, 1957; Editor of publications/Associate Editor of *Image*, 1958–1959; Appointed Assistant Director, George Eastman House, 1960–1963; Regional Editor of *Aperture*, 1960–1966; Associate Director and Curator of Photography, George Eastman House, 1965–1969; Founder-Member and Chairman, Society for Photographic Education, 1963–1965; Founder and Director of the Photographic Studies Workshop (now Visual Studies Workshop), Rochester, New York, 1969; Director of the Photographic Studies Program, State University of New York, Buffalo, 1969–1980; Founder and Editor *Afterimage* magazine, 1972–1977; Initiated *Oracle*, 1983; Founding member of Photo Archives Belong, Rochester, New York, 1984; Received National Endowment for the Arts Fellowship, 1974; NEA Senior Fellowship, 1985; Friends of Photography Peer Award in Creative Photography (for distinguished career in photography) 1989. Honorary Doctorate in Fine Arts by the Corcoran School of Art, Washington, DC, 1995. Infinity Award for Lifetime Achievement from International Center for Photography, 2000.

Individual Exhibitions

1958 *Seven Days a Week*; George Eastman House, Rochester, New York

1960 *Nathan Lyons*; Rochester Institute of Technology, Rochester, New York

1965 *Nathan Lyons: Photographs*; University of Minnesota, Minneapolis, Minnesota

1971 *Notations in Passing*; University of Colorado, Boulder, Colorado

1972 *Recent Photographs by Nathan Lyons*; Columbia College, Chicago, Illinois

1974 *Nathan Lyons*; Light Gallery, New York, New York

1974 *Notations in Passing*; Spectrum Gallery, Light Impressions, Rochester, New York

1977 *Nathan Lyons: 100 Photographs from Notations in Passing*; University of Maryland, Baltimore County, Maryland

1982 *Verbal Landscape* (with Bart Parker); Museum of Fine Arts, Houston, Texas

1983 *Nathan Lyons and the Visual Studies Workshop*; SICOF 10th International Exhibition, Milan, Italy

1986 *Riding First Class on the Titanic: A Work in Progress*; Catskill Center for Photography, Woodstock, New York

2000 *Notations: A Retrospective Exhibition*; Howard Greenberg Gallery, New York, New York

2000 *Riding First Class on the Titanic!*, Addison Museum of Art, Andover, Massachusetts, and traveled to International Center of Photography, New York, New York; George Eastman House, Rochester, New York; University of Maryland, Baltimore, Maryland; Houston Center for Photography, Houston, Texas

2003 *After 9/11*; Acta International, Rome, Italy; Foto Septiembre, Mexico City, Mexico; Light Works, Syracuse, New York

Group Exhibitions

1959 *Photography at Mid-Century*; George Eastman House, Rochester, New York

1960 *The Sense of Abstraction in Contemporary Photography*; Museum of Modern Art, New York, New York

1960 *New Talent in the USA, 1960*; The American Federation of Arts, New York, New York

1961 *Fourteen Photographers from the Carl Siembab Gallery*; Museum of Fine Arts, Boston, Massachusetts

1963 *Photography in the Fine Arts IV*; Metropolitan Museum of Art, New York, New York

1964 *The Photographer's Eye*; Museum of Modern Art, New York, New York

1965 *Nathan Lyons—Joan Lyons*; Alfred University, Alfred, New York

1966 *American Photography: The Sixties*; Sheldon Memorial Art Gallery, University of Nebraska, Lincoln, Nebraska

1967 *Photography in the Twentieth Century*; National Gallery of Canada, Ottawa, Canada

1968 *Photography and the City: The Evolution of an Art and a Science*; Smithsonian Institution, Washington, D.C.

1969 *Nathan Lyons, Danny Lyon*; The University of Connecticut, Storrs, Connecticut

1969 *The Photograph as Object*; National Gallery of Canada, Ottawa, Canada, and traveling

1970 *Being Without Clothes*; Creative Photo Gallery, MIT, Cambridge, Massachusetts

1974 *Photography in America*; Whitney Museum of American Art, New York, New York

1977 *The Great West: Real/Ideal*; University of Colorado, Boulder, Colorado, and traveling

1978 *Mirrors and Windows: American Photography Since 1960*; Museum of Modern Art, New York, New York, and traveling

1985 *American Images*; Barbican Art Gallery, London, England, and traveling

1985 *City Light*; International Center of Photography, New York, New York

1986 *American Images: Photography 1945–1980*; Manchester City Art Gallery, Manchester, England

1987 *Photography and Art: Interactions Since 1946*; Los Angeles County Museum of Art, Los Angeles, California

1990 *Some Photo Teachers from the Rochester Area: Chiarenza, Cooper, Gussow, Hook, Lyons, Lyons, McCarney, Mertin, Smith, Wyman*, RIT Photo Gallery, Rochester, New York

1991 *Patterns of Influence: Teacher/Student Relationship in American Photography Since 1945*; Center for Creative Photography, University of Arizona, Tucson, Arizona
1998 *Urban Visions*; Addison Gallery of American Art, Andover, Massachusetts
2004 *In The Center of Things: A Tribute to Harold Jones*; Center for Creative Photography, University of Arizona, Tucson, Arizona

Selected Works

Untitled, 1959
Maroon Bells, Colorado, 1969
Phoenix, 1974
Notations in Passing, 1974
Riding 1st Class on the Titanic!, 1974–1987
After 9/11, 2001–2002

Further Reading

By Lyons:

Photographers on Photography. Englewood Cliffs, NJ: Prentice-Hall, 1966. (Currently in 20th edition). Translated by Bruno Boueri in Italian as *Fotografi Sulla Fotografia*, Torino: Agora Editrice, 1990.
Points of View: The Stereograph in America; A Cultural History. Edited by Edward W. Earle. Rochester, NY: Visual Studies Workshop Press, 1979.
Introduction. *Vision and Expression*. Contemporary Photographers Series, New York: Horizon Press in collaboration with George Eastman House, 1969.
Photography in the Twentieth Century. Contemporary Photographers Series in conjunction with an exhibition prepared for the National Gallery of Canada. New York: Horizon Press, in collaboration with George Eastman House, 1967.
The Persistence of Vision. Contemporary Photographers Series. New York: Horizon Press, in collaboration with George Eastman House, 1967.
Toward a Social Landscape. Contemporary Photographers Series. New York: Horizon Press, in collaboration with George Eastman House, 1966.
Aaron Siskind: Photographer. Edited and with an introduction by Nathan Lyons. Rochester: George Eastman House, 1965.

Under the Sun: The Abstract Art of Camera Vision. With Walter Chappell and Syl Labrot. New York: George Braziller, Inc. 1960.
Notations in Passing. Cambridge, MA: MIT Press, 1974.
Verbal Landscape/Dinosaur Sat Down. Buffalo, NY: Center for Exploratory & Perceptual Art and Albright Knox Gallery, 1987.
Riding 1st Class on the Titanic! Photographs By Nathan Lyons. Preface by Adam D. Weinberg and afterward by Leroy F. Searle. Andover, MA: Addison Gallery of American Art, Phillips Academy, distributed by MIT Press, 1999.
After 9/11. Introduction by Marvin Bell and afterward by Richard Benson. New Haven, CT: Yale University Art Gallery, 2003.

On Lyons:

Doty, Robert, ed. *Photography in America*. New York: The Whitney Museum of American Art, 1974.
Finkel, Candida. "Photography as Modern Art: The Influence of Nathan Lyons and John Szarkowski." *Exposure* 18:2 (1981): 22–35.
George Eastman House. *A Collective Endeavor: The First Fifty Years of George Eastman House*. Rochester, NY: George Eastman House, 1999.
Goldberg, Vicki. "Subtle Juxtapositions From A Diffident Force for Change." *New York Times* (May 12, 2000).
Grundberg, Andy, and Kathleen McCarthy Gauss, eds. *Photography and Art, Interactions Since 1946*. New York: Abbeville Press, 1987.
Hume, Sandy, Ellen Manchester, and Gary Metz, eds. *The Great West: Real/Ideal*. Boulder, CO: University of Colorado, 1977.
"Nathan Lyons: After 9/11." *Contact Sheet* 123, 2003.
Newhall, Beaumont. "New Talent USA: Photography." *Art in America* 48, no. 1 (1960): 38–47.
Pelizzari, Maria Antonella. "Nathan Lyons: An Interview." *History of Photography* (Summer 1997): 147–155.
Saharuni, Randy. "Nathan Lyons: The Tip of the Iceberg." *Paris Photo* no. 24 (Feb/March 2003): 88–97.
Searle, Leroy. *Four Photographers By Four Writers*. Boulder, CO: University of Colorado, 1987.
Tucker, Anne Wilkes, ed. *In Sequence, Target III: Photographic Sequences from the Target Collection of American Photography*. Houston, TX: The Museum of Fine Arts, 1982.

M

DORA MAAR

French

Acknowledged primarily for her role as Pablo Picasso's muse and mistress, Dora Maar is now being recognized for the merits of her long artistic career. She was established as an artist before Picasso entered the Parisian art scene, having studied painting with André Lhote and photography with Henri Cartier-Bresson. It was Cartier-Bresson who suggested to Maar that she become a photojournalist, which she did in the early 1930s, traveling to Britain and Spain. These photographs of street life are in direct contrast to her earlier elegant fashion photography, but she is perhaps best known for her paradoxical Surrealist images.

In the early thirties, the French set designer Pierre Kéfer invited Maar to share his studio in Neuilly, and they collaborated on portraits and advertising as well as fashion photography. Her first professional job was photographing Mont Saint-Michel for a book the art critic Germain Bazin was producing. Through a mutual friend, Maar was introduced to the Hungarian-born photographer Brassaï, who at that time was well-established as a photographer. She was also influenced by Louis-Victor Emmanuel Sougez, whom she considered a mentor. He was a founder of the New Photography movement (in Germany, *Neue Sachlichkeit* or New Objectivity). When Maar was gravitating between painting and photography, Sougez urged her to pursue photography. The Kéfer-Maar studio closed in 1934 when Maar's father provided her with a studio and darkroom of her own near the church of Saint-Augustine in the eighth arrondissement of Paris. This address, 29 rue d'Astorg, became the title of one of her most famous Surrealist photomontages.

Paul Eluard's Surrealist poem "Identités" was dedicated to Maar and points to her ambiguities. She read and signed numerous Surrealist manifestoes and participated in several Surrealist exhibitions. Her subject matter is rooted in Surrealist thought and writing; Maar's flower pictures are thought to have been stimulated by Georges Bataille's 1929 essay, "The Language of Flowers." Her work seems also to have been inspired by the concept of the minotaur, half beast and half man, expounded upon in the Surrealist publication, *Le Minotaure*. This is best expressed in *Portrait of Pére Ube*, 1936, the name of the protagonist in Alfred Jarry's trilogy of plays first produced in 1896. Using a close-up of a baby axoloti (or armadillo though it has not been confirmed) as her model for Ube, Maar may have inspired Picasso's *Dream and Lie of Franco* (1937). Maar achieved many of her

images through photomontage and photocollage, a method of cutting, pasting, and rephotographing.

Maar also became involved in leftist anti-Fascist political groups such as Masses and contre-Attaque, through which she met Surrealist poet André Breton and photographer Man Ray. Maar photographed many of the Surrealist artists, and she and Man Ray worked together to illustrate the poet Paul Eluard's *Le Temps Déborde*. It was Eluard who, late in 1935, introduced Maar and Picasso on the set of *Le Crime de Monsieur Lange*, the socialist-inspired film written by Jean Renoir and Jacques Prévert. Although Maar remembered this brief meeting, Picasso did not; and Eluard's friend Jean-Paul Crespelle's account of the meeting in the Café de Deux Magots in Saint Germain, a famed Left Bank meeting place for artists, writers, and intellectuals, has become the accepted meeting place. Maar was engaged in a dangerous game—flinging a knife between her fingers. At times she missed and, according to Crespelle, "a drop of blood appeared between the roses embroidered on her black gloves." Fascinated by Maar, Picasso sought her expertise in printing photographic proofs from glass plates (clichéverre).

Mary Ann Caws has pointed out in *Picasso's Weeping Woman: The Life and Art of Dora Maar* that the two main themes in Maar's work—fashion and the avant-garde, and the street life of the impoverished—reflect the "constant pull between the two sides of her character, between her exuberance and her self-constraint." Her political activism also emerged in her work, especially her set photography for *Le Crime de Monsieur Lange*.

Dora Maar's paradoxical impulses can also be identified through the early work she did for erotic magazines and the extreme Catholicism she turned to in later life. Again quoting Caws, Maar "turned from Picasso to God." Another of her themes was the isolation of humanity. Maar photographed lone figures in the streets of London, Paris, and Barcelona. These images are considered metaphors for her own situation by some scholars because, after her breakup with Picasso, she eventually became a recluse.

Picasso's and Maar's tumultuous relationship took place between 1936–1944. After the defenseless Spanish town of Guernica was bombed by the German Condor Squadron on Sunday, 26 April, 1937, Picasso began painting his monumental mural of the same title. He had been commissioned to create the mural for the Spanish Pavilion in the Paris Universal Exposition that would open May 1937, but had previously been uninspired. *Guernica* has become what many scholars believe is his masterpiece. His inspiration came from the expressions he read on Maar's face as she learned about the attack, inspiring the

"Weeping Woman" image in *Guernica* as well as other paintings. Maar was the only person Picasso permitted in the studio during the five-week gestation of the painting; he even allowed her to paint a few strokes. Brassaï had previously served as Picasso's official photographer, but now Maar chronicled the master and the development of the masterpiece with her camera, yet she abandoned photography thereafter because of Picasso's consistent belittling of her talent. Maar was also the subject of a number of Picasso portraits. In *Dora Maar Seated* (1937), the youthful Maar appears confident and optimistic.

As the war in Europe intensified and France became occupied by Germany, the Maar/Picasso relationship deteriorated. Maar had been devoted to Picasso, taking a back seat to him personally and professionally. When he left her for Françoise Gillot, she suffered a nervous breakdown. Eventually receiving psychiatric treatement from the psychoanalyst Jacques Lacan, Maar became more self-confident and composed. She resumed her friendship with Brassaï, made new friends, and continued painting. In the 1980s, in her seventies, Maar returned to photography.

Picasso never left her totally, and Maar was never able to recover fully from his rejection; she maintained that she was not his mistress, but he was her master. Although he had tormented her, she was the one woman in his life whose intellectual capacity was equal to his. She turned to religion for solace and kept mementoes of their seven years together throughout her long life.

Illustrating Bazin's book was Maar's first professional work, and illustrating André and du Bouchet's poem, *Earth of the Mountain*, was her last (1961). Maar exhibited her work extensively during the forties. Collector/critic Heinz Berggruen has established a new museum in the Western Stoler Building, part of the Charlottenburg Palace Complex, in Berlin, where the work of Dora Maar is featured in one room.

MARIANNE BERGER WOODS

See also: **Brassaï; Cartier-Bresson, Henri; Man Ray; Manipulation; Photography in France; Surrealism**

Biography

Born Henrietta Théodora Markovitch 22 November 1907 in Paris to an immigrant Yugoslav architect and a French Catholic housewife. Childhood spent in Buenos Aires where her father was involved in numerous construction projects. Fluent in French and Spanish, which later endeared her to Picasso. At 19, returned to Paris to study painting and photography in Paris at the Academie Julian and the Ecole de Photographie. Her painting lessons in André Lhote's atelier brought her in contact with Cartier-Bresson, and it was during this period that

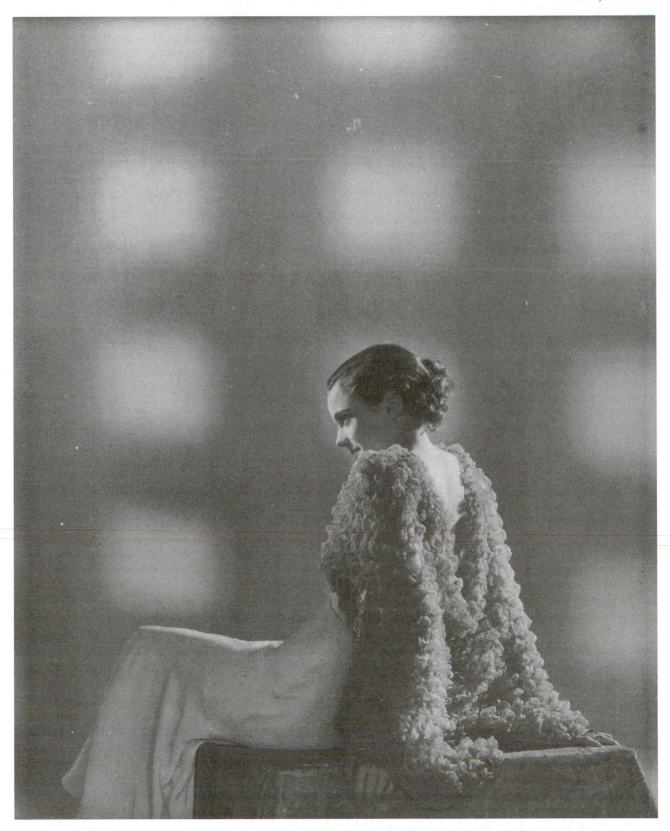

Dora Maar, Untitled (fashion photography), Photo: Jacques Faujour.
[*CNAC/MNAM/Dist. Réunion des Musées Nationaux/Art Resource, New York*]

she changed her name to Dora Maar for professional purposes (retaining Théodora Markovitch legally). Although she never married, she is known to have had affairs with filmmaker Louis Chavance and writer Georges Bataille before meeting artist Pablo Picasso. Died in Paris on July 16, 1997 at age 89.

Solo Exhibitions

1944 Bucher Gallery, Paris, France
1945 René Drouin Gallery, Paris, France
1946 Pierre Loeb, Paris, France
1957 *Dora Maar: Paysages*; Berggruen Gallery; Paris, France
1958 *Dora Maar*; Leicester Galleries, London, England
1983 *Dora Maar d'apr'es Dora Maar: Portraits Raisonnés avec Chapeau: Antonio Saura*; The Galerie; Paris, France
1990 *Dora Maar: Oeuvres Anciennes*; Galerie 1900–2000; Paris, France
1995 *Dora Maar: Fótografia*; Centre Cultural Bancaixa; Valencia, Spain

Group Exhibitions

1936 Charles Rafton Gallery
1994 *Picasso and the Weeping Women: The Years of Marie-Théresa Walter and Dora Maar*; Los Angeles County Museum of Art; Los Angeles, California and traveling to Art Institute of Chicago, Chicago, Illinois
2001 *About Faces*; C & M Arts

Further Reading

Benhamou-Huet, Judith. "New Light on Picasso: Dora Maar's Secret Diary." *Art Press* 240 (November 1998).

Caws, Mary Ann. "More than a Mistress & Muse: Known Best as Picasso's 'weeping woman,' Dora Maar was a Talented Artist in Her Own Right." *Art News* 99 (October 2000).
———. *Picasso's Weeping Woman: The Life and Art of Dora Maar*. Boston: Little, Brown and Co., 2000.
———. *With or Without Picasso: A Biography*. London: Thames and Hudson, 2000.
Caws, Mary Ann and Christian-Martin Diebold. *Les Vies de Dora Maar. Bataille, Picasso et les Surréalistes*. Paris: Thames and Hudson, 2000.
Combalia, Victoria. "Dora Maar, Photographer." *Art Press* 199 (February 1995).
———. "New Light on Dora Maar and Georges Bataille." *Art Press* 260 (September 2000).
Danto, Ginger. "Dora Maar: Galerie 1900." *Art News* 89 (November 1990).
Daix, Pierre. "De Pablo et Dora." *Conaissance du Arts* 553 (September 1998).
Hobson, Mary Daniel. "Explication: A Montage by Dora Maar." *History of Photography* 19 (Summer 1995).
Huntington, C. "For Dora Maar." *Virginia Quarterly Review* 77 (Spring 2001).
Krauss, Rosalind E. "Claude Cahun and Dora Maar: By Way of Introduction." In *Bachelors*. Cambridge, MA and London, England: Massachusetts Institute of Technology, 1999.
L'Enfant, Julie. "Dora Maar and the Art of Mystery." *Woman's Art Journal* 17 (Fall '96/Winter'97).
Lord, James. *Picasso and Dora: A Personal Memoir*. New York and London, 1993.
Tariant, Eric. "Dora Maar's Legacy: Great Provenance, Great Works." *Art Newspaper* 10 (October 1998).

MADAME D'ORA

Austrian

Dora Kallmus began her photographic career in the early twentieth century documenting Vienna's cultural and court figures. She was born in Vienna on February 20, 1881, to a distinguished Jewish family; her father, Dr. Phillip Kallmus, was a court lawyer. When she was just a young girl, her mother died, leaving Kallmus and her sister Anna to be raised by a grandmother and a governess.

Originally Kallmus had designs on a career as an actress. Dissuaded by her family she subsequently considered becoming a milliner or dressmaker, but turned to photography instead. In 1906, she expressed the desire to become a photographer and open her own studio. Through her uncle's mediation, Kallmus received formal training in photography. Early in 1907, she began a five-month apprenticeship in a prominent studio in Berlin where photographic techniques were considered more progressive than in Austria.

Leading society photographer Nicola Perscheid, who operated studios in Berlin and Leipzig, was persuaded by a hefty sum paid by Kallmus' father

to become her mentor but because of her sex, she was still denied the full spectrum of technical training. While Kallmus learned the basic principles of portraiture, how to photograph, copy, retouch, and deal with clients, she never fully learned all the basic camera operations.

Undaunted by this shortcoming, however, Kallmus opened her own studio in Vienna during the fall of 1907 simply called "d'Ora" perhaps to disguise her Jewish origins. She enlisted the help of Perscheid's former first assistant Arthur Benda to act as studio manager and to handle the technical equipment, leaving Kallmus free to cultivate her clientele. Their partnership endured until 1926.

From 1908 on, Kallmus began to call herself Madame d'Ora. Many of her first patrons were referred through personal and family relations. A list of her earliest sitters reads like a who's who of Vienna's elite society sprinkled with the names of illustrious literary and artistic types such as Alma Mahler-Werfel.

Following the model of Perscheid, the collaborative work by Benda and Kallmus reflected the photographers' attention to artistic lighting and treatment. Besides printing in silver and gum, they were interested in a straight color printing process known as Pinatype, a forerunner of dye-transfer printing invented in France in 1903.

Considered at the onset of her career to be but a 'professional amateur,' within a few years of her studio's opening, Kallmus had established herself as an art photographer, known for her elaborate light management and ability to create artistic photographs that corresponded to her sitter's personality. Although Kallmus hardly ever had a camera in hand, reserving her talents for stylistic compositions while Benda took care of the technical end of things, her creative photography and personal and family connections helped attract rich and famous patrons predisposing a successful following.

In her photographic portraiture Madame d'Ora introduced a compelling mixture of drama and sophistication that earned her the patronage of Europe's most celebrated names. Her early interest in theater, film, and fashion never diminished as is evident in the costuming and posing of her photographed subjects. In an advertisement for a 1913 seasonal appearance in Berlin, the studio suggested that ladies arrive with soft materials, furs, mugs, evening coats, shawls, and hats, with which Madame d'Ora might create artistic photographs. The practice of assembling her subjects in imaginative costume and dramatic poses draws a comparison to the posturing and composition used by Vienna Secession painter Gustav Klimt.

Beginning in 1915, theatrical photographs taken in her studio preoccupied d'Ora. Photographs of actors were in demand and actors became patrons of studios whose photographs were well received by the print media. The initiative for a portrait would often come from Kallmus. It was in this capacity that she formed a friendship with the celebrated dancer Anna Pavlova whom she invited to her Berlin studio in 1913. She became enthralled with photographing the new modern dance movement that had recently become popular in Europe.

Coupling her knowledge of the theater for expressive posing with her keen fashion sense in costuming her subjects, Kallmus synthesized her model's outward appearance with their inner values. Additionally, her photographs exuded a precision and vitality reflective of the photographer's concern with form—the contour of the model does not blend with the surroundings but projects forth from a dark or very light background. These effects were accomplished in the studio where artificial lighting was managed by Kallmus' elaborate staging techniques.

When Emperor Karl became King of Hungary in 1916/17, d'Ora gained access to wives of Hungarian magnates during the coronation festivities. In 1917, her studio obtained permission to photograph the Emperor Karl and his family. After spending the first quarter of the century photographing Austrian-Hungarian aristocracy, Kallmus moved to Paris where her works captured the vitality of the 1920s fashion and entertainment milieu.

While still in Vienna around 1910, Kallmus, sensing the trend toward more photographic representation in advertising media, had photographed several times the hats of the Viennese designer Rudolf Krieser; these were some of her particularly imaginative creations. Arriving in Paris initially in the early 1920s when the demand for fashion photographs in magazines was on the rise, Madame d'Ora found fashion photography to be an important and lucrative genre.

Soon Kallmus preferred to photograph fashion over portraits because the process represented constant change and stimulating challenge, one in which she varied the disposition of her images to correspond with the fashion items that were being photographed. Her fashion photographs represented the top design houses including Patou, Rochas, Chanel, Lanvin, and Worth.

Much of Kallmus's success was due to her keen sense for business. In the summers from 1921 to 1926, Kallmus and Benda followed the 'international' set to the elegant health resort Karlsbad, Czechoslovakia, where they ran a studio in the

Olympic Palace Hotel. It was this exposure to an intercontinental clientele that had given her the idea to open the Paris studio. To increase their photography opportunities there Kallmus worked hard to establish solid relationships with editors of magazines in German- and French-speaking countries. Kallmus adjusted to the new city but the move caused a rift in the relationship with Benda. He eventually returned to Vienna.

In Paris during the twenties, d'Ora's clientele drew from similar demographics as it had done in Vienna: artists, entertainers, and women of the highest social ranks were among her sitters. The designer Coco Chanel, the actor Maurice Chevalier, and the singer Mistinguett were among those who sought her expressive and glamorous photographic style and with whom she became friends. Sittings with the American actress Anna May Wong, American dancer Josephine Baker, and the painter Tamara de Lempicka likewise produced some of her most memorable photographs. Her cool, calculated fashion and entertainment photos and portraits were sometimes described as *style moderne*—the French version of the German *Neue Sachlichkeit* or New Objectivity.

With the Nazi occupation of France in 1940, Kallmus spent the remaining war years hiding in the small remote town of Lalouvesc, France. During that time, she lost her sister and an assistant to the extermination camps. After the war, she returned to Paris and lived a quiet existence. She resumed making portraits with the assistance of a young Dutch photographer Jan de Vries. These portraits express a reflexivity not seen before in her earlier works.

Other post-World War II subjects dealt with changing circumstances related to war trauma. She did a series of photographs in a refugee camp close to Vienna and work originating in an asylum for refugee women. Her themes include a series documenting daily activities in Parisian abattoirs or animal slaughterhouses. As a late body of work these images augment symbolic indictments of war and the Holocaust. Kallmus was killed in a motorcycle accident, October 30, 1963, in Steiermark, Austria.

MARGARET DENNY

See also: **Fashion Photography; History of Photography: Interwar Years; Portraiture**

Biography

Born Dora Philippine Kallmus 20 February 1881, Vienna, Austria. Five-month apprenticeship in Berlin with Nicola Perscheid 1907. Opened studio called "d'Ora" in Vienna, fall 1907. Hired Arthur Benda, Perscheid's first assistant as technical assistant, association lasted 1907–1926. Operated a seasonal studio in Berlin 1913; began theatrical photographs in 1915. Photographed coronation festivities of King of Hungary 1916/17. Moved to Paris and opened a studio in 1925, specialized in fashion and entertainment photography. Operated a studio in the Olympic Palace Hotel in the health resort of Karlsbad, Czechoslovakia, during the summers from 1921 to 1926. Lived in seclusion near a small rural town Lalouvesc, France, during Nazi occupation; returned to Paris at the end of the war, opened studio with assistant Dutch photographer Jan de Vries until 1955. Died 30 October 1963, Steiermark, Austria.

Selected Works

Alma Mahler-Werfel, c. 1915
Maria Likarz, c. 1916
Expressionist Portrait of the Actor Harry Walden, Vienna, 1918
Die Revuetänzerin Josephine Baker, 1928
Anna May Wong, c. 1929
Femme dans une robe Chinoise, c. 1930
Danièle Parola, 1931
The Small Servant, 1933

Selected Exhibitions

1906 Photoklub; Vienna, Austria
1909 Kunstsalon Hugo Heller; Vienna, Austria
1912 Kunstsalon Hugo Heller; Vienna, Austria
1913 Kunstsalon Keller and Reiner; Berlin, Germany
1914 Professional Photographer's Society of New York Annual Convention; Buffalo, New York
1914 *Meisterbund österreichischer Photographen, Arkadenhof des k.u.k.* Österreichischen Museums für Kunst und Industrie, Vienna, Austria
1916 Galerie Arnot; Vienna, Austria
1958 Galerie Montaigne; Paris, France
1969 Staatliche Lichtbildstelle; Hamburg, Germany
1971 Landeslichtbildstelle; Bremen, Germany
1980 Museum für Kunst und Gewerbe; Hamburg, Germany

Further Reading

Blake, A. H. "The Work of Madame d'Ora." *Photo-Era,* 29, 6 (December 12): 280–284.

Faber, Monika. *D'Ora: Vienna and Paris 1907–1957: The Photographs of Dora Kallmus.* Poughkeepsie, NY: Vassar College Art Gallery, 1987.

Kempe, Fritz. *Nicola Perscheid/Arthur Benda/Madame d'Ora.* Hamburg: Museum für Kunst und Gewerbe, 1980.

"Madame d'Ora on Her Methods." *Wilson's Photographic Magazine* 49 (1912): 485–486.

Rosenblum, Naomi. *A History of Women Photographers.* New York: Abbeville Press, 2000.

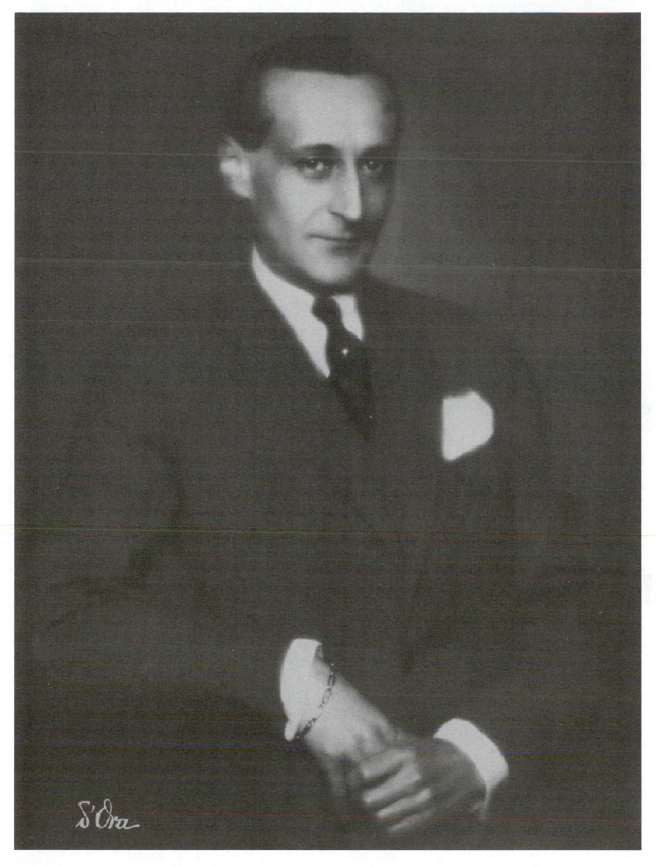

Madame d'Ora, Portrait of Mallet-Stevens, 1930.
[*CNAC/MNAM/Dist. Réunion des Musées Nationaux/Art Resource, New York*]

MAGNUM PHOTOS

Magnum is a cooperative photographic agency devoted to the artistic and editorial independence of all its members. Founded in 1947 by Robert Capa, Henri Cartier-Bresson, George Rodger, and David Seymour ("Chim"), Magnum became the world's preeminent international photo agency, representing photographers from all over the world and every point on the photojournalistic spectrum.

Many of Magnum's early members had built their reputations on war photography. They shared a common bond of leftist political views that informed the cooperative organization of the agency. Rather than proposing common political agendas, aesthetic sensibilities, or personal goals, Magnum strives for idealism in its members, who share an unmatched dedication to the power of photography and the independence of the individual photographer.

Magnum was the brainchild of Robert Capa (born Endre Friedmann), a Hungarian exile who moved to Paris from Germany in 1933. He became known as the world's greatest war photographer while documenting the Spanish Civil War. In Paris he befriended several other photographers, artists, and political activists, many of whom were also recent émigrés. During this time, the Popular Front was gaining tremendous strength, and its supporters began to harness the propagandistic power of the photograph to rally additional support for their cause. Meanwhile, the surging popularity of newspapers and illustrated magazines in Europe and the United States created endless demand for photographs documenting current events.

As photojournalism became an increasingly popular career, particularly among leftist political activists in Europe, new issues arose concerning the governance and ownership of their photos. Most magazines and newspapers hired photojournalists to work on individual assignments. The original photographs, negatives, and copyrights for all the material produced through the course of that assignment usually then belonged to the magazine or newspaper that commissioned the work. This system allowed photographers little control over how their works were used: cropping their images or isolating them from their original contexts could significantly alter the photograph's meaning or original composition, and the pho-tographer was powerless to stop it. Furthermore, photographers could only receive income from each photograph once, regardless of how frequently the image was reproduced. Photographers had little choice but to continue to work under this system because of the high costs associated with traveling to remote locations. Because photojournalists relied on news agencies to cover the initial financial costs of each project, working on projects without editorial support was exceedingly difficult.

During the 1940s, many photographers began to advocate for greater control over their work. By 1943, Robert Capa had conceived of a photographers' cooperative that would strengthen the rights of its individual members through unification. Although Capa discussed his vision with several photographer friends, gaining support from George Rodger and David Seymour, among others, it would be several years before his plans came to fruition. In the meantime, Capa joined the American Society of Magazine Photographers, where he advocated for the rights of photojournalists to have more control over their assignments, negatives, photographs, and copyrights.

In the spring of 1947, Capa finally organized a meeting of interested people, including Bill Vandivert, a photographer for *Life*, his wife, Rita, and Maria Eisner, who had founded and run Alliance Photos in Paris in the 1930s. Over lunch at the Museum of Modern Art in New York, they established Magnum Photos, Inc. Henri Cartier-Bresson, David "Chim" Seymour, and George Rodger were not present (and in fact, had no idea such a meeting was taking place), but were nevertheless made vice-presidents of the organization. This group of seven members became the original shareholders of Magnum. They planned for offices in New York and Paris, to be run respectively by their new president, Rita Vandivert, and Maria Eisner, now secretary and treasurer. The group assigned each photographer a region of specialty: Bill Vandivert would cover the United States, "Chim," Europe; Cartier-Bresson, Asia; and Rodger, the Middle East and Africa; Capa would float across all regions as needed. Although office staff managed the agency's day-to-day operations, including promoting Magnum, attracting and coordinating assignments, and mana-

ging copyrights, the photographers themselves would make all decisions about the cooperative. Magnum's services were paid through a percentage of each photographer's earnings: Magnum would receive 40% of fees paid for assignments received through the agency, 30% for assignments made directly through the photographer, and 50% of each photographer's reprints. Any profits would be divided amongst the shareholders to offset the year's fees.

After the first year, Bill and Rita Vandivert left Magnum, with Bill believing he would fare better with his existing magazine relationships. Maria Eisner took over as president, but with now only four photographers, the group needed additional members. Capa, Chim, Cartier-Bresson, and Rodger agreed that members should not only be first-rate photographers, but should also fit in with the group's ideals. Werner Bischof, the first Magnum invitee, had recently made a name for himself by photographing the devastation in Europe following World War II. He joined in 1949. Bischof explained what convinced him to join this new venture: Magnum's photographers were "the best in the world—Capa, Cartier-Bresson, Chim, and Rodger. What is important to me is that they are all sound people and socialist-inspired...They are free people, too independent to tie themselves to one magazine" (Miller, 1997, 74). Ernst Haas, Magnum's next inductee, received simultaneous invitations to join Magnum and *Life*. In a letter turning down *Life*'s offer, he explained, "What I want is to stay free, so that I can carry out my ideas... I don't think there are many editors who could give me the assignments I give myself" (Miller 1997, 75).

Magnum continued to hand-select new members they saw as a good fit, such as Dennis Stock, the winner of a *Life* contest for young photographers. It also admitted eager new photographers with enough gumption (or luck) to bring in a portfolio, such as Eve Arnold and Erich Hartmann. Many of Magnum's early members joined after meeting and receiving encouragement from a current member. In the early years, Magnum was more of a friendly club than an elite agency. Through this spirit of camaraderie, many of the more experienced photographers, including Capa and Cartier-Bresson, advised young members on editing or traveling in unfamiliar territory. Occasionally new recruits worked with senior members as assistants and researchers, which functioned much like an apprenticeship, although no such formal arrangement existed. Many young Magnum members note the excellent education they received by studying the agency's archives, which included vast numbers of contact sheets from some of the world's best photographers. These junior members started with small projects and gradually moved up to more important assignments.

After asking Maria Eisner to leave when she became pregnant, Capa took over as president of Magnum in 1951. He found the position tedious and passed the responsibility on to Rodger after less than a year. Rodger, too, disliked the position. At Magnum's inception, Rodger had suggested hiring two businessmen as directors of the agency, to leave the photographers free to take pictures. His idea then was dismissed, as the other members did not want to relinquish control to non-photographers. As president, Rodger again suggested establishing a board of directors to oversee the agency's administration. This time, the members agreed that Capa would return to the position of president, but to reduce his responsibilities, they would form a board of directors comprised of the original Magnum founders and hire an editorial manager to handle the business administration. They hired John Morris, then picture editor at *Ladies' Home Journal*, who was one of Magnum's best customers. Almost immediately, Morris and Capa began arguing about whether to expand the agency. Morris did not see financial viability without growth, and Capa did not believe the cooperative could support more than a dozen or so photographers.

Magnum's reliance on its photographer-members for governance was intended to help ensure the artistic integrity of the organization and, to some extent, support it against pressure to submit unwillingly to commercial demands. The downfall of being run by its members was that, as photographers, they had only a secondary interest in the business of running the company. This lack of business development has caused tremendous difficulties for the organization, which—despite its success—has seemed on the verge of financial collapse since its inception.

Magnum's precarious finances have caused much conflict within the organization. The focus on each photographer's artistic or journalistic freedom over his or her financial responsibility to the organization has left some members feeling that they carry the bulk of the agency's financial burden. Commercial assignments are usually the most lucrative assignments, even for the best photographers. The photographers willing to work on such projects are Magnum's lifeblood—it could not survive on photographers' personal projects alone. On the other hand, many members feel that working on commercial projects compromises the artistic integrity of their agency. Tension between those photographers who consider themselves artists

and those who identify themselves as journalists has existed since the beginning of Magnum. Magnum bridges this hazy line by supporting each photographer in his or her own personal goals.

In its policies and philosophy, Magnum prizes the photographer's independence above everything. A former Magnum bureau head once said, "Magnum isn't a democracy—it's anarchy in the truest sense because the guiding principle is not the greatest good for the greatest number, but the rights of the individual to do whatever they like" (quoted in Miller). Because it embraces individual independence, Magnum photographers do not fit any single profile; there is no "Magnum aesthetic." Nevertheless, certain trends prevail, such as the use of black-and-white rather than color film; a strong editorial component even in documentary photographs; a consistent ability to capture the essence of human emotions. The one common tie amongst all Magnum members is complete devotion to photography and the independence of the photographer. Magnum described this devotion in a 1961 brochure as a dedication "to continuing photojournalism in the tradition established by the three Magnum photographers who have died on photographic assignments of their own choice" (Miller, 1997, 195).

Capa was in Indo-China in 1954, photographing his fifth war, when he was killed by a landmine. The same day, Magnum members learned of his death, they also received news that Werner Bischof had died in an accident in Peru. At Capa's death, Chim stepped forward to take his turn as president. He would be killed two years later during fighting near the Suez Canal.

Amidst uncertainty over the future of the organization that seemed built around Capa, his brother, Cornell Capa, resigned from his position at *Life* to join Magnum. Cornell's involvement boosted morale tremendously. He became a leader in the organization and would assume the presidency after Chim's death.

The founding members felt that reorganization would be necessary for Magnum to survive without Capa. At the next annual meeting, they established a system for admitting new members, after which time membership in Magnum became extremely selective. To be considered, a photographer must submit a large portfolio of work to be judged by the current members. If it is approved by a majority of members, the applicant is offered membership as a nominee. Nominees may claim association with Magnum, but they have no voting rights in the organization. After two years as a nominee, the photographer may submit a more extensive portfolio for review. Following majority approval, the nominee becomes an associate member of Magnum, but still does not enjoy voting privileges. With full membership, granted only after a third portfolio review, the photographer receives full voting rights and becomes a part-owner of the agency.

By 1960, moving images of current events were available almost immediately via television. Film required time to be processed even before it could be printed and distributed. Many illustrated journals of the 1930s and 1940s redirected their focus from news of current events to social and lifestyle topics. As part of a brief attempt to carve a niche in this new field, Magnum created the short-lived Magnum Films in 1964. It had closed by 1970. In 1972, *Life* magazine, one of the largest clients for many photojournalists, closed (it would reopen in a monthly format in 1978).

Despite a reduced demand for photojournalism, Magnum has continued to grow to become an organization with membership limited to 50. In 1987, Magnum opened its third office, in London. Its immediate success inspired the opening of a Tokyo Magnum office in 1990.

By asserting the rights of individual photographers to control their own work, Magnum increased the artistic integrity of photojournalism. Magnum has thrived in the territory where art and photojournalism intersect. But in the process of elevating photojournalism to art, Magnum photographers were faced with a new issue, voiced by London art critic Marina Vaizey in response to Magnum's 1989 exhibition *In Our Time*:

> Have these starving people, these slum dwellers, these prostitutes and the insane, given their consent for their plight to be shown not just as the news, but in an art gallery? It is a curious thing that somehow, in these hundreds of photographs, almost all of which are concerned with the human condition, the terrible is so gorgeously memorable.

(quoted in Miller 1997, 278)

At the start of the twenty-first century, as it continues to struggle with many of the issues haunting it since the start, Magnum's strength lies in the devotion of its international stable of photographers and the depth, breadth, and quality of their work.

Members of Magnum

1947 (founding members)

Robert Capa (b. 1913, Hungary, d. 1954, Indochina)
Henri Cartier-Bresson (1908–2004, France)

George Rodger (1908–1995, England)
David Seymour ("Chim") (b. 1911, Poland, d. 1956, Suez)
William Vandivert (b. 1912, U.S., resigned 1948)

1949

Werner Bischof (b. 1916, Switzerland, d. 1954, Peru)

1950

Ernst Haas (b. 1921, Austria)
Erich Lessing (b. 1923, Austria)

1952

Erich Hartmann (b. 1922, Germany, d. 1999, U.S.)

1954

Cornell Capa (b. 1918, Hungary)
Elliott Erwitt (b. 1928, U.S.)
Burt Glinn (b. 1925, U.S.)
Kryn Taconis (b. 1918, Holland, resigned 1960)

1955

Inge Morath (b. 1923, Austria)
Marc Riboud (b. 1923, France)

1957

Eve Arnold (b. Philadelphia)
Brian Brake (1927–1988, New Zealand, resigned 1967)
W. Eugene Smith (1918–1978, U.S.)
Dennis Stock (b. 1928, U.S.)

1958

Wayne Miller (b. 1918, U.S.)

1959

René Burri (b. 1933, Switzerland)
Bruce Davidson (b. 1933, U.S.)
Sergio Larrain (b. 1931, Chile)
Nicolas Tikhomiroff (b. 1927, France)

1961

Hiroshi Hamaya (1915–1999, Japan)

1964

Charles Harbutt (b. 1935, U.S., resigned 1981)

1965

David Hurn (b. 1934, England)
Constantine Manos (b. 1934, U.S.)

1967

Ian Berry (b. 1934, England)
Marilyn Silverstone (b. 1929, U.S.)
Burk Uzzle (b. 1938, U.S., resigned 1982)

1968

Bruno Barbey (b. 1941)

1970

Hiroji Kubota (b. 1939, Japan)

1971

Philip Jones Griffiths (b. 1936, Wales)
Josef Koudelka (b. 1938, Czechoslovakia)

1972

Leonard Freed (b. 1929, U.S.)

1974

Paul Fusco (b. 1930, U.S.)
Gilles Peress (b. 1946, France)

1975

Richard Kalvar (b. 1944, U.S.)

1976

Micha Bar-am (b. 1930, Berlin)
Miguel Rio Branco (b. 1946, Canary Islands)
Guy le Querrec (b. 1941, France)

1977

Mary Ellen Mark (b. 1940, U.S., resigned 1981)
Raghu Rai (1942, India)

1979

Raymond Depardon (b. 1942, France)
Alex Webb (b. 1952, U.S.)

1980

Susan Meiselas (b. 1948, U.S.)

1982

Eugene Richards (b. 1944, U.S.)

1983

Martine Franck (b. 1938, Belgium)
Chris Steele-Perkins (b. 1947, Burma)

1985

Abbas (b. 1944, Iran)

1986

Jean Gaumy (b. 1948, France)
Harry Gruyaert (b. 1941, Belgium)
Peter Marlow (b. 1952, England)

1988

Michael Nichols (b. 1952, U.S.)
Eli Reed (b. 1946, U.S.)

1989

Thomas Höpker (b. 1936, Germany)
James Nachtwey (b. 1948, U.S.)
Ferdinando Scianna (b. 1943, Italy)

1990

Stuart Franklin (b. 1956, England)
Carl De Keyzer (b. 1958, Belgium)
Patrick Zachmann (b. 1955, France)

1993

Steve McCurry (b. 1950, U.S.)
Larry Towell (b. 1953, Canada)

1994

Nikos Economopoulos (b. 1923, Greece)
Mao (b. 1962, Beijing)
Martin Parr (b. 1952, England)
Gueorgui Pinkhassov (b. 1952, Russia)

1995

Chien-Chi Chang (b. 1961, Taiwan)

1996

Alex Majoli (b. 1971, Italy)

1997

David Alan Harvey (b. 1944, U.S.)
Lise Sarfati (b. 1958, Algeria)
John Vink (b. 1948, Belgium)
Donovan Wylie (b. 1971, Northern Ireland)

1998

Luc Delahaye (b. 1962, France)
Kent Klich (b. 1952, Sweden)

2002

Mark Power (b. Britain)

2003

Paolo Pellegrin (b. 1964, Italy)
Bruce Gilden (b. 1946, U.S.)

RACHEL KEITH

See also: **Arnold, Eve; Bischof, Werner; Burri, René; Capa, Robert; Cartier-Bresson, Henri; Davidson, Bruce; Documentary Photography; Erwitt, Elliot; Franck, Martine; Haas, Ernst; Hamaya, Hiroshi; Hartmann, Erich; Koudelka, Josef; Life; Mark, Mary Ellen; Meiselas, Susan; Morath, Inge; Parr, Martin; Peress, Gilles; Riboud, Marc; Salgado, Sebastião; Seymour, David "Chim"; Uzzle, Burk; War Photography**

Exhibitions

1955 *The Family of Man*, Museum of Modern Art, New York, New York (several members represented)
1957 Magnum group exhibition, Premiere Exposition Internationale Biennale de la Photographie, Venice
1960 *The World as Seen by Magnum Photographers*, Library of Congress, Washington, D.C., and traveling
1967 *The Concerned Photographer*, International Fund for Concerned Photography, Inc., Riverside Museum, New York, New York, and traveling
1979 *This Is Magnum*, organized by Pacific Press Services, Tokyo and Osaka, Japan
1981 *Paris/Magnum*, Musée du Luxembourg, Paris, France, and traveling
1989 *In Our Time: The World as Seen by Magnum Photographers*, American Federation of the Arts with the Minneapolis Institute of Arts, Minneapolis, Minnesota, and traveling
1999–2000 *Magna Brava: Magnum's Women Photographers*, Scottish National Portrait Gallery, Edinburgh
2004 *Magnum Football*, Kanton, China

Further Reading

Ignatieff, Michael. *Magnum Degrees*. London: Phaidon Press, 2000.

Manchester, William Raymond. *In Our Time: The World as Seen by Magnum Photographers*. New York: American Federation of Arts with Norton Press, 1989.

Miller, Russell. *Magnum: Fifty Years at the Front Line of History*. New York: Grove Press, 1997.

Stevenson, Sara. *Magna Brava: Magnum's Women Photographers, Eve Arnold, Martine Franck, Susan Meiselas, Inge Morath, and Marilyn Silverstone*. Munich: Prestel, 1999.

MAISON EUROPÉENNE DE LA PHOTOGRAPHIE

The Maison Européenne de la Photographie, situated in the historic heart of Paris, is a major centre for contemporary photographic art. Opened in 1996 and created and directed by Jean-Luc Monterosso, the M.E.P. represents a completely new kind of cultural establishment. It houses an exhibition centre, a large library, a video viewing facility with a wide selection of films by or about photographers, and an auditorium. It is designed to make the three fundamental photographic media—exhibition prints, the printed page, and film—easily accessible to all.

The mansion which houses the M.E.P., situated at no. 82, rue François Miron, was built in 1706 for Hénault de Cantobre, the royal tax collector. It has belonged to the City of Paris since 1914, and was chosen as the site for the M.E.P. in 1990. The city authorities asked the Yves Lion firm of architects to undertake the restoration of the original building, as well as the addition of a new wing on the rue de Fourcy. The façade overlooking the street, the period ironwork, and the central staircase are all fine examples of classical architecture, and as such all are listed features.

The M.E.P. has some 15,000 square feet of exhibition space on several floors. New selections of works from the permanent collections are shown regularly in addition to the temporary exhibitions.

The Collection

Established in the early 1980s, the collection consists of over 15,000 works and is representative of international photography from the end of the 1950s to the present day. The acquisition of several complete series of photographs (including Robert Frank's "Les Américains," Josef Koudelka's "Prague 1968," and Raymond Depardon's "Correspondance new-yorkaise") has made it possible to organize coherent monographic exhibitions. Major donations have also augmented the collection, for example from Dai Nippon Printing (Tokyo) and the Reader's Digest Foundation. The Polaroid Company of Boston has placed 1,500 original Polaroid prints in trust of the Centre, and an entire gallery is devoted to Irving Penn, one of the greatest photographers of the second half of the twentieth century.

The permanent collection reflects the art of photography in all its various forms, from photojournalism to fashion photography to works that stand halfway between photography and the plastic arts.

The inaugural exhibition at the M.E.P. in spring 1996 was entitled *Une Aventure Contemporaine: la Photographie* and looked at the most important developments in photography over the last forty years. Since then a series of large retrospectives and themed exhibitions have offered opportunities to discover—or rediscover—the work of some of the most important figures of recent photographic history, such as an exhibition of Pierre et Gilles, the Paris of William Klein, or " Errances" (wanderings) by Raymond Depardon.

The Roméo Martinez Library

The library's catalogue is built around the collection of the historian Roméo Martinez, for 20 years editor-in-chief of *Camera* magazine. It now has some 18,000 titles, including a large number of first editions, spanning the last 50 years of the history of photography. It provides both researchers and members of the photography-loving public with an exceptionally extensive overview of photographic publishing the world over. There are, for

example, 1,000 Japanese books available for consultation. Library staff is on hand to provide visitors with help and advice, and the catalogue can be consulted via self-service computer terminals. And the library also has a selection of CD-ROMS. Finally, a selection of the most important photography magazines is available for consultation.

Films and Videos

The *Vidéothèque* in the Roméo Martinez Library provides access to videos via independent viewing terminals. It has over 1,000 titles, including film portraits of photographers, interviews, and series on historical and aesthetic developments in photography. There are also films made by famous photographer/filmmakers, including Robert Frank, William Klein, Alain Fleischer, and Raymond Depardon.

The 100-seat Bernard-Pierre Wolff Auditorium screens videos and films linked to current exhibitions. Public discussions, conferences, and lectures on the various ways the photographic image is used also take place here.

Other Activities

The ARCP conservation and restoration workshop is directed by Anne Cartier-Bresson; the workshop's essential aim is to restore and preserve the extensive photographic collections of the various museums, libraries, and archives belonging to the City of Paris. It works hand in hand with a number of research and teaching establishments in France and abroad.

A bookshop, a café, and a website (*http://www.mep-fr.org*) complete the services offered to the public. Since the opening approximately 150 exhibitions have been organised and 50 catalogues published.

JEAN-LUC MONTEROSSO

See also: **Frank, Robert; Klein, William; Koudelka, Josef; Museums: Europe; Penn, Irving; Photography in France; Pierre, et Gilles**

MAN RAY

American

A leading experimental artist of the avant-garde of Paris during the 1920s, Man Ray was one of the most formidable Surrealist photographers and was known, along with László Moholy-Nagy, as the creator of camera-less photography in the modern era. By the time his work was recognized in the Museum of Modern Art's 1936 exhibition *Fantastic Art, Dada, Surrealism* it had already been widely published. His wide-ranging experimental process, moreover, had already attained significant stature within Modernist artistic discourse since it had continued and reinvigorated the debate between painting and photography begun around the turn of the twentieth century. As a photographer he created a number of the iconic images of the century, including *Tears* of 1932 and the portraits of Marcel Duchamp as his female alter-ego Rrose Selavy of 1920–1921.

Born on August 27, 1890, as Emmanuel Radnitsky to a Jewish family in Philadelphia, Pennsylvania, the artist spent most of his youth in Brooklyn,

New York, after his parents moved there in 1897. Having entered high school in 1904, the young Radnitsky learned freehand and industrial draughtsmanship. Four years later he was offered a grant to study architecture only to turn it down, claiming that the construction of buildings was not as interesting as creating an interior's ambiance. Soon after, Rudnitsky began taking courses in drawing and water color at the Ferrer Center. Named after a Spanish anarchist, this educational institution was devoted to the practice of libertarian principles.

In 1911, the aspiring artist moved to Manhattan after meeting Alfred Stieglitz at the 291 Gallery. However during the spring of the following year, Rudnitsky moved again to Ridgefield, New Jersey, where he began work as an advertising draughtsman. Upon visiting the now-legendary Armory Show held in New York in 1913, he discovered the European avant-garde. Although he continued working as a draughtsman for a publisher of maps and atlases, he partnered with the poet Alfred

Kreymborg and sought to create an artist's community in Ridgefield. In 1914, Rudnitsky married poet Adon Lacroix (Donna Lecoeur), with whom he had been living for quite some time and officially changed his name to Man Ray.

During the fall of that year, Man Ray met French avant-garde artist Marcel Duchamp, who was at that time living in New York and had his first solo exhibition at the Daniel Gallery, which featured a collection of sketches and 30 paintings. Arthur J. Eddy, a prominent attorney involved in developing policies for modern trade, purchased six paintings, which led Man Ray to move back to Manhattan. In 1915, he purchased his first camera for the purpose of documenting his own art work, but was soon using it to explore new avenues of creativity. His interest in nuance, for example, appeared in his articulation of pictorial shadows and was reflected in a painting from 1916 titled *The Rope Dancer Accompanies Herself With Shadows*. While attending a number of soirees at the home of Walter Arensberg Man Ray associated with many notable artists such as Americans Charles Demuth, George Bellows, and the French painter Francis Picabia. He also became an active member in the nascent New York Dada movement.

Prior to his second solo show at the Daniel Gallery during the winter of 1916, Man Ray experimented relentlessly, designing a rotating collage titled *Revolving Doors*. In 1917, he painted his first "aerograph," which is a depiction made by airbrush that emulates photographic effects, titled *Suicide*. At this time, he also made the first of his "Eggbeater" sculptures, which transformed the notion of mundane utility into a latent sexual metaphor. Man Ray's work was beginning to be collected in 1918 by Ferdinand Howell and inspired him to reproduce *The Rope Dancer* into an aerograph.

The rapid development and use of technology, despite the benefit of new industries that developed in Western society, to create fearsome instruments of war during the First World War caused those who were involved in the Dada and Surrealist movements to decry the use of the machine. To intellectuals of the post-World War I era, the notion of freedom was believed to exist in anarchy. Seeking intellectual and material autonomy, Man Ray published a single issue of an anarchist magazine titled *TNT* after the newly-developed explosive in March 1919. At this time, he also separated from his wife and began a correspondence with leading European Dada figure Tristan Tzara.

The following year he began collaborating with Marcel Duchamp and attempted to make an anaglyphic movie with two cameras. On April 29, he signed the constitution of "Société Anonyme Inc." along with Duchamp and Katherine Dreier, a collector of Modern art and founding director of the Society of Independent Artists. During the summer, Man Ray followed Duchamp to Paris where he was introduced to the Dadaists. During November of that year, Man Ray created his first rayograph, also known as a photogram, which depicted a silhouette upon paper without the use of either a negative or a camera.

At the opening of his third solo show at the Galerie des Six, he met composer Erik Satie with whom he worked to create *The Gift*, an iron whose face bristled with nails, one of his many Dadaist objects that transform everyday items into sculptures rife with mystery or paradox, including the now legendary *Object to be Destroyed*, of 1923–1932, a metronome affixed with a photographic cut-out of an eye. He also made the acquaintance of the famous French model, Kiki de Montparnasse, of whom he made striking portraits, along with other denizens of the Parisian avant-garde, including Gertrude Stein and Jean Cocteau. By 1923, Man Ray was an established photographer undertaking portrait and fashion assignments, and hired Berenice Abbott as his assistant. His famous image of Kiki shot nude from the back and embellished with the "F"-holes of a violin, *Le Violon d'Ingres*, appeared in a 1924 issue of *Littérature*. *Vogue* also published some of his fashion photography in May of that year.

From the mid-1920s to the late 1930s, Man Ray worked on avant-garde films with a number of artists, including Marcel Duchamp and his "Anemic Cinema," and published his work in both monographs and books of poetry. By 1929, Lee Miller became his assistant. Man Ray later returned to New York, in the summer of 1940, and stayed there until 1951. After returning to Paris, however, he spent less time with photography and focused more of his time on painting. His photographic work, however, brought him great acclaim: In 1961, he received the gold medal for photography at the Venice Biennale and in 1967, he received worldwide recognition in a show titled, *Salute to Man Ray* that was held at the American Center in Paris. By the time of his death on November 18, 1976 in Paris, Man Ray was a legend for his work that propelled Surrealism into a lively, historic art

movement. Man Ray's Parisian studio was kept intact after his death by his widow, Julia, but was destroyed in a fire in 1989. The Man Ray Trust has been established to preserve what remains of his archive and disseminate his artistic legacy.

JILL CONNER

See also: **Abbott, Berenice; Dada; History of Photography: Interwar Years; History of Photography: Twentieth-Century Pioneers; Manipulation; Miller, Lee; Modernism; Moholy-Nagy, László; Photogram; Photography in France; Solarization; Surrealism**

Biography

Born in Philadelphia, Pennsylvania, on 27 August 1890, as Emmanuel Rudnitsky. Family moved to Brooklyn, New York in 1897. Attended high school and studied draughtsmanship in 1904. Studied drawing and watercolor at the Ferrer Center in 1910. Moved to Manhattan in 1911. Moved to Ridgefield, New Jersey in 1912. Married Adon Lacroix, legally changed name to Man Ray and had his first solo show at the Daniel Gallery in 1914. Purchased first camera for documentation purposes in 1915. Published anarchist magazine titled *TNT* and separated from Adon Lacroix in 1919. Began collaborating with Marcel Duchamp, signed Sociéte Anonyme Inc. manifesto, moved to Paris and created first rayograph in 1920. Hired Berenice Abbott as his studio assistant in 1923. *Le Violon d'Ingres* published by *Litterature* in 1924. Hired Lee Miller as his studio assistant in 1929. Recognized in *Fantastic Art, Dada, Surrealism* organized by the Museum of Modern Art, New York in 1936. Returned to New York in the summer of 1940. Returned to Paris in 1951. Received a gold medal for photography in Venice in 1961. Recognized by the American Center in Paris with *Salute to Man Ray* in 1967. Died in Paris, France on 18 November 1976.

Individual Exhibitions

1915, 1916, 1919 Daniel Gallery; New Jersey
1923 "Coeur à Barbe"; Theatre Michel, Paris
1967 "Salute to Man Ray"; The American Center, Paris

1971 Two Retrospectives; Boymans van Beuningen Museum, Rotterdam and Galleria Schwarz, Milan

Group Exhibitions

1920 *Exhibition of Painting by American Modernists*; Museum of History, Science and Art, Los Angeles
1926 *Société Anonyme*; Brooklyn Museum, New York
1936 *Fantastic Art, Dada, and Surrealism*; Museum of Modern Art, New York
1985 *L'Amour fou: Photography and Surrealism*; Corcoran Gallery of Art, Washington, D.C., and traveling
1996 *Rrose Is a Rrose Is a Rrose: Gender Performance in Photography*, Solomon R. Guggenheim Museum, New York, New York

Selected Works

Cliché Verre, 1917
Dust Breeding (on Duchamp's Large Glass), 1920
Portrait of Jean Cocteau, 1922
Rayogram, 1923
Object to be Destroyed, 1923–1932
Le Violon d'Ingres, 1924
Kiki de Montparnasse as Odalisque, ca. 1925
Noire et Blanche (Black and White), 1926
Place de la Concorde, ca. 1926
Mrs. Henry Rowell, 1929
Primacy of Matter over Thought, 1929
Sleeping Woman, 1929
La Tête, 1931
Les Larmes (Tears), 1932
The Lovers (My Dream), 1933

Further Reading

Annear, Judy, ed. *Man Ray*. London and Sydney: Thames & Hudson and Art Gallery of New South Wales, 2004.
Baldwin, Neil. *Man Ray, American Artist*. Cambridge, Mass.: Da Capo Press, 2001.
Krauss, Rosalind, and Jane Livingston. *Amour Fou: Photography and Surrealism*, New York: Abbeville Press, 1985.
Esten, John and Willis Hartshorn. *Man Ray: Bazaar Years*. New York: Rizzoli, 1988.
Foresta, Merry, ed. *Perpetual Motif: The Art of Man Ray*. New York: Abbeville Press, 1988.
Hartshorn, Willis, John Esten and Merry Foresta. *Man Ray: In Fashion*. New York and Seattle: International Center of Photography and University of Washington Press, 1991.
de L'Ecotais, Emmanuelle and Katherine Ware. *Man Ray*. Cologne: Taschen, 2004.
Penrose, Roland. *Man Ray*. London: Thames & Hudson, 1989.

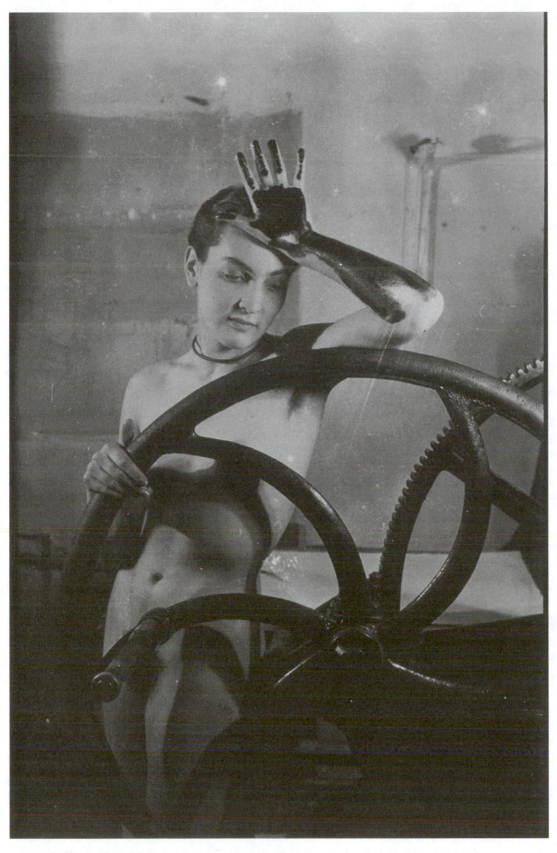

Man Ray, Erotique voilée (Portrait of Meret Oppenheim), Circa 1933, After the original negative, Photo: Georges Maguerditchian.
[*CNAC/MNAM/Dist. Réunion des Musées Nationaux/Art Resource, New York*]

FELIX H. MAN

German

Like Erich Salomon, Wolfgang Weber and a few other photographers, Felix H. Man appeared as a leading exponent of the modern photojournalism that made his breakthrough in the weekly press of Germany toward the end of the 1920s. He was a member of the famous German photo agency *Dephot* (Deutscher Photodienst) and soon became a leading figure in the development of the British illustrierte press. His significance to the history of photography lies as well in the area of color photography and also in the advancement of art historical scholarship. From the 1950s on, he was more interested in art history, which he had studied before 1920. He wrote books about graphic art, and from 1961–1975 he was editor of *Europäische Graphik*, a series of portfolios of original artworks.

Felix H. Man was born as Hans Felix Sigismund Baumann on November 30, 1893 in Freiburg/Breisgau in Germany. His family came from Riga, which was at that time part of Imperial Russia. When he was 10, his father gave him his first camera. He soon was taking pictures of anything he saw, and he started to develop and print the pictures himself in a cellar darkroom. In 1912, he matriculated and studied art and art history, and his camera became less important to him. During his service in the German army between 1914 and 1918 in World War I, he took up photography again. Almost all the pictures of this period, mainly taken in the trenches and behind the lines, were lost during the bombing of World War II.

In 1926, Man moved to Berlin and worked for the publishing house Ullstein Verlag as an illustrator. He was drawing at that time, but soon he began to find that the growing market for his photographs was pushing his drawing aside. By the end of the 1920s, he became production chief of the photojournalism department of *Dephot*, founded by Simon Guttman and Alfred Marx and serving various daily papers. Joining him there were Walter Bossard and Kurt Hübschmann, later known as Kurt Hutton of *Picture Post*.

Around 1930, Man was working for the *Münchner Illustrierte Presse* (MIP) and the *Berliner Illustrirte Zeitung* (BIZ), both rapidly growing and in keen competition. His main subjects were on one hand, portraits of statesmen, artists, musicians in action, imposing theatrical productions; and, on the other hand, the simple life of villages and their inhabitants or the streets of Munich, Berlin, or London to which he traveled on assignments. Unlike Wolfgang Weber, Harald Lechenperg, or Walter Bossard, who were traveling worldwide as photojournalists, Man was largely confined to work on the continent and in England, although he later traveled to North and South America and India. From 1930 to 1931, he went to Italy and made his famous reportage *A Day with Mussolini*, printed on five pages in the *MIP* and widely reprinted.

Between 1929 and 1931, the *MIP* published over 80 reports by Man. At this time, he worked very close with Stephan Lorant, chief editor of the *MIP* and an important figure of the new photojournalism of the 1920s and 1930s. When the Nazis took over Ullstein Verlag in 1934, Man emigrated to England, where he again met Stephan Lorant working for the magazine *Weekly Illustrated* in London. After six months, Man left the paper and over the next three years had a difficult time. Unable to obtain a work permit, he was forced to leave England every three months. (In 1948 he finally became a British citizen.) He shot photographs for the *Daily Mirror*, film companies, fashion magazines, and for the pocket magazine *Lilliput*, which Lorant had started in London.

In October 1938, Stephan Lorant founded *Picture Post*, and Felix Man and Kurt Hutton joined him as photographers. From the beginning, *Picture Post* was a great success, and Man sometimes had more than three substantial reportages. Although Lorant left Europe for the United States in 1940, Man continued to work for *Picture Post*, leaving for a short time to try to start a new magazine and to study the problems and possibilities of color photography. He returned to *Picture Post* in 1948, principally to produce color picture stories.

At the beginning of the 1950s, Man again left *Picture Post* and completed some color assignments for U.S.-based *Life* and *Sports Illustrated* magazines. He also began concentrating on art subjects, and he made studies of a number of famous artists at work in their studios, among them painters Pablo Picasso and Georges Braque, architect Le Corbu-

sier, and sculptor Henry Moore. These pictures were published as a book in 1954 under the title *Eight European Artists*, which was edited by Man. He also started a collection with original graphics (which he built up to one of the largest private collections of lithograhs) and did research on graphic art, studying its history and techniques. He wrote several books and articles on lithography, painting, and cultural affairs as well as continuing to photograph until his death in 1985.

In most of his reportages, the pictures were put together in a way that they were able to tell the story, making a text almost unnecessary. In this context, Man often made use of the portrait, putting it in sequences, in particular, and in this way relating the content intensively to reality. Unlike many photojournalists who shoot multiple rolls of film to find the right pictures in the solitude of the studio, Man was able to seize the precise significant moments from the passing scene, capturing the essence of the occasion in sequences of 20 or 30 pictures. The pictures themselves were documentary and simple, showing artless realism and only using natural light, keeping the truth of the atmosphere.

KRISTINA GRUB

See also: **Life Magazine; Photography in Germany and Austria; Picture Post; Salomon, Erich; Weber, Wolfgang**

Biography

Born as Hans Felix Siegismund Baumann in Freiburg/Breisgau, Germany, 30 November 1893. Started making photographs, 1903. Studied art and art history in Munich and Berlin, 1912–1914; service in the german army, 1914–1918; continued his studies at the Kunstgewerbeschule in Munich, 1918–1921; illustrator and photographer for Ullstein Verlag, Berlin, 1926–1933; production chief for photojournalism for *Dephot*, 1928; photoreporter for *Münchner Illustrierte Presse*, 1929–1932; immigrated to England, 1934; co-founder of *Weekly Illustrated*, 1934; photographer for *Daily Mirror*, *Liliput* (since 1937) and *Picture Post* (since 1938); photojournalist for *Life*, 1950–1951. Moved to Lugano, Switzerland, 1961 and Rome, 1972. Recipient of the "Kulturpreis" of the DGPh (German Photographic Society), 1965. Died in London, 1985.

Selected Individual Exhibitions

1961 Galerie Loehr; Frankfurt/Main, Germany
1965 Deutsche Gesellschaft für Photographie; Cologne, Germany
1971 *Felix H. Man: Pionier des Bildjournalismus*; Münchner Stadtmuseum; Munich, Germany
1975 *Felix H. Man-Photographs and Picture Stories 1915–1975*; Fotografiska Museet; Stockholm, Sweden
1977 *Felix H. Man-Pioneer of Photo-journalism*; Goethe Institute; London, Great Britian

1978 *Felix H. Man-Sechzig Jahre Fotografie*; Kunsthalle Bielefeld; Bielefeld, Germany
1981 *60 ans de la photographie*; Bibliothèque Nationale and Goethe Institute; Paris, France
1983 *Felix H. Man-Bildjournalist der ersten Stunde*; Staatsbibliothek Preußischer Kulturbesitz; Berlin, Germany

Selected Group Exhibitions

1959 *Hundert Jahre Photographie*; Museum Folkwang; Essen, Germany
1977 *Documenta 6*; Museum Fridericianum; Kassel, Germany
1992/3 *Photo-Sequenzen*; Haus am Waldsee; Berlin, Germany
2001/2 *Kiosk*; Museum Ludwig/Agfa Foto-Historama, Cologne and Altonaer Museum; Hamburg, Germany

Further Reading

Gidal, Tim N. *Deutschland: Beginn des modernen Photojournalismus*. Frankfurt and Lucerne: Main, 1972.

Eskildsen, Ute. *Fotografien in deutschen Zeitschriften 1924–1933*. Stuttgart: Institut für Auslandsbeziehungen, 1982.

Man, Felix H. *Sechzig Jahre Fotografie*. Bielefeld, Germany: Kunsthalle Bielefeld, 1978.

———. *Man With Camera: Photographs from Seven Decades*. New York: Schocken Books, 1984. As *Felix H Man: Photographer aus 70 Jahren*. Munich, 1983.

———. *Bildserien aus nah und fern. Pionier des modernen Bildjournalismus*. Freiburg/Breisgau, 1995.

Books by Man

150 Years of Artists' Lithographs 1803–1953. London, 1953.
Eight European Artists, photographed and edited by Felix H. Man. Introduction by Graham Greene and Jean Cassou, 1954.
Graham Sutherland. Das graphische Werk 1922–1970 (Catalogue raisonnée of Graham Sutherland's graphic work). Munich, 1970.
Europäische Graphik IX. Munich: Galerie Wolfgang Ketterer, 1974.

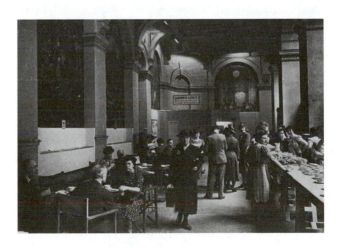

Felix H. Man, *Restaurant in British Museum*.
[© *Hulton-Deutsch Collection/CORBIS*]

MANIPULATION

Photographic manipulation is any change or adjustment made to the photographic image through altering the exposure, development, printing processes, or final image. Manipulation in the camera is achieved through multiple exposures, using specific types of lenses that distort perception, filters attached to the lens, and special films. Multiple exposures are images taken on the same piece of photographic film, and can be of two completely different photographic scenes or of the same subject captured in more than one way. Wide angle, telephoto, and photomicrography (extreme image magnifications) alter the perception of the image from what the human eye is capable of viewing without such optical tools. Filters can alter how light is projected onto the film in the camera. Manipulation through the use of films sensitive to other energies outside of the visible spectrum, such as infrared film, create images based on heat and can be combined with filters for further effects. High-contrast film produces images that have extreme texture and graininess, which further manipulates the photographic image.

The photographer, through framing, cropping, and the use of specific vantage points to define the photographic image, also controls manipulation in the camera. Cropping, which defines the edges of a photographic print, can alter how an image is perceived by changing basic spatial clues within the pictorial space. Framing alters how an image is perceived as well. Using a low or high viewpoint will flatten an image and change how depth is shown in the pictorial space. The same manipulations that occur in a camera and with lenses can also be created in the darkroom. Changing the lens and the lens housing in the enlarger creates effects such as vignetting and distortions in perspective.

Darkroom manipulations occur through deliberate changes in the film developing process to controls such as time and temperature and with the introduction of specific types of chemicals. Reticulation is achieved through extreme temperature fluctuations during film development. This can range from small cracks in the film emulsion to warping of the entire image surface of the film. Intensification and reduction, techniques used on previously processed negatives, allow for areas of the negative to be re-altered chemically. Intensification increases the density of shadow areas on a negative, and reducing agents can be applied to specific parts of the emulsion to remove silver from the image. The Sabattier effect, often incorrectly called solarization, exposes the film or the photographic print to light midway through the development process and creates a reversal of tones in the image and a Mackie line (a thin black line) between the dark and light areas in the image. Cross-processing of color films (processing negative film in E-6 chemistry and positive film in C-41 chemistry) will skew the color, tonal, and contrast range of the film. Retouching with chemicals such as Red Cocaine or spotting dye can further alter film, and the emulsion can be scratched or etched from the film's surface with a variety of tools.

The darkroom process allows manipulations to occur during printing such as burning (adding time or intensity to a specific area to increase density), dodging (removing time or intensity from a specific area to decrease density), flashing (applying an intense burst of light to the image), diffusing the light projected through the enlarger with filters or other materials, and masking areas of the print with various types of filters or acetate. Contrast filters, placed in the enlarger and used with variable contrast black-and-white printing paper, can manipulate the contrast range. High-contrast printing is done through a process known as posterization, which reduces the continuous-tone image to a range of only a few tones. Multiple negatives may be produced for each tone, and printed together on the same sheet of paper. Specific films and graded paper will also produce effects that manipulate the normal tonal range of an image. Manipulation of the negative in the enlarger, such as sandwiching more than one image, will combine all involved negatives into one composite image. This can also be done through multiple printing, which projects individual negatives onto one sheet of paper. Photograms eliminate the negative altogether, and are created by placing objects on top of a sheet of photographic paper much like a contact print. Negative prints use the paper print of an image as the negative and produce a reversal of the tones. The digital darkroom of programs such as Adobe Photoshop allows

traditional darkroom manipulations on the computer screen and further increases the ease of compositing multiple images and changing color and tonal variations, and may mimic special darkroom effects such as reticulation and posterization.

Toning and non-silver processes alter the basic chemical and color of a printed image. Toning can add a specific colorcast or alter the intensification of the tonal range. Non-silver processes such as platinum, palladium, gum bichromate, cyanotype, and hybrids of the photographic and silkscreen mediums further manipulate the photographic image. Spotting (retouching the print to eliminate dust and scratches), bleaching (lightening or eliminating part of a photographic print), and hand-coloring photographs are manipulative techniques that occur after the darkroom process.

The uses of manipulation in photography occur for aesthetic and commercial purposes. Fine-art prints created from many negatives mimicked the traditional narrative paintings of neoclassical artists, and manipulation in the darkroom was a characteristic of photographers such as Man Ray and László Moholy-Nagy, who used photograms and the Sabattier effect extensively in their work. Multiple exposures in the camera were a staple of Harry Callahan's images during his time in Chicago in the 1950s and 1960s, and Jerry Uelsmann's multiple printing techniques incorporate up to 20 enlargers and image fragments into one composite work. Digital manipulations are also utilized in contemporary fine art pieces. Commercial photography, such as fashion and product advertisements, utilizes high-contrast images, cross-processing of color films, and retouching through computerized and traditional darkroom techniques to produce a flawless final image. Photojournalism is one area of photography where manipulation is rare because of ethical reasons, and journalistic integrity forbids modifications of images published as factual documents.

JENNIFER HEADLEY

See also: **Callahan, Harry; Cropping; Dada; Darkroom; Digital Photography; Dodging; Ethics and Photography; Film: High-Contrast; Film: Infrared; Filters; Hand Coloring and Hand Toning; Image Construction; Infrared Photography; Lens; Man Ray; Masking; Moholy-Nagy, László; Multiple Exposures and Printing; Non-Silver Processes; Photogram; Sandwiched Negatives; Solarization; Uelsmann, Jerry**

Further Reading

Adams, Ansel and Robert Baker. *The Ansel Adams Photography Series 1: The Camera.* Boston: Little, Brown and Company, 1991.

Adams, Ansel and Robert Baker. *The Ansel Adams Photography Series 2: The Negative.* Boston: Little, Brown and Company, 1981.

Adams, Ansel and Robert Baker. *The Ansel Adams Photography Series 3: The Print.* Boston: Little, Brown and Company, 1983.

Brugioni, Dino A. *Photo Fakery: The History and Techniques of Photographic Deception and Manipulation.* Dulles, VA: Brassey's, 1999.

Gassan, Arnold. *Handbook for Contemporary Photography.* Rochester, NY: Light Impressions Corporation, 1977.

Stone, Jim. *Darkroom Dynamics: A Guide to Creative Darkroom Techniques.* Newton, MA: Focal Press, 1985.

Vestal, David. *The Craft of Photography.* New York: Dorset Press/Marboro Books: 1978.

ROBERT MAPPLETHORPE

American

While he did not begin his artistic career with a camera, Robert Mapplethorpe's photographs earned him a reputation that transcended the boundaries of the art world and permeated popular culture. This notoriety was due partly to the inherent strength of his images but also a result of heated controversies over the transgressive nature of his subject matter. Mapplethorpe's body of work—largely comprised of nudes, flowers, and portraits—is characterized by a remarkable clarity of vision that emphasizes a sensual formalism. His thematic scope is exceptionally consistent, as the themes that occupied him as a young student remained with him throughout his relatively brief artistic career.

Mapplethorpe was born to a middle-class, Catholic family in Floral Park (Queens), New York in 1946, and in 1963 he enrolled in art school at the Pratt Institute in Brooklyn. One of his most formative relationships was with the singer and poet Patti Smith, whom he met in the late sixties. The two became involved with the underground New York punk scene centered at the club Max's Kansas City, and moved into a room at the Chelsea Hotel, a landmark of bohemian New York. Smith and Mapplethorpe had a short-lived romantic relationship but remained lifelong friends and confidantes, and she would serve as one of his most frequent models.

While in art school, he was not immediately drawn to photography, but instead focused on the more traditional mediums of drawing, painting, and sculpture. He began to create mixed-media collages and assemblage pieces, often including images he lifted from the gay pornographic magazines sold around Times Square. As Mapplethorpe came to desire more control over the raw materials for these assemblages, he began taking his own photographs.

His interest in the medium was particularly spurred on in 1971 when he met John McKendry, curator of photographs and prints at the Metropolitan Museum of Art. McKendry supplied Mapplethorpe with a Polaroid camera, showed him the photography archives at the Museum, and brought him to Europe to meet art collectors. The following year, Mapplethorpe met another influential figure, curator Sam Wagstaff, with whom he developed a non-exclusive but long-term intimate relationship. Wagstaff supported Mapplethorpe in his photographic endeavors, providing him with studio space in Manhattan and in 1976 giving him a Hasselblad camera. He and Wagstaff avidly collected photographs, and Mapplethorpe was especially drawn to turn-of-the-century artists, including Baron von Gloeden, Julia Margaret Cameron, and F. Holland Day and Nadar.

Mapplethorpe's early pieces often played with religious and sexual imagery, yet he was not so much interested in blaspheming religious authority as he was in sanctifying carnal acts. He made several multi-panel works resembling altarpieces, including some triptychs that employed mirrors to implicate the viewer in their sexual imagery. His earlier interest in more tactile, non-photographic mediums led him to view his photographs not merely as images, but as unique art objects. This tendency is demonstrated by his utilization of unconventional frames and mixed media, as well as his experimentation with various printing processes, from his early photo-transfers of magazine images onto cloth and canvas, to the platinum prints on linen he created in 1987.

Mapplethorpe exercised a great amount of directorial control over his compositions. He was not interested in documenting chance encounters, and most of his photography was done within the confines of his studio. He frequently placed drop cloths or backdrop paper behind his subjects, as if to emphasize the nature of his pictures as "set-ups."

The images that cemented his notoriety were his pictures of the sado-masochistic homosexual underground, a subculture with which he was directly involved. His explicit photographs of erect penises, men in bondage gear, and various sexual acts not usually seen by mainstream society had a volatile impact and led to a number of controversies. A 1983 solo exhibition at the Palazzo Fortuny in Venice was closed to minors due to the content of the artwork. The greatest disputes over his work, however, occurred shortly after his death in 1989, and made him a key figure in the so-called "culture wars" of the 1980s and 1990s. In June 1989, the Corcoran Gallery in Washington, D.C., fearing potential public outcry, canceled their plans to exhibit the Mapplethorpe solo show *The Perfect Moment* just two weeks before it was set to open. The following year, when the exhibition traveled to the Contemporary Arts Center in Cincinnati, the gallery and its director were indicted for (and subsequently acquitted of) obscenity and child pornography. The latter charges were a result of Mapplethorpe's few nude photographs of children, which were essentially innocent on their own terms but became questionable due to his reputation as a documenter of sexual deviance.

The great dynamic in Mapplethorpe's work is the tension between his subject matter, which is powerfully transgressive and sometimes shocking, and his manner of composition, which is highly traditional and classicist. His interest in beauty and symmetry is present even in his most jarring compositions featuring sado-masochistic acts. He was particularly interested in photographing black men, posing their chiseled bodies in ways that clearly enunciate the formal language of classical sculpture. Toward the end of his career, these references became even more straightforward when he began photographing gleaming white Greek sculptures. He treated inanimate objects and human subjects with an equal amount of formalist enthusiasm; his *Eggplant* of 1985 seems a blatant reference to Edward Weston's iconic *Pepper* of 1930, particularly with its sensual overtones and keen attention to texture and shadow.

Although Mapplethorpe was interested in photographing nudes for both their formal possibilities and their capacity to arouse, he never objec-

tified his models into simple flesh. He preferred to emphasize the humanity of sexuality, which is underlined by the fact that he always titled his figure studies with the names of his models (unless they specified a preference to remain anonymous). This naming emphasizes the personhood of his subjects as well as their complicity in his works.

His photography is also notable for its problematization of dualisms of gender and sexuality. In some 1980 self-portraits, he plays with androgynous imagery by fashioning himself as a woman in make-up and fur, not unlike Marcel Duchamp's alter-ego, Rrose Selavy. His 1983 book of photographs of body-building champion Lisa Lyon features her in a number of poses that humorously undermine stereotypes of femininity.

Mapplethorpe did not hesitate to utilize his art for commercial projects, and often did fashion shoots and celebrity portraits for various magazines, including *Interview*, *Vanity Fair*, and *Harper's*. His early involvement in the New York music scene also led him to create photographs for a number of album covers for Patti Smith, Television, Laurie Anderson, and others.

Mapplethorpe died in 1989, three years after he was diagnosed with AIDS. The Robert Mapplethorpe Foundation, launched by the artist the year before his death, continues to promote photography and fund AIDS research.

SHANNON WEARING

See also: **History of Photography: the 1980s; Portraiture; Representation and Gender**

Biography

Born in Floral Park, New York, 4 November 1946. Studied advertising design and graphic arts at Pratt Institute, Brooklyn, New York, 1963–1970, M.F.A., 1970. Received grant from New York State Creative Artists Public Service Program (CAPS), 1979; National Endowment for the Arts (NEA) grant, 1984; established Robert Mapplethorpe Foundation, 1988. Died in Boston, Massachusetts, 9 March 1989.

Individual Exhibitions

1973 *Polaroids*; Light Gallery; New York, New York
1977 *Flowers*; Holly Solomon Gallery; New York, New York
 Erotic Pictures; The Kitchen; New York, New York
1978 *Robert Mapplethorpe*; Chrysler Museum; Norfolk, Virginia
 Film and Stills; Robert Miller Gallery; New York, New York
1981 *Robert Mapplethorpe*; Kunstverein, Frankfurt, Germany and traveling

1983 *Lady, Lisa Lyon*; Leo Castelli Gallery; New York, New York and traveling
 Robert Mapplethorpe Flowers; Galerie Watari; Tokyo, Japan
 Robert Mapplethorpe, 1970–1983; Institute of Contemporary Arts; London, England and traveling
 Robert Mapplethorpe Fotografie; Centro di Documentazione di Palazzo Fortuny; Venice, Italy and traveling
1985 *Robert Mapplethorpe: Process*; Barbara Gladstone Gallery; New York, New York
1986 *Robert Mapplethorpe: Photographs 1976–1985*; Australian Center for Contemporary Art; South Yarra, Victoria, Australia
1988 *Robert Mapplethorpe*; Stedelijk Museum; Amsterdam, Netherlands and traveling
 Mapplethorpe Portraits; National Portrait Gallery; London, England
 Robert Mapplethorpe; Whitney Museum of American Art; New York, New York
 Robert Mapplethorpe: The Perfect Moment; Institute of Contemporary Art, University of Pennsylvania, Philadelphia, and traveling
1991 *Robert Mapplethorpe*; Musée d'Art Contemporain, Fondation Edelman; Pully/Lausanne, Switzerland
1992 *Mapplethorpe versus Rodin*; Kunsthalle Düsseldorf, Germany
 Robert Mapplethorpe; Tokyo Metropolitan Teien Art Museum, Japan, and traveling
 Mapplethorpe; Louisiana Museum of Modern Art; Humlebaek, Denmark, and traveling
1993 *Robert Mapplethorpe Self-Portraits*; Solomon R. Guggenheim Museum; New York, New York

Group Exhibitions

1973 *Polaroids: Robert Mapplethorpe, Brigid Polk, Andy Warhol*; Gotham Book Mart; New York, New York
1974 *Recent Religious and Ritual Art*; Buecker and Harpsichords; New York, New York
1977 Documenta 6; Kassel, Germany
1978 *The Collection of Sam Wagstaff*; Corcoran Gallery of Art; Washington, D.C.
 Mirrors and Windows: American Photography Since 1960; Museum of Modern Art; New York, New York and traveling
1981 *Autoportraits photographiques*; Centre National d'Art et de Culture Georges Pompidou; Paris, France
 Inside Out–Self Beyond Likeness; Newport Harbor Art Museum, Newport Beach, California and traveling
1981 Biennial Exhibition, Whitney Museum of American Art; New York, New York
1982 *Counterparts: Form and Emotion in Photographs*; Metropolitan Museum of Art; New York, New York
 Documenta 7; Kassel, Germany
1984 *The Heroic Figure*; Contemporary Arts Museum; Houston, Texas and traveling
1986 *The Nude in Modern Photography*; San Francisco Museum of Modern Art, San Francisco, California
1988 *First Person Singular: Self-portrait Photography, 1840-1987*; High Museum at Georgia-Pacific Center; Atlanta, Georgia
1989 *Photography Now*; Victoria and Albert Museum; London, England
 On the Art of Fixing a Shadow: One Hundred and Fifty Years Years of Photography; National Gallery of Art;

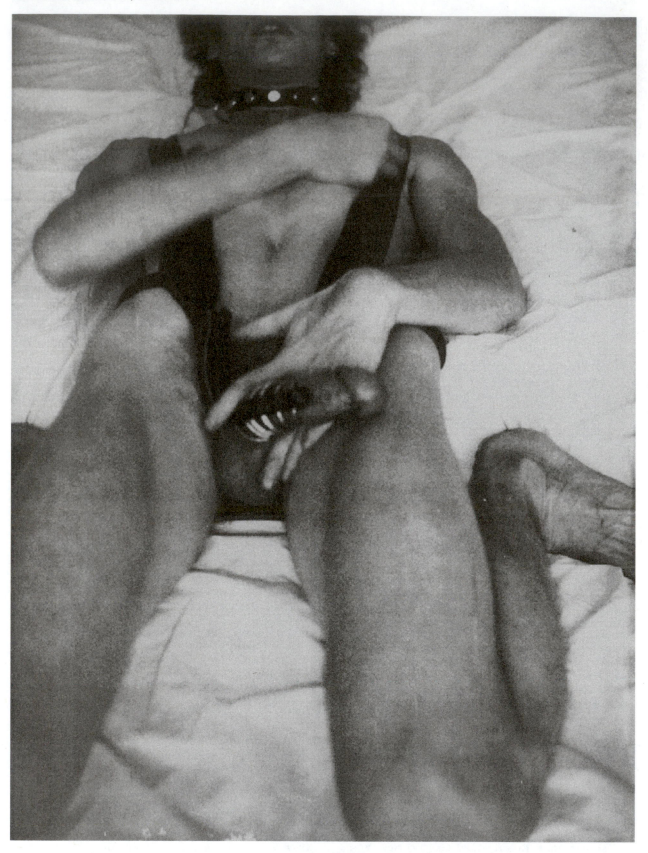

Robert Mapplethorpe (1946–1989),Untitled (Self portrait), circa 1972, Polaroid (B/W), 4¼ ×
3¼ inches, 10.8 × 8.3 cm, MAP# PD303.
[*Courtesy Cheim & Read, New York*]

Washington, D.C. and Art Institute of Chicago, Chicago, Illinois (and traveled to Los Angeles County Museum of Art, Los Angeles, California)

1990 *The Indomitable Spirit*; International Center of Photography; New York, New York, and traveling
 The Art of Photography: 1839–1989; Seibu Museum of Art; Tokyo, Japan

1993 *Abject Art*; Whitney Museum of American Art; New York, New York

1994 *Fictions of the Self: The Portrait in Contemporary Photography*; Weatherspoon Art Gallery, University of North Carolina at Greensboro, North Carolina

Selected Works

Brian Ridley and Lyle Heeter, 1979
Man in Polyester Suit, 1980
Self-portrait, 1980
Orchid, 1982
Eggplant, 1985
Thomas, 1987
Calla Lily, 1988
Nipple, 1988

Further Reading

Celant, Germano. *Mapplethorpe*. Milan: Electa, 1992.

Celant, Germano, and Arkady Ippolitov, with Karole Vail. *Robert Mapplethorpe and the Classical Tradition: Photographs and Mannerists Prints*. New York: Guggenheim Museum, 2004.

Danto, Arthur C. *Playing with the Edge: The Photographic Achievement of Robert Mapplethorpe*. Berkeley, Los Angeles, and London: University of California Press, 1996.

Kardon, Janet, David Joselit, Kay Larson, and Patti Smith. *Robert Mapplethorpe: The Perfect Moment*. Philadelphia: Institute of Contemporary Art, University of Pennsylvania, 1988.

Levas, Dimitri, ed. *Pictures: Robert Mapplethorpe*. New York: Arena Editions, 1999.

Mapplethorpe, Robert. *Certain People: A Book of Portraits* Text by Susan Sontag. Pasadena: Twelvetree Press, 1985.

Marshall, Richard, Richard Howard, and Ingrid Sischy. *Robert Mapplethorpe*. New York: Whitney Museum of American Art, 1988.

Morgan, Stuart. "Something Magic." *Artforum* 25 (May 1987): 118–123.

Sontag, Susan. "Sontag on Mapplethorpe." *Vanity Fair* 48 (July 1985): 68–72.

MARY ELLEN MARK

American

For three decades, Mary Ellen Mark has photographed members of subcultures around the world, including heroin addicts in England, runaway adolescents on the streets of Seattle, women confined to a locked psychiatric ward of Oregon State Hospital, circus performers in India, prostitutes in Bombay, and children with cancer at a camp in California. Her constant subject is people within a social context, and she generally aims for an empathetic but unsentimental expression of humanistic values. One of the most widely respected documentary photographers working today, Mark moves seamlessly between journalistic and fine arts contexts: she has completed many editorial assignments for magazines, photographed advertising campaigns, and published books of her personal projects; her work has been shown in numerous gallery and museum exhibitions worldwide; and her photographs are included in significant museum and private collections.

Born in Philadelphia in 1940 to a middle-class family, Mark received her undergraduate training in the fine arts, receiving a BFA in art history and painting from the University of Pennsylvania in 1962. She embraced photography while continuing at the University of Pennsylvania as a graduate student in the Annenberg School for Communication, receiving an MA in photojournalism in 1964. After graduation, she went to Turkey to photograph on a Fulbright Scholarship, then traveled throughout Europe. In 1966, she moved to New York City, where she still lives, and began to work as a freelance photojournalist. In 1968, she traveled for the first time to India, a country that has inspired some of her most significant work. In her career, she has photographed throughout the United States, and in many other parts of the world, among them England, Spain, India, Vietnam, and Mexico. Mark's work has appeared in magazines such as *Life, Time, Paris-Match, Ms., New York Times Magazine, Vanity Fair, Vogue*, and *The New Yorker*, as well as virtually all the leading photography magazines and journals. She has published 14 books of her photographs; and her images have been published in many anthologies and exhibition catalogues.

Early on, Mark also achieved success as a photographer for the film industry, a lucrative career direction that helped subsidize her social documentary projects. She shot production stills for dozens of films, including *Alice's Restaurant, The Day of the Locust, Apocalypse Now, Ragtime, One Flew Over the Cuckoo's Nest*, and *Silkwood*. The film stills brought her notice and assignments from magazines, including a 1969 commission from *Look* to create a photo-essay on Federico Fellini directing the film *Fellini Satyricon*, which Mark considers her breakthrough story in photojournalism.

Constantly curious about the vagaries of human experience, Mark specializes in social documentation and portraiture, working mainly in black and white. While some of her editorial work has involved portraits of celebrities, including film stars and directors, writers, artists, and musicians, more often Mark has photographed those she calls the "unfamous," meaning people outside the mainstream whose lives are not conventionally newsworthy. She is drawn particularly to outcasts whose lives play out within a troubled situation that isolates them, such as poverty, illness, or addiction; and to people who live in social groups that function like a substitute family, such as performers in an itinerant circus or the inhabitants of a brothel. The diversity of her topics reflects both the assignments offered to her and her personal interest in certain topics; she manages to fund personal projects through a variety of means, including grants, financial support from non-profit organizations, and selling her ideas to magazines and other commercial outlets.

Mark's preferred method is to proceed with a project by immersing herself over an extended period in the world of her subjects, developing a relationship with her subjects and learning to see nuances in the conditions of their environment. To cite several examples: Mark and the writer Karen Folger Jacobs lived for 36 days in a women's maximum security unit in a mental institution in Oregon, resulting in the book *Ward 81* (1979); Mark spent several months on two separate trips to India in 1980 and 1981 photographing Mother Teresa and her Missions of Charity in Calcutta for a *Life* magazine assignment and subsequent book; and she traveled with 16 different circuses during two three-month trips to India to produce the book *Indian Circus* (1993). Sometimes Mark will stay in touch with people long after a project is finished. For example, she has returned to Seattle repeatedly to photograph Erin Blackwell, or "Tiny," who was 14 when Mark first photographed her in 1983 for a photo-essay for *Life*, including the often reproduced image, *"Tiny" in Her Halloween Costume,*

Seattle, Washington, USA. The latter assignment led to the Academy Award nominated film *Streetwise* (1985), directed and photographed by Mark's husband, the filmmaker Martin Bell, and to Mark's 1988 book of the same title.

In her photo-essays, Mark is more interested in revealing individual personalities set within their sociological context than in telling a conventional narrative with a beginning, middle, and end. Precedents for her work include the work of photojournalists Margaret Bourke-White, Dorothea Lange, and W. Eugene Smith. Mark is interested in exploring the emotional and psychological tenor of small societies, and makes no pretense to objectivity. About *Ward 81*, Mark observed, "I just wanted to do photographs that I believed in without having any rhyme or reason or theory, or having to spell out a sort of storytelling. I wanted to show their personalities—that was the thing that drew me to them" (Fulton, 11–12). More generally about her intentions for her work, Mark stated, "I think each photographer has a point of view and a way of looking at the world...that has to do with your subject matter and how you choose to present it. What's interesting is letting people tell you about themselves in the picture" (Fulton, 27).

Mark wants each of her images, including those that are part of a photo-essay, to be able to stand alone as a single image, to sum up and provide insight into the personality and life of a particular subject. A hallmark of Mark's style is that her subjects are aware of the camera and make eye contact, projecting themselves into the lens. This intimacy reflects Mark's capacity to engage her subjects on a personal level; the approach also involves viewers, since the subjects appear to be gazing directly at them. Mark favors black-and-white over color photography, but occasionally shoots in color, including the images made for her book *Falkland Road: Prostitutes of Bombay* (1981), which show prostitutes in Bombay situated in the colorfully patterned interior rooms of brothels. Although Mark demands high technical quality in her prints, she does not undertake her own darkroom work. She mostly uses small, handheld 35 mm cameras, and likes to work close to her subjects with short lenses. She also has shot with medium-format and 4 × 5-inch view cameras. She used the large 20 × 24 inch Polaroid camera for her study of twins, shot over several years at the annual Twins Days Festival in Twinsburg, Ohio, and published in the book *Twins* (2003).

JEAN ROBERTSON

See also: **Documentary Photography; Magnum Photos; Portraiture**

Biography

Born in Philadelphia, 1940. BFA in painting and art history, University of Pennsylvania, Philadelphia, 1962; MA in photojournalism, Annenberg School of Communication, University of Pennsylvania, 1965. Fulbright Scholarship to photograph in Turkey, 1965–1966. Freelance photojournalist living in New York from 1966. Contributing photographer to *The New Yorker*; has published photo essays and portraits in many publications, including *Life, Time, Paris-Match, Ms., New York Times Magazine, Vanity Fair*, and *Vogue*. Published 14 books of her photographs. Photography workshops taught in Mexico and throughout the United States since 1974. Elected to Magnum Photos, 1977; left Magnum to work independently, 1982. Numerous honors and awards, including: three grants from the National Endowment for the Arts, 1977, 1979, and 1990; Leica Medal of Excellence, 1982; Robert F. Kennedy Journalism Award, 1984; Photographer of the Year Award from The Friends of Photography, 1987; World Press Award for Outstanding Body of Work Throughout the Years, 1988; George W. Polk Award for Photojournalism, 1988; John Simon Guggenheim Fellowship, 1994; Hasselblad Foundation Grant, 1997; the Cornell Capa Infinity Award from the International Center of Photography, 2001; World Press Photo Award, 2004; and five honorary doctorate degrees.

Selected Individual Exhibitions

1976 *Bars*; The Photographers' Gallery; London
1976 *Ward 81*; Forum Stadtpark; Graz, Austria; and traveling
1981 *Falkland Road*; Castelli Graphics; New York, New York and traveling

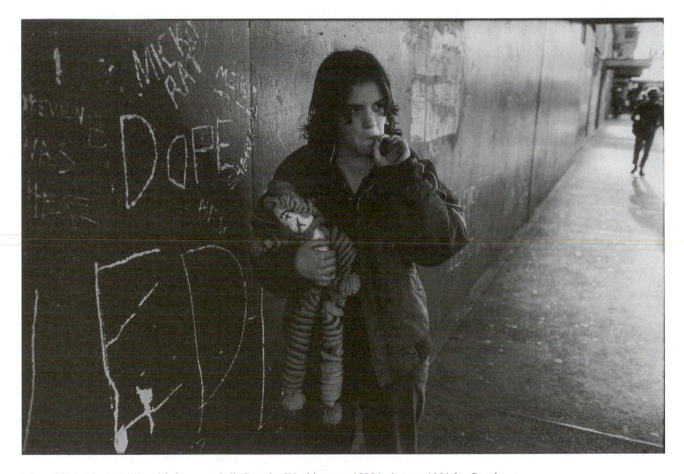

Mary Ellen Mark, Lillie with her rag doll, Seattle, Washington, 1983/print ca. 1991 by Sarah Jenkins, gelatin silver print, 37.2 × 55.4 cm, gift of the photographer.
[*Photograph courtesy of George Eastman House,* © *Mary Ellen Mark*]

1983 *Mother Teresa and Calcutta*; Friends of Photography; Carmel, California; and traveling
1987 *Mary Ellen Mark: Photographs*; Museum of Art, University of Oklahoma; Norman, Oklahoma
1988 *America*; Pasadena Art Center; Pasadena, California
1991 *Indian Circus: Platinum Prints*; Castelli Graphics; New York, New York and traveling
1992 *Mary Ellen Mark: 25 Years*; International Museum of Photography and Film, George Eastman House; Rochester, New York; and traveling
1996 *The Master's Series: Mary Ellen Mark*; School of Visual Arts; New York, New York and traveling
2000 *Mary Ellen Mark: American Odyssey*; Boras Konstmuseum; Boras, Sweden; and traveling
2002 *Mary Ellen Mark: Photographs*; Leica Gallery, Prague Castle; Prague, Czech Republic
2003 *Twins*; Marianne Boesky Gallery/Kennedy Boesky Photographs; New York, New York

Selected Group Exhibitions

1975 *Women of Photography: A Historical Survey*; San Francisco Museum of Modern Art; San Francisco, California
1979 *American Images*; International Center of Photography; New York, New York
1983 *Phototypes: The Development of Photography in New York*; Whitney Museum of American Art; New York, New York
1987 *American Dreams*; Centro Reina Sofia; Madrid, Spain
1988 *Homeless in America*; Corcoran Gallery of Art; Washington, DC
1989 *In Our Time: The World As Seen By Magnum Photographers*; International Center of Photography; New York, New York
1997 *India: A Celebration of Independence, 1947–1997*; National Gallery of Modern Art; New Delhi, India and traveling
1997 *Defining Eye: Women Photographers of the 20th Century*; Saint Louis Art Museum; St. Louis, Missouri
2000 *Picturing the Modern Amazon*; The New Museum of Contemporary Art; New York, New York
2001 *In Response to Place*; Corcoran Gallery of Art; Washington, DC; and traveling
2002 *New York: Capital of Photography*; Jewish Museum; New York, New York and traveling

Selected Works

Street Child, Trabzon, Turkey, 1965
Federico Fellini on the Set of Fellini Satyricon, *Rome, Italy*, 1969
Laurie in the Ward 81 Tub, Oregon State Hospital, Salem, Oregon, 1976
Mother Teresa at the Home for the Dying, Mother Teresa's Missions of Charity, Calcutta, India, 1980
Tiny in Her Halloween Costume, Seattle, Washington, USA, 1983
The Damm Family in Their Car, Los Angeles, California, USA, 1987
Contortionist with Sweety the Puppy, Raj Kamal Circus, Upleta, India, 1989
Leprosy Patient with Her Nurse, National Hansen's Disease Center, Carville, Louisiana, USA, 1990
Craig Scarmardo and Cheyloh Mather, Boerne Rodeo, Texas, USA, 1991
Three Acrobats, Vazquez Brothers Circus, Mexico City, Mexico, 1997

Further Reading

Fulton, Marianne. *Mary Ellen Mark: 25 Years*. Boston, Toronto, and London: Little, Brown, and Company, 1991.
Hagen, Charles. *Mary Ellen Mark*. London: Phaidon, 2001.
Marcus, Adrianne, ed. *The Photojournalist: Mary Ellen Mark & Annie Leibovitz*. New York: Thomas Y. Crowell, 1974.
Mark, Mary Ellen. *Falkland Road: Prostitutes of Bombay*. New York: Alfred A. Knopf, 1981.
Mark, Mary Ellen. *Mary Ellen Mark: American Odyssey, 1963*, New York: Aperture, 1999.
Mark, Mary Ellen. *Photographs of Mother Teresa's Missions of Charity in Calcutta: Untitled 39*. Carmel, California: The Friends of Photography, 1985.
Mark, Mary Ellen, and Nancy Baker, ed. *Streetwise*. Philadelphia: University of Pennsylvania, 1988.
Mark, Mary Ellen. *Twins*. New York: Aperture, 2003.
Mark, Mary Ellen, text by Karen Folger Jacobs. *Ward 81*. New York: Simon and Schuster, 1979.
Sullivan, Constance, and Susan Weiley. *The Photo Essay: Photographs by Mary Ellen Mark*. Photographers at Work Series. Washington, DC: Smithsonian Institution Press, 1990.

MASKING

Masking in photography is a process by which an object, or mask, blocks out an unwanted portion of the image. Masking may take place before, during, or after the picture is made, in the form of mechanical manipulations that alter the reality captured.

The term masking may also be applied more theoretically to describe the visual complexity of the medium of photography. The three categories of literal, technical, and metaphorical masking frequently co-exist. For example, a photograph of a

mask, whether it has been manipulated during processing or taken without excessive alteration, typically relates to a deeper meaning, to things that lie physically and conceptually outside the frame.

Early in the twentieth century, European artists appreciated African, Oceanic, and pre-Columbian masks primarily because they were unusual, unfamiliar, and more "honest" in their proximity to nature rather than civilization. The Expressionists, Cubists, and Surrealists were inspired by artifacts to explore approaches that were not limited by intellectual or empirical thinking including exaggeration, abstraction, and imagination. Similarly, masking in photography allows an artist to expand beyond documentation into the realm of creative experimentation. Like the masking traditions revered by modernist artists, masking in photography emphasizes the processes of making and interpreting images while, at the same time, it calls attention to and even questions the act of representation.

Walker Evans's 1935 photographs of the Metropolitan Museum of Art's African art collection not only depict masks but also illustrate one of the most basic types of masking. Almost unnoticeably, the edges around the backdrop of a work print show the hardwood floor and white wall and reveal the "real" environment for this image: the museum. While looking at this picture, it is easy to focus on the central image of the mask and ignore the margins. Having to deal with such distractions is unusual because in studio photography, the periphery has usually been eliminated by the photographer's selective eye and the ability to crop with the viewfinder or in the darkroom. The process of elimination that has not yet taken place here is typically concealed during the photographic process and transformed into the final pristine image.

Technical masking encompasses more radical alterations that intentionally create a very different image from the one presented to the camera. For example, mask cut-outs or masking tape is used to cover areas that should not be exposed in combination printing and double exposure. Silver tape is frequently used to mask extraneous borders from 35 mm slides, and filters are used during exposure and development to enhance or downplay certain colors or tones. Masks are often used to achieve color correction for color separations and offset lithography (See Jaffe et al., *Color Separation Photography* 1965, pp. 75–99). Color correction masks utilize the subtractive method of color production based on the primary colors of light and the four-color printing process. For example, a blue-filter separation negative subtracts all the blue light to print yellow, a green filter prints ma-

genta, a red filter prints cyan, and white light produces black. Digital imaging masks regulate contrast, allow multiple images to be layered seamlessly, and sharpen blurred edges (London, et al., *Photography* (2002), pp. 240 and 243). Because crucial details may be lost during digital recording, Adobe Photoshop's Unsharp Mask (USM), like its film predecessor, combines two blurred versions of an image to actually sharpen the image. The areas of overlap in the blurred versions distinguish an edge and allow contrast to be enhanced on either side of the edge. The reversals and complementary mixes so integral to film photography and four-color printing are present but often less obvious in the processing and refinement of digital images.

Virtually undetectable with digital technology, technical masking can be traced to the experiments of nineteenth-century photographers, including Gustave Le Gray, Oscar Gustav Rejlander, and Henry Peach Robinson. It is also found in the work of such twentieth-century photographers as Anton Bragaglia, Claude Cahun, Alvin Langdon Coburn, Hannah Höch, Man Ray, and Wanda Wulz. Jerry Uelsmann began using what would become a common method of building images in digital processes before digital technology was available by combining separate black-and-white film negatives in which the manipulation, though often discernable, is made as seamless as possible. Uelsmann's *Untitled (Cloud Room)* (1975) creates a dreamlike image of a dining room with a cloud-filled sky as the ceiling. Images like *Untitled (Cloud Room)* function most successfully when their manipulation is detectable in an intriguing way so that the fictional and factual aspects truly enhance one another.

Metaphorical masking relates to the underlying meaning in a photographic image: what is not readily visible, such as an ambiguity in meaning or the creation of a persona. This kind of complexity occurs in all types of imagery, but the convergence of objective facts and subjective interpretation is unique in photography because these aspects necessarily rely on one another for full impact.

Clarence John Laughlin uses a combination of literal, technical, and metaphorical masking in *The Masks Grow to Us* (1947). A woman wearing a veil over her head and a pearl necklace is shown with a second face, perhaps a mask or mannequin whose features closely resemble hers, superimposed on top of the left side her face. The bottom of the composition looks kaleidoscopic and the woman's face is slightly blurred. Laughlin's caption reads:

In our society, most of us wear protective masks (psychological ones) of various kinds and for various rea-

sons. Very often the end result is that the masks grow to us, displacing our original characters with our *assumed* characters. This process is indicated in visual, and symbolic, terms here by several exposures on one negative—the disturbing factor being that the mask is like the girl *herself*, grown harder, and more superficial.

(Laughlin 1973, 120)

The Masks Grow To Us includes literal masking in the depiction of a mask, technical masking by using multiple exposures, and metaphorical masking through the reference to the assumptions of psychological masks, which are virtually unrepresentable.

In the second half of the twentieth century, such photographers as Diane Arbus, Ralph Eugene Meatyard, Yasumasa Morimura, Cindy Sherman, Lorna Simpson, and Joel-Peter Witkin use masks or costumes to signal a self-conscious representation of the struggle between meaning and surface appearance. Masking encompasses and embraces oppositions consistently encountered in the photographic process. The tension between black and white, negative and positive, tangible and elusive, reality and creativity are consistently negotiated in such a way that they compliment and inform one another.

M. KATHRYN SHIELDS

See also: **Bragaglia, Anton Giulo; Cahun, Claude; Darkroom; Dye Transfer; Evans, Walker; Laughlin, Clarence John; Manipulation; Multiple Exposures and Printing; Print Processes; Uelsmann, Jerry**

Further Reading

Andrews, Phillip. "Unsharp Mask Unmasked" *Montage Magazine* 2000; http://www.photocollege.co.uk/montage/mtrap/Unsmask.htm (accessed May 17, 2005).

Cotton, Dale and Brian D. Buck. "Understanding the Digital Unsharp Mask." *The Video Journal/The Luminous Landscape.* http://www.luminous-landscape.com/tutorials/understanding-series/understanding-usm(accessed May 17, 2005).

Jaffe, Erwin, Edward Brody, Frank Preucil, and Jack W. White. *Color Separation Photography for Offset Lithography with an Introduction to Masking.* Pittsburgh: Graphic Arts Technical Foundation, Inc., 1965, 1959.

Laughlin, Clarence John. *Clarence John Laughlin: The Personal Eye.* Introduction by Jonathan Williams, stories by Lafcadio Hearn, captions by the photographer. New York: Aperture, Inc., 1973.

London, Barbara, John Upton, Ken Kobré, and Betsy Brill. *Photography.* 7th Ed. Upper Saddle River, NJ: Prentice Hall, 2002.

Savedoff, Barbara. *Transforming Images: How Photography Complicates the Picture.* Ithaca, NY: Cornell University Press, 2000.

Webb, Virginia-Lee. *Perfect Documents: Walker Evans and African Art, 1935.* New York: Metropolitan Museum of Art, distributed by Harry N. Abrams, Inc., 2000.

ANGUS McBEAN

Welsh

Angus McBean, a noted theatrical and portrait photographer, was a master of stagecraft who developed a sharply focused style employing dramatic lighting with lustrous highlights and deep shadows. His portraits of theatrical celebrities and other notables, glamorous and often in extreme close-up, seemed revolutionary in their time. A subset of his style, with which he is most often identified, was heavily influenced by Surrealism and its now familiar vocabulary of devices and clichés; these pictures achieved bizarre effects through elaborately constructed sets, photomontage, multiple exposure, the use of scissors, and other photographic "trickery" and manipulation.

McBean always seemed to be indulging a childish quest for fun, and he wrote that he had "used the new romantic idea merely for its fun value—merely as a relaxation from a busy life of portraiture and stage photography—and have produced many amusing and some good compositions." He was dedicated to the production of illusions, for which the theater is an obvious metaphor, and he sought to produce more or less convincing illusions through photographic means.

As a teenager, he bought a 2½ × 3½-inch Autographic Kodak camera and photographed Welsh

architecture. Pressured by family, the young man planned to become an architect. He briefly attended the local technical college but was an indifferent student, distracted by movies and other extracurricular pursuits. He turned to banking, but a lackluster performance in a series of jobs convinced him (and others) that his talents lay elsewhere. Having once been fascinated by the theatrical masks he had seen in performances in Newport, he began making masks, beginning with one of his own face. His father died in 1924, after which McBean, his mother, and sister moved to London. Beginning in 1925, he worked for seven years as a trainee at Liberty's, restoring and selling antiques.

He had built a darkroom and studio in his mother's house at Acton and was determined to earn a living in the world of theater. He devoted his time to photography and mask-making, initially without income. At an exhibition of his masks and photographs he had organized for a West End tea-shop, McBean met the renowned society portrait photographer, Hugh Cecil. Although McBean was eager to learn craftsmanship and technique from Cecil, he privately disdained the formulaic soft-focus portraits for which the older photographer was acclaimed. After a year in his employ, McBean left Cecil to open his own studio in Belgrave Road, Victoria, where he could practice his distinctive style of portraiture.

From 1935 to 1955, McBean became one of Britain's most well-known photographers, building upon his talent for theatrical mask making and set design. In 1932, he received his first stage commission, to make masks for Ivor Novello's play, *The Happy Hypocrite*. Novello was pleased with the masks and, after finding that McBean was also a photographer, invited him to photograph the show. McBean soon became known as the "court photographer" of the theatrical world. His pictures were published in magazines such as *The Sketch*, *Theatre World*, and *Playgoer* as well as used by the theater companies as publicity stills.

Intrigued by the strange juxtapositions and dream imagery of Surrealism which he saw in an exhibition of paintings by William Acton in 1937, as well as fashion pictures by photographers such as Horst P. Horst, McBean developed a style of humorously fantastic portraiture. His interest in Surrealism was not profound; he was mainly attracted to the world of fantasy associated with the movement. His photographic output stands as one of the best, if not the most obvious, examples of stagecraft and the directorial mode in photography,

involving elaborate preparation and manipulation of the subject and setting, as well as photographic manipulation or trickery after the exposure. He photographed noted British stage and film actors Vivien Leigh, Laurence Olivier, John Gielgud, Paul Scofield, and others.

While his surrealistic portraits enjoyed considerable popularity, they were also sometimes controversial. In 1940, his picture of Diana Churchill's apparently disembodied head aroused so much dismay that, in a bizarre twist of fate, he was imprisoned for two and a half years, although he returned to his work after his release, and his theatrical photography again flourished. McBean's activities in this field diminished in the 1950s, due to changing customs and economic circumstances in the theater (including the elimination of the traditional two-hour "photo call" at rehearsals upon which he had relied) and a lack of picture magazines as outlets for his work.

In the 1960s, however, McBean began to be in demand to produce record album covers. Although his style was not a natural fit with the new popular culture of the 1960s, in 1963 he made a famous, atypical photograph of the Beatles looking down a stairwell, a straightforward portrait deriving from a Bauhaus aesthetic. The appreciative Beatles asked him to repeat the pose for their updated look in 1970.

After the 1960s, McBean stopped taking photographs and devoted himself to the production of collages from fiberglass and metal, designing wallpaper, and renovating his medieval house in Suffolk, Flemings Hall. McBean's collection of negatives and other archival material was purchased in the early 1970s by the Theatre Library at Harvard University, but he destroyed the remainder of his glass plates. In his last photographic phase, he came out of retirement to do color fashion photography for *L'Officiel* in 1983, then worked for the French *Vogue*. He died in 1990.

Although much of McBean's imagery may seem overwrought and even silly to later critics, his work in the genre had considerable impact on fashion and advertising photography of the late twentieth century. His theatrical photographs—whether in his naturalistic but glamorous, dramatic style or in his whimsical, fanciful mode—constitute a valuable document of the heyday of mid-century British theater.

DAVID HABERSTICH

See also: **Fashion Photography; Horst, Horst P. Manipulation; Portraiture; Surrealism**

Biography

Born in Newbridge near Newport, Monmouthshire, South Wales, June 1904. Attended technical college, Newport, briefly, followed by an unsuccessful series of bank jobs. Father died 1924; family moved to Acton, London, 1925. Trainee in antiques department, Liberty's, 1925–1932. Worked for photographer Hugh Cecil for about a year, then opened his own portrait studio in Belgrave Road, Victoria. Theatrical commissions (masks, set designs, and photographs) from 1933, including reproductions in many periodicals. Began Surrealist experiments, 1937. Closed Belgrave Road studio, 1940. Incarcerated 1940–1942. Theatrical work suffered during World War II because theaters were closed. Opened new studio in Endell Street, Covent Garden, 1945. Redesigned interior of the Academy Cinema, Oxford Street, 1952. Obtained contracts for LP record album covers, 1950s–1960s. Featured in a BBC television documentary, 1982. Retired from photography; designed wallpapers for friends and explored other craft projects. Color fashion photography for *L'Officiel*, 1983, then French *Vogue*. Died June 9, 1990.

Individual Exhibitions

1932 Masks and photographs; Pirate's Den; London
1964 Photographs; organized by Kodak; London
1976 *A Darker Side of the Moon*; Impressions Gallery of Photography; Colliergate, York, England
1982 The Photographers' Gallery; London
1982 The B2 Gallery; Wapping; England

Selected Works

"French without Tears" by Terence Rattigan, 1937
Pamela Stanley "Surrealized" in her Role as Victoria Regina, 1938
Vivien Leigh "Surrealized," 1938
Diana Churchill, 1940 (the cover of *Picture Post*, which led to the *British Journal of Photography* controversy and German propaganda)
Binkie Beaumont, 1947
Tyrone Power, Hildy Parks, Jackie Cooper and the cast of Mister Roberts, 1950
Audrey Hepburn, 1951
Charles Laughton in "A Midsummer Night's Dream," Stratford, 1959
The Beatles, 1963
The Beatles, 1970

Further Reading

McBean, Angus. *Handicrafts of the South Seas: An Illustrated Guide for Buyers*. Rev. 2d ed. Noumea, New Caledonia: South Pacific Commission, 1976.

———. *Shakespeare Memorial Theatre: A Photographic Record*, with a critical analysis by Ivor Brown, London: M. Reinhardt. [Began with issue for 1948/1950.]
McBean, Angus, and Lorenzo Maria Bottari. *Dialogo tra Fotografia e Pittura*. Siracusa: EDIPRINT, c1987.
Williams, Valerie. "Angus McBean: Photographer." *Photographic Journal*, July/August 1976 (Vol. 116, No. 4): 216–220.
Woodhouse, Adrian. *Angus McBean*. Foreword by [Lord] Snowdon. London: New York: Quartet Books, 1982.
———. *Angus McBean*, text by Adrian Woodhouse; editorial advisory board, Cornell Capa *et al*. London: Macdonald, 1985.

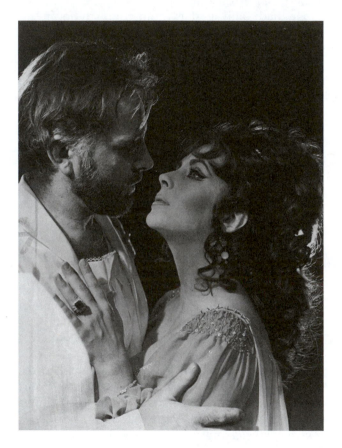

Angus McBean, Elizabeth Taylor and Richard Burton in Dr. Faustus.
[© *Hulton-Deutsch Collection/CORBIS*]

RALPH EUGENE MEATYARD

American

At first glance, Ralph Eugene Meatyard's black-and-white photographs from the 1950s and 1960s seem like informal, playful snapshots of his family and friends, suburban backyards, and peaceful countryside. On closer inspection, his remarkable photographs reveal a multitude of mysterious and disconcerting elements. Lawns are scattered with broken bits of discarded dolls; enigmatic ghost-like figures emerge from the shadows; children's faces are frequently obscured by grotesque Halloween masks in decrepit rooms, enacting inscrutable dramas or charades. In every image, there is something askew. Meatyard employed his knowledge as an optician; his interest in Zen philosophy, photographic language, and metaphorical representation; and ideas taken from contemporary painting, literature, and art theory to compile a rich variety of photographic experimentation representing the "scientific nature of camera vision and the spiritual essence behind the visual world" (Tannenbaum 1991).

Meatyard, born in Normal, Illinois in 1925, graduated from high school in 1943 and entered the Navy. He attended Williams College in Williamtown, Massachusetts in 1943–1944 under the Navy's V-12 program, where he became interested in the works of poets and writers Ezra Pound, Gertrude Stein, and William Carlos Williams. He was an avid reader, which later translated into an interest in having his photographs accompanied by text and collaborating on various projects with writers and thinkers such as Roger Mertin, Wendell Berry, Guy Davenport, Jonathan Greene, and James Baker Hall, who were his contemporaries and formed his intellectual and aesthetic circle. After the war, Meatyard married Madelyn McKinney in 1946, and he apprenticed as an optician in Chicago. He received his license in 1949 and began working in Bloomington, Illinois. In 1950, he left to study philosophy at Illinois Wesleyan University, Bloomington, and after one semester he accepted a job as an optician with Tinder-Kraus-Tinder in Lexington, Kentucky where he worked until he opened up his own shop in 1967.

Meatyard purchased his first camera in 1950 to photograph his newborn son, and he quickly became intrigued by the different ways he was able to express himself and make visible hidden worlds with a camera. In 1954, he studied with art historian and photographer Van Deren Coke. In the same year, he joined the Lexington Camera Club (led by Coke) and the Photographic Society of America, a national organization of amateur photographers with a thrust towards photojournalism. He participated in the PSA's competitions, salons, and national shows during the years 1954 and 1955, exhibiting his photographs which contained the seeds of his later abstractions, blurred images, and fabricated scenes.

It was his involvement with the Lexington Camera Club that nurtured his interest in non-conventional photography by emphasizing personal expression and encouraging its members to photograph figuratively and literally in their own backyards. In 1956, Van Deren Coke included his photographs in an exhibition, *Creative Photography*, at the University of Kentucky, along with those of Ansel Adams, Aaron Siskind, Harry Callahan, and other modern masters. His first joint project (1955–1956), a collaboration with Coke, was a documentation of Georgetown Street, a popular thoroughfare in Lexington. It was a methodical photographic survey reminiscent of projects carried out by the Farm Security Administration and the Photo League in the 1930 and 1940s. This was first time Meatyard utilized the series, a practice that he continued throughout his photographic career.

In the summer of 1956, Meatyard attended a workshop at Indiana University, Bloomington, Indiana, with Henry Holmes Smith, Minor White, and Aaron Siskind, where the concepts of abstract photography, technical experimentation, and the expressive power of the photograph solidified his work. Influenced by the Abstract Expressionists, he embarked on a project where he painted images for the express purpose of photographing them. He also began a series of images of sunlight reflected on the surface of water, which he continued for the rest of his life. Other projects of this period included the "No-Focus," pictures which were abstracted forms of pure light against darkness; and the Zen Twigs and Motion-Sound series, both of which utilized "the fluid boundaries between objects and the

spiritual and natural energy inherent in them" (Tannenbaum, 1991).

In 1957, Meatyard shared an exhibition with Coke at A Photographer's Gallery in New York City. His first one-man show was held at Tulane University in New Orleans in 1959, the year in which Coke published a Meatyard portfolio in *Aperture* with an accompanying text. Meatyard was included by Beaumont Newhall in the New Talent in the Photography U.S.A. section of *Art in America* in 1961. During 1967–1970, he collaborated with the writer Wendell Berry on work which resulted in the book *The Unforeseen Wilderness* (1971), to convey the essence of the Red River Gorge, a wilderness area in Kentucky.

"Produced throughout his career, Meatyard's figurative works are romances as Ambroise Bierce defined the genre: stories that need never actually have taken place to ring true" (Tannenbaum 1991). In these photographs, he was creating the illusion of childhood, free of care and full of curiosity, as in *Untitled (Child with Hubcap)*, c. 1959. The images are staged realities drawing upon juxtapositions, dreams, alienation, and in many cases, conflict. By posing family members with strange props and masks and bringing together symbols of death and decay with children, he explored a deeper layer of meaning and truths behind relationships, the transition from childhood to adulthood, consciousness, and existence.

In 1970, Meatyard discovered he had cancer. He continued to photograph what would become his most enigmatic series, *The Family Album of Lucybelle Crater*, which he had begun just before his diagnosis. A name adapted from a character in a Flannery O'Connor short story, it was based on the concept of informal but staged poses of a family album and Gertrude Stein's essay, "Portraits and Repetitions" (1935). Meatyard employed his wife, Madelyn, as the central constant masked figure photographed alongside a myriad of masked family members and friends including himself.

Meatyard died on 7 May 1972. His powerful and unique work, which aligned fabricated figurative imagery with deep psychological introspection, set the stage in contemporary art practice for figures such as Cindy Sherman, Richard Prince, and Jeff Wall, although his impulse to record the mysterious and ultimately inexplicable nature of everyday human existence is far removed from the postmodern strategies explored by these artist-photographers. His photographs continued to be seen following his death in a number of exhibitions and publications, most notably a major traveling retrospective, *Ralph Eugene Meatyard: An American Visionary*, organized by the Akron Art

Museum in 1991; *Ralph Eugene Meatyard (Aperture 18)*; and *The Family Album of Lucybelle Crater*, both in 1974. His photographs are included in numerous major collections, including the George Eastman House, the Metropolitan Museum of Art, the Museum of Modern Art, New York, and the Smithsonian Institution, Washington, D.C.

VINCENT CIANNI

See also: **Photography in the United States: the South**

Biography

Born in Normal, Illinois, 15 May 1925. Attended Williams College, Williamtown, Massachusetts under the Navy V-12 program, 1943–1944; Illinois Wesleyan University, Bloomington, Illinois, 1950; studied under Van Deren Coke in Lexington, Kentucky and joined the Lexington Camera Club and Photographic Society of America, 1954; attended photography workshop in Bloomington, Indiana; studied with Henry Holmes Smith and Minor White, 1956. Married Madelyn McKinney; apprenticed as optician in Chicago, 1946; licensed in 1949; opened own optical business, Lexington, Kentucky 1967. Exhibited in *Creative Photography*, organized by Van Deren Coke, with Adams, White, Siskind, Callahan, the Westons and others, 1956; exhibited with Van Deren Coke at A Photographer's Gallery, New York City, 1957; first solo exhibition at Tulane University, 1959; selected by Beaumont Newhall for "New Talent in Photography USA" section of *Art in America*, 1961. Published *Ralph Eugene Meatyard*, Gnomem Press, 1970. Died in Lexington, Kentucky, 7 May 1972.

Individual Exhibitions

1956 A Photographer's Gallery; New York (With Van Deren Coke)
1959 Tulane University, New Orleans, Louisiana
1961 University of Florida; Gainesville, Florida
1962 Carl Siembab Gallery; Boston, Massachusetts
1967 Bellarmine College; Louisville, Kentucky
 University of New Mexico; Albuquerque, New Mexico
1970 Institute of Design, Illinois Institute of Technology; Chicago
 Center for Photographic Studies; Louisville, Kentucky
 Visual Studies Workshop; Rochester, New York
1971 Art Institute of Chicago; Chicago, Illinois
 George Eastman House; Rochester, New York
 J.B. Speed Art Museum; Louisville, Kentucky
 Massachusetts Institute of Technology; Cambridge, Massachusetts
1972 Charles W. Bowers Memorial Museum; Santa Ana, California
 Columbia College; Chicago, Illinois
1973 Witkin Gallery; New York, New York
1974 Colorado Springs Fine Arts Center; Colorado Springs, Colorado
1975 Madison Art Center; Madison, Wisconsin
1976 Center for Visual Arts Gallery, Illinois State University; Normal, Illinois. Traveled to American Cultural Center, Paris

1983 Olympus Gallery; London
1987 Hewlett Gallery, Carnegie Mellon University; Pittsburgh, Pennsylvania
1990 Arizona State University; Tempe, Arizona
1991 Comptoir de la photographie; Paris, France
 San Francisco Museum of Modern Art; San Francisco, California
1992 University of New Mexico; Albuquerque, New Mexico
 National Museum of American Art, Smithsonian Institution; Washington, D.C.
 Akron Art Museum; Akron, Ohio

Selected Group Exhibitions

1954 *Second Southeastern Salon of Photography*; 1954 International Exhibition; Orlando, Florida
 Seventh Hartford International Exhibition of Photography; Wadsworth Athenaeum; Hartford, Connecticut
1955 *Seattle International Exhibition of Photography*; Seattle Art Museum; Seattle, Washington
1956 *Creative Photography*; University of Kentucky; Lexington, Kentucky
1958 *Coke Collection*; Indiana University; Bloomington, Indiana
1959 *Photographer's Choice*; Indiana University; Bloomington, Indiana
 Sense of Abstraction; Museum of Modern Art; New York, New York
1960 *Fotografie della Nuova Generazione*; Milan, Italy
1961 *Six Photographers*; University of Illinois; Urbana, Illinois
1962 *Photography U.S.*; deCordova Museum; Lincoln, Massachusetts
1963 *Photography 63/An International Exhibition*; George Eastman House; Rochester, New York
1964 *30 Photographers*; State University of New York at Buffalo, New York
1966 *American Photography: The Sixties*; Sheldon Memorial Art Gallery; University of Nebraska, Lincoln, Nebraska
1967 *Photography International*; San Jose State College; San Jose, California
 Photography in the Twentieth Century; traveling exhibition by George Eastman House for National Gallery of Canada
1968 *Contemporary Photographs*; University of California at Los Angeles, California
 Five Photographers; University of Nebraska; Lincoln, Nebraska
 Photography 1968; Morlan Gallery, Transylvania College; Lexington, Kentucky
1969 *Light*; Massachusetts Institute of Technology; Cambridge, Massachusetts
 The Camera and the Human Façade; Smithsonian Institution; Washington, D.C.
1972 *The Multiple Image*; Creative Photography Gallery, Massachusetts Institute of Technology; Cambridge, Massachusetts
1976 *Local Light: Photographs Made in Kentucky*; Center for Photographic Studies, Louisville; and traveled to University of Kentucky, Lexington; and other venues in Kentucky
1977 *Contemporary South*; United States Information Agency; toured Far East and Europe

1978 *I Shall Save One Land Unvisited: Eleven Southern Photographers*; Corcoran Gallery of Art; Washington, D.C. and Virginia Polytechnic Institute; Blacksburg, Virginia and traveling
1979 *Photographic Surrealism*; New Gallery of Contemporary Art; Cleveland (now Cleveland Center for Contemporary Art). Traveled to Dayton Art Institute; Dayton, Ohio and Brooklyn Museum of Art; Brooklyn, New York
1984 *La photographie créative: Les collections de photographies contemporaines de la Bibliothèque Nationale*; Bibliothèque nationale de Paris, France
1986 *Facets of Modernism*; San Francisco Museum of Modern Art; San Francisco, California
 Staging the Self: Self Portrait Photography; National Portrait Gallery; London, England
1987 *Modern Photography and Beyond*; National Museum of Modern Art; Kyoto, Japan.
1988 *Vanishing Presence*; Walker Art Center; Minneapolis, Minnesota and traveling to Winnipeg Art Gallery; Winnipeg, Manitoba, Canada; Detroit Institute of Arts, Detroit, Michigan; High Museum of Art at Georgia Pacific Center; Atlanta, Georgia; Herbert F. Johnson Museum of Art, Cornell University; Ithaca, New York; and VirginiaMuseum of Fine Arts; Richmond, Virginia
 Southern Visions; San Francisco Museum of Modern Art; San Francisco, California
 The Lexington Camera Club 1939–1972; University of Kentucky Art Museum; Lexington

Selected Works

Untitled (Georgetown Series: four children), c. 1955–1956
Light #3 (Light on Water), 1959
Untitled (Boy holding flag and doll), 1959
Untitled (Child as Bird), c. 1960
Untitled (Zen Twig), 1960
Untitled (Interior with two boys), 1961
Romance (N.) From Ambrose Bierce #3, 1962
Madonna, 1964
Untitled (Red River Gorge #21: fog on stream), c. 1967–1971
Untitled (Motion-Sound: garden path with vortex), c. 1968–1972
Untitled (Girl atop woman), c. 1970–1972
Lucybelle Crater and Close Friend Lucybelle Crater in the Garden Arbor, 1971

Further Reading

Beardmore, Susan, and A.D. Coleman. *True Stories and PhotoFictions*. Cardiff, Wales: Ffotogallery, 1987.
Berry, Wendell, with photographs by Ralph Eugene Meatyard. *The Unforeseen Wilderness: An Essay on Kentucky's Red River Gorge*. Lexington, Kentucky: University of Kentucky 1971. Reprinted by North Press, Berkeley, California, with a new foreword and revised text by Wendell Berry, 1991.
Coke, Van Deren. *Ralph Eugene Meatyard: A Retrospective*, Normal: Illinois State University, 1976.
Greene, Jonathan, ed. *Ralph Eugene Meatyard*. With works by Arnold Gassan and Wendell Berry. Lexington, Kentucky: Gnomon Press, 1970.
Meatyard, Ralph Eugene. *Father Louie: Photographs of Thomas Merton by Ralph Eugene Meatyard*. New York: Timken Publishers, 1991.

Meatyard, Ralph Eugene. *The Family Album of Lucybelle Crater*. Millerton, New York: The Jargon Society, 1974.

Tannenbaum, Barbara, ed. *Ralph Eugene Meatyard: An Amercan Visionary*. New York: Rizzoli, 1991.

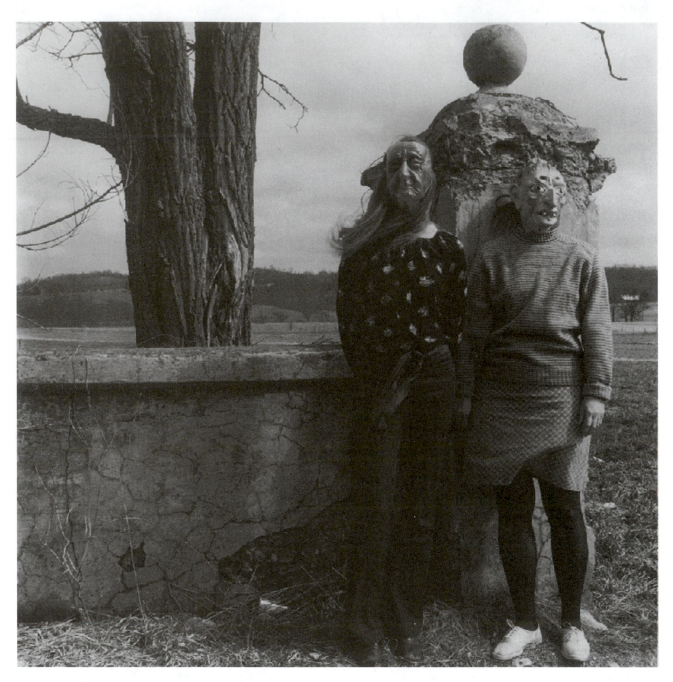

Ralph Eugene Meatyard, Lucybelle Crater & her 15 yr old son's friend Lucybelle Crater, 1970–1972, The Family Album of Lucybelle Crater, p. 7.
[© *The Estate of Ralph Eugene Meatyard, courtesy Fraenkel Gallery, San Francisco*]

SUSAN MEISELAS

American

One of the leading women photojournalists of the late twentieth century, Susan Meiselas is known for her uncompromising, often disturbing, but sympathetic documentations of subcultures considered tawdry and people suffering the atrocities of war. Her work has been hailed as offering a new type of photojournalism, where the subject speaks for himself or herself through the inclusion of his or her voice in interviews or extended titles.

Born in Maryland in 1948, Susan Meiselas graduated with a degree in Anthropology from Sarah Lawrence College, Bronxville, New York in 1970, before completing a Master's Degree in Visual Education at Harvard University in New Haven, Connecticut. While at Harvard, she took her first photography class. She also worked as an assistant editor to renowned documentary filmmaker, Frederick Wiseman. Between 1972–1974, Meiselas used photography as an educational tool, organizing workshops for teachers and young children from the South Bronx, New York. During this same period, Meiselas spent her summers documenting striptease acts at carnivals in New England, Pennsylvania, and South Carolina. Interested in what motivated the women performers, most of whom hailed from small towns in America, Meiselas photographed them behind the scenes, and recorded their stories. By virtue of her sex, she was automatically excluded from attending the male-only shows. To photograph the women on stage, she disguised herself as a man. As carnival strip shows have now largely vanished, the resulting body of photographs forms a valuable sociology document.

When *Carnival Strippers* was first exhibited in 1975 it was accompanied by a sound track derived from the recordings that Meiselas had made. When it was published in book form in 1976, 75 black-and-white photographs were reproduced and juxtaposed with transcribed extracts from those recordings. Significantly, the selected quotations were not intended as captions, but as parallel or complementary narratives to the photographs. In 2003, a revised edition of *Carnival Strippers*, including an audio CD, was published.

Carnival Strippers was considered an important body of work not only for its sympathetic portrayal of women considered part of the underbelly of society, but also because it marked Meiselas's entry into Magnum Photos and signaled the start of her career as a freelance photographer. She was nominated to join the agency in 1976; she became a Magnum Associate in 1977 and a Full Member in 1980. The project is also crucial to understanding the way in which Meiselas works. Characteristic of Meiselas's documentary method is the manner in which she encourages people to speak for, and about, themselves—a skill that derives, perhaps, from her training in anthropology and her work in education. Her experimental use of image and text differs from the convention of photograph-plus-caption, which she explored to great effect in subsequent projects, such as *Nicaragua: From June 1978–July 1979* (1981), *Kurdistan: In the Shadow of History* (1997), and *Encounters with the Dani: Stories from the Baliem Valley* (2003). Her purpose is to expand the experience of the photographs, and so engage more fully with the viewer and the people whose lives she documents.

Meiselas's book, *Nicaragua*, is now regarded as a watershed in photojournalism. She traveled independently to Nicaragua in the late 1970s, before the popular insurrection was launched. When political upheavals reached a crisis point and the media began to take notice, Meiselas's pictures were published internationally. Interested in producing a longer-term, more reflective response to the situation, she continued to make photographs in the area. As the book title makes explicit, the images in *Nicaragua* date from June 1978 and July 1979. They chronicle the overthrow of General Anastasio Somoza Garcia by the Sandinistas. As examples of war photography or photojournalism, these images are unusual, both in terms of format, and in the way in which they are organized as a publication. One way this project differs from other examples of the genre is that Meiselas shot in color. Although not the first time images of war were made in color, the saturated, seductive hues sit edgily with the often tightly framed images of conflict, fear, and death. But more significant is the manner in which the book is organized. Divided into two sections, the first part sequences photographs with no captions, obliging the reader to experience the chaos and confusion of the insurrection and its origins

without any anchoring words. In the second section, the photographs are reproduced as black-and-white thumbnails with lengthy explanatory titles. There are also a number of texts, including a chronology of events leading up to the revolution and various interviews, among them official quotes from Somoza as well as testimony from a housewife named Rosa Atilia. The ambiguity of the first section is thus contextualized by the voices of those whose history is being documented in the second. While it becomes apparent that Meiselas's sympathies are with the Sandinistas, she again explores a type of reportage that encompasses competing perspectives and not reducing the complexity of her subject to a single, or simplistic point of view. Most important, her device of using disparate texts derived from interviews and conversations moves towards challenging the criticism most often leveled at a documentary impulse: the silencing or disempowering of those who are photographed.

Meiselas's subsequent projects, also resulting in books, *Kurdistan* and *Encounters with the Dani*, both use the juxtaposition of image and text, drawn from a variety of sources, as a rhetorical device. In each case, Meiselas takes on the role of editor more than author. The intention of the two books is to collect together and negotiate the competing representations and implications derived from encounters between different peoples. In addition to the book *Kurdistan*, Meiselas has initiated a website project, *www.akaKurdistan.com*, which aims to establish a virtual archive of visual artifacts and reminiscences.

Encounters with the Dani evolved out of Meiselas's collaboration with the filmmaker Robert Gardner, whom she had met at Harvard, and who in the early 1960s had lived with and filmed the Dani of Baliem Valley, West Papua, a Stone Age society. It is a kind of dossier; historical and geographical documents are brought together with personal testimonies in a way that is overwhelming. Meaning is not presented as a *fait accompli* through the use of a single, captioned image. Rather, it is endlessly generated and moderated out of an array of interpretations.

Meiselas was active in Chile, El Salvador, and Nicaragua, and she has received various awards for her work in Central America. They include the Robert Capa Gold Medal for outstanding courage and reporting (1979), the Leica Medal for Excellence (1982), a MacArthur Fellowship (1992), and the Hasselblad Foundation Prize (1994). Meiselas has co-produced two films in collaboration with Richard Rogers and Alfred Guzzetti: *Living at Risk: The Story of a Nicaraguan Family* (1985) and *Pictures from a Revolution* (1991). Her photographs have been published widely, for example, in *Time*, the *New York Times, Paris-Match*, and *Life*. She continues to undertake projects that combine education, oral history, and photography, including a program titled *A Photographic Genealogy*, which she developed as a consultant to the Polaroid Corporation.

JANE FLETCHER

See also: **Life Magazine; Magnum Photos; Social Representation**

Biography

Born in Baltimore, Maryland, 21 June 1948. Graduated with degree in Anthropology, Sarah Lawrence College, 1970; Ed. M, Harvard University, School of Education, 1971. Honorary Doctor in Fine Arts, Parson's School of Art, 1986; Honorary Doctor in Fine Arts, The Art Institute of Boston, 1996. Photographic Consultant, Community Resources Institute, New York, New York, 1972–1974; Artist in Residence, South Carolina Arts Commission, 1974–1975; Faculty, Center for Understanding Media, New School for Research, New York; Freelance Photographer, Magnum Photos, New York, 1976–present. Awards: Robert Capa Award, 1979; Photojournalist of the Year, ASMP, 1982; Leica Award for Excellence, 1982; National Endowment for the Arts Fellowship, 1984; Engelhard Award, Institute of Contemporary Art, 1985; Lyndhurst Foundation, 1987; MacArthur Fellowship, 1992; Maria Moors Cabot Prize, Columbia Journalism School, 1994; Missouri Honor Medal, Missouri School of Journalism, 1994; Hasselblad Foundation Prize; 1994, Rockefeller Foundation, Multi-Media Fellowship, 1995. Living in New York, New York.

Individual Exhibitions

1977 A.M. Sachs Gallery; New York, New York
1981 FNAC Gallery; Paris, France
1982 Side Gallery; Newcastle-on-Tyne, England
1982 Camerawork; London, England
1984 Museum Folkwang; Essen, Germany
1990 *Crossings: Photographs by Susan Meiselas*; Art Institute of Chicago; Chicago, Illinois
1994 Hasselblad Center; Göteborg, Sweden
1998 Leica Gallery; New York, New York
2000 *Carnival Strippers: Photographs by Susan Meiselas*; Whitney Museum of American Art; New York, New York
2001 Canal de Isabel II; Madrid, Spain
2003 Foam Fotographie Museum Amsterdam; Amsterdam, Netherlands

Group Exhibitions

1982 *New Color Work*; Fogg Art Museum; Harvard University, Cambridge, Massachusetts
1984 *El Salvador*; Museum for Photographic Arts; San Diego, California
1986 *On the Line*; Walker Art Center; Minneapolis, Minnesota
1989 *The Art of Photography*; Museum of Fine Arts; Houston, Texas
1989 *In Our Time*; International Center of Photography; New York, New York

Selected Works

Lena's First Day, Essex Junction, Vermont, 1973
Lena After the Show, Essex Junction, Vermont, 1973
The Girl Show, Tunbridge, Vermont, 1974
Children rescued from a house destroyed by 1,000-pound bomb dropped in Managua. They died shortly After 1978–9
"Cuesta del Plomo" Hillside outside Managua, a well-known site of many assassinations carried out by the National Guard. People searched here daily for persons, 1978
Traditional Indian dance mask from the town of Monimbo, adopted by the rebels during the fight against Somoza to conceal identity, 1978

Further Reading

Meiselas, Susan. *Carnival Strippers*. New York: Farrar, Straus & Giroux, 1976.
Meiselas, Susan. *Nicaragua: From June 1978–July 1979*. New York: Pantheon, 1981.
Meiselas, Susan, ed. *El Salvador: The Work of Thirty Photographers*. UK: Writers and Readers, 1983.
Meiselas, Susan, ed. *Chile From Within, 1973–1988*. New York: W.W. Norton, 1991.
Meiselas, Susan. *Kurdistan: In the Shadow of History*. New York: Random House, 1997.
Meiselas, Susan. *Pandora's Box*. London and New York: Trebruk and Magnum Editions, 2001.
Meiselas, Susan. *Encounters with the Dani: Stories from the Baliem Valley*. New York: ICP and Gottingen, Germany: Steidl, 2003.
Meiselas, Susan. *Carnival Strippers* (revised edition). New York, Whitney Museum of American Art and Gettingen, Germany: Steidl, 2003.
Stevenson, Sara. *Magna Brava: Magnum's Women Photographers*. New York: Prestel, 1999.

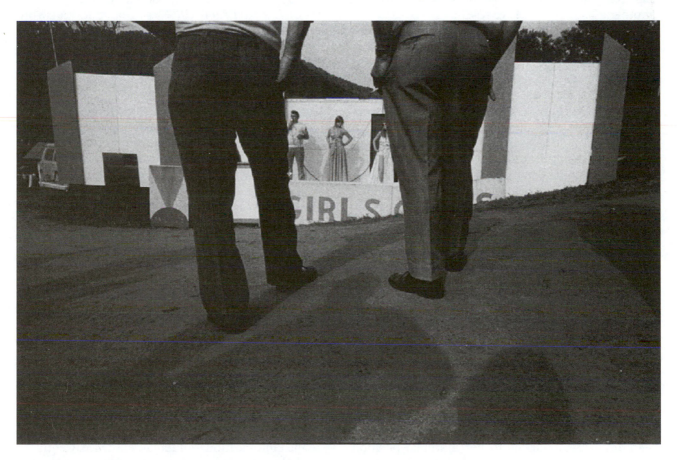

Susan Meiselas, The Girl Show, Tunbridge, Vermont, 1974.
[© *Susan Meiselas/Magnum Photos*]

ANNETTE MESSAGER

French

Annette Messager escapes easy categorization as both a photographer and a contemporary artist. Her works, which first appeared in the early 1970s, are as ambiguous as the titles she gives them—*Collectionneuse* (The Collector), *Artiste* (The Artist), *Femme pratique* (Practical Woman), *Truqueuse* (The Special Effects Artist), *Colporteuse* (The Pedlar), *Paradeuse* (The Exhibitionist), and *Gardeus* (The Herder), just to name the most important ones. Her works vary from simple illustrated books to large, complex installations made with soft toy animals and knitted objects, with body parts made of colorful fabric, and with shells, plastic bags, mirrors, and stuffed animals. Within this rich array of materials and techniques, photography and as well as "found" photographs play a decisive role.

Annette Messager was born in 1943 in the small town of Berck in northern France. After winning a photography competition sponsored by Kodak and the prize of traveling through Asia, she began studying art at the Ecole des Arts Décoratifs in Paris—a conscious decision against the option of the conservative Académie des Beaux-Arts. She traveled in a circle of like-minded young artists; among them were Christian Boltanski (with whom she has shared a long relationship), Jean Le Gac, and Paul-Armand Gette. In the atmosphere of revolt in May of 1968, she rejected "high art" and sought to connect art with life as practiced at the time by the Fluxus group and its French members Ben Vautier and Robert Filliou, by the Italian Arte Povera group, and by Joseph Beuys, the Belgian conceptual artist Marcel Broodthaers, Gilbert & George, and many others. Media considered unartistic strongly appealed to her; her seemingly banal themes—informed by post-structuralist philosophy that assigned virtually as much importance to context as to object—loaded such media with significant cultural meaning.

Messager viewed her turn to the everyday, to the low in quality, and to the second class—including photography, which in the 1960s was still not recognized as an art form on the same level as painting or sculpture—as analogous to her marginal position as a woman in the world of art and in society-at-large; she pursued subversion through affirmation.

In the 1970s, she created dozens of what have been termed album collections, into which went handcrafts and palaver about beauty and universal dreams of love and happiness. To examine the roll of mass media in defining models, Messager used a great many images of women, including professional models, from newspapers, magazines, and especially from women's magazines. She cut out these photographs and glued them into inexpensive paper booklets, manipulating them through placement and drawing upon them to create an ostensive revolt against female norms, including crossing out the eyes of babies.

In her role as Frau Everywoman, Annette Messager incorporates the taboo, the cruel, and the uncanny into her work. Based in content and aesthetic form on the thrillers of Alfred Hitchcock, the series *Les feuilletons* (1978) is a large format work made of cut-outs of color photographs with charcoal sketches. Her sexual fantasies, especially underlying desires for women in glossy magazines, run free in *Les effroyables aventures d'Annette Messager truqueuse* (1975)—a work in which the photographs are based on sketches. This work represents a second variant of her artistic practice utilizing photography, one that plays with the idea of the medium's truthful representation of reality. A third variation is found in her drawings based on photographs. *Le bonheur illustré* (1975/76), a series of 180 color pencil drawings, was created from travel industry brochures; like the German painter Gerhard Richter, she used photos as "models"; and like Sigmar Polke, another leading German painter, she was fascinated by popular culture.

With her photo albums bringing together an inventory of everyday, domestic artifacts, Messager widened her survey of visual clichés and collective fictions and connected photography with an increasingly wide range of media. Inspired by European and non-European folk art, popular forms including advertising, Surrealism, and the contemporary trend of mixing genres, Messager developed a hybrid form symbolic of what she perceived as the patchwork culture of the late twentieth century and appropriate to the multiple modes of female existence. Central to her photography, which was always black and white, was the human body or parts of the body.

Messager, in fact, often makes reference to nineteenth- and early twentieth-century medical and criminal photography, especially Jean-Martin Charcot's photographs of women diagnosed as hysterics in the Salpêtrière hospital in Paris.

In the early 1980s, Messager began covering walls with the fantastic world of *Chimères*. She constructed witches, spiders, grotesque trees, bats, and giant moles made from torn photographs painted in shrill colors that depict eyes, noses, mouths, tongues, and sexual organs. This technique of ripping a fragmentary image from a whole creates a forceful representation that blends the aesthetic of the street fair with Surrealism, showing the influence of Hans Bellmer's grotesque artworks assembled from doll body parts. With *Mes petites effigies* (1987), she began using stuffed animals as voodoo dolls, which she wrapped in black-and-white photographs of human limbs and with the accompanying texts evokes a cultish aura. Her playful imitation of stuffed animals presents the recurring parallel in her works between photography and taxidermy—both freezing life and transforming the subject into a fetish.

She further emphasizes the fetishistic character of photography in works such as *Les Lignes de la main* (1987–1988) and *Mes Trophées* (1986–1988). In these works, large format photographs of the soles of feet, the palms of hands, posteriors, and elbow joints create idyllic landscapes that yield all kinds of mythical creatures, heavenly bodies, and ornamentation. Precursors to this art are the gallant Cartes du Tendre of the Rococo period, tattoos, instruction manuals for chiromancy, and the clichéd figure of the hysterical woman. In general, Messager's works—her repertoire of forms and motifs—come from a variety of sources, combining art history and folklore.

Her voyeuristic representation of body parts is in part inspired by Catholic votive imagery, which fascinated Messager as a child. *Mes Voeux* (1988/89) is indebted to the dense presentation of these images in chapels and churches. It features an ensemble of black-and-white framed photographs that are hung from strings, showing nostrils, lips, outstretched tongues, a single finger, toes, navels, armpits. These parts stand in for various people but do not form the sum of a single body. Sexual zones are also not overlooked; she includes nipples, male genitalia, and pubic hair. By isolating and amassing these images, Messager ridicules the voyeurism of porno magazines and at the same time plays with the voyeurism of the viewer, which she impedes by the sheer quantity of accumulated, overlaid, and detailed sectioning of her photographs. Messager prizes photography precisely as a technology of reproduction.

Dépendanceindépendance from 1995, an installation in the form of a heart, consisting of 500 elements taken from works created in the previous 20 years, creates once again the ambivalent magic and ironic mesmerizing power of photography lost in other works such *Les restes* (1998/99) and *Les Répliquantes* (1999/2000). In the 1990s, important museums such as the Museum of Modern Art in New York and Reina Sofia in Madrid acknowledged Messager's artistic originality with solo exhibitions.

BRIGITTE HAUSMANN

See also: **Bellmer, Hans; Beuys, Joseph; Boltanski, Christian; Feminist Photography; Photographic "Truth"; Photography in France; Representation and Gender; Surrealism**

Biography

Annette Messager, born 1943 in Berck-sur-Mer, studied at the Ecole des Arts Décoratifs in Paris; numerous travels; lives and works in Malakoff near Paris.

Individual Exhibitions

1973 *Annette Messager Sammlerin, Annette Messager Künstlerin*; Städtische Galerie im Lenbachhaus; Munich, German
1978 *Serials, Annette Messager*; Holly Solomon Gallery; New York, New York
1981 *Annette Messager*; San Francisco Museum of Modern Art; San Francisco, California
1983 *Annette Messager: Chimères, 1982–1983*; Musée des Beaux-Arts; Calais, France
1984 *Les Pièges à Chimères d'Annette Messager*; Musée d'Art Moderne de la Ville de Paris; Paris, France
1986 *Annette Messager, Peindre, Photographier*; Musée d'Art Moderne et d'Art Contemporain; Nice, France
1989 *Annette Messager: Comédie Tragédie, 1971–1989*; Musée de Grenoble; Grenoble, Switzerland and traveling
1990 *Contes d'été*; Musée Départemental, Château de Rochechouart; Rochechouart, France
1991 *Annette Messager. Faire des histoires/Making up stories*; Mercer Union and Cold City Gallery; Toronto, Canada and traveling
1993 *Faire Figures*; Fonds régional d'art contemporain Picardie; Amiens, France
1995 *Annette Messager. Faire Parade 1971–1995*; Musée d'Art Moderne de la Ville de Paris; Paris, France
1995 *Annette Messager*; Los Angeles County Museum of Art; Los Angeles, California and traveling
1997 *Dépendanceindépendance*; Gagosian Gallery; New York, New York
1998 *C'est pas au vieux singe qu'on apprend à faire la grimace*; Musée national des Arts d'Afrique et d'Océanie; Paris, France.
1998 *Annette Messager. Map of Temper, Map of Tenderness*; Brown University, David Winton Bell Gallery; Providence, Rhode Island
1999 *Annette Messager. La procesión va por dentro*; Museo Nacional Centro de Arte Reina Sofia; Madrid, Spain
1999 *Annette Messager. Dépendanceindépendance*; Hamburger Kunsthalle; Hamburg, Germany

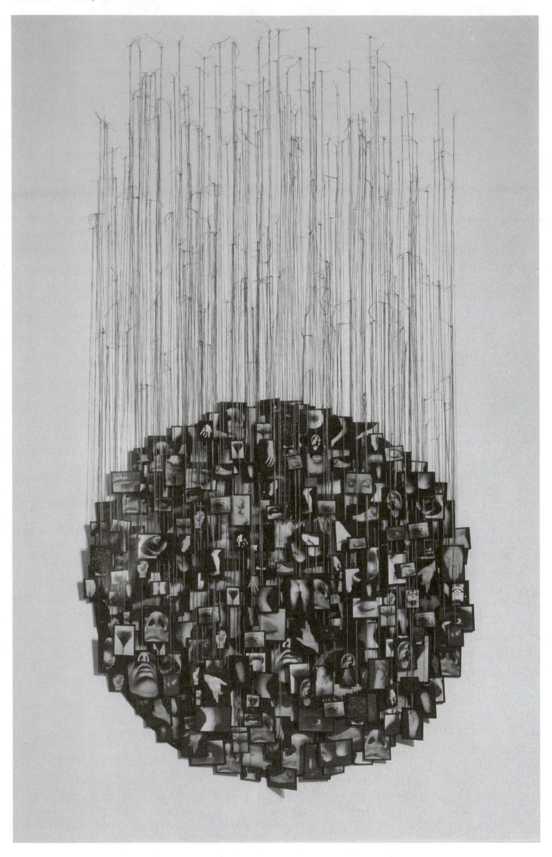

Annette Messager, Mes Voeux or "My Vows," 1989, 262 black-and-white photographs set under glass and hung from the wall with string, Photo: Philippe Migeat.
[*CNAC/MNAM/Dist. Réunion des Musées Nationaux/Art Resource, New York*]

Group Exhibitions

1976 *Biennale di Venezia*; Venice, Italy
1976 *Identité—Identification*; CAPC-Musée d'art contemporain Bordeaux; Bordeaux, France and traveling
1976 *Christian Boltanski/Annette Messager; das Glück, die Schönheit und die Träume*; Rheinisches Landesmuseum; Bonn, Germany
1977 *Documenta 6*; Kassel, Germany
1979 *French Art*; Serpentine Gallery; London, England
1979 *European Dialogue*; Sydney Biennale; Sydney, Australia
1980 *L'Arte degli anni Settanta. Biennale di Venezia*; Venice, Italy
1981 *Autoportraits photographiques, 1898–1981*; Centre Georges Pompidou; Paris, France
1983 *New Art 83*; Tate Gallery; London, England
1985 *Dialog*; Moderna Museet; Stockholm, Sweden
1989 *L'invention d'un art*; Centre Georges Pompidou; Paris
1991 *L'Excès et le retrait. 21. Biennale von São Paulo*; São Paulo, Brazil
1992 *Parallel Visions: Modern Artists and Outsider Art*; Los Angeles County Museum of Art; Los Angeles, California
1993 *Et Tous Ils changent le Monde. 2. Biennale de Lyon*; Lyon, France
1993 *Trésors de Voyage. Biennale di Venezia*; Venice, Italy
1995 *Masculin-Féminin*; Centre Georges Pompidou; Paris, France.
1996 *Comme un oiseau*; Fondation Cartier; Paris, France
1997 *Deep Storage*; Haus der Kunst; Munich, Germany, and traveling
1997 *Rrose Is a Rose Is a Rrose: Gender Performance in Photography*; Solomon R. Guggenheim Museum; New York, New York
1998 *L'étonnante gravité des choses simples*; Abbaye Saint-André, Centre d'art contemporain; Meymac, France
1999 *Puppen, Körper, Automaten. Phantasmen der Moderne*; Kunstsammlung Nordrhein-Westfalen; Düsseldorf, Germany
2000 *Ich ist etwas Anderes. Kunst am Ende des 20. Jahrhunderts*; Kunstsammlung Nordrhein-Westfalen; Düsseldorf, Germany
2000 *Closer to one another*, Havana Biennale; Havana, Cuba
2000 *Présumés innocents. L'art contemporain et l'enfance*; CAPC-Musée d'art contemporain Bordeaux; Bordeaux, France

Selected Works

Album Collection No. 3: Les enfants aux yeux rayés, 1972
Album Collection No. 18: Les Tortures volontaires, 1972
Les effroyables Aventures d'Annette Messager truqueuse, 1975
Les Feuilletons, 1978
Chimères, 1982/84
Mes Petites Effigies, 1987
Les Lignes de la main, 1987/88
Mes Trophées, 1987/88
Mes Vœux, 1988/89
Dépendanceindépendance, 1995

Further Reading

Annette Messager. *Les Approches*. Brüssel: Lebeer Hossmann, 1973.
———. *Mes Clichés par Annette Messager collectionneuse*. Liège: Yellow Now, 1973.
———. *Les Tortures Volontaires*. Kopenhagen: Berg, 1974.
———. *Ma Collection de proverbes par Annette Messager collectionneuse*. Milan: Giancarlo Politi, 1976.
———. *Mes Enluminures*. Dijon: art&art, 1988.
———. *Mes Ouvrages*. Arles: Actes Sud, 1989.
———. *Nos Témoignages*. Köln: Oktagon, 1995.
Lemoine, Serge. *Annette Messager. Comédie Tragédie, 1971–1989*. Grenoble: Musée de Grenoble, 1989.
Annette Messager: Faire Parade 1971–1995. Paris: Musée d'Art Moderne de la Ville de Paris, 1995.
Conkelton, Sheryl, and Carol S. Eliel, *Annette Messager*. Los Angeles: Los Angeles County Museum of Art and New York: Museum of Modern Art, 1995.
Annette Messager: La procesión va por dentro. Madrid: Museo Nacional Centro de Arte Reina Sofia, 1999.
Grenier, Catherine. *Annette Messager*. Paris: Flammarion, 2000.

RAY K. METZKER

American

Using black-and-white photography from his student work through his latest landscapes, Ray K. Metzker has proven himself a master of this medium in the late twentieth century—his experimentation with and challenging of long-held tenets of photography have been hallmarks of his career.

Best known for his multiple-image compositions, Metzker enriches each of his works through intensive darkroom efforts and investigation of material expressions.

Born in Milwaukee, Wisconsin in 1931, Metzker started photographing at age 13, continued his photographic studies at Beloit College, briefly worked as a commercial photographer, and taught photogra-

phy in the U.S. Army for two years while stationed in Korea. The education that was to inform his distinctive visuals and photographic experimentation, however, came from Chicago's Institute of Design (ID), where Metzker worked with Aaron Siskind and was the protégé of Harry Callahan.

His Masters thesis and first professional series, *My Camera and I in the Loop* (1957–1958), comprised distanced observations of Chicago denizens in the cityscape and was immediately recognized by an exhibition at the Art Institute of Chicago. Such "humanist" observations of people and their surroundings would inform several series, including *Europe* (1960–1961), *Philadelphia* (1963), many of his famous *Composites* (1964–1984) and *City Whispers* (1981–1983). Many of these works convey the psychological isolation of city dwellers, especially as they are dominated by their architectural surroundings.

Hired as a professor at the Philadelphia College of Art in 1962 where he has been an important force in photographic education ever since, Metzker moved to the city that he would feature in many of his works and which still calls home.

Taking cues from his Bauhaus-inspired experimentation at ID, in the early sixties Metzker started to explore multiple images in his works. In the *Double Frame* series (1964–1966), he printed two frames that were contiguous on a roll, often one vertically and one horizontally oriented, to create an overall picture. Metzker incorporated into the composition the black line between frames and often blended it with peripheral dark shapes. This use of black areas and high-contrast whites and grays was to characterize Metzker's work through the sixties and seventies.

In 1964, Metzker began to expand his exploration of multiple images, thus starting his best-known works, *Composites*, which are collages of many prints arranged in grids to create unified compositions. Taking photographic repetition to its logical conclusion, Metzker made works such as *Torso I* and *Torso II* (1965) that are composed of multiple but identical prints mounted on a board. Though these and other early *Composites* maintain an intimate scale, in 1965, Metzker started making large *Composites* of Philadelphia streetscapes with narrow strips of multiple-exposed paper prints. These works did not have identical images, but similar patterns of lights, buildings, or pedestrians. Metzker produced a dynamic visual rhythm by juxtaposing varying images that had some similar and some disparate elements. In *Sailing on 9th* (1966), one sees an urban street with repeated buildings and point of view. Trucks, individuals, and an image-obliterating white reflection change from scene to

scene. Metzker does not offer a linear narrative; rather, he gives us a formal arrangement of values that defies one's expectations of cinematic vision. In *Sailing on 9th*, he repeats the central building motif four times across a single narrow print. Metzker avoids deadpan composition by laterally shifting the repeated elements and introducing the optical lacunae of stark black or white shapes. The syncopation evident in these works marks Metzker's love of twentieth-century music including jazz and composers such as Francis Poulenc and Erik Satie. Along with the *Composites'* distinctive formal qualities, Metzker conveyed the cacophony and visual disjunction of urban life. Metzker often juxtaposed and mounted several prints to make larger works that measured up to six feet. This scale, which gave the works the gallery presence of a canvas, anticipated the assembled photographic documents of the conceptualists and the large photographic works that characterize photography of the eighties and nineties.

Through the late sixties and early seventies, Metzker made sojourns to New Jersey beaches to escape Philadelphia's summer heat. On the sands of Atlantic City and Cape May, Metzker photographed unaware individuals and couples asleep in the sun on beach blankets and chairs. The resulting *Sand Creatures* photographs show people in a vulnerable, yet relaxed, state. *Sand Creatures: Cape May* (1973) reveals Metzker's long shadow superimposed atop a sleeping, comely woman. This juxtaposition suggests Metzker's self-aware imposition, even as he recalled of this series, "I took what they presented—delicate moments—unadorned and unglamorous, yet tender and exquisite."

Predominately an urban photographer through the sixties, in 1970, Metzker turned his attention to the desert landscape while a Visiting Professor at the University of New Mexico in Albuquerque. This study marked a new direction for his work—one that would dominate his output through the eighties and nineties.

Sensing that his landscapes were unoriginal, in 1976, Metzker started to investigate formal possibilities for the photographic depth of field. In his *Pictus Interruptus* works, the photographer disrupted his scenes with objects that he would place in front of a corner of the lens. The resulting break in illusionistic depth forces viewers to focus on the images' overall formal qualities, even as they try to identify the blurry, occluding object.

Since the late seventies, Metzker's landscapes have often included out-of-focus foreground elements that create visual tension or harmony with the rest of the photographic field. His *Castagneto, Italy* works from

the *Feste di Foglie* series (1985) and his *Door County, Wisconsin* photographs that make up the *Door Suite* (1988) are examples of this rich, formal investigation of landscapes. This extended meditation on the natural world continues to the present and also includes his *Earthly Delights* (1987–1988) *Bernheim,* (1989) *Nature's Realm,* (1990–1994), *Moab I* (1994–1996) and *Moab II* (1997–1998) series. While these landscape works seem to be straight photography, Metzker often achieves their remarkable compositional balance and tonality in the darkroom through careful cropping, dodging, and burning. The results are often high-contrast images with "luminescent" foliage, or lush, "painterly" passages evocative of Impressionism. These unabashedly gorgeous images of trees, grasses, rocks, water, and sky call to mind the spirituality, beauty, and sense of the sublime advocated by the Romantics and Transcendentalists.

WILLIAM V. GANIS

See also: **Bauhaus; Callahan, Harry; Institute of Design; Multiple Exposures and Printing; Siskind, Aaron**

Biography

Born in Milwaukee, Wisconsin 1931. The artist lives and works in Philadelphia, Pennsylvania; Moab, Utah and other locations. B.A., Beloit College, Beloit, Wisconsin, 1953; active service, United States Army, Korea, 1954–1956; M.S. Institute of Design, Illinois Institute of Technology, Chicago, Illinois, 1958. Moved to Philadelphia, Pennsylvania, 1962. Professor of Photography, Philadelphia College of Art (now Philadelphia University of the Arts), 1962–1980; Professor, University of New Mexico, Albuquerque, 1970–1972; Professor, Columbia College, Chicago, 1980–1983; Distinguished Professor, George Washington University, Washington, D.C., 1987–1988. John Simon Guggenheim Memorial Foundation Fellowship, 1966, 1979; National Endowment for the Arts Grant 1974, 1988; La Napoule Foundation Residency, 1989; Bernheim Arts Fellowship, 1989; Mayor's Art and Culture Award, Philadelphia, 1991.

Individual Exhibitions

1959 *My Camera and I in the Loop*; Art Institute of Chicago; Chicago, Illinois

1967 *Ray K. Metzker*; Museum of Modern Art; New York, New York

1974 *New Mexico*; Dayton College of Art; Dayton, Ohio and The Print Club of Philadelphia; Philadelphia, Pennsylvania

1978 *Ray K. Metzker: Multiple Concerns*; International Center for Photography; New York, New York

1979 *Pictus Interruptus*; Light Gallery; New York, New York

1985 *Unknown Territory: Ray K. Metzker Photographs 1956–83*; Museum of Fine Arts, Houston, Texas; San Francisco Museum of Modern Art, San Francisco, Cali-

fornia; Art Institute of Chicago, Chicago, Illinois; the Philadelphia Museum of Art, Philadelphia, Pennsylvania; the High Museum of Art, Atlanta, Georgia; International Museum of Photography and Film, The George Eastman House, Rochester, New York; National Museum of American Art, Washington DC

1991 *A New Leaf: Photographs by Ray Metzker*; Art Institute of Chicago; Chicago, Illinois

1997 *Ray K. Metzker: When Darkness Reigns*; Laurence Miller Gallery; New York, New York

2000 *Voyage of Discovery: The Landscape Photographs of Ray. K. Metzker*; Cleveland Museum of Art, Cleveland Ohio; and Philadelphia Museum of Art, Philadelphia, Pennsylvania.

Group Exhibitions

1958 *Photographs from the Museum Collection*; Museum of Modern Art; New York, New York

1963 *Photography 63/An International Exhibition*; The New York State Exposition; Syracuse, New York and George Eastman House; Rochester, New York

1968 *Photography and the City*; Smithsonian Institution; Washington, D.C.

1970 *Bennett, Steichen, Metzker: The Wisconsin Heritage in Photography*; Milwaukee Art Center; Milwaukee, Wisconsin

1976 *Philadelphia, Three Centuries of American Art*; Philadelphia Museum of Art; Philadelphia, Pennsylvania

1978 *Mirrors and Windows: American Photography Since 1960*; Museum of Modern Art; New York, New York and traveling

1981 *Erweiterte Fotografie/Extended Photography*; Association of Visual Artists, Vienna Secession; Vienna, Austria

1983 *Harry Callahan and His Students: A Study in Influence*; Georgia State University Art Gallery; Atlanta, Georgia

1989 *On the Art of Fixing a Shadow: One Hundred and Fifty Years of Photography*; National Gallery of Art, Washington, D.C., Art Institute of Chicago, Chicago, Illinois, Los Angeles County Museum of Art, Los Angeles, California and traveling

1990 *Photography Until Now*; Museum of Modern Art; New York, New York

1992 *Special Collections: The Photographic Order from Pop to Now*; International Center of Photography; New York, New York

2002 *Taken By Design: Photographs from the Institute of Design, 1937–1971*; Art Institute of Chicago; Chicago, Illinois (traveled to San Francisco Museum of Modern Art, San Francisco, California and Philadelphia Museum of Art, Philadelphia, Pennsylvania

Selected Works

Europe: Frankfurt, 1961
Philadelphia, 1963
Torso II, 1965
Sailing on 9th, 1966
Double Frame: New York City, 1966
Sand Creatures: Cape May, 1973
Pictus Interruptus: Camden, New Jersey, 1977
City Whispers: Chicago, 1981
Castagneto, Italy, 1985
Moab, Utah, 1993

Further Reading

Edwards, Hugh. *My Camera and I in the Loop: Photographs by Ray Metzker*. Chicago: The Art Institute of Chicago, 1959.

Atkinson, Tracy, and Arnold Gore. *Metzker* from series *Bennett, Steichen, Metzker: The Wisconsin Heritage in Photography*. Milwaukee: Milwaukee Art Center, 1970.

Isaacs, Chuck. "Ray K. Metzker: An Interview." *Afterimage* (November 1978): 12–17.

Metzker, Ray K., *Sand Creatures: Photographs, Ray K. Metzker*. New York: Aperture, 1979.

Tucker, Anne Wilkes. *Unknown Territory: Photographs by Ray K. Metzker*. New York: Aperture/The Museum of Fine Arts, Houston, 1984.

Metzker, Ray. K, and Richard Woodward. *Ray K. Metzker: Composites*. New York: Laurence Miller Gallery, 1990.

Metzker, Ray K., and Laurence Miller. *City Stills*. New York: Prestel USA, 1999.

Metzker, Ray K., and Evan H. Turner. *Ray K. Metzker: Landscapes*. New York: Aperture, 2000.

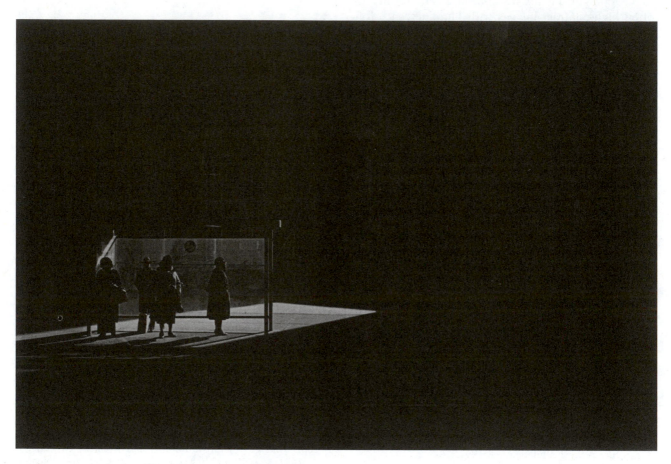

Ray Metzker, Philadelphia, 1963, gelatin silver print on paper.
[© *1963, Ray K. Metzker. Smithsonian American Art Museum, Washington, DC/Art Resource, New York*]

PHOTOGRAPHY IN MEXICO

Photography arrived in Mexico during 1839, a few months after its invention in Europe. During the nineteenth century, it was largely the province of portraits, which were usually of society's poles. On the one hand, the wealthy had represented themselves so as to appear modern and successful; on the other, the lower classes were portrayed as "popular types": Indians or similarly exotic people engaged in picturesque occupations, often hawkers of strange merchandise. There was little of the landscape and cityscape photography seen in Europe, but the different governments in power soon found the medium useful for making visual records of prisoners and prostitutes. In what would later be called photojournalism, daguerrotypes were made of the U.S. troops occupying Saltillo during 1847, the first photographs ever taken in a war zone.

Portraiture reached new heights in the late nineteenth and early twentieth centuries, with the work of Romualdo García and Natalia Baquedano, the latter a pioneer woman photographer in Mexico. Commercial-documentary photography was largely the domain of foreigners such as Americans William Henry Jackson and Charles B. Waite, and the French-born Abel Briquet, who were contracted by railroad and steamship lines to document the country's modernization under Porfirio Díaz (1876–1910), and thus further stimulate foreign investment. Guillermo Kahlo (father of the painter, Frida) was employed by the Porfirian government to document the colonial buildings, and he traveled the country for four years, producing exquisite large-format images which constitute the biggest and most systematic inventory of the cultural patrimony under Spanish rule. However, the real milestone of this period was the photojournalist debut of the Casasola brothers, Agustín Víctor and Miguel, who took their first press pictures in 1902.

The Casasola Archive contains the best-known photographs in Mexico, for they have been disseminated repeatedly in illustrated histories which have played a role in state building and party dictatorship. Images of Porfirian progress and its antithesis, the Mexican Revolution (1910–1917), are indelibly imprinted in Mexican minds, thanks to the collection Agustín Víctor began to form when he founded the first Mexican photojournalist agency in 1912, spurred by the sudden arrival of photographers and filmmakers who flooded the country to cover the first great social conflagration of the twentieth century. Agustín Víctor was an entrepreneur, as well as a photographer, and the pictures of more than 480 individuals can be found in the Casasola Archive, making it difficult to isolate and analyze the work of the different image makers, something further complicated by the fact that little research has been done on the publications in which photographs from the Casasola Archive appear.

During the Porfiriato, it appears that Casasola photographs in *El Mundo Ilustrado* (weekly supplement of the newspaper, *El Imparcial*) represented the social classes of that society in radically different, though complimentary, ways. "Political news" was dedicated to the order and progress wrought under President Porfirio Díaz, focusing on his ceremonies, state appointments, and diplomatic receptions, as well as his official visits and "informal" trips. However, the activities of dissenting groups, strikes, and the resistance of Indian communities were considered antisocial conduct; they were portrayed as a military, not a political problem. The populace was divided along the same lines. Society people appeared in the social chronicles, while the lower strata were represented as picturesque types or criminals, if they were unfortunate enough to end up in the police columns.

There is no evidence in the Casasola Archive of the photography that denounces social and political inequalities as can be seen in the pictures of Jacob Riis or Lewis Hine in the United States, and it appears that no such imagery developed in the rest of Latin America. The reform movements to which Riis and Hine were related had no counterparts in Mexico, but the Casasolas did take photographs during the Porfiriato with some implicit criticism of social conditions, and they documented the protest movement against Díaz's reelection in 1910. Further, it appears that the Casasolas developed a distinctly modern style of graphic journalism, capturing Díaz in unposed photos, as well as working with a view to creating photo-essays.

The Revolution presented photojournalists, for the first time, with the visual manifestations of con-

stant social ferment: lines of people awaiting the distribution of foodstuffs in the midst of famine, protests with banners that clamor for "WATER, WATER, WATER," and women demanding "Work for all." However, photography (as glimpsed through the Casasola Archive) continued largely to corroborate the political interpretations of whatever regime held power in Mexico City, and to whom the advertising of opposition gains in the countryside was anathema. There are interesting images: for example, those made in 1913 of Francisco Madero's overthrow during the "Tragic Ten Days" could be among the first combat photographs of the twentieth century and the touching farewells between women and soldiers in the train station are still evocative. But, in general, the images of the revolution that most dominate are of the different leaders who passed through Mexico City.

After the armed struggle ended, the Casasolas maintained the agency, and among their assignments was the work Agustín Víctor did for the Mexican government during the 1920s and 1930s as the photographic coordinator of various state offices. Thus, it comes as no surprise that in his archive there are few images of post-Revolutionary Mexico that focus on the continuing social inequalities. However, though his prison photography was made for the yellow sheets of tabloid journalism, some images carry at least an implicit criticism of class injustice: sad-eyed teenage prostitutes stare back at the camera; men in bare feet and ragged clothing stand in front of well-clad lawyers to be judged; street urchins, their faces smeared with filth, are corralled by police who seem to take little joy in their task; officers taunt transvestites who appeal to the camera with their eyes.

Edward Weston and Tina Modotti came to Mexico City in 1923, and their presence was to have an important influence on Mexican photography. Integrating themselves into the cultural effervescence, they entered into the world of the muralists and other artists. Weston was already famous when he arrived in Mexico, but it was here that he effected the break with Pictorialism that would define twentieth-century photography throughout the world. Eschewing the soft-focus that attempted to imitate painting, he insisted that he was uninterested in the question of whether photography was art or not; his concern was whether a given image was a good photograph. He was wary of the intrinsic picturesqueness of Mexico and battled to avoid it. One result of his search to define the new medium can be seen in his 1925 images of a toilet, which served to demonstrate photography's power for reproducing the beauty of the mundane.

Tina Modotti was known as his apprentice, and she followed his example of hard-focus photography that revealed things in themselves. However, her commitment to social justice led her to fill Weston's form with a radically different content, perhaps inaugurating critical photography in Latin America. What are probably the first examples of published photographs which questioned the new Mexican order can be found in a handful of her images that appeared during the 1920s in the newspaper of the Mexican Communist party, *El Machete*. There, depictions of social inequities were accompanied by cutlines pointing out the contradictions between the promises of the Revolutionary regime and the reality of most people's lives. For example, one image of a little girl carrying water was ironically titled "The Protection of Children," and the cutline stated: "There are millions of girls like this in Mexico. They labor strenuously for 12 to 15 hours a day, almost always just for food...and what food! Nevertheless, the Constitution...."

Modotti's photos were an appropriate counterpart to the lithographs that were placed on *El Machete*'s pages by its founders, the muralists José Clemente Orozco, David Alfaro Siqueiros, and Diego Rivera, and they were a welcome change from the fuzzy images of Soviet leaders that had been the paper's photographic staple. Accustomed to carefully planning her images, she did not feel comfortable photographing in the street. She had no qualms, however, about creating a photomontage such as *Those on top and those on the bottom* (1928) to make her point. In the lower half of this photo, a poor man in rags sits on the curb of a city street forlornly holding his head in his hand. In the upper half, a billboard looms with an advertisement from a fashionable men's store: a painting of a monocled, light-skinned man in a tuxedo is helped into his overcoat by his mestizo butler, and the pitch for Estrada Brothers clothiers claims that they "Have everything a gentleman needs to dress elegantly from head to toe."

The real battle between those who wanted to represent Mexico through picturesque modes and those who resisted the appeal of the exotic began in the 1920s as part of the search for national identity provoked by the Mexican Revolution. Ironically, the controversy is most easily embodied—at least initially—in the positions adopted by foreigners: on one side, that of Weston and Modotti, who rejected such stereotyping; on the other, that of Hugo Brehme. A German who arrived in Mexico in 1908 (he died there in 1954), Brehme was the leading light of the magazine *Helios*, published by the Association of Mexican Photographers, and his

position in the controversy is encapsulated in the title of the book he edited in Spanish, German, and English: *Picturesque Mexico*. Photographers such as Rafael Carrillo and Luis Márquez joined Brehme in believing that their idyllic and bucolic perspective was the proper way to represent Mexico. Though they used *Helios* as a platform to attack the direct, realist vision of Weston, Modotti, and Manuel Álvarez Bravo as being "an imitation of foreign exoticisms," their photography was nonetheless oriented toward giving readers outside Mexico what they expected. Thus, when asked if there was a Mexican School of Photography, Luis Márquez responded:

> Mexico is an absolutely photogenic country: its archeological ruins, its colonial monuments and its peculiar landscape are the foundation of the photography that has developed there. Showing its diversity, the monumental and the typical, has made Mexico known in foreign lands.

The greatest of Mexico's photographers, Manuel Álvarez Bravo, was no doubt stimulated by the presence of Weston and Modotti. He, in turn, was a definitive influence on the most aesthetically experimental Mexican photojournalists of the period between 1950 and 1970, Nacho López and Héctor García, and through them on the New Photojournalism of Mexico. Lola Álvarez Bravo was the first wife of Manuel Álvarez Bravo, and she used his name from the time they were married in 1925 until her death in 1993. Lola's best photography manifests the sort of understated irony for which Manuel is famous, a modest esthetic in which the photographer's presence is rarely noted. In one or another image, she expressed with particular poignancy her situation as a woman: for example, the powerful photo of a woman who—covered by a grid of shadows which take on the form of bars—slumps in her window and gazes into space, *In Her Own Prison* (ca. 1950). For many years, Lola lived in the shadow of Manuel (though they separated in 1934). In 1965, a major exhibit of Lola's work was held in the Palace of Fine Arts, but it was only with her "discovery" in 1979 by the French critic Olivier Debroise that her imagery began really to be seen in exhibitions and books. This is not unexpected, for Lola worked for many years as a photojournalist for minor magazines that were seen by a very limited audience.

Photojournalism has been the cradle of photography in Mexico, but visual representations of politicians were almost uniformly laudatory of those in power, prior to the founding of a genuinely critical press in the 1970s. As in much of the world,

illustrated magazines were a paramount form of visual culture and the primary venue for photographs, from the mid-1930s to the mid-1950s. In Mexico, José Pagés Llergo was the founder of the most important pictorial gazettes, and his productions—*Rotofoto* (1938), *Hoy* (1937), *Mañana* (1942), and *Siempre!* (1953)—were the *Life* and *Look* of Mexico. The constraints within which these publications functioned can be appreciated in his guiding dictum: he asserted that his journalists had no restraints, "as long as they don't touch the President of the Republic or the Virgin of Guadalupe." In fact, *Hoy* and *Mañana* were far more restrictive than Pagés's relatively pluralistic code in their reverence for the powerful. However, *Rotofoto* offered images that went against the grain. Because of that, the magazine lasted only 11 issues, from 22 May to 31 July, 1938, before it was destroyed by goons from the official labor union. Still, though short-lived, it was an agile, provocative, and fundamentally graphic attempt to vindicate the place of photojournalists in Mexican publications. In the 1950s, *Siempre!* became the first really pluralistic periodical in Mexico.

Despite governmental control of the press during the party dictatorship which lasted until 2000, some photojournalists challenged the status quo. Among the first to do so were the Hermanos Mayo, who arrived in Mexico during 1939, fleeing from their defeat as members of the Republican forces in the Spanish Civil War. Composed of five "brothers"—Francisco (Paco), Faustino, Julio, Cándido, and Pablo—this photojournalist collective had taken on the "nom de guerre" of Mayo in honor of May Day. In Mexico, their commitment to working-class democracy was largely co-opted by the mass media, but they revolutionized Mexican photojournalism by introducing the 35-mm Leica camera and using it with such skill as to overcome the objections to its "tiny negatives." A direct result of that technological innovation were dynamic photographs taken in the very center of action. The Hermanos Mayo played somewhat the same role that other refugees from Europe, such as Robert Capa and Alfred Eisenstadt, did in U.S. publications. Since their arrival, they have provided images for more than 40 newspapers and magazines, and their archive of some five million negatives is the largest in Latin America.

Notwithstanding their technical contributions, perhaps the most important assest of the Mayo was their development of a photographic discourse which insists that identity is formed in the process of people making something out of what their situation is making of them. Social struggles of

the 1950s and 1960s offered the Mayo many opportunities for constructing their visual dialectic. Their images may be the best taken of the 1958–1959 strikes, where teachers, telegraphers, and railroad and oil workers clashed with government forces during one of the most important movements in Mexico since the revolution of 1910–1917. There, they captured the outrage evident on a telegrapher's face as he glared from the background in the occupied offices at a bayonet-bearing soldier who dominates the photo's foreground. The Hermanos Mayo also covered the student movement of 1968, preserving for perpetuity the dialectic of oppression and resistance in images of students captured and forced to lie on the ground during the army's invasion of the university: even under the reflected glare of the bayonets that threaten them, they persist in their pursuit of free expression by flashing the sign of "Victory."

Nacho López is a pivotal figure in Mexican photography. He enjoyed the most autonomy within mass-circulation magazines, usually selecting his own themes and, in some cases, being given the power of decision over image choice and lay-out. His focus on the daily life of the downtrodden was an attempt to rescue the importance of the seemingly insignificant, the dignity of the poor, and the significance of the apparently commonplace. He represents a sharp break with prior Mexican photojournalism, both in terms of his social commitment as well as in the aesthetic explorations which mark him a true author of images and the foremost practitioner of the photoessay form in Mexico.

López was clearly the chosen photojournalist of *Siempre!*, the most respected periodical, for his essays appear in the first six issues. There, in 1954, López published the single most critical photoessay to appear in the illustrated magazines, "Only the humble go to hell." For López, Hell was the police stations where only the poor were at the mercy of "insolent, insulting, and ill-humoured police who are indifferent to the pain they cause the helpless"; the rich paid off the police in the street in order to spare themselves such ignomiky. Corrupt and with impunity, the Mexican police were as deserving of a critique in 1954 as they are today, but López's indictment was one of very few that can be found in the entire history of the Mexican press.

Although his career as a photojournalist lasted only from 1950 to 1957 (he then went on to work in the cinema), López's concern for the downtrodden, his aesthetic search, and his insistence on carrying out authorial intent were a crucial example to later generations of Mexican photojournalists. His reflections on his craft were important guidelines for his colleagues and students: "My profession is the most appropriate to understand dialectically the world of contradictions, to exhibit the struggle of classes, and to comprehend man as an individual." He left an important legacy in his classes at the National University (UNAM); Elsa Medina, one of the outstanding New Photojournalists, said: "He taught me to see."

Héctor García is another important Mexican photojournalist who began his career in the 1950s. His pictures of the 1958–1959 strikes were so damning of government intervention that the newspaper *Excelsior* refused to publish them. Forming the magazine *Ojo, una revista que ve*, García was able to print images of striking railroad and oil workers, as well as of the brutal beating of a male nurse who attempted to aid a woman overcome by tear gas. García embodies contradictions characteristic of the "perfect dictatorship" within which Mexicans lived under the rule of the official party: he produced many flattering images while working for President Luis Echeverría during the 1970s, but was one of the first photojournalists to explicitly critique the country's powerful. In a 1947 photograph, he poked fun at the wealthy, showing their foibles in an image where a tuxedo-suited man raises the toes of his shoes to free the long train of the woman's fancy dress on which he has trod. García also produced one of the few photos in which the sharp class distinctions characteristic of Mexico are made manifest: it is September 15th, and people are strolling near the central plaza (Zócalo) where the yearly "Cry of Independence" will soon take place. In the foreground is a poor peasant couple, loaded down with bundles of goods they hope to sell in order to eke out their precarious existence. Behind them come a very different twosome, dressed in evening clothes. The title García placed on the image speaks eloquently about the unfair distribution of wealth (and the muted protest against it): *Each With Their Own Cry* (1965).

In a photo taken in 1955, García directly confronted the cultural mechanisms utilized by the governing party to legitimize its rule. A young sugar cane cutter, covered with the filth of his grueling task, stands in front of a typical post-Revolutionary mural of a colonial scene in which an overseer whips peasants as they work in a cane field. Wall paintings such as this emphasize the Spanish exploitation of the Mexican people and, by extension, sanction the Revolutionary regime by inferring that such oppression is now a thing of the past. By placing the cane cutter against the mural, and submerging him into it through lowering the contrast, García creates a confrontation between

history and myth, and exposes the lies of such officialist renditions of yesterday and today.

Weekly magazines had provided photographers a place to publish during the first "Golden Age" of Mexican graphic reportage from the end of the 1930s to the mid-1950s, but during the 1970s, a second flowering occurred, as that role was taken over by daily newspapers. In 1977, Manual Becerra Acosta led a movement to create a cooperative newspaper, and, to this day, *Uno más uno* describes itself as "The pioneer of graphic journalism in Mexico." In that daily, young photographers were given great latitude, and visual experimentation took precedence over the usually monotonous task of "covering" events. The respect given photojournalism was even more pronounced in *La Jornada*, the newspaper founded in 1984 by dissidents who left *Uno más uno*. From its very inception, *La Jornada* was conceived as a graphic medium: the artist Vicente Rojo designed the daily's format to include an image on every page, whether a photograph or a cartoon.

The new generation of photojournalists have published their work and earned their daily bread in *Uno más uno* and *La Jornada*: Pedro Valtierra, Elsa Medina, Marco Antonio Cruz, Francisco Mata Rosas, Fabrizio León, Andrés Garay, Raúl Ortega, Guillermo Castrejón, Eniac Martínez, Frida Hartz, Jorge Acevedo, Rubén Pax, Luis Humberto González, Angeles Torrejón, Christa Cowrie, José Antonio López, Aaron Sanchéz, and Daniel Mendoza, to mention only some. Far from believing in the objectivity which prior graphic reporters such as Agustín Casasola or Enrique Díaz employed as a smokescreen to dissimulate the services they provided to the state appartus, and fundamentally opposed to the use of photographs as either filler or simple illustration, some members of the New Photojournalism summed up their position in a statement that accompanied a 1988 exhibit of their work:

> A new generation of image creators now exists that recognizes the ideological, cultural, and symbolic character of their work; who obviously maintain the premise of their duty to inform, but without pretending to be a "faithful" register of reality....They are conscious that what they transmit is their point of view, opinions, and the position they assume in front of the events they see day after day.

The New Photojournalists have treated representatives of the State in ways to which they are little accustomed. For example, Marco Antonio Cruz ironically recast props of official symbolism in the photograph he made of President Miguel de la Madrid against a painted backdrop during a 1984 political meeting. In what must surely be the first critical image of a president in office, De la Madrid appears at the very bottom of the photo, with a huge black cloud over his head on which is written "UNEMPLOYMENT," and from which a lightening bolt comes that is aimed directly at him. In another image characteristic of the New Photojournalists, Andrés Garay photographed in 1984 the then all-powerful leader of the oil workers, Joaquín Hernández Galicia, seated at a table behind bottles of rum and brandy, which dominate the foreground. Though the image nearly cost Garay a beating, and it required great finesse to secretly carry the film from the banquet, the photo is a faithful representation of the new generation's work. Fabrizio León produced an acidic commentary on the Mexican electoral process in 1988 when he pilloried Miguel Bartlett, then President of the Federal Election Commission and architect of the fraud that gave the presidency to Carlos Salinas, by photographing his haughtiness through the smoke of his cigarette. The Chiapas Rebellion of 1994 provided the New Photojournalists with much fodder, and the 1998 photo by Pedro Valtierra of the combat between Indian women and soldiers is the most famous picture to come out of that struggle. In Valtierra's image, the Indians rise up against the impositions to which they have been subject in reality and, as well, in the systems of representation with which the State has legitimized itself. They push back, and seem to be winning the age-old struggle to define their culture in ways that differ sharply from the picturesque terms in which they have too often been depicted.

Political critique is innovative in the Mexican context, but the most unique element of the New Photojournalism is the development of a documentary form within a newspaper format. This has resulted from the newpapers' emphasis on picturing daily life activities, which allows photographers to publish images that have no relation whatsoever to "news." Thus, photojournalists can follow their own personal interests, confident that they will have a space to publish if their pictures are esthetically interesting. This freedom has also allowed the New Photojournalists to explore alternative venues for their images, such as books, magazines, exhibits, and posters, with the result that many—including Francisco Mata Rosas, Guillermo Castrejón, Eniac Martínez, and Marco Antonio Cruz—have undertaken extended documentary projects. Finally, the incorporation of women has been an important force in transforming a guild and a photographic genre, usually dominated by men.

Documentary photography that is not photojournalism has had a long history in Mexico, and

it has often focused on Indians. Some photographers, working for the National Indigenist Institute, have demonstrated great sensitivity toward their subjects. Individuals such as Julio de la Fuente and Alfonso Fabila established a respectful esthetic for photographing Indians in the 1940s. They were followed in this by photographers such as Gertrude Duby Blom, who began in the 1950s, and in later years by Nacho López and Alfonso Muñoz. Mexico's natural exoticism, however, makes it an easy mark for photographers who prefer the attractions of "Orientalism." Bernice Kolko produced images in the picturesque vein during the 1950s. In one image, an old peasant woman with a lined face is portrayed as the essence of motherly abnegation, sitting in front of a thatched roof that provides textured reference to idyllic tropicalism, and posed with her hands folded together as if she were praying (perhaps for her release from such romantic nonsense). More recently, Flor Garduño is the Mexican photographer who is probably most given to the stereotypical representation of her culture, often staging images by dressing Indians in exotic clothing and placing them in picturesque surroundings. The Chiapas Rebellion of 1994 brought a different sort of attention to the Indians, and the most interesting result has been the project to teach Indian women to photograph, one of whose results has been the book, *Camaristas: Mayan Photographers* (1998).

Graciela Iturbide's work also falls into photographs which tempt with their picturesque qualities, though hers is a complex and sophisticated photography which has the greatest audience outside of Mexico. Iturbide and the renowned Mexican writer, Elena Poniatowska, collaborated on a documentary project about the city of Juchitán, Oaxaca, which resulted in the book, *Juchitán of the Women* (1989), a paean to a mythical matriarchal society embodied in images such as Juchiteca women dancing together. Iturbide later ratcheted this idealization of rural Mexico up another level in her work, *In the Name of the Father* (1993). Here, Iturbide presents the "grotesque-picturesque" in photos of the traditional, though ghastly, slaughter of goats in Oaxaca brought down from the highlands by Mixtec shepherds at the end of the rainy season; Iturbide's images of dead goats piled up on textured *petates* or whose bloated corpses lie next to sleeping babies provide a macabre spectacle. Iturbide creates especially moving pictures when she photographs her own culture, as in the image of a woman sitting alone in a bar under a mural painting (1972) or the cultural blending so typical of the late twentieth century

in her iconic work *Mujer Angel (Angel Woman), Sonora*, 1979 which shows an Indian woman in traditional raiment striding into the countryside carrying a portable radio.

Outside the pale of photojournalism, several Mexican photographers of the late decades of the twentieth century merit serious attention. David Maawad and Alicia Ahumada have produced superb documentary studies of Hidalgo and other areas outside of Mexico City; theirs are among the few photographs free of the taint of the picturesque which so haunts Mexican imagery. Mariana Yampolsky has also made some wonderful photographs of the countryside, its inhabitants and architecture. Within the sphere of art photography, Gerardo Suter has created constructed images that are provocative, and the work of Humberto Chavez combines an intense intellectualism with an overwhelming sensuality. Pedro Meyer is among the pioneers of digital imagery in the world, and he has argued for years that the computer revolution will erase the frontier between fiction and documentary, as well as liberate photographers from "reality."

Notwithstanding the explorations of many individual image makers, the history of Mexican photography has largely been written in photojournalist and documentary images. One reason for this is that the country has demonstrated a concern with conserving its photographic heritage which is unique in Latin America. The Fototeca of the INAH (National Institute of Anthropology and History) was constructed in Pachuca, a cold and dry location to the north of Mexico City, furnished with up-to-date equipment, and technicians trained in advanced conservation procedures; it contains the Casasola Archive, as well as those of Tina Modotti and Nacho López. The National Archive (AGN) also has large holdings, including the five million negatives of the Hermanos Mayo. This heritage has been disseminated through a vast number of publications, perhaps the most significant of which is *Río de luz* (River of Light), a series that includes many of the most important Mexican and Latin American photographers. The series has functioned largely under the editorship of Pablo Ortiz Monasterio, himself an important contemporary photographer.

The prominence of photography in Mexico was both recognized and stimulated by the 1994 founding of the Centro de la Imagen (Center of the Image). Under the directorship of Patricia Mendoza, the Center has created an extraordinary space for photography, including constantly changing exhibits, workshops taught by photographers and historians from all over the world, and a

Manuel Alvarez-Bravo, Umbral (Threshold), 1947/print 1977, gelatin silver print,
24.2 × 19.4 cm, Gift of Frederick Meyers.
[*Photograph courtesy of George Eastman House,* © *Manuel Álvarez-Bravo*]

library worthy of note. The Center also coordinates the activities of *Fotoseptiembre* (PhotoSeptember), the bienniels of photography and photojournalism, and the publication of the magazine, *Luna Córnea*. The health of Mexican photography can be gauged in the feverish effervescence of the many activities undertaken in the Centro de la Imagen.

JOHN MRAZ

See also: **Archives; Bravo, Manuel Álvarez; Documentary Photography; Modotti, Tina; Photography in Latin America: An Overview; Photography in South America; Pictorialism; Portraiture; Propaganda; Socialist Photography; Weston, Edward**

Further Reading

Debroise, Olivier. *Fuga mexicana: México*. Consejo Nacional para la Cultura y las Artes, 1994. Un recorrido por la fotografía en México.

García, Héctor. *Escribir con luz*. Mexico City: Fondo de Cultura Económica, 1985.

Jefes, héroes, caudillos: Archivo Casasol. Mexico City: Fondo de Cultura Económica, 1986.

Jiménez, Blanca, and Samuel Villela. *Los Salmerón. Un siglo de fotografía en Guerrero*. Mexico City: INAH, 1998.

Massé, Patricia. *Simulacro y elegancia en tarjetas de visita. Fotografías de Cruces y Campa*. Mexico City: INAH, 1998.

Meyer, Pedro. *Truths and Fictions: A Journey from Documentary to Digital Photography*. New York: Aperture, 1995.

Mraz, John. *Nacho López y el fotoperiodismo mexicano durante los años cincuenta*. Océano-INAH, 1996.

Mraz, John, ed. Issue on *Mexican Photography, History of Photography*, 20, no. 4, 1996.

Mraz, John, and Jaime Vélez. *Uprooted: Braceros Photographed by the Hermanos Mayo*. Houston: Arte Público Press, 1996.

Noble, Andrea. *Tina Modotti: Image, Texture, Photography*. Albuquerque: University of New Mexico Press, 2000.

El poder de la imagen y la imagen del poder: Fotografías de prensa del porfiriato a la época actual. Chapingo, Mexico: Universidad Autónoma Chapingo, 1985.

Vélez, Jaime, et al. *El oho de vidrio: Cien años de fotografía del México indio*. Mexico City: Bancomext, 1993.

JOEL MEYEROWITZ

American

Originally a street photographer, Joel Meyerowitz came to prominence as an advocate and pioneer of color photography in the 1970s. His early style was characterized by black-and-white urban scenes in the 1960s. Over a decade later, he created color photographs of seascape, landscape, and cityscape with a quiet, emotive sensibility. In his introduction to the Meyerowitz publication *Bay/Sky*, novelist Norman Mailer once asked, "Is there one of his prints that does not express his ongoing quest for the instant when nature can reveal itself through mood, light, mist, seaweed, wind, or the endless vortices of water in its dialogue with sand?"

Meyerowitz was born and raised in New York City in 1938. After high school, he enrolled at Ohio State University, Columbus, where he studied painting and medical drawing from 1956–1959. After graduation from college, he worked as an art director in New York City. While on location supervising a shoot with photographer Robert Frank, Meyero-

witz became inspired by Frank's quick but focused working method. He eventually quit his job and devoted his time to photographing in 1962. Influenced by the tradition of street photography that he knew from the work of Frank and French photographer Henri Cartier-Bresson and through a close working relationship with Garry Winogrand, he began shooting black-and-white images with a 35-mm Leica camera. For the subject of his photographs, he chose urban life in New York City during the 1960s, and he captured the irony and strangeness he found in the streets.

By the 1970s, Meyerowitz began to shoot color, and as an early practitioner of the medium, he was instrumental in changing prevailing attitudes in the art world toward color photography. Serious fine art photographers had, for the most part, disregarded color film and the resulting prints, finding that the color produced was often exaggerated or unrealistic. Meyerowitz found that color was critical to the accurate representation of the visual world and that color illuminated his own memory of that experi-

ence. In color work, he was able to discard narrative subject matter and emphasize the formal qualities of the photograph in regard to light and its emotive qualities. These characteristics were essential to the aesthetic development of color photography as it emerged in the late 1970s and early 1980s.

In the mid-1970s, Meyerowitz received acclaim for his earliest color series taken during summers spent in Provincetown, Massachusetts, when he began photographing the seascape of Cape Cod. Instead of shooting with a 35-mm camera for this series, he used an antique 8 × 10-inch Deardorff view camera, which enabled him to create large negatives that yielded nearly grainless images with clarity and detail. Meyerowitz expressed a sensitivity to the mood of a scene by capturing various atmospheric conditions, light effects, and the changing quality of color throughout various times of the day and into dusk. The most notable images from this period include a series of photographs taken on the porch of his summer home. As in the work *Porch, Provincetown*, 1978, Meyerowitz carefully observed the light as it fell upon the architectural elements that framed an open expanse of sea in the distance. The photographs were included in the book *Cape Light*, a publication that eventually became a classic work of color photography.

Works from the Cape Cod series led to subsequent color work and publications. He produced photographs of St. Louis in 1977 for a project commissioned by the Saint Louis Art Museum. While on four extended trips to the city during different seasons of the year, Meyerowitz made over 400 negatives. The St. Louis Arch became a significant, recurring element throughout this series in terms of its scale, its role in relation to the city, and its constancy throughout a variety of weather conditions and changes of season. Briefly, Meyerowitz turned his attention away from the land to the individual and embarked on a new series of portraits of redheads while vacationing at his summer home in Cape Cod; they appeared in his 1990 book *Redheads*.

In the last two decades of the century, Meyerowitz photographed the Manhattan skyline. After spending his summers in Cape Cod, he would return each fall to the city, and, beginning in 1981, he regularly shot from his twelfth-floor studio on West 19th Street. With 50 feet of windows and a clear view looking south, he observed the play of light as storms and weather systems passed over lower Manhattan. He became captivated by the skyline of New York City—he noted:

I thought I was being called by the scale of the city seen against the sky, but, of course, what really excited me

was the towers of the World Trade Center on the horizon. The towers were by turns hard-edged and glinting, like the Manhattan schist they stood on, or papery, or brooding and wet, smothered in tropical cloud banks carried up by the sea. Some days they were pewter, or gilded, or incandescent...

This body of work, which he amassed without exhibiting, was originally conceived as an urban landscape series. He made what turned out to be a final photograph just days before the Twin Towers of the World Trade Center were destroyed by Islamic terrorists on September 11, 2001, and the entire series of images immediately took on new significance.

Meyerowitz was away from New York during the attacks. Returning to find that photography of the site, which quickly came to be called Ground Zero, was prohibited, he was determined to gain access to record history and create an archive for the city of New York. He stated, "My task is to make a photographic record of the aftermath: the awesome spectacle of destruction; the reverence for the dead; the steadfast, painstaking effort of recovery; the life of those whose act of salvation has embedded itself deeply into the consciousness of all of us in America and around the world." He was granted access through his alliance with the Museum of the City of New York (the only photographer allowed complete access to the site), and the museum selected photographs from this series for inclusion in *After September 11: Images from Ground Zero*, a special exhibition that has traveled worldwide since 2002.

Meyerowitz is the author of numerous books, including the well-regarded history *Bystander, The History of Street Photography*, co-authored with Colin Westerbeck. He has had one-man exhibitions at the Museum of Modern Art, Art Institute of Chicago, San Francisco Museum of Modern Art, and Boston Museum of Fine Art, and has work in museums and private collections in the United States and abroad. He has recently produced and directed his first film, *POP*, an intimate diary of a three-week trip he made with his son Sasha and his father Hy, who has Alzheimer's Disease.

NANCY BARR

See also: **Frank, Robert; Street Photography; Winogrand, Garry**

Biography

Born in New York City in 1938. Studied painting and medical drawing at Ohio State University, Columbus, Ohio, 1956–1959, receiving a B.F.A in 1959. Self-taught in photography. Worked as an advertising art director, New York, 1959–1963. Independent photographer, New York, since

1963. Adjunct Professor of Photography 1971–1979 and Mellon Lecturer in Photography, 1977, Cooper Union, New York. Associate Professor of Photography, Princeton University, New Jersey, since 1977. Recipient of John Simon Guggenheim Memorial Fellowship, 1971 and 1979. Creative Artists Public Service Grant, New York, 1976; St. Louis Art Commission Grant, 1977; National Endowment for the Arts Grant, 1978; National Endowment for the Arts Grant, with Colin Westerbeck, 1978; National Endowment for the Humanities, 1980; Photographer of the Year Award, Friends of Photography, Carmel, California, 1981. Works as freelance commercial photographer; lives in New York.

Individual Exhibitions

1966 George Eastman House; Rochester, New York

1968 *My European Trip*; Museum of Modern Art; New York, New York

1974 Virginia Museum of Fine Arts; Richmond, Virginia

1978 *Cape Light*; Museum of Fine Arts; Boston, Massachusetts

1979 *Saint Louis and the Arch*; Saint Louis Art Museum; St. Louis, Missouri

1979 *Photographs*; Akron Art Museum; Akron, Ohio

1980 Stedelijk Museum; Amsterdam, Netherlands

1981 San Francisco Museum of Modern Art; San Francisco, California

1981 University of Oregon Museum of Art; Eugene, Oregon

1982 Provincetown Art Association and Museum; Cape Cod, Massachusetts

1985 *A Summer's Day*; Hong Kong Arts Center, Hong Kong, China (traveled to Brooklyn Museum of Art, Brooklyn, New York; Minnesota Museum of Art, St. Paul, Minnesota; High Museum of Art, Atlanta, Georgia; Art Forum Museum of Modern Art, Tokyo, Japan; San Jose Museum of Art, San Jose, California)

1989 *The White Nights*; Cleveland Museum of Fine Arts; Cleveland, Ohio

1991 *A Summer's Day*; Art Forum Museum of Modern Art; Tokyo, Japan

1992 *Atlanta and the Atlantic Center*; IBM Permanent Installation; Atlanta, Georgia

1994 *Joel Meyerowitz: On the Street, Color Photographs, 1963–1973*; Art Institute of Chicago; Chicago, Illinois

2001 *Joel Meyerowitz "Looking South: New York City Landscapes, 1981-2001"*; Ariel Meyerowitz Gallery; New York, New York

2002 *After September 11: Images from Ground Zero*; Museum of the City of New York; New York, New York (traveled worldwide)

Group Exhibitions

1963 *The Photographer's Eye*; Museum of Modern Art; New York, New York

1967 *Photography in the 20th Century*; National Gallery of Canada; Ottawa, Canada (toured Canada and the United States, 1967–1973)

1968 *Ben Shultze Memorial*; Museum of Modern Art; New York, New York

1970 *Portraits*; Museum of Modern Art; New York, New York (traveled worldwide)
 10 Americans (at *Expo '70*); Osaka, Japan

1971 *New Photography U.S.A.*; Museum of Modern Art; New York, New York (toured the United States and Canada)

1977 *Inner Light*; Museum of Fine Arts; Boston, Massachusetts
 American Photography; Philadelphia Museum of Art; Philadelphia, Pennsylvania

1978 *Mirrors and Windows: American Photography Since 1960*; Museum of Modern Art; New York, New York
 The Spirit of the New Landscape; Bowdoin College Museum; Brunswick, Maine

1979 *American Images: New Work by 20 Contemporary Photographers*; Corcoran Gallery, Washington, D.C. (traveled to International Center of Photography, New York, New York; Museum of Fine Arts, Houston, Texas; Minneapolis Institute of Arts, Minneapolis, Minnesota; Indianapolis Institute of Arts, Indianapolis, Indiana; American Academy, Rome, Italy)

1981 *American Photographers and the National Parks*; Corcoran Gallery; Washington, D.C. (traveled to Minneapolis Institute of Arts, Minneapolis, Minnesota)
 A Sense of Order; Institute of Contemporary Art; University of Pennsylvania; Philadelphia, Pennsylvania
 Inside Spaces; Museum of Modern Art; New York, New York
 The New Color: A Decade of Color Photography; Everson Museum of Art; Syracuse, New York

1982 *Color as Form: A History of Color Photography*; International Museum of Photography, George Eastman House; Rochester New York
 International Photography 1920–1980; National Gallery of Australia; Canberra, Australia

1983 *Response to Nature*; Tisch Hall of Fine Arts, New York University; New York, New York
 Color in the Street; California Museum of Photography; Riverside, California
 Views and Vision: Recent American Landscape Photography; International Center of Photography; New York, New York

1984 *Autoscape: The Automobile in the American Landscape*; Whitney Museum of American Art; New York, New York

1985 *American Images 1945–1980*; Barbican Center; London, England
 Light; San Francisco Museum of Modern Art; San Francisco, California
 A Decade of Visual Arts at Princeton; Princeton Art Museum; Princeton, New Jersey
 The Nude in Photography; Munich State Museum; Munich, Germany

1986 *City Light*; International Center of Photography; New York, New York

1988 *Legacy of Light*; DeCordova Museum and Sculpture Garden; Lincoln, Massachusetts
 Evocative Presence; Museum of Fine Arts, Houston; Houston, Texas

1989 *On the Art of Fixing a Shadow: One Hundred and Fifty Years of Photography*; National Gallery of Art; Washington, D.C. and Art Institute of Chicago, Chicago, Illinois (and traveled to Los Angeles County Museum of Art, Los Angeles, California)

1991 *Pools*; Moscow Art Museum; Moscow, Russia

1992 *The Art of the Real: Edward Hopper and Photography*; Volksmuseum; Essen, Germany

1994 *Bystander: The History of Street Photography*; Art Institute of Chicago; Chicago, Illinois (traveled to San Jose Museum of Art, San Jose, California)

St. Louis Suite; Society for Contemporary Photography; St. Louis, Missouri

After Art: Rethinking 150 Years of Photography, Selections from the Joseph and Elaine Monsen Collection; Henry Art Gallery, Seattle, Washington

1995 *On the Streets*; International Center of Photography; New York, New York

Picturing the South: 1860 to the Present; High Museum of Art; Atlanta, Georgia

1998 *Years Ending in Nine: FotoFest Exhibition*; Museum of Fine Arts, Houston; Houston, Texas

Photography's Multiple Roles: Art, Document, Market, Science; Museum of Contemporary Photography, Columbia College; Chicago, Illinois and traveling

In Over Our Heads: The Image of Water in Contemporary Art; San Jose Museum of Art; San Jose, California

1999 *Street Photographs, New York*; Turin Biennale; Turin, Italy

Human Events/Urban Events; Centro Culturale di Milano; Milan, Italy

Modern Starts, People, Places, Things; Museum of Modern Art; New York, New York

Selected Works

Porch, Provincetown, 1978

The Arch, 1980

The Twin Towers, 2001

Futher Reading

Eauclaire, Sally. *The New Color Photography*. New York: Abbeville Press, 1981.

Kozloff, Max. "Joel Meyerowitz." *Aperture* (1977): 32–35.

Meyerowitz, Joel. *At the Water's Edge*. Boston: Bulfinch Press, 1996.

———. *Cape Light*. Boston: Museum of Fine Arts, 1978.

———. *Joel Meyerowitz*. London: Phaidon, 2001.

———. *St. Louis and the Arch*. Boston: New York Graphic Society in association with the Saint Louis Art Museum, 1980.

———. *Redheads*. New York: Rizzoli, 1991.

———. *Wild Flowers*. Boston: Little, Brown, 1983.

———. *A Summer's Day*. New York: Times Books, 1985.

———. *Creating a Sense of Place*. Washington: Smithsonian Institution Press, 1990.

Meyerowitz, Joel, and Norman Mailer. *Bay/Sky*. Boston: Bulfinch Press, 1993.

Westerbeck, Colin, and Joel Meyerowitz. *Bystander: A History of Street Photography*. Boston: Little, Brown, 1994.

DUANE MICHALS

American

Self-taught in photography, Duane Michals has redefined photography by traveling a path unrestricted by the rules of the medium in order to explore its possibilities, always seeking expression and imagination rather than an adherence to specific, traditional forms. Michals is particularly known for his narrative sequences, in which he plays upon the cinematic aspect of photography. He has written, "I believe in the imagination. What I cannot see is infinitely more important than what I can see... (*Real Dreams*, Addison House, 1976). Like graphic riddles, his "photostories" symbolize intangible realities. His career as a photographer has been unusual, with equal success in the commercial field and in the fine arts.

Raised in McKeesport, Pennyslvania where he was born in 1932 to a working-class family, Michals spent a great deal of time with his Slovakian grandmother, who lived with his family. He credits her with his later development of an alter ego, Stefan Mihal, whose life Michals might have led, complete with the suburban home, factory job, and middle-class family. During high school, he became interested in art and on weekends started taking watercolor painting classes at the Carnegie Institute in Pittsburgh and then at the Carnegie-Mellon University. Enabled by a scholarship, Michals went on to study at the University of Denver, where he earned a B.A. in Art in 1953. Drafted into the United States Army shortly after graduation, he served as a second lieutenant in Germany during the Korean War. In 1956, after his army stint was over, Michals decided to study graphic design at the Parsons School of Design. After one year, he left to begin working as a graphic designer/assistant art director at *Dance* magazine.

Within a year, in 1958, he accepted a keyline/paste-up and design position with the publicity department at Time, Inc. That same year, it was on a three-week trip to Russia that Michals first became interested in photography when, with a borrowed camera, he took candid shots and portraits of Russian people. Upon

his return to the United States, he saw the greater potential of his Russian portraits and began to move into the commercial photography field, finding steady success. His first group exhibition, which also featured the work of Garry Winogrand, was in 1959 at the Image Gallery in New York. Starting with his initial commercial commission doing the publicity stills for the Broadway musical revue, *The Fantasticks*, Michals soon found steady work doing freelance photography for such varied magazines such as *Esquire, Mademoiselle, Show, Vogue, The New York Times, Horizon,* and *Scientific American*.

Then, in 1964, Michals began a personal project photographing the empty, unpeopled spaces within the city, seeing their stage-like implications. By 1966, frustrated with the weaknesses of the camera and the rules about what photography was supposed to be, he began doing photographic sequences of 5 to 15 images. Like all of his "photo-stories," each preconceived and staged sequence in natural light is simple and logical yet seemingly illusory. These narrative tableaux anticipate the fictive strategies popular to the postmodernist artists of the 1980s.

Derived from his belief "what I cannot see is infinitely more important than what I can see," Michals' early sequences, such as *The Spirit Leaves the Body* (1968), *Fallen Angel* (1968), and *Chance Meeting* (1969), build a story while simultaneously increasing the psychological tenor. Each three and a quarter by five inch image is masterfully emotionally psychological, sexually provocative, and elusive in its realistic representation. Influenced by the fusion of reality/unreality in the Surrealist paintings of Rene Magritte and the haunting *pittura metafisica* of Giorgio de Chirico's paintings, as well as the documentary tradition in photography, Michals has developed a style of telling unresolved graphic riddles in tableau form. Fuzzy focus, double exposure, the blur, and other imperfections of the photographic process enhance the immediacy of each scene. Thematically, the photographs of Duane Michals dwell upon his obsession with love and death. The place of dreams, unconscious, and spiritual wishes become the subject for his camera as the intangible materializes. The strength of Michals' vision lies in his acknowledgment of our spiritual yearnings and desires.

An early interest in verse and the works of Walt Whitman led Michals to begin writing poetry in 1972. In 1974, Michals began to write on his photographs, thereby subverting the viewer's literal expectations. The touch of the hand is apparent. Mistakes are included, leaving an impression of chance and authenticity. One of his best-known images, "A Letter from My Father," is a photograph taken in 1960 but reprinted in 1975, the year his father died, with Michals' handwritten thoughts. Poignant and private, the poetic handwritten text tells about an unfulfilled promise, adding a dimension that is markedly different than that of the visual.

Michals continued to push the boundaries placed upon photography. In 1975, Michals eliminated photography altogether in *Failed Attempt to Photograph Reality* by writing on a piece of paper, including the words "...To photograph reality is to photograph nothing." Then, anticipating the hybrid conceptualism of the postmodernists, Michals began painting on his own photographs in 1978. In *Ceci n'est pas une photo d'une Pipe* (1978), a reference to Magritte, Michals sought to show the inevitable limitations of the single photograph. In the late 1970s, Michals began to include more overt references to his homosexuality. In his books, *Homage to Cavafy* (1978) and *The Nature of Desire* (1986), his ideas on normality as being culturally defined, the beauty within both sexes, and the legitimacy of affection between sexes comes through the eloquent openness of his words and images.

Working simultaneously in both the commercial and fine art photography fields, Michals has managed to bridge the historical friction between them, seeing the mutual possibilities and exchange of ideas long before the 1990s acceptance of fashion photography as art. He sees no division and does his commercial work alongside his art photography. Preferring real, naturally lit locations, yet disdaining both the studio and the darkroom, all of his work contains a lyrical element, as exemplified in his album cover, *Synchronicity*, for the musical group The Police. His commercial success has granted him the financial ability to pursue his personal fine art work.

Since 1964, Michals has been represented in major solo exhibitions throughout the world, and his photographs are found in both museum and private collections internationally. Beginning with *Sequences* in 1970, over 20 books of his images have been published. *The Essential Duane Michals* (1997), a compilation of his ongoing photographic career, includes both his commercial and fine art photography. Michals lives in New York City.

SUSAN TODD-RAQUE

See also: **Hand Coloring and Hand Toning**

Biography

Born in McKeesport, Pennsylvania, 18 February 1932. Studied art at the University of Denver (1949–1953), B.A., 1953; studied art at Parsons School of Design (1956–1957); self-educated in photography. Assistant art director, *Dance Magazine*, New York, 1957; paste-up artist,

Look magazine, New York, 1957–1958. Freelance photographer, worked for *Vogue, Esquire, Mademoiselle, Scientific American,* and others, since 1958; first photo sequences, 1966; writing on his photographs, 1974; painting on photographs, 1978. Recipient, Creative Artists Public Service Award Grant, 1975; National Endowment for the Arts Grant, 1976; Carnegie Foundation Photography Fellow, Cooper Union, New York, 1977; International Center of Photography Infinity Award for Art, 1991; Officier dans l'Ordre des Arts et des Lettres, France, 1993. Lives and works in New York City.

Selected Individual Exhibitions

1963 Underground Gallery; New York (also 1965, 1968)
1968 Art Institute of Chicago, Chicago, Illinois
1970 Museum of Modern Art; New York
1971 George Eastman House; Rochester, New York
1972 Museum of New Mexico; Albuquerque, New Mexico
San Francisco Art Institute
1973 Galerie Delpire; Paris
International Cultural Center; Antwerp, The Netherlands
Kolnischer Kunstverein; Cologne, Germany
1974 Frankfurter Kunstverein; Frankfurt, Germany
Galerie 291; Milan, Italy
School of Visual Arts; New York, New York
Light Gallery; New York, New York
1975 Texas Center for Photographic Studies; Dallas, Texas
Contemporary Arts Center; Columbus, Ohio
Nova Gallery; Vancouver, British Columbia, Canada
Museum of Modern Art; Bogota, Colombia
Gemeentemuseum; Apeldoorn, Netherlands
Musee d'Art Moderne de la Ville de Paris, Francis
1983 Galerie Watari; Tokyo, Japan
Duane Michals—Photographs/Sequences/Texts 1955–1984; Museum of Modern Art; Oxford, England and traveling
1988 *Someone Left A Message For You: Photographs by Duane Michals*; Art Institute of Chicago, Chicago, Illinois
Duane Michals Photographies; FRAC Aquitaine; Bordeaux, France
1989 *Duane Michals Photographien 1958–1988*; Museum für Kunst und Gewerbe; Hamburg, Germany and traveling
1990 Modern Art Center; Calouse Gulbenkian Foundation; Lisbon, Portugal
The Duane Michals Show; Museum of Photographic Arts; San Diego, California
Duane Michals: Portraits; Butler Institute of American Art; Youngstown, Ohio and traveling
1994 *Duane Michals*; Louisiana Museum; Humlebaek, Denmark
1995 *Duane* Michals; Right Gallery; Kamakura, Japan and traveling
1998 Centro de Arte Reina Sofia; Madrid

Group Exhibitions

1959 Image Gallery; New York, New York
1966 *American Photography: The 60's*; University of Nebraska; Lincoln, Nebraska
Towards a Social Landscape; George Eastman House; Rochester, New York

1967 *Twelve Photographers of the American Social Landscap*; Brandeis University; Waltham, Massachusetts
1969 *Portraits*; Museum of Modern Art; New York
1970 *Being Without Clothes*; Massachusetts Institute of Technology; Cambridge, Massachusetts
1974 *Photography in America*; Whitney Museum of American Art; New York
1977 *La Photo Comme Photographie*; Centre d'Arts Plastiques Contemporain de Bordeaux; France
Documenta; Kassel, Germany
Kunsterphotoghen in XX Jahrhundert; Kestner-Gesellschaft; Hannover, Germany
1978 *Art about Art*; Whitney Museum of American Art; New York
1979 *American Photography in the 70's*; Art Institute of Chicago, Chicago, Illinois
1985 *American Images, Photographs 1945–1980*; Barbican Art Gallery; London
Self-Portrait Photography 1840–1985; National Gallery; London
1986 *Photofictions—Subjective Setups*; The Ffoto gallery; Cardiff, Wales
1988 *First Person Singular: Self Portrait Photography*; High Museum of Art; Atlanta, Georgia
1989 *Invention and Continuity in Contemporary Photography*; Metropolitan Museum of Art; New York
The Cherished Image: Portraits from 150 Years of Photography; National Gallery of Canada; Ottawa, Canada
Vanishing Presence; Walker Art Center; Minneapolis, Minnesota and traveling
1990 *The Indomitable Spirit*; International Center of Photography; New York and traveling
Word as Image: American Art 1960–1990; Milwaukee Art Museum, Milwaukee, Wisconsin
1991 *Motion and Documen—Sequence and Time: Eadweard Muybridge and Contemporary American Photography*; National Museum of American Art, Washington D.C. and traveling
1997 *Foto Text Text Foto* Frankfurt Kunstverein; Frankfurt, Germany
1999 *From Camouflage to Free Style 2*; Musee d'art moderne de la Ville de Paris, Paris, France
2000 *Dreams 1900–2000: Science, Art and the Unconscious Mind*; Binghamton University Art Museum, SUNY; Binghamton, New York and traveling

Selected Works

The Spirit Leaves the Body, 1968
Fallen Angel, 1968
Sequences, 1973
Things Are Queer, 1973
Failed Attempt to Photograph Reality, 1975
Real Dreams: Photostories, 1977
Ceci n'est pas une photo d'une pipe, 1978
The Nature of Desire, 1986
Album: The Portraits of Duane Michals 1958–1988, 1988
Eros and Thanatos, 1992

Further Reading

Bailey, Ronald H. *The Photographic Illusion*. Los Angeles: Alskog, 1976.

Coleman, A.D. "Duane Michals." *Camera and Darkroom* (November 1992): 22–31.

Kozloff, Max. *Now Becoming Then*. Pasadena, California: Twelvetrees Press, 1990.

Livingstone, Marco, ed. *The Essential Duane Michals* Boston: Bulfinch Press Book, Little Brown & Company, 1997.

Sand, Michael. "Duane Michals." *Aperture* No. 146 (Winter, 1997): 52–61.

BORIS MIKHAILOV

Ukrainian

Boris Mikhailov has come to be considered one of the key post-Soviet artists within both the Western and Eastern canons of contemporary photography. He was born in Kharkov in the former USSR, and his career has spanned the Soviet control of his country through the declaration of Ukrainian independence. Incorporating diverse photographic strategies, aesthetics, and subject matter, he has created a challenging and wide-ranging body of work noted for its critique of Soviet life, contemplation of social changes after the fall of communism, and its broader ongoing examination of the role of both the photographer and the photograph within diverse political, geographic, and social contexts.

From the start, Mikhailov's work challenged the rules that defined what was acceptable as art under the Soviet regime. It was at the age of 27 that Mikhailov took his first photograph—a portrait of a "sensual and Western-looking woman smoking a cigarette" (Williams 2001). Despite attempts to have it publicly exhibited, the photo was repeatedly denied because its subject matter was deemed inappropriate. A few years later, when officials discovered nude photos of his wife among his private documents at work, he was fired from the state-owned camera factory where he had been employed as a technical engineer. Yet in spite of this, he resolved to devote himself exclusively to the medium around 1967, beginning a career as a black-market commercial photographer and privately pursuing his own artistic projects.

Choosing to bypass the heavily censored state-sponsored channels for making and showing photographs—namely camera clubs, magazines, and public exhibitions—Mikhailov gravitated towards a more radical and underground culture for circulating his work. He participated in clandestine exhibitions arranged in private homes known as "kitchen shows." Here, he slowly began to gain recognition for his work and for the first time found himself in the company of like-minded artists critical of Soviet life. It was at one of these exhibitions that Mikhailov met the Russian artist Ilya Kabokov, who went on to notably influence the development of his work and introduce him to the wider Moscow scene of dissident artists and intellectuals.

Mikhailov's photographic projects have almost always taken the form of extended series, often completed over the course of several years, and widely varying from one another in terms of their formal aspects, conceptual strategies, and subject matter. Key to understanding many of Mikhailov's pieces is appreciating the extent to which he was directly and indirectly reacting to controls and restrictions placed upon photographic practice in the USSR. Any photo that questioned Soviet power or way of life, any portrayal of the naked body, and the very act of photographing without permission in most public spaces were strictly forbidden. Meanwhile, official images of the idealized Soviet citizen were everywhere in the culture, portraying something Mikhailov and many others felt was entirely distant from their own reality.

In the thick of these conditions, Mikhailov set out to make his early works, *Red Series* (1968–1975), *Luriki* (1971–1985), and *Sots Art* (1975–1986), each experimenting with aesthetic devices, such as a snapshot style of shooting, the hand-coloring of pictures, and re-appropriation of found photos, to pointedly articulate his discontent with the Soviet status quo. The *Red Series* contrasts drearily prosaic moments in communist life against the crowning visual symbol of Soviet power and control—the color red. Both *Luriki* and *Sots Art* play sarcastically with the Russian tradition of hand coloring photographs, thereby transforming this popularized aesthetic into a means

to critique idealization and representation. Of all his projects, these three have been the most closely associated with the work of the Moscow Conceptualists, a group of artists including Ilya Kabokov, Eric Bulatov, and Oleg Vassiliev, who radically and ironically sought to comment on the legacy of the Russian avant-guard and Social Realism in order to address the failures and hypocrisy in their society.

The next important phase in Mikhailov's work, which includes the projects *Unfinished Dissertation* (1985) and *Salt Lake* (1986), explored ways to question the stability and objectivity of more traditional photojournalistic-looking images. Combining black-and-white photos with sloppy hand-written text in no discernable relationship to one another, *Unfinished Dissertation* epitomizes the futility of subjectivity inside an environment in which it is not allowed to exist. Displayed on the backside of a lengthy and incomplete academic dissertation that Mikhailov happened upon in the garbage, the work irreverently reveals authority, meaning, and truth as little more than facade. *Salt Lake* takes as its subject the bathers on the shores of a lake near Slavjansk. What might at first be mistaken for idyllic images of a summer outing, at closer inspection reveal another fissure in the myth of the Soviet utopia—as the viewer slowly realizes that the lake is surrounded by a dirty and inhospitable industrial landscape.

As dramatic historical changes occurred around him—the fall of communism and the declaration of Ukrainian independence—Mikhailov's photographic work kept close stride. His most acclaimed post-Soviet bodies of work, *By the Ground* (1991) and *Case History* (1997–1998), document the uneasy transition from a socialist to capitalist model of society. *By the Ground* consists of street scenes in Kharkov and Moscow shot from a camera held at waist level, pointed down. The melodramatic formal qualities of the panoramic, sepia-toned pictures, in contrast with the banality of the scenes portrayed, cleverly parallel the tension felt between the promise of freedom and the slow and complicated moment towards tangible social and political change. *Case History*, undoubtedly Mikhailov's most well-known and controversial work to date, unflinchingly records the plight of the newly created homeless population known as the *bomzhes*. Diseased bodies, depraved sexuality, lawless children, feral animals, and gruesomely desperate living conditions are the subject matter of this body of almost 500 color documentary-style photographs. When asked about the reaction of his subjects to being photographed, Mikhailov explains:

> Most often they were more interested in contact and conversation and in the help they could receive, but sometimes they wanted the situation in which they found themselves to be known, so that someone would take and interest in it.
>
> ("A Discussion Between Boris Mikhailov and Jan Kaila")

Critics were quick to point out the fine ethical line that this work straddles—as Mikhailov paid his subjects to pose and often directed their performances in front of the camera. Some voiced outrage over the sensationally voyeuristic portrayal of tragic circumstances for a Western audience, while others defended the work as an important socio-historical record and desperate call for help.

Mikhailov's career has spanned more than 35 years, and he continues to exhibit and publish widely in the East and West. He has been the recipient of many prestigious international awards, including: the Coutts Contemporary Art Award, the Hasselblad Award, and the Citibank Photography Prize. He continues to photograph and currently splits his time between his native Kharkov and Berlin, Germany.

LAUREL PTAK

See also: **Photography in Russia and Eastern Europe**

Biography

Born in Kharkov, USSR (now Ukraine), August 25, 1938. Educated as an engineer. Employed as technical engineer at Kharkov Camera Works from 1962–1967, and through the 1970s as a hand-retoucher of photographs and commercial photographer. Teaching appointments at Swiss Federal Institute of Technology and Collegium Helveticum, Zurich, Switzerland, 1998–1999; Harvard University Department of Visual and Environmental Studies, Cambridge, Massachusetts, 2000. Recipient of Light Work Fellowship, Syracuse, New York, 1994; Coutts Contemporary Art Foundation Award, Zürich, Switzerland, 1996; DAAD Fellowship, Berlin, Germany 1996–1997; Kulturstiftung Landis & Gyr Fellowship Zürich, Switzerland, 1998–1999; Hasselblad Foundation International Award in Photography, Göteborg, Sweden, 2000; Citibank Private Bank Photography Prize, London, England, 2001; General Satellite Corporation Prize, Russia, 2003. Lives and works in Kharkov, Ukraine, and Berlin, Germany.

Individual Exhibitions

1990 *The Missing Picture: Alternative Contemporary Photography from the Soviet Union*; List Visual Arts Center, MIT; Cambridge, Massachusetts
1994 *U Zemli*; XL Gallery, Moscow, Russia
1995 *After the Fall*; Institute of Contemporary Art; Philadelphia, Pennsylvania
1996 *Boris Mikhailov: A Retrospective*; Soros Center of Contemporary Art; Kiev, Ukraine

1998 *Boris Mikhailov*; Stedelijk Museum; Amsterdam, Netherlands

1999 *Case History*; DAAD Gallery; Berlin, Germany

2000 *Hasselblad Award Winner*; Hasselblad Center; Göteborg, Sweden

2001 *Boris Mikhailov*; Saatchi Gallery; London, England

2002 *The Insulted and the Injured*; Pace/MacGill Gallery; New York, New York

2003 *Retrospective*; Fotomuseum Winterthur; Wintherthur, Switzerland and traveling

Group Exhibitions

1988 *New Soviet Photography*; Museet for Fotokunst; Odense, Denmark and traveling

1989 *Contemporary Soviet Photography*; Kunsthuset; Stockholm, Sweden

1991 *Carnegie International*; The Carnegie Museum of Art; Pittsburgh, Pennsylvania

1993 *New Photography 9*; Museum of Modern Art; New York, New York

1994 *Photo-reclamation*; The Photographers' Gallery; London

1995 *Contemporary Russian Photography*; Academy of Arts; Berlin, Germany

1996 *Russian Jewish Artists in a Century of Change: 1890–1990*; The Jewish Museum; New York, New York

1999 *Global Conceptualism: Points of Origin 1950s–1980s*; Queens Museum of Art; New York, New York and traveling

2000 *How You Look At It*; Sprengel Museum; Hannover, Germany

2001 *Citibank Private Bank Photography Prize*; The Photographers' Gallery; London, England

From the '60s until now...; Museum of Modern Art; New York, New York

2003 *Cruel and Tender: The Real in the Twentieth-Century Photograph*; Tate Modern; London, UK

2004 *Verbal Photography: Ilya Kabakov, Boris Mikhailov and the Moscow Archive of New Art*; Museu Serralves; Porto, Portugal

Selected Works

Untitled, from the "Red Series," 1968–1975

Untitled, from "Luriki," 1971–1985

Untitled, from "Sots Art," 1975–1986

Untitled, from "Untitled Dissertation," 1985

Untitled, from "Salt Lake," 1986

Untitled, from "By the Ground," 1991

Untitled, from "Case History," 1997–1998

Untitled, from "Case History," 1997–1998

Untitled, from "Case History," 1997–1998

Boris Mikhailov, Untitled, From "Salt Lake" Series, 1986.
[*Copyright: Boris Mikhailov, Courtesy of Pace/MacGill Gallery*]

Further Reading

"A Discussion Between Boris Mikhailov and Jan Kaila." In *Boris Mikhailov: The Hasselblad Award 2000* by Gunilla Knape and Boris Groys. Göteborg: Hasselblad Center and New York: Scalo, 2001, 87.

Hiller, Andrew. "Boris Mikhailov's Case History." *Aperture* 164 (Spring 2001).

Mikhailov, Boris. *Case History*. Zurich, Berlin, New York: Scalo, 1999.

Mikhailov, Boris. *Look At Me I Look At Water, or, Perversion of Repose*. Göttingen: Steidl, 2004.

Mikhailov, Boris. *Salt Lake*. Göttingen: Steidl, 2002.

Stahel, Urs, ed. *Boris Mikhailov: A Retrospective*. Fotomuseum Winterther and Zurich: Scalo, 2003.

Tupitsyn, Margarita. *Mikhailov, Boris: Unfinished Dissertation, or, Discussions With Oneself*. Zurich, Berlin, New York: Scalo, 1998.

Tupitsyn, Margarita and Victor. *Verbal Photography: Ilya Kabakov, Boris Mikhailov and the Moscow Archive of New Art*. Porto: Museu Serralves, 2004.

Williams, Gilda. *55: Boris Mikhailov*. London: Phaidon, 2001.

LEE MILLER

American

Lee Miller was a noted Surrealist, studio and fashion photographer, and war correspondent whose work for *Vogue* magazine during World War II is often considered to be her most important contribution to the history of photography. Although she changed careers a number of times, Miller's enduring legacy can be found in her images, as photography became the one passion that sustained her for much of her adult life.

Born in Poughkeepsie, New York in 1907, Elizabeth (known as Lee) Miller was raised in a household where photography was a prevalent influence. Miller's father Theodore was both a successful businessman and avid amateur photographer. Characterized as a privileged yet rebellious adolescent, Miller was expelled from numerous private schools before being sent to Paris with a governess in 1925. Beginning her formal artistic education while in France, she studied at L'École Medgyes pour la Technique du Théâtre, and upon her return to the United States in 1926, Miller enrolled in the Art Students League of New York. A beautiful and highly photogenic young woman, Miller's studies were sidetracked by her brief but highly successful career as a model for *Vogue* magazine, where the leading fashion photographers of the day, including Horst P. Horst, Edward Steichen, Arnold Genthe, and George Hoyningen-Huene, photographed her.

In 1929, Miller returned to Paris and inserted herself into the atelier of Surrealist Man Ray. Although familiar with photography since her childhood, it was in Man Ray's studio that Miller learned about photographic technique. While Miller modeled for Ray, she also produced her own photographs and assisted Ray in his darkroom. It was here that Miller claimed to have contributed to the rediscovery of the Sabattier effect, a nineteenth-century process that had been all but forgotten. Also called solarization, it is a darkroom technique in which film is purposely exposed to light during the development process, encouraging a partial reversal of printed black-and-white tones. Man Ray is typically credited with the revival of the technique, but Miller recalled the moment of discovery in Ray's darkroom differently. She claimed that it was her accidental action of exposing unfixed film to light that encouraged the development of a technique that later became a signature of both Miller's and Man Ray's work.

In Paris, Miller also starred (as an armless statue) in Jean Cocteau's avant-garde film, *Le Sang d'un poete* (Blood of the Poet), and she had her first exhibition of her photographs. She also ended her affair with Man Ray after meeting Egyptian businessman Aziz Eloui Bey, whom she married in 1934 following the suicide of Bey's wife.

Miller left France in October of 1932, but not before building an independent and successful photography studio in Paris. She repeated this success upon her return to New York City, opening a studio at 8 East 48th Street with her younger brother Erik. Miller's work was well received almost immediately in the United States, and she was featured in a one-woman show at the Julien Levy Gallery in December of 1932, just two months after returning to her home country. She photographed a number of

luminaries in the arts, including composer Virgil Thompson, artist Joseph Cornell, and actress Gertrude Lawrence. She closed her New York studio in 1934, however, to relocate to Cairo with her husband, and she drastically curtailed her professional photographic practice. During a trip to Paris in 1937, Miller met British artist and Surrealist patron Arthur Penrose, with whom she traveled in Europe, leading to the dissolution of her marriage and her relocation to England in June of 1939.

Once again in a more central location and creative milieu, Miller's photographic career revived. In January of 1940, she began working for British *Vogue*. In her capacity as a studio photographer, she produced countless images of various celebrities and wartime fashions. Independently of the magazine, Miller documented the hardships encountered in England during the blitz, and in 1941 a number of her photographs were published in the book *Grim Glory: Pictures of Britain under Fire*. Edited by Ernestine Carter and with a preface by Edward R. Murrow, the book described the blitz through image and text, and was marketed in the United States, allowing the American public a glimpse into the wartime conditions in England.

Encouraged by *Life* magazine photographer David E. Scherman (of whom she made a famous portrait posing with his photo equipment and wearing a gas mask), Miller was accredited as a U.S. forces war correspondent in 1942, although women were not allowed to photograph combat. Although the photographic assignments received from *Vogue* remained relatively benign immediately after her accreditation, including portrait assignments of *Life* magazine photographer Margaret Bourke-White and members of the Women's Royal Naval Service, the designation eventually allowed her the latitude to travel outside of the *Vogue* studios and to report on a number of dangerous wartime situations. In 1944, Miller traveled to Normandy, France six weeks after D-Day and photographed a U.S. Army evacuation hospital. These images were published in the September 1944 issue of *Vogue* alongside her written transcript outlining the subject. After publication of the story, Miller regularly served as both photographer and reporter for *Vogue*, as she followed the U.S. Army eastward during the waning months of the war.

Arriving in Paris shortly after the city's liberation from German occupation, Miller produced numerous fashion photographs, the most notable of which *Vogue* Magazine published in its October and November 1944 issues. After Paris, Miller continued into hostile territory with the U.S. Army, focusing exclusively on the destruction left in the wake of World War II. Her most powerful photographs from this time period were taken in the German concentration camps of Dachau and Buchenwald. Although highly disturbing and graphic, Miller's images of prisoners and defeated SS guards were reproduced in the June 1945 edition of American *Vogue*, giving readers an unprecedented glimpse into the horrors that befell the citizens of Europe.

Miller continued to work for *Vogue* after the close of World War II, covering stories in Denmark, Austria, and Hungary. In February of 1946, she returned to London, where she married Roland Penrose one year later. After the birth of her only child, Antony, in September 1947, Miller worked for *Vogue* sporadically. Although she largely abandoned photography, she did continue to photograph the many notable visitors to the Penrose farm in Chiddingly, East Sussex, including artists Max Ernst and Pablo Picasso. Her later years were spent dedicated to her new passion for cooking and traveling with Penrose until her death in 1977. Although recognized for her work as a photographer during the early stages of her career, Miller had become remembered primarily for her work as a model and muse to Man Ray until her son Antony published her biography, *The Lives of Lee Miller*, in 1985. He later edited the book *Lee Miller's War: Photographer and Correspondent with the Allies in Europe*, a 1989 publication that concentrated on her experiences with the U.S. Army during World War II. Antony Miller also established and directs the Lee Miller Archive in East Sussex, England, which conserves and publishes the Lee Miller photographic heritage.

JULIA DOLAN

See also: **Bourke-White, Margaret; Fashion Photography; Gallery; Levy, Julien; Life Magazine; Man Ray; Solarization; Surrealism; War Photography**

Biography

Born in Poughkeepsie, New York, 23 April 1907. Attended L'Ecole Medgyes pour la Technique du Théâtre , Paris, France, 1925; The Art Students League, New York, 1926; first instructed in photography by Man Ray, Paris, France, 1929; studio photographer, 1930–1934; photographer and writer for British *Vogue* Magazine, 1940–1947; contributed occasional articles until 1959. Died in Chiddingly, East Sussex, England, 27 July 1977.

Individual Exhibition

1933 Julien Levy Gallery; New York, New York
1978 Mayor Gallery; London, England

1984 *Lee Miller in Sussex*; The Gardner Centre, University of Sussex; Brighton, England, and traveling

1985 *The Lives of Lee Miller*; Staley-Wise Gallery; New York, New York

1986 Photographers' Gallery; London, England, and traveling

1989 *Lee Miller, Photographer*; Corcoran Gallery of Art, Washington, DC (traveled to New Orleans Museum of Art, New Orleans, Louisiana; Minneapolis Institute of Art, Minneapolis, Minnesota; San Francisco Museum of Modern Art, San Francisco; California, International Center of Photography Midtown, New York; Art Institute of Chicago, Chicago, Illinois; Santa Monica Museum of Art, Santa Monica, California; Yokohama Museum of Art, Yokohama, Japan; Fundacio Joan Miro, Barcelona, Spain)

1992 *Lee Miller's War Photographs, 1944–1945*; Institute of Contemporary Arts; London, England, and traveling

1998 *The Legendary Lee Miller New Zealand Tour*; Robert McDougall Art Gallery; Christchurch, New Zealand (traveled to Govett-Brewster Art Gallery, New Plymouth, New Zealand; City Gallery, Wellington, New Zealand; Waikato Museum of Art and History, Hamilton, New Zealand; Aotea Centre, Auckland, New Zealand)

1999 *The Legendary Lee Miller Tour*; Ivan Dougherty Gallery, College of Fine Arts; University of New South Wales, Sydney, Australia (traveled to Ian Potter Museum of Art, University of Melbourne; Melbourne, Australia)

Selected Group Exhibitions

1931 *Group Annuel des Photographes*; Galerie de la Pleiade; Paris, France

1932 *Modern European Photography*; Julien Levy Gallery; New York, New York

1932 *Exhibition of Portrait Photography, Old and New*; Julien Levy Gallery; New York, New York

1955 *The Family of Man*; Museum of Modern Art; New York, New York, and traveling

1976 *Photographs from the Julien Levy Collection*; Art Institute of Chicago; Chicago, Illinois

1978 *Dada and Surrealism Reviewed*; Hayward Gallery; London, England

1982 *Atelier Man Ray, 1920–1935*; Centre Georges Pompidou; Paris, France

1985 *The Indelible Image*; Corcoran Gallery of Art; Washington, D.C., and traveling

1985 *L'Amour fou: Photography and Surrealism*; Corcoran Gallery of Art; Washington, D.C., and traveling

1987 *La Femme et le Surrealisme*; Musée Cantonal des Beaux Arts; Lausanne, Switzerland, and traveling

1991 *Vogue 75th Anniversary*; Royal College of Art; London, England (traveled to Redfern Gallery, London, England)

1994 *The Vital Link*; Royal Navy Museum; Portsmouth, England

1994 *Dachau Liberation 1945*; KZ-Gedenkstätte; Dachau, Germany

1995 *Cologne Liberation 1945*; Historiches Archiv der Stadt; Cologne, Germany

1995 *Ende und Aufgang, Photographen in Deutschland um 1945*; Deutsches Historiches Museum; Berlin, Germany

1996 *The Lost Bodies: Photography and Surrealists*; Centre Cultural; Barcelona, Spain

1996 *A History of Women Photographers*; The New York Public Library; New York, New York (traveled to The National Museum of Women in the Arts, Washington, DC; Santa Barbara Museum of Modern Art, Santa Barbara, California; Akron Art Museum, Akron, Ohio)

1997 *Forties Fashion and the New Look*; Imperial War Museum; London, England

2001 *The Surrealist and the Photographer: Roland Penrose and Lee Miller*; The Scottish National Gallery of Modern Art; Edinburgh, Scotland

Selected Works

Solarised portrait of a woman, Paris, 1930
Floating head (Portrait of Mary Taylor, New York), 1933
Monastery of Wadi Natrun, Egypt, 1935
Bloody But Unbowed: Pictures of Britain under Fire, 1941
David E. Scherman, London, England, 1943
Buchenwald, 1945
Dead German Guard in Canal, Dachau, 1945

Further Reading

Apropos Lee Miller. Frankfurt am Main: Verlag Neue Kritik, 1995.

Hermann, Brigitte. *Atelier Man Ray: Berenice Abbott, Jacques-André Boiffard, Bill Brandt, Lee Miller: 1920–1935*. Paris: Le Centre, 1982.

Livingston, Jane. *Lee Miller, Photographer*. New York: Thames and Hudson, 1989.

Penrose, Antony, ed. *Lee Miller's War: Photographer and Correspondent with the Allies in Europe, 1944–1945*. Boston: Little, Brown and Co., 1992.

Penrose, Antony. *The Lives of Lee Miller*. New York: Holt, Reinhart, and Winston, 1985.

The Surrealist and the Photographer: Roland Penrose, Lee Miller. Edinburgh: The Scottish National Gallery of Modern Art, 2001.

RICHARD MISRACH

American

Richard Misrach is popularly recognized as one of the foremost American landscape photographers working at the end of the twentieth century. The greater part of his oeuvre forms a comprehensive collection of images centered on an investigation of and response to the American desert; dynamic, large-format color photographs that capture the splendor and formal essence of a unique terrain, yet simultaneously highlight social and political concerns. Misrach views the desert as metaphor, where serene beauty exists alongside the conflict and violence of pollution and other aspects of environmental damage wrought of human agency.

Misrach's love of photography was kindled in the late 1960s when he was a psychology student at the University of California at Berkeley. In 1973, he received a National Endowment for the Arts Visual Artist's Fellowship, which enabled him to complete and publish his first book, a black-and-white portrait documentary series entitled *Telegraph 3 A.M.: The Street People of Telegraph Avenue, Berkeley, California* (1974). These nighttime images were taken in an effort to raise money for a food bank, but resulted in somewhat of a personal crisis for Misrach. He considered the production of a coffee-table book of people in poverty as problematic and questioned the role of the legitimacy of the photographer as political activist.

These concerns continued to percolate as Misrach began to engage the landscape of the American West as his subject in the latter part of the 1970s. At this time, his formal influences included Minor White and Edward Weston, and he later rediscovered the work of nineteenth-century expeditionary photographers Timothy O'Sullivan and William Henry Jackson. Yet the traditions in landscape photography formed by the legacy of such image-makers dictated that the American wilderness often served as mere scenery to human existence. Misrach veered from this approach and instead chose to highlight the effects of human encroachment on the environment. In addition, unlike his photographic predecessors, he began to use color. Working with an 8 × 10-inch Deardorff camera, Misrach found that he was able to capture a myriad of details in his subject, and the importance of light, and subsequently color, began to play a major role

in his working method. In anticipating the moment he wanted to arrest, Misrach learned to wait and watch all day for the perfect light.

The reward for Misrach's patience and his political desire to articulate the fragile balance between humans and nature can clearly be seen in numerous stunningly beautiful, minimalist landscape images from his epic *Desert Cantos* project and in his 1996 exhibition, *Crimes and Splendors: The Desert Cantos of Richard Misrach*. Now spanning decades in production, Misrach's *Cantos*—the titled is inspired by the long poems of Dante Alighieri and Ezra Pound—are a group of works that exist as individual photographic series with unique landscape subjects, but which are connected by aesthetic and metaphorical concerns.

Misrach's first four cantos (*The Terrain, The Event I, The Flood, The Fires*), produced from 1979 to 1985, focus on basis elements of the desert that he encountered where the landscape appears to be reclaiming or asserting itself, and also reveal evidence of past and continuing human activity. In these initial series, Misrach introduced significant themes, such as ecology, militarism, and tourism, which recur and overlap in later works. As curator Anne Wilkes Tucker has observed, Misrach successfully threads cultural and environmental violence through several cantos produced in the late 1980s (Tucker 1996). Silent scarred bombing range landscapes comprise *Canto V: The War (Bravo 20)*, where abandoned military installations and the rusty equipment of war litter the desert; these images formed the basis for Misrach's book *Bravo 20: The Bombing of the American West* (1990). By contrast, *Canto VI: The Pit*, focuses on mass burial piles of animal corpses. Here, the surreal detritus, while organic, ultimately bespeaks human intrusion, suggesting problems of disease, pollution, or possible nuclear toxicity. Similar metaphoric implications of destruction and violence can be understood from the defaced porn images of *Canto XI: The Playboys,* in which Misrach photographed bullet-hole riddled pages of two *Playboy* magazines he found at a Nevada test site.

Later cantos, such as *XVII: The Skies* and *XXI: Heavenly Bodies*, might, upon first glance, suggest less political impetus. Misrach focuses our attention

upwards, presenting distilled views of desert skies that are quietly beautiful in a way that potentially references traditions in abstract painting. The overwhelming sense of scale suggests the greater power of natural forces as opposed to human agency. Yet in *The Skies*, the individual titles of the photographs noting their location, such as "Mecca, California" or "Jerusalem Mountain, Arizona," must surely be understood as topographical signifiers. Similarly, in the night sky images of *Heavenly Bodies*, where Misrach's camera records the movement of stars, planet, and aircraft, location plays an important part in the formation of meaning. Arousal of the issue of cultural ownership comes when the viewer realizes these are skies over Native American desert lands. Even at his most subtle, Misrach maintains a connection to his political motivations.

Equally, when working in new landscapes outside of the western states, the photographer sustains a keen interest in the juxtaposition between humans and nature. In 1998, Misrach received a "Picturing the South" commission from the High Museum of Art, Atlanta. For this project, he photographed an area along the Mississippi River between Baton Rouge and New Orleans, popularly but distressingly known as Cancer Alley. While recognized as a seat of great antebellum cultural history, the natural resources of this area have also been ravaged by decades of pollution from the petro-chemical industry. Here again, in *Pictures from the South* (1998–2000), in images of vibrant green polluted swamps, Misrach's seductive rich color photographs challenge the viewer to consider the often sickening results of human agency in the environment.

Works from Misrach's recent series *On the Beach* (2003) are similarly unnerving. Inspired by Nevil Shute's 1950s post-apocalyptic novel set in a world slowly dying from the effects of an atomic war, Misrach captures figures within a vast expanse of a beach or water. Often the view is unsettling and anonymous. Human subjects are dwarfed by their empty but exquisite surroundings. It is through such minimal and serene beauty that Richard Misrach's social concerns are consistently and perhaps most cleverly revealed. And while he may not have been the first to bring politics into the discourse of landscape photography, he is certainly one of the most successful contemporary artists to use a strategy of juxtaposition between aesthetics and an informed ecocritical polemic.

SARA-JAYNE PARSONS

Biography

Born in Los Angeles, California, 1949; University of California, Berkeley, B.A., Psychology, 1971; National Endowment for the Arts Visual Artist's Fellowship, 1973; Western Book Award for *Telegraph 3 A.M.* (Cornucopia Press, 1974), 1975; Ferguson Grant, Friends of Photography, Carmel, California, 1976; National Endowment for the Arts Fellowship, 1977; John Simon Guggenheim Memorial Fellowship, 1979; International Center for Photography Infinity Award for *Desert Cantos*, 1988; Silver Medal Award at the International Book Design Exhibition for *Desert Cantos*, Leipzig, Germany, 1989; Eureka Fellowship, Fleishhacker Foundation, San Francisco, 1991; PEN Literary Award for *Bravo 20: The Bombing of the American West*, 1991; Media Alliance Meritorious Award for *Bravo 20: The Bombing of the American West*, 1991; Koret Israel Prize, 1992; National Endowment for the Arts Fellowship, 1992; Distinguished Career in Photography Award, Los Angeles Center for Photographic Studies, 1994; Golden Light Award, Best Retrospective Book for *Crimes and Splendors*, Maine Photographic Workshops, 1996; *Picturing the South*, a commission from the High Museum of Art, Atlanta, 1998; Photo-eye Books Best Contemporary Monograph for 2000, runner-up, for *The Sky Book*, 2000; Kulturpreis for Lifetime Achievement in Photography, German Society of Photography, 2002. Living in Berkeley, California.

Individual Exhibitions

1977 *Richard Misrach: Night Work*; Oakland Museum; Oakland, California; ARCO Center for Visual Arts; Los Angeles, California

1979 *Richard Misrach: Night Desert Photographs*; Musée National d'Arte Moderne; Paris, France; Camera Obscura Gallery, Stockholm, Sweden; and Grapestake Gallery; San Francisco, California

1983 *Richard Misrach: Recent Desert Photographs*; Los Angeles County Museum of Art; Los Angeles, California;

1984 *Richard Misrach: Color Desert Landscapes*; Etherton Gallery, Tucson, Arizona; Blue Sky Gallery, Portland, Oregon; Elizabeth Leach Gallery; Portland, Oregon

1985 *Richard Misrach: Recent Work*; Fraenkel Gallery; San Francisco, California

1986 *Richard Misrach: Four Cantos*; Houston Center for Photography; Houston, Texas

1988 *Richard Misrach: Desert Cantos*; Art Institute of Chicago; Chicago, Illinois and National Gallery of Art; Wellington, New Zealand

1990 *Desert Canto VI: The Pit*; The Photographers' Gallery, London and Parco Gallery, Tokyo, Japan

1991 *Bravo 20*; Ansel Adams Center, Friends of Photography; San Francisco; Blue Sky Gallery; Portland; Oregon; and California Museum of Photography; Riverside, California

1992 *Desert Canto XII: Clouds (non-equivalents)*; Jan Kesner Gallery; Los Angeles, California

1994 *Desert Canto XVIII: Skies*; Jan Kesner Gallery; Los Angeles, California

1995 *Pictures of Paintings*; Fraenkel Gallery; San Francisco, California

1996 *Crimes and Splendors: The Desert Cantos of Richard Misrach*; Museum of Fine Arts; Houston, Texas and Center for Creative Photography, Tucson, Arizona

1997 *New Work (Heavenly Bodies)*; Fraenkel Gallery; San Francisco, California

1999 *Golden Gate Studies: The View from my Front Porch 1997–1999*; Robert Mann Gallery; New York, New York

2000 *Richard Misrach (Heavenly Bodies, Night Skies)*; Curt Marcus; New York; and Michael Hue Williams; London, England

2000 *Cancer Alley*; High Museum of Art; Atlanta, Georgia

2001 *Richard Misrach*; FIAC; Paris, France (Michael Hue-Williams Gallery)

2002 *Richard Misrach: Battleground Point*; Robert Mann Gallery; New York, New York

2003 *Richard Misrach: On the Beach*; Grant Selwyn Gallery; Los Angeles, California

Group Exhibitions

1973 *Places*; San Francisco Art Institute; San Francisco, California

1977 *Night Landscape*; Oakland Museum; Oakland, California

1978 *Mirrors and Windows*; Museum of Modern Art; New York, New York

1979 *Beyond Color*; San Francisco Museum of Modern Art; San Francisco, California

1980 The Photographers' Gallery; London, England

1981 *Whitney Biennial*; Whitney Museum of American Art; New York, New York

1982 *Flash*; Rochester Institute of Technology; Rochester, New York

1985 *American Images: American Photography from 184–1980*; Barbican Art Gallery; London , England

1987 *American Independents: New Color*; Museum of Contemporary Photography; Columbia College, Chicago, Illinois

1989 *Decade by Decade*; Center for Creative Photography; Tucson, Arizona

1990 *Myth of the West*; Henry Art Gallery; Seattle, Washington

1991 *Whitney Biennial*; Whitney Museum of American Art; New York, New York

1992 *This Sporting Life, 187–1991*; High Museum of Art; Atlanta, Georgia

1993 *Between Heaven and Home*; National Museum of American Art, Smithsonian Institution: Washington, D.C.

1994 *Landscape as Metaphor*; Denver Art Museum; Denver, Colorado

1995 *Pulp Fact*; The Photographers' Gallery; London, England

1996 *Perpetual Mirage: The Desert West in Photographic Books and Prints*; Whitney Museum of American Art; New York, New York

1997 *Scene of the Crime*; UCLA at the Armand Hammer Museum of Art and Cultural Center; Los Angeles, California

1999 *More than Meets the Eye*; Photographic Society; Hamburg, Germany

2000 *100 al 2000: il Secolo della Fotoarte*; Photology, Milan, Italy

2001 *In Response to Place*; Corcoran Gallery of Art; Washington, D.C.

2003 *The Gray Area: Uncertain Images: Bay Area Photography 1970s to Now*; CCAC Wattis Institute for Contemporary Arts; San Francisco, California

Selected Works

Canto I: The Terrain, 1979–1984
Canto II: The Event I, 1981–1985
Canto III: The Flood, 1983–1985
Canto IV: The Fires, 1983–1985
Canto V: The War (Bravo 20), 1986
Canto VI: The Pit, 1987
Canto XI: The Playboys, 1990
Canto XII: The Clouds
Canto XV: The Salt Flats, 1999
Canto XVI: The Paintings, 1991–1995
Canto XVIII: The Skies, 1992–
Canto XXI: Heavenly Bodies, 1995–
Canto XXII: Night Clouds, 1994–
Golden Gate Studies: The View from my Front Porch, 1997–2000
Pictures from the South, 1998–2000
On the Beach, 2003

Further Reading

Berry, Jason. "Cancer Alley: the Poisoning of the American South." *Aperture* no. 162 (Winter 2001).

Dyer, Geoff. "Photographs from "On the Beach: Richard Misrach." *Modern Painters* 17, no. 1, (Spring 2004).

Foster, Hal. "Death in America." In *October, The Second Decade, 1986–1996*. Boston: MIT Press, 1998.

Longmire, Stephen. "Back West: Reviewing American Landscape Photography." *Afterimage* 25 (September 1997).

Misrach, Richard. *Telegraph 3 A.M.: The Street People of Telegraph Avenue, Berkeley*. California: Cornucopia Press, 1974.

Misrach, Richard. *Bravo 20: The Bombing of the American West*. Baltimore: Johns Hopkins University Press, 1990.

Misrach, Richard. *Violent Legacies: Three Cantos*. New York: Aperture, 1992.

Misrach, Richard. *Desert Cantos del desierto*. Granada, Spain: Diputacion de Granada, 1999.

Misrach, Richard. *The Sky Book*. Santa Fe, NM: Arena Editions, 2000.

Misrach, Richard. *In Response to Place*. :Nature Conservancy, 2001.

Misrach, Richard. *Desert Cantos*. Albuquerque, NM: University of New Mexico Press; Albuquerque, 1987.

Misrach, Richard. *Pictures of Paintings*. New York: Blind Spot/Powerhouse Books, 2002.

Misrach, Richard. *Richard Misrach: Golden Gate*. Santa Fe, NM: Arena Editions, 2001.

Odom, Michael. "Richard Misrach: Museum of Fine Arts, Houston." *Artforum International*, 35 (February 1997).

Ritchie, Matthew. "Richard Misrach, Curt Marcus." *Flash Art* no. 183 (Summer 1995).

Solnit, Rebecca. "Reclaiming History: Richard Misrach and the politics of landscape photography." *Aperture* no. 120 (Summer 1990).

Tucker, Anne Wilkes. *Crimes and Splendors: The Desert Cantos of Richard Misrach*. Houston: Museum of Fine Arts Houston, 1996.

Richard Misrach, Outdoor Dining, Bonneville Salt Flats, 1992, Crimes and Splendor, p. 159.
Original in color.
[*Courtesy Fraenkel Gallery, San Francisco*]

LISETTE MODEL

American

Lisette Model was born Elise Amelie Felicie Stern (the family name was later changed to Seybert) to a wealthy and cultured Jewish Viennese family. She enjoyed a privileged private education and early associations with Vienna's artistic and intellectual community. Model studied piano and later became a student of avant-garde composer Arnold Schöenberg, a fellow iconoclast. Through their friendship, Model initially pursued a music career, beginning singing lessons in Paris in the early 1920s. From her initial days in Paris, Model associated with the artistic and intellectual community including the Surrealists and other free-spirited successful women in their circle. In 1926, her family left Vienna and moved to the south of France, following the death of Model's father.

During the early 1930s, Model abandoned music and singing altogether to study drawing and painting. She subsequently turned to photography, influenced in her career choice by her younger sister Olga, a photographer in her own right, from whom Model learned rudimentary darkroom procedures, camera application, and materials. Shortly, after being introduced to photography, she received a demonstration on the use of the Rolleiflex from Rogi André, André Kertész's first wife. The two women spent time together walking the streets of Paris while André pointed out photographic opportunities. Model's first photographs were of family and friends, including photographer Florence Henri and her future husband Evsa Model.

The photographer Ergy Landau, in whose studio Olga worked, played an equally important part in advancing Model's career. Through her association with Landau, Model met Charles Rado of the Rapho Agency, a photo distribution firm founded in 1933 by Landau in collaboration with Brassaï and Rado. Charles Rado, who was in charge of photo distribution, acted as an agent to promote Model's work.

Model's French period (1926–1938) is largely shrouded in mystery. One of her first photography projects was done in the summer of 1934 while she was visiting her mother at their family home in Nice. On the Promenade des Anglais, Model found potential subjects for her scrutinizing gaze, an assortment of rich character types—wealthy French, American, and Russian tourists. In February 1935, her photographic work of the materialist culture of the Côte d'Azur graced the cover of *Regards* magazine, an *AIZ*-like publication supported by the Communist Party. In addition to her *Promenade* series, Model's French work constitutes a poignant social documentary of marginal personages—street vendors and the homeless in Paris and Nice, old Nice, a few Parisian street scenes, and the zoo in Vincennes.

On September 6, 1937, she married painter Evsa Model; the couple immigrated to the United States the following fall. Once established in America, in 1940 Model began working as a laboratory technician for a Long Island weekly magazine, *PM*. The magazine's picture editor Ralph Steiner recognized the quality of Model's work and in January 1941, he published seven of her photographs, including some from the *Promenade* series in *PM's Weekly*, under the heading, "Why France Fell." Model worked for Steiner from 1940–1941.

Through her association with Steiner, Model met many of New York's creative forces—Sid Grossman, co-founder of the Photo League, and Alexey Brodovitch, art director of *Harper's Bazaar*; she enjoyed an intimate association with both of them. In 1941, Model began a 12-year freelance relationship with *Harper's*; her first assignment, to document people at leisure on Coney Island, became one of her iconic series. Model was an active contributor to *Harper's* during the 1940s and 1950s, preferring to work on a non-assignment basis creating her photographic narratives on speculation. In addition to her work at *Harper's*, Model took on freelance assignments between 1941–1953, working for popular magazine publications, *Look* and *Ladies Home Journal* among others. Model worked as an independent photographer in New York from 1953 until her death in 1983.

A regular member of the New York Photo League, whose leftist politics of the 1930s coincided with her own, Model participated in the group's exhibitions, newsletter, lectures, and symposia. Due to the conservative climate of America following World War II, Model was reticent to discuss her French period, in particular her association with the *Regards* publication. Even so, in 1947, the Photo League was investigated, and its members fell under the scrutiny of the McCarthy era and were black-

listed. Model was interrogated by the F.B.I. in 1954, as were many of her friends, employers, and neighbors. Additionally, she continued to be cautious about any current political affiliations that might be perceived as subversive and thus connecting her to far-leftist organizations. Perhaps as a result of this scrutiny during this period, Lisette and her husband experienced reduced employment opportunities; the couple was supported during the more difficult financial times through the generosity of friends Berenice Abbott, Ansel Adams, Edward Steichen, and Edward Weston.

Following closely the style she practiced in Europe, Model's American photographs—a sometimes ruthless indexing of human topology—received quick recognition with exposure in museums, galleries, and galleries, and fashion magazines, and through the Photo League. Model's inspiration was drawn from American glamour, window displays, jazz clubs, and circus performers. Her subjects ranged from the sublime to the non-idealized even grotesque chosen from New York's leisure world of entertainment and shopping, including the Lower East Side and Coney Island, where she caught one of her most famous images—a rotund, exuberant bather standing in a sumo-wrestler pose (*Coney Island Bather, New York*, 1937–1941). Her lens focused on people in every station of life, and her photographs capture an eerie beauty with their intuitive and uncompromising honesty.

Model's portrait style features exaggerated "types" characterized by their high contrast, deep shadows, often drastic cropping, and unusual perspectives. In her *Running Legs* series of shoppers on New York's Fifth Avenue, Model objectifies and fragments the figure as she allows only legs and feet within the camera frame. In another series titled *Reflections*, Model photographed refractive images of New York store windows, a body of images that draws comparison to works by Eugène Atget. Other subjects capturing her attention included the blind realized in a 1944 series *Lighthouse, Blind Workshop* published by *Harper's*, and jazz musicians, although her intention to publish a book on jazz performers was never realized.

Much of Model's lasting contribution to the field of photography came in the form of her mentorship as an instructor. When her husband took a teaching assignment in Northern California in the late 1940s, Model likewise found an opportunity to teach photography at the San Francisco Institute of Fine Arts in 1947. During this time, Model met Ansel Adams, and the two photographed in Yosemite National Park together. In 1951, Model began teaching at the New York School of Social Research, where she remained on staff for 30 years (1951–1982). Beginning in 1954, her teaching methods evolved into a more informal approach, but her notebooks outlining her principles point to her firm, if eccentric, opinions. Among her many students were Robert Frank and Diane Arbus. Model's influence on Arbus was especially strong in demonstrating how what might at first glance seem grotesque can be rendered beautifully and sympathetically. Model once described to her students the battle she waged against complacency and ambition for its own sake:

> The thing that shocks me and which I really try to change is the lukewarmness, the indifference, the kind of taking pictures that really doesn't matter....This kind of looking for a good photograph or the *trying* to self-express oneself—you see self-expression but the motivation is not something irresistibly important. It is something [which is done] in order to make a career, to be proud of one's photographs, to become a great photographer, to become famous....The so-called great photographers or great artists...they don't think so much about themselves. It is what they have to say that is important.

(Thomas 1990)

MARGARET DENNY

See also: **Abbott, Berenice; Adams, Ansel; Florence Henri; Grossman, Sid; History of Photography: Postwar Era; Look; Photo League; Steichen Edward; Street Photography; Weston, Edward**

Biography

Born in Vienna, Austria, November 10, 1901; naturalized American citizen. Educated privately in Vienna; studied music with Arnold Schöenberg in Vienna; trained in voice and music in Paris, 1920s. Self-taught in photography from the early 1930s. Married painter Evsa Model in Paris September 6, 1937; the couple immigrated to America, fall of 1938; Lisette naturalized in 1944. Career in America: laboratory technician *PM* magazine, editor Ralph Steiner, 1940–1941; freelance photographer, New York 1941–1953, *Harper's Bazaar, Ladies Home Journal, Look*, among others; independent photographer 1953–1983. Recipient of awards: John Simon Guggenheim Memorial Fellowship, 1965; Honorary Member, American Society of Magazine Photographers, 1968; Honored Photographer, *Recontres Internationales de la Photographie*, Arles, France, 1978. D.F.A.; New School of Social Research, New York, 1981. Died in New York City, March 30, 1983.

Individual Exhibitions

1941 Photo League; New York
1943 Art Institute of Chicago; Chicago, Illinois

1946 California Palace of the Legion of Honor; San Francisco, California
1949 Museum of Modern Art; New York and traveling
1975 Focus Gallery; San Francisco, California
1976 Sander Gallery; Washington, D. C.
1977 Galerie Zabriskie; Paris (with Diane Arbus and Rosalind Solomon)
1979 Vision Gallery; Boston
 Port Washington Public Library; New York (with August Sander)
1980 Galerie Fiolet; Amsterdam, The Netherlands
1981 Galerie Viviane Esders; Paris, France
1984 *Homage à Lisette Model 1906–1983*; Galerie Vivian Esders; Paris, France
1988 *Lisette Model/Vintage Photographs*; Germans Van Eck Gallery; New York

Selected Group Exhibitions

1940 *60 Photographers: A Survey of Camera Aesthetics*; Museum of Modern Art; New York
1943 *Action Photography*; Museum of Modern Art; New York
1949 *4 Photographers: Model/Croner/Callahan/Brandt*; Museum of Modern Art; New York
1954 *Great Photographs*; Limelight Gallery; New York
1955 *The Family of Man*; Museum of Modern Art; New York and traveling
1967 *Photography in the 20th Century*; National Gallery of Canada; Ottawa and traveling
1975 *Women of Photography*; San Francisco Museum of Art and traveling
1979 *Photographie als Kunst 1879–1979*; Tiroler Landesmuseum Ferdinandeum; Innsbruck, Austria and traveling
1980 *Photography of the 50s*; International Centrer of Photography; New York and traveling
1985 *American Images 1945–1980*; Barbican Art Gallery; London and traveling

Selected Works

Promenade des Anglais; Nice, 7 August 1934
Famous Gambler; French Riviera, ca. 1934
Sleeping by the Seine; Paris, between 1933 and 1938
Circus Man; Nice, between 1933 and 1938
Man with Pamphlets; Paris, between 1933 and 1938
Reflections New York, between 1939 and 1945 [*Reflections* series]
Sammy's (Sailor and Girl, Sammy's Bar); New York, c. 1940
Albert-Alberta, Hubert's Forty-Second Street Flea Circus; New York, c. 1945
Café Metropole; New York, c. 1946
Coney Island Bather; New York, between 1939 and July 1941
Wall Street; New York, between 1939 and 10 of October 1941
Running Legs, Fifth Avenue; New York, between 1940 and 1941 [*Running Legs* series]
Lower East Side; New York, between 1939 and 1945 [series]
Woman with Veil; San Francisco, 1949
Louis Armstrong; between 1954 and 1956 [jazz series]

Further Reading

Abbott, Berenice. *Lisette Model*. Millerton, NY: Aperture, 1979.
Misselbeck, Reinhold, and Ann Thomas, *Lisette Model: Photographien 1933–1983*. Heidelberg: Edition Braus; Köln: Museum Ludwig, 1992.
Thomas, Ann. *Lisette Model*. Ottawa: National Gallery of Canada, 1990.
Stourdzé, Sam, and Ann Thomas. *Lisette Model*. Paris: Baudoin Lebon: L. Scheer, 2002.

MODERN PHOTOGRAPHY

Modern Photography began life as *Minicam* in September 1937, a magazine devoted towards the "miniature camera" of the day. The first issue hit the newsstands a few months after the launching of *Popular Photography* magazine, and the two magazines would stay rivals and competitors for over 50 years. The initial focus of *Minicam* was on the new 35-mm and twin-reflex cameras, as opposed to the medium- and large-format cameras that were the norm of the day (though the magazine featured articles on all cameras, regardless of format). *Minicam* was published by Automobile Digest Publishing Company, Cincinnati, Ohio, and was printed in "digest" size (6½ × 9½ inches). Change was inevitable since the small format of the magazine made it a challenge to attract advertisers. Twelve years later, in August 1949, *Minicam* was purchased by the Photographic Publishing Company, New York. Not only did the publication now establish itself as an east coast publication, but beginning with the September 1949 issue,

the magazine became full-sized and its name was changed to *Modern Photography*, the name that would grace the front of the magazine until publication ceased in July 1989.

The competition between *Popular Photography* and *Modern Photography* was as much about circulation and ad space as it was about editorial coverage. Both magazines had rival technical staffs and equipment testing laboratories; if one magazine had an innovative piece of equipment to test cameras or lenses, the other was bound to try to get it. The rivalry extended into the publishing of annual issues as well. Both magazines tried to corner the market on annual specialty photographic magazines focused on specific equipment or picture-taking techniques; *Modern* publishing their Photo Buying Guide, Photo Information Almanac, How to Photograph Nudes, and Rock Photo (guide to photographing rock concerts), among others.

Thousands of readers turned to *Modern* each month for the latest advice about improving their picture-taking techniques or to view portfolios of talented photographers, (one highlight from the 1970s was a 32-page essay and portfolio on Leni Riefenstahl). Probably the most important aspect of the magazine for its loyal readers was its equipment testing (each month different equipment would be tested in "Modern Tests") and technical features. It was vital for the editorial staff of *Modern* to be considered the authority in camera and lens testing, and to ensure that the magazine maintained a state-of-the-art laboratory, and strove to make the technical results as reader-accessible as possible. *Modern* also employed experts from the highly regarded Japan Camera Inspection Institute (JCII) as editorial correspondents to help make "Modern Tests" as technically accurate as possible. Other popular departments were "Hard Knocks," in which editors would praise and/or pan reader photos; The Camera Collector; Keppler's SLR

Notebook, a monthly column by the editorial director/publisher; and "Too Hot to Handle," where the staff would answer readers' probing questions.

Reader satisfaction was crucial to the success of *Modern Photography*. Equipment that passed "Modern Tests" would be given a *Modern Photography* "Seal of Approval" that guaranteed to readers that the equipment purchased by the consumer would perform as tested by the magazine, or it would be repaired or replaced until it did. *Modern* also had an extensive section of mail order advertisers in the back of the magazine, and to ensure customer satisfaction devoted a page in each magazine to explaining the vagaries of mail order practices.

The publishing imprint of *Modern* saw many changes over the years. In 1963, 14 years after Photographic Publishing brought it to New York, the magazine was sold to Billboard Publications, and four years later it was sold again to ABC Leisure Magazines, Inc., a division of ABC, which became ABC Consumer Magazines. In 1986, *Modern Photography* was purchased by Diamondis Communications, Inc., a subsidiary of Hachette Publications, Inc. After the publication of *Modern*'s July 1989 issue, it merged with its archrival of many years, *Popular Photography*. At the time of the merge, *Modern Photography* had a monthly circulation base of 500,000.

Though *Modern Photography* exists in name no more, in many ways the current *Popular Photography*, with the publisher, editor-in-chief, and managing editor all hailing from *Modern*, is a successful melding of the two giant American consumer photographic publications of the twentieth century.

BOB LAZAROFF

See also: **Popular Photography; Riefenstahl, Leni; Vernacular Photography**

MODERNA MUSEET

The Fotografiska Museet, now incorporated into the Moderna Museet, began in 1964 when photography enthusiasts founded the *Fotografiska Museets Vänner* (Friends of the Photography Museum). Earlier, interest in Swedish photography first appeared when the

National Museum introduced *Modern svensk fotokonst* (Modern Swedish Photography) in 1944 and *Svensk fotografi av idag-svartvitt* (Swedish Photography today—black and white) in 1954. Meanwhile, Otte Skold, Director of the National Museum, suc-

cessfully persuaded the Swedish government to create a museum specifically dedicated to twentieth century art. At that time, an Association of Friends of Moderna Museet was formed. Its collection of 150 art works was transferred in 1958 from the National Museum to this new Museum of Modern Art (Moderna Museet), which was to be located in an empty naval drill hall on the island of Skeppsholmen in Stockholm. After Skold's death later that year, Pontus Hulten was appointed director and along with cutting-edge exhibitions of contemporary and kinetic art, he was responsible for an important photography exhibition in 1962, *Svenskarna sedda av 11 fotografer* (The Swedes as seen by 11 Photographers).

The decade of the 1960s brought great success to the new museum as concerts, poetry readings, and films drew large audiences. In 1964, a major exhibition introduced the Swedish public to American Pop Art followed in 1965 by the exhibition, "Helmut Gernsheim's Duplicate Collection Classic Camera." This internationally-recognized collection, along with Professor Helmer Bäckström's historical photographic collection acquired in 1964, became the foundation of the Fotografiska Museet, which was formally established in 1971 when the Fotografiska Museet's Friends Association gifted their collection of photographs to the National Museum. During the following years, numerous organizations, notably The Swedish Photographers Association, The Swedish Tourist Organization, The Photographic Society, Stockholm, The Swedish Tourist Traffic Association, the National Association of Swedish Photography, The Press Photographer's Club, *TIO Fotografer* (Studio Ten Photographers) as well as private individuals donated photographs, thus, establishing photography as a permanent fixture on Sweden's artistic scene.

Later in 1971, the entire collection of photographs and photographic literature was consolidated and transferred to the Modern Museum. As part of the reorganization of the National Museum's collections in 1973, the Fotografiska Museet became a department within the Modern Museum in 1976 and in December of that year, its activities moved into the Museum's west gallery. In 1978, curators Åke Sidwall and Leif Wigh contributed to the growing international debate on photography with *Tusen och en Bild* (Thousand and One Images), a wide-encompassing survey on the rise and development of photography. The Fotografiska Museet continued to organize exhibitions on a wide-encompassing diversity of subjects, including *Genom Svenska Ogon* (Through Swedish Eyes), 1978–1979; *Bäckströms Bilder!* (Backstroms Pictures), 1980; *Se dig om I glädje* (Look back in Joy), 1981; *and Bländande Bilder* (Dazzling Pic-

tures) 1981–1982. In 1983, a large retrospective of the photographs of Henri Cartier-Bresson took place. In 1984 *Fotografier från Bosporen och Konstantinopel* (Photographs from the Bosphoros and Constantinople) and in 1985, the first retrospective of Irving Penn expanded the Museum's exhibition activities on international photographic subjects.

Meanwhile, Moderna Museet was challenging the Swedish public with discussions of Postmodernism by highlighting such artists as painters Andy Warhol, Marcel Duchamp, Francis Picabia, the group of American and European sculptors known as the Minimalists, and photographer Cindy Sherman. Along with its collection of world-renowned photographers, including nineteenth-century master Julia Magaret Cameron and major twentieth-century figures August Sander, Diane Arbus, Bill Brandt, and Lotte Jacobi, there are significant Swedish photographers, such as Sune Jonsson (b. 1930) whose love and respect for Nordic nature is found in people and places in the sparsely populated regions of the countryside, and Christer Strömholm (b. 1918), founder of the Kursverksamheten's School of Photography, whose deeply moving works display the vulnerabilities of life. Other Swedish photographers are Lennart af Petersens, Karl Sandels, Walter Hirsch, Lennart Olson, Harald Lönnqvist, Annika von Hausswolff, Emma Schenson, and Monica Englund-Johansson.

In 1990–1991, with the need for more space and better conditions, an architectural competition was held for the construction of a new building for the Moderna Museet. Over 211 proposals were received with Rafael Moneo of Spain, winner of the 1996 Pritzker Architecture Prize, proclaimed the winner. In 1993, the old drill hall held its last exhibitions, a retrospective of the work of Gerhard Richter and the photographs of Chilean contemporary artist Alfredo Jaar, and closed after 35 years.

While Moneo's three-storey modernist building was rising, temporary premises in a former tram depot in the city center housed installations, including an exhibition of a gift of 100 Irving Penn photographs. The new Modern Museum opened in February 1998, the year in which Stockholm became the European Cultural Capital and with the new premises, the status of the photography collection with some 300,000 objects changed. In his introduction to the Moderna Museet's catalogue, then director David Elliott outlined what he recognized as the task of the modern museum and stating that "the art of the whole world must be considered," as he set a global outlook for the institution. The Fotografiska Museet lost both its name and its independent department status and is today housed in the Department of Exhibitions and Collections of the

Modern Museum. There is no permanent installation; however, temporary exhibitions take place on a regular basis. Recent interest in Nordic photography throughout Scandinavia has led to the founding of the Nordic Network for the History and Aesthetics of Photography in 2003 whose aim is to make Nordic history of photography more visible and to serve as a platform for discussions on international theoretic developments and literature.

The Library

The Photography Library together with a Study Room for eight researchers provides a unique environment for the public to conduct photographic research. The Library began with several important book collections, namely that of Helmut Gernsheim and Professor Helmer Bäckström as well as the collection of *Fotografiska Föreningen* (the Photographic Society, Stockholm). All give the collection its distinguishing strength in the historical development of Swedish photography and its relationship to the world photographic scene. Today the Moderna Museet houses the largest photographic library in northern Europe and contains literature on individual photographers, books on world photographic history, and exhibition catalogues as well as a pioneering collection of artists' films and videos. Its periodicals' section is unparalleled in Sweden, comprising press clippings from a selection of Swedish newspapers, some 200 magazines from around the world, and an extensive historical archive, including documents in 11,000 vertical files on Swedish and foreign photographers and photographic issues.

CYNTHIA ELYCE RUBIN

Sune Jonsson, The Farmers Albert and Tea Johansson, 1956, Collections of Moderna Museet, Stockholm.
[*Courtesy Moderna Museet, Stockholm*]

See also: **Museums: Europe**

Further Reading

Moderna Museet/Modern Museum. London: Scala Books, 1998.

Sidwall, Ake, and Leif Wigh. *Bäckströms Bilder! The Helmer Bäckström Collection in Fotografiska Museet.* Stockholm: Fotografiska Museet, 1980.

Wigh, Leif. *Blandande Bilder/New Trends and Young Photography in Sweden.* Stockholm: Fotografiska Museet, 1981.

————."Zum Museum für Photographie." *Moderna Museet Stockholm.* Bonn: Kunst-und Ausstellungshalle der Bundesrepublik Deutschland, 1996.

————. "You've Got to Be Modernistic." *Utopia & Reality: Modernity in Sweden 1900–1960.* New Haven/New York: Yale Press and Bard Graduate Center for Studies in the Decorative Arts, Design, and Culture, 2002.

————. "Helmut Gernsheim and His Photographic Collection in Sweden." *Helmut Gernsheim: Pioneer of Photohistory.* Mannheim: Forum Internationale Photographie der Reiss-Engelhorn-Museum, 2003.

————. *Anna Riwkin: Portrait of a Photographer.* Stockholm: Moderna Museet, 2004.

MODERNISM

The term "modernism" loosely describes a vast and dynamic field of cultural and aesthetic innovation that emerged in the first decades of the twentieth century. A response to the industrialization and mechanization that shaped Western culture in the eighteenth and nineteenth centuries, modernism first announced its innovations through painting and literature. James Joyce's *Portrait of the Artist as a Young Man* (1916) slices the novel into distinct literary styles, experiments with the fluidity of language, and suspends narrative time to represent the vicissitudes of subjective experience and perception. Marcel Duchamp's *Nude Descending a Staircase No. 2* (1912) (the Armory show's *succés de scandale*) triumphantly culminates the fragmentation, analysis, and multiplication of perspectives variously explored by impressionist, post-impressionist, and Cubist painters.

Although photography was associated with modernity's technological inventions and had become the defining feature of mass visual culture, it had a somewhat late and an unsettled place in modernism. And yet even though photography came late to the scene as a medium in which modernism was expressed, it had informed literature and painting's innovations. Modern artists working in every medium were compelled by the camera's capacity to represent what Walter Benjamin later described in "A Short History of Photography" (1931), as the "optical unconscious"—that which the physical eye cannot see. Duchamp's *Nude Descending a Staircase No. 2*, which arrests and depicts motion's minute fragments in painterly shards, could not have appeared in a culture bereft of photography's deepening and expanding of vision's capacities.

While photographic vision informed Futurism, Surrealism, and Dada's dismantling of aesthetic hierarchies, it was these fine arts movements that helped to break open photography's experimental paths. It is particularly the Dadaist use of montage, which cuts photographs from their original contexts and then juxtaposes them with text and typography, that calls attention to the image as sign, and therefore undermines the assumption that the photograph renders a positivistic truth. The deconstruction of the photographic image is in tension with, but not wholly unrelated to, another impulse in modernist photography: exploring the photograph's unique capacity to represent traces of the material real, what Rosalind Krauss describes as the photograph's indexical relation to that which it depicts. Many modern photographs, particularly those that veer toward abstraction, are explorations of and meditations on the limits and possibilities of the photographic medium. Man Ray's "rayographs" and László Moholy-Nagy's "photograms," cameraless images produced from placing and exposing objects on light-sensitive paper, as well as Alfred Langdon Coburn's Vortographs, kaleidoscopic compositions of mirrored light and shadow, are just a few of modernist photographers' attempts to discover the fundamental qualities of the photograph.

Reflecting on the unique capacities of the photograph and defamiliarizing perspectival form became two interrelated tropes for exploring photography's visual language. Looking at her own image in a

vertical mirror that is held up against a bare wall by two mirrored balls, Florence Henri's austere and sexually suggestive *Self Portrait* (1928) stages photography's geometries of reiteration. In many of his photographs of young Parisian bohemians such as *Groupe joyeux au bal musette* (1932) Brassaï depicted those in proximity to cafe mirrors, therefore presenting images of the photographed subjects as well as their reflections. Writing about Brassaï's visual commentary on the photograph's capacity for "self reflection," Craig Owens argues in "*Photography en abyme*" (1978) that the mirror's doubling of the subjects "functions as a reduced, internal image of the photograph." Even more compelling for reading photography's interpretative play are the images of people only visible in the photograph through their mirrored reflection.

In 1936, when Walter Benjamin published "*The Work of Art in the Age of Mechanical Reproduction*," he theorized and contextualized many European and Russian photographers' enthusiasms about photography's revolutionary potential. In the 1920s and 1930s, photographers such as Alexandr Rodchenko and László Moholy-Nagy theorized and created a photographic practice called New Vision, and attempted to enliven viewers experiencing modern life through stagnant perceptual and aesthetic traditions. Using smaller format cameras and unencumbered by the need for tripods, Moholy-Nagy and Rodchenko explored the perspectives offered by the modern city—its high-rises and dramatic scales, its geometries of contrast, its industrial patterns and textures—and experimented with what Christopher Phillips describes as "the purposefully disorienting vantage point" (1989). Moholy-Nagy's *Berlin Radio Tower* (1928) is shot from far above ground such that the spaces, shadows, and objects below intersect into a dense and abstract pattern, implicitly celebrating the technological and industrial shaping of modern life. Rodchenko's *Sawmill, Piles of Wood* (1931) depicts, from far below, one moment in the process of carrying and stacking plywood. Dynamically askew, Rodchenko's photographs defamiliarized the habitual human-centered perspectives, "shooting from the belly button." Defending his work against critics who claimed his photographs indulged in distortion, in "*The Paths of Modern Photography*" (1928) Rodchenko declares: "Photography—the new, rapid, concrete reflector of the world—should surely undertake to show the world from all vantage points, and to develop people's capacity to see from all sides."

Modernism in photography can be rightly said to have emerged in Europe in the avant-garde circles of Berlin, Munich, Vienna, Paris, and Prague. In the United States, paradoxically, Alfred Stieglitz essentially kept photography in the past to establish its "modern" value as a fine-arts medium. Distressed by the proliferation of photographs in mass culture and the rise of the Kodak amateur, Stieglitz worked to convince the world that photography's aesthetic stature could be raised to that of painting and drawing largely by mimicking the accepted aesthetic qualities of these mediums. Encouraged by an early correspondence with the late nineteenth-century naturalist photographer Peter Henry Emerson, and armed with a wealth of new technical knowledge, Stieglitz produced and promoted Pictorialist photographs—soft focus images of pastoral scenes thematically and compositionally derived from nineteenth century paintings. Between 1902 and 1907, Stieglitz became American photography's most influential figure and established America's first institutions for art photography. With the Munich and Vienna Secessions as its rebellious predecessors, Stieglitz founded the Photo-Secession in 1902 to mark modern American photography's break with its more conservative past, personified by the Camera Club of New York. His Gallery 291 displayed Pictorialist photographs, and came to be the first American venue to feature the drawings, paintings, and sculpture of European modernism. The journals *Camera Notes* (1897–1902), and then *Camera Work* (1902–1917) focused on the photograph's potential for artistry and established standards of eloquence in photographic reproduction. The work of Edward Steichen, Gertrude Käsebier, Clarence White, and Frank Eugene were regularly featured in these Stieglitz forums. These artists manipulated their photographs to Pictorialist perfection through attentive printing, cropping, and retouching. Their elegantly crafted platinum and gum bichromate prints dovetailed with the gauzy, soft, and reflective photographic effects and symbolist themes.

Around 1910, however, Stieglitz's photographic practice shifted from Pictorialist to so-called "straight" photography—images taken in the open air with a rapid exposure and presented with a minimum of cropping and other manipulation. Many of Stieglitz's straight photographs seem to formally and thematically embody the liminal space between the nineteenth and twentieth centuries. Photographs such as *From the Back Window* (1915) have the textured effects of weather and atmosphere—giving them hazy chiaroscuro nostalgia—but are also detached and compositionally abstract.

The abstract logic of Stieglitz's straight photography was developed in the late 1920s into the 1930s to pristine extremes by Edward Weston's sharp, incisive, close-up photographs of gleaming organic forms and Paul Strand's austere and attentive photo-

graphs of urban, mechanical, architectural geometries. Weston's style of modernism, however, relied on the large-format camera, but with the negatives precisely exposed so that the need for darkroom manipulation was limited and quickly became a sort of classicism of freezing beautiful, awe-inspiring images in lush blacks and whites, mimicked by a large contingency of west-coast based photographers including Ruth Bernard and Ansel Adams.

But as much as Stieglitz secured photography's place in modernism, he limited its meaning and scope, particularly in terms of its political engagement. In *Reading American Photographs* (1989) Alan Trachtenberg argues that Stieglitz's definitions of modern photography occluded and narrowly defined Lewis Hine's "radically reformative achievement"—his portrayals of the workers, immigrants, and children forced to the impoverished edge of New York's industrial economy around the turn of the twentieth century. However, the two poles that Stieglitz's and Hine's work represents—portraying the aesthetics of repetition, perception, and abstraction and critiquing capitalism's effects—were unpredictably debated and synthesized in postmodern photographic practice.

KIMBERLY LAMM

See also: **Bernhard, Ruth; Brassaï; Dada; Deconstruction; Futurism; Henri, Florence; Hine, Lewis; History of Photography: Interwar Years; History of Photography: Twentieth-Century Developments; History of Photography: Twentieth-Century Pioneers; Käsebier, Gertrude; Krauss, Rosalind; Langdon Coburn, Alfred; Man Ray; Moholy-Nagy, László; Montage; Photogram; Photo-Secession; Pictorialism; Steichen, Edward; Stieglitz, Alfred; Strand, Paul; Surrealism; Weston, Edward; White, Clarence**

Further Reading

Benjamin, Walter. "Uber den Begriff der Geschichte." 1931, in *Illuminationen: Ausgewählte Schriften 1.* Frankfurt am Main: Verlag, 1977; as "A Short History of Photography." Trans. Phil Patton. *Classic Essays on Photography.* Ed. Alan Trachtenberg. New Haven, CT: Leete's Island Books, 1980: 203.
———. "Das Kuntswerk im Zeitalter seiner technischen Reproduzierbarkeit." 1936, *Zeitschrift für Sozialforschung,* V. 1; As "The Work of Art in the Age of Mechanical Reproduction." *Illuminations.* Ed. Hannah Arendt. Trans. Harry Zohn. New York: Schoken Books, 1968.
Crow, Thomas. "Modernism and Mass Culture in the Visual Arts." In *Modernism and Modernity.* Ed. Benjamin Buchloch, Serge Guilbaut, and David Solkin. Halifax: The Nova Scotia College of Art and Design Press, 1983.
Krauss, Rosalind. "The Photographic Conditions of Surrealism." *October* 19 (Winter 1981).
———. "Notes on the Index Part 1." *October* 3 (Spring 1977).
Owens, Craig. "Photography en abyme." *October* 5 (Summer 1978).
Phillips, Christopher, ed. *Photography in the Modern Era: European Documents and Critical Writings, 1913–1940.* New York: Metropolitan Museum of Art and Aperture, 1989: ix.
Rodchenko, Alexandr. "Puti sovremennoi fotografi." *Novyi lef* no. 9 (1928); As "The Paths of Modern Photography." Trans. John E. Bowlt, in *Photography in the Modern Era: European Documents and Critical Writings, 1913–1940.* Ed. Christopher Phillips. New York: Metropolitan Museum of Art and Aperture, 1989: 257.
Sekula, Allan. "On the Invention of Photographic Meaning." In *Photography Against the Grain: Essays and Photo Works, 1973–1983.* Ed. Sekula. Halifax: The Nova Scotia College of Art and Design Press, 1984.
Solomon-Godeau, Abigail. *Photography at the Dock: Essays on Photographic History, Institutions, and Practices.* Minneapolis: University of Minnesota Press, 1991.
Trachtenberg, Alan. *Reading American Photographs: Images as History Matthew Brady to Walker Evans.* New York: Hill and Wang, 1989: 165.

Alexandr Rodchenko, At the Telephone Na telefone, From a series on the production of a newspaper, 1928, Gelatin-silver print, 15½ × 11½", Mr. and Mrs. John Spencer Fund.
[*Digital Image © The Museum of Modern Art/Licenced by SCALA/Art Resource, NY Photo © Estate of Alexander Rodchenko/RAO, Moscow/VAGA, New York*]

TINA MODOTTI

Italian

Italian-born Tina Modotti worked predominantly in Mexico from 1923 until 1930, and produced a body of work that initiated a Modernist photographic aesthetic in that country. She was one among a number of artists and intellectual expatriates who traveled to Mexico between the wars, and who contributed to the flowering of the Mexican Renaissance. Modotti's signature style integrated precise formal clarity with incisive social content, and her work may be seen in the context of other modernists of the period who worked in what is known as the New Vision style. In contrast to European photographers situated in post-war metropolises, however, Modotti tailored her vision to the conditions she found in Mexico: a country—in flux following 10 years of unrest—attempting to transform its agrarian economy to reflect the modernization that had been accomplish abroad. The subject of her photographs often depicted the back-breaking labor necessary to achieve the mechanized changes sought by the post-Revolutionary government. Her legendary life and love affairs, early death, and a photographic career that was initially in the shadow of the great master Edward Weston made Modotti for many years an underrecognized figure in twentieth-century photography.

Modotti arrived in Mexico City from California in August, 1923 with Weston; together, they established an important photography studio that flourished until Modotti left in 1930 (Weston returned to the United States in 1926). Modotti had immigrated to America from her birthplace of Udine, Italy in 1913, joining her father and a sister who had settled in San Francisco. There she worked in the textile industry and began acting in the amateur theatre of the vibrant Italian Colony. In 1918, she moved to Los Angeles with Roubaix de l'Abrie Richey (known as Robo), and they lived together as a married couple. He was a poet, writer, and artist who had refashioned himself from a Oregon farm boy into a sophisticated California bohemian. A great beauty, Modotti quickly found work in Hollywood's burgeoning film industry, starring in the 1920 production *A Tiger's Coat*, and finding roles in two other movies.

In addition to acting, Modotti earned a living modeling for a number of artists, including photographers Jane Reece, Arnold Schröder, Wallace Frederick Seely, Johan Hagemeyer, and, most importantly, Weston. Some of Weston's most sensual nudes are of Modotti, and they began a liaison sometime around 1921.

In 1922, after the death of Robo and of her father, Modotti decided to become a photographer. Although she acknowledged that Weston had been crucial to that decision, a number of factors may have contributed. Her uncle, Pietro Modotti, operated a successful photography studio in Udine, turning out portraiture, still lifes, and landscape photographs, and running an influential school of photography in the north of Italy. In addition, when her father first arrived in San Francisco, he opened a short-lived photography studio. Most significantly, however, Modotti's experience as an actor and model came into play: working on the "other" side of the camera gave her insight to the mechanics of picture making and the aesthetic issues such as composition. In short, becoming a photographer allowed her to "seize control of the gaze."

In Mexico, Modotti managed their studio, and in exchange, Weston instructed her about the techniques of photography. Both artists used a large-format camera, which required careful composition on the ground glass. Her first camera was a 4 × 5-inch Corona, a stationary view camera that required a tripod, but she later bought a hand-held 3¼ × 4¼-inch Graflex. She used the Corona for formal portraiture and to document the murals created by the artists of the Mexican Renaissance (Diego Rivera, Clemente Orozco, David Alfaro Siqueiros), supporting herself by both activities. She used the Graflex for more spontaneous images that she made on the streets of Mexico. Like Weston, Modotti subscribed to precise composition on the ground glass, and both used the contact method of printing by placing their negative directly on sensitized paper and exposing it in the sun.

Modotti's oeuvre can be divided into two periods: 1923–1924 and 1925–1930. Her earliest subjects were still-lifes, a genre she used to study formal issues such as light, pattern, composition, and tone. But unlike her teacher, Modotti usually

sought to imbue her subject with symbolic content. *Roses* (1924), for example, is a tightly constructed near abstraction of four white roses that also functions as a *momento mori*, suggesting the transitory nature of life. Modotti's architectural studies from this period are marked for their complicated spatial configurations and delicate tonal gradations. In 1925, Modotti began to photograph outdoors, and her *Telephone Wires* (1925) marks a change in her work, in which now distinctive modernist elements are evident. In keeping with New Vision aesthetic, she often approached her subjects from novel, extreme vantage points and photographed machine-age subject matter, the result being an abstracting of space and form. And like many political artists of the day, Modotti consciously brought a social element to her work.

In 1927, Modotti officially joined the Communist Party, already populated by many of her Mexican friends and colleagues, among them, Frida Kahlo, Rivera, Orozco, and Siqueiros, who contributed their artistic skills in the service of the cause, believing that art could be the catalyst for social and political change. Modotti's strongest images from this period include *campesinos* (peasant farmers) and *obreros* (workers) engaged in protest or in manual labor, as in *Workers Parade* (1926) and *Tank No. 1* (1927). For her, images of workers expressed both the humanity of the people and the heart of the Communist movement. She also returned to still life in 1927, and she made a series of "revolutionary icons," careful arrangements of a guitar, a bandolier, a dried ear of corn, and a sickle, for example, *Bandolier, Guitar, Sickle* (1927).

The receptivity to public art fostered in post-Revolutionary Mexico in the early 1920s began to diminish toward the end of the decade as government policies turned more conservative. Modotti's subject matter was seen as provocative, if not inflammatory. *Workers Reading* El Machete (1927), for example, was a potent reminder that the Revolution's promise of universal literacy for the lower and working classes, many of whom were of Indian decent, was as yet unfulfilled. In this tightly composed image of two young *obreros* reading the Communist organ, Modotti adroitly illustrates the strategy of activist participation in changing the conditions of the underprivileged.

But while Modotti herself was conscious of photographing with a "class eye," she was equally concerned about making photographs that met the criteria she learned from Weston. She made two series in 1929 that demonstrate this point: *Woman from Tehuantepec*, (1929) and *Hands of the Puppeteer*, (1929). Her heroic heads of the women of Tehuantepec, who control the political life of the region, are emblematic without being ethnographic. And when she made images of a puppeteer's hands, the tight cropping and straight-on frontality contribute to the powerful metaphor: those in power control and manipulate those without.

In December 1929, Modotti's work was exhibited in a solo exhibition that was well received. Her love affair with Julio Antonio Mella, founder of Cuban Communist Party who was gunned down in her company, and her involvement with radical politics (she was accused of plotting the assassination of President Pascual Ortiz Rubio) caused her to be deported from Mexico as an undesirable alien in 1930. Her photography career ended, and over the next 12 years she traveled to Moscow, Paris, and Spain in the service of the International Red Aid. Modotti returned to Mexico in 1939 and died at the age of 45 three years later.

SARAH M. LOWE

See also: **History of Photography: Interwar Years; Modernism; Photography in Mexico; Weston, Edward; Worker Photography**

Biography

Born Assunta Adelaide Luigia Modotti Mondini in Udine, Italy 16 August 1896. Minimal formal education as a child; emigrated to San Francisco, California to join her father in 1913. Moved to Los Angeles with common-law husband, artist Roubaix (Robo) de l'Abrie Richey, in 1918; he died in 1922. Moved to Mexico City with Edward Weston, who taught her photography, 1923. Exhibited with Weston in Mexico until his departure, 1926. Produced hundreds of copy prints of the Mexican Mural movement; published photographs in dozens of international journals, magazines, and periodicals. Joined the Mexican Communist Party, 1927. Romantically involved with Julio Antonio Mella, founder of Cuban Communist Party, 1928. Accused of his murder and acquitted, 1929; expelled from Mexico as an undesirable alien, 1930. Moved to Germany, 1930 and then Moscow, 1931. Gave up photography and worked for the International Red Aid in Russia 1931–1934, in France, and in Spain during the Spanish Civil War, 1935–1939. Returned to Mexico with Italian Communist Vittorio Vidali, 1939. Died Mexico City, 6 January 1942.

Selected Individual and Two-Person Exhibition

1924 Aztec Land Shop; Mexico City, (with Edward Weston)
1925 Museo del Estado; Guadalajara, Mexico, (with Edward Weston)
1926 Sal de Arte; Mexico City, (with Edward Weston)
1929 Universidad Nacional Automoma de México, Biblioteca Nacional; Mexico City
1942 *Exposition de fotografía: Tina Modotti, (Memorial exhibition)*; Galería de Arte Mexicana; Mexico City

1977 *Tina Modotti*; Museum of Modern Art; New York

1982 *Frida Kahlo and Tina Modotti*; Whitechapel Art Gallery; London, England (traveled to Grey Art Gallery; New York, New York)

1995 *Tina Modotti: Photographs*; Philadelphia Museum of Art; Philadelphia, Pennsylvania (traveled to Houston Museum of Fine Art; Houston, Texas and San Francisco Museum of Modern Art; San Francisco, California)

2004 *Tina Modotti & Edward Weston: The Mexico Years*; Barbican Art Galleries, Barbican Centre; London, England

1975 *Women of Photography*; San Francisco Museum of Modern Art; San Francisco, California

1978 *Photographs of Mexico: Modotti/Strand/Weston*; Corcoran Gallery of Art; Washington, D.C. (traveled to El Museo del Barrio; New York, NY

1981 *Cubism and American Photography, 1910–1930*; Sterling & Francine Clark Art Institute; Williamstown, Massachusetts

2000 *Mexican Modern Art: 1900–1950*; National Gallery of Canada; Ottawa, Canada

Selected Group Exhibitions

1929 Group Show, Berkeley Art Museum; Berkeley, California

1930 *Photography 1930*; Harvard Society for Contemporary Art; Cambridge, Massachusetts

1930 *International Photographers*; Brooklyn Museum; Brooklyn, New York

Selected Works

Roses, 1924
Telephone Wires, 1925
Worker's Parade, 1926
Bandolier, Guitar, Sickle, 1927
Tank No. 1, 1927
Campesinos reading "El Machete," 1927

Tina Modotti, Hands Washing, ca. 1927, Gelatin-silver print, 7⅜ × 8¹⁵⁄₁₆″, anonymous gift.
[*Digital Image © The Museum of Modern Art/Licensed by SCALA/Art Resource, New York*]

Hands Washing, ca. 1927
Woman with a Flag, 1928
Mella's Typewriter or *La Téchnica*, 1928
Hands of the Puppeteer, 1929
Woman from Tehuantepec, 1929

Further Reading

Albers, Patricia. *Shadows, Fire, Snow: The Life of Tina Modotti*. New York: Clarkson N. Potter, 1999.

———. *Tina Modotti: The Mexican Renaissance*. Paris: Jean-Michel Place, 2000. Includes an essay by Karen Cordero Reiman, "Cloaks of Innocence and Ideology: Constructing a Modern Mexican Art, 1920–1929."

Barckhausen, Christiane. *Auf den Spuren von Tina Modotti [Following the traces of Tina Modotti]*. Köln: Paul-Rugenstein, 1988; as *Verdad y leyendda de Tina Modotti*, La Habana, Cuba: Casa de las Américas, 1989.

Constantine, Mildred. *Tina Modotti: A Fragile Life*. New York: Paddington Press, 1975. Second edition, New York: Rizzoli, 1983.

D'Attilio, Robert. "Glittering Traces of Tina Modotti." *Views* (Boston) 6, no. 4 (Summer 1985).

Lowe, Sarah M. *Tina Modotti Photographs*. New York: Harry N. Abrams, 1995.

Modotti, Tina. "Sobre Fotografía/On Photography." *Mexican Folkways* 12 (October/December 1929).

Wollen, Peter, and Laura Mulvey. *Frida Kahlo and Tina Modotti*. London: Whitechapel Art Gallery, 1982.

Stark [Rule], Amy. "The Letters from Tina Modotti to Edward Weston." *The Archive* [Tucson, AZ] no. 22 (January 1986).

LÁSZLÓ MOHOLY-NAGY

Hungarian-American

László Moholy-Nagy's reputation as one of the most influential figures in twentieth-century photography has withstood the vagaries of fashion and the advance of thought about the medium of the postwar era, a dialogue that his ideas were instrumental in nourishing. A painter, sculptor, designer, film maker, theorist, and teacher, as well as a pioneering experimental photographer, Moholy-Nagy seemed the embodiment of a twentieth-century Renaissance man, equally at home in the classroom, studio, experimental laboratory, and the realm of ideas.

László Moholy-Nagy was born in 1895 into a farming family in the village of Bácsborsod in an agricultural area of southern Hungary, where he grew up and attended elementary school. For his secondary education, he attended the gymnasium in Szeged, where he studied law. In Szeged, he first came into contact with the intellectual elite that was to shape modern Europe. Poet Gyula Juhász was a mentor, as Moholy-Nagy also nurtured ambitions to be a writer. Drafted into service in 1914 during World War I, he served on the Russian front in the artillery. Wounded and hospitalized twice during the war, Moholy spent his recovery drawing, a childhood interest. Upon his discharge after suffering a hand wound, he returned to the study of law after the war in Budapest, but around the time of the bloodless bourgeois revolution in 1918 and the

subsequent rise of Communism with the proletarian takeover, Moholy-Nagy abandoned further study to return to Szeged and take up the life of an artist. Although active in the intelligentsia, Moholy was not essentially political; he moved first to Vienna, then to Berlin in 1920, where he met the Czech-born Lucia Schultz, his future wife and collaborator. Moholy-Nagy became a member of the organization of vanguard Marxist Hungarian artists then actively shaping the new regime; they issued a manifesto in 1922 titled "Constructivism and the Proletariat," published in their periodical *MA (Today)*. Early artistic efforts included coediting and designing the *Buch neuer Künstler (Book of New Artists)* with Lajos Kassák, a leader of the Hungarian artistic and political avant-garde.

A turning point in his life, however, came in 1923 when the architect Walter Gropius, who had been impressed by an exhibition he had seen, invited Moholy-Nagy to teach at the Bauhaus, founded in Weimer four years earlier. Asked to teach the foundation course, replacing the painter Johann Itten, Moholy remained at the school for five years, first in Weimar and then when the school moved to Dessau. The Bauhaus was a radical new idea in pedagogy. Unlike traditional arts training, which was based on mastering accepted forms, often through copying masterworks, the Bauhaus had a hands-on approach combined with the philosophy that art was integral to the fabric of daily life; it aimed to train the

whole human being and to combine art and technology in the service of society. Photography, however, did not yet play a role of any significance at the Bauhaus. Although Lucia was a trained photographer, Moholy-Nagy was self-taught, yet it was his concern with the medium that brought it to the fore in the Bauhaus curriculum, with such figures as Erich Consemüller, the brothers Andreas Feininger and T. Lux Feininger, and Walter Peterhans making significant contributions.

Moholy-Nagy's vision of art was idealistic, yet practical. Concerning the function of the artist, he wrote:

> Art is the senses' grindstone, sharpening the eyes, the mind and the feelings. Art has an educational and formative ideological function, since not only the conscious but also the subconscious mind absorbs the social atmosphere which can be translated into art.... What art contains is not basically different from the content of our other utterances, but art attains its effect mainly by subconscious organization of its own means. If that were not so, all problems could be solved successfully through intellectual or verbal discourse alone.

(*Moholy-Nagy*, Passuth, 363–364)

Photography was, in Moholy-Nagy's mind, the ideal creative medium for the times, able to construct a "New Vision" *(Neue Sehen)*, which in 1927 became the title of his highly influential book. In the new world, transformed so fundamentally by the modern technology emerging in Europe, he sought new possibilities for perceiving and interpreting modern life, and found them in what he termed the "pure design of light." Together with Lucia Moholy, he developed the camera-less technique of the photogram, which had been independently developed by others, including Man Ray. He delighted in all manner of technical imagery, including X-rays, photomicrographs, and motion photography. Exploring Constructivist ideas, he shot from radical angles, including the bird's-eye and worm's-eye views advocated by Alexandr Rodchenko and El Lissitzky, whom he had met in 1921 during a sojourn in Dusseldorf. A notable example is *Bauhaus Balconies* of 1926 (also known as *Dessau*, 1926). Part of his duties at Bauhaus was to plan, edit, and design publications, and he produced 14 *Bauhausbücher* including his influential text, *Malerei, Fotographie, Film* (*Painting, Photography, Film;* 1925) as Number 8 in the series. Through his teaching and writing, Moholy extended his conviction that photography was an essential part of the modern sensibility.

Political pressures at the Bauhaus effected Moholy-Nagy's (as well as Walter Gropius's) departure and return to Berlin in 1928. His marriage to Lucia ended in 1929, and he remarried in 1931 to Sybil Pietzsch. In Berlin, Moholy worked as a designer, including stage set designs for *Tales of Hoffman* and *Madame Butterfly*, and he painted and experimented relentlessly with the new materials of modernity, such as plastics. He was particularly fascinated by the play of light on and through these materials, and soon had fashioned what he called "Light-Space Modulators" to demonstrate the interaction of light as a dynamic element in sculpture. With his abstract light-pictures or photograms, manipulated images, including multiple exposures, and montage and collage techniques, Moholy-Nagy was a pioneer of experimental photography. His graphic design was similarly experimental and advanced, combining photography, text, and formal "fine arts" elements, and he was one of the first to recognize the value of photography as an instrument for commercial art and advertising. The "Typofoto," a combination of image and text, played a central role in his own publications, and then was taken up and continued by Herbert Bayer. He also made films.

Along with dozens of other modern artists, Moholy-Nagy was forced to flee before the increasing tyranny of the Nazi regime as it took hold of Germany in the mid-1930s. He first made his way to Amsterdam and then to London in 1935, where he continued to actively photograph, completing commercial assignments including photographic illustrations for the book *The Street Markets of London* and a book on Eton College. He also continued to experiment, particularly with sandwiching multiple negatives, which he called "superimpositions," and with forays into the use of color.

For his fellow Hungarian refugee and director Alexander Korda, he created special effects for Korda's adaptation of H.G. Wells's *The Shape of Things to Come* in 1936, although they were not used in the final film. He also worked on a documentary film about the London Zoo with writer and social theorist Julian Huxley. In 1937, there was another turning point—he was invited to America to set up a new school of industrial arts training.

In Chicago, a center of industry and mercantilism, an effort to find a director for a proposed school for industrial art had resulted in an offer to the architect Walter Gropius. Gropius, however, had only recently accepted the offer of a professorship at Harvard, and he recommended his close friend for the position. In May of 1937, Moholy-Nagy traveled to Chicago and agreed to head the New Bauhaus—American School of Design, as it was initially known, to be housed in the mercantile baron Marshall Field's former mansion. The prospectus he

prepared to demonstrate his curriculum was in the form of a chart fashioned of concentric circles. It outlined a five-year program of study, with general first-year courses on the outermost layer. "Light, Photography, Film, and Publicity" are grouped together in one block in the third year of study, after students have completed its prerequisite, "Science." In short order, Moholy appointed a faculty, drawing on his former Bauhaus associates, including Hin Bredendieck, who had been one of his students, and Gyorgy Kepes, who was to teach the Light Workshop, as the photography department was initially known. Early students in the Light Workshop, including Nathan Lerner and Arthur Siegel, eventually became photography instructors at the New Bauhaus as well.

Moholy's teaching method, so admired by his students and associates, largely bewildered the industrialists funding the school. They complained of seeing strange and inexplicable models and objects (surely Light-Space Modulators) lying about the school's classrooms and were distressed by the collegial nature of the instruction, which promoted collaboration and interaction between instructor and student and the students themselves. After only a year, the school's governing board, the Association of Arts and Industries, attempted to fire Moholy on the grounds he lacked "teaching experience," among other flaws. When faced with overwhelming support for Moholy from his students and faculty, the AAI board, claiming financial difficulties as a continuing effect of the Great Depression, closed the school, in spite of Moholy's five-year contract. It was this contract which in fact brought into being the School of Design. Moholy successfully sued the AAI and immediately set up a new school in an abandoned bakery on Chicago's near north side. Classes at the School of Design commenced in February of 1939. Moholy had taken a position as a designer for the Parker Pen Company as well as for Spiegel's mail order department store, and he plowed some of his earnings back into the school. He had also found an enlightened patron, Walter C. Paepcke, the executive who ran the progressive Container Corporation. Under Paepcke's patronage, Moholy was finally able to realize the school he had envisioned. He appointed a Board of Advisors that included New York curator Alfred Barr of the Museum of Modern Art, educator John Dewey of the University of Chicago, and his friends Walter Gropius, and Julian Huxley, among others. In 1944, the name of the school was changed to the Institute of Design.

In his own work, during the Chicago years, Moholy-Nagy worked extensively with a Leica camera, including experimenting with color slide photography. At the Institute of Design, he worked with students to help with the war effort, including designing camouflage.

Diagnosed with leukemia in 1945, Moholy returned to his first love, painting, creating among other works, a series of abstract canvases titled *Leuk* after the disease that would kill him in the fall of 1946. His widow, Sybil Moholy-Nagy, pulled together his many various writings into a posthumously published book, *Vision in Motion*. Moholy-Nagy's legacy lived on, however, at the Institute of Design, which thrived, attracting such teachers as Harry Callahan (whom Moholy hired just a few months before his death) and Aaron Siskind, and graduating such talents as Kenneth Josephson, Art Sinsabaugh, and Barbara Crane. The International Museum of Photography and Film, George Eastman House, Rochester, New York has an in-depth collection of Moholy's photographic works, from the private collection of his widow. Moholy-Nagy,'s daughter, Hattula, has continued to promote Moholy-Nagy's work. Materials are archived primarily in the Archives of the Illinois Institute of Technology (which subsumed ID in 1949), which hold original manuscripts documenting the early years of the Institute of Design and at the Bauhaus-Archiv in Berlin.

LYNNE WARREN

See also: **Bauhaus; Feininger, Andreas; History of Photography: Interwar Years; History of Photography: Twentieth-Century Pioneers; Institute of Design; Peterhans, Walter; Photography in Germany and Austria**

Biography

Born, Borsód (present-day Bácsborsód), Mohol Puszta, Hungary, 20 July 1895. Drafted into Austro-Hungarian Army and sent to Russian front, 1914. Wounded and recuperated in Odessa, Russia, military hospital, 1914, Galicia, Italy, 1917; discharged and returned to study of law, at the Royal University in Budapest. Co-founder *MA* group of avant-garde artists, 1917. Left university and Hungary, 1918. Briefly stayed in Vienna, then Dusseldorf, then resided in Berlin, 1920. Married to Lucia Schulz, 1921. Invited by Walter Gropius to head up Metal Workshop and Foundation Course at Weimar Bauhaus, 1923; published *Malerei, Fotographie, Film*, 1925. Moved to Dessau when Bauhaus relocated, 1925. Left Bauhaus in 1928. Experimented with camera-less photography, Constructivist principles. Moved to Berlin, worked as stage and set designer, and operated commercial design studio, 1928–1934. Built first "Light-Space Modulator," 1930. Married Sybil Pietzsch, 1931. Fled Nazi Germany, 1934 to Amsterdam, then London, 1935. Documentary photography and films, commercial work, 1935–1937. Invited

to head new school of industrial design in Chicago, 1937, established "New Bauhaus–American School of Design." Reorganized and renamed School of Design, February of 1939 (later Institute of Design). Succumbed to leukemia, in Chicago, 24 November 1946.

Selected Works

Jealousy, 1925
Leda und der Schwan, 1925
Self-Portrait, Berlin (also known as *Mondegesicht*; photogram), 1926
Two nudes, ca. 1925
Sailing, 1926
Massenpsychose, 1927
Pont Transbordeur in the Rain, Marseille, ca. 1929
Fotogramm III, ca. 1929
Light Space Modulator (gelatin silver print), 1930
Superimposition, ca. 1935
Study with Pins and Ribbons, 1937–1938
Laboratory, 1938
Plexiglas mobile sculpture in repose and in motion (gelatin silver print), 1943
Sculpture, Plexiglas (gelatin silver print), 1945

Individual Exhibitions

1922 Galerie der Sturm; Berlin, Germany
1931 Delphic Studios; New York, New York
1934 Stedelijk Museum; Amsterdam, Netherlands
1935 Royal Photographic Society; London, England
1947 Museum of Non-Objective Paintings (now Solomon R. Guggenheim Museum); New York, New York
1953 Kunsthaus Zurich; Zurich, Switzerland
1969 *Moholy-Nagy Retrospective*; Museum of Contemporary Art; Chicago, Illinois and traveling to Santa Barbara Museum of Art, Santa Barbara, California; University Art Museum, Berkeley, California; Seattle Art Museum, Seattle, Washington, and Solomon R. Guggenheim Museum, New York, New York
1975 *Photographs of Moholy-Nagy from the William Larson Collection*; Claremont College, Claremont, California and traveling
1978 *Photographs and Paintings by Moholy-Nagy*; Rochester Memorial Art Gallery; Rochester, New York
1982 *Moholy-Nagy*; Center for Creative Photography, University of Arizona; Tucson, Arizona
1983 *Moholy-Nagy: Fotoplastiks: The Bauhaus Years*; Bronx Museum of the Arts, Bronx, New York
1985 *Moholy-Nagy, Photography, and film in Weimar Germany* (also known as "*László Moholy Nagy: the Evolution of a Photographic Vision*"); Wellesley College Art Museum, Jewett Arts Center; Wellesley, Massachusetts and traveling to the Museum of Fine Arts, Houston, Texas and Art Institute of Chicago, Chicago, Illinois
1990 *Moholy-Nagy: A New Vision for Chicago*; Illinois State Museum; Springfield, Illinois
1991 *Moholy-Nagy, Werke von 1917–1946*; Museum Fridericianum; Kassel, Germany
1996 *László Moholy Nagy: From Budapest to Berlin, 1914–23*; Illinois Art Gallery; Chicago, Illinois
2002 *László Moholy-Nagy: The Late Photographs*; Andrea Rosen Gallery; New York, New York and traveling to Galerie de France, Paris, France, and University of

Michigan Museum of Art Museum, Ann Arbor, Michigan

Group Exhibitions

1929 *Film und Foto: Internationale Ausstellung des Deutschen Werkbundes, Ausstellungshallen und Königbaulichtspiele*; Stuttgart, Germany
1932 *Modern European Photography*; Julien Levy Gallery; New York, New York
1938 *Bauhaus 1919–1938*; Museum of Modern Art; New York, New York
1971 *Photo Eye of the 20's*; George Eastman House; Rochester, New York
1979 *Photographie als Kunst 1879–1979/Kunst als Photographie 1949–1979*; Tiroler Landesmuseum; Innsbruck, Austria, and traveling
1980 *Avant-Garde Photography in Germany 1919–1939*; San Francisco Museum of Modern Art; San Francisco, California
1982 *Color As Form: A History of Color Photography*; George Eastman House; Rochester, New York and traveling
 Repeated Exposure: Photographic Imagery in the Print Media; Nelson-Atkins Museum of Art; Kansas City, Missouri
1986 *Self-Portrait: The Photographer's Persona 1840–1985*; Museum of Modern Art; New York, New York
1989 *The Art of Persuasion: A History of Advertising Photography*; International Museum of Photography, George Eastman House; Rochester, New York and traveling
 The Art of Photography: 1839–1989; Museum of Fine Arts; Houston, Texas and traveling
 On the Art of Fixing a Shadow: One Hundred and Fifty Years of Photography; National Gallery of Art, Washington D.C. and Art Institute of Chicago, Chicago, Illinois and traveling to Los Angeles County Museum of Art, Los Angeles, California
 Stationen Der Moderne; Berlinische Galerie im Gropiusbau; Berlin, Germany
1990 *L'Invention d'un Art*; Centre Georges Pompidou; Paris, France
 The Past and Present of Photography-When Photographs Enter the Museum; National Museum of Modern Art; Tokyo, Japan and traveling
1993 *The New Bauhaus School of Design in Chicago. Photographs 1937–1944*; Illinois Art Gallery; Chicago, Illinois and traveling to Ansel Adams Center for Photography; San Francisco, California, and Banning + Associates; New York, New York
1994 *Experimental Vision: Evolution of the Photogram Since 1919*; Denver Art Museum; Denver, Colorado
1996 *Moscow-Berlin, Berlin-Moscow 1900–1950*; Berlinische Galerie, Museum für Moderne Kunst; Berlin, Germany
2002 *Taken by Design: Photographs from the Institute of Design, 1937–1971*; Art Institute of Chicago; Chicago, Illinois and traveling

Further Reading

Haus, Andreas. *Moholy-Nagy: Photographs and Photograms.* New York: Pantheon Books, 1980.
Ichikawa, Masanori, *et al.*, eds. *The Past and the Present of Photography.* Tokyo: The National Museum of Modern Art, 1990.
Kostelanetz, Richard, ed. *Moholy-Nagy.* New York: Praeger Publishers, 1970.

Laszlo Moholy-Nagy, Lightplay: Black/White/Gray (Ein Lichtspiel: Schwarz/Weiss/Grau),
c. 1926, Gelatin silver print, 14¾ × 10¾ (37.4 × 27.4 cm) Gift of the photographer.
[*Digital Image © The Museum of Modern Art/Licensed by SCALA/Art Resource, New York*]

László Moholy-Nagy, *Frühe Photographien (Das Foto-Taschenbuch 16)*. Berlin: Galerie Nishen, 1989.

Moholy-Nagy, László. *Malerei, Fotographie, Film*. Mainz and Berlin: Florian Kupferberg, 1967 (facsimile edition).

———. *László Moholy-Nagy: Kunst und Dokumentation*. Mannheim, Germany: Städtische Kunsthalle, 1983.

———. *Vision in Motion*. Chicago: Paul Theobald, 1947.

Moholy-Nagy, Hattula. "A reminiscence of my father as photographer." In *The New Bauhaus School of Design in Chicago. Photographs 1937–1944*. New York: Banning + Associates, 1993.

Moholy-Nagy, Sibyl. *Moholy-Nagy: Experimental in Totality*. New York: Harper's, 1950. Reprinted London and Cambridge, Mass.: MIT Press, 1969.

Passuth, Krisztina. *Moholy-Nagy*. London: Thames and Hudson, Ltd., 1985.

Sobieszek, Robert. *The Art of Persuasion: A History of Advertising Photography*. New York: Harry N. Abrams, 1988.

———. *Color as Form: A History of Color Photography*. Rochester, N.Y.: International Museum of Photography, 1982.

Selz, Peter. "Modernism Comes to Chicago: The Institute of Design." In *Art in Chicago, 1945–1995*. Lynne Warren, ed. London and Chicago: Thames and Hudson Ltd. and Museum of Contemporary Art, 1996.

Travis, David, and Elizabeth Siegel, eds. *Taken by Design: Photographs from the Institute of Design, 1937–1971*. Chicago: Art Institute of Chicago, 2002.

Ware, Katherine, ed. *In Focus: László Moholy-Nagy Photographs from the J. Paul Getty Museum*. Los Angeles: J. Paul Getty Museum, 1995.

MONTAGE

Montage refers to a variety of related artistic techniques developed during the early part of the twentieth century in photography, film, literature, and the plastic arts, whereby parts of separate works are appropriated and juxtaposed to make a new artwork. Usually, the heterogeneity of the components is foregrounded by leaving visible the seams where the pieces were put together; often too, a break in visual, temporal, or narrative continuity foregrounds the technique. The terms collage, assemblage, and photomontage have at times been used interchangeably with montage, but they may be used with slightly different valences as well. Collage is often favored as a term to describe still, non-photographic images that have been "cut and pasted" together; assemblage often refers to three-dimensional, sculptural works that are created from other pre-existing objects. Since the term "montage" was made famous by Sergei Eisenstein in conjunction with his film, *Battleship Potemkin* (1925), this term is more often associated with film than with other media, while photomontage is the term often used to describe a montage made from still photographs.

The origins of montage techniques (as a form of artistic practice) is generally acknowledged to be in 1912 with Cubism, when Pablo Picasso and Georges Braque began integrating materials such as newspaper scraps or waxed paper into their paintings. Though similar techniques had been used in advertising for some time previous, it was not done with any apparent theory or organized practice. It is with Cubism that montage techniques enter the artistic vocabulary. Photomontage began as an avant-garde practice with the Berlin Dada group. Two sets of artists have claimed to be its originators: Raoul Hausmann and Hannah Höch on the one hand; John Heartfield (Helmut Herzfeld) and George Grosz on the other. Whomever the innovators may have been, photomontage seems to have been fully assimilated as an aesthetic practice by 1919. The impetus was to create a sense of shock and distance in the viewer. This often was accomplished by using images that were familiar (or of a familiar type), but combining, cutting, or manipulating them in a way that placed them in an entirely new context. In Höch's *Cut with a Kitchen Knife* (1919), for example, images taken from mass media periodicals are combined to make a statement, however elliptical, about the position of the recently enfranchised "New Woman" of Weimar Germany. Images of the establishment are juxtaposed with those of a female form who seems to "cut" through what stands in her way. This is typical of Dada photomontage: images are taken from one context (magazines or newspapers), manipulated, and given a new context in order to impart a new message, often counter to the originally intended one.

The Surrealists, working in the period between World Wars I and II, used similar ideas in a different way. Rather than revealing their manipulation

of the images, the Surrealist artists hid them. Instead of cutting and pasting images, they manipulated their photographs in the darkroom before printing them, or they used tricks of light and shadow to present fantasy as reality. Both André Kertész, in his *Distortion* series (1933), and Man Ray, in his numerous photographs of the nude female torso, used the photograph to transform the nude female form into something else. Man Ray's famous *Untitled* (1927) endows his model with tiger stripes by way of the shadows cast by a gauze curtain. Their artworks present a manipulated world as if it were a real one. The intention here is similar to that of Dada photomontage, to induce an estrangement in the viewer regarding his own world and his certainty about it. However, the Surrealists' interest in the interior life, in dreams and nightmares, and in psychoanalysis led them to favor these techniques over the more direct ones that had been used by the Berlin Dadaists.

Both of these avant-garde groups used montage techniques in their art to produce a sense of shock and estrangement in their viewers in an attempt to make art into a form of social praxis—that is, to fuse art with everyday life. Yet when works from the two groups are compared, there is little chance that they will be confused. Montage techniques remained an enduring feature of art for nearly a century precisely because of their great flexibility. They allow the artist to create an artwork that has a clear and effective message and to do so in a highly individual way. Montage has often, for these reasons and others, been used by those who make political or social statements with their art. Montage was used by the avant-gardes of the left. Many in both the Dada and Surrealist groups had ties—though often tenuous ones—to the Communist party. However, montage is by no means the exclusive province of those on the left. It has also been used quite effectively by avant-gardists of the right, such as the Italian Futurists, whose interest in collage and montage strategies following Cubism stemmed from their advocacy of speed and technology.

Soon after its acceptance by the avant-gardes as a legitimate artistic practice, montage's flexibility and power was redirected with new vigor toward non-artistic purposes, particularly in advertising and propaganda. In the United States, montage has been used in these arenas in a much more overt way than it has been in art or literature. The appeal is nearly identical: montage provides a way for a message—whether commercial or ideological—to be presented in a way that makes a strong impression while giving the appearance that the viewer is making independent connections between disparate images rather than having a viewpoint or opinion forced upon her. When discussing propaganda, it is often difficult to separate it from works that would be considered "art," since many montages that were designed as works of art have also had a propagandistic impulse behind them.

A significant part of the appeal of montage throughout its history has been the ease with which artists are able to use it to combine avant-garde and mass cultures. It breaks down the barriers between high and low art, as well as those between art and commerce and/or propaganda. There was a rich tradition of this kind of artwork in the former Soviet Union, where many artists affiliated with the Communist party used montage to political effect. For instance, in the poster by El Lissitzky, *The Current is Switched On* (1932), photomontage is used to convey the industrial power of the Soviet Union as it provides literal (electric) power to its citizens. At the same time, scope and scale are manipulated to attribute a mythological largeness to the figure of Stalin, whose head and shoulders loom large in the right half of the image. The left upper quadrant of the poster shows an enormous hand switching on electric power. Both of these unnaturally large human figures are juxtaposed against a background of a nighttime cityscape, lit with an abundance of lights, including spotlights. The effect is not a romanticized one, but rather one of practical force. This is a city for workers.

In the United States, similarly, montage has been used as a form of propaganda. One well-known example is the large photomontage that was a part of the *Road to Victory* exhibition, organized for the Museum of Modern Art from 21 May to 4 October, 1942. This exhibit featured one large wall of photomontage, where an enlarged photograph of soldiers marching to battle is juxtaposed with photographs of "typical" American couples, young and old, in the city and the country. The message seems fairly clear: the thousands of anonymous soldiers marching into battle during World War II are ensuring America's victory, and thus the continuation of the American way of life. Subtlety is not a common feature of montage.

The interaction between advertising and montage has also been an enduring and fruitful one. Many of photomontages of the historical avant-gardes—Dada, Futurism, and Surrealism—were born from this exchange. Not only did artists like Höch use materials from mass culture, but many of them, such as Heartfield worked as commercial artists and turned their montages into posters or post cards rather than exhibiting them in traditional

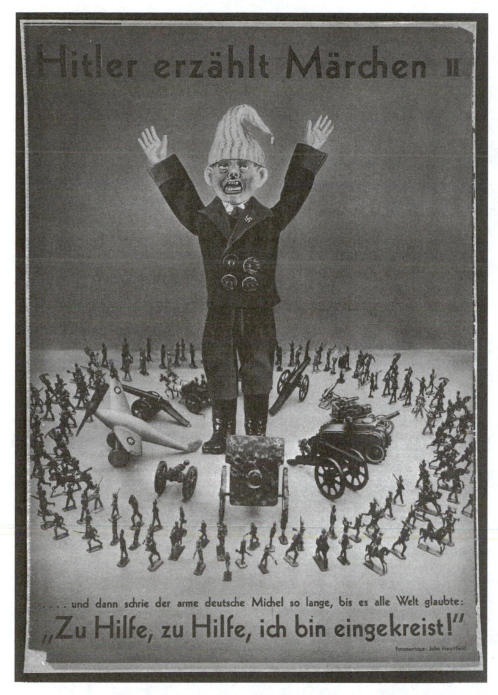

John Heartfield, Hitler erzahlt Marchen II (Hitler tells fairy tales II), from "AIZ, Das Illustrierte Volksblatt," March 5, 1936, p. 160, rotogravure print, rephotographed montage with typography, 37.5 × 26.5 cm, Museum Purchase, ex-collection Barbara Morgan. [*Photograph courtesy of George Eastman House*]

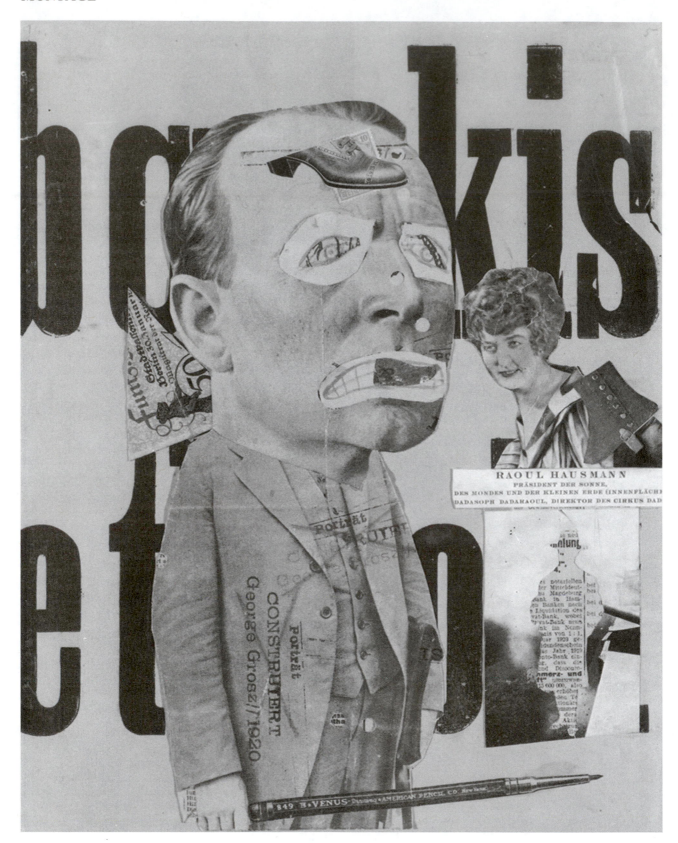

Raoul Hausmann, The Art Critic, 1919–1920, Lithograph and photographic collage on paper, 31.8 × 25.4 cm.
[*Tate Gallery, London/Art Resource, New York*]

means. More recent artists have tended to follow a similar pattern. The German artist Klaus Staeck, for instance, produced a book of photomontages that used famous images and slogans from advertising but manipulated the images to give them new meaning. Barbara Kruger, an American artist, takes images from magazines (many from the post-World War II period) and gives them new captions. *You Are Not Yourself* (1984) shows a woman's crying face reflected in a shattered mirror. The words of the caption appear to be pasted on the image, as if in a ransom note. Kruger's technique is quite similar to Heartfield's, particularly in the use of the caption. Here, the image and caption reflect on the reification of the image of the woman in American advertising. Tibor Kalman, a Hungarian-born American graphic designer, used montage techniques in advertising, but also in advertising-like works that held political and social messages. Kalman's design firm was responsible for a highly controversial series of advertisements for the Italian clothing company, Bennetton, which contained images such as a priest and a nun kissing, or a Black woman nursing a White baby. Kalman was also the editor of the magazine, *Colors*, which utilized remarkably similar images and graphics in articles on social issues such a racism and homophobia. Kalman, unlike many montage artists, was fully immersed in the advertising world. His graphic design firm, M&Co. was extremely successful financially, designing corporate annual reports, commercial packaging, and mainstream advertising campaigns; yet the political message behind much of his work and his statements are not easily reconciled with the corporate work. As media technology has advanced and sped up over the past 50 years, it has increasingly borrowed and assimilated both the techniques and the visual arsenal of the montage artist. Whether or not there is sufficient visual power in montage to continue as an artistic technique and a political weapon remains to be seen.

SCARLETT HIGGINS

See also: **Dada; Futurism; Heartfield, John; History of Photography: Twentieth-Century Developments; History of Photography: Twentieth-Century Pioneers; Höch, Hannah; Image Construction; Kertész, André; Kruger, Barbara; Man Ray; Manipulation; Photographic "Truth"; Propaganda; Surrealism**

Further Reading

Ades, Dawn. *Photomontage*. London: Thames and Hudson and New York: Random House, 1976.

Benjamin, Walter. "Der Surrealismus." In *Angelus Novus*, Frankfurt am Main: Suhrkamp, 1966; As "Surrealism: The Last Snapshot of the European Intelligentsia." In *Reflections: Essays, Aphorisms, Autobiographical Writings*. Ed. Peter Demetz, Trans. Edmund Jephcott, New York: Schocken Books, 1968.

Benjamin, Walter. "Das Kunstwerk im Zeitalter seiner technischen Reproduzierbarkeit." In *Illuminationen*, Frankfurt: Suhrkamp Verlag, 1955; As "The Work of Art in the Age of Mechanical Reproduction." In *Illuminations*. Ed. Hannah Arendt, Trans. Harry Zohn. New York: Schocken Books, 1968.

Buck-Morss, Susan. *The Dialectics of Seeing: Walter Benjamin and the Arcades Project*. Cambridge, MA: MIT Press, 1989.

Bürger, Peter. *Theorie der Avantgarde*. Frankfurt am Main: Suhrkamp Verlag, 1974; As *Theory of the Avant-garde*. Trans. Michael Shaw. Minneapolis: University of Minnesota Press, 1984.

Caws, Mary Ann. *The Surrealist Look: An Erotics of Encounter*. Cambridge, MA: The MIT Press, 1997.

Evans, David, and Sylvia Gohl. *Photomontage: A Political Weapon*. London: G. Fraser, 1986.

Hoy, Anne H. *Fabrications: Staged, Altered, and Appropriated Photographs*. New York: Abbeville Press, 1987.

Perloff, Marjorie. *The Futurist Moment: Avant-garde, Avant Guerre, and the Language of Rupture*. Chicago: University of Chicago Press, 1986.

Teitelbaum, Matthew, ed. *Montage and Modern Life, 1919–1942*. Cambridge, MA: MIT Press, 1992.

Waldman, Diane. *Collage, Assemblage, and the Found Object*. New York: Harry N. Abrams, 1992.

INGE MORATH

German

Inge Morath's life and work revolve around two poles: literature and photography. She began as a writer, photographed numerous authors, married the playwright Arthur Miller, and for 25 years, she has been a popular lecturer on her own achievements in photography. She considers herself a photo journalist in the widest sense of the word, and she clearly describes why photography is settled in the vicinity of literature as her own personal contribution to the world: "The power of photography resides no doubt partly in the tenacity with which it pushes whoever gets seriously involved with it to contribute in an immeasurable number of forms his own vision to enrich the sensibility and perception of the world around him" (Kunsthalle Wien 1999).

Inge Morath was born in Graz, Austria in 1923 and grew up in Germany. She belongs to the so-called *Lost Generation* who were robbed of their youth, future, and perspectives by the national-socialist regime. As a twenty-year-old, she started to study interpreting under war-time conditions, looking for the only legal way to develop her early-discovered linguistic ability. In her autobiography, she gives an impressive description of meeting foreigners immediately after the end of the war, receiving help from them, and her surprise at how trustworthy they were after everything that she had learned to the contrary through propaganda.

Inge Morath's road to the renowned press bureau Magnum Photos was shorter than her road to photography. She accompanied Ernst Haas, with whom she had worked in Vienna on his assignments, but she was independent enough to take on her own jobs, quickly advancing from translator to critic, from interpreter to author. As picture editor of the magazine *Heute*, she was able to provide Ernst Haas with commissions and ideas for series for over half a year. In 1947, she accompanied him on further assignments at distinguished photojournalist Robert Capa's invitation but soon relocated to London.

According to her own account, Inge Morath learned photography like writing in a foreign language. In London, she was an unpaid assistant of Simon Guttmann, who had pioneered the idea of photo agencies in the 1920s, and she learned the basics of daily shooting and work in the darkroom under difficult conditions. When she returned to Paris in 1953, Robert Capa gave her the status of an associate with Magnum. Henri Cartier-Bresson provided her with expert advice on her early work and tips on how to improve it. It is his transition to irony and measured distance that impressed Inge Morath in him above all others. In this way, he handed her the key to emancipate herself from the social roles of woman and the professional role of caption-writer by using abstract picture compositions. The principle of this technique can be seen in her early photographs.

In a 1955 image, Mercedes Formica stands on a narrow balcony, looking past observers and photographer into the vague distance, while behind her several Madrid streets are stacked up on top of each other. The photograph is upright and, due to the positioning of the woman on the extreme left-hand edge, seems so narrow that it is only the car in the lower third of the picture that stops one thinking it is an anamorphotic projection. A technique of photographic abstraction becomes an iconological sign; the distortion characterizes a member of bygone classes just as the emphasis on the vertical characterizes the slightly nervous tension of feminine self-determination in Spain's masculine society.

Inge Morath's operational base moved to the United States. With increasing distance from the Magnum offices, her working methods changed: the lonely journeys and series as direct commission from the agency became rarer. Inge Morath became more and more like a simultaneous translator of actual events. The most important expression of this new, original development is a series of staged single and group portraits which Inge Morath began in New York; she shows the artist Saul Steinberg and his personal circle of friends, all of whose faces are hidden behind paper masks. Another series of this type was taken at the shooting of the film *The Misfits*, showing Marilyn Monroe as an "ecstatic" but unpretentious dancer.

Morath's career was interrupted, however, by her marriage to Arthur Miller and the birth of her daughter Rebecca Miller. She took up projects again in the late 1960s. As her projects became bigger and more complex and could no longer be

squeezed into the confines of a magazine, she undertook books. Many of these projects were closely connected to Arthur Miller's literary and political activities. During this period, Morath also proved herself to be an adept portraitist. Her method was to talk to people, alone and in groups, get close to them, then distance herself again to bring her camera into the situation, camouflaging it with talk and other distractions. Only then would she begin to shoot, studying the first results, rejecting them, starting the process a second, a third, countless times— and often returning in the end to the very first shot.

The difference between her photographic process and the resulting photographs is significant, and it corresponds to the difference between talking and writing: photographing is the performative act; photos are written, corrected, and edited products of lengthy preparation. Inge Morath's mastery developed fully when she employed her communicative competence to this process, and she achieved this at the side of that gifted communicator Arthur Miller. She accompanied him on trips to Russia, China, Latin America, Asia, and Europe. One of her most important photographs of this period is of Joseph Brodsky whom she persuaded to take a walk on the roof of the Peter and Paul Fortress in Leningrad in 1967. On one hand, the shock of the bright light is clearly felt as they step out onto the roof after climbing up through the protective darkness; on the other hand, she cleverly adapts the perspective of the spy from the Soviet government who was certainly present to monitor their actions.

Inge Morath's pictures demonstrate how linguistic competence and artistic activity can be combined. And they also show qualities that photography as a medium and genre still has in the age of motion and electronic media. Inge Morath has added her photographic skill to her linguistic competence, and that has enabled her to achieve extraordinary things— not only in the act of talking and photographing, but more in the resulting pictures and texts.

ROLF SACHSSE

Biography

Born in Graz, Austria, 27 May 1923. Studied in literature and Romance languages, Berlin and Bucharest, 1942–1945. Translator for the *United States Information Services* and

Inge Morath, Joseph Brodsky takes a walk in Leningrad, Leningrad, Russia, 1967.
[© *Inge Morath/Magnum Photos*]

contributor to *Heute* magazine in Vienna, 1946–1949. Cooperation with the photographer Ernst Haas and free-lance author in Vienna and Paris, 1949–1950. Freelance author, began own photography and internship with Simon Guttmann in London, 1951–1953. Associate Membership with Magnum Photos and first assignments in photography, Paris, 1953. Assistant to Henri Cartier-Bresson, Paris and Spain, 1953–1954. Magnum commission by Robert Capa for portraying women in Spain, 1954–1955. Full membership with Magnum since 1955. Journeyed to Iran, 1956. Has lived in U. S. since 1959. Married to Arthur Miller, 1962; one daughter, Rebecca. Journeyed to the USSR, 1965, to China, 1978. Grand Austrian State Award for Photography, 1991. Honory Gold Medal of the Federal Capital Vienna, 1999. Lives in Roxbury, CT.

Individual Exhibitions

1956 Galerie Wuerthle; Vienna
1958 Leitz Gallery; New York
1964 Art Institute of Chicago; Chicago, IL
1969 Oliver Woolcott Memorial Library; Litchfield, CT
1971 Art Museum Andover; Andover, MA
1972 University of Miami; Miami, FL
1974 University of Michigan; Ann Arbor, MI
1979 Grand Rapids Art Museum; Grand Rapids, MI
1980 *Photographien aus China*; Kunsthaus; Zürich, Switzerland
1982 Galerie Fotohof; Salzburg, Germany
1986 *Portraits*; Gotham Bookmart Gallery; New York, traveling through the U.S. and Germany
1991 *Russian Journe*; Berman Gallery; New York
1992 *Fotografien 1952–1992*; Neue Galerie der Stadt Linz; Linz, traveling through Austria, Germany, Czechia, the U.K., Tokyo
1995 *Spain in the Fifties*; Museo de Arte Contemporáneo; Madrid, traveling through Spain and Latin America
1996 *The Danub*; Neues Schauspielhaus; Berlin, traveling through the U.S., Hungary, The Netherlands, France, and Germany
1999 *Life As A Photographer*; Kunsthalle; Vienna

Group Exhibitions

1976 *Women see Women*; First Women's Bank; New York
1988 Photojournalists' Union; Moscow
1998 *Celebrating 75 Years*; Leica Gallery; New York

Selected Works

Mrs. Eveleigh Nash; The Mall; London, 1953
Doña Mercedes Formica on Her Balcon; Calle de Recoletos; Madrid, 1955
Window Washers; Rockefeller Center; New York
Alberto Giacometti in his Studio; Paris, 1958
Saul Steinberg with Mask in his Yard; New York, 1959
Marilyn Monroe in Ecstatic "Dance": The Misfits; Reno, Nevada, 1960
Joseph Brodsky on the Roof of the Peter and Paul Fortress; Leningrad, 1967
Joseph Brodsky takes a walk in Leningrad; Leningrad, Russia
Bikers; Beijing, 1978

Further Reading

Aubier, Dominique, and Inge Morath. *Fiesta in Pamplona*. New York : Universe Books 1956.
Miller, Arthur, and Inge Morath. *In Russia*. New York : A Studio Book, Viking Press 1969.
Andreyev, Olga Carlisle, and Inge Morath. *Grosse Photographen unserer Zeit*. Luzern: Bucher 1975.
Kaindl, Kurt, ed. *Inge Morath Fotografien 1952–1992*. Salzburg: Edition Fotohof, Otto Müller, 1992.
Wein, Kunsthalle, Gerald Matt, and Sabine Folie, ed. *Inge Morath: Life As A Photographer*. Munich: Kehayoff, 1999.
Morath, Inge. *Spanien in den Fünfziger Jahren*. Altzella: Internationales Fotomuseum Inge Morath Batuz Foundation, 2000.

YASUMASA MORIMURA

Japanese

Born in the port city of Osaka in 1951, Morimura grew up in the unfashionable heartland of Japan. The economic hub of the Kansai region of Japan, Osaka lacks the illustrious history of nearby Kyoto or the cosmopolitanism of neighboring Kobe. Despite this starting point, Morimura became one of the most provocative and cosmopolitan photographers of the late twentieth century. He is best known for taking photographs which copy icons of western culture but include his own face or body in the place of the central character. This is especially disconcerting for the viewing audience, as the characters he replaces are often women such as Madonna, Marilyn Monroe, and the Mona Lisa.

Brought to prominence by having his pictures displayed at the 1988 Venice Biennale and by the inclusion of his work in several touring shows of Japanese photographers in the late 1980s, he sealed

his arrival with his 1990 *Daughter of Art History* exhibition in Tokyo. Morimura's photographs are large, glamorous, and playful, but they also have a serious intent. Whereas modernist art is often iconoclastic, Morimura's postmodernism can best be described as icono*plastic*. He manipulates some of the most celebrated images from the history of western painting, twentieth-century poster art, and contemporary culture to make accepted images provocative once again. He achieves this primarily by using the crafts and techniques associated with movie-making: building sets, creating costumes and makeup, carefully controlling the lighting, and using himself as model. He works primarily in sequences such as *Marilyn*, *Mona Lisa*, or *Judith* (after Cranach the Elder's *Judith with the Head of Holofernes*) in which the settings of the pictures, the relationships of the elements of the picture, and its tone are changed from one photograph to the next, tracing a narrative of the image's deconstruction.

Morimura is often compared to the American Cindy Sherman because of their shared penchant for tongue-in-cheek tableaux and sexually subversive self-portraits. Morimura acknowledges her influence in his photograph "To My Little Sister: for Cindy Sherman" (1998)—which reprises Sherman's "Untitled #96" (1981)—with himself as the subject. Sherman's main influence comes through her *Untitled Film Stills* (1977–1980) and *History Portraits* (1989–1990) in which her self-portraits are at their most iconic and most disruptive of gender stereotypes.

Three crucial differences exist, however, in Morimura's work that set him apart from Sherman. First, whereas Sherman is a woman dressing as a woman for her pictures, Morimura often, but not exclusively, cross-dresses as a woman, changing the nature of the challenge to essentialist views of art and gender in the photographs. Second, Morimura is Japanese and thus ethnically different from the western celebrities whose images he emulates, his work alluding to such aspects of contemporary life as cultural colonialism and racial stereotyping. Finally, Morimura uses specific images rather than generic ones, dealing with cultural icons as a genre rather than exploring the genres that an iconic image might represent. For example, he made a number of Marilyn Monroe pictures based on several of the most famous images of the actress, whereas Sherman's *Untitled Film Stills* are original, anonymous pictures based on the genre that the Monroe pictures embody.

By inscribing himself into pictures where the central character often is neither male, Japanese, nor an artist, Morimura destabilizes assumptions about gender, nationality, or race, and the function of the artist. Morimura's best-known and difficult images are those in which he appears in the place of an alluring icon of femininity, often making little attempt to disguise that he is male and very unlike the original subject. By doing so, Morimura deflects the prurient heterosexual male gaze which he feels determined the "originals," and he can be understood as a cross-dressing male artist in the western tradition or as an *onnagata*, (men who play women characters) in the Japanese *kabuki* tradition. Whether understood within one or both of these traditions, he reminds us that the object of desire is always determined by convention. This is best exemplified by his *Self-Portrait (Actress)/Black Marilyn* (1996), in which he reprises Marilyn Monroe's famous skirt-blown-up pose, except that in this picture Morimura, rather than Marilyn, has let the black skirt blow up to reveal a large, fake semi-erect phallus complete with bushy black pubic hair. The photograph trumps the coy concealment of conventional desire through three "revelations": Morimura is pretending to be Marilyn Monroe "revealing" the epitome of male desire as male; Marilyn's famous holding down of the skirt is "revealed" as an attempt to hide a prosthetic penis; the black pubic hair (of *Black* Marilyn) "reveals" that this most famous of blonde models is a bottle blonde.

In the late twentieth century, the flow of transnational capital was marked in the public consciousness by the more visible flow of images across national borders. With a picture like *Self-Portrait (Actress)/After Catherine Deneuve 3* (1996), Morimura highlights the orientalist bias of the original picture. In the original poster, the exotic Japanese setting sells the star to the western audience for her films after whom eastern audiences are encouraged to model themselves. By replacing Deneuve with a Japanese face, the image that had first arrived in Japan as a western image selling the Japanese an orientalized western view of themselves is re-appropriated as an ironic Japanese view of orientalism.

Morimura provokes a similar reappraisal of Manet's *Olympia*, redone as *Portrait (Futago)* (1988–1990). By making Olympia a Japanese model, Morimura highlights the racially motivated demotion of the Black figure who stands behind her, a character neglected not only by Manet but also by the feminist critics that had argued on behalf of Olympia in the 1980s.

Morimura was trained as a painter at the Kyoto City University of Arts, and in his early work, he often used his skills in this area to create his images. At the end of the century, he moved more towards

digital means to create his tableaux. He also used digital technology to create such works as *Yen Mountain*, in which he substituted the portraits on Yen notes with his own face, or to design on his self-promotional website modelled after that of a department store.

DAN FRIEDMAN

See also: **Constructed Reality; Photography in Japan; Postmodernism; Representation and Gender; Representation and Race; Sherman, Cindy**

Biography

Born in Osaka, Japan 1951. Educated in Osaka. 1974–1978 Kyoto City University of Arts. 1978 Graduated with BA in Fine Art. First exhibition in Kyoto in 1983. First self-portrait in 1985 as Vincent Van Gogh. Featured in Venice Biennale, 1988. Critical acclaim for his *Daughter of Art History* exhibition in Tokyo brings him to international notice, 1990. International exhibitions and collaborations in New York, London, and Milan plus touring shows across Europe and Australia throughout the mid-1990s. New work involving sculpture, live performance, and web design in the latter part of the decade. Lives and works in Osaka.

Individual Exhibitions

1983 Galerie Marronnier; Kyoto, Japan
1984 Hiramatsu Gallery; Osaka, Japan
1986 *Mon amour violet et autres*; Gallery Haku; Osaka
1988 On Gallery; Osaka, Japan
 Gallery NW House; Tokyo
1989 *Criticism and the Lover*; Mohly Gallery; Osaka, Japan
1990 *Daughter of Art History*; Sagacho Exhibit Space; Tokyo
 Nicola Jacobs Gallery; London
1991 Thomas Segal Gallery; Boston, Massachusetts
 Luhring Augustine Gallery; New York, New York
1992 Museum of Contemporary Art; Chicago, Illinois
1993 *9 visages*; Fondation Cartier pour l'art contemporain; Jouy-en-Josas, France
 Visions of Beauty; Nishida Gallery; Nara, Japan
1994 *Psychoborg*; The Ginza Art Space; Shiseido, Tokyo
 Psychoborg; The Power Plant, Toronto; Walter Philips Gallery, The Banff Center for the Arts, Alberta, Canada
 Rembrandt Room; Hara Museum of Contemporary Art; Tokyo
1996 *Morimura Yasumasa: The Sickness unto Beauty, Self Portrait as Actress*; Yokohama Museum of Art; Yokohama, Japan
 Actress and Art History; Center for Contemporary Photography; Melbourne, Australia
1997 *Actors and Actresses*; Contemporary Arts Museum; Houston, Texas
 ART & PUBLIC; Geneva, Switzerland
1998 *Self-portrait as Art History Morimura Yasumasa*; Museum of Contemporary Art, Tokyo; The National Museum of Modern Art, Kyoto; Marugame Genichiro Inokuma Museum of Contemporary Art

Group Exhibitions

1984 *Can't You See We Are Not Reticent?* Gallery [vju:], Osaka
1985 *Smile with Radical Will*; Gallery 16; Kyoto
1987 *Yes Art deluxe*; Sagacho Exhibit Space, Tokyo; Gallery Haku, Osaka, Japan
 November East Wind; ON Gallery, Osaka, Japan; P&P Gallery, Seoul, Korea
 Photographic Aspect of Japanese Art Today; Tochigi Prefectural Museum of Fine Arts; Utsunomiya, Japan
1988 XLIV La Biennale di Venezia, Aperto '88; Venice, Italy
 Art Now '88; Hyogo Prefectural Museum of Modern Art; Kobe, Japan
1989 *Against Nature: Japanese Art in the Eighties*; San Francisco Museum of Modern Art, San Francisco; Akron Art Museum, Ohio; List Visual Arts Center, Massachusetts Institute of Technology, Cambridge, Massachusetts; Seattle Art Museum, Seattle, Washington; The Contemporary Arts Center, Cincinnati, Ohio; Grey Art Gallery and Study Center; New York University, New York; Contemporary Arts Museum, Houston, Texas; ICA Nagoya, Japan
 Art Exciting '89: Beyond the Present; The Museum of Modern Art, Saitama, Japan; Queensland Art Gallery, Brisbane, Australia
 Europalia '89 Japan: Japanese Contemporary Art 1989; Museum of Contemporary Art; Ghent, Belgium
1990 *Reorienting: Looking East*; Third Eye Centre; Glasgow, United Kingdom
 Culture and Commentary: An Eighties Perspective; Hirshhorn Museum and Sculpture Garden; Washington, D.C.
 Japanese Contemporary Photography: Twelve Viewpoints; Tokyo Metropolitan Museum of Photography-*Tokyo à Paris*; Pavillon des Arts; Paris, France
 Japanische Kunst der 80er Jahrer; Frankfurter Kunstverein, Frankfurt am Main: Bonner Kunstverein, Bonn; Hamburger Kunstverein, Hamburg; Kunstlerhaus Bethanien, Berlin; Musuem Moderner Kunst, Wien
 Japan Art Today: Elusive Perspectives/Changing Visions; The Cultural Center of Stockholm, Stockholm, Sweden; The Exhibition Hall Charlottenborg, Copenhagen, Denmark; Helsingin Kaupungin Taidemuseo, Helsinki, Finland; The Reykjavik Municipal Museum, Reykjavik, Iceland; Museum of Modern Art, Seibu Takanawa, Karuizawa
1991 *Metropolis*; Martin-Gropius-Bau; Berlin, Germany-*Trans/Mission- Art in Intercultural imbo*; Rooseum Center for Contemporary Art; Malmo, Sweden
 Zones of Love: Contemporary Art from Japan; Toyko Museum of Contemporary Art, Tokyo; Art Gallery of Western Australia, Perth; Art Gallery of South Australia, Adelaide; Waikato Museum of Art and History, Hamilton, New Zealand; Dunedin Public Art Gallery, Dunedin, New Zealand; Museum of Contemporary Art, Sydney, Australia
 A Cabinet of Signs: Contemporary Art from Post-Modern Japan; Tate Gallery Liverpool; Whitechapel Art Gallery, London; Malmö Konsthall, Sweden
1993 *Post Human*, FAE Musée d'Art Contemporain, Lausanne, Switzerland; Castello di Rivoli, Museo d'Arte Contemporanea, Torino, Italy; Deste Foundation for Contemporary Art, Athens, Greece; Deichtorhallen Hamburg, Germany

Homage to Spanish Still Life by Yasumasa Morimura & Miran Fukuda, Nagoya City Art Museum; Nagoya, Japan

1994 *Japanese Art After 1945: Scream Against the Sky*; Yokohama Museum of Art, Yokohama, Japan; Guggenheim Museum SoHo, New York

Inside Out: Contemporary Japanese Photography; The Light Factory Photographic Arts Center, Charlotte, North Carolina; Kemper Museum of Contemporary Art, Kansas City, Missouri

1995 *Cocido y Crudo*; Museo Nacional Centro de Arte Reina Sofia; Madrid

Objects, Faces and Anti-Narratives—Rethinking Modernism; Tokyo Metropolitan Museum of Photography; Tokyo, Japan

Japan Art Today; Louisiana Museum for Moderne Kunst, Humlebaek, Denmark, Kunstnernes Hus, Oslo, Norway; Wäinö Aaltosen Museo, Turku, Finland; Liljevalchs Konsthall, Stockholm; Osterreichisches Museum fur Angewandte Kunst, Vienna; Deichtorhallen in Hamburg

Duchamp's Leg; Walker Art Center, Minneapolis, Minnesota; Center for the Fine Arts, Miami, Florida

1997 *Images of Women in Japanese Contemporary Art 1930's–1990's*; Shoto Museum; Tokyo

Rrose is a Rrose is a Rrose: Gender Performance in Photography; Solomon R. Guggenheim Museum; New York, New York

1998 *Tastes and Pursuits: Japanese Art in the 1990s*; New Delhi National Modern Museum; New Delhi, India

Selected Works

Self-Portrait, Gogh, 1985
Portrait (Futago), 1988–1990
Yen Mountain, 1991
Self-Portrait (Actress)/Black Marilyn, 1996
Self-Portrait (Actress)/After Catherine Deneuve 3, 1996
To My Little Sister: for Cindy Sherman,1998
Judith (1991)
Monna Lisa: In its Origin/In Pregnancy/In The Third Place, 1998

Further Reading

Annear, Judy. "Mirrors in the Water: The Work of Yasumasa Morimura." *Binocular* (November 1992): 149–157.

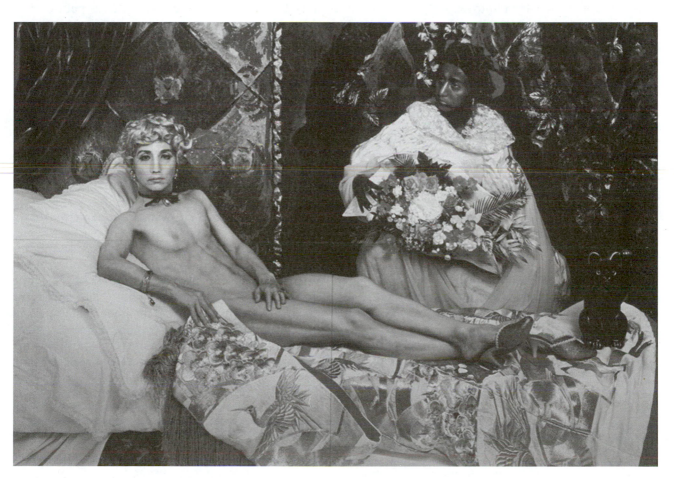

Yasumasa Morimura, Portrait (Futago), 1988.
[© *Courtesy of the artist and Luhring Augustine, New York*]

Francis, Richard. "Your Bag of Thrills." In *A Cabinet of signs: contemporary art from post-modern Japan*. Liverpool: Tate Gallery Liverpool, 1991.

Friis-Hansen, Dana. "Miran Fukuda and Yasumasa Morimura." *Flash Art* (Summer 1992): 128.

Monroe, Alexandra. *Japanese Art after 1945: scream against the sky*. New York: Harry N. Abrams, 1994.

Morimura, Yasumasa. *Daughter of Art History: Photographs by Yasumasa Morimura*. Millerton, New York: Aperture, 2003.

WRIGHT MORRIS

American

In 1933, Wright Morris left college for a year of travel in Europe and bought his first camera, a Zeiss Kolibri, in Vienna. Although he returned to California in 1934 hoping to become a writer, Morris remained intrigued by photography. In 1935, he began with cloud studies captured on his Rolleifex; he then turned to photographing alleys, structures, and artifacts. By 1936, Morris began writing short prose paragraphs that anticipate the style of his 1946 publication *The Inhabitants*.

Moving east to Middlebury, Connecticut, Wright traveled to Cape Cod and other parts of New England, where he worked with his first view camera, a 3¼ × 4¼-inch Graphic. It was in 1938 that he first encountered photographs by Walker Evans, who became one of Morris's most important photographic influences. By 1939, he had conceived of a photo-text project; it was approved for publication by James Laughlin at New Directions. Morris also interviewed with Roy Stryker of the Farm Security Administration photography project, although Stryker was confused by and ultimately not impressed with the lack of people in Morris's photographs, and thus he was not hired by this now-legendary government make-work program.

The 1940s represent Morris's most important period. He sold two photographs submitted in a photography contest to the Museum of Modern Art in 1940 and published his first photo-text essay. His photographic mission had crystallized: he sought to capture icons of the American landscape in order to preserve the past as well as to celebrate the beauty conveyed by utilitarian structures that had often fallen into disrepair. A large proportion of photographs from the 1940s depict barns, houses (interiors and exteriors), barbershops, churches, and grain elevators. Morris believed that the absence of people in these photographs paradoxically "enhanced" their presence: the structures and objects, he argued, strongly suggested the "appropriate inhabitant."

Wright's working method was the photographic expedition, which culminated in his first and defining experiments in photo-texts—*The Inhabitants*, published in 1946, and *The Home Place*, published in 1948. His first photographic tour lasted nine months: in 1940 and 1941 he traveled through the south, midwest, and southwest to California then back to New York. His first Guggenheim Fellowship allowed Morris to travel to the West Coast again in 1942, returning to New York via Nebraska, his birth state.

In 1943, he undertook yet another photo-safari that began in California and culminated with his relocation in Bryn Mawr, Pennsylvania, but included travel through Colorado and Nebraska. His second Guggenheim Fellowship permitted Morris to embark on a photographic trip to Nebraska in May and June of 1947, by which time he was using a 4 × 5-inch view camera.

In *The Inhabitants*, Morris juxtaposes a photograph on the right with text on the left in each spread. Images of buildings predominate; not one person appears. Instead of short, descriptive, or factual captions that were by then traditional in the photographic series, the text combines what seems to be part of a running narrative by the author with self-contained paragraphs that employ varying personae. The former reads like an essay or non-fiction; the latter like an excerpt from a short story or novel. Conceptually, this was a daring experiment on Morris's part, for instead of recording the inhabitants of these buildings and locales through his camera, he provides for their existence through his imagination in the form of words.

These texts, however, do not function as prose poems that describe the photographic content or offer a symbolic equivalent. Rather, they are echoes

that hover within the visual traces that the camera has set down. Part of what makes Morris's method unique is that the photographs and texts do not create a sequential narrative. He utilized a boldface headline to establish a linear, progressive unfolding over the course of the book. At times the headlines interact with or refer to the text that follows, especially in those which give voice to people Morris had met and sometimes knew well, such as family members. *The Inhabitants*, as unique as it is, however, might be considered the raw material or draft for what is arguably a more radical experiment in photo-text—*The Home Place*, published two years later in 1948.

The text of *The Home Place* is a novel, a consciously crafted narrative with characters, plot, and setting. Interwoven with the text are photographs without captions. These images are paired on each spread of the book with the ongoing text. The first photograph and first sentence of the novel give a false impression that the pairs of images and texts will directly connect throughout the work. Subsequent spreads, however, diverge from a direct connection. For many spreads, there is no mention in the text of what is displayed in the facing photograph; sometimes there is not even any concrete reference to an image within the entire novel. *The Home Place* was unprecedented in its design and concept and might be said to anticipate artists' books that emerged in the 1960s.

Because Morris had published two novels, his theory and execution of the photo-text, particularly in *The Home Place*, were confusing to reviewers (who considered him a novelist first) as well as to his readers. In an interview from the 1970s, Morris indicates that although *The Home Place* was well received, it pointed out a dilemma: he was losing readers and picking up lookers. By the 1950s, Morris abandoned his photo-text experiments and concentrated on a career exclusively in words. His publisher declined to include photographs in Morris's 1949 novel, *The World in the Attic*, and although he intended his third Guggenheim Fellowship in 1954—a trip to Mexico—to include photography, he abandoned his photographic ambitions as he became deeply immersed in the novel that he was writing.

By 1967, Morris had returned to photography and photo-texts. Over the next 20 years, he produced two new photo-texts, *God's Country and My People* and *Love Affair—A Venetian Journal*, and provided the words to a third, *Picture America*. He also published several essays and books on photography, including *Photographs & Words* and *Time Pieces: Photographs, Writing, and Memory*. Before his death in 1998, Morris lived to see a renewed interest in his photographs and his photo-texts; a major retrospective exhibition was held at the San Francisco Museum of Modern Art in 1992. His legacy relates not just to the photographs that he took but even more significantly to his ideas on and experimentation with the creative (as opposed to documentary) use of photography and text.

NANCY M. SHAWCROSS

See also: **Artists' Books**

Biography

Born in Central City, Nebraska, 6 January 1910. Attended Pomona College (1930–1933). Three John Simon Guggenheim Memorial Fellowships (1942 and 1946 in photography, 1954 in literature). National Book Award (1957 for *The Field of Vision*). National Institute Grant in Literature (1960). Professor of Creative Writing, California State University, San Francisco (1962–1975). Honorary degrees from Westminster College and University of Nebraska (1968) and from Pomona College (1973). Mari Sandoz Award (1975). Senior Fellowship, National Endowment for the Humanities (1976). Distinguished Achievement Award, Honorary Life Membership, Western Literature Association (1979). Robert Kirsch Award, Los Angeles Times (1981). American Book Award (1981 for *Plains Song*). Commonwealth Award for Distinguished Service in Literature, Modern Language Association (1982). Mark Twain Award (1982). Whiting Writers Award, The Whiting Foundation (1985). Life Achievement Award, National Endowment for the Arts (1986). Died 25 April 1998.

Individual Exhibitions

1975 *Wright Morris: Structures and Artifacts, Photographs 1933–1954*; Sheldon Memorial Art Gallery, University of Nebraska; Lincoln, Nebraska, and traveling

1979 *Wright Morris*; University Art Museum, University of California; Berkeley, California

1983 *Time Pieces: The Photographs and Words of Wright Morris*; Corcoran Gallery of Art; Washington, D.C.

1992 *Wright Morris: Origin of a Species*; San Francisco Museum of Modern Art; San Francisco, California

2001 *At Home with Wright Morris: Photographs and Books by Wright Morris*; Sheldon Memorial Art Gallery, University of Nebraska; Lincoln, Nebraska

Selected Works

Picture America, with James Alinder, 1982

Photographs & Words, 1982

Wright Morris: Structure and Artifacts, Photographs, 1933–1954, 1976

Time Pieces: Photographs, Writing, and Memory, 1989

Writing My Life: An Autobiography, 1993 (comprising *Will's Boy: A Memoir*, 1981; *Solo: An American Dreamer in Europe: 1933–1934*, 1983; *A Cloak of Light: Writing My Life*, 1985)

Further Reading

Morris, Wright. *The Inhabitants*. New York: Charles Scribner's Sons, 1946.

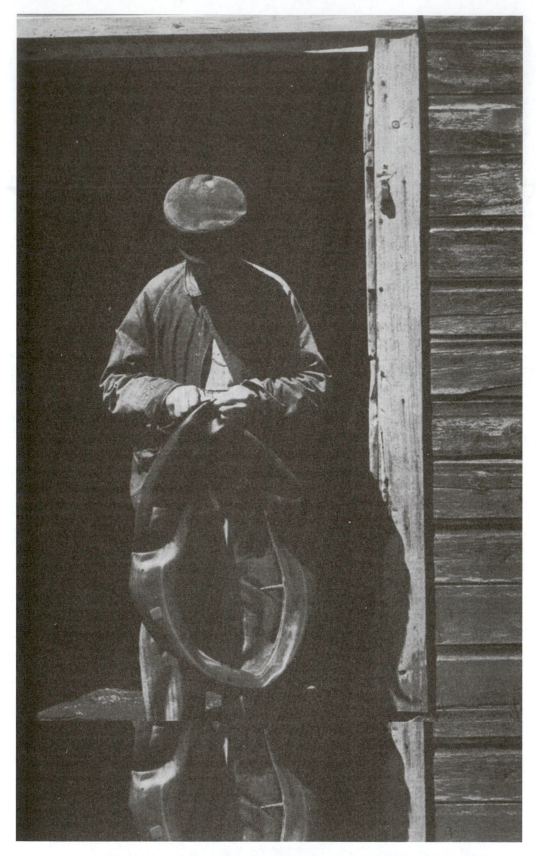

Wright Morris, Uncle Harry with Inner Tube, from The Home Place by Wright Morris, 1948.
[*Reproduced from The Home Place by Wright Morris by permission of the University of Nebraska Press. Copyright 1948 by Wright Morris*]

———. *The Home Place*. Lincoln: University of Nebraska Press, 1948.

———. *God's Country and My People*. New York: Harper & Row, 1968.

———. *Love Affair–A Venetian Journal*. New York: Harper & Row, 1972.

Shawcross, Nancy M. "Counterpoints of View: The American Photo-text, 1935–1948." In *Literary Modernism and Photograph*. Westport, Conn.: Greenwood Publishing Group, 2002.

Trachtenberg, Alan. "Wright Morris's 'Photo-texts.'" *The Yale Journal of Criticism* 9:1 (1996): 109–119.

———. *Distinctly American: The Photography of Wright Morris*. London: Merrell Publishers Ltd., 2002.

Wydeven, Joseph J. *Wright Morris Revisited*. New York: Twayne Publishers, 1998.

STEFAN MOSES

German

Born in 1928 in the Silesian town of Liegnitz, Stefan Moses is one of the most important German photographers of the second half of the twentieth century. In addition to his photographic features for magazines, including *Neue Zeitung, Das Schönste, Revue, magnum,* and starting in 1960, also for *Stern,* his success was particularly due to his independent projects, in which he brought together concept and candid photography and created an innovative visual language with a unique personal character. Starting in the 1960s, he compiled books of portraits and photo series, which had a broad influence, including *Manuel* (1967), *Transsibirische Eisenbahn* (Trans Siberian Railroad, 1979), *Deutsche* (Germans, 1980), *Abschied und Anfang—Ostdeutsche Porträts* (A Farwell and a Beginning—East German Portraits 1991), *Jeder Mensch ist eine kleine Gesellschaft* (Each Person is a Small Society, 1998) and *DDR—ende mit wende* (GDR—back from the turning point, 1999).

Through today, he has remained true to the portrait as both a photographic genre and manifold psychological portrait of German society. "Germany and the Germans" has been at the core of his lifelong work. His extensive series reflect the social and cultural development of the Bundesrepublik. The project, *East German Portraits* from 1989 and 1990 could be considered the most important photographic work about the process of German reunification. His oeuvre, a "synonym for photography in Germany," as one critic described, constitutes a significant contribution to the discussion surrounding the issue of German identity.

For over five decades, Moses has been creating portraits of the Germans in the stylistic tradition of the "roving photographer." His images—of old and young, artists and intellectuals, poor and rich, their homes and celebrations, organizations and schools—have garnered him the role of the chronicler and portrait photographer of German post-war society. His approach is understandably simple. Ordinary and prominent citizens in Cologne, Berlin, or Munich are depicted in front of a gray felt cloth that he carries with him. The neutral background functions like a stage, and the poses take on an emblematic quality. The individual is removed from a familiar environment, and this relativizes his or her social standing. These typological portraits are individualized studies of universal relevance—"the shortest of all operas ever written," according to the German art historian, Wolfgang Kemp.

Moses approaches his countrymen from both East and West with analytical intuition and affectionate warmth. His photographs demonstrate a sensitive, curious, and inquisitive view of his contemporaries. With a profound understanding of human nature, he studies the people he encounters with great psychological sensibility, and he penetrates physiognomies in a way that builds on a dialogue with the earlier systematic photo series of August Sander and Irving Penn.

The list of people Moses has photographed reads like a *who's who* of the German-speaking intellectual and cultural elite: Theodor W. Adorno, Ingeborg Bachmann, Ernst Bloch, Heinrich Böll, Willy Brandt, Hans Magnus Enzensberger, Max Frisch, Günter Grass, Walter Jens, Erich Kästner, Thomas Mann, Ludwig Meidner, Bernhard Minetti, Alex-

ander Mitscherlich, Carl Orff, Botho Strauß, Martin Walser and Peter Zadek—major figures of twentieth-century Germany.

The contemporary events he documented and the German cultural personalities he photographed are of unparalleled breadth. His colleagues at the magazine *Stern*, for example, Robert Lebeck, Thomas Höpker, and Max Scheler, primarily worked in foreign photographic journalism—particularly in the 1960s. In contrast, Moses preferred to travel in Germany, which he describes as "the most interesting country in the world".

Following in the footsteps of his father, a passionate hobby photographer who died at a young age, Moses took his first photographs in 1936 with a large-format Steinheil camera that had belonged to his father. From then on, photography "had taken hold of him." At 15, while forced to work for a Breslau photo company, he began his professional training with Grete Bodlée, a photographer of children. Stefan Moses learned how to use the small-format Leica and how to compose a photographic portrait. Due to his Jewish ancestry, he was sent to the Ostlinde work camp, from which he managed to escape in 1945. Late that same year, he continued his training in Erfurt. After completing his apprenticeship, he was engaged as a theater photographer for the Weimar Nationaltheater in 1947. This was the initial source of his great enthusiasm for the theater, which remains with him today.

In 1950, shortly after the founding of the GDR, he moved to the Schwabing section of Munich—renowned as a bohemian neighborhood since the turn of the century. His colleagues and friends, Jo von Kalckreuth and Herbert List, lived next door. Moses worked as a photojournalist for newspapers and magazines. Today, he still sees no difference between journalistic and artistic photography.

A few of his series are particularly outstanding. *Manuel*, the first publication as photo series in postwar Germany, soon became a cult book of the 1960s generation of parents. Here, Moses depicts his son Manuel's first year of childhood as a poetic story told in images. For his series *Die großen Alten* (The Great Elders), Stefan Moses chose the German forest as his backdrop. Since the 1960s, he has created his unmistakable portraits of German politicians, authors, and artists in this mythical and magical setting.

For over four decades, the photographer has asked painters, sculptors, and even some colleagues to create a mask out of materials from their immediate surroundings. This series, *Künstler machen Masken* (Artists Make Masks), which is still being continued today, was initiated in 1964 with portraits of the sculptor Gerhard Marck and the painter Ernst Wilhelm Nay.

Moses has German philosophers and thinkers photograph themselves in a standing mirror that he provides, so that the photographer appears in the background of this conceptual series, called *Spiegelbilder* (Mirror Images), as the inspirational director of the scene.

Since the 1970s, Moses has consistently compiled and published photo essays. In 1979, this approach took the form of the trend-setting publication, *Transsibirische Eisenbahn* (Trans Siberian Railroad), with 26 photo narratives, evocative and metaphoric images of human encounters.

Since 1953, he has been hot on the heels of photographic subjects from throughout the world and has researched his reports through different trips to regions of North and South America and Asia, but largely in numerous European countries, Israel, Italy, Austria and also Hungary, where he documented the Hungarian Revolution of 1956. With its numerous awards, exhibitions, and publications, this consistent and continuously expanding body of work has also been internationally recognized as one of the most outstanding German contributions to photography in the second half of the twentieth century. In 1990, Moses was awarded the David-Octavius-Hill Medal of the Gesellschaft Deutscher Lichtbildner (GDL), and the following year he received the "Honors Award of the City of Munich," awarded to a photographer for the first time. In 1994, Moses was the first photographer to be named a proper member of the Academy of the Fine Arts in Munich. The photographer's archive (negatives, slides, original prints, records) is in the collection of the Photography Museum within the Munich City Museum, which featured the first international retrospective of his work in 2002. An accompanying monograph has been published in order to do justice to the exhaustive scope of this photographer's work.

MATTHIAS HARDER

Biography

Born in 1928 in Liegnitz in Lower Silesia. 1936, first photographs with his father's large-format Steinheil camera. 1943, beginning of his professional training as an assistant to the children's photographer, Grete Bodlée. Training continued after the end of the war as an apprentice in Erfurt. 1944–1945, interned in the Ostlinde labor camp 1947–1950, first employment as a theater photographer in the Nationaltheater in Weimar. 1950, moved to Munich, where he worked as a photojournalist for magazines, such as the *Neue Zeitung, Revue, Das Schönste*, and magnum. Traveled to New York, South America, Israel, and Asia in the 1950s and 1960s. 1960–1968, features for the magazine *Stern*; began his long-term photographic projects about

Germany and the Germans, which ultimately became his central themes. Independent projects, including books like *Manuel* (1967), *Transsibirische Eisenbahn* (1979), *Deutsche* (1980), *München* (1980) and *FlicFlac* (1981) 1989–1990, Photo series *Abschied und Anfang—Ostdeutsche Porträts* commissioned by the Deutsches Historisches Museum in Berlin. 1990, awarded the David-Octavius-Hill Medal of the photographic society, Gesellschaft Deutscher Lichtbildner (GDL) 1991, honored with the cultural recognition award of the city of Munich. 1994, named a proper member of the Akademie der schönen Künste in Munich. 1995, the Photography Museum of the Munich Stadtmuseum purchased the photographer's archives. 2001, Honorary Award of the Stankowski Foundation, Stuttgart.

Individual Exhibitions

1988 *Transsibirische Eisenbahn*; Holbeinhaus, Kunstverein; Augsburg, Germany

1990 *Stefan Moses*; Städtische Galerie Filderhalle; Leinfelden-Echterdingen, Germany

1991 *Abschied und Anfang. Ostdeutsche Porträts*; Deutsches Historisches Museum; Berlin, Germany, traveling through Germany and abroad

1998 *Selbst im Spiegel—Jeder Mensch ist eine kleine Gesellschaft*; Bayerische Akademie der Schönen Künste; München, Germany

1999/2000 *ende mit wende—DDR*; Schillermuseum; Weimar, Germany (traveling through Germany: Galerie der Stadt Stuttgart, and Stadtmuseum Hofheim)

2000 *Manuel*; Argus Fotokunst; Berlin, Germany

2001 Ernst Bloch-Zentrum; Tübingen, Germany

2002/3 *Deutsche Vita—Retrospektive*; Fotomuseum im Münchner Stadtmuseum, traveling through Germany and abroad

Group Exhibitions

1965/66 *Ost und West—Fotoreportagen* (Thomas Höpker, Stefan Moses, Max Scheler, Eberhard Seeliger); Museum für Kunst und Gewerbe; Hamburg, Germany (traveling through Germany: Stadtmuseum München, Kunstverein Bremerhaven, Bezirksamt Berlin-Reinickendorf)

1979 *Fotografie 1919–1979 Made in Germany—Die GDL-Fotografen*; Fotomuseum im Münchner Stadtmuseum; München, Germany

 Deutsche Fotografie nach 1945; Kasseler Kunstverein; Kassel, Germany

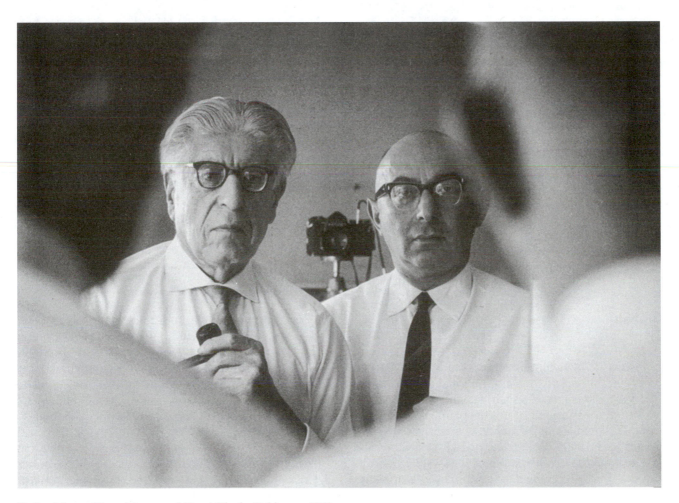

Stefan Moses, Hans Mayer and Ernst Bloch, Tubingen, 1963.
[© *Fotomuseum im Munchner Stadtmuseum*]

1980 *Deutsche Fotografie nach 1945*; Kunstverein; Wolfsburg, Germany

1993 *Denk ich an Deutschland*; Kupferstich-Kabinett, Staatliche Kunstsammlungen; Dresden, Germany; National Portrait Gallery, London, GB

1996 *Das deutsche Auge. 33 Photographen und ihre Reportagen—33 Blicke auf unser Jahrhundert*; Deichtorhallen; Hamburg, Germany

1997 *Deutsche Fotografie. Macht eines Mediums 1870–1970*; Kunst und Ausstellungshalle der Bundesrepublik Deutschland; Bonn, Germany

1998 *Die Macht des Alters*; Deutsches Historisches Museum/Kronprinzenpalais; Berlin, Germany (traveling through Germany)

Künstlerporträts; Vereinte Versicherungen; München, Germany

Signaturen des Sichtbaren—Ein Jahrhundert Fotografie in Deutschland; Galerie am Fischmarkt Erfurt; Germany

Somewhere Else with My Fingerprints/Die Nerven enden an den Fingerspitzen; SK Stiftung Kultur; Köln, Germany (traveling through Germany: Kunstverein München und Kunsthaus Hamburg)

Selected Works

Pensionierter Kellermeister, Hofbräuhaus München, 1960s (Serie: Deutsche)

Agrotechniker—Mechanisatoren, Neukirchen-Wyhra, 1990 (Serie: Ostdeutsche Porträts)

Ernst Bloch und Hans Meyer, Tübingen 1963 (Serie: Spiegelbilder)

Manuel und Katze mit chinesischen Tiermasken, Ammersee 1965 (Serie Manuel)

Willi Brandt, Siebengebirge, 1983 (Serie: Die großen Alten)

Joseph Beuys beim Ausstellungsaufbau, München, 1968 (Serie: Sequenzen)

Further Reading

Hoferichter, Ernst. *München. Stadt der Lebensfreude*. München: Kindler, 1958 (mit 46 Photos von Stefan Moses).

Manuel. *Ein Bilderbuch von Stefan Moses*. Hamburg: Christian Wegner Verlag, 1967.

Moses, Stefan. *Transsibirische Eisenbahn. Sechsundzwanzig Photogeschichten*, München: Prestel, 1979.

———. *Deutsche. Porträts der sechziger Jahre*, München: Prestel, 1980.

———. *Abschied und Anfang. Ostdeutsche Porträts 1989–1990*, hg. v. Christoph Stölzl, Ostfildern: Cantz, 1991.

———. *Jeder Mensch ist eine kleine Gesellschaft*, Katalogbuch zur Ausstellung in der Bayerischen Akademie der Schönen Künste, München: Prestel, 1998.

———. *ende mit wende-DDR. 200 Photographien 1989–1990*, Ostfildern: Hatje Cantz, 1999.

Bahners, Patrick. "Die beste Seite. Zum siebzigsten Geburtstag des Fotografen Stefan Moses." In: *Frankfurter Allgemeine Zeitung*. Frankfurt, Samstag, 29. August 1998.

Kempe, Fritz. "Stefan Moses" In *ost & west. fotoreportagen*. Museum für Kunst und Gewerbe Hamburg (Hrsg.), Hamburg 1965.

Meyer, Claus Heinrich. "Ostdeutschland auf grauem Filz. Die inszenierten Porträts des Photographen Stefan Moses-eine Ausstellung im Berliner Zeughaus" In: *Süddeutsche Zeitung*. München, 21./22. September 1991, S. 111.

Sager, Peter. "Moses-Menschen" In Peter Sager. *Augen des Jahrhunderts. Begegnungen mit Fotografen*. Regensburg: Lindinger & Schmid, 1998, S. 142–151.

UGO MULAS

Italian

Ugo Mulas is an Italian photographer perhaps best known for documenting the art and artists participating in the prestigious international art exhibition, the *Venice Biennale*. As such, his photographic work captured a panorama of artists, painters, and sculptors of American and European avant-garde of the 1950s and 1960s. Working in black-and-white and Polaroid formats, his work is not limited to the production of documents about artists. During his career, Mulas has elaborated a unique sensibility that explores and questions the photographic act.

Born in Hugo Mulas in Pozzolengo, Italy in 1928, as a young man he studied law and took evening classes at the Academy of Fine Arts in Brera in 1951–1952. Mulas was largely self-taught, and for him the camera became an instrument used to relate his experiences on the streets of Milan and in its periphery. Some of his earliest work offers night views seemingly void of human beings. He also photographed at the Giamaica Bar, a gathering place for Milanese intelligentsia, where Mulas began doing photographic portraits and formed friendships with many artists, sculptors, theater artists, novelists, and journalists.

Through the efforts of a journalist friend, Mulas became, from 1954 to 1968, the official photographer of the *Venice Biennale*. As such, he was able to document meetings between artists, art dealers, curators, exhibition designers, and he captured the "behind the scenes" story while the huge exhibition was being set up in numerous different halls and buildings. But these pictures oscillate between two poles: the documenting of events considered fashionable, such as parties, gatherings in bars (as in the photograph of the French sculptor César in discussion with a Japanese couple) and capturing events related to the artistic life of the *Biennale* (i.e., the 1962 work showing Alberto Giacometti receiving the Biennale's Grand Prize in which Mulas focused on the emotion on the face of the Italian sculptor as he attempts to hide his sentiment with his hands, or the 1964 pictures of Robert Rauschenberg in a gondola on the Grand Canal).

In 1962, Mulas went to the Italian city of Spoletto, which hosts a yearly municipal arts festival, to photograph an outdoor sculpture exhibition that had been mounted that year. In these works, Spoletto is transformed into a night space where urban architecture and contemporary sculptures are intermingled. In the early 1960s, with his pictures of the American abstract sculptor David Smith in the foundry where he forged his monumental sculptures, Ugo Mulas conceived a dialogue between the artworks and their environment, capturing another behind-the-scenes artistic activity that had to that point rarely been seen in photographs. This dialogue and play between artists and their works appear as well in the memorable pictures Mulas captured of Alexander Calder, renowned for his mobiles, in Saché, France, in 1961, and in Calder's studio in Roxbury, Massachusetts. Mulas's work in this area became a model for other pictures featuring sculptors with their works in the studio or situated in specific places.

From 1964 to 1969, Ugo Mulas, with the help of gallery owner Leo Castelli and writer Alan Solomon, undertook several stays in New York, where he embarked on an important series of pictures of leading American artists of the era. Most show the artists in various environments, and they include sculptors John Chamberlain, Claes Oldenburg, George Segal, Marcel Duchamp (of whom Mulas took a photograph studying the famous picture showing him playing chess with a nude woman); and painters Jim Dine, Jasper Johns, Roy Lichtenstein, Barnett Newman, Larry Poons, Robert Rauschenberg, James Rosenquist, Frank Stella, Andy Warhol, and Tom Wesselmann. These photographic series were collected for the publication *New York, Arte e persone*, in 1967, published in English as *New York: The New Art Scene*. In that same year, Ugo Mulas had his first solo exhibition at the Galleria Il Diaframma in Milan.

The avant-garde Italian painter Lucio Fontana has been one of Mulas's primary artist subjects. Fontana, known for violently slashing the canvases of his paintings to create a clear space where everything—action, time, and light—converge in a point of violent paroxysm, is featured in a 1964 photographic series which is indicative of a transition in Mulas's career. These photos describe moments, suspended in time, before Fontana employed a knife to make cuts in the canvas. Mulas amplifies the artist's action by emphasizing contrasts and by focusing on the artist's body movements.

After this series, Mulas's work becomes more poetic as well as becoming illustrations for poetry. He began to photograph Monterosso in Liguria, where his sea scapes might be said to have become part of a four-hand opus *Allegria di Ungarelli* on which Mulas and the poet Eugenio Montale collaborated in 1969.

In the late 1960s, as Mulas began rethinking his photographic aims, he worked on a number of theatrical productions, particularly with the director Virginio Puecher in *Wozzeck*, an Alban Berg opera, in 1969–1970, and Benjamin Britten's opera *The Turn of the Screw*, in 1969. Mulas had previously worked as a theatrical photographer with Giorgio Strehler for Carlo Bertolazzi's *El nost Milan* in 1955–1956, for Bertold Brecht's *Threepenny Opera*, in 1955–1956, and for Bertold Brecht's *Life of Galileo*. But the works of the late sixties first brought together projections of architecture images and landscapes brought to the egde of abstraction through use of solarization.

During the last two years of his life, Mulas conceived a final work, which can be seen as a theoretical and photographic legacy. This series entitled *La Verifiches* (The Verifications) of 1971–1972, condenses, in some ten pictures that are accompanied by texts relating his reflections upon photography, his lifetime of photographic experience. The titles evoke the various aspects of photographic practice and include: *Tribute to Niépce; Photographic operation; self-portrait for Lee Friedlander; Time in photography, to J. Kounellis; The blow-up, the sky for Nini; The laboratory, one hand developed, the other one fixed, to Sir John Frederick William Herschel; Lenses, to Davide Mosconi, photographer; Sunlight, diaphragm, exposure time; Optics and space, to A. Pomodoro; The legend, to Man Ray*.

MULAS, UGO

Ugo Mulas wrote about the late series: "I have given this name to this series of photographs because my intention is to understand the sense of the activities I have never ceased to accomplish, at times up to 100 times a day for years, without ever questioning them in themselves apart from their utilitarian function."

THOMAS CYRIL

See also: **Portraiture**

Biography

Born Pozzolengo near Desenzano del Garda, Italy, 1928. Service in the Italian Army, 1945–1948; studied law, 1948–1952. Night school at the Fine Arts Academy in Brera, and developed in interest in photography, 1951–1952. Worked as caption writer in a photographic agency in Milan, 1952–1953. Showed his first professional photographic work at the Venice Biennale, 1954–1955, Official photographer of the Venice Biennale, 1954–1968, Traveled to New York to document artistic scene, 1964–1967. Photographed Benjamin Britten's opera, *The Turn*

Ugo Mulas, Bar Giamaica, Milan, 1953–1954.

of the Screw at the Piccola Scala at Milan; photographed jewelry for Arnaldo Pomodoro, 1969–1970. Fell ill, 1970 and undertook last series titled *la Verifiche*. Died 2 March 1973 in Milan, Italy.

Individual Exhibitions

1960 *XII triennale di Milano*; Piccolo Teatro; Milan, Italy
1967 *New York: The New Art Scene*; Galleria II Diaframma; Milan, Italy
1969 *Campo Urbano*; Como, Italy
1971 *Kunstler in New York, 1964*; Kunsthalle; Basel, Switzerland
 Verifiche; Galleria dell'Ariete; Milan, Italy
1972 *Marcel Duchamp*; Galleria Multicenter; Milan, Italy
1973 *Ugo Mulas Immagini e Testi*; Palazzo della Pillota; Parma, Italy
1974 *Ugo Mulas fotograpfo*; Kunsthalle; Basel, Switzerland
1978 *L'avantguardia Americana, fotografie di Ugo Mulas*; Villa Panza di Biumo; Varese, Italy
1982 *Ugo Mulas, Alexander Calder a Saché e a Roxbury, 196–1965*; Galleria dell' Immagine; Rimini, Italy
1983 *Ugo Mulas, David Smith working in Italy*; Accademia Americana; Rome, Italy
1984 *Ugo Mulas, Fotografos 1928–1973*; Musée Rath; Geneva, Switzerland
1986 *Ugo Mulas Photographs New York Art Scene'60s*; M. Gallery; Tokyo, Japan
1988 *Ugo e gli scultori Fotografie di Ugo Mulas dal 1960 al 1970*; Galleria L'Isola; Rome, Italy

Group Exhibitions

1971 *Castellini, Ugo Mulas, Pistolleto*; L'Ariete Grafica; Milan, Italy
1973 *Combattimento per un'immagine, fotografie e pittori*; Galleria Civica d'Arte Moderna; Turin, Italy

1974 *Contemporanea*; Parcheggio di Villa Borghese; Rome, Italy
1977 *Documenta 6*; Museum Fridericianum; Kassel, Germany
 L'occhio di Milano, 48 fotografi 1945–1977, Rotonda di Via Besana; Milan, Italy
1983 *La sperimentazione negli anni 1930/1970*; Galleria Comunale d'Arte Moderna; Bologna, Italy
1987 *La Fotografia vista da Leonardo Sciascia Ignoto a me stesso*; Mole Antonelliana; Turin, Italy
1988 *Storie dell'ochio/Fotografi ed eventi artistici in Italia dal'60 all'80*; Galleria Civica & Palazzina dei Giardini Pubblici; Modena, Italy
1989 *150 anni di fotografia in Italia: un itinerario*; Palazzo Rondanini alla Rotonda; Rome, Italy
 L'insistenza dello sguardo. Fotografie italiane 1839–1989; Palazzo Fortuny; Venice, Italy

Selected Works

Bar Giamaica, Milan, 1953–1954
David Smith, 1962
Andy Warhol, 1964
Lucio Fontana, 1965
Marcel Duchamp, 1965
Verifica, 1971

Further Reading

Muraro, Michelangelo, and Peggy Guggenheim. *Ugo Mulas, Invito a Venezia*. Milan: Mursia, 1962.
Lodi, Mario, and Palmira Maccarini. *Trenta bambini Mulas una città*. Venizia: La Biennale, 1976.
Mulas, Ugo, and Hendel Teicher. *Ugo Mulas: fotografo 192–1973*. Genève: Musée d'art et d'histoire, 1984.
Celant, Germano. *Ugo Mulas*. New York: Rizzoli, 1990.
Cavazzi, Lucia, and Germano Celant. *Ugo Mulas*. Milan: Federico Motta, 1993.

MULTIPLE EXPOSURES AND PRINTING

Multiple images in photographic prints are created through a number of methods: multiple exposures with or without a flash in the camera, sandwiching negatives in the darkroom, printing from multiple negatives and enlargers in the darkroom, and digital manipulation. These techniques have been used through most of photography's history for creative and technical control over images.

Multiple exposures consist of exposing one piece of film more than once in the camera. This is achieved through a variety of techniques, depending on the film format and camera specifications. Medium and large format film (as used in view cameras) can be easily exposed multiple times by not changing or forwarding the film inside the camera. Some point-and-shoot and 35-mm cam-

eras are more difficult tools for multiple exposures because of the mechanism that forwards the film within the camera; an interlock between the shutter release and film advance may only allow one exposure per frame. This function may be manually overridden by rewinding the film either fully or partially, or by triggering the film release button on the camera body to rewind the film. The bulb (B or T setting) shutter mode may also be used and a dark slide placed over the lens, allowing the photographer to control the shutter and exposure of each individual light imprint on the film by using the time-exposure function.

Multiple images on one frame of film may take the form of two (or more) different scenes, or the same scene shot more than once, or of a partial image. This latter technique may be achieved by using a black piece of cardboard or dark slide to block out part of the image area in each multiple exposure. Also, one scene shot and recorded in exactly the same manner will allow for effects that cannot be achieved in a single exposure, such as a large amount of depth of field, to be created in the composite shot. Using an electronic flash or a strobe light in a darkened room can also result in the same effect as manually exposing a frame of film more than once in the camera under more conventional conditions. While the shutter is kept open, the flash or strobe light is used to create a quick burst of illumination, and may be repeated numerous times to fully illuminate an image or portray motion.

Exposing the film multiple times will create overlapping images and have an impact on the exposure time, and thus overall density of the film. To ensure an intelligible exposure, each individual exposure or shot must be metered and the combined exposure time should approximately equal that shown by the light meter reading in the camera for a single exposure. For example, if an image is created by two exposures, each shot must be half of the total exposure that would be required for a proper exposure of one image of the scene. Dividing the meter reading given by the shutter speed and aperture setting by the number of images taken is generally accurate for most multiple exposures, but excessive multiple images placed on one sheet of film may produce what is known as reciprocity failure. Reciprocity failure occurs because film's sensitivity to light as it is exposed may be altered during the process of exposing multiple times, and unpredictable overexposure, underexposure, or color shifts may result.

Darkroom techniques for multiple exposures include sandwiching negatives and multiple printing. Sandwiching negatives places two or more images on top of each other in the enlarger's negative holder with the composite image created by exposing the negatives during printing on photographic paper. Placing more than one negative in the enlarger increases the overall image density and this must be compensated with increased intensity of the enlarger's light source or with a longer exposure, or a combination of the two. Increased density may also alter the image contrast and necessitate additional burning and dodging in selected areas.

Multiple printing is a darkroom technique that exposes individual negatives onto one sheet of photographic paper to form a composite image. This technique can be achieved in one of two ways: by using multiple enlargers to print individual negatives, or using the same enlarger to print multiple negatives that are changed with each image exposure. The unexposed areas of photographic paper for composite printing must be covered as each individual image element is printed, and multiple test strips for exposure, contrast, and color balance (if printing color) must be utilized to master this technique. Areas where individual negative areas overlap may also be problematic, and advanced burning and dodging of these areas will provide a more finessed transition from one negative element to another. During multiple printing, registration of the print in the easel or registration of the negative carrier in the enlarger is necessary to form matching edges in the print and exact overlapping of the individual negative exposures. Advanced darkroom manipulation techniques such as flashing, masking, and split filtration printing may also be integrated into the multiple printing processes.

Digital darkroom programs such as Adobe Photoshop have widened the range of tools and processes available for photographers. Scanning of traditional film images and importing of digital documents creates a compositing tool in the computer, and each image element can be added to a complex composition. The tools used in this process are different from the traditional darkroom and film exposure methods, but achieve similar creative results. Cutting and pasting of individual image elements allow a composite to be created on layers in the imaging program, and blending of these elements is achieved through digital effects such as feathering the edges, changing opacity, and masking of image elements. The digital tools can also be integrated back into the traditional darkroom process, and an inter-negative or transparency can be printed from the composite created in Adobe Photoshop on most conventional inkjet printers. This document can in turn be utilized in

the traditional darkroom for singular and multiple printing techniques.

Multiple exposures and printing are techniques that have been used by fine art photographers since the invention of the medium. Nineteenth-century master Henry Peach Robinson incorporated many individual negatives into his fine art montage pieces, and multiple exposure was a hallmark of the photographic avant-garde in Paris, Vienna, Munich, and Berlin between the world wars. Edmund Kesting and Bauhaus master László Moholy-Nagy were notable practitioners of multiple exposure and printing techniques. More recently, in the 1950s multiple exposures in the camera were practiced by Harry Callahan and encouraged in his many students at Chicago's Institute of Design as well as Louis Fauer in his nighttime photographs of New York City. Jerry Uelsmann and John Paul Caponigro are two late-twentieth century masters of multiple printing, Uelsmann utilizing up to 20 enlargers in his traditional darkroom and Caponigro a master of digital compositing with tools such as Adobe Photoshop.

JENNIFER HEADLEY

See also: **Burning-In; Callahan, Harry; Camera: 35 mm; Camera: An Overview; Camera: Digital; Camera: Point and Shoot; Dodging; Enlarger; Institute of Design; Kesting, Edmund; Manipulation; Moholy-Nagy, László; Sandwiched Negatives; Uelsmann, Jerry**

Further Reading

Barnier, John, ed. *Coming Into Focus: A Step-By-Step Guide to Alternative Photographic Printing Processes.* San Francisco, CA: Chronicle Books, 2000.

Blacklow, Laura. *New Dimensions In Photo Imaging.* Boston, MA: Focal Press, 2000.

Caponigro, John Paul. *Adobe Photoshop Master Class.* Berkeley, CA: Peachpit Press, 2000.

Graves, Carson. *The Elements of Black and White Printing.* Boston, MA: Focal Press, 2000.

Hirsch, Robert. *Photographic Possibilities: The Expressive Use of Ideas, Materials, and Processes.* Boston, MA: Focal Press, 1991.

James, Christopher. *Alternative and Non-Silver Photographic Processes: Working Notes.* Upper Saddle River, NJ: Delmar Publishers, 2000.

Nettles, Bea. *Breaking the Rules: A Photo Media Cookbook.* Rochester, NY: Inky Press Productions, 1992.

Stone, Jim. *Darkroom Dynamics: A Guide to Creative Darkroom Techniques.* Boston, MA: Focal Press, 1979.

VIK MUNIZ

Brazilian

The career of Vik Muniz echoes what nineteenth-century critic Charles Baudelaire called the photographer during his own era: "operator." Muniz's artistic strategies connect him with this description in that he uses photography as a means to an end that is not strictly photographic. The pictures for which Muniz is known in fact consist of images made from chocolate, sugar, dust, ink, wire, cotton, urban detritus, and other materials that are then photographed.

This modus operandi places Muniz's photography within a lineage of early twentieth-century photographers and artists such as Man Ray and his photographs of dust, and Salvador Dali's and Brassaï's pictures of found objects that they called involuntary sculptures. Muniz is also linked to conceptual artists who used photography as documentation of an event, performance, and as supplement to an idea. Yet Muniz's work is as emphatically about photography's ability to mimetically reproduce the world as it is about its power of illusion. This dichotomy is one of the impulses that drive Muniz's art, though to construe it as being solely about perception is to undermine its formal and conceptual rigor. Muniz has emphasized that his work is more than visual sleight of hand: "I like illusions that say something about reality or, at least, our ability to cope with it" (Muniz, *Seeing is Believing* 1998).

Beginning his artistic career as a sculptor, Muniz's focus was on creating objects. As his sculptures became more like visual puns imbued with double meanings, Muniz progressively reconfigured sculpture from its three-dimensional format into a two-

dimensional one. The paradox was that these early three-dimensional works incorporating photography began to increasingly privilege the picture and its capacity for illusion rather than sculpture's material presence. This was slowly arrived at by combining photography with found objects that enabled the art work to both literally and figuratively address the world outside of it. Exemplary of this early work are *Tug of War* and *Two Nails* of 1989. In *Tug of War,* a real "rope" is the link between two photographs of individuals each tugging the end of a rope. In "Two Nails," Muniz exploits the historical illusory device of *tromp l'oeil* through the interplay of a photograph of a piece of paper nailed to a wall that, in turn, is itself nailed onto the wall by a real nail. This work demonstrates what would remain a leitmotif in Muniz's later work: photography's slippage between its indexical quality, that is, its ability to record the world, and its antithesis when it is embodied as a real, tangible object. These early works also explore the image as it shifts from perception to identification within the viewer.

The Best of Life (1988–1990) is a group of pictures of news events taken from the magazine that gives the series its name. Muniz drew famous photographs that recorded events such as the lone Chinese man stopping tanks in Tiananman Square and Neil Armstrong walking on the moon from memory and then photographed these drawings. By reconfiguring these images through his personal recollection, Muniz explores the relationship between our collective understanding of history via images provided to us by the news media, and our individual engagement with these images. *The Best of Life* series marks Muniz's practice of conceptual photography in which the idea that structures the work and resonates from it takes precedent over the work's formal qualities. However, by presenting his pictures as gelatin silver prints that imbue them with the aesthetic of a traditional photographic medium, Muniz becomes concerned with the convergence of forms and images that produce multi-layered narratives.

The Sugar Children (1996) further conveys Muniz's coupling of materials and meaning. *The Sugar Children* features images of the sons and daughters of impoverished sugar mill workers; these images are rendered by Muniz with sugar on black paper and then photographed. Although it is a sweetener, within the context of *The Sugar Children,* sugar becomes a bitter pill to swallow, producing a scathing social commentary. This could also be said of Muniz's *Pictures of Chocolate* (1997–1998), most notably his photograph of Freud titled *Sigmund*.

This photograph and others in the series—such as *(Milan) Last Supper*— produce a visually poetic work that powerfully evinces the marriage of form and image. In *(Milan) Last Supper*, chocolate is an analogue of the food pictured as being served during Jesus Christ's last supper that pushes the limits of the visual experience of art through indexical associations. That is, in the same way that a photograph is traditionally a recording of an event in the real world, in *(Milan) Last Supper*, it serves as an index of something not usually the experiential province of art: the sense of taste. Taste is also an element with *Sigmund*, albeit couched in Freud's own ideas about psychosexual development. For chocolate now alludes to both Freudian oral gratification or the oral stage, and to the anal stage by way of the picture's viscosity alluding to excrement.

Muniz has also looked at photography's own history, producing the series *Equivalents,* a reference to Alfred Stieglitz's famous series of skies and clouds, as well as works in which he drew with dust photographic documentations of installations by famous Minimalist sculptors such as Donald Judd.

Muniz exploits the conceptual coupling of materiality with narrative, or meaning and its vehicle of articulation—be it drawing or photography or pictures made with sugar, chocolate, thread, wire, or dust—like no other contemporary photographer. Muniz's practice continues to engage formal and conceptual arenas that push the boundaries of photography in myriad directions, and his interest in emerging technology and image-producing media will surely secure his importance not only for twentieth-century photography, but for twenty-first as well.

RAÚL ZAMUDIO

See also: **Appropriation; Brassaï; Conceptual Photography; Discursive Spaces; Formalism; Image Theory; Man Ray; Postmodernism; Representation; Semiotics; Stieglitz, Alfred**

Biography

Born in 1961, Sao Paulo, Brazil; lives and works in New York City. Attended the FAAP (Fundaçao Armando Alvares Penteado), where he studied advertising and moved to New York in 1983. Began working in photography in 1998 and shows his first photographs at Stux Gallery in New York City under the title of *Individuals* in 1991. Since then, has had numerous international exhibitions in galleries, museums, fairs, and biennials.

Individual Exhibitions

1989 Stux Gallery; New York
1991 Meyers/Bloom Gallery; Santa Monica

Stephen Wirtz Gallery; San Francisco
1991 Gabinete De Arte Rachel Arnaud; Säo Paolo, Brazil
Galerie Claudine Papillon; Paris, France
1992 *Individuals*; Stux Gallery; New York
Claudio Botello Arte; Turin, Italy
1993 *Equivalents*; Ponte Pietra Gallery; Verona, Italy (traveled to Tricia Collins Contemporary Art; New York)
1994 *Representations*; Wooster Gardens; New York
1995 *The Wire Pictures*; Galeria Camargo Vilaça; Säo Paolo, Brazil
1997 *The Sugar Children*; Tricia Collins Contemporary Art; New York
The Best of Life; Wooster Gardens; New York
1998 *Pictures of Thread*; Wooster Gardens; New York
1999 Centre national de la photographie; Paris, France
Galeri Lars Bohman; Stockholm, Sweden
Gian Enzo Sperone Gallery; Rome, Italy
Galeria Módulo; Lisbon, Portugal
2001 Museu de Arte Moderna; Rio de Janeiro, Brazil
Museu de Arte Moderna; Sao Paulo, Brazil
Whitney Museum of American Art; New York
Reparté; Woodruff Art Center; Atlanta, Georgia
Fondation Huis Marseille; Amsterdam, The Netherlands
Galeria Camargo Vilaca; Sao Paulo, Brazil
Museé de l'Élisée Lausanne, Switzerland
Seeing is Believing; Tang Teaching Museum and Art Gallery; Saratoga Springs, New York (traveled to Museum of Contemporary Photography, Chicago; International Center of Photography, New York)

Group Exhibitions

1992 *Life Size: Small, Medium, Large*; Museo D'Arte Contemporaneo Luigi Pecci; Prato, Italy
1994 *Single Cell Creatures*; Katonah Museum of Art; Katonah, New York
Time to Time; Castello de Rivera; Torino, Italy
Sound, Museo D'Arte Moderna Boizano; Itlay
1997 *Photography XIII*; Museum of Modern Art; New York
Asi esta a cosa; Centro Cultural Arte Contemporaneo; Mexico City, Mexico
Coleción Ordónez Falcón de fotografia; IVAM Centre Julio Gonzalez; Valencia, Spain
Shadow Pla; San Jose Institute of Contemporary Art; San Jose, California
Some Assembly Required; Art Institute of Chicago; Chicago, Illinois
Changing Perspective; Contemporary Arts Museum; Houston, Texas
Mostra America; Fundação Cultural de Curituba; Curituba, Brazil
Garbage; *Thread Waxing Space*; New York
The Photographic Condition; San Francisco Museum of Modern Art; San Francisco, California
1998 XXIV Bienal Internacional de Säo Paulo; Säo Paulo, Brazil
Le Donné, le fictive; Centre national de la photographie; Paris, France
Urban Canibal; Paço das Artes; Säo Paulo, Brazil
1999 *Museum as Muse*; The Museum of Modern Art, New York City, United States

Abracadabra; The Tate Gallery; London, United Kingdom
2000 Biennial Exhibition; Whitney Museum of American Art; New York
Photography Now; Contemporary Arts Center; New Orleans, United States The Corcoran Biennial; Corcoran Gallery of Art; Washington, D.C., United States
2001 *Proyecto Mnemosnyne*; Coimbra, Portugal

Selected Works

Cogito Ergo Sum, 1989
Individuals, 1992–1993
Faucet, 1994
Paper and Wire, 1995
Little Calist Can't Swim, 1996
Sigmund, 1997
Torso (After Frantisek Drtikol), 1997–1998
12,000 Yards (Etretat, After Courbet), 1998
Still, After Cindy Sherman, 2000
After Richter, 2001

Vik Muniz, Big James Sweats Buckets, from the series Sugar Children, 1996, Gelatin silver print on paper, 14 × 11″, Museum purchase made possible by the Horace W. Goldsmith Foundation.
[*Smithsonian American Art Museum, Washington, DC/Art Resource, New York; Photo © Vik Muniz/Licensed by VAGA, New York, New York*]

Further Reading

Barill, Renato. *Anni Novanta*. Bologna: Galleria d'Arte Moderna, 1998.

Decter, Joshua. *Vik Miuniz*. New York: Stux Gallery, 1989.

Kismaric, Susan. *"Vik Muniz, New Photography."* New York: 13 *MoMA Magazine, Fall* 1997.

Lieberman, Rhonda. *Traumatic Objects: Theres no Place Like Home*. Saö Paulo, Brazil: Gabinette de Arte Raquel Arnaud, 1991.

Millazo, Richard. *Vik Muniz: the Wrong Logician*. New York and Verona, Italy: Grand Salon, 1993.

Vescoovo, Marisa. *Vik Muniz*. São Paulo: Gabinete de Arte Rachel Arnaud, 1998.

Wilson, Beth. *Vik Muniz*. New York: Stux Gallery, 1989.

Zamudio, Raúl. "Vik Muniz: Operations with/in Photography." *NYARTS*, June 2000.

MARTIN MUNKACSI

Hungarian

Martin Munkacsi, New York's leading fashion photographer during the 1930s and 1940s, was born on May 18, 1896 in Koloszsvar, Hungary, near the town of Munkasc (now Cluj Napoca, Romania), the historic capital of Transylvania. The fourth of seven children in a working-class Jewish family his original surname—either Mermerlstein or Marmorstein—was changed, by the family to Munkasci upon moving to Disco-Szent-Marton, Hungary (now Tirnavani, Romania); the new name, invented during this era of pogroms, was distinctly Hungarian and not identifiably Jewish.

At 16, Munkacsi left home and settled, on his own, in cosmopolitan Budapest. Bright and energetic, he started his professional life as a writer, contributing reports on soccer matches and automobile races to *Az Est*, a sports daily. By 1921, as a self-taught photographer working with a home-made camera, Munkacsi was regularly providing sports photographs for *Az Est* and documenting performances for *Theatre Life*, a weekly review. Munkacsi's natural métier was as a sports photographer; he displayed a virtuosic talent for capturing, in a still image, the pure exhilaration of movement.

Munkacsi relocated to Berlin in 1927 and signed a three-year contract with Ullstein Verlag, the city's major publishing house. His first credited story appeared in the October 14th issue of *Berliner Illustrirte Zeiting*, Ullstein's weekly picture magazine. With a circulation of two million, *Berliner Illustrirte Zeitung* was the most widely read magazine of its kind in the world and, in the United States, is best remembered as the template for *Life* magazine.

Munkacsi's work appeared in other Ullstein publications: *Die Dame*, the German equivalent of *Vogue*; *Uhu*, an "arty" monthly featuring essays and photographs of nudes; and *Knipsen*, a book for amateur photographers. Occasionally, he worked for Ullstein's competitors, *Die Woche* and *The Studio*.

Throughout this period (1930–1934), Munkacsi claimed—with characteristic bravado and somewhat questionable credibility—that he was the highest-paid photographer in Berlin. He did, undeniably, enjoy great success and traveled extensively on assignment throughout Europe, Africa, and the Americas. As Henri Cartier-Bresson later recalled: "In 1932, I saw a photograph by Martin Munkacsi of three black children running in to the sea ["Liberia, c. 1930," published in *Das Deutsche Lichtbild*, 1932], and I must say that it is that very photograph which was for me the spark that set fire to the fireworks... and made me realize that photography could reach eternity through the moment. There is in that image such intensity, spontaneity, such joy of life, such a prodigy, that I am still dazzled by it even today."

During a brief 1933 visit to New York, Munkasci was hired by *Harper Bazaar*'s legendary editor Carmel Snow to shoot his first fashion layout. Snow had been introduced to Munkacsi's photojournalism by Frederic Varady, a Hungarian artist, and Edward Steichen, then employed as the chief photographer for Condé Nast. In her memoir, Snow wrote about that initial shoot, the revolutionary turning point in fashion photography when Munkacsi took the model out of the confines of the studio:

> The resulting picture of a typical American girl in action, with her cape billowing out behind her, made fashion history. Munkacsi's was the first action photograph

made for fashion, and it started the trend that climaxed in the work of Avedon today.

As life in Germany grew increasingly untenable, the Berlin-based publishers Ullstein Verlag capitulated to anti-Semitic pressure by firing Jewish employees and hiring Nazi editors. When Munkacsi turned in a rather straightforward assignment, photographing fruit for one of Ullstein's women's magazines, five of his prints were rejected by one of the new editors. "These are bananas," was the explanation. "Bananas are not an Aryan fruit!" Munkacsi left Germany and emigrated to the United States, arriving in New York in May, 1934. That year, he signed an exclusive contract with *Harper's Bazaar*. Munkacsi's photographs (and occasional writing) appeared regularly in the magazine; under Carmel Snow's editorship and Alexey Brodovitch's art direction, *Harper's Bazaar* established itself as the most sophisticated fashion magazine of the time.

In 1934, working with Kurt Safranski, the former managing editor of Ullstein, Munkasci helped develop a dummy for a new picture magazine. Their project, rejected by the Hearst Publishing Corporation, was eventually sold to Henry Luce and was eventually realized as *Life* magazine—with Safranski as managing editor and Munkacsi contributing photographs.

In 1940, Munkacsi received a $4,000 per month contract from *Ladies' Home Journal* to photograph their popular feature "How America Lives." He was said to be earning more than $100,000 a year and liked to quip, "A photograph isn't worth a thousand words, it's worth a thousand bucks!" Munkacsi's contract with *Ladies' Home Journal*, however, ended in 1946, when the magazine pages were taken over almost entirely by color photography. Unable to make the transition from black-and-white to color photography, Munkacsi received fewer major magazine assignments and worked as a freelance photographer for the Reynolds Company, King Features, and the Ford Motor Company. He also worked as a lighting director and cameraman on the stop-action animation puppet feature of *Hansel and Gretel*.

Although Munkacsi continued to take photographs and write (his autobiographical novel, *Fool's Apprentice*, was published in 1945), his once radical vision had moved firmly into the mainstream, and he found himself out of touch with the changing times. In 1963, while attending a Hungarian team's soccer game at Randall's Island, New York, Munkacsi suffered a fatal heart attack.

In a memorial to Munkacsi published in *Harper's Bazaar* (June, 1964), Richard Avedon wrote:

> He wanted his world a certain way, and what a way! He saw what was free in it, happy in it, and however much he suffered, and he did suffer, his pain never destroyed his dream. Without illusions there would be no art and possibly no life in the world. The art of Munkacsi lay in what he wanted life to be, and he wanted it to be splendid. And it was.

SUSAN MORGAN

See also: **Fashion Photography; History of Photography: Interwar Years**

Biography

Martin Munkacsi born May 18, 1896, Koloszvar, Hungary. Active in Budapest, Hungary as sports photographer for *Az Est*, 1921–1922; relocated to Berlin, Germany and active as sports photographer and photojournalist, primarily for *Berliner Illustrirte*, 1927–1934. Immigrates to New York City, 1934; worked as fashion and features photographer closely associated with *Harper's Bazaar* until 1946; his work also appeared frequently in *Ladies' Home Journal, Life*, and other popular American publications. Died July 14, 1963, in New York City.

Exhibitions

1937 *Photography 1839–1937*; Museum of Modern Art; New York, New York
1940 *Tudor City Artists and Photographers*; New York, New York
1965 *Glamour Portraits*; Museum of Modern Art; New York, New York
　　The Photo Essay; Museum of Modern Art; New York, New York
1975 *Fashion Photography: Six Decades*; Emily Lowe Gallery; Hofstra University, Hempstead, New York, and Kornblee Gallery, New York, New York
1977 *The History of Fashion Photography*; International Museum of Photography; Rochester, New York
1978 *Spontaneity and Style: Munkacsi, A Retrospective*; International Center of Photography; New York, New York
1979 *Life: The First Decade*; Grey Art Gallery, New York University; New York, New York
　　Fleeting Gestures: Dance Photographs; International Center of Photography; New York
1980 *Avant Garde Photography in Germany 1919–1939*; San Francisco Museum of Modern Art; San Francisco, California
1981 *Lichtbildnisse: das Portrat in der Fotografie*; Rheinisches Landesmuseum; Bonn, Germany
1985 *Martin Munkacsi*; Photofind Gallery; Woodstock, New York
　　Shots of Style; Victoria and Albert Museum; London
　　Self-Portrait: The Photographer's Persona 1840–1985; Museum of Modern Art; New York, New York

1989 *The New Vision: Photograph between the Wars*; Metropolitan Museum of Art; New York, New York
1990 *German Photography*; Metropolitan Museum of Art; New York, New York
 Martin Munkacsi; Fashion Institute of Technology; New York, New York
2003 *As It Happened: Photographs from the Gilman Paper Company Collection*; Metropolitan Museum of Art; New York
 Henri Cartier-Bresson's Choice; Cartér-Bresson Foundation; Paris
 Frida Kahlo: Portraits of an Icon; Flint Institute of Arts; Flint, Michigan

Selected Works

Soccer Player, Hungary, c. 1923
Car Racing, Europe, c. 1929
Summer Camp, near Bad-Kissingen, Germany, 1929
On the Beach, Germany, 1929
Madrid, 1930
Liberia, (also known as *Black Boys on the Shore of Tanganyika*) c. 1930
Das Deutsche Lichtbild, 1932
Having Fun at Breakfast, Berlin, c. 1933
Louis Brokaw, (Harper's Bazaar), December, 1933
Frida Kahlo and Diego Rivera, Mexico, 1934
Jumping A Puddle (Harper's Bazaar), April, 1934
Katharine Hepburn standing by Howard Hughes's plane (Harper's Bazaar), February, 1935
Fred Astaire, (Life), 1936
New York World's Fair (Harper's Bazaar), September, 1938
Roof Baby, New York, 1940

Further Reading

Beaton, Cecil, and Diane Buckland. *The Magic Image: The Genius of Photography from 1839 to the Present Day*. Boston: Little, Brown and Co., 1975.

Coke, van Deren, Ute Eskildsen, and Bernd Lohse. *Avant-Garde Photography in Germany 1919–1939*. San Francisco, California: San Francisco Museum of Modern Art, 1980.

Gruber, Renate, and L. Fritz Gruber. *The Imaginary Photo Museum*. Cologne: 1981. New York. Harmony Books, 1982.

Hall-Duncan, Nancy. *The History of Fashion Photography*. Rochester, New York: International Museum of Photography, 1977.

How America Lives. New York: Henry Holt, 1941.

Littman, Robert, Ralph Graves, and Doris C. O'Neill. *Life: The First Decade 1936–1945*. New York 1979; London, 1980.

Martin Munkacsi: Retrospektive Fotographie. Bielefeld/Dusseldorf: Edition Marzona, 1980.

Mellor, David, ed. Germany: *The New Photography 1927–33*. London, 1978.

Morgan, Susan. *Martin Munkacsi (An Aperture Monograph)*. Millerton, New York: Aperture, 1992.

Munkacsi, Martin. *Fool's Apprentice*. New York: Reader's Press, 1945.

Munkacsi, Martin. *Nudes*. New York: Greenberg, 1951.

Osman, Colin. *Munkacsi: Spontaneity and Style*. New York: International Center of Photography, 1978.

Snow, Carmel, and May Louise Aswell. *The World of Carmel Snow*. New York: McGraw Hill, 1962.

Sullivan, Constance, ed. *Nude Photographs 1850–1980*. New York: Harper and Row, 1980.

White, Nancy, and John Esten. *Style In Motion: Munkacsi Photographs of the '20s, '30s, and '40s*. New York: Clarkson N. Potter, 1979.

MUSEUM FOLKWANG

The photography collection in the Museum Folkwang, Essen, Germany, is a division of the Museum of Modern Art, and considered one of Germany's most important collections of photographs. Although the collecting of photography has been ongoing, in 1978 the photography collection of the city of Essen was integrated into the museum, greatly expanding the number and scope of the holdings.

At the end of the century, the collection held roughly 50,000 photographs, most of which are vintage prints. Though it has a rich collection of nineteenth century photographs, the main focus is on the twentieth century. Areas of special emphasis include the photography of 1920s, photojournalism of the 1950s and 1960s, the Subjective Photography of Otto Steinert and his circle, and international contemporary photography from the 1980s to the end of the century. The museum also has strong thematic holdings in portraiture and architectural photography. With its comprehensive program of exhibitions and its collecting initiatives, the museum is unique in that it combines an interest in historical archiving with the promotion of the most up-to-date developments in contemporary photography. Two areas are important to consider. One is the history of the holdings

assembled by Otto Steinert, which comprise the cornerstone of the museum's collection, and the other is the long tradition of photography archiving and mounting exhibitions in the Museum Folkwang in general.

When Otto Steinert was made a professor of photography at the *Folkwangschule für Gestaltung* in 1959, he began to build the collection as a photo-historical archive for the school. It was a teacher's collection that would allow one to use original prints in the classroom. From the very beginning Steinert united teaching, collecting, and exhibiting, and in recognition of this historical usage, since 1959 the museum has sponsored a yearly exhibition on the history of photography.

The first exhibition of photographs mounted by the museum, however, was the presentation of another collector's holdings, the famous historian of photography Helmut Gernsheim, whose collection provided an overview of over 100 years of photography, from its beginnings to the 1930s. (This collection, however, was purchased by Harry Huntt Ransom and became the centerpiece of the Harry Ransom Humanities Research Center at the University of Texas, Austin.) Following this exhibition, the school purchased the omnibus volume of photographs made by the portrait photographer Hugo Erfurth and the *Neue Sachlichkeit* (New Objectivity) photographs of Albert Renger-Patzsch. But in the early years, the collection grew sporadically rather than systematically. In 1961, at the first European photography auction, Steinert acquired another cadre of photographs, among them a portfolio of 144 images from the pioneers of photography David Octavius Hill and Robert Adamson. In the 1960s, Steinert was interested in the work of Heinrich Kühn, a turn of the century art photographer, and in photographs from the 1920s, which shaped acquisitions. In the mid-1960s, as interest in photojournalism increased, Steinert began collecting works of Felix H. Man, Erich Salomon, and Robert Lebeck. By 1978, the collection contained around 3,800 photographs.

The integration of the photography collection into a museum of modern art was an important recognition of photography as art within a museum context in West Germany. This path-breaking move can be traced back to the 1920s and the Museum Folkwang's long-standing relationship with the medium of photography. Under the influence of the then curator Kurt-Wilhelm Kästner and the photographer and Folkwang instructor Max Buchartz there arose in Essen in the late 1920s and 1930s a forum for photography. In 1929, even before *Film und Foto*, the well attended and influential photography exhibition in Stuttgart, Kästner created the exhibition *Fotografie der Gegenwart*. Following this, he presented *Das Lichtbild* (1931), an exhibition from Munich that he and Max Buchartz enlarged with works from students in Essen. The first individual exhibition of photographs by Florence Henri (1933) was the last exhibition Kästner curated before the Nazis removed him from his position. After the war, Steinert reconnected to what Kästner had begun by establishing a yearly exhibition series "*Beiträge zur Geschichte der Fotografie*," held from 1959 to 1978.

In 1979, Ute Eskildsen, a student of Otto Steinert, took over the photography division and continues to guide it into the twenty-first century, continuing the interweaving of the historical and the contemporary. The museum expanded its holdings in the areas that Steinert had focused on in his collecting, architectural photography and human representation. It has also filled gaps in its special collection of photography from the 1920s so that the holdings range from the experimental Bauhaus photography to New Objectivity, and include the estates of Helmar Lerski, Germaine Krull, and numerous collections from German-Jewish emigrants, such as Lotte Erell and ringel+pit, the studio of Ellen Auerbach and Grete Stern. There is also a reprint of August Sander's epic work, *Menschen des 20. Jahrhunderts*, which Steinert himself never could procure for his collection. Another area of considerable attention is the 1950s, with holdings from the members of the photography group "fotoform" and from the exhibition series *Subjektive Fotografie* organized by Otto Steinert, an area enlarged by the purchase of Steinert's private collection.

A strong interest in contemporary photography also motivates the museum's purchases. Among them are collections by the Americans William Klein and William Eggleston, and Michael Schmidt. In addition the museum secured the estates and archives of Helmuth Kurth, Walter Peterhans, Fee Schlapper, Wolfgang Weber, and the archives of Peter Keetman.

When they transferred the school's collection to the public museum, staff took inventory of the holdings over the following years. Now the public can access the collection with a filing system ordered by author and a slide library ordered by keyword. Once a week anyone can view original prints. Unknown works are conserved and restored to public attention by means of the numerous exhibitions and their accompanying catalogues that are grouped around the central areas of the collection. Robert Knodt has been responsible for the scientific handling and conservation of the collection since 1985.

As a further resource the museum offers pedagogical guides to its exhibitions, as well as courses on the key areas of the collections and on the themes of the exhibitions using original prints from the museum's holdings.

The exhibition program features six to eight projects per year. Exhibitions with historical themes are interchanged with exhibitions of contemporary photography. Among historical exhibitions, the focus has been on the photography of the *Neues Sehens* movement. In 1979, to honor its 50th anniversary, the museum reconstructed the *Film und Foto* exhibition, one of the most important for experimental photography of the 1920s. In 1982, the museum presented the works of the photographer Helmar Lerski. In the following years there were important individual exhibitions and catalogues for photographers of the 1920s, such as Anne Biermann, Sasha Stone, and Walter Peterhans. In 1994–1995, a large group exhibit took place of female photographers from the interwar period, "*Fotografieren hieß teilnehmen—Fotografinnen der Weimarer Republik.*" In 1999, the collection featured a retrospective of the works of the photographer Germaine Krull. Since the 1980s a great number of young photographers have had their first museum exhibition within the photography collections—Michael Schmidt is an example. Internationally renowned photographers such as Lee Friedlander, William Klein, and Robert Frank have had individual exhibitions at the Museum Folkwang.

In 1982, when artistic photography was still rarely in high demand, the museum began sponsoring a scholarship for contemporary German photography in collaboration with the Alfried Krupp von Bohlen und Halbach-Stiftung. In 2000, the Krupp Stiftung also began sponsoring a program for young curators. In addition, with support from the Dietrich Oppenberg Stiftung, the museum initiated the Albert Renger-Patzsch Prize to support European photography book production.

ESTHER RUELFS

See also: **Auerbach, Ellen; Erfurth, Hugo; History of Photography: Interwar Years; Lerski, Helmar; Man, Felix H.; Museums: Europe; Photography in Germany and Austria; Renger-Patzsch, Albert; Peterhans, Walter; Salomon, Erich; Sander, August**

Further Reading

Eskildsen, Ute, ed. *Albert Renger-Patzsch. Bilder aus der Fotografischen Sammlung und dem Giradet Archiv.* Essen: Museum Folkwang, 1997.

Eskildsen, Ute, ed., *Ein Bilderbuch. Die Fotografische Sammlung im Museum Folkwang.* Essen, Göttingen: Steidl Verlag, 2003.

Eskildsen, Ute, ed. *Der Fotograf Otto Steinert.* Göttingen: Steidl Verlag, 1999.

Eskildsen, Ute, ed. *Metamorphosis through Light. (Verwandlungen durch Licht)*, Freren, Germany: Luca Verlag, 1982.

Eskildsen, Ute, and Simone Förster, eds.

Wenn Berlin Biarritz wäre. Architektur in Bildern der Fotografischen Sammlung im Museum Folkwang. Essen: Museum Folkwang, 2001.

Florian, Ebner. "Fotografische Sammlung Museum Folkwang Essen." *Eikon* Heft 18/19/20 (1996): 19–26.

"Interview mit Ute Eskildsen, Kustodin der Fotografischen Sammlung Museum Folkwang Essen." *Eikon* Heft 18/19/20 (1996): 26–34.

Otto Steinert und Schüler. Fotografie und Ausbildung 1948–1978. Essen 1990.

Sammlung Otto Steinert. *Fotografien. Fotografische Sammlung im Museum Folkwang.* 2nd edition. Essen 1985.

THE MUSEUM OF MODERN ART OF NEW YORK

The Museum of Modern Art of New York (MoMA) did more than any other institution to shape the art of photography in the twentieth century. Over the course of the century it played a crucial role in enhancing the aesthetic and financial importance of photography as well as helping to define the scope of photography as an art form. The museum achieved this through the exhibitions it organized, through its collecting policies, and through the activities of its now-legendary curators of photography: their choices, catalogue notes, and books.

Since its foundation in 1929 MoMA has consistently led the way in the display and collection of photographs. Initially these photographs were included in traveling exhibitions or exhibitions of other art forms—most notably architecture. With the formal creation of a Department of Photography, in 1940, the Museum consolidated its presence as the leading champion of photography as a form of art rather than as primarily a scientific, marketing, or educational tool. Since then the Museum has expanded the art of photography to incorporate those other, more functional, aspects of the form.

The following account of the Museum's involvement with photography is in two sections. The first section provides a historical overview of photography at MoMA. This includes a brief account of the relationship to photography of the founders and early officers of the Museum, as well as a description of MoMA before there was an official Department of Photography, followed by an account of the trends and key exhibitions under each of the four heads of the Department. The second, shorter section will deal with the effect that photography had on MoMA and the influence that MoMA exerted upon photography during the course of the twentieth century.

Before MoMA

The history of photography at MoMA does not start ex nihilo with the foundation of the Museum but rather, as with the other departments of that now august institution, it begins with a scattered interest that predated the Museum and which existed independently of the Museum in its early years. The most important forum for photography was the Photo Secession group (1902–1917) which included, among others, the work and participation of Edward Steichen and Alfred Stieglitz. In the United States early aesthetic guidelines for the newly-possible art of photography grew up around a number of galleries in New York that displayed and sold photographs and around the Photo-Secession group which, along with its journal—Camera Work, promoted the idea of photography as art and inspired a generation of photographers and photography collectors.

MoMA before the Department of Photography

From its inception the MoMA was open to new ideas. One of the major reasons that its wealthy founders brought it into being was to supersede the stuffiness and institutional inertia of the existing galleries and museums. Likewise, the reason that they brought Alfred H. Barr to direct it was his fearless exuberance about the "new." Barr was the Director and guiding light for the first few decades of MoMA. Originally recommended to the founders by Paul J. Sachs of the Fogg Museum at Harvard, Barr—an art history professor at Wellesley—came to MoMA as a young man and was largely responsible for museum staff appointments and artistic direction.

Shortly before he arrived at the Museum, in 1929, Barr had been to Europe and the new art he had seen during his travels was the European avant-garde—a movement which had many photographer practitioners (most notably expatriate American Man Ray). In his course on modern art at Wellesley, Barr included not only photography but architecture and machine-made products, which provided an indication of his views on the possibilities of art and of the direction he intended for MoMA. Indeed, in a comment in the Museum's inaugural Bulletin celebrating the Museum's opening in 1929 Barr noted that the Museum would probably expand in time to include departments such as film and photography.

Barr drew, and periodically updated, a genealogical flow chart of modern art, placing a version on the cover of his 1936 book Cubism and Abstract Art from the exhibition of the same name. This highly influential chart gave ample scope for entirely new genres or, in the case of photography, for the collation of a series of existing practices into a single genre. Despite, or because of, this openness the Museum's first acquisition of a photograph—Lehmbruck: Head of a Man by Walker Evans (given by Lincoln Kirstein in 1930)—was not a deliberate departure from previous types of museum acquisition but a pragmatic move to accept a donation. It was only the 23rd work of art that MoMA had acquired. In 1931, with the death of Lillie P. Bliss (one of the Museum's founders), the fledgling Museum acquired a substantial art collection including several photographs. Although it was not until the founding of the Department that it was actively enlarged, the photograph collection had now properly begun.

The Museum began in rented space in the Heckscher Building (on Fifth Avenue and 57th Street) but quickly moved around the corner to bigger premises on 53rd street owned (and later donated) by the Rockefellers. The first two exhibitions at the new location of the Museum on 53rd Street relied upon photography. The first—Modern Architecture: International Exhibition in 1932—coined the name of the pre-eminent architectural style of the next 30 years and relied for its argument on 75 or more large photographs illustrating the new building and design practices coming out of

Europe. The second exhibition on 53rd Street was the first to include photography explicitly. The Advisory Committee wanted to show domestic artwork alongside the new art that was coming in from Europe, and Barr wanted a chance to display photography as an independent art. *Murals By American Painters and Photographers* (1932) gave exactly that opportunity and he turned to Lincoln Kirstein for help.

Kirstein, a friend of architect and MoMA Architecture Curator Philip Johnson and one of the founding members of the Harvard Society for Contemporary Art, went on to serve on the Junior Advisory Committee of MoMA. Kirstein turned to his friend and New York gallery owner Julien Levy for help, and between them they procured the photographs that were displayed. Kirstein was also the director of the 1933 exhibition of Walker Evans prints (which he later donated) of nineteenth century homes—the first one-man photography show at MoMA. Kirstein was one of three especially generous donors who gave time, money, and photographs to the Museum and later to the Department. Over an extended period of time the second of the three donors, James Thrall Soby, gave over 100 Man Ray prints, served as trustee, curator, administrator, collector, organizer of exhibitions, and author of publications that accompanied them. The third, David McAlpin (an investment banker and amateur photographer), was related to the Rockefellers who were so instrumental in creating the Museum. He was friendly with painter Georgia O'Keeffe, Alfred Stieglitz's wife, and secured gifts of her husband's prints; he acquired a handful of Edward Weston and Man Ray photographs, and, among other things, provided $1,000 to fund the first (and only) Photographer's Fellowship in 1946.

Before there was a Department of Photography, there existed a department that dealt specifically with a photomechanical art. Although with hindsight it appears obvious that there should be separate departments for "Film" and "Photography" there is no intrinsic rationale for separating the art of these two photographic processes. It was little more than chance that Iris Barry, a former film critic, should move (via the MoMA library) from London's *Daily Mail*, to set up the Film Library in 1935 (re-named the "Department of Film" in 1966). A film library was anything but a foregone conclusion since, although it realized the "filmotek" of the original plans, it only came about after two years of committee work had been spent exploring the possibility. Indeed, "Photography" and "Film" might easily have been two parts of a larger "Department

of Machine Art" suggested by Philip Johnson's 1934 *Machine Art* exhibition, on display during the committee's deliberations.

When Iris Barry moved from the library to take charge of the Film Library she was replaced as librarian by the photographer and historian Beaumont Newhall. This placed him in an ideal position to advance the cause of photography within the institution. In 1936, he was invited to curate the exhibition that would become the 1937 exhibition *Photography 1839–1937*. Sam Hunter quotes the then President of MoMA, A. Conger Goodyear, describing it as "one of the most complete and satisfying exhibitions in the Museum's history." It was the first comprehensive photography exhibition ever attempted in the United States: In it, Newhall introduced photography as a museum art, presented the museum as an educational institution, and paved the way for a Department of Photography with himself at its helm.

The Department of Photography under Beaumont Newhall, 1940–1946

Funded by a $5,000 grant from David McAlpin, Beaumont Newhall's researches for the 1937 exhibition had been extensive, and they culminated in his publication of the catalogue for the 1937 exhibition as *Photography: A Short Critical History* (1938). This was subsequently expanded into the standard history book of photography. With frequent revisions through the decades *A History of Photography from 1839 to the Present Day* remains one of the most important English language books on photography.

The opening at the new building on 53rd Street in May 1939, meant that there was more space, among other things, to display photographs. With celebration and its own special issue of the Museum's *Bulletin*, the Department of Photography at the Museum of Modern Art was formally established in 1940. Although the Brooklyn Museum had a Department of Photography (the only one in the country), MoMA boasted the first curatorial department in any museum to be devoted exclusively to photography. In the bulletin, Newhall announced his intention for the Department to

function as a focal center where the aesthetic problems of photography can be evaluated, where the artist who has chosen the camera as his medium can find guidance by example and encouragement and where the [public can study] the classics and the most recent and significant developments in photography.

Its opening exhibition was *Sixty Photographs*—curated by Newhall along with the prominent photographer Ansel Adams who had been lured away from California by McAlpin. Although small compared to the century-spanning 1839–1937 exhibition, *Sixty Photographs* sent a clear message that the new department would not limit itself stylistically but, as it said in the bulletin, would rather be guided by the principle that quality in photography works best through the evocation of "an epoch by preserving a moment in the passage of time."

Newhall put on an Edward Weston retrospective in 1946 and a Henri Cartier-Bresson exhibition in 1947 with the help of Levy and Kirstein but there was little he could do that would have surpassed the founding of the Department or his seminal 1937 exhibition. His job was made more difficult by the entry of the United States into World War II and his subsequent call up. While he was on active duty his wife Nancy kept the Department going, continuing to raise funds and to put on exhibitions. Towards the end of the war there was an attempt to change the focus of photography at MoMA by setting up a Center of Photography. This was based in a Quonset hut in the Museum garden and Willard Morgan, a close friend of the Newhalls, was brought in as Director. Overly ambitious, the Center achieved little apart from an unsuccessful national snapshot competition sponsored by Kodak. Morgan soon departed, leaving Newhall in charge again.

Under Newhall MoMA's library had been carefully systematized. He brought the same care to the newly-formed Department, which he established as an independent entity within the Museum. It acquired holdings and published them, it developed an unrivalled institutional presence in world photography and, for better or for worse, it turned photography into a museum art. The 229 prints that the Department began with had already multiplied almost ten-fold to over 2,000 by the time Newhall left. Some of these were gifts from donors such as Soby, Kirstein, and McAlpin, and the rest had come through thoughtful accumulation. A careful curator and expositor, Newhall set consistently high standards over more than 30 exhibitions. A victim of internal politics, he presided over the Department for a shorter time than any other person of the twentieth century.

The Department of Photography Under Edward Steichen, 1947–1962

In 1942, the flamboyant photographer, patriot, and showman, Edward Steichen, had been asked to guest-curate an exhibition that became the 1942 *Road to War* exhibition. It was a collection of photographs from many sources explaining the entry of the United States into the War, with texts by Steichen's brother-in-law, the poet Carl Sandburg. It was a resounding success for the middle-aged U.S. Lieutenant Commander. After the death of Alfred Stieglitz in 1946, Steichen was the most eminent photographer in the nation and one with a flair for marketing. With the failure of Willard Morgan and his Center for Photography, Steichen was linked with another ambitious plan. Without the Committee on Photography or Newhall having been consulted, Steichen was asked to take over as director of photography at MoMA. It was assumed that Newhall would stay on as a glorified archivist and historian but instead he immediately stepped down. Steichen was not able to take up his post for more than a year, and when he eventually arrived at MoMA, the activities of the Photography Department had sputtered to a halt.

During his 15 year tenure Steichen swept the Department up in his undimming enthusiasm for the changing face of photography. The exhibitions moved from the "classical-historical" tendencies of Newhall to a broader, more populist vision influenced by the burgeoning field of photojournalism. He presided over the first important bequest of a collection of photographs to the Department—51 Stieglitz photos donated in 1950 by Georgia O'Keeffe—as well as devising and curating the most popular photography exhibition in history—*The Family of Man* (1955).

In the aftermath of the war Steichen put together a series of international portraits to show the diversity and beauty in what he called, in the catalogue, the "essential oneness of mankind through the world." He sifted through 2 million photographs before making the final selection of 503 prints that demonstrated a shared humanity scattered through numerous genres and locales. In the end the prints came from 68 countries and from 273 different photographers. The exhibition itself was seen by over 7 million people worldwide and the catalogue sold well into the millions. Along with Newhall's *History of Photography* it was still selling well at the century's close.

Steichen had been a founding member of Photo-Secession and identified with its refined aesthetic but before he took over the Department of Photography he had been Chief Photographer at Condé Nast as well as having worked for the Navy and the Army during the World Wars. His changed sensibility and relative breadth of interest was reflected in the 1951 exhibition *Forgotten Photographers*, which reflected

the less self-conscious tradition of photography carried out daily in the practical, commercial, and amateur spheres. As well as an ideological action, the exhibition further helped Steichen broaden the still narrow audience of people who would come to see photographs in a museum. Although radically different, *The Family of Man* and *Forgotten Photographers* shared the photojournalistic notion of prioritizing the message of the exhibition over that of any individual's photographs.

Although a photographer of note, Steichen did not display his work at MoMA until he had already announced his retirement. His own retrospective—*Steichen the Photographer*—in 1961 provided a lively insight into his work and was no exception to his self-professed aim to promote the "aliveness of the melting pot of American photography." MoMA had long since reneged on its plan to divest itself of earlier work as time passed, meaning that expanding and shaping the collection was of paramount importance. Despite his belief in the domestic product Steichen also made important acquisitions from Europe and Latin America, giving the collection an international breadth in keeping with the world view of the curator of *The Family of Man*.

While his successor, John Szarkowski, would achieve the reputation as a nurturer of young talent, Steichen was responsible for inspiring and recognizing the generation coming up in the 1950s. Steichen enjoyed capturing the tone of the moment rather than delving into the past: There were few historical exhibitions and only two books published by the Department during his tenure (*The Family of Man*, and *Steichen the Photographer*). He worked with Robert Frank before his groundbreaking series *The Americans* was published; he exhibited Harry Callahan and Aaron Siskind early in their careers; and he bought two Rauschenberg prints in 1952—before any other work by Rauschenberg had entered any other Museum collection.

The Department of Photography Under John Szarkowski, 1962–1992

John Szarkowski, who was picked by Steichen to succeed him in 1962, went on to have such an impact on photography that *US News and World Report* could claim with little exaggeration in 1990 that "Szarkowski's thinking, whether Americans know it or not, has become our thinking about photography." During his directorship photography went from being barely accepted in the art world to being an established, respected, and highly sought after museum art. This change went hand-in-hand with the rocketing market value of photographic prints of the 1970s and 1980s. The sudden appreciation in value of photographic prints meant that the Museum's collection, as well as growing in size to over 20,000 prints by Szarkowksi's departure, had also grown exponentially in value.

At pains to distinguish himself from Steichen, Szarkowski's first show, *Five Unrelated Photographers* (1963), moved away from Steichen's category-based exhibitions and displayed five photographers (Garry Winogrand, Ken Heyman, George Krause, Jerome Liebling, and Minor White) who were distinctly different from one another. Steichen had steered clear of one-person shows; in an eight year span Szarkowksi exhibited André Kertész (1964), Dorothea Lange (1966), Henri Cartier-Bresson (1968), Brassaï (1968), Bill Brandt (1969), Eugène Atget (1969), Walker Evans (1971), and Clarence H. White in major one-person exhibitions. Berenice Abbott, Bruce Davidson, Duane Michals, and August Sander were among many others who received smaller, yet important, treatments.

Szarkowski also successfully mounted thematic exhibitions, curating *The Photographer and the American Landscape* (1963), before moving to the first of his two important theoretical exhibitions. His directorship was bookended by these epic theoretical exhibitions: *The Photographer's Eye*, at the beginning of 1964, brought Szarkowski's vision of photography to the forefront of public attention; *Photography Until Now* at the end of his tenure (1989) established his view of the approved history of photography.

The Photographer's Eye revolutionized the field of photography by displaying works of acknowledged masters side by side with magazine spreads and anonymous documentary photographs. Diverging markedly from his predecessors he brought together a wide array of photography including anthropological collections, industrial prints, and photographs by artists of their own paintings or sculptures to celebrate the newly enlarged display space available to the Department. Between his two epics Szarkowski put together other "study" exhibitions to investigate issues in photography, such as narrative in *The Photo Essay* (1965) and the expanding scope of the camera's eye in *Once Invisible* (1967) but his swansong was the ambitious *Photography Until Now*, which still lives on in the eponymous book. In that show Szarkowski cemented his position as the eclectic champion of the photographic art in its vitality no matter where it is found.

Between the two huge Museum building projects that took place in 1964 and 1984, Szarkowski built up

the Department with a number of acquisitions and exhibitions. The *New Documents* show in 1967 ushered in a new generation of American artists (Lee Friedlander, Winogrand, and Diane Arbus among others) many of whose prints MoMA bought. His energy for publication seemed limitless as the Department published a vast number of its own catalogues espousing quality work by such photographers as Harry Callahan (*Callahan*, 1976), Lee Friedlander (in *New Documents*, 1967), Garry Winogrand (*Public Relations*, 1977), and Diane Arbus (in *New Documents*, 1967, and her retrospective in 1972) as well as managing the influential survey of American photography since 1960, *Mirrors and Windows* (1978).

While Szarkowski concentrated on emerging and contemporary photographers who were quickly recognized as modern masters, the Department also occasionally looked back to earlier photographers. In 1971, an important Walker Evans retrospective was mounted that harked back not only to the first photograph acquired by the Museum in 1930, but to the first photography book that Szarkowski himself bought, as he recalled fondly in an interview in the art and literary magazine *Grand Street*. In 1975, Szarkowski organized MoMA's second major retrospective of Edward Weston, (the first had been in 1946) confirming him as a major influence on twentieth century photography.

Ironically, for a forward-looking director, one of the most important undertakings of the Department under Szarkowski was a historical project. In 1968, the Museum finally acquired the funds to buy a vast collection of work by Eugène Atget (1856–1927) from Julien Levy and Berenice Abbott. The cataloguing, preservation, and display of over 5,000 prints, duplicates, and negatives from the collection took over a decade, led to four exhibitions and to four volumes of *The Work of Atget*. As well as having documentary value about historical Paris and technical value in showing what equipment was available around the turn of the century, Atget's work is simply beautiful.

The selling of the Museum's air rights and subsequent redevelopment project in the early 1980s expanded the Museum's exhibition space. Szarkowski used his seniority and stature to obtain increased storage and display space for the Photography Department. Szarkowski hired Susan Kismaric as an assistant curator during this period, and she brought the new space into play with shows such as *British Photography from the Thatcher Years* (1990) and Barbara Kruger's 1988 *Picturing Greatness*.

Szarkowski's achievements at MoMA were manifold. They included rethinking exhibitions to allow for heterogeneity and re-shaping the boundaries of the art of photography to include industrial, scientific, journalistic, or advertising prints, with more traditional "art" photography. In taking this broader view of photography he was steering away from the narrower artistic and aesthetic qualities of the Photo-Secession tradition or of Steichen's later years. Szarkowski's move towards a more Catholic understanding of photography was in no way intended to dilute the seriousness of the field, but rather to include previously overlooked genres and fields of photography in the gaze of the collector and the purview of the scholar.

The Department of Photography Under Peter Galassi, 1992–Present Day

In 1992, John Szarkowski stepped down after 30 years of service. In his place he appointed Peter Galassi, a curator in the Department since 1974 who had been responsible for the influential 1981 exhibition *Before Photography*. In this exhibition Galassi suggested that photography was not the product of an arbitrary confluence of cultural and technological developments but rather a legitimate inheritor of a particular, albeit minor, pictorial tradition that predated photography and was evident in certain late eighteenth century paintings. As director Galassi has continued to view photography as part of an interwoven, organic continuum of artistic production. As part of "MoMA2000"—the Museum's millennial review of itself and its subjects—he organized, along with the Director of the Museum and the other departmental directors, several interdisciplinary exhibitions and wrote about their content and conceptualization.

Galassi wasted no time in stamping his imprimatur on the Department. He used the occasion of the exhibition *American Photography 1890–1965* (1997) to write his own history of both U.S. photography and photography at MoMA. As well as providing an invaluable overview to both of these subjects it explains the tradition that Galassi saw himself following. In 2000, Galassi continued this engagement with tradition in *Walker Evans and Company*, an exhibition that was not simply a Walker Evans retrospective like Szarkowski's 1971 show, nor a nostalgic review of the photographer whose print was the first to be acquired by MoMA (although it was symbolically tied to both of those things) but also a way of showing how views on Evans' photography and its context had changed over the years.

Concentrating on the interconnectedness of art forms has not deterred Galassi from holding impor-

tant exhibitions devoted exclusively to photography. In his first year as Director of the Department he curated Philip-Lorca diCorcia's show *Strangers* (1993) an exhibition that defamiliarized the types of photography that Szarkowski had brought into the Museum, opening or re-opening them for enjoyment and analysis. In the catalogue that accompanied the exhibition Galassi quotes with approval diCorcia's observation that "photography is a foreign language that everyone thinks they speak." The last major show before the Museum again closed down—for its second set of major renovations and expansions in 20 years—was the first, and eagerly awaited, show of Andreas Gursky in the United States (*Andreas Gursky* (2001)). The show was a major critical and popular success and Galassi's fluent and scholarly catalogue was in the best of MoMA's educational traditions.

Influence of Photography on MoMA

Written into the mission statement of MoMA is the central principle of education. As well being a legal requirement for the Museum's foundation in the city of New York, Barr, Goodyear, and the founders had a burning desire to spread the message of modern art. Photography enabled the spread of this message: bringing the inaccessible to the public in three separate ways. First, the Museum used photography as a marketing device to attract visitors. Second, it allowed the Museum to arrange exhibitions where the original work could not be viewed. The Museum often displayed architecture—an inconceivable undertaking without the ability to photograph and collate pictures of buildings in one gallery. Likewise the site installations of the conceptual art movements would have been substantially different had photography not existed or had museums such as MoMA not taken photographs seriously as a mode of display. Third, photography allowed exhibitions to extend beyond the Museum. Starting in 1933, Elodie Courter was taking "Circulating Exhibitions" around the city and the country for those who could not get to MoMA itself. The success of these touring exhibitions depended on their use of photographs to illustrate the art that could be seen at the Museum. Both the architectural displays and the Circulating Exhibitions pre-dated the Department of Photography, but were, each in their own way, crucial to the development of MoMA as an aesthetically broad-based, artistic, and educational facility.

Over the course of the century the Museum became increasingly concerned with market for-

ces and the commodification of the building and collection. This explains the Board of Trustees abandonment of Barr's original plan to divest non-contemporary art—the artworks had simply become too valuable to discard—and decision to sell the building's air space in the face of widespread public condemnation. Photography played an important part in this self-conscious movement of the Museum towards treating its own art as a commodity. The building on 53rd Street set a new standard for museums in providing a street view that looked more like a shop than a museum and for providing, in its entry-level lobby space, a large shop from which it was possible to buy cheap prints of works from the permanent collection and some from the temporary exhibitions. More than any other museum MoMA gave its shop a position of prominence and sold photographs to its visitors by the million—in the form of catalogues, books, postcards, and posters.

As well as its building, its subject, and its collection, MoMA has managed to successfully package and sell the scholarship of its curators. MoMA has justly become famous for the quality of its publications. However, not only the Department of Photography, but the Departments of Film, Painting, Sculpture, and Architecture all relied on photography to make their books compelling, and in many cases, even possible.

Influence of MoMA on Photography

In addition to being so highly influenced by photography in the spheres of education and marketing as to be unthinkable without it, MoMA had a profound effect on photography in the aesthetic and commercial spheres. Although the acceptance of photography into exhibition space was part of a larger social movement towards the democratization of art, MoMA was the institution that wielded most influence to secure photography its own place in the museum. By treating photography as a recognizable and distinct genre, and one whose aesthetic had to be treated seriously, MoMA gave the discipline a sense of identity and *gravitas*.

Initially this sense only extended as far as the museums that took their lead from MoMA but, by the late 1970s and 1980s, this soon spread to commercial auction houses, raising the prices of photographic prints. This was partly due to the assumption that art, in general, was a good investment and partly due to increased demand from collectors whose appetite had been whetted by MoMA's ceaseless proselytizing. Photography would not have been

considered an acceptable form of art investment had MoMA not constantly presented it as the equal of painting and sculpture in exhibition after exhibition and, by forming a Department in 1940, given it institutional parity with them.

The nature of the unit of photographic art was also largely determined by MoMA. Walter Benjamin's famous essay "The Work of Art in the Age of Mechanical Reproduction," which demystified the "aura" of art, was published in 1936, the same year as Beaumont Newhall put together his exhibition on the history of photography. This latter could easily have been influenced by the same arguments that swayed Benjamin against fetishizing the object of art itself. Photographers work with a combination of cameras, film, and paper to make photographs. Depending on the exact process, rendering prints from a stored image is usually, at least theoretically, reproducible. As such it would make sense for the negative, or the copyright of the image to be the accepted unit of exchange for photographic art. However, the Museum's insistence on buying, collecting, and exhibiting photographic prints—in exactly the same way as paintings or sculptures were bought, collected, and exhibited—meant that the print had become the accepted commodity in photographic art by the end of the twentieth century.

Despite these numerous and far-reaching interventions in the history of photography, perhaps the most enduring impact that MoMA has had on photography has been on the scope of the art form. By forming a Department of Photography the Museum made it clear that it thought of photography as more than simply a technique (there is no Department of Pointillism, for example). Photography nowadays is used in marketing, education, science, industry, and history; its products are found on any imaginable surface constituting, *inter alia*, artworks, documents, and evidence; it is used for business, pleasure, sport, and religion. Over the twentieth century, and especially under the stewardship of John Szarkowski, MoMA has opened the possibility that any print produced by anyone, for any reason, might have enough aesthetic significance to merit its treatment as art.

DANIEL FRIEDMAN

See also: **Abbott, Berenice; Adams, Ansel; Arbus, Diane; Atget, Eugène; Brandt, Bill; Brassaï; Callahan, Harry; Cartier-Bresson, Henri; Davidson, Bruce; diLorca Corcia, Philip; Evans, Walker; Frank, Robert; Gursky, Andreas; Kertész, André; Kruger, Barbara; Lange, Dorothea; Levy, Julien; Liebling, Jerome; Man Ray; Michals, Duane; Newhall, Beaumont; Photo-Secession; Rauschenberg, Robert; Sander, August; Siskind, Aaron; Steichen, Edward; Stieglitz, Alfred; Szarkowski, John; Weston, Edward; White, Clarence; White, Minor; Winogrand, Garry**

Further Reading

The Bulletin of the Museum of Modern Art no. 2, vol. 8 (Dec-Jan 1940–1941) New York, The Museum of Modern Art.

The Museum of Modern Art, New York: The History and the Collection. New York: Harry N. Abrams in association with The Museum of Modern Art, 1984.

Als, Hilton, and John Szarkoswki. "Looking at Pictures." *Grand Street* 59 (January 1997): 102–121.

Galassi, Peter. *American Photography, 1890–1965, from the Museum of Modern Art, New York.* New York: Harry N. Abrams in association with The Museum of Modern Art, 1995.

Galassi, Peter. *Philip-Lorca diCorcia.* New York: Museum of Modern Art, 1995.

Galassi, Peter, Robert Storr and Anne Umland. *Making Choices: 1929, 1939, 1948, 1955.* New York: The Museum of Modern Art, 2000.

Levin, Michael D. *The Modern Museum: Temple or Showroom.* Jerusalem: Dvir Publishing House, 1983.

Lynes, Russell. *Good Old Modern: An Intimate Portrait of the Museum of Modern Art.* New York: Atheneum, 1973.

Newhall, Beaumont. *A History of Photography from 1839 to the Present Day.* New York: Museum of Modern Art, 1949.

Philips, Christopher. "The Judgment Seat of Photography." *October* 22 (Fall 1982): 27–64.

Staniszewski, Mary Anne. *The Power of Display: A History of Exhibition Installations at the Museum of Modern Art.* Cambridge, MA: The MIT Press, 1998.

Steichen, Edward. *The Family of Man: The Photographic Exhibition Created by Edward Steichen for the Museum of Modern Art.* New York: Published for the Museum of Modern Art by Simon and Schuster, 1955.

Szarkowski, John. *The Photographer's Eye.* New York: Museum of Modern Art, 1966.

MUSEUMS

The Two Families of Museums

There are well-known institutions that have, apart from paintings or other art forms, or those dedicated to history, culture, or science, some generous, unique collections of photographs, negatives, plates, or cameras; while other museums and galleries exclusively dedicate themselves to photography. What sets museums apart from the many other institutions that have extraordinary collections of photographs—public archives, national libraries, private foundations, newspapers and press agencies, various governmental agencies and departments—is that museums have a mission to collect, conserve, exhibit, and educate. Famous institutions such as the Centre national de la photographie in Paris or the Royal Photographic Society in London are not museums *per se*, but are nonetheless very dynamic because of their conferences, publications, and learning programs.

In the first category are respected institutions like the Metropolitan Museum, or the Museum of Modern Art in New York City (MoMA), the Musée d'Orsay in Paris, the Victoria and Albert in London, and the McCord Museum in Montréal, which are multidisciplinary, or "general museums," some featuring incomparable collections dedicated to photography.

On the other side, the International Museum of Photography and Film at the George Eastman House, Rochester, New York, the Musée Nicéphore Niépce in Chalon-sur-Saône, France, the Alinari Museum in Florence, Italy, the Musée Suisse de l'appareil photographique (The Swiss Camera Museum), Vevey, Switzerland, could be ranked in the second category of specialty museums of photography.

Although there are notable exceptions, specialty museums often tend to focus on "artistic" photography and the avant-garde, while most art and science museums that exhibit photographs have a broader conception, sometimes with a more historical, ethnological, and technical approach.

The Role of the Museum in the Acceptance of Photography

During the nineteenth century, photographs were acquired by only a handful of institutions. In England, as early as 1857, the South Kensington Museum, which became the Victoria and Albert, had collected the new medium. Thus in the early years of the twentieth century, the presence of photographs in art museum collections, along with the opening of galleries and specialized museums in photography, are seen as eloquent proofs that finally acknowledged the recognition of photography as an art form.

The collecting of photographs by museums closely followed the passion for the medium by some of its leading practitioners. Since 1905, Alfred Stieglitz had run the Little Galleries of the Photo Secession, on 291 Fifth Avenue, in New York City. In 1910, Stieglitz organized an exhibition of Pictorialist photographs at the Albright Art Gallery, which was well attended and widely written about, beginning that institution's early interest in the medium. Stieglitz played a major role in the acceptance of photographs by the Museum of Modern Art, the Art Institute of Chicago, and the Museum of Fine Arts (MFA) in Boston.

According to its website, the MFA "was one of the earliest museums in the country to collect photography." This initiative began in 1924, when Stieglitz made a donation of some 27 of his photographs, now held in the MFA Department of Prints, Drawings, & Photographs, a typical departmental structure for many general art museums. Again reflecting how photography was truly valued, while donations were accepted, the MFA's first purchase of photographs (a group by Edward Weston) was not until the late 1960s.

Founded in 1929, the Museum of Modern Art (MoMA), freed from traditional notions about what constituted fine arts by the very definition of its founding, innovated by establishing a special department for photography under art historian Beaumont Newhall in 1940. When photographer Edward Steichen, well known in the fine-arts community for his sequence of leading French sculptor Auguste Rodin's *Balzac*, was appointed as director for the photography section in 1947, it was another confirmation that the profession was recognized as a dynamic part of contemporary art.

If most museums dedicated to photography concentrate on the visual result of the medium, others

depict the technical dimensions. Dedicated to one of photography's founders, the Musée Nicéphore Niépce opened in 1972 in the city where the scientist was born, Chalon-sur-Saône, in central France. Although Niépce's collections and cameras were reunited as soon as 1861, they were not accessible to the general public for almost a century. This collection now has over two million photographs, plus thousands of optical objects, and early apparatus as old as Niépce's prototypes from 1816. The Niépce Museum also organizes demonstrations of camera obscura. The technical advances in the field continue to form the core of public collections: Mixing art, science and optics, a unique museum dedicated to holography was created in Paris on 25 March 1980 as the Musée de l'Holographie.

Photography as Narrative

Many museums and similar institutions that are not related to the fine arts but to humanities (or historical, ethnographic, social issues), such as the Red-Cross Museum (Musée international de la Croix-Rouge) in Geneva use among other artifacts all kinds of photographs to represent their duties, mission, and history. Under the influence of new museology, recent museums tend to conceive the exhibition of any kind as a storytelling medium, rather than a place to see separated elements that only have beauty and rarity in common.

Since many people tend to believe that photographs tell the truth about reality, museums depicting photographs play a central role in the social representation of oneself and others, contributing to the nation-building and the construction of a national identity, past and present. As any media, museums must be seen as places of interpretative processes and vehicles of ideologies.

Catalogues and Art Books

The role of all museums in supporting photography and its practitioners has been greatly expanded by the widespread commitment of institutions to publishing, often with very little or no profit. Considered an essential part of scholarship, exhibition catalogues have burgeoned in the last several decades of the twentieth century, with many museums publishing both art books that reproduce via photography, paintings and other artworks from their permanent collections and temporary exhibitions. Some professional photographers such as Alfred Stieglitz or Patrick Altman (b. 1950) even specialize in the photographic reproductions of art works into books, postcards, and posters. Once relatively rare among the publication of monographs, books focusing on photographers are routinely published by museums to accompany temporary exhibitions. Less common at the end of the century are publications documenting museums' photography collections. Keeping abreast of developments in the museum field, among others, UNESCO publishes a journal in four editions (English, French, Spanish, Russian), *Museum International*, about issues related to museology.

A Wave of New Museums

Perhaps coincidental to the celebrations of the 150th anniversary of the birth of photography in 1989, the 1980s were an incredible period of growth for museums exclusively dedicated to photography, with numerous openings of new facilities, most the first ever in their respective countries. While Ireland had its Gallery of Photography in Dublin since 1978, Iceland's Reykjavík Museum of Photography (Ljósmyndasafn Reykjavíkur) was created in 1981. In Bradford, West Yorkshire, England, a National Museum of Photography & Television opened in 1983 to tremendous attendance. In 1984, Denmark opened in Herning its Danish Museum of Photography (Danmarks Fotomuseum), followed in 1987 by the Museet for Fotokunst (Museum of Photographic Art) in Odense, and later in 1999, a National Museum of Photography (Det Nationale Fotomuseum) was launched in Copenhagen.

The Canadian Museum of Contemporary Photography (CMCP) was created in 1985 from the photographic division of the archives owned by the National Film Board of Canada and the National Gallery of Canada. Uncharacteristic of most museums, the CMCP began its activities by presenting rotating exhibitions in various locations, and opened its own building only in 1992, in Ottawa.

Although its name does not give a clue, the Musée de l'Elysée in Lausanne, Switzerland, is a museum solely dedicated to photography. It opened in 1985, the same year as the Fratelli Alinari Museum of the History of Photography was inaugurated in Florence, Italy. In Charleroi, Belgium, the Musée de la Photographie was created in 1987. In 1990, the Tokyo Metropolitan Museum of Photography was Japan's first comprehensive art museum especially devoted to photography and optical imagery, soon followed by the Nara City Museum of Photography in 1992.

A first Hungarian Museum of Photography was opened in Kecskemét in 1991. The following year, in the United States, the Griffin Museum of Photography was created in Winchester, Massachusetts. The Latvian Museum of Photography was established in

1993 in Riga (Latvia, a former part of USSR). In 1994, the Norway government purchased the private Preus Fotomuseum (Preus Museum of Photography), which had opened in 1976; since 2001, it is known as the Norsk Museum for Fotografi-Preus fotomuseum, in the city of Horten. Launched in 1998, the Thessaloniki Museum of Photography was the first and only photography museum in Greece. In February 2000, the Finnish Museum of Photography opened at the Cable Factory in Helsinki. In about two decades, the number of museums related to photography in the world has more than quadrupled.

New Technologies and Their Impact on Museums

Along with their traditional missions of collecting, conserving, and exhibiting, museums at the end of the century moved toward the massive task of digitizing their collections, Although rife with problems, including obtainment of copyright and the expense of equipment and staffing, this area will inevitably became more and more central to most museums' missions. New technologies have also allowed for so-called virtual museums to offer countless photographs through the World Wide Web. The American Museum of Photography is a virtual museum that can only be visited on the Internet, at (http://www.photography-museum.com/). However, museums as we have always known them remain vital institutions for conserving, protecting, and selecting photographs, and educating the public in various ways.

YVES LABERGE

See also: **Conservation; Internet and Photography; Museums: Canada; Museums: Europe; Museums: United States**

Further Reading

Hooper-Greenhill, Eilean. *Museums and the Interpretation of Visual Culture*. London: Routledge, 2001.
Lent, Max, and Tina Lent. *Photography Galleries and Selected Museums: A Survey and International Directory*. Venice, CA: Garlic Press, 1978.
McDarrah, Fred W., Gloria S. McDarrah, and Timothy S. McDarrah. *The Photography Encyclopedia*. New York: Schirmer Books, 1999.
Robertson, Bruce. The South Kensington Museum in context: An Alternative History. http://www.le.ac.uk/museumstudies/m&s/robertson.pdf (accessed May 19, 2005).
Ross, Max. "Interpreting the New Museology." *Museum and Society* 2 (July 2004) 84–103.

Websites

The Alinari Museum. Florence (Italy). http://www.alinari.com/en/museo.asp (accessed May 19, 2005).
The American Museum of Photography (a Virtual Museum). http://www.photography-museum.com/ (accessed May 19, 2005).
Culture, France. Photo. http://www-texte.culture.fr/PatrimoineMonumentsJardins/Photographier/c687 (accessed May 19, 2005).
International Council of Museums (ICOM). Working group on photographic records. http://icom-cc.icom.museum/WG/PhotographicRecords/ (accessed May 19, 2005).
Musée de la Photographie (Charleroi, Belgium). http://www.museephoto.be (accessed May 19, 2005).
Musée international de la Croix-Rouge. Geneva. http://www.micr.ch/index_e.html (accessed May 19, 2005).
The Musée Suisse de l'appareil photographique [The Swiss Camera Museum at Vevey, Switzerland]. http://www.cameramuseum.ch/f_basis.html (accessed May 19, 2005).
Musée de l'Elysée, Lausanne: un musée pour la photographie (Switzerland). http://www.elysee.ch/ (accessed May 19, 2005).
Musée de l'Holographie. Paris. http://www.museehologra phie.com/museeFR.htm (accessed May 19, 2005).
Musée Nicéphore Niépce, Chalon-sur-Saône, France. http://www.museeniepce.com (accessed May 19, 2005).
Museum of Fine Arts, Boston. Collections of Prints, Drawings, & Photographs. http://www.mfa.org/artemis/collections/pdp.htm (accessed May 19, 2005).

MUSEUMS: CANADA

In terms of Western civilization, Canada is a very young country, with the birth of the Confederation as recent as 1867. Photography as a young medium parallels Canada's youth as a country and the enthusiasm with which the medium has been accepted and collected is evident from the holdings in various Canadian museums.

National identity in Canada is very much dependent on its cultural institutions and their ability to provide a cohesive force across great variances in

demographics, climate, topography, and economics. Since Confederation, cultural institutions such as the Canadian Broadcasting Corporation and the National Film Board have held the country together and created a cohesive force across the vast land mass. From these public institutions with audiences of "middle Canadians" has evolved an interest in the medium of photography that is now embedded in collections in museums across Canada. Photography as a democratic art form and leveler of variances suits Canada's national personality in its accessibility, documentary nature, transportability, and ease of communication as a medium.

Many of Canada's finest museums across the country boast excellent photographic collections that in many cases rival those of major world institutions. Only a selection of the better known of these museums are highlighted, with other photographic treasures to be found in this vast country.

Art Gallery of Greater Victoria

The fine art collection of the Art Gallery of Greater Victoria began in the early 1940s, and became open to the public in 1947. The Gallery, now with over 17,000 works of art, is one of Canada's finest museums. The focus of the Art Gallery is to engage the public in nuances of the art world, while striving to be the leader in visual arts in British Columbia and Canada. Housed in an historic nineteenth century mansion, the collection includes Asian, historic Canadian and European and contemporary art with an emphasis on Canadian and Japanese art. The contemporary art consists of mainly works from artists in western Canada, and includes photography.

Although only about five years in the making, the photography collection now holds almost 200 works. The works are by Canadian photographers, and include many pieces by the photographer Claude Benoit. The Gallery has recently begun to exhibit new media. One notable exhibition in July of 2004 was *Farheen Haq, Breathing Space*, a photography and video installation.
www.aggv.bc.ca

Art Gallery of Hamilton

With its first acquisition of 29 paintings by William Blair Bruce in 1914, the Art Gallery of Hamilton (AGH) has been continually expanding, and is now Ontario's third largest public art gallery. The strength of the AGH lies in its 8,500-plus works permanent collection, emphasizing nineteenth century European, historical Canadian, and contemporary Canadian art. Particular attention has been placed on women artists, as well as twentieth century Canadian artists. All works in the AGH collection can be recognized as significant achievements in bringing an understanding of visual arts for the people of Hamilton, and abroad.

Within the permanent collection are over 320 photographs by many significant Canadian and international artists. As the entire collection grows, the photography collection is expected to grow as well. Many of the artists are contemporary, including Suzy Lake, Evergon, Geneviève Cadieux, Angela Grauerholz, and Robin Collyer. An important photographic exhibition hosted by the AGH currently on tour of the region is *The Eye of Edward Steichen*, featuring Steichen's work from the 1920s and 1930s. Currently, the AGH is under construction, but will reopen in the Spring of 2005 with two major exhibitions; *Lasting Impressions: Celebrated Works from the Art Gallery of Hamilton*, and *Heaven and Earth Unveiled: European Treasures from the Tanenbaum Collection*.
www.artgalleryofhamilton.on.ca

Art Gallery of Newfoundland and Labrador

The permanent collection of the Art Gallery of Newfoundland and Labrador (AGNL) is a culmination of the Memorial University of Newfoundland collection, begun in 1961, the J.K. Pratt Memorial collection, begun in 1986, and the AGNL collection begun in 1994. The entire permanent collection now held at the AGNL comprises over 5,500 works of art. The AGNL holds examples of painting, printmaking, drawing, sculpture, indigenous crafts, experimental media, and photography. The first priority of the AGNL is to collect works of art by contemporary and historical artists in the Newfoundland and Labrador area. The collection also includes works about the area, as well as many works by other contemporary Canadian artists. The AGNL has accepted a mandate to provide for the public visual works of art that hold the ideas and aesthetics of the artist in their communities.

Modest in comparison to the entire collection, the AGNL holds a collection of contemporary photography. Of the approximately 100 works, Canadian artists represented include Marlene Creates and Steven Livick. The AGNL generally presents about 20 exhibitions per year. Two significant exhibits including photography were *Manfred Buchheit, A Retrospective*, in 1996 and *Light Proof* in 2000.

Art Gallery of Nova Scotia

In 1908, the Nova Scotia Museum of Fine Arts was founded, and in 1910, the permanent collection was begun. The museum then became the Art Gallery of Nova Scotia (AGNS) in 1975, and today boasts a collection of over 10,000 works of art. The beautiful Victorian architecture of the Dominion Building is the AGNS's home for historic and contemporary Nova Scotian, Canadian, international, and folk art. The permanent collection includes paintings, drawings, sculptures, photography, video, and decorative arts dating back to the eighteenth century. The AGNS also houses many major loans from the Nova Scotia College of Art and Design, as well as other institutions from the province of Nova Scotia. The focus of the Gallery is to bring visual arts and the public together, as well as the exploration and enjoyment of the works.

The AGNS has over 600 photographs in its permanent collection. With both historical and contemporary works, the photography collection is a fine example of mainly Canadian artists. Historical works include the photography of George Nass, Sid Kerner, and Ronald Caplan. Contemporary works include those from Canadian artists Susan McEachern, Steven Livick, and Thaddeus Holownia. International works are also collected, such as those by Gary Wilson and Franco Fontana. In 2003, an important retrospective of the Canadian photographer Tim Zuck was exhibited, titled *Tim Zuck: Learning to talk*.

www.agns.gov.ns.ca

Art Gallery of Ontario

The permanent collection of the Art Gallery of Ontario (AGO), originally the Art Gallery of Toronto, was begun in 1900. Over a hundred years later, the collection now holds over 36,000 works, representing a thousand years of art making. The collection includes European Old Masters, Group of Seven, and Canadian and international contemporary works. In the spring of 2005, AGO will be unveiling its "Transformation." With the help of many donations, the Transformation will include new art, a new building, and new ideas.

The photography collection within the contemporary collection of AGO is a mixture of Canadian and international artists, including Jeff Wall, Steven Livick, Edward Steichen, Cindy Sherman, and Martha Rosler to name a few. The AGO also has a significant collection of the photographer Captain Linneaus Tripe. One of the strengths of the photography holdings is the unique collection of portraits. Some of these portraits were exhibited recently in the show *In Situ*, showcasing the photographs of other artists in their studios. Edward Steichen's photograph of Brancusi in 1927 is a great example of art of the subject of making art.

www.ago.net

Canadian Centre for Architecture

In 1979, the Canadian Centre for Architecture (CCA) was founded with the purpose of building public awareness of the role of architecture in society. With the help of Phyllis Lambert, the founding director of the institution, the CCA began collecting works dating from the seventeenth century to the present documenting the architecture of the world. The collection consists of drawings, paintings, sculpture, and photography.

The photography collection within the CCA showcases the history of photography relating to architecture. With over 55,000 photographic items dating back to the beginning of the medium, the collection studies the role of photography in representing the created environments of the time. The collection holds over 72 daguerreotypes, some dating back to 1840 and being among the most import extant daguerreotypes today. In addition, the collection holds many works from nineteenth century photographers from the United Kingdom, such as William Henry Fox Talbot; from France, such as Edouard Baldus, including major albums done for the railways; Georg Bridges from Greece; Robert Macpherson of Italy with some of the finest work in existence today; and Charles Clifford from Spain, to name just a few. Photographs from the early twentieth century include works on civil engineering projects and construction sites. The collection also has many works by twentieth century photographers involved in the interpretation of modern architecture, such as Alfred Stieglitz, Charles Sheeler, Paul Strand, and Walker Evans, all represented by a number of iconic images.

The CCA often holds exhibitions dedicated to their photography collection. A recent important exhibition in 2004 was *West 27th Street, Manhattan*, showcasing photographs by John Veltri of the city of New York in 1966, before its redevelopment.

www.cca.qc.ca

Canadian Museum of Contemporary Photography/Musée canadien de la photographie contemporaine

The Canadian Museum of Contemporary Photography/Musée canadien de la photographie contemporaine (CMCP/MCPC) was founded in affiliation with the National Gallery of Canada in 1985. The history of its collection, however, dates back to the 1960s, as the Still Photography division of the National Film Board of Canada. A good portion of the works dating from 1962 to 1985 is from the collection of the National Film Board. Opening its doors to the public in 1992, the CMCP/MCPC currently holds over 160,000 photographic works, spanning over 40 years. The collection comprises works by Canadian-born or Canadian-resident artists. As one of only a few national museums devoted specifically to photography, the CMCP/MCPC has successfully held up its mandate of collecting the best of documentary and fine art photography produced by Canadian contemporary artists. The incredibly large body of work that it holds represents an internal view of Canada's recent history, society, and culture. In addition to photographs, the collection includes negatives, books, filmstrips, assemblages, installations, and video art.

Contemporary Canadian artists represented include Jeff Wall, Kelly Wood, Lynne Cohen, Michael Snow, Damian Moppett, and Jocelyne Alloucherie, among others. The CMCP holds many exhibitions each year. A significant past exhibition was in 2003, titled *Confluence: Contemporary Canadian Photography*, showcasing the best of Canadian photography from the last decade. Additionally, a significant recent exhibition in September 2004, titled *Phil Bergerson: Shards of America*, showcased the Toronto-based photographer's work about literal and figurative signs that people leave behind. In 2002, CMCP/MCPC was the only North American venue for a major retrospective of the Robert Frank exhibition, *Moving Out*.

www.cmcp.gallery.ca

Edmonton Art Gallery

In 1924, the Edmonton Museum of the Arts held its first exhibition with only 24 paintings borrowed from the National Gallery of Canada. By 1929, it had its first permanent location and the beginning of its permanent collection. After several facility changes, and an ever-growing collection, in 1974, the collection moved to its present location, and is now known as the Edmonton Art Gallery. With over 5,000 works in the permanent collection, the Gallery includes Canadian and international art, both historical and contemporary. Media collected includes paintings, sculptures, installations, and photography. The primary mandate of the gallery is to preserve the artistic heritage of Canada. This includes a program called *"Adopt a Painting"*, through which the public can help to restore some of the artwork that is deteriorating.

The photography collection within the Gallery holds over 1,200 works, and continues to grow. The photographs held are a mixture of historical and contemporary, Canadian and international, as well as traditional and experimental. The Canadian artists include Vicky Alexander, Raphael Goldchain, and Lauren Greenberg. Major international artists include Ansel Adams and Walker Evans. An important exhibition in recent years was *Technicolour*, in 2003, including the works of Canadian photographers Chris Cran, Clay Ellis, Geoffrey Hunter, Angela Leach, Chris Rogers, and Arlene Stamp, and included photographs relating to the visual language of today's newest technologies.

www.edmontonartgallery.com

Glenbow Museum

As Western Canada's largest museum, the Glenbow Museum consists of an art collection, a library, and an archives section. The museum boasts a collection of over a million objects. As a multidisciplinary institution, the collection includes cultural history, ethnology, mineralogy, and military history. The focus of the museum is therefore multifaceted. The art collection within the Museum contains over 28,000 works, including contemporary, historic, Western Canadian, and Inuit art. The main focus of the art collection is to represent Canadian artists, with a large portion of Western Canadians. Within the contemporary art collection is the photography collection with works by such Canadian photographers as Alan Dunning, Craig Richards, Iain Baxter, Douglas Curran, and George Webber to name a few.

Within the Glenbow archives, there are approximately 79,000 photographs for research purposes. Although most of these works are by non-artists, the collection is a significantly large one including many documentary works. The exhibitions held by the museum are usually multimedia, and many include photography. One particular show coming in 2005 is *Our River: Journey of the Bow*, featuring works about Alberta's famous Bow River.

www.glenbow.org

Library and Archives Canada/Bibliotèque et Archives Canada

In 1872, as a branch of the Department of Agriculture, the archives began collecting documents of national significance. Today, the archives hold millions of films, documentaries, architectural drawings, works of art, music, and the most substantial holding of Canadian photography in the country. Collected since the 1870s, with images dating back to the 1850s, the photography department now holds over 21.3 million photographic images. Similar to museums, the archives is an institution providing knowledge to the public through their collections and services. The majority of photographs were acquired from Canadian studios, newspapers, and government agencies. All of the works deal with Canadian life, Inuit peoples, government, and history.

http://collectionscanada.ca

MacKenzie Art Gallery

One of the earliest art collectors in western Canada, Norman MacKenzie, directed in his will that the majority of his collection be given to the University of Saskatchewan in the hopes that an art gallery would be built to house it. In September of 1953, the Norman MacKenzie Art Gallery officially opened. With a range of historical to contemporary art, including works by over 5,000 different artists worldwide, the collection represents art from Western Canada, as well as national and international, and an emphasis on Saskatchewan art. Within the collection are examples of fiber arts, painting, sculpture, drawing, collage, and most recently, photography.

The photography collection, although small in comparison to the rest of the collection, is a fantastic representation of Canadian artists. Some of the artists include Shelagh Alexander, Lynne Cohen, Evergon, and Frances Robson. Of the 175 and increasing number of photographs in the collection, the emphasis is on mid-career and established contemporary Canadian photographers. The MacKenzie Art Gallery has held many significant exhibitions, the most recent ones including photography. In October of 2004, the gallery held an exhibition titled *The Body*. This exhibition showcased works from the permanent collection, including photography, painting, and drawing depicting the human figure, from Renaissance nudes to modern abstractions.

www.mackenzieartgallery.sk.ca

McCord Museum of Canadian History

Founded in 1921 by David Ross McCord, the McCord Museum holds more than 1.2 million objects. As a public research and teaching museum, it is dedicated to the preservation and reflection of the social history of Canada. With exhibitions, cultural activities, tours, and publications the museum seeks to present an interactive experience for the public.

In 1956, the museum acquired the archives of Montreal photographer William Notman, a veritable visual history of Canada. The 450,000-plus photographic collection encompasses the famous Notmam & Sons studio photographs spanning over 78 years. The photographs cover the period of time from 1840–1935, and include landscapes, portraits, events, and other historical photographs. The photography collection also includes about 600,000 images by other photographers, including Alexander Henderson and John Taylor. This archive inspired the exhibition *After Notman: Photographic Views of Montreal, A Century Apart*, which paired photographs taken by the Notman studio of views of Montreal a hundred years ago with the photographic views of Montreal today by the photographer Andrzej Maciejewski.

www.mccord-museum.qc.ca

Montreal Museum of Fine Arts/Musée des beaux-arts de Montréal

Bishop Francis Fulford founded the Art Association of Montreal in 1860 to establish an art library that was lacking in Montreal at the time. In 1879, the Art Association became the Musée des beaux-arts de Montréal/Montreal Museum of Fine Art, and was the first institution in Canada specifically designed for an art collection. Today, after almost a century-and-a-half of collecting, the museum holds a collection of over 30,000 works including sculpture, paintings, drawings, works on paper, and photographs dating from antiquity to contemporary. The main focus of the museum is the promotion of works by Canadian and international artists to provide the public with a breadth of artistic heritage. The museum's permanent collection is divided in sections, Ancient Cultures, European Art, Canadian Art, Inuit and Native American Art, and Contemporary Art.

Within the contemporary collection is a significant collection of photography. With over 600 works, the collection holds examples of Canadian and international photographers. Important Cana-

dian artists represented include Louise Abbott, Raymonde April, and Michel Campeau. In addition to Canadian photographers, the collection includes works by Brassaï, Dorothea Lange, Eadweard Muybridge, and Germaine Krull. The museum has held many exhibitions dedicated to the medium of photography, including *Herbert List, Romantic Wanderer*.

www.mbam.qc.ca

National Gallery of Canada/Musée des beaux-arts de Canada

Beginning in 1880, the National Gallery of Canada (NGC) has collected over 50,000 works including Canadian, European, American, Contemporary, Modern, Inuit, and photographic art. The main focus of the NGC is to develop, maintain, and make known throughout Canada a collection of international art, both historic and contemporary, with a special reference to Canadian art.

The photography collection, although the youngest of NGC's collections, is the largest with over 20,000 photographs. Established in 1967 by James Borcoman, it comprises one of the top major international photographic collections covering the entire history of the medium, from 1839 to the present. Many different types of photographs are represented in the collection, such as daguerreotypes, ambrotypes, gelatin silver, and platinum prints, and many examples of color as well as new modern photographic techniques. Rather than just single important images, the collection represents several in-depth bodies of work to give the viewer a greater understanding of the artist's work. Many famous and socially significant artists are represented in the collection, including Julia Margaret Cameron, Eugène Atget, Walker Evans, August Sander, Diane Arbus, and Edward Weston, to name a few. In addition to the historic artists, the collection also represents many contemporary photographers, such as Roger Mertin, David Heath, Lynne Cohen, and Gary Schneider. Many important exhibitions are organized from the NGC's photographic permanent collection, including the 2004 exhibition *Faces, Places, Traces*, showcasing 97 photographs, newly acquired by the NGC. The most notable images of the newest acquisition were several vintage prints by Paul Strand.

www.national.gallery.ca

Vancouver Art Gallery

Founded in 1931, at the end of the twentieth century the Vancouver Art Gallery's permanent collection boasted over 8,000 works of art including paintings, sculpture, mixed media, and photography. With an emphasis on British Columbia artists, the Vancouver Art Gallery also holds the largest public group of paintings by the renowned modernist Emily Carr and represents a comprehensive resource for visual arts in the region.

Since the 1980s, the gallery has been building a strong collection of photo-based art, which now includes almost 800 works. Vancouver is renowned for its contemporary photography, specifically the "Vancouver School," a group of photographers working in photoconceptualism. The Vancouver Art Gallery's permanent collection includes many of these "Vancouver School" works, such as those by Stan Douglas, Rodney Graham, Jeff Wall, and Ken Lum, among others. The Vancouver Art Gallery is also home to the archive of renowned Pictorialist John Vanderpant. In addition to Vancouver-based artists, the permanent collection holds the works of such important photographers as Andreas Gursky, Cindy Sherman, Thomas Struth, and many others. The main focus of the photography collection is to build a dialogue on photography and the conceptual and material possibilities that surround the medium. In 2003, the Vancouver Art Gallery held an exhibition titled *The Big Picture: Recent Acquisitions from the Collection of Alison & Alan Schwartz* showcasing the gallery's $3.5 million acquisition of photographic works from 20 different artists, including Matthew Barney, Thomas Ruff, and many other European, British, and North American artists.

www.vanartgallery.bc.ca

Winnipeg Art Gallery

Since its founding in 1912, the Winnipeg Art Gallery (WAG) has held up its mandate to develop and maintain the visual arts in Manitoba and Canada, and to involve the public in the arts. Since its inception, the WAG has collected over 22,500 works, ranging from the fifth century to the present. The collection encompasses historical, decorative, Inuit, contemporary, and photographic arts, with an emphasis on Canadian artists, specifically those from Manitoba.

The photography collection within the WAG concentrates on the twentieth century, with a strong emphasis on Canadian photographers. Consisting of over 1,100 photographs, the genres represented range from social and documentary, landscape and portraiture, as well as contemporary photo-based works.

Many successful Canadian photographers are represented in the collection, such as Sam Tata, David McMillan, Barbara Astman, and Sorel Cohen. The collection also includes works by important international photographers, including Diane Arbus, Brassaï, Henri Cartier-Bresson, and Lotte Jacobi. In 1985, the collection was given an important gift of 200 photographs, representing a 70-year span of André Kertész's work.

Exhibitions are frequently mounted from the photography collection such as that of American artist, Mark Ruwedel, *Written on the Land*, showcasing his photography of humankind's impact on the land.

www.wag.mb.ca

PENELOPE DIXON

See also: **Photography in Canada**

Further Reading

Bailey, Clayton. *Waitings: Photographs*. Winnipeg: Winnipeg Art Gallery, 1978, exhibition catalogue.

Dikeakos, Christos. *Christos Dikeakos: Vancouver Art Gallery*. Exh. cat. Vancouver: Vancouver Art Gallery, 1986.

James, Geoffrey. *Thirteen Essays on Photography*. Ottawa: Canadian Museum of Canadian Photography, 1992.

Karsh, Yousuf. *Karsh: The Art of the Portrait*. Ottawa: National Gallery of Canada, 1989.

Magicians of Light: Photographs from the Collection of the National Gallery of Canada. Essay by James Borcoman. Chicago: University of Chicago Press, 1993.

McMann, Evelyn De R. *Montreal Museum of Fine Arts, Formerly Arts Association of Montreal: Spring Exhibitions 1880-1970*. Toronto: University of Toronto Press, 1988.

Riddel, W.A. *The MacKenzie Art Gallery: Norman MacKenzie's Legacy*. Regina: MacKenzie Art Gallery, 1990.

Riordon, Bernard, and Mora Dianne O'Neill, et al. *AGNS Permanent Collection: Selected Works*. Halifax: Art Gallery of Nova Scotia, 2002.

Treasures of the Glenbow Museum. Calgary: The Glenbow Museum, 1991.

Treasures of the National Archives of Canada. Toronto: University of Toronto Press, 1992.

Triggs, Stanley. *William Notman's Studio: The Canadian Picture: McCord Museum of Canadian History*. Montreal: Le Museé, 1992.

MUSEUMS: EUROPE

European museums are the repositories for many of the premier collections of photography in the world, and are especially rich in nineteenth-century material. Many general museums with comprehensive collections have some photography holdings, but the major collections require special mention. As well, there are a number of museums devoted solely to the medium.

Austria

Albertina Fotosammlung, Vienna

Founded in 1999, the photography department of the Albertina is a collection of Austrian and international historical and contemporary photography. Holdings include the archives of the Höhere Graphischen Bundes-Lehr-und Versuchsanstalt (Vienna Training and Research Institute of Graphic Art directed by Josef Maria Eder) of Austrian and international photographs, photo-literature, and cameras from the beginnings of photography, including holdings of the Technische Universität and collections of the Photographische Gesellschaft Wien (founded 1861) of predominantly nineteenth century materials, with a large number of Austrian and French Calotypes, and results of different kinds of physical and optical experiments ; the Langewiesche Archiv (on loan from the Austrian Ludwig Foundation, Vienna) of the famous publisher of *Die Blauen Bücher* and *Der Eiserne Hammer* consisting of approximately 10,000 images printed between 1907 and 1960 with works of Gutschow, Albert Renger-Patzsch, Rudolf Koppitz, Lucia Moholy, and others, and Convoluts of the former Kaiserliche Bibliothek with early examples of photography in Austria, predominantly donations from the Kaiser Franz Josef. In 2003, the Albertina began a series of exhibitions concentrating on photography in Austria in galleries of approximately 800 square meters.

www.albertina.at

Rupertinum, Museum Moderner Kunst, Österreichische Fotogalerie (Austrian Photo-Gallery), Salzburg

Founded in 1983, the Photo-Gallery is the only museum in Austria dedicated to collecting contemporary Austrian photography and features approximately 15,000 prints. Although the collection includes works from the early part of the century, including Pictorialism and works by photographers Inge Morath, Ernst Haas, and Franz Hubmann, the majority of the collecting is since the end of the Second World War, including Austrian Aktionismus (Otto Mühl, Hermann Nitsch, Rudolf Schwarzkogler, Günter Brus), and workgroups of Arnulf Rainer and the generation that emerged in the 1980s, including Valie Export to contemporary digital photography. Three to four temporary exhibitions are mounted per year. An extended photo-library is part of the museum's library. A biannual competition has been mounted since 1983, and a purchase prize, the Rupertinum Fotopreis is offered.

www.fotonet.at/rupertinum
www.rupertinum.at

Belgium

Museum voor Fotografie, Antwerpen

In 1984, the Province of Antwerp purchased the Huis Vlaanderen (Flanders Warehouse) for the purpose of turning it into the Museum of Photography that opened 1986. The major collections were formed from an exhibition at the Sterdoxhof Museum tracing the art and science of photography that was mounted in 1965. Thus in dealing with the history of photography, equal emphasis is placed on the images and equipment in the museum's permanent exhibition. The museum features five galleries with approximately 1,200 square meters. An average of 18 temporary exhibitions each year accompany the permanent installation. The museum also features a library of approximately 20,000 volumes focusing on Belgian and international photography as well as photo magazines.

www.provant.be

Musée de la Photographie de la Communauté française à Charleroi—Centre d'art contemporain, Charleroi

In the heart of French-speaking Belgium, at Charleroi, a converted neo-gothic Carmelite nunnery houses the Musée de la Photographie. Although the museum opened in 1987, the photo-collection was founded in 1978 and contains over 80,000 images, more than 1 million negatives (most of them black and white), and 2,500 cameras. Collections focus on documentary and social photographs (Archives de Wallonie); and Belgian photographers, with significant holdings of Léonard Misonne, Gustave Marissiaux, Willy Kessels, Charles Leirens, Julia Pirotte, Serge Vandercam, etc. 2,000 square meters are devoted to the history of photography and exhibitions by contemporary artists with 10 to 12 exhibitions are mounted each year. The museum also features a discovery area; a library with more than 6,000 books and around 100 magazines; a documentation center; a bookshop; and publishes its own magazine, *Photographie Ouverte* (founded in 1978 with four issues per year).

www.musee.photo.infonie.be

Croatia

Muzej suvremene umjetnosti (Museum of Contemporary Art), Collection of Photography, Film and Video, Zagreb

Founded in 1954, the Zagreb Museum of Contemporary Art integrates several galleries, collections, and a library. The beginnings of the center date back to 1973 when a department for new media was established. The largest part of the museum's collection consists of post-1950 works by both Croatian and foreign artists. The 1950s and 1960s are represented by photojournalist Mladen Grcevic for Magnum Photos, a large collection of reportage and art photos by Milan Pavic and Ante and Zvonimir Brkan, and structuralist films by Tomislav Gotovac from the mid-1960s. Important modernist Croatian photographs of the 1920s and 1930s are also featured, including works by Ivana (Koka) Tomljenovic Meller, who studied at the Bauhaus Dessau.

www.mdc.hr/msu

Czech Republic

Uměleckopr✓ myslové museum (Museum of Decorative Arts, Department of Graphic Arts and Photography), Prague

The museum was founded in 1900, the photo-collection in 1902. The extended photo-collection holds highlights of twentieth century Czech photography, especially of the modernists of the 1910s to the 1930s: ca. 60,000 prints and 30,000 negatives. Main holdings are of leading international Czech figures Josef Sudek (ca. 21,000 prints, 27,000 negatives), Frantisek Drtikol (ca. 5,000 prints, 300 negatives) as well as Josef Koudelka, Jan Svoboda, and photographers of Magnum agency. One gallery of 240 square meters is devoted to one to two exhibitions per year in the main building of the

museum; an average of three exhibitions are held in the Josef Sudek Gallery, and the museum organizes and sponsors other projects in the Czech Republic and abroad. The Library of the Museum of Decorative Arts is the largest Czech public library specializing in art and related fields, including photography books and magazines.

www.knihovna.upm.cz

Moravská galerie v Brně (Moravian Gallery in Brno), Brno

The photography department of this extensive general museum, one of the most important in the Czech Republic, was founded in 1962. Highlights are photographs of the 1920s and 1930s with numerous examples of Czech modernists including Josef Sudek, Jaromír Funke, František Drtikol, Karel Kašpařík, and others. The Cloister at the former Governor's Palace (one of the museum's three buildings) is devoted to photography; every year about seven exhibitions, most of them monographic exhibition, of both Czech and foreign photographers are featured.

www.moravska-galerie.cz

Denmark

Danmarks Fotomuseum, Herning

This museum devoted entirely to photography was established by former photo dealer Sigfred Løvstad with his comprehensive collection of photographic equipment, especially historic cameras. The museum was established in 1983 with the collections enlarged in 1984 when the National Museum in Copenhagen deposited most of their historical photo collection. Permanent exhibitions cover photography from its beginnings to the present day with an emphasis on the history of the camera. Other special features of the collection include photographs by Hans Christian Andersen and a display of holographs and their associated technology. The museum consists of eight galleries of 535 square meters, and features approximately eight temporary exhibitions per year of both Danish and foreign photographers.

www.fotomuseum.dk

Museet for Fotokunst, Brandts Klaedefabrik, Odense

Founded in 1987, the museum features approximately 7,500 items, including significant holdings of Danish photographers Keld Helmer-Petersen, Viggo Rivad, Gregers Nielsen, Per Bak Jensen, Jytte Rex, Igor Savchenko (Belarus), Herman Försterling (Germany), William Eggleston (USA), and Pentti Sam-mallahtu (Finland). The major goals of the museum include the preservation of Danish photo history and promotion of the art of photography to the Danish public. Approximately 12 temporary exhibitions are mounted each year, four that feature experimental work by younger artists in a series called "The Platform" and one that features works from the collection. The museum houses a library with almost 4,000 items on photography, and publishes a bilingual journal: *KATALOG*. The museum also hosts the Odense Foto Triennale festival.

www.brandts.dk/foto

Finland

Suomen valokuvataiteen museo, Finlands fotografiska museum, Helsinki

Founded in 1969 in a former cable factory, the Finnish Museum of Photography specializes in historical and contemporary Finnish photography. As such the museum sponsored the national project "Memory of the Photograph" to rescue Finnish photographs with the aim of helping photographic archivist in Finland to catalogue and manage their collections. Research and data networks are key features of the museum which features 900 square meters of exhibition space including galleries for permanent and temporary exhibitions, including a gallery devoted to exhibitions by emerging photographers. The Museum houses a modern conservation laboratory, a central photographic archive, and a library.

www.fmp.fi

France

Bibliothèque nationale de France, Estampes et photographie (Prints and Photography Department), Paris

The premier collection of photographic material in France, the photo collection of this ancient institution, represents more than 4 million photographs covering the entire history of photography. Areas of particular significance for twentieth century photography are works by Eugène Atget, and over 100,000 works of contemporary photographers. The Bibliothèque nationale maintains one of the largest photo-libraries in France and awards two major photography prizes, Prix Nadar and Prix Nièpce, for young photographers living in France. Works from the collection are exhibited on a regular basis in the Galerie Colbert as an experimental exhibition venue for contemporary photography. Complete online services are available for research and viewing of photographs, including virtual exhibitions.

www.bnf.fr

Centre Méditerranéen de la Photographie, Bastia Cedex

This Center was founded in 1990 as a foundation falling under the cultural plan for Corsica established early in the twentieth century. The Center highlights not only Corsican photographers and international photographers working in Corsica but also photography of the Mediterranean area. The collection holds more than 500 works by approximately 80 photographers plus the archive of the Corsican photographer Ange Tomasi, featuring works from 1900 to 1950. Exhibition space consists of three galleries of 350 square meters wherein approximately 10 exhibitions are presented each year. CMP also collaborates to mount exhibitions at other cultural institutions in Corsica. The Center is also responsible for two photo biennials, the Biennale Photographique de Bastia and the Biennale Photographique Bonifacio, and it publishes *Le bulletin de Centre Méditerranéen de la Photographie*.

www.cmp-corsica.com

Maison Européenne de la Photographie, Paris

The museum opened in 1996 in the heart of Paris in the historic Hôtel Hénault de Cantobre with its rapidly-growing collection concentrating on international contemporary photography from the 1950s to the present day. The museum's Library Roméo Martinez is built around the collection of the famous editor of *Camera* magazine, and holds more than 12,000 books covering the history of photography from the end of the World War II to the present, including a number of first editions as well as magazines and essential research materials on the history of photography. The Video Library features more than 700 tapes showing the work of contemporary photographers. The museum also features an auditorium and the Atelier de Restauration et de Conservation des Photographies de la Ville de Paris (ARCP), founded in 1983 to help preserve the various photographic collections and archives of the City of Paris.

www.mep-fr.org

Centre National d'Art Moderne, Centre Georges Pompidou, Paris

In 1975, the Musée national was transferred under the authority of Centre Georges Pompidou, the photography collections included. Today the Centre National d'Art et de Culture houses more than 13,000 prints (and many more negatives) of the twentieth century with extraordinary examples of famous photographers, especially early twenti-eth century Man Ray, Dora Maar, Brassaï, Florence Henri, Germaine Krull, Lucien Lorelle, Roger Parry, Maurice Tabard, Hans Bellmer, André Kertész, László Moholy-Nagy, and others, plus thousands of photographs that document other artists and their work including Constantin Brancusi, Hans Arp, Pablo Picasso, and others. The museum features a large photo-library.

http://www.cnac-gp.fr

Musée Français de la Photographie, Bièvres

The museum was founded in 1960 by the collectors Jean and André Fage and opened in 1964. In 1974, the museum was reinstalled at its current site in Bièvres, which was renovated in 1998. The collection holds numerous historical cameras, and other diverse photographic and technical equipment shown in a permanent exhibition about the history of photography from its invention to the present day. The museum's photo collection is mainly focused on the nineteenth century, but twentieth century photography and contemporary works are also represented in the archive and shown in three to four temporary exhibitions each year.

www.photographie.essonne.fr

Musée Réattu, Arles

The museum was founded in 1868 with the photo-collection begun in 1962 through the efforts of Lucien Clergue and Jean-Maurice Rouquette. The MR now holds more than 4,000 works of the highest quality, many of them coming as donations from the photographers themselves. Highlights include works by masters of the 1920s and 1930s such as Edward Weston, Germaine Krull, François Kollar, Dora Maar, and Man Ray. The festival Rencontres Internationales de la Photographie in Arles encouraged other photographers and collectors to donate, expanding the collection to include works by Ansel Adams, Robert Doisneau, Lucien Clergue, Izis, William Klein, Jerry Uelsmann, Arthur Tress, Yousuf Karsh, Cucchi White, Eva Rubinstein, and Keiji Tahara. From 1985 on the collection of "photographie changerienne" and photography as part of conceptual art was extended. Photo-objects of Pascal Kern, Jochen Gerz, Mimmo Jodice, Alain Fleischer, Jacqueline Salmon, and others came into the collection. The acquisition strategy now shows more about the dialogue between photography and other arts. The collection also features photographs of the city of Arles. The museum keeps a changing permanent photo exhibition and mounts two to four temporary exhibitions each year.

Germany

Berlinische Galerie, Landesmuseum für moderne Kunst, Photographie und Architektur, Berlin

Founded in 1975 to collect and exhibit works by Berlin-born or based artists, beginning with the Berlin Secession. It features a comprehensive collection, including photography. Of particular relevance are the archives and estates of Heinrich Zille, Erich Salomon, Marta Astfalck-Vietz, and Herbert Tobias; a collection of photography of the former German Democratic Republic (East Germany); and a collection of contemporary photographers including Dieter Appelt, Thomas Florschuetz, Elfi Fröhlich, and Michael Schmid.

www.berlinischegalerie.de

Kunstbibliothek, Staatliche Museen Preussischer Kulturbesitz, Berlin

Founded in 1867, as one of the first libraries specializing in art, the Kunstbibliothek has grown and expanded over the years to include, besides library collections, approximately 100,000 examples of architectural, fashion, commercial, industrial and fine-arts photography, including a large collection of German and international photography of the nineteenth and twentieth centuries. Particular artists include Ernst Juhl, Fritz Matthies-Masuren, László Moholy-Nagy, Max Burchartz, Albert Renger-Patzsch, Helmar Lerski, Thomas Florschuetz, and Dieter Appelt. The museum also features the archives of Fritz Matthies Masuren (acquired 1915) and Ernst Juhl (acquired 1916). In 1994, the Library relocated to its own building that features an exhibition space of 285 square meters that mounts one or two exhibitions per year.

www.smb.spk-berlin.de

Fotografische Sammlung im Museum Folkwang, Essen

The Department of Photography was founded in 1979 within this comprehensive museum. The collection consists of international photography of over 50,000 works of the twentieth century with an emphasis on portraiture, architectural photography, photojournalism, and postwar developments including works of the group fotoform and those associated with Subjektive Fotografie. The collection holds the estates of Helmar Lerski, Germaine Krull, Wolfgang Weber, Walter Peterhans, and Otto Steinert and the archives of Peter Keetman and the ringl+pit Studio. Other early twentieth century figures featured include Heinrich Kühn, Hugo Erfurth, László Moholy-Nagy, Albert Renger-Patzsch, August Sander, and Edward Steichen. Exhibition space consists of two galleries that feature four to six exhibitions each year.

www.museum-folkwang.de

Museum für Kunst und Gewerbe, Fotosammlung, Hamburg

The photography collection of one of Germany's most important general museums was founded in 1900 and since 1987 has existed as an independent space of the museum. One of the oldest and most important collections in Europe, it covers the history of photography from its beginnings to the present day. Highlights are the early years of photography (with about 1,300 items), a collection of historical cameras and photo-equipment, art photography of around the turn of the twentieth century (2,700 items of the Collection Ernst-Wilhelm Juhl), photographers of the *Neue Sehen* (New Vision) movement of the 1920s, Japanese photography, and the *Subjektive Fotografie* of postwar Germany, photojournalism, and contemporary trends. In recent years a particular collecting focus has been fashion photography, with the museum acquiring works by Irvin Penn and others. The photo department holds also the complete personal library and the archive of Fritz Kempe, the Collection Willem Grütter, the estate of Wilhelm Bandelow, the Foundation Mode Welten of F.C. Gundlach, and the foundation Gerhard Kerff. A supplementary photo-library with more than 10,000 volumes is part of the museum library. Since 1991 the Reinhart Wolf-Prize, given by the Reinhart Wolf Foundation for young talent exemplifying new tendencies in photography has been administered by the museum. Forum Fotografie, founded in 1994, is an exhibition space for contemporary experimental photography.

www.mkg-hamburg.de

Staatliche Galerie Moritzburg, Halle/Saale

The Staatliche is the leading museum of the Sachsen-Anhalt region, housed in a former castle. Photography was collected since the very beginnings of the museum in 1885 and the collection stands at more than 50,000 items. Of particular interest are the estates of the Swiss photographer Hans Finsler, director of the photo-class at the Hallesche Kunstschule at Burg Giebichenstein, Halle, 1927–1932, donated in 1986, and Finsler's assistant, Gerda Leo. Other important areas of collecting are Vanguard Photography of the 1920s and 1930s *(Neue Sehen)*, East German

photography after 1945 with the archive of the former Fotokinoverlag Leipzig, and the photo-collection of the former society of photography of the Kulturbund of the GDR, photography from Eastern Europe after 1945, and international contemporary photography. The photo library houses more than 8,000 books.

www.moritzburg.halle.de

Sprengel Museum, Hannover

Founded in 1979, the Sprengel is one of Europe's leading contemporary art museums. The formal department of photography and new media was begun in 1993 although regular exhibitions of photography have been held during the museum's history. Collecting is focused on international photography since the 1970s, especially American social documentarians. Special collections include, on permanent loan since 1992, the Ann and Jürgen Wilde Collection of over 1,500 vintage photographs of Albert Renger-Patzsch, Karl Blossfeldt, and others, and since 1993, the Siemens Kulturprogramm Collection with 600 prints of contemporary photography and since 2001, the Heinrich Riebesehl archive with more than 3,000 vintage prints and approximately 15,000 negatives. The Sprengel also administers the Spectrum Prize for international photography. Exhibition spaces include two galleries of 1,275 square meters that present six to seven exhibitions each year.

www.sprengel-museum.de

Museum Ludwig and Agfa Foto-Historama, Cologne

The Agfa Foto-Historama is located within Museum Ludwig, founded in 1976 and devoted to contemporary art. The Photo-Historama is one of Europe's most important collections devoted to the cultural history of photography. In 1986, after having been housed in temporary quarters for many years, the collection found a new home in the Ludwig, and was placed on permanent loan to the city of Cologne. At the core of the collection is the private collection amassed by Erich Stenger. Acquired in 1955, this collection covers all aspects of the history of photography. Additional holdings are 300 portraits by Hugo Erfurth and the archives of the Agfa Kamerawerk in Munich, featuring approximately 20,000 photographic and reproduction devices from all fields of the twentieth century photographic industry. The Photo-Historama mounts exhibitions in three galleries of 220 square meters.

www.museenkoeln.de/ludwig

Fotomuseum im Münchner Stadtmuseum, München

In 1888, the Historische Museum of the city of Munich was founded, and although photography was incorporated into its collection from its beginnings, it wasn't until 1961 that the photo museum as part of the city museum was founded, forming one of the most important photo collections in Germany. The collection features extensive nineteenth century holdings. Twentieth century holdings include the archives and estates of Franz Grainer, Frank Eugene, Fritz Witzel, Victor Knollmüller, Theodor Hilsdorf, Filip Kester (12,000 prints), Barbara Lüdecke (3,000 prints), Thomas Höpker (5,000 prints), Hubs Flöter (5,000 prints), Rudolf Carl Huber, Hermann Rüdisühli, Richard Seewald, Karl Hubbuch, Waldemar Bonsels, Franz Hanfstaengl, Theodor Hilsdorf, Alois Löcherer, Stefan Moses (20,000 prints), Herbert List, Regina Relang (20,000 prints), Erich Retzlaff, Renata Riederer, Jo von Kalkreuth, Norbert Przybilla, Walter Hege (1,000 prints), and others; the archive of the journal Quick 1946–1990 (ca. 100,000 prints), the photo archive of the Deutscher Kunstverlag with photographs of the Preussische Messbildanstalt (5,000 prints), an archive Berlin of fashion photography 1930–1945 (4,000 prints), an archive of amateur snapshots 1890–1990 (ca. 180,000 prints), and the collection Uwe Scheid that also includes rare photo-literature and phototechnical equipment. Important photographs by Willi Moegle, Josef Breitenbach, Hanna Seewald, the group fotoform, Fritz Henle, Joseph Albert, Hilmar Pabel, Will McBride, Heinrich Hoffmann, August Sander, Alfred Eisenstaedt, Felix H. Man, Lotte Jacobi, André Kertész, Hans Namuth, Erich Salomon, and J. Heydecker are also featured. Since the 1980s efforts have focused on collecting international contemporary photography, and a major renovation of galleries was made at the turn of the twenty-first century. The Fotomuseum also houses an extensive photo library with more than 10,000 books and magazines and a department for photo conservation. It also mounts numerous symposiums, workshops, and lectures.

www.stadtmuseum-online.de

Great Britain

National Museum of Photography, Film & Television, Bradford

Founded in 1983 as a part of the National Museum of Science and Industry. The museum has become one of the most-visited museums in Britain with its collection including more than 3.5 million items of historical, social, and cultural value. These include the world's first negative, the earliest television footage, and early examples of moving pictures.

The photo collection is one of the largest and most important in Great Britain and traces the technical and aesthetic developments of photography from the earliest experiments in the 1830s to examples of contemporary practice across many genres and applications of the medium. The collection also features concentration in documentary advertising, and amateur photography. Highlights include important works by international twentieth century masters, including Lewis Hine, Edward Steichen, Alfred Stieglitz, Man Ray, László Moholy-Nagy, Bill Brandt, Ansel Adams, Brassaï, Margaret Bourke-White, Robert Capa, Henri Cartier-Bresson, Giselle Freund, Yousuf Karsh, and Weegee. Works of the postwar generation, many emerging in the 1980s, include Richard Billingham, Chris Killip, Chris Steele Perkins, Martin Parr, Cornelia Parker. and Jo Spence. Other important holdings are the Zoltán Glass archive (10,000 negatives) and the archive of *The Daily Herald*. This archive, which represents a remarkable picture of British social life from 1912 to the 1960s, consists of over 2,500,000 prints and 100,000 negatives and contains many photographs from agencies such as Associated Press, Planet News, U.P.I., and the Press Association. A 1999 renovation updated the museum facilities to provide one of the most technologically sophisticated exhibition spaces in Europe, offering interactive displays, learning laboratories, and a wealth of on-line materials as well as permanent and changing exhibitions, workshops, and lectures.

www.nmpft.org.uk

National Portrait Gallery (NPG), London

The museum was founded in 1856 to provide a repository of historical portraits in all mediums regardless of the artistic quality of the portrait. Collecting was sporadic in the area of photography with the National Photographic Record (NPR), which began in 1917 the most significant means of acquisition. In the 1970s, under the directorship of Roy Strong, photography became a more integral part of NPG's activities with the founding of a department of photography and film. Attendance to a 1968 exhibition of Cecil Beaton was significant, and served to spur collecting of more contemporary materials. Holdings include approximately 160,000 photographs, with approximately 9,000 prints from the NPR (1917–1970); the Benjamin Stone collection of Members of Parliament and visitors to the House of Commons between 1897–1906; the Howard Coster Collection; the Elliott and Fry Studio collection of 20,000 negatives and prints; the Ida Kar Collection of writers and artists; the Cecil Beaton

Collection of over 1,200 prints; the Dorothy Wilding Collection of 710 prints of celebrities and royals; and the Angus McBean Collection of 113 prints. Generally one large photographic exhibition is held each year with changing permanent displays. Extensive education and research facilities, conservation laboratories, and on-line services are also offered.

www.npg.org.uk

The Royal Photographic Society, Bath

Formed in 1853 with Queen Victoria and Prince Albert as patrons, it was granted the use of the title "Royal" by decree in 1894. The Society's mission today, as in 1853, is "to promote the Art and Science of Photography." Membership is open to everyone with an interest in photography. The Society is currently located at The Octagon, Bath, which houses the Society's offices and its internationally important collection. The Society's famous collection is part of Britain's national heritage. It includes over 150,000 photographs, books, items of equipment, and other unique material from 1827 to the present day. The collection covers the whole evolution of photography and the variety of photographic processes. There are also modern classics by Edward Weston, Ansel Adams, and Yousuf Karsh and a steadily growing emphasis on the work of contemporary photographers. Material by the Secessionist photographers, including Alvin Langdon Coburn, Edward Steichen, and Alfred Stieglitz is strong, as is the history of early colour photography. RPS mounts an extensive series of workshops, master classes, lectures, courses, conferences, meetings, field trips, seminars, public darkroom, and photo competitions.

www.rps.org

Imperial War Museum, Photograph Archive, London

Containing over 6 million images, the Photograph Archive is a rich source of material on the two world wars with photographs by Bill Brandt, Bert Hardy, and Cecil Beaton among others. Its coverage spans the entire twentieth century and is international in scope. The impact of war on civilians and the contribution of Commonwealth countries are documented in depth; other nations are also included. More recent material shows the British Army's international contribution to NATO and humanitarian relief efforts.

www.iwm.org.uk

The Tate, London

Photographs as part of contemporary art have been acquired since 1972. The several hundred

photographs in the collection are not part of a separate section but exceptional examples of the contemporary art scene. They are mostly conceptual works of outstanding British and international artists. Photography is exhibited as part of the changing exhibitions. The Tate also houses extensive photographic materials in the Tate Archives concerning mostly British art and artists.

www.tate.org.uk

The Victoria and Albert Museum, Department of Prints, Drawings, Paintings and Photographs, Photography Collection, London

V&A holds the national collection of the art of photography, and is one of the largest and most significant photography collections in the world, international in scope and ranging from 1839 to the present. The museum holds approximately 300,000 prints in the primary collection plus thousands of photographs of works in the various other collections, known as the Picture Library. The V&A's Theatre Museum, and the Indian and South East Asian department also hold photographic archives. Important twentieth century photographers represented include Henri Cartier-Bresson, Bill Brandt, Don McCullin, and many others, with an index available in the Print Room. Since 1977 the National Art Library has made substantial acquisitions of photography publications, including key journals, monographs, early texts, exhibition catalogues, and experimental publications. These are supplemented by 'Information Files' on photographers and institutions, containing such materials as press cuttings, exhibition announcements, and sometimes correspondence. A changing selection of nineteenth and twentieth century and contemporary photographs, drawn from the collection, forms special exhibitions and illustrates a history of photography in the Canon Photography Gallery. Exhibitions of photography are mounted each year, and extensive educational resources include "Education Boxes" of photographs in the Print Room that contain selections of work ordered into three themes: The History of Photography, Photographic Processes, and Techniques and Contemporary Photography.

www.vam.ac.uk

Hungary

Magyar Nemzeti Múzeum (Hungarian National Museum), Történeti Fényképtár (Historical Photo Gallery), Budapest

Hungary's largest photo archive preserves about one million photographs of which half a million are individually registered, the remainder arranged by subject in chronological order. The collection dates back to 1874 when the first daguerrotype was registered in the Hungarian National Museum. The archive's goal is to collect and systematize photo material covering all aspects of the Hungarian history and maintain its important collection of the history and technological history of photography, reflecting that the two predecessors of the present archive were the Historical Gallery established within the Hungarian National Museum in 1884 and the Museum for Contemporary History founded in 1957. Since 1995 the Historical Photoarchive has been an independent department of the Hungarian National Museum with five galleries of 1,500 square meters, mounting one photography exhibition per year.

www.origo.hnm.hu

Magyar Fotográfiai Múzeum (Hungarian Museum of Photography), Kecskemét

In 1991, in an historic building that was once a synagogue, the collection of over 75,000 items amassed by the Association of Hungarian Art Photographers since 1958 for the purpose of establishing a museum was finally opened. MFM is the only museum solely devoted to photography in Hungary. Now consisting of more than 500,000 photographs and 80,000 negatives from the 1840s to the present, the collection's main focus is on Hungarian photographers including André Kertész, Brassaï, Cornell Capa, Robert Capa, László Moholy-Nagy, György Kepes, Paul Almásy, Rudolf Balogh, Alajos Martsa, Muky and Martin Munkácsi, Baron Lorand Eötvös, Károly Divald, Angeló, Olga Máté, Balázs Orbán, Ferenc Hopp, Imre Kinszinski, Károly Escher, Tibor Honti, Jindrich Štreit, Stefan Lorant, Gergely Palatin, János Reisman, Antal Simonyi, József Pécsi, Pál Rosti, Iván Vydareny, as well as contemporary photographers Tanás Féner, Péter Korniss, Gábor Kerekes and almost five hundred additional Hungarian and foreign photographers. A special collection, Fotohungarika, containing Hungarian-related works of foreign photographers who have worked in Hungary such as Erich Lessing, Mario de Biasi, Ferdinando Scianna, Chim, and Henri Cartier-Bresson is being developed. Collections also feature cameras, archival documents, books, booklets, and audio and video recordings. The museum also features a conservation laboratory, a database information center, and extensive online resources. Approximately eight to ten exhibitions are mounted at the museum and others are sponsored abroad, supported by a series of monographs titled "A magyar

fotográfia történetébõl (From the history of Hungarian photography).

www.fotomuzeum.hu

Ireland

National Library of Ireland, National Photographic Archive, Dublin

The photographic collections, almost 300,000 items, of the National Library of Ireland are now housed in the National Photographic Archive. While most of the collections are historical there are also some contemporary collections, the majority of the material, however, focusing on Irish society, landscape, and history. Collection focuses include landscape photography, studio portraits, photojournalism, and early tourist photographs. Significant twentieth century collections include the Cardall Collection of approximately 5,000 negatives for postcards from the 1950s and 1960s, the Clonbrock Collection of over 2,000 glass plates spanning the years 1860–1930, the Eason Collection of 4,000 negatives for postcards dating 1900–1940, the Keogh Collection of political events and studio portraits from 1915–1930, the Morgan Collection consisting of aerial views of Ireland 1957–1958, the O'Dea Collection of 5,300 prints covering all aspects of railway transport in Ireland between 1937–1966, a collection of Panoramic Albums containing views of coastal scenes, and the Poole Collection of 60,000 glass plates images of the South East of Ireland dating 1884–1954. The archive building incorporates modern storage, a conservation area, darkrooms, and a reading room in addition to its exhibition gallery. Many database resources are accessible through the reading room, and online cataloguing information is also available.

www.nli.ie

Italy

Museo di Storia della Fotografia Fratelli Alinari (The Museum of History of Photography Fratelli Alinari), Florence

Opened in 1985 as a museum by the Fratelli Alinari company, one of the world's oldest firms in the field of photography, the Alinari houses 800,000 prints showing the development of photography as an art as well as photographic equipment from 1839 to the present day. The first museum in Italy devoted solely to photography, the collection is particularly rich in Italian photographers. Also located in the Palazzo Alinari, is the Alinari archives with 400,000 glass-plates and 750,000 negatives on film

that preserve the photographic record of the art, economy, and way of life of Italian and European society from photography's beginnings to the present day. Alinari technicians work actively to make prints from these original negatives for both exhibitions and commercial purposes. An integral part of the Alinari Museum is the Library of History of Photography, from the origins to the present day. A Conservation Workshop was founded in 1996 in collaboration with the Opificio delle Pietre Dure. The museum and the Alinari firm organize traveling photo exhibitions in Italy and worldwide and host important exhibitions developed elsewhere. Educational resources include an on-line digital catalogue, edu.alinari.it, that includes 85,000 pictures, both historical and modern.

Books, periodicals, poster books, and multimedia are published by the Fratelli Alinari Publishing House.

www.alinari.it
www.alinari.com

Latvia

Latvijas fotograáfijas muzejs (Latvian Museum of Photography), Riga

Founded in 1991 and opened to the public in 1993, the museum collects, preserves, and exhibits the photographic heritage of Latvia. The collection is one of the most significant in Latvia and includes approximately 10,500 items plus documents and photographic and darkroom equipment. Research is conducted into the history of Latvian photography as an inseparable and unique component of Latvian culture as well as into its role in the overall evolution of world photography. Collections include negatives by Karlis Lakse (1920–1945), works by an unknown photographer in Ventspils (port in Latvia; 1944–1945), photographs by war reporter Janis Talavs (1943–1945), negatives and slides by Roberts Kalnins (1930–1970), and negatives and prints by Andris Stamguts (1970–1980). The exhibition space consists of four galleries of 207 square meters for the permanent collection covering the development of photography in Latvia (1839–1941) and two galleries with 90 square meters that feature 12 to 15 temporary exhibitions per year focusing on international contemporary photography, contemporary Latvian figures, and works by Latvian nationals living elsewhere. The museum has a specialized photo library with 2,400 books and 3,600 magazines and offers online resources on contemporary Latvian photographers.

www.vip.latnet.lv/museums/photo

The Netherlands

Nederlands Fotomuseum, Rotterdam

Founded in 1992 the Fotomuseum's collection holds the negatives, transparencies, and prints from 70 Dutch photographers of the nineteenth and twentieth century who worked for press agencies, theatre companies, film companies, fashion houses, industry, the government, and publishers. A unique feature of the museum is that it holds agreements by which its holdings can be sold to the public for various commercial or private uses.

Ten to fifteen exhibitions each year are mounted in the museum's three galleries of 600 square meters, focusing mainly on the contemporary photography of the Netherlands. Bilingual (Dutch/English) publications are produced. The museum features a comprehensive Restoration Department offering conservation and restoration services to the public. The museum library emphasis is on photography theory, the history of photography, and Dutch photograph since 1945 and contains not only books but extensive digital materials and an online catalogue.

www.nederlandsfotomuseum.nl
www.nfi.nl

Stedelijk Museum, Amsterdam

The photographic collection of this general museum (founded in 1885) began in 1958 with gifts of two collectors. Currently the collection contains 9,000 photographs of international as well as Dutch artists, many of these a permanent loan of the Dutch government. Of particular interest are works by László Moholy-Nagy, Gertrude Käsebier, Paul Strand, Eugène Atget, Cecil Beaton, Robert Capa, André Kertész, Johan van der Keuken, Diane Arbus, Nan Goldin, and Rineke Dijkstra and concentrations of works by Eva Besnyö (78), Erwin Blumenfeld (42) and Ed van der Elsken (240). The library features over 2,500 photo-books and periodicals as part of the general art library of the museum. Photography exhibitions are mounted as part of the general program.

www.stedelijk.nl

Norway

Norsk Museum for Fotografi, Preus Fotomuseum, Horten

Based on the collection of the Preus fotomuseum from Preus Foto corporation, the Norsk Museum was founded in 1994 when this collection was acquired by the state for the purpose of establishing a national museum for photography in Norway. Located on the fourth floor of the Karljohansvern, owned by the Ministry of Defense in a space called Storehouse No. 1, its charter is for the preservation, collection, and dissemination of photographs in Norway, with a particular focus on art photographs. The collections and exhibitions contain Norwegian and international photographs, cameras, and other objects that illustrates the development of photography. The museum also features an international library with 20,000 volumes on the prehistory and history of photography, photographic techniques, history of the camera, photography as a form of art and documentation, and all types of photographic activity and related topics. The periodicals collection comprises around 1,000 titles, 100 of which are current. The library incorporates a number of Norwegian and international archives, foremost among them the Narath Archive.

www.museumsnett.no/fotografimuseum
www.foto.museum.no

Poland

Muzeum Narodowe Wroclaw (National Museum of Warsaw, Photography Department), Warsaw

The photo collection was founded in 1963. Holdings include ca. 10,500 photographs. The collection concentrates on creative photography, especially Polish art photography since the beginning to the present. Particular artists include Hermann Krone, Józef Czechowicz, Jan Bułhak, Witold Romer, Zbigniew Dłubak, Frantciszek Groer, Aleksander Krzywobłocki, ZdisłBeksinski, Natalia NN, and Edward Hartwig. Photo-literature is included in the museum library.

Galleries for temporary exhibitions comprise 6 rooms and 250 square meters, and two or three photo exhibitions per year.

www.rej.com.pl/m_narodowe

Museum Sztuki (Museum of Fine Arts), Lodz

Founded in 1930, the museum is one of the oldest museums of modern art in Europe. In 1977, the Department of Photography was founded featuring about 3,000 photographs, as well as artists' videos. The department houses a unique international collection of avant-garde art, covering the period from the 1920s to the 1930s, and collecting is concentrated on contemporary photography, especially of Poland and Central Europe. Featured photographers are Florence Henri, Anton Stankowski, Stanisław Ignacy Witkacy, Werner Bishof, František Vobecký, Vilem Reichmann, Christian Boltanski, Annette Messager,

Derek Boshier, John Hilliard, and Barbara Kasten. Special archives include photography and photographic albums of Poland (1912–1939) by Jan Bułhak and in the Department of Graphics and Modern Drawing, an archive of Polish avant-garde photomontages of Kazimierz Posadecki, Janusz Maria Brzeski, Mieczysław Berman, and photograms of Karol Hiller from the 1920s and 1930s. Postwar reportage and sociological photography (Zofia Rydet, Bohdan Dziworski, Tomasz Tomaszewski, Adam Bujak and Anna Bohdziewicz) and photography related to avant-garde movements (Zbigniew Dłubak, Andrzej Pawłowski, and Marek Piasecki) are featured. A selection of Socialist Realism from the 1950s is another area of concentration, as well as a large number of works by artists of the Toruń-based group Zero 61. Books and catalogues, mainly Polish-language, and magazines on photography are collected by the museum library. Two to three temporary exhibitions are mounted each year.

www.muzeumsztuki.lodz.pl

Muzeum Historii Fotografii (Museum of the History of Photography), Cracow

Founded in 1986 and located in a historic villa, MHF is the only museum in Poland that exclusively collects and shows photography. The collection, made up in part of that amassed by the Cracow Photographic Society, comprises some 55,000 photographs, cameras, and other photographic equipment. The collections focus on Polish history, including cultural, political, and military photography, and especially photography of the region and of the city of Cracow. Highlights include works by Jan Bułhak, the first coloured slides (autochromes) by Tadeusz Rząca, and complete documentation of the works of Władysław Marynowicz—the Polish photographer active in Britain. Recently, the museum has started a collection of fine arts photography, featuring. the works of Erich Lessing, Edward Hartwig, and Fortunata Obrąpalska. The technical aspects of photography are another area of interest in the museum, with the permanent display consisting of photographic equipment. The library holds approximately 5,500 volumes. Approximately 10 temporary exhibitions are held each year in nine galleries within the museum's 230 square meter building.

www.mhf.krakow.pl

Portugal

Centro Português de Fotografia, Porto

The museum was founded in 1997 to be the national center for collecting photography in Portugal. Collection focuses on both Portuguese and international photography from its beginnings to the present day. The CPF also maintains an archive that holds negatives and prints of Portuguese photographers and studios. This archive is divided into two parts, one located in Porto holding the collections belonging to the northern part of the country and the other in Lisbon holding the collections of southern Portugal. These archives hold over 2.5 million works. Highlights of the collection include Bernard Plossu, Paulo Nozolino, Duarte Belo, Emílio Biel, Nicholas Nixon, Neal Slavin, and Bruce Gilden. The most important and representative collections in the Archives are those of Domingos Alvão (1869–1946), Aurélio da Paz dos Reis (1862–1931), Joshua Benoliel (1878–1932), portraits of the prisoners in Cadeia da Relação (1880s–1905), and the newspaper *Século*. CPF's library holds approximately 1,600 books and 200 magazines, as well as a database information service. CPF features many educational programs, including workshops, seminars, and book publishing. The permanent display is an overview of the history of Portuguese photography and historical cameras. Eight temporary exhibitions are mounted each year of both Portuguese and international developments in photography.

www.cpf.pt

Spain

Universidad de Navarra, (University of Navarra), Pamplona

The photo collection was founded in 1990. Owners of the growing photo collection are: Legado Ortiz Echagüe, Fundación Universitaria de Navarra, and Universidad de Navarra.

Special collections include the José Ortiz Echagüe Collection with ca. 1,700 photographs, cameras, and other technical equipment; a nineteenth century Spanish Collection with ca. 4,600 photographs; and the Juan Dolcet Collection with ca. 750 photographs. The whole collection aims to form a Spanish photo collection that covers photography in Spain from its beginnings until today. The photo library holds ca. 1,200 books and magazines. Approximately four to five temporary exhibitions are held per year. Publications, courses, congresses, symposiums, conferences are also produced.

www.unav.es

Museu Nacional d'Art de Catalunya, Barcelona

A museum devoted to the history of Catalan art, including photography, displaying works from the

eleventh century until 1950. The result of the consolidation of two collections of early and modern art in 1990, the photography department was begun in 1996. While the collecting of international art has begun, the strength of the museum is photography by Catalonians. The collection holds approximately 1,200 photographs with concentrations by Joaquim Pla Janini, Josep Lladó, Josep Masana, Emili Godes, Otho Lloyd, Oriol Maspons, Francesc Català-Roca, Toni Catany, Joan Fontcuberta, Pere Formiguera, and Humberto Rivas. Two to three photography exhibitions are mounted each year.

www.mnac.es

Instituto Valenciano de Arte Moderno, Valencia

A museum devoted solely to modern and contemporary art, IVAM was founded in 1989. The IVAM holds more than 2,000 photographs in two areas of concentration: the master photographers of the twentieth century such as Robert Frank, Walker Evans, Bernard Plossú, Eugène Atget, André Kertész, Robert Capa, Weegee, and Gabriel Cualladó and photography since the 1970s including Cindy Sherman and Richard Prince. IVAM mounts temporary exhibitions of photographers from the collection and contemporary developments.

www.ivam.es

Museo Nacional Centro de Arte Reina Sofiá, Madrid

A museum devoted to modern and contemporary art under the ministry of culture of Spain, MNCARS features a growing photography collection of approximately 1,000 examples of twentieth century photography. Highlights of the collection are the photographs taken by Dora Maar of the process of the painting of *Guernica* by Pablo Picasso on permanent display. The focus is on contemporary Spanish and international photography including Jean Marc Bustamante, Günther Förg, Andreas Gursky, Axel Hütte, Thomas Ruff, and Thomas Struth.

www.museoreinasofia.mcu.es

Sweden

Moderna Museet, Fotografiska Museet, Stockholm

The Moderna Museet was founded in 1958 (new building 1998), the photo museum as a department in 1973. The result of the integration of several holdings, including those brought together by the Fotografiska Museets Vänner (Friends of the Museum of Photography; founded 1964) and the Helmut Gernsheim Collection and the Helmer Bäckström historical collection, the collection includes works from the 1840s to the present day. Particularly rich in works by Swedish Pictorialists, including John Hertzberg, Henry B. Goodwin, Ferdinand Flodin, and Ture Sellman. Altogether it comprises some 300,000 objects of international and Swedish photography. Important Swedish photographers represented include Sten Didrik Bellander, Kerstin Bernhard, Hans Hammarskiöld, Hans Malmberg, Anders Petersen, and Christer Strömholm. Other holdings include collections of Svenska Fotografernas Förbund (Swedish Photographer's Association), Svenska Turistföreningen (Swedish Tourist Club), Svenska Turisttrafikförbundet (Swedish Touristtraffic Association), Fotografiska föreningen (The Photographic Society), Riksförbundet Svensk Fotografi (National Association of Swedish Photography), and the collection of Pressfotografernas Klubb (Pressphotographer's Club). The museum also features a library of approximately 20,000 volumes, a history archive with 12,000 items catalogued by Swedish and foreign photographers, institutions, museums, galleries, exhibitions and exhibition activities, and a conservation workshop. Approximately five to ten exhibitions are mounted each year.

www.modernamuseet.se

Hasselblad Center, Göteborg

The Erna and Victor Hasselblad Photography Center, known as the Hasselblad Center, was established in 1989 to promote scholarly research and education in photography. The Center operates research projects, organizes seminars and lectures, has a library and archives for students and researchers, and awards a prestigious annual prize, The Hasselblad Foundation International Award in Photography. The exhibition hall of the Hasselblad Center is situated in the Göteborg Museum of Art where an average of six exhibitions are mounted annually, with the work of the Hasselblad Award winner shown in November and December. The Center is also assembling a collection that concentrates on the work of Nordic photographers including Sune Jonsson, Christer Strömholm; Stig T. Karlsson; Adriana Lestido; Pål-Nils Nilsson and of Hasselblad Award winners Ernst Haas, Edouard Boubat, Manuel Alvarez Bravo, Robert Häusser, Henri Cartier-Bresson, Hiroshi Hamaya, William Klein, Sebastião Salgado, Susan Meiselas, and Boris Mikhailov. The Library contains approximately 5,000 books, catalogues, and exhibition catalogues. It also holds a number of annual volumes of different photographic magazines and a clippings archive. In 1998, the Center acquired the photography library of Rune Hassner. It is now

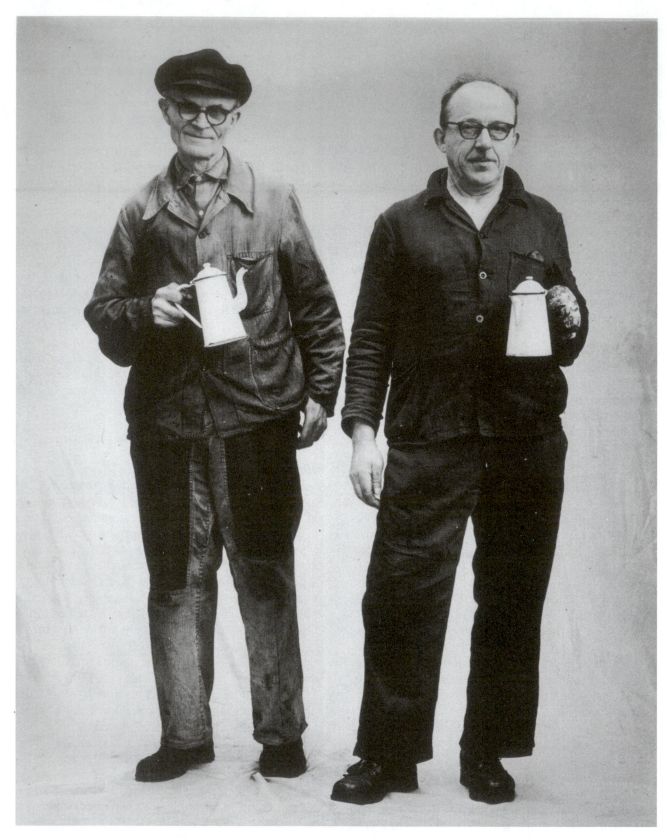

Stefan Moses, Metallarbeiter, Essen 1963.
[© *Fotomuseum im Munchner Stadtmuseum*]

being coordinated within the Hasselblad Center library. The Center also publishes the magazine *HASSELBLADCENTER*.

www.hasselbladcenter.se
www.hasselbladfoundation.org

Switzerland

Musée de l'Elysée, Lausanne

Known as "a museum for photography," the museum was founded in 1985. Housed in an eighteenth century villa, the museum exhibits and collects photography from its beginnings to the present day and in all its aspects including journalism, advertising, fashion, social documentary, and scientific and fine art photography, and houses approximately 27,000 items, including the International Polaroid Collection with over 4,600 prints and the Association for Contemporary Photography Collection with approximately 450 prints. Highlights include works by Adolphe Braun, Gianni Berengo Gardin, Robert Capa, Gilles Caron, Adrien Constant de Rebecque, Jean-Gabriel Eynard, Francis Frith, Mario Giacomelli, Gabriel Lippmann, Lucia Moholy, John Phillips, Sebastião Salgado, André Schmid, and Christine Spengler. The museum houses a great number of historical archives including the Association for Contemporary Photography Archive. The library contains thousands of books, numerous photo journals, and a reading room. The museum mounts 15 to 20 photo exhibitions each year in six galleries on four floors with approximately 1,200 square meters. The program is international.

www.elysee.ch

Fotomuseum Winterthur, Winterthur

Founded in 1993, the Fotomuseum collects both art photography and applied photography in the areas of architecture, fashion, and industry. The collection consists primarily of contemporary photography, starting with an in-depth representation of work by Swiss-born Robert Frank. The 1960s and 1970s are represented by Lewis Baltz, Larry Clark, William Eggleston, Valie Export, Hans-Peter Feldmann, Peter Hujar, and Urs Lüthi, and recent international developments bring the collection up to the present day. The Fotomuseum Winterthur seeks to acquire groups of works rather than single examples. The applied photography archive is especially rich in industrial photography from the Van Roll firm. Five to seven exhibitions are mounted in five galleries of 550 square meters.

www.fotomuseum.ch

FRANZ-XAVER SCHLEGAL

MUSEUMS: UNITED STATES

The history of twentieth-century photography in the United States has certainly been inextricable from, if not entirely symbiotic with, the history of its institutions. These institutions have ranged from small galleries to grand museums, from alternative exhibitions spaces to subject-driven archives. Considering, for example, the aspirations and activities of Alfred Stieglitz, it would be easy enough to argue for his place as a forefather of later twentieth-century photography curators. His galleries displayed photography with the instructive aim of securing the medium a place within the long-established hierarchies of art. Such public displays were supplemented in print by his journals *Camera Work* and *Camera Notes*, to say nothing of his enthusiastic collecting practices.

Indeed, some of the most important museum photography collections have been graced by gifts from Stieglitz's vast holdings of American photography. However familiar such practices may have become to the operation of museums later in the century, the fact remains that Stieglitz ran a gallery with the intent to sell—albeit intermittently—the works of art he exhibited by the artists he supported. This example of Stieglitz is intended to acknowledge at the outset of this discussion the complicated and sometimes contradictory points of intersection between institutional categories that are considered distinct more often than may be warranted. Like the galleries run by Stieglitz during his lifetime, a variety of institutions have impacted the developments of photogra-

phy in the last century. Nevertheless, public museums have often generated discussions about the nature, dissemination, and explication of photographs through their exhibition, acquisition, and preservation practices. Representing the breadth of form and function of the medium, these practices show some signs not of disappearing, but of pliability and innovation, at the outset of the twenty-first century.

The Library of Congress was the first public institution in the United States to add a photograph to its permanent collection (1845). This act is particularly noteworthy in the history of photographic institutions since it predates such notable early collections as the *Société Heliographique* founded in Paris in 1851 and the Royal Photographic Society established in London in 1853. Photographs entering the Library of Congress for most of the nineteenth century were meant as supporting visual documents to such major historical events as the Civil War or as records of development of cities, towns, and even individual buildings. This approach to photography fueled certain photographers' fights at the turn of the century to claim photography as one of the fine arts. This fight for artistic legitimacy, most often linked to the Photo-Secessionist group in New York, longed for photography to be collected and displayed in the same fashion as painting. This directive inspired Stieglitz's seminal *International Exhibition of Pictorial Photography* which, in 1910, filled the Albright Art Gallery in Buffalo, New York, and broke all that museum's previous attendance records. Eventually, Stieglitz and his cohorts hoped to find similar institutional success in the country's leading art museums.

While there were some other early photography exhibitions (in 1900 at the Art Institute of Chicago, for example), a single institution and its librarian remain responsible for the first comprehensive effort to present photography's history in the context of an art museum exhibition. Nearly a century after the Library of Congress's first photography acquisition, the Museum of Modern Art, New York, (MoMA) became one of the only museums in the United States to regularly exhibit photography. In a 1932 exhibition of murals by leading American artists Lincoln Kirstein—with the help of Julien Levy—invited photographers Berenice Abbott and Edward Steichen to participate. The following year, Kirstein displayed Walker Evans's photographs of American Victorian architecture. But it was not until Beaumont Newhall was hired as the museum's new librarian that photography was given its most constant institutional advocate.

Newhall immediately set about organizing an exhibition that would become a touchstone in all

subsequent histories of photography, to say nothing of its impact on exhibitions of photography. *Photography 1839–1937* incorporated more than 800 works, grouped according to their technical processes (e.g., daguerreotype, calotype) and cultural application (e.g., journalism, science, artistic expression). The exhibition aimed to trace and locate developments that were medium-specific, even technique-specific as in Newhall's proposal that certain photographic methods yielded images notable for their significant details while others were distinguished by their array of tonal masses. In choosing to include astronomical photographs, X-ray images, sports photography, film stills, and aerial photography, Newhall seems to have been more interested in how to look at—and subsequently comprehend—wide-ranging photographic practices. This outlook remains remarkable, especially given that a more restricted view of the medium would certainly have better championed photography's artistic merit, a position that continued to appeal to many museums' interests and acquisitions as photography gradually came into its own.

In 1940, Newhall was appointed the museum's curator of photography, the first such post in any museum. Over the next seven years, Newhall continued to consider the specificity of photography in nearly 30 separate exhibitions ranging from historical French photography to emerging artists such as Helen Levitt. Increasingly, he became more interested in the medium as a means of personal expression, a view that seems to have been helped by his close working relationship with Ansel Adams. Despite Newhall's efficacy, MoMA's trustees chose to appoint Edward Steichen as director of the department in 1947 and Newhall resigned. Christopher Phillips has interpreted this sudden changing of the guard: "Simply put, it seems clear that Newhall's exhibition program failed equally to retrieve photography from its marginal status among the fine arts and to attract what the museum could consider a substantial popular following" (Phillips, 23). If this was the case, MoMA had chosen wisely. For in Edward Steichen they found someone whose primary interest in photography by that time was not its artistic aims, but its illustrative and persuasive capabilities.

Elsewhere in the United States during these years, photography began to enter the collections of other museums. Alfred Stieglitz made gifts of his photographs to the Metropolitan Museum of Art in 1928 and 1933. Upon his death in 1946, the Metropolitan received a bequest that expanded the collection to over 600 works. The Art Institute was another beneficiary of Stieglitz's bequests, receiving

a substantial portion of his collection in 1949, which marked the beginnings of their photography collection. Shortly after MoMA acquired its first photographs, the institution that was to become the San Francisco Museum of Modern Art (SFMoMA) was founded in 1935. From its inception, SFMoMA advocated strongly for photography's place in modern art as well as in the institution's programming. Without a doubt, this decision owed much to the active group of San Francisco photographers, the f/64 Group, whose members included Ansel Adams, Imogen Cunningham, and Edward Weston. Advocating a sharp and unaffected style of photography, the group coalesced at a major exhibition of their work at the M. H. de Young Memorial Museum, also in San Francisco. The work of these photographers was among the first to enter SFMoMA's permanent collection, prompting regular exhibitions and an expanding collection, as when Ansel Adams encouraged Georgia O'Keeffe, Stieglitz's widow, to donate dozens of his photographs to the museum in 1952.

In 1949, the International Museum of Photography (as it is currently known) opened at the George Eastman House in Rochester. George Eastman had founded Eastman Kodak Company, which was almost single-handedly responsible for the popularizing of photography at the end of the nineteenth century. Their famous slogan, "You push the button, we do the rest," lured many to begin making photographs as a personal hobby or family chronicle. Eastman himself had been an avid photographer in addition to collector. Fifteen years after his death in 1932, the first museum in the United States dedicated solely to photography and moving pictures was chartered. Beaumont Newhall was appointed curator of the collections and, from 1958 to 1971, he served as the director of Eastman House. Newhall's exhibitions and friendships with leading photographers of the day not only greatly affected the Eastman House programs, but the development and education of photography students at the nearby Rochester Institute of Technology. Under Newhall's tenure, the museum's holdings expanded exponentially, creating one of the greatest photography collections in the world.

After an extremely successful career in fashion and portrait photography and while heading up U.S. naval combat photography during World War II, the ever-versatile Edward Steichen mounted two highly patriotic exhibitions at MoMA. *Road to Victory* (1942) and *Power in the Pacific* (1945) were unabashed explorations of American military might that utilized photographs in strikingly new ways through placement, size, and juxtaposition. It was as if Steichen had taken the photo-essays from picture magazines established in the decade before in the pages of *Life* and made them three-dimensional. Using photographs to illustrate a particular narrative, Steichen's efforts provide two early examples of an exhibition-driven blurring of boundaries between the documentary and propagandistic uses of photographic images. Such story-telling exhibition practices not only propelled him into the director's seat of the MoMA Photography Department, but they would reach a global zenith in his next major project.

In January 1955, Steichen inaugurated what, by many accounts, still reigns today as the most widely attended photography exhibition ever, *The Family of Man*. Both the exhibition installation and the book based on it relied on a series of juxtapositions of photographs made around the world. It took Steichen three years to sort through the 2 million photographs and eventually select some 503 images by 273 photographers, grouped according to theme. Reprinted to unify tones, to heighten dramatic contrasts, and to resize according to visual impact (from 5 × 7 inches to wall-sized), each photograph was presented as a tightly cropped image, without border or frame, mounted on board. Once harmonized in this fashion, the photographs were arranged on columns, hung from wires and rods, suspended in the air, and mounted on panels. The work's original captioning or title—along with most other deference toward the artist—was eliminated in favor of the thematic for a particular section that was complemented by quotations, proverbs, and tales from a host of cultures.

Through sequential thematic groupings such as Birth, Family, Work, Love, and Death, *The Family of Man* intended to replicate a universal course of human life as sequences of moments that were highly photographic and photographable. Steichen's universal aims also prompted an extended tour of the exhibition in U.S. venues and, beginning in 1959, worldwide venues from Moscow to Paris to Japan. In total, more than 10 million visitors experienced a version of *The Family of Man*. Marked by such a strong humanist impulse, the exhibition managed to pull at the heartstrings of a public caught between the shadows of World War II and the Cold War, while also inciting strong criticism, perhaps most famously from the cultural critic and theorist Roland Barthes. Yet whatever its faults as a tribute to the photographers who took the photographs or as an honest pictorial investigation of the experience of life in various parts of the globe, it must be said that Steichen succeeded in collapsing categories that photo history and photography institutions—MoMA included—had long struggled to establish.

The slippage promoted by *The Family of Man* between photojournalism, artistic expression, scientific and technical data, and amateur snapshot today appears as a perhaps unintentional articulation of postmodernism *avant la lettre*.

By the 1960s, the tide had most certainly changed in photography's favor. There now existed multiple departments in museums devoted to the collection and display of photographs. The wildly successful touring tenure of *The Family of Man* had proven that public interest in photography was as fervent as it was far-reaching. As Beaumont Newhall retrospectively characterized it:

> ...the scheduling of major photographic exhibitions by leading art museums in Europe and America; the growing interest in photography on the part of individuals as well as institutions; the inclusion of courses in the photographic arts by universities and art schools are all steps toward the ultimate unquestioned acceptance of the potentials of the camera.
>
> (Newhall 294)

Photography, in other words, had come into its own.

At MoMA, John Szarkowski succeeded Steichen and moved the department quickly away from the more encompassing social conception of photography to one that would emphasize the medium's aesthetic character. Szarkowski worked to codify photographic practice during his tenure at MoMA, hoping to establish and define the peculiarities of the medium. In exhibitions such as *The Photographer's Eye* (1964) and *Looking at Photographs* (1973), he intended to discern a style and tradition that was firmly grounded in the formal and technical characteristics. As he famously explained in his introduction to the former of the two exhibition catalogues, "This book is an investigation of what photographs look like, and why they look that way" (John Szarkowski, *The Photographer's Eye*, New York: Museum of Modern Art, 1966, p. 1). Szarkowski's efforts to discern and distill the essence of photography would quickly meet with harsh criticism as those in a younger generation, their everyday lives steeped in photographs of all stripes, found fault with formalism.

It was Szarkowski's 1967 exhibition *New Documents*, however, which perhaps most indelibly marked the history of late twentieth century photography. Intending to identify the most recent developments of the previous decade, Szarkowski focused on the work of Diane Arbus, Lee Friedlander, and Garry Winogrand, all of whom he considered to have inherited and created anew the documentary photography tradition of the 1930s. In fact, Diane Arbus's retrospective exhibition in 1971 drew crowds to MoMA larger than those for *The Family of Man*, suggesting a new level of public excitement about photography. *New Topographies: Photographs of a Man-Altered Landscape* at the George Eastman House also identified an emerging trend in the broadly-construed field of landscape photography, notably the emphasis on the altered landscape as a subject of contemporary photography. Works by Robert Adams, Bernd and Hilla Becher, Joe Deal, Nicholas Nixon, Stephen Shore, and Henry Wessel, Jr., among others, considered the effect of the developed landscape in urban centers, tranquil suburbia, and forsaken buildings. The exhibition mounted by the Metropolitan Museum of Art, which had not theretofore particularly dealt with photography, *Harlem on My Mind*—often labeled the first of modern-day museum blockbusters and one of the great controversies in museum history—secured its place in twentieth century photo history. A thematic exhibition not confined by media, *Harlem on My Mind* was single-handedly responsible for the historical recovery of James VanDerZee as one of the leading photographic portraitists of his day.

By the outset of the 1970s, photography's popularity with art museums and publics alike was increasingly undisputed. Between 1973 and 1990, the number of photography collections in the United States more than quadrupled and the number of photographers in those same collections skyrocketed from well over 1,000 to over 32,000. The market for photography ballooned similarly; prices for photographs between 1975 and 1990 escalated by approximately 650 percent (Alexander, 698). These figures undoubtedly reflect the activities of those photography institutions or departments established at the time. For example, the years 1974 to 1976 saw the founding of the International Center of Photography in New York, the Center for Creative Photography in Arizona, and Museum of Contemporary Photography in Chicago collections.

The formation of the Photographs Collection at the J. Paul Getty Museum is perhaps among the most astounding examples of this buying curve. In 1984, the art world was stunned to learn of the Getty's acquisition of the complete holdings of three private collections and portions of several others. Amounting to more than 25,000 photographs, these acquisitions demonstrated the relative ease and affordability of amassing a collection of significant breadth and depth. The same amount of funds that might be directed to a single Old Master painting could, in the early years of this market, yield an entire department's worth of photographs. Photography was quickly becoming an institution

itself. That is to say, photography's establishment in these decades—the "photo boom" as it is sometimes called—had relied widely on standardization, historicization, and definition. As Douglas Nickel has commented:

> A latecomer to institutional attention and intellectual respectability, the field suddenly found itself in the 1980s in the uncomfortable position of being the arriviste of academic subjects, both newly sanctioned by officialdom and an occasion for heated controversy....[I]t also encountered a growing body of critical writing that took exception to the methods of photography's formal canonization, one that argued against the mapping of traditional art historical approaches and values onto photographic subjects and, ultimately for the nonidentity of photography and photographic history itself.
>
> (Nickel 548)

Indeed, many of these critical objections were provoked by museums' sanctioning of photography as art, worthy of collection, displaying, and preserving in its own right.

Douglas Crimp, among others, provided a salient example of this trend when he outlined the removal of photographic books and albums from the shelves of the New York Public Library. These objects were then reassembled as the Library's Photographic Collections, a physical move that embodied the separation of photography from its subject, a triumphal dislocation that allowed photography to be understood *only* in the context of art.

> Whereas we formerly have looked at Cartier-Bresson's photographs for the information they conveyed about the revolution in China or the Civil War in Spain, we will now look at them for that they tell us about the artist's style of expression. This consolidation of photography's formerly multiple practices, this formation of a new epistemological construct in order that we may now *see* photography, is only part of a much more complex redistribution of knowledge taking place throughout our culture.
>
> (Crimp 1989, 8)

Crimp was not alone in theorizing the institutional structures—and strictures—newly placed on photography. Other critics began illuminating the classificatory, exploitative, regulatory, and racist uses of photography. Victor Burgin, Rosalind Krauss, Christopher Phillips, Allan Sekula, Abigail Solomon-Godeau, Sally Stein, and John Tagg were chief among those who attempted to reveal and contextualize the power and politics of photography vis-à-vis their institutions.

Not coincidentally, certain artists had begun using photography to convey and problematize some of these same perceptions of the medium. Artists with

practices as diverse as those of Vito Acconci, John Baldessari, Dan Graham, Louise Lawler, Sherrie Levine, and Robert Smithson began to use photography in new and provocative ways that raised questions crucial to museums: how is such work to be classified, exhibited, and interpreted? For example, Cindy Sherman famously declared in the press release accompanying her book *Untitled Film Stills* that she was *not* a photographer. Instead, she classified herself as a performance artist utilizing photography. Thus, the 1990 *Index to American Photographic Collections* could make note of the fact that Sherman's work could be found not in the Art Institute of Chicago's photography collections, but in those of the contemporary department. While this is no longer the situation (both departments now hold Sherman's work), such a classification is more than mere syntax; it had a direct impact on determining the context in which Sherman's work would be exhibited and thus viewed. Such a classification originally determined that it was institutionally more productive and appropriate for Sherman's images to be surrounded by works contemporary to hers regardless of medium rather than by other examples of, say, photographic self-portraiture.

The questioning of the boundaries of media specificity made so explicit in the work of someone like Sherman continue to haunt broadly the conception of photo history and, more specifically, to define exhibition and acquisition practices in today's museums. Once a sign of photography's arrival and success, departments dedicated exclusively to photography must now work to explain that exclusivity. Some choose a kind of forced historicism, wanting to attract only those photographers' work that explicitly refers to either the medium's history or its technology, particularly as it was shaped and understood by museums in the twentieth century. Some have sought out artists who do just the opposite, intending to push or even break down the boundaries of the medium. Some have chosen to collaborate across media boundaries—meaning, institutionally, between departments—in order to breed a different kind of interpretive exhibition, one that perhaps in the end dwells on photography's ubiquity as in MoMA's *Open Ends*. And still others have coyly extended arguments of medium specificity by mixing together photography and film and video. This outlook has yielded such recent major exhibitions as the International Center of Photography, New York's, *Strangers: The First ICP Triennial of Photography and Video*, which inaugurated a series of exhibits devoted to the collective consideration of shared themes between the two media and the Solomon R. Gug-

genheim Museum's *Moving Pictures*, which surveyed video, film, and photography of the past four decades. While *Strangers* remained largely focused on the over-arching theme of the Other as encountered in what they termed photographic media, the Guggenheim proposed specific affinities between the media in the exhibit: all are essentially photo-based, reproducible, and omnipresent in mass culture forms such as television, advertising, cinema, and journalism.

The continued consideration of the boundaries of photography has also prompted new attention on those photographs that had increasingly been marginalized in mainstream museum collection and exhibition practices. While this trend has now been reversed to a certain extent with recent acquisitions by the Met and others of vernacular photographs, alternative collections that have developed outside museums provide some clues about what museums had previously disavowed, overlooked, or omitted from their purview. Two serviceable examples of such alternative collections are the Burns Collection and the Kinsey Institute's collection. Burns Collection is home to more than 700,000 photographs including some 60,000 examples of early medical photography ranging from the 1860s to 1920. Additionally, the collection is home to images of what might be considered the darker side of life and, therefore, of photography's subjects—crime, death, disaster, disease, murder, racism, riots, and war. The Kinsey Institute for Research in Sex, Gender, and Reproduction was established in 1947 by Dr. Alfred C. Kinsey, the pioneer in the research of human sexual behavior and author of the infamous "Kinsey Reports." His photographic collection was an intricate part of his data collection on the topic, begun in 1938. Arranged categorically by position or act, these nearly 96,000 photographs from the United States, Europe, and Asia include work by such photographers as Judy Dater, George Platt Lynes (the second largest holding of his work worldwide), Irving Penn, and Joel-Peter Witkin.

Increasingly, museums must operate as businesses in order to make ends meet. In the case of acquisition and exhibition policies, this outlook has led to corporate underwriting as attested to by the many exhibition catalogue forewords that are penned by company CEOs and Chairs of the Board. Such funding opportunities have no doubt assisted museums in a time of ever-diminishing government support, but they have also called into question the viability of curatorial freedom. Of course, curators have long relied on the fostering and maintaining of relationships with collectors (be they individual or corporate), dealers, and artists, making it possible to wonder if there ever

was complete curatorial independence. Nevertheless, following the so-called culture wars of the 1990s, some have argued that museums are no longer willing to absorb the risks implicit in mounting exhibitions of photographers or subject matter that could be taken—or mistaken—as questionable. As the examples of Sally Mann, Robert Mapplethorpe, and Andres Serrano, one person's support of provocative artwork was another person's source of indignation.

Despite and perhaps in spite of such institutional setbacks, public interest in photography remains seemingly insatiable. Any doubt about this was rent asunder by the role photography played—both outside of and within museums—in the wake of September 11, 2001. In two small storefronts in Soho, New York, and just over a mile from the site of the atrocity, thousands of photographs hung from floor to ceiling. Bystanders, residents of New York, and those with a photographic reaction to the events they wanted to share—many of them amateurs without any particular aesthetic or photographic training—in addition to professional photographers contributed their photographs of the events of that day and its aftermath to the display. *here is new york: a democracy of photographs*, as the exhibition was titled, was as remarkable for the overwhelming number of submissions and attendant sales of the images to raise money for victims' children as it was for the astounding numbers who visited this unofficial quasi-museum (more than 100,000 within the first two months). This photographic catharsis of sorts might seem singular or location-specific, yet the museological reaction to September 11 confirmed just the opposite. Across the country, but especially in New York of course, museums installed exhibitions within months of the tragedy. From MoMA's collection-generated *Life of the City* (which included a small-scale installation of *here is new york*) to the New York Historical Society's presentation *New York September 11 by Magnum Photographers*, from the Met's display of historical photographs of the city, entitled *New York, New York*, to the nationally touring *September 11: Bearing Witness to History* from the Smithsonian, museums emerged as spaces for the contemplation and comprehension of the events, a role confirmed by public attendance. Notably, the overwhelming majority of such exhibitions were comprised entirely of photographs. This unity of institutional response suggests that in a time of ever-changing media technologies, photography's lure remains as potent as ever.

Museums and their Collections

Below is a list of selected U.S. museums and a summary account of their history, the size of their

photography holdings, and, when possible, the notable concentrations in the work of either specific periods or individual photographers. This is intended as a sketch, not an exhaustive account, of some of the most significant photographic collections in the United States. For additional information, please refer to the "Further Reading" section below as well as separate entries on individual museums located elsewhere in the *Encyclopedia*.

Art Institute of Chicago

Although its first photography exhibition occurred in 1900, the AIC did not begin a permanent collection until 1949, prompted by Georgia O'Keeffe's gift of a substantial portion of the Alfred Stieglitz Collection. The AIC would distinguish itself with the purchase of the entire Julien Levy Collection, making it a stronghold of early twentieth-century American and European photography, as well as a gift from Edward Weston of more than 200 photographs. Among its nearly 17,000 photographs, works by Paul Strand, Eugène Atget, and André Kertész are represented in depth.

www.artic.edu

Center for Creative Photography

Located at the University of Arizona, in Tucson, the CCP functions as a museum and archive, claiming more archives and individual works by North American photographers of the twentieth century than any other museum. Such photographers as Ansel Adams, Lola Álvarez Bravo, Richard Avedon, Louise Dahl-Wolfe, W. Eugene Smith, and Edward Weston number among the 180-plus archives housed there. Supporting the archives is an art collection of vintage prints by those listed above as well as Wynn Bullock, Harry Callahan, Andreas Feininger, Aaron Siskind, Frederick Sommer, Edward Steichen, and Paul Strand.

www.library.arizona.edu/branches/ccp/home

J. Paul Getty Museum

The Department of Photographs was initiated in 1984 after one of the largest acquisitions in photohistory. Acquiring the complete collections of Bruno Bischoffberger of Zurich, Samuel Wagstaff of New York, and Volker Kahmen/Georg Heusch located near Bonn, Germany. In addition, the Getty purchased large portions of the American and European collections of Arnold Crane and the early French photographs collected by André and Marie-Thérèse Jammes as well as a number of more specialized private collections. All told, more than 25,000 photographs, hundreds of daguerreotypes, and albums holding thousands of mounted photographic prints amounted to one of the finest collections ever assembled. Ranging from some of the earliest photographic experiments to the late 1960s, the collection has particular depth in the work of the following photographers who practiced their art in the twentieth century: Eugène Atget, Manuel Álvarez Bravo, Bernd and Hilla Becher, Hans Bellmer, Brassaï, Harry Callahan, Henri Cartier-Bresson, Imogen Cunningham, Walker Evans, T. Lux Feininger, Lewis Hine, Gertrude Käsebier, André Kértesz, Yasuo Kuniyoshi, Man Ray, Lisette Model, László Moholoy-Nagy, Sigmar Polke, Albert Renger-Patzsch, Alexandr Rodchenko, August Sander, Aaron Siskind, W. Eugene Smith, Edward Steichen, Alfred Stieglitz, Paul Strand, Doris Ulmann, Weegee, Edward Weston, and Garry Winogrand.

www.getty.edu/museum

International Center of Photography

The ICP was founded in 1974 in New York by Cornell Capa, brother of Robert Capa who was known for his intense and proximate views of the Spanish Civil War and the World War II invasion on the beaches of Normandy. Founded to support the legacy of "concerned photography" and serving as both a museum and a school, the ICP's permanent collection totals more than 60,000 photographs that span the medium's history. Documentary and human-interest photography dominate the collection in the work of such photographers as Berenice Abbott, Harry Callahan, Capa, Henri Cartier-Bresson, Aaron Siskind, and Weegee. Also of note is the 1990 gift of the Daniel Cowin Collection of African American History and the purchase of the AIDS Graphics collection in 2000. The ICP has also committed itself to emerging electronic imaging media as evidenced by the first triennial of photography and video in 2003.

www.icp.org

International Museum of Photography and Film at George Eastman House

Founded in 1949 with the arrival of Beaumont Newhall. Holds major collections of work by Lewis Hine, Alvin Langdon Coburn, Edward Steichen, and others, including over 400,000 photographs and negatives covering the landmark processes from the technical evolution of the medium. Representing over 8,000 photographers, including most of

the major figures in photo-history, the collection also boasts one of the largest daguerreotype collections in the world, a large number of early British and French photography, nearly 500 vintage prints by Eugène Atget, and 20,000 prints and negatives bequeathed by the pictorialist photographer Alvin Langdon Coburn. Both Alfred Stieglitz and Edward Steichen donated large bodies of work, the latter numbering nearly 4,300 vintage prints. The Eastman House holdings of Lewis Hine's photography are considered definitive. The collection also encompasses more vernacular and popular forms of photography such as personal albums, stereocards, travel albums, astrological images, lantern slides, and press and war photographs.

www.eastmanhouse.org

Library of Congress

Both the nation's oldest federal institution devoted to culture and the world's largest library, the Library of Congress in Washington, D.C., has collected photographs since 1845. Since then its holdings have grown to include over 13 million photographs, which include negatives, transparencies, and several thousand related books and periodicals. Its particular mission is to amass pictorial documents of the people, achievements, environments, and history of the United States. The Library claims an unsurpassed collection of photographs of the following: the American Civil War, Lewis Hine's work for the National Child Labor Committee, American architecture, Pictorialism, the Farm Security Administration, American news agencies, and photojournalism (e.g., the archives of such periodicals as *Look* and *U.S. News and World Report*).

www.loc.gov

Metropolitan Museum of Art

The Metropolitan Museum of Art, New York, (MMA) acquired photographs as early as 1928 when Alfred Stieglitz made the first of a series of gifts to the institution in the form of 22 of his own photographs. Over the years, curators of the (then) Prints Department added to the collection. In 1992 a separate Department of Photographs was established. Today the collection of more than 20,000 is grounded by four collections acquired over the years. Stieglitz, the museum's first photographic patron proved to be one of its most generous and bequeathed to the museum over 600 photographs from his personal collection. These photographs encompass icons of the Photo-Secession and Pictori-

alism, including three of Edward Steichen's painterly and differently toned prints of *The Flatiron*. In 1987, the Ford Motor Company donated their collection of European and American avant-garde photography. Strongest in the period between the two world wars, works by Berenice Abbott, Brassaï, Walker Evans, André Kértesz, Man Ray, and László Moholy-Nagy form this collection's core. More recently, the Walker Evans Archive of negatives, personal papers, and collected ephemera joined the department's holdings in 1994 and the Rubel Collection of early British photography was acquired in 1997. Works by such artists as Adam Fuss, Felix Gonzalez-Torres, and Hiroshi Sugimoto represent the MMA's commitment to contemporary photography.

www.metmuseum.org

Museum of Contemporary Photography

Established at Columbia College in Chicago in 1976, it represents a concentrated collection of post-war photography made in the United States. Among its 6,000-plus photographs are the works of such major figures as Harry Callahan, Barbara Crane, Dorothea Lange, David Plowden, Jerry Uselmann, and Louise Dahl-Wolfe. The MCP is deeply devoted to the work of photographers from the Midwest. Since 1982, its "Midwest Photographers Project" has regularly highlighted the work of both established and emerging regional photographers.

www.mocp.org

Museum of Modern Art

The first and frequently considered to be the most influential of all photography departments, MoMA, New York's first photography acquisition occurred in 1930. The department was formed 10 years later. The collection has grown to encompass over 25,000 works from the dawn of photography to the present, many by the recognized masters of the photographic canon.

www.moma.org

Museum of Photographic Arts

Founded in 1983 and located in San Diego, California, the Museum of Photographic Arts (MoPA) is yet another museum devoted exclusively to photography. MoPA in fact collects, as it calls it, "the entire spectrum of the photographic medium." In its collecting, the Museum attempts to trace the entire history of photography and also focuses on the materials and documents related to the history and process of

photography. The collection is strong in early twentieth century masters, Latin-American artists including Mario Cravo Neto, Graciela Iturbide, and Sebastião Salgado, photojournalism, post-World War II American photography, and social documentary and Soviet Russian photography, including works by Russian Constructivist Alexandr Rodchenko.

www.mopa.org

San Francisco Museum of Modern Art (SFMoMA)

Distinguished as one of the oldest photography collections in the United States, SFMoMA began acquiring photographs in 1935 from local contemporary photographers who would quickly come to prominence across the nation as the f/64 Group. Works by Ansel Adams and Imogen Cunningham numbered among its earliest acquisitions. In the 1950s and 1960s, photographs by Jack Delano, Walker Evans, Dorothea Lange, Russell Lee, Arthur Rothstein, Alfred Stieglitz, Edward Weston, and Marion Post Wolcott were acquired. Today, SFMoMA holds one of the nation's foremost collections of photography.

www.sfmoma.org

Whitney Museum of American Art

Although photography featured in early exhibitions overseen by Gertrude Vanderbilt Whitney as far back as 1917 and has appeared in Whitney Biennials since 1977, the Whitney Museum's Photography Collection was not formally established until 1992 with the first full-time curator appointed seven years later. The exclusively American collection now numbers well over 2,000 photographs.

www.whitney.org

KATHERINE BUSSARD

See Also: **Art Institute of Chicago; Center for Creative Photography; Corporate Collections; Eastman Kodak Company; Galleries; Library of Congress; Museums; Museums: Europe; Museum of Modern Art; Newhall, Beaumont; Private Collections; Steichen, Edward; Szarkowski, John**

Further Reading

Alexander, Stuart. "Photographic Institutions and Practices." *A New History of Photography*. Ed. Michel Frizot. English edition. Cologne: Könemann, 1998.

Burgin, Victor, ed. *Thinking Photography*. New York: Macmillan, 1982.

Crimp, Douglas. "The Museum's Old/The Library's New Subject." *The Contest of Meaning: Critical Histories of Photography*. Ed. Richard Bolton. Cambridge, MA: MIT Press, 1989:8.

Crimp, Douglas. *On the Museums Ruins*. Photographs by Louise Lawler. Cambridge, MA: MIT Press, 1993.

Eskind, Andrew H. and Greg Drake, eds. *Index to American Photographic Collections: Second Enlarged Edition*. Boston, MA: G. K. Hall & Co., 1990.

Krauss, Rosalind. *The Originality of the Avant-Garde and Other Modernist Myths*. Cambridge, MA: MIT Press, 1985.

Naef, Weston. *J. Paul Getty Museum Handbook of the Photographs Collection*. Malibu, CA: J. Paul Getty Museum, 1995.

Newhall, Beaumont. *The History of Photography, from 1839 to the Present: Completely Revised and Expanded Edition*. Fifth edition. New York: The Museum of Modern Art, 1982. Reprinted 1994.

Nickel, Douglas. "History of Photography: The State of Research." *Art Bulletin*. 83:3 (September 2001), 548–558.

Phillips, Christopher. "The Judgment Seat of Photography." *The Contest of Meaning: Critical Histories of Photography*. Ed. Richard Bolton. Cambridge, MA: MIT Press, 1989.

Rule, Amy, and Nancy Solomon, eds. *Original Sources: Art and Archives at the Center for Creative Photography*. Tuscon, AZ: CCP, 2002.

Sekula, Allan. *Photography Against the Grain: Essays and Photoworks, 1973–1983*. Halifax: Press of the Nova Scotia College of Art and Design, 1984.

Sobieszek, Robert A. *Masterpieces of Photography from the George Eastman House Collections*. New York: Abbeville Press, 1985.

Solomon-Godeau, Abigail. *Photography at the Dock: Essays on Photographic History, Institutions, and Practices*. Minneapolis: University of Minnesota Press, 1991.

Tagg, John. *The Burden of Representation: Essays on Photographies and Histories*. Amherst, MA: University of Massachusetts Press, 1988.

N

HANS NAMUTH

German

Hans Namuth, best known for his portraits of artists, began his career as a photojournalist and enjoyed commercial success as an advertising photographer. Namuth's status in twentieth century photography, however, rests on his sensitive portraits of artists and other creative people. His reputation as a portraitist was established by his photos of the preeminent Abstract Expressionist painter, Jackson Pollock. Unlike his predecessors, Pollock worked with unprimed, unstretched canvases placed directly on the floor of his studio, fostering a dynamic technique with his media: he moved energetically around his canvas, stepped directly onto it, and attacked the surface with unprecedented vigor. Documenting Pollock's movement, in both still photography and film, Namuth emphasized the performative aspect of this artist's technique. Indeed, Namuth's recording of Pollock's energy is so closely aligned with the artist's "classic" phase that the canvases are rarely considered without reference to Namuth's photographs of their creation.

Namuth's career as a photographer consists of two distinct phases interrupted by the tragic effects of Nazi Germany and World War II. Born in Essen, Germany in 1915, Namuth was arrested by Nazis in his hometown in 1933 for distributing anti-Hitler leaflets. His father, a member of the Nazi party, secured his release and supplied him with an exit visa enabling Namuth to flee to Paris. A fellow German acquaintance in Paris, Georg Reisner, introduced Namuth to commercial photography. Learning the trade from Reisner, Namuth sold his work to Alliance Photo and Three Lions who placed his work in publications such as *Paris-Match*. In 1936, Namuth and Reisner were assigned by *Vu* to cover the Workers' Olympiad in Barcelona. Coincidentally, they arrived to cover the event the day before the Spanish Civil War began. They photographed the war for *Vu* and other European publications, eventually leaving Spain to work as freelance photojournalists in France for the remainder of the decade.

In 1939, when France declared war on Germany, Namuth was interned and eventually joined the French foreign legion. He was discharged a year later (1940), fleeing to Marseilles and eventually securing passage to New York in 1941. In an effort to secure Reisner's freedom, Namuth sold his camera, but his friend committed suicide in late December before leaving France. Initially, Namuth worked in menial positions at various commercial photography studios in New York City. In January

1943, he joined the U.S. Army and left for Europe in December of that year. Namuth was discharged in October 1945, returned to the United States, and pursued photography as a hobby. However, in 1946, when the company he worked for, Tesumat, Inc., went bankrupt he returned to photography as a profession.

In 1946, Namuth traveled to Guatemala and photographed the natives of Todos Santos in collaboration with anthropologist Maud Oakes. These works were exhibited the following year at the Museum of Natural History in New York. During this period, Namuth took a few classes with Josef Breitenbach, an acquaintance from his days in Paris, at the New School for Social Research. Thereafter, he studied with Alexey Brodovitch, his most important influence, in an informal class taught at Richard Avedon's studio. Brodovitch, the art director of *Harper's Bazaar*, provided Namuth with numerous opportunities in fashion and advertising photography, and from 1949 through the mid-1950s, Namuth routinely published photographs in this magazine. Simultaneously, he worked on advertising campaigns for clients like Ford Motor Company and Shell Oil for some of New York's most prestigious advertising agencies, such as Pix Corporation and Doyle, Dane and Bernbach. Frequently, Namuth incorporated children into his assignments, taking pride in his avoidance of traditional poses by shooting his subjects as they played once they were no longer conscious of the camera's presence. This technique became a hallmark feature of his subsequent portraits of artists, architects, writers, and composers.

During this period of commercial success, Namuth sought ways to satisfy his ambitions as a creative artist. At an opening for Long Island artists, Namuth introduced himself to Jackson Pollock and asked if he could take pictures of him at his studio. Pollock had previously been photographed by Martha Holmes and Rudolph Burckhardt but was inclined to avoid photographers. Nevertheless, Pollock invited Namuth to his studio in late July 1950, and over the next four months, Namuth shot countless photographs and directed two short films of Pollock and his work. While neither Holmes nor Burckhardt had secured Pollock's confidence to such a degree that he was willing to paint in front of them—their photographs are staged with the artist posed as if painting—Namuth gained Pollock's trust and was allowed to shoot the artist as he worked.

Due to flaws in the lens of his camera, Namuth used prolonged exposure times, which emphasized the artist's movement; the scale of the canvases is reiterated by the blurred movement of the artist darting in and around the surface. This frozen-in-time movement has been cited as the source of Harold Rosenberg's formulation of the concept of "Action" painting in his landmark essay, "The American Action Painters." However, this supposed influence is based on flawed conclusions; not only did Rosenberg deny this influence, but he developed his concept of "Action" before he saw Namuth's photographs. Nonetheless, Namuth's photographs and films, Pollock's canvases, and Rosenberg's essay were vital resources for the following generation of American artists who found in the work of all three men a new approach to art-making that encouraged such postmodern developments as conceptual art, installation art, and performance art.

Aware that Pollock's physical encounter with his canvases was a quality that his camera could merely suggest, Namuth convinced Pollock that filming him would be even more compelling. Initially filming in black-and-white from afar, Namuth disliked the results. He struck upon the idea of Pollock painting on glass with the camera directly beneath the surface. Namuth convinced the artist of this project and, shooting in color, he finished filming on Thanksgiving Day, 1950.

Namuth's career as a portraitist took off after the photographs of Pollock were published in *Art News* and *Portfolio* in 1951. Gaining the trust of his subjects, Namuth photographed countless artists in their studios, often while they were working. One of his most compelling portraits was of painter Barnett Newman in 1951. The opposite of the performance-based photographs of Pollock, this portrait nonetheless typifies many of Namuth's compositional conceits. He preferred to show artists *mise-en-scène*, surrounded by his or her work. In the case of Newman, the artist contemplates a few paintings propped against a wall in his studio; light from the windows bathes the scene with a somber mood that parallels Newman's interest in the sublime.

Namuth published his portraits of artists, writers, architects, and composers in many of the most recognized magazines of the 1950s and 1960s, such as *Harper's Bazaar*, *Holiday*, *Cosmopolitan*, *Vogue*, and *Fortune*. He published many cover portraits for *Art News* from the early 1970s until 1983. In the 1980s, Namuth also worked closely with *Architectural Digest* and *Connaissance des Artes*, publishing numerous portraits for both magazines. One of his most significant collaborations was with Brian O'Doherty on the book *American Masters*, which was published in 1973. Namuth worked

on this project for 10 years, and it resulted in his most successful exhibition, *American Artists*. During this period, Namuth directed and produced many films of such luminaries as painters Willem de Kooning and Josef Albers, architect Louis Kahn, and sculptor Alexander Calder.

Namuth's skill at disarming his often formidable subjects and capturing them in unstaged situations that revealed the intimacy of the act of creation left him without an easily identifiable "signature" style, unlike many other well-known portraitists. He died in New York in 1990, however, leaving a visual legacy that not only documented the American art world of the latter half of the twentieth century, but considerably enriches its understanding.

BRIAN WINKENWEDER

See also: **Fashion Photography; History of Photography: Postwar Era; Portraiture**

Biography

Born in Essen, Germany, 17 March 1915. Opened photography studio with Georg Reisner in Puerto da Pollensa, Majorca, 1935. Photojournalist for *Vu* during Spanish Civil War, 1936. Joined French Foreign Legion, 1939. Demobilized from French Foreign Legion, 1940. Arrived in New York City, 1941. Began military service in U.S. Army, 1943. Discharged from U.S. Army, 1945. Traveled to Guatemala and photographed natives at Todos Santos, 1946. Studied photography with Josef Breitenbach and Alexey Brodovitch, 1949. Photographed and filmed Jackson Pollock at work, 1950. Published photographs of Pollock in *Portfolio* and *Art News*, 1951. Began photographing for *American Masters*, 1963. Filmed *Willem de Kooning: The Painter*, 1964. Produced numerous commissioned portraits for the cover of *Art News*, 1971–1983. Portrait commissions, *Architectural Digest*, 1983. Published more than 100 portraits of artists in *Connaissance des Arts*, 1983–1990. Received special recognition at Recontres Internationales de la Photographie d'Arles, 1988. Died in East Hampton, New York, 13 October 1990.

Individual Exhibitions

1948 *Guatemala: The Land the People*; Museum of Natural History, New York, New York, and traveling
1959 *17 American Painters*; Stable Gallery, New York, New York
1973 *American Artists*; Castelli Gallery, New York, New York
1974 *American Artists*; Corcoran Gallery of Art, Washington, D.C.
1975 *Early American Tool*; Castelli Gallery, New York, New York, and traveling
1977 *The Spanish Civil War*; Castelli Graphics, New York, New York
1977 *Living Together*; Benson Gallery, Bridgehampton, New York

1978 *Small Retrospective*; Himmelfarb Gallery, Water Mill, New York
1979 *Todos Santos*; Castelli Graphics, New York, New York, and traveling
1979 *Jackson Pollock*; Museum of Modern Art, Oxford, England, and traveling
1980 *Pictures from the War in Spain, 1936–1937*; Galerie Fiolet, Amsterdam, The Netherlands
1981 *Artists 1950–1981: A Personal View*; Pace Gallery, New York, New York
1982 *Hans Namuth*; Castelli Gallery, New York, New York, and traveling
1988 *Hans Namuth*; Recontres Internationales de la Photographie d'Arles, Arles, France
1990 *Portraits of Artists*; Parrish Art Museum, Southampton, New York
1999 *Hans Namuth, Portraits*; National Portrait Gallery, Washington, D.C.

Group Exhibitions

1975 *The Photographer and the Artist*; Sidney Janis Gallery, New York, New York
1977 *Hommage à Pollock et à Kline*; Galerie Zabriskie, Paris, France
1979 *Self-Portrait*; Center for Creative Photography, Tucson, Arizona
1982 *Counterparts: Form and Emotion in Photographs*; Metropolitan Museum of Art, New York, New York
1983 *Portraits of Artists*; San Francisco Museum of Modern Art, San Francisco, California

Selected Works

Barricade in Toledo, 1936
Pablo Cassals, 1940
Jackson Pollock, 1950
Jackson Pollock (two short films), 1950
Barnett Newman, 1951
Saul Steinberg, 1952
Elaine de Kooning and Willem de Kooning, 1953
Frank O'Hara and Larry Rivers, 1958
Buckminster Fuller, 1959
Stephen Sondheim, 1960
John Steinbeck, 1961
Jasper Johns, 1962
John Cage, 1963
Tony Smith, 1970
Louis I. Kahn: Architect (film), 1974
Mark di Suvero, 1975
Alexander Calder: Calder's Universe (film), 1977
Louise Bourgeois, 1978
Louise Nevelson, 1979
Romare Bearden, 1980
Andy Warhol, 1981
Leo Castelli and His Artists, 1982
Alfred Stieglitz: Photographer (film), 1982
Ellsworth Kelly, 1983
Take an Object: A Portrait, 1972–1990 (film), 1990

Further Reading

Carr, Carolyn Kinder. *Hans Namuth Portraits*. Washington DC: Smithsonian Institution Press, 1999.

Namuth, Hans. *Fifty-two Artists: Photographs by Hans Namuth.* Scarsdale, NY: Committee for the Visual Arts, 1973.

Namuth, Hans. *Early American Tools.* Verona, Italy: Olivetti, 1975.

Namuth, Hans. *Artists, 1950–1981: A Personal View.* New York: Castelli Photographics, 1981.

O'Connor, F.V. "Namuth's Photographs of Jackson Pollock as Art Historical Documentation." *Art Journal* 39 (Fall 1979): 48–49.

Orton, Fred. "Action, Revolution and Painting." *Oxford Art Journal* 14.2 (1991): 1–17.

Rose, Barbara. "Hans Namuth's Photographs and the Jackson Pollock Myth." *Arts* 53 (March 1979): 112–119.

Rose, Barbara. *Pollock Painting.* New York, Agrinde Publications, 1980.

Strickland, C. "Camera and Action." *Art and Antiques* (September 1991): 74–83.

Varnedoe, Kirk, with Pepe Karmel. *Jackson Pollock.* New York: Museum of Modern Art, 1999.

Winkenweder, Brian. "Art History, Sartre and Identity in Rosenberg's America." *Art Criticism* 13.2 (1998): 83–102.

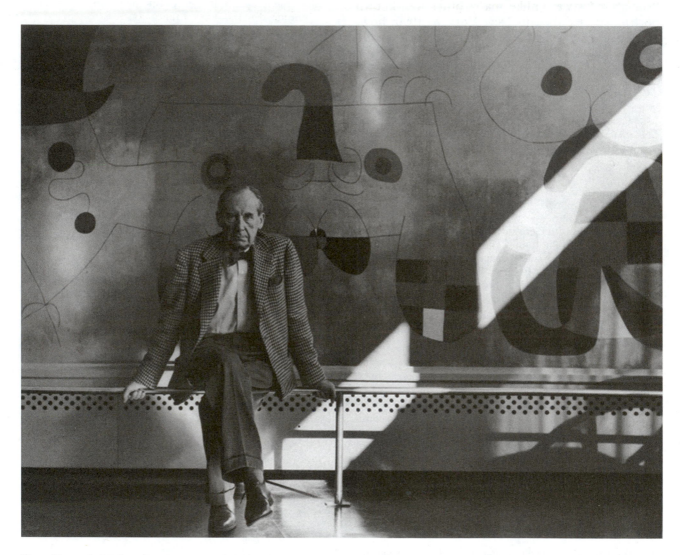

Hans Namuth, Walter Gropius, 1952. Gelatin Silver Print, 19.6 × 24.5 cm.
[*National Portrait Gallery, Smithsonian Institution/Art Resource, New York*]

NATIONAL GEOGRAPHIC

It was common practice in the 1880s in the American capital for scientific associations and other societies to form, duplicating similiar men's clubs and other associations so widespread in Great Britain. *National Geographic* magazine was started by the National Geographic Society in January 1888 by 33 individuals in downtown Washington, D.C. The organization elected Boston attorney and philanthropist Gardiner Greene Hubbard as its first president. The invitation dated 10 January 1888 to that 13 January organizational meeting at the Cosmos Club's Assembly Hall stated clearly that it was "for the purpose of considering the advisability of organizing a society for the increase and diffusion of geographical knowledge."

The *Washington Evening Star* coverage of the founding of the society consisted of one paragraph on the front page of its four-page edition. The article listed its officers and its objectives.

To publish and disperse the lectures delivered by members, the inaugural issue of a thin *National Geographic* magazine appeared in October 1888. Directed by a committee of mostly academicians, the publication would be considered dry and dull by any standards. Likewise, the plain-looking, terra-cotta-colored cover would not win any design contests. That initial press run with a cover price of 50 cents was sent to 200 charter members of the society who undoubtedly would enjoy reading such articles as "Geographic Methods in Geologic Investigation" or "The Classification of Geographic Forms by Genesis." Even nonscientific readers, if there had been any at that time, might enjoy "Fighting for Life Against the Storm" in that inaugural issue. Written by Everett Hayden, the article scientifically depicted the blizzard of 11 to 14 March 1888 in the northeastern United States and emotionally described the harrowing adventures of New York pilot boat No. 3.

It would take seven months for the second issue of *National Geographic* to be produced. The volunteer staff waited until there were enough dissertations or academic lectures to fill another volume. The April 1889 main feature was "Africa, Its Past and Future."

Despite their individual price of 50 cents, *National Geographic* subscriptions were given free as an incentive bonus for members who paid their yearly dues of $5. Lifetime memberships were available for $50. Even with low prices, membership in the society only reached 1,178 by 31 May 1895.

Future issues would be published more regularly, and by January 1896, the magazine became a monthly with a lowered sales stand price of 25 cents. The terra-cotta cover was replaced with a buff color. The contents, staff, authors, and the legend "An Illustrated Monthly" appeared on the cover.

The September 1896 issue contained an article and photo spread titled, "The Recent Earthquake Wave on the Coast of Japan," that occurred on 15 June of that year. Produced by Eliza Ruhamah Scidmore, an associate editor and the only woman serving on the board at that time, the striking photographs showed floating corpses, beached ships, and splintered homes.

Even more surprising to readers was the November 1896 issue, which featured the first of what were to be many photographs of topless female natives to grace the pages of *National Geographic* magazine. Titled "Zulu Bride and Bridegroom," the picture is a wedding portrait in which the two are looking into the camera while shaking hands, perhaps a sealing of their recently exchanged wedding vows.

Notwithstanding its modest redesign, the provocative photographs, the occasional nontechnical article, and the claim to being "An Illustrated Monthly," *National Geographic* continued to be produced by a volunteer committee of those who desired a more academic approach to the subject of geography within its pages.

Hubbard died in 1897 with the society in debt for $2,000. He was succeeded reluctantly in January 1898 by his 51-year-old son-in-law, Alexander Graham Bell, who continued to devote considerable time working on his inventions of a flying machine and a method to record sound. Bell was not a geographer nor interested in what he deemed to be primarily a local social club. Other than paying his dues, Bell had not participated actively in the organization. His eventual acceptance of the offer was based more on family loyalty to the dream of his father-in-law than geographic aspirations. After a few months of minimal growth in membership or

circulation, however, Bell announced his intention of turning *National Geographic* into a higher quality publication. He proposed increasing circulation by relying less on newsstand sales and more on membership expansion. His thoughts were that people would be interested in geography only if it were presented in an entertaining way. The phrase "to sugarcoat the pill" was mentioned frequently after Bell took over the reins of the organization. Bell also expressed a desire to use photographs that went along with the articles, rather than the occasional pictures or maps that were independent of any text.

Bell made another decision that would have an impact on *National Geographic* for decades. He hired a full-time editor with writing and editing skills. His idea to hire an editor may have met more resistance from the volunteer editorial staff until they learned Bell would pay the individual out of his personal funds. Gilbert Hovey Grosvenor had helped with proofs and layout of his historian father's two-volume *Constantinople* in 1895, considered by many to be the first scholarly book to use abundant photographs. Asked if he could turn *National Geographic* into a magazine as popular as others of the day—*Harper's Weekly, Munsey's, The Century, McClure's*—the 23-year-old schoolteacher and graduate student told Bell that he could, but that it would take time.

Grosvenor turned down Bell's offer of substantial monetary assistance accepting a monthly salary of $100, which was considerably less than what he was earning as a teacher of languages, chemistry, and algebra at the New Jersey Englewood Academy for Boys.

On 1 April 1899, Grosvenor began his tenure at the publication. Bell showed him the society's small rented office, half of which had to be shared with the American Forestry Association. Noticing the lack of a desk, Bell told the young hire he would send his own desk to the society's headquarters for his use. That afternoon a walnut rolltop was delivered. Crammed into the small space were six large boxes full of *National Geographic* magazines that were returned unsold from newsstands. Despite Bell's original offer, the job was not that of managing editor, but only as assistant editor and only for a three-month trial period.

With what can now be seen as an early example of direct marketing, Grosvenor was successful in recruiting additional members for the society by sending an impressive personal letter on quality stationery to prospective nominees. His efforts were not overlooked by the editorial committee. Bell tore up the three-month contract before the

end of April and confirmed Grosvenor's appointment as assistant editor for one full year. The June issue listed the new assistant editor. It appeared below that of John Hyde, editor, and all 12 associate editors. The editorial committee was so appreciative of Grosvenor's recruiting drive, however, that it voted to give him wide powers, including continuing solicitations.

Grosvenor, like Bell, realized that offering the magazine as a bonus for membership would be successful only if the publication proved interesting reading. Geography would have to be transformed from a dull, academic subject to a popular, entertaining topic. Grosvenor told Bell that the Greek root word for geography means a description of the world. Therefore, such universal topics as people, plants, animals, birds, and fish would be suitable topics for the pages of the magazine. Bell offered his support, agreeing that illustrations and maps would make *National Geographic* more readable for laypersons.

Grosvenor received a stamp of approval from the board of managers in September of 1900 when it named him managing editor and raised his annual salary to $2,000. He continued to improve the publication by printing shorter articles of more general interest. He thought that readers in the United States would be interested in stories and photographs of their newly acquired possessions—Cuba, Puerto Rico, and the Philippines. He was able to obtain inexpensive photographs from national government agencies and used the new photoengraving method to reproduce them for *National Geographic* magazine. In December 1904, while he was facing a deadline with 11 pages that were still empty, a Russian explorer's unsolicited package of 50 photographs arrived on his desk. He went out on a limb when he decided to use several pictures of the mysterious "forbidden city" of Lhasa in Tibet for those 11 pages in the January 1905 issue. The photographer's only requested payment was a credit line. Rather than being dismissed for such action, as he expected, Grosvenor was congratulated and thanked by members. He was voted onto the ruling board and the executive and finance committees. A French ambassador complimented Grosvenor with the Legion of Honor for his efforts to "vulgarize geography."

A short time later there was a repeat of the previous success. William Howard Taft, former governor-general of the Philippines and now secretary of war, offered his second cousin, Grosvenor, photographs of the island nation. The April 1905 magazine printed 138 photos on 32 pages. That issue was so popular in building membership that

an extra press run was required to meet demand. The year started with 3,400 members for the society, but by December 1905 there were 11,000. Grosvenor would provide direction for the National Geographic Society for the next 66 years.

Those multiple-page spreads and the introduction of color photography by 1910 transformed *National Geographic* magazine into the top tier of photojournalism. Noted journalism historian Frank Luther Mott said that the use of color transformed the magazine into its own class of publication. Grosvenor had experimented with color in 1906, using it with maps in the August and September issues. That same year saw another first in the pages of *National Geographic*, several flashlight photographs of animals at night. Taken by George Shiras III, these included deer, fish, and porcupines. In the November 1910 issue, the publication ran the biggest collection of color pictures to appear in a single magazine up to that time. Covering 24 pages, the hand-tinted spread was titled "Scenes in Korea and China." Another common sight today, the foldout photograph, started in 1911. A large panoramic shot of the Canadian Rocky Mountains unfolded into a seven-inch by eight-foot keepsake.

The society's first of many monetary grants, now that it was on solid financial footing, was awarded in 1906 to Commander Robert E. Peary in the amount of $1,000 to help fund his exploration of the North Pole region. (Peary, in fact, had been featured in an article in the first *National Geographic* back in October 1888. It described the young civil engineer's explorations in search of a proposed ship canal through Nicaragua.) That first grant was followed by one less publicized for $25,000 to pay for his 1909 North Pole discovery. Over the next few years, National Geographic Society became embroiled in a prolonged controversy as to whether Peary or Dr. Frederick A. Cook was the first to actually discover the North Pole. With the *National Geographic* backing, both financially and in print, Peary became unofficial winner. The controversy paid off for the magazine, whose circulation figures jumped to 107,000 by 1912.

Earlier expeditions had been sponsored by the society, however, including its first in 1890 and 1891 for mapping Mount St. Elias along the uncharted border between Alaska and Canada. During that outing, the explorers discovered Mount Logan, Canada's highest peak at 19,524 feet. Since the society did not have funds at that time, Hubbard provided the money for that northern trip. The organization's fortune was secure enough by 1911 that Grosvenor declared that it would provide 15 percent of its dues revenues to support expeditions and

research proposals every year. He also realized that explorers needed to take cameras along to record their discoveries. One rule to photographers was to avoid getting Westerners in the shot, thus contaminating the picture. Society-sponsored expeditions from 1912 to 1915 led to restoration of Machu Picchu, the ancient city of the Incas, in the Peruvian Andes. A $10,000 grant in 1912 allowed its discoverer, charismatic Yale professor Hiram Bingham III, to fill an issue of *National Geographic* with "In the Wonderland of Peru." The coverage included maps, drawings, a now-common foldout panorama, and 234 photographs taken by Bingham with a magazine-supplied camera.

More flashlight photos ran in 1913, but this time Shiras had the animals trip a wire to take their own pictures. The series was another step of aligning the magazine with a growing conservation movement by shooting with cameras, not guns.

While vacationing in Europe in 1913, Grosvenor saw signs of war. Arriving back at the office, he had 300,000 maps of Europe produced for insertion into *National Geographic* ready for when the battles began the following year, beginning the long tradition of map inserts. Similarly, in 1918 the magazine printed a map showing troops along the Western Front. Americans wanted to know where their soldiers were fighting and the map became required reading for that purpose. Circulation continued to skyrocket, even during the war when many other publications saw declines. In 1914, the number was 285,000. At war's end, four years later, it had jumped to 650,000. Two years later, with the former-isolationist United States a world power, circulation leaped beyond three-quarters of a million.

From 1916 to 1921, with the help of its members bestowing individual gifts along with the society donations, the organization was instrumental in purchasing land to protect the West Coast's giant sequoias and redwoods. The next popularization project was massive, stemming from a January 1924 article on Carlsbad Caverns in southwest New Mexico. More photographs appeared in a September 1925 follow-up story.

Advancements in aviation enabled Grosvenor to publish aerial photographs. *National Geographic* readers in 1922 were entertained with "Fighting Insects with Airplanes: An Account of the Successful Use of the Flying-Machines in Dusting Tall Trees Infested with Leaf-Eating Caterpillars." Other aerial subjects included the Alps, the Amazon, the Andes, the Arctic, Canada, Mount Everest, and Palestine.

Another society-sponsored trip to the North Pole was successful on 9 May 1926. This one was by

airplane with Navy pilots Robert E. Byrd Jr. and Floyd Bennett. *National Geographic* took advantage of the publicity and the popular Byrd received the society's highest award, the Hubbard Gold Medal, the following month. Grosvenor would continue supporting Byrd, and the young pilot would continue promoting *National Geographic* as well as supplying it with aerial and traditional photographs. The society provided a $75,000 grant for Byrd's flights over the South Pole and surface explorations of Antarctica during all of 1929.

After providing aerial photographs, *National Geographic* decided to take cameras underwater for its readers. In January 1927, an expedition produced color photos below the Gulf of Mexico near the Dry Tortugas, small islands west of the Florida Keys. The camera was sealed in a brass box with a glass window for the lens. Shots taken below 15 feet of the surface needed auxiliary light, provided by the flash of one pound of magnesium powder. The dangers of this assignment were evident when one ounce exploded early, severely burning W.H. Longley, a zoologist.

Borrowing photographic plates from Europe, chief lab technician Charles Martin was able to use them for color photographs taken from dirigibles. The September 1930 magazine carried what was claimed to be the first-ever color photo taken from the skies. The plate was directed at the U.S. Capitol from the Goodyear airship *Mayflower*. Its motors had been turned off to eliminate vibrations. Other scenes captured Washington, D.C. and New York. They were taken by Grosvenor's son, Melville Bell Grosvenor, newly appointed assistant editor of *National Geographic* and a graduate of the Naval Academy.

The magazine was the first to print aerial photos proving the earth's curvature. In November 1932 it published the moon's shadow on earth during a solar eclipse. In 1936, it produced the first color shot of the sun's corona during a total eclipse. Thanks to George Eastman that same year, Kodachrome film became available in rolls, eliminating the clumsy, heavy, and often fragile glass plates that previously had to be used.

The rush to deadline in 1905 that caused that first photo spread was no longer a problem at National Geographic. In fact, by the mid-1940s, the magazine had a supply of 350,000 unused photos in its files, along with several thousand unpublished articles.

Grosvenor retired in 1954, and three years later his son took control of the magazine. He beefed up the international staff, hiring 50 full-time writers and 15 full-time photographers. The now common photo cover was started in 1959.

It did not take long for *National Geographic* to rise to the top of a photographer's dream assignment. Not only was there excellent color reproduction of their creative work on thick, quality paper, but the contracts paid top dollar. Also reimbursed were the complete expenses of photographers on location, typically to exotic locations for extended periods of time. One calculation put the number of 36-exposure rolls of color film shot in a typical assignment at 250 to 350. The average appearing in the magazine's main feature is 30 to 40 prints.

Veteran photographers who have enjoyed a long association with *National Geographic* include Sam Abell, William Albert Allard, James P. Blair, Jonathan Blair, Sisse Brimberg, Jodi Cobb, Reza Deghati, David Doubilet, David Alan Harvey, Chris Johns, Ed Kashi, Karen Kasmauski, Emory Kristof, Joe McNally, Joel Sartore, James Stanfield, and Alex Webb.

Today *National Geographic* with its familiar yellow border boasts a paid circulation of about 9 million and a monthly readership of 40 million. The average subscriber is 56 years old with a median household income of $81,700. Several foreign-language editions have been launched over the past decade. There are now 25 editions in 23 languages other than English. Its interactive website, started in July 1996, was redesigned in September 2000. Its online store offers books, guides, posters, prints, cameras, and equipment.

Spin-off magazines—such as the 1 million copies of *National Geographic World*, introduced for junior members in 1975 and renamed *National Geographic Kids in 2002*, and the 1.2 million circulation of *National Geographic Adventure*, launched in 2001 and aimed at the 18- to 34-year-old market—and hundreds of books have provided additional outlets for photographers over the years. Its first feature film, "K-19: The Widowmaker," was released in July 2002.

RANDY HINES

See also: **Aerial Photography; Representation and "the Other"; Underwater Photography**

Further Reading

Abramson, Howard S. *National Geographic: Behind America's Lens on the World.* New York: Crown Publishers, 1987.

Allen, Thomas B., ed. *Images of the World: Photography at the National Geographic.* Washington, DC: National Geographic Society, 1981.

Bryan, C.D.B. *The National Geographic Society: 100 Years of Adventure and Discovery.* New York: Harry N. Abrams Inc., 1987.

Diary of a Planet. National Geographic Media Kit. Washington, DC: National Geographic Society, 2001.

Heacox, Kim, and Leah Bendavid-Val. *National Geographic Photographs: The Milestones*. Washington, D.C.: National Geographic Society, 1999.

Livingston, Jane, Frances Fralin, and Declan Haun. *Odyssey: The Art of Photography at National Geographic*. Charlottesville, VA: Thomasson-Grant, 1988.

National Geographic Expands Its World. National Geographic Press Room: Fact Sheet. Washington D.C.: National Geographic Society, 2004.

Newhouse, Elizabeth L., ed. *Unlocking Secrets of the Unknown with National Geographic*. Washington, D.C.: National Geographic Society, 1993.

www.nationalgeographic.com/publications (accessed May 20, 2005).

PHOTOGRAPHY IN THE NETHERLANDS

Photography is seen and practiced as a flexible medium by most photographers in the Netherlands. Long a center of innovative design, architecture, and art education, photography's various usages in the Netherlands have created a heterogeneous field, wherein little importance on aesthetic purism is placed. During the 1970s, throughout most of Europe, only occasionally would interesting exhibitions of photography be presented to the general public that would arouse and sustain interest in the medium as reflective of the spirit of our time and that illustrated photography's unique value.

In the Netherlands, only the Prentenkabinet of the University of Leiden had a relatively good collection of Dutch photography and a small number of important photographs from abroad. Besides this, few art connoisseurs and a very small percentage of the Dutch population knew about photography and photographers of their own countries and of other countries. Galleries seldom held photography exhibitions, and museums had only a few important shows. Of the prewar era, only Paul Citroen, Paul Schuitema, Piet Zwart, Jan Kamman, and Ed van der Elsken were internationally known.

In the early 1970s, there was an infusion of new energy into photography. The situation rapidly changed with the opening of two photo galleries in Amsterdam in 1974: first the Canon Photo Gallery and one month later, Gallery Fiolet. As a consequence, the Stedelijk Museum and the Rijksmuseum in Amsterdam became more interested and started to collect photographs and regularly organize photo exhibitions. All these activities, together with the interest of the press, helped to bring a new awareness of photography to the public.

Another important aspect is that, today, photographic equipment (analogue and digital) lies within everyone's reach and the step to a start in photography has become much smaller. Young people can try more easily to photograph and are more likely to present the results to qualified people who might give them the chance to exhibit what they are doing, how they are doing it, and to outline the dimensions of their exploration.

The photographers with a humanistic vision in the 1950s were Ed van der Elsken, Dolf Toussant, Dolf Kruger, and Violette Cornelius. They stimulated a group of "people photographers" as Sem Presser, Kryn Taconis, Cas Oorthuys, Eva Besnyö, Maria Austria, Aart Klein, Emmy Andriesse, Carel Blazer, Charles Breijer, and Ad Windig. In the 1960s, photographers such as Sanne Sannes and Gerard Fieret started a new concept with the dynamic use of the camera to create strong black-and-white pictures.

In the present situation of photography in world culture, more and more individual and organized activities are taking place. With an increase in books, catalogues, magazines, and printed matter, the Dutch museums of contemporary art have demonstrated great interest in this medium, giving to it a place of primary importance by holding several important one man shows and historical exhibitions, thus closing a gap of several years of almost complete inertia. They started several new initiatives in the 1990s: Nederlands Fotoarchief (1989), het Nederlands Fotogenootschap (1991), het Neder-

lands Foto Instituut (1994), het Nederlands Fotorestauratie Atelier (1994), Huis Marseille in Amsterdam (1999), het Fotomuseum Amsterdam (2001).

The Hague Museum of Photography opened at the end of 2002 with the successful exhibition *Photographers in the Netherlands 1852–2002*. Each year, the museum presents at least four interesting up-to-the-minute exhibitions, focusing sometimes on established names and sometimes on new talent. The museum works with the University of Leiden Print Room, which possesses one of the largest and most important collections of historical photographs in Europe. The museum shares premises with the GEM, a new museum of contemporary art which aims constantly to juxtapose work from The Hague, The Netherlands, and the wider world. Its exhibitions encompass a wide range of disciplines: video and other installations, painting and sculpture, multimedia, performance art, film, photography, drawing, digital art, and design. Apart from exhibitions, the GEM is a venue for a range of other activities such as lectures, discussions, performances, concerts, film shows, and book presentations.

The Maria Austria Instituut in Amsterdam is famous for archiving. Within its collection are the complete works of Eva Besnyö, Louis van Beurden, Carel Blazer, Hein de Bouter, Fred Brommet, Hans Buter, Hans Dukkers, Paul Huf, Frits Gerritsen, Henk Jonker, Wubbo de Jong, Wim van der Linden, Frits Lemaire, Philip Mechanicus, Wim Meischke, Boudewijn Neuteboom, Ad Petersen, Jaap Pieper, Arjé Plas, Sem Presser, Kees Scherer, Robert Schlingemann, Nico van der Stam, Waldo van Suchtelen, Ed Suister, Jan Versnel, Johan Vigeveno, Ad Windig, Bram Wisman, Eli van Zachten, Wim Zilver Rupe, Maria Austria, and the KLM Archive.

Examining photographers today it is clear that their pictures are refreshingly new pictures with a motivated statement in which feeling and experiences are the basis of a new visual dialogue. Several Dutch photographers share a Dutch way of composing the image, the use of space and light, and the timing is similar in many photographers as is the constant research into mystery, the creation of patterns of light, shadows, abstractionism, and a certain "surreal esprit." Their work has roots that go back in history to where the enigma of space, light, and the depth of luminous tones were the ingredients in the works by great masters. The proper use of light can make the ordinary seem unusual, it can reveal the unfamiliar, evoke moods and emotions, and together with the use of space and the timing it can exert a grip on the spectator.

Seen from the point of view of semiotics or sign theory, photography possesses above all an essential indexical character, because as an imprint of light the photographic image is directly and physically connected to its referent. Every photograph thus is a unique trace of the real. This results in the "unavoidable feeling of reality that you can't get rid of, even though you know all the codes that are in the game and which are fulfilled in the production." If the viewer sees the photograph as an index, then the mimetic and the symbolical play a subordinate role. The work of Paul Huf and Eddy Postuma de Boer provide examples of this tendency.

On the other hand, the photograph is only pure index for a brief moment, because as soon as it is viewed, it has been separated from reality. The principle of photographic space-time distance is a counterpoint to the indexical principle of physical proximity. The photograph is the memento of the definite lost, and herein lies its fictional potential: it is open for any narrative the viewer can (re)construct. The works of Jan Dibbets and Ger van Elk are representative.

The photographers from the Netherlands use various aspects of growth and decay. Contemporary photographers doing so are Frans Lanting, Anton Corbijn, Rineke Dijkstra, and Inez van Lamsweerde.

Contemporary photography in the Netherlands can be considered as an autonomous discipline, and it would be more useful to analyze its applications in other fields. In the first place, contemporary photography is characterized by an approach to photography that actually does depart from reality, yet renders this reality from a very specific angle/perspective as a result of the photographic technique and design it employs. In particular, the processes that are typical of the medium of photography, for instance, repetition, paradox, and the gap between actual reality and its representation, are often recurred to. This contemporary, emphatically visually oriented photography is characterized by a certain degree of alienation from reality as the latter can be perceived and often stands out by its markedly illusory character.

Photography is able to create a duplicate world/reality that is of a more dramatic nature than the natural world. By imaging this reality in a fragmented manner, the photographer suggests that there is a need for another, a second reality, which ought to be conquered by the photographer.

In the second place, one needs to point out that contemporary photography is quite ambiguous. It consists of showing a parcel of reality, framed by the camera or in the darkroom, and—considering the objective nature of this procedure—is entitled to lay serious claims to thorough epistemological validity or genuine knowledge of reality. In addi-

tion to this, it is at the same time a calling into question of the reality value of a given image and of the manner in which the objective is being "disobjectified" by the subjectivity of both the creator and of the spectator, which, in turn, is enhanced by contextual influences on and conditioning of both of these. This very ambiguity has been called the paradox of photography. The art of photography presents this paradox in its most acute and incisive manner. Each and every photograph constitutes a *doxa*: it is reality as it is, quite often with conclusive argumentative evidence.

The argument departs from the assumption that photographs are taking over the place of reality, because of the simplified and at the same time credible image that they produce of it. As such, Sontag's theory hardly pertains to the pictures by Jo Brunenberg, who makes the phallic nature of flowers and the flower-like aspects of the penis merge, and does so via the intimacy of partial images, which are kept almost pictogrammically small.

The American essayist Susan Sontag goes so far as to label the discoveries of the 1980s as "marginal," and adopts a polemic stance with regard to the inclination of both photographs and critics to cluster in schools. According to her line of reasoning, and as opposed to the art of painting, there is only one type of photography and, as a whole, it is of an overall eclectic and global nature, operates by annexation, and is closely connected with reality.

Theo Derksen is another photographer who brings together visual images that form a moving portrait of human existence. The photographs by Theo Derksen reveal the movement and rhythms of life, the volatile mysteries, and the loneliness. His photographic imagery shows a sharp-minded but passionate vision of every life. They give voice to the silent spirit of every man, every woman, and every child who struggles to survive in a conflict-prone world. By photographing out of focus, Theo Derksen denationalizes well-known geographical locations, which after they have been mixed up form a new, admittedly non-existent country. And that is perhaps the thread in this overview: the ambivalence between photography's reference to reality and its openness for the imaginary is especially interesting for artists who are investigating how place and the perception of it can be represented.

JOHAN SWINNEN

See also: **Dijkstra, Rineke; Klein, Aart; Stedelijk Museum; van der Elsken, Ed; Zwart, Piet**

Further Reading

Boom, Mattie, and Hans Rooseboom. *A New Art: Photography in the Nineteenth Century*. Rotterdam: Rijksmuseum, 1996.

Leijerzapf, Ingeborg, and Harm en Botman. *Henri Berssenbrugge, Passie – energie – fotografie*. Walburg Pers, 2001.

Merlo, Lorenzo. *New Dutch Photography*. Amsterdam: Kosmos, 1980.

Swinnen, Johan. *De Paradox van de Fotografie, Een kritische geschiedenis*. Antwerpen: Hadewych, 1992.

Van Sinderen, Wim. *Fotografie in Nederland. Een anthologie 1852–2002*. Gent: Ludion, 2002.

BEAUMONT NEWHALL

American

Beaumont Newhall, a gracious and learned New England patrician, was a pioneering historian, a consummate scholar, an enthusiastic teacher, and a photographer. His unprecedented seven-decade career as curator, museum director, art historian, teacher, scholar, author, librarian, and photographer established photography's vital role in art history. Working in partnership with his wife, Nancy, also a native of Lynn whom he married in 1936, Newhall created a basic framework for the discipline of modern photographic history. He felt his involvement with the history of photography, which he understood to be fluid and always changing as more understanding is achieved, was his greatest accomplishment, not his achievements at any single institution. *The History of Photography from 1839 to the Present Day*, is a founding document for the field. Understandable to the general public and valuable to scholars as well,

the book has gone through five editions. His message was clear: that photography is a fine art on par with all other arts, painting, sculpture, prints, architecture, and film.

Newhall was instrumental in the creation and development of the department of photography at the Museum of Modern Art (MoMA). He continued on to a distinguished and innovative career as curator and director of the George Eastman House in Rochester, New York, and later as teacher at the University of New Mexico creating a foundation that set standards for photographic scholarship. He enthusiastically shared his knowledge and insight with students, scholars, colleagues, and people around the world, setting an inspirational example. He encouraged many of his students to pursue careers in photography and then generously helped launch those careers. Many became historians and curators who have ensured photography's remarkable stature and popularity.

Newhall's philosophy is best summed up in his own words

> History is research, and history is interpretation, and history is presentation—in that order. Research is the easiest to learn and the most fun. The interpretation becomes difficult and the presentation requires a real stage-setting and careful structuring—even the shortest piece I do is structured.

Beaumont Newhall was born in Lynn, Massachusetts in 1908. When he was 15, he taught himself film processing in his mother's darkroom, where she made portraits of family and friends. He dreamed of going to Hollywood and becoming a film director but attended Harvard University to study art history, graduating in 1930. A year later he obtained a master's degree, having participated in Paul Sachs's famous museum studies course, which appealed to Beaumont for its "hands on" approach.

In 1936, Newhall was offered a job as librarian at the new MoMA by director Alfred Barr, also a product of Sachs's Harvard class. Shortly thereafter, Newhall was allowed $5,000 to mount the first exhibition of the history of photography. The result was one of the most ambitious and wide ranging photography exhibitions ever assembled. Opening spring 1937, Newhall's landmark survey *Photography 1839–1937* presented 841 items, including cameras, apparatus, and negatives alongside photographs that summarized the medium's first 100 years. Beaumont's keen understanding of the technical specifications, not only of each camera but each photographic process, allowed a richer understanding of the photographer's intentions as well as the image itself, bridging the science and art of photography. This exhibition was

also the genesis of Newhall's history; the show's handsome, fully documented catalogue was to far outstrip the show in significance and influence. Lewis Mumford in his review in *The New Yorker*, noted that Newhall "did an admirable job in ransacking the important collection for historic examples; his catalogue, too, is a very comprehensive and able piece of exposition—one of the best critical histories I know in any language."

The show circulated to 10 American museums from coast to coast. Among the contemporary photographers represented—today's twentieth century masters—were Ansel Adams, Paul Strand, Edward Weston, and Margaret Bourke-White. An expanded version of Newhall's catalogue essay was published in book form by the museum the following year as *Photography: A Short Critical History*. It was widely translated and regarded as the classic history of photography.

The Museum of Modern Art was effectively the only museum in America that regularly exhibited photography in the 1930's. As a result of his position, Newhall became friendly with many of the most important photographers of his time, including Edward Weston, Ansel Adams, and Henri Cartier-Bresson. Cartier-Bresson's emotionally-charged work especially appealed to Newhall as he was a fan of the small-format camera and its ability to capture the spontaneous.

Newhall was named MoMA's first curator of the newly established Department of Photography in 1940 and eventually became its first director. Like his MoMA colleague, architect Philip Johnson, Newhall was a strong advocate of Modernism and helped to define the movement as it emerged in the United States and Europe. He had the gift of a great collector-curator, which is to buy decisively and with total assurance in his acquisitions. In order to purchase works, Newhall had received the modest sum of $1,000 from arts' patron David H. McAlpin. Newhall wrote in his memoir *Focus* that he

> Spent half the money in the next few days. I went down the street to the Delphic Studio galleries and bought the entire one-person exhibition of some fifty photographs by László Moholy-Nagy for five hundred dollars. These were, for the most part, made in the mid-1920s, while he was teaching at the Bauhaus...That collection, plus the work I later acquired for the George Eastman House, constitutes the greatest collection of Moholy-Nagy in this country.

In 1942, when Newhall served in the Army Air Force during World War II, Nancy Newhall became acting curator of MoMA's photography department and eventually organized over a dozen exhibitions including the first major retrospective of Paul Strand.

Under her curatorship, then little-known photographers Helen Levitt, Eliot Porter, W. Eugene Smith, Aaron Siskind, Harry Callahan, and Weegee received their first serious attention and scholarship.

In 1947, Newhall was awarded a Guggenheim Foundation fellowship to rework his book, and the new version was published in 1949 by MoMA under the title *The History of Photography, 1839 to the Present*. He continued to revise and expand his study over the next 35 years, with the last revision in 1982.

In 1948, Newhall was appointed the first curator of the newly established George Eastman House in Rochester, New York, where he served for 10 years before becoming the museum's director until his retirement in 1971. At Eastman House, Nancy Newhall worked on exhibitions, and with her husband, advised the collection of Exchange National Bank of Chicago, the first collection of photographs assembled for an American corporation. Together they were founding members of the influential San Francisco-based organization Friends of Photography for the promotion of photographic education. After his retirement from Eastman House, Newhall became a visiting professor of art at the University of New Mexico, where he helped to establish the first doctoral program in the history of photography at an American university.

Few have had a greater impact on interpreting the history of fine art photography, but also on the culture of photography than Beaumont Newhall. Newhall died in 1993; Nancy had died in 1974, struck by a tree while white-water rafting. The Beaumont and Nancy Newhall papers are archived at the Getty Research Institute, Los Angeles, California, and are available at the Online Archive of

Beaumont Newhall, Charis Weston's Typewriter.
[© *1940, Beaumont Newhall,* © *2005, the Estate of Beaumont Newhall and Nancy Newhall. Permission to reproduce courtesy of Scheinbaum and Russek Ltd., Santa Fe, New Mexico*]

California (www.oac.cdlib.org). Further papers are archived at the Marion Center Library at the College of Santa Fe, New Mexico.

DIANA EDKINS

See also: **Adams, Ansel; Barr, Alfred; Bourke-White, Margaret; Callahan, Harry; Cartier-Bresson, Henri; Friends of Photography; History of Photography: Twentieth-Century Developments; History of Photography: Twentieth-Century Pioneers; Levitt, Helen; Modernism; Moholy-Nagy, László; Museum of Modern Art; Porter, Eliot; Siskind, Aaron; Strand, Paul; Weegee; Weston, Edward**

Biography

Born in Lynn, Massachusetts, 1908. Attended Harvard University and earned a B.A. *cum laude* in 1930 and also from Harvard an M.A. in 1931. Studied at the Institut d'art et d'Archeologie, University of Paris, Courtauld Institute of Art, and the University of London. Lecturer at the Philadelphia Art Museum in 1931. An assistant in the Department of Decorative Arts at the Metropolitan Museum of Art, New York. Librarian at the Museum of Modern Art, New York in 1935. In 1940, became its first curator of photography and served as curator from 1940 to 1942 and from 1945 to 1946. During World War II, Newhall was a major in the Air Force and served as photographic interpreter in Egypt, North Africa, and Italy. He then served as curator and director of the Eastman House from 1948 to 1971. Throughout his career, Newhall taught the history of photography and photographic arts at such institutions as the University of Rochester, Rochester Institute of Technology, State University of New York at Buffalo, as well as at the Salzburg Seminar in American Studies, Austria. He lectured all around the world. He became a professor at the University of New Mexico in 1972 and was named Professor Emeritus in 1984. He served as an honorary trustee of the Eastman House until his death. Died Santa Fe, New Mexico, February 26, 1993.

Selected Works

Photography 1839–1937. Exh. cat. New York: Museum of Modern Art, 1937.
Photography: A Short Critical History. (Revised edition of *Photography 1839–1937*. New York: Museum of Modern Art, 1938.
The Photographs of Henri Cartier-Bresson. With Lincoln Kirstein. New York: Museum of Modern Art, 1947.
The History of Photography from 1839 to the Present Day. New York: Museum of Modern Art, 1949. (Revised and enlarged in 1964, 1971, 1978, and 1982); Japanese edition (same title) Tokyo: Hakuyosha, 1956; French edition : *L'Histoire de la photographie depuis 1839 et jusqu'a nos jours*. (French edited by Andre Jammes). Paris: Belier-Prisma, 1967; British edition (same title) London: Secker & Warburg, 1982; German edition: *Geschicte der Photographie*. Munich: Schirmer-Mosel, 1984.
Masters of Photography. With Nancy Newhall. New York: George Braziller, 1958.
Latent Image: The Discovery of Photography. New York: Doubleday, 1967. Italian edition: *L'Immagine latente*. Bologna: Zanichelli, 1969.
Focus: Memoirs of a Life in Photography. Boston: A Bulfinch Press Book, Little, Brown and Company, 1993.

Further Reading

Beaumont Newhall, Colleagues and Friends. Exh. cat. Santa Fe, NM: Museum of Fine Arts, Museum of New Mexico, 1993.
New Documentary Photography, U.S.A. Exh. cat. Introduction by Nancy Howell-Koehler, essays by Beaumont Newhall, William Messer, and Joseph Rodriguez, Cincinnati, OH: Images, Inc., 1989.

ARNOLD NEWMAN

American

With a professional career that has spanned more than 66 years, Arnold Newman, called the "father of the environmental portrait," is known for memorable portraits of artists, statesmen, writers, and musicians that render an unparalleled assemblage of twentieth-century genius. During his prolific career, Newman also photographed still lifes, experimented with collages, and produced documentary studies of rural African-Americans. His portraits of ordinary people are less known; however, they display Newman's trademark connection between photographer and subject, the *sine qua non* of humanity that exists without regard to financial or social station. Breaking with long-standing portrait conventions, Newman incorporated a person's living or working spaces into the portraits, whether by object, symbol,

or space. In this way, the subject's surroundings are not mere background but include elements indicating interactions between society and his subjects, setting up a dialogue that establishes one creative unit. Newman, nevertheless, eschews any attempt at establishing a formula.

My idea of photography came from the snapshot. As a boy I remember seeing photographs of Teddy Roosevelt. In the official portrait, he looked like an embalmed, overstuffed walrus. But in another, a snapshot, he was photographed with his foot on top of an animal he'd shot and was grinning like mad and one could sense from a photograph like this what the man really looked like, how he stood, even what he was like as a human being. I began to develop an idea that combined the reality of the snapshot with a creative graphic approach. I wanted to show where a person lived and worked, a kind of reality combined with a carefully worked out composition. I didn't set out to do something different so much as to do something that interested me.

Born in New York City, the second of three sons of Isidor and Freda Newman, Arnold moved at the age of two to Atlantic City where his father pursued a dry goods business. When that faltered, he managed small hotels in Atlantic City and in Miami. In 1936, Newman graduated from high school and with his parents' blessing studied art, earning a scholarship to the University of Miami in Coral Gables, Florida. Plans of becoming a painter ended two years later when family financial difficulties caused his departure from academia. A chance encounter on the Atlantic City boardwalk soon changed his life when Leon Perskie, a professional photographer and family friend, encouraged Newman to work in Philadelphia where Perskie's son owned a chain of inexpensive portrait studios in the Lit Brothers department stores. Soon Newman was living in Philadelphia with his childhood friend, Ben Rose, who graduated from the School of Industrial Arts in photography under the tutelage of Alexey Brodovitch, art director at *Harper's Bazaar*. Newman planned to work by day and study art at night but, after watching his friends photographing, he soon borrowed a camera and began to develop his own photographic vision.

Work, meanwhile, meant churning out 40–60 portraits daily. Stifled by the humdrum, Newman started photographing people on his own, experimenting with techniques promulgated by modernism and abstraction. He was influenced by the works of painters Pablo Picasso and Piet Mondrian, and the Farm Security Administration photographs, especially those of Walker Evans, whose catalogue for the 1938 exhibition, *American Photographs* at the Museum of Modern Art (MoMA) had opened Newman's eyes to a new way of seeing.

He then returned to Florida where he accepted more lucrative employment as manager of the Tooley-Myron chain portrait studio in West Palm Beach. By 1941, Newman couldn't wait to start working independently and began photographing people in their everyday surroundings—on the porch or on the street—away from the artificiality of the studio. On the advice of friends, Newman traveled to New York City to see Beaumont Newhall, MoMA's Curator of Photography. Impressed by Newman's portfolio although not by his printing skills, Newhall recommended that he see Alfred Stieglitz. Discovery by Newhall and Stieglitz, two illustrious names in the history of American photography, propelled Newman to leave Florida and move to New York City. Finally able to practice his own unique style of portraiture, Newman set out to find interesting people, such as painters, sculptors, and other creative people who worked well with his environmental concept. Raphael Soyer became the first of what Newman calls his "experimental subjects." A joint exhibition with Ben Rose at the A.D. Gallery followed in 1941. Attended by New York's advertising and cultural elite as well as by Ansel Adams and Newhall, who purchased a print for MoMA's permanent collection, this event launched Newman's professional career.

U.S. Army orders obliged Newman to return to Miami in 1942, but after receiving a deferment, he stayed on to open Newman's Portrait Studio in Miami Beach. Its success did not keep him from returning to New York City again and again to photograph such artists as Piet Mondrian, Marc Chagall, Charles Burchfield, John Sloan, and Max Ernst. Throughout his career, Newman has followed his maxim that "a good portrait must first be a good photograph." From early on, he was interested in abstraction and in shapes; he found strength in geometric design and being able to interconnect geometric shapes in new and unusual ways. "For me photography is intellectual excitement," he says, "a joy and the occasional experience of rich satisfaction in creating an image that pleases me as well as others. Is it a portrait? Is it art? That is up to others to debate. I am pleased just to make a good photograph."

In December 1945, the Philadelphia Museum of Art organized *Artists Look Like This*. Critical acclaim convinced Newman to move to New York City permanently, and he received his first assignment for *Life*, a portrait of playwright Eugene O'Neill. Among the first photographs he did for *Harper's Bazaar* was composer Igor Stravinsky seated at a grand piano, an image rejected

by the editor but one that has since become Newman's most widely-recognized. Numerous commissions for magazines such as *Fortune*, *Holiday*, *Vanity Fair*, and *Look* followed.

Newman's innovative approach to portraiture influenced media and advertising through key publications in the United States and abroad. Exhibitions and purchases of his work by major museums, including the Metropolitan Museum of Art, New York; Victoria and Albert Museum, London; and the Stedelijk Museum, Amsterdam have led to global recognition.

Newman's place in the history of photography as a portrait photographer with an artist's sense of composition and observation and a field researcher's rapport with his subject was set more than 50 years ago. Newman credits this "gift" to his early hotel experiences as catalyst for a lifelong fascination with people. "I think people are the most exciting things we have," he recounted in an interview, "not interesting faces, but interesting people. They don't have to be famous. I just love people and what they do with their lives."

CYNTHIA ELYCE RUBIN

See also: **Evans, Walker; Farm Security Administration; Life Magazine; Look; Museum of Modern Art; Newhall, Beaumont; Portraiture**

Biography

Born in New York City, 3 March 1918. Raised and attended schools in Atlantic City, New Jersey, and Miami, Florida. Attended the University of Miami (Coral Gables, Florida), 1936–1938. Works for chain portrait studios, 1938–1941. Moves to New York City, 1941. Returns to Miami and opens Newman's Portrait Studio in Miami Beach, 1941–1945. Returns to New York City, 1945, and moves to studio on West 67th Street, 1948. Marries Augusta Rubenstein, 1949, two sons. Begins New York Times ad series, 1951; recipient of the Photokina Award, Cologne, Germany, 1951; Commissioned by *Life* to cover presidential candidates, 1951; U.S. Senate essay for *Holiday* includes portraits of Kennedy, Johnson, and Nixon, 1953; first of continuing assignments to Europe where he photographs British parliament, German leaders, and Paris art figures, 1956; founded Photography Dept., Israel Museum, Jerusalem, 1965; teaches Master Class at Cooper Union, New York City, 1968–1972; American Society of Magazine Photographers Life Achievement in Photography Award, 1975; lectures in Australia, 1981; recipient of Doctor of Fine Arts, University of Miami, Miami, Florida, 1981; Advertising Club of New York Award of Excellence, 1983; named Honorary Fellow, with Augusta Newman, of the Israel Museum, Jerusalem, 1986; recipient of Doctor of Humane Letters, Art Center College of Design, Pasadena, California, 1987; lectures in Sweden, 1988; lectures in Venezuela, 1989; recipient of Honorary Doctorate, University of Bradford, England, 1989; recipient of Doctor of Fine Arts, the New School

for Social Research, Parsons School of Design, New York City, 1990; "Director's Visitor" at Institute for Advanced Study, Princeton, New Jersey, 1991; lectures in Santa Fe, 1992; World Image Award and Scholarship named for Arnold Newman, the New School for Social Research, Parsons School of Design, New York City, 1993; recipient of Doctor of Human Letters, Academy of Art College, San Francisco, California, 1996; recipient of Honorary Doctorate of Fine Arts, University of the Arts, Philadelphia, Pennsylvania; recipient of Doctor of Fine Arts Honoris Causa, Corcoran College of Art and Design, Washington, D.C., 2000; recipient of Honorary Doctorate of Fine Arts, University of Hartford, Hartford, Connecticut, 2003; French Ministry of Culture and Communication, Commandeur de l'Order des Arts et des Lettres, 2003.

Individual Exhibitions

1941 With Ben Rose; A.D. Gallery, New York, New York
1942 *Artists Through the Camera*; Brooklyn Museum, Brooklyn, New York
1946 *Artists Look Like This*; Philadelphia Museum of Art, Philadelphia, Pennsylvania
1951 The Camera Club; New York, New York
1953 *Photography by Arnold Newman*; Art Institute of Chicago, Chicago, Illinois
1955 *Arnold Newman Collective Work*; Portland Art Museum, Portland, Oregon
1956 *Arnold Newman Photographs 1940–1954*; Museum of Art, Santa Barbara, California
　　 Arnold Newman Photographs 1940–1954; Ohio University, Athens, Ohio
　　 Arnold Newman Photographs; Miami Beach Art Center, Miami, Florida
1958 *Arnold Newman Portraits*; Cincinnati Art Museum, Cincinnati, Ohio
1963 *Arnold Newman Portraits*; Biennele Internazionale della Fotografia, Venice, Italy
1972 *Arnold Newman*; Light Gallery, New York, New York
1976 The Photographers' Gallery; London, England
1978 Fotografiska Museet; Stockholm, Sweden
　　 Arnold Newman Portraits; Israel Museum of Art, Jerusalem, Israel
1979 *The Great British*; National Portrait Gallery, London, England, and traveled to Light Gallery, New York, New York
1986 *Arnold Newman: Five Decades*; Museum of Photographic Arts, San Diego, California, and traveled to The Art Institute of Chicago, Chicago, Illinois; Minneapolis Institute of Arts, Minneapolis, Minnesota; Massachusetts Institute of Technology, Cambridge, Massachusetts; Norton Gallery and School of Art, West Palm Beach, Florida; New York Historical Society, New York, New York; Fort Worth Art Museum, Fort Worth, Texas; Cincinnati Art Museum, Cincinnati, Ohio; Holland Foto Foundation, Amsterdam, Netherlands; Joan Miró Foundation Museum, Barcelona, Spain; Frankfurter Kunstverein, Frankfurt, Germany; Musée de l'Elysée, Lausanne, Switzerland; Museum of Modern Art, Oxford, England; Odakyu Department Store Gallery, Tokyo, Japan; Hankyu Department Store Gallery, Osaka, Japan
1989 *Arnold Newman: Portraits, Collages and Abstractions*; Old Town Hall, Prague, Czechoslovakia, and traveled to National Gallery, Bratislava, Czechoslovakia; House of Art, Brno, Czechoslovakia

1990 *Arnold Newman's Americans*; National Portrait Gallery, Washington, D.C., and traveled to Detroit Institute of the Art, Detroit, Michigan; LBJ Library and Museum, Austin, Texas; Columbus Museum of Art, Columbus, Georgia; Greenville County Museum of Art, Greenville, South Carolina; Worcester Art Museum, Worcester, Massachusetts; USIA exhibit, Budapest, Hungary

1993 *Arnold Newman*; Museum of Contemporary Art, Caracas, Venezuela

1999 *Arnold Newman's Gift: Sixty Years of Photography*; International Center of Photography, New York, New York

2000 *Arnold Newman*; Corcoran Gallery of Art, Washington, D.C. *Arnold Newman*; L'Hotel de Sully, Paris, France, and traveled to Galerie du Château d'Eau, Toulouse, France; Louisiana Museum of Modern Art, Copenhagen, Denmark; Palazzo Magnani, Reggio Emilia, Italy

Group Exhibitions

1943 *Masters of Photography*; Museum of Modern Art, New York, New York

1959 *Photography at Mid-Century*; George Eastman House, Rochester, New York

1964 *The Photographer's Eye*; Museum of Modern Art, New York, New York

1980 *Photography of the 50s*; International Center of Photography, New York, New York and traveled to the Center for Creative Photography, Tucson, Arizona; Minneapolis Institute of Arts, Minneapolis, Minnesota; California State University at Long Beach, Long Beach, California; Delaware Art Museum, Wilmington, Delaware

1991 *Artist's Choice: Chuck Close, Head-On/The Modern Portrait*; Museum of Modern Art, New York, New York

Selected Works

Georgia O'Keeffe and Alfred Stieglitz, New York, 1944
Igor Stravinsky, New York, 1946
Jackson Pollock, Springs, Long Island, 1949
Senator John F. Kennedy, Washington, D.C., 1953
Pablo Picasso, Vallauris, France, 1954
Alfried Krupp, Essen, Germany, 1963
Andy Warhol Collage, The Factory, New York, 1973

Further Reading

Newman, Arnold. *Newman, Arnold. Five Decades*. San Diego, CA: Harcourt Brace Jovanovich, 1986.

———. *Arnold Newman: Selected Photographs*. New York: Howard Greenberg Gallery, 1999.

———. *Arnold Newman's Americans*. Boston: Bulfinch Press, 1992.

———. *Artists: Portraits from Four Decades by Arnold Newman*. Boston: New York Graphic Society, 1980.

———. *Faces USA*. New York: American Photographic Book Publishing Co., 1978.

———. *One Mind's Eye: The Portraits and Other Photographs of Arnold Newman*. Boston: David R. Godine, 1974.

Newman, Arnold, and Robert Craft. *Bravo Stravinsky*. Cleveland, OH: World Publishing Co., 1967.

Newman, Arnold, and Bruce Weber. *Arnold Newman in Florida*. West Palm Beach, FL: Norton Gallery, 1987.

Philippi, Simone, ed. *Arnold Newman*. Cologne: Taschen, 2000.

The Great British. Boston: New York Graphic Society, 1979.

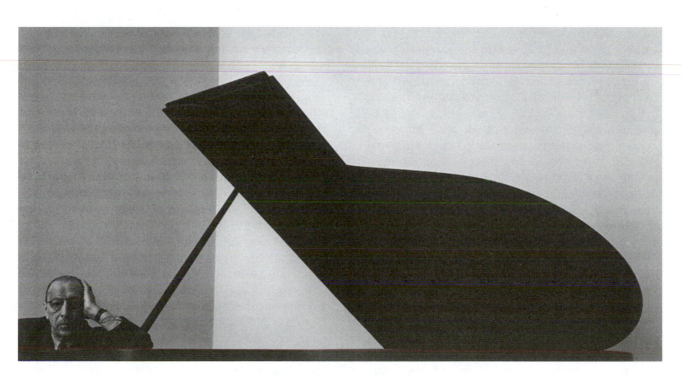

Arnold Newman, Igor Stravinsky, composer, conductor, New York, 1946.
[© *Arnold Newman*]

HELMUT NEWTON

German

Born Helmut Neustaedter in Berlin in 1920, to Jewish parents, he grew up in privileged circumstances in the home of his wealthy button-manufacturer father and American mother. Newton's father sent him to attend the city's American School, but he was a bad student and was expelled when his fascination with photography, sparked by an Agfa box camera bought when he was 12, along with his interest in girls, overshadowed his interest in learning. After leaving school in 1936, the young Newton apprenticed to top photographer Elsie Simon, known as Yva, until he was forced to flee after the start of Hitler's vicious pogroms against German Jews two years later. Upon flirting with death by consorting with Aryan girls, his parents managed to secure him passage on a ship to China, but he stopped off in Singapore, where he got a job as a photojournalist at the *Straits Times* newspaper, a job he held for just two weeks, after which he was fired for incompetence.

There he met a glamorous older Belgian woman, and, powered by an epic sex drive, became her lover; he caroused around the British colony until moving to Australia in 1940, just ahead of the Japanese invasion. After briefly being interned as a German citizen, he later joined the Australian army, serving five years, and, in 1948, married actress June Brunell, a fellow photographer who later would both photograph Newton and work with him on his books. She sometimes published under the name Alice Springs, a legendary sheep station in the Australian outback. She would remain his partner for more than 55 years until his death. It was during this time he changed his name to Newton, opened a small photo studio in Melbourne, and soon began contributing fashion photos to *French Vogue* in 1961, a magazine that he stamped with his trademark images for a quarter century. Throughout the years, Newton shot extensive campaigns for the major fashion houses, began shooting celebrities and royalty, and contributed to magazines such as *Playboy*, *Queen*, *Nova*, *Marie-Claire*, *Elle*, and the American, Italian, and German editions of *Vogue*.

His stark and provocative style set a new industry standard. He began to photograph overtly sexual images after a major heart attack in 1971 and with the encouragement of his wife. His nudes became his signature and the self-reflexive, often isolated poses of the models frequently caused controversy in the art world. With the publication of his erotic photo book *White Women* in the 1970s, he won the sobriquets "The Prince of Porn" and "The King of Kink" (nicknames that he disdained). His sado-masochistic stamp was so visually arresting he was constantly turning down offers to direct feature films. His work began fetching upwards of $100,000 each at auction. One of his most well known publications is the oversized *Big Nudes*, which distributed his work to a wider audience, where he has been celebrated by novelists, such as J. G. Ballard and semioticians, such as Marshall Blonsky, and criticized by the Moral Majority and feminists. In 1998, Scalo publishers released *Pages from the Glossies*, a collection of not just his most important fashion shots, but of the entire magazine pages, giving context to their original reception—a rare opportunity in photo publishing.

One of the most ambitious projects surrounding Newton was one of his last. In 2000, he had a mammoth retrospective at the International Center of Photography in New York (the first show in its new mid-town gallery). Also that year, art publishers Taschen released *Sumo*, a collection so big it came with its own table. The book, which weighs some 65 pounds, had a limited print run of 10,000 copies and carried a price tag of $5,000—making it the most expensive book ever published. But somehow this would seem fitting for the man who came to weave so fluidly into the worlds of super-celebrity, super-power, and super-wealth. No matter how exclusive or infamous his subjects might be, they were all props in Newton's world, playthings for an imaginative boy who grew up in the heady world of the Weimar Republic.

An Australian citizen, Newton lived in Monte Carlo in the summer and at Hollywood's famed Chateau Marmont hotel in the winter. He defied convention with his paradoxical images—in his most controversial and iconic images one finds, for example, icy coldness coupled with heated passion and painful emotional distance mixed with an unnerving intimacy. In Newton's realm the viewer is, for all intents and purposes, a voyeur. Subjects of his photographs seem to hand themselves over to him, in body and soul, all the while representing Newton himself first and foremost. No matter what

celebrity or movie star is pictured, it will always be identified first as "a Newton." A good example of this autobiographical tendency is that through his controversial career, he evoked his close scrape with the Nazis (his mentor Yva died at Auschwitz). He shot, for instance, a series of portraits of the most surprising subjects for a Jew who had spent his life wandering the world, including former United Nations chief Kurt Waldheim, who was linked to the Nazis, and far right-wing French political leader Jean-Marie Le Pen. According to his 2003 autobiography, when he photographed Leni Riefenstahl, Hitler's official documentarian, she made him promise not to "call her an old Nazi." But the ever-exuberant Newton never dwelled on his past—or his seemingly unbelievable luck. He was always pushing forward the boundaries of acceptable imagery, and pushing himself ever further in his art. Productive and highly sought after until the end of his life, Newton died of injuries from a car accident at the Chateau Marmont in Hollywood, California in 2004. Shortly before his death, he had established the Helmut Newton Foundation in a former Prussian Officers' club adjacent to the railway station in Berlin where he had fled Nazi persecution and donated approximately 1,000 works to his native city.

MARC LEVERETTE

See also: **Erotic Photography; Fashion Photography; Nude Photography; Portraiture**

Biography

Born in Berlin, Germany, 31 October 1920. Attended the Werner von Trotschke Gymnasium and the American School in Berlin, but expelled from both. Apprenticed under the German photographer Else Simon, known as Yva. Worked as freelance photographer, journalist, and later fashion and celebrity photographer for numerous publications (including *Playboy*, *Vanity Fair*, *Harper's Bazaar*, *Vogue*, etc.). Became associated with Marlborough Gallery, New York, and G. Ray Hawkins Gallery, Los Angeles, early 1980s. Awarded Tokyo Art Directors' Club Prize, 1976; American Institute of Graphic Arts Award for *White Women*, 1977–1978; named Chevalier des arts et des lettres by the French Minister of Culture, 1989; Awarded the Grosses Bundesverdienstkreuz by the Federal Republic of Germany, and named Chevalier des Arts, Lettres et Science by S.A.S. Princess Caroline of Monaco, 1992; *Life* Legend Award for lifetime achievement in magazine photography; 1999. Died in Hollywood, California, 23 January 2004.

Selected Individual Exhibitions

1975 Galerie Nikon; Paris, France
1976 Photographers' Gallery; London, England
1979 American Center; Paris, France
1980 G. Ray Hawkins Gallery; Los Angeles, California
1982 Galerie Photokina; Cologne, Germany
1982 Studio Marconi; Milan, Italy
1984–1985 *Retrospective*; Musée d'Art Moderne, Paris, France
1985 *Retrospective*; Museo dell' automobile, Turin, Italy
1985–1986 Galerie Artis; Monte Carlo, Monaco
1986 *Retrospective*; Foto Foundation, Amsterdam, The Netherlands and traveling
1988 *New Nudes*; Hamilton Gallery, London, England
1988 *Retrospektive*; Berlinische Galerie/Martin-Gropius-Bau, Berlin, Germany and traveling
1988–1989 *Portraits Retrospective*; National Portrait Gallery, London, England
1988–1989 *Nouvelles Images*; Espace Photographique de Paris Audiovisuel, Paris, France
1989 *New Images*: Galleria d'Arte Moderna, Bologna, Italy
1989 *Fashion Photographs & Portraits*; Prefectural Museum of Art, Fukuoka, Japan
1989 *Helmut Newton in Moscow*; Puschkin Museum & Perwaia Galeria, Moscow, Russia
1989 *Helmut Newton: Nevas Imagenes'*; Fundación Caja de Pensiones, Madrid, Spain
1989 *Fashion Photographs & Portraits*; Seibu Art Museum, Funbashi Japan and traveling
1989–1990 *New Images*; Carlesberg Glyptonthek Gallery, Copenhagen, Denmark
1990 Hochschule für Graphik und Buchkunst; Leipzig, Germany
1991 Museum of Modern Art; Bratislava, Czechoslovakia
1992 *Naked and Dressed in Hollywood*; Pascal de Sarthe Gallery, Los Angeles, California
1993–1994 *Helmut Newton. Aus dem photographischen Werk*; Castello di Rivoli, Turin, Italy and traveling to Fotomuseum Winterthur, Winterthur, Switzerland; Josef-Albers-Museum, Bottrop, Germany; and Deichtorhallen, Hamburg, Germany
1996 *Helmut Newton—Photography*; Navio Museum, Osaka, Japan
1997 *Helmut Newton in Sweden*; Hasselblad Foundation at the Göteburg Museum, Göteburg, Sweden

Selected Group Exhibitions

1975 *Fashion Photography, Six Decades*; Emily Lowe Gallery, New York, New York
1977 *The History of Fashion Photography*; International Museum of Photography and Film, George Eastman House, Rochester, New York
1978 *Fashion Photography*; Galerie Photokina, Cologne, Germany
1980 *Instantanés*; Centre Georges Pompidou, Paris, France
1980 *20/24 Polaroid*; Galerie Zabriskie, Paris, France
1982 *50 années de photographie de* Vogue *Paris*; Galerie Photokina, Cologne, Germany, and Musée Jacquemart-André, Paris, France
1985 *Shots of Style*; Victoria and Albert Museum, London, England
1988 *Splendeurs et misères du corps*; Musée d'art Moderne, Paris, France
1989 Ministry of Culture of the Soviet Union; Moscow, Russia
1989 *The Art of Photography*; Museum of Fine Arts, Houston, Texas
1991 *Appearances*; Victoria and Albert Museum, London, England

1993 *Vanities, Centre national de la photographie*; Hôtel Salomon de Rothschild, Paris, France
1993 *Regards d'artistes sur la femme*; Hôtel de la Monnaie, Paris, France

Selected Works

Croix-Valinor, 1976
Jenny Kapitan—Pension Dorian, Berlin, 1977
In My Studio, Paris, 1978
The Princess of Polignac, Paris, 1979
They Are Coming, 1981
Charlotte Rampling, Paris, 1984
Daryl Hannah, Los Angeles, 1984
Michael Caine, 1985
Cyberwomen 2, 2000

Further Reading

Bachardy, Don. *Stars in My Eyes*. Madison: University of Wisconsin Press, 2000.
Ballard, J.G. "The Lucid Dreamer." *Bookforum* (1999).
Blonsky, Marshall. "The Courtier's Contempt: Helmut Newton's not so *Beau Monde.*" In *American Mythologies*. New York: Oxford University Press, 1992.
Harrison, Martin. *Appearances: Fashion Photography Since 1945*. New York: Rizzoli International Publishers, 1991.
Newton, Helmut. *White Woman*. Preface by Philippe Garner. New York: Congreve; London: Quartet Books; Munich: Schirmer/Mosel; Paris: Filipacchi, 1976.
———. *Big Nudes*. Preface by Bernard Lamarche-Vadel. Paris: Editions du Regard, 1981.
———. *White Women*. Japan: Kodansha, 1983.
———. *Helmut Newton—Portraits*. Paris: Musée d'Art Moderne de la Ville de Paris, 1984.
———. *World Without Men*. Text by Helmut Newton and Xavier Moreau. New York: Farrar, Strauss, Giroux, 1984.
———. *Big Nudes*. Munich: Schirmer/Mosel, 1987–1990.
———. *Helmut Newton—Portraits*. London: National Portrait Gallery; and Munich: Schirmer/Mosel, 1988.
———. *Helmut Newton—Sleepless Nights*. Munich: Schirmer/Mosel, 1991.
———. *Pages from the Glossies*. Milan: Scalo, 1998.
———. *Autobiography*. New York: Nan A. Talese, 2003.
———. *Sumo*. Los Angeles: Taschen, 2000.
Newton, Helmut, and Alice Springs. *Us and Them*. Milan: Scala, 1999.

NICHOLAS NIXON

American

Nicholas Nixon achieved national attention in the early stages of his career, when his subjects were primarily industrial landscapes and aerial city scenes. Having established his approach to the American landscape, Nixon applied the same methodology to human subjects, which have comprised the vast majority of his career. Working in series, Nixon seeks to document human relationships, experience, and identity as physical, nearly-quantifiable forces, things ruled by time and transformation, perpetually in process, and evidenced in abundant display on the surfaces of human faces and bodies. What is distinctive and unusual about Nixon's work with people is the interplay of the personal and the impersonal: his interest in cataloguing the human experience via classical, historically clinical photographic procedures favored by Edward Weston and Walker Evans. Nixon shoots exclusively with black-and-white film and large-format view cameras, ranging in size from 8 × 10-inch to a 14 × 17-inch camera built especially for him. For Nixon, the challenge has been to marry traditional technology with instantaneous imagery, to render the careful rigor of the view camera responsive to the energy and nuance of human character and interaction. He writes "Maybe part of my artistic ambition is to keep the lively part of snapshots and get rid of the dull, studied part of portraits, but maintain the best juice of both. And mix the two together (Nixon 1991)."

Born in Detroit in 1947, Nixon's early professional life was structured around his interest in public service. After receiving his bachelor's degree in English Literature from the University of Michigan in 1969, Nixon volunteered with the VISTA (Volunteers In Service to America) program in St. Louis (1969–1970) and soon thereafter became a high school teacher in Minneapolis (1970–1971) before enrolling in an M.F.A. program at the University of New Mexico. In 1974, he received his master's degree in photography and accepted a teaching position at the Massachusetts College of Art in Boston. He began photographing large cityscapes of the Boston area

using an 8 × 10-view camera, chronicling the density and complexity of urban development from high vantage points—work that positioned Nixon squarely inside of a rising movement of young photographers documenting the "social landscape."

In 1975, curator Bill Jenkins assembled ten artists, Nixon among them, whose work exemplified this new movement in documentary photography, in a George Eastman House group exhibition titled *New Topographics: Photographs of a Man-Altered Landscape*. Other photographers included in the exhibition were Robert Adams, Lewis Baltz, Bernd and Hilla Becher, Joe Deal, Frank Gohlke, John Schott, Stephen Shore, and Henry Wessel, Jr. While it was not the first major exhibition for all of these artists (both Robert Adams's *The New West* and Lewis Baltz's *New Industrial Parks* preceded the *New Topographics* exhibition), it was the first time the working methods and collective identity of the New Topographics, as the group came to be known, were declared in a formal, public way. The exhibition was seminal in that it placed a startling new approach within the traditions of documentary and landscape photography while at the same time clearly outlining a radical departure from those traditions. While artists such as Ansel Adams were producing epic portraits of an untouched and idealized "nature," the New Topographics were documenting the profound reconfiguration of the American environment in areas of concentrated human activity: industrial parks, chemical plants, expressway loops, housing tracts, and shopping centers. As a generation of artists who had never experienced the natural landscape without also experiencing its counterforce—industrialism—the New Topographics assumed the task of re-claiming the terrain of landscape photography by focusing on the prosaic and profoundly "man-altered landscape." They aimed to render their subjects without ceremony or sentimentality, adopting an overtly ascetic approach to their images (taking as their model real estate and survey photographs). In framing the landscape, they actively rejected the "subjective" themes of beauty and idealism and chose, instead, the "objective" study of place—geographical, cultural, and political. The New Topographics artists worked to minimize the role of style, and instead strove to see the environment clearly and wholly as it truly appears. Many of them worked in series as a way of equalizing the value of individual images and democratizing a system of visual meaning that can subordinate its subjects to authorial control and isolate subjects from cultural context.

By the time of the *New Topographics* exhibition, Nixon had already begun to apply this ideology to photographs of human subjects. Nixon's work with human subjects (e.g., *School*, *The Brown Sisters*, *Pictures of People*) melds the technical precision and scrutiny of the large format view camera with the emotional and cultural specificity of the snapshot, a technique that has become his trademark. Speaking about his role in the continuum of great view camera photographers, Nixon has said:

> I'm honored to be using the same methods as Atget, as Walker Evans. I want to honor what is possible. I'd like to go deeper, get closer, know more, be more intense and more intimate. I'll fail, but I'm honored to be in the ring trying. I'd like to go deeper than Stieglitz did about his marriage. It's arrogant, but I'd like to try.

(Ollman 1999)

To subjects at close range, this format is, if not unkind, certainly unromantic in its relentless attention to discrete variations in human surfaces: pores and wrinkles and hairs achieve stunning prominence in Nixon's photographs, almost as if he believes it possible to uncover the physical substance of what is ineffable and elusive in human identity and relationships. In 1975, Nixon produced the first image of his ongoing series *The Brown Sisters*, which chronicles his wife, filmmaker and journalist Bebe Nixon, and her three sisters in a series of annual portraits, one selected for each year. Included in its nascence in the 1978 exhibition *Mirrors and Windows* at the Museum of Modern Art, New York, *The Brown Sisters* is one of Nixon's most recognized achievements. The fact that the images are produced as a series, always composed in the same way—the camera always at eye level, the four women arranged in the same order—connects each image to the others and plots them along a temporal trajectory, prompting the viewer to examine the four women, not as figures suspended in a single "decisive moment," but as the collective site of an ongoing and changing narrative; across the series, uniformity gives rise to variation, and the relationships and identities of the four sisters are evidenced by the slow, steady transformation of this human landscape.

Throughout the 1980s, Nixon's attention encompassed a wide variety of human subjects, his photographs striving to penetrate the broadest possible spectrum of societal issues. His images of "porch life" in Kentucky (from the series *Pictures of People*, 1988) document the starkness and lyricism of quotidian family life in an economically-depressed swath of rural America. Notable in this series is the 1982 image *Covington, Kentucky*, which shows a young boy on a porch basking in a patch of sunlight, his arms outstretched and his head thrown

back as, with eyes closed, he appears to stand in time suspended, soaking the sun's rays in a gesture that is as deep in its expression of physical experience as it is ordinary. By contrast, Nixon's *Family Pictures* series (1985–1991) examines the artist's own immediate, familial relationships—those with his wife, Bebe, and their two children, Clementine and Sam—in some cases, offering a glimpse of the artist breaching the frame in order to demonstrate the full scope of these relationships.

In his *School* series, published in 1998, a collaboration with Pulitzer Prize-winning child psychiatrist Robert Coles, Nixon spent two years among the children of three Boston-area schools: an elementary school in Cambridge, the Perkins School for the Blind, and the prestigious Boston Latin school. Working alongside Coles, Nixon chronicled the habits and routines of children ranging from the very gifted to the severely impaired, gathering with clinical precision the subtle, fleeting gestures that play on the surface and provide physical clues to the unknowable, ineffable experience of an interior self. *Gary Moulton, Perkins* is one such image—remarkable in its delicacy and allusion to this interior, notable as proof of Nixon's success as an acquisitive documentarian working in abstract, emotional terrain.

Nixon's desire to "go deeper, get closer"—his continued efforts to achieve clarity of representation by effacing himself as an author—has led him, over the course of his career, to increasingly complex and culturally potent subjects. His series *People with AIDS* (*PWA*), a collaboration with his wife, Bebe Nixon, attempted to document people living with HIV/AIDS, the effect the disease has on their lives, their families, and their identities. The series aroused fierce condemnation and outrage from the HIV/AIDS-activist community at its debut in 1988 at the Museum of Modern Art (MoMA). The published series is a combination of image and text—text that, by and large, features the words of 15 HIV-positive people talking about what is happening to their bodies as they confront the realities of their illness. The MoMA exhibition, however, consisted of selected images only, a decision responsible for much of the furor surrounding the exhibition, led primarily by members of the activist organization AIDS Coalition to Unleash Power (ACT UP), who believed the *PWA* series, in its unabashed survey of the physical deterioration and anguish attendant to advanced stages of AIDS, perpetuated dangerous myths about people suffering from the disease, myths that would ultimately encourage discriminatory policies that harm people living with HIV/

AIDS. ACT UP demonstrators staged public protests outside of the museum, distributing manifestoes and leaflets that demanded images of HIV-positive people "who are vibrant, angry, loving, sexy, acting up and fighting back," as well as "no pictures without context." Robert Atkins, a journalist and art historian who wrote extensively about the *People with AIDS* controversy, describes the special burden of proof Nixon's *People with AIDS* series faced:

> Nixon's pictures are, in fact, often grim accounts of the virus' murderous capability, but they are also a welcome record of its effect on a diverse, not-always-gay population of heterosexual women-of-color and hemophiliacs. As the first body of work exhibited on an extremely public stage, they also suffered from impossible expectations...Nixon's pictures were somehow expected to appeal to everybody: to simultaneously win over bigoted or uncommitted museum goers [sic]; and to foment activism and buck up the spirits of people with AIDS. No single body of work could possibly work such magic.

(Atkins 1999)

In many ways, the controversy surrounding the *People with AIDS* exhibition is similar to that surrounding the *New Topographics* exhibition: where the *New Topographics* exhibition challenged the public's expectation of what constitutes a photographic landscape, Nixon's *People with AIDS* series challenged presiding notions of what constitutes a fair and honest portrait—inevitably raising the question of artistic responsibility: to one's subject, as well as one's audience. For the *People with AIDS* series, the question rested, specifically, on how one documents illness responsibly—particularly one so stigmatized in American culture. Our intuitive belief that the intimacies and details of our most personal experiences are entitled to a certain degree of privacy is well-supported by much of traditional portraiture, which holds such mysteries at bay, well-protected within the fog of romanticism and mystery. These notions are directly challenged by portraits such as Nixon's, which neither covet nor protect, but aim instead to disable such mysteries and expose the realities they would otherwise obscure. The question of artistic responsibility is especially acute when the subject's control over their own image is limited, as is the case with the *People with AIDS* series, as well as Nixon's work with the *Perkins School for the Blind*. When the subject cannot return the viewer's gaze (*Perkins School for the Blind*), or cannot control the physical manifestations of a debilitating illness (*People with AIDS*), the viewer is confronted with an identity whose ownership remains ambiguous: who controls this physical identity, if not the subject? The degree to which Nixon's images seem to privilege the

viewer in this relationship is potentially discomfiting at the same time that it is potentially irresistible.

Nixon continues to work in the domestic and public realm. Throughout the early years of the twenty-first century, Nixon has produced images of delicate intimacy and bald sensuality as part of his *Couples* series, in which lovers of all ages and sexes are catalogued in their most tender and passionate moments. In another collaboration with Bebe, the Nixon's produced a series titled *Room 306: A Year in Public School*, which examines their son Sam's sixth-grade class as a microcosm for the ongoing, often intractable issues facing the American public school system. His more recent *Boston Public Garden* series interestingly combines elements of both his landscape work and his photographs of people, focusing on the interaction between couples in public parks; human relationships suspended, hinged, and nested among the architecture of the public terrain.

JENNIFER SCHNEIDER

See also: **Adams, Robert; Baltz, Lewis; Documentary Photography; Gohlke, Frank; Shore, Stephen; Social Representation**

Biography

Born in Detroit, Michigan in 1947. Received B.A. in English from the University of Michigan in 1969; received M.F.A. in Photography from University of New Mexico in 1974. VISTA volunteer in St. Louis 1969–1970; high school teacher in Minneapolis, MN 1970–1971. Began photographing Bebe Brown in 1970; married Bebe (Brown) Nixon in 1971; began work on *The Brown Sisters* series in 1975. Assumed teaching position in 1974 at the Massachusetts College of Art in Boston, MA. Selected for 1975 group exhibition, *New Topographics: Photographs of a Man-Altered Landscape* at the International Museum of Photography, Rochester, New York. Begins association with Light Gallery, New York, 1980. Massachusetts Council of the Arts, "New Works" Grant, 1982; National Endowment for the Arts Photography Fellowship, 1976, 1980, 1987; John Simon Guggenheim Memorial Foundation Fellowship, 1977, 1986; Friends of Photography Peer Award, 1988; George Gund Foundation Fellowship, 2000.

Individual Exhibitions

1976 *Nicholas Nixon*; Museum of Modern Art, New York, New York
1977 Vision Gallery; Boston, Massachusetts
1982 Institute of Contemporary Art; Boston, Massachusetts
 Rochester Institute of Technology; Rochester, New York
1983 Friends of Photography; Carmel, California
 Madison Art Center; Madison, Wisconsin
1984 California Museum of Photography; Riverside, California
1984 Corcoran Gallery of Art; Washington, D.C.

1985 Ackland Art Museum; University of North Carolina, Chapel Hill, North Carolina
1985 *Photographs by Nicholas Nixon: Portraits 1975–1985*; Art Institute of Chicago, Chicago, Illinois
1986 Cleveland Museum of Art; Cleveland, Ohio
1988 Museum of Fine Arts; Boston, Massachusetts
1988 *Nicholas Nixon: Pictures of People*; Museum of Modern Art, New York, New York
1989 Detroit Institute of Arts; Detroit, Michigan
1989 Milwaukee Art Institute; Milwaukee, Wisconsin
1989 San Francisco Museum of Modern Art; San Francisco, California
1989 Victoria and Albert Museum; London, England
1990 Saint Louis Museum of Art; St. Louis, Missouri
1991 Museum of Photographic Arts; San Diego, California
1994 Sprengel Museum; Hannover, Germany
1995 *Nicholas Nixon*; Musée de l'art Moderne, Paris, France
2001 *Nicholas Nixon: Lovers*; Fraenkel Gallery, San Francisco, California

Group Exhibitions

1975 *New Topographics: Photographs of a Man-Altered Landscape*; International Museum of Photography, George Eastman House, Rochester, New York
1977 *Court House*; Museum of Modern Art, New York, New York
 Nicholas Nixon and Stephen Shore; Worcester Art Museum, Worcester, Massachusetts
 New York: The City and its People; Yale University School of Art, New Haven, Connecticut
1978 *Mirrors and Windows: American Photography since 1960*; Museum of Modern Art, New York, New York
 14 New England Photographers; Museum of Fine Arts, Boston, Massachusetts
 Nicholas Nixon/William Eggleston; The Cronin Gallery, Houston, Texas
1979 *American Images*; Corcoran Gallery of Art, Washington, D.C.
1980 *Photography and Architecture*; Fraenkel Gallery, San Francisco, California
 American Photography of the '70s; Art Institute of Chicago, Chicago, Illinois
1981 *American Children*; Museum of Modern Art, New York, New York
1982 *The Contact Print*; Friends of Photography, Carmel, California
 20th Century Photographs from the Museum of Modern Art; The Seibu Museum of Art, Tokyo, Japan
1984 *Les Ages et les Villes: Frederick Cantor—Nicholas Nixon*; The American Center, Paris, France
1986 *Variants*; Museum of Modern Art, New York, New York
1987 *Twelve Photographers Look at U.S.*; Philadelphia Museum of Art, Philadelphia, Pennsylvania
1990 *Photography Until Now*; Museum of Modern Art, New York, New York
1991 *Eadweard Muybridge and Contemporary American Photography*; Addison Gallery of American Art, Andover, Massachusetts, and traveling
1992 *Fables of the Visible World*; Massachusetts College of Art, Boston, Massachusetts
 Pleasures and Terrors of Domestic Comfort; Museum of Modern Art, New York, New York
1995 *Visions of Childhood*; Bard College, Annandale-on-Hudson, New York

Hidden Faces; Paul Kopeikin Gallery, Los Angeles, California

1997 *About Faces: The History of the Portrait in Photography*; Fogg Art Museum, Cambridge, Massachusetts

1998 *Newly Acquired Works*; Seattle Art Museum, Seattle, Washington

1999 *The Model Wife*; Museum of Photographic Arts, San Diego, California

2000 *How You Look At It*; Sprengel Museum, Hannover, Germany

People/Places; Museum of Modern Art, New York, New York

2001 *A City Seen*; Cleveland Museum of Art, Cleveland, Ohio

2003 *Cruel and Tender: The Real in the Twentieth-Century Photograph*; Tate Modern, London, England

Selected Works

The Brown Sisters, (series) 1975–
Cutaway View of SE Expressway Boston, 2002
Northeast View from Hancock Building Boston, 2002

From *Couples* series: *A.I., H.I. Truro*, 2003 *C.H., R.H. Boston*, 2001 *Y.A., J.S. Switzerland*, 2000

From *People with AIDS* series (pub. 1988): *T.M.G. Braintree Tom Moran*, 1987 *Tom Moran, November 1987*, 1987

From *Pictures of People* series (pub. 1988): *Covington, Kentucky*, 1982 *Yazoo City, Mississippi*, 1979

From *School* series (pub. 1998): *Gary Moulton*, 1991 *Jamie Watkins*, 1991

Further Reading

Atkins, Robert. "Off the Wall: AIDS and Public Art." In *Artery: The AIDS-Arts Forum* (1999).

Atkins, Robert. "Censor Sensibility." *Village Voice* (Dec. 20, 1988): 116.

Atkins, Robert. "Moving Pictures." *Village Voice* (Dec. 24, 1991): 84–85.

Jenkins, William, ed. *New Topographics: Photographs of a Man-Altered Landscape*. Rochester, NY: International Museum of Photography at George Eastman House, 1975.

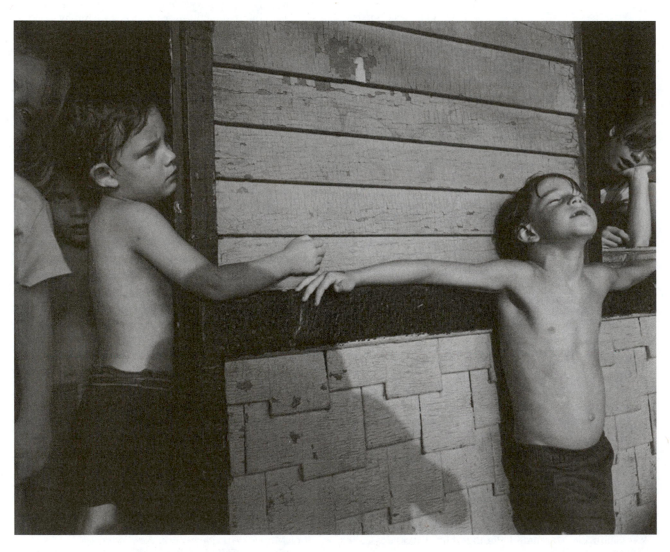

Nicholas Nixon, Covington, Kentucky, 1982.
[*Courtesy Fraenkel Gallery, San Francisco*]

Nixon, Nicholas. *Pictures of People*. Introduction by Peter Galassi. New York: Museum of Modern Art, 1988.

Nixon, Nicholas. *School: Photographs From Three Schools*. Essay by Robert Coles. New York: Bulfinch Press/Little, Brown, 1998.

Nixon, Nicholas, and Bebe Nixon. *People with Aids*. Boston: David R. Godine, 1991.

Ollman, Arthur. *The Model Wife*. San Diego, CA: Museum of Photographic Arts, 1999.

Renato Danese, ed. *American Images*. New York: McGraw-Hill, 1979.

Szarkowsi, John. *Mirrors and Windows: American Photography Since 1960*. New York: Museum of Modern Art, 1978.

Weski, Thomas. *How You Look At It*. Hannover, Germany: Sprengel Museum, 2000.

NON-SILVER PROCESSES

For the past hundred years, when we speak of a photographic print, we speak of a silver halide emulsion on paper. Silver salts suspended in gelatin have been the mainstay of the photo industry since mass production began in 1886. Yet although the earliest experiment to capture light in the late eighteenth century and early years of the nineteenth century did involve the use of silver, in the 1840s when photography was finally established, the list of newly discovered light-sensitive emulsions reads like a cookbook of photochemistry. Most processes were short-lived. The few that survived were employed at various times during the twentieth century as important alternatives to the silver process in fine arts photography and printmaking.

Tintype, daguerreotype, cyanotype, kallitype, carbon prints, bromoil, Van Dyke brown, platinum prints (platinotypes), palladium prints, and gum bichromate were among the most popular early processes that are still used today. They are labor-intensive, difficult, sometimes dangerous processes that often produce images that cannot be duplicated in a subversion of photography's modern definition as a process by which multiple, identical copies can be produced. Inherent in all these processes, however, is a pictorial style that alters and transforms the photographic image through surface, texture, color, and tonalities that are unique to the process.

All of these processes reflect the struggle of early photographers to make photographic images that would not fade. Many of these processes used silver in some step of the process yet came to be called "non-silver" to differentiate them from the silver gelatin print, which solely relies on silver. As early as 1822, Joseph Nicéphore Niépce, a printmaker with poor drafting skills, made the first successful photographic plate after coating a glass plate with bitumen of Judea thinned with oil of lavender. The bitumen was exposed to sunlight through an engraving, oiled to make it transparent. After several hours, the exposed areas of the bitumen coating became insoluble. The still soluble bitumen, protected by the lines of the engraving, washed away in turpentine and oil of lavender. Further experiments with pewter plates instead of glass led to the first permanent photograph from nature. In 1826, using a camera aimed from his third floor window in Gras, France, Niépce recorded the view. It was an eight-hour exposure.

In 1829, he formed a partnership with Louis-Jacques-Mandé Daguerre. Legend has it that Daguerre, aware of Niépce's experiments with silver-plated copper and vapors of iodine, began experiments with iodized silver. By chance, he placed an iodized silver plate in a cupboard used for storing chemicals. Upon opening the cupboard a few days later, he was surprised to find an image on the plate. Through the process of elimination, he discovered that mercury vapors from a broken thermometer had revealed the latent image. The Daguerreotype was born a few years later in 1837, when Daguerre discovered that treating the plate in a salt solution after exposure would stabilize the action of the mercury on iodized silver.

Meanwhile, just across the English Channel, another struggling draftsman, Wiliam Henry Fox Talbot, unhappy with his efforts to capture the view from Lake Como using his pencil and a projection device called a camera lucida, switched to a portable version of the camera obscura and began his own experiments with the photographic print. Talbot began his research with silver salts, patent-

ing the calotype process in 1841. In this "salted paper" process, the paper is first coated with a solution of silver chloride or ammonium chloride combined with a sizing agent such as arrowroot, starch, or gelatin. The paper was then sensitized with a coat of silver nitrate and allowed to dry. After exposure through a negative to sunlight, the print was washed in water to remove the unexposed silver nitrate. The image was gold-toned then fixed in sodium thiosulfate and washed again to remove the excess fixer. The final prints ranged in color from reddish brown or, if gold-toned, anywhere from reddish to purplish brown. The color depended on the sizing, trace materials found in the paper, and length of time in the toning bath. The calotype process is similar to the Van Dyke brown and kallitype processes.

The inexpensive alternative to a daguerreotype followed on the heels of Frederick Scott Archer's published results on the use of collodion to make glass plate negatives in 1851. The tintype, a direct descendant of the collodion process, was invented by an American, Hannibal L. Smith in 1856. It was simply a thin metal plate, lacquered black then coated with the collodion and potassium iodide emulsion and sensitized with silver nitrate. The image was developed in pyrogallic acid and fixed in sodium thiosulfate.

While silver was making headway into the mainstream of photographic processes, other light-sensitive materials were also being explored, including ferric (iron) salts, a process to become known as cyanotype. In 1842, Sir John Herschel, renowned British astronomer and the first to note the importance of sodium thiosulfate as a fixer, discovered that ferric ammonium citrate or ferrous chloride combined with potassium ferricyanide and coated on a sheet of paper, placed under a negative and exposed to sunlight, then washed out in water, produced a blue positive image. The process was easy to combine with other non-silver processes and the relative simplicity of the cyanotype (or blueprint) process ensured its popularity for generations to come. Engineers and draftsmen continue to use it for copying line drawings. Herschel also noted that ferrous salts could reduce silver to its metallic state, leaving the door open for the development of the kallitype in 1899, an iron printing process that allows the development of an image similar to platinotypes, but which is much less expensive and can be used on fabrics.

The cyanotype process may have been an important and true alternative to silver, and far less susceptible to the problems of impermanence in the silver-based processes, but it remained relentlessly blue. The discovery of the pigmented processes in the 1850s seemed like the answer.

These pigmented processes were the result of the research of three men: Mongo Ponton, who discovered the light sensitivity of bichromates; William Henry Fox Talbot, who noted that soluble colloids such as gum arabic and gelatin mixed with bichromate lose their solubility; and Alphonse Louis Poitevin, who added pigment to the colloid.

The carbon process, in which carbon black is suspended in potassium dichromate and a colloid such as gelatin, albumen, or gum arabic, and brushed on the paper, dried, and exposed to sunlight through a negative, proved to be the most popular process of its day. Later fine-tuned as the carbon transfer process, it involved exposing the negative to the colloidal film mounted on thin tissue, stripping the tissue away, and transferring the final image to a paper backing. The dry transfer process, developed in 1935 as a means to make permanent color prints, grew out of the carbon transfer process.

Gum bichromate came along a few years later, in the 1860s. Watercolor pigments were added to the gum arabic and ammonium dichromate solution and exposed to sunlight through a negative. (Alternately, starch and gelatin could be used as an emulsion, and potassium or sodium bichromate could be used to fix the light.) Gum bichromate became a popular process among the Pictorialists in the 1890s and has continued to attract photographers and printmakers with its versatility of palette and its ability to combine well with other processes. Another version of the gum bichromate process is the casein bichromate process. In this process casein—milk solids dissolved in ammonia—is used instead of gum arabic.

Bromoil, developed in 1907 by C. Welbourne Piper and E.J. Wall, is another of the bichromate pigment processes. In this case, the gelatin-bromide print is treated with a bichromate solution, thus bleaching the dark silver image and chemically altering the gelatin. An oil pigment could thus be absorbed into the print in proportion to the original silver image. In an earlier version of this, the bichromated gelatin is hardened through exposure to sunlight through a negative. The print is soaked in water and oil-based pigments are brushed or rolled on, penetrating the print more or less, depending on the amount of water the emulsion has absorbed. It was a frequent choice among the Pictorialists. The Fresson Process, a patented secret process developed by Theodore–Henri Fresson, is a version of the bromoil process still in use today.

Platinum prints and the less expensive but similar palladium prints are still widely used today and are by far the most popular of all the non-silver processes. Sir John Herschel was the first to realize the potential for platinum as a light-sensitive material, but it was William Willis who perfected their use and patented the process in 1873. In platinum printing, ferric oxalate and potassium chloroplatinite coat the paper, which is exposed to sunlight through a negative. The ferric salts become ferrous in proportion to the exposure. The print is developed in potassium oxalate, which dissolves the ferrous salts and reduces the platinum to its metallic state. The unexposed ferric salts remaining on the paper are removed by a dilute solution of hydrochloric acid. The final image is in pure platinum, a highly stable metal that is rarely affected by the environment. The tonal range is extraordinary, making platinum prints the connoisseur's choice in photographic prints.

With the exception of the platinum and palladium processes, most of these alternatives to silver would have disappeared entirely after the introduction of commercially manufactured silver-based papers in the mid-1880s if photographers had been content to remain outside the arenas of fine art. With the invention of roll film and easy-to-operate box cameras, photography was considered no more than a photomechanical process easily employed to record the visible world. An artist, however, did no such thing: an artist interpreted the world through personal sensibilities. Photography, to be recognized as an art medium, had to reflect its abilities through modulation of tonalities and details, to respond to the artist's interpretation of a subject. Informed by the academic standards applied to the painting and graphic arts of their day, the Pictorialists began their quest to secure photography's position as an art form.

Alternatives to the silver print were thus reconsidered, this time for their ease of manipulation and their ability to reflect the photographer's individual interpretation of the image on the negative. Experimentation with these earlier processes led to new and more flexible formulas for non-silver imagery.

Gum bichromate was an immediate success among photographers with higher artistic aspirations when the French photographer Robert Demachy rediscovered the process and introduced it to the European community at the 1894 London Salon. The French and Austrian Pictorialists quickly seized upon it because of its great range of manipulation and in America, Alfred Stieglitz, Edward Steichen, and Gertrude Käsebier were among the many who championed its potential.

Stieglitz was an active proponent of photography as a fine art. As the founding editor in 1903 of the vastly influential magazine *Camera Work*, Stieglitz was a pivotal figure on the American front of the Pictorialist movement. He was the instigator of the Photo-Secession and organized the seminal exhibition of art photography at the National Arts Club in New York City in 1902, *Pictorial Photography, Arranged by The Photo-Secession*. The Photo-Secession consolidated the already influential Pictorialist movement in America, bringing together like-minded photographers in both Europe and America for active dialogues, technical information, and exhibitions, spreading the word about not only the gum bichromate process, but the photogravure and platinum print, or platinotype, as it was more commonly called during this era.

Photogravure, an intaglio printmaking process using potassium dichromate and gelatin as a photo-resist on copper plate (another of Talbot's discoveries), was also popularized by Steiglitz in America. The etching process yielded a richness in detail and tonality consistent with fine intaglio prints. The plates were hand-rubbed with different colors of ink and hand-pulled on art papers. Multiples could be made, but like any hand-worked craft, the effort was labor-intensive and reflected the printer's sensibilities.

Platinum printing continued as a popular medium among the Pictorialists, especially when it was combined with other processes such as gum bichromate, carbon, and cyanotype. British and American photographers took the lead in experimenting with gum and platinum printing. The leading American-born Pictorialist, Alvin Langdon Coburn, a frequent exhibiter of the combined processes, is often credited with the invention of this technique. The French and the Austrians were best known for their work in gum bichromate, although Robert Demachy, an early champion of the gum process, became the leading proponent of the oil transfer process. Bromoil, its less complicated cousin, gradually replaced it as a first choice among amateurs well into the 1940s. By 1910, Pictorialism had reached its peak. In America, the fabled 1910 exhibition of Photo-Secessionists at the Albright Gallery, in Buffalo, New York, beat all attendance records for the gallery. Six hundred or so photographs were on display to 16,000 viewers. In 1917, the last issue of *Camera Work* was published featuring the work of Paul Strand. The era of "straight photography" and its almost exclusive reliance on the gelatin silver print had begun.

Gertrude Käsebier, The Heritage of Motherhood, ca. 1904/print 1916, gum bichromate print,
27 × 24.9 cm, Gift of Hermime Turner.
[*Photograph courtesy of George Eastman House*]

Non-silver processes were relegated to the pages of photo history books until the new wave of "alternative processes" suddenly appeared along with the growth of photography departments in American art schools in the late 1960s. Art students, influenced again by the painters of the day who used photo images extensively in their work—notably Andy Warhol and Robert Rauschenberg—began to rediscover the non-silver processes. Teacher-photographers Robert Heinecken, Betty Hahn, and Bea Nettles, a professor at the University of Illinois Champaign-Urbana, were among the pioneers of this renewed interest in non-silver processes. Nettles introduced Kwik Print, a proofing method for commercial platemakers, as an easier alternative to the gum process for photographers. Her guide to Kwik Print and other non-silver processes, *Breaking the Rules: A Photo Media Cookbook*, has been in print since first appearing in 1977.

The Alternative Processes movement employed photo-printmaking techniques such as photo-silkscreen, intaglio, and litho as well as the earlier non-silver processes. It was largely seen as a reaction to the aesthetic of the straight black-and-white print that continued to exemplify fine art photography. The goal was to expand the definition of photography and photographic materials. The movement reached its peak in the important traveling exhibition, *The Alternative Image* organized by the John Michael Kohler Arts Center in Sheboygan, Wisconsin in 1983.

As the twentieth century turned and new technologies in photographic imaging make quality photo manipulation and reproduction even more accessible, particularly digital printing in the form of the laser print or ink-jet print, a new movement in "Historical Processes" is unfolding. Once more, the early, non-silver processes, including daguerreotype and tintype, are being re-examined. Once more, the craft of the hand, the one-of-a-kind search for the artist's sensibility is the goal.

KAY KENNY

See also: **Camera Obscura; Coburn, Langdon, Alvin; Developing Processes; Digital Photography; Film; Hahn, Betty; Heinecken, Robert; History of Photography: Nineteenth-Century Foundations; Käsebier, Gertrude; Photo-Secession; Photo-Secessionists; Pictorialism; Rauschenberg, Robert; Steichen, Edward; Stieglitz, Alfred**

Further Reading

Blacklow, Laura. *New Dimensions in Photo Imaging*. Boston: Focal Press, 1989.

Bunnell, Peter C. *Non-Silver Printing Processes*. New York: Arno, 1973.

Crawford, William. *The Keepers of Light*. Dobbs Ferry, NY: Morgan and Morgan, 1979.

Gassan, Arnold. *Handbook for Contemporary Photography*. 3rd ed. Athens, OH: Handbook Co., 1974.

Hirsch, Robert. *Exploring Color Photography*. 3rd ed. Dubuque, IA: Brown and Benchmark, 1997.

Kohler, Ruth DeYoung, and Patricia Gleason Fuller, curators. *The Alternative Image*. Exh. cat. John Michael Kohler Arts Center.

Lucida, James, and Judith Watts. *Enhanced Photography*. Glouchester, MA: Rockport, 1999.

Newhall, Beaumont. *The History of Photography*. 5th ed. New York: Museum of Modern Art, 1993.

Reeve, Catharine, and Marilyn Sward. *The New Photography*. New York: Da Capo Press, 1986.

LORIE NOVAK

American

Lorie Novak has been conjuring memories for nearly two decades, reflecting images of herself, then others onto landscapes and through empty rooms that resonate with a real or imagined personal history. They are snapshots and fragments, bits of visual memory and oral history from her own family archives as well as others, projected over and over again until they become streams of archetypes, familiar enough to be borrowed freely amongst participants and viewers alike.

Through family snapshots in projected installations, Novak mines deep cultural memories, encouraging viewers to recollect their own family histories. The startling merge between cultural history and private moments of family life that Novak achieves in her work captures the spirit of the gen-

erations of Americans born and raised after World War II much as the legendary 1955 *The Family of Man* exhibition did for previous generations.

In 1954, just as color film became readily available to the amateur photographer, Novak was born in Los Angeles. As the first child and grandchild in her family she was frequently photographed. Her grandparents had emigrated from Central Europe at the time of the pogroms, and she was the beginning of the second generation in America.

At the University of California in Los Angeles, she studied photography with Robert Heinecken, and decided to pursue a career as an artist. She transferred to Stanford University, where she received her B.A. in Art and Psychology in 1975.

While wandering through Europe the summer after college, she accidentally ran a roll of film through her camera twice. The combined images were a breakthrough that began her exploration of melding of time and places. Following her M.F.A. from the School of the Art Institute of Chicago, Novak began exhibiting photographs of interiors (living rooms, bedrooms, kitchens) altered by colored lights and slide projections of shadows, light patterns, and landscapes, layering time and spaces through projected images.

One day, while experimenting with the slide projectors, she put in a slide from her childhood: "There I was in this room with this ghostly projection of myself as a child, and that's what got me started examining family photos. A lot of it is a search for truth, what photographs mean. That ghostly vision of myself as a child was a turning point in my work."

Throughout the 1980s, Novak created color photographic prints from montaged slides projected onto the bare walls of empty rooms. Working with snapshots gleaned from her family's archives, she chose images for their emotional evocation of familial relationships and childhood. Eventually, she added images from the news media, creating a chronological and cultural context for her collected family memories. In 1987, while in residence at the MacDowell Colony in New Hampshire, she began a series of landscape works where she projected slides directly into the landscape at night. The ground, trees, and sky became a stage: a dark backdrop that resonated with feelings of fear, longing, and decay.

Critical Distance, 1987–88 was her first installation designed to be experienced in its projected form. In early 1991, Novak installed *Traces* at the University Art Museum at California State University, Long Beach. *Traces* was followed by *Playback* in 1992, a five projector installation commissioned by The Southeast Museum of Photography in Day-

tona Beach, Florida, for the traveling exhibition *Betrayal of Means/Means of Betrayal.*

In *Playback*, the 15 minute sequence included live radio with preprogrammed stations offering the sound equivalents of the media images. *Playback*, however, was more autobiographical than earlier works: the material was more chronological, and images, both public and private, were now updated with each exhibition.

Novak began to enlarge the family snapshot pool in *Collected Visions I* commissioned by the Houston Center of Photography in 1993 with funds from the National Endowment for the Arts. In this installation, music composed by Elizabeth Brown and slides of women and girls examine the representation of girlhood and the experience of coming of age. Novak collected family snapshots from friends, students, and colleagues, as well as women from the Houston community, who provided her with a wide range of images from varied generational, ethnic, and social backgrounds.

The similarity as well as the differences among the photographs led Novak to collect more photographs of both sexes and inspired the creation of *Collected Visions* on the Web, www.cvisions.cat.nyu.edu. With a project grant from the Center for Advanced Technology at New York University, Novak teamed with sound designer Clilly Castiglia, web designer Betsey Kershaw, and programmer Kerry O'Neill and launched the *Collected Visions* website in 1996 at a conference on family photographs at Dartmouth College, Hanover, New Hampshire. The site, complete with a searchable database and opportunity to write and include personal stories, is an interactive archive of family snaps and narratives donated from people all over the country. By 2001, the site had over 2,500 photographs submitted by over 350 people.

In 2000, Novak completed the third part of the *Collected Visions* project, a computer-based installation that draws on the website's extensive archive of snapshots. *Collected Visions 2000* debuted at the International Center of Photography's midtown New York gallery. The computer-driven installation used high-resolution digital projectors and a high-quality streaming media system created specifically for the project by Jonathan Meyer. Music composed by Elizabeth Brown for viola, flute, shakuhachi, piano, and toy accordions was mixed with people's voices commenting on their family photographs. As the images streamed forward, words and music, cultural and personal memories intersected, morphing time and place, familial relationships and cultural identities into American archetypes.

In a search that began with her own family's images, Novak sought to examine the question of how photographs shape our memories. In *Collected Visions 2000*, her innovative exploration of personal and cultural memory (through the often casual and fragmented family snapshot) culminates in a collection of memories, family photographs, and photo essays that examine and reinforce our sense of common history. Her photographs and installations have been exhibited at institutions such as the International Center of Photography, The Center for Creative Photography at the University of Arizona, Tucson, and the Museum of Contemporary Art in Chicago, and in many group exhibitions, including the Museum of Modern Art, New York, and the Art Institute of Chicago. As of this writing, she is the Chair and Associate Professor of the Photography and Imaging Department at Tisch School of the Arts at New York University.

KAY KENNY

See also: **Family Photography; Vernacular Photography**

Biography

Born in 1954 in Los Angeles, California. Attended University of Los Angeles, 1971–1973. Received BA in Art and Psychology from Stanford University in 1975, MFA from School of the Art Institute of Chicago, 1979. Adjunct Faculty at New York University Tisch School of the Arts 1986–1991. Associate Professor of the Department of Photography and Imaging at Tisch 1991, and Chair 1999 to present. Co-director of Urban Ensemble through which Tisch School of the Arts students engage in community-based arts projects. A New York Foundation of the Arts Artist in Residence for the Washington Houses Community Center After School Program, New York, N.Y., 1988–1990. National Endowment for the Arts Individual Artist Fellowship in Photography; 1990, Lewis Comfort Tiffany Foundation Grant Polaroid Corporation Materials Grant, 1978–1980, Phelan Award, Photography, San Francisco Foundation, 1982, and residencies at Jacob's Pillow Dance Festival Yaddo, 1988, 1983, Djerassi Foundation, Woodside California, 1990, Rockefeller Foundation's Bellagio Center, Bellagio, Italy, 1997, and MacDowell Artist Colony, 2000, 1997, and 1990. Lives in Brooklyn, New York.

Individual Exhibitions

1980 S.F. Camerawork; San Francisco, California
1981 Arco Center for the Visual Arts; Los Angeles, California
1982 University of Rhode Island; Kingston, Rhode Island
1985 Stanford University Museum of Art; Stanford, California
　　Film in the Cities; St. Paul, Minnesota

　　Tampa Museum of Art; Tampa, Florida
1990 *Projections, Photographs 1983–1990*; Madison Art Center, Madison, Wisconsin
　　Critical Distance; Addison Gallery of American Art, Andover, Massachusetts
1991 *Traces: A Site Specific Projected Installation*; Museum of Contemporary Art, Chicago, Illinois, and The University Art Museum, California State University, Long Beach, California
　　Portland School of Art; Portland, Maine
1993 *Breda Fotografica*; De Beyerd Museum, Breda, The Netherlands (Slide installation *Playback* and photographs)
　　Collected Visions 1; Commissioned Slide/Music Installation with Music by Elizabeth Brown, Houston Center for Photography, Houston, Texas
1994 Rhode Island School of Design; Providence, Rhode Island
1996 *Playback*; Manchester Craftsman's Guild, Pittsburgh, Pennsylvania
1996 *Collected Visions on the Web*; World Wide Web project sponsored by the Center for Advanced Technology at New York University, http://cvisions.cat.nyu.edu
1998 *Connecticut Visions*; World Wide Web project commissioned by the CT Historical Society, http://www.ctvisions.org
2000 *Collected Visions: A Computer-based Installation*; International Center of Photography Midtown, New York, New York; 2001, Zilka Gallery, Wesleyan University, Middletown, Connecticut
2001 *Lorie Novak. Photographs 1983–2000* and *Collected Visions: A Computer-based Installation*; Center for Creative Photography at the University of Arizona, Tucson, Arizona

Selected Group Exhibitions

1984 *Color Photographs, Recent Acquisitions*; Museum of Modern Art, New York, New York
1987 *Photography on the Edge*; Haggerty Museum, Milwaukee, Wisconsin
　　Visual Paradox; John Michael Kohler Art Center, Sheboygan, Wisconsin
　　Family Portraits; Wright State University, Dayton, Ohio
1989 *The Presence of Absence: New Installations*; Circulated by Independent Curators Inc., New York, New York
1991 *The Pleasures and Terrors of Domestic Comfort*; Museum of Modern Art, New York, New York; 1992–1993, Baltimore Museum of Art, Baltimore, Maryland; Los Angeles County Art Museum, Los Angeles, California; Contemporary Arts Center, Cincinnati, Ohio
　　Imaging the Family. Photographs by Tina Barney, Lorie Novak, and Larry Sultan; David Winton Bell Gallery, Brown University, Providence, Rhode Island
　　Re:memory—Picturing the Private Past; Birmingham Museum of Art, Birmingham, Alabama
　　Sequence(con)Sequence; Bard College, Annandale-on-Hudson, New York
　　The Photography of Invention: American Pictures of the 1980s; National Museum of American Art, Washington, D.C.; Museum of Contemporary Art, Chicago Illinois,; Walker Art Center, Minneapolis, Minnesota

1992 *Parents*; Museum of Contemporary Art, Wright State University, Dayton, Ohio

 flesh & blood; Friends of Photography, San Francisco, California

 Selections 2, Work from the Polaroid Collection; Photokina, Cologne, Germany, and traveling

1993 Tufts University Art Gallery, Medford, Massachusetts; Fleming Museum, Burlington, Vermont

1996 *Embedded Metaphor*; Independent Curators Inc., New York, New York, and traveling

 The Familial Gaze; Hood Museum of Art, Dartmouth College, Hanover, New Hampshire

 The Enduring Illusion; Stanford Museum of Art, Stanford, California

1997 *Telling Our Own Stories: Florida's Family Photographs*; The Southeast Museum of Photography, Daytona Beach, Florida

1999 *The Changing Face of the Family*; The Jewish Museum, New York, New York

 Defining Eye: Women Photographers of the Twentieth Century; UCLA Hammer Museum of Art, Los Angeles, California; National Museum for Women in the Arts, Washington, D.C.

 Landshapes; Southeast Museum of Photography, The Southeast Museum of Photography, Daytona Beach, Florida, and traveling

2000 *Voyages Per(formed): Early Photography and Travel*; The Southeast Museum of Photography, Daytona Beach, Florida; 2001, Photographic Resource Center, Boston, Massachusetts

2001 *At Home: Domestic Imagery in Modem Art*; Victoria and Albert Museum, London, England

Selected Works

Critical Distance, slide installation, 1987–1988
Traces, slide/sound installation, 1990–1991
Playback, slide/sound installation, 1992
Collected Visions I, slide installation with music by Elizabeth Brown, 1993–1994

Lorie Novak, Excerpt from "layback," slide installation with live radio scan, Lorie Novak, 1992; wall images, 16 × 24′, pool 5′ in diameter.
[© *Lorie Novak, 1992. Courtesy of the artist*, www.lorienovak.com]

Collected Visions on the Web, World Wide Web project sponsored by the NYU Center for Advanced Technology, http://cvisions.cat.nyu.edu, 1996

Connecticut Visions, World Wide Web project sponsored by the Connecticut Historical Society, URL: cvisions.org, 1998

Collected Visions, Computer-based installation with music by Elizabeth Brown, software by Jonathan Meyer, sound design by Clilly Castiglia, stories edited by Elizabeth Brown, Lorie Novak, and Neta Lozovsky, 2000

Voyages Per(Formed), (artists' book), 2000

Further Reading

Bloom, John. "Interiors: Color Photographs by Lorie Novak, 1978–1985." Reprinted in *Photography at Bay*. Albuquerque, NM: University of New Mexico Press, 1993.

Esders, Viviane, ed. *Our Mothers*. New York: Stewart, Tabori, & Chang, 1996.

Galassi, Peter. *Pleasures and Terrors of Domestic Comfort*. New York: Museum of Modern Art, 1991.

Hirsch, Marianne. "Surviving Images: Holocaust Photographs and the Work of Postmemory." *The Yale Journal of Criticism* 14.1 (Spring 2001): 5–37.

Hirsch, Marianne. *FAMILY FRAMES Photography, Narrative, and Postmemory*. Cambridge, MA: Harvard University Press, 1997.

Hirsch, Marianne. "Projected Memory: Holocaust Photographs in Personal and Public Fantasy." In *Acts of Memory: Cultural Recall in the Present*. Edited by Mieke Bal, Jonathan Crewe, and Leo Spitzer. Hanover, NHM: University Press of New England, 1999.

Lahs-Gonzales, Olivia, and Lucy Lippard. *Defining Eye: Women Photographers of the Twentieth Century*. Saint Louis, MO: St. Louis Art Museum, 1997.

Novak, Lorie. "Collected Visions." In *The Familial Gaze*. Marianne Hirsch, ed. Hanover, NH: University Press of New England, 1999.

Rosenblum, Naomi. *A History of Women Photographers*. New York: Abbeville Press, 1994.

Smith, Joshua. *The Photography of Invention*. Cambridge, MA: MIT Press, 1989.

Willis, Deborah. *Imagining Families: Images and Voices*. Washington, D.C.: The Smithsonian Institution, 1994

NUDE PHOTOGRAPHY

The first photographs of the nude appeared roughly simultaneously with the first cameras. It is a truism that every new communication medium is rapidly turned to the production of pornography, and it is this very problem that has plagued photographers who wished to depict the nude human figure. Distinctions between the nude as art, the nude as erotica, and the nude as pornography/obscenity can be imprecise, subjective, and culturally dependent.

The earliest manifestations of the photographic nude in the twentieth century involved the production of the infamous "French postcards," which were for sale in the streets of Paris from about 1905 to 1925. The development of the picture postcard meant that images could be mass produced cheaply instead of being printed from a negative one at a time. The trade flourished in Paris because of the city's notoriously relaxed attitude toward sexuality, as well as the availability of a large pool of talent on both ends of the camera—many artists resided in the City of Light, along with a substantial number of women of easy virtue, who were willing to commit the (then) scandalous act of posing nude for photographs.

It is perhaps not coincidental that professionally-taken nude photos in the United States began in a similar milieu. Around 1912, E. J. Bellocq, about whom little is known, took a series of photographs featuring the prostitutes of New Orleans famed "Storyville" district. Although not all of Bellocq's photos involve nudes (some are quite touching in their innocent domesticity), many of them do.

In the early years of the twentieth century, those who wished to take and/or publish photographs of the nude figure had to contend with the fundamental assumption on the part of many that photography is not really art, since it involves both mechanical and chemical processes in its creation. More traditional forms, it was argued, such as painting and sculpture, depended entirely on the artist's skill and vision and thus represented "pure" art. In contrast, photography seemed more technical than artistic. This prejudice plagued all early photographers, regardless of their subjects, but it was felt particularly acutely by those photographing the nude. For if the nude figure was not considered art, then it would, by default, be con-

strued as pornography (or at best, eroticism) and subject to social and legal sanction.

For years, photographers sought to gain respectability for their nascent art form by having their product imitate classical art forms, especially painting. This effort was clearly manifest in nude photography produced in the late nineteenth and early twentieth century. Nudes are portrayed reclining on beds or sofas, gazing dreamily off into the middle distance, surrounded with luxurious fabrics and unlikely props.

This approach gradually gave way to the work of the Photo-Secessionists, led by Alfred Stieglitz, who wanted photography to be accepted in its own right as an art form, and sought to achieve this goal by using the techniques that were unique to photography—such as special printing techniques, retouching of negatives, and the use of soft focus and filters, in an attempt to duplicate the look of the traditional fine arts mediums of painting and prints. But it was Stieglitz himself who realized that this approach was limiting, and he eventually sought to develop a uniquely photographic style, especially as it involved the nude. Nude photography as we know it today has its origins with Stieglitz's later work, especially the studies of his wife, Georgia O'Keeffe, as well as in the works of Edward Weston, known for their combination of artistic sensibility, passion, and a sense of the power of the camera as a recorder of reality. Weston's nude studies from the 1920s and 1930s of his various mistresses and wives, including Tina Modotti, set the standard for fine arts black-and-white nude photography; his famous studies of vegetables and shells also defined the artistic nude in demonstrating how black-and-white photography can capture the surface of things to create a sensuous, provocative image.

Others who helped bring nude photography into the modern era include European photographers of the 1920s and 1930s, including Maurice Tabard, Erwin Blumenfeld, and Brassaï, influenced by Surrealism and the theories of the subconscious promulgated by Sigmund Freud. Man Ray used the nude in his photograms to create sensuous and new representations of the female body; André Kertész and André Steiner experimented with distortion techniques to create startling images of human flesh. In the United States, two pioneering women photographers made modernist nude studies. Imogen Cunningham photographed both the male and female nude. Ruth Bernhard highlighted the curves of the female body by contrasting it with the hard edges of geometric figures. Paul Outerbridge Jr. was an innovator in the use of color photography, creating a series of nudes as early as the 1930s.

The choice of subject has always been an issue for those concerned with photography, and nowhere is this more true than when the subject involves nudes. One important issue involves gender. The vast majority of work featuring the nude focuses on female subjects. Set aside the last two decades of the twentieth century, and the female figure probably occupies 95% or more of all nude studies published. Many have raised the legitimate question of why this should be so.

One answer involves simple demographics. Traditionally, photography has been both a business and a hobby carried out by men (although this has been changing in recent decades). A heterosexual man interested in photographing nudes will probably be drawn to the female form, given the inherent beauty that most men find in the female body, as well as the sexual stimulation which female nudes usually provide. Sexually, men tend to be much more responsive to visual stimuli than women, which probably explains why "skin magazines" appealing to men proliferate while those aimed at women are rare.

However, another explanation has been offered by some feminist critics, who argue that the predominance of nude female images represent men's continuing power over women. Thus, as one "takes" a photograph, one simultaneously "possesses" the subject of the photo. In this view, a man photographing a nude woman is both objectifying and possessing her—and, if the photo is later sold, exploiting her as well.

The relative paucity of male nudes until recently may also be explained in part by longstanding Western homophobia. Homosexuality was (and in some ways, continues to be) a stigma, and a man who sought out nude male models ran the risk of being perceived as homosexual. If the male nudes were published, the risk increased geometrically. Likewise, a man viewing male nudes, even if his interest was purely aesthetic, faced the suspicion that he found the images sexually attractive, with all the attendant cultural condemnation that involved.

Another issue of subject choice involves children. It is well recognized that children have sometimes been victims of sexual exploitation, some of which has taken the form of photographs. Child pornography (also called "kiddie porn"), which refers to pictorial materials (whether still or in motion) of sexual acts involving children is rightly condemned by many societies and considered a serious criminal offense. But beginning in the 1970s, some countries extended the definition of child pornography to include photographic depictions that did not involve acts commonly consid-

ered obscene. Great Britain passed the Protection of Children Act in 1978, which made illegal indecent photographic representations of children. However, the act does not define the term "indecent," which has led to such actions as the prosecution of BBC news anchor Julia Somerville for sending to a photo lab nude, non-sexual pictures of her preadolescent daughter.

In the United States, relevant federal law includes the Child Protection Act (1984), which denies child pornography protection under the First Amendment, and the Child Pornography Prevention Act (1996), which makes it a federal crime to possess or distribute images that sexually exploit or appear to sexually exploit minors. In addition, each state has its own laws on the subject. The inherent difficulty in defining terms such as "indecent" and "exploit" has led to unsuccessful action against American photographer Jock Sturges, active in the 1970s through the end of the century, for his work depicting adolescent nudists, and threats of legal action against photographer Sally Mann, who has published two books that included photos of her young children nude or partially clothed. The ambiguity of some state laws has resulted in prosecution (or threats thereof) of parents in California, Maryland, Missouri, and Ohio. In each case their offense involved bringing to a photo lab negatives depicting their children naked. Even Edward Weston's 1920s-era nude photographs of his son Neil, considered of the highest artistic merit, have become increasingly difficult to present. Weston was not alone in photographing children nude; around the turn of the century, nude studies of children were a common artistic photography subject, and women, notably Bay Area Photo-Secessionist Anne W. Brigman, were especially active in this genre.

In terms of genre, nude photography may be divided into the categories of art, anthropology, erotica, advertising/fashion, photojournalism, and body culture. Each of these, along with their most prominent practitioners, will be discussed below.

The list of important nude photographers is long and distinguished. In addition to those already named, it includes the turn-of-the century American innovator Charles Schenk, who in 1902 published the first book of nude photos in the twentieth century, *Draperies in Action*, a series of collotypes that explored motion and form. In the early decades of the century, Arnold Genthe photographed dancers, nude or nearly nude, including the legendary Isadora Duncan and others following her free-spirited, naturalistic style of dancing. Harry Callahan's models (often his wife Eleanor) always

seem remote—mentally removed from their surroundings and their very nudity. Paris-based Emmanuel Sougez used the nude to portray the apotheosis of femininity with strong, naturally posed models in front of drapery in seminal works from the 1930s. Hungarian-born Ferenc Berko, who spent much of his career in Aspen, Colorado, often ignored the face entirely in his classic nudes of the 1930s through 1950s, as did the prolific French artist Lucien Clergue, whose nudes are often portrayed in or near the sea (such as the famous *Sea Nude, Carmargue*, 1958) or in controlled environments in which the body is a canvas upon which light and dark creates striking patterns. The distinguished photography teacher and instructional author Charles Swedlund was interested in advancing technique, and his nudes are often the products of his experiments with shutter speed, focus, and film stock. Bill Brandt, in contrast, used the wide-angle lenses and the archaic technology of a pinhole camera to photograph the nude figure, creating highly distorted images that downplayed sexuality.

At the end of the century, numerous artists presented nudes in photography, as opposed to nude photography. This is an important distinction: in much contemporary photography, nudity is presented as any other element, with no particular formal or stylistic emphasis on the depiction and which is most often part of a larger aesthetic project. Gilbert & George, for example, often present nudes in an overall scheme of social and political commentary. A deliberately informal, snapshot style of depicting the nude began to emerge in the 1980s. This important tendency is typified by such figures as Nan Goldin, who presents a diary of all aspects of the lives of her circle of friends; Wolfgang Tillmans, who shows his subjects naked for seemingly no particular reason, or Boris Mikhailov, who while favoring a social realist style, convinced Russian derelicts to take off their clothes when having their pictures made.

Anthropology, in this context, refers to photographic studies of foreign cultures. In some of those cultures (especially those in tropical climates), nudity or semi-nudity may be the norm, so photographic representations will necessarily include the nude.

In the United States, the most accessible source for this kind of photography was, for many years, the magazine *National Geographic*. But the magazine's approach to the subject raises some interesting racial issues. *National Geographic* regularly published photos of women with bare breasts; in addition, it sometimes included photos clearly showing the naked genitals of men—but these displays of flesh only occurred if the subjects were non-white. Between the 1950s and the

1990s (the magazine has since changed its policies, and no longer publishes nudes of any race), *National Geographic* presented nude or semi-nude photos of members of several African tribes (Nuba, Zulu, Dyak, and Masai, among others), several tribes of South American Indians (including the Jivaro and Urueu-Wau Wau), residents of Yap Island, New Guinea, and the Adama Islands, and even African-American entertainer Josephine Baker. But not one person of Caucasian ancestry was similarly displayed.

Erotica is, of course, designed to prompt sexual desire. As such, erotic nudes are often confused with pornography by consumers, critics, and courts. The essential difference is one of artistic intent and skillful execution. American law defines pornography as that which lacks redeeming social value. Erotica, therefore, is that which possesses such value. In America, pubic hair in a photograph was long considered a mark of pornography and was thus shunned by respectable photographers—although this distinction fell by the wayside in the 1970s. This distinction has been similar in Japan, where censorship of nudes was rigorous into the 1980s, and so-called "hair nudes" freely published and shown only in the closing years of the century. As late as 1986 leading photographic magazines publishing artistic nudes have been prosecuted for obscenity. Nudes by Araki Nobuyoshi helped break down these long-standing taboos, and books featuring "fully" nude photographs of television and movie actresses were runaway best sellers in the late 1990s.

Important photographers in the erotica genre include Bunny Yeager, a former "figure model" herself who achieved fame in the 1950s photographing model Betty Page; Helmut Newton, whose often fetishistic nudes disturbed as often as they stimulated, and Robert Mapplethorpe, whose explicit homoerotic photographs caused considerable controversy in the last two decades of the century. A subcategory of erotica includes historical male nude photography by fashion or glamour photographers such as George Platt Lynes.

Advertising in America (although not in Europe) has tended to shy away from nudity, unless it is portrayed very discreetly. J. Frederick Smith, well known as a pin-up illustrator, was also a master at creating beautiful but culturally acceptable nudes for magazine advertising. Fashion magazines, whose editorial content is itself a form of advertising, have been less restrained. Beginning in the 1960s, publications like *Vogue* and *Harper's Bazaar* often featured elegantly photographed nudes or semi-nudes by such masters of the form as Richard Avedon, Hiro, and Irving Penn.

Body culture, a term originating in Germany's Weimar Republic in the 1920s, includes athletics, body building, and nudism. Nudity and athletes have a long association, since the competitors in the original, Greek Olympics are said to have competed in the nude. In acknowledgement of this tradition, the official poster for the 1912 Stockholm Olympics featured several nude athletes, their genitals carefully hidden. Posters for the Olympics of 1920 (Antwerp), 1924 (Paris), and 1952 (Helsinki) also featured artistic photos of nude male competitors. Discreetly posed photos of Olympic athletes constituted the cover story of the July 1996 issue of *Life* magazine.

Body builders, by definition, desire their muscular forms to be displayed, and such exhibitions have usually involved minimal clothing so as to maximize the aesthetic experience for the viewer. Some body builders have dispensed with clothing entirely, posing for photos in the nude. Photographers specializing in unclothed male bodybuilders include David Leddick, Reed Massengill, and Don Whitman. Bill Dobbins and Paul Goode have been among those best known for focusing on female competitors.

Nudism is a philosophy that contends that the human body is inherently beautiful, and maintains that nudity is not necessarily sexual. Nudist organizations have been publishing magazines portraying this lifestyle for decades, the first of which was the German magazine *Gymnos*. The first American nudist publication was *The Nudist*, founded in 1929. Nudist photography typically features subjects of both genders, all ages, and a wide variety of body types. Lighting is generally natural, artificial poses are discouraged, and anything smacking of erotica is shunned.

Photojournalism is characterized by three elements: timeliness (it is part of the record of contemporary events); objectivity (the image accurately depicts the event that took place); and narrative (combines with verbal elements to give a coherent account). Probably the best known example of the nude in photojournalism is Nick Ut's 1972 Pulitzer Prize winning photo of a nude, preadolescent Vietnamese girl fleeing her napalmed village. Many photojournalists had difficulty finding a market for nudes, since few mainstream publications would publish "full frontal nudes," and only a limited number would consider more modest depictions, such as those involving a rear or side view of the subject. These policies were relaxed somewhat beginning in the 1980s, and it became possible to find discretely-portrayed nudes (i.e., no genitalia on view) in publications such as *Time*, *Newsweek*, and *People*.

Edward Weston, Torso of Neil, 1925, Platinum/palladium print, 9⅛ × 5½″, Purchase.
[© 1981 Center for Creative Photography, Arizona Board of Regents. Digital Image
© The Museum of Modern Art/Licensed by SCALA/Art Resource, New York]

NUDE PHOTOGRAPHY

The development of the Internet has made photography of all sorts easily available to consumers, including nudes. Although many of the nude photos available on the World Wide Web involve hard-core pornography, the work of some of the best photographic artists can also be located, making them available to a far larger audience than ever before.

J. JUSTIN GUSTAINIS

See also: **Bernhard, Ruth; Blumenfeld, Erwin; Brandt, Bill; Brassaï; Callahan, Harry; Cunningham, Imogen; Erotic Photography; Gilbert & George; Hiro; Kertész, André; Life Magazine; Mapplethorpe, Robert; Mikhailov, Boris; National Geographic; Newton, Helmut; Nobuyoshi, Araki; Outerbridge Jr., Paul; Penn, Irving; Photo-Secessionists; Pin-Up Photography; Ray, Man; Representation and Gender; Steiner, André; Stieglitz, Alfred; Tabard, Maurice; Weston, Edward**

Further Reading

Chandler, David. "Birth of the Post-Modern Body." *Creative Camera* no. 336 (October/November 1995).

Cunningham, Imogen, and Richard Lorenz. *Imogen Cunningham: On the Body*. Boston: Bulfinch Press, 1998.

Davis, Melody D. *The Male Nude in Contemporary Photography*. Philadelphia: Temple University Press, 1991.

Edwards, Susan H. "Pretty Babies: Art, Erotica, or Kiddie Porn?" *History of Photography* 18 (Spring 1994).

Goldsmith, Arthur A. *The Nude in Photography*. Chicago: Playboy Press, 1975.

Kelly, Jain. *Nude: Theory*. New York: Lustrum Press, 1979.

Kohler, Michael. *The Body Exposed: Views of the Body: 150 Years of the Nude in Photography*. Zurich, Switzerland: Edition Stemmle, 1995.

Kuhnst, Peter, and Walter Borgers. *Physique: Classic Photographs of Naked Athletes*. London and New York: Thames and Hudson, 2004.

Lacey, Peter. *Nude Photography: The Art and Technique of Nine Modern Masters*. New York: Amphoto, 1985.

Lewinski, Jorge. *The Naked and the Nude: A History of the Nude in Photographs, 1839 to the Present*. New York: Harmony Books, 1987.

Peeler, David P. "Alfred Steiglitz: From Nudes to Clouds." *History of Photography* 20 (Winter 1996).

Sullivan, Constance. *Nude: Photographs, 1850–1980*. New York: Harper & Row, 1980.

Tarrant, Jon. "From First Flesh to Modern Pornography." *British Journal of Photography* no. 7383 (June 19, 2002).

INDEX

INDEX

D

I

INDEX

X

Z